Marcel Duchamp
Life

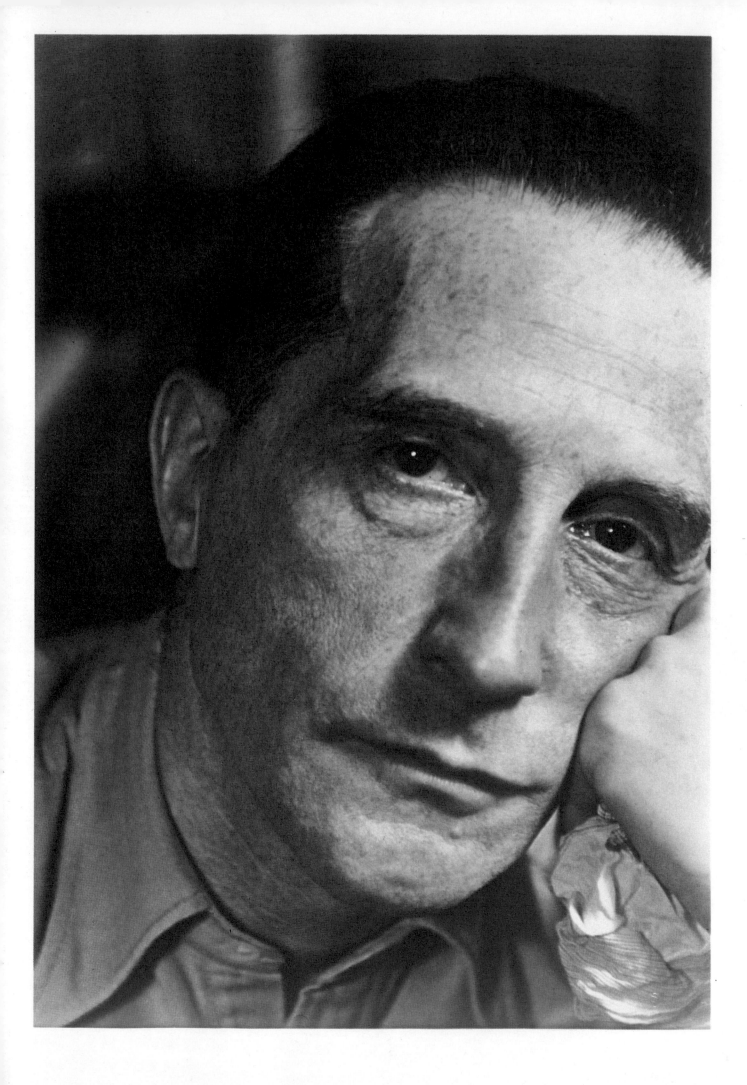

Jennifer Gough-Cooper
Jacques Caumont

Ephemerides on and about Marcel Duchamp and Rrose Sélavy

1887–1968

Thames and Hudson

Madame Alexina Duchamp was the first to read
these *Ephemerides* together with Jacqueline Monnier.
We would like to thank them for their close
interest and encouragement in this work in progress.
Jennifer Gough-Cooper
Jacques Caumont

19.5.1914

taking action to prevent moth in the fur-lined coat." Duchamp proposes that a reply to the Villons can be posted to him at Sanary, care of his sister Yvonne, where he will be until 26 May.

*

It is raining again. Marcel and Roché have a good talk over lunch at the Bec Fin. In the afternoon they go up to La Tronche on the northern outskirts of the city to see Alec Ponisovsky, a friend of Peggy Guggenheim's, but he is not at home.

After returning to the Bec Fin for dinner, Marcel gives Roché a chess lesson at the Café Bourgoin.

1943. Tuesday, New York City
"The Spring Salon for Young Artists," which opens today at Art of this Century [13.3.1943], includes pictures by Matta, Motherwell, Ad Reinhardt, a "painting construction" by Harry Holtzman, and *Stenographic Figure* by Jackson Pollock. The exhibition has been selected from works by artists under thirty-five years of age by a jury composed of Alfred Barr, Marcel Duchamp, Peggy Guggenheim, Piet Mondrian, Howard Putzel, James Thrall Soby, and James Johnson Sweeney.

On selection day, Mondrian was the first juror to arrive and Jimmy Ernst observed that he started looking at the works standing around the gallery. When he stopped at *Stenographic Figure* by Jackson Pollock, Peggy Guggenheim went over and remarked, "Pretty awful, isn't it." Mondrian finally said that he was not so sure: "I'm trying to understand what's happening here. I think this is the most interesting work I've seen so far in America... You must watch this man."

Stunned, Peggy said, "You can't be serious. You can't compare this and the way you paint."

"The way I paint and the way I think are two different things," replied Mondrian.

As the other jurors arrived, Peggy took them over to look at the Pollock saying: "Look what an exciting thing we have here!"

In fact Mondrian agreed to be on the jury because he particularly wanted to help Holtzman, the student who rescued him in 1940 from impoverishment in Paris. By drawing attention to the Pollock, and demonstrating that he was not only interested in his own work, Mondrian achieved his goal and the jury decided to include both the Holtzman and the Pollock in the exhibition.

1944. Thursday, New York City
In the morning Marcel learns that Florine Stettheimer died on 11 May. He writes a letter of condolence immediately to her sisters Ettie and Carrie: "You know what admiration I had for her painting and her attitude in general to understand just how much I have been struck by the sad news..."

He wonders whether there is anything he can do "in the domain of painting corresponding with her last wishes" and asks them to be kind enough to let him know when he can call to see them both.

1946. Saturday, Paris
On the back of a letter which Mary Reynolds has written to Jean Brun, Duchamp adds that he heard, soon after his arrival, about Brun's visit to Rue Hallé and has read "with great interest" the "fable de la fontaine".

"Naturally, the Green Box enters your library without [passing through] customs and give me the pleasure," he requests, "of accepting it without any further ceremony."

*

At two o'clock in the afternoon Marcel calls to see Roché again at Arago.

1961. Thursday, New York City
One hundred and eighty-three paintings, drawings, collages, objects and pieces of sculpture by contemporary artists, collected by Duchamp with Teeny's help [2.3.1961], are auctioned. At a quarter to two the "Property of the American Chess Foundation donated for the benefit of its Artists' Fund and from other owners" is sold at the Parke-Bernet Galleries, 980 Madison Avenue.

The Artists' Fund [which is subsequently renamed the Marcel Duchamp Fund], "will be administered by the American Chess Foundation," states Sidney Wallach in the foreword to the sale catalogue, "to provide a greater degree of participation by US chess masters in important and international chess events."

At the expense of a few artists, whose works go for "disastrous prices", the sale nevertheless makes over $37,000. A copy of the *Boîte-en-Valise* [7.1.1941] is sold for the "fabulous price" of $1,100.

After so much hard work it is a relief that the sale is over: convinced that they "are just not made for this kind of thing", Teeny and Marcel decide "never again".

1966. Wednesday, Neuilly-sur-Seine
Recounting his meeting the previous day with Jean Hélion in a letter to Noma and Bill Copley, Marcel recommends that the Cassandra Foundation give the artist an award "which he deserves from every angle... It is up to you," Marcel continues, "to decide *oui, non, ou merde.*"

19 May

1914. Tuesday, Paris
"Only the pictures by the Benjamin of the family were missing," writes Apollinaire in his article entitled "Une Gravure qui deviendra rare" for *Paris-Journal*, reporting on Paul-Napoléon Roinard's reading at Villon's studio on Sunday. He explains to his readers that Marcel Duchamp, whose talents, in his opinion, "are the most evident and newest," has become librarian at Sainte-Geneviève [3.11.1913]... And that is why, for two years now, we no longer see any picture by Marcel Duchamp anywhere."

Indeed, although he sent works to the Armory Show [17.2.1913] in New York, Duchamp has not exhibited in Paris since the "Section d'Or" [9.10.1912]. Avoiding the life of a professional painter, he has this part-time job at the library, which enables him to continue working quietly for himself.

After being steeped in the discussions at Puteaux on mathematics, measurements and the fourth-dimension, Duchamp has created his own unit of measurement.

"If a horizontal thread one metre long falls from a height of one metre on to a horizontal plane twisting as it pleases and creates a new image of the unit of length." And "without controlling the distortion," Duchamp performed the operation three times. "The shape thus obtained was fixed onto the canvas by drops of varnish."

This experiment "to imprison and preserve forms obtained by chance" – Duchamp's own chance – is entitled *3 Stoppages Etalon.* Conversely to Roussel's pun with *etalon à platine* [10.6.1912], Duchamp's starting point is *stoppages et talons*, a shop sign in the Rue Claude-Bernard advertising invisible mending and heel repairs to socks and stockings. It follows that Duchamp's *mètre etalon*, or standard metre,

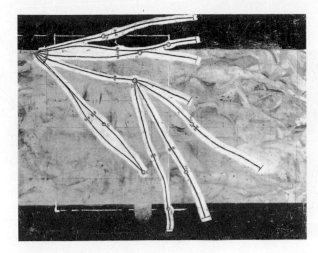

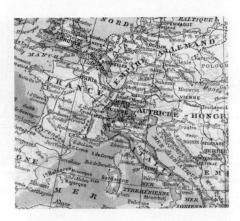

should be made with sewing thread, therefore, rather than any other material.

Using each of the three "curved metres" of *3 Stoppages Etalon* three times, Duchamp has established the form of the nine Capillary Tubes, conduits for the Illuminating Gas. He draws the plan of these Capillary Tubes onto an old canvas which has on it an unfinished version of *Jeune Homme et jeune Fille dans le Printemps* [24.8.1911], and on top of that, a half-scale plan perspective [22.10.1913] of the Large Glass.

The nine numbered circles marked on this *Réseaux des Stoppages*, as the canvas is called, indicate the final position in plan of each Malic Mould in the lower section of the Large Glass.

It has been observed that, by some strange coincidence, this Network of Stoppages resembles the diagrammatic relationship on a Thomas Cook map of certain European cities which Duchamp visited in 1912, taking Rouen as a starting point.

1921. Thursday, New York City
Suzanne and Jean Crotti have sent Marcel a copy of the catalogue of their exhibition which opened at the Galerie Montaigne in Paris on 4 April. For Tristan Tzara, who is organizing a Salon Dada to open in June at the same gallery, they have asked Marcel whether he would like to exhibit. He replies to Suzanne saying: "As you know very well, I have nothing to exhibit – that the word *exposer* resembles the word *épouser*…"

As he plans to be back in Paris before the Salon closes, Marcel thinks that the exhibition will be very amusing for him, as nothing at all is happening in New York. With prohibition, "the slightest pleasure is expensive now and *la soûlographie* has become very highbrow." He is waiting to be at sea "to drink a cocktail at normal prices or cocktails at a normal price."

Further to a request for documents of works exhibited by Crotti at the Montross Gallery [4.4.1916], Marcel has seen the photographer Peter Juley and obtained two prints of "the head", and he is going to contact Charles Sheeler for photographs of *Le Clown*. He promises to bring some jazz records for Suzanne and Mad Turban.

Wondering what kind of pictures Suzanne is buying and selling and whether she is in contact with de Zayas, one of the most respected dealers in New York, Marcel tells her: "If you are in need of an assistant, maybe I could fill the bill."

1924. Monday, Paris
In the evening Mary Reynolds and Marcel go with Roché, Mrs Rumsey and three other friends to a show and then have dinner afterwards in a restaurant in Rue Fontaine. Meeting her for the first time, Roché is very taken with Mary, Marcel's American friend, "a beautiful, tall dancer, calm and noble." According to Roché it is a jolly evening.

1926. Wednesday, Venice
After breaking his journey in Milan, Duchamp arrives in Venice in the evening and joins Miss Dreier at the Hotel d'Italie Bauer-Grünwald on the Grand Canal. Invited to spend four days with her to compare notes on the preparations for the international exhibition of the Société

Anonyme, Duchamp has brought with him the list of works which he has already collected in Paris for the first shipment to New York. While Duchamp has been occupied in Paris [8.5.1926], Miss Dreier has been to select work in Hanover, at the Bauhaus in Dessau, and also in Berlin, Dresden, Prague and Vienna.

1941. Monday, Grenoble
In the morning Roché accompanies Marcel to the Banque de France, the station, the Préfecture [25.4.1941], and the Musée de Grenoble to see André Farcy. Fascinated by his friend's organization, Roché compares again the method in Marcel's life to the way he plays chess. They return to the Bec Fin for lunch.

As Roché has agreed to lend him 30,000 francs, Marcel writes a signed receipt on the headed notepaper of the Hôtel Moderne. He also writes a note to Alec Ponisovsky, whom they failed to see the previous day, concerning the arrangements between the three of them.

In the evening they take the cable car to the Restaurant Gras for dinner but, compared to Saturday, the sunny panorama is obliterated by the rain. Afterwards they go to the Brasserie de Savoie until Marcel boards his train, which departs for Marseilles at ten-forty.

1942. Tuesday, at sea
The voyage from Marseilles [14.5.1942] in splendid weather seems more like a cruise as the ship hugs the coast of Spain. At night all the lights are blazing. Steaming towards Casablanca, today the *Maréchal Lyautey* passes Gibraltar.

1944. Friday, New York City
Duchamp and Miss Dreier have lunch with the artist David Burliuk and his wife at the Town Hall Club to discuss the book about him which Miss Dreier is preparing.

1947. Monday, New York City
Marcel dines with the Kieslers at their apartment.

1958. Monday, New York City
On the day that Charles de Gaulle gives a press conference in Paris at the height of the uprising in Algeria, Teeny tells Jackie: "We have been glued to the news, it will be a miracle if France pulls itself out of this." Referring to their plans for the summer, Teeny writes: "We still feel like coming… Marcel suggests that if France gets too difficult in June, we might start by a month in Spain…"

1960. Thursday, New York City
Needing decisions prior to the printing of his typographic version [9.5.1960] of the Green Box, Richard Hamilton has sent Marcel photographs of the paste-ups of certain pages and the draft of his text to be printed as an appendix. Marcel has found nothing to correct in the text, and has sent it to George Heard Hamilton as requested, commenting: "I think it is exactly what most readers don't but should know."

Having no corrections on the pages Marcel says: "I adore the hand-coloured page!" For the Wasp, he agrees that Richard should use a half-tone photograph and superimpose the text. Regarding the title on the cover, "naturally the black dots go with the white ones," Marcel confirms.

*

Marvin Lazarus has brought his photographs [11.12.1959] to show Duchamp and, as he evidently likes them, decides to give Duchamp a complete set.

During their conversation, Lazarus finds Duchamp difficult to listen to because he is so fascinating to watch. "Duchamp's motions are a

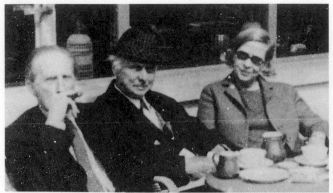
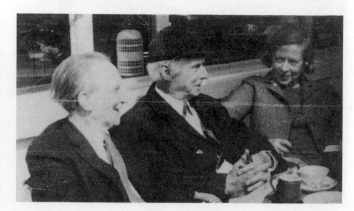

19.5.1967

ballet," he writes later. "Duchamp is friendly. His face however is not volatile… his face seems to sit there – his lips occasionally are pursed; his eyes will squint for a moment. Nothing dramatic… There is almost a mask – which in most persons you would resent. However, there is such a feeling of amused warmth and life behind the mask you feel charmed rather than resentful.

"And why is there this life? It is Duchamp's hands. They are never still – but they are seemingly never in motion. They glide from one arm to the other. They are suddenly clasped together. In a moment he is leaning his face on an outstretched finger. A finger touches his eye, it causes a squint that is sinister. In a moment that position is gone. A finger to his lips. A hand on an elbow. I sat there and watched a choreography which almost hypnotized me. One would think this endless motion would be distracting, but to the contrary one feels a fantastic feeling of calm and repose. It is the face, the calm backdrop of his face which coordinates all these motions into the man."

1967. Friday, Paris
The Duchamps and Max Ernst are photographed while sitting together on the terrace of a café.

20 May

1900. Sunday, Blainville-Crevon
At nine-fifteen in the morning, a week after the second ballot, the new council meets at the Mairie to elect the mayor and his deputy. In the customary secret ballot, Eugène Duchamp is unanimously re-elected mayor of Blainville, and Déquinemare is elected deputy mayor.

1917. Sunday, New York City
Beatrice Wood has a happy day in the company of Marcel and Roché.

1924. Tuesday, Paris
After drinking more *cafés crèmes* together at six in the morning, Roché accompanies Marcel to the Hôtel Istria, Rue Campagne-Première. Sitting on Marcel's bed, they discuss possible business and recall times at the studio on 67th Street, Beatrice Wood and Lou Arensberg.

1931. Wednesday, Brussels
As announced in the April number of *L'Echiquier*, today is the closing date for applications at subscription price for copies of *Opposition and Sister Squares are Reconciled* by M. Duchamp and V. Halberstadt, a book in three languages and three colours, to be published by *L'Echiquier*, 274 Avenue Molière [18.12.1930].

1935. Monday, Paris
To exhibit his optical discs, now protected with a trademark [9.5.1935], at the annual Concours Lépine for inventors and small manufacturers opening on 30 August, Duchamp pays a deposit of 200.50 francs [650 francs at present values] to the Association des Inventeurs et Petits Fabricants Français, 12 Rue des Filles-du-Calvaire.

*

Further to his telegram to Miss Dreier [12.5.1935] requesting her not to exhibit the Stoppages, Dee writes to her again. He explains that *3 Stoppages Etalon* [19.5.1914] is "3 canvases blue-black on which only a very fine line is made by thread glued down with varnish"; on the bottom of each is written the title and date. "When I made the panel *Tu m'* [8.7.1918]," explains Dee, "I made from the *Stoppages Etalon* 3 wooden rulers which have the same profile as the thread on the canvas. *And then* in 1920 or 21 I built the 'revolving glass', which has nothing to do with the *Stoppages Etalon*."

Referring to his previous letter [3.5.1935], in which he described *Rotative Plaques Verre* [20.10.1920], Dee says that the five glass panels, iron chassis and electric motor were "unmounted and put in a long box, specially made for it at your place… that made a very heavy box". He continues firmly: "I cabled not to exhibit the *Stoppages Etalon* and you can't show 3 panels of glass unmounted when there should be five and a motor, etc. I hope you will find it again."

Thanking Miss Dreier warmly for inviting him to New York, Dee tells her that this year "it is utterly impossible" because of preparing his "playtoy" for the Concours Lépine. "This means trying to launch it in a businesslike way."

1936. Wednesday, Le Havre
On a card representing the famous liner *Normandie*, pride of the French line since she was launched a year ago, Duchamp writes to Dr Dumouchel. "I am leaving soon. Will I see you in

August in Paris?" he asks his old schoolfriend, who is staying at Auffay, just inland from Dieppe.

*

After moving from the dry dock that morning with two new propellers, the *Normandie* is lying alongside Quai Joannes Couvert ready to sail. Duchamp is among the six hundred passengers, including the French writer Jules Romains, and various personalities of stage and cinema, to board the ship by what is claimed to be "the longest gangplank in the world".

Sailing for New York via Southampton, the huge liner leaves the port just after one o'clock. There are crowds on the quays, crowds on the south jetty, at the Place Guynemer, and lining the Boulevard Clemenceau and the Boulevard Albert-1er.

Everyone, it seems, is out to watch the grandiose sight of the *Normandie* slipping past the breakwater to the outer harbour and out into the open sea.

1938. Friday, Paris
During their discussions when he calls to see Roché at 99 Boulevard Arago, Marcel says he is against "possession" and the complications of life.

1942. Wednesday, Santa Barbara
Louise and Walter Arensberg have lent a Braque, a Rouault and *Nu descendant un Escalier*, No.2 to an exhibition at the Santa Barbara Museum of Art for the benefit of the Allied Charities. This special show has been organized for the four-day United Nations Festival representing Free France. The occasion, which provides the unique meeting of Duchamp's celebrated painting together with Picasso's *Guernica*, also in the exhibition, attracts hundreds of visitors.

1945. Sunday, New York City
Marcel dines with Frederick Kiesler and Julien Levy.

1961. Saturday, New York City
"I find your letter so illuminating that I want to send it to Mr Guggenheim [16.5.1961]," writes Marcel to Brookes Hubachek. As time is short before his departure on 29 May, Marcel asks Brookes to cable him. This move, Marcel suggests, "might start a private correspondence on the subject" of Villon's *Portrait of the Artist's Father*, which Brookes would so much like to possess.

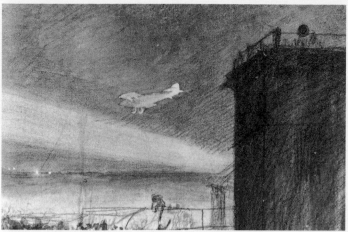

21.5.1927

1963. Monday, Rome
Teeny and Marcel arrive from Orly on a beautiful flight "over the snow-covered Alps with vistas in between the clouds". They are met by their hosts the Baruchellos and "auto-jeted" into Rome.

An exhibition of paintings by Gianfranco Baruchello opens that evening at La Tartaruga, coinciding with Duchamp's arrival. At the gallery, which is on the Piazza del Popolo, Duchamp meets his old friend Tristan Tzara and Baruchello introduces him to the art historian Giulio Carlo Argan. A dinner party is held afterwards at a villa in the Borghese gardens.

21 May

1915. Friday, Paris
Still determined to leave Paris and go to New York [27.4.1915], Marcel has been to the Compagnie Générale Transatlantique to enquire about departures at the end of the month. As there is no ship leaving on 29 May, he plans to book a passage on the *Rochambeau*, departing on 5 June. He has also been to Saint Germain-en-Laye to break the news to his brother Raymond, who finds the idea a good one but is against Marcel's leaving so soon. As Marcel suspected, his brother, for sentimental and family reasons (which he shares), would prefer him to wait a while. Having taken everything into consideration, however, Marcel has decided not to change his mind.

In spite of all his friends being at war, Marcel is trying to gather some material for Walter Arensberg's magazine. He writes to Walter Pach that he intends to speak to a number of friends who could provide poems or prose and try to find someone who could be relied on to correspond regularly with Arensberg.

Repeating his determination to find a job in New York even if it prevents him from painting, Marcel tells Pach not to worry, and adds: "I am worried enough to have caused you so much worry. But I hope to make up for all that."

*

After various studies for elements in the lower part of the Large Glass, Marcel has turned his attention to the Bride's domain above. The commands of the Pendu femelle, the suspended form extracted from the painting *Mariée*

[25.8.1912], are to pass through 3 nets, or Draft Pistons. The three Pistons are surrounded by a "kind of milky way *flesh colour*", which is "to be used as a support for the inscription" at the top of the Glass. To prepare the Pistons, Marcel made three photographs of a square piece of white gauze, but incorporating an element of chance as he did for the *3 Stoppages Etalon* [19.5.1914].

"I wanted to register the changes in the surface of that square, and use in my Glass the curves of the lines distorted by the wind," Marcel explained. "So I used a gauze, which has natural straight lines. When at rest, the gauze was perfectly square – like a chessboard – and the lines perfectly straight – as in the case of graph paper. I took the pictures when the gauze was moving in the draught to obtain the required distortion of the mesh."

1926. Friday, Venice
Writes a postcard to Brancusi to say that he will probably be back in Paris late on Wednesday evening.

1927. Saturday, Paris
Because of the extreme shortage of accommodation in Paris, it has been decided that after their wedding the couple will temporarily share Marcel's small seventh-floor studio at 11 Rue Larrey [22.4.1927] if the search for an apartment is unsuccessful. As Henri Sarazin-Levassor has expressed the desire to visit the studio, Marcel has invited him for a drink.

In the evening Sarazin arrives with his mistress, the opera singer Jeanne Montjovet, and his daughter Lydie. Suddenly shouts and cheers can be heard from the street below. From the bedroom window they can see excited crowds of people looking up into the cloudless sky. At about 900 feet is the *Spirit of St Louis* piloted by Charles Lindbergh arriving from across the Atlantic on his historic flight, which brings New York not more than 34 hours from Paris. Caught in the excitement which has been

building up all afternoon after a report from Kerry and then Cherbourg, Sarazin proposes they drive to Le Bourget. They are not alone. Traffic is at a standstill, everyone is out on the streets and, according to Lydie, Jeanne Montjovet utters startled cries as if her last hour has come.

1937. Friday, Paris
In his chess column for *Ce Soir*, Duchamp selects a prize-winning problem devised by the Frenchman, L. Romani and, for beginners explains chess notation. He comments on a beautiful endgame played by Dr Alekhine against Tylor in the recent tournament at Margate, and concludes by giving the results of the USSR championship, which has just finished at Tbilisi.

1942. Thursday, Casablanca
When the *Maréchal Lyautey* docks on arrival from Marseilles, the 293 transit passengers, including Duchamp are transferred to the Résidence Baulieu at Ain Sebea on the northern outskirts of the city.

1947. Wednesday, New York City
For the catalogue of Antoine Pevsner's exhibition at the Galerie René Drouin, 17 Place Vendôme, Duchamp sends a telegram with the message: "I the undersigned declare I have known Antoine Pevsner since 1923 and am indebted to him for many a surprise – Marcel Duchamp."

1962. Monday, New York City
Duchamp informs Roché's widow, Denise, that, as he and Teeny arrive in Paris on 25 May and go to Cadaqués on 31 May, they propose to visit her at Sèvres on either 26 or 27 May.

*

In the afternoon Duchamp receives Bill Camfield [4.4.1961], who has chosen Francis Picabia as the subject of his dissertation at Yale University, and he suggests numerous people who might help with his research.

1963. Tuesday, Rome
After visiting the Sistine Chapel decorated by Michelangelo, Teeny and Marcel have lunch in a restaurant recommended to them by Bernard and Jackie Monnier. "We loved it," Teeny told Jackie later, "and had the best *osso buco* and *fraises des bois* we have ever had."

22.5.1936

22 May

1915. Saturday, Paris
Attempting to fulfil a request from Walter Pach [21.5.1915], Duchamp has an appointment with Madame Ricou from whom he hopes to obtain some articles by Alexandre Mercereau, the co-director of the review *Vers et Prose*, to take with him to New York for Walter Arensberg's magazine.

1917. Tuesday, New York City
Marcel dines at the Brevoort with Francis and Gabrielle Picabia, Henri Pierre Roché, Arthur Burdett Frost and Beatrice Wood, who dances with Arthur Cravan. Afterwards in torrential rain they first go to Marcel's studio and later to Louise Norton's house, 110 West 88th Street, where the Picabias live on the ground floor.

1936. Friday, Paris
Opening of the "Exposition Surréaliste d'Objets" organized by André Breton [6.1.1936] at Charles Ratton's gallery, 14 Rue Marignan. In an article published in *La Semaine de Paris*, Breton announces: "Here, displayed for the first time in public, several objects from Picasso's studio which take their place historically with the celebrated 'readymade' and 'assisted readymade' by Marcel Duchamp, also exhibited."

Some two hundred items are listed in the catalogue; by Duchamp is *La Bagarre d'Austerlitz* [22.9.1935], and *Why not Sneeze?* [11.5.1935], exhibited next to *Egouttoir* (a replica of the lost original [15.1.1916]) which is given pride of place in a vast glass case.

1938. Sunday, Paris
In order to make a miniature reproduction on cellophane for his "album" [5.3.1935], Dee

sends Miss Dreier detailed instructions for Mr Coates, who is to photograph the Large Glass [5.2.1923] at The Haven sometime during the summer. He requires a photograph with a black background to make the cracks in the glass as clear as possible, and also one with a white background so that the outlines of the painted forms on the glass, such as the Malic Moulds and Chocolate Grinder, are precise. Dee plans to have the forms and the cracks printed from halftone cuts that he will cut out in order to leave the cellophane transparent; the colour will be added using a stencil process.

1947. Thursday, New York City
Five days before Kiesler's departure to Paris, where he is to install the Surrealist exhibition with Matta's help, Duchamp, who will remain in New York, dines with the Kieslers.

1948. Saturday, New York City
With plans for a visit to the country the following day, Maria Martins and Marcel dine with the Kieslers.

1952. Thursday, New York City
Following his recent visit to Washington to discuss the donation of the whole or part of Miss Dreier's private collection to the Phillips Gallery, Duchamp has received a letter from Duncan Phillips indicating that he believes he can accept the gift but would like to see photographs of the paintings and sculpture before making a decision.
Duchamp confirms that he will have the photographs made the following week and suggests that Mr and Mrs Phillips might like to visit Milford in August to actually see the collection.

1961. Monday, New York City
On receiving a telegram in the morning from Brookes Hubachek, Marcel forwards Hubachek's letter [20.5.1961] to Mr Harry F. Guggenheim with a note as requested.

*

After reading the report on one of his first paintings, *Jardin et Eglise à Blainville* [2.12.1949], by Louis Pomeranz of the Art Institute of Chicago, which Brookes Hubachek has sent him for his comments, Marcel says that he does not remember the canvas having been extended at the top and bottom edges, but suggests (as Pomeranz recommends) that the picture is provided with a

new stretcher and is relined, unless the cost is prohibitive. Left to Brookes on Mary's death [30.9.1950], the painting was, at this time, inscribed on the back: "Blainville the house where I was born and the church where I was baptized one of the earliest oils 1902. To Brookes from Mary/Marcel Duchamp 1951."

1963. Wednesday, Rome
With Gianfranco Baruchello, Teeny and Marcel make an excursion to Tivoli and have lunch in the gardens of Hadrian's Villa, which is filled with the Emperor's replicas of ancient Greek statues.

1965. Saturday, Paris
At half past eleven in the morning, Duchamp has an appointment with Louis Carré.

1967. Monday, Paris
In the afternoon, Teeny and Marcel visit Yvonne Savy [19.1.1967] at her studio near the Place Clichy, where David Mann, director of the Bodley Gallery, is awaited at about two-thirty to select the paintings for Yo's exhibition.

23 May

1917. Wednesday, New York City
After lunching with Henri Pierre Roché and Marius de Zayas, Francis Picabia, the editor of *391* who is unhappy about competition from the *Blind Man* [5.5.1917], provokes Roché to a duel. A game of chess between the rival editors is to be decisive: Picabia is victorious, sounding the death knell for the *Blind Man*.

1922. Tuesday, New York City
At seven-thirty Marcel is invited to dine at the Stettheimers' with Dr Sulzberger, Carl van Vechten and Mr and Mrs Gaston Lachaise.

1926. Sunday, Venice
"Understand nothing about this 'town', where everything is travelling except the pigeons," writes Duchamp on a card to Jacques Doucet; there is some sun and he will be back in Paris on Wednesday.

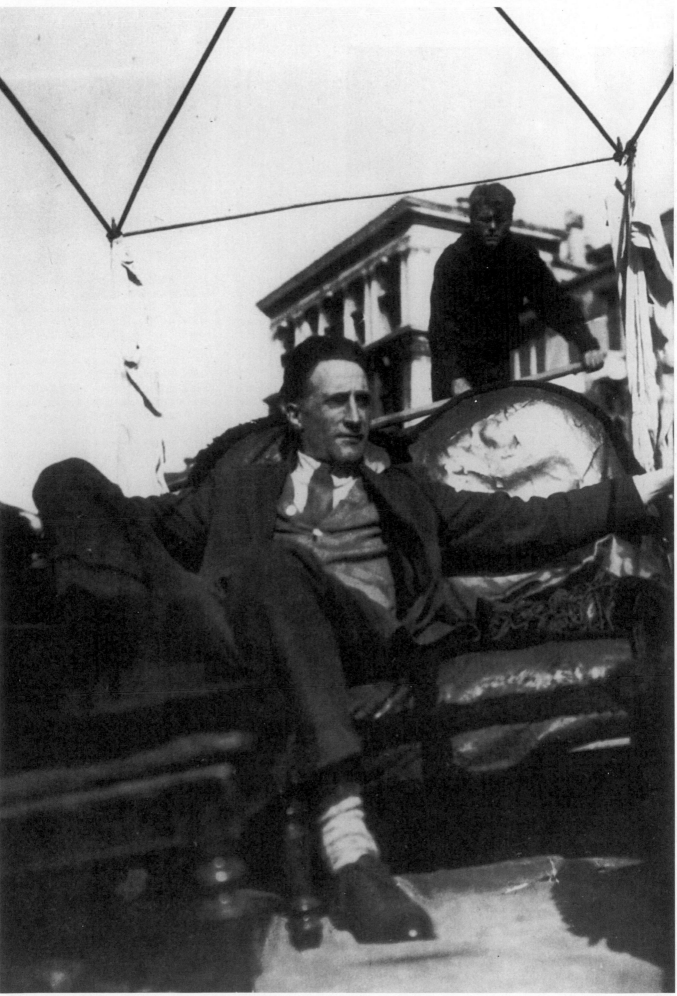

23.5.1926

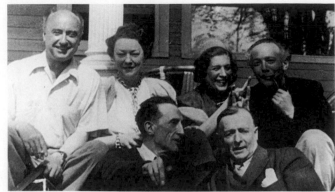

23.5.1948

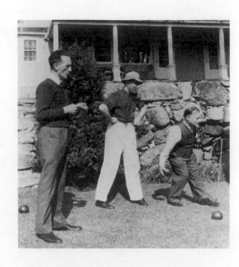

Not averse to trying the local means of transport, Duchamp is photographed by Miss Dreier at one moment during their visit, while they are being ferried by gondola on the Grand Canal.

1947. Friday, New York City
Like the previous evening, Marcel dines with the Kieslers.

1948. Sunday, New York City
At nine-thirty in the morning Maria Martins and Marcel leave the city with Kiesler for a day in Connecticut to see Enrico Donati, Arshile Gorky, Yves Tanguy and Kay Sage. After lunch at the Tanguys' they play bowls on the lawn in front of the house.

1949. Monday, New York City
Following his visit to Philadelphia on 6 May, Duchamp tells Fiske Kimball that he has recounted his "mission" to the Arensbergs [8.5.1949], "describing to them as clearly as possible the spatial elasticity" of the museum. As he is unable to recall all the details, corridors and staircases, Duchamp requests photostats of sections 6 and 7, both first and second floors.

1951. Wednesday, New York City
While in Chicago for a few days the previous week at Brookes Hubachek's invitation to unpack the shipment of Mary Reynolds' books [14.10.1950], which he had prepared for transport from Paris after her death [30.9.1950], Marcel learned from Brookes that a dealer in Chicago had a Brancusi sculpture for sale, but he did not have time to see it before returning to New York. By coincidence, Walter Arensberg has seen a photograph of the object in question and asks Marcel if there is any way of tracing the owner, so as to deal with him directly. In his reply, Marcel promises to make discreet enquiries through Brookes Hubachek.

1953. Saturday, New York City
Since André Breton agrees to his maquette being published separately from the almanac [23.4.1953], the next step is to obtain 2 or 3 quotes from printers in France. Fleur Cowles and Duchamp have delegated Enrico Donati, who plans to be in Paris in June, to arrange the final details with Breton. Duchamp plans to devote the following weeks to getting the photographic work done in New York.

Duchamp thanks Breton for having "spanked" the author of the "silly" article in *Combat* [30.4.1950]. This stupidity has its advantages: they themselves are probably less senile, he says, than these young so-called art critics.

1963. Thursday, Naples
After "four perfect days in Rome", Gianfranco and Elena Baruchello take Teeny and Marcel south to Naples in their Ferrari "that goes like the wind". At the Ristorante Dante e Beatrice, Elena photographs the group at the table while a local caricaturist draws the profile of Marcel who confides to him "we are colleagues".

24 May

1896. Sunday, Blainville-Crevon
The baptism of Yvonne, the sixth child born to Lucie and Eugène Duchamp on 14 March 1895, is a family celebration requiring preparation. Mme Duchamp has written to her eldest son Gaston, now twenty-one and studying painting in Paris with the academician Cormon, asking him to provide the menus. As well as giving an order to the butcher, making provisions of Bordeaux, Madeira and liqueurs, and purchasing blue candles with matching candle-rings, Lucie has ordered flowers for the table and a bouquet for the godmother. She has checked the glassware, arranged for the rooms to be polished, the bedrooms prepared and the drawing room cleaned. For her own toilet, Lucie has had her embossed dress adjusted, the rose pink blouse washed, and collected her gloves. She has made sure of a supply of tie pins and various ribbons including a natural coloured one for Suzanne. The two youngest – Marcel, who is now eight, and Suzanne – have been practising their monologues and a courtesy visit has been made to the parish priest.

At the ceremony in the church, the child is baptized Marie Madeleine Yvonne. Her godfather is her eldest brother Emile Mery Frédéric Gaston Duchamp and her godmother, Marguerite Blanche Duchamp, Gaston's first cousin the eldest daughter of Mery Duchamp [7.7.1888], Maître Duchamp's brother.

1922. Wednesday, New York City
Marcel calls on Beatrice Wood.

1924. Saturday, Paris
In his room at the Hôtel Istria, Marcel has a visit from Roché.

1934. Thursday, Paris
Worried that his letter sent on 18 May to Roché, poste restante at Arcachon, has not reached him, Marcel writes again.

1936. Sunday, at sea
Aboard the *Normandie*, the day before the ship is due to dock in New York, Marcel writes a postcard of the great liner to Meret Oppen-

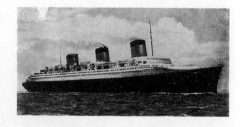

heim in Basel (the card is forwarded to her in Paris), saying: "Here is a manufactured object for an eventual exhibition at the bottom of the sea…"

1937. Monday, Paris
Although the work will not be finished for another month, Albert Lebrun, President of the Republic, nevertheless opens the Exposition internationale de Paris, which is entitled "Art et technique du temps présent". Fifty-two countries have built pavilions covering a whole quarter of central Paris creating a broad vista from the new Palais de Chaillot across the Seine to the Eiffel Tower. Raoul Dufy has painted a vast fresco covering 600 square metres entitled *La Fée Electricité*. In the Spanish pavilion, pictures by Miró hang with Picasso's *Guernica*, lament for the Basque village destroyed by Stuka bombers on 26 April.

"You did not come to the Paris exposition of 1937 on the opening night when I asked you," are the first lines of Kay Boyle's poem: "A Complaint for Mary and Marcel."

"You did not visit the Belgian or the Rus-

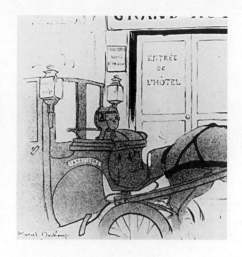
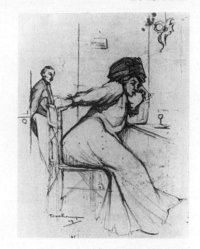

25.5.1907

sian or the Italian or the German pavilions or ride up in the lift with the smell of roses thick as smoke but sweeter in your eyes. You were expecting Man Ray or Nancy Perry or Dali or Brancusi to come and sit in the garden with the tiger lilies with you."

While the Eiffel Tower is fêted with a gigantic firework display, Mary Reynolds and Marcel stay quietly at Rue Hallé.

1942. Sunday, Santa Barbara
In *News-Press,* Donald J. Bear, the director of the Museum of Art, compares "the two most provocative documents in modern painting", which are presently on exhibition [20.5.1942] in the museum: *Nu descendant un Escalier, No.2* [18.3.1912] and *Guernica,* painted by Pablo Picasso in 1937.

Today the show attracts more than 500 visitors. Because of the great interest and the level of donations raised for the Allied Charities, Mr Bear with the agreement of the lenders extends the exhibition into June.

1944. Wednesday, New York City
The Large Glass [5.2.1923], which has been on loan to the museum from Miss Dreier since 10 September 1943, is included in "Art in Progress", a survey prepared for the fifteenth anniversary of the Museum of Modern Art.

1946. Friday, Paris
Roché and his wife Denise call at 11 Rue Larrey [?] to inspect Totor's stove. They decide to take it and make arrangements for it to be collected the following day.

1962. Thursday, New York City
Before taking an Air France flight leaving for Paris at eleven-thirty that evening, Marcel writes to both Brookes and Bill Hubachek in Chicago giving them his addresses in Europe during the summer.

1967. Wednesday, Neuilly-sur-Seine
Through Arne Ekstrom in New York, *Time* magazine have requested permission to use *Paysage à Blainville,* a view from the edge of the garden looking east across the water meadows, as a cover illustration which is to be financed by Sanka coffee. Arne thinks that the *Moulin à Café* [20.10.1912] would be more

appropriate but Marcel gives his consent, "above all as coffee will not find its way into my landscape."

25 May

1907. Saturday, Paris
In the company of such celebrated satirists as Albert Guillaume, Abel Faivre, Caran d'Ache, Léandre and Lucien Métivet, the first Salon des Artistes Humoristes organized by Félix Juven, director of *Le Rire,* opens at the Palais de Glace. The humorists differ, they claim, from their famous predecessors: they are "no longer 'incoherent', leaving that quality to the ruling powers..." But they believe they have retained all the "gaiety" of the Expositions des Incohérents, memorable for many gems, notably Alphonse Allais' monochromes published later in his *Album Primo-Avrilesque.*

Two drawings by Albert Guillaume published in *Le Rire* illustrate reactions to the show: in one, a giggling maniac with his trousers undone is expelled by a gendarme; in the other, a gorgeous young woman helpless with mirth, her bodice split to the waist, is escorted by the police from the exhibition.

Taking part in what is apparently his first

exhibition at the age of nineteen, Duchamp presents five drawings. Two have been lost, *Inquiétude de Cocu* and *Les Toiles de X,* which has the tantalizing caption: "They are not even good to bung in the loo. Because you can't stand back."

In the drawing entitled *Flirt* the girl is about to play the grand piano [*piano à queue*] for the young man: "Ne trouvez-vous pas, Monsieur, que ce piano a des sons clairs et limpides?" Lui (spirituel): "Oh oui, Mademoiselle, c'est un piano (très... aqueux)."

Femme Cocher links the invention of the taximeter which first appeared in November 1906, with the recent innovation of driving licences for women cab drivers, previously a male domain. In Duchamp's drawing the empty cab with its meter ticking away stands in front of a hotel entrance: the cab driver, for the same tariff, is providing additional services for her fare.

Entitled *Le Lapin* [Stood up], a woman sitting at the bar in utter dejection is watched by a waiter in the background. Faced with paying for a brandied cherry, she reflects: "If I'd known... I would have taken only a small beer."

1917. Friday, New York City
Readers of the second number of the *Blind Man* [5.5.1917] have been invited to support the magazine by attending a fancy dress ball, "a newfashioned hop, skip and jump" at the Ultra Bohemian, Prehistoric and Post Alcoholic Webster Hall, 119 East 11th Street. The publicity proclaims that the dance will not end until dawn... The *Blind Man* must see the sun. It points out that there is a difference between a tuxedo and a Turk and "guests not in costume must sit in bought-and-paid-for boxes" costing $10 excluding advance admission of $1.50, and $2 at the door. The poster is decorated with Beatrice Wood's drawing of a high-stepping man thumbing his nose [29.4.1917], and the ball is well attended.

At eight-thirty, watched by the Arensbergs, Marcel, Roché, Aileen Dresser and the organizers of the ball from their central box on the balcony, Beatrice in a beautiful brocade costume executes the Russian dances she was taught by Ivan Clustine, Pavlova's ballet master. Later interrupting the "continuous syncopations" the Japanese dancer, Mishio Itow, also performs for the revellers.

The night grows wilder. Just before midnight, bored by the conversation and with sev-

25.5.1917

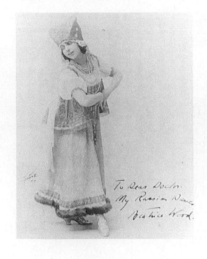

eral cocktails too many inside him, Marcel decides to climb over the rail onto a wooden pole, planted at a rake of forty-five degrees from the balcony, which has a bunch of flags on its summit. Unable to dissuade him from his exploit, Roché watches as Marcel with his full-length cape billowing out behind him, "like a lady-bird on a large stalk," crawls slowly up the flagpole. "It was feared that he would fall on the dancers, but his movements were steady and he soon became part of the décor. Sometimes he stopped and he was forgotten." Eventually when Marcel reaches the flags, there is a round of applause. He acknowledges it by raising his pink paper hat before sliding rapidly down the mast and back to the safety of the box.

1920. Tuesday, Paris
The day after the President Deschanel falls from the train in his pyjamas, Picabia publishes *Cannibale*, No. 2. Among the contents there is an announcement for the Société Anonyme's "First Exhibition of Modern Art" [30.4.1920] and a poem by André Breton entitled "Psst", listing 20 Bretons in the Parisian telephone directory, one of which is: Roquette 09-76, Breton et Cie (Soc. anon.) Charbon gros, q.la Rapée, 60, (12e).

1927. Wednesday, Paris
Some days ago Dee received a long letter from Miss Dreier with news of the enthusiastic reception at the Albright Art Gallery, Buffalo, of the International Exhibition (a modified version of the show held at the Anderson Galleries [25.1.1927]) and the sale of Brancusi's sculpture, *Mademoiselle Pogany II*, to the gallery. Both Dee and the sculptor are delighted. This purchase might carry some weight at the forthcoming Brancusi trial in New York and, as Maurice Speiser [27.1.1927], representing Brancusi is in Paris, Dee has given him the name of the director of the Albright, Mr William M. Hekking.

It is time to break the news to Miss Dreier of his sudden engagement to Lydie Sarazin-Levassor [12.5.1927], whom he describes as "not especially beautiful nor attractive – but seems to have rather a mind which might understand how I can stand marriage". Dee admits, however, "all these 'mights' and 'seem' to have no disillusions when too late... I am a bit tired of this vagabonding life and want to try a partly resting

one. Whether I am making a mistake or not is of little importance as I don't think anything can stop me from changing altogether in a very short time if necessary."

Aware of the financial consequences, Dee explains, "I am not going to be rich. Her money is for the present hardly enough to make her live, and is hers." Hoping that by keeping two apartments he will be able "to keep several hours or days" for himself, Dee confesses to Miss Dreier that "all this, of course, might seem foolish to another person than you". Indeed, according to his sister-in-law Yvonne, he has decided not to invite anyone from his side, finding this kind of exhibition ridiculous, and even his young sisters Yvonne and Magdeleine do not know yet that Marcel is to be married.

1932. Wednesday, Paris
Dines with the family and Miss Dreier at Puteaux, but leaves immediately after the meal to attend a meeting in preparation for the chess games by telephone with Buenos Aires due to start the following day.

Dee hardly utters ten words during supper. "Yet he is less silent with me this year than last," observes Miss Dreier; and they have only quarrelled once: "I don't see why we quarrelled so last year," she confides to her sister Mary.

Having a "beautiful time with his chess," Dee amused Miss Dreier by telling her recently. "I might be a scientist but I am much too playful for that. Even if I discovered a Newton Theory, an Einstein would come along a few centuries later and upset it again!"

Dee modestly wonders why Alekhine [26.7.1931], the chess champion of the world, seems to like being with him. "Dee's own inner life is remarkably fine," reflects Miss Dreier, "he has no use for people the moment they seek worldly success and don't do what they do out of love for it alone – but how many do..."

1936. Monday, New York City
As the *Normandie* does not dock until thirty-four minutes past three in the afternoon, Duchamp misses the train to West Redding which he was proposing to catch [11.5.1936].

1942. Monday, Ain Sebaa
Having managed to avoid being incarcerated in the camp for transit passengers [21.5.1942], Duchamp has found a comfortable bathroom to

sleep in while awaiting his departure to New York. From his temporary address, 35 Rue du Pas-de-Calais at Ain Sebaa on the coast to the north of Casablanca, Duchamp writes to tell his old friend Dumouchel that he was in Sanary for almost a year [2.7.1941] and, regretting that he did not write to him enough, says that in these momentous circumstances he is always thinking of them.

1946. Saturday, Paris
Roché has arranged for four strong men to collect Totor's stove from Rue Larrey [?] at a quarter to three.

1947. Sunday, New York City
Marcel dines again with the Kieslers.

1948. Tuesday, Geneva
M. Dubout, Conseiller d'Etat attached to the Département de Justice et Police, informs the Galerie Maeght that a copy of the catalogue, *Surréalisme en 1947* [7.7.1947], which was posted to a Mr X living in Geneva, has been seized by the Procureur Général of the Confederation, not because of its contents, but of its cover, which is considered "immoral".

1954. Tuesday, Cincinnati
Now that he has "more or less recovered" from pneumonia following the removal of his appendix [18.4.1954], Duchamp's surgeon has recommended a month's rest in New York before performing the prostate operation. Marcel requests Roché to telephone his family with the news.

1960. Wednesday, New York City
Following his election to the National Institute of Arts and Letters on 2 February, Duchamp attends the induction ceremony commencing at three o'clock in the afternoon at the Academy Auditorium, 632 West 156th Street, and is seated on the stage between two other new members, the architect Gordon Bunshaft and the poet Richard Eberhart. Léonie Adams, Secretary of the Institute, introduces Duchamp, who stands when his name is announced, as "a painter of international prestige, who has spent the greater part of his life in New York, has for several decades, both for the fertility of his work, and his motive influence in modern painting, been a legendary figure in the world of art".

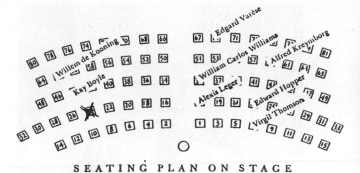

SEATING PLAN ON STAGE

25.5.1960

25.5.1965

Among the new honorary members are Aldous Huxley, Alexis Saint-Léger Léger (St John Perse), Joan Miró, Boris Pasternak and Dmitri Shostakovich. Virgil Thomson, who also gives an address entitled "Music Now", is elected to the Academy. After the ceremony, refreshments are served on the terrace.

In the American Academy and National Institute of Arts and Letters annual exhibition, the works of Duchamp (*Portrait de M. Duchamp père, assis* [6.5.1911] and *Broyeuse de Chocolat*, No.2 [8.3.1915]) together with those of two other new members, Willem de Kooning and Alexander Calder, "have astonishing impact", according to Carlyle Burrows, in these "rather august surroundings".

1961. Thursday, New York City
Sends a note to Bill Camfield [4.4.1961] at New Haven endeavouring to reply to the questions in his letter and confirms that he "never painted or intended to paint a painting entitled Golden Section at any time…"

*

Duchamp attends the opening at the Guggenheim Museum of the exhibition "One hundred paintings from the G. David Thompson Collection", where he hopes to have a minute with Mr Harry F. Guggenheim regarding Brookes Hubachek's proposals [16.5.1961].

1962. Friday, Paris
After an overnight flight from New York, Teeny and Marcel arrive at Orly. Before going to Spain they will stay for a few days with the Monniers, 108 Rue du Bac, and see Villon.

1965. Tuesday, Paris
Marcel and Teeny, the Man Rays and the Monniers attend the Festival de la Libre Expression at the Centre Americain des Artistes, 261 Boulevard Raspail. On the programme that evening is *Dechirex*, a happening by Jean-Jacques Lebel, and *Centre for Death* by Lawrence Ferlinghetti.

1967. Thursday, Neuilly-sur-Seine
Serge Stauffer has written asking why Duchamp used hearts for the cover of *Cahiers d'Art* [16.8.1936] and whether the allusion to "fluttering hearts" was intentional. Duchamp remembers that he heard about "cœurs volants" in a conversation with an optical physician when he

was trying to sell his *Rotoreliefs* [30.8.1935] at the Concours Lépine. Without any further research, he took up the idea for the cover of the magazine and entitled it *Cœurs volants*. He remarks to Stauffer that in fact there are many combinations of two colours that give this effect, particularly in the half-light.

26 May

1909. Wednesday, Rouen
On the Feast of Joan of Arc, in a ceremony at the Church of Saint-Godard, Marcel's youngest sister Magdeleine takes her first communion. After mass all the family and relations enjoy a traditionally sumptuous lunch which is held at the Grand Hôtel d'Angleterre, Cours Boieldieu, by the River Seine. The meal commences with soup, *Crème Sultane*, followed by *Filets de Sole Marguery* and then the main courses: *Selle d'Agneau Duroc* and *Salmis de Caneton au Royal Porto*. After *Sorbet au Kirsch* to freshen the palate, *Poularde de la Bresse rôtie* is served with *Cœurs de Laitue*, *Petits Pois à la française* and also *Turbans de Langouste en Bellevue*. *Mousse Suzette* precedes the dessert, subject of the etching decorating the menu which two of Magdeleine's brothers have devised: "The dolls show Villon's hand, maybe I did the cake," says Marcel.

1917. Saturday, New York City
Even after the ball, Marcel is still in an equilibristic mood: watched by Roché and Beatrice, he tries walking along the white painted edge of the Elevated with his companion, a young widow "whom he is healing in his own way".

The Arensbergs have invited a number of friends back to their apartment for scrambled eggs and wine. Too weary to go home, Mina Loy leads Beatrice and Aileen, followed by Charles Demuth, upstairs to Marcel's studio, where they collapse onto the wide bed. Marcel finds himself a narrow space to lie on against the wall and Beatrice, oblivious of any discomfort, squeezes herself against him and happily doesn't sleep a wink.

1922. Friday, New York City
"I hoped to see you Tuesday at the sumptuous dinner (with wine) of my secretary typist," commences Duchamp's typed letter to Henry McBride, to which he has added by hand in brackets "Ett. Stttttt.". In the name of the Société Anonyme, Duchamp asks the critic whether, in one of his next "Sundays" of the *New York Herald* he would mention the translation of *Les Peintres Cubistes* by Apollinaire [17.3.1913], the first instalment of which is due to appear in the Spring number [8.5.1922] of the *Little Review*.

"I await what you have promised: articles for the brochure, and your choice of possible illustrations," Duchamp reminds McBride, referring to the publication commissioned by the Société Anonyme about a month ago.

1926. Wednesday, Paris
Arrives at the Hôtel Istria late in the evening from Venice [23.5.1926] after a stop in Milan to see the painter Carlo Carrà. Meanwhile Miss Dreier has gone south from Venice to Rome on her quest for works to include in the Société Anonyme exhibition at Brooklyn.

1927. Thursday, Paris
On an invitation to his wedding [12.5.1927] which is to take place on 8 June, Duchamp writes a note to Jacques Doucet saying that this is the reason for his silence, and asks if he may come and see him one day soon.

1936. Tuesday, West Redding
Carl Rasmussen, the building contractor, who has attempted to repair the Large Glass [5.2.1923], arranges delivery to the Sears barn, one of the outbuildings on Miss Dreier's estate. As the two large pieces of glass had been packed together face to face [26.1.1927] after the Brooklyn exhibition [19.11.1926], to Du-

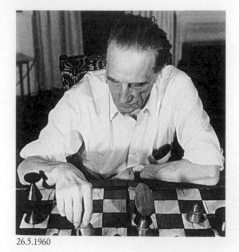

26.5.1960

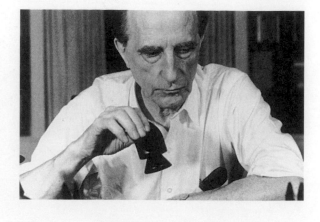

champ's delight there is a symmetry in the cracks. Thanks to the technique he employed, whereby the drawing of the forms was made by gluing wire on the glass, very few of the pieces of glass are displaced, which makes the task of repairing it possible.

1947. Monday, New York City
On the eve of Frederick Kiesler's departure to Paris, Marcel undertakes to check in the baggage at Air France for his friend.

1949. Thursday, Milford
Aiming to publish the catalogue of the collection of the Société Anonyme before President Seymour's resignation takes effect in June 1950, Dee and Miss Dreier have a working session on the layout of the book.

1960. Thursday, New York City
In the evening, a week after his previous visit Marvin Lazarus calls at 28 West 10th Street to take photographs of Duchamp with the Max Ernst chessmen. Lazarus notices that Duchamp seems tired and doesn't "move around" as he did at the first session [11.12.1959] in the early afternoon. According to Lazarus, Duchamp feels neglected: the Museum of Modern Art is only interested in the market, all his things have been sold and he doesn't produce anymore.

27 May

1927. Friday, Paris
With Lydie Sarazin-Levassor, Marcel attends the premiere of *La Chatte* by Georges Balanchine at the Théâtre Sarah-Bernhardt. Diaghilev has chosen Naum Gabo to do all the design work and Henri Sauguet has written the music. Gabo, assisted by his brother Antoine Pevsner, has created a geometrical construction of transparent forms made of a cellulose acetate, brilliantly lit, creating a dazzling atmosphere of "quicksilver radiance" enhanced by flashes from the dancers, as their costumes, also incorporating clear plastic, catch and reflect the light.
 During the interval Marcel's fiancée [12.5.1927] is the object of a certain curiosity.

They meet the Chicagoans Mr and Mrs John Alden Carpenter [26.4.1927], and Roché, who has brought Alice Roullier [26.2.1927]. Roché's first impression is disastrous, but he thinks and hopes it may change. Overwhelmed by the occasion and greatly embarrassed, Lydie returns to her seat.
 Later Marcel rejoins her pale with anger: he has met Léonce Rosenberg who is furious that the pictures he lent to the Société Anonyme for the Brooklyn exhibition [19.11.1926] will only be delivered back to him against payment of the expenses...

1932. Friday, Paris
During two consecutive days at the Cercle Caïssa, recently founded by Tauber, Duchamp is a member of the Paris team which, as a group, plays two chess games by telephone against a team in Buenos Aires.

1942. Wednesday, Ain Sebaa
"Spring here (kind of summer) is luxuriant and of course the restrictions are already forgotten, omelettes and meat give you colic..." writes Marcel to Roché while awaiting the *Serpa Pinto*, which is due to depart from Casablanca on 7 June.
 "The camp is a horror (no beds and one dormitory with mattresses, a hundred men and women) but I managed to escape that [25.5.1942]... Here I am sleeping alone in a bathroom, very comfortable; it is by the sea, 7 km from Casa[blanca]."
 Marcel asks Roché to send an Inter-zone card (like the one sent to Breton [17.1.1941]) to Mary Reynolds who is due to leave for New York via Hendaye and Lisbon on 16 June.

1947. Tuesday, New York City
At half past eight in the morning Marcel accompanies the Kieslers and two friends, Alice and Lillian, to La Guardia airfield. Kiesler, who is entrusted with the installation of the Surrealist exhibition [17.5.1947] (due to open at the Galerie Maeght at the end of June), finally departs for Paris at eleven o'clock. Later at three, Marcel takes Stefi Kiesler to the pier.

1953. Wednesday, New York City
Cables Henri-Martin Barzun in New Rochelle: "Unable to reply very busy sorry impossible tonight writing = Duchamp."

1954. Thursday, Cincinnati
After their unexpectedly prolonged stay with Olga and Nick Carter [25.5.1954], Teeny and Marcel return to their top-floor Manhattan apartment at 327 East 58th Street, between First and Second Avenue.

1960. Friday, New York City
Concerned about the rapid deterioration of certain pictures in the collection of the Société Anonyme at Yale University, Marcel writes to George Heard Hamilton, the curator, saying that he understands perfectly that Yale has no budget for repairs but suggests that if George can estimate the cost he will ask Mary Dreier, before she leaves for Maine, if she will agree to meet the expenses.

*

With the pages corrected [19.5.1960], Richard Hamilton has sent Marcel the last batch of drawings for the typographic version of the Green Box [16.10.1934]. In giving his approval Marcel invites Richard and his wife, Terry, to visit them in Cadaqués during the second half of August.

1963. Monday, Naples
After a long weekend exploring the hinterland, the site of the ancient Greek city of Paestum, the famous ruins of Pompeii and the island of Capri, Teeny and Marcel travel by train to Taormina, where they stay at the Hotel Timeo, which is situated near the Greek theatre and offers a magnificent view of the sea and Mount Etna.

1968. Monday, New York City
In an article entitled "Marcel Duchamp: Where Art has Lost, Chess is the Winner", published by the *New York Times,* Rita Rief recounts how Duchamp "has won for the world an abundance of artist-designed chess sets".
 As the journalist looked at sets by Max Ernst, Alexander Calder, John Cage and Man Ray on the refectory table in their apartment, Duchamp said that he never collected chess sets: "We have them because we have received them from friends."
 Rita Rief discovered that it was Duchamp who persuaded Salvador Dali to design "the chessmen, save the Rooks [pepper and salt shakers], modelled on the fingers and parts of hands of Dali and his wife", for the exhibition

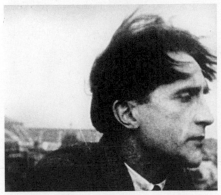
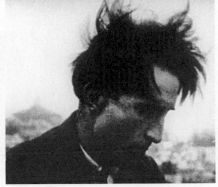
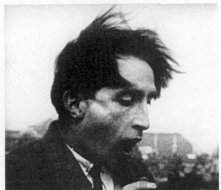

28.5.1924

"Hommage à Caïssa" [7.2.1966]. The set is now in prototype and will be sold for the benefit of the American Chess Foundation.

And it was during a chess game that Duchamp persuaded Arman [29.12.1964] to have his "hexagonal-shaped, nut-like pieces" cast in brass or bronze.

Duchamp showed the journalist his own *Pocket Chess Set* [23.3.1944], and explained, "I did the first one of these portable sets in the 1930s [7.3.1926]. We use this set in travelling or in bed or any time we need it."

28 May

1924. Wednesday, Paris
When Roché calls at the Hôtel Istria, Duchamp has already gone out.

Picabia, Duchamp and Man Ray are the principal actors in the sequences of *Entr'acte* to be filmed on the roof of the Théâtre des Champs-Elysées this afternoon. Into the seventh day of shooting, the film, which is from a scenario by Picabia commissioned by Rolf de Maré for the Ballets Suédois, is directed by René Clair with three collaborators: the cameraman J. Berliet, and assistants R. Caillaud and G. Lacombe.

Starting with the arrival of Picabia, Berliet then films the chess sequence. Duchamp and

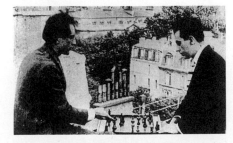

Man Ray sit astride the low balustrade at the edge of the roof with the chessboard between them. As they play, a medium close-up of Duchamp's head, a chimney on the left and an aerial view of Paris in the background, is followed by a close-up. They then shoot a series of close-ups of Duchamp startled, gasping in total astonishment, his hair swept forward by the

wind. Shots of the chessboard with Duchamp's and Man Ray's hands are followed by one with the sudden, powerful jet of water from a hose, which washes away the chesspieces and both the players.

1927. Saturday, Paris
At one o'clock Marcel meets Roché (whose birthday it is) and Mrs Brewster [26.2.1927] for lunch near the Halle aux Vins.

1937. Friday, Paris
For his weekly column in *Ce Soir*, Duchamp publishes the chess problem composed by Edouard Pape, winner of the first prize in the match between Spain and France, and comments on the game between Foltys and Keres which was played on 29 April in the international tournament of Prague. Amongst the news items, Duchamp announces various results: the match between Spain and France, the impressive score of Flohr in the simultaneous games played in Holland, and Tartakover's victory in Rotterdam.

1948. Friday, Milford
Disappointed with Mr Lozinski's work, Miss Dreier as president of the Société Anonyme and Duchamp as Secretary write officially to George Heard Hamilton requesting that the Société Anonyme and Mrs van Doesburg take over the responsibility of completing the material for the catalogue, and that Yale University set aside $500 for this special research work.

1953. Thursday, New York City
"My first reaction is that I have no right to say anything except that I am very deeply touched by Miss [Ettie] Stettheimer's thought," replies Duchamp to Joseph Solomon, who has written to him about the portrait of Rrose Sélavy [24.10.1926] by Florine in Ettie's collection. "I have always felt that art works should be liberated from their sentimental elements and start as soon as possible on their journey, a journey longer than human life," continues Duchamp, who promises to telephone Ettie and arrange to see her.

1961. Sunday, New York City
On the eve of his departure for Lisbon Duchamp replies to a very long letter from Serge Stauffer. He gives short replies to every-

thing except the final question, concerning Duchamp's double conception of the fourth dimension, which is not only graphic but tactile. "The erotic act, perfect situation quadrimensional – without using these words, this idea is an old idea of mine, an obsession explained by the fact that a tactile sensation which envelopes every side of an object approaches a tactile sensation of four dimensions. Because of course none of our senses have a quadrimensional application except perhaps touch, and consequently the act of love as tactile sublimation could be envisaged, or rather felt, as a physical interpretation of the 4th dimension."

*

After learning from Henri Marceau that the new hanging of the Arensberg Collection in Philadelphia is progressing [5.5.1961], Duchamp writes: "Unfortunately we must wait until the autumn to see the final result…" He gives his address in Cadaqués "if by chance" Marceau goes to Spain.

29 May

1898. Sunday, Blainville-Crevon
At the collegiate church, situated a few yards from his home, Marcel, together with three other boys and five girls of the parish, takes his first communion.

1913. Thursday, Paris
Writing about the Russian season at the Théâtre des Champs-Elysées, a critic comments: "We have talked at great length, argued, carped about all these choreographic and dra-

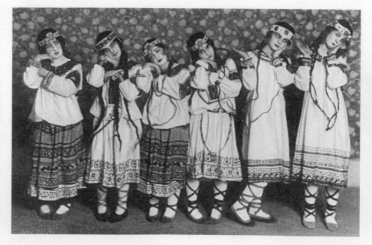

29.5.1913

matico-musical events; nothing... has been indifferent. We will talk a long time about *Jeux* or the *Nocturnes* by M. Debussy, of *Le Sacre du Printemps* by M. Stravinsky..."

Duchamp is present when Nijinsky's "new conception of choreography ... for which M. Stravinsky has written the disconcerting music" is performed in public for the first time. "The author of *L'Oiseau de Feu* and the attractive *Pétrouchka* has wanted to evoke in *Le Sacre du Printemps* the barbaric rhythms of prehistoric Russia, to revive in the laws of music a harmonic paganism, which is translated also in the movements of the dancers. Have the composer and choreographer been successful?" asks the critic. "Some aesthetes cry their enthusiasm; some spectators are noisily of a contrary opinion."

For Duchamp, "the music, the setting and dances, those emotions in gesture and posture made clear for the first time by Nijinsky, have no counterpart in his admiration..." But it is above all, perhaps, the tumultuous reception of the new ballet which deeply impresses him: "I will never forget the yelling and the screaming."

1917. Tuesday, New York City
After writing his article about the elections for *Le Temps*, Henri Pierre Roché sees Marcel and Isadora Duncan.

1920. Saturday, New York City
Having finally sold all the gowns to a businessman from San Francisco [26.2.1920], Gaby Picabia embarks on a ship sailing for France. At Marcel's request Gaby gives the very rare copy of *Case d'Armons* (Apollinaire's personal gift) to the Société Anonyme, which has given her a mission to contact Archipenko, Picabia and Brancusi about exhibiting in the gallery and to ask Tzara if he will send a "monthly public letter" about the modern art movement in Europe.

1947. Thursday, New York City
Marcel has an early supper with Stefi Kiesler at 56 Seventh Avenue and stays until ten o'clock.

1949. Sunday, New York City
"Thank you for taking all this trouble," writes Marcel to Roché, confirming that the size of the original ampoule for Arensberg's *Air de Paris* [27.12.1919] is that drawn in his previous letter

[9.5.1949], and not the smaller version in the *Boîte-en-Valise* [7.1.1941]. Marcel invites Roché to make one for himself at the same time.

1958. Thursday, New York City
In the evening Teeny and Marcel board a flight to Paris.

1961. Monday, New York City
Sends Bill Hubachek his annual instructions and contact addresses before taking a night flight with Teeny to Lisbon.

1963. Wednesday, Taormina
The Duchamps take a chauffeur-driven car to make an excursion south along the coast to Catania and thence to the Piazza Armerina, where the Roman Villa Casale is decorated with very fine mosaics.

Afterwards they go to Enna, the town known as the Belvedere of Sicily, which is situated almost in the centre of the island.

1967. Monday, Neuilly-sur-Seine
"All is well, the translation that I read appears to be very accurate," Duchamp assures Monique Fong, who has translated an unpublished essay by Octavio Paz entitled "Marcel Duchamp o el castillo de la pureza" [13.2.1967]. "It will accompany my exhibition," explains Duchamp, referring to the show which is due to open on 7 June at the Galerie Givaudan.

Looking forward to seeing her in Neuilly after her visit to Sydney, at the end of September, Duchamp asks Monique to make enquiries while she is in Australia about the exhibition of his work belonging to Mary Sisler [13.1.1965], which is due to be shown there.

30 May

1934. Wednesday, Paris
Marcel sends Roché a receipt for the cheque he has now received and which, effectively, had crossed with his letter [24.5.1934]. His work on the stencil for the reproduction of *9 Moules Mâlic* [19.1.1915] is advancing but not without difficulty [18.5.1934].

"I will, perhaps, send you a proof," warns Marcel, "for you to criticize and not for you to praise."

1947. Friday, New York City
In the evening at six Marcel visits Stefi Kiesler and stays to supper.

1950. Tuesday, New York City
Recommends to Fiske Kimball the work of Nicolas Calas on Hieronymus Bosch: "The method, far from orthodox, is particularly interesting and original and I thought that maybe one or some lectures dealing principally with the *Epiphanie* by Bosch which the museum of Philadelphia possesses could be of great interest."

1953. Saturday, New York City
The telegram Duchamp sent to Barzun on Wednesday arrived too late: "All my excuses, and the most paltry," writes Duchamp, "for not having replied to your first letter and above all for standing you up involuntarily." For Barzun's exhibition project, Duchamp has nevertheless seen Alfred Barr, who "guarantees nothing, nor promises anything", but who proposes that a lunch be arranged with the director of the Museum of Modern Art, René d'Harnoncourt, and the three of them during the week of 7–14 June. Duchamp invites Barzun to choose two possible days: "I will forward them so that they choose the final day and the place."

1954. Sunday, New York City
Confirms to Mrs Marianne Martin, who is preparing his biographical notes for the Philadelphia Museum of Art, that he took his citizenship papers in February [9.3.1954] and is now expecting "the final OK, which should have come long ago".

Regarding his paintings: she may mention that he was baptized in the church at Blainville, represented in the picture of 1902 [18.12.1949]; "Marcel Lefrançois was the nephew of our cook," explains Duchamp, "and the portrait [29.12.1949] was painted during one of his visits to his aunt." As for the identity of the sitter of *L'Homme au Balcon* by Albert Gleizes, Mrs Martin should write to Dr Henri Barzun, "who knew Gleizes intimately at the time."

1958. Friday, Paris
Teeny and Marcel arrive at Orly from New York to spend the summer months in a potentially less "untenable" climate [8.8.1957]. For the first month they will be staying at 58 Rue Mathurin-Regnier, the house lent to them by Max Ernst and Dorothea Tanning.

1961. Tuesday, Lisbon
On arrival from New York, Teeny has time to write a postcard to Jackie before their connecting flight to Barcelona is called. Due to land in the Catalonian capital at midday, Teeny and Marcel will stay overnight before continuing their journey to Cadaqués.

1963. Thursday, Taormina
In the morning Teeny and Marcel visit the Villa Sant'Andrea, a hotel at sea level with a tree-sheltered garden leading to the beach, where Teeny has a swim. After lunch they return to their hotel for a nap, but when he awakes Marcel is very sick and the doctor who attends him diagnoses food poisoning.

31 May

1913. Saturday, Paris
In the evening Duchamp attends a gathering of artists and poets at a tavern, Place de l'Alma. Among those present are Roger Allard, Henri-Martin Barzun and Gaston Sauvebois.

1917. Thursday, New York City
Francis and Gaby Picabia throw a party for about twenty friends at 110 West 88th Street, in the apartment lent to them by Louise Norton. Feeling like a little boxing for fun, Arthur Cravan [20.4.1917] challenges the painter Arthur Frost. To the dismay of Roché, who is worried on Frost's account, the burly Englishman exchanges some resounding punches with the tall, thin American.
After the boxing, Picabia and Roché have a wrestling match, rolling on the carpet until Picabia is lying helpless on his back with Roché straddling him and holding his fists.
"What does that prove?" asks Picabia.
"Nothing!" replies Roché, letting him go.

Picabia tackles his opponent again, turning fiercely from wrestling to jujitsu. With a footlock he suddenly has Roché at his mercy.
"What does that prove?" asks Roché.
"Everything!" says Picabia.
"It's a way of playing chess," remarks Marcel.
"With more dust," adds Gaby with her knowing smile.

1922. Wednesday, New York City
At two o'clock, Duchamp attends a directors' meeting of the Société Anonyme at Mr McLaren's offices, 38 Pine Street, with Paul Gross and Mary Knoblauch. Matters to be discussed are: the Henry McBride publication [26.5.1922], the collaboration with Jane Heap for the *Little Review* (which is to include Mary Knoblauch's translation of *Les Peintres Cubistes* by Apollinaire [17.3.1913]) and in particular, following Miss Dreier's telegram from China, which requests them to reserve $2,000 for "next winter's work", the allocation of funds for these two projects.

*

In the evening as on the previous Wednesday, Marcel calls to see Beatrice Wood.

1931. Sunday, Paris
After her visit to Munich, Miss Dreier is back at her new studio [12.4.1931] and wants to take a young German sculptor to meet Brancusi. As he has been unable to reach Brancusi by telephone, Marcel proposes that they call on 2 June at five o'clock. "If you are unable to receive us," writes Marcel to the sculptor, "send me an express letter tomorrow Monday, Morice."

1954. Monday, New York City
Thanking her for her letter about Walter Arensberg's death [29.1.1954], Marcel writes to Beatrice Wood: "I have difficulty getting used to the idea that he went so quickly, and your explanation of drugs is obviously correct."
The news for Beatrice: his marriage to Teeny Matisse [16.1.1954]; his recent operation [18.4.1954], with another in prospect; his citizenship papers [9.3.1954], and his supervision of the installation of the Arensberg collection at Philadelphia.
"…A year fully occupied."

1961. Wednesday, Cadaqués
Coming in the evening over the mountains from

Barcelona, Teeny and Marcel arrive in Cadaqués where they plan to spend another summer.

1962. Thursday, Paris
After a week in Paris principally to see Villon, "who works sitting down but with less enthusiasm than before his accident," but also his wife Gaby who is bedridden since her stroke last year, Teeny and Marcel take an overnight train to Cerbère, travelling in a first-class Wagon-lits compartment.

1966. Tuesday, Neuilly-sur-Seine
"In haste to thank you for your splendid catalogue of the glass giving a perfect account of your long work [16.2.1965]," writes Marcel to Richard Hamilton before leaving for Milan.

1967. Wednesday, Rouen
In the morning, the day before "Les Duchamps" [15.4.1967] closes, in a short ceremony attended by the mayor of Rouen, M. Tissot, a number of officials, Mlle Popovitch and members of the family (including Magdeleine and Teeny), Duchamp unveils another plaque [28.4.1967], and the Rue de la Bibliothèque becomes Rue Jacques Villon.

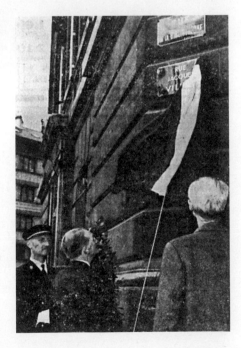

1.6.1963

1 June

1921. Wednesday, New York City
In reply to Jean Crotti's cable renewing the request [19.5.1921] on behalf of Tristan Tzara for his participation in the Salon Dada, Galerie Montaigne, Duchamp sends his brother-in-law in Neuilly-sur-Seine, 5 Rue Parmentier, a short telegram: "PODE BAL = DUCHAMP." [Nothing doing.]

1925. Monday, Paris
Preparing his departure for Monaco, Duchamp is still in his room at twelve-twenty and misses his appointment with Dumouchel.

1926. Tuesday, Paris
Lunches with Roché in the restaurant of the Café de la Paix, Place de l'Opéra. After the disappointment with Cézanne [6.4.1926], they are more optimistic about their "de La Fresnaye business".

1933. Thursday, Chicago
Twenty years after its first visit to the Art Institute of Chicago [24.3.1913], *Nu descendant un Escalier*, No.2 [18.3.1912], lent by Walter and Louise Arensberg, returns to the museum for "A Century of Progress", an exhibition of paintings and sculpture on loan from American collections.

1953. Monday, Paris
In its June issue, *La Nouvelle Nouvelle Revue Française* publishes "Souvenirs sur Marcel Duchamp", a miniature portrait by Henri Pierre Roché, the author of *Jules et Jim* [15.5.1953]. When he first met Duchamp in New York [4.12.1916], "he was creating his own legend," writes Roché, "a young prophet who wrote scarcely a line, but whose words would be repeated from mouth to mouth, from whose daily life anecdotes and miracles would be construed."
In Duchamp's studio in New York, "stretched out horizontally on trestles and looking like glass tables were the huge panes on which he was laboriously working… On certain areas he let 'layers of dust' accumulate [20.10.1920]…" notes Roché. "Apparently useless objects were all around, providing atmosphere: a snow shovel, a bicycle wheel [15.1.1916], a pitchfork, a metal coat hanger fixed to the floor. In one corner a large *Sculpture de voyage* [8.7.1918] made from lively coloured rubber strips, spread itself out like a spider web."
Roché describes the Large Glass [5.2.1923], "the most important work, the Credo and last Will of Marcel Duchamp," as a "fresco on glass… [a] desire epic, fairy tale and mechanical ballet, pious homage to the Creator's ingenuity, with a meticulousness endeavouring to equal his own". He also mentions that "it is washable on both sides under the shower and, as opposed to canvas, 'has no dust on its backside'.".
After a passage on the Valise [7.1.1941], "full of many ingenious foldings" into which "Duchamp has condensed his life work", Roché anticipates the publication of interviews with James Johnson Sweeney, and then quotes Duchamp:
"When an unknown artist brings me something new, I all but burst with gratitude."
"My irony is that of indifference: meta-irony."
"There is no solution because there is no problem."

1961. Thursday, New York City
In reply to the old question of just exactly what chess is, an art, a science or a game, Duchamp says that it cannot be classified as art because it is too violent an expression. "Chess is a sport. A violent sport," he tells Frank R. Brady in a recent interview published in *Chess Life*. "This detracts from it most artistic connections," Duchamp continues. "Of course one intriguing aspect of the game that does imply artistic connotations is the actual geometric patterns and variations of the actual set-up of the pieces and in the combative, tactical, strategical and positional sense. It's a sad expression though – somewhat like religious art – it is not very gay. If it is anything, it is a struggle."
Have any players of the past contributed to chess in the way that Dadaists and Cubists did for art?
For Duchamp both Reti and Nimzovitch, players considered "eccentric" because of their non-classical approach, contributed a great deal with their hyper-modernism. He smiles, "Nimzovitch is my God. He brought new ideas to the game."
· Duchamp believes that the life of an artist has similarities with that of a chess player: "The plight of the chessmaster is much more difficult though – much more depressing. An artist knows that maybe someday there will be recognition and monetary reward but for the chessmaster there is little public recognition and absolutely no hope of supporting himself by his endeavours. If Bobby Fischer came to me for advice, I certainly would not discourage him – as if anyone could – but I would try to make it positively clear that he will never have any money from chess…"
Although Duchamp has given up tournament chess "because of the strain", he tells Brady that he goes over several games a week from recent events and firmly believes in the therapeutic value of the game: "it teaches restraint and observation. One is inclined to look around a bit before making a move."

1962. Friday, Cadaqués
From the frontier station, Cerbère, the Duchamps take a taxi to Cadaqués where they return to the apartment which they have occupied each summer for the last few years [14.4.1959].

1963. Saturday, Taormina
After his sickness, "Marcel is much better this morning," writes Teeny happily to Jackie. "He's up and smoking!" He also addresses a postcard to Dumouchel, purchased in Capri [27.5.1963], of the famous Blue Grotto.

1964. Monday, Neuilly-sur-Seine
Concerning his forthcoming voyage in Italy, Duchamp receives a telephone call from Baruchello.

1966. Wednesday, Milan
For the dealer Arturo Schwarz, who has acquired from Dr Dumouchel one of the 3 copies of the photographic edition of the original *Boîte de 1914* [25.12.1949], Duchamp writes a note of authentication.

1967. Thursday, Paris
For the catalogue of the Salon d'Automne

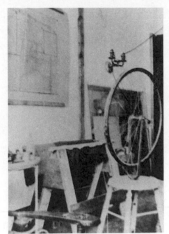

3.6.1918

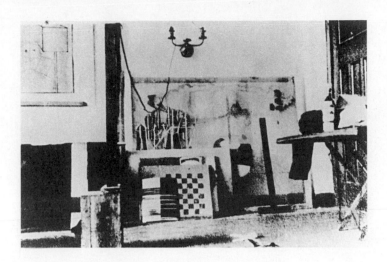

opening today at the Grand Palais, Duchamp has translated the text that Miss Dreier wrote on Suzanne Duchamp for the catalogue of the Société Anonyme. Nine of the paintings shown in "Les Duchamps" [15.4.1967] are hung in a small retrospective devoted to Suzanne's work, including *Le Readymade malheureux de Marcel* [14.4.1919].

1968. Saturday, Lucerne
On a card illustrated with a view of the lake and the Alps in the distance, Marcel writes to Brookes Hubachek: "We left Paris a week ago with just enough gas to make Basel..." He and Teeny have been staying in Lucerne, far from the turmoil reigning in Paris. "We hope that France will be all right again soon."

On an excursion in their Volkswagen one wet day to Lake Geneva, Marcel searches unsuccessfully for the waterfall at Chexbres [5.8.1946], which inspired him for the setting of *Etant donnés* [31.3.1968]. But although he would like to have shown it to Teeny, the landscape of the water mill is now hidden in its overgrown ravine by tall trees.

2 June

1918. Sunday, New York City
With 48 hours' leave, Roché arrives at eight in the morning on the overnight train from Washington. He goes straight to the studio at 33 West 67th Street, but Totor is away. Making himself at home he has a bath and changes.

In the evening, Roché dines with the Arensbergs at the Café des Artistes and spends the rest of the evening with them. After walking arm in arm with Mary Sturges and Yvonne Chastel across Central Park, he accompanies Yvonne to her hotel on 42nd Street and then returns to sleep at Totor's studio.

1924. Monday, Paris
Amongst the audience at the dress rehearsal of Jean Cocteau's *Roméo et Juliette* at La Cigale are Marie Laurencin, Jacques Doucet, André Gide... At the bar, their backs turned to him,

Roché sees Mary Reynolds [19.5.1924] and Marcel, already intoxicated, "looking their very best." Man Ray, who is with Kiki, watches them coldly.

1926. Wednesday, Paris
Roché brings a collector to the Hôtel Istria to see Marcel's Picabias [15.5.1926], but he is not there.

1951. Saturday, New York City
After Naum Gabo's operation, Duchamp writes wishing him a quick recovery.

1958. Monday, Paris
Just three days after his arrival from New York Totor has an appointment at seven o'clock with Roché in Arago. Roché, who doubted when they last met [2.2.1954] that he would ever see his friend again, travels from Sèvres.

1967. Friday, Paris
Duchamp is one of the spectators at "Manifestation No. 3" by Buren, Mosset, Parmentier and Toroni, which takes place at three o'clock in the theatre of the Musée des Arts Décoratifs. After paying five francs entrance, members of the public are confronted with four large canvases, one by each of the artists, hung symmetrically in a square. After forty-five minutes of waiting for the performance to start, a leaflet is distributed to the audience which reads: "Obviously it is only a matter of looking at the canvases of Buren-Mosset-Parmentier-Toroni."

3 June

1918. Monday, New York City
After tea with Alissa Franc, Roché returns to Totor's studio for a rest. Finding the disarray so beautiful, he takes photographs with his Kodak of different corners of the room and meditates on "the atmosphere, its purpose, its utility, its generosity".

Roché takes a nap until nine and then joins friends at the Arensbergs' before catching the train at midnight to return to Washington.

1922. Saturday, New York City
Duchamp is invited to tea at Florine Stettheimer's. Mr and Mrs Adolf Bolm, Ismail Smith, Louis Bernheimer and Catherine Dudley are among the guests; Carl van Vechten brings Mrs Harvey (Dorothy Dudley?).

1924. Tuesday, Paris
The chessboard sequence [28.5.1924] completed today for *Entr'acte*, Marcel meets Roché and Erik Satie (who was in Monte Carlo in January to attend the performance of *Le Médecin malgré lui* by Gounod) at the Café du Dôme in Montparnasse. Amidst laughter and much joy, Marcel explains his martingale [20.4.1924]. Satie, who wrote in February's issue of *Création*, "Monte Carlo is the land of games – double-games even," is the perfect listener.

At a table in front of them, Roché notices Mary Reynolds, "so beautiful and severely gracious."

1925. Wednesday, Monaco
"Splendidly installed at the Hôtel de Marseille [28.2.1925]," Duchamp writes two postcards, one to Jacques Doucet saying that he will send him news soon of his "new techniques", and the other, illustrated with the Casino of Monte Carlo, to Dr Dumouchel, apologizing for Monday morning. Marcel adds that he intends curing his pains with lots of sun.

1926. Thursday, Paris
With Mary Reynolds, Roché, Helen and Franz Hessel, Marcel goes to a performance of the

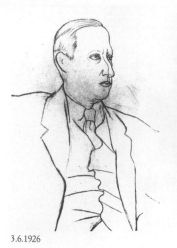

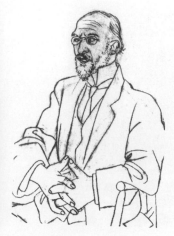

3.6.1926

Ballets Russes. The programme includes not only some "classics", *Les Noces*, *Parade* and *Pétrouchka*, but also the premiere of *Jack-in-*

the-Box, a recently discovered score by Satie, orchestrated by Darius Milhaud, and with décor and costumes by André Derain. Afterwards Roché doesn't feel strong enough to drink until morning with his friends.

1936. Wednesday, New York City
After a week at The Haven where he has commenced the task of repairing the Large Glass [5.2.1923], Duchamp is in New York for a short break and visits Julien Levy at his gallery on the fourth floor at 602 Madison Avenue. He talks briefly to Frank Merchant from the *Literary Digest*, and arranges to meet him again later in the day.

1947. Tuesday, New York City
Duchamp has dinner in the evening with Matta and Stefi Kiesler.

1953. Wednesday, New York City
After a recent conversation with James Johnson Sweeney, in which the new director of the Guggenheim Museum asks Duchamp whether Brancusi might agree to an exhibition, as complete as possible, at his museum, Duchamp writes to Morice: "I replied that you might perhaps give your consent if I agreed to represent you in the presentation of the exhibition."

Brancusi would be invited to New York to supervise the installation and, explains Duchamp, "I also told Sweeney that you would be responsible for the maquette of the catalogue with your photos; if it is necessary we can print the catalogue in Paris... I hope you will be tempted by the voyage and," concludes Duchamp, "I would be really delighted to revive the good hours of 1927 and 1933 with you."

1961. Saturday, Cadaqués
Marcel writes and signs a receipt for George Staempfli.

1963. Monday, Taormina
Writes two postcards, both with the famous volcano in eruption, one to Robert Lebel giving his agreement to a second edition of *Sur Marcel Duchamp* [6.4.1959], the other to Mary Dreier thanking her for the early birthday present, adding, "Sicily is wonderful and we are under the Etna at Taormina."

1964. Wednesday, Neuilly-sur-Seine
Before taking the night train to Milan, Marcel writes a short note to Noma and Bill Copley enclosing the curriculum vitae of Jorge Piqueras.

4 June

1927. Saturday, Paris
In accordance with French tradition, a few days before their wedding Marcel and Lydie meet in the presence of Henri Sarazin-Levassor, Maître Pierre Girardin (acting for the Sarazins), and Me Alexandre Lesguillier (acting for Duchamp), to read and sign the marriage contract, under which the husband and wife administer their separate properties.

One article determines that all pictures, sculptures and modern prints will always be considered as belonging to Marcel.
However, when it is announced that the life annuity settled on Lydie by her father amounts to 2,500 francs a month [6,500 francs at present values], Marcel's dissatisfaction can be read on his face in spite of his

efforts to remain calm. He knew already that the marriage would not make him rich [25.5.1927], but the extraordinarily meagre sum for Lydie is barely enough for her alone to live on. After the contract has been signed by all the parties, Marcel takes Lydie to the Luxembourg Gardens, where he paints a sombre picture of their future. Lydie realizes for the first time, with alarm, that her fiancé has no regular income.

1928. Monday, Paris
At one o'clock Roché arrives on foot from Arago to have lunch with Marcel in his studio, 11 Rue Larrey. Later in the afternoon an old friend [Dumouchel?] calls by and takes Roché to see the early paintings he has by Marcel.

1931. Thursday, Paris
Together with members of his family and Roché, Marcel is invited by Miss Dreier to tea at her studio, which is now "in working order" [31.5.1931] and where she has already started on a painting. As she recently described it to her sister Mary: "Though on the 5th floor I am not above the tree tops – so low is the old house. It is 16 Place Dauphine, which is the little square which faces the Palais de Justice, in the heart of old Paris... The view is too beautiful overlooking the Seine... and my apartment overlooks the big department store of the Samaritaine."

1936. Thursday, West Redding
Back from his short visit to New York, Marcel continues to repair the Large Glass [5.2.1923], assisted for a couple hours by Carl Rasmussen, the builder from Bethel.

1937. Friday, Paris
Duchamp selects an endgame by Henry Rinck, prizewinner of a competition organized by the *Leader* in 1903, to publish in *Ce Soir*. He gives the solution of Problem No. 11 by L. Romani, and annotates a game played in the recent USSR championships by Rauzer and Iline-Genevsky using the Philidor Defence. Amongst numerous news items, Duchamp announces the dates of the French championship to be held in Toulouse, and the university and school championship in Nantes; he reports Marseilles' triumph in the Coupe du

4.6.1963

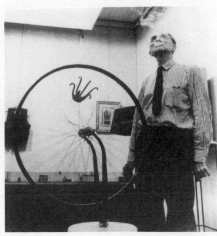

4.6.1964

Littoral et du Languedoc, and Nice's win over Geneva; he gives the results of the tournaments in Vienna and Budapest, the championship of Prague, and Holland's win in the match against Great Britain.

He also announces that tonight at ten minutes past five Radio-Paris will broadcast a talk on the history of chess, introduced by Mme Picabia.

1941. Wednesday, Marseilles
Writes confirming to Beatrice and Francis Steegmuller in New York that the most rapid way to assist the Villons is via Hubachek in Chicago, whose sister Mary Reynolds in Paris will help them directly. "It is possible," continues Marcel, with two question marks, "that I take a boat in July for the USA. In any case I am going back to Paris and return to Marseilles on 22 June."

1946. Tuesday, Paris
Roché comes by train from Sèvres to meet Totor at two o'clock in Arago with his questionnaire.

1950. Sunday, New York City
Following an enquiry from the Arensbergs as to whether they might be able to acquire *La Partie d'Echecs* [1.10.1910], recently exhibited at the Sidney Janis Gallery [27.2.1950], Marcel has spoken to Walter Pach, who "declared that he always wanted the painting to go to the [Arensberg] collection, that if he put a very high price at the different occasions he showed it, it was because he really did not want to sell it to 'strangers'". On hearing that Arensberg "could not consider such prices", Pach said that he would be prepared to accept an offer if Arensberg wants to make one.

In a letter Marcel tells the Arensbergs: "I tried to guess what sum [Pach] had in mind in order to guide your thoughts and came to the conclusion that something like 3,500 or 4,000 would surely be a good basis."

If they don't want to make an offer, Marcel suggests: "In the form of a conversation I can propose this or that sum and see his reaction."

As requested by Walter, Marcel encloses a few documents on Hieronymus Bosch by Nicolas Calas [30.5.1950].

1951. Tuesday, New York City
After receiving information from Hubachek about the Brancusi for sale in Chicago [23.5.1951], Marcel writes to the Arensbergs, giving them the name and address of the dealer, Frank J. Oehlschlaeger.

1953. Thursday, New York City
Further to his letter to Brancusi the previous day about the proposals for a major exhibition at the Guggenheim Museum, Marcel tells Roché the news: "...I have offered my services as supervisor like at Brummer's in 1927 and 1933." [17.11.1926 and 17.11.1933]

*

"From memory I believe you wanted to question me in addition to the information you have from Marcel Jean," writes Duchamp to Lebel referring to a letter he has been unable to find. "Agreed, I await the investigation unflinchingly."

1956. Monday, New York City
At eight o'clock in the evening Monique Fong calls to see Duchamp at 327 East 58th Street.

1957. Tuesday, New York City
For Robert Lebel's book, Arnold Fawcus of Trianon Press has sent Duchamp a first proof of the frontispiece, the small *Moulin à Café* [20.10.1912]: "Very bad," Duchamp tells Lebel.

He has written to Maria Martins asking her to provide Fawcus with a good black-and-white photograph, and suggests that Lebel try to contact Georges Girardot, the colourist he prefers, who worked on the contents of the Valise before the war.

Fawcus has also proudly composed the first two pages of the book. Lebel calculates that "at this rate we have for not more than 23 years..." and advises Duchamp, "in case the Mexican revelation has inspired a few new works, there will be time therefore to include them in the *catalogue arraisonné*."

Marcel replies: "No Mexican production, only ruins [18.4.1957]." He has, however, started colouring the photographs of the Large Glass for the de luxe edition [25.3.1957].

"It will take me 3 months," he calculates, "...one hour a day and with magnifying spectacles."

1963. Tuesday, Palermo
From Taormina, after changing trains in Messina, Teeny and Marcel take a connection, which arrives in Palermo at eight-thirty in the evening. They have reserved a room at the Hotel delle Palme, a refuge for many celebrities, including the author of *Impressions d'Afrique* [10.6.1912], Raymond Roussel, who died on the second floor in room 224 on 14 July 1933.

1964. Thursday, Milan
"The *Roue de Bicyclette* [15.1.1916] is my first readymade, so much so that at first it wasn't even called a readymade," Duchamp tells Arturo Schwarz. "It still had little to do with the idea of the readymade," he explains. "Rather it had more to do with the idea of chance. In a way it was simply letting things go by themselves... probably to help your ideas come out of your head. To see that wheel turning was very soothing, very comforting, a sort of opening of avenues on other things than material life of every day..."

Proceeding by pictorial translation, is it entirely fortuitous that, when fixed together, the two elements "roue" (wheel) and "selle" (stool) become a portrait or homage to one of the men he admired the most at the time for his "delirium of imagination", Raymond Roussel [10.6.1912]?

After a number of replicas, the first in 1916 for his studio at 33 West 67th Street, and again in New York [2.1.1951], Stockholm [21.8.1960] and London [17.5.1964], an edition of 8 has been made under his supervision, which he signs today on his arrival from Paris.

While in Milan, Duchamp decides with Schwarz to make further editions from his readymades: *A Bruit secret* [23.4.1916], *Why not Sneeze?* [11.5.1935], *Peigne* [17.2.1916] and *Apolinère Enameled* [15.3.1945].

1968. Tuesday, Lucerne
After ten days in Switzerland, Teeny and Marcel travel to Zurich airport and fly to London.

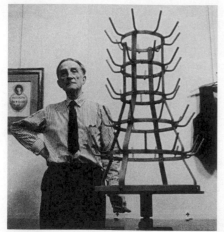
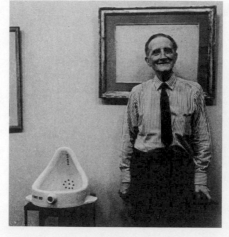
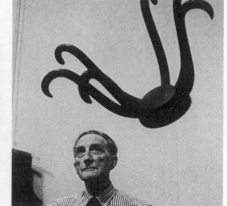

5.6.1964

5 June

1924. Thursday, Paris
After their evening together in Montparnasse on Tuesday, Duchamp, Roché and Satie meet Gaby Picabia and another friend for lunch at La Chope Pigalle. Afterwards they all attend a rehearsal of the orchestra for *Les Aventures de Mercure* at the Cigale.

Roché likes the empty theatre with sun shining through the windows, and finds Satie exquisite.

1942. Friday, Casablanca
"After 18 days of very pleasant holiday in Morocco [21.5.1942], we leave the day after tomorrow," writes Marcel to Jessie and Bob Parker, who have offered him their hospitality when he arrives in New York. Marcel suggests that the date of the arrival of the *Serpa Pinto* might be obtained from HIAS, 425 Lafayette Street, and promises to telephone them from the pier.

1946. Wednesday, Paris
In the evening Mary Reynolds and Marcel take the train to Sèvres to dine with Denise and Henri Pierre Roché in Avenue de Bellevue.

1956. Tuesday, New York City
"We have received your book [*Deux anglaises et le continent*]," writes Marcel to Henri Pierre Roché, "and I have devoured it avidly… It has the freshness of youth and seems to have been written by the man you were fifty years ago. The *tour de force* is not to have dampened the explosion by a style or reflexions too adult. Tell me how the early readers reacted…"

Referring to *9 Moules Mâlic* [19.1.1915], Marcel says: "Since our stay at Arago in Paris [14.11.1954] Teeny dreams of possessing my glass, which she saw every morning on awaking. As you know, she has nothing of mine."

Would Roché consider selling Teeny the glass for $14,000? Teeny would find the sum by selling a Rouault and one of the Mirós.

1960. Sunday, New York City
Duchamp thanks Simon Watson Taylor [30.12.1959] for the special number of the *Evergreen Review* entitled "What is 'Pataphysics'?", saying that it is a "great success" in New York.

Inviting Watson Taylor (who is a steward for the British Overseas Airways Corporation) to visit him when he next flies to New York, Duchamp hopes that it will be before he himself leaves for Europe on 29 June.

1961. Monday, Cadaqués
Writes a postcard to Louis Carré in Paris confirming that he and Teeny will attend the party at Bazoches on 15 June.

1964. Friday, Milan
Preview at the Galleria Schwarz of "Omaggio a Marcel Duchamp", an exhibition of drawings, prints, documents and photographs, but which is organized principally to launch the replicas, each in an edition of eight, of thirteen historic readymades.

The book, *Marcel Duchamp readymades, etc. (1913–1964)*, published for what is termed the fiftieth anniversary of the first readymade, contains a catalogue of over a hundred items shown in the gallery, together with essays by Walter Hopps, Arturo Schwarz and Ulf Linde.

In the evening at a dinner party held at the home of Arturo Schwarz, Duchamp dedicates the printed cotton napkins belonging to Enrico Baj, Alik Cavaliere and Roberto Crippa, after adding some red and green patches made with *vino rosso* and peppermint.

1965. Saturday, Neuilly-sur-Seine
In a postscript to Teeny's letter to Arne Ekstrom announcing that "Marcel is competing with Gemini 4 and [will] be on TV… in the next few days," Marcel says that Takis is giving him a magnetic machine for the exhibition which he was organizing for the American Chess Association, "Hommage à Caïssa", to be held at Cordier & Ekstrom early in 1966.

1966. Sunday, Venice
"Delightful to see Peggy without premeditation," writes Duchamp in French in the guest book at the Palazzo Venier dei Leoni on the Grand Canal.

1968. Wednesday, London
"Ambling into the new I.C.A… [Duchamp] picks his way through the overflowing audience, and for two and a half hours listened with total composure to Mr Schwarz's high-pressure hypothesizing…"

"Credited with all manner of vagrant fancies and subterranean implications (beyond, of course, those which he himself has already thesaurized) [Duchamp] gazed into the middle distance," observed John Russell, the art critic of the *Sunday Times*. "Was the violin, as Mr Schwarz asserted, a symbol of onanism rather than a valuable component in family chamber music? Duchamp gazed on."

Later at supper, when he meets Arturo Schwarz, Duchamp exclaims: "Capital! I couldn't hear a word, but I enjoyed it very much." Teeny Duchamp and close friends, however, are deeply shocked by Schwarz's analysis of the Large Glass [5.2.1923], which is based on the hypothesis of Duchamp's incest with his sister Suzanne.

*

Duchamp is interviewed by Joan Bakewell on BBC Television's programme "Late Night Line Up".

6 June

1909. Sunday, Rouen
Marcel has etched the menu cards, retouched with watercolour, for the family lunch to celebrate the first communion of Simone, the daughter of Lucie Duchamp's first cousin Georges Delacour.

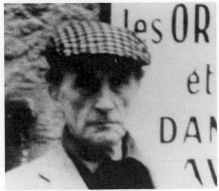

6.6.1968

1915. Sunday, Bordeaux
Duchamp boards the *Rochambeau* for his first Atlantic crossing. He has left the keys of his apartment in Paris with Léo and Marthe, the girlfriends of Tribout and Dumouchel. Intending to continue work on the Large Glass, he is taking with him the small glass, *9 Moules Mâlic* [19.1.1915] and the plans on paper [22.10.1914].

Late at night the ship steams out to sea with all its lights extinguished until the danger from submarines has receded. However, with the intention of retaining the neutrality of the United States of America after the sinking of the *Lusitania*, today Kaiser Wilhelm II has forbidden any further submarine attacks on either enemy or neutral passenger ships, these attacks being the reason for the departure of the *Rochambeau* from Bordeaux instead of Le Havre.

1919. Friday, Buenos Aires
"I have been very negligent. I should have answered your letter a long time ago," confesses Marcel to Walter and Magda Pach. Not having heard from Barzun, coupled with Pach's pessimism, Marcel has abandoned the idea of sending an exhibition from New York [4.4.1919]: "I decided to give up the project in which there were only troubles for me anyway," he admits. "That was wrong, from the monetary point of view B.A. is a city where everything new (for them) is a financial success and even in modern painting there is a market."

Although he says he has worked a little and played chess a great deal, Duchamp claims he has been very lazy. He tells the Pachs that he is leaving for France via London on 20 June: "I dread very much my return to Puteaux, where poor Raymond will be missing [7.10.1918]. It is really an awful thing that one realizes with

greater and greater precision as the simple event recedes in time."

1921. Monday, New York City
Three days before his departure for Europe, Marcel calls to see Beatrice Wood.

*

Opening of the "Salon Dada" in Paris at the Galerie Montaigne. Since Duchamp has refused to exhibit [1.6.1921], the organizers decide to leave the space reserved for him empty, with only notices pinned to the wall.

1924. Friday, Paris
At midnight Marcel is at the Café du Dôme with Mary Reynolds, Roché and others.

1927. Monday, Paris
At one o'clock Lydie and Marcel meet Roché for lunch near the Halle aux Vins. Afterwards the three of them go to 11 Rue Larrey. Although very dubious about Marcel's decision [27.5.1927], Roché now believes that he "understands" his friend's marriage, which is to take place the following day.

1928. Wednesday, Paris
Although he has to be off to his chess club immediately after dinner, Marcel accepts Mary Reynolds' invitation to dine at her apartment, 14 Rue de Monttessuy, with Helen Hessel and Roché. Both the women are looking beautiful, according to Roché, and Mary looks happy.

1946. Thursday, Paris
Preview at three in the afternoon of "Hommage à Antonin Artaud", an exhibition of paintings, drawings, sculptures and manuscripts, organized by Pierre Loeb at the Galerie Pierre, 2 Rue des Beaux-Arts, for the benefit of Artaud. Duchamp is represented by *Poisson japonais*, a very small pencil drawing embellished with several strokes of white gouache, which he used for one of his *Rotoreliefs* [30.8.1935]. The items exhibited are to be auctioned on 13 June by the actor, Jean-Louis Barrault.

1953. Saturday, New York City
Since the lunch that he promised to arrange between Alfred Barr, René d'Harnoncourt and Henri-Martin Barzun is to be held on 11 June, Duchamp cables Barzun: "Agreed Thursday 1:15 Plaza."

1960. Monday, New York City
Marcel has visited Mary Dreier to ask her whether she would finance the urgent restoration work on certain pictures in the Société Anonyme Collection at Yale University [27.5.1960]. He tells George Heard Hamilton: "She is certainly willing to help… although would like a more detailed account of what has to be done and… the amount of money it all entails." Marcel asks Hamilton if, before Saturday, he can send an estimate and also calculate what capital sum would be required for an endowment, because "she is leaving Tuesday 14th for Maine and is very anxious to have something done before she leaves".

1965. Sunday, Neuilly-sur-Seine
Writes to Gabriel White, the director of the Arts Council of Great Britain, accepting his proposal of a major exhibition at the Tate Gallery, London. As Richard Hamilton is behind this project, Marcel sends him a note, typed by Teeny, saying that he has just received the letter from Mr White, "who seems to be in touch with Mrs Sisler and Mr Turner of Philadelphia… So let's hope…"

1967. Tuesday, Paris
Following the exhibition in Rouen of the four siblings [15.4.1967], only the work of Marcel Duchamp and his brother Raymond Duchamp-Villon is shown in the exhibition opening at three o'clock at the Musée National d'Art Moderne, 13 Avenue du Président Wilson.

1968. Thursday, London
In the morning at Richard Hamilton's house in Highgate before he flies back to Zurich, Marcel is interviewed for the *Sunday Times* by John Russell, who saw him the previous night at the Institute of Contemporary Arts. "Marcel Duchamp would stand out anywhere," he remarks, "but he likes, even so, to adapt to his surroundings, with a close-curled Sinatra hat in Las Vegas [13.10.1963], peasant straws and linens at Cadaqués… and in London the nonchalant cap-and-cardigan of a landowner up from his estates."

"Duchamp has been all his life one of the greatest poets of disengagement," believes Russell. "As for his work, he regards it as public property, for people to comment on as they

6. 6.1968

6.6.1968

please. This is tiresome for those who want the 'final word'… but it also makes for a relaxed, divagatory mode of speech, laced with three- and four-sided verbal jokes, and for unhurrying puffs at the cigars (ten every day) which have now replaced the battered stem-pipe of the lifelong chess player."

Talking about his early travels, Duchamp reflects: "It's curious, I come of a sedentary family, and my brother Jacques Villon never went anywhere if he could help it, but I took an intense pleasure in being away. I would have gone anywhere in those days. If I went to Munich [21.6.1912] it was because I met a cow-painter in Paris [1.3.1910], I mean a German who painted cows, the very best cows of course, an admirer of Lovis Corinth and all those people… Munich had a lot of style in those days. I never spoke to a soul, but I had a great time."

Hamilton gets Duchamp to agree that when he was in Herne Bay [8.8.1913] he was completing the notes for the Large Glass [5.2.1923], and in Buenos Aires in 1918–1919 he worked on "the problem of time and the successive image in art" [4.4.1919], so "that these visits were not really a matter only of daydreaming".

On this short visit to London at the invitation of Editions Alecto, Duchamp is mulling over possible English translations of *Morceaux Choisis*, his new set of etchings:

Morceaux choisis d'après Cranach is drawn from his own *tableau vivant* of Adam and Eve in *Ciné-Sketch* [31.12.1924]. *Après l'amour*, a couple lie *post coitum* in somnolent embrace, (inspired possibly by *Amantes de Mazatlan*, the canvas hanging in the Mexican guest room [25.2.1965]?).

Morceaux choisis d'après Rodin uses the immortal Kiss, changed in but one small detail: "After all," Duchamp says with a smile, "that must have been Rodin's idea. It is such a natural place for the hand to be".

Le Bec Auer takes the illuminating gas held aloft by the, as yet, still secret reclining nude of *Etant donnés* [31.3.1968], but a male presence carefully masks the female identity.

Morceaux choisis d'après Ingres I, signed by Duchamp "Marcellus D.", incorporates from *Bain Turc* the Sultan's favourite playing a lute. The fingerboard of the instrument is held by Virgil who, in Ingres' composition *Virgil lisant l'Enéide à Livie, Octavie et Auguste*, has reached the moving and dramatic passage, "Tu Marcel-

lus eris", announcing the death of Marcellus.

Encore une Mariée mise à nu… represents a nude girl kneeling on a prie-dieu, enveloped in a veil-like milky nimbus, with a distinct aura of Rigaut's "air embaumé", borrowed by Rrose Sélavy for *Belle Haleine, Eau de Voilette* [6.2.1930]. According to Duchamp, "the bride has finally been stripped here."

Morceaux choisis d'après Ingres II, switches a sapphic beauty from *Bain Turc* with the Sphinx, enabling Oedipus, in an exchange of hands, to renew his approach to the question with a certain liberty.

Le Roi et la Reine places two chesspieces designed by Duchamp for his *Pocket Chess Set* [23.3.1944] with a weightless accumulation of cubes, or blank dice, taken from his poster designed for a chess tournament in Nice [2.9.1925].

Finally, *Morceaux choisis d'après Courbet* appropriates the languid *Femme aux bas blancs* belonging to the Barnes Foundation [3.12.1933], to which Duchamp has added an inquisitive bird: "He's curious, and further-more he's a falcon, which in French yields an easy play on words; so that here you can see a false cunt and a real one."

"I don't know how to call them in English. Pieces? Bits? Parts? Extracts? 'Morceaux' is something of all of those, and none of them. I did the prints originally to go with Schwarz's book," [*The Large Glass and Related Works, Vol. II*] Duchamp explains, drawing on his fourth cigar, "but the Italian printers have refused three of them. The Pope's veto per-haps…"

7 June

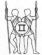

1926. Monday, Paris
"Received the couple safely on their return," Duchamp informs Jacques Doucet. "They seem to be enchanted with their escapade," he remarks, referring undoubtedly to *La Femme aux Allumettes and Le Beau Charcutier*, or maybe *Monsieur Poincaré* [8.4.1926]?

Duchamp hopes to move this week from his room at the Hôtel Istria [8.12.1923] to the studio at 82 Rue des Petits-Champs, the

house which belonged to Picabia's grand-father, the photographer Alphonse Davanne, and where Picabia was born. "I will ask you to call by as soon as the electrician permits it because although in the attic, it's dark up there," Duchamp tells Doucet.

*
The same day, Roché takes delivery of *A propos de jeune Sœur* [8.3.1915], which he recently acquired [6.4.1926] from the estate of the late John Quinn [28.7.1924].

1927. Tuesday, Paris
On the day before their church wedding, the civil marriage takes place in the *mairie* of the *16ème arrondissement*. The bride wears a navy blue dress trimmed with white and a large black straw hat. Marcel is in morning dress, ordered especially for the occasion from the tailors of Scottish origin, Auld Baillie. Francis Picabia and Jacques Villon are Marcel's wit-nesses. The mayor himself conducts the cere-mony and makes a short speech, concluding with the words: "I hope, Madame, that you will always inspire your husband."

Afterwards, in a relaxed atmosphere, Henri Sarazin-Levassor gives a luncheon party at the Automobile Club in one of the attractive re-ception rooms overlooking the Place de la Concorde.

Just after five o'clock, Marcel calls at Impasse Ronsin. As Brancusi is not at home, he leaves a note proposing that if the sculptor doesn't want to come to the church tomorrow, Marthe "can come to the ceremony if that amuses her".

The family dinner in the evening at 6 Square du Bois de Boulogne, which Marcel attends, is gloomy and tense. The die is cast, Sarazin has fulfilled with a certain brio his wife's condition for a divorce.

1928. Friday, New York City
The Fifth Avenue Bank of New York credits Duchamp's account with $100 received from Miss Dreier.

1933. Wednesday, Paris
At three o'clock, a preview of the "Exposition Surréaliste" at Pierre Colle's gallery, 29 Rue Cambacérès. Among the paintings, drawings, objects and collages is a copy of *Pharmacie* [4.4.1916].

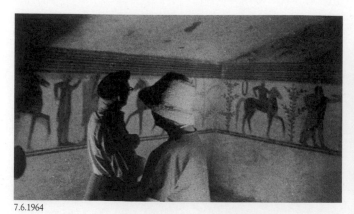

7.6.1964

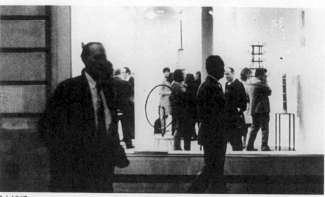

7.6.1967

1942. Sunday, Casablanca
Making his 13th transatlantic crossing, Duchamp is aboard the fine Portuguese ship, the *Serpa Pinto*, when it sails for New York. As the

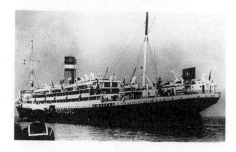

Germans and British have given their authorization "it is not even a question of fear at being torpedoed". In contrast to his first ocean voyage in wartime [6.6.1915], the ship steams out to sea with all its lights blazing.

To pay his passage, Duchamp received half the sum from Arensberg and to find the remaining $400 finally managed to sell Miss Dreier's Verlaine [24.9.1939]. He is sharing his cabin with a chess player…

1949. Saturday, New York City
Has lunch with Fleur Cowles, who expresses interest in featuring "The Western Round Table on Modern Art" [8.4.1949] in a future issue of her magazine *Look*.

Later Duchamp writes to Douglas MacAgy enclosing the corrections to his "erratic" statements made at the symposium in San Francisco. Recommending that MacAgy does not edit any of the points made by Frank Lloyd Wright concerning degeneracy, homosexuality and morgues, Duchamp argues "these are the points the reading public will be most interested in – and they are the points generally brought up against modern art". Duchamp believes "it is also interesting for the general public to see a F. L. Wright take position against modern art, so thoroughly".

Referring to Frank Lloyd Wright's remarks about Stéphane Mallarmé, Duchamp thinks it is a case of mistaken identity: "Mallarmé never went down the cellarways – he led a very dignified bourgeois life of a teacher of English – I think F. L. Wright mistakes Mallarmé for Verlaine, who was a bum." As Mallarmé never

wrote a poem entitled "Les Yeux" either, Duchamp suggests that the architect be asked to "reconsider the whole episode – it really makes no sense".

Feeling "the physical benefit" in his muscles after his trip to California, Duchamp tells MacAgy: "my brain also is decidedly more alert after such a whipping."

1952. Saturday, New York City
Using paper stamped with the message "*style télégraphique pour correspondance en retard*" and his address, Marcel confirms to Marcel Jean [15.3.1952] that the note "Jura–Paris" does owe its title to the voyage with Apollinaire, Gabrielle and Francis Picabia to Etival [26.10.1912].

1958. Saturday, Longpont-sur-Orge
Marcel and Teeny, Robert Lebel, Arnold Fawcus and Roché are the guests at a dinner party given by Bill and Noma Copley.

1959. Sunday, Cadaqués
"Dear Maggy dear Mouchel," writes Marcel on a postcard to the Dumouchels, "…will be going behind Grasse from 18 July to 13 August and will come to see you in Nice…"

1964. Sunday, Milan
Baruchello, who attended the opening of Marcel's exhibition [5.6.1964] with his daughter Anita, drives Teeny and Marcel in his Citroën DS 19 from Milan to Florence. On the way they stop at Ravenna and visit the tomb of Galla Placidia, a plain brick building which hides a rich interior of mosaics on a dark blue ground.

After visiting the basilica of S. Apollinare in Classe, standing in the countryside five kilometres outside Ravenna at the place where Vescovo Apollinare di Ravenna was martyred, they continue via Bologna to their destination: the Excelsior Italie on the Piazza Ognissanti, Florence.

1966. Tuesday, Neuilly-sur-Seine
On his return from Italy, Marcel finds word from Richard Hamilton and replies the same day: "Thanks for your letter announcing that we don't have to sleep on the steps of the Tate!"

*

Receives a telephone call from Arturo Schwarz, who confirms that he will be arriving in London on 17 June.

1967. Wednesday, Paris
At an evening preview, the day after the opening of the exhibition at the Musée National d'Art Moderne, Béatrice and Claude Givaudan present "Readymades et éditions de et sur Marcel Duchamp" at 201 Boulevard Saint-Germain. Shadows cast from various readymades exhibited are painted on the walls of the gallery.

The invitation card printed in green and red is decorated with a double shadow of Duchamp's head in profile, a hand holding a cigarette to his lips.

8 June

1915. Tuesday, at sea
Marcel crosses out the image of Bordeaux on a postcard, adds an arrow pointing west "at

1,000 km" and writes to his sisters-in-law, Gaby and Yvonne: "All submarine danger averted. The sea a lake: very few seasick. We left Bordeaux (all lights extinguished) Sunday night. One sleeps very well. I play chess all the time. We will arrive Tuesday 15 in New York. Very good society of passengers not too pompous. Fine ship, to be recommended. I cannot bring myself to start learning English from my little book. *Vous embrasse*, Marcel."

1918. Saturday, New York City
In the afternoon at her home, 102 West 76th Street, Ettie Stettheimer has a French lesson with Duchamp, "a queer but charming French boy," while she has her nails manicured.

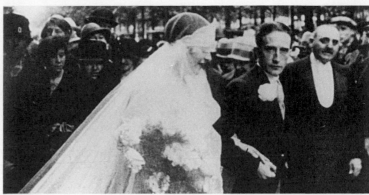

8.6.1927

1927. Wednesday, Paris
It is a perfect summer's day for the kind of white wedding with all the trappings and fuss that Lydie wanted and dreamed of, and which Marcel has accepted [14.5.1927]. At midday, when the bride arrives with her father Henri Sarazin-Levassor at the Temple de l'Etoile, 54 Avenue de la Grande-Armée, the Protestant church is already very crowded. Preceded by two young pages and a bevy of bridesmaids, Lydie finds the long walk up the aisle, with the eyes of all Montparnasse upon her, intimidating. From his place next to his sister Suzanne, Marcel moves to Lydie's side and the service commences: hymns, prayers, a violin solo, follow in succession.

At Marcel's request, the pastor Maroger, a friend of the Sarazins, has agreed to the exchange of gold bracelets instead of the traditional rings ("as long as you don't ask me to put them around your ankles"), but the clasps are so small that he is unable to fasten them and has to signal for the next hymn. After signing the register in the sacristy, the couple and their close relations receive each guest in turn, an interminable file of felicitations. Those hoping for or expecting something authentically Dada to occur are disappointed; the eccentricity is, in fact, the entirely bourgeois manner in which the proceedings are conducted.

Man Ray, assisted by Kiki, is waiting to film Lydie and Marcel as they come out of the church, leaving the sound of the Wedding March from *Lohengrin* behind them. They appear and pause on the pavement, waiting for their car to draw up. To the crowd of curious pressing strangers the groom is solemn, attentive, with a huge white carnation in the buttonhole of his morning coat; the bride, carrying an immense bouquet of matching carnations, smiles and negotiates with assistance her entry to the car, swathed in tulle followed by yards and yards of train. In their wake, Man Ray films Sarazin escorting Suzanne, who is wearing a fashionable cloche hat. They are followed by Jacques Villon, Germaine Everling, Jean Crotti and Francis Picabia who, roaring with laughter, mimics Man turning the handle of the camera...

Inexplicably the time for the reception at 6 Square du Bois de Boulogne has been omitted from the invitation card, so that by the time Marcel and Lydie arrive the mansion is already full of people, champagne is flowing and the buffet lunch fast disappearing. On the whole the presents are grotesque, a discouraging assortment of lamps, vases and tableware. The only object which really pleases them is a laboratory-style Cona coffee percolator. To their delight, Picabia brings a watercolour entitled *Union d'Intellectuels*. When Lydie enquires later about its symbolic significance, Marcel advises her never to try to understand a work of art, but to sense it: "An artist expresses himself with his soul, with the soul it must be assimilated. That's what counts."

The musicians hired to serenade the company never turn up, so the guests, who arrived earlier than expected, also leave earlier. Seeing Roché on his own, Lydie asks for Helen Hessel, but Marcel failed to send her an invitation [13.5.1927]. As he is going, Man Ray invites Roché for a ride in his car, a Voisin. Before her own departure with Marcel, Lydie is summoned to her father's study where he presents her with a cheque for two months' income precisely in accordance with the provisions of the marriage contract [4.6.1927].

That evening Marcel and Lydie dine at Brancusi's with Marthe, Germaine and Francis Picabia. They cannot afford a proper honeymoon and, besides, Marcel has promised Miss Dreier that he will supervise the return of pictures from the Société Anonyme's Brooklyn exhibition [19.11.1926]. Later in the summer, however, they plan to go south to Mougins.

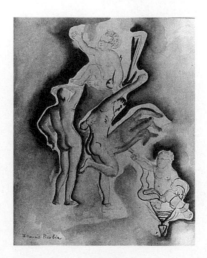

1947. Sunday, Milford
Marcel visits Miss Dreier for the day principally to discuss whether the Société Anonyme should purchase the canvas by Theo van Doesburg, *Composition Simultanée*, which has recently been in an exhibition of the artist's work at Peggy Guggenheim's gallery, Art of this Century.

Given the present financial climate, Duchamp considers that the purchase should not be made without funds in the bank to cover it.

Miss Dreier is disappointed, but knows that "Duchamp is wise, as he generally is…" They decide, however, to ask Nelly van Doesburg, the artist's widow, if she would be prepared to lend them the picture in the meantime, and Duchamp promises to call Nelly on his return to New York that evening.

1948. Tuesday, New York City
Accepting Miss Dreier's invitation to lunch on Saturday at the Town Hall Club, Marcel also tells her: "This little film will cost very little money and I hope to sell one copy to the Museum of Mod[ern] Art, I am borrowing a camera through David Hare."

1964. Monday, Florence
While Baruchello goes to Bologna, Teeny and Marcel spend the day in Florence.

*

Jeu d'échecs avec Marcel Duchamp by Jean-Marie Drot, the film which was shot in the exhibition at Pasadena [2.11.1963] and in the apartment in New York [1.12.1963], is broadcast on French television.

9 June

1917. Saturday, New York City
Beatrice Wood works in Marcel's studio and later dines with him and Henri Pierre Roché at Bergens restaurant. Together they then attend a performance at eight-twenty of *Love o' Mike*, the "smartly staged" comedy by Thomas Sidney with music by Jerome B. Kern, which is a current hit at Maxime Elliott's on 39th Street near Broadway.

9.6.1918

1918. Sunday, Bedford Hills
The three sisters and their mother Mrs Stettheimer are already installed at Rupert Hughes' farm for the summer. Carrie is working on her doll's house, Florine at her painting:

Our Parties
Our Picnics
Our Banquets
Our Friends
Have at last a *raison d'être*
Seen in colour and design
It amuses me
To recreate them
To paint them.

Marcel takes the train with Carl van Vechten and the sculptor Elie Nadelman to Bedford Hills for the day. After a short interlude in New York, Ettie, preoccupied with the rival attentions of Duche and Nadelman, arrives by car with her married sister Stella Wanger and the Marquis de Buenavista. According to Ettie it is a "pleasant but uneventful day".

1921. Thursday, New York City
Before his departure on the *France*, which is due to sail at noon for Le Havre, Marcel

chooses a postcard illustrated with the ship's "Grand Salon Louis XIV" and, on the back, draws a hand waving a handkerchief towards Tarrytown, the summer residence of the Stettheimers.

Ettie is working on her book, *Love Days*. The idea first came to her at the end of August 1916: "a collection of days in a life, very complete and detailed, perhaps 7 given cross sections of a whole development up to maturity". Although it is not until Easter Day 1919 that "...the 1st day is finished", the following July, Ettie "has an inspiration", to rename the days

Love Days, "and make them frankly love crisis episodes."

She has now almost finished four parts, including the unpredictable day in which Susanna receives an unexpected visit from a French friend soon after his return to New York [6.1.1920]:

"Here he was, leaving the lift and remembering to close the door carefully, and then turning to her with affectionate smiles...

Susanna held out her cheek; he kissed it lightly. She was but half conscious of his physical nearness, but she was at once intensely conscious of her increased comfort, expansion, and satisfaction in his presence.

Delaire spoke in French in the first excitement of their meeting.

"You are well? You look it. You didn't expect me so soon in New York, did you?"

"No we didn't. Not until summer. And you, are you well, Pierrot? ...But this is a wonderful day for me, everything is different and better than it promised. And now you are in it. I am so very glad to see you back, Pierre, my dear, even if you have changed."

"You think I have, Susanna?"

He was already lighting a cigarette, seated opposite to Susanna, who slouched in the bergère in great content. "I know so," she said. "You're a new creature... You're no longer Pierrot, you are Pierre. You've shed the *gamin*, Pierre!"

"*Vraiment!*" he laughed, obviously pleased, but noncommittal.

"*Vraiment*; I hardly know you," she continued, smiling at him happily. "It's not only your shaved head – and I won't tell you whether I like it or not – but I don't feel the same towards you." He raised his head and looked at her. "No, I mean you don't give me the same feeling, so you must be different."

"Why not you?" he asked conversationally, but with an attentive glance.

"Oh!" Susanna had not thought of this. "I may have... Still, I don't feel changed. Do you think I have? Do I give you a different feeling, Pierre?"

"Who knows! At any rate you have clipped your hair too, so, *chère amie*, you have nothing on me, as you say here."

...His voice was light and sweet, so really was he, she thought, as she absorbed him with her blunt stare. Most people considered him beautiful as well as irresistibly *sympathique*, but Susanna could not share this view of him. She thought rather that his delicate fairish classicality of a dry and cerebral quality had all of beauty except

beauty's peculiar thrill. And now, his head shorn of its most vital, fluid and adventurous feature, the long fair hair he brushed firmly back, now his almost naked skull, though in itself correct enough, revealed with brutal frankness the structural bony materiality of the whole. He looked even less vitalized, less sappy than before, she thought; more rigid, more 'nature morte'. How horrible of me to think so...

"Anyway I've not cut mine for the same reason as you. I've cut mine to make myself more attractive, not less!" She laughed; a teasing laugh.

"I'll tell you why I've cut my hair if you want to know," Delaire's gentle, monotonous voice put in.

"But I don't want to know. I don't want to witness your capitulation to the laws of thought. For that's what you're doing in offering me a casual explanation, *cher ami*! Samson, you know, lost his strength with his hair: you seem to be in danger of losing your mystery!"

...She felt him pleasantly as a charming and rare creature, sensitive, delicate and with a rare polished finish. She knew him as set, definitely set somehow, in character, and subtly eccentric in intellect, although she was unable to follow rationally his philosophy of complete rejection of what he conceived to be the trammels of convention, and convention for him included all intellectual tools that had become masters: language and logic itself, and indeed all forms of culture that were past and yet potent...

"You know I'm just as fond of you in spite of your cropped head and the torn veils of mystery," she continued. "We're great friends in spite of all, Pierre?"

"In spite of all," he echoed.

...She handed him some sketches that had been made of her during his absence, asking his opinion of them. For though so radical a painter himself he was a most dependable judge of all forms of art, old and new...

"Not badly done, but not in the least like you," he pronounced.

"Oh, don't you think so? I thought it suggested me strongly."

"*Comment* – you think this suggests you – you think you're like this snaky woman?" he asked surprised.

"I don't know, I really don't know much about myself, you know." Susanna lay back in her chair, her hands clasped behind her head, and smiled contentedly across at him. "I don't mind not knowing: it makes everything that happens seem so unexpected and dramatic – an adventure really."

"And are you telling me that you like adventures!" Delaire laughed ironically, but his classic

9.6.1921

face seemed to inquire rather than scoff.

"But I love them," she replied.

"But you never have any," he objected.

"But I have them all the time, on the contrary," she insisted with astonished eyes.

"You wouldn't come abroad with me when I suggested it twenty-four hours before the boat sailed!" [2.8.1918] He laughed derisively but gently.

"But that wasn't because it would have been an adventure, but because I didn't want to!"

"*Parfaitement!* You don't want adventures; you don't like them." He stated this with emphasis and satisfaction.

He thought that he had cornered her, and she seemed cornered, she admitted...

"But you see," she said, "I regard the bare fact of your having asked me to go as an adventure in itself – unforeseen, unaccountable, fantastic, odd, though pleasant."

Delaire burst into his rare explosive laughter.

"Sophist!" he commented.

"Probably..."

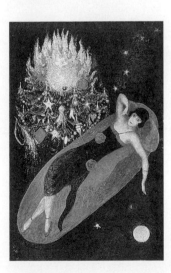

[After he has gone.]

She was truly glad he was back; she disliked his frequent absences in different parts of the world, not only because they deprived her of him, but because he seemed so little related to places that it was impossible to discern what geographical change could possibly mean to him, and disquieting that he nevertheless indulged in it...

It was a pity she was not in love with him, nor he with her. And it suddenly came to her with a kind of cold logical conviction that this was the matter: he was not in love with her. If he were, she suddenly thought to know, if a great emotion had communicated itself from him to her, it might have resulted in her falling in love. Instead there was this strange tendency – strange in so positive a personality – to be neutral in relationship, so to say. And suddenly Susanna was quite certain that he forgot her in between their meetings even more completely than she forgot him.

Too bad, too bad that they had not fallen in love; their love would perhaps have illuminated for each the dark places of the other, and made each transparent for the other, or not transparent so much as incandescent. And the miracle of spiritual interpenetration might have eventuated...

A love-morning, she thought; love tales, love poems, love thoughts – everything but love practices..."

1922. Friday, New York City
In the morning Marcel sees Ettie and puts "the fasteners" on her manuscript [9.6.1921] of *Love Days*, which Carl van Vechten has offered to take to Knopf, the publishers.

1926. Wednesday, Paris
Mary Reynolds and Marcel meet Roché and Helen Hessel at 99 Boulevard Arago and lunch together nearby at the Petit Buffalo at 132 Avenue d'Orléans.

1952. Monday, New York City
Meets Monique Fong who is in the city on one of her regular visits from Washington.

1960. Thursday, New York City
Following his appointment as chairman of the American Chess Foundation's Arts Committee for American Chess, Duchamp sends a circular letter to a number of friends in the art world inviting them to join his committee, the purpose of which is to raise funds for a greater degree of American participation in international chess events.

1963. Sunday, Palermo
Sends a telegram to Baruchello announcing their arrival in Rome the following day and posts a card of the Greek theatre in Taormina to his cousin, Dr Robert Jullien, in Paris saying: "Finishing Sicily will be in Paris 17th. Glad to know that Gaston's heart is holding. Well, a hope..."

*

When the news of Jacques Villon's death at seven-forty that morning at his home in Puteaux

reaches them, Marcel and Teeny change their plans and fly to Rome the same evening. Gianfranco and Elena Baruchello come to meet them at the airport.

1964. Tuesday, Florence
On their second day in Florence Baruchello takes Marcel to the Uffizi, which he did not see on his first visit to the city [19.10.1925]. They stand silently in the atrium looking at the Cimabue *Madonna* [9.11.1959]

According to Baruchello, Duchamp gazed at the painting "with the air of being on equal footing: Duchamp and Cimabue were equals

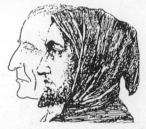

and had nothing to fear from each other".

They then look at Giotto; afterwards Duchamp tells Baruchello: "Art history is something very different from aesthetics. As far as I can see, art history is what remains of an epoch in a museum, but it's not necessarily the best of the epoch, and it's probably, in fact, a kind of expression of the mediocrity of an epoch, since the beautiful things have all disappeared because the public never wanted to preserve them."

Later in the day, after Marcel has visited Florence "a little bit more seriously" than in the 1920s, Baruchello drives the Duchamps to Pisa and then to the port of Livorno where they stay at the Hotel Palace.

1966. Thursday, Neuilly-sur-Seine
At his studio, Duchamp gives one of a series of interviews lasting approximately two hours to the French art critic Pierre Cabanne, which is stenotyped by Claude Meyer. After starting with some general reflections, Duchamp's conversations with Cabanne are structured chronologically, starting with his childhood at Blainville-Crevon.

*

In the afternoon at five, Duchamp has an appointment with Louis Carré.

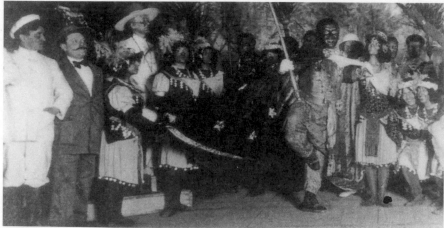

10.6.1912

10 June

1900. Sunday, Blainville-Crevon
In accordance with tradition, Suzanne is dressed like a bride in white for her first communion at the collegiate church in the village. For the family lunch to celebrate the occasion, Jacques Villon has illustrated the menu with an aquatint of Suzanne in her billowing dress with its flowing train.

On the same day, Eugène and Lucie Duchamp's youngest child Marie Thérèse Magdeleine, born on 22 July 1898, is baptized.

1912. Monday, Paris
Before the weekend the court's decision refusing an extension to Raymond Roussel's play at the Théâtre Antoine had already been made public and there was a full house on Sunday. *Le Gaulois* predicts that at the last performance, which is tonight, "everybody will want to see the play, or see it again."

During its limited run, Duchamp saw *Impressions d'Afrique* [with the Picabias and Apollinaire?], and discovered the underlying process whereby Raymond Roussel created his strange world of curious inventions with such astonishing results. At a time when Duchamp believed that the succession of "isms" in painting was leading to a dead end, it was Roussel who showed him the way.

Roussel used various methods in his process of writing based on homophones. Taking a word at random, he "drew images by distort-

ing it, a little as though it were a case of deriving them from the drawings of a rebus". Thus, *Empereur* deformed into *hampe* (pole), *air*

L'HORLOGE à VENT du PAYS de COCAGNE

(wind), and *heure* (time), gave him the wind-clock of the land of Cockaigne. The trademark of a talking-machine, Phonotypia, spotted by Roussel, gave him *fausse* (wrong) note *tibia*, which resulted in the story of the Breton Lelgoualch.

l'unijambiste LELGOUALCH jouant de la Flûte sur son propre tibia

Using two homophones connected with the preposition *à* as in: *Palmier à restauration* (the edible palm-shaped biscuit – a French speciality), inspired Roussel to introduce the palm tree of the Place des Trophées, which is consecrated to the restoration of the Talou dynasty.

Or to give another example: *Etalon à platine* means "standard metre in platinum", but also "stallion with the gift of the gab".

When the curtain goes up, the spectator sees an equatorial phantasmagoria: the shore of the African kingdom of Ponukélé with a ship in distress at sea. After a terrible hurricane the *Lyncée*, destined for Buenos Aires, drifts rudderless. In a few minutes the ship runs aground and the passengers and crew come ashore.

"Saved, at last!" shouts Juillard, the historian. Suddenly, black warriors appear from right and left with their king, Talou VII (played by M. Dorival). In spite of his feathered headdress and savage appearance, the king has a certain urbanity and speaks French. While reassuring the Europeans, now his prisoners, he nevertheless orders his men to unload the ship.

"Ka néito faké duh rais todé vik déhenn!"

While the warriors carry away trunks and kitbags the passengers present themselves to the king. In reply, Talou speaks proudly of his kingdom and demands a ransom.

Condemned to stay three months, the time for an emissary to travel "d'Ejur à Paris" and back, the prisoners decide to fight boredom by founding an unusual club.

All members will be required to distinguish themselves by presenting either an original work, or some kind of sensational performance at a gala to celebrate the return of their liberating emissary.

Each member declares heroically what he will do. Carmichael, a young singer with a female soprano voice, will perform his virtuoso act dressed as a woman; Bedu, the inventor, will present a new kind of loom (*métier*) with a curious system of paddle-blades (*aubes*) [derived from *Métier à aubes*: "early morning profession"]; Aristide Jenn, the ringmaster, will introduce his group of freaks, animal trainers, acrobats, including the clown Whirligig and a dwarf from whom he is never separated; the great Italian tragic actress, Adinolfa (played by Mme Léonie Yahne), will declaim the ringing verses of Tasso; Soreau explains his six *tableaux vivants* in order of appearance: Handel writing an oratorio based on a theme which has been mechanically constructed using chance; Canaris creating an echo when calling out the word "Rose" at random, which produces at the same time (to everyone's surprise) the penetrating scent of roses in the air...

The second act is set on a bright day in Ejur, the capital of Ponukélé. The European prisoners (who include the author himself, dressed as a sailor) witness a bizarre duel be-

tween Talou VII and Yaour IX to settle once and for all the deep-rooted hostilities between their rival kingdoms. Both kings are in feminine disguise: Talou is wearing Carmichael's blue gown and flaxen wig, much admired by Yaour, who has been lent Adinolfa's costume of Marguerite from *Faust*, the cause of his defeat (*revers*). [Episode inspired by *Revers à marguerite*: "lapel with a flower in the buttonhole".]

Throughout the play, punishments and attractions follow in succession transporting the spectator from the shores of the Atlantic, to Ejur, and then to "a clearing in the magnificent tropical garden of Béhuliphruen, where the incredible vegetation is almost magical and fantastic".

Among the punishments, Talou has Rul (his wife and mother of Sirdah) and Mossem (his prime minister and lover of Rul) executed for abandoning Sirdah in the same manner as Geneviève de Brabant. It is the Zouave, a deserter living in the virgin forest, who finds the child and educates her so that when Talou speaks in his native tongue, Sirdah translates for the prisoners.

Norbert Montalescot, the brother of Louise (inventor of the painting machine) escapes death by winning Talou's wager to build a life-

size statue, light enough to travel on rails made from calf's lights (*mou de veau*) without crushing them. [Inspired by *Mou à raille*: "mocked, spineless creature".]

Djizmé, the young mistress of Mossem, is not so lucky. Summoned to lie on a strange couch when an electric storm is brewing, her head placed in an iron skull-cap which is link-

ed to a lightning conductor, and her feet in a pair of metal shoes connected with a wire to the earth, when lightning strikes Djizmé is instantly electrocuted.

The gala takes place in the celebrated Place des Trophées, a rectangular open space with closely planted lines of trees marking the four boundaries. The words "Club des Incomparables" written in silver on three lines in a glittering surround of broad golden rays, like those around the sun, decorates the pediment of the little theatre.

A crowd of Ponukéléans waits in anticipation and the prisoner Nair, on his pedestal, continues weaving his tissue finer than a spider's web to trap mosquitoes, a life sentence imposed by Talou.

Among the attractions shown in the course of preparation or during the gala: a worm playing the zither (more practical than the guitar), presented by the Hungarian Skariofszky [Derived from *Guitare à vers*, "Guitare" being the title of a poem by Victor Hugo]; the wind-

clock in the land of Cockaigne; the one-legged Lelgoualch whose flute is made from his own tibia; the cries of pain or alarm, sobbing, exclamations of pity, loud coughing and comical sneezes produced by Stephen Alcott and echoed by the reverberating chests of his six sons; the white wall of dominoes ingeniously built by Whirligig using the black spots to draw the outline of a priest; the chemist Bex's demonstration of his automatic orchestra using Bexium, a new metal endowed with a prodigious thermal sensitivity, which produces a range of sounds, from the harp to the hunting horn...

"Yes, tomorrow we are going, tomorrow we

are leaving Ejur..." declares Julliard on behalf of the Europeans at the end of the gala. The curtain then falls on "this drama of adventure, this scientific fantasy, this philosophical comedy", which is also a pageant of musical invention.

One of the highlights of the play, in the fourth act, is undoubtedly the "Jeroukka", a boastful epic reciting Talou's exploits and written by the king himself. Set to music by Willy Redstone, the "Jeroukka" is sung by M. Dutilloy of the Opéra-Comique. Unfortunately the meaning is lost on everyone except the king's subjects, as Sirdah does not translate it:

Dass kaéner ti doméré
Loka lurnipéis dojenn
Gopa iar élijez tohur
Né déléjaz tenn ma dremm...

1927. Friday, Paris
Duchamp calls to see Carrie Stettheimer on her first day in Paris and introduces her to his wife, Lydie. Carrie immediately relays the surprising news to her sisters at West End, New Jersey, describing the bride as "a very fat girl" whom Duche married in church only two days ago. Ettie and Florine will undoubtedly lose no time in passing on the gossip.

1952. Tuesday, New York City
Roché's idea for a small exhibition [7.5.1952] has fallen through. Marcel writes: "Drop the homage idea a while it will come later, if it comes... Greetings to Carré and thank him for his good intentions."

1954. Thursday, New York City
Invites Mrs Martin [30.5.1954] to 327 East 58th Street on 15 June, saying: "I will be delighted to answer all the questions if I can."

1958. Tuesday, Paris
Duchamp has an appointment at six-thirty with Louis Carré.

1961. Saturday, New York City
Duchamp intended the title of *Nu descendant un Escalier* [18.3.1912] "to be provocative", writes Katharine Kuh in *Saturday Review*, "inferring that even the nude, art's favourite subject, could not escape the demands of mechanization."

10.6.1968

11.6.1965

1963. Monday, Puteaux
In the afternoon Marcel and Teeny arrive at Orly airport from Rome and then join other members of the family and friends in their vigil at 7 Rue Lemaître: Marcel's sisters, Suzanne, Yvonne and Magdeleine; Mme André Mare, her daughter Anne-Françoise Vène, Mme Louis Carré and Georges Herbiet.

On entering the studio, Marcel goes immediately to his dead brother's side. Herbiet observes that he looks at Villon's face a long while, standing erect and motionless. Finally, he touches his shoulder as if taking his leave, a gesture which Herbiet had seen him do before, and then turns round.

"He is like Father, without the beard," he says calmly to his sisters. Nevertheless, there are tears in his eyes.

1964. Wednesday, Livorno
After their overnight stay on the coast, Baruchello takes the Duchamps through the hills of Tuscany to Volterra, and the four-teenth-century town of San Gimignano. After calling at Siena, they drive south to Rome where Marcel and Teeny are guests of Gianfranco Baruchello at Via Baglivi 7.

1965. Monday, Neuilly-sur-Seine
Marcel and Teeny fly from Paris to Rome, where they are invited to stay with the Baruchellos.

1968. Monday, Genoa
Driving south in the Volkswagen from Zurich [6.6.1968] on their way to Cadaqués, Marcel and Teeny made their first stop in the Centovalli, the high frontier zone between Switzerland and Italy. They had lunch with the dramatist Meran Mellerio, Marcel's first cousin [15.9.1924], at his home, the Villa Siberia. Convinced that posterity is a constant of thought, genius being the force of posterity, Meran reflects: "What is my existence compared to being Homer?" He is stupefied that Marcel seems to have succeeded in being at the turning point of posterity by the negation of posterity. "It's the *tour de force* of the whiskers on Mona Lisa [6.2.1930]," Meran observes. The eternal discussion between Faust and Mephistopheles…

After this interlude, Marcel and Teeny spend two days in Milan before arriving in Genoa. The good ship *Kangaroo*, which is to take them with the Volkswagen to Barcelona, sails at four-thirty in the afternoon.

11 June

1926. Friday, Paris
Council of war at 8 Impasse Ronsin: Marcel, Roché and Brancusi envisage buying *en bloc* the 27 sculptures by Brancusi from the estate of John Quinn [28.7.1924] to save them from being auctioned with the rest of the collection. Roché feels uncertain about the deal because of Brancusi's "peasantry".

1936. Thursday, London
Four works by Duchamp (who lends a Brancusi to the show [7.5.1936]) are included in the "International Surrealist Exhibition", which opens today at the New Burlington Galleries.

1937. Friday, Paris
In his fifteenth column prepared for *Ce Soir*, Duchamp selects a chess problem by A. Goulaiev, which won second prize in a competition organized by a Soviet chess review. Presenting Alekhine's game against Héil in the 1925 tournament in Baden-Baden from 200 collected in the world champion's book [16.4.1937], Duchamp comments that it contains "perhaps the most beautiful and most profound combination that has ever been created on the chessboard". In closing, Duchamp reminds his readers that the second talk on chess is at ten past five on Radio-Paris.

1953. Thursday, New York City
At one-fifteen Duchamp has an appointment with Alfred Barr, René d'Harnoncourt and Henri-Martin Barzun at the Plaza.

1960. Saturday, New York City
Marcel has shown Mary Dreier George Heard Hamilton's letter estimating the cost of gradually restoring the Société Anonyme collection [6.6.1960]. Unable to donate a capital sum for this purpose, she has decided to give about $1,500 a year during her lifetime. Marcel tells George: "you may receive the first instalment very soon."

1961. Sunday, Cadaqués
On the feast of the Apparition of Ubu Roi, having received a copy of Régente Marie-Louise Aulard's article submitted to him by the

Sérénissime Provéditeur-Délégataire, but which has in fact already been published [31.3.1961], the Transcendant Satrape pens his reply:

"There is no error of fact and all the conformism-subversion dissertation is very flavoured with pataphysic… A detail in the title: is it the Sous-commission des Péremptions or rather the Sous-commission des Préemptions?"

*

Informing Cleve Gray that as he has not found an idea for the book cover, he feels obliged to abandon the project. "I am anxious to tell you immediately," writes Duchamp, "so that you can quickly look for someone else."

1964. Thursday, Rome
For *La Verifica incerta*, Baruchello films Duchamp in his studio, Via Baglivi 7, and shoots exterior scenes at his father's villa, Via Cassia 140. Baruchello also makes a series of portrait photographs of Duchamp in a checked shirt, seated in a *bergère* and smoking a cigar.

1965. Friday, Rome
Duchamp attends the opening of an exhibition of his work, including the readymades, lent by the Galleria Schwarz [5.6.1964] to Dino Gavina, the interior decorator. The installation of

the show at Gavina's studio, Via Condotti 11, which is much admired by Duchamp, has been made to designs by the Venetian architect Carlo Scarpa.

Later Gavina holds a dinner party for the Duchamps at the Ristorante Bottaro, amongst the guests are Lucio Fontana, Carlo Scarpa and Gianfranco Baruchello.

1966. Saturday, Paris
At one o'clock Duchamp has a rendezvous with Louis Carré and the academician Jean Paulhan.

1968. Tuesday, Barcelona
In the morning at seven o'clock the *Kangaroo* arrives from Genoa. Marcel and Teeny disembark with the Volkswagen and drive north to Cadaqués.

12 June

1918. Wednesday, New York City
Marcel receives a visit from Beatrice Wood, who has just arrived to spend a week in the city. Since the previous autumn [14.8.1917] she has been working at the French theatre in Montreal. Endeavouring to sever herself from her mother, in an act of desperate folly rather than love, she has recently married the manager of the theatre.

1919. Thursday, Buenos Aires
At Miss Dreier's request Duchamp cables a list of hospitals for the book she is writing entitled *Five Months in the Argentine from a Woman's Point of View* [4.4.1919].

1933. Monday, Folkestone
Opening day of the International Team Tournament for the Hamilton-Russell Cup, organized by the British Chess Federation, which is being held at the Leas Cliff Hall, its terraces overlooking the English Channel. The members of the French team, captained by the world champion Dr Alekhine, are L. Betbeder, V. Kahn, M. Duchamp and A. Voisin.

After the speeches of welcome by Canon A. G. Gordon Ross, president of the British

Chess Federation, and the mayor of Folkestone, play begins. France wins against Belgium, and Duchamp draws his game against P. Devos.

1946. Wednesday, Paris
At two-forty in the afternoon Duchamp and Roché have an appointment at the Galerie Drouin, 17 Place Vendôme.

1948. Saturday, New York City
At one o'clock Dee has an appointment to lunch with Miss Dreier at the Town Hall Club.

1960. Sunday, New York City
"I was very touched by your thought permitting more travel, more amusement, more summer," writes Duchamp to Mary Dreier. He says that before leaving for Europe he will see George Heard Hamilton concerning the priorities for restoration in the Société Anonyme collection [11.6.1960].

1961. Monday, Cadaqués
Barely two weeks after their arrival in Spain [30.5.1961], Teeny and Marcel fly from Barcelona to Orly airport to spend a few days in Paris.

1963. Wednesday, Puteaux
Duchamp is the chief mourner at the funeral of his eldest brother Jacques Villon, who died aged 87 on 9 June. At eleven in the morning a simple religious service is conducted by the Abbé Maurice Morel, himself a painter, in the plain modern church of Notre-Dame-de-Pitié et Sainte-Mathilde. Flanked with wreaths and sheaves of flowers, the coffin shrouded with the national colours rests on two trestles; at its foot, displayed on a cushion, lies the medal of the Grand Officier de la Légion d'Honneur and the Croix de Guerre. At the end of the service, after a distant roll of drums, a black soldier in a splendid uniform sounds the last post.

The way is lined with soldiers of the 5ème Régiment du Génie, come to give homage with their flag and their band, as the procession progresses slowly in the sunshine from the church to the black-draped façade of the Mairie. The spacious hall has been transformed into a mortuary chapel, lit with ornate monu-

mental torches. To the left of the entrance a small dais has been erected for the orators.

M. Georges Dardel, Sénateur, Président du Conseil Général de la Seine and mayor of Puteaux, speaks of the population's pride for Villon, who lived at Rue Lemaître for so many years [3.11.1905]. "Puteaux was chosen by Villon. But also Puteaux gave him his affection. Because the good people of our town were deeply grateful to the great artist for having done so much for its renown."

M. Jean Cassou, director of the Musée National d'Art Moderne, speaks of the "reason and sense harmonizing in the poetics of Villon, in the music of Villon. This music," he says, "is one of the supreme realizations of our time."

Representing Minister M. André Malraux, M. Gaëton Picon renders homage "to a life which was a part of the glory and honour of contemporary France" and to Villon's work, which is "everything that death is not – intelligence, perseverance, order, clarity, respiration, joy".

*

In the afternoon at four-thirty Villon is laid to rest on the hillside overlooking Rouen on the very edge of the Cimetière Monumental, the place chosen by his grandfather Nicolle for the family graves [17.8.1894].

*

For a broadcast in homage to Jacques Villon, Duchamp is interviewed by Georges Charbonnier.

13 June

1923. Wednesday, Paris
As Marcel is due to arrive from Brussels, where he is living [4.3.1923], Picabia, who has an appointment with Breton in the evening at nine, is hoping to meet Marcel and bring him to see Breton.

1924. Friday, Paris
When Roché calls at the Hôtel Istria, Marcel has already gone out, his suitcases are packed ready to leave for the chess tournament in Brussels. After searching a while, Roché finds Marcel, Man Ray and a pretty brunette having

14.6.1949

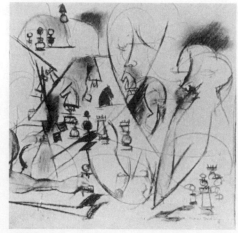

15.6.1912

lunch at a small restaurant in Boulevard Raspail. He joins them and discovers that the girl "with eyes of fire", who is called Yvonne, is a typist from Angoulême in Charentes.

Offering to accompany Marcel to the Gare du Nord, Roché insists, and Marcel too, that Yvonne goes with them. Arm in arm in the back of the taxi, Roché realizes with delight that Yvonne loves Marcel. On the station platform, after exchanging a quick, profound kiss of farewell, Marcel tells the girl with a smile, pointing to Roché: "I'm leaving you in good hands."

1927. Monday, Paris
Mme Sarazin-Levassor invites Marcel and Lydie to lunch at 6 Square du Bois de Boulogne.

1930. Friday, Paris
Miss Dreier, who has been invited by both the Rand School of Social Science and the New School for Social Research to give lectures and organize exhibitions, has proposed to Dee: "If I paid you the six hundred dollars which I will get for the lectures, would you come over next year and stand by me?" He declines, saying that he admires her but doesn't feel "any audience is worthy of so much trouble," and reminds her, "we have discussed often enough this question and I am sure that you understand my attitude."

On the other hand, to enable Miss Dreier to spend a part of each year working in Paris, on her behalf Marcel has finalized with the Bristol Bureau a seven year lease for two studios at 16 Place Dauphine, Ile de la Cité.

1933. Tuesday, Folkestone
In the second round of the International Team Tournament, France plays Poland, and in his game against C. Makarczyk, Duchamp resigns.

In the afternoon, the mayor of Folkestone holds a reception at the Leas Cliff Hall.

1950. Tuesday, New York City
"From time to time I exceed my limits," writes Marcel of his chess to Roché after two months silence. "I manage to be just about average which is rather the synonym for mediocrity. At least it greatly amuses me!"

The bust in bronze of Marcel by Louis

Féron [29.12.1949] is due to be exhibited in Paris at the Musée d'Art Moderne: "When you are passing that way, tell me if you have seen it…"

1963. Thursday, Paris
Sends an express letter to Louis Carré with a number of names and addresses to whom invitations for 17 June should be sent.

*

The radio programme entitled "Hommage à Jacques Villon", for which Duchamp was interviewed by Georges Charbonnier, is broadcast on FR3.

1964. Saturday, Rome
In a letter to Brookes Hubachek, Marcel says that he hopes to see Elizabeth Humes while he is in Rome this coming week.

14 June

1922. Wednesday, New York City
Thanking McBride for the press clippings, which are to be used for the brochure [26.5.1922], Marcel promises to find the five illustrations. "I will ask Sheeler if he has photos of Matisse, Picasso and Brancusi," he writes. "Concerning Picabia, I have a number of *391* in which there is a drawing by him

which is simply an ink blot… which he calls *La Sainte Vierge* – Do you think that's too Dada?" Otherwise he will find something else from de Zayas.

With sketches, Marcel explains his idea for the front and back covers using commercial index files; if there is enough space, he proposes "starting from the first page with extremely small type, to end on the last page with large type, changing the progressing size of the type at each page."

Not sure yet how he will incorporate the illustrations, Marcel asks McBride for his thoughts on "the idea in general".

1926. Monday, Paris
Roché calls to see Marcel at the Hôtel Istria to settle their accounts and tell him that all seems to be well with their de La Fresnaye plan [1.6.1926].

1929. Friday, Paris
On the eve of the Tournoi International de Paris, in which Duchamp is playing, a reception is held at the Hôtel Régina in honour of the twelve participants. Toasts are proposed and speeches delivered. Organized by the Parisian chess clubs – and notably the Cercle Potemkine – for the Fédération Française des Echecs, the tournament is directed by Vitaly Halberstadt.

1933. Wednesday, Folkestone
In the third round of the International Team Tournament, France plays the United States. After the thirty-seventh move in his game against A. W. Dake, Duchamp resigns.

1949. Tuesday, New York City
In the morning Marcel receives from Villon his only copy of the "Section d'Or" [9.10.1912] catalogue.

Required for Miss Dreier's work on the catalogue of the Société Anonyme, Marcel forwards it to her together with his translation of René Blum's foreword and the notice he has written on the sculptor Alexander Calder. "Would it be a good idea if I came up to Milford next Saturday 18th," Dee enquires, "at the usual hour?"

*

Enclosing a copy of the Société Anonyme's 1926 Brooklyn catalogue, Duchamp ships a *Boîte-en-Valise* [7.1.1941] *XVIII/XX*, to Marguerite Hagenbach.

The original drawing made for it, *L'ombre sans cavalier*, is a strange transmutation: the

shadow of his chess Knight takes the form of a fish tail, an *ombre-chevalier* (or char).

1957. Friday, New York City
"Summer in New York with some weekends by the sea," writes Totor whose painstaking activity, he tells Roché, is colouring 15 large photographs [25.3.1957] of the Large Glass for the "super luxes" examples of Lebel's book due to be published at the end of the year: "it's a deadline even!"

1959. Sunday, Cadaqués
"I find a photo which I hope will illustrate the article by Michel Leiris to your satisfaction," writes the Transcendant Satrape Duchamp to the Transcendant Satrape Latis of the Collège de 'Pataphysique. "I will be happy to reread this article and I hope even to receive the next number of the review in Paris... *Bien pataphysic à vous*, Marcel Duchamp."

1966. Tuesday, Paris
Has an appointment with Louis Carré and M. Gottlieb Senn at 10 Avenue de Messine.

15 June

1912. Saturday, Rouen
In the afternoon, without any pomp and ceremony or speeches, the 3rd exhibition of the Société Normande de Peinture Moderne opens at the Salle du Skating, situated on the island Lacroix. A member of the Hanging Committee, Duchamp exhibits two paintings of his own, *Portrait* (or *Dulcinée*) [30.9.1911] (which is hung next to *La Toilette* by Marie Laurencin) and *Portrait de Joueurs d'Echecs*. Both pictures date from the period in 1911, when Duchamp was exploring Cubism, before he painted *Nu descendant un Escalier* [18.3.1912].

In the second canvas the chess players are his brothers, Villon on the right, Duchamp-Villon on the left. The arrangement of their successive profiles, drawn in an indefinite space using a "technique of demultiplication", is the result of a number of charcoal and ink studies that Duchamp made in the autumn of 1911, notably: *Pour une Partie d'Echecs*, in which a square, central composition is flanked by two smaller ones, and *Etude pour les Joueurs d'Echecs*, where heads, arms and chessmen are anchored centrally by two crossing arabesques.

As a "tempting" experiment, Duchamp painted the canvas after dark by the green flame of gaslight: "when you paint in a green light and then, the next day, you look at it in daylight, it's a lot more mauve, grey, more like what the Cubists were painting at the time. It was an easy way of getting a lowering of tones, a grisaille."

Significant for showing a group of Cubist pictures for the first time in Normandy, the exhibition installed in only a part of the vast rollerskating hall, excites much local controversy. But it is above all Francis Picabia's large and very striking canvases *Tarentelle, Port de Naples* and *Paysage*, hung together on a central panel, which cause the greatest bewilderment. Visitors are constantly gathering before them wondering what on earth these pictures represent.

*

In a rare article on Raymond Roussel [10.6.1912], "Une nouvelle Ecole littéraire", published in today's issue of *Fantasio*, André Arnyvelde declares: "Nothing seems impossible since the arrival of M. Raymond Roussel. A new world opens on art, all the arts, from literature to philosophy."

Discussing *La Vue* by Roussel, a volume containing a long poem of 4,000 lines describing the marine landscape, which is set into the shaft of a pen-holder, Arnyvelde quotes the following lines:

La vue est une très fine photographie
Imperceptible sans doute, si l'on se fie
A la grosseur de son verre, dont le morceau
Est dépoli sur un des côtés, au verso...
Mon œil gauche fermé complètement
* m'empêche*
De me préoccuper ailleurs, d'être
Par un autre spectacle ou par un autre attrait
Survenant au dehors et vus par la fenêtre...

1915. Tuesday, New York City
A symbol for all newcomers, the monumental Statue of Liberty, holding a lamp in an outstretched arm high above her head, dominates Bedloe's Island in New York harbour. On nearby Ellis Island all aliens are "processed" by the immigration officers. Found to be of sound mind, in good physical health, five feet ten inches high, with brown hair, chestnut eyes, and fifty dollars in his pocket, Duchamp is granted admission to the United States of America.

As the *Rochambeau* docks, it becomes so hot that Duchamp thinks there must be a fire blazing nearby. On the quayside, waiting to greet him, is Walter Pach his friend, correspondent [21.5.1915] and cicerone.

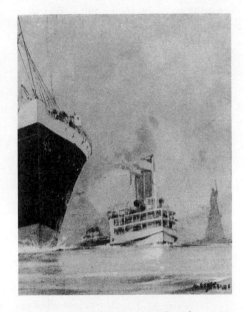

He takes Duchamp immediately to 33 West 67th Street, the home of Walter Arensberg, a Harvard man, Imagist poet and collector, who wants to meet the Frenchman who has been famous in America since the Armory Show [17.2.1913], and offer him his hospitality.

1919. Sunday, Buenos Aires
Marcel begins writing a letter to Lou and Walter Arensberg in New York: "On the point of departure, I am starting to pack..."

15.6.1965

16.6.1935

1922. Thursday, New York City
Further to his letter of the previous day, Marcel sends McBride the photographs provided by de Zayas: Picasso, Picabia, Matisse and Laurencin. Sheeler has promised a Rousseau and a Brancusi. He requests the critic to number the photos in order of preference: "so that if it's too expensive," Marcel explains, "I can eliminate the last numbers."

1927. Wednesday, Paris
In the auction organized by Me Alphonse Bellier "Tableaux modernes, pastels, aquarelles, gouaches, dessins, sculpture", the two Pablo Picasso gouaches belonging to Duchamp, *Tête*, dated 1909, and *Portrait de Monsieur X...* [10.2.1927] from the same period, are sold at Drouot for 8,500 francs and 8,000 francs respectively [21,250 francs and 20,000 francs at present values].

1933. Thursday, Folkestone
In the morning France beats Latvia (one of the leading teams) 2–1 in the fourth round of the International Team Tournament. Invalidating his opponent's opening, Duchamp constructs a crushing position, which he consolidates carefully to win his game against Feigin.
In the afternoon France plays the British Empire and Duchamp draws his game against R. P. Michell.

1935. Saturday, Paris
Organized for the benefit of the French team, which is to participate in the International Chess Team Tournament at Warsaw in August, Dr Alekhine plays 36 simultaneous games, winning 27 of them and losing only six. During the evening many spectators gather in the hall of the newspaper *Le Jour*, following certain games with great interest. Playing together in consultation, the Committee of the Fédération Française des Echecs, which comprises Pierre Biscay (president), Marcel Berman (vice-president) and Duchamp, loses its game against the world champion.

1947. Sunday, New York City
In the evening at seven, Marcel dines with Stefi Kiesler.

1958. Sunday, Paris
Robert Lebel organizes a big party at his home

at 4 Avenue du Président Wilson, in honour of Duchamp and Man Ray. Among the guests are Allen Ginsberg, William Burroughs and Gregory Corso, who become tipsy. Ginsberg kisses Duchamp and gets Duchamp to kiss Burroughs. Becoming increasingly drunk, the three Beat Generation writers crawl along the floor between the other guests in pursuit of Duchamp. When Ginsberg feels up his trouser leg and calls him "Maître", Duchamp almost kicks him, hating the pretension.

1961. Thursday, Bazoches-sur-Guyonne
In Jacques Villon's honour and to mark the occasion of his exhibition at the Galerie Charpentier, M. and Mme Louis Carré give a magnificent reception at their country house for hundreds of guests, which commences at five o'clock. All the members of the Duchamp family are present, including Marcel and Teeny, who have come especially from Cadaqués [12.6.1961].
The sun shines, champagne flows generously; the French colours and the Breton flag flutter in the breeze. To spare his lawn, or the ladies' stiletto heels, Carré has had miles of plastic grass laid for the occasion.
Later, for those who are invited to stay on, a sumptuous supper, with dishes decorated flamboyantly with pheasant and peacock feathers, is served on the terrace lit with mirror-spotlights.
In musical homage the Ensemble Baroque de Paris plays "Jacques Villon", the seventh melody from Poulenc's *Le Travail du Peintre*.

1965. Tuesday, Rome
An idea of Baruchello's to divert Duchamp from his anxiety of flying: in the morning at a quarter to eleven, after Duchamp has expelled the finest Havana cigar smoke into a quart bottle and sealed it, Baruchello writes a label for it, which they both sign.
While the Duchamps have been in Rome, Baruchello has taken his guests to Spoleto and Anticoli Corrado the town that Marcel visited many years before [19.10.1925].

*

At two o'clock in the afternoon Teeny and Marcel arrive safely at Linate airport, Milan.

1966. Wednesday, London
In the afternoon, Richard Hamilton goes to the airport to meet Teeny and Marcel, who arrive

from Paris Orly on flight AF816. Guests of the Arts Council of Great Britain, which is organizing the retrospective at the Tate Gallery, the Duchamps stay at St Ermin's Hotel, Caxton Street.

1967. Thursday, Neuilly-sur-Seine
"...I share your view regarding the botchers of catalogues," writes Duchamp to Marcel Jean, who is upset that the bibliography in the recent catalogues of Rouen and Paris [6.6.1967] omits his *Histoire de la Peinture Surréaliste* [30.12.1959]. "Nevertheless it is a lack of decency which I would not like you to reproach me for."

16 June

1917. Saturday, New York City
It is a fine day. At ten in the morning Roché collects Marcel by car and takes him for a weekend in the country with Beatrice Wood.

1918. Sunday, Paris
In the *Mercure de France*, Guillaume Apollinaire defends the Richard Mutt case by drawing on the facts and reasoning published in the *Blind Man* [5.5.1917]. "The Society of Independent Artists' attitude is obviously absurd," he argues, "because it is based on an indefensible position that art cannot ennoble an object, and in the case in point it ennobled it singularly by transforming into Buddha an object of hygiene and male convenience."
By refusing to exhibit *Fountain* [9.4.1917], Apollinaire says, "they prove to be less liberal than the Paris Indépendants, who exhibited the painting by Boronali [18.3.1910], well aware that it was a joke or rather a put-up job, and they exhibited it simply because those who had planned it had paid the twenty-five francs required to exhibit, and they do not believe either that they have the right to prohibit even a farce."

1921. Thursday, Le Havre
After her transatlantic voyage, the *France* docks at seven-thirty in the morning and the passengers disembark. Planning to spend a few

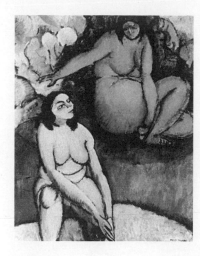

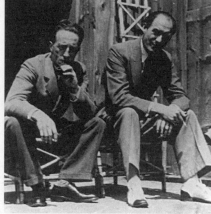

16.6.1936

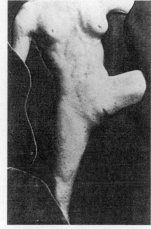

16.6.1966

days with his parents at 71 Rue Jeanne d'Arc before returning to Paris, Duchamp takes the train as far as Rouen.

1926. Wednesday, Neuilly-sur-Seine
Duchamp and Roché are invited to lunch with the Doucets at 33 Rue Saint-James.

1933. Friday, Folkestone
In the sixth round of the International Team Tournament, France is due to play the Estonian team, which has not yet put in an appearance and therefore loses by default.

1935. Sunday, Paris
At the age of 46, Ferdinand Tribout suddenly collapses and dies in the car driven by his wife Léo on their return from a weekend in Normandy. Duchamp's great friend at the Lycée Corneille in Rouen and author of "Contribution à l'étude radiologique des pneumopathies aigues", published in *Presse Médicale* in October 1933, almost certainly owes his early death to his dangerous pioneering medical research at the Hôpital Laennec where he was the director of the Laboratory of Electro-Radiology.
Duchamp gave many of his early drawings and paintings to his close friends including Tribout, who at his death owned quite a collection, including *Baptème*, painted in 1911. In the sequel to *Le Buisson* [21.4.1911], both nudes are seated in a rich, luxuriant landscape: the red figure turns with outstretched hand towards the nude in the foreground, who has her hands clasped on one knee.
During 1910 when Duchamp made a number of portraits, he painted one of Tribout and gave it to him. Composed to include the pipe grasped in his right hand in one corner of the canvas, it captures Tribout's bright, laughing face in the most spontaneous of Duchamp's portraits.

1936. Tuesday, Becket
Miss Dreier has brought Duchamp and the Swedish drama and music critic Hans Alin to visit Ted Shawn in Massachusetts. While staying at Shawn's farm, they also visit the Jacob's Pillow Dance Festival and School of Dance at Lee, which is organized by Shawn, where Duchamp is photographed sitting on a step in the theatre with Alin.
Interviewed by a reporter from the *Berkshire*

County Eagle, Duchamp explains that he is repairing the Large Glass [5.2.1923]: "It's a job I can tell you, but fun. Like doing a jigsaw puzzle, only worse. I decided I couldn't cement the pieces together, so I'm arranging them between two pieces of plate glass."
Wearing rough tweed trousers and coat, Duchamp puffs at his pipe and declares that "death is an indispensable attribute of a great artist". While the artist lives, continues Duchamp, "his voice, his appearance, his personality – in short, his whole aura – intrudes such that his pictures are overshadowed. Not until all these factors have been silenced, can his work be known for its own greatness."

1942. Tuesday, Bermuda
On her voyage from Casablanca [7.6.1942], the *Serpa Pinto* calls at Bermuda and remains in port for several days.

1944. Friday, New York City
"Chessing, lessoning, starting a few boxes, my usual life," writes Dee to Miss Dreier in West Redding. He encloses Daniel Catton Rich's letter explaining that the Art Institute of Chicago is unable to accept the Lehmbruck sculpture on extended loan. "I thought I might come up in July around the 10th, before or after," suggests Dee, "if this period is convenient for you."

1956. Saturday, New York City
For the "Three Brothers" exhibition that he is organizing [27.12.1955], Duchamp writes to Lee Malone, director of the Museum of Fine Arts of Houston, concerning various points for the catalogue [3.4.1956].

1958. Monday, Paris
In the afternoon at three, the Duchamps visit the Rochés at Sèvres to prepare the things stored there [11.2.1951] for collection by Lefebvre-Foinet's men the following day. Teeny (whose hat, pendant and blue spectacles fascinate Roché) goes to the attic with Denise while Marcel makes some corrections to the manuscript, "Souvenirs sur Marcel Duchamp" [22.1.1958]. After their departure at six, Roché admires the charm they have and their calm.

*

In the evening Teeny and Marcel go to see Ionesco.

1959. Tuesday, Cadaqués
Using some stout brown paper which has already protected a package from Fernando Solernou Enrich of Barcelona, Marcel wraps and posts a photograph [14.6.1959] to M. Latis at Clinamen, 7 Rue Jean Richepin, Lozère (Seine-et-Oise).

1962. Saturday, Cadaqués
Makes an excursion for the day across the border to France.

1965. Wednesday, Milan
At five o'clock Duchamp has an appointment with Arturo Schwarz.

1966. Thursday, London
"Beware of fresh paint" warns Duchamp in his address to about 100 fellow artists at a joyful dinner held in his honour at the Tate Gallery. "The biggest day in the lives of many little French boys is the day of their communion. But for me," he declares, "this is the greatest day."
It is the first day of celebrations marking the opening of the Duchamp exhibition organized by Richard Hamilton for the Arts Council of Great Britain at the Tate Gallery. Over 240 works are displayed, including a number of replicas made by Hamilton, notably that of the Large Glass [5.2.1923], which has just been completed [31.5.1966].
A loan from Maria Martins, which Hamilton finds rather mysterious, is entitled *Etant donnés le gaz d'éclairage et la chute d'eau*. It is a small female torso with legs stretched apart, described in the catalogue as "pencil on vellum (?) over gesso, and velvet on cardboard", and has the following description in French on the back: "This Lady belongs to Maria Martins with all my affection Marcel Duchamp 1948–49."

"Are you Marcel Duchamp?" the man from the *Observer Weekend Review* asked Man Ray during the pre-preview for the Press. "Yes, I am," replied Man Ray. "Let me say that I'm pleased with my retrospective show at the Tate. I think the organization is wonderful. It's come at the right moment in my life. I was born in 1860, which makes me 106 right now... I must introduce you to my friend, Marcel Duchamp."

18.6.1963

The real Duchamp then told the journalist that life for him is cruel, ridiculous and meaningless: "I prefer chess, where people can be passionate and yet the gambits and mental activity ultimately, like life, mean nothing. Vanity is my one weakness you know, or otherwise I would have left the world years ago."

Duchamp noticed two young women studying the famous Nude: one with her head enclosed in an aluminium helmet and her body sheathed in aluminium, the other in a very, very short skirt... The women looked at the Nude, and Duchamp looked at the women.

"They are exhibits too," he remarked to the *New York Times* reporter: "There really ought to be a photographer."

After autographing catalogues for the young women, he concentrated on answering the journalists' questions.

"Art is a matter of choice. You choose materials, tools, subject. The readymade," he explained, "skips the earlier stages and comes to the final conclusion."

Can art be anything? "Yes, anything," Duchamp replied.

William Marshall of the *Mirror* asked whether the exhibition is art or a gigantic leg-pull. Duchamp laughed and said: "Yes, perhaps it *is* just one big joke."

1968. Sunday, Cadaqués
"As you say, the earth has lost its equilibrium and consequently people their heads," writes Marcel to Brookes Hubachek, referring to the recent assassination of Robert Kennedy in Los Angeles.

He recounts again [1.6.1968] their escape from France, "on the day when there was no more distribution of gasoline – with a full tank and a jerry can of 20 litres we made it to Basel..." The news is now better from Paris, "but it seems that guerrilla warfare is replacing the barricade system there."

As for Cadaqués: "no turbulence for the moment and no signs of any in the near future."

*

Marcel also writes to Richard Hamilton asking him to thank John Russell for his article [6.6.1968] and whether he would intervene in the "delicate" problem of his return air tickets Zurich–London [4.6.1968], which Editions Alecto agreed to pay for.

17 June

1917. Sunday, New Haven
After lunch in New Haven, Roché, Totor and Beatrice drive to Springfield where later in the evening they watch a Charlie Chaplin movie before retiring to bed.

1926. Thursday, Paris
"The Legrain frames are ready and beautiful," Duchamp tells Miss Dreier, referring to two paintings to be included in the Brooklyn exhibition [26.5.1926]: *Fish* by Marcoussis, to echo its title, is adorned with an operculated oak frame and *Song* by Villon is framed with sycamore and aluminium. As he has sold "some" de La Fresnaye [14.6.1926], Duchamp has paid the invoice from the framer and one presented by Lefebvre-Foinet.

After lunching with him recently, Duchamp has persuaded John Storrs to send a brass sculpture [16.4.1926] in addition to the three in stone to the exhibition. Although there are difficulties with Jean Arp and Max Ernst, who are both away, Duchamp has obtained a small study from the Galerie Van Leer relating to Ernst's décor for Diaghilev's ballet, *Roméo et Juliette*.

"Brancusi is almost ready and has repaired *Leda* wonderfully..." says Duchamp, and thanks Miss Dreier for suggesting a Brancusi exhibition to Dr Creutz in Krefeld.

For his own page of the catalogue, Duchamp says: "I also would prefer a gondola photo [23.5.1926] than the big one I sent you."

1933. Saturday, Folkestone
In the seventh round of the International Team Tournament, France plays Austria, and Duchamp loses his game against E. Glass. In the afternoon, France plays Denmark, and Duchamp draws his game against J. Nielsen.

At the end of the day's play France is lying in fifth place behind the United States, Sweden, Poland and Czechoslovakia.

1938. Friday, Paris
Duchamp is among those included in "Guil-laume Apollinaire et ses Peintres", an exhibition, which opens at the Galerie de Beaune, 25 Rue de Beaune, at nine o'clock in the evening.

1952. Tuesday, New York City
In the evening at six o'clock Duchamp meets Monique Fong.

1954. Thursday, New York City
After the doctor's call in the morning, Duchamp writes to Roché in Paris: "We leave around 25th for Cincinnati [27.5.1954] where the surgeon will scrape me around 28th... Will keep you informed," and signs: "Martini."

1959. Wednesday, Cadaqués
Marcel has received a copy of UPPERCASE and writes to Richard Hamilton: "I can't tell you how pleased I am to see the first pages in their final stage [20.4.1959].

The setting," he continues, referring to an extract of the English version of the Green Box, "keeps in pace with the inner spirit of the original writing and I am sure the complete translation will lend itself to a perfect understanding of the French."

1960. Friday, New York City
Duchamp sends Simon Watson Taylor one or two small corrections to his English translation of *Histoire de la Peinture Surréaliste* [30.12.1959] and signs "*cordiapata* Marcel Duchamp".

1961. Saturday, Paris
After a five-day interlude in Paris, Teeny and Marcel return to Cadaqués.

1963. Monday, Paris
At five in the afternoon an exhibition of 15 sculptures by Raymond Duchamp-Villon is inaugurated in the presence of Duchamp at the Galerie Louis Carré, 10 Avenue de Messine.

1965. Thursday, Milan
After a couple of days in Milan, Marcel and Teeny fly to Zurich.

1966. Friday, London
The painter Sir William Coldstream, who is vice-chairman of the Arts Council, hosts a small luncheon in Duchamp's honour at L'Ecu de France, 109 Jermyn Street, at a quarter to one.

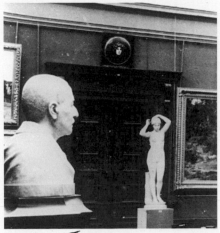

19.6.1912

Invitations to the more public private view of the Marcel Duchamp exhibition at the Tate Gallery (which is held in the afternoon from one o'clock until six) are disc-shaped replicas of *Rotorelief No.11 – Eclipse Totale* [30.8.1935].

As the complete set of *Rotoreliefs* are shown in movement in the exhibition, a small hole has been punched in the back cover of the catalogue (entitled *The almost complete works of Marcel Duchamp*), through which the visitor is invited to view the illusions created by the design on each disc.

18 June

1937. Friday, Paris
In addition to selecting the chess problem for the week in his regular column for *Ce Soir*, Duchamp features the centenary of Paul Morphy, born on 22 June, by analysing one of his most famous games played in London in 1858.

He announces that the prize-giving of the recent inter-club tournament organized by the Ligue de Paris will take place on 26 June at the Café Buffalo in Place Denfert-Rochereau; a tournament has just started at Kemeri, near Riga; he congratulates the "likable" Tartakover on winning the International Championship of Poland; he reports that in Amsterdam recently the two champions Euwe and Alekhine played a game with living chessmen in front of 25,000 spectators; and reminds readers of the weekly talk on chess broadcast by Radio-Paris.

1954. Friday, New York City
Replying to a note from Alfred Barr, who has been invited by Bill Copley to serve as an adviser to the William and Noma Copley Foundation (incorporated in the State of Illinois on 3 May 1954), Marcel, who has agreed to serve on the board of the foundation, writes: "I hope that you will accept Copley's invitation without knowing exactly what he intends doing; I am sure we could be useful to him." He then enquires on Teeny's behalf if the Barrs can come for dinner on 22 June.

1958. Wednesday, Paris
At the Gare du Nord (before boarding a train for Brussels?), Marcel sends an express letter to Patrick Waldberg, regretting that on 26 June he is not free for dinner, but that if Beckett and Waldberg can, he will meet them at five-thirty at Montparnasse, at "the Select for example".

1959. Thursday, Cadaqués
"Here not at all hot but very fine weather and we will not be going further south…" writes Marcel to Kay Boyle.

*

As Robert Lebel has sent news of the exhibition at the Galerie La Hune [5.5.1959], Marcel declares: "I'm longing to be in Paris to see if we can rouse the appearance of the ordinary [edition of the book]." As for the commission [15.4.1959], he tells Lebel: "The 3 illustrations are being carried out – 2 are almost finished and the third is in the head."

1963. Tuesday, Milan
Planning to discuss the possible publication of *Marchand du Sel* in Italian with Arturo Schwarz, Duchamp arrives by air from Paris with Teeny. As on their previous visit the year before [10.9.1962] (although their host is in Lausanne), they stay in Enrico Baj's apartment. Duchamp invites Bruno Alfieri, the editor of *Metro* [10.1.1963], to Via Privata Bonnet, and shows him the drawing he has made for the cover of the magazine: *Aimer tes héros*, which, like *L.H.O.O.Q.* [6.2.1930], plays on the letters of the title of the magazine.

19 June

1912. Wednesday, Basel
In reaction against "retinal" painting as emphasized by the Impressionists, Pointillists and Fauves, when he visits the museum Duchamp is very impressed by the important collection of paintings by the Swiss artist Arnold Böcklin, whose idyllic compositions (including *Magna Mater* and *Klio, auf Wolken thronend*) are strangely and powerfully haunting.

"I leave Basel tomorrow morning for Constance," writes Duchamp on a postcard to his friend Dumouchel in Paris, adding, "a very fine museum."

1924. Thursday, Paris
While Marcel is in Brussels [13.6.1924], Roché shuttles between Mary Reynolds and Yvonne Fressingeas, whom he calls "Saintonge". He obtains the confidences of both of them regarding their feelings for Marcel.

Mary recounted the rupture with her parents, who wanted her to remarry after her husband's death during the war; her wish for liberty and her various adventures. Her regret at Marcel's incapacity to love her as she loves him.

Saintonge told Roché how she lost her virginity at fifteen, her different experiences, her adventure with Marcel, her love for him and fidelity for the last two months, and her doubt that he is capable of being attached to anyone.

At one o'clock, Roché visits Saintonge's small room. With undisguised joy and pride she shows him a postcard which Marcel has sent her from Brussels.

1933. Monday, Folkestone
In the ninth round of the International Team Tournament it is Alekhine, Betbeder, Kahn and Voisin who play for France against Italy. In the afternoon France plays Lithuania, and Duchamp's game against J. Vistaneckis is adjourned.

1935. Wednesday, Paris
After keeping vigil all night with Tribout's widow and her niece Babette, Marcel attends the funeral of Dr Ferdinand Tribout, who died on Sunday.

1943. Sunday, New York City
At seven-thirty Marcel dines with the Kieslers.

1946. Wednesday, Paris
At eleven-fifteen, Duchamp and Roché have an appointment with Louis Carré at 10 Avenue de Messine [to discuss a Calder exhibition?].

1963. Wednesday, Milan
Planning to visit Lyons, Grenoble, Aix-en-Provence… Marcel and Teeny leave Italy by train, passing the frontier at Brig.

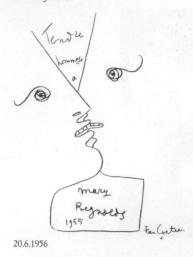

20.6.1956

Calder

MD

MARY LOUISE
REYNOLDS
COLLECTION

1965. Saturday, Neuilly-sur-Seine
After visiting Rome, Milan and Zurich, Teeny and Marcel arrive by air at Orly and return to 5 Rue Parmentier.

*

The Duchamp exhibition lent by Arturo Schwarz opens at the Museum Haus Lange, Krefeld.

1966. Sunday, London
A discussion between Duchamp, the artists Sir William Coldstream, Richard Hamilton and Ronald Kitaj, and the critics Robert Melville and David Sylvester, is recorded by the BBC.

20 June

1912. Thursday, Basel
After breaking his journey eastwards in Switzerland, Duchamp takes the morning train to Constance.

1917. Wednesday, Tarrytown
After playing chess with Picabia and Roché from midday until four, Marcel takes the dancer-poet Paul Thévénaz with him to André Brook. It is the day of the Stettheimer sisters' weekly French lesson. Florine considers the day "too short for its beauty, the peonies are blooming, the roses, it's very gorgeous – even gaudy". Thévénaz, describes Florine, "was a very young faun, who turned somersaults on the green, danced, smiled and seemed unconcernedly happy. He suited the garden. I hope he will play about in it again."

1919. Friday, Buenos Aires
Now that he has finished packing, Marcel continues a letter to the Arensbergs commenced four days ago. Reviewing the nine months spent in Argentina [19.9.1918], Marcel considers that he has worked very well, even if he hasn't had much fun. "I feel I am quite ready," he explains, "to become a chess maniac. Everything around me takes the shape of the Knight or the Queen, and the exterior world has no other interest for me other than in its transformation to winning or losing positions…"

1922. Tuesday, New York City
Beatrice Wood visits Marcel's studio at the Lincoln Arcade Building and they dine together.

1923. Wednesday, Brussels
After a week in Paris [13.6.1923] Marcel is back at 22 Rue de la Madeleine. Unable to organize an exhibition in Paris of five canvases by Joseph Stella, he tells the artist in New York: "When I return to Paris in a month I will see Frantz Jourdain and will try to obtain a promise of support from him…" Marcel advises Stella to arrive not later than the end of August, and to bring the pictures with him. Even if he doesn't exhibit at the Salon d'Automne, Marcel will find him a place just as good.

1927. Tuesday, Paris
"Back from honeymoon in some districts of Paris," writes Duchamp to Jacques Doucet, who attended the wedding on 8 June. "Would you like me to show you my Brancusis in the studio I have rented especially to cover them?" asks Duchamp, and suggests collecting Doucet from 46 Avenue du Bois on Thursday at three.

1933. Tuesday, Folkestone
In the eleventh round of the International Team Tournament, France plays Hungary, and Duchamp loses his game against A. Lilienthal.
Duchamp also loses to J. Vistaneckis in the game adjourned from the previous afternoon.

1936. Saturday, West Redding
Miss Dreier gives Duchamp a cheque for $43.50 to reimburse him for a bill he has paid from the Danbury Glass Company for polished plate glass and 50 cents of expenses related to repairing the Large Glass.

*

After his meetings with Duchamp at The Haven and in New York [3.6.1936], Frank Merchant's article "Restoring 1,000 glass bits in panels" is published in the *Literary Digest*. The author points out the irony of Duchamp, an iconoclast, busy "recreating" one of his works: the Large Glass [5.2.1923]. While watching him at his task, Merchant learned that, for Duchamp, the shattered glass was "a catalogue of ideas" instead of "a mere picturization".
Duchamp also explained: "For me, painting is out of date. It is a waste of energy, not good engineering, not practical. We have photogra-

phy, the cinema, so many other ways of representing life now… Of course, there will always be painters. But for me, there is no religion for life in it any more." It is ironical too, considers Merchant, that both Duchamp's most important works, the Large Glass and *Nu descendant un Escalier* [18.3.1912], "are in this country, though at opposite ends": the former in a porticoed Connecticut house, the latter at Walter Arensberg's, in Hollywood.

1940. Thursday, Arcachon
Concerned about Marcel's future in occupied France and having offered him assistance in an earlier letter, Walter Arensberg follows it up with a telegram addressed poste restante, Arcachon: "Do you need help? Walter."

1950. Tuesday, New York City
"It is more than a month since we lunched together so pleasantly," writes Marcel to Henry McBride, who has gone back to the country. Requesting another lunch when he next comes to town, Marcel says: "I hear that *Art News* is going to publish your article on the conversation at Sweeney's [17.3.1950]."

1955. Monday, New York City
Duchamp finds Marcel Jean's homage to Yves Tanguy [15.1.1955] published in *Les Lettres Nouvelles*, no. 25, which the author has sent him, "very pure and illuminating" and hopes that Kay Sage "will incorporate it in the catalogue – of the Museum of Modern Art – and of a large Tanguy exhibition in Paris if it takes shape".
As a journalist from Pittsburgh has requested some of his chess games for publication, Duchamp asks Marcel Jean to send him a copy of the one against Tartakover [30.6.1929], which is to appear in *Histoire de la Peinture Surréaliste*.

*

Regarding the price of 36 million francs [more than 3 million francs at present values] for a Braque, Marcel Totor remarks to Roché who has seen Sidney Janis: "It seems a bit high to me, but after all Braque must know."

*

Marcel thanks Alfred Barr for sending him a copy of the letter he has sent to the Naturalization Division of the Immigration and Naturalization Service of the Department of Justice at 70 Columbus Avenue, saying that it is more than a

21.6.1912

year [9.3.1954] since the petition for Duchamp's final citizenship papers was filed. "It will be interesting to see the developments," writes Marcel. "Should I receive any news I will let you know immediately."

1956. Wednesday, New York City
"The catalogue of Mary Reynolds' collection which will be embellished with your homage is going to appear very soon at the Art Institute of Chicago," writes Duchamp to Jean Cocteau, asking for a list of friends to whom he would like copies of the book sent.

Brookes Hubachek, who with Duchamp's help [14.10.1950] brought the books, albums, magazines, catalogues of exhibitions and pamphlets from Paris to Chicago after his sister's death [30.9.1950], has sponsored the bibliography and also the publication *Surrealism & its Affinities*, for which Duchamp has written a short preface. As well as the illustrations provided by Cocteau and Villon, Sandy Calder has made drawings of Mary and her cats. The olive-green cover is inspired by Mary's binding for *Les Mains Libres* by Paul Eluard, illustrated by Man Ray: on both the front and back, an unsewn kid glove lies flat, the thumb folded towards the palm and its slender orifice at the place where the reader places his hands to open the volume.

To identify the items of the collection, Duchamp has also made a special bookplate: the profile of Mary's head with one of the earrings designed by Sandy Calder using her initials drawn as if it were hanging from her ear.

1958. Friday, Brussels
After a short visit to the Belgian capital, where he saw "50 Ans de l'Art Moderne" [17.4.1958] and met René Magritte, Duchamp returns to Paris.

1966. Monday, London
At midday the Duchamps have an appointment with Lee Miller.

In the evening at nine there is a party at Sotheby's to celebrate the forthcoming auction on 23 June, which is being held for the benefit of the Institute of Contemporary Arts.

21 June

1912. Friday, Munich
In the evening, after a long uneventful journey by train from Constance, Duchamp reaches the Bavarian capital. His guide is Max Bergmann, whom he met in Paris two years before

[1.3.1910]. While Bergmann was in Paris, Duchamp went out of his way to make his visit a memorable one. Besides advising him about exhibitions to visit, Duchamp took him to Versailles [26.4.1910] and introduced him to the night life of Montmartre. Bergmann hoped he could repay his friend's kindness, and Duchamp has accepted Bergmann's invitation to Munich, just when he has resolved to break with the past.

1917. Thursday, New York City
It has been a very hot day. In the evening, to cheer up Beatrice Wood, who is still shocked and heartbroken since Roché admitted that he has been unfaithful to her, Francis Picabia and Marcel take her to Coney Island. Knowing that she is afraid of roller coasters, they persuade her to ride on the most dangerous one again and again until she controls her screams. They

enjoy themselves enormously – particularly Bea, who feels that with Marcel's arm around her she can face anything.

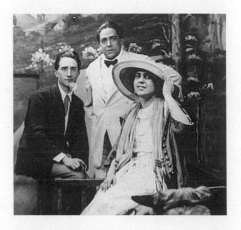

1926. Monday, Paris
In the morning Duchamp writes from the Hôtel Istria to Jacques Doucet: "Can you come to visit the new 'home' of my canvases, 82 Rue des Petits-Champs [7.6.1926], Wednesday afternoon between 3 and 4 for example?"

1928. Thursday, Paris
With invitations from Gaby Picabia to dine the following evening at Versailles, where she is living, Duchamp tells Brancusi that a friend of Gaby's will take them by car.

"Unless countermanded, I will come to you at six-thirty Friday and will tell the friend in question to come to your place. Reply. Affectionately, Morice."

1933. Wednesday, Folkestone
In the morning France is beaten by Sweden in the twelfth round of the International Team Tournament, and Duchamp loses his game against E. Lundin. In the afternoon against Czechoslovakia Duchamp draws his game against K. Opocensky.

1935. Friday, Paris
Totor invites Roché to lunch at his studio at 11 Rue Larrey, which is encumbered with the stock of discs [10.5.1935] for the Concours Lépine [20.5.1935]. Totor's cleaning woman, Roché notices, is very handy and quick.

21.6.1964

1958. Saturday, Paris
Marcel sends an express letter to Claire and Gilles Guilbert [17.2.1956], regretting that, due to their "infernal" last eight days in Paris, he and Teeny are unable to have dinner with them on Wednesday. "If you like we will telephone you," Marcel writes, "and will call to see you for a few minutes around six one afternoon."

1961. Wednesday, Cadaqués
"We have heard such good reports on the Stockholm show [16.5.1961] that we are very much tempted to go to Stockholm at the end of August from Paris," writes Duchamp to Pontus Hulten. Enquiring about the cost of flying there but returning by train and boat via Copenhagen and Antwerp, Duchamp adds: "Please give my best regards to Mr Linde, who did a splendid job, it seems, on my Large Glass."

1964. Sunday, Rome
After their zigzag with Baruchello from "Milan to Ravenna [7.6.1964], Florence [9.6.1964], Livorno, Rome and Spoleto – not forgetting the Monsters" (the fantastic sculptures in the park of the Villa Orsini at Bomarzo, north of Rome), Teeny and Marcel fly back to Paris Orly.

1966. Tuesday, London
At noon, Duchamp meets Sir Roland Penrose at the Institute of Contemporary Arts on the Mall.

*

Later in the day Marcel and Teeny fly back to Paris.

1967. Wednesday, Paris
Towards the end of the morning, for the television producers P. A. Boutans and J. M. Meurice, Philippe Collin interviews Duchamp for approximately twenty minutes in the basement of the Galerie Claude Givaudan.

Collin asks Duchamp what he means by the English term "readymade."

After explaining the word in French, Duchamp says: "There is always something 'readymade' in a picture; you don't make the brushes; you don't make the colours, you don't make the canvas. So going further, in removing everything, even the hand, you arrive at the 'readymade'. There is nothing left which is made. Everything is 'readymade'... It is a natural consequence of following one's reasoning to a logical conclusion."

Collin quotes Breton's definition from memory, that a readymade is a manufactured object elevated to the position of an art object by the mere choice of the artist.

"It's always the choice of the artist. When you make even an ordinary picture, there is always a choice. You choose your colours, you choose your canvas, you choose the subject, you choose everything. There is no art... It's essentially a choice. The choice obviously depends on the reasons for your choice... Instead of choosing something which you like, or something which you dislike, you choose something that has no visual interest for the artist. In other words, to arrive at a state of indifference towards this object; at that moment, it becomes a readymade.

"If it is something you like, it's like roots on the beach. Then it's aesthetic, it's pretty, it's beautiful; you put it in the drawing room. That's not the intention at all of the readymade..."

Is the readymade also against what you call the "seduction of the retina"?

"It's possible, yes; but that's something else. It's also for pictures. It's for oil painting generally which is made to please the retina, to be judged for the retinal effect of the picture. There is no more anecdote, no more religion; there is nothing else... I am rather uneasy when there is nothing more than this retinal effect. I am against it, and that's why I don't like abstract art very much, because it only seeks to please the retina. That's not enough in my opinion."

How should a readymade be looked at?

"It should not be looked at, in the end. It is simply there; one has the notion by the eyes that it exists. But one doesn't contemplate it like a picture. The idea of contemplation disappears completely. Simply take note that it's a bottle rack [15.1.1916], or that it's a bottle rack that has changed its destination."

Did Duchamp make the shadows of the readymades on the walls of the gallery for any particular reason?

"No, it was simply, particularly for the readymades, to show a different form now with the perspective of the light projection. And then to give a gaiety to a rather solemn thing."

Referring to the replicas of his readymades, Duchamp says: "If one makes an edition of eight, like a sculpture, like Bourdelle or anyone, that isn't an exaggeration. There is a thing called multiples, getting to 150, 200 copies. There, I object because that's really too vulgar; in a use-

less way it vulgarizes things which could have an interest if they were seen by less people. There are too many people looking in the world; it is necessary to do away with the number of people looking. So, that's another problem...

"It is not the visual question of the readymade that counts; it's the fact that it exists even. It can exist in your memory. You have no need to look at it to enter the domain of the readymade... It is completely grey matter; it is no longer retinal."

And the verbal aspect of the readymades, the introduction of language?

"Yes, that's very important for me. In certain cases I added a sentence. On the bottle-rack I added a sentence when I made it in [19]14... And as it was lost... I don't remember the sentence I wrote, so the new ones don't have a sentence. Several times I added titles like that, because it adds a colour, in the figurative sense of the word. It's a verbal colour. So what one does adds a dimension provided by words which are like a palette with colours. One adds one colour more, verbal colours."

At the end of the interview Collin asks Duchamp what he is doing at the moment.

"Quite simply waiting for death. Now understand that there comes an age when you no longer need to do anything, unless you want to. I do not want to work or do something. I am fine. I find that life is so good when one has nothing to do, at least working I mean. Even painting... Questions of art no longer interest me at all."

Creation for you never had a notion of working, it was always—

"—a stumbling block. I found to work for a living is a stupidity. But that's another question!"

Afterwards Duchamp returns to the ground floor, where the exhibition "Readymades et éditions de et sur Marcel Duchamp" [7.6.1967] is installed, and he signs in blue ink 100 numbered proofs of the poster before letters.

At the gallery on the same day bids received for the etching Les Joueurs d'Echecs [11.5.1965] are opened according to Duchamp's wishes as inscribed on the print itself:

FOR SALE BY SILENT AUCTION
Put your offer in an unsealed envelope
and leave it in the letter box. The bids will
be opened at the Givaudan Gallery on
Wednesday 21 June 1967.

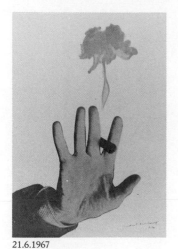

21.6.1967

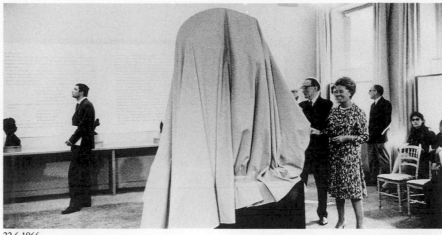

22.6.1966

22 June

1917. Sunday, New York City
In the evening Marcel accompanies Roché and Louise Arensberg in a taxi to the Mousetrap.

1919. Sunday, Buenos Aires
Having entrusted Miss Dreier with several of his optical experiments [4.4.1919], in his own luggage Duchamp takes the set of wooden chessmen that he designed and carved, except

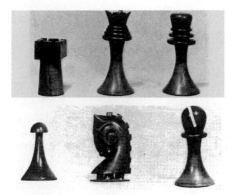

for the Knights, which were made by a local craftsman. For Marguerite Mellerio in Paris, he is bringing a circular tablecloth embroidered for her by her cousin, one of Zéo Enrico's five daughters, a family living in Buenos Aires.
 Due to sail at three o'clock in the afternoon, Duchamp boards the *Highland Pride*, a ship of the Nelson Line captained by R. N. Robinson.

1927. Wednesday, Paris
As Jacques Doucet prefers to see the Brancusi sculpture on Friday rather than Thursday [20.6.1927], Duchamp sends the collector an express letter in the evening to confirm the appointment.

1933. Thursday, Folkestone
France plays Iceland in the penultimate round of the International Team Tournament and Duchamp is forced to resign his game against P. Sigurdsson.

1942. Monday, Bermuda
After a week in port [16.6.1942], the *Serpa Pinto* sails for New York.

1954. Tuesday, New York City
The Duchamps have invited Margaret and Alfred Barr to dinner [18.6.1954] at 327 East 58th Street.

1959. Monday, Cadaqués
Referring to the interview made with George Heard Hamilton earlier in the year [19.1.1959] Duchamp writes to Richard Hamilton: "I hesitate to make another interview for the BBC on a larger scale for fear that I will have to answer questions which I never asked myself. In other words, I am willing to cooperate but would like to have a more detailed account of the subjects I am to discuss."

*

Duchamp also replies to a letter from Marcel Jean [22.11.1958] concerning the presentation of his book *Histoire de la Peinture Surréaliste*, which is due to be published at the end of the year: "Everything you say pleases me and I hope you don't have any spokes in the wheels."

1964. Monday, Paris
Writes a note to Maurice Lefebvre-Foinet authorizing him to give a *Boîte-en-Valise* to Pontus Hulten, who will settle with him directly.

1966. Wednesday, Paris
During the press conference commencing at five in the afternoon at the Galerie Louis Carré, 10 Avenue de Messine, Duchamp unveils *Le Cheval-Majeur*. Made from the *Grand Cheval* by Duchamp-Villon, the sculpture (which was baptized by Duchamp [24.6.1964]), weighs 525 kilos and revolves slowly on its plinth. In Duchamp's absence, the work has been supervised by the sculptor Gigioli.
 Duchamp explains to Pierre Descargues of the *Tribune de Lausanne*: "My brother started his studies of horses around 1913, culminating in the *Grand Cheval*, which he completed in 1914. A bronze had already been made from the plaster; I found it a good idea to make a larger version now which would better express the strength of this sculpture. I liked the height of one metre fifty, which, on the plinth, gives the dimension to his work, the volume of a horse."
 Referring to the exhibition in London [16.6.1966], Descargues asks Duchamp, since

officially for so long now he is a chess player, whether he considers that 200 items in the catalogue isn't rather a lot?
 "It's true," he replies with a smile. "It's a lot. I didn't believe I'd worked so much… John Cage credits himself for introducing silence into music. Me, I boast of having praised laziness in the arts. I wonder whether people still believe me."

23 June

1917. Saturday, Tarrytown
Duchamp arrives at André Brook to spend the weekend with the Stettheimers.

1919. Monday, La Plata
After steaming down the coast from Buenos Aires and making a short call at La Plata, the *Highland Pride* sails for Montevideo.

1933. Friday, Folkestone
In the final round of the International Team Tournament Duchamp is not called to play in the French team, which beats Scotland. In the final results the United States is the winning team ahead of Czechoslovakia. France lies eighth, and Duchamp's personal result is only 2 wins and 2 draws out of 13 games played.
 In the evening a banquet presided over by Canon A. G. Gordon Ross, president of the British Chess Federation, is held at the Grand Hotel to which all the players are invited. Lord Dunsany proposes the toast of the International Chess Federation, Dr Rueb replies and there are speeches by J. Bedrnicek of Czechoslovakia, Canon Gordon Ross, Sir Umar Hayat, W. M. P. Mitchell and the mayor of Folkestone. During the evening, when the winners are announced, Dr Rueb presents the Hamilton-Russell Team Tournament Cup to Frank Marshall, captain of the United States team.

1941. Monday, Grenoble
On a final "mission" [25.4.1941] between occupied Paris and the unoccupied zone, Duchamp brings the remaining precious contents for 50 copies of his *Boîte-en-Valise* [7.1.1941] to Grenoble where he also hopes to obtain his passport and visa [21.4.1941].

23.6.1966

1946. Sunday, Bridgeport
In an article for the *Bridgeport Post*, Anne Whelan describes the "most sensational of the changes" that Miss Dreier has made to the historic Georgian house on West River Street, built in 1832, which she moved into a week before Easter [21.4.1946]. "In the hall of the old mansion was an elevator to the second floor... It is a fine place of reception. [Duchamp] has painted the exterior of the lift with the same motif as the startling wallpaper of the hall, so that the elevator merges easily and gracefully into the whole scheme." Illustrating the article is a photograph of Miss Dreier operating the lift. The decoration of scattered brown autumn leaves, the journalist reports, was made by Duchamp shortly before he sailed for France [1.5.1946].

1958. Monday, Blainville-Crevon
Wishing to make one or two pilgrimages to places of his childhood during their visit to France, it is today that Duchamp would like to show Teeny the place of his birth [28.7.1887], which he believes he has not seen since his parents moved to Rouen [27.3.1905].
In his letter to Maître Le Bertre requesting this "exceptional favour", Duchamp explained that he is one of Maître Duchamp's sons who had "the luck" to be born in Blainville. "We hope to arrive from Paris by car at about three in the afternoon," announced Duchamp, "and we hope too not to bother you with this visit, short because we will be returning to Paris the same evening."

1959. Tuesday, Cadaqués
"Thank you for your letter full of sadness shared by us all," writes Marcel to Beatrice Wood of Roché's death [15.4.1959]. "I received a very long letter from Denise giving me a comforting description of Pierre's last moments." After telling Bea their plans for the summer and that they are temporarily without an address in New York [3.4.1959], he says: "Happy to know that you are working with joy and profit."

1960. Thursday, Paris
On Duchamp's behalf, Jean Tinguely and Daniel Spoerri write to Alain Bernardin, confirming their conversation of the previous day. Although the show, which Duchamp has not seen, at SOHO [20.12.1959], "Ballet avec les

Rotoreliefs de Marcel Duchamp," in its present form is to be stopped, authorization is given to use one of the *Rotoreliefs* [30.8.1935] enlarged in the show entitled "Ouverture hélicoïdale", a nude lit stroboscopically will appear to be descending a staircase.
As Max Ernst and Dorothea Tanning are friends of Bernardin, they plan to invite Teeny and Marcel with the Monniers to see the show at the Crazy Horse Saloon. This is arranged and everyone enjoys the evening tremendously.

1966. Thursday, Paris
Following the press preview the previous day, from four until seven at the Galerie Louis Carré, Duchamp hosts the opening party celebrating the first exhibition of *Le Cheval-Majeur* by his brother, Raymond Duchamp-Villon. The illustrated catalogue, which includes texts by and about Raymond Duchamp-Villon, is sold for the benefit of the American Chess Foundation [7.2.1966].
One of the guests is a friend from the past, Jeanne Serre [21.4.1911] whom Marcel has not seen for over forty years. After the death of Marcel Serre, Jeanne married Henry Mayer in 1921. It was after Mayer's death that Jeanne decided to renew contact with the Duchamps, first Gaston and then Marcel.
When Marcel asks what has become of the child, the reply is that Yvonne [6.2.1911], as Jeanne had always wanted – even determined – is a painter. Marcel had told Teeny previously of the child and how once, quite by chance in the metro, he had met the little girl, Yo, holding onto her mother's hand.
Teeny asks Jeanne whether they might meet Yvonne and her husband Jacques Savy and a date is arranged.
The meeting takes place one day soon afterwards in Yo's studio in Montmartre. Jacques Savy is a chess player and Yo's painting, which she signs Sermayer, naturally intrigues Marcel. Teeny is very touched by the remarkable mental and physical resemblance of Yo to Marcel, particularly the hands. Jeanne had never revealed the relationship of Marcel to Yo, and they all feel reticent about even mentioning the details of the situation, wanting to respect the deep reserve of everyone involved.

*

Writes a note to Arturo Schwarz giving him the dimensions of the menu engraved for

Simone Delacour's communion luncheon party [6.6.1909].

*

In London, the film *Rebel Ready-made*, made by Tristan Powell for "New Release", is broadcast by the BBC.

*

An example of *Objet-dard* [6.12.1953], which Her Majesty Queen Elizabeth II noticed when she visited the preview exhibition accompanied by Sir Roland Penrose, is sold to Joseph Hirshhorn in the auction held at Sotheby's in London to raise funds for the Institute of Contemporary Arts.

24 June

1917. Sunday, Tarrytown
The Stettheimers have been at André Brook for almost two weeks: "all lovely except that the Garden isn't stationary enough," writes Ettie. "It keeps transforming itself at a furious pace." Duchamp is staying the weekend and the Baron and Baroness de Meyer, Fania Marinoff and Carl van Vechten come from New York for lunch. Later the Marquis de Buenavista and a friend, Mr Chalfin, and Kooms come to tea and supper resulting in what Ettie describes as "a highly successful rowdy party".

1927. Friday, Paris
Marcel tells Walter and Magda Pach in New York of his recent marriage [8.6.1927] saying: "It is a charming experience so far and I hope that will continue. My life hasn't changed in any way," he declares, "I must make money but not for two. Let's hope that some luck each year will help the couple to live comfortably." Marcel is sorry that they are not coming to Europe: "A day will come when you will meet my wife who is really very nice."
Turning to business, Marcel would like to sell a small Odilon Redon [2.7.1913] watercolour which he bought a while ago and asks Pach if Alexander and Florence Bing might be interested. As for the Brancusi torso which Mrs Bing liked, it is still in Brummer's storage in New York.

24.6.1917

At three o'clock in the afternoon, Duchamp is due to meet Jacques Doucet [22.6.1927] at 46 Avenue du Bois and take him to see his Brancusi sculptures [13.9.1926], which are on display in the studio which Duchamp has rented for them.

*

Meanwhile at West End in New Jersey: "I must tell you some interesting news [10.6.1927]," writes Ettie in a measured tone to Alfred Stieglitz. Duchamp is married – to a Mlle Saracen or Sarasin, a young lady of the bourgeoisie... I feel so sorry for him, tho' I hope without good cause. But," she continues stoically, "I am somewhat relieved nevertheless and that will tell you a little how I feel about him! Perhaps you feel similarly." Gloomily she admits her disillusion: "I rather expected just about this to happen, even the lack of practical brilliancy of the solution."

1935. Monday, Paris
On learning from Lefebvre-Foinet that Kandinsky has had difficulty in retrieving his watercolours from Howard Putzel in California [30.3.1935], Duchamp writes to enquire whether, except the one sold and the two kept by the dealer, the artist has now received all the other works safely. Saying that he has still not received the $100 proceeds of the sale, which was promised over a month ago, Duchamp remarks: "There is sometimes a delay in paying on the part of the purchaser – as you know!"

1936. Wednesday, New York City
Taking a rest for a day or two from repairing the Large Glass at The Haven [20.6.1936], Duchamp calls to see Alma Reed at the Delphic Studios, 724 Fifth Avenue.

1938. Friday, West Redding
Supervised by Miss Dreier, Mr Coates spends the greater part of the day photographing the Large Glass according to Duchamp's written instructions [22.5.1938].

1946. Monday, Paris
Receives a telephone call in the morning from Roché to say that Sandy Calder will be visiting Arago that same afternoon at two o'clock (to discuss the proposed exhibition in October at the Galerie Louis Carré? [19.6.1946]).

1947. Tuesday, New York City
Apparently the main shipment from America has not yet arrived in Le Havre for "Le Surréalisme en 1947" (due to open in Paris on 7 July). Marcel writes with some alarm to André Breton, reminding him that unless the cases are collected by truck from the port, the shipment will take another 15 days to reach Paris.

Confirming all the last details for the exhibition which are in hand in New York, Marcel promises that Man Ray will be bringing with him a contribution for the auction to be held during the exhibition for the benefit of Benjamin Péret: using his motif for the forthcoming catalogue cover, Marcel has dedicated and signed a breast [17.5.1947].

In the evening, Marcel dines with Stefi Kiesler whose husband has been in Paris nearly a month [27.5.1947] to install the exhibition.

1950. Saturday, New York City
Marcel has met Walter Pach and made Arensberg's offer of $4000 for La Partie d'Echecs [1.10.1910] which has been accepted.

The question of making a photographic version of Jeune Homme triste dans un Train [17.2.1913] for the Arensbergs [5.7.1942] is progressing.

James Johnson Sweeney is back from Venice where he saw Peggy Guggenheim who owns the picture, and the photographer who has given a first estimate.

Regarding the future of the Arensberg collection, Marcel agrees that there is little prospect with the National Gallery. "Shall I go to Philadelphia incognito," Marcel asks the Arensbergs, "to get a rough estimate of 'running feet' in their galleries?"

1951. Sunday, New York City
In the evening, on finding a note from Monique Fong who has arrived from Washington, Duchamp telephones to invite her to dine with him the following evening.

1954. Thursday, Cincinnati
After his prostate operation which is completed by one o'clock in the afternoon, a telegram is sent to Roché: "Successful operation Mar Teeny." Feeling no ill effects, at seven Marcel is smoking his pipe.

1955. Friday, Lausanne
In the exhibition "Le Mouvement dans l'Art Contemporain" at the Musée Cantonal des Beaux-Arts, Duchamp is represented by Rotative Demi-sphère [8.11.1924], the Rotorelief (Disques Optiques) [30.8.1935] and the drawing entitled 2 Nus: un fort et un vite [19.8.1912].

1962. Sunday, London
The television programme "Monitor", in which Duchamp is interviewed by Katharine Kuh [29.3.1961] and Richard Hamilton [27.9.1961], is broadcast by the BBC this evening.

1964. Wednesday, Neuilly-sur-Seine
For their proposed enlarged version in bronze of Raymond Duchamp-Villon's sculpture, the Grand Cheval, Duchamp suggests to Louis Carré that its title could be Le Cheval-Majeur.

*

Following Duchamp's correspondence with Dr Beeren [17.5.1964], replicas of the two readymades [5.6.1964], Roue de Bicyclette and Egouttoir [15.1.1916], are included in "Nieuwe Realisten / Nouveau Réalisme", an exhibition of New Figuration, Pop Art, Traditional and Social Realism, etc., which opens at the Gemeentemuseum in The Hague.

1966. Friday, Milan
An important number of replicas of works by Duchamp are lent by the Galleria Schwarz to the exhibition "Cinquant'anni di Dada. Dada in Italia 1916–1966", currently being mounted at the Civico Padiglione d'Arte Contemporanea.

1968. Monday, Cadaqués
Catching up on some correspondence, Duchamp writes thanking Joe Solomon in New York for his letters and clippings.

Duchamp also replies to Jeanne Levin in Florida saying that he has asked Arturo Schwarz to send her information about his 1965 edition of Rotorelief (Disques Optiques) [30.8.1935].

Mrs Levin should explain when she writes to Schwarz in Milan that she already has the set of disks and only wants the box and motor.

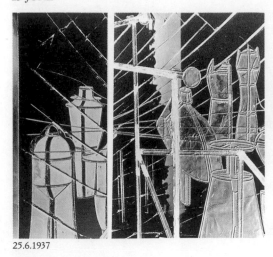 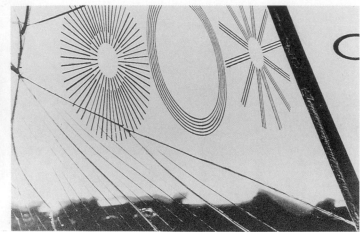

25.6.1937

25 June

1912. Tuesday, Munich
With a card of the Rhine at Basel, Marcel writes to "Mesdames Nicolle", his aunt Ketty, his grandmother and her daughter Julia Bertrand [24.7.1900] in Neuilly: "Ideal weather. Voyage without incident, arrived in Munich Friday evening. I embrace the three of you very affectionately, Marcel."

1919. Wednesday, Montevideo
The *Highland Pride* [22.6.1916] sails from Montevideo, leaving the River Plate, and takes a course northwards to Rio de Janeiro.

1921. Saturday, Paris
At ten-thirty in the evening Henri Pierre Roché visits Yvonne Chastel and Marcel who are living at 22 Rue de la Condamine, Suzanne's apartment before her marriage [14.4.1919]. The two men have both returned to Paris within a few days of each other, Roché from Berlin, Marcel from New York [16.6.1921]. As Marcel shows his friend drawings for his new set of chessmen (those similar in design to the rubber stamps made in Buenos Aires [7.1.191] or the Marshall's chessmen [20.10.1920]?), Roché rediscovers the "exquisite smile, subtle and gay" which bewitched him when they first met in New York [4.12.1916].

Yvonne, Marcel's companion in Buenos Aires, is "ample, stretched out in a deck chair on her balcony, healed, looking beautiful."

1929. Tuesday, Paris
In the eighth round of the Tournoi international de Paris, Duchamp plays and beats George Koltanowski. It is a game which is widely commented on and Duchamp himself makes notes on the game.

BLANCS	NOIRS
Koltanowski	**Duchamp**
1 P2D.4D	C1CR.3FR
2 P2FD.4FD	P2R.3R
3 C1CD.3FD	P2D.3D
4 P2R.4R	P2CD.3CD
5 P2FR.4FR	F1FD.2CD
6 F1FR.3D	C1CD.2D
7 C1CR.3FR	P3R.4R
8 P4D.5D	

Les complications qui auraient suivi le gain d'un pion à 5R par 8 P4FR.5R × P — P3D.4R × P ; 9 4D.5R × P — C3FR.5CR, ou bien par 8 P1FR.5R × P — P3D.4R × P ; 9 C3FR.5R × P—F1FR.5CD auraient permis aux Noirs de regagner le pion ou d'obtenir une attaque sur le Roi blanc très découvert.

8	P2CR.3CR
9 roq	P4R.5FR × P
10 F1FD.4FR × P	F1FR.2CR
11 P4R.5R	P3D.4R × P
12 C3FR.5R × P	roq
13 D1D.2D	

Pour affaiblir le Roi noir par F4FR. 6TR.

13	C3FR.4D × P
14 C5R.7D × C	C1D.5FR × F
15 C7D.8FR × T	
Si 15 D2D.4FR × C — D1D.2D × C, laissant aux Noirs une meilleure position et un pion de plus.	
15	F2CR.5D +

Les Blancs abandonnent./

1936. Thursday, New York City
While on leave from West Redding, Marcel dines at seven-thirty with the architect Frederick Kiesler, his wife Stefi and Mr and Mrs Sidney Janis.

1937. Friday, Paris
"What a surprise you gave me!" writes Duchamp to Frederick Kiesler who has written on the Large Glass [5.2.1923] in the May issue of the *Architectural Record*. "It gave me very great pleasure to read your article… First the spirit of the article, then your interpretation and the presentation of your ideas! Thank you for having wanted to look at the glass with such attention and to have clarified points that few people know about."

"I don't remember," Duchamp continues, "if you have a green box [16.10.1934] which, in fact, is the 'manuscript' of the glass. I am

sending you a copy by the next post, hoping that in glancing through it you will see how right you are."

To reproduce the Large Glass in his "album" [5.3.1935], Duchamp is inspired by the celluloid print inserted in the *Architectural Record*, but he needs photographs of the glass viewed from the front without any perspective and asks Kiesler if Berenice Abbott can provide what he needs.

*

"I have started the reproduction in colour of 5 paintings of mine," Dee writes to Miss Dreier, referring to the work on his "album" which he calculates will take him all summer. "Next winter I expect to attack the big glass and *Tu m'* [8.7.1918]."

Having telephoned the previous day for news, Dee tells Miss Dreier that the colourist's work on her lithographs [11.5.1937] will not be finished until August, and he encloses an up-to-date budget. "How is The Haven this year?" he enquires, "My regards to Mr Penny and Cocky [the parrot]."

In last week's column for *Ce Soir* [18.6.1937], Duchamp announced that today, to mark the centenary on 22 June, he would publish the biography of Paul Morphy.

1938. Saturday, Paris
"Thank you for the cards," writes Duchamp to André Breton in Mexico, "they indicate that you do not regret this voyage. Perhaps it's notice of a world tour. Here, nothing sensational to report," he declares, "except for the significance of your absence."

Yves Tanguy is leaving for London soon where his exhibition at the Galerie Guggenheim Jeune opens on 5 July and, Duchamp tells Breton, "Paalen has produced a luxurious catalogue suitably framing your preface."

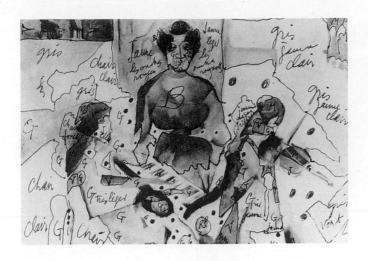

25.6.1965

1941. Wednesday, Grenoble
Lunches with Denise Roché and shows her the *Boîte-en-Valise* [7.1.1941] which he has brought on his final "mission" from Paris for Pierre [25.4.1941].

Later Marcel dispatches the *Valise* to Lyons as Roché has requested. As no passport has arrived for him yet [28.4.1941], the director of the Musée de Grenoble, André Farcy, arranges for Duchamp to meet the *secrétaire-général* of the *préfecture,* who agrees to make enquiries in Vichy and report back to him in two or three days.

1942. Thursday, New York City
As the *Serpa Pinto* docks at Staten Island, Duchamp completes his thirteenth voyage across the Atlantic. He considers it was "perfectly darling... This was the best trip of all. It was perfectly delicious. All the lights were on and we had dancing on deck every night."

After disembarking, Duchamp goes to 1 Gracie Square, where Robert Parker has invited him to stay. He receives a phone call from Betty Chamberlain, Alfred Barr's assistant at the Museum of Modern Art, and promises to speak to Miss Dreier who is waiting to hear from him.

1946. Tuesday, Paris
At three in the afternoon, Totor is due to meet Roché at the Galerie Drouin, 17 Place Vendôme.

1951. Monday, New York City
After learning that his suspicions were justified and that his brother has not received any payment from the museum, Duchamp writes to thank Alfred Barr for investigating the question of royalties for the reproduction of Jacques Villon's engraving of *Mariée*. The original print, a limited edition co-signed by Duchamp, was one of a series of reproductions or interpretations of famous pictures made by Villon for Bernheim-Jeune during the 1920s.

*

After being detained at work, Monique Fong arrives late at 210 West 14th Street. In the studio they start talking about the Place Blanche, the celebrated haunt of the Surrealists in Paris, and then Duchamp takes Monique to dine in "a very attractive restaurant on 13th Street which could have been in Montmartre". Breton and the Surrealists continues to be their subject of conversation. "Duchamp himself has such a very rare, very free intelligence," observes Monique, "more free certainly than Breton because he aims at nothing. He is extremely kind too and one doesn't feel uncomfortable at all to be with him." For Monique it is "a very good, precious evening" which, happily for her, Duchamp invites her to repeat.

1959. Thursday, Paris
At a further auction for the benefit of Benjamin Péret [24.6.1947], which is held at the Hôtel Drouot, Duchamp has donated a *Gilet* [15.11.1958]. The red-and-black striped cotton flannel waistcoat has five buttons, each bearing a letter in lead type: PERET.

*

The Transcendant Satrape Marcel Duchamp is nominated president of the Sous-Commission des Formes et des Grâces, which deals with rules, formalities, exceptions, exemptions, bounty – and figures, advantages, curves, aestheticisms, seductions, and titillations of all kinds.

LA GVIRLANDE

René Clair Marcel Duchamp Ergé Max Ernst
Jean Ferry Ionesco Henri Jeanson
Michel Leiris Liù Latrenhi
Joan Miró Opach Pascal Pia Jacques Prévert
Raymond Queneau Camille Renault Maurice Saillet
Boris Vian Oktav Votka

TRANSCENDANTE

He is also nominated president of the Sous-Commission de la Gloire et des Protubérances, the sociological and medical organism, qualified to diagnose the "rotten", but also to provide astringent or emollient prescriptions in association with the S. C. des Solutions Imaginaires and the S. C. des Possibilités.

1961. Sunday, Cadaqués
Having identified the authentic images from his film *Anémic Cinéma* [30.8.1926], Duchamp returns the photographs to Serge Stauffer in Zurich asking him not to publish the images which have been added by an unknown hand, or eventually to mention that a version exists for which he is not responsible.

After giving instructions with regard to the delivery of the two *Boîte-en-Valise* [7.1.1941] to Switzerland, Duchamp sidesteps Stauffer's plea to discuss the meaning of life by writing: "Be hearing from you soon then, and we will speak about life another time."

*

Consoles Brookes Hubachek after Harry F. Guggenheim's response is negative [16.5.1961]: "It was hard to expect him to oblige which he might have done had he been alone to decide," and for his coming holiday wishes him "a glorious Basswood" [26.8.1956].

1965. Friday, Paris
Duchamp is the guest of honour at an Oulipians' luncheon presided over by François Le Lionnais, held at the Restaurant La Frégate, Quai Voltaire, at a quarter to one. The members of the OUvroir de LIttérature POtentielle are installed at two small tables by the window overlooking the river: Duchamp is seated between Raymond Queneau and Jean Lescure, with Le Lionnais opposite. According to Lescure, "Le Lionnais spoke a great deal, much more than Duchamp... It was all very relaxed, very chatty and full of nods and winks, laughter and allusions."

26 June

1941. Thursday, Grenoble
Writes to Victor Brauner proposing a rendezvous with him on Tuesday in Marseilles.

1946. Wednesday, Paris
Victor Brauner receives a telegram from Julien Levy accepting the terms of Duchamp's letter proposing the detailed arrangements upon which Brauner would be prepared to enter into a contract with Levy for the American rights to his work.

1947. Thursday, New York City
"Details continue to spoil my days," writes Dee in the evening to Miss Dreier. "Now I have to collect drawings and paintings by the Surrealist

26.6.1967

painters here who want to contribute to an auction sale [24.6.1947] of their works for the benefit of Benjamin Péret, a poet, now in great need in Mexico City."

1950. Monday, New York City
Much to Miss Dreier's dismay, the position of the signature on her canvas *Abstract Portrait of Marcel Duchamp* [1.3.1945] which has recently been acquired by the Museum of Modern Art has caused the reproduction to be printed upside down in the museum's bulletin, Volume XVII, no. 2–3, 1950.

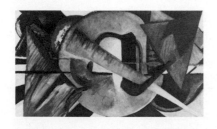

To save the day, Duchamp calls at the museum and has no difficulty in eradicating the signature on the picture and Alfred Barr agrees to have the portrait properly reproduced in the next issue of the bulletin with an erratum notice.

1955. Sunday, New York City
"My memories of the appearance of a bicycle wheel mounted on a kitchen stool in my studio in 1913 are too vague and could only be transformed in thoughts a posteriori," writes Duchamp to Guy Weelen, organizer of the exhibition in Lausanne [24.6.1955]. "I only remember that the mood created by this intermittent movement was somewhat similar to the dance of a wood fire; it was like a reverence to the useless side of a thing generally used for other ends... I was probably delighted with the movement of the wheel as an antidote to the habitual movement of an individual around the contemplated object."

1958. Thursday, Paris
Duchamp has proposed to meet Patrick Waldberg and Samuel Beckett at five-thirty in Montparnasse [18.6.1958] before receiving

the Rochés at 58 Rue Mathurin-Régnier. However, as Denise has a cough, the dinner is cancelled.

1964. Wednesday, Neuilly-sur-Seine
"We have so much to thank you for that we don't know where to begin," writes Duchamp to Arturo Schwarz. "First, the exhibition [5.6.1964] is certainly remarkable and next all the trouble you took – and then the catalogue, a 'chef d'oeuvre' and a document so important for us."

By the same post Duchamp sends Schwarz a large tube containing the plan for the replica of *In Advance of the Broken Arm* [15.1.1916] which, as Duchamp has indicated on the drawing, "is perfect except for a reinforcement in iron *ungalvanized.*"

1967. Monday, Paris
For the television programme "Le Corbillard et le Chameau", directed by Jacques Floran and broadcast by the ORTF, Duchamp is one of the participants in a discussion on René Clair's film *Entr'acte* [4.12.1924], prior to the screening of the film itself.

27 June

1927. Monday, Paris
Evidently disturbed by the news of Duche's sudden volte-face [10.6.1927], Florine Stettheimer tells Henry McBride of her nightmare: "[Duche] had grown baldish, and his forehead and headtop were made of milk-glass from which he wiped the drops of perspiration." She even imagines that "he may be able to increase her to a size bigger than Gertrude Stein".

"Duchamp married!!!" replies Stieglitz to Ettie [24.6.1927]. "Well yes I am surprised – still not – and still am. I oughtn't to be surprised for

Duchamp married . ₩.

last winter I remarked to him now that he had become 'Salesman of Art' – what next? ... So it's marriage, Carrie writes to a bourgeois girl... At any rate it's a woman he married. That's all right

enough to suit any of us insisting on Convention of some sort being served – even by Duchamp. At any rate he ever surprises – What next?" Stieglitz ponders acidly, "Father of six or seven? And if she has no means (except the one of getting children) he'll have to invent some way – just by way of support of the family. And then," he concludes triumphantly, "we'll have the aristocrat completely the bourgeois. And that's the way the World seems to prefer it – even like it. Duchamp married!!!"

*

"Your letter was a great help and I rely on your reaction to prove my move to be good," writes Dee to Miss Dreier, referring to his marriage [8.6.1927]. "As I said in my first letter [25.5.1927]," he continues, "my life won't be changed essentially and if I have to make my living I don't intend to feel too responsible for the upkeep of a household." He promises to send Miss Dreier a photograph of his wife as soon as Man Ray has taken it.

Business: the return shipment of works from the Société Anonyme's Brooklyn exhibition has arrived. Might Miss Dreier, like Walter Pach, help him sell his Odilon Redon [24.6.1927], which he describes as "almost like a shapeless Kandinsky"? Might his recent purchase of Meryon's *La Morgue* interest her brother?

"I may go this winter to New York for a month to help [with] fixing a stair railing that Brancusi is working on for Mrs Rumsey," he says. "But I really don't know how I can afford it... Affectionately from the two weds, Dee."

1929. Thursday, Paris
Preoccupied by the closing stages of the Tournoi international de Paris [14.6.1929], Marcel writes an express letter to Alice Roullier [15.2.1928] at the Hôtel Bedford: "My brother asks me to invite you to dinner on Sunday 6 or 7 July. Can you? Will telephone you at the beginning of next week, affectionately Marcel."

1933. Tuesday, London
Mary Reynolds and Marcel (who has come to town after the chess tournament in Kent [23.6.1933]) choose a statue of Peter Pan, the boy who never grew up, to send to Brancusi with the message: "London is charming with a little sun."

1935. Thursday, Paris
Invited by Mary Reynolds and Marcel to lunch, Roché brings Denise and his son Jean-Claude to

28.6.1919

14 Rue Hallé where, in the tiny garden, he admires the *Deux Pingouins* by Brancusi.

1942. Saturday, New York City
Travels to West Redding to spend the first week-end since his return to New York [25.6.1942] with Miss Dreier at The Haven.

1943. Sunday, New York City
At nine in the evening, Mary Reynolds and Marcel meet the Rifkins, Reiss and the Kieslers, with whom at midnight they go to Romany Marie.

1945. Wednesday, New York City
Only seven weeks after the end of the war there is news from Paris. Mary Reynolds, Dee tells Miss Dreier, "is delighted with her place and the people she knows there but life is very dear."
He also passes on the news from Francis Steegmuller of his brother in Paris: "Villon is not only a painter there but a school... The best form of recognition he has ever wanted." Recalling the days when Villon was a struggling cartoonist, Dee considers it was "better for the quality of his work that recognition should have come so late. He will avoid the check-signing method of painting in use so much today among our best artists."
"Here life has been quietly hot, I am trying to put a little order in my studio which is too much of a mess." Of his other activities he says: "I still have some lessons. ... Sometime after July 4th," he adds, "I would like to spend 24 hours in Haven!"

1947. Friday, New York City
Marcel has lunch with Stefi Kiesler and Robert Parker.

1960. Monday, New York City
To those accepting to join his Arts Committee for American Chess which is to raise funds for the American Chess Foundation [9.6.1960], Duchamp reveals that he is planning an auction of paintings and he hopes that each member of his committee "will give a painting or a drawing (or several) for such a purpose".

1967. Tuesday, Neuilly-sur-Seine
"The pictures are coming back from the Salon d'Automne [1.6.1967] tomorrow, and I have asked Lefebvre-Foinet to send you the portrait

of Villon by Suzanne, which I hope you will like as much as I do and which you have accepted for the museum of Rouen," writes Duchamp to Mlle Popovitch. "After the different ceremonies around your exhibition [15/28.4.1967, 31.5.1967]... I send you all our great thanks in my capacity as 'interim' chief of the clan (Villon and Duchamp-Villon having preferred eternity to the ground of even Norman cows)."

1968. Thursday, Cadaqués
"We have made a beautiful trip through Switzerland, Italy and in Genoa [10.6.1968] took a boat for Barcelona with the car... Give us your news and your plans for the summer," Marcel requests Arne Ekstrom, wishing him a "delightful one".

28 June

1917. Thursday, New York City
Marcel sees Beatrice Wood who later takes her collie dog to visit the Arensbergs.

1918. Friday, New York City
When she comes to New York from Bedford Hills [9.6.1918] a few days every week, "bunking" in her sister's studio, Ettie's main occupation is to keep her dates for lunch, dinner, roof gardens and theatres from getting mixed up. Today is no exception. After lunch together, Carl van Vechten insists they call on the sculptor, Elie Nadelman, with whom Ettie has a date to dine on the Ritz roof that evening...

At five Ettie has extricated herself to take tea with "little Duche" at the Beaux-Arts Café. Afterwards they go up to Florine's studio but when Ettie wants to dress for dinner Duche, for amusement, refuses to leave. It is not until she gets down on her knees to beg him that he consents to go.

1919. Saturday, at sea
While the *Highland Pride*, with Duchamp aboard, steams towards Rio de Janeiro [25.6.1919], the German delegation signs the Peace Treaty at the Château de Versailles.

At the same time in the window of an antique dealer in Rouen, Place Restout, situated on the north side of the Musée des Beaux-Arts, is exhibited an interpretation of the dramatic painting by Antoine-Louis Janet-Lange (a pupil of Ingres and Horace Vernet) entitled *La France signant les préliminaires d'un traité de paix*, the one of 1871! The copy of this historic picture, also dated 1871, was painted by Emile Nicolle's brother-in-law Léonce Lelarge, a classical painter and the father of two daughters: Jeanne, who married Léon Leseigneur, and Armande, who married Jean van Linden [26.9.1912].

1926. Monday, Paris
Meeting them at twelve o'clock at 99 Boulevard Arago, Marcel has lunch with Roché and Miss Alice Roullier from the Arts Club of Chicago.

1941. Saturday, Grenoble
In the morning Marcel leaves the Hôtel Moderne and goes to see Alec Ponisovsky [18.5.1941] who is at Veyrier-du-Lac, situated near Annecy about a hundred kilometres north of Grenoble.

1942. Sunday, West Redding
An unexpected storm is caused by Miss Dreier's concern to allow Dee to rest, when she asks Edward or Marie to take Dee's breakfast to his room and they threaten to leave.
During the day Miss Dreier explains her situation to Dee and asks him to help her. Having failed to persuade Yale University to take over her private collection in addition to the gift already made of the Société Anonyme Collection [14.10.1941] and failed to realize her ambition of a Country Museum on her estate [19.7.1941], Miss Dreier is decided on selling The Haven when conditions are right.

1946. Friday, Paris
At just after half past eleven, Totor meets Roché at Arago and they have lunch together.

1950. Wednesday, New York City
"Give me some details about Mary's condition as soon as she is back from La Preste," Marcel urges Roché. "Is it only the kidneys, or kidney? Strange that the infection is not vanishing, even gradually."

30.6.1922

After a spell at the American Hospital in Neuilly at the beginning of May, Mary Reynolds is taking a cure in the Pyrenees with Franz Thomassin [13.7.1937] but, in great pain, she is unable to walk or sleep and cannot eat. To Hélène Hoppenot in Bern she writes: "The great hope is to get it over and try and pick up weight, appetite and nerves in the following month."

1958. Saturday, Paris
Unable to see the Guilberts [21.6.1958] before leaving Paris on Tuesday, Duchamp writes saying: "Fortunately we return to Paris around 15 September and then, if you are here, time will bend to our requirements."

1963. Friday, Ile de Porquerolles
After their lightning visit to Milan [18.6.1963] and their meanders from Lyons to Grenoble and Aix-en-Provence, the Duchamps are staying at the quiet Mas du Langoustier on the western tip of the island.
 Thinking of the young friends who so kindly collected them at short notice from the airport in Rome earlier in the month [9.6.1963], Duchamp writes to Elena and Franco: "All this Italian period of our life is full of delicious moments and you are the people responsible for our very pleasant visit to Rome [23.5.1963] and for the discovery of corners that we didn't know." Saying that now he is looking forward to rest in Cadaqués, Duchamp adds: "Don't forget your promise to come, and write us the date – even approximate – of your arrival."

1965. Monday, Neuilly-sur-Seine
Replying to Cleve Gray's news that Macmillan Publishers would like to publish his autobiography and the suggestion of making recordings which Cleve would edit, Duchamp replies: "I flatly refuse to write an autobiography. It has always been a hobby of mine to object to the written I, I, I's on the part of the artist."

Regarding the project with Arne Ekstrom to publish another batch of notes, a sequel to the Green Box [16.10.1934], Duchamp explains to Cleve: "The manuscript you are translating is being printed here and will be ready by the end of September. Arne is working out a beautiful box for the whole thing (texts and your translation)."

As they will not be returning from Cadaqués until late in September, Duchamp tells Dr Wieland Schmied of the Kestner-Gesellschaft that they will be unable to attend the opening on 6 September. Proposing to go to Hanover on 27 or 28 September, Duchamp enquires whether the date of the opening can be postponed, and if not, whether Dr Schmied would receive them during the exhibition.

1966. Tuesday, Neuilly-sur-Seine
In the morning Marcel and Teeny leave in the Volkswagen, registration number 4936 TT 75, to visit Grenoble, Nice and Aix-en-Provence on their way to Cadaqués.

1967. Wednesday, Neuilly-sur-Seine
In the morning Marcel and Teeny leave for Cadaqués.

29 June

1913. Sunday, Puteaux
It has become a custom on a Sunday afternoon for the Duchamp brothers to receive their friends at 7 Rue Lemaître. As it is fine everyone gathers in the luxuriant garden shaded by the great horsechestnut tree. The painters Albert Gleizes and Francis Picabia have come today, among the writers Jacques Nayral [20.4.1912] and Henri-Martin Barzun, who has brought his family. There are the usual diversions from the long and passionate discussions on art: archery, ball games including *boules* and *spirobole*, other games of skill such as the devil-on-two-sticks or cup-and-ball, and naturally Marcel's own board game of chance, the steeplechase [9.4.1910].

*

Guillaume Apollinaire composes his manifesto *L'Antitradition futuriste* for Marinetti in which he says "shit" to various concepts and personalities past and present, and offers a rose to many of his avant-garde friends including Albert Gleizes, Francis Picabia, Marcel Duchamp, Henri-Martin Barzun, etc.

1933. Thursday, Paris
After a few days in London [27.6.1933] Mary Reynolds and Marcel travel back to Paris.

1942. Monday, West Redding
Dee returns to New York City after spending the weekend at The Haven.

1946. Saturday, Paris
Marcel has lunch with Henri Pierre Roché and Maria Martins at the Côtelette, 43 Rue de la Rochefoucauld, not far from the Gare Saint-Lazare.

1948. Tuesday, Paris
To mark the publication of *Documents surréalistes* by Maurice Nadeau, an exhibition "Tracts et papillons surréalistes 1920–1940" opens at the Galerie La Hune. Mary Reynolds has lent "all relics of Duchamp" and feels "very miserable and widowed".

1957. Saturday, New York City
"About a month ago I went to the Guggenheim Museum and saw the repair made to *Nu descendant*... [11.3.1957] and I was filled with admiration," writes Duchamp to Henri Marceau of the Philadelphia Museum of Art. "Not only there remains no trace of the accident but indeed the relining and cleaning gives new life to our dear friend."
 Following the visit of Frank Trapp of Amherst College who is planning a "revival" of the Armory Show [17.2.1913], Duchamp urges Marceau in spite of the risk of accidents to lend not only *Nu descendant un Escalier*, No.2 [18.3.1912] but other pictures from the Arensberg Collection, to the exhibition.
 He also tells Marceau that Gabrielle Buffet has enquired whether the three large Picabia's belonging to the museum could be lent to a retrospective exhibition being planned in Paris.

1958. Sunday, Paris
After the cancelled dinner party on Thursday, before leaving Paris the Duchamps are invited to Sèvres by Roché, who is quite delighted by their visit, finding the couple "suave, quiet and marvellous". Finding their "charm inexplicable", Roché remarks that "they complement each other: years ago, who would have predicted it?"
 Marcel spends some time carefully looking through the proofs of Roché's text [22.1.1958] for Robert Lebel's book and corrects them himself "perfectly".

30.6.1959

1960. Wednesday, New York City
Marcel and Teeny leave for Europe where they will spend the summer. First stop Cadaqués for two months.

1961. Thursday, Cadaqués
"Finally," writes Duchamp to Robert Lebel who is planning to visit Cadaqués, "I have reserved the so-called de luxe apartment in the house next to ours with a view of the beach and the lighthouse in the distance: 2 rooms, kitchen, bathroom without bath, cold shower, no hot water but electricity and butane gas included in the price of 5,500 pesetas from 15 to 31 August."

*

"Since my arrival here [31.5.1961] I have been working on your text," writes Marcel to Enrico Donati, "and here is all that I managed to produce." Suggesting that it could be reproduced in facsimile or typographically in the catalogue of Donati's forthcoming exhibition at the Palais des Beaux-Arts in Brussels, Duchamp requests to see a proof before publication. Inspired by Donati's Fossil Series of pictures which will be in the exhibition, the text reads:
"Une NNNNNNNNNNNN de réciFs OSCILL[Entre]
FAUSSE ILE, FOSSILE et FAUX CIL.
Fossiles d'Enrico, de près ou de loin, sûrement pas agraires."

1965. Tuesday, Paris
In his gallery at 34 Rue Jacob, Jean Larcade [28.3.1963] exhibits the *Boîte-en-Valise* [7.1.1941] in his mixed exhibition entitled "Pop Por / Pop Corn / Corny".

30 June

1919. Monday, Rio de Janeiro
After calling at Rio where a number of passengers join the ship, the *Highland Pride* [22.6.1919] sails out into the Atlantic Ocean.

1922. Friday, New York City
Having found a photograph of Picabia's *Tableau peint pour raconter non pour prouver* to illustrate the brochure [15.6.1922], Marcel

writes to McBride mentioning that it is one of the pictures (exhibited under the title *A Little Solitude in the Middle of Suns*) which was shown at the Modern Gallery [5.1.1916]), and which he referred to in his article for the *New York Sun*. Marcel has also found a printer.

With the list of illustrations established (Brancusi, Matisse, Rousseau, Picasso, Braque, Picabia, Derain and Marie Laurencin), Marcel asks whether McBride agrees with him that it is a good idea to include a Derain, Braque, Brancusi and Rousseau, even though these artists are not referred to in the articles. Should the date of each article be mentioned, and the illustrations be incorporated in the articles or put together at the end?
"I hope to have 16 different types (in size and of the same family)," says Marcel. Planning to start the layout on 5 July, he urges McBride: "Tell me your last wishes, because as you say, it is not easy to exchange typographic ideas by letter."

1926. Wednesday, Paris
Marcel sends word to Brancusi that he has forgotten to mention that he is dining with friends this evening: "I will come to you at about eleven tonight for a small drink."

1929. Sunday, Paris
At the banquet on the final day of the Tournoi international de Paris attended by all the participants and a certain number of chess celebrities, the prize for the winner is awarded to the Grand Master S. Tartakover.

Although Duchamp finishes last in this tournament of very strong players, he nevertheless drew his game with Tartakover, the winner, drew also against Miss Menchik, the women's world champion, and beat Koltanowski [25.6.1929] in one of the games considered for a special prize. However the world champion Alekhine, and M. Bernstein, who have been chosen to make the awards, decide to reserve their decision.

1941. Monday, Grenoble
After a weekend at the Lake of Annecy, Duchamp spends part of the day in Grenoble before taking the train to Marseilles.

1942. Tuesday, New York City
Five days after Duchamp's arrival from Casa-

blanca, André Breton gives a party for him at his apartment on West 11th Street.

1946. Sunday, Paris
Marcel and Villon are also guests at the dinner party Mary Reynolds gives at 14 Rue Hallé for the ambassador, Henri Hoppenot, and his wife Hélène, who are visiting Paris from Bern. In the precarious political period following the war, it is only a few days since Georges Bidault became leader of the French government. "Marcel has difficulty adjusting himself to the Parisian atmosphere," confides Mary in a low voice to Hélène. "He lives in terror of the Communists," she explains. "He believes he will be one of their first targets if they come to power."

1950. Friday, Hollywood
At a meeting of the board, the trustees of the Francis Bacon Foundation elect Duchamp to be an active member, trustee and vice-president of the foundation, which will enable him to negotiate the gift of the Arensberg Collection to the Philadelphia Museum of Art.

*

On his last day in office at Yale University, President Charles Seymour receives the first copy of *Collection of the Société Anonyme*, the catalogue of the art collection donated to Yale [14.10.1941]. Prepared by Miss Dreier and Duchamp in collaboration with George Heard Hamilton and with assistance from Nelly van Doesburg [26.11.1948] and Stefi Kiesler, the catalogue is the result of more than two years' intensive work [1.12.1947]. As well as being closely involved with every aspect of the publication, Duchamp himself has written short texts on 33 of the artists.

1959. Tuesday, Cadaqués
Returning to Paris, Marcel brings with him the three illustrations for Robert Lebel [15.4.1959] which he conceived and executed during his stay in Cadaqués.

"You can do absolutely anything you wish," Lebel had told him. A few days after returning from Perpignan [4.5.1959], Marcel made *With my Tongue in my Cheek*. His cheek bulging with a large nut which he had put in his mouth, Teeny cast the side of Marcel's face in plaster which he then placed onto a drawing of his profile.

1.7.1912

A few days later he made *Torture-morte*. A plaster cast of a foot, mounted vertically on wood, exposes the sole tormented by Spanish flies.

For the third, which he has entitled *Sculpture-morte*, Marcel placed a selection of vegetables in marzipan made by the *pâtissier* Bonnevie [4.5.1959] in an Arcimboldo-style arrangement with a cherry, bumblebee and a beetle on wrapping paper from the shop in Perpignan.

1962. Saturday, Cadaqués
In the morning Puignau, the mayor of Cadaqués and the main builder of the town, sends his best mason and an elderly man to start work on the fireplace, which is to be built to Marcel's design providing a log fire in the living room of the apartment [14.4.1959].

1963. Sunday, Nice
Held up by an air-controllers' strike, Marcel and Teeny will not now be installed in Cadaqués to start their "convent life without moving" before 3 July. On a card with a view of Cézanne's mountain Sainte-Victoire near Aix-en-Provence, Teeny writes to thank Enrico Baj for the night spent at his apartment in Milan [18.6.1963].

1965. Wednesday, Neuilly-sur-Seine
To launch Richard Hamilton who is preparing to build a replica of the Large Glass [5.2.1923] for the exhibition at the Tate Gallery [16.2.1965] and has raised some questions, Marcel sends him the information he can and says: "But I think the best for general size is the pencil drawing one-tenth scale [22.10.1913] which was reproduced on the cover of the Pasadena catalogue [7.10.1963] and which belongs to Jeanne Reynal."

*

Writes to Maître Le Bertre [23.6.1958] thanking him for his kind invitation to Blainville, "Unfortunately we have been very busy since our arrival in France and I ask you to postpone this visit until the end of September when we return from Spain."

Duchamp promises Le Bertre that on his return to New York he will try to find out which museum has the retable which once belonged to the church at Blainville. Although some of the old sculptures remain in the church, the retable was sold in the nineteenth century.

1 July

1900. Sunday, Paris
A summer evening in the garden at Blainville when Marcel examines the source of miniature illuminations in the grass watched by his sister, is the inspiration for Jacques Villon's drawing *Les Vers Luisants*, published in *Cocorico*. As Marcel puts out his hand to pick up a glow worm, Suzanne exclaims: "Be careful, you'll burn yourself!"

1912. Monday, Munich
Max Bergmann, who urged Duchamp to visit him in Munich, no longer has his studio at 59 Georgenstrasse by the Akademie, but has recently moved to Haimhausen, about 20 kilometres north of the city. With his friend Ludwig

Correctur für Landschaft = Tier- und Figürliches =

Bock, also a painter, he has taken a house near the church in Sonnenstrasse, where they plan to offer open-air classes in landscape, figure and animal painting. Bergmann, with his cart drawn

by Elsa the donkey, can meet Duchamp from the train at Lohhof.

In the gentle landscape there is much to explore: the tiny village chapel in the woods dedicated to the Virgin; also Mariabrunn, an isolated source marked only by a church and a small brewery supplied by the precious fountain, which has a simple beer garden shaded by trees – an attractive objective for any promenade. On their way to the Isar they would pass Neufahrn where, according to myth, the place to build the church was directed by the Heilige Kümmernis. Can the presence here of Wilgeforte have escaped Duchamp? A popular saint in the Pays-de-Caux in Normandy, mirrored by the cult of the Heilige Kümmernis in Bavaria, Wilgeforte was the virgin princess and reluctant bride who became miraculously bearded when, like Christ, she was stripped bare by her executioners.

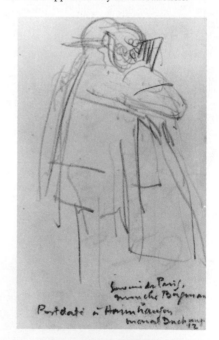

On such a visit to Haimhausen, in friendly souvenir of the time they spent together in Paris [29.4.1910], Duchamp dedicates for Bergmann a drawing he made of a couple embracing: the young woman, her hair coiled over her ears, is Jeanne Serre [16.4.1910].

But today, ten days after his arrival, Duchamp rents a small furnished room from August Gress, a young machine-operator of his own age

1.7.1959

1.7.1966

with an apartment on the second floor at 65 Barerstrasse. A short walk from the Alte Pinacothek, Duchamp's room is in the centre of Schwabing which, with the university and the Akademie nearby, is second home to Bergmann and his friends. Almost opposite in Blütenstrasse lives the Romanian artist Lascar Vorel (mentioned with Gress in a note by Duchamp), whose girlfriend, the talented Mucki Bergé, sings at the Alter Simpl, 37 Türkenstrasse.

On the corner of Schellingstrasse and Barerstrasse stands the Schelling-Salon, a large café offering billiards and chess, where Duchamp is certainly fascinated by a giant chessboard on the ceiling of an alcove, commemorating a game played in London during the international tournament in 1851 between Adolf Anderssen and Kieseritzky.

1922. Saturday, New York City
Marcel joins Ettie Stettheimer, Fania Marinoff and Carl van Vechten for lunch at the Beaux-Arts Café and afterwards he accompanies the ladies and Louis Bernheimer to Sea Bright, New Jersey, where the Stettheimers are residing in their aunt's house for the summer.

1924. Tuesday, Paris
Satisfied with his result, Duchamp is back from Brussels [13.6.1924], where he was placed fourth in the recent chess tournament won by E. Colle.

1926. Thursday, Paris
Marcel, Roché and Miss Roullier [28.6.1926] are invited to dine at Brancusi's studio, but according to Roché the sculptor is in a bad mood.

1928. Sunday, Paris
Duchamp learns that Brummer's brother has died and he believes that this may have "the most unexpected consequences for the gallery" and for his own position.

1936. Wednesday, West Redding
Duchamp signs the estimate from Charles F. Biele & Sons to make the satin nickel silver frames for the Large Glass which are to be glued according to a sketch dated 30 June and encloses a money order deposit of $25.

1941. Tuesday, Marseilles
At noon Duchamp is due to meet Victor Brauner in the bistro at the headquarters of the

Emergency Rescue Committee. It is this organization, directed by Varian Fry, with its headquarters in New York, which is helping artists, intellectuals, musicians and their families to escape France either legally or illegally.

On learning that the regulations governing the admission of aliens to the United States have changed as from today and that the American consulate now requires special authorization cabled from the State Department, Washington, to issue a visa to Yves Tanguy for example, Duchamp realizes that his last mission to Grenoble [23.6.1941] was just too late. Instead of returning to Sanary that evening as planned, he stays in Marseilles.

1958. Tuesday, Paris
In the morning Marcel and Teeny take a hired car and leave for a "Tour of France and a month in Spain".

1959. Wednesday, Paris
On his arrival from Cadaqués, Duchamp attends the opening of Jean Tinguely's "Metamatics" exhibition at the Galerie Iris Clert, 3 Rue des Beaux-Arts. With the assistance of the curious black painting machines filling the gallery, the visitors are invited to create their own abstract paintings and a prize is offered for the best one. In his shirtsleeves, Duchamp is watched by Tinguely and Iris Clert as he addresses a small Meta-matic and chooses the colours for his experiment with this new form of creation.

1960. Friday, Cadaqués
Teeny and Marcel take up residence for two months in the same apartment as the previous year [14.4.1959] with a terrace overlooking Port Alguer.

1962. Sunday, Cadaqués
"We have already been here a month with perfect weather," writes Marcel to Brookes Hubachek. "The same apartment, the same maid, for four years, give us the feeling of owning this place, and fortunately the cost of living has not changed in any noticeable way." He gives his friend in Chicago news of the Villons, whom they saw recently in Paris [31.5.1962].

1965. Thursday, Neuilly-sur-Seine
After spending ten days at 5 Rue Parmentier, Teeny and Marcel leave for Spain.

1966. Friday, London
To mark the occasion of the retrospective at the Tate Gallery [16.6.1966], *Art and Artists* issues a special number in tribute to Duchamp. In addition to contributions by Robert Lebel, Richard Hamilton, George Heard Hamilton and Simon Watson Taylor, the Paris editor of the magazine, Otto Hahn, publishes a lively interview with Duchamp entitled "Passport No. G255300".

"I live like a provincial, out of touch with everything," Duchamp claims. "In New York one gets 300 private view cards a month… And as I don't go to exhibitions, I'm out of touch." Admitting to going to a Happening from time to time, Duchamp recounts that he met Andy Warhol recently at the Cordier & Ekstrom opening [7.2.1966].

"Dali had just finished his piece, and they had laid on a little ceremony. Warhol had brought his camera and he asked me to pose, on the condition that I kept my mouth shut for twenty minutes… A very cuddly little actress came and sat by me practically lying on top of me, rubbing herself up against me. I like Warhol's spirit. He's not just some painter or movie-maker. He's a *filmeur*, and I like that very much."

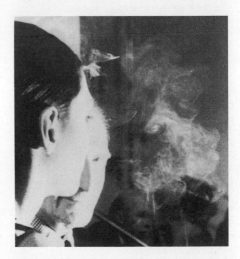

Duchamp's name is often associated with John Cage, remarks Otto Hahn.

"If people choose to associate us it's because we have a spiritual empathy, and a similar way of looking at things. An extraordinary thing about him is his ability to remain con-

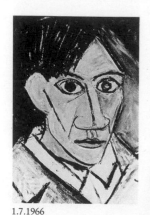
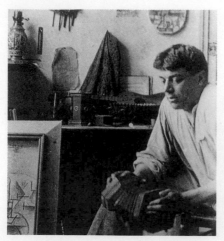

1.7.1966

stant. He thinks in a light-hearted way, without elaborating; things based in humour. He never stops inventing language, and he doesn't explain; he's not a schoolmaster... He's got away from the boring side of music."

Duchamp talks about Satie, the Groupe des Six, and Honegger, which leads the journalist to ask about Varèse.

"Forty years ago he was a pain in the ass. Completely dedicated to his music. Not at all amusing, no sense of humour. I remember a supper with Ionesco – what a joker – where Varèse didn't understand a thing. There was no understanding. The thing which distinguishes Varèse's music is violence; and I'm sure Cage doesn't like that at all. It's again a question of forms. To make a noise like Mozart or to make a noise like Varèse is the same thing. Varèse is louder. Stockhausen and Boulez are on the same lines, only slightly less loud. I should think Cage is opposed to that: with him, it's Satie. And Satie, even if he could, would not have made electronic music.

"When he was better known, and more accepted, Varèse didn't need to explain himself so much. It was better. More bearable. There's no lack of pains in the ass among artists though; Metzinger for example. And Delaunay... You couldn't meet him for more than five minutes without wanting to run away. Egomaniacs."

Don't you like music, enquires Otto Hahn.

"I'm not anti-music. But I don't get on with the 'catgut' side of it. You see, music is gut against gut: the intestines respond to the catgut of the violin. There's a sort of intense sensory lament, of sadness and joy, which corresponds to retinal painting, which I can't stand. For me music isn't a superior expression of the individual. I prefer poetry. And even painting, although that's not very interesting either.

"... The bore with art, as it is now, is the necessity for having the public on its side. Under the kings, it was at least a little better: the sanction of a single person, or of a small clique was sufficient... I'll be thought a reactionary and a Fascist – but I don't give a damn: the public makes anything look indifferent. Art has nothing to do with democracy."

Has Duchamp always been interested in Surrealism?

"It's the only movement of the century... The Surrealists tried to break away from the sensual and superficial aspect, but in the end they came back to it."

Wasn't Duchamp technical advisor for several Surrealist exhibitions?

"I did the décor: the strings [14.10.1942], or the sacks of coal hung from the ceiling [17.1.1938] to try and get a bit of gaiety into it. The danger is of being academic; and one cannot put up a successful show without a bit of gaiety. I tried to lend some, although the Surrealists were not lacking in it themselves. They had managed, despite everything to hang onto a gay side, which came from Dada. One cannot easily gloss over Dada."

How does Duchamp explain the return to Dada after Surrealism has held the stage for 30 or 35 years?

"Because Dada never received its due. It was just a brush fire, soon forgotten. Surrealism appeared and threw water on the fire. But a characteristic of the century now coming to a close is the 'double-barrelled gun effect': Kandinsky, Picabia and Kupka invented abstraction. Then abstraction was finished. No one talked about it any more. It came back 35 years later with the American Abstract Expressionists. One can say that Cubism came back in an impoverished form with the postwar Ecole de Paris. Dada has also come back. Double-barrelled, second shot. It's a phenomenon peculiar to this century... Another characteristic of this century is that artists come in pairs: Picasso-Braque, Delaunay-Léger, although Picabia-Duchamp is a strange match. A sort of artistic pederasty. Between two people one arrives at a very stimulating exchange of ideas. Picabia was amusing. He was an iconoclast on principle."

Hahn remarks that there was never any Dada in England.

"The English woke up to modern art very late. Forty years ago the idea of art did not interest them very much. 'Art' with a capital A couldn't even have been in the dictionary! It could be only conceived of in terms of the Portrait, or the eighteenth-century Englishman. Doubtless, this was because of the monarchy. In a monarchy, painters paint portraits, and exhibit at *salons*."

Duchamp's life seems to have followed a very pure trajectory. Isn't that a retrospective illusion; or is it true, asks the journalist.

"It's an illusion. Nothing was intentional. The most I had decided was not to make a living by painting. It's neither a trajectory, nor a virtue, nor a work of art in itself. If you like you could

say painting has never been 'my cup of tea'. It's all different today: painters make a lot of money. They really rake it in – and I don't blame them. They're quite right, but I can't help bracketing them with good businessmen."

Otto Hahn asks Duchamp why he chose the name R. Mutt to sign *Fountain* [9.4.1917].

"Mutt come from Mott Works, the name of a large sanitary equipment manufacturer. But Mott was too close so I altered it to Mutt, after the daily strip cartoon 'Mutt and Jeff' which appeared at the time, and with which everyone was familiar. Thus from the start there was an interplay of Mutt: a fat little funny man, and Jeff: a tall, thin man... I wanted any old name. And I added 'Richard' [French slang for 'moneybags']. That's not a bad name for a *pissotière*."

And the interpretation of *Roue de Bicyclette* [15.1.1916]?

"The wheel serves no purpose, unless it's to rid myself of the conventional appearance of a work of art. It was a fantasy. I didn't call it a work of art. Actually I didn't call it anything. I wanted to finish with the idea of creating works of art. Why should they be static?"

And the geometry book left out in bad weather [14.4.1919]?

"It was only humour. Nothing but humour, humour. To disparage the seriousness of a book full of principles."

Are the Readymades, like the Large Glass [5.2.1923], the fruit of lengthy development?

"The Readymades are completely different from the Large Glass. I made them without any object in view, with no intention other than unloading ideas. Each Readymade is different, there is no common denominator between the ten or twelve Readymades, other than that they are all manufactured goods. As for recognizing a motivating idea: no. Indifference. Indifference to taste, taste in the sense of photographic reproduction, or taste in the sense of well made materials. The common factor is indifference."

And the criticism that Duchamp has betrayed his heroic standpoint by authorizing reproductions of the Readymades?

"Ah. Complaining and whining, are they? They ought to be saying 'It's atrocious, it's an outrage, a disgrace.' It would have suited them nicely to have me shut up in some category or formula. But that's not my style. If they're dissatisfied, *Je m'en fous*. One musn't give a f— *et merde*, ha ha..."

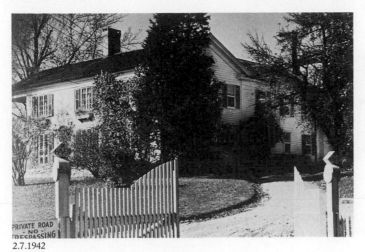

2.7.1942

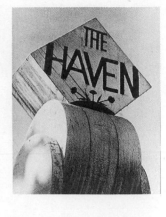

2 July

1913. Wednesday, Neuilly-sur-Seine
In the wake of the famous Armory Show [17.2.1913] which closed in Boston on 19 May, Duchamp writes belatedly to Walter Pach in New York about the sale of his four paintings: "I am very happy and thank you for the dedication with which you have defended our painting."

Mr Torrey [1.3.1913], proud possessor of *Nu descendant un Escalier* [18.3.1912] has been in Paris: "A very kind man," Duchamp remarks to Pach, "he appeared to be very pleased to meet us." When he presented Torrey with *Encore à cet Astre* [18.3.1912], the sketch which preluded the Nude, the American asked for confirmation that the work of the group at Puteaux was derived from Cézanne. "I am sure most of my friends would say so," answered Duchamp, "and I know that he is a great man. Nevertheless, if I am to tell what my own point of departure has been, I should say that it was the art of Odilon Redon."

Is Pach working a lot? "I am terribly upset at the moment and I'm not doing anything at all," Duchamp admits. "These are short unpleasant moments." In August, however, he plans to spend some time in England.

1921. Saturday, Paris
"An idiot!" complains Marcel, who loses all his bets on the result of the Dempsey-Carpentier fight in New Jersey. Only a few minutes after the Frenchman has been knocked out in the fourth round, the news is transmitted by radio to France.

1924. Wednesday, Paris
Just before noon when he is getting dressed in his room at the Hôtel Istria, Marcel receives a visit from Yvonne, alias Saintonge, happy to find him again [13.6.1924]. She curls up in the armchair while he lathers his face with shaving soap. After a few minutes there is another knock at the door: it is Roché. "I'm lunching in town," announces Marcel. "Have lunch with Roché," he tells Yvonne, "I'll come and see you if you like this afternoon." As soon as he has finished dressing, Marcel goes out and Roché takes Saintonge to lunch at Henriette's.

*

In the afternoon, as good as his word, Yvonne's "Prince Charming" visits her at 88 Boulevard de Port-Royal. Certain that she and Roché have made love in his absence, Marcel gently interrogates: "Have you been to Roché's? Is his bed comfortable?" Yvonne fiercely denies it, but in vain. After making love to her "quickly like a bird", he is gone again.

*

Announcing his return from Brussels, Duchamp writes an express letter to Jacques Doucet. "Will certainly give you a hand to mount the globe [12.3.1924]," he promises, and adds that Man Ray has taken an "excellent

photo" of the spiral motif drawn for the optical machine which, if Doucet has no objection, is due to appear as an insert in *391*.

1928. Monday, Paris
Since the paintings by Dorothea Dreier and Louis Eilshemius arrived [18.4.1928], Marcel has been unable to place them and tells Miss Dreier: "I have shown them to different dealers... None of them were enough enthusiastic to start anything. The attitude of these people is strictly businesslike nowadays."

As the position with Brummer now seems to be in the balance [1.7.1928], Dee is philosophical about his finances: "I have arranged my studio here to live, so perfectly, that I don't see why I should ever make any effort toward 'more money' as it costs me very little to live this way."

*

Believing that "Picabia today is one of the few who are not a 'sure investment'", Duchamp writes to Alfred Stieglitz saying it is "wonderful" of him to have kept three paintings after the exhibition [30.3.1928]. "The feeling of the market here is so disgusting," says Duchamp, "Painters and Paintings go up and down like Wall Street Stock. It was not exactly like that 20 years ago, and much more amusing."

1941. Wednesday, Marseilles
After learning the previous day that the regulations governing the admission of aliens to the United States has been changed, Duchamp sends a telegram to alert Walter Arensberg [19.11.1940] and suggests that, for more information, he contact Alfred Barr at the Museum of Modern Art, who is handling the refugee problem.

With a refuge at Sanary, where his sister Yvonne Duvernoy lives, all Duchamp can do now is to wait.

1942. Thursday, New York City
Duchamp lunches with Stephan Lion, who mentions that he might have a potential purchaser for Miss Dreier's estate, The Haven [28.6.1942].

*

To mark Marcel's return to New York, at seven-thirty Peggy Guggenheim, now Mrs Max Ernst, throws a cocktail party at her magnificent house overlooking the East River at 440 East 51st Street.

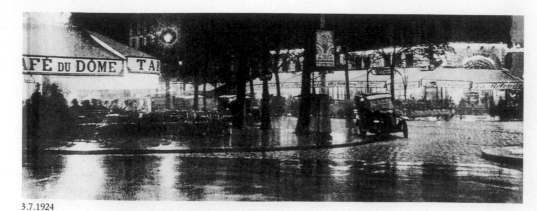

3.7.1924

1943. Friday, New York City
"I haven't done such excellent business for years, used as I am to spending without earning – I assure you that it is demoralising in my case," writes Marcel to Kay Boyle three weeks after receiving a large cheque from Ann Watkins. Taking "revenge" for this "outrageous joke" with the means at his disposal, Marcel proposes to give Kay one of the 20 copies of the *Boîte-en-Valise* [7.1.1941]. "You will find it ready when you return eastwards," he promises and concludes: "My best wishes for Joseph and the children and a good spanking for you."

1945. Monday, New York City
In the morning Duchamp meets Robert Tenger, the publisher of *Le Surréalisme et la peinture: suivi de Genèse et perspective artistiques du surréalisme et fragments inédits*. Finding the plain green hard cover "rather severe", Duchamp writes to Elisa and André Breton in Reno, Nevada, suggesting that this same binding could be treated in a similar way to the book on Yves Tanguy that he is designing.

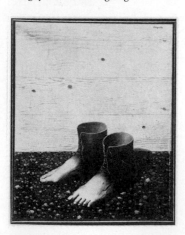

"Take the bare feet, Magritte's shoes. Instead of black, make a print in sanguine on pink paper (or just white). This bloodshot reproduction would be imprinted in the middle of the board and also imprinted your name, the title of the book (without "*suivi de...*") and Brentano's below."
As he is to meet Tenger again next Monday, Duchamp asks Breton to reply by return and airmail: "If you prefer something else than the Magritte; if you see it differently in a word your decision."

1962. Monday, Cadaqués
Most of the day Marcel watches the masons building the fireplace, which was started on Saturday. Fascinated by their speed and efficiency, every few minutes Teeny hears Marcel crying "Bravo!"

In the evening Francine and Cleve Gray, who are visiting George Staempfli, come to supper.

1963. Tuesday, Nice
The air-controllers' strike over [30.6.1963], Marcel and Teeny fly to Barcelona on their way to Cadaqués.

1964. Wednesday, Neuilly-sur-Seine
After spending six weeks at 5 Rue Parmentier [21.4.1964], Teeny and Marcel leave their "comfortable although scarcely furnished" studio and take the night train at nine o'clock from Paris to Spain.

1967. Sunday, Paris
A short interview with Duchamp filmed in the exhibition at the Musée d'Art Moderne [6.6.1967] is shown on the television news.

1968. Tuesday, Cadaqués
Preoccupied by the aftermath of the political events in May, Duchamp writes to his old friend Dumouchel: "One must hope that the increase in salaries and all the reforms will have a positive effect upon the other obstacles, inflation, unemployment, price increases, etc. Otherwise in October it will start again. I am too old," he continues, "to meddle, even to have an opinion about all this nonsense."

3 July

1912. Wednesday, Munich
In accordance with the laws of the Kingdom of Bavaria, Duchamp's identity and his address in the city are registered by the administration.

1917. Tuesday, Tarrytown
Florine Stettheimer learns from Adolf Bolm that he has persuaded Diaghilev's conductor, Pierre Monteux, to include in his Independence Day programme *Carnaval à Paris* by Swendow, the

music which he recommends for Florine's ballet, *Orpheus of the Four Arts*. As the three sisters have invited Duche to André Brook for Independence Day, they call him in New York, invite him to the concert and ask him to buy the tickets.

1918. Wednesday, New York City
At midnight Marcel meets Henri-Martin Barzun and Roché (who is on leave from Washington) at the Vanderbilt. They discuss art and politics, Barzun deep in his "post-unanimist" aesthetics, his *La Terrestre Tragédie* and his brochure of judgment on the whole world. Roché finds Barzun is sometimes right and concise, and at other times voluble to the point of being ridiculous. After a walk, they have supper at Childs and separate at three in the morning.

1924. Thursday, Paris
"Yes, your first impression was right, and I was pleased [19.5.1924]," Mary Reynolds confides to Roché, "Marcel is my lover." Totally unburdening her cares and anxieties [19.6.192], Mary tells Roché that Marcel has loved (and perhaps still loves) very common women; he keeps her at a distance, fearing for his liberty, convinced that she wants to cling to him. He comes to see her every day but insists that their relationship remain secret and forbids her to speak to him at the Café du Dôme, where they both go every

4.7.1920

evening [3.6.1924]. Mary says she loves Marcel but believes him to be incapable of loving.

Roché understands the dilemma: like a butterfly Marcel is drawn to beauty and he cannot do otherwise than go to Mary; but against her he protects his life, his calm, his solitude, his games of chess, his amorous fantasies… To her confidant, Mary repeats Marcel's declaration: "Ah, you know Pierre. So perhaps he will become your lover. He's had lots of my mistresses."

1926. Saturday, Paris
The second shipment for the Société Anonyme's international exhibition at Brooklyn is almost ready: three cases contain sculptures by Pevsner and Storrs [17.6.1926]; *Leda* by Brancusi; and the paintings framed by Legrain: Picabia's *Midi* [21.3.192], Villon's *Song* and Marcoussis' *Fish*.

One of the Pevsner's is the recently completed portrait of Duchamp [27.4.1926] made in coloured celluloid which, Dee tells Miss Dreier,

"is really very good… It is a big piece and really much more finished than what we have seen of him." Knowing that the sculptor needs some money, Dee asks Miss Dreier to pay Pevsner the $300 he is asking, suggesting that she could take his $200 instead of depositing it in his bank.

Concerning the other artists, there is no news from Rome and Duchamp has given up Arp, the third Max Ernst and van Doesburg. As for Picasso [31.3.1926]: "I don't think very necessary to have such successfully marketed stuff in your exhibition of efforts."

1953. Friday, New York City
Meets Monique Fong [12.5.1953] and, pressing her to write to the United Nations and other organizations, encourages her to stay in the United States of America.

1954. Saturday, Cincinnati
After recovering from his operation [24.6.1954], Duchamp leaves the Christian Holmes Hospital. He and Teeny are invited to stay with Olga and Nick Carter in the country near Cincinnati before returning to New York on 12 July.

1962. Tuesday, Cadaqués
"The fireplace is a beauty," Teeny tells Jackie now that the work is finished. "Marcel kept [the men] happy with cigars and wine and hovered around like a chicken sitting on her eggs."

1964. Friday, Cadaqués
Early in the morning a friend meets the train from Paris. On the Duchamps' arrival in Cadaqués, Maria runs down to greet them; they unpack as quickly as they can to feel quite at home again.

4 July

1917. Wednesday, New York City
As planned, Duche goes to André Brook to spend Independence Day with the Stettheimers. Later he, Ettie and Florine motor into town in time for the concert where they meet, among others, the Bolms (who engineered their last-minute attendance), Florine's neighbour the portrait painter Funk, and Edgar Varèse.

Listening to Swendow's music, Florine "endeavours to have some special feeling", but the result is negative for her own purposes: "I want a composer all to myself," she decides, "and tell him what to do."

After this disappointment, the sisters have supper with Duche at the Beaux-Arts Bar, but Ettie finds the place has "a horrid, vicious kind of atmosphere". Their stroll together around Bryant Park in the moonlight, "Fleischman baths flashing their ad, automobiles, cigarettes and Christus advertised in a perpendicular row," Ettie considers is "the most striking and picturesque part of the evening".

1920. Sunday, Asbury Park South
The celebrations are to culminate in a recital by Caruso followed by fireworks. On the seafront, which has been transformed pictorially into a sweeping stage, where a crowd of players promenade, gambol and repose, Florine Stettheimer commemorates Independence Day with a painting. All eyes are on Duche strolling with Fania Marinoff: Carl van Vechten, his arms folded, watches them from the height of a draped, tassled stand, and Florine in white, pausing at the railing dividing sand from pavement, turns her gaze in their direction, her head haloed by a small parasol.

1931. Saturday, Paris
Accompanying Roché to Helen Hessel's for dinner, Marcel gives them a chess lesson, though Kadi is absent [18.4.1931]. Alternating their moves, Marcel and Helen play against Roché, who wins the first game. The second game is epic: Emmy, the children's nurse, leans over the three players, rooting for Marcel; Roché rises to the challenge and, concentrating hard, plays his best. Wanting Marcel to win, Helen retires from the game, which Roché then loses but not without feeling that he has learnt a great deal from the endgame.

1947. Friday, New York City
At eight-thirty in the evening Marcel spends an hour with Stefi Kiesler at 56 Seventh Avenue.

1948. Sunday, New York City
At seven-thirty Marcel goes to the Kieslers' for dinner.

1962. Wednesday, Cadaqués
In the mail from Jackie, Marcel is delighted to receive *Les Lettres françaises* with F. Molnar's regular chess column, bringing him "the first good chess news he has been able to find in days".

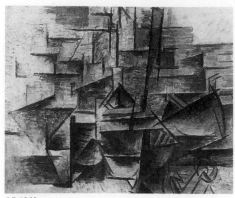

6.7.1960

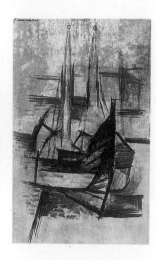

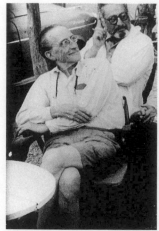

6.7.1966

1965. Sunday, Cadaqués
Planning to stay until mid-September, Marcel and Teeny arrive in Cadaqués from Paris [1.7.1965].

5 July

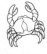

1922. Wednesday, New York City
After celebrating Independence Day (at Sea Bright with the Stettheimers [1.7.1922]?), Duchamp starts work as promised on the Société Anonyme's brochure for Henry McBride [30.6.1922].

1939. Wednesday, Paris
As he is invited with Mary Reynolds to dine with the Rochés, Marcel takes with him a copy of *Rrose Sélavy* [19.4.1939]. Denise shrieks with laughter at the "risqué thoughts" contained in the little book, while Pierre describes the aphorisms as "precise, precious fantasies".

1942. Sunday, New York City
"This is my first day of rest since my landing," writes Marcel to Lou and Walter Arensberg. "Today everybody is gone to the country and N.Y. is quiet."

In the following week Marcel will move from the Parkers', "who have been angels," to spend the summer in New York at Peggy and Max Ernst's house, 440 East 51st Street. As all the cases with the items for the *Boîte-en-Valise* [7.1.1941] are stored there, Marcel can immediately start their assemblage.

With the intention of taking his first papers, Marcel tells the Arensbergs (who were instrumental in securing his departure from France) that he plans to follow the routine procedure enabling him to stay in America: renew his six-month visa for a further six months and then change it into a regular immigration visa. Remembering Walter's interest two years ago in *Jeune Homme triste dans un Train* [17.2.1913], Marcel promises to enquire about making a "life-size" replica, which he would colour by hand. He encloses a book he brought with him on Stéphane Mallarmé [probably *Mallarmé l'obscur* by Charles Mauron, Ed. Denoël, 1941] which, Marcel says, "I hope will interest you."

1946. Friday, Paris
Totor calls to see Roché in Arago.

1947. Saturday, New York City
Goes to visit Miss Dreier at Milford.

1950. Wednesday, Philadelphia
In his official capacity for the Francis Bacon Foundation [30.6.1950], Duchamp reviews every proposition made by the Philadelphia Museum of Art for the Arensberg Collection with Fiske Kimball "at his desk" and afterwards they look at the rooms available. Fiske Kimball calculates that in the 20 rooms on three floors there are 1,400 running feet as opposed to 1,100 offered by the Art Institute of Chicago [20.10.1949]. Duchamp notices the effective side lighting provided by high windows on the first and second floors and the fact that no partitions have been built yet on the second floor.

*

La Partie d'Echecs [1.10.1910] is shipped from New York to the Arensbergs in Hollywood [24.6.195]. After the sale Walter Pach gives Marcel a cheque for $500.

1954. Monday, Cincinnati
Marcel sends Roché "the bulletin of liberation" from the hospital [3.7.1954] and asks him to telephone the good news to the family. "I admit," he writes, "that it's a new and immense pleasure to piss like everyone else, a pleasure that I have not known for 25 years [11.9.192]." He hopes that Roché himself will benefit from his stay in the Corrèze.

*

"I would very much like to go to Philadelphia to arrange the 'glass' with you [7.4.1954]," writes Duchamp to Henri Marceau, asking him for a date which could be 15 July or afterwards.

1964. Sunday, Cadaqués
In the evening, Teeny and Marcel have supper with the Baeklands.

6 July

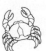

1921. Wednesday, Rouen
On visiting his parents again [16.6.1921], Marcel finds two letters from Ettie Stettheimer waiting for him. "It was a very great pleasure for me to see Tarrytown again [28.7.1917]," replies Rose-Mar cel, "where you and I have spent such good times, without flirting though. Not everyone can abstain from flirting. So the Gods have an eye on us."

As regards life in France, Marcel maintains that "nothing has changed here. It's hopelessly the same thing". Referring to the episode at the Concert Bruitiste on 17 June, which resulted in the closure the following day of Tzara's Salon [6.6.1921], he recounts: "The Dadas made too much noise at (against) a Futurist performance. To punish them their exhibition was closed. From afar, these things, these Movements are enhanced with a charm which," Marcel assures her, "they don't have in close proximity."

Marcel has seen Gleizes briefly and suggested an exhibition of Florine's paintings. Will Carrie's doll's house be finished on his return? And Ettie's book *Love Days*? [9.6.1921] "I who am doing nothing," says Marcel, "I want you to work – Dada logic."

1924. Sunday, Paris
In the afternoon Marcel goes to Yvonne and makes love to her [2.7.1924].

1936. Monday, West Redding
Miss Dreier gives Duchamp a cheque for $223 to reimburse him for payments made to the builder Carl Rasmussen and the metalworker Charles Biele for costs of labour and materials in repairing the Large Glass [5.2.1923].

1950. Thursday, New York City
Enclosing a photograph of *Still Life with Newspaper* by Juan Gris from Miss Dreier's private collection, Duchamp writes to Duncan Phillips in Washington to enquire whether he would be interested in purchasing it. As Miss Dreier wants to sell it, but not through a dealer, Duchamp explains: "I am responsible for the idea of writing you first because I feel that the painting is worthy of your collection."

1960. Wednesday, Cadaqués
Using a postcard with a view of the town with fishing boats in the foreground (painted by Picasso in 1910), the church and their roof terrace, Marcel writes to Robert Lebel in Paris saying that he has heard much of *Francis Picabia et 391*, the "floundering" book, being prepared by Michel Sanouillet for Le Terrain Vague.

7.7.1888

"Astonishing the inaccuracy," remarks Marcel referring to the short article by Jean Saucet published in *Paris-Match* on 18 June, which is peppered with factual errors and illustrated with the study for his famous Nude [18.3.1912] and the chronophotographic portrait of him by Eliot Elisofon [26.4.1952]. "Where are you? where are you going?" Marcel asks Lebel.

1961. Thursday, Cadaqués
"Is there any chance that you might come and spend a few days here," enquire Teeny and Marcel of Terry and Richard Hamilton. "We hate these big gaps between seeing you… We would get you a room and you could have your meals with us." They would meet them from the train at Figueras, either after a flight to Barcelona from London, or from the overnight Paris–Barcelona express. "The weather is delicious," writes Teeny, "and I hope our next visitors will be YOU."

1963. Saturday, Cadaqués
Replying to Noma and Bill Copley's letter of condolence following the death of his brother [9.6.1963], Marcel writes: "Poor Villon wanted to live a 100 years and in his last moments had dreadful nightmares… After all these emotions we have regained the tranquillity of Cadaqués." He is sorry to hear that they have already left Europe: "Teeny and I hope to see the boat stopping again in the harbour of Cadaqués." [14.8.1961]

To ensure the safe transfer to Chicago of the paintings given by Mary Reynolds to Elizabeth Humes, Marcel requests Baruchello to telephone her, "and go to see her a few minutes so that she shows you her small Tanguy, her small Dali, her small Man Ray, which she wants to send back to the USA." Can he also have an estimate made for the transport so that Elizabeth Humes can write to Brookes Hubachek for the sum due to the shipping agent.

1964. Monday, Cadaqués
"Good news Cadaqués still has the same old magic for us," writes Teeny to Jackie who is on holiday in the Alps. "The heat, air, sun and stars are all in place. Marcel who never once got to wear his shorts last summer put them on the day we arrived [3.7.1964] and they seem to be his uniform so far. I can see he is enjoying himself repairing his shade corner and arranging the guest room into his work room."

1966. Wednesday, Cadaqués
A few days after their return to the same apartment overlooking the cove with the fishing boats, Teeny and Marcel write to Gabriel White of the Arts Council thanking him for "all the time and trouble" he spent in organizing the "first complete one man show" at the Tate Gallery [16.6.1966]. To Richard Hamilton, who was responsible for hanging the show and making the catalogue, they write: "You worked it out to perfection and we know what a labour of love it was! We also want to congratulate you for the whole year's work on *The Bride stripped bare…* [the replica of the Large Glass]. It added so very much to the completeness of the Show."

7 July

1888. Saturday, Blainville-Crevon
In the collegiate church, opposite the house where he was born [28.7.1887], Lucie and Eugène Duchamp's third son is baptized Henri Robert Marcel by the *curé* of the village, Father Jullien. His godfather is one of his uncles, Mery Duchamp, a chemist living in Paris; his godmother is Julia Pillore, the eighteen-year-old daughter of Marie Nicolle by her first marriage to Léon Pillore, the late proprietor and editor of the *Pays-de-Caux*, the newspaper published at Saint-Valéry-en-Caux.

Léon, who wrote under the name of Saint-Valéry, was not only the author of three brochures, *L'Eau et le Gaz*, vigorously promoting the importance of proper water and gas supplies for the inhabitants of Saint-Valéry-en-Caux and the town's slaughterhouse, fisheries and street lighting, but also wrote a novel entitled *Age de Cuivre*, which he submitted to Gustave Flaubert for an opinion as to whether he should continue to write fiction.

On 15 January 1870, while giving some warm encouragement and candid, detailed criticism (indicating that he had read the book very carefully), Flaubert advised Saint-Valéry: "You must always write when you want to do so. Our contemporaries do not know (any more than ourselves) what will remain of our works. Voltaire did not imagine that the most immortal of his books was *Candide*. No man is

great during his lifetime, only posterity decides. So work, if your heart is in it… as for material success, great or small… it is impossible to predict anything. The smartest (those who claim to know the public) are betrayed every day…"

After the signatures of the parents and godparents in the parish register, are those of the grandparents: Catherine Duchamp, who has travelled many miles from Massiac in the Auvergne to be present; the eminent engraver Emile Nicolle and his second wife Marie. Other signatures include those of Gaston and Raymond, Marcel's elder brothers, and Lucie's sister, Ketty together with her husband Fortuné Guilbert.

1904. Thursday, Rouen
With 257 other candidates, Duchamp presents himself, registers and sits the second part of the Baccalauréat examination.

1921. Thursday, Paris
On his return from Rouen, Duchamp has some errands to run at the Bon Marché and the Hôtel Wagram for Ettie Stettheimer (to whom he wrote the previous day); he has also promised to find her some mauve flannel.

1922. Friday, New York City
Signing himself Rrrose, "I left with tears in my eyes," writes Marcel to Ettie after visiting the Stettheimers at Sea Bright [1.7.1922]. "(Why not?). To you who do not like men who cry, I did not want to show it."

Answering her question about the French expression "*J'en suis bien aise*", Marcel explains that, immortalized by a popular song, it is still used and gives her an example: "I am so glad to hear that Fania is still slightly crazy, that the 4 July fireworks awoke your sentiments of patriotess and that you have purchased some needles for the Victrola."

Rrrose sends "generous and general kisses" to all the family with an afterthought: "I am betting on Lenglen."

1924. Monday, Paris
In the evening Marcel accompanies Gaby Picabia to a concert of American music at the Salle Pleyel. Roché brings Mary Reynolds, who avoids sitting near Marcel.

After the concert, while Marcel takes another woman home, Roché, Mary, Man Ray and Pierre de Massot have a drink in a lively

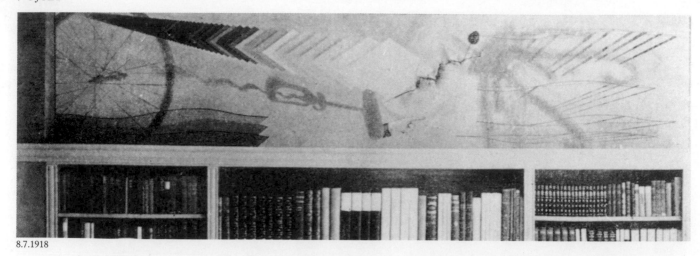

8.7.1918

bar. In an hour, Marcel is back and the whole group moves on to a place where they can dance until six in the morning.

1942. Tuesday, New York City
In the evening out on the roof of the Colony Club Dee dines with Miss Dreier who has come to the city on a short visit from West Redding. He tells her that while Peggy Guggenheim is in the country during the summer, she has offered him a studio with a balcony overlooking the East River at Hale House.

1946. Sunday, Paris
At ten o'clock in the morning Totor telephones Roché who is due to fly by Constellation to Washington on Wednesday. He will be travelling with Maria Martins, who is returning home after a short trip to Paris [29.6.1946].

1947. Monday, New York City
To mark the occasion of the opening of "Le Surréalisme en 1947" in Paris, at seven in the evening Marcel takes Stefi Kiesler to dine at the Romany Restaurant on the junction of 14th Street and Second Avenue.

*

Originally conceived by André Breton and Duchamp earlier in the year [12.1.1947], "Le Surréalisme en 1947" opens at the Galerie Maeght, 13 Rue de Téhéran, where the exhibition rooms on the first floor have been transformed under Frederick Kiesler's direction into a succession of strange and fantastic environments.

Approached by a staircase of sacrosanct books, the first room is that of Superstitions, an egg-shaped space formed of green cloth in which Kiesler, "in a first effort towards a continuity Architecture-Painting-Sculpture," has installed "a collective work": *Le lac noir* by Max Ernst, *La cascade figée* by Miró, *Le Whist* by Matta, *Le totem des religions* by Etienne Martin, *L'homme-angoisse* by David Hare, *Le vampire* by Julio de Diego, *Le mauvais œil* by Enrico Donati, *La figure anti-tabou* by Kiesler, and *L'echelle qui annonce la mort* by Yves Tanguy. Next to *Le totem des religions* is a peephole to view: *Le rayon vert*, the subject allocated to Duchamp. (In Jules Verne's novel of that title, Miss Campbell at the end of the first chapter vows that she will never marry until she has seen the green ray.) For this piece, which

Duchamp entrusted his friend to build, Kiesler made a drawing showing how with sheets of blue and yellow gelatine he intended to produce the optical phenomenon – a flash of green, which apparently occurs just after the sun has set on the sea.

The following two rooms are arranged in accordance with Duchamp's original plans. In the Salle de la Pluie a curtain of torrential rain falls on banks of artificial grass; the billiard table serves as a useful base for a sculpture by Maria Martins. The Labyrinth of initiations, conceived by Breton, is a long rectangular space decorated in midnight blue and divided into 12 octagons, each comprising an altar devoted to "a being, a category of beings or an object susceptible of being endowed with mythical life". The seventh altar, under the sign of Libra, is dedicated to the mysterious *Soigneur de Gravité*, planned but never realized on the Large Glass [5.2.1923].

It falls to Roberto Matta to make this shrine [1.2.1947]. He has used various elements including a pedestal table tipped at an angle with a ball on it defying the laws of gravity... a flatiron inscribed "A REFAIRE LE PASSE" and an evocation of *3 Stoppages Etalon* [19.5.1914]. For the latter, one of Duchamp's favourite works, Matta enlisted Kiesler's help to ensure that: "a straight horizontal thread of one metre in length falls from a height of one metre onto a horizontal plane while twisting at will."

It is Duchamp who has designed and realized with Donati's help [17.5.1947] the cover for the catalogue: the sensual, three-dimensional *Prière de toucher*. Unlike the gilded mirrors at Pigall's, each decorated with a carved female breast [22.3.1910], these are soft foam-rubber falsies.

The pink cardboard cover of each "de luxe" version of the catalogue is adorned with a female breast glued to a ragged piece of black velvet [24.6.1947].

1954. Wednesday, Cincinnati
Writes a note to Hans and Friedl Richter saying that if they come to New York after 12 July to telephone and come to see him.

1962. Saturday, Cadaqués
Having received an "enthusiastic" letter from Nancy Thomas after the broadcast [24.6.1962] of their interview [27.9.1961], Marcel writes to Richard Hamilton: "You seem to have had a wonderful time in your exploration of the Glass and I am very pleased and grateful to you for having taken so much trouble and time." He continues, "We here in Cadaqués are dreaming that you might find a way to come and see us here this year."

8 July

1918. Monday, New York City
Although he has not worked on the Large Glass for some time, Marcel tells Jean Crotti that he has now finished *Tu m'*, a long panel to fill a space between bookshelves and ceiling in Miss Dreier's New York apartment [9.1.1918]. This aerial composition, his first oil on canvas since 1914, is a "résumé" of earlier works and ideas. Using his own basis of measurement *3 Stoppages Etalon* [19.5.191], Marcel has woven into the shadow play games with measurement, perspective, reality, illusion, various sorts of dimensions and translations. There are evocations of *Roue de Bicyclette* [15.1.1916], his *Porte-chapeaux* and even, by association, *Egouttoir* [15.1.1916]. On the other hand, unlike these tangible readymades, the corkscrew (which invisibly is to provide the "uncorking" at the end of the Bachelor's operations in the Large Glass) exists only by its shadow falling across the canvas of *Tu m'*.

On the left, Roussellian in guise when complete, *Roue de Bicyclette* in its spectral form is set free from its four-legged stool. Behind it is a field of red lines situating the horizon at the top edge of

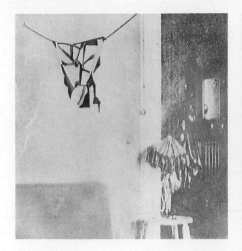

the canvas. Below, the three solid dark rulers of *3 Stoppages Etalon* are echoed in their ethereal form on the right of the composition. (Having no actual rulers, Marcel made a set in wood to enable him to trace their form.) Zooming forward from infinity in the upper left corner to the centre of the canvas are numerous lozenges of colour, graded from the most distant greys and sombre tones to the secondary shades, orange, purple and green to the primaries, blue, red and finally yellow, the colour which is "secured" to the canvas with a real bolt.

Below the yellow lozenge (in reference to "a world in yellow"?) is an indicating hand emerging from the handle of the very elongated, shadowy corkscrew, its extreme tip stretching from the hub of the wheel. The finger points to the right, beyond a dreadful rend painted in *trompe-l'œil* on the canvas but "held together" with three real safety pins. At the point where the "goupillon" or bottle-brush sticks out from the rip in the painting, there is a white geometrical flat surface standing vertically at an angle like a partition from which float the almost immaterial *Stoppages Etalon*. Attached to these, intermittently along their length, are multicoloured, rule-defying rods of varying dimensions, each circumscribed by columns of circles drawn with a compass. Over the whole of this area, where the horizon is now at the bottom edge of the canvas, looms the grapnel-like shadow of the "perroquet" or upturned *Porte-chapeaux*.

Using a projector from different angles to cast shadows of the objects on to the canvas, Marcel drew their outlines by hand. Yvonne Chastel obligingly painted the swatch of colour samples [12.4.1918] while Marcel found a sign painter, A. Klang, who was willing to paint the hand and sign it. As for the title, the spectator is at liberty to complete it by choosing any verb commencing with a silent 'h' (as in *harceler*) or with a vowel...

Also for Miss Dreier, Marcel has already started something else less retrospective, which he considers "more interesting" called *Sculpture de Voyage*. A sculptural innovation, the piece is made from variously coloured rubber bathing caps "cut into irregular strips", Marcel explains to Crotti, "and glued together, not flat, in the middle (in the air) of my studio, and attached with string to the different walls and nails of my studio. It makes a kind of multi-coloured spider's web."

The idea of a voyage is literally in the air because Marcel is planning to leave for Buenos Aires in August, "and probably Yvonne too... For several reasons that you know," writes Marcel. "Nothing serious; only a kind of strain on the part of the A[rensberg]s. Some ill-intentioned people have probably managed things that way." Although he has seen Louise, it is a month since he has seen Walter, who is in Pittsburgh after the death of his mother. The atmosphere in New York has changed: "Restraint reigns." Marcel cannot find much enthusiasm to continue work on the Large Glass: "Probably another land would let me have a little more zest."

Asking Crotti not to tell his family of his plans, Marcel says that he will write to his parents and his brothers from the ship. "My very vague intention is to stay a long time there, probably several years; that is to say, to be severed completely, in fact, with this part of the world."

That evening before writing to Crotti, Marcel plays the part of a wounded soldier "tended to by a superb nurse" in a scene for Léonce Perret's film, *Lafayette! We come!* starring E. K. Lincoln and Dolores Cassinelli. In Perret's description of the complicated plot (in which Leroy Trenchard loves Thérèse Verneuil, who poses also as a mysterious Princess, a German spy and Red Cross nurse), Marcel's little scene takes place in Lyons:

"Under the shade of the large trees in the hospital grounds groups of blinded patients under the care of devoted nurses are sitting or strolling about. Some of the young patients are knitting with the aid of especially made needles while others are smoking or just listening. These form a group to which Thérèse Verneuil [Dolores Cassinelli] is reading. Thérèse is interrupted in her reading by the arrival of an attendant who whispers some words in her ear and points out to her in the distance a young woman dressed in black..."

1922. Saturday, New York City
Marcel wins his bet of the previous day when, in 26 minutes, Suzanne Lenglen has a decisive win 6–2, 6–0 over the American Molla Mallory in the final of the ladies' lawn tennis championship at Wimbledon.

1941. Tuesday, Sanary-sur-Mer
From the Hôtel Dol, Marcel writes to Roché suggesting that they meet at noon on 14 July in the station waiting room or buffet at Saint-Raphaël and asks him to confirm the rendezvous.

Concerned about the new State Department regulations [1.7.1941] which require fresh affidavits on new forms by two guarantors instead of one, Marcel follows a cable to Arensberg [2.7.1941] by a letter to Brookes Hubachek in Chicago asking him if, in addition to his own case, he would act for Mathieu Ponisovsky, father of Alec [28.6.1941].

1944. Saturday, West Redding
After its rejection by Harry N. Abrams, Miss Dreier's proposal that the Société Anonyme publish the book she has prepared on David Burliuk has been accepted by the Russian artist. When he arrives from New York to spend the weekend at The Haven, Dee assists Miss Dreier in making a selection of paintings to be reproduced in the book.

Suspecting that he doesn't eat enough because he claims to hate restaurant cooking, Miss Dreier is delighted to find that Dee has a good appetite and "seems quite well".

As the date of the Democratic Convention approaches, politics is one of their subjects of conversation. Miss Dreier learns that Dee "has a great fear of [Thomas] Dewey [the Republican candidate] in relation to the Foreign Policy of America, should he be elected" as president.

1948. Thursday, Washington Bridge
In an evening expedition from New York, Marcel, Maria Martins, Yves Tanguy, Kay Sage and Frederick Kiesler dine together at the Terrace Restaurant.

9.7.1958

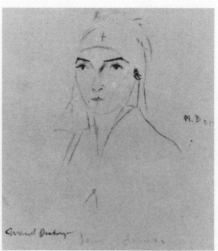

9.7.1966

1950. Saturday, New York City
"I am very proud to become vice-president of the Francis Bacon Foundation," writes Marcel to Lou and Walter Arensberg. He gives them a report on his visit to Philadelphia [5.7.1950] saying: "you have ample room for everything, pre-Columbian sculpture included," and he sums up: "Fiske Kimball is all keyed up again and ready to see your points with sympathy." Marcel agrees with Walter about "no sales and (almost?) no loans" when the gift of their collection is finalized.

*

Marcel writes by return to Mary Reynolds at the Hotel Bellevue, Souillac, where she is due to arrive today via Perpignan from La Preste [28.6.1950] assisted by Franz Thomassin. By resting there a week or two, she hopes to gain strength for the long journey back to Paris.

1951. Sunday, New York City
"For the glass, in principle I have no objection," writes Marcel to Roché following a request from Sidney Janis to borrow *9 Moules Mâlic* [19.1.1915] for his exhibition "Brancusi to Duchamp", due to open on 17 September. He warns Roché that in the transport the three pieces of glass will rub against one another, "which could partially destroy what is left." As for the central glass, which is broken, "the pieces are only held together by the lead wires and the colour! Think about it and explain to Janis."

*

After hearing from Monique Fong [25.6.1951] that Elisa and André Breton have left Paris and gone to the Lot for a while, Marcel writes to them at Saint Cirq-Lapopie. Aware of the unrest in the Surrealist group, Marcel compliments Breton on one of the most recent documents, *Haute Fréquence*.

As Michel Sanouillet, who is preparing his thesis on Dada, is in Paris and wishes to meet Breton but has not had any reply to his request for an interview, Marcel intercedes on behalf of the young professor of Toronto University.

1961. Saturday, Cadaqués
If Robert Lebel, as soon as he arrives in Barcelona, sends word to say which night he will be arriving, "we could then assure you a pillow feet in water," Marcel tells him, "until 15 [August] if need be."

9 July

1917. Monday, New York City
Marcel spends the day with Beatrice Wood. At the Modern Gallery, 500 Fifth Avenue, they find Roché busy discussing projects with Marius de Zayas.

1930. Wednesday, Paris
Replying by return cable to Miss Dreier in New York who has asked whether he will select pictures for a Société Anonyme exhibition to be held in January, Dee's answer is: "Yes delighted Duchamp."

1944. Sunday, West Redding
In the afternoon after spending the weekend with Miss Dreier, Dee returns to New York. As there has been an "open house" today for prospective purchasers to visit The Haven, Miss Dreier receives so many callers that she has been unable to spend much time with her guest.

1947. Wednesday, New York City
"Here it is completely quiet, the summer that you know. Not a soul," Marcel tells Roché. "One goes out in shirtsleeves and I never go beyond 14th Street." While asking for news of the Surrealist exhibition, which has just opened in Paris [7.7.1947], Marcel remarks that "Kiesler is a very good chap" and that he has a right to their support, because he is disliked by certain "right-minded people", their "so-called friends, very modern men just as long as it sells".

1958. Wednesday, Massiac
From the town of his ancestors where he takes Teeny to see the family café [21.12.1908] and his relatives who live nearby, Marcel writes a postcard illustrated with the Grottes de Domme in the Dordogne Valley to Roché. Since leaving Paris [1.7.1958], as well as visiting the strange formations of stalactites and stalagmites at Domme, Teeny and Marcel have visited the famous painted caves of Lascaux with Max Ernst and Dorothea Tanning.

1961. Sunday, Cadaqués
Marcel has all the tickets to take a party of 22 to see a very special toreador: the hotel waiter Ruiz, who is appearing in his last bullfight. "The whole afternoon was bloodcurdling," Teeny tells Jackie, "… a kind of one-day Hemingway. It had the reaction on us that after we got home we took two stiff drinks, ate like pigs and collapsed in bed."

1966. Saturday, Cadaqués
"So many things and movements have happened in the last 3 weeks," writes Marcel to Brookes Hubachek in Chicago, "that I had to wait our arrival in Cadaqués to be able to give you an account. First London [15.6.1966]," recounts Marcel, "a week with the opening of the show, dinners, few speeches, and hardly any time to see the town. Then Paris: unveiling *chez* Carré [22.6.1966] of Raymond Duchamp-Villon's *Cheval-Majeur*... Finally we meandered in our little Volkswagen from Paris to Grenoble and Nice and Aix-en-Provence and Cadaqués (one week)..." Remembering the evening with Richard Hamilton at Raymond's Review, as an afterthought he adds: "P.S. Stripteases in London better than the best Minsky's of yore."

*

Having received a photograph from Arnold Fawcus of *Soeur Aspirine*, a drawing of a nurse who worked in the same hospital as Suzanne [17.10.1916] during the first war, Marcel forwards it to Arturo Schwarz. "It is not the portrait of Suzanne as a nurse, but the portrait of a friend of Suzanne, whose name I don't remember."

10 July

1903. Friday, Rouen
Duchamp presents himself and registers to sit the first part of the Baccalauréat examination.

1912. Wednesday, Munich
On a postcard representing the vast Festsaal of the notorious Hofbrauhaus, Marcel writes to Yvonne Duchamp-Villon's brother, Jacques Bon, who lives at 3 Rue Lemaître in Puteaux.

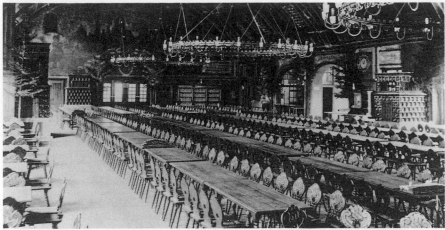

10.7.1912

"Do you remember these huge rooms, full of smoke and the people themselves full of beer? – It's stupefying. I smoke a lot of 'Virginia' delicious long cigars with a straw. Tell Gaby [Villon] that I thank her very much for her nice letter – Give my respects to the doctor and Mesdames Bon, very cordially, Marcel."

1921. Sunday, Paris
The opening line from a letter which Marcel wrote to Francis Picabia in January from New York: "mâcheur Fran[cfort sau]cisse Pis qu[e quand elle s']habilla", is published in *Le Pilhaou-Thibaou*, the illustrated supplement of *391*. From the same letter, Funny-Guy (alias Picabia), who is assisted by his new manager Pierre de Massot, has taken up Duchamp's suggestion and prints:

"If you want a rule of grammar:
The verb agrees with the subject consonantly:
For example:
Le nègre aigrit
Les negresses s'aigrissent ou maigrissent."
[Using this rule in English, for example:
The negro grows, The negress digresses or egresses.]

Fortuitous or not, it is significant that in printing the two authors' names, after Duchamp, Rose Sélavy [20.10.1920] goes to press as "Rrose Sélavy".
 In the same undated letter to Picabia, Marcel wrote: "I have at last attended a little to selling the Dadas 391 and the books [8.2.1921]." Enclosing a cheque, Marcel admitted that Man Ray had been more successful, and announced their issue of *New York Dada* [which appeared sometime in the spring]: "Will you be kind enough to ask Tzara to write a short printer's authorization… Here, Nothing, always Nothing, very Dada."

1924. Thursday, Paris
Duchamp meets Miss Dreier, recently arrived in Paris, and Roché who afterwards takes Miss Dreier to visit Georges Braque in his studio.

1930. Thursday, Paris
Maïastra, the magnificent, mythical bird by Brancusi which Dee has agreed to let Miss Dreier have for her garden at The Haven [28.4.1930], is now installed. "I planted the set-ting five years ago," she wrote, "and the trees this year have reached their right height." Some photographs she enclosed show Dee the slope from the house and the three terraces: one with the pergola, the second with the sunken garden and the third with *Maïastra* leading to the pool. Also in the garden is a black statue by Adelheid Roosevelt (once a pupil of Duchamp-Villon), and a meteor "which descended and landed in a nearby field – beautiful as well as terrifying". Of The Haven, Miss Dreier said, "I love this place more and more… There is a bigness – a serenity – which is too wonderful. And then the birds."

At night, while packing, Dee replies telling Miss Dreier that from the photographs *Maïastra* "looks very very beautiful and so does the garden". He promises to write from Germany. "The tournament in Hamburg sounds very interesting: Alekhine is playing with us (French) and many other great players will take part."

1935. Wednesday, Paris
Denise and Henri Pierre Roché call at 11 Rue Larrey and much admire the display unit Marcel has made to show his optical discs [21.6.1935] revolving. Everything is ready for the Concours Lépine which opens on 30 August.

1938. Sunday, Paris
With the $25 which he is expecting from the Museum of Modern Art, New York, in payment for a copy of *Anémic Cinéma* [30.8.1926], Duchamp proposes to pay Berenice Abbott for her photographs [25.6.1937] of the Large Glass, a matter of disagreement [8.3.1938] which has now been settled.
 In anticipation of the work to be done on the miniature version of the Large Glass for his "album" [22.5.1938], Duchamp is "experimenting the same kind of reproduction" on *9 Moules Mâlic* [19.1.1915]. Very busy with these reproductions which he hopes to have two-thirds finished by the end of the year, he writes to Miss Dreier: "I don't know when I can dream of going to America."

1956. Tuesday, New York City
On receiving "an SOS letter" from Antoine Pevsner, Duchamp writes to George Heard Hamilton requesting that the University reconsider their refusal to lend his portrait [3.7.1926] to the Musée National d'Art Mod-erne for an important exhibition of Pevsner's work. With the artist's promise that "if there is any kind of *accroc* he will be on hand to repair it," Duchamp asks: "Could you in any way have 'no' change to 'yes'?"

1958. Thursday, Le Puy
After Massiac, Teeny and Marcel visit Le Puy, city of the Virgin, with its romanesque cathedral, the sanctuary of the Black Virgin, which was a gift from Saint Louis on his return from the seventh crusade.

1964. Friday, Cadaqués
Sees Salvador Dali and learns that his canvas *L'Enigme de Guillaume Tell*, a very large picture painted in 1934, is for sale.

11 July

1930. Friday, Paris
At nine in the morning Duchamp leaves for Hamburg, where he is to play for France in the International Team Tournament organized by the German Chess Union.

1931. Saturday, Prague
Duchamp arrives in the Czechoslovakian capital to attend the 8th Congress of the International Chess Federation and to play for France in the International Team Tournament. Led by Dr Alekhine, the other members of the French team are Kahn, Gromer and Betbeder.

1937. Sunday, Paris
At the Hôtel George V, Duchamp makes a drawing in the autograph book of Mrs Charles B. Goodspeed, president of the Arts Club of Chicago, where an exhibition of his was held earlier in the year [5.2.1937].

1942. Saturday, New York City
Spends an evening with André Breton at his apartment on 11th Street, in the company of Frederick Kiesler and Leonora Carrington.

1949. Monday, New York City
Sending Hélène and Henri Hoppenot in Bern some reels for the tape recorder [28.12.1948],

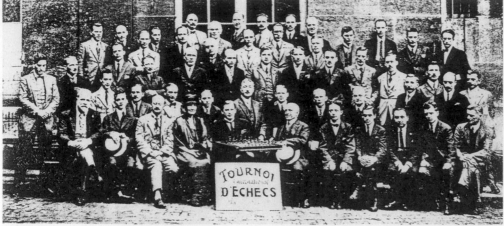

12.7.1924

Marcel writes: "Here after a great heat wave the fine weather is back and N.Y. is nevertheless pleasant in summer due particularly to the absence of the New Yorkers..." Mary Reynolds has told him, with delight, of their voyage in the Tessin together.

1950. Tuesday, New York City
After receiving a cable and letter from him concerning Mary Reynolds and a letter from Mary herself [8.7.1950], Marcel writes to Roché: "The main thing is to know whether she will overcome these 'colon bacilli' which resemble the North Koreans like two peas in a pod." Marcel hopes he won't have to go to Paris and wonders what he should say to Mary's brother, Brookes Hubachek, from whom he has no news.

1964. Saturday, Cadaqués
Informs Pontus Hulten, Director of the Moderna Museet in Stockholm, of his visit to Dali the previous day. If he is interested in *L'Enigme de Guillaume Tell,* Duchamp advises Hulten to write to Dali immediately, "at least to ask him for an option," because the picture is about to leave for Japan. "Personally I find this picture one of the most important of the good period," declares Duchamp and adds: "Good luck then."

1967. Tuesday, Cadaqués
At the eleventh hour the Municipality of Saint-Tropez have banned *Le Désir attrapé par la Queue,* a play by Pablo Picasso which Jean-Jacques Lebel was engaged to present with the author's permission. Duchamp signs the declaration of protest and posts it back to Jean-Jacques Lebel in Paris.

12 July

1924. Saturday, Paris
At the last moment Duchamp is invited to play for the French team in the first chess olympiad. As he is "playing twice a day – starting today", Duchamp explains to Jacques Doucet that he will be unable to go with him to visit the Picabias at Le Tremblay. "I telegraphed Satie to telephone you at St James so that you meet at my place tomorrow at eleven." He promises to write to Ruaud [27.12.1923] and to see

Doucet as soon as he has found someone for the globe of the optical machine [2.7.1924].

*

Organized to coincide with the Olympic Games which are being held in Paris, the tournament is opened by M. Sauphar, mayor of the *9ème arrondissement,* in the assembly hall of the *mairie* near Richelieu-Drouot. Replacing André Muffang, Duchamp is playing for the first time for France with Aimée Gibaud, Fred Lazard and Georges Renaud.

The 54 players, representing 18 nations, are divided into nine groups for the Preliminary tournament, commencing at two o'clock. Playing in Group 7, in the first round Duchamp loses his game against Chepurnov of Finland.

In the evening at eight, against the Russian Victor Kahn, whom he met in Rouen [2.3.1924], Duchamp also loses his game.

1925. Sunday, Monte Carlo
From the Hôtel de Marseille, where he has been staying since the beginning of June [3.6.1925], Duchamp writes a card to Brancusi in Paris: "Your young lady is perfectly well-behaved. She swims frantically and is becoming as red as a lobster." As he is planning to stay until mid-September in the south, Duchamp suggests that Brancusi take a train to Monaco: "I am delighted with this place and with the green gaming table."

1930. Saturday, Hamburg
In the evening at eight, the opening ceremony of the F.I.D.E. Congress takes place in the assembly room of the Provinzialloge von Niedersachsen. W. Robinow, president of the German Chess Union and also president of the city's famous chess club (which is celebrating its centenary), welcomes the guests and the draw for the order of games is made. Seventy-two players representing eighteen countries are participating in the Team Tournament for the Hamilton-Russell Cup. With the world champion, Dr Alekhine, the members of the French team are L. Betbeder, M. Duchamp, A. Gromer and A. Voisin.

1936. Sunday, West Redding
Totor has not replied to Roché because, he explains, "I have become a glazier who, from nine until seven in the evening thinks of nothing else than to repair broken glass." In three weeks, he thinks, "the Bride will have found her feet again."

If Alfred Barr still wants *Why not sneeze?* [11.5.1935] for "Fantastic Art, Dada, Surrealism" at the Museum of Modern Art in December, Totor tells Roché to be sure that it is packed "so that the weight of the marble doesn't strain the bars or the base of the cage".

1938. Tuesday, Paris
"This letter is a work of art," writes Duchamp to Claire and Gilles Guilbert, referring to their correspondence addressed to a third person. "My prognostic is that he will take the piano clef and the consequences," Duchamp advises them, "based on the fact that he has not to see you (face to face) in order to choose the arithmetically advantageous solution..."

1942. Sunday, New York City
Following their evening with André Breton, Marcel is invited to the Kieslers' at seven and they dine together at Tichino's.

1954. Monday, New York City
The Duchamps arrive home in the evening after staying with the Carters in the country near Cincinnati [3.7.1954].

1961. Wednesday, Cadaqués
Celebrating Jackie's birthday in her absence, Teeny and Marcel eat *langouste* and "in her honour" open the bottle of champagne that she gave them.

1964. Sunday, Cadaqués
"If Yvonne Lyon has a definite idea about what she wants we can't do otherwise than propose her price to Arne [Ekstrom]," Marcel advises Richard Hamilton referring to the sale of *Belle Haleine, Eau de Voilette* [6.2.1930]; "if she wants to discuss the price in order to please

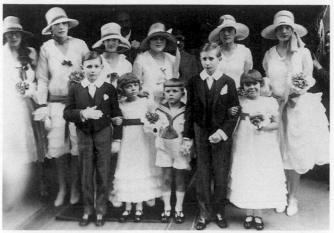

13.7.1927

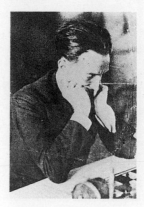 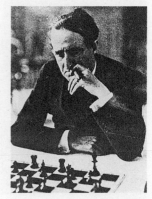

13.7.1930

Arne, me and herself at the same time, my suggestion would be a price around $500."

1966. Tuesday, Cadaqués
Thanks Pierre Cabanne for sending him the first in the series of interviews [9.6.1966]. "Amusing to read even for me! ... I await, then, the other interviews as soon as they are ready. Delighted." Duchamp also congratulates Cabanne for his article on *Le Cheval-Majeur* [22.6.1966].

13 July

1924. Sunday, Paris
In the third round of the Preliminary tournament commencing at two o'clock, Duchamp loses against Rueb, president of the Netherlands Chess Federation.
In the evening starting at eight, Duchamp wins his game against Kleczynski from Poland.

1927. Wednesday, Paris
With Marcel and Man Ray watching them from their table at the Café du Dôme, Lydie dances with Kiki on the Boulevard Montparnasse with hundreds of others, starting to celebrate the storming of the Bastille in the traditional way.

*

Startled by Florine's incredible news [27.6.1927], Henry McBride has replied: "Why didn't he then, since he likes 'em fat, marry Katherine Dreier? But Charles [Demuth] tells me the new one is rich, too. So perhaps it's all for the best."
Florine however is still haunted by the marriage of Duche and writes again to McBride: "He had a church wedding. Six bridesmaids in white muslin, pink sashes, pink picture hats. Two little Kate Greenaway girls. Two little Eton-jacketed boys. The Bride in silver cloth. I think," Florine says critically, "she should have worn a wedding gown of near glass with a near (or real?) wire trimming – spiral design. However," she sighs, "so few do the appropriate thing."

1930. Sunday, Hamburg
In the first round of the International Team Tournament, France plays the United States. Frank J. Marshall [20.10.1920] has played – and won – so many games against Duchamp that he

underestimates his opponent on this occasion. To his great delight and pride, Duchamp holds the legendary Marshall to a draw.

*

In the flush of success, Totor writes a postcard to Roché: "I drew against Marshall!! I am saved."

1931. Monday, Prague
Not having participated in the previous rounds of the International Team Tournament, Duchamp plays for France in the third round against Yugoslavia, but loses his game against E. Konig.

1937. Tuesday, Paris
With Mary Reynolds and Franz Thomassin, the translator of *Macbeth*, Duchamp attends a rehearsal for the press at the Théâtre Antoine of the French adaptation of Shakespeare's play and *Oedipe-Roi* by Jean Cocteau. These two plays, which Cocteau describes as being "the two dramas the most atrocious" he knows, are presented on the occasion of the Exposition Universelle

and performed by Les Jeunes Comédiens 37. In *Macbeth*, directed by Julien Bertheau, Jean Marais plays the part of Malcolm.
Noticing Henry McBride sitting just in front of them, when the lights go up for the interval Marcel taps the American critic on the

shoulder and they go together to the bar where they proceed to have a party. "For the first time," declares McBride, "I had something like a good time."
In *Oedipe-Roi*, which is directed by the author himself, Jean Marais interprets a text by Cocteau for the first time.

1938. Wednesday, Paris
With Lefebvre-Foinet who is to submit an estimate for transport to the States, Duchamp goes to the storage place in Neuilly to check Miss Dreier's furniture.

1950. Thursday, New York City
"The Société Anonyme Catalogue is finished [30.6.1950]. In a fortnight you will be sent a copy," writes Marcel to Suzanne and Jean Crotti in Paris. Wishing to send copies to Ivan Goll, Waldemar George, André Salmon and Georges Ribemont-Dessaignes, Marcel requests the Crottis to mark their addresses on his letter and send it back by return of post.

14 July

1917. Saturday, New York City
Marcel dines with the Picabias and Beatrice Wood.

1919. Monday, Las Palmas
After two weeks crossing the Atlantic from Rio de Janeiro [30.6.1919], the SS *Highland Pride* reaches Grand Canary Island – while in Paris the National Day is celebrated with a victory parade. Duchamp's ship remains only a few hours in the port and takes on board four additional passengers.

1922. Friday, New York City
In the late evening, Marcel joins a party at the Beaux-Arts Café [1.7.1922] where Ettie, who is in town from Sea Bright [7.7.1922], has dined with Carl van Vechten, Fania Marinoff and Louis Bernheimer. Ettie has been to collect her manuscript, *Love Days*, fastened by Duche [9.6.1922], which has been accepted by Alfred Knopf, but will not be published until next year.

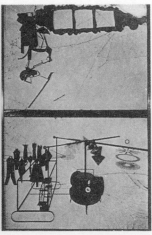

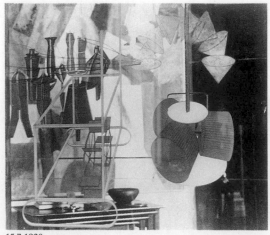

14.7.1938

15.7.1920

1924. Monday, Paris
Before returning at two o'clock to the *mairie* of the *4ème arrondissement* where the chess olympiad is being played, Duchamp calls at the Hôtel Brighton, 218 Rue de Rivoli, to see Miss Dreier. He learns that she has gone motoring to the valley of Chevreuse. "Good for you," he writes on a scrap of paper confirming their meeting the next day.

In the final round of the Preliminary tournament, Duchamp wins his game against the Romanian Davidesco and, with 2 points, is placed third in his group ahead of Kahn, Rueb and Kleczynski. While the winner of each group is entitled to play in the Premier tournament, the rest will now play in the Subsidiary tournament.

1930. Monday, Hamburg
In the second round of the Team Tournament, France plays Romania and Duchamp draws his game against Taubmann.

1931. Tuesday, Prague
Playing for France against the United States of America, Duchamp loses his game against H. Steiner. "Lovely voyage, but miserable chess!" is Duchamp's unequivocal message on a postcard to Dumouchel in Paris.

1936. Tuesday, West Redding
Miss Dreier gives Duchamp a cheque for $85.50 to reimburse him for two invoices he has settled, one for John Shail's time on the Large Glass prior to his arrival at The Haven [26.5.1936], and the second for 2 nine-foot lengths of nickel silver, the same calibre as the frames ordered on 1 July from Biele & Sons in New York, together with cement and putty.

1938. Thursday, Paris
Dee writes to Miss Dreier warmly thanking her for the photographs of the Large Glass: "Mr Coates did exactly what I need – and I hope the reproduction will be worthy of his photographs." He adds how grateful he is "for the results" of her collaboration [24.6.1938].

1941. Monday, Saint-Raphaël
In the morning Totor travels a hundred kilometres eastwards along the coast from Sanary by train and, as arranged [8.7.1941], meets Roché who has come by train from Nice. After taking rooms at the Hôtel Beau-Rivage, they walk to the jetty and then along the promenade by the beach before returning to have lunch near the station, making a careful choice of restaurant.

Learning that Totor is recovering from bronchitis and is suffering from constant eye trouble, Roché realizes it is the first time that he has seen his friend so low. Totor tells Roché that his departure to New York is now uncertain [1.7.1941] but that he is still trying to leave. In their conversations, Roché senses that Totor is pro-Russian in a way.

In the evening they have dinner at the Excelsior and then return to their hotel to play chess on the veranda. Giving Roché a Rook, Totor wins.

1945. Saturday, West Redding
Spending a weekend at The Haven, one of the last before the house is sold, Dee learns from George Heard Hamilton's letter to Miss Dreier that Matta's *Bachelors Twenty Years After* has recently been acquired for the Yale University Art Gallery.

During the day, Dee's throat becomes in-flamed, making it painful to swallow, which greatly alarms Miss Dreier.

1947. Monday, New York City
At ten in the morning, accompanied by Maria Martins, Marcel calls on Stefi Kiesler for half an hour.

1950. Friday, New York City
On receiving the "rather interesting" but inconclusive reply regarding *Still Life with Newspaper* by Juan Gris [6.7.1950], Duchamp immediately sends Duncan Phillips' letter to Miss Dreier suggesting how she might continue the negotiations because the sale of the painting is required to finance the catalogue of the Société Anonyme. "But I feel that if there was not such a hurry," Dee tells Miss Dreier, "it would have been a nice solution for you and for Gris" to sell the picture to the Phillips' Collection.

*

Duchamp briefly answers a questionnaire from Hans Bolliger in Zurich who has been asked by Alfred Skira to compile biographical and bibliographical notices on artists for his publication: *Histoire de la Peinture Moderne*. Duchamp indicates that "more complete information" on him is available in Alfred Barr's books [9.12.1936]. In view of the article on Dada that Bolliger has been asked to write for the same book, Duchamp sends a list of artists who should be included in the article.

1952. Monday, New York City
Duchamp replies to three additional questions [7.6.1952] concerning the Large Glass [5.2.1923] posed by Marcel Jean. Firstly he confirms the text on the drawing *La Mariée mise à nu par les Célibataires* [7.8.1912]: "Mécanique de la pudeur, Pudeur mécanique" (Mechanics of modesty, Mechanical modesty).

Secondly, unable to remember now whether it is essential or not for the "theoretical 'running' of events", Duchamp says that he eliminated the Hook, "at least for execution on the large glass." Thirdly, he explains, "the axle of the Water Mill, at its extreme right, rests on the side of the Grinder (not on its axle there is no 'action' at all of one upon the other)."

1954. Wednesday, New York City
While confirming that only twenty or twenty-five copies of the *Pocket Chess Set* [23.3.1944] were made (although he "intended to make a

15.7.1936

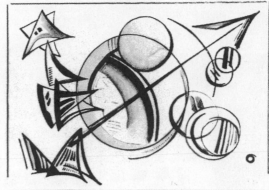

15.7.1937

commercial proposition of it"), Duchamp gives Marianne Martin the dates when the Arensbergs lived at 33 West 67th Street, which he has checked with Walter Pach.

1965. Wednesday, Cadaqués
Drawing a little French flag by the date, Marcel announces: "Another drama." He explains to Jackie that the film he has ordered from the photographer Beguier of the Large Glass from the miniature in the *Boîte-en-Valise* [7.1.1941],

is much too large for his purposes. He asks her to take the reproduction back and give fresh instructions to Beguier: "Also tell him to send me this work to Cadaqués as quickly as possible so that I can start the engravings that Schwarz has asked me for."

15 July

1920. Thursday, New York City
"I received the note from Mad [8.1.1918] asking me to send these letters to you and 2 others as if she was in N.Y. What a character! Where has she gone?" writes Marcel to Yvonne Chastel in Paris.

A letter has just arrived from Gaby [29.5.192], telling him that Yvonne herself considers she has turned over a new leaf. "Try both of you," he advises Yvonne, "to get rid of this persecution mania that I have as well but which I don't suffer from."

New York has changed. It is "dismal and full of gossip"; the Arensbergs have given notice to move from 67th Street where, as McBride recently noticed, "the big, and still uncompleted, *chef-d'œuvre* in glass... posed near the entrance is sobriety itself... and assumes all the reticence of a piece of furniture or of a Rembrandt in the Metropolitan Museum of Art."

Although Marcel sees everyone, he has "intimate relations with no one. That's one of

the advantages of my situation as Mac," he maintains. "People have much more respect for me than before. Their attitude amuses me intensely."

Having moved recently from 246 West 73rd Street back to the Lincoln Arcade Building [1.1.1916], for $35 a month Marcel has room 316, which is half the size of the one he occupied previously. It is whitewashed and he is busy arranging it, hoping to work "seriously" with the movie camera he has acquired.

The "delightful, quite hot summer" in New York seems to suit him, "I feel really better," he tells Yvonne, "Drinking milk by gallons... It's excellent and simple to take."

1923. Sunday, Paris
As he has decided to abandon Brussels [20.6.1923], Duchamp rents a studio at 37 Rue Froidevaux, not far from the Place Denfert-Rochereau at Montparnasse.

1924. Tuesday, Paris
In the afternoon at two-thirty Duchamp is due at the Hôtel Brighton, where with Miss Dreier (who leaves on Wednesday for Cologne) he has arranged to meet Max Ernst at three.

Returning in the evening to play in the first round of the Subsidiary tournament of the chess olympiad, Duchamp loses his game against Steiner of Hungary.

1927. Friday, Paris
Following Marcel's triumph in managing to find an apartment for his wife [21.5.1927], although she is still living at 11 Rue Larrey, Lydie starts paying the rent at 34 Rue Boussaingault.

1930. Tuesday, Hamburg
The third and fourth rounds of the International Team Tournament are played today. In the morning France is beaten by Sweden and Duchamp resigns his game against G. Stoltz. In the afternoon Duchamp loses his game against the German player Sämisch.

1936. Wednesday, West Redding
"The Glass is half finished," Miss Dreier announces happily to her sister Mary. "The frames have come [1.7.1936] and the first one was put into its frame today... [Duchamp] is so excited about it."

At a moment when he is not occupied with the Large Glass, Duchamp replies to James Johnson Sweeney, associate editor of *Transition*, declining his invitation to write for the review.

1937. Thursday, Paris
Puzzled at receiving two additional lithographs from Miss Dreier because he already has 39 coloured ones and one black forming the collection of 40 [2.4.1937], Dee asks what he should do: "I am afraid we have enough black only for one more... Half of the stencils are done," he continues, "and I have looked over the proofs... I think you will be satisfied."

1941. Tuesday, Saint-Raphaël
After spending Bastille Day together, Totor takes the train back to Sanary and Roché accompanies him as far as Les Arcs.

16.7.1940

1943. Thursday, New York City
Goes to see a film showing at 1660 Broadway with Mary Reynolds and others, including the Kieslers.

1945. Sunday, West Redding
Feeling better than the day before, in the evening Dee returns from The Haven to New York. He has promised Miss Dreier that he will cable her if his throat doesn't improve.

1947. Tuesday, New York City
After receiving his letter and clippings about the exhibition "Le Surréalisme en 1947" [7.7.1947], Duchamp cables his "felicitations and kisses to all" to Kiesler at the Hôtel Lutétia in Paris.

1950. Saturday, New York City
"I am starting a training tournament this coming week and I am scheduled to play almost every day until I go to Binghamton," explains Dee to Miss Dreier, enquiring whether he can change the date of his visit to Milford from 25 to 24 July. "Also," he suggests, "we ought to wait for your sister Mary to come back and have the Birthday party later like last year."

1959. Wednesday, Paris
After discussing plans for another exhibition, in *Bief: Jonction Surréaliste* Marcel Duchamp and André Breton announce enigmatically "an exceptional rendezvous" for the end of the year…

16 July

1924. Wednesday, Paris
At eleven in the morning to mark the first chess olympiad, all the players, delegates and officials are invited to a reception at the *hôtel de ville* of Paris. After the speech of welcome made by the vice-president of the City Council M. Pointel, the president of the Netherlands Chess Federation M. Rueb replies. The foreign delegates are then invited to tour the magnificent reception rooms of the historic building.

In the second round of the Subsidiary tournament starting at two in the afternoon, Duchamp loses his game against the Czech player Vanek.

Commencing at eight in the evening, Duchamp plays against Rozic from Yugoslavia and wins.

1927. Saturday, Paris
At one o'clock Totor calls at Arago to see Roché, who has recently returned from London, where he visited Yvonne Chastel.

1930. Wednesday, Hamburg
In the fifth round of the International Team Tournament the French team beats Norway and Duchamp draws his game against M. Olsen.

1931. Thursday, Prague
In the morning the British Empire team struggles against France and Duchamp holds W. Winter to a draw.

In the eighth round, France plays Italy and Duchamp's game against E. Hellman is adjourned.

1938. Saturday, Paris
Denise and Henri Pierre Roché are invited to lunch at 14 Rue Hallé, Mary Reynolds and Marcel's "new house". Finding it better than Bellevue and Arago put together (although it doesn't have the altitude of Bellevue), Roché praises the comfort, admires the home-made lamps, and describes the small garden as "sufficient".

1940. Tuesday, Arcachon
Since the beginning of the month the French government has been installed in Vichy following the armistice on 22 June dividing France into two zones. With Jean and Suzanne Crotti, Mary Reynolds and Marcel are sharing the Villa Franck-Liane, Rue Goyard, where they plan to stay until September. As Marcel has found a good printer he is able to continue work on the reproductions for his *Valise* [16.5.1940].

A close friend who arrived in June is Elsa Triolet [13.10.1926], an erstwhile resident of the renowned Hôtel Istria. One fine day, seeing the invaders for the first time, she caught sight of Marcel, shaded by a wide-brimmed straw

hat, quite innocently marching down the street in Arcachon at the head of a column of German soldiers.

Also taking refuge in the seaside town before the Germans arrived were Salvador Dali and his wife Gala, whose game of chess one day with Marcel was interrupted when Dali stole a chesspiece for the picture he was painting.

"We are right in the occupied zone," writes Marcel to Roché in Gaillac, "waves of Germans follow one another here on leave… As civilians," he explains, "we are not hit by the occupation – quite adequate provisions – only the rain is too frequent."

"The organization of the country has not been as disagreeable as I might have feared," Marcel tells Lou and Walter Arensberg, "but civilian life continues without the Germans interfering much. Many refugees from Belgium and the North have left and the Germans who come here are here 'to rest' (4 days by parcels of 4,000 at a time). They come and go non-stop."

As for communications: "There are only very few trains for Paris, reserved also for the mail and officials. The railway bridges have all been dynamited." Villon is in the unoccupied zone, staying with the Mare-Vène families at La Brunié in the Tarn, only 200 kilometres from Arcachon, but Marcel "cannot go to see him (lack of trains)".

In reply to Arensberg's offer of assistance, Marcel remarks: "It seems to be more difficult now to send money from America to France. Besides our accounts are settled for the Brancusis." He proposes "amongst the small things" available, the cheque [3.12.1919] drawn for his dentist which Dr Tzanck would sell for $50. Otherwise there is the original *L.H.O.O.Q.* [6.2.1930]: "Do you think that $100 is too much for the said Joconde?"

1941. Wednesday, Sanary-sur-Mer
In the morning Totor writes a note to Roché: "Back safely with an excellent souvenir of a St Raphaël that I didn't know… And you?"

1956. Monday, Peterboro
From the MacDowell Colony in New Hampshire, where he and Teeny are "living like fighting cocks", Duchamp writes to Henri Marceau saying that for the catalogue he is working on

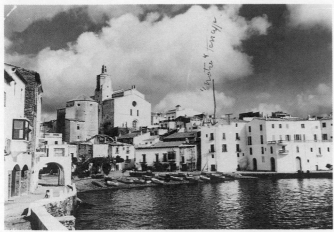

16.7.1967

for the "Three Brothers" he now needs three black-and-white photographs [3.4.1956]: *Professeur Gosset* by Duchamp-Villon, *Nu descendant un Escalier*, No.1 [18.3.1912] and *Why not sneeze?* [11.5.1935]. Can the prints, with the bill, be sent to him at Peterboro before the end of the month, or to New York after 1 August?

1966. Saturday, Cadaqués
Although Duchamp posted back the first interview [12.7.1966] the day after it arrived, Pierre Cabanne has still not received it. "I should have put 'Express' on the parcel," writes Duchamp and encloses the interview received that afternoon. "I await then the 2nd, 4th and 5th and will return them to you immediately."

1967. Sunday, Cadaqués
On receiving a letter from Pierre Belfond about an English translation of *Entretiens avec Marcel Duchamp* [25.1.1967], Duchamp writes to Pierre Cabanne enclosing the letter: "Tell me if you agree and I hope that you will have a financial word to say."

*

To Yo and Jacques Savy, whom they believe to be on "the other side of the Mediterranean", Teeny and Marcel send a postcard requesting their address at Menton and news of the catalogue for Yo's exhibition at the Bodley Gallery in November [22.5.1967].

17 July

1924. Thursday, Paris
Commencing at two in the afternoon, Duchamp wins his fourth round game against Smith from Canada.

In the following round of the Subsidiary tournament starting at eight in the evening, Duchamp draws his game against the Spanish player Marin.

1930. Thursday, Hamburg
The French team is beaten by Holland in the sixth round of the International Team Tournament and Duchamp loses his game against Landau.

1931. Friday, Prague
In the ninth round of International Team Tournament, which is played in the afternoon, France draws against Holland, and Duchamp wins his game against J. H. Addicks.

1940. Wednesday, Arcachon
From the café-brasserie Aux Sports, Marcel replies to two letters from Beatrice Wood saying: "Life, since the occupation, is organized – we have very little contact with the Germans. They are chiefly occupied in finding and taking petrol for their cars."

Promising to tell Roché of her good intentions, he gives her his address at Gaillac in the Tarn saying: "it is difficult for us to move about at the moment. But that will not last." Marcel hopes "in the course of the year to leave France," and adds: "In any case the 'dramatic' is over."

1941. Thursday, Sanary-sur-Mer
For an appointment in the evening at about seven with Alec Ponisovsky [8.7.1941] Duchamp goes to Toulon.

1948. Saturday, New York City
After receiving news from Louise Arensberg about a forthcoming exhibition of their collection, Duchamp writes to Katharine Kuh at the Art Institute of Chicago: "Indeed I will be delighted to see you in October in N.Y. and talk things over with Mr Catton Rich and yourself. Just let me know a few days before you arrive."

1949. Sunday, New York City
Following a visit to the Institute of Contemporary Art at Boston, which is proposing to organize an exhibition of Jacques Villon and Lyonel Feininger, Duchamp has written to his brother for further documentation which he has now received.

Forwarding the papers to the director of the exhibition, Frederick S. Wight, Duchamp says that he has also asked Ernest Brummer to search in his archive for the names of purchasers from the two Villon exhibitions held at his gallery.

1950. Monday, New York City
Alarmed by a card from Mary Reynolds to Roché, "revealing her present nervous state and also her frailty," Marcel has written to her

brother Brookes in Chicago to warn him of the gravity of the situation.

"I have never uttered the word cancer," he says to Roché, "but do you think that there is a dreadful possibility there? – Don't hesitate to tell me."

Could he write to Franz Thomassin at Souillac [8.7.1950] to find out what the doctors said in La Preste: "If you communicate with him, do it without Mary knowing, a telegram is dangerous because he would probably receive it in Mary's presence. Perhaps the simplest would be to write him an ordinary letter asking him to telephone you at St Robert or in Paris and mention this idea of cancer which is worrying me."

Marcel does not intend to leave for Paris: "either she doesn't know her condition and my arrival would be a dangerous shock for her morale, or she can still recover if it is really colon bacillus."

"The main thing is to die without knowing it, which incidentally always happens that way; but to avoid the fears and physical sufferings."

1958. Thursday, Sainte-Maxime
From Le Puy [10.7.1958] and Fleury where Teeny's half-sister and her family live, the Duchamps join Marcel's sister Suzanne at Kermoune, the villa lent to them by Claude Blancpain [21.7.1949] a close friend of the Crottis.

Suzanne knows Kermoune well, having stayed there many times with her husband Jean. After Jean's death [30.1.1958], Suzanne is happy to have Marcel and Teeny's company this summer. The villa is situated on the hillside just behind the town, not far from the sea. There is a large terrace before the house: through the pine trees shading the garden, there is a view of the sea.

1965. Saturday, Cadaqués
"Thank you for your letter of July 6 and your amusing idea to which I subscribe wholeheartedly," writes Duchamp to Dr Schmied [28.6.1965], who is now proposing to have two "vernissages" at the Kestner-Gesellschaft: one at the beginning and one at the end of the exhibition.

Having decided to take the night train from Paris to Hanover on 27 September, Duchamp asks Dr Schmied for the exact time of its departure.

18.7.1908

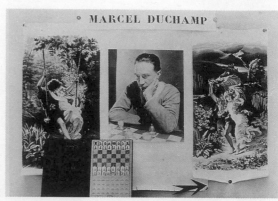

18.7.1946

18 July

1891. Saturday, Blainville-Crevon
Baptism of Suzanne Marie Germaine, the fifth child of Lucie and Eugène Duchamp, born on 20 October 1889. The godfather is her uncle Fortuné Désiré Guilbert, and her godmother Augustine Vacher, widow of L'Hullier and a good friend of the Duchamps.

1908. Saturday, Veules-les-Roses
On a wild night of atrocious wind and rain, the Duchamp family returns for another holiday at Les Peupliers, the villa situated in a narrow lane not far from the turbulent grey sea. Most of the trunks, valises and boxes are left to be unpacked the following day.

1924. Friday, Paris
Duchamp loses his game against the Italian Romi in the afternoon session of the Subsidiary tournament; however in the seventh round, starting at eight o'clock the same evening, he beats Wreford Brown of Great Britain.

1926. Sunday, Paris
At eleven o'clock in the morning, Marcel has an appointment with Roché.
Duchamp writes from the Hôtel Istria accepting Jacques Doucet's invitation to dinner on Thursday. "Francis [Picabia] cabled me that he has delayed his voyage to Paris," adds Duchamp. "I expect him I think next week."

1930. Friday, Hamburg
France is beaten by Austria in the seventh round of the International Team Tournament and Duchamp loses his game against Kmoch. In the eighth round France plays Denmark, and Duchamp draws his game against Gemzoe.

1931. Saturday, Prague
Duchamp does not play in the French team against Germany, but in the eleventh round he plays for France against Switzerland and draws his game against W. Michel.

1946. Thursday, Paris
Mary Reynolds and Marcel dine with the Hop-penots' daughter Violaine, her husband and their son.
The bookshop La Hune on Rue Casimir-Delavigne has a window display devoted to Duchamp, which includes a copy of his *Pocket Chess Set* [23.3.1944] (to mark the publication in *Fontaine* of the article "Arts et Métiers de Marcel Duchamp" by Michel Leiris?).

1947. Friday, New York City
Replies to Elisa and André Breton's letter remarking that "Le Surréalisme en 1947" [7.7.1947] would appear to be a success. Hoping that Aimé Maeght has posted him a catalogue, Marcel would also like to see some photographs of the installation. Will Breton make a small album so that all this work doesn't just evaporate in September? Did he have time to install the room of "Surrealists in spite of themselves" and the kitchen [12.1.1947]?

1958. Friday, Sainte-Maxime
The day after their arrival, while in Saint-Tropez, Duchamp sends a telegram to Robert Lebel in Paris: "Telephone morning 182 Saintemaxime = Duchamp."

1959. Saturday, Le Tignet
Three days after leaving Paris, Teeny and Marcel arrive at Le Tignet, a small village eleven kilometres west of Grasse. From the front terrace of the house lent to them by Maurice Fogt (the father of Mimi [18.4.1957]), is a splendid view across the sloping garden, with its regiment of clipped yews and olive groves, to the Massif de Tanneron and the sea.

1963. Thursday, Cadaqués
To Jean Tinguely, who is in Lausanne busy

J'espère que vous vous balancer toujours encore doucement
Jean Tinguely

starting to build *Eureka* for the 1964 Swiss National Exhibition, Marcel writes: "Thank you for your ballooned message which Jackie brought to me here," and gives him instructions regarding a *Boîte-en-Valise* for Yoshiaki Tono in Japan.

19 July

1914. Sunday, Puteaux
In the afternoon the Duchamps receive Albert Gleizes, Henri-Martin Barzun, his wife and son, accompanied by the critic Sébastien Voirol and his wife.

1917. Thursday, Long Beach
Marcel, Picabia and Roché arrive on the five o'clock train from New York to visit Isadora Duncan. Seduced by the ocean, the girls and dinner with a movie, they decide to stay overnight.

1924. Saturday, Paris
In the eighth and final round of the Subsidiary tournament starting at two in the afternoon, Duchamp draws his game against Fernandez Coria of the Argentine.

1927. Tuesday, Paris
At one o'clock Marcel calls to see Roché at Arago and they have lunch together at Couteau's, 32 Avenue d'Orléans. Helen Hessel (who was not invited to the wedding [8.6.1927]) joins them for the dessert.

1930. Saturday, Hamburg
The French team is beaten by England in the ninth round of the International Team Tournament and Duchamp loses his game against Sir George A. Thomas, one of his opponents in Nice [20.2.1930].

1931. Sunday, Prague
The committee of the Prague Chess Congress invites all the competitors to make a guided tour of the city, followed by an excursion to Karlstein Castle.

1936. Sunday, West Redding
At Miss Dreier's invitation, the specialist in

Voici ce que je vint de RENCONTRER
↓

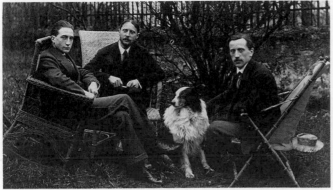

18.7.1963

20.7.1923

fine-grain photographic processes, Walter Buschman, calls at The Haven at about eleven o'clock with his wife and son. He photographs various paintings, and Duchamp discusses with him the problem of photographing the Large Glass, which is repaired but not yet installed [15.7.1936].

1941. Saturday, Sanary-sur-Mer
Giving his address at the Hôtel Dol, Duchamp writes to the Secrétaire-Général at the *préfecture* in Grenoble reminding him of their recent meeting [25.6.1941]. Enquiring whether there has been any response from Vichy, Duchamp reminds the Secrétaire-Général of his mission to Los Angeles and informs him that he has written confirmation from the American consul in Marseilles that an American visa will be issued to him on presentation of his French passport and exit visa.

*

Prompted by the news from René Lefebvre-Foinet that Duchamp wants to leave France for the United States, Miss Dreier, like the Arensbergs [2.7.1941], takes up Duchamp's case for his return to the States inviting him to help her achieve her goal "with the standards it should have". With her usual drive, Miss Dreier is eager for Duchamp to assist with plans to establish two museums, one in Los Angeles for the Arensberg Collection and one at The Haven for the Société Anonyme. Concerned about the future of the Large Glass after her death and judging that it should not be moved, Miss Dreier's solution is to turn her house into a "Museum in the Country" [8.8.1939].

"Cable Danbury if passport issued can work on Washington," instructs Miss Dreier by telegram. Dee replies immediately saying that he does not yet have a passport but he will cable as soon as he does.

1942. Sunday, New York City
To Varian Fry [1.7.1941], who was escorted out of France in September 1941, Duchamp writes that the envelope has arrived from Bermuda [22.6.1942] sooner than he had hoped. He encloses the letter and authorization for Fry to make a "withdrawal" and adds: "Before long some marching songs…"

*

Goes to visit Miss Dreier at The Haven and stays overnight.

1954. Monday, Philadelphia
Duchamp assists Henri Marceau and George Barbour with the installation of the Large Glass [5.2.1923] in its permanent home at the Philadelphia Museum of Art. Situated in the midst of the very fine Arensberg Collection [27.12.195], the Glass is positioned in one of the large rooms exactly as Duchamp has suggested [7.4.1954].

Two aluminium pipes, six inches in diameter and about eight metres long, the height of the ceiling, provide the main support. Marceau has suggested that the old wooden supports can be done away with and that, with careful measurement, the screws and keyholes in the pipes could be matched up. It only requires a slight deflection of the pipes to slip the Glass into place.

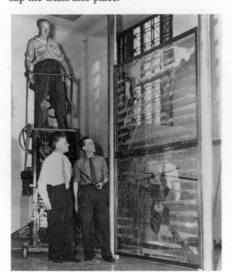

When the very delicate operation has been completed, a photographer captures Henri Marceau and Duchamp, pipe in hand, looking at the Large Glass, with Barbour viewing it from the height of the museum's mobile elevator.

With the installation nearing completion, the galleries of the Arensberg Collection are to be opened to the public in the autumn.

1966. Tuesday, Cadaqués
Posting the second interview "express" to Pierre Cabanne, Duchamp writes "I don't understand at all" and suggests, if the first one doesn't turn up [16.7.1966], to correct it on the proofs from the printer.

20 July

1917. Friday, Long Beach
In the morning Marcel and Roché remember that they have a date with Beatrice Wood. Roché telephones her to cancel it. After the ocean breezes, they return by train to New York and the intense heat.

In the meantime Beatrice has been to see Gaby Picabia and has decided to sever her relationship with Roché [21.6.1917].

1923. Friday, Paris
The evening starts with iced cocktails at the apartment of Yvonne Georges which she serves to her guests Marcel, Man Ray and Roché from a trunk transformed as a bar. Marcel courts a sturdy blonde Russian-American, who shows them the extent of the suntan on her thighs.

Later everyone is installed at the Café du Dôme. Roché notes that Marcel's pursuit, direct and precise, is now rapidly bearing fruit; Man Ray is exquisite and Kiki is authoritatively vulgar and coarse. Obscenity reigns. Roché decides to go home to bed.

1924. Sunday, Paris
The results of the first chess olympiad are announced in the evening at a ceremony commencing at eight-thirty in the *mairie* of the *9ème arrondissement*. In honour of the winners, the national flag of Latvia hangs on the right of the platform in the brilliantly lit assembly room and to the left, the flags of Czechoslovakia and Hungary. After a speech by M. Mesurer, who presides, the secretary of the Fédération Française des Echecs M. Vincent reads the results of the tournaments.

The winner of the Premier tournament, becoming champion of amateur chess players is Armand Matisson of Latvia. Apscheneek of Latvia is in second place and Colle of Belgium in third. Because of the rather eccentric scoring system used in the olympiad, although none of their players won a place in the Premier tournament, Czechoslovakia nevertheless wins the Team tournament, followed by Hungary and Switzerland.

21.7.1903

Of the 18 nations taking part, France is placed seventh in the final result. In the Subsidiary tournament of 44 players, Duchamp is placed exactly halfway down the list.

*

On the same day the Fédération Internationale des Echecs (F.I.D.E.) is founded and the members elect its first president, Dr A. Rueb of the Netherlands.

1930. Sunday, Hamburg
In the tenth round of the International Team Tournament Czechoslovakia beats the French team, but Duchamp manages to retain half a point for France by holding Reijfir to a draw.

1935. Saturday, Paris
Establishes an account for Roché of all the expenses from 1 March to date for the fabrication and presentation [10.7.1935] of his optical discs [10.5.1935], totalling 4,616 francs (15,000 francs at present values).

1942. Monday, West Redding
After twenty-four hours or so at The Haven, Dee returns to New York.

1948. Tuesday, New York City
At seven-thirty Marcel dines with the Kieslers at 56 Seventh Avenue.

1960. Wednesday, Cadaqués
To realize the new nightclub spectacle, Duchamp suggests to Alain Bernadin [23.6.1960] that he buy a postcard of *Nu descendant un Escalier*, No.2 [18.3.1912] at the stand in the Louvre, and adds: "We are going to Greece in September and will be in Paris around 28 Sept[ember]. Hope to see you then."

21 July

1903. Tuesday, Caen
Ten days after sitting the written papers of the Baccalauréat in Rouen, Duchamp presents himself for the oral examination covering various subjects and selected texts of Greek, Latin and French authors. Faced with Plato's *Crito*, Duchamp is awarded 11 marks out of 20 for his explication of chapter XIV, in which Socrates shows how the Laws of his country might plead with him that more than any other Athenian he has pledged to obey them. The philosopher might have gone elsewhere but has been the most constant resident in the city; at his trial he might have chosen exile but preferred to face death with indifference; can he now break his covenant, he asks Crito, and flee like the vilest of slaves?

For the Latin text Duchamp is asked to discuss the epistle by Horace, *Ars Poetica*, which begins with the propos that "painters and poets have always had the right to venture all" – but with limits, subordinating imagination to good sense and order. In addition to stating that "all works are temporal", that "words cannot retain brilliance and lasting influence" and suggesting that "it may be necessary to represent as yet unknown ideas with new signs", the Roman poet compares a poem to a picture: "One is agreeable seen close to; another is to be looked at from afar; one requires twilight,

the other daylight, without having to dread the perception of the critic." Again Duchamp is awarded 11 out of 20.

With the French author, Duchamp fares better and achieves 13 marks out of 20. The subject is *Lettre sur les Occupations de l'Académie* written in 1714 by Bossuet's enemy, François de Salignac de la Mothe Fénelon; in addition to commenting on their projects, the letter proposes a new approach to History. Remarking on the "civil war" between the factions in the Academy, Fénelon writes: "I commence by hoping that the Moderns outshine the Ancients."

In German, Duchamp is questioned on *Lichtenstein*, a historical romance by Wilhelm Hauff set in Swabia during the early sixteenth century when Duke Ulrich of Württemberg is fighting the Swabian confederacy. Georg von Sturmfeder, a student at Tübingen fighting for the confederacy, the hero of the story, is in love with Marie, daughter of the Ritter von Lichtenstein, a fervent supporter of Ulrich; but they appear to be irrevocably separated... Out of 40, Duchamp receives 24 plus.

The subject in Geography is the Pyrenees and in History the Fronde, the civil war lasting from 1648 to 1652 in which factions of nobles sought to overthrow Anne of Austria's government and Cardinal Richelieu's successor Mazarin. In both these subjects Duchamp obtains only 2 marks out of 10.

The interrogation in Mathematics is in two parts, first, in Arithmetic and Algebra the examiners ask Duchamp to explain the standard form of a simple equation, for which he receives 14 marks out of 20; secondly, in Geometry and Cosmography he is asked to define the basis of the system of celestial coordinates, for which he is awarded his best marks, 16 out of 20.

With the addition of marks already received for written exams (the Latin unseen, 13 out of 20 and French composition, 8 out of 20), Duchamp has a total of 114 marks, thus scraping through the first part of the Baccalauréat with the mention "passable".

1919. Monday, Gravesend
After the long voyage from Buenos Aires [22.6.1919], the SS *Highland Pride* has reached the Thames estuary and is at roads like many other vessels waiting to dock in the busy port of London.

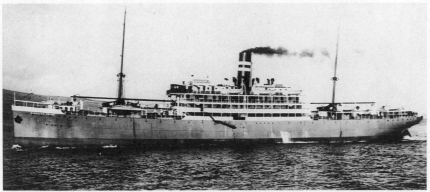
21.7.1919

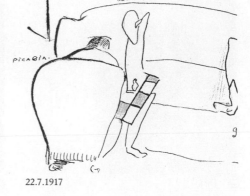
22.7.1917

1927. Thursday, Paris
After the purchase of the Brancusis [13.9.1926], the exhibitions in New York [17.11.1926] and Chicago [4.1.192], and some discussion over the documentation [18.5.1927], Totor and Roché meet at 99 Boulevard Arago and sign the agreement, dividing the sculptures between them.

1930. Monday, Hamburg
France beats Spain, taking three points in the eleventh round of the International Team Tournament, and Duchamp wins his game against Lafora.

1931. Tuesday, Prague
Not called to play against Romania in the fourteenth round, Duchamp nevertheless joins the French team to play against Poland but he loses his game against P. Frydman.

1936. Sunday, West Redding
"Perhaps you know that I have been here, for two months already," writes Duchamp to Alice Roullier in Chicago. "I am repairing my broken glass and the repairs are coming to an end." He tells her that Arensberg has invited him to California, and on 3 August "will be passing through Chicago... And if you are in town and the wait between trains is long enough," Duchamp promises, "I will telephone you." As in a week's time he will be in New York, Duchamp asks her to reply to the Carnegie Hall studio [21.4.1936].

1937. Wednesday, New York City
Following Miss Dreier's instructions a draft of 1,221 francs (3,000 francs at present values), is sent to Duchamp to pay the costs of her portfolio of lithographs [25.6.1937].

1942. Tuesday, New York City
At eight o'clock Marcel is invited by Peggy Guggenheim to dinner at Hale House with Sandy Calder and the Kieslers [7.7.1942].

*

Writing again to the Arensbergs [5.7.1942], Marcel refers to the *Boîte-en-Valise* [7.1.1941] saying: "I brought one box for you, ready except for the leather case to be made... As I put an 'original' in each box I wonder whether you would like the model-*coloriage* I made by hand of the 'nude' – or would you rather choose something else?" Asking for a rapid reply, Mar-

cel continues: "I urge you to accept it as a feeble token of gratitude until I find more ways to thank you." He tells the Arensbergs that he sells the "de luxe" boxes for $200, thus hoping to make enough to live on for a year, and adds: "Do you see anyone amongst your friends in Hollywood who would want a copy?"

1949. Thursday, New York City
Wishing to make a gift to Henri and Hélène Hoppenot in Bern of a *Boîte-en-Valise* [7.1.1941] to arrive on Christmas Day, Marcel writes to Suzanne and Jean Crotti enquiring whether their Swiss friend Claude Blancpain might arrange the special delivery if he sent it early.

1954. Wednesday, New York City
Monique Fong has written to say that since they last met a year ago [3.7.1953], she has got married. "CHAR MONICA," replies Monsieur Duchamp from his studio on 14th Street. "Many things have isolated me for a (certain!) time:
1 – marriage
2 – appendicitis (operated)
3 – pneumonia (cured)
4 – prostate (operated)
... Do you never come to N.Y.? *Feraites-moi signe*," writes Duchamp (inventing the future imperative of the verb "to do"), asking her to let him know when she will be passing by 14th Street.

1966. Thursday, Cadaqués
"Rest at last in the turbulence of Cadaqués in the month of July," writes Marcel to Robert Lebel adding that his son "Jean-Jacques was a marvellous supporter in London [17.6.1966]."

22 July

1898. Friday, Blainville-Crevon
At five in the evening, Marie Thérèse Magdeleine, their seventh child, is born to Lucie and Eugène Duchamp. Their two eldest boys are already students in Paris, Gaston interrupting his studies at the Faculté de Droit to do his military service and Raymond at the Ecole de Médecine. Nearing the end of his first year at the Lycée Corneille [1.10.1897] in Rouen, Mar-

cel is boarding at the Ecole Bossuet and only Suzanne and Yvonne are at home.

1917. Sunday, New York City
After dinner while playing chess with Picabia, Marcel and Roché learn that Gaby Picabia is to have an operation and is going to hospital the following day.

1919. Tuesday, London
From her anchorage at Gravesend, the SS *Highland Pride* enters Victoria Dock, F Jetty West, for clearance by officers of His Majesty's Customs and Excise. Disembarking from the ship after the long journey from Buenos Aires [22.6.1919], Duchamp plans to spend three days in London before returning to France. He has written to Mary Desti, who is living in London, announcing his return to Europe, and Mary has written to Yvonne Chastel [11.3.1919] urging her to come to London.

1921. Thursday, Paris
In case he is unable to be at the Gare de Saint-Lazare to meet the boat train from Le Havre, Duchamp has given Man Ray instructions to take a taxi to 22 Rue de La Condamine. If he is not at home he will leave the key of the top-floor apartment with the concierge.

However, Duchamp is at the station and he takes his American friend to the room he has reserved for him at the small hotel in Rue de Boulainvilliers, where Tristan Tzara [6.7.1921] has been living.

Duchamp then takes Man Ray to the Café Certà, Passage de l'Opéra, which is frequented by his new friends the young Dada writers and poets. It was here that Picabia introduced Duchamp to André Breton recently, and their friendship was instantaneous: "there was an immediate exchange and correspondence." In Breton's circle is Jacques Rigaut (secretary of Jacques-Emile Blanche), a "very free and easy" fellow with whom Duchamp has "a great sympathy", Louis Aragon, Paul Eluard and his wife Gala, Théodore Fraenkel and Philippe Soupault. Man Ray is surprised that there are no painters in the group.

1926. Thursday, Neuilly-sur-Seine
Duchamp meets Roché, and later at seven they are both guests of M. and Mme Jacques Doucet, 33 Rue Saint-James.

22.7.1951

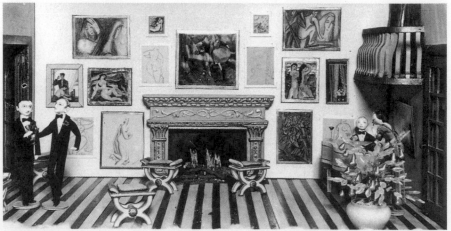

23.7.1918

1930. Tuesday, Hamburg
Playing for the French team against Hungary in the twelfth round of the International Team Tournament, Duchamp loses his game against Kornel Havasi.

1931. Wednesday, Prague
As the official delegate for France [12.5.1931], in the morning Duchamp is due to attend the open meeting of F.I.D.E. at the *hôtel de ville*. However, as the adjourned games occupy the morning sitting, Duchamp resumes his game against the Italian E. Hellman from the eighth round, which ends in a draw.

In the fifteenth round the French team (Alekhine, Gromer, Kahn and Betbeder) scores 3 points against Denmark.

1936. Wednesday, West Redding
"I'm waking up," Marcel assures Brancusi. "For 2 months I have been repairing broken glass and I am very far from my Parisian ways." He tells the sculptor that *La Colonne sans fin*, formerly belonging to John Quinn [13.9.1926], is to be installed in Miss Dreier's garden [6.9.1935].

1940. Monday, Arcachon
On the day the British reject a peace offer from the Germans, Marcel writes to Roché saying that they plan to go to Bordeaux the following day or the day after, and mentions that Peggy Guggenheim is installed with Laurence Vail in Megève with the six children.

1942. Wednesday, New York City
From the Parkers' home at 1 Gracie Square, where he has been staying since he arrived in New York [25.6.1942], Duchamp moves to Hale House, 440 East 51st Street, where Peggy Guggenheim has invited him to live while she and Max Ernst spend the summer in Massachusetts.

At Hale House there is the material to assemble 50 copies of the *Boîte-en-Valise* [7.1.1941], which was transported with Peggy's art collection from Grenoble [25.4.1941].

1947. Tuesday, New York City
Maria Martins invites Stefi Kiesler and Marcel to dine at her house.

1950. Saturday, New York City
"Janis asked me to write to you on the subject of his exhibition in which he would like to exhibit your Princess," writes Marcel to Brancusi assuring him of the gallery's reputation. His exhibitions with a retrospective interest "have always been well received".

1951. Sunday, New York City
Walter Arensberg has written to Marcel announcing the arrival [15.2.1951] of *Portrait du Dr R. Dumouchel*. Though filthy it is in excellent condition, and they are "quite bowled over" by it.

"I am so happy," replies Marcel, "that Dumouchel arrived in good health, although very dirty." He tells them that Miss Adler, who has been restoring a number of his pictures [2.5.1951], "will have no difficulty" cleaning it; the oil paint – which she already knows was by Behrendt – was recommended to him by his German friend Max Bergmann [1.3.1910].

In response to the Arensbergs' puzzlement at "the curious mit-like aura or halo about the hand", Marcel explains that although "it is a definite 1910 painting in technique, yet the 'halo' around the hand... is a sign of my subconscious preoccupation towards a metarealism. ... It has no definite meaning or explanation," he continues, "except the satisfaction of a need for the 'miraculous' that preceded the Cubist period."

After studying it alongside other paintings of the period 1910–11 in their collection, *Portrait de Joueurs d'Echecs* [15.6.1912], *Portrait de M. Duchamp père, assis* [6.5.1911] and *Peau Brune* [19.1.1915], Walter declares: "It certainly suggests a very strange relationship... It makes us feel that 1910 – taken altogether in relationship to the Chess Players of 1911 [15.6.1912] – corresponds in some way or other to a great divide."

To Walter's remark that "from the point of view of chronological sequence" it gives him the impression of "successive moves in a game of chess", Marcel says that his comparison "is absolutely right, but when will I administer checkmate or will I be mated?" he wonders...

1966. Friday, Cadaqués
On learning that Pierre Cabanne has still only received one corrected interview out of the three, Marcel is "more and more regretful", and, enclosing the fourth, repeats his suggestion of making the corrections on the proofs [19.7.1966]. He awaits the fifth...

1967. Saturday, Cadaqués
Teeny and Marcel travel across the border to the ancient walled city of Carcassonne to meet Marjorie Hubachek and her daughter Midge for lunch. In the afternoon the Hubacheks drive to Toulouse and the Duchamps return to Cadaqués.

23 July

1918. Tuesday, Bedford Hills
The Birthday series has already commenced with Mrs Stettheimer's anniversary in the extreme heat of the previous day. Duche, who spent an evening with Florine and Ettie in New York the week before, is invited today to celebrate Carrie's birthday. With him he brings a gift for her beautiful doll's house – a miniature version measuring only 9.5 by 5.5 millimetres, drawn in ink and pencil – of his famous *Nu descendant un Escalier*, No.2 [18.3.1912], to add to the collection of modern pictures hanging in the ballroom.

Ettie is perplexed by the news that Duche, that "poor little floating atom," plans to leave in August for Buenos Aires where "he has no prospects nor friends". The only reason he gives for going, according to Ettie, is that "he doesn't think he is happy here any more". Three times during the day Duche asks her to go with him... But not knowing what that expresses, Ettie tells him he may call on her if he becomes sick and penniless. She doesn't believe he would do so. "A strange boy, but a dear," she muses.

1924. Wednesday, Paris
When Marcel arrives at 14 Rue de Monttessuy, he finds Roché having tea with Mary Reynolds [3.7.1924]. The conversation becomes alternately bipartite. Roché notices that Mary has become suddenly pale, effaced and cowardly before Marcel, but notices that she is trembling with joy in his presence; Roché considers that Marcel is a perfect individualist who has no cares for the collective interest and pursues research that he believes to concern himself alone.

After a while Roché leaves them, having an appointment at Arago with another of Marcel's mistresses: Saintonge [2.7.1924].

23.7.1951

1927. Saturday, Paris
Marcel and Roché have tea at the Hôtel Bedford with Alice Roullier, who has just returned to Paris [27.5.1927].

*

Eager to see a picture of the bride, Miss Dreier has asked Man Ray for one, saying: "I feel that the greatest contribution to Modern Art in the Home is Duchamp's marriage [8.6.1927]."

In response to Miss Dreier's request, today Man Ray sends her a photograph of Mme Marcel Duchamp saying: "To tell you the truth, when Marcel told me of his getting married, it had the same effect on me as if he had told me he was going to paint Impressionist landscapes from now on. But when I met Lydie, I realized he was rather inclined to Rubens."

1928. Monday, The Hague
Before the Team Tournament of the second chess olympiad commences, the participants are invited by the Netherlands Chess Federation to a lunch at the Café Hollandais, presided over by Dr Rueb [20.7.1924], during which a representative of each team comes forward to draw the team's number. In his address the president mentions the absence of the Hamilton-Russell Cup which, due to the unresolved question of amateur status, cannot be offered to the winning team this year.
After lunch the teams gather in the historic Ridderzaal of the Binnenhof, where each table is decorated with the appropriate national flags and each ashtray, in the form of a turreted open box, contains a selection of cigars and cigarettes. In the first round France plays Switzerland, and Duchamp's long game against E. Voellmy is adjourned. In the second round France has a bye.

1930. Wednesday, Hamburg
In the thirteenth round of the International Team Tournament, France is beaten by Iceland and Duchamp resigns his game against Gutmundsson.

1931. Thursday, Prague
In the afternoon the burgomaster holds a reception in the *hôtel de ville* for all those participating in the Prague Chess Congress.

1936. Thursday, West Redding
From The Haven, Miss Dreier takes Duchamp to spend the day with her brother Edward and his wife Ethel. They learn that John Dreier wants to set up a goat farm, an idea that greatly amuses them because Duchamp has a Swedish friend in Washington, Connecticut, who started one.

1942. Thursday, New York City
Together with the sculptor Ossip Zadkine and Robert Locher, Florine's *compère* in her most recent picture *Cathedrals of Art*, Duche is invited by the sisters to a small dinner party to celebrate Carrie's birthday. After cocktails and appetizers, the guests are treated to clam cocktails followed by a main course of rice and liver-stuffed squabs, French peas and salad, accompanied with champagne; as a dessert, there is vanilla ice-cream with raspberries and *petits fours*.
After dinner several other guests arrive, and the birthday cake is served with wine and fruit-cup.

1951. Monday, New York City
Making an evening expedition to Garden City, Long Island, at six-thirty with Mr Kelly, Duchamp goes to see the condition of the mural painted in 1905 by Miss Dreier in the chapel at St Paul's School. Afterwards they have dinner together with Mr Kelly's family at the Garden City Hotel before returning to New York.
Upon his return to the studio at ten-thirty, Marcel reports in a letter to Miss Dreier that there seems to be no damage, but the mural needs a serious cleaning and he advises varnishing it for preservation purposes. Mr Kelly is willing to go on with the work and they can talk about details when Marcel goes to Milford on 28 July.
"The difference between the angel of night and the angel of day is still very marked," remarks Marcel. "I must also add that the chapel is not so gold and shine as the photos show it and that your painting brings an aura of peace to the room."

1958. Wednesday, Sainte-Maxime
The first week at Kermoune has been "hectic every hour". Teeny, who has managed to swim every day, tells Jackie: "Suzanne is much more social than we are… The Copleys live the other side of St Tropez so we've been there a lot, it's much more country over there and it's beautiful." Today Teeny and Marcel go to Nice.

1961. Sunday, Cadaqués
Having just received word from Lefebvre-Foinet that he is sending two *Valises* to her respective sisters, "one this week and one next week," Duchamp sends the news to Rose Fried [19.2.1961]. "I hope they will be properly packed this time," he writes, "and that you won't have to go through Keating."

1962. Monday, Cadaqués
With Teeny and a friend Marcel makes a day's expedition across the border to Perpignan with three pieces of baggage (including a box of cigars for himself) weighing 16 kilos, which they take to Laurens Transports for delivery to Paris by road. Marcel writes a card to Bernard Monnier from the Brasserie de la Loge, saying: "Will you give instructions then to the concierge to pay the cash on delivery which I preferred (as guarantee)."

1964. Thursday, Paris
While Duchamp is in Cadaqués, the interview he gave to Otto Hahn is published in *L'Express* with the subtitle: "Why a painter, that the Americans hold equal to Picasso, has not painted for forty years." Despite his reputation across the Atlantic, comments Hahn, Duchamp remains misunderstood in France and his *nihilisme d'affirmation* has hardly influenced the Ecole de Paris. Duchamp doesn't propose

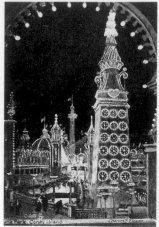
24.7.1915

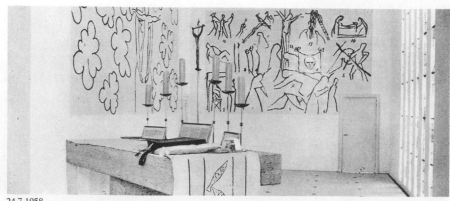
24.7.1958

a style of painting but an attitude of mind. Believing that painters don't have to die at their easel because generals don't die on the battlefield, Duchamp divides his time between Paris, New York and Cadaqués, leading the life of an Oculist Witness.

Why this renunciation, enquires Hahn, after such international success?

"It's that I have never lived as a painter-artisan who does so many paintings a year and who sells them at such a price... I didn't want to repeat myself; so I severed myself from the professional life of painters. But it is also because I am not an artist to that extent. There are other ways to live."

You refuse to repeat yourself, but would you accept, like Vasarély, having your works produced in thousands of copies?

"No. That a limited edition of eight copies is made, as for my readymades... that, yes... It's rarity which confers the artistic certificate."

How did you come to choose an object made in mass production to create a work of art?

"The readymade is the consequence of the refusal which made me say: There are so many people who make pictures with their hands, that one should end up not using the hand."

How did you make your choice of readymades?

"That depended on the object. My fountain-urinal [9.4.1917] started with the idea of playing an exercise on the question of taste: choose an object that has the least chance of being liked. There are very few people who find a urinal marvellous... But one can make people swallow anything: that's what happened. Yet I drew people's attention to the fact that art is a mirage. A mirage, exactly like in the desert, the oasis which appears. It's beautiful until one dies of thirst, obviously. But one doesn't die of thirst in the domain of art. The mirage is substantial."

What difference do you make between art and crazes?

"Taste is temporary, it's fashion. But what we consider as an aesthetic form is relieved of taste. We wait then fifty years and fashion disappears. The things then acquire a meaning. In the end it's a dirty trick: another form of taste. What it wasn't at the time, it becomes later. If one is logical, one doubts the history of art."

You don't believe it?

"The public is victim of a really staggering plot. The critics speak of 'the truth of art' as one says 'the truth of religion'. People follow like sheep... Me, I don't accept, it doesn't exist... Besides, I believe in nothing because to believe gives rise to a mirage."

Would you wish, for the sake of truth, a world rid of the mirage, a society without art?

"No. I only said that art was a mirage. A mirage very pretty to live with, but a mirage all the same. I find that it doesn't exist, but I did not say that it was bad."

When one reads the interpretations that critics give to your work, one has the impression sometimes that they embroider on your intentions?

"There is a great imaginative content in my works. *La Mariée mise à nu par ses Célibataires, même* [5.2.1923] is overflowing with imagination. Each element of the picture refers to an idea. Each time I had an idea I noted it on paper, I let it simmer. Like that for eight years... It should have been accompanied by a catalogue, like the one of 'Armes et Cycles de Saint-Etienne', with explanatory description of every detail. But I did not do it and my Green Box [16.10.1934] is only a summary."

What does "même" mean in your title *La Mariée mise à nu par ses Célibataires, même*?

"*Même* doesn't refer to anything. It has a sense of poetic affirmation. As Breton says, humour of affirmation. Neither denigration nor a joke, but humour which amplifies. Somewhat the 'Ha ha' of Jarry."

You like games with language?

"Language is an error of humanity. Between two beings in love, language is not what is the most profound. The word is a very worn pebble which applies to thirty-six nuances of affectivity... Language is useful to simplify, but it is a method of locomotion that I detest. That's why I like painting: an affectivity which is addressed to another. The exchange is made with the eyes."

None the less, with the pseudonym Rrose Sélavy, you were interested in language?

"It was to amuse myself. I have a very great respect for humour, it's a protection which allows one to pass through all the mirrors. One can survive, even success."

How do you envisage the evolution of art?

"I envisage nothing. I am only a man who

looks and who likes novelty. It's for that that I am quite a supporter of Pop Art... To make the public swallow that, that's what delights me. Remark, one cannot get it swallowed without there being anything underneath, otherwise it would be thrown up in fifteen days."

What must there be behind novelty?

"In order for an idea to be transformed into an act, it needs an irrefutable reflection, a whole mental attitude, in a word: an idea..."

Are you against informal abstraction?

"Not at all. I am against the attitude which consists of reducing painting to a retinal emotion. Since Courbet, it is believed that painting is addressed to the retina: the retinal titillation. Previously painting had quite other functions. It could be religious, philosophical, moral... Painting was a bridge which permitted access to something else. Fra Angelico did not take himself to be an artist, he didn't make art. He took himself to be an artisan who worked for God. It was later that art was discovered in his work."

Do you think the present craze for art is a good thing, and that it is good to open official museums to the revolt of young painters?

"If genius succeeds too quickly, it is finished. There are fifty geniuses today, but almost all of them are going to throw their genius in the dustbin. In order for a fellow to go through life without letting himself be devoured, he must pass plenty of traps. Geniuses are two a penny, but they are swallowed up, commit suicide or are transformed into show-offs on the boards. But all that is but an illusion, a reflection. Let's be content with the beauty of the mirage, since that's all there is."

24 July

1900. Tuesday, Levallois-Perret
At eleven o'clock Marcel's godmother [7.7.1888] Julia Pillore is married in a civil ceremony at the *mairie* to the painter Paulin Bertrand, member of the Société des Artistes Français. The bride's witnesses are Eugène Duchamp and the painter Charles Chocarne-Moreau; Paulin's witnesses are his brother Simon (who is an architect) and Louis Antoine Vigouroux.

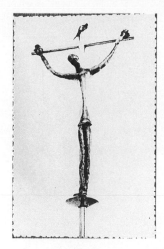

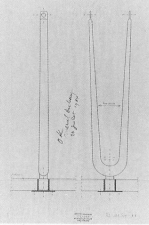

24.7.1964

After studying medicine, Julia has taken after her father, Léon de Saint-Valéry (alias Léon Pillore), and become a lady of letters.

1915. Saturday, New York City
Duchamp has already met, very briefly, the art collector John Quinn at his home, 58 Central Park West. One of the forces behind the Armory Show [17.2.1913], the lawyer was also instrumental in bringing about the crucial reform of the American tariff laws by promoting the repeal in 1913 of the existing laws that had required import duties on works of art, thus clearing the way for the duty-free import of modern art.

Following his telephone call to Duchamp that morning, in the afternoon at four Quinn takes Duchamp to Coney Island with the art critic of the *Evening Sun*, Frederick James Gregg, the painter Walt Kuhn, and a young lady.

Although not a word of French is spoken, Duchamp has a "very amusing evening: Luna

Park, Steeple Chase, dinner at Feltman, return by car", and his regard for the lawyer increases.

Amid the general conversation, Quinn voices his fears that the war may cause the death of Cubism, and questions generally the future of European art. Duchamp vows, as soon as his English improves: "to get him to discard this 'political' vision of art".

He tells Pach later: "I will endeavour to thoroughly explain to him our ideas which are outside all influence of environment or

period – up to a certain point, obviously. It could be profitable for him and for me to shake up these two points of view in the same basket."

1928. Tuesday, The Hague
Duchamp draws his adjourned game against Voellmy of Switzerland and then, in the third round of the Team Tournament, draws his game against H. Wagner of Germany.

1931. Friday, Prague
In the seventeenth round of the Team Tournament, France plays Hungary and Duchamp loses his game against K. Sterk.

1950. Monday, New York City
Following his visit to Milford earlier in the day, Duchamp replies on behalf of Miss Dreier to Duncan Phillips' letter [14.7.1950] regarding her picture by Juan Gris, *Still Life with Newspaper*. "[Miss Dreier] would rather have this painting in your collection than elsewhere," Duchamp tells Phillips, "for she feels that it would be appreciated."

With his agreement, Miss Dreier would like to lend him the painting which, Duchamp says, "would give you time to study it carefully and decide whether it belongs to your collection."

1954. Saturday, New York City
"As you anticipated it, the operation [24.6.1954] went smoothly," Duchamp tells Mary Dreier. "I must say that doctors today help the patient to ignore pain and this is certainly a great blessing. Nature does the rest."

1958. Thursday, Vence
From Nice, where they have stayed overnight, Teeny and Marcel travel the short distance into the hills to Vence, where they go to visit the Chapelle du Rosaire decorated by Henri Matisse.

Before returning to Sainte-Maxime, Marcel writes to Dumouchel on a card illustrated with Matisse's crucifix: "Take a bus and come to see Vence, it's worth it."

1964. Friday, Cadaqués
Duchamp signs and dates the blueprint for the Galleria Schwarz edition of *Roue de Bicyclette* [15.1.1916].

25 July

1900. Wednesday, Levallois-Perret
Following the civil ceremony the previous day, Julia Pillore is married to Paulin Bertrand at the church of Saint-Justin de Levallois-Perret by M. Bardinal, the parish priest.

1928. Wednesday, The Hague
In the morning France plays the United States in the fourth round of the Team Tournament and Duchamp loses his game against S. Factor. In the fifth round, which is played in the evening, Duchamp's game against W. Petrow of Latvia is adjourned.

1930. Friday, Hamburg
France is beaten by Poland in the fifteenth round of the Team Tournament and Duchamp loses his game against Przepiorka.

In the evening all the participants in the Chess Olympiad are invited by the Hamburg Senate to a reception at the town hall. In his address M. Ross, the mayor of Hamburg, welcomes the players and emphasizes the cultural importance of chess.

1931. Saturday, Prague
Duchamp plays for France against Czechoslovakia in the eighteenth and final round, and loses his game against K. Skalicka.

1942. Saturday, New York City
"...Some news from this country which, like Switzerland, has no knowledge of restrictions," writes Duchamp to Jules Bublin, Roché's banking friend in Geneva. Undoubtedly destined for Roché, the news is that while Peggy Guggenheim is in Cape Cod with Max Ernst she has lent him her house in Beekman Place [22.7.1942], "spacious and ideal for the summer"; the fabrication of 50 Boîtes-en-Valise is getting under way; he will not be going to California, but Arensberg may come to New York or Boston and Peggy's museum is due to open in October...

1958. Friday, Sainte-Maxime
At five in the afternoon, before leaving for

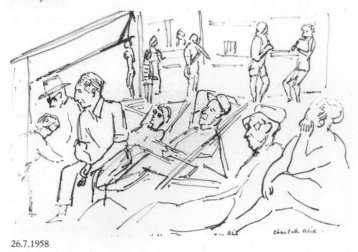

26.7.1958

Sanary, Duchamp sends a telegram to Michel Sanouillet at Châteauneuf-de-Mazenc, inviting him to lunch at the Villa Kermoune on either Monday or Tuesday. In his country house, some fifteen kilometres east of Montélimar, Sanouillet is editing Duchamp's writings, which are to be published by Erik Losfeld in Paris.

26 July

1916. Wednesday, New York City
In the evening Duchamp delivers to John Quinn's apartment, 58 Central Park West, three paintings by Jacques Villon, *Portrait de J. B. peintre* (which represents the artist's brother-in-law Jacques Bon), *Acrobate* and *Portrait de femme*.

1920. Monday, New York City
It is four months since they last met. Learning that she is unhappy and hard up, Marcel telephones Beatrice Wood and invites her to dine at the Brevoort. Their conversation deliberately avoids Bea's disastrous marriage [12.6.1918] and after dinner they walk to Washington Square to watch a chess tournament in progress.

Having accompanied her home to the house where Elizabeth Hapgood's mother has lent her an apartment, Marcel hands Bea an envelope saying firmly: "Read this when you are alone in your room. Do not open it in front of anyone," and, deaf to her protestations, embraces her and walks quickly away.

Bea is puzzled by these instructions and wonders, fleetingly, whether it might be a proposal of marriage. In her room, she opens the envelope and discovers that Marcel, himself living on a shoestring, has given her fifty dollars.

1923. Thursday, Rouen
While visiting his parents, Marcel writes a long letter to Ettie Stettheimer who, remembering his birthday, has sent him a handkerchief. Marcel confesses his shame at failing to cable her some Brussels lace in return, but he was convinced that he would see her disembark with Henry McBride when the critic arrived in France at the beginning of July. McBride, who sails any day now, will surely relate to Ettie, on his return, the superb dinner they enjoyed at Brancusi's, the

exquisite sauce for the rabbit concocted by the sculptor himself, not forgetting the "séance Dada" (attended by McBride but not Duchamp) which caused such a stir on 6 July.

While in Brussels [21.2.1923], Marcel has spent many hours at the chessboard, gaining him a high rating among the best Belgian players: "I am starting with the small nations," he declares. "Maybe one day I will decide to become French Champion, which would not be very remarkable." Now he is back and looking for a job. But Paris bores him intensely. There are so many New Yorkers in the city, Montparnasse is like Greenwich Village "with avenues wider than Sixth, even the temperature has tried imitating the thermometers of New York".

For Florine, he recounts that McBride has described the double portrait of himself and Rrose Sélavy in glowing terms and suggests, as he has been drawn to serve on the selection committee this year, that she submit a painting to the Salon d'Automne.

Duchamp remarks that he has no news from Carrie and wonders "O Carrie – like *Crito*" [21.7.1903], whereabouts she is directing the well-being of the family this summer.

He concludes by saying that he has no idea when he will return again to America, and how disappointed he is that none of the four Stettheimer ladies has come to France this year. He signs the letter, Leonardo-like, in mirror writing.

Marcel Duchamp (in mirror writing)

1928. Thursday, The Hague
In the morning Duchamp draws his game against M. Chwonjnik of Poland and later in the day wins his adjourned game against the Latvian Petrow.

1930. Saturday, Hamburg
Duchamp finds a moment on the penultimate day of the International Chess Tournament to write a postcard to Miss Dreier in New York (which is forwarded to her in West Redding), saying: "Very bad tournament, beautiful city," and promising to write soon.

1931. Sunday, Prague
The team results are announced at the banquet, final ceremony of the Congress hosted by the Czechoslovakian Chess Association. The Hamilton-Russell Cup, occupying the place of honour surrounded by flowers, has been won narrowly during the day by the United States. Led again by Dr Alekhine the World Champion, the French team for which Duchamp has been playing as a reserve during the fortnight, is placed 14 out of the 19 participating countries. Duchamp's personal score is a single win and three draws out of nine games played.

1937. Monday, Copenhagen
From the Hotel Kongen af Danmark, Marcel writes to Roché saying that he is finding his

two weeks in Denmark delightful and will be back in Paris next Monday, or thereabouts.

1940. Friday, Arcachon
Travels to Bordeaux to visit Lloyds Bank, Rue Esprit-des-Lois, in order to make enquiries regarding Lloyds in Paris.

1942. Sunday, New York City
Finding himself temporarily custodian of Hale House on Beekman Place [22.7.1942], Duchamp invites some friends to a party.

1944. Wednesday, New York City
Dee is invited to lunch with Miss Dreier at the Plaza. In the busy restaurant they both have an omelette with a roll and cream-cheese instead of butter. To follow, Miss Dreier chooses a salad and watermelon while Dee takes blueberries. With an iced coffee each, the bill comes to $4.70 without the tip, which Miss Dreier finds quite exorbitant.

1946. Friday, Paris
After again seeing Miss Baud, a passenger on

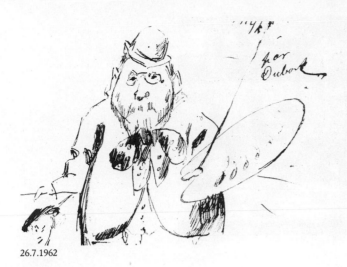

26.7.1962

the *Brazil* [9.5.1946], Duchamp writes to Virgil Thomson on behalf of Denise Morand saying that she "would like to play your works in her concerts", and adds, "I think that she would like to have your advice and some information."

1955. Tuesday, New York City
Assisting Sidney Janis with loans for his forthcoming exhibition entitled "Analytic Cubism 1910–1912", Marcel adds a note on Janis' letter to Villon, whom they would like represented by his painting *Homme lisant un journal* belonging to M. Bouret.

1958. Saturday, Sanary-sur-Mer
Taking the "log-book" of Kermoune (which they have brought from Sainte-Maxime) for everyone to sign, Suzanne, Teeny and Marcel together with Phonso and Yvonne Duvernoy travel to the ancient hill town of La Cadière-d'Azur where a family reunion has been organized.

The gathering is held on the ramparts of the town at Christian and Colette de Ginestet's house where Jacques Villon is a guest; the painter Yves Alix and his wife Charlotte join the party, increasing the variety of artistic flavours.

While on the beach of Les Lecques in the afternoon, Dr de Ginestet cannot resist making a sketch of his friends as they relax together: the Alix pair sitting on the sand; Villon in his peaked cap, Yvonne wearing dark glasses, both reclining in deck chairs; Phonso shaded by his wide straw hat, Suzanne in profile and Marcel with his pipe; in the background, the refreshment bar is not too far away.

1962. Thursday, Cadaqués
The BBC "Monitor" programme on 24 June prompted Thérèse Wilson in Scotland to write to Duchamp, who replies, after consultation with his sister Suzanne, giving the genealogy of the families.

"The sister of our grandmother Nicolle [Marie Sophie Eugénie Gallet] was your great-grandmother Madame Lelarge [Marie Estelle Gallet]." Born in Le Havre to Zélie and Jean-Baptiste Gallet, a naval officer, both sisters married artists: Emile Nicolle [15.8.1894] and Léonce Lelarge [28.6.1919]. "Your grandmother Madame Jeanne Leseigneur," explains Duchamp, "had two daughters, Renée and Léonie Leseigneur and a son Léon Leseigneur, your father."

1967. Wednesday, Christchurch
"I don't mind a bit of good clean fun in the art world – but you have to draw the line somewhere," declares Councillor P. J. Skellerup who, in defence of New Zealand morals, marks the 50th "anniversary" of *Fountain* [9.4.1917] by withdrawing it and *Prière de toucher* [7.7.1947] from the touring exhibition of the Mary Sisler Collection [13.1.1965].

27 July

1901. Saturday, Rouen
The afternoon classes at the Lycée Corneille are cancelled in order that the professors may attend the girls' prize-giving at the Lycée Jeanne d'Arc, and the boys are allowed home for the holidays. Duchamp's report reads: "Is far from what he could achieve."

1916. Thursday, New York City
Receives a telephone call in the morning from Walter Pach saying that John Quinn has decided to purchase the three Villon paintings which Duchamp delivered to him the previous evening. "I am pleased that those pictures will belong to your collection," writes Duchamp later to Quinn, "I am sure my brother will appreciate your kindness."

As Villon is mobilized, Duchamp suggests that Quinn sends the money for the pictures, which amounts to 2,850 francs, to Gaby Villon as "she is able to get the money more easily than he is on account of the war".

1924. Sunday, Paris
At noon, Marcel and Roché have arranged to see Brancusi.

1928. Friday, The Hague
To enable the participants to enjoy an evening reception at the headquarters of F.I.D.E. [20.7.1924], hosted by the Descendo Dicimus Club, the seventh and eighth rounds of the Team Tournament are played in the morning and the afternoon.

In both sessions Duchamp draws his games: first against A. Dunkelblum of Belgium and then against the Swedish player G. Stoltz.

1930. Sunday, Hamburg
In the seventeenth and final round of the International Chess Tournament, France plays Latvia. Duchamp draws his game with Petrow, whom he beat at the Hague two years ago [26.7.1928]. The tournament is finally won by Poland and in spite of the World Champion Dr Alekhine playing for their team France is placed twelfth out of the 18 participating countries. The prize-giving takes place in the evening at the banquet held in the Logenhaus, Welckerstrasse.

Playing "an average of 8 hours a day", Duchamp "could not find a minute" during the tournament to see Miss Dreier's friends. However he found the town very "agreeable to live in" and enjoyed "a very neat German hospitality".

1936. Monday, West Redding
Seventeen pounds of putty, five glass strips and silver cement are collected from Charles F. Biele & Sons, New York, and delivered to The Haven for the assembling [15.7.1936] and installation of the Large Glass [5.2.1923] in the library of Miss Dreier's house. Duchamp has two hours' help from Carl Rasmussen, the builder.

1938. Wednesday, Paris
Dee thanks Miss Dreier for her birthday letter from West Redding. The letters containing their reactions [14.7.1938] to Mr Coates' photographs of the Large Glass have crossed in the post and Dee, therefore, repeats his enthusiasm for them. He is already working on the miniature cellophane reproduction of the Large Glass for his album, which will take two or three months, and promises to send her the results as the work progresses.

In reply to Miss Dreier's question about riches and poverty, and who, of the two of them, has the most in relation to their present responsibilities, Dee insists on reimbursing half of the photographer's account, preferring to send her the money in September, but offering to send it straight away if necessary.

Endeavouring to help Miss Dreier come to terms with her "spending problem", or as she herself expresses it, her attempts "to solve and understand the question of supply", Dee submits that there should be a great distinction between spending and giving. "Often (not always) spending is giving to yourself. Giving is generally meant for others: one gives to others." If Miss Dreier were to analyse her reasons for spending,

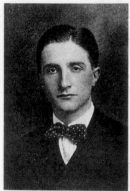

28.7.1915

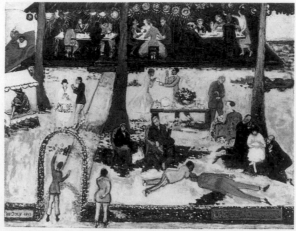

28.7.1917

Dee argues, and the spending were to gratify her own needs or desires, as a counterbalance he suggests: "Introduce then the martyr idea; suffering from not acquiring the needed, the desired. How much the martyr is unbearable."

1963. Saturday, Cadaqués
Enclosing with his letter a list of the objects and books formerly belonging to Mary Reynolds [30.9.1950] which are to be sent by Elizabeth Humes to the Art Institute of Chicago, Marcel impresses on the Baruchellos, who are assisting with the operation [6.7.1963], the importance of finding a first-class transporter to ensure that the shipment is packed properly in several cases and arrives safely. As Brookes Hubachek is prepared to spare no expense, Marcel suggests that the shipment might be sent "in bond" so that it goes straight to the Institute where it would be opened in the presence of customs and a curator, "this to avoid the repacking by unscrupulous customs staff."

1967. Thursday, Frankfurt-am-Main
On the eve of his 80th birthday, the *Frankfurter Allgemeine Zeitung* publishes an interview accorded recently by Duchamp to Werner Spies.

28 July

1887. Thursday, Blainville-Crevon
Following the rainstorm during the night, the day dawns fine and dry. By midday it is hot and, in the light southerly breeze, billowing clouds drift across the sky. In the heart of the Norman village, opposite the parish church, is the *notaire's* house, a pleasant eighteenth-century building situated at the edge of the meadows watered by the River Crevon. Here at home, as the clock in the church tower strikes two, Lucie, wife of the *notaire* Eugène Duchamp, gives birth to her third son whom they name Henri Robert Marcel.

From his father, Marcel receives a heritage rooted in the Auvergne and an orderly, analytical mind; from his mother a most respectable Norman ancestry and artistic sensibilities. Justin Isidore, known as Eugène, was born in Massiac in 1848, the youngest son of a café

owner, Jean Duchamp and his wife Catherine, whose distinctive and handsome profile Marcel inherits. Starting his career in the Administration, in April 1874 shortly after his father's death, Eugène moved from his post at Ganges (Hérault) to the Register Office in Damville (Eure) and, it would appear, within a short time he won the heart of Mademoiselle Lucie Nicolle, whom he married in Rouen on 15 September the same year.

Marie Caroline Lucie was born in Rouen in 1856; she inherited a love of drawing and painting from both her parents Emile and Sophie Nicolle. Also from her mother (who died when Lucie was only ten) she became wealthy in her own right with a share of the Gallet-Pillore fortune, providing her with a rich dowry on her marriage to Eugène. Two of the Gallet ancestors based in Le Havre were sea captains, one of whom, Jean-Baptiste (Marcel's great-grandfather), was decorated for escaping from an English prison during the Napoleonic war. The Pillores, who were settled in Rouen and eminent in the fields of medicine, magistrature and the arts, were related by marriage to the Comtes de Brihon, whose Château de la Viézaire at Saint-Gilles-de-Crétot was a favourite subject in the sketchbooks of Marcel's maternal grandmother.

With the safe arrival of a son, joy replaces the grief suffered at the death of their infant daughter Madeleine the previous December.

At five o'clock, Eugène Duchamp, accompanied by the retired bailiff Edouard Papillon and the retired *notaire* François de Saint-Requier, goes to the *mairie*, which is across the green from the market place. The mayor, Ferdinand Richard, instructs his deputy to inscribe the details of the birth in the register to which the gentlemen then put their signatures.

1900. Saturday, Rouen
At midday, everyone in Rouen of importance in the armed forces, magistrature, letters, sci-

ences and arts, public administration, commerce and industry is gathered in the traditional courtyard setting of the Lycée Corneille for the annual prize-giving, which is presided over by General Gallimard.

The main speaker this year is M. Rancés, professor of English, who treats his subject, "The Ideal Lycée", in a literary style tempered with touches of irony and humour, pleasing the reformists in the audience. M. Rancés starts by comparing the "jails" of education portrayed by Montaigne with the "palaces" built for today's pupils and then describes the Lycée of his dreams where the pupils and their masters enjoy complete harmony and a new syllabus creates engineers and poets who understand and speak each others language. Finally, addressing the leavers, the professor advises: "leave our moribund century with its hesitations and weaknesses, and prepare yourselves joyously, resolutely and vigorously to welcome the dawn of this new century."

The applause stretches as far as the pupils on the tiers and continues warmly until the General rises in turn to speak. Eventually, the moment for which everyone is waiting: M. Genevray, the vice-principal of the school, reads the honours list. In the Fourth Form, Division Two, Duchamp and Tribout both receive honourable mentions for Mathematics; in addition, Tribout takes second prize for Latin Unseen and has mentions for Latin Prose, Greek, Recitation and German.

At the end of the long ceremony, Duchamp is freed to enjoy his thirteenth birthday.

1903. Tuesday, Blainville-Crevon
On his sixteenth birthday Marcel posts a card illustrated with a view of the majestic gothic church of Saint-Ouen and its Portail des Marmousets to his classmate Ferdinand Tribout at 37 Rue Saint Nicolas, the address of his father's renowned music shop situated in the centre of the Norman capital, between Saint-Ouen and the great cathedral.

Although he hopes they will meet at the school prize-giving on Friday, Marcel invites Tribout to spend the day with him in the country on Saturday. He gives his friend very precise instructions, suggesting that he catch the 8:40 a.m. train (Chemin de Fer du Nord) from the station Rouen-Martainville arriving at Morgny half an hour later. From Morgny there

is an omnibus for Blainville, but Duchamp warns there are two at the station and Tribout must be sure to take the right one. Marcel proposes to wait for him at Blainville, which is the first stop, half an hour's ride in the horse-drawn vehicle from Morgny. "You will be in Blainville at a quarter to ten. Bring your bike if you have it and if it's fine."

1908. Tuesday, Veules-les-Roses
Marcel chooses a picturesque view of the path by the watercress beds at this small seaside village to send to his friend Louis Langlois at the insurance company where he works in Paris. In a lazy scrawl, he apologizes for not having written sooner: "One is so idle by the sea!!!" The whole band of Marcel's friends, like swallows, have returned. The holidays are full of promise.

"I am enjoying myself very much here – Painting, tennis, casino. It's a good life," writes Marcel who, celebrating his twenty-first birthday, has come of age.

1915. Wednesday, New York City
On his 28th birthday, six weeks after his arrival [15.6.1915], Duchamp writes in French to Walter Pach with details of what he has been doing. After asking him whether he has received the parcel containing the palette and whether his portrait photograph taken by Pach's father is for *Vanity Fair* or for himself, Duchamp reports on his outing with John Quinn the previous Saturday. "Of course, not a word about you," he assures Pach, "Discretion – not a word about Davies... Indeed," reflects Duchamp, "Quinn could be a support of friendliness for me." In conclusion, Duchamp adds: "I am still working, very pleased, will write to you soon in English."

1917. Saturday, Tarrytown
It was Ettie's idea: a birthday party for Marcel at their summer residence, André Brook [24.10.1916]. Until the last moment, it is uncertain who will come and whether the temperature will be bearable, but it is a perfect day: "cool and sunny and, at night, windless and moony." With the Stettheimer sisters' customary careful preparations and their special gifts for both visual and tasty feasts, the fête is a "series of pretty pictures" and a great success.

TABLEAU I: The afternoon. The guests are arranged on the lawn under the shady maple trees. Duchamp arrives later than anyone else,

driven at speed from Manhattan by the ebullient Francis Picabia in his dashing red sports car. The three sisters, dressed in virginal white, pamper their guests: Carrie pours tea for the suave Marquis de Buenavista; Florine floats across the lawn, disengaging herself from the "very talkative, serious" Albert Gleizes to welcome Marcel and his companion as they make their entrance through the floral arch into the garden; Ettie, seated "sur l'herbe" at the foot of a maple, reads *Emotion* to the sombre suited Leo Stein kneeling at her feet and to Henri Pierre Roché, his tall frame spread-eagle on the grass.

Avery Hopwood stirs his tea, listening attentively to the unmistakably "European and feminine" Juliette Gleizes while Carl van Vechten, in a green suit just a shade darker than the wicker chair in which he is lounging, chats to Elizabeth Duncan [29.10.1916] seated by his side. The dazzling Fania Marinoff, in royal blue with a wide-brimmed black straw hat, is curled up on the covered swing and is joined by Marcel who takes the place next to her. Picabia, that *enfant terrible*, sporting a buttercup yellow jacket, throws his portly frame full length on the ground and no doubt distracts Roché from Ettie's readings.

TABLEAU II: The evening. Three tables are set for dinner on the terrace which is hung with blue, green and yellow Japanese lanterns. Folded cards prepared by Marcel identify the place for each guest when viewed against the light.

Marcel is seated at the top of his "table of painters" with Fania on his left, Florine on his right; Gleizes is next to Florine and Picabia is opposite Gleizes. At the little round table in the middle, Carrie is facing Mme Gleizes, with Buenavista on her left and Carlo on her right. Ettie is at the head of her table, flanked by Roché and Hopwood, who in turn are seated next to Leo Stein and Elizabeth Duncan.

There is "quite an atmosphere": some find it very French, others Italian. Then, in the flickering light from the hanging lanterns and the candles on the tables, Ettie rises dramatically and

raises her glass to Marcel at the other end of the terrace. Picabia and Gleizes are too deep in conversation to pay heed, but Leo Stein turns in his chair and adjusts his black hearing trumpet, the better to hear Ettie's toast. Marcel stands to respond and Fania claps her hands with joy.

These two tableaux will soon become united on one canvas. For Florine, the day is a "classic" and she has in mind to call it *La Fête à Duchamp*.

1918. Sunday, West Redding
At Miss Dreier's recently acquired farm, III Roses, Marcel has a "private party, so to speak, which saves any comparison with the magnificence of last year" and receives a pipe for his birthday.

1921. Thursday, Puteaux
It is a scorchingly hot day. Duchamp and Villon are quietly playing chess when Henri Pierre Roché, John Quinn and Mrs Foster arrive at 7 Rue Lemaître. In the studio, the visitors are particularly drawn to *Le Cheval* by Duchamp-Villon (from which Quinn commissions a bronze), and the bicycle wheel upon which Duchamp fixes his drawings of spirals in order to film them in rotation with Rrose Sélavy's camera [20.10.1920].

1924. Monday, New York City
In the morning John Quinn dies at the age of fifty-five. A key figure in the defence of modern art [24.7.1915] and in his time the greatest American collector of contemporary French art, Quinn commissioned Henri Pierre Roché in 1919 to help him acquire "works of museum rank", which include many masterpieces by Cézanne, Matisse, Picasso, Rousseau and Seurat. There are also 27 sculptures by Brancusi in his collection. When Roché, in Paris, receives Jeanne Foster's cable informing him of Quinn's death he immediately sends the news to Brancusi in Saint-Raphaël. As the sculptor has no official dealer, steps will have to be taken to protect the pieces from the disastrous eventuality of being auctioned wholesale.

On his death, John Quinn also owned three Duchamps: *La Partie d'Echecs* [1.10.1910], *A propos de jeune Sœur* [8.3.1915] and *Peau brune* [19.1.1915], which were purchased from the Carroll Galleries prior to Duchamp's arrival in America.

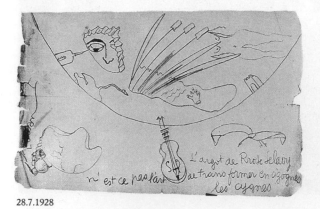

28.7.1928

1928. Saturday, The Hague
Today Duchamp has a rest from the second chess olympiad, whose hospitable organizers offer the players either a visit to Amsterdam to attend the opening of the Olympic Games, or the more popular choice of a trip via Leiden along the famous canals and across the meers.

*

Publication in Paris of André Breton's tale *Nadja*, which describes "the most prominent episodes of his life... introducing him to an almost forbidden world, the one of sudden comparisons, of petrifying coincidences, of each individual's own reflexes, of chords struck as on a piano, of flashes making one see, but *see...*"

One such episode is an evening in Breton's studio above the Cabaret du Ciel when Desnos, in transatlantic telepathy with Rrose Sélavy [1.12.1922], sleeps but at the same time writes and speaks:
"And Desnos continues to see what I do not see, what I see only gradually as he shows it to me. He borrows the personality of the most rare man alive, the most indefinable, the most deceptive, the author of *Cimetière des Uniformes et Livrées*, Marcel Duchamp. He has never seen him in reality... Who has not seen his pencil put these astonishing poetic equations to paper, without the slightest hesitation and with prodigious speed, and not been assured like me that they could not have been prepared earlier..."

1930. Monday, The Hague
His chess tournament in Hamburg finished, Marcel has made a special stop in the Dutch capital on his way back to Paris in order to see Beatrice Wood who has come from America to attend the Krishnamurti meetings in Holland. Marcel waits all day in vain.

1936. Tuesday, West Redding
In the morning, Carl Rasmussen brings his men Batsford, Platt and Hendriekson to The Haven for the day to install the Large Glass in the library supervised by Dee. After two months' painstaking work, cementing key pieces and leaving the others to be held by gravity, Dee's birthday is a cause for double celebration: Miss Dreier marks the occasion with a gift of a wristwatch and (with apologies to Lewis Carroll) writes him a poem:

The time has come, the Walrus said
To know the Time of the Day.
But how can this be done, good Sir
When you no watch display.

Ah wait a bit, the Walrus said
With all this sand at hand
A watch should not be hard to find
And, Sir, that would be grand!

They talked a bit; they walked a bit;
Then heard, a loud – tick-tack!
The Walrus picked it up and said
We now can turn right back.

1942. Tuesday, New York City
On a very hot, thundery day, Dee meets Miss Dreier at the Plaza, they have lunch together in the air-conditioned Persia Room and afterwards go to see Peggy Guggenheim's collection at Hale House. During a tremendous cloudburst, the telephone rings: it is Joseph Cornell, astonished to hear Duchamp's voice. Finding the telephone call "one of the most delightful and strangest experiences" he has ever had, Cornell invites Duchamp to visit him on Friday.

*

Marcel spends the evening at the Kieslers' with the two composers Virgil Thomson and John Cage.

1951. Saturday, Milford
Invited by Miss Dreier to celebrate his sixty-fourth birthday with her at home, Dee catches the twelve-thirty train from New York to Milford. During the afternoon, they discuss the condition of Miss Dreier's mural in the school chapel at Garden City [23.7.1951] and Dee agrees to obtain George Of's opinion regarding its restoration without delay.

1956. Saturday, Peterboro
Duchamp acknowledges the photographs of *Nu descendant un Escalier*, No.1 [18.3.1912] and *Why not Sneeze?* [11.5.1935], which he received the previous day and confirms to Henri Marceau's assistant Mrs Kane that the third photograph he requested [16.7.1956] for the "Three Brothers" catalogue should be sent to New York.
Teeny thanks Miriam Gabo for the sample, "which is absolutely the dream of Marcel's life," and says they will be returning to New York on Tuesday, "where we will remain with occasional jumps to East Hampton before we go to Minnesota for ten days."

1957. Sunday, East Hampton
Marcel is invited to celebrate his 70th birthday with Teeny at Denise and David Hare's house on Georgica Pond. David has made a massive, hermaphroditic crown of plaster into which green leaves and two cucumbers have been planted. One cucumber at the front has been split vertically and arranged to form the female genitalia, the other stands in masculine erection at the back. It is a veritable feast for the eye, with which he crowns Marcel.

1960. Thursday, Cadaqués
Broaching the question of "their" exhibition which is to take place in November, Marcel explains the limitations of the D'Arcy Galleries to Breton and says that he doesn't think that Bonnefoy is prepared to spend much on the kind of decorative effects which have been the hallmark of Surrealist exhibitions in the past. He requests Breton to write and promises to outline his ideas for the show on returning to Paris at the end of September.

1961. Friday, Cadaqués
Wishing to drop the subject, Duchamp writes to Simon Watson Taylor: "I really prefer not to insist on the syllables that I raised [11.6.1961]."

1963. Sunday, Cadaqués
The guest room is ready for Richard Hamilton, who arrives by car today to spend a week with Teeny and Marcel and prepare his lecture for Pasadena.

1964. Tuesday, Cadaqués
In reply to a request from Douglas Gorsline [9.5.1964] that he sign a bottle rack for him, Duchamp explains that as he has recently authorized an edition of replicas [4.6.1964], to protect the edition he cannot sign any more. "But signature or no signature your find has the same 'metaphysical' value as any other readymade," Duchamp assures Gorsline, "[it] even has the advantage to have *no* commercial value..."

1965. Wednesday, Cadaqués
The telegram to Duchamp from the Kestner-Gesellschaft, Hanover, reads: "Many happy returns of the day and all the best."

28.7.1936

29.7.1963

1967. Friday, Cadaqués
To celebrate, Marcel has a birthday cake which is ablaze with eighty candles.

1968. Sunday, Cadaqués
Man Ray photographs the birthday cake which is decorated with ten candles, each one representing ten years, thus assuring Marcel another nineteen years – at least.

29 July

1899. Saturday, Rouen
Today the summer holidays commence at the Lycée Corneille. "Good year on the whole," states Duchamp's school report, "his eagerness, however, has slackened a little this term."

1901. Monday, Rouen
The prize-giving at the Lycée Corneille is held in the morning instead of the afternoon when, in previous years, the suffocating heat under the heavy canvas stretched across the courtyard has been unbearable for young and old alike. Even though the ceremony commences early, at nine o'clock, there has never been such an attractive gathering of beautifully dressed ladies in the audience and the establishment is well represented by numerous dignitaries on the platform.

After the band of the 74ème Régiment d'Infanterie has played *La Marseillaise*, it falls to M. Jourdan, the professor of History [2.10.1900], to make the customary address. Developing his theme, "The spirit of travellers throughout the ages," the speaker shows how man has gradually conquered the globe: "You cannot find the reason for hatching the map of the world in green, pink or blue in trade treaties," argues the professor. In conclusion, M. Jourdan advises the boys to read the tales of travellers until Destiny chooses those who will follow in the great men's footsteps.

M. Mastier, who presides at the ceremony, then also speaks of voyages, but those which can be made in the holidays without going anywhere... Although a book such as *Voyage autour de ma Chambre* by Xavier de Maistre, he advises, can never be repeated "one can travel most agreeably across the shelves of a library", Mastier tells the boys.

Finally, the vice-principal M. Janelle reads out the honours list. Duchamp can congratulate two friends in his class: Robert Dacheux (the grandson of Saint-Requier [28.7.1887]) wins second prize for Latin Prose, and Ferdinand Tribout takes second prize for Greek Unseen and obtains honourable mentions for Latin Unseen and Latin Prose.

1918. Monday, New York City
On returning from West Redding at five o'clock, Marcel discovers to his great disappointment that he has missed the Stettheimer sisters by a few minutes and that they have returned to Bedford Hills.

Preoccupied with his forthcoming departure for Argentina, he telephones to enquire when the *Crofton Hall* will be sailing, which, he is informed, will not be before 10 August.

In the evening, Marcel writes to the "Three Friends" whom he so narrowly missed that afternoon: "Are you coming to N.Y. this week?" he enquires. "I would love to have you to dinner, or lunch according to your preference."

In case he doesn't see them in the meantime, Marcel enquires which train he should take on Saturday to Bedford Hills. Promising to bring Miss Ettie the Columbia particulars, he carefully and significantly draws a ring around the word "Miss", and signs "affectionately all three, Marcel Duche".

1922. Saturday, Sea Bright
Arrives to spend the weekend with the Stettheimers [14.7.1922].

1925. Wednesday, Rouen
While Duchamp is in Monaco [12.7.1925], Maître Maurice Pavé, the *notaire* responsible for the settlement of the Estate of the late Lucie and Eugène Duchamp, who both died earlier in the year on 29 January and 3 February respectively, issues a cheque to Duchamp for the sum of 5,000 francs [18,000 to 20,000 francs at present values], representing a payment on account of his inheritance.

*

When Roché has lunch with Jacques Doucet at his home in Neuilly, he is shown Duchamp's "tactile turning wheel" [8.11.1924] which is installed in Doucet's bedroom.

1928. Sunday, The Hague
From the United States, Duchamp receives a birthday cable from Miss Dreier with the message: "All success for the coming year."

In the ninth round of the International Team Tournament, France plays Czechoslovakia, resulting in 2 points for each country, and Duchamp draws his game against J. Schulz.

1937. Thursday, Copenhagen
Infra-mince [infra-thin] is a subject to which Duchamp has given much thought during his fortnight in Denmark, now drawing to a close. Today, he dates a short note in which he examines *infra-mince* separation: that between two forms cast in the same mould and "identicals" however identical they may seem or are. He considers that two men are not an example of identicality, on the contrary, but admits the existence of a broad concept ranging from a general classification of objects to the most identical of castings. He suggests it is more useful to look at the *infra-mince* difference between two "identicals" than to say, for example, that "two twins are alike as two peas in a pod".

1942. Wednesday, New York City
The party at the Kieslers' with Marcel, John Cage and Virgil Thomson continues until two o'clock in the morning.

1946. Monday, Paris
Mary Reynolds and Marcel set off for a holiday in Switzerland, taking the night train for Bern, which departs at ten minutes past eleven from the Gare de Lyon.

1947. Tuesday, New York City
At eight Marcel is invited to dine at Maria Martins' with Stefi Kiesler, whose husband is still in Europe. Later, Enrico Donati and Miss Eakins join the party which continues until midnight.

1951. Sunday, New York City
Makes a fruitless search for George Of's telephone number. In the evening, instead of calling him, Duchamp writes giving Of all the details regarding the proposed restoration of Miss Dreier's mural in the chapel of St Paul's School and asks him for a prompt reply.

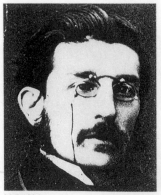

30.7.1904

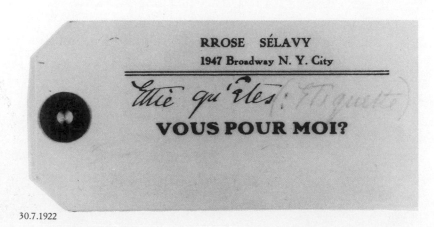

RROSE SÉLAVY
1947 Broadway N. Y. City

VOUS POUR MOI?

30.7.1922

1963. Monday, Cadaqués
While sitting in their apartment, Marcel and Teeny are photographed by Farrell Grehan.

30 July

1898. Saturday, Rouen
By noon the parents and boys are seated under canvas in the vast courtyard of the Lycée Corneille, which is decorated as usual with banners and flowers, waiting for the prize-giving to begin. Upon the arrival of General Langlois who is presiding at the ceremony, the local officials and personalities walk in procession to the platform. After *La Marseillaise* has been played by the band of the 74ème Régiment d'Infanterie, M. Roche, the young professor of Rhetoric, rises to deliver his speech.

With perfect diction and a deft turn of phrase, the professor warns the boys not to be deceived by fine phrases, to challenge labels, to beware of sophists, false leaders and false prophets. He advises them to question themselves, to remain independent and free, never to take decisions haphazardly, and never to become machines, but men of free will and warm hearts.

When General Langlois has also addressed the audience, the headmaster, M. Desfours, makes some announcements and then, punctuated by cheers from the boys on the tiers, the vice-principal reads the honours list. Completing his first year at the Lycée [1.10.1897] Duchamp has no award but his friend from the Ecole Bossuet, Ferdinand Tribout, receives no less than seven honourable mentions.

1904. Saturday, Rouen
The scene for Duchamp's last prize-giving at the Lycée Corneille is as charming as ever: under the canvas stretched across the school courtyard the floral decorations and greenery are deftly placed to hide the worst of the crumbling fabric; the velvet-draped platform, trimmed with clusters of tricoloured flags, is bedecked with a variety of uniforms, notable for their increasing scarcity, but from afar the effect is much the same. The military band, directed by M. Dupouy, plays *La Marseillaise* signalling the entrance of the professors and their principal guests.

M. Lebon, ex-mayor of Rouen, takes the seat of honour with, at his side, the headmaster, M. Desfours, and M. Lecaplain, head of Science, who has been teaching Marcel physics this year. M. Parodi, Marcel's professor of philosophy [2.10.1903] and the guest speaker, adjusts his pince-nez and reads his long speech at high speed on the dominating concept in education, that of love and respect for Truth. Those in the audience who are quick enough to catch what he says enjoy such impassioned phrases as:
"There are no bars so serried, no wall so high, nor discipline so narrow that can stop the subtle, impalpable filtration of ideas…"
"With Science, the idea of truth has appeared on our horizon of morality…"
"Neither in art, nor in philosophy do we allow 'intellectual customs examination'; we do not believe in infallible orthodoxy, nor official poetry, nor immutable kinds of Beauty or Truth…"
"It is fitting that opinions and certitudes are thrashed by all opposing winds of thought…"
"To be veracious… is to endeavour to obtain acts and men as a newly awakened intuition…"
"There is triumphant persuasion and infallible intuition…"
Parodi concludes his speech by evoking the Aryan exodus in search of enlightenment. In doing so he quotes a phrase from *Carnet d'un Solitaire*, a collection of his own poems:
"The voyage continues, tireless, and it is their sons who press on with it."

M. Lebon follows and, to everyone's dismay, has prepared two speeches: one in honour of M. Thiers, which is considered out of place; in the second he reminds his audience of his speech at the prize-giving exactly seventeen years and a day ago, pronounced when he was mayor, which causes many in the audience to wonder why the present mayor wasn't invited instead.

M. Lebon's hour is long indeed. The vice-principal, M. Frontard, eventually reads the honours list which is uncommonly subdued: the boys have been given strict instructions to restrain their cheering; instead of the habitual marching to and from the platform to collect the books one by one, the awards are made in bulk and the music is regrettably sporadic.

Notwithstanding the tediousness of the proceedings, Duchamp, Tribout and Barbazin are proud, no doubt, of their success in the Bac-

calauréat exams [7.7.1904]. In addition, Duchamp crowns this, his last ceremony at the Lycée Corneille, by carrying off the Médaille d'Excellence for Drawing, awarded by the Société des Amis des Arts. This prize lends additional weight to Duchamp's case for his future: he has made up his mind to become an artist and follow his brothers to Paris, and he needs his father's permission to do so.

1922. Sunday, Sea Bright
Born at midnight between 30 and 31 July, Ettie Stettheimer has chosen today to celebrate her birthday with Marie Sterner, Dr Pope, Phyllis Ackermann, Henry McBride, the van Vechtens and Duche, one of the guests who stayed overnight. To mark the other birthday which took place two days earlier, Ettie gives Duche and Rrose a box of pink writing paper. They reciprocate by presenting Ettie with a set of tailor-made beige card luggage tags, complete with string. Printed at the top, lengthways in small letters, is the name of the sender: *RROSE SELAVY*, and underneath, her address, *1947 Broadway N.Y. City*. Instead of the destination, *VOUS POUR MOI?* is printed in large capitals. Unhappily, *Etiquette: vous pour moi?* (or "Ettie, who are you for me?") elicits very little in Marcel's favour. Ettie thinks the label "does more credit to his thoughtfulness than his thinking power" and her response may be found in *Pensée-Cadeau: vers à un ami*, which she writes during the summer at Sea Bright.

Je voudrais être faite sur mesure
pour toi, pour toi
Mais, je suis ready-made par la nature,
pour quoi, pour quoi?
Comme je ne le sais pas j'ai fait des rectifications
Pour moi —

However much the guests appreciate their day, Ettie enjoys nothing and complains of feeling "stagnant". Not even Knopf's decision [14.7.1922] to publish her novel *Love Days*, has shaken her from her despondency. The eight "love episode crisis" in her book are based on her close friends, amongst whom Duchamp as Pierre Delaire [9.6.1921] is relegated to a minor role. Ettie, alias Henrie Waste, admits her difficulty in disguising herself as the heroine, Susanna, and is convinced that her own Hugh was only "half Hugh" and

30.7.1946

31.7.1902

never attained the "fine" side of Susanna's leading man. From the increasing isolation of her ivory tower, she sighs: "I certainly *need* a *new* batch of friends."

1926. Friday, Paris
At two in the afternoon, Totor receives a visit from Roché in his "gallery" at 82 Rue des Petits-Champs [21.6.1926], where he has installed the pictures by Picabia.

1928. Monday, The Hague
In the morning, Duchamp draws his game against D. Reca, a member of the Argentine team, which is beaten by France.

The eleventh round of the International Team Tournament is played in the evening. Duchamp plays against D. Marotti of Italy, but none of the French team complete their games which are adjourned until the following day.

1930. Wednesday, Paris
The day after his return from Hamburg and before leaving for Nice, Marcel calls at Arago and finds Roché with Alice Roullier, who is making her annual visit [27.6.1929] to France. When Marcel recounts that he waited for Beatrice all day on Monday in the Hague, Roché is not astonished that with their "confidence, abbreviations and breeziness" there has been a mistake with the date. Hoping to prevent Beatrice from waiting fruitlessly for Marcel next Monday, Roché sends her a cable.

In the evening Marcel and Roché dine together in the shadow of the Lion of Belfort, Place Denfert-Rochereau.

1936. Thursday, West Redding
Miss Dreier gives Duchamp a cheque for the sum of $109.34, reimbursing him for three invoices, those submitted by Carl Rasmussen, the Danbury Glass Company and Charles F. Biele & Sons Company, which Duchamp has paid out of his own pocket.

1946. Tuesday, Bern
The night train from Paris is due to arrive in the morning at eleven forty-two. From the station, Mary Reynolds and Marcel go to the French Ambassador's residence on Sulgeneck-strasse, where the towering wrought-iron gates open onto a spacious informal garden of lawns and trees. A gravel drive leads to the imposing Louis XIII-style mansion. The horseshoe-

shaped flight of steps to the entrance is sheltered by an astonishing glass porch, resembling some oriental headpiece of vast dimensions, structured with a radiating iron framework and supported on slender iron pillars hung with lanterns. On entering the house, the visitors find themselves in a vast hall which provides access to the comfortable, airy reception rooms on the south side of the building and the ambassador's study; a sturdy oak staircase leads to the upper floors and the walls, for the most part, are hung with modern paintings, from the Hoppenots' personal collection. Fine examples of Picasso, Léger, Braque and other twentieth-century masters indicate their discernment in the field of modern art.

Mary suggests that she and Marcel stay at a small hotel in the city, but Hélène Hoppenot has prepared the guest room on the southwest corner of the first floor for Mary and a smaller room under the mansard, with a splendid view across to the Bundeshaus and the Aare Valley, for Marcel.

As it happens, the embassy staff is almost non-existent because Tong, the manservant, who is vexed by his imminent return to China, is in bed; the butler Louis has flu; the kitchen maid Charlotte has her arm in a sling and the cook Marius has just announced that he wants to return to France in October... Mme Hoppenot remembers taking all these domestic adversities in her stride and notes in her diary: "There was no one left except Mary and Marcel who arrived!"

1952. Wednesday, New York City
Duncan Phillips has told Duchamp which seventeen works of art, including Duchamp's small glass *A regarder d'un Œil, de près, pendant presque une Heure* [4.4.1919], he proposes to accept from Miss Dreier's estate for the Phillips Gallery [22.5.1952]. As he cannot accept the whole list, Phillips suggests that the remaining 12 items be presented to the Watkins Gallery of the American University in Washington.

In reply, Duchamp tells Phillips that he will recommend the proposals to his co-executors and mentions that as "Yale University has expressed the desire to have an exhibition in memory of Miss Dreier", they hope any works which the Phillips Gallery receives will "be available for such memorial".

31 July

1899. Monday, Rouen
Commencing at one-thirty, the prize-giving this year at the Lycée Corneille is presided over by M. Marcel Cartier, mayor of Rouen, and it is M. Martin, professor of History who has the honour of making the address. Delivered with authority and well received, judging by repeated "bravos" from the audience, the theme of M. Martin's speech is that History, particularly that of the nineteenth century which, he says, "contributes to educate men, worthy of the name, real citizens, who must not be seeking a simple diploma in preparing their Baccalauréat, dispensing with all subsequent research."

The mayor recalls the days when he himself sat on the benches of the Lycée and, addressing the boys, he wisely counsels them to listen attentively to their professors whom, he assures them, will know how to make of them men of action.

1902. Thursday, Rouen
It is a grey morning without a ray of sunshine for the prize-giving ceremony at the Lycée Corneille and the colourfulness of the scene is due to the ladies' magnificent hats and dresses and to the great variety of splendid uniforms worn by the VIPs, who seem to be more numerous than ever on the platform.

M. Charlier, professor of Philosophy, tells the boys that it is not enough to learn, but to understand; to appear knowledgeable is not sufficient and one really must be informed; the manner of learning is more important than the knowledge itself and rather than basking in the approval of others, it is better to gain self-respect.

After a speech from M. Rack, the attorney general, praising the good works of the Republic in the wake of the Revolution, M. Desfours, the headmaster, makes some announcements before the reading of the honours list. Duchamp receives an honourable mention for Mathematics and his friend Tribout, next to whom Duchamp stood recently for a Second Form group photograph, obtains five mentions for his progress in Greek, Latin and German.

31.7.1924

1903. Friday, Rouen
The only radiant element missing again this year from the solemn occasion at the Lycée Corneille is the sun. The elegant, gracious audience is seated under the canvas hung across the courtyard of the school by nine o'clock sharp, the moment for the municipal band to strike up the *Marseillaise* and for the dignitaries to take their places on the platform.

M. Guillon [1.10.1901] is the main speaker. He starts his address, entitled "Geography", by describing a feeling for Nature which is very old, but at the same time very young. After its recognition in times past, it was forgotten for a very long time; it reappeared in the eighteenth century and was at its strongest in the nineteenth century. The Ancients were deeply affected by Nature because they lived close to it but, on the other hand, the Middle Ages had no experience of Nature when "the shadow of the castle [fell] heavily on the countryside". Nature reappeared with the Renaissance, disappeared with Louis XIV, when it was reviewed, corrected and embellished by Le Notre's ingenuity, to show up again, fresh and smiling, with Jean-Jacques Rousseau, Bernardin de Saint-Pierre and Chateaubriand.

"But should we really claim to know all our scenic treasures," asks M. Guillon, "when the assemblage of Montpellier-le-Vieux, the wonderful gorges of the Tarn and the limestone chasm of Padirac have only recently been discovered?

"Today there remain only a few plains in Asia and some river valleys in Africa where intrepid explorers persist in seeking rare plants, unknown fish and the Legion of Honour...

"But enough for today. It is time for the prize-giving which you have been awaiting... As for the short geography lesson which you have just heard, you will easily forgive it, knowing that it is the last."

When the audience has finished applauding the professor, the *préfet*, M. Fosse, who is presiding, outlines the history of education and states what he considers it should be under the Republic. After the headmaster M. Desfours has announced the exam results, including Duchamp's safe passage through the first part of the Baccalauréat [21.7.1903], the vice-principal M. Frontard reads out the honours list.

Towards the end, M. Frontard comes to the awards for Duchamp's classmates. Paul Barbazin receives mentions, as does Ferdinand Tribout for Latin, Greek and German, making

up for his disappointment in failing, quite unexpectedly, his oral exam ten days earlier.

There is still the prize for Drawing offered by the Société des Amis des Arts to come, for which Marcel's greatest rival is his talented friend Robert Pinchon [14.5.1903]. "Médaille d'Excellence," M. Frontard pauses, "Robert Pinchon of Rouen!" As the tall young Pinchon returns to his seat, amid cheers from his comrades on the tiers, M. Frontard announces: "First Prize, Marcel Duchamp of Blainville-Crevon!"

1924. Thursday, Paris
At one o'clock in the morning, when he comes to her room at 88 Boulevard de Port-Royal, Marcel finds that Yvonne has reserved a surprise for him: the night before she leaves for a holiday in Angoulême is to be a memorable one, and desiring to please him, she has prepared for her Prince Charming "a bouquet of three flowers".

On the sofa-bed covered with her large shawl there are three naked girls instead of one: Yvonne, his mistress with eyes of fire; Jeanne, calm, kind and balanced; Mimi, the fairest of the three, with long hands and the figure of a boy, but nervous and full of attack. They are perfumed, their hair carefully waved, and a little tipsy.

He quickly understands and delighted, until dawn proves equal to the task. Although he takes Mimi on his knees first, as Roché predicted he would, Marcel is full of tact and shows no preference. The girls cry out, almost shriek with pleasure. There are moments when all three caress him at the same time, helping him to make love to one, to another. For a long time he makes love to Jeanne, taking his pleasure with her. When he turns to Mimi he feigns his enjoyment in order to reserve himself finally for Yvonne.

Determined to have a detailed account from Totor as soon as possible, Roché goes to the Hôtel Istria early in the morning. Too early: Totor's key is still hanging at the reception desk. Not wishing to be robbed of a first-hand description, Roché hails a taxi and goes to the Gare d'Orléans. He searches for Saintonge in the station and then inspects the train, compartment after compartment. Finally he finds the girl sitting upright, in a deep sleep. He rouses her and, as there is half an hour before the train departs, steps down onto the platform with her to hear exactly what happened.

Incorrigible, Roché returns to the Hôtel Istria and finds Totor in bed, sleeping as deeply as Saintonge. "What youngsters!" he says on waking, stretching himself. "They certainly know how to make love. There were moments when I didn't know where I was, when all three were occupied with me at the same time." Amused and with his air of modesty, Totor confirms quite simply the events of the night, as described by Saintonge, and praises her tact. "Pity," he says to Roché, "that you were not there to help me."

*

After sleeping from eight o'clock until noon, Totor then has lunch with Roché at Roseline's.

1928. Tuesday, The Hague
Resuming his game from the night before, Duchamp draws against D. Marotti, which results in a win for France over Italy.

Later, in the twelfth round, Duchamp draws his game against H. Weenick, giving France a draw against Holland.

In the evening France beats Romania 3–1 and Duchamp draws his game against Dr S. Balogh.

1936. Friday, West Redding
"Duchamp is a dear," reflects Miss Dreier, whose own capacity for hard work is considerable, "but his concentration on just one subject wears me out," she complains, "leaves me limp." However the huge task of repairing the Large Glass is now satisfactorily completed, excepting a small detail to be corrected at the end of August on Dee's return from visiting the Arensbergs in Hollywood.

Keen to make an edition of her *40 Variations* and discovering that Dee "is now crazy about printing" Miss Dreier has discussed the project before his departure and Dee "thinks that he can have it done".

*

In New York, Duchamp visits George Of to report on the condition of *Odalisque* by Alice Halicka and to give Miss Dreier his opinion of her painting *Madrigal*.

1942. Friday, New York City
Following their unexpected telephone conversation on Tuesday, Duchamp is due to visit Joseph Cornell at Utopia Parkway in Flushing. Cornell is counting on the visit to provide him with "much needed inspiration" to finish the boxes he is working on.

1.8.1917

1951. Tuesday, New York City
The temperature in Duchamp's room on 14th
Street is in the nineties [over 30° centigrade],
and he writes to Miss Dreier: "Even my fans
can't take it." He thanks her very much for the
birthday party and says that he is also writing to
Mary Dreier. Regarding the proposed restora-
tion of *The Good Shepherd*, Duchamp reports
that having mislaid George Of's telephone
number, he has written to him and is awaiting
his reply before seeing Knoedler. As requested,
he went to the address which Miss Dreier gave
to him, but found no trace of any Mr Astor.

1956. Tuesday, Peterboro
From the MacDowell Colony in New Hamp-
shire, Teeny and Marcel return to Manhattan.

1958. Thursday, Sainte-Maxime
In the evening, Bill Copley, just arrived from
Paris, gives Duchamp the details of his meeting
with Erik Losfeld, who is planning to publish the
writings edited by Michel Sanouillet [25.7.1958].
As the manuscript has only recently been
submitted for his approval and he has signed
no contract with Losfeld, Duchamp believes he
will be able to arrange matters in September,
and he writes assuring Lebel who is concerned
that Sanouillet's book may have dire effects on
his own, which is being prepared with Fawcus.
In order that Fawcus has no excuse for pro-
crastination, Duchamp urges Lebel to com-
plete the texts, bibliography and *catalogue
raisonné* as soon as possible. "The most impor-
tant thing is to push Fawcus as much as possi-
ble," he advises, "I have written to him to this
effect and, in spite of everything, have accepted
the date of 22 Sept[ember] morning," which is
the day proposed for a press conference.

1 August

1887. Monday, Blainville-Crevon
With the Archbishop of Rouen's dispensation,
Father Julien, the parish priest, privately bap-
tizes the infant Marcel four days after his birth.

1917. Wednesday, Tarrytown
It is the day after Ettie Stettheimer's birthday,
and being Wednesday, it is reserved for the sis-

ters' French lesson with Duchamp. "Little
Marcel", as Ettie calls him, comes out to André
Brook for the evening, after a violent storm has
reduced the temperature from a steamy 98
degrees to 80 or 84 degrees [37°–27/29° C].
With him Marcel brings a print of his portrait
by Edward Steichen, captured recently at the
memorable party immortalized in Florine's
painting: *Sunday Afternoon in the Country*. Dif-
fused sunlight delineates Marcel's classical pro-
file against the shade of the veranda. Wearing a
white shirt and natty polka-dot bow tie, his
head is slightly bowed, with a solemn expres-
sion and penetrating gaze.

1928. Wednesday, The Hague
After the civic reception held in the afternoon
at the Raadszaal, Javastraat, to which the dele-
gates of the International Chess Federation and
all the players were invited, the fourteenth
round of the Team Tournament is played in
the evening: Denmark beats France 3–1 and
Duchamp loses to E. Anderssen.

1931. Saturday, Budapest
The orchestra is playing one of Brancusi's fa-
vourite melodies in a high key as Marcel writes
a postcard to the sculptor in Paris telling him
how much he and Mary Reynolds are enjoying
"everything Hungarian"! The signatories of the
card, Morice and Gallina, who have already
spent two of their four days in the capital,
announce their return to Paris in about ten
days.

1936. Saturday, New York City
Since arriving in Manhattan the previous day,
Duchamp has been busy: for the final adjust-
ment to the Large Glass, Biele will send two
strips of glass by express from New York to
The Haven, and he has also called on Louise
and Sandy Calder.
Recounting to Miss Dreier his visit on Friday
to George Of, Dee says that Alice Halicka's
Odalisque "is framed, but the glass broke… It
will look very nice when this double framing is
finished." After studying Miss Dreier's *Madri-
gal*, he finds that "as usual" the painting is
much better than the photograph; his only crit-
icism is that the background is "too lightly
treated" and he suggests that she "add a little
more thought to the background" so that it
harmonizes with the rest of the picture, "which
is very fine and delicate."

After two months at The Haven, Marcel is
still getting up early and "wondering subcon-
sciously why there is no glass around to clean…
Still dazed," he intends to rest on the train.

1942. Saturday, New York City
At Marcel's suggestion, Sidney Janis writes
again to the Arensbergs offering them the large
canvas, *Réseaux de Stoppages* [19.5.1914],
which belonged for many years to Joseph Stel-
la. At $1,000, the price is less than previously
offered because Janis is not intending to take
any profit or commission.
Marcel and Janis have also talked at length
about plans, already discussed with the Arens-
bergs, to bring together their collection, the
Janises' and Miss Dreier's. "[Marcel] has recent-
ly visited Miss Dreier and finds that her best
things are still in her possession," writes Janis.
"This sounds better than one was led to expect
when it was announced that the Société
Anonyme collection was given to Yale
[14.10.1941]."
Janis, who has subscribed for a *Boîte-en-Valise*
[7.1.1941], says that Marcel is busy working on
his boxes: "He is fine, looks well, although a bit
older, and is happy to be back in America."

1948. Sunday, New York City
In the *Art Digest*, Judith K. Reed reviews an
exhibition at the Chinese Gallery, 38 East 57th
Street, in which a portrait of Duchamp by
Reuben Nakian is shown. Duchamp sat for the
portrait in 1943. The sculptor, who has made
many portrait heads of his friends and other
artists, may have met Duchamp through Gas-
ton Lachaise.

1953. Saturday, New York City
While waiting for Douglas Glass, Marcel writes
to Roché at Saint-Robert in Corrèze and thanks
him for *La Nouvelle Revue Française*. He com-
pliments Roché on his text, "Souvenirs sur
Marcel Duchamp" [1.6.1953], and assures him

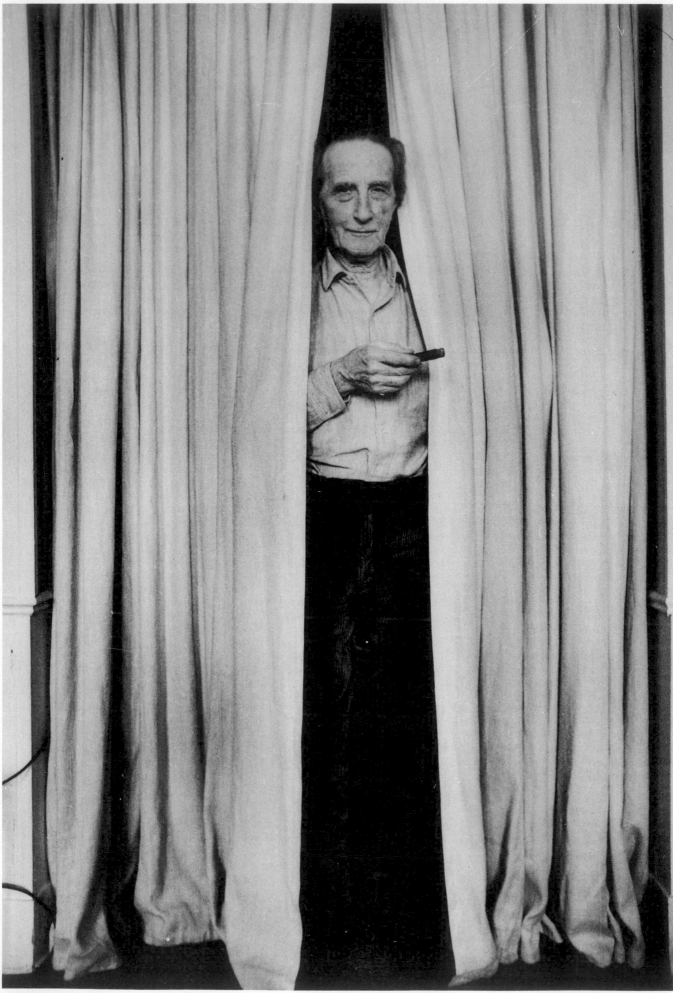

1.8.1967

2.8.1915

that the cuts made in it, due to "the meanness, not to say animosity of the gentlemen", are barely discernible; all the better, he believes, for the complete article to appear when the books by Janis and Lebel are published. After more than a year, Roché is still endeavouring to mount a Duchamp exhibition in Paris, but Marcel has reservations: he is against the word "Festival" and doesn't care for "Homage", although he considers that the latter has the advantage of being a general-purpose term; but above all, as the Philadelphia Museum will not lend, important works would be missing.

1957. Thursday, East Hampton
Following Robert Lebel's news that the photograph of the *Moulin à Café* requested from Maria Martins [4.6.1957] in Brazil is "mediocre", Marcel writes asking Maria if she would send the canvas to Paris via the diplomatic bag. Also for Lebel's book, Marcel has just finished translating *The Creative Act* [5.4.1957] into French.

1958. Friday, Sainte-Maxime
The fortnight's holiday with Suzanne Crotti is at an end. Before leaving the villa hidden in a fold of the hills above the town, Duchamp has put the fragile work entitled *Des délices de Kermoune*, a souvenir of his visit and a gift for the owners of the property, Claude and Bertrande Blancpain [21.7.1949], in a grey cardboard box and has placed it safely inside the yellow linen cupboard, leaving instructions for his sister to alert Claude Blancpain.

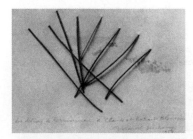

The picture is, indeed, drawn directly from the place itself: a small blue triangle of transparent watercolour evokes the gleam of water at the horizon visible from the terrace of the house, a counterpoint to the patches of dappled earth-colours suggesting the tiled roofs partially masked by the dense vegetation; conjured by its very own needles, the extremities of which pierce

the paper and are thus held firm in the characteristic outspread, upward-reaching form of the tree, an umbrella pine in the garden stands strident across the view to the sea.

From Sainte-Maxime, the Duchamps travel to the airport at Nice where Marcel, while awaiting for their flight to Barcelona via Marseilles, plans to telephone his old school friend Dr Dumouchel.

The one-and-a-half-hour flight is made in "the most beautiful weather in the world", but Barcelona is unbearably hot and they are relieved to find a breath of air in Cadaqués.

1967. Tuesday, New York City
An article published by *Vogue* entitled "The *new* New York Art Scene", draws on material from Alan Solomon's forthcoming book. The author believes that the sources of the work of Robert Rauschenberg, Jasper Johns, Jim Dine and Claes Oldenburg "were in part based on the general modern current of Dada, Surrealism and Constructivism… but most of all, probably, on the art of Marcel Duchamp, which they knew… mostly in a vague way from the illustrations in books… Only later did they discover Duchamp almost by surprise as a person living in New York among them." Solomon considers that more than a historical source, it is Duchamp's attitude which is so much in tune with the younger generation: "He does not behave like a master but instead brings a wry sense of humour to bear on himself and his surroundings."

Accompanying the article (but not included in the book) is the image of Duchamp standing before the CBS building, taken in 1965 by Ugo Mulas, the Milanese photographer. The book is to be illustrated with photographs by Mulas (taken during the same period) of Duchamp at his apartment, 14 West 10th Street, and at the Museum of Modern Art.

2 August

1915. Monday, New York City
During the summer while the Arensbergs [15.6.1915] are out of town, Marcel has been invited to stay in their apartment, 33 West 67th Street. Walter and Louise have been at Pomfret

in Connecticut, but Louise has now gone to stay with friends for a month and Walter has come back to the city for a few days before going to Pittsburgh.

Inviting Marcel to meet Wallace Stevens, Walter organizes dinner for the three of them at the Brevoort, the hotel with a café famed for its Parisian atmosphere on the corner of Fifth and 8th, one block north of Washington Square. Marcel speaks very little English, and when the three of them speak French, Stevens finds that "it sound[s] like sparrows around a pool of water". Realizing that the author and critic Carl van Vechten is sitting at a nearby table with his wife Fania, a strikingly beautiful actress, Walter is embarrassed and tells Stevens that van Vechten "bores him to death". When the couple hurry out, they pass Arensberg's table with their heads down and Walter breathes a sigh of relief.

After dinner they return to the apartment and Walter shows Stevens some of Marcel's work. Modestly, Stevens tells his wife: "I made very little out of them. But naturally, without sophistication in that direction, and with only a very rudimentary feeling about art, I expect little of myself."

1918. Friday, New York City
Of the three sisters, it is Ettie who accepts Marcel's invitation [29.7.1918] and comes to town from Bedford Hills. The rendezvous is arranged for one o'clock at Henri's Restaurant. After lunch they spend the better part of the afternoon searching the shops for a tortoiseshell ring. Finally, in a small jewellery shop on 46th Street run by an oriental who seems to know his client, having drawn blank with tortoiseshell, Marcel purchases a guard-ring, to give to Ettie.

There is an interlude while Ettie dines with her sister Stella; then Marcel bravely perseveres with his courtship, although Ettie, who is also sentimentally attracted to Elie Nadelman, persists in remaining aloof from any attachment of the heart. But for Marcel time is running out: does he try again to persuade her to sail with him to Buenos Aires [23.7.1913]? He scratches something on the ring and then offers it to the young lady who, while accepting it, rather ungraciously declares that he had better send her a decent one when he has made his fortune in South America.

*

On leave again from Washington [3.7.1918], late in the evening while he is eating ice-cream

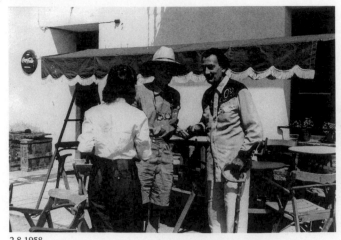

2.8.1958

3.8.1908

with Mercanton, Riesenfeld and Alissa Franc on the roof of the Astor, Roché catches sight of Totor in the street below.

1920. Monday, New York City
The Artists' Packing and Shipping Company have instructions to collect two paintings and a piece of rubber floor covering from the gallery premises of the Société Anonyme, 19 East 47th Street, for delivery to Duchamp's studio at 1947 Broadway.

The Société Anonyme opens its third exhibition of twelve paintings and a sculpture loaned by Walter Arensberg. Duchamp is represented by *A bruit secret* [23.4.1916] which the journalist from the *Evening World* describes as "a ball of wrapping twine surrounded by a metal compress. The thing is to guess what it is, in an art sense," he informs his readers, "and if you do this correctly you ought to get a prize. You deserve it at all events."

1928. Thursday, The Hague
In the fifteenth round, France beats Spain and Duchamp draws his game against T. Aguilera.

1935. Friday, Paris
Duchamp pays the balance of 150 francs [500 francs at present values] for the hire of a stand [20.5.1935] to exhibit his invention at the Concours Lépine, which opens on 30 August.

1936. Sunday, New York City
Duchamp leaves Carnegie Hall, where Daniel MacMorris, a neighbour of Miss Dreier, has started work on his portrait. He deposits the key of the studio with the man in the office at 161 West 56th Street and at Grand Central Station boards the Lake Shore Ltd. leaving at 7:15 p.m. for Chicago. (Unless he departed on the Mohawk in the morning.)

During the sitting, the portraitist quizzed Duchamp about his famous *Nu descendant un Escalier* [18.3.1912]. Duchamp denied that it is a painting in the accepted sense, a juxtaposition of two or more colours on a surface, preferring to describe it as an "organization of kinetic elements, an expression of time and space through the abstract expression of motion". To avoid juggling with a myriad of pigments, he restricted the Nude to brown tones.

When MacMorris asked what has been the greatest criticism of the Nude, Duchamp replied:

"Its designs form an arbitrary pattern which is apt to be considered for its own beauty, forgetting the message of movement it conveys… But remember, when we consider the motion of form through space in a given time, we enter the realm of geometry and mathematics, just as we do when we build a machine for that purpose… Now if I show the ascent of an aeroplane or liner plunging through the sea, I try to show what they do, not what they are. I don't make still-life pictures of them. When the vision of the Nude flashed upon me, I knew it would break for ever the enslaving chains of Naturalism. Technically it was well painted. But when I sent it to the Salon des Indépendants, they all threw a fit."

Duchamp confided that for him the Nude has grown into a kind of Frankenstein and that he has become "only a shadow figure behind the reality of this painting". This eclipse inspires MacMorris in composing the portrait: reversing the image, the artist decides to paint the figure of Duchamp strong and clear, while a detail of the Nude, in the background, remains haunting and nebulous.

1945. Thursday, Lake George
The setting of the oldest house, right at the water's edge, is an "extraordinary luxury of silence and solitude". Denis de Rougemont and

Consuelo de Saint-Exupéry are waiting at the foot of the vast wooden balcony built on stilts which, through a screen of tall pine trees, overlooks the unchanged landscape of Lake Hori-

can, the stage for Hawkeye's adventures and the death of the last of the Mohicans. They have invited their friend, but do not know when he will come. Using an old recipe with chalk on a red ground, Consuelo draws a horse's head, thin and smiling, Duchamp personified, to lure him to this enchanted place.

During the morning, their guest duly appears. Gazing across the lake – the scene undoubtedly recalls another magic place – he exclaims: "It's the Savoy!" Then: "It's also the Tyrol, or the Italian lakes. Well, it's a lake, and everything is alike."

In the late afternoon the neighbours call. They are "nice, too nice" and drink quantities of cocktails. De Rougemont observes that Marcel, "polite and charming to the point of invisibility" drinks only a thimbleful of vermouth. In a discussion after their departure, Duchamp laments that the masses cannot be educated, that they detest and are in league against free, creative individuals, while consolidating *their* reality, the material world. Science decrees its so-called laws drawn from this world, but future effort, he predicts, will be to invent silence, slowness and solitude in negation of the way the world is today.

That depends on the real desire of man, replies de Rougemont; it is up to man to choose whether he wants to invoke the spirits of noise and speed or those of slowness and silence. Then Dr M. V. interjects an awful premonition: "…Soon you will have the most dazzling proof of the reality of scientific laws… We calculate movements of the electron, the power of cosmic rays, we'll run engines with that! Try to do as much with your spirits!"

Duchamp considers that these arguments betray, once again, the mythical nature of physics and mathematics: their so-called demonstrations rely on their rules, nothing but tautologies which lead back to myths.

"Take the notion of cause: cause and effect different and opposite. It's quite indefensible. It's a myth from which the idea of God has been drawn, considered as a model for all cause. If one doesn't believe in God, the idea of cause has no meaning…"

Before retiring to bed de Rougemont gives Duchamp *Le Nouvel Esprit scientifique* by Gaston Bachelard to read; he has marked the passage explaining that, according to Millikan's theory of cosmic rays, movement occurs in conditions of material void, in such inanity that the movement itself creates the corpuscular mass.

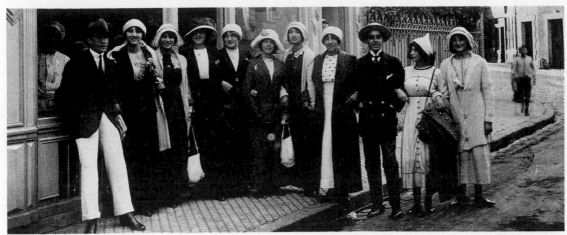

3.8.1911

1947. Saturday, New York City
Duchamp lunches with Alfred H. Barr, Jr.

1951. Thursday, New York City
Having received George Of's explicit reply [31.7.1951], Duchamp forwards it to Miss Dreier with his own comments. He proposes that the cleaning of the mural be undertaken by a local man, if Mr Kelly can find someone whom Duchamp, wishing to supervise the work personally, will instruct. He recommends that scaffolding be built above the altar in the chapel, rather than relying solely on a stepladder (because of the proximity of the altar to the mural), and he informs Miss Dreier that he has called Kelly and will lunch with him on 7 August, the earliest feasible date.

Duchamp promises that the next time he is in Milford, he will take the portrait of Miss Dreier's father to New York for repair, by George Of himself most probably.

*

Lunch with Alfred Barr, who has proposed that they meet at Dufour, 1135 Madison Avenue, is short because Barr has a deadline to meet for his forthcoming book on Matisse.

1955. Tuesday, East Hampton
Writes to Betsy Jones, secretary to Alfred Barr who is in Europe, thanking her for the copy of the letter Barr has received from the Immigration and Naturalization Service [20.6.1955] which states that "the necessary investigation in Mr Duchamp's case has not as yet been completed". As Duchamp is due to return to New York on Labour Day [5 September]: "Tell Mr Barr that I hope to see him when he returns," he requests Miss Jones.

1958. Saturday, Cadaqués
Following the "adventurous hot day" which ended in a taxi drive from Barcelona, Teeny is discovering the "little town which certainly has escaped every sophistication" since Marcel first stayed there 25 years ago [13.8.1933]. By correspondence with Meliton, who in the 1930s from his café – the central meeting place – already acted as banker and agent for everything, they are renting a three bedroom apartment with no terrace or view of the sea, behind the church. "It is all very simple," Teeny tells Jackie, "no hot water and the stove is for wood and the mattresses are of straw." There is no linen, but Meliton has lent them sheets and

towels. "Everything else is here, dishes, pans, etc... I haven't cooked yet," explains Teeny, "because we have no wood."

Returning to their apartment after lunch Marcel and Teeny buy a spirit lamp so that they can: "heat a little water without lighting the stove for tea, shaving, etc."

*

In the middle of the night Teeny is woken by "something soft and strange – a big white cat". She chases it out and discovers another in the living room. "Our little apartment is really funny," reflects Teeny, "underneath us there's a mule that is put there to sleep every night."

1961. Wednesday, Cadaqués
Duchamp writes to Pontus Hulten at the Moderna Museet [21.6.1961] informing him of his flight plans to Stockholm on 29 August and his desire to return by train via Copenhagen to either Amsterdam or Rotterdam, there being no direct service to Antwerp.

*

To Jean Larcade of the Galerie Rive Droite [21.10.1958] who has requested an invoice for $1,000, Duchamp explains: "I will come to see you and we will settle this invoice question which I would now prefer to be paid in Francs in Paris." Also when in Paris he would like to sign the new edition of *Feuille de Vigne femelle* [12.3.1951] to be issued by Larcade, "in a more 'original' way than a 'printed' form in the cast."

3 August

1908. Monday, Veules-les-Roses
A moment in the sunshine outside the Casino where her friends are gathered is captured by Carmen Cartaya who is celebrating her seventeenth birthday. On the left of the group is Odette, easily identifiable as a Cartaya because over her long, full skirt and blouse she is wearing a hound's-tooth check coat, identical to those worn by her two sisters. With both hands thrust into the trouser pockets of his flannel suit and sporting a neat straw boater, Marcel is standing sideways to the camera, turning his back to Odette. The moustached Lucien Haas is looking at the photographer over the shoulders of Roland Jourdan (Mercedes Cartaya's

fiancé), whose head is turned towards the two ladies next to him: Germaine Annebicque and Suzanne Duchamp. Standing between Suzanne (whom the Cartaya sisters privately consider is rather a flirt) and the white nautical figure of Julien Dambé, is Marcel's great friend, the tall Georges Ayzaguer whose mother, from the Argentine, is married to a Basque laryngologist. Sitting on the ground, hugging his knees and wearing a loud checked cloth cap, is Etienne Annebicque.

1911. Saturday, Veules-les-Roses
Carmen Cartaya celebrates her twentieth birthday by inviting her friends to a party at the Tennis Club. In the afternoon, Marcel and another young man accompany nine young ladies to the Pâtisserie Beaufils in the main street near the church: Carmen and her sister, Mercedes; the Blocman sisters, Odette, Suzanne and Simone; their cousin, Odette Bockairy; Camille Gaudin, Suzanne Niseron and Mathilde de Heeckeren. After ordering a selection of delicious cakes, the photograph to mark the occasion is taken of them all in front of the shop including, through the window, the smiling face of the pastry chef himself.

At the Tennis Club, the proprietress Mme Grimont has prepared some excellent chocolate for the guests to drink.

1914. Monday, Yport
Marcel is staying at the Villa Franceline with his parents at the coast when, following the order for general mobilization the previous day, Germany declares war on France. As he has already been discharged from military service [1.9.1909], unlike his brothers, Marcel is

not called up, permitting him to continue with his preparatory work for the Large Glass.

3.8.1914

From an idea first conjured in Rouen at the Brasserie de l'Opéra, and further developed in an intermediary drawing, Marcel has been making a full-scale working drawing of the Sieves, part of the Bachelor apparatus.

It is amusing to note that Footitt, the clown and famous partner of Chocolat, whose Cascading Hats are remarkably evocative of these funnels or conical shapes, had a particular weakness for ladies' riding habits: "Ces dames s'entourent de gaze, pour allumer; moi, c'est pour voir clair." (These women envelope themselves in gauze, to tease; for me, [the gas] is to see clearly by.)

1917. Friday, New York City
Encumbered with enough luggage for three weeks' holiday, Ettie Stettheimer comes to town from André Brook with her mother and sisters. After attending the Adolf Bolm dress rehearsal with Florine and saying goodbye to her family, Ettie has supper with Marcel at the Belmont. It would appear that Marcel then escorts Ettie to her train compartment which has been reserved to take her to Lake Placid for a change of air in the mountains.

1918. Saturday, New York City
Marcel finally takes his leave of Ettie at half-past midnight.

Later, they both travel by train to Bedford Hills, where Marcel is invited to spend the weekend.

1926. Tuesday, Paris
Marcel has lunch with L. [?] and Roché at the restaurant of the Café de la Paix.

In the evening the same trio dines with Alice Roullier [1.7.1926] and, after visiting "the gallery" of Marcel's at 82 Rue des Petits-Champs [30.7.1926], go to Man Ray's studio which Marcel has been using to work on his film of abstract spiral forms with Man Ray's help.

1928. Friday, The Hague
In the penultimate round, Duchamp plays the shortest game of the tournament against the Austrian H. Müller:

Employing an English opening, Müller moves a pawn forward (c4) and Duchamp does likewise (e5); the Knights then each leap to the fore in turn (Nf3 Nc6; Nc3 Nf6); the White Queen's pawn edges out (d4) and is captured by the Black King's pawn (exd4); the White King's

Knight immediately retaliates (Nxd4) and the Black King's Bishop advances swiftly across the board (Bb4); the White Queen's Bishop counter attacks (Bg5) but a black pawn steps towards him (h6) forcing the Bishop to retreat (Bh4).

After a long pause the Black King's Knight leaves his post and spectacularly sacrifices his Queen (Ne4 ?!) to the White Bishop (Bxd8); a skirmish of Knights follows (Nxc3) and the White King's Knight, tit for tat, captures the Black Queen's Knight (Nxc6 !) at the expense of *his* Queen who, surprisingly, remains stationary and falls to the Black King's Knight (Nxd1 +). As a result the White King is in check, a menace easily forestalled by the White King's Knight returning to take the threatening Black Bishop (Nxb4); realizing his position is hopeless, with only one pawn for the piece, Duchamp resigns.

France is defeated by Austria 1–3.

1931. Monday, Budapest
On the next stage of their holiday, Mary Reynolds and Marcel embark on a river steamer to sail slowly up the Danube to Vienna.

1936. Monday, Chicago
After the stop at Cleveland, but before his train arrives in Chicago, Dee takes a sheet of the railroad company's printed paper, "New York Central System/*en route*," and writes to Miss Dreier thanking her for her long letter. The curtained bed on the train is "fine"; he has ordered, from Biele's, the two extra strips of glass to replace the newspaper bands between the upper and the lower parts of the Large Glass, and will have two or three days at The Haven at the end of the month to complete the repairs; he tells her where he has left the key to her studio and requests that she give the office instructions about his collecting it again on his return to New York.

On arrival in Chicago, Marcel intends telephoning Alice Roullier at her office in the Fine Arts Building and to meet her, if he has time, before his train departs for San Francisco.

1945. Friday, Lake George
In the morning, Duchamp returns *Le Nouvel Esprit scientifique* by Bachelard to de Rougemont after reading the passage in question, and says that he thinks he understands everything, or almost everything. He has already forgotten the meaning of *épistémologie* and finds the word irritating. "Inanity, on the other hand," declares

Duchamp, "pleases me very much. But there is a term which I don't understand at all: movement. What does this chap of yours call movement? If he defines it as the opposite of repose, that doesn't work, nothing is in repose at the universe. His movement then is only a myth."

At lunch on the balcony, Duchamp suggests that, in fact, everything in the world happens anarchically; laws are simply pretexts, are not respected and we could do without them. If money could be abolished, life would be much easier: the baker would continue to bake bread because he enjoys it – someone must do it; you could take one or two loaves a day without paying, you cannot eat more and it would be useless to stock more because you couldn't sell it.

In the evening, Duchamp returns to the same subject, declaring that the family is a good example of human beings living in anarchy: "The children take what they need from the table or the kitchen; there is no price paid or legal formality, everything takes place freely between father and son, things are settled between them, there is enough for everyone…"

Duchamp confesses that since the death of his father [3.2.1925] he feels deprived of any frame of reference. "*Père et repères*… [Fathers and frames of reference…] I can no longer take responsibilities. Marriage, for example. It seems to me that first of all I should go and ask my father's opinion… Probably I never grew up."

"The moment of crisis for an artist is around the age of forty. It is then that he should change himself completely or be resigned to copying himself."

1948. Tuesday, New York City
In the evening Duchamp and Frederick Kiesler are invited to dine at the home of Leo Castelli. Sidney Janis, Duchamp and Castelli form the committee charged with organizing an exhibition of Modern Art for the Fundação de Arte Moderna, São Paulo, in September.

1955. Wednesday, East Hampton
Marcel and Teeny have already spent three weeks by the sea in the house lent to them by Gardie [6.8.1954].

Writing to Roché, Marcel thanks him for the letter from the printer in Saint-Lô to whom he has forwarded Skira's letter; he has seen Sidney Janis, who gave him the latest news from France; he spent two days being filmed at the Philadelphia Museum of Art "with Sweeney as

4.8.1918 4.8.1959

partner" for NBC television's "Wisdom" series and, referring to the progress of Robert Lebel's book, Marcel is pleased that relations are good between Lebel and Breton.

1956. Friday, New York City
In the evening James Johnson Sweeney and Marcel discuss the catalogue of the "Three Brothers" exhibition and estimate the quantity required by the Guggenheim Museum and the Museum of Fine Arts in Houston. For Sweeney there is no question, as Marcel has suggested, of paring down the project, and he proposes that the budget of approximately $10,000, the sum originally agreed upon to be shared equally, should stand.

1963. Saturday, Cadaqués
The opening of the retrospective at Pasadena (which was postponed [8.3.1963]) is fast approaching, but Walter Hopps' letter informing the principal guest of the date in early October has not been forwarded from Paris. During the week Richard Hamilton [28.7.1963] and Marcel chose a postcard for the American of Salvador Dali posing proudly with a sturdy Port-Lligat fisherman: Duchamp merely requested Hopps to write, and Hamilton wrote that he spent many happy hours with Marcel gaining information for his lecture.

4 August

1918. Sunday, Bedford Hills
It rains dismally. Albert Gleizes and Henri-Martin Barzun [30.8.1914], the poet (recently arrived on a mission for the French army) whom Marcel wants Ettie to meet, come out from New York, but Carl Sprinchorn, also invited, sends his regrets at the last moment.

It is apparent that the emotional tensions as well as the showers dampen the mood of the assembled company. Donning their Puteaux hats, as it were, Gleizes and Barzun play the roles of Marcel's elder brothers and spend most of the day "trying to moralize tactfully to Duche". Evidently, they also try to persuade Ettie to have a change of heart with regard to Marcel, but Ettie deems that both of them are themselves "more influenced than influencing".

As his ship is not due to sail to Buenos Aires

before 10 August, the sisters arrange to see Duche in New York on Wednesday night to bid him farewell.

*

Packing his bag at the apartment of Alissa Franc [2.8.1918] to return to Washington on the night train, Roché notices that *9 Moules Mâlic* [19.1.1915], which he has left temporarily with her, has scratched the piano.

1919. Monday, Rouen
Ten days or so after his return to France from Buenos Aires via London [22.7.1919], Marcel, who is visiting his parents, writes a letter to the Stettheimer sisters, which is forwarded to them at Lake Placid from New York. He sounds pleased to be home and is learning French again for their benefit. "Of course you have completely forgotten me," he accuses them, "it is not the same for me."

Buenos Aires, Marcel concedes, was not madly exciting, but he managed to work a little and the food was good, reminding him of their dinner parties in New York. "I have not forgotten the weekends either and heaps of detail which assume such magnitude from a distance."

1926. Wednesday, Paris
Discusses again with Roché the plan to buy back the Brancusis [11.6.1926] that belonged to John Quinn.

1928. Saturday, The Hague
Duchamp writes to Brancusi from the Hotel-Café-Restaurant Américain to tell him that he will be back in Paris on Monday evening and plans to call on him the following afternoon. He adds: "I haven't played badly," indicating his satisfaction with a win and ten draws in 14 games, and only one more game to play.

1947. Monday, New York City
Between seven and seven-thirty in the evening Marcel calls to see Stefi Kiesler and then sends a cable to Charles Henry Ford, the editor of *View*, at Flagstaff, Arizona: "Would you care to issue special number on Paris Surrealist show [7.7.1947] Kiesler will bring back all documents please wire Duchamp."

1955. Thursday, East Hampton
Catching up on some overdue correspondence, Duchamp writes to Marcel Jean [20.6.1955], thanking him for the copy of the chess game he

played with Tartakover in Paris [30.6.192], which he forwarded immediately to the gentleman in Pittsburgh who had requested it.

Duchamp thanks him for the news of Tanguy and Paris. To Marcel Jean's predictions on Picasso, the "Manet, Manet, Manet of our epoch", Duchamp remarks (just after the announcement that the Americans, like the Russians, are to build a series of space satellites), "if you live long enough (and not that long) you will find them copied so to speak word for word in *Space Art News* of 1980!"

*

After receiving and reading his *Chantage de la Beauté*, Duchamp tells Lebel: "I read [it] as I read Plato [21.7.1903], that is to say at top speed – nevertheless a lot has stayed glued to my grey matter."

1959. Tuesday, Le Tignet
Having executed the small etching measuring 12.2 by 15 cm, on which he has engraved three monumental unornamented letters, an emphatic *NON*, to illustrate *Première Lumière*, a poem by Pierre-André Benoit, Duchamp sends it by post to the author-publisher in Alès with a rapid note to say that he is just leaving Le Tignet for three days and will be returning to Paris on Monday.

5 August

1926. Thursday, Paris
The day after rediscussing their plan to purchase the Brancusis, it is Marcel's turn to be reticent [11.6.1926]. Concerned by the amount of capital to be invested, Marcel telephones Roché and tells him that the deal is too expensive.

1928. Sunday, The Hague
In the final round France loses to Hungary, the clear winner of the International Team Tournament, and Duchamp loses his game to A. Steiner.

The Chess Congress closes with a farewell dinner and prize-giving, which is held in the Palmarium at the Zoological Gardens.

1936. Wednesday, San Francisco
After 36 hours or so rattling across country from Chicago, Duchamp's train is due to arrive at seven fifty-two a.m. (or eight thirty-two depend-

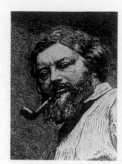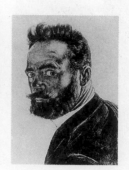

5.8.1946

ing on whether he travelled on the "City of San Francisco" or the "San Francisco Overland").

As he is arriving, Marcel writes a postcard to Alfred Stieglitz with a view of the Bryce Canyon National Park, Utah (purchased during the stop at Salt Lake City?), informing him that he will be sailing back to Europe from New York on 2 September.

During his twelve hours in the city before continuing his journey to Los Angeles, Duchamp visits the exhibition "Cubism and Abstract Art" at the Museum of Art and is impressed by the spacious hanging of the pictures – a "perfect" presentation in his opinion. However he doesn't meet the director of the museum, Dr Morley, as he had hoped to, but her assistant.

1945. Sunday, Lake George
Late at night, after working on problems with a game of Chinese chequers, they turn to a game of question and answer, written simultaneously. Denis de Rougemont's first question: "*Qu'est-ce que c'est le génie?*"; Marcel reads his reply: "*L'impossibilité du fer* – another pun, of course!"

1946. Monday, Chexbres
After several days enjoying the warm hospitality of the Hoppenots at the French embassy in Bern [30.7.1946], Mary Reynolds and Marcel are staying at the Bellevue, a small hotel built on the ledge, recommended to them by Hélène Hoppenot, who stayed there as a child. Dominating the steep vineyards of Lavaux, the hotel has a stupendous view across Lake Geneva to the mountains of Savoy.

Within a stone's throw is the deep ravine of the Forestay, the mountain stream dividing Puidoux from Chexbres. There, where its racing waters drive the millwheels belonging to the cluster of rural industries clinging to the rocky slope, as it plunges with a roar on its precipitous course to the lake below, is the waterfall which Marcel wants to photograph, finding it perfect for the décor of the new piece burgeoning in his mind.

During the day, Mary and Marcel explore

Vevey and are captivated by the romantic lakeside market town with its memories of Jean-Jacques Rousseau, Lord Byron, Gustave Courbet, Hodler and Vallotton. For the Hoppenots, they ask an estate agent, M. Flouck, about houses for sale in the area.

1951. Sunday, New York City
Having received advice from George Of [2.8.1951] and consulted Miss Dreier, Duchamp telephones Fritz Glarner and has a preliminary discussion with him about the cleaning of Miss Dreier's mural, *The Good Shepherd*.

1966. Friday, Cadaqués
About a week ago Duchamp received the fifth and final interview [22.7.1966], which he has reviewed, but he is waiting until 25 August to post it by express mail, as Cabanne has requested. "I am, on the whole, very satisfied with myself and thank you for conducting the five interviews with such zest."

To Cabanne's question regarding M. Fassio, Duchamp replies that he neither knows him personally nor his work ["La Machine à lire Roussel" in *Bizarre*, no. 34/35, 1964] and does not know whether his book is published.

6 August

1910. Saturday, Paris
In the issue with its cover deftly drawn and coloured by Albert Guillaume evoking *Le Radeau de la Méduse* in weather conditions more clement than those described by Géricault, *Le Rire* publishes a drawing by Duchamp. A young man, still in his braces and shirtsleeves, looks at himself in the mirror hanging above the mantelpiece and combs his hair. The young lady sitting on a sofa waiting to go out loses her patience: "What a long time you take to comb your hair," she complains. Quoting *L'Orgueilleux* by Destouches, the young man replies: "La critique est aisée, mais la raie difficile." [Criticism is easy, but art is difficult.]

1931. Thursday, Vienna
Duchamp chooses a card of the Schloss Schönbrunn, for a while occupied by Napoleon and where Aiglon passed his last days, to send to

Brancusi at 11 Impasse Ronsin. He writes that he will be in Paris on Tuesday and that their voyage from Budapest [3.8.1931] to Vienna was very good, signing himself "Morice".

1936. Thursday, Hollywood
After travelling on an overnight train from San Francisco, Marcel's first impression on arrival at 7065 Hillside Avenue is that the "Arensbergs' house is buried in foliage and surrounded by all kinds of trees and vegetation." He remarks: "The house itself has three spacious rooms downstairs and bedrooms upstairs… The air is delicious, I must admit that I have not seen yet what people seem to object [to] in Hollywood 'bad taste'."

1945. Monday, Lake George
Duchamp is up before anyone else and this morning, like every morning, Denis de Rougemont finds him sitting on the gallery smoking his pipe and reading chess problems, a pastime which occupies him for about four hours a day. "*Echec de l'art, art des échecs, échec à l'art* – it's the word of his life," writes de Rougemont in his diary after several days of conversation.

Duchamp is convinced that it is not so much exacting deliberation but often the opponent's involuntary thought transmission that wins a game. They cannot play for want of a chess set: Duchamp's own *Pocket Chess Set* [23.3.1944] which he guarantees "résistant aux secousses et déraillements", is too small for two to play.

Considering that one meal a day is sufficient, Duchamp happily forgets breakfast: most food, especially meat, is not absorbed, he believes, and only crams the stomach… And he deplores "the time spent going shopping, then cooking, then eating, then washing up, and starting all over again".

Later, from his desk, through the open door, de Rougemont can see into part of Duchamp's room: "[He] is lying on his bed, the *Pocket Chess Set* in one hand, his pipe in the other. For not more than five minutes he works on the fragile collages, reproductions of his work, the contents of the *Boîte-en-Valise* [7.1.1941]; he then lies down, does nothing, smokes a little and returns to chess."

De Rougemont asks Duchamp whether it is true that he decided one fine day, at the time of his greatest triumph in America, to give up painting for ever. "Not at all!" he protests with a hint of amused indignation. "I didn't give up by attitude. I didn't decide anything at all! I am simply waiting for ideas… I had thirty-three ideas, I painted thirty-three pictures. I don't

- Ce que t'es long à te peigner.
La critique est aisée, mais la raie difficile.
Dessin de DUCHAMP.

6.8.1910

6.8.1960

want to copy myself like all the others. You know, to be a painter is to copy and multiply the few ideas one has had now and then. It's to exhibit life by one's hand. That's what makes a painter. Since the creation of a market for paintings, everything has changed radically in the field of art. Look at how they produce. Do you think they like that, and enjoy painting fifty times, a hundred times the same thing? Not at all, they are not even producing paintings but cheques."

He shows de Rougemont one of the sixty-nine items from the *Boîte-en-Valise*: a reproduction of *Chèque Tzanck* [3.12.1919]. De Rougemont enquires whether the dentist accepted it.

"Whyever not, it's not a fake cheque because it's completely made by me! And signed! Nothing could be more genuine. And at least it couldn't be considered artistic…"

"You are surely the first artist who has been known to pull his own leg [*se mettre en Boîte lui-même*]," teases de Rougemont.

Duchamp laughs. "The only annoying thing is that I had to buy back this cheque from my dentist to include it in my Valise!" (Arensberg did not purchase the cheque when offered to him [16.7.1940].)

*

From Authon-du-Perche, where he is on holiday, Paul Eluard writes to Louis Parrot inviting him to collaborate on the book that Louis Carré has asked him to prepare on Jacques Villon and his two brothers: "Aged seventy, [Villon's] career is picturesque and also full of interest as well as talent… He has carried conscience and modesty to such a point it leaves one dumbfounded. Besides this unselfishness is also extreme in Marcel Duchamp and a good section on him must be attached to the book: I will ask Gabrielle Buffet (Picabia) for it."

1946. Tuesday, Chexbres

Mary Reynolds writes a spirited thank-you letter to Henri and Hélène Hoppenot, declaring that she and Marcel "are still travelling under their star from Bellevue to Bellevue". Mary finds the Hôtel Bellevue at Chexbres "a very pleasant introduction to Bellevue-Chardonne", situated on the hillside just a few kilometres east, which they "anticipate as perfection".

Marcel writes a paragraph expressing his enthusiasm for the "ideal" holiday, thanks to the French ambassador and his wife. As for the view: "The weather has a hand in it and every hour the lake changes her gown."

1949. Saturday, Milford

Dee visits Miss Dreier who is not feeling well, and she forgets to tell him that Hans Richter has agreed to present his 1919 scroll drawing *Preludium* as a gift to the Société Anonyme Collection.

1950. Sunday, New York City

That Manhattan is empty delights Dee, but the weather is cold and he gives some words of comfort to Miss Dreier, when writing to her, saying: "it is easier to protect oneself from summer cold than from summer heat."

With his own letter, Dee encloses one from Duncan Phillips' assistant accepting the offer of the loan [24.7.1950] of Juan Gris' *Still Life with Newspaper*, and confirms that without delay he has arranged for Budworth to ship the painting, insuring it for $5,000 at a cost of about $7. He hopes that its anticipated sale to the Phillips Collection, Washington, will end as well as it has started.

1952. Wednesday, New York City

On the twenty-fourth day of tatane 79, fête of Pissedoux, Corporal of free man, (according to Alfred Jarry's own calendar) Duchamp joins the *estimable* Collège de 'Pataphysique.

1954. Friday, East Hampton

The Duchamps are spending a few days by the sea in a little house on Long Island that is very familiar to both of them. Belonging to Teeny's best friend Gardie, Mrs Rolf Tjeder (the sister of Olga Carter [18.4.1954]), it is the house which Marcel has come to many times in the summer of the last two or three years to visit Teeny.

Sending Roché another intimate bulletin [5.7.1954] of his steady recovery from the prostate operation [25.6.1954], Marcel says that even "sex exercises are quite normal". He enquires about Roché's convalescence [18.11.1953] at Saint-Robert in Corrèze and tells him that he and Teeny have decided to stay in New York this summer, except for maybe ten days' chess at the New York State Championship near Rochester.

Marcel describes the permanent installation [19.7.1954] of the Large Glass in the midst of the Arensberg Collection at the Philadelphia Museum of Art, and remarks: "I am very pleased with their willingness to make something satisfactory in the presentation."

1960. Saturday, Cadaqués

Duchamp replies to Serge Stauffer's letter of 24 July, enclosing his answers (which he has pre-

pared with great care) to all – or almost all – of his hundred questions. Among these answers (which can only be summarized here) Duchamp says that he probably knew Raymond Roussel's *Locus Solus* in 1914 or 1915; his first research for *La Mariée mise à nu par ses Célibataires, même* [5.2.1923] was in Munich in 1912 dating from the same time as the two *Vierge* [7.8.1912]; it was Suzanne Crotti who must have bought the geometry book for *Ready-made malheureux* [14.4.1919]; *Aéroplane* [19.8.1912] has nothing to do with the Bride [25.8.1912]; Louise Varèse did have a chimney cowl; he worked at the Bibliothèque Sainte-Geneviève from the end of 1913 [1.11.1913] until May; *A la manière de Delvaux* [14.10.1942] is a photographic version (a detail) of Delvaux's painting; "The Richard Mutt Case" was written by the editorial board of the *Blind Man* [5.5.1917]; he has forgotten the inscription for *Egouttoir* [15.1.1916]; the Large Glass is not a "ruin", simply "wrinkled"; the *Cœurs Volants* [16.8.1936] on the cover of *Cahiers d'Art* is the original; the small glass *9 Moules Mâlic* [19.1.1915] was placed against an armchair on castors, which rolled away and it broke [24.1.1918]; André Breton did not baptize the ninth Malic Mould "Stationmaster", because when Duchamp made the *9 Moules Mâlic* Breton was only 16 (!); there is only one version of *Fresh Widow* [20.10.1920], and if the knobs are at different heights, the knobs may have fallen off and been replaced differently; Rrose Sélavy [20.10.1920] still lives, appearing rarely or not at all; it is correct that the Large Glass is "unfinished" because the Toboggan and other details are missing; the Dust Breeding [20.10.1920] was conceived specially to colour the Sieves; the text *Rendez-vous du 6 février 1916* was composed "laboriously" over several weeks; he claims not to have read or heard of the Futurist Manifesto, published in *Le Figaro* on 20 February 1909, when he painted the *Nu descendant un Escalier* [18.3.1912]; *3 Stoppages Etalon* [19.5.1914] is an independent work, later employed in the Large Glass and *Tu m'* [8.7.1918]; *Portrait de Joueurs d'Echecs* [15.6.1912] was painted by gaslight to experience the chromatic distortion in the green-based light of the Bec Auer; "une crécelle" is a toy which makes a noise when turned by hand; *Recette* [7.1.1941] was written in order to play with the idea of a "kilo of feathers and a kilo of lead"; the windows [22.9.1935] avoided the business of making paintings; Breton's "Post Coitum animal triste" is not a general rule; he won't dis-

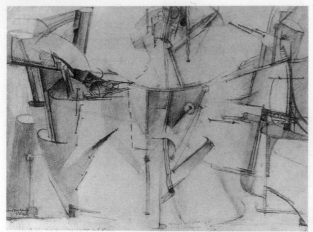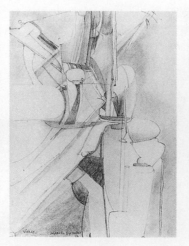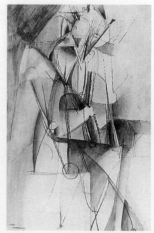

7.8.1912

cuss the sociological effects of man's physical strength and his, so called, superiority over woman; he claims that there is "un esprit de famille" between the "cyclist" and the "slope" in the lithe cyclist climbing a hill (*Avoir l'apprenti dans le soleil* [25.12.1949]); the flesh colour of Milky Way is painted directly on the back of the glass and protected by sheets of lead; as the *Trébuchet* (a readymade coat rack) was nailed to the floor of his studio in New York, he doesn't think that it was exhibited at the Bourgeois Galleries [1.4.1916]; he believes it was he who invented the pun with the letters *L.H.O.O.Q.* [6.2.1930]; yes, he left out the point in the centre of the small circle of the Oculist Witnesses, yes, he removed the base line under the Grinder, yes, he shortened the axle to the left of the Water Mill, yes, he cut the Bayonet at the level of the Scissors when repairing the Large Glass, and strengthened the whole by solidifying the strips of glass between the upper and lower halves [28.8.1936]; he was drawn to Max Stirner, at least his *Unique et sa Propriété*; he doesn't remember the stereoscopic film made in 1920–21 but has always enjoyed anaglyphs [4.4.1919]; categorically, he has no unpublished texts "in reserve, or to unearth" [!!!]; and the door of the Rue Larrey [9.10.1937] still exists and functions, et cetera, et cetera.

7 August

1912. Wednesday, Munich
It is now little more than five weeks since Duchamp settled into his small rented room at 65 Barerstrasse [1.7.1912] in the heart of Schwabing. He has discovered the cafés where the artists meet, noticed the Picassos in the Odeonsplatz, bought a copy of Kandinsky's book *Über das Geistige in der Kunst, insbesondere in der Malerei*, which is in all the bookshops, and goes to the Alte Pinakothek every day.

One of the popular arts in this region is *Hinterglasbilder* (or behind-glass pictures), in which saints and seasons are painted in pure colours, rendered more vivid and luminous by the transparent glass; Duchamp has already made three drawings, the first entitled *La Mariée mise à nu par les Célibataires*. Subtitled "Mechanics of Modesty, mechanical Modesty", with dart-like movements a central figure is

aggressively stripped bare by two others, "like the Christ…" admits Duchamp.

Both the other drawings are entitled *Vierge* as though, to borrow an expression from the Futurists, Duchamp is asserting that "[his] hands are sufficiently chaste to start everything again". Indeed the next step is a canvas, *Le Passage de la Vierge à la Mariée*, which is not "a physiological passage", but "a passage in my life of painting, one after the other – a pun again. A pun in the title, that idea of the titles… The pun is a poetic element like rhyme. A rhyme is a poem."

Literary influence in his work is nothing new but since he saw a performance at the Théâtre Antoine of *Impressions d'Afrique* [10.6.1912], Duchamp has fallen under the spell of Raymond Roussel. The play has given him "the general approach" to Roussel's unique method of writing. Applying to pictorial art this process of "juxtalinear translation" (as he describes the formula of homophone in which two words or phrases sounding the same but with different meanings determine the narration), Duchamp realizes that he can kick over the traces and create something entirely new.

To his grandmother Marie Nicolle, Duchamp writes: "Life here very agreeable, but am missing the intimacy of Neuilly." He posts the card, representing Schloss Nymphenburg, which "has the pretension to recall Versailles" [26.4.1910] at the post office nearby on the corner of Nordendstrasse and Adalbertstrasse.

1917. Tuesday, New York City
Meets Beatrice Wood.

1924. Thursday, Paris
In the morning before leaving for Normandy, Duchamp manages to obtain the two plates in copper and sheet steel for his optical machine [12.7.1924], which he delivers to the assembler. They negotiate a price not to exceed 1,000 francs [4,000 francs at present values], which Duchamp hopes will turn out to be much less.

In order to rejoin his parents who are on holiday in Val de la Haye, Marcel can take one of the evening sailings from Rouen down the River Seine to La Bouille.

1926. Saturday, Paris
At three o'clock in the afternoon, Roché is invited to see the rushes (or a working copy?) of Totor's film [3.8.1926].

1929. Wednesday, Les Rousses
"It is cold – fire in the bedroom – but perfect air a change from the south," writes Marcel, who is on holiday with Mary Reynolds in the Jura Mountains, not far from Etival [26.10.1912]. He asks Brancusi in Paris. "Where are you? What are you doing? Where are you going?" and signs the postcard "Morice".

1936. Friday, Hollywood
The day after Marcel's arrival, Beatrice Wood (who moved to Los Angeles in 1928), her friend Helen Freeman and the photographer Sherrill Schell call at the Arensbergs' house. Bea finds that Marcel still has "the same beautiful expression".

1943. Saturday, New York City
Stefi and Frederick Kiesler dine at seven with Mary Reynolds and Marcel (at Mary's apartment, 28 West 11th Street?).

1945. Tuesday, Lake George
Before lunch, on the balcony overlooking the lake, Denis de Rougemont asks Duchamp for examples in his *Infra-mince* category [29.7.1937] apart from the one he has seen on the back cover of *View* [15.3.1945]: "When the tobacco smoke also smells of the mouth which exhales it the two odours are married by *infra-mince*."

"Indeed, one can hardly give anything but a few examples," replies Duchamp. "It's something that still defies our scientific definitions. I chose on purpose the word *mince* [thin] which is a human, affective word and not a precise laboratory measure. The noise or music which corduroy trousers make, when one moves," he says, pointing to his own, "pertains to *infra-mince*. The hollow in paper between the front and the back of a thin sheet… It's a category," Duchamp continues, "which has occupied me a great deal over the last ten years [29.7.1937]. I *believe* that by the *infra-mince* one can pass from the second to the third dimension. To be studied!"

"Have you noticed," enquires Duchamp a little later, "that I can see you looking, see you seeing, but I cannot hear you listening, nor taste you tasting, and so forth?"

At lunch, de Rougemont remarks how soothing and satisfying the view [2.8.1945] through the pines of the distant mountains is to him.

"No doubt you are long-sighted," says Duchamp. "Wait – an instant-theory which has just occurred to me: the long-sighted are unhappy in

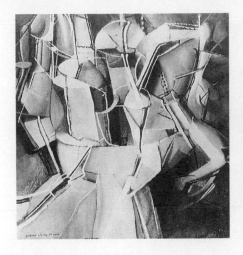

the cities because their gaze is constantly blocked against a wall, which creates an inexplicable, physical discomfort. On the contrary, the short-sighted are at home in the cities, but feel lost and sort of dizzy in front of a landscape like this one. To be verified, of course."

1946. Wednesday, Chexbres
From the Hôtel Bellevue [5.8.1946] Mary and Marcel make an excursion to Lausanne where they hope to meet Henri and Hélène Hoppenot, their hosts at the embassy in Bern.

1951. Tuesday, New York City
After lunching with Mr Kelly and suggesting that he arrange for scaffolding in the chapel, Dee tells Miss Dreier that Fritz Glarner who seems to be "an expert at cleaning paintings" [5.8.1951], may be the man to restore her mural *The Good Shepherd.* He will take him to see it and ask for an estimate so that Mr Kelly can apply for funds from his Foundation.

1958. Thursday, Cadaqués
"We are having the most heavenly time," declares Teeny, "I have bathed almost every day in a different little beach or rocky bay which we walk to – Marcel has been an angel to come with me and he's gotten all sunburned – Cadaqués itself is the quaintest town you could ever imagine. Around every corner is a surprise view that delights one – It is certainly a wonderful change from Sainte-Maxime, etc." Intending to purchase a mask for Teeny, "to look under the sea," the Duchamps go to Figueras.

8 August

1913. Friday, Herne Bay
Acting as chaperon, Marcel has accompanied his sister Yvonne across the Channel to the north Kent coast where she is taking a course in English at Lynton College.
Today Marcel posts two cards, one of the Royal Exchange in London addressed to his grandmother Nicolle saying: "...In Yvonne, I have a very pleasant interpreter – we are playing lots of tennis – superb weather..."
In reply to Dumouchel, who has written from

Paris, Marcel writes: "The traveller is enchanted. Superb weather. As much tennis as possible. A few Frenchmen for me to avoid learning English, a sister who is enjoying herself a lot..." He asks whether Paris is hot, for news of Tribout and news of their quarter by the Panthéon [7.4.1910], "the neighbourhood of great men," and completes the inscription on the building: "...their grateful country."
The postcard for Dumouchel is of the pier, rebuilt in 1898, a broad promenade extending on stilts out to sea. In the recently constructed Grand Pier Pavilion, prettily illuminated at night, there is a spacious hall serving as theatre, concert hall and ballroom where, during the season, entertainments are organized daily in the afternoon and evening.

For Marcel's distraction during his stay, there is a wealth of choice. Apart from a programme of moving pictures (the Victorian melodrama *East Lynne* and *Trilby* at the Bijou Theatre), for three nights, commencing on 11 August, the Pier Theatre is presenting *Oh! I Say,* an English adaptation of the famous French farce *Une Nuit de Noces* by Henri Kéroul and Albert Barré, in which the main characters are none other than Marcel Durosel and Sidonie de Matisse...
Although every Saturday and Monday evening there is dancing on the pier, on Monday 18 August following the Regatta, a Grand Fête and Gala Night with a firework display is announced. The particularly appealing vaudeville programme organized by the Herne Bay Entertainment Committee on 25 August includes the band of the Queen's Own Cameron Highlanders, various singers, Bi-Bo-Bi the Parisian Musical Eccentric, the Tissots with their "living marionettes" and last but not least, Madame La Vie. An adept at "panel poses" evoking famous mythological and historical subjects, Madame La Vie reserves the most popular and most spectacular for the climax of her act: the burning of Joan of Arc at the stake at Rouen...

As "a magical (distant) backdrop" for his Large Glass, Marcel is impressed by the Pier Pavilion and envisages "garlands of lights against a black background (or a background of the sea, Prussian blue and sepia) Arc lights – figuratively fireworks".

1917. Wednesday, Tarrytown
"It's Duchamp day": Florine and Carrie are expecting their regular French lesson. Ettie is still at Lake Placid in the mountains [3.8.1917] and Duche finds the house incomplete without her resolute voice resonating from the terrace.
There is Indian corn for lunch which Marcel finds "delicious, sweet", in spite of him "not liking this sort of vegetable much on account of the gymnastic difficulty in eating it". He asks the sisters whether they would like to pose for him: Carrie finds that he has "too caricatural a mind" and "is not at all enthusiastic" but Florine promises to procure some paper for his next visit.

In the evening the playwright Avery Hopwood, who had planned to come and play tennis with Marcel but was unable to, invites them all to dine at Harmon a few miles north of Tarrytown. He takes them to the Nikko Inn, run by a Japanese called "Colonel Moto", which overlooks the Hudson River.

1924. Friday, Val de la Haye
"I am much further forward with the work of the montage," reports Duchamp to Jacques Doucet referring to having found the copper and steel for the optical machine the previous day, and he proposes a meeting at Man Ray's, with M. Ruaud [12.7.1924] (if he hasn't gone on holiday), between 12 and 16 August in Paris.

1926. Sunday, Paris
In the morning at ten-thirty, when they meet again, does Roché manage to overcome Marcel's reticence about the Brancusi deal which he expressed on Thursday?

*

Each day a "detail" prevents Duchamp from leaving for the south, but he hopes to depart on Wednesday: "My film [7.8.1926] to edit," he explains to Jacques Doucet whom he would like to meet before leaving Paris. "I am also awaiting some important news which will determine my voyage to New York this winter." As this news concerns a decision from Brummer to hold a Brancusi exhibition (a factor in determin-

9.8.1919 9.8.1959

ing whether he and Roché will go ahead with their plan to buy 27 Brancusis [5.8.1926]?), Duchamp says: "It would be much more amusing to tell you this viva voce." Where and when would Doucet like to meet him?

1936. Saturday, Hollywood
The Arensbergs hold a party for Marcel, inviting Edward Weston, Charis and Leon Wilson, Jack and Frances Case, Helen and Lloyd Wright (the son of Frank Lloyd Wright), Sherill Schell and Beatrice Wood.

1939. Tuesday, Paris
It is the first time in 21 years that Miss Dreier has forgotten Dee's birthday. The reason, she explains, is that "a very exciting idea has shot up – what do you think," she asks him, "of the idea of selling [The Haven] for a – Country Museum?"

Concerned about the future of her collection, a month ago Miss Dreier wrote: "Of course the truth of the matter is that the tremendous care these pictures now demand is way beyond my strength and purse," and wonders about selling them at auction. As for the Société Anonyme, she declared: "just another museum of the present-day type would really not interest me."

"The idea of selling your country place for a Country Museum is a good idea," replies Dee, saying that he remembers meeting Dr William Hekking, who would be in charge. "But if you are to abandon all your collection with it," he warns, "I have a certain apprehension. You don't know who the buyers are and how long they will last." If the house and the collection of the Société Anonyme are sold "as the basis of the country museum", Dee suggests that Miss Dreier might lend them her private collection, including the Large Glass: "I would keep a chance of saving something," he advises, "if this museum turned out to be the wrong thing."

Referring to Brancusi's *Colonne sans fin*, Dee says: "The column is yours [22.7.1936] and I agree to whatever you decide to have done to it for preservation. As long as the outside appearance is not changed."

1945. Wednesday, Lake George
Walking back from the village, Denis de Rougemont reads of Hiroshima in the newspaper, and to everyone gathered on the gallery of the house he finds himself telling the story as if he had just come back from the scene of devastation. Rather than terror or meditation, the shock of the news provokes discussion which continues until midnight.

Finally, Duchamp interrupts a chess problem to say that the atomic bomb confirmed his point of view: science is only mythology, its laws and the material itself are pure myth, and are no more or less real than the conventions of any old game.

"Nevertheless the bomb exploded at the appointed time!" remarks the doctor.

"Good evidence," replies Duchamp. "Everything had been arranged for that!"

1949. Monday, New York City
A few days after receiving them from his brother, Marcel forwards an etching of Baudelaire by Jacques Villon and a book on Raymond Duchamp-Villon to Lou and Walter Arensberg. Mentioning that the Art Institute have invited him to Chicago for the opening of the exhibition on 19 October, Marcel tells the Arensbergs: "I count on seeing you at the vernissage," and adds, "The heat is terrific here – but one survives, by moving the least possible."

1951. Wednesday, New York City
In the afternoon, as agreed the previous day, Duchamp telephones Mr Kelly, who suggests that the meeting with Glarner to see Miss Dreier's mural at Garden City be on 14 August. Duchamp is then unable to reach Glarner to confirm the appointment.

1957. Thursday, New York City
"Paris, if it is like New York this year, must be unbearable," Marcel tells Roché, who is in Corrèze. With Teeny, he has spent three weeks of the heat wave at East Hampton on the northern tip of Long Island where there is "the Ocean on one side and calm water on the other".

"I don't remember at all the large portrait of me by Picabia (1935)," remarks Marcel saying that maybe a photo would jog his memory. As he has finished the translation of *The Creative Act* [5.4.1957] for Robert Lebel, he encloses a copy for Roché.

1967. Wednesday, Cadaqués
Belatedly thanks Pierre de Massot for sending him a copy of *André Breton le septembriseur*, recently published by Le Terrain Vague, which he confirms he "has received and devoured".

9 August

1917. Thursday, New York City
Very late at night Duchamp writes to Ettie Stettheimer at Lake Placid in the Adirondack Mountains, to tell her of his visit the day before to Tarrytown: the corn he enjoyed for lunch, his proposal to draw the sisters' portraits, and the outing in the evening with Avery Hopwood, for whom he has developed a "tremendous liking".

"Obviously the house was incomplete without you," he writes gallantly, "this resolute voice, that resounds from the terrace without ever an echo daring to counterbalance it with a slightly different solution, was missing." He is not doing anything different and says: "I have a kind of diminishing interest for the few rare things which attracted me. This to allow you to scorn a little more from the heights of your good health, from your mountains. I have done my best to write to you a really empty letter, don't be cross with me, it's the most sincere expression of my feeling at the moment."

1919. Saturday, Paris
Confirming his intentions to meet Miss Dreier when she arrives from New York, Duchamp sends a telegram to her ship: "Will surely be Rotterdam Tuesday."

After an absence of four years, Duchamp finds Paris "very difficult, very funny, very curious". It was extremely hot when he returned to the capital a few days ago and the streets were deserted. His first objective was to find Picabia at his new address in Rue Emile-Augier where he now lives with Germaine Everling [13.8.1918]. Gaby Picabia, in the last month of pregnancy with Picabia's fourth child, is still occupying the large apartment at 32 Avenue Charles-Floquet near the Champ-de-Mars and has happily invited Duchamp to stay with her until his return to New York.

1926. Monday, Paris
After a gay and successful lunch with Alice Roullier and Ernest de Journo at La Villette, Marcel and Roché take *9 Moules Mâlic*

10.8.1923

[19.1.1915] to be reframed by Pierre Legrain: the glass had cracked again [24.1.1918] recently when Helen Hessel [7.3.1926] stood it too close to the fire.

1941. Saturday, Sanary-sur-Mer
After Yale University's recent refusal to accept The Haven and the Société Anonyme Collection to form a Country Museum [8.8.1939], Miss Dreier has decided to accept their request for the collection on its own. She sends a telegram to Duchamp asking for his approval, to which he replies by return: "Agree to Yale proposition concerning Société Anonyme Collection."

1942. Sunday, West Redding
Arrives from New York and stays the night at The Haven.

1946. Friday, Chexbres
Writes to thank Ettie Stettheimer for the surprise case delivered to him on the *Brazil* [3.5.1946]. He kept several bottles "for the family", Marcel recounts, "who, on my arrival in Paris, drank the champagne to your health."
Of Europe after the war: "...there is no famine," says Marcel, "many impoverished or poorly paid people who subsist with difficulty – the prices, the salaries and the black market – you know the story. In Paris the trees are greener than ever," he explains, "because car fumes and chimney smoke have not stopped them growing in their own way during the war."
Very distressed at the death of Alfred Stieglitz, Marcel remarks: "New York without Stieglitz is no longer our New York," and he asks Ettie to send his condolences to Georgia O'Keeffe. Providing he can get his visas without delay on his return to Paris, Marcel still hopes to be back in New York for Florine's exhibition [1.3.1946] which is due to open on 1 October.

1949. Tuesday, New York City
"The distortion left–right is more perceptible in a writing on oneself than in the reflection of the mirror," Duchamp tells Jean Suquet, who has studied the Green Box [16.10.1934] belonging to Mary Reynolds and is proposing to write a book on Duchamp's Large Glass [5.2.1923] entitled *Miroir de la Mariée*.

*

As he would like to show Alfred Barr the photographs of Maria Martins' recent sculpture, which he has received from her, Duchamp writes a note to Barr suggesting that "after this precise 'vague de chaleur' [heat wave]" they either meet at the Museum of Modern Art or have lunch together. "I leave 26 August for Rochester (Chess Tournament)," explains Duchamp, "until 6 Sept[ember]."

1950. Wednesday, Paris
Gaby Picabia, who has also been keeping the Hoppenots informed of the deterioration in Mary Reynolds' condition [17.7.1950], follows up a recent letter to Marcel with a telegram.

1951. Thursday, New York City
Informs Miss Dreier about the arrangements made with Mr Kelly the previous day – yet to confirm with Glarner – and requests "a line or two" from her, "if it is not too much asking."

1952. Saturday, New York City
The tête-à-tête at 210 West 14th Street starts in gaiety until Marcel starts questioning Monique Fong about MT and says that she cannot continue that sort of game…

1959. Sunday, Le Tignet
After several excursions, including one to the Gorges du Verdon, followed invariably by a rest at the house, "the Haut Var now signifies for us a familiar domain," writes Duchamp to Maurice Fogt. "We have managed, I think, to incorporate ourselves with the house and also the surroundings," he remarks, sending Fogt by way of thanks a drawing, *Du Tignet*. A view of the distant hills seen from the house [18.7.1959], one of the telegraph poles bordering the lane to the west of the property stands in the foreground.

Marcel also incorporates the hills on the horizon with the Bride's domain in a drawing entitled *Cols alités*. In this, the telegraph pole, Science triumphant [14.10.1942], appears to be linked to the Scissors in the Bachelors' domain of the Large Glass [5.2.1923], itself an expression of causality.

1967. Wednesday, Cadaqués
Following his difficult negotiations with Editions Alecto, Richard Hamilton has written at length to Marcel, who says: "I am perfectly willing to go along with you in this adventure," (to make two separate details of the Large Glass on glass), and suggests a formula for them to co-sign the edition.

"It doesn't often happen that you have to wait until the age of 80 just to read the 'perfect echo' sentences of what you feel," writes Marcel to Monique Fong. "Thank you then for having succeeded." In "Marcel Duchamp" by Monique Fong, which was published in the May–June issue of *Les Lettres Nouvelles*, the author has included Duchamp's statement: "Esotericism should not be mental, it should have ritual [14.11.1952]."

10 August

1922. Thursday, New York City
"Share Ettie," pleads Rose, "2 long weeks have passed since our birthday [30.7.1922], it's the beginning of 'many happy returns'." Writing in the evening on a sheet of the pink paper, which he would like to have boxes of, Duche tells Ettie that he has dyed his shirt "a marvellous, raincoat-like, dark bottle green" and declares: "I am waiting with impatience that you come to N.Y. to show off Rrose Sélavy in bottle green."
"My unmethodical way of life continues," says Duche, who is still working on the McBride publication [5.7.1922] for the Société Anonyme and giving French lessons "here and there".
For Florine there is a message requesting the revised version of her poem on mosquitoes with her signature and a reminder to send her canvases to Paris; to Carrie, Duche mentions the Carrie-Rose restaurant that nearly opened: "I very much regret not getting up an hour earlier that morning… to be seen as a waiter (which is the characteristic of the French abroad when they have not been decorated with the Légion d'honneur)."
Sending her a brochure by the young Pierre de Massot [10.7.1921], Duche advises Ettie: "Perhaps avoid showing it to Mrs Stettheimer, who doesn't want me to look at *Jugend*."

1923. Friday, Paris
Sends an express letter asking Brancusi to meet him at eight that evening at the Hôtel Westminster, Rue de la Paix, where Louise Hellstrom, possessor of Duchamp's *WANTED* poster, is staying. "Although Francis [Picabia]

has telephoned his wife that he is ill," Duchamp says, "I think he will be at his rendezvous with me at seven-thirty."

1928. Friday, Paris
After a few days in Paris on his return from The Hague [5.8.1928], Marcel leaves for Nice. Helen Hessel, Roché and Brancusi join him for dinner at the buffet in the Gare de Lyon before he boards the night train.

1936. Monday, Hollywood
Calls to see Beatrice Wood, who shows him her drawings. Marcel encourages her to continue her experiments in pottery.

1937. Tuesday, Paris
On their return from Denmark [29.7.1937], Mary and Marcel invite the Rochés to lunch in the little garden at 14 Rue Hallé. Brancusi's *Deux Pingouins* [17.2.1937] are still standing in the green grass and a huge cat watches. Mary has cooked an "exquisite" chicken: while Denise enjoys the breast, Pierre dissects the parson's nose. Later when Mary shows Pierre the binding she has made for his *Don Juan*, he thinks about asking her to bind his son's precious illustrated diary.

1942. Monday, West Redding
In the morning Duchamp and Miss Dreier leave The Haven for New Haven, where they are invited to lunch by Dean Meeks of Yale University. It is Duchamp's first visit to Yale and although at the last moment the university's president, Seymour, is unable to stay for lunch (which is also attended by Dr Sizer and George Heard Hamilton), it is a great success in spite of Duchamp's tiredeness.

When they visit "5000 Years of Picture Making" at the Yale University Art Gallery, Duchamp, George Heard Hamilton, Dr Sizer and Miss Dreier are photographed for the *New Haven Register* standing in front of Miss Dreier's painting, *Two Worlds*, which is hanging in the exhibition.

*

Back at Hale House in the evening, Duchamp dines with the Ernsts, who have returned from Provincetown and after Max's brush with the FBI have decided to stay in New York for the summer after all [22.7.1942]. The other guests are André Breton and Frederick Kiesler.

10.8.1958

1958. Sunday, Cadaqués
With Gala and Salvador Dali, Teeny and Marcel make a boat tour of "all the most rugged part of the coast, almost as far as the French border".

Also when Robert Descharnes is in Cadaqués, he photographs the meeting one day of Duchamp and Dali at Meliton's [2.8.1958]. He follows their promenade behind the church and in the streets of Cadaqués, and also photographs the Duchamps' visit with the Monniers to the Corral de Gala: at the entrance, behind Dali posing on the steps, are Teeny, Jackie, Gala, Bernard, Marcel and Robert Descharnes' wife Michèle.

1959. Monday, Le Tignet
After three weeks of being "literally spoilt by the gardeners and above all by Madame Lorenzi", Teeny and Marcel leave Le Tignet for Nice airport and fly back to Paris. They return to 58 Rue Mathurin-Régnier, the house belonging to Max Ernst and Dorothea Tanning.

11 August

1918. Sunday, New York City
"I am going away again, that's becoming an obsession of mine," writes Marcel to Roché at the French Mission in Washington. He has left a picture by Eilshemius, a parcel containing copies of the *Blind Man* [5.5.1917] and the care of some of Beatrice Wood's drawings, which Roché will find on the balcony in the Arensbergs' apartment. As his ship is due to leave for Buenos Aires on Tuesday, it is a message of farewell: "Good bye dear, be seeing you in 2 years' time – at least."

Marcel has also moved the two halves of the Large Glass down from his studio to the Arensbergs' apartment. The unfinished glass inspired *Love – Chemical Relationship*, a poem published in the June issue of the *Little Review*, in which the author Else, Baroness von Freytag-Loringhoven, expresses her passionate feelings for Marcel:

"Thou now livest motionless in a mirror!
Everything is a mirage in thee – thine world is glass – glassy!

Glassy are thine ears – thine hands – thine feet and thine face.
Of glass are the poplars and the sun.
Unity – *Einklang* – harmony – *Zweifellosigkeit*!
Thou are resurrected – hast won – livest – art dead!
BUT I LOVE THEE LIKE BEFORE. BECAUSE I AM FAT YELLOW CLAY!
THEREFORE I LOVE THAT VERY THIN GLASS WITH ITS COLOUR-CHANGE; BLUE – YELLOW – PURPLE PINK…"

1931. Tuesday, Munich
In the morning Marcel sends a telegram to Brancusi with the message: "Telegraph one thousand francs poste restante Munich before this evening = Duchamp." The sculptor responds immediately enabling Marcel to collect 164 Reichmarks [2,500 francs at present values].

1936. Tuesday, Hollywood
Lou and Walter Arensberg throw a large party for Marcel to which many celebrated people are invited.

1952. Monday, Milford
As one of the three executors of Miss Dreier's estate [29.3.1952], Duchamp is at the house to supervise the removal of the art books for their transfer to the library at Yale University and to ensure that the books which may interest Mary Dreier, also an executor, are not disturbed until she returns from Maine. In a recent letter asking for her permission to start the work, Duchamp explains to Mary that "it will take several trips and several weeks to complete the job", and promises, "I will see to it that you can make your choice at leisure when you come back."

He also thanks her warmly for the "two beautiful Spanish shawls" for Suzanne Crotti and Gaby Villon which belonged to Miss Dreier.

In fact Duchamp has been devoting a great deal of time to an inventory of all the works of art, and Mr Kelly (of Chambers, Clare & Gibson) is "amazed at the progress he has made". Duchamp was also present when *Russian Carnival* by Kandinsky – purchased by the Guggenheim Foundation in 1946 but retained by Miss Dreier during her lifetime – was handed over to the museum recently. As the executors are also concerned about such details as keeping the garden of the house tidy, Duchamp has agreed to speak to the gardener about his hours, with an eye to controlling costs.

1958. Monday, Cadaqués
"The voyage across France [was] without incident," writes Marcel to Roché in Saint-Robert, "but full of surprises; Lascaux [9.7.1958], l'Auvergne, descent on the right of the Rhône." They also visited Roché's son and his family at Aubenas-les-Alpes, where they are "nicely installed in their countryside, which they are improving every day. He is working a great deal at photography," says Marcel, "and seems to take his job as father seriously."

1968. Sunday, Cadaqués
"Don't count on me to write an article on anything – it is absolutely impossible for me to do it," writes Duchamp to Rose Fried, who has to respond to a request by *Studio International* for a historical account of her gallery. He suggests helping by talking with her on his return to New York after 15 October.

12 August

1903. Wednesday, Granville
On the first stage of a short touring holiday, Marcel arrives in the evening at the port of Granville, a busy seaside resort situated in the southwest corner of the Cherbourg peninsula.

1906. Sunday, Saint-Pair
After forty-eight hours' leave spent with his family, on holiday near Granville [12.8.1903], Duchamp returns to his barracks at Eu.

1919. Tuesday, Rotterdam
Travels to Holland to meet Miss Dreier who has just arrived on the SS *Rotterdam* from New York. It is due to Duchamp's persuasiveness that the German consulate issues a German passport to Miss Dreier, who is anxious to visit her relatives in Germany now that the war is over.

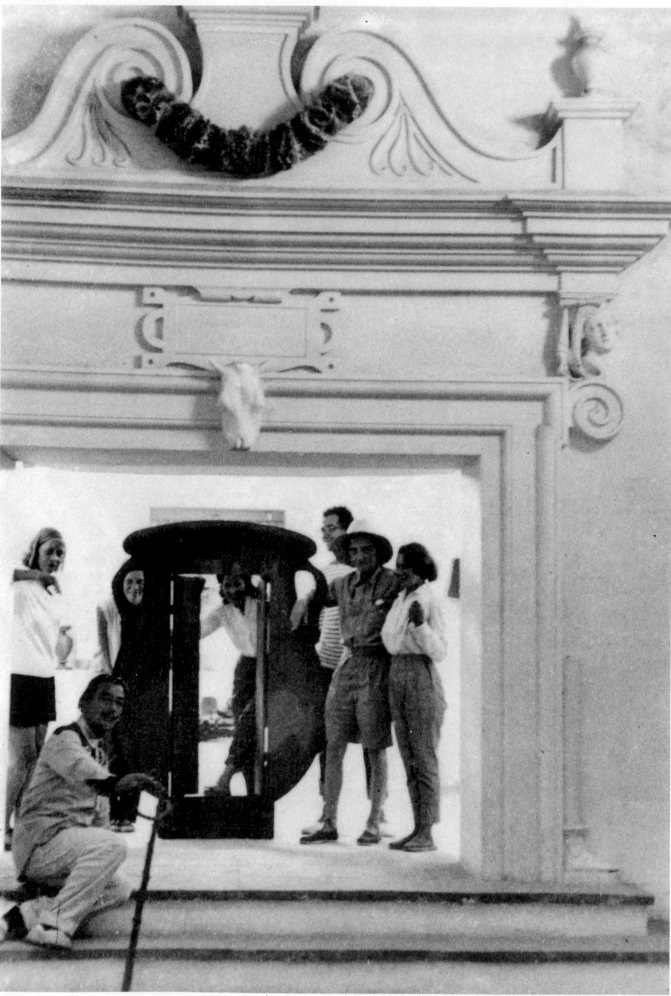

10.8.1958

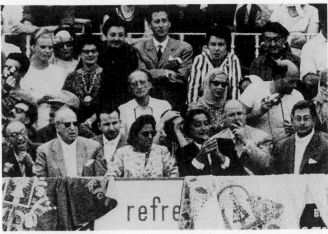

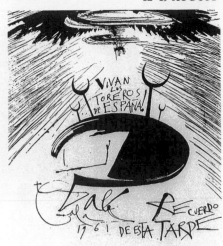

12.8.1961

1924. Tuesday, Paris
Upon his arrival at the Hôtel Istria from Val de la Haye in the evening, Duchamp finds a reply [8.8.1924] from Jacques Doucet proposing a meeting at eleven-thirty the following morning at Man Ray's studio, which he hastily confirms.

1931. Wednesday, Paris
On his arrival from Munich at midnight, Marcel writes a quick note to Brancusi, who had cabled him funds the previous day: "Arrived safe and sound. Long story that I will come and tell you tomorrow Thursday after lunch."

1958. Tuesday, Cadaqués
Choosing a postcard of Salvador Dali's swans swimming in the cove before his house at Port-Lligat, Marcel writes to Dumouchel saying that on arrival from Nice [1.8.1958] Barcelona was "terribly hot", and he continues, "Fortunately Cadaqués is very breezy and our *piso* (apartment) is very comfortable... [2.8.1958]"

1961. Saturday, Figueras
A special "Homage to Salvador Dali" is organized in Figueras which is attended by the Duchamps and many others from Cadaqués.

At four in the afternoon at Vilasacra, a town situated on the road from the coast, the "motorized caravan" is due to assemble to escort Dali the last four kilometres to Figueras. Giants and mammoth heads await his arrival half an hour later at the Plaza de Toros. At five o'clock the "Extraordinary Bullfight" is to take place, starring the famous matadors Curro Giron, Paco Camino and Fermin Murillo who, after the

lancing and planting of darts, will kill six brave bulls reared by the Molero Hermanos from Valladolid. The programme states that: "after the aerial rapt of one bull by helicopter... at the end of the fiesta, darts will be planted in a bull sculptured in plaster, the work of Niki de Saint Phalle and Jean Tinguely."

According to Teeny and Marcel, the "metal" bull exploded "with great noise and great success". The rest of the evening is devoted to Salvador Dali, who is escorted regally from the bullring – first to the house where he was born for the unveiling of a commemorative plaque, then to the town hall to receive the traditional Hoja de Higuera (Fig Leaf) and, finally, to the ruins of the Teatro Principal, site of his future museum. After attending a variety show at the Casino and Coca-Cola's firework display, everyone is invited at eleven to dine in the school yard of the Instituto Muntaner.

13 August

1903. Thursday, Granville
To Tribout in Rouen, Duchamp writes a postcard illustrated with the Rhinoceros, a prominent rock in the Iles Chausey, a remarkable seascape transformed dramatically by the exceptional tides of 16 metres which uncover twice a day a vast realm of rocks and marine vegetation richly inhabited by lobsters and shrimps...

1917. Monday, New York City
With Roché, Marcel visits Isadora Duncan and becomes "pretty drunk".

1918. Tuesday, New York City
Marcel has received cards from the Picabias, who have been in Switzerland for several months. After a period of dividing his attentions between Gaby, who is in Gstaad with the children, and his mistress Germaine Everling in Lausanne while he is treated for a nervous breakdown, Francis is now installed with his family and his mistress in a hotel suite at the spa of Bex, recommended to him by his doctor to avoid the Spanish flu epidemic.

In New York "everything has changed and [there are] fewer ways of enjoying oneself", Marcel complains to Picabia on the eve of his departure to Buenos Aires. "Varèse has become a steady man who will succeed next winter... Arensberg hasn't written a word since *391* [24.8.1917]... I haven't seen Stieglitz, de Zayas sometimes..." As for gossip, "Roché [who] is the best informed is in Washington for good."

Knowing Picabia's restlessness, Duchamp cannot really believe that he has stayed in Gstaad for almost a year. He asks him to come to the Argentine: "I would very much like to play chess with you again. If it bores us we shall easily find an island. The advantage is that it's far away."

*

As a farewell to Florine, with ink and coloured pencils, Duchamp draws a map of the Americas with, in the position of New York State, a country house and the dates 1915–1918. A ragged line labelled "27 days + 2 years" descends from New York as far as the big question mark at Buenos Aires, with a point marked "coal" and the equator marked "Hot".

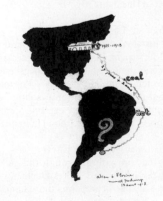

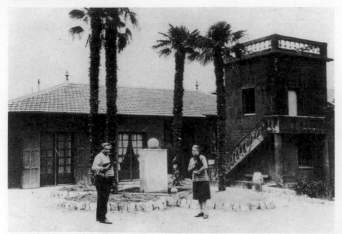 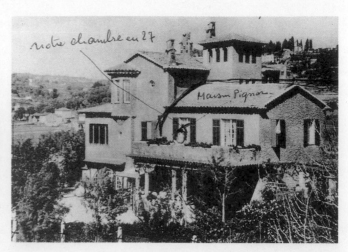

13.8.1927

1924. Wednesday, Paris
Duchamp has an appointment to meet Jacques Doucet at Man Ray's studio to discuss progress on the optical machine [8.8.1924].

1927. Saturday, Mougins
Finally liberated from his obligations in Paris [23.7.1927], including those of the Société Anonyme [27.6.1927], Marcel has come with his young wife to the Côte d'Azur. Taking three days in Lydie's little Citroën to drive south, they stopped the first night at the Hôtel du Sauvage in Tournus. "After dinner," recalls Lydie, "we went for a walk. An astonishing sight awaited us: the bank of the Saône was covered with a thick cloud of very light, inoffensive insects. The whole town was there. With calico fixed to the end of ordinary broomsticks, they were filling sacks. What could they do with them, I asked. 'Perhaps they are edible', Marcel suggested. 'Ephemeron omelette! What a speciality!'"

At Orange, they saw a play at the Roman amphitheatre.

Installed at Marthe Pignon's house abutting the Château de Mai, home of Picabia and Germaine Everling, the Duchamps have Jean and Suzanne Crotti too as neighbours [5.9.1926]. From time to time they also see Man Ray and Kiki [13.7.1927], who are on holiday in Cannes.

Leaving Lydie at Mougins, Marcel is one of five participants in a chess tournament starting today in Nice. Organized by the Groupe des Joueurs d'Echecs, it is an opportunity for Marcel to obtain some useful training before the French Championship which commences on 4 September in Chamonix.

1933. Sunday, Cadaqués
"We are installed here at Cadaqués, kind of Spanish Villefranche [8.9.1931], very pleasant, warm, breeze," writes Marcel to Brancusi inviting him to join them. He and Mary Reynolds have rented the Casa Lopez for a month, "we have a maid for the cooking," explains Marcel, "and the prices are really half [those] in France."

1949. Saturday, New York City
"It was great fun going through the galley proofs of the catalogue," writes Duchamp to Katharine Kuh who is preparing the exhibition publication for the Louise and Walter Arens-

berg Collection at the Art Institute of Chicago. He found "nothing of importance" but mentions that Brancusi himself gave the title *La Négresse blonde* [as the book by Georges

Fourest is entitled] to his sculpture, rather than *Négresse blanche*, when they were composing the catalogue together for the Brummer exhibition [17.11.1926].

1951. Monday, New York City
Manages finally to reach Fritz Glarner who is available to go to see *The Good Shepherd* in the chapel of St Paul's School at Garden City the following day, as proposed by Mr Kelly [8.8.1951].

1959. Thursday, Paris
"Re-read it all and your new ending indeed more finalizing and summarizing than the first," writes Duchamp to Patrick Waldberg, referring to "Marcel Duchamp. L'Unique et ses propriétés", which is to be published in the October issue of *Critique*. "Nothing to point out," continues Duchamp, "except a great pleasure to look at myself in the mirror." Paris is "cool and pleasant", he tells Waldberg and they are hoping to visit Dorothea and Max Ernst at Huismes on 20 August for a few days.

14 August

1903. Friday, Jersey
Travelling abroad for the first time to spend the weekend of the Feast of the Assumption on the largest of the Channel Islands, Duchamp arrives by steamer at St Helier after a three hour crossing from Granville.

1917. Tuesday, New York City
For several weeks Beatrice Wood has been in a state of despair [20.7.1917]. Before leaving for Canada where she has accepted a theatrical agent's proposal to work for a month at the French Theatre in Montreal, Bea announces her decision to Marcel, Roché, Arensberg and Picabia who promise to come and visit her.

1918. Wednesday, New York City
After living for more than three years in New York [15.6.1915], Duchamp embarks on the SS *Crofton Hall* to sail south to Buenos Aires. He takes with him his precious working notes for the Large Glass (left for the meantime in Arensberg's care [11.8.1918]) and Yvonne Chastel, who has decided to accompany him [8.7.1918].

1929. Wednesday, Les Rousses
In the morning Marcel receives a card from Brancusi [7.8.1929], who has been ill and is recovering at Aix-les-Bains on the shores of the Lac du Bourget, about 70 kilometres south of Geneva. As they are thinking of visiting Geneva the following week, Marcel asks the sculptor, "Are you strong enough to come there for the day or an evening?"

Mary Reynolds and Marcel can easily reach Geneva by descending the Jura Mountains to Nyon where there is a regular paddle steamer service on the lake. "I will send you a telegram on the eve of my departure giving you the time of my arrival in Geneva," writes Marcel, "I will give you a rendezvous at the station Eaux Vives…" and he asks Brancusi to reply by telegram.

1951. Tuesday, New York City
As agreed the previous day, Marcel takes Fritz Glarner to inspect Miss Dreier's mural, *The Good Shepherd*. Standing on a ladder, Glarner examines the painting with a "searchlight" and advises that no restoration is necessary. He recommends that it be cleaned and waxed.

1958. Thursday, Cadaqués
To Lily and Marcel Jean, Duchamp posts a card illustrated with a street filled with dancers of the *sardana* on which he has written: "After the sardines of the Coast the *sardanas* of Cadaqués are resting." Then, referring to the boat trip with Dali [10.8.1958] to see Buñuel's rocks, which for a time in 1930 were strewn

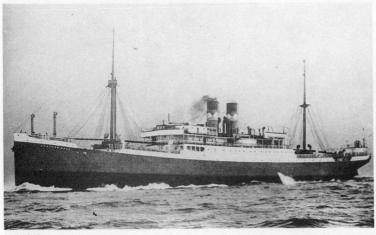

14.8.1918

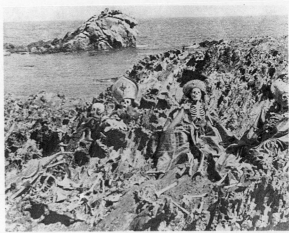

14.8.1958

with skeletons wearing mitres, he jokes: "Have seen again the landscape of *L'Age d'Or* in the flesh without bishops."

1961. Monday, Cadaqués
"We were very disappointed that you couldn't get down here this summer," types Teeny to Terry and Richard Hamilton in a letter which Marcel also signs. As they are planning, after their visit to Scandinavia, to be in Paris from 20 September for nearly two weeks, "We hope," continues Teeny, "you can get over for a few days."

They have seen Bill and Noma Copley, who "came by in a yacht a few days ago. They came," explains Teeny, "for a Bull Fight in honour of Dali [12.8.1961]."

15 August

1894. Wednesday, Saint-Valéry-en-Caux
At four in the morning, Marcel's grandfather, the painter and engraver Emile-Frédéric Nicolle, aged sixty-four, dies of a stroke at his home in the Rue Nationale.

Son of Eliza Marie Dollone and Jean-Pierre Nicolle, a candle-maker, Emile Nicolle was born in Rouen, where he also completed his studies and started work as a clerk with the *notaire* Maître Kréchel. After a spell in Provins, he returned to Rouen, abandoned this career and found employment with an oil manufacturer, M. Harel. However with the assistance of his future father-in-law, who advanced him capital from his daughter's dowry, he acquired the practice of a ship broker and married Marie Sophie Eugénie Gallet of Le Havre in January 1856.

With his wife, who enjoyed drawing and played the piano, Nicolle shared a great love of the arts. In 1858 under the pseudonym E. Colline, he published a series of caricatures in the *Petit Journal*; other illustrations and cartoons followed and from 1864 he started exhibiting regularly at the Salon de Paris. But in August 1867, aged 36, Sophie died leaving four young children, Lucie, Henry, Ketty and Zélie, only two months old.

Having decided to devote all his time to painting and engraving, in 1875 Nicolle left the maritime affairs to his partner M. Benoni Roux. Certain very fine examples of the 20 etchings that he made with great precision and affection of the monuments and streets in the ancient Norman city for the publication *Vieux Rouen*, were honoured at the Exposition Universelle in 1878. At his initiative, a petition endorsed by fellow engravers and delivered in 1881 to the municipal council of Rouen resulted in the foundation of the Galerie d'Estampes et d'Histoire Locale, the first museum of prints in France. As member of the Société d'Emulation, at the *hôtel de ville* Nicolle gave a lecture combined with a demonstration on etching entitled *Dissertation élémentaire sur la gravure à l'eau-forte et les états de planches*, which was published shortly afterwards in June 1885.

At Saint-Valéry-en-Caux in May 1883 Nicolle married Marie Cary, widow of Léon Pillore, the cousin of Sophie Gallet. In 1886, when the young Duchamp brothers Gaston and Raymond started attending the Lycée Corneille in Rouen, they were particularly attracted to their grandfather's household in the Rue de Champs-des-Oiseaux with not only the fascination of its artist's studio but also the opinions of the family which included those of the attractive eighteen-year-old Julia, Marie's daughter, a spirited, hard-working, intelligent young lady, Marcel's godmother [7.7.1888].

1924. Friday, Paris
The day before his departure for Germany, Duchamp writes to Jacques Doucet acknowledging the receipt of 190 francs and confirms that the mechanic will be attending to the optical machine [13.8.1924] while he is away. "I hope that with all the details, the object will work end of September at the latest."

*

After an outburst from Mary Reynolds one day, Marcel appears to have taken it as a pre-

text to break their liaison [23.7.1924]. However he calls for an hour at 14 Rue de Monttessuy to see her, but without showing any indication of wishing to continue their affair.

1943. Sunday, New York City
At the Brevoort: "Man and woman sitting casually at table with bottle, glasses, etc. on it," reads Maya Deren's shooting script for the film *Witch's Cradle*, which continues: "Woman is bored, drinks, looks out at the street. Man playing string game with his hands. One end dangles free, the other end leads off in back of him…"

Early in the afternoon, accompanied by Stefi and Frederick Kiesler, Maya Deren shoots the opening sequences of her film on the terrace of the famous artists' café on the corner of Fifth and 8th. Identified with his miles of twine [14.10.1942], Duchamp plays with a length of string which in the woman's imagination is to become alive, to crawl up his trouser leg and up his sleeve. Pajarito, Matta's wife and also an artist, plays the woman who later in the film is transported to a magical environment of surrealist paintings and sculptures in the Art of this Century gallery [20.10.1942], designed by Kiesler.

The inspiration of the film is the architecture of the gallery and the objects within it. "I was concerned with the impression that Surrealist objects were, in a sense, cabbalistic symbols of the twentieth century," writes Maya Deren who considers that: "the surrealist artists, like feudal magicians and witches, were motivated by a desire to deal with the real forces of underlying events… and to discard the validity of surface and apparent causation."

After the scene at the café terrace, Deren then continues filming Duchamp entwining his hands with string on the Kieslers' terrace at 56 Seventh Avenue.

1951. Wednesday, New York City
"I was sure that Dumouchel [22.7.1951] could be surprisingly fresh after Miss Adler's shower," writes Marcel to Louise and Walter Arensberg who find that the result of cleaning the picture "is really something fantastic". Considering that unlike *Portrait de M. Duchamp père* [6.5.1911] there is no Cézanne influence, Walter remarks: "in some ways… this portrait is unique in your whole output."

15.8.1943

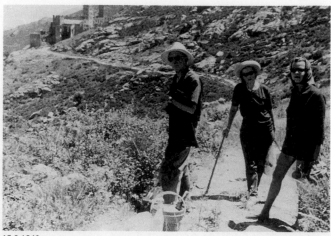

15.8.1962

As the Arensbergs have received a tax demand for all purchases made outside the State of California between 1935 and 1940, from memory Marcel makes an approximate list of items purchased through him. There are four Brancusi sculptures, *Le Baiser* [sold to the Arensbergs in

1926], *Trois Pingouins* and *Chimère* from his own collection [2.11.1930], and *Le Poisson* from Peggy Guggenheim; a Calder mobile and two Duchamp-Villons, *Tête de Cheval* and *Portrait du Professeur Gosset*; *Disques de Newton, étude pour: La fugue à 2 couleurs*, 1912, by Kupka; *Jardin Gobe-Avions* by Max Ernst and *Les Six Eléments* by René Magritte; Villon's *Abstraction*, Pierre Roy's *Système Métrique* and *Le Poète et sa Muse* by de Chirico. At an auction [27.11.1935] Marcel purchased *Violon et Pipe* by Georges Braque for the Arensbergs. During the same period he sold them a number of his own works: *Portrait de M. Duchamp père* which belonged to Jean Crotti, *Baptême* [16.6.1935], *Vierge*, No.2 [7.8.1912], which turned up in Paris [19.2.1939], *Why not Sneeze?* [11.5.1935] belonging to Roché, *Mariée* [25.8.1912], originally given to Picabia (subsequently owned by Paul Eluard, André Breton and Julien Levy), and *Le Buisson* [21.4.1911] which was originally a gift from Marcel to Dr Dumouchel.

1959. Saturday, Paris
On the Feast of the Assumption at one o'clock the Duchamps lunch with Monsieur and Madame Louis Carré.

1962. Wednesday, Cadaqués
Suzanne, who has come to spend a fortnight with her brother and sister-in-law, arrives in George Staempfli's big car in which Teeny has chosen to bring her from the station. It is one of the vehicles used the day of the picnic in the mountains at the monastic ruins of San Pedro de Roda where there is a spectacular view of the coast.

1968. Thursday, Cadaqués
"Dear Yo, dear Chaques," types Teeny to the Savys [2.3.1968], a slip which amuses Marcel who writes: "(combination Jacques–échecs)." Pleased to hear that they have been in Menton since the beginning of the month, they remark: "we also play a lot of chess: what a drug!"

"I have two friends," continues the letter, "one has a very fast boat and the other a slow boat. I alternate... We like our new apartment very much, our terrace is more practical than last year's and our bedroom overlooks the sea, the 'Salon' as well. Marcel is busy drawing a plan of a Spanish fireplace which is to be built immediately, but as Spaniards are Spaniards we won't perhaps see it this year."

16 August

1924. Saturday, Paris
In the morning at the Hôtel Istria before he has risen, Totor receives a visit from Roché who has been doing some shopping. Roché can't help noticing the black hair of the girl who is still lying in Totor's bed. An hour later Totor is having lunch with the same girl whom Roché recognizes as a model, a regular at the Café du Dôme. Judging the girl unworthy of Totor, common even, Roché accepts that this is his friend's way of protecting his liberty.

When Roché takes Helen Hessel to 14 Rue Monttessuy later in the day, Mary Reynolds tells them of Marcel's visit the previous day. Although holding little hope, she nevertheless wants to see Marcel again before he goes abroad. On their way back to Arago by taxi, Helen and Pierre take Mary to Montparnasse, where she joins Marcel on the terrace of the Café du Dôme.

Later Marcel leaves on a night train [?] for Germany where, with Miss Dreier, he plans to visit Berlin and the Bauhaus in Weimar.

1936. Sunday, Hollywood
In the morning, Duchamp visits Twentieth-Century Fox with Kenneth MacGowan, an associate producer and friend of the Arensbergs.

"This trip has been wonderful," Dee writes to Miss Dreier and thanks her for sending on his copy of *Cahiers d'Art*, published earlier in the year [14.4.1936], with its cover of the bright blue and red *Cœurs volants*, which he had left in the middle drawer of the writing desk in his room at The Haven. The issue, which he wants to show Arensberg, includes an article on his work by Gabrielle Buffet-Picabia, which is also entitled "Cœurs volants".

*

After meeting Duchamp at the Arensbergs, Arthur Millier's article appears in the *Los Angeles Times*, illustrated with a photograph of the Frenchman studying a chess problem seated by his famous *Nu descendant un Escalier* [18.3.1912].

"Duchamp is quitting chess for the same reason he quit painting," Millier reports. "As to what he will do next he hinted that he is working out a system to measure the imaginative power in works of art." Visiting the West Coast for the first time, Duchamp told the journalist that he found California "a white spot in a gloomy world".

1951. Thursday, New York City
In the morning Duchamp meets Mr Kelly to report on his visit with Glarner to Garden City on Tuesday. Glarner estimates $200 for cleaning the mural, which will take him about seven days and requires a scaffold to be built. Mr Kelly, who is to discuss the matter with the dean of St Paul's School, asks Duchamp to arrange for Glarner to send him an explanatory letter.

After receiving her telegram cancelling his visit to Milford on account of urgent medical treatment, Dee writes to tell Miss Dreier of his progress with Glarner and Kelly.

1953. Sunday, New York City
Leaves the city to join Brookes Hubachek at Basswood in the wilds of Minnesota near the Canadian border, north of Duluth.

1956. Thursday, New York City
In the afternoon Marcel works with James Johnson Sweeney, director of the Guggenheim Museum, on preparations for the "Three Brothers" exhibition due to open in the museum on 8 January. Sweeney mentions that Jean Cassou of the Musée National d'Art Moderne has ex-

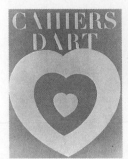

16.8.1936

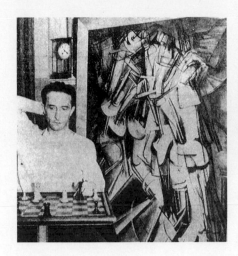

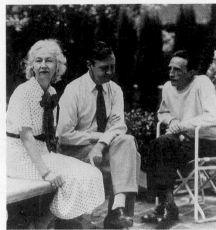

17.8.1936

pressed interest in having the exhibition, which is also due to travel to Houston, Texas. Marcel agrees that in spite of the stipulation that pictures from the Arensberg Collection must not be outside the Philadelphia Museum of Art for longer than six months at a time, everything possible should be done so that Cassou can have the show in Paris after Houston.

1962. Thursday, Cadaqués
The day after Suzanne's arrival, Teeny and Marcel take her with them to have supper with one of the regular summer visitors to Cadaqués and a close friend, the Peruvian painter Rodriguez.

1967. Wednesday, Cadaqués
In reply to a request from Pierre de Massot for a copy of *L'Opposition et les Cases conjuguées sont réconciliées* [15.9.1932] for Bernard Delvaille, Marcel says that he thinks he has a copy in New York. Delvaille should write to him therefore after his return to America, which will be around 18 October.

17 August

1894. Friday, Rouen
The funeral of Emile-Frédéric Nicolle, who died on 15 August in Saint-Valéry-en-Caux, takes place at ten o'clock in his parish church in Rue du Nord. After the service the coffin is taken from the church of Saint Joseph to the Cimetière Monumental dominating the city from the northern hillside, and placed in the family tomb where Nicolle's first wife Sophie Gallet, her father and uncle and two of his children, Henry (d. 1880) and Zélie (d. 1886), are buried. The place is not far from the tomb of the Pillore family [28.7.1887], marked by a slender, sculpted column.

1928. Monday, New York City
The Fifth Avenue Bank of New York credits Duchamp's account with the $100 received from Miss Dreier.

1931. Monday, Paris
When he has lunch with Roché at Les Maronniers, 53bis Boulevard Arago, Totor admits he

has a slight fever and may have to have an operation.

*

"Man Ray tells me that you have become chess mad," writes Duchamp to the beautiful Lee Miller, "congratulations from another lunatic." He invites her to play two games by correspondence using the English notation. "Later on when I see you in Paris," Duchamp continues, "I will teach [you] the algebraic notation, which is much more convenient."

1936. Monday, Hollywood
While they are sitting in the rear garden at 7065 Hillside Avenue, Beatrice Wood takes a series of photographs of Marcel with Louise and Walter Arensberg.

1952. Sunday, New York City
"Agree absolutely with you," writes Marcel, replying to a long letter from Crotti discussing "L'Œuvre du XXème Siècle" [4.5.1952], "not forgetting," he adds, "that Sweeney had to organize this whole show in 6 weeks... I remember that in my conversations with him on this subject, I had suggested the idea of giving at least a small panel (very small) to Dada... He did nothing about it, naturally." To assuage his brother-in-law's disappointment at not being included in Sweeney's exhibition and as Sidney Janis has entrusted him with "the organization of ideas" for a Dada exhibition next March or April, Marcel asks Crotti if he will lend *Le Clown* made in 1916 [26.10.1918].

"You ask my opinion of your work, my dear Jean," says Marcel. "It's too long to say in a few words – and above all for me who has no belief at all – of the religious kind – in artistic activity as a social asset.

"Artists of all times are like Monte Carlo gamblers, and the blind lottery advances some and ruins others. To my mind, neither the winners nor the losers are worth bothering about. It's a good personal deal for the winner and a bad one for the loser.

"I don't believe in painting in itself. Every picture is made, not by the painter, but by those who look at it and grant it their favours; in other words, a painter who knows himself or knows what he's doing doesn't exist – there is no exterior sign that explains why a Fra Angelico and a Leonardo are equally 'recognized'.

"Everything happens through pure luck. Artists who, during their life, have known how to make the most of their junk are excellent travelling salesmen, but nothing guarantees the immortality of their work. And even posterity is a real bitch, who eludes some and revives others (El Greco), but may indeed still change opinion every 50 years...

"In your particular case, you are certainly victim of the 'Ecole de Paris', this great joke that has lasted 60 years (the pupils themselves award the prizes, in money).

"In my opinion, there is refuge only in esotericism – for 60 years now, we have been watching a public exhibition of our balls and multiple erections..."

"I will not speak to you of your sincerity because that is the most ordinary banality and the least valuable. All liars, all bandits are sincere...

"In 2 words: do less self-analysis and work with pleasure without worrying yourself about opinions – your own or those of others."

1964. Monday, Cadaqués
"I received the 2 photos safely (Jeannine [30.9.1940] and you) and sent them to N.Y.," writes Marcel to Gabrielle Picabia. As Jeannine has not replied to his letter "asking for details", Marcel enquires: "Has she received my letters?"

18 August

1903. Tuesday, Jersey
In the morning, after spending a long weekend at St Helier, Duchamp boards the steamer and crosses in a rough sea to Saint-Malo.

1916. Friday, New York City
In the afternoon Duchamp receives a letter from John Quinn enclosing a draft of 1,500 francs (a little more than half the amount due on the Villon paintings [27.7.1916]), with the promise of a second draft in six weeks' time. Quinn also encloses two letters, one from Rouault and one from Metzinger, which he asks Duchamp to translate for him.

19.8.1903

19.8.1912

1918. Sunday, at sea
Aboard the SS *Crofton Hall*, four days from New York, a rumour circulates that when the ship was steaming past Atlantic City, not many miles away, a submarine sank an oil tanker.

1924. Monday, Weimar
With Miss Dreier Duchamp visits the Bauhaus school of architecture and applied arts, founded in 1919 by Walter Gropius, where Kandinsky (vice-president of the Société Anonyme [13.12.1922]) and Paul Klee (who is particularly looking forward to meeting Duchamp) are both professors.

1926. Wednesday, Paris
With recent confirmation that a Brancusi exhibition is to be mounted in New York at the Brummer Gallery [8.8.1926] in November, Marcel meets Roché at Arago. Later they take Paul Morand, whom they have invited to write the preface for the catalogue, to meet Brancusi at his studio and see "his small exhibition room".

1951. Saturday, New York City
After receiving further details from the Arensbergs about the tax demand, Marcel considers that of the list he sent them on Wednesday only *Violon et Pipe* by Braque [27.11.1935] and *Mariée* [25.8.1912], purchased from Julien Levy in 1937, should be subject to any tax, "all the other items were bought from the artist or from an individual collection."

1955. Thursday, East Hampton
"The other day I saw the 'rushes' of my conversation [3.8.1955] and it isn't too artificial," writes Marcel to Roché, who is referred to in one of Sweeney's questions. "It's always a shock to hear oneself speak," he continues. "The finished copy will not be ready before October or November and I will let you know."

1956. Saturday, New York City
The Duchamps travel to Chicago, where Brookes Hubachek is due to accompany them to Basswood [21.8.1953]. If Hubachek, who is "in a frenzy of work", is unable to leave his office today, he plans to follow them to the wilds of Minnesota in a few days.

1957. Sunday, New York City
"Your idea in German fills me with joy," Du-

champ tells Serge Stauffer in Zurich who has started translating the notes from a copy of the Green Box [16.10.1934] lent to him by Meret Oppenheim. "Regarding the final presentation," advises Duchamp, "I think it is unnecessary to retain the fidelity of facsimile regarding the form and the texture of the paper. Most important," he considers, "is the arrangement on the page of the lines and the words evoking the original arrangement as faithfully as possible." Returning the completed texts which Stauffer had difficulty in deciphering, Duchamp also includes for him a copy of *View* magazine [15.3.1945].

1960. Thursday, Cadaqués
After his 100 questions have been answered [6.8.1960], with apologies Serge Stauffer has sent some supplementary ones to which Duchamp replies: to explain in *Réseaux des Stoppages* [19.5.1914] that "each line passes from a single point except line 8 which is the departure point of the second group", he draws a sketch of the 3 groups of 3 networks of stops; *Recette* [7.1.1941] has no direct relationship (only a vague imprecision) with the photo upon which it is written; there is the same imprecision of language between a kilo of feathers and a kilo of lead; *With my Tongue in my Cheek* [30.6.1959] is a common expression in America meaning "pince sans rire" and it is pure coincidence that Mrs Kuh used it in a catalogue [19.10.1949]; he gave no reason to himself at the time for no longer wanting to "finish" the Large Glass [5.2.1923]; there is no category, only a family resemblance between the 3 objects *Objet-Dard* [6.12.1953], *Feuille de Vigne femelle* [12.3.1951] and *Coin de Chasteté* [16.1.1954]; those individuals who are capable of hearing the "echo" emitted from good works of art are those who direct art at each period – this "aesthetic echo" [8.4.1949] has nothing to do with the average or even refined taste of the period; to show the form of the Bec Auer gas lamp, by which he painted *Portrait de Joueurs d'Echecs* [15.6.1912], he makes a drawing; in the Large

manchon
en sorte d'étoffe
blanche d'amiante?

Glass there is no relationship between the Wilson-Lincoln system and the Oculist Witnesses which is like an oculist barrier between the end of the Toboggan operations and the Handler of Gravity; there is a similarity between "demultiplication of the target" and the gearing down mechanism of a bicycle; except for the axis and height of each Mould, the drawing in perspective of *9 Moules Mâlic* [19.1.1915] was not very elaborated; at the time of the Brooklyn exhibition [19.11.1926], before the Large Glass was broken, the Bayonet never went as far up as the horizontal, insulating glass strips, and both the base line indication for the Grinder and the three patches caused by the remains of the silvering for the Oculist Witnesses [20.10.1920] have since disappeared, et cetera, et cetera.

1962. Saturday, Cadaqués
At ten-thirty in the evening Marcel has promised to play chess for Llanse against Rosas and he has asked Teeny to play as well.

1968. Sunday, Cadaqués
"Your letter of 8 January 68 (!) arrived here in Cadaqués a few days ago," Marcel tells Kay Boyle. "Apart from the regret for this delay in replying, we were very pleased to know where you are and to send you our best wishes for 1969..." He thanks Kay for her book which he is "very curious to read" and asks her to send it to Neuilly before 14 October. "Perhaps in N.Y. this winter..." he adds.

19 August

1903. Wednesday, Saint-Malo
"I left Jersey yesterday morning Tuesday in rather a rough sea," writes Duchamp on a postcard of waves breaking against the ramparts which he posts to his friend Tribout in Rouen. "No seasickness. We arrived in Saint-Malo very glad to set foot on French soil. (What patriotism!) I do not know when I will be back, probably Monday. But before I will go to see the Mont-Saint-Michel. I am content as always. You also I suppose. Good handshake, my respects to your parents. I am not giving you an address, letters take two days..."

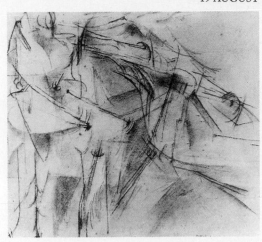

1912. Monday, Berlin
It has already been a notable year for progress in air-travel. On 13 January Vedrines broke the record for speed by flying at 142 kilometres an hour, and since the flying men learned to navigate through cloud, many have been competing to be the first pilot to fly from Paris to Berlin nonstop. Brindejonc des Moulinais made an attempt on 8 August from Villacoublay but was forced to land in Westphalia. Today this landmark in the history of aviation is reached when in the evening Edmond Audemars, who set off from Paris the previous day, lands triumphantly in Berlin.

Sometime during his stay in Munich [21.6.1912], Duchamp makes a drawing, separate from his other studies [7.8.1912], entitled *Aéroplane* in which, from a construction of metallic fuselage, a thrusting skyward movement is indicated with a small arrow.

In fact that spring Duchamp had witnessed at close range the takeoff and landing of such a craft at Toussu-le-Noble when Picabia arranged with Henri Farman, whom he had met one night at L'Ane Rouge, to take his wife flying.

"We took the Duchamps with us," remembers Gabrielle Picabia, to whom Marcel at the time gave his drawing entitled *2 Nus: un fort et un vite*. "It was an enormous field where all the future aviators trained with those who had managed to fly. I went up in an aeroplane with Farman. It was a funny machine, there was a small bicycle seat behind him. I was to sit there and was warned not to touch anything.

"We went to Chartres – and from time to time Farman turned round to see if his passenger was still alive or not. There was a dreadful noise, so I made great signs to tell him that all was well and I was really delighted.

"And then we came down, which was something else. Naturally I must have thanked Farman and then I was cornered by the Duchamps, and Villon simply said that a mother shouldn't expose herself to danger.

"There were discussions about the Machine which, at that time, was considered as anti-artistic and an enemy of the mind."

1916. Saturday, New York City
Duchamp confirms to John Quinn of his receipt the previous day of the draft, which he has already forwarded to Gaby Villon by registered post, and the letters of Rouault and Metzinger. "I will send you the letters translated as soon as possible, I hope, in a couple of days," writes Duchamp and adds, "I want you to come and see me soon at the studio."

1929. Monday, Les Rousses
As promised [14.8.1929], on the eve of his visit to Geneva Marcel sends a telegram to Brancusi in Aix-les-Bains: "Will be tomorrow Tuesday 2h13 at boat station Eaux Vives at Geneva = Duchamp."

Later a telegram arrives from Brancusi indicating the unlikelihood of his meeting Marcel and Mary the following day in Geneva. "We won't go to Aix-les-Bains tomorrow," writes Marcel the same evening to Brancusi, "It's a bit far." However if the sculptor is in Aix until 2 September, Marcel suggests visiting him there just before returning to Paris. "So write to me how long you reckon staying in Aix and take good care of yourself – That's very important!"

1933. Saturday, Cadaqués
As Miss Dreier is to have an exhibition of her own work at the Academy of Allied Arts in New York and Villon's coloured aquatint of her painting *Zwei Welten* will be included, she has asked Dee whether Villon would write a few words for the catalogue. Might Pevsner and Roché also write a few lines? Will Dee translate all this for her? Wondering where he is, Miss Dreier complains: "You do try the soul of your friends when you never write or let them hear from you."

"I just received your letter," replies Dee, "and feel ashamed not to have written sooner," but says he has written immediately to Villon, and "is writing" to Roché and Pevsner.

He is pleased to announce that sales have reached a thousand copies of his French version of *Comment il faut commencer une partie d'échecs* by Eugène Znosko-Borovsky [2.9.1932], published earlier in the year by Les Cahiers de l'Echiquier Français. "I would not be surprised," Dee tells Miss Dreier, "if we had to print a second edition," and adds, "I am trying to write a sort of complement to my first book [*L'Opposition et les cases conjuguées sont réconciliées*, 15.9.1932] but this does not seem to work so far."

1936. Wednesday, Hollywood
Beatrice Wood calls on the Arensbergs and sees Marcel.

1941. Tuesday, Vichy
On a short visit to the seat of Pétain's government to press for the delivery of his French passport [25.6.1941], the first step before he can obtain authorization to go to America, Marcel sends a telegram to Roché at Saint-Martin-en-Haut proposing to meet him in Lyons on Thursday before returning to Grenoble.

1959. Wednesday, Paris
Saying that their "London programme will be scheduled" when the Copleys and Hamiltons arrive in Paris, Duchamp reminds Richard Hamilton, who is finalizing the typographic version in English [17.6.1959] of the Green Box: "As you know, I am not a bit keen about the BBC broadcast and will do it only to help the book (if it does)."

*

"*Avoir l'apprenti dans le soleil* [25.12.1949] is the title of a drawing," writes Duchamp to Serge Stauffer, "representing *un cycliste étique* climbing a hill reduced to a line. This drawing with its title," Duchamp explains, "belongs to a group of 16 (?) scraps of paper (like the green box) gathered in a box and dated 1914… It was the period," he continues, "when I hoped to achieve a complete dissociation between the written word and the drawn image to expand the significance of both (as far as possible from a descriptive title, in fact suppression of the concept 'title')."

The small circle above the Oculist Witnesses in the Large Glass [5.2.1923] should have had an optical lens glued to it similar to the one in the small glass (*A regarder d'un Œil, de près…* [4.4.1919]), but Duchamp explains: "it was at this moment that I left the glass unfinished and the lens was never glued. It is on a vertical plane and is not subject to any distortion of perspective."

While stating that he has never read a single treatise on alchemy, which he believes "must be quite inadequate", Duchamp argues that one cannot 'do alchemy' as one can, with an appropriate language, 'do law or medicine'.

"But one cannot," he declares, "do alchemy throwing words around or in full consciousness superficially."

20.8.1968

21.8.1945

20 August

1908. Thursday, Veules-les-Roses
The first results of the annual Lawn Tennis Championships are published in today's edition of *L'Auto*. In the first round of the Ladies' Singles, Miss Dobson beat Miss Ayzaguer 6–4, 6–4; Miss [Carmen] Cartaya [3.8.1908] beat Miss Finke 7–5, 6–3; and in the second round, Miss Cartaya beat Miss Dobson 7–5, 7–5.

In the first round of the Men's Doubles, MM. Warden and Puech beat MM. [Georges] Ayzaguer and [Marcel] Duchamp 6–0, 6–1.

1929. Tuesday, Les Rousses
Although they learnt the previous day that Brancusi cannot come from Aix-les-Bains to meet them, in the morning Mary Reynolds and Marcel travel to Nyon where they board a paddle steamer bound for Geneva.

1931. Thursday, Paris
Having lunched together on Monday, Totor calls to see Roché in Arago and they go together to visit Helen Hessel in Rue Ernest-Cresson [4.7.1931].

1936. Thursday, Hollywood
At 7065 Hillside Avenue, on the eve of his departure, Louise and Walter Arensberg hold a dinner for Marcel, inviting Helen Freeman Corle and Beatrice Wood.

Marcel has profited from his visit to the Arensbergs to make detailed notes on his works in their collection for his "album" [5.3.1935]. For the collotype work, he requires precise colour notes of each painting, and he has met Sam Little, the photographer who will provide him with the black-and-white prints for reproduction.

1941. Wednesday, Vichy
"I am just passing through here and I think that I have at last obtained the French passport," writes Marcel to Beatrice and Francis Steegmuller. "But I still have to deal with the American visa [2.7.1941]." The contents of his boxes safely in Grenoble [23.6.1941], Marcel still

hopes, in spite of everything, to reach the United States soon.

The Steegmullers' letter dated 17 July addressed to Sanary confirms not only that they have received all Marcel's letters and that "the reckonings were exact except the cheque of $25 lost or at least blocked", but also that their regular payments to Villon are now being arranged through Brookes Hubachek in Chicago and his sister Mary Reynolds in Paris [4.6.1941].

*

Giving his address at the Hôtel Mallet, 22 Rue de la Laure, Duchamp writes to thank Georges Hugnet for having paid the quarter's rent on 11 Rue Larrey.

*

Referring to the communication of 25 April from the *préfecture*, the secretariat of the Vichy police informs the *préfet* in Grenoble that the exit visa requested by Duchamp may be granted.

1945. Monday, New York City
"Thank you for the invitation to Connecticutian delights," writes Duchamp to Hans Richter. "Not possible this week, I am going to Saratoga for a chess tournament. But in a fortnight or 3 weeks it could be arranged and I would willingly stay 48 hours with you…"

1955. Saturday, East Hampton
Marcel writes "lazily" to Suzanne and Jean Crotti: after returning to New York on Monday, he and Teeny go to Cazenovia for ten days and will be back in New York around 3 September. Where in French Switzerland, enquires Marcel, will Jean's travelling exhibition be held?

1959. Thursday, Paris
The Duchamps are invited to spend a few days with Dorothea and Max Ernst at Huismes, in Touraine.

1968. Tuesday, Cadaqués
For the French edition of Arturo Schwarz's book *L'Œuvre complète de Marcel Duchamp* to be published by Georges Fall, Duchamp suggests to the author an item for a number of "de luxe" copies. "I have thought of making an anaglyph (red and green) [6.8.1960] apropos of a Spanish chimney… [15.8.1968]. This hand-made anaglyph (like *Stéréoscopie à la Main* [4.4.1919]) should produce a three-dimensional

effect when viewed through a pair of spectacles with green and red coloured filters. How many copies do you need," asks Duchamp. "For a small number I could make the entire edition by hand (originals) but for a large number I will have my original printed…"

21 August

1918. Wednesday, at sea
"The sea is very calm, and I only have light in the evening in a very hot and stuffy smoking room on account of the submarines [18.8.1918],"

writes Marcel to Walter and Lou Arensberg from the SS *Crofton Hall* after a week at sea. There is no one to play chess with but, he says, "I am working on my papers, which I am putting in order. … No seasickness yet."

1929. Wednesday, Geneva
"Look after yourself [and] write," Marcel instructs Brancusi on a postcard. "I will go to Aix[-les-Bains] around 1st or 2 Sept if you are still there." He signs "Morice", and Mary Reynolds adds her signature.

1933. Monday, Cadaqués
"We are settled here with Mary [Reynolds] in a little house, if not delightful, at least sufficient," writes Marcel, inviting Man Ray to join them for a while. "Ideal weather and charming peseta," he continues, mentioning that Salvador Dali, whom they see often with Gala, would like some photographs taken of the Gaudí buildings in Barcelona to publish in *Minotaure*.

1936. Friday, Hollywood
After a fortnight [6.8.1936] with Louise and Walter Arensberg, Marcel boards a train to return east.

 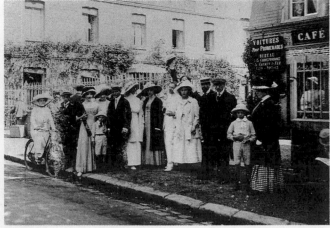 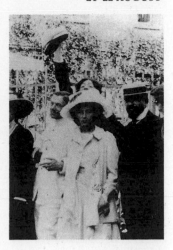

21.8.1955 22.8.1909

1941. Thursday, Lyons
In the morning at eleven o'clock Marcel, who has come from Vichy, meets Roché on a street corner. Roché who arranged to take a bus with Germaine Richer from Saint-Martin-en-Haut the previous evening, accompanies Marcel to the Hôtel Claridge. After lunch at the Richers', Roché spends a long time looking at the "beautiful box in brown suede like [his] shoes", which Marcel has made for him [25.6.1941].

They explore Lyons thoroughly on foot, which they enjoy, and although Marcel's eyes have improved since Saint-Raphaël [14.7.1941], Roché takes him to see a friend's oculist: tobacco is suspected as being the cause of his troubled vision.

In the evening after making careful investigations they select a restaurant and dine very well at a table outside on the pavement.

1945. Tuesday, New York City
To Denise and Pierre Roché's three cards and long letter Totor answers in economic sentences.

"Generalities – I have managed to live here almost as in Paris that is to say by avoiding public life (exhibitions, cocktail parties) – In spite of that I had to assist with putting together a No. of *View* [15.3.1945] which Mary [Reynolds] must have shown you."

He often sees James Johnson Sweeney, "(yes, the same who lunched at the Restaurant St Marcel)" who is now director of the Museum of Modern Art: "I am telling my whole life to him like a confessor," Totor reveals, "and that has already lasted six months at the rate of 2 hours a week! – By the way, he wants you to tell him… how the Rousseau (*Bohémienne endormie*) [7.2.1924] came to the coll[ection] Quinn (thanks to you) on leaving Laval (where apparently the canvas given by Rousseau had been rolled up and forgotten by the Municipal Council)… Give him all the details," he urges Roché, "the controversy about its authenticity etc.

"Certainly [Sweeney] would very much like to buy *Adam et Eve* [by Brancusi] when monetary conditions are more stable.

"Wols – Very happy to see him 'emerge' – but Kay Boyle and I consider that it is much better for him at the moment not to come to the USA where there is only benefit for the names already made in Europe.

"My glass (yours) [*9 Moules Mâlic*] Sweeney had thought of buying it for the museum. They have nothing of mine and it amuses me greatly at the thought that all these people have waited so long to want to buy something; obviously now the prices have changed."

Regarding Roché's proposal to found an institution called "Fondation Post-Mortems" to make a collection of private journals of artists from all over the world, to which he would leave his own diaries (1903–1945) to be published *post-mortem* [17.5.1941], Totor writes: "Of course the idea is excellent. To carry it out is complicated," and suggests, with Roché's permission, to speak to Sweeney about it.

"Yes I will return in spring 1946," promises Totor: "I much prefer to stay here egotistically and also send parcels – tell me what you miss the most." He writes: "Peace is really very perceptible here. Perhaps it was the lack of interest for the 'war in China' but now it is indeed sincere relief at the thought of peace, trimmed especially with the titivations of the atomic bomb…" [8.8.1945].

1952. Thursday, New York City
Just prior to leaving for Cazenovia where he will play in the annual tournament of the New York State Chess Association, Duchamp receives a letter from Fiske Kimball of the Philadelphia Museum of Art regarding *Le Roi et la Reine entourés de Nus vites* [9.10.1912], but does not have time to reply to it.

1955. Friday, Basswood Lake
Inspired by the moonlit lakeside scene viewed from the houseboat, Marcel takes a sheet of pale blue blotting paper and with ink, pencil, talcum powder and a bar of chocolate draws his impression of the flaxen moon glinting in the still waters as it emerges from the forest and dedicates it [*Clair de lune sur la baie à Basswood*] in French to Margerie and Brookes Hubachek, his hosts.

1960. Sunday, Cadaqués
Further to questions from Pontus Hulten about loans for the exhibition "Bewogen Beweging", which he is organizing with the Stedelijk Museum, Duchamp promises to write to Henri Marceau at the Philadelphia Museum concerning *Nu descendant un Escalier*, No.3 [29.4.1919] and *Broyeuse de Chocolat*, No.2 [8.3.1915].

If Maria Martins does not wish to lend *Moulin à Café* [20.10.1912], which is in Brazil, then there is the facsimile reproduction in the *Boîte-en-Valise*. Agreeing to a reconstruction of *Roue de Bicyclette* [15.1.1916], Duchamp also says: "A reproduction in reduced scale of the big glass is all right – Don't bother sending it to me."

1967. Monday, Cadaqués
Using a postcard of the towering ramparts of Carcassonne, Marcel writes to Yo and Jacques Savy in Menton, addressing them as "Dear Rosebuds" of Rosebud. Instigator of Yo's forthcoming New York exhibition at the Bodley Gallery in November, Marcel declares: "I am writing to Lefebvre-Foinet to remind him to take your canvases on 1st Sept.," and asks: "Have you any news of the catalogue?"

22 August

1909. Sunday, Veules-les-Roses
In the morning sunshine before the railings of the Grand Hôtel des Bains, Marcel joins the band of friends including the dapper Julien Dambé, Camille Marchand with his cloth cap, Simone and Suzanne, the two Blocman sisters, and the three Cartayas, Carmen [29.1.1909], Mercedes and Odette, who have gathered to bid farewell to Roland Jourdan and Marcel Langlois.

1916. Tuesday, New York City
Having made the translations of the letters [19.8.1916], Duchamp posts them back to John Quinn and writes: "I hope you will not have any difficulty in understanding them."

1919. Friday, Paris
Meets Jean Metzinger and talks about Stéphane Bourgeois [1.4.1916] and "the deep taste he shows for Cubism…"

1927. Monday, Nice
In the chess tournament, which commenced on 13 August, today Duchamp plays against G. Renaud and eventually resigns. "An interesting game," considers the winner, "in spite of the inexactitudes committed on both sides – or *because* of these inexactitudes."

23.8.1911

23.8.1936

1941. Friday, Lyons
In the morning Totor does some more shopping with Roché, who admires his way of preparing things. They have a nice lunch at the end of the Pont de la Guillotière, with chocolate for Totor, and then play two games of chess at the Café Neuf: Roché loses but learns. After a good talk, Totor leaves for Grenoble and Roché returns to Saint-Martin-en-Haut.

1946. Thursday, Chardonne
In the afternoon, Mary Reynolds and Marcel manage to catch the estate agent, M. Flouck, and visit the property in Chexbres, less than five minutes walk from the railway station, which may be of interest to the Hoppenots [5.8.1946]. Mary finds it "beautiful, with an abundance of fruit trees apples pears peaches plums all loaded with fruit…" The house is too small and the conservatory too large, but Mary is interested in the hen house: "not quite a semicircle built in the hill with a tiled roof," which she thinks would make a very nice summer living room. "In fact," she considers, "there are all sorts of possibilities and I wish I were rich."

1955. Monday, New York City
After six weeks by the sea at East Hampton in the house lent to them by Gardie [3.8.1955], the Duchamps return to Manhattan for a few days before leaving for Cazenovia.

1963. Thursday, Cadaqués
After receiving news from Bernard Monnier that a cheque from Yvonne Lignières has arrived, which, Marcel says, "will be used for the next Valises," he advises his son-in-law that he is awaiting a third bank transfer from Arturo Schwarz.

23 August

1908. Sunday, Veules-les-Roses
Play is interrupted at the annual Tennis Championships by appalling weather conditions and the rain. However a few matches are played during the brighter intervals. Wardin and Puech (who knocked out Duchamp and Ayzaguer in the first round [20.8.1908]) win their third round match comfortably in the men's

doubles; in the eighth round of the mixed doubles, Carmen Cartaya and her partner Daeschner beat Mlle Moriets and M. Benson; and in the men's singles, Lemoine beats Blocman, and Maroger loses to Jourdan, who in turn is beaten by Wardin in the fourth round.

In the afternoon at about three o'clock the sun is shining and it is decided that the final of the ladies' singles between Carmen Cartaya and Mlle Anquetil will be played. Superstitious, Carmen hurries home to find her green veil and to change for the match. Playing a set with Dobson against Blocman and Mlle Anquetil to warm up, and winning it 6–3 gives Carmen confidence. The final is played on court number two in front of a great crowd, with Dobson as umpire.

Carmen wins the first four games, but her opponent rallies to take the next two, before Carmen wins the first set 6–2 to great applause from all her friends. Handicapped by a painful stitch in her side and consequently unable to cover the court sufficiently, Carmen loses the second set 4–6, but one of her spectacular net volleys is much applauded. Tiring a little by the third set, Carmen is grateful that Hauffman at one end and Duchamp at the other are acting as ball boys. At 2–5 down and with a match point to Mlle Anquetil, Carmen suddenly pulls herself together and finally vanquishes her opponent 9–7. "Bravo, partner!" cries Daeschner and almost crushes Carmen's arm with his strong handshake. Surrounded by a crowd all wanting to congratulate the winner, someone sees to it that the new champion kisses Duchamp.

1911. Wednesday, Rouen
The day the Press announces the astonishing theft of Leonardo da Vinci's *Mona Lisa* from the Louvre where it has been hanging since 1804, at four in the afternoon in a civil ceremony at the *hôtel de ville* Suzanne Duchamp marries Charles Victor René Desmares, a chemist, who lives at 75 Rue des Carmes. As well as her parents, Suzanne's eldest brothers Gaston and Raymond sign the register as witnesses for the bride; Charles' widowed mother, who lives in Cherbourg, and her two sons-in-law sign as witnesses for the groom.

1917. Thursday, New York City
The evening at Joel's with Walter Arensberg, Aileen [Dresser?] and three or four of her friends ends in a punch-up. Some brutes from another table approach, singing loudly, and

want to start kissing the girls: "Drunker than us," recounts Marcel, "they chucked Walter to the ground without injury and I received a great punch in the ear…"

1918. Friday, Barbados
After nine days at sea sailing south from New York, the SS *Crofton Hall* reaches Bridgetown.

1926. Monday, Paris
"Happily surprised by your letter, ashamed by my proverbial laziness," writes Duche to Ettie Stettheimer, "I wish you, like myself, 'happy returns', since the lines of age are parallel, but also because it is necessary that 2 lines of 'something' meet to produce friendship and sometimes love."

Invited to organize a Brancusi exhibition in New York [18.8.1926], Duche tells Ettie: "You will see me from 20 October in the parallel streets of New York… The last time I arrived in New York I had cut my hair [9.6.1921], this time you have changed apartment: will I recognize you without the red damask background?"

1929. Friday, Les Rousses
As Brancusi has confirmed that he will be staying in Aix-les-Bains until the beginning of September [19.8.1926], Marcel proposes to join him there with Mary Reynolds and he asks Brancusi to let him know the price of a room at his hotel.

1936. Sunday, Albuquerque
"In the train, I'm coming back and I'm not dead. Taking the *Normandie* on 2 September will be in Paris on 7 or 8," writes Duchamp to Dumouchel his hand shaking with the movement of the train. He mails the postcard (which shows a spectacular view of the Grand Canyon from near Lipan Point) during the stop at Albuquerque on the Rio Grande in New Mexico.

He also writes to Brancusi.

1941. Saturday, Grenoble
After two days in Lyons, Duchamp is back in Grenoble. Confirmation of the decision taken in Vichy on 20 August concerning Duchamp's exit visa is received at the *préfecture* by cable at nine-twenty in the evening.

1947. Saturday, New York City
Before leaving for Endicott, where he is entered to play in the New York State Championship Tournament which is being held at the

24.8.1911

24.8.1917

IBM Country Club, Marcel has commented on Roché's detailed description of the exhibition "Le Surréalisme en 1947" [7.7.1947]. "I have quite a clear idea now," he wrote, "and I really regret that this kind of performance is too similar to a hastily staged play and the sets are of papier-mâché... This is true of everything that is done today, under the sign of the speedy and perishable."

Of the apartment in Paris, which Roché shared with his mother until her death, Marcel wrote: "I pray that you keep Arago, there are too many memories, it's a public monument."

1950. Wednesday, New York City
Marcel has only received $21 from the publisher of *The Dada Painters and Poets* by Robert Motherwell for Gabrielle Buffet-Picabia's contribution. "I was unable to argue," he explains to Gaby. "But I advise you to protest to Motherwell and insist on the $50."

1952. Saturday, Cazenovia
Opening at Cazenovia Seminary of the New York State Chess Championship, in which Duchamp is playing.

1954. Monday, Philadelphia
Visiting the museum to see the Louise and Walter Arensberg Collection, which is "presented with plenty of air in some ten rooms", Duchamp lunches with Carl Zigrosser and is "very touched by the kindness of the directors", who have consulted him on every detail of the installation.

1963. Friday, Cadaqués
On a card more or less representing the view from their terrace, the Duchamps tell Djuna Barnes that after a "wonderful summer" in Cadaqués, they are next going to Venice and Greece.

24 August

1903. Monday, Blainville-Crevon
On the last stage of his rapid tour of Jersey, Saint-Malo and the Mont-Saint-Michel, Marcel spends a day in the train travelling across Normandy and arrives home at seven in the evening.

1911. Thursday, Rouen
The ancient stones and Gothic tracery of Saint-Godard's church, the light diffused by the brilliant colours of its early stained glass windows, is the setting for the wedding of Suzanne Duchamp and Charles Desmares. Well-attended by their families and friends, the traditional marriage service, commencing at eleven-thirty, is embellished with music played by the young organist, a violinist and cellist who accompany the voice "so enthralling and so pure" of Mme Moreau-Villette.

After the ceremony the wedding breakfast is held nearby at the Hôtel de France, 85 Rue des Carmes. The guests are offered cream of chicken soup, salmon trout, sweetbreads and then duck followed by an iced mousse of pink champagne before being served turkey, lettuce hearts, crawfish and artichoke hearts. Following the ice cream with crystallized fruit and various desserts [including no doubt the traditional set piece made of miniature cream puffs piled high into a slender pyramid and glazed with caramel], Georges Delacour, one of Lucie Duchamp's cousins [6.6.1909], proposes the toast. The motif for the menu engraved by Villon, a blue bird poised on a leafy branch, is inspired by Maeterlinck's current success, a fairy tale entitled *L'Oiseau Bleu*, about a symbol of happiness.

As a wedding present, Marcel gives his sister a canvas which he painted in June and July entitled *Jeune Homme et Jeune Fille dans le Printemps*, a stylized garden paradise, in which the two main figures of the mystical composition are reaching up into a bower of foliage.

1915. Tuesday, New York City
For a short seaside holiday, Duchamp receives by post a return boat ticket to Spring Lake, a timetable and details of the arrangements made on his behalf by John Quinn [28.7.1915].

Duchamp, who is advising Quinn about the finish of *Femme assise* by Duchamp-Villon (and has recently been with the collector and Miss Harriet Bryant, the director of the Carroll Galleries, in a taxi to the Roman Bronze Works, Long Island, where a cast has been made), also receives a banker's order for 2,150 francs and a letter for Raymond Duchamp-Villon. Quinn hopes Duchamp will have time to translate the letter and forward it with the order before his departure for Spring Lake the following day.

1917. Friday, New York City
His ear swollen and still bleeding from the previous night's punch-up, Marcel sends Lou Arensberg a copy of the latest issue of *Rongwrong*. The magazine publishes Marcel Douxami's criticism of *391* [5.5.1917], and the moves of the chess game played by the rival editors, Roché and Picabia [23.5.1917], whose win for *391* seals the fate of the *Blind Man* [5.5.1917] and was the inspiration for a prose poem by Walter Arensberg published in the current issue of *391*. *Rongwrong* also includes contributions from Carl van Vechten, Helen Freeman and Allen Norton: "Men may come and men may go, but women go on for ever."

"Summer here is exactly like winter," Marcel tells Lou, who has disappeared to Boston. "We drink a bit, I have been drunk a few times. Apart from that I hardly work – I have a few lessons. We go to bed earlier (3 a.m. instead of 5)." He says that Walter looks well. "And you," Marcel enquires, "what are you doing? So far away, are you so sick of New York... And when are you coming back to us?" He would be so pleased if Lou would write to him.

1918. Saturday, Barbados
As it will be twenty days before the next port of call, while coal is taken aboard the *Crofton Hall*, Duchamp goes ashore in the heat at Bridgetown. Using an envelope from the Ice House Hotel, he posts his letter to the Arensbergs [21.8.1918].

To the three Stettheimer sisters, he sends a postcard of Queen's College: "Delightful voyage, without the shadow of a submarine," he writes. "The boat is slow and gentle."

1937. Tuesday, Paris
"It's a cousin of my own [30.8.1935]," remarks Dee thanking Miss Dreier for the Stroboscope disc, an instrument used for regulating gramophones, which she has sent him for his birthday.

The portfolios for the *40 Variations* "are finished and very beautiful" and Dee has chosen the finest of the lithographs to complete the set [15.7.1937], which should be ready in September.

Regarding the Verlaine manuscript [29.9.1936] that Dee is trying to sell for Miss Dreier, it is back from Switzerland but unsold.

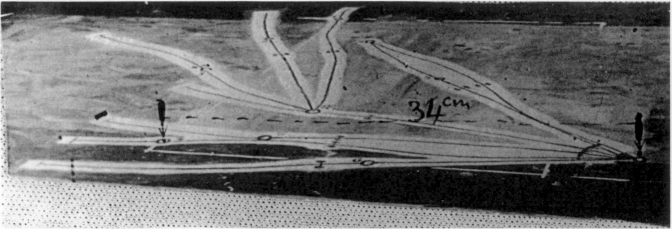

24.8.1963

Miss Dreier's discussions with Frederick Kiesler about leaving The Haven as a museum have left her feeling "that the whole thing is like a white elephant and that it might be better to sell everything and to return the gifts to their owners". The first time that he has heard of her "being depressed", Dee says: "I hope it was only a 'low' day." Keeping together the paintings and sculptures which she has collected is, to him, "more important than thinking of a Monument or any grandiose form of doing it."

1941. Sunday, Veyrier-du-Lac
From Grenoble, Duchamp returns to see Alec Ponisovsky at the Villa Magdeleine [28.6.1941].

1946. Saturday, Chardonne
Mary and Marcel leave their second Hôtel Bellevue [6.8.1946] situated on the hillside with a funicular down to Vevey and the lake, and take a train up the Rhône Valley to Sion. The ancient see and historic town is dominated, rather like Le Puy, by two rocky promontories.

1951. Friday, New York City
Leaves for Syracuse to attend the New York State Chess Association congress.

1957. Saturday, Binghamton
With Teeny, Marcel attends the annual New York State Chess Association congress which opens today at the Roberson Memorial Center. He anticipates playing nine games and says he has "no hope of being champion".

1963. Saturday, Cadaqués
Concurs with Lebel that "the portrait is certainly drawn by Picabia (although not absolutely sure)" and regarding the signature: "I have a very vague memory of having signed this drawing," Duchamp ventures, "probably all between two glasses of mirth at Mougins or even in Paris…"

*

"Here are my answers to your troubles," replies Duchamp to Richard Hamilton who, after spending a week in Cadaqués [28.7.1963], is back in London and endeavouring to complete his lecture on the Large Glass.
After the holiday in Herne Bay [8.8.1913], Duchamp explains that in October 1913 he took a new studio at 23 Rue Saint-Hippolyte [22.10.1913]. Here he commenced the "General plan Perspective on the plasterwork mainly for the bottom glass from the focal point on the

line of the *vêtements de la Mariée*".
The next step, in November (?), "after establishing the Choc[olate] Grinder and the Glider," was to place the Malic Moulds on the plan so that once in perspective they would "be within the general frame and not fall outside the glass".
Then in December (?) he continued "first placing in the plan the 9 moulds and then perspectiving that rectangle and seeing that in this perspective form they would be all visible inside the edges of the glass". Duchamp's decision to add a ninth mould, "which did not change anything to the general operation," he states, "must have taken place around Dec[ember 19]13 or Jan[uary] Feb[ruary 19]14."
During the first six months of 1914, he "began operating on the perspectiving of the 9 *tubes capillaires* so that each tube would meet the head of one *moule mâlic*". First he made a large painting in plan [19.5.1914] with the idea of photographing it "horizontally from the correct perspective angle", which turned out to be "too inaccurate". Instead he squared the painting, "to obtain through the same squaring in perspective the final perspective drawing of the tubes as they are now."
From memory Duchamp thinks the final perspective drawing for the Sieves [3.8.1914] "may or may not have been made in Paris". [In fact it was drawn in Yport.]

1966. Wednesday, Cadaqués
Writes a postcard to Joseph Solomon, who has heard about the imminent publication of another box of notes. "I certainly will have a copy of *A l'Infinitif* reserved for you when it comes out (probably in the fall)", Duchamp promises him.

25 August

1903. Tuesday, Blainville-Crevon
On a card representing the small granite chapel of Saint-Aubert, the bishop of Avranches in the eighth century, Marcel tells Tribout: "On the whole I am very pleased to be back because it's exhausting a voyage like that! … The Mont-Saint-Michel of which you have seen a hundred photos is even more interesting inside than outside. (I mean its appearance). Jersey is pretty much England. But a lot of French is spoken.

St Helier, the capital where we stayed four days, looks particularly English. To begin with, King Street and Queen Street was enough to discover the English air of a place… Saint-Malo: an old town with well preserved ramparts. Dinard a very chic resort. A warm handshake. Your friend MD."

1912. Sunday, Munich
On a card decorated with an exquisitely carved portrait bust of a lady from the choir stall of Ulm Cathedral, Duchamp writes to Julia Paulin-Bertrand: "At the same time as yours, I received a very nice card from Bonne Maman telling me of your fears of heatwave. Here continual rain, cold. Completely acclimatized; it still remains for me to understand German better than I do…"

After completing *Le Passage de la Vierge à la Mariée* [7.8.1912], Duchamp works on the next step, the Bride itself: "a juxtaposition of mechanical elements and visceral forms" which not only incorporates structures from the two drawings entitled *Vierge* [7.8.1912] but also refines the previous canvas's central motif, the conical shaped Sex Cylinder or Wasp, which is connected by tubes to the Reservoir of Love Gasoline below and by a pole to the Arbour-type shape above. Although this weird machine from "plastic necessity" remains "at rest", it does not prevent its strange qualities from coming to life one night and Duchamp dreams of the Bride becoming a monstrous beetle which lacerates him with its giant elytra.

Abandoning his brushes for certain areas of the picture, which he entitles *Mariée*, Duchamp uses his fingers to apply the oil paint, creating a

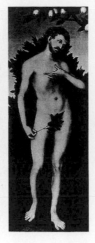
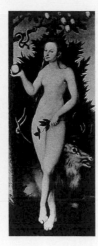

25.8.1912

25.8.1938

rich, glowing surface not unlike the pictures by Lucas Cranach he so much admires.

Not only in the Alte Pinacothek, but also in the museums which he visits during the summer (Vienna, Dresden and Leipzig), Duchamp looks at the pictures by Lucas Cranach: "I love those Cranachs... I love them. Cranach the old man. The tall nudes. That nature and substance of his nudes inspired me for the flesh colour."

1915. Wednesday, New York City
In the afternoon, after telephoning John Quinn to tell him which boat he has decided to take, Duchamp embarks at the foot of West 42nd Street, taking the Intracoastal Waterway, which in just under three hours will bring him to Spring Lake on the coast of New Jersey. Quinn has reserved a room for him at the Essex Hotel, ten minutes walk from the station, where Duchamp is due to be met by Miss Bryant [24.8.1915].

1917. Saturday, New York City
With Ettie Stettheimer and her brother Walter in army uniform, Duche takes some refreshments at Henri's before accompanying Ettie and her valises to the station.

1924. Monday, Paris
The day that Mary Reynolds leaves for a holiday in the chateau at Anticoli Corrado near Rome, where she has four rooms at her disposal, Marcel meets Roché.

1927. Thursday, Mougins
"Not seen any water since I saw you," writes Marcel to Brancusi, whose studio in Impasse Ronsin was recently severely damaged by torrential rain. Planning to leave Mougins on Monday, Marcel tells the sculptor that after the tournament in Chamonix he will return to Paris on 18 or 19 September.

1936. Tuesday, Chicago
Before arriving in Chicago from California, Marcel descends from the air-conditioned train in Saint Louis for a haircut. The heat is such that he thinks there must be a fire nearby, but it is just the air temperature, which is 110 degrees Fahrenheit [43° Centigrade].

Marcel has arranged to see Alice Roullier of the Arts Club as he has to change trains at Chicago; he also has a brief conversation with Daniel Catton Rich of the Art Institute, who is interested in showing *Anémic Cinéma* [30.8.1926] in a season of art and experimental films.

Marcel also has time to meet C. J. Bulliet, [15.2.1927] who interviews him for the *Chicago Daily News*. "Painting is now dedicated the world over to propaganda – to subject matter," he tells the journalist. "It is the reaction from that abstract [art] that used to interest me... It is as true in Europe as in America – even more so – that people's minds are concentrated on politics, including the artists. Both Fascism and Communism are bent on regimenting people, robbing them of their individuality. It is no atmosphere in which creative art can thrive. The zest, the joy, is gone."

1938. Thursday, Paris
Marcel is back from Vittel, where he was on holiday with Mary Reynolds and purchased a postcard to send to Dr Dumouchel illustrated with the bearded lady, Mme Delait.

In the morning a response from Alfred Barr makes it clear that the reason Marcel has never been paid $25 for the copy of his film *Anémic Cinéma* [30.8.1926] is that Barr has never received it. As it was Man Ray who was charged two years ago with sending it to the Film Library of the Museum of Modern Art, Marcel writes to enquire what has happened and asks Man for an address where he could eventually have a positive print made.

1941. Monday, Grenoble
"I've got it," Marcel tells Roché triumphantly after sending numerous telegrams and writing to Brookes Hubachek in Chicago with the news that he now has a passport [23.8.1941].

1944. Friday, New York City
For Miss Dreier, Dee is keeping an eye on proof corrections to the illustrations for the book on Burliuk [8.7.1944]. Regarding the loan to the Museum of Modern Art of her Lehmbruck sculpture, he is waiting for James Thrall Soby to return from holiday to show it to him. Dee promises to send some sugar to Miss Dreier next week and adds: "Naturally the heat stopped the day after I got the fan!"

1951. Saturday, Syracuse
Duchamp is one of the participants in the New York State Chess Championship Tournament opening today at the Student Union Building at Syracuse University.

1961. Friday, Cadaqués
Replying to Richard Hamilton's news that the BBC would like to film him for its "Monitor" programme, Marcel says he could go to London for two days on 26 September. Richard and the programme's producer Nancy Thomas could arrange to visit him in Paris beforehand, but no earlier than 20 September, when he and Teeny return from Sweden and "a few short trips".

1966. Thursday, Cadaqués
Under separate cover, Duchamp sends the fifth and final interview [9.6.1966] by express post as promised [5.8.1966] to Pierre Cabanne, and writes suggesting that he telephone Neuilly around 22 September.

26 August

1913. Monday, Herne Bay
"Excuse this delay in reassuring you about my monetary fate," writes Duchamp on a postcard to Dumouchel [8.8.1913] in Paris. "All is well.

We will spend the first 4 days of September in London and 10 days with the family at Yport."

1926. Thursday, Paris
In the morning Marcel meets Benjamin [?], Helen Hessel and Roché at Arago and the four of them have lunch afterwards at Couteau's at 32 Avenue d'Orléans.

1936. Wednesday, Cleveland
After Chicago, Duchamp makes another stop on his return east at the Cleveland Museum of Art in order to make colour notes for the reproduction of his *Nu descendant un Escalier* [18.3.1912], which is on loan from the Arensbergs in the museum's "Twentieth Anniversary Exhibition". Finding the entire staff "horribly

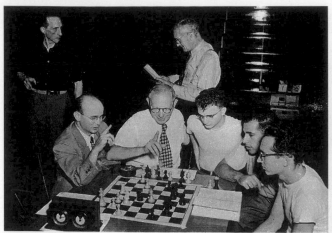

27.8.1949

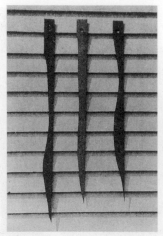

29.8.1936

sombre, embarrassed and reserved", Duchamp wonders whether he has done something wrong until the director, William M. Milliken, confesses that through some dreadful error, the exhibition catalogue records Duchamp as having been dead for three years: (1887–1933).

1941. Tuesday, Grenoble
Now possessor of a passport and an exit visa, Duchamp travels back to Sanary.

1942. Wednesday, New York City
Apparently, when Marcel suddenly embraces her at a huge party studded with stars and personalities to celebrate her birthday, Peggy Guggenheim is jealously torn between remaining in the company of Marcel or joining Howard Putzel and Jean van Doren in the studio upstairs, where Max Ernst is selling a painting to Gypsy Rose Lee. When she discovers that Max has given Gypsy another painting as a wedding present, Peggy is furious.

1949. Friday, New York City
Travels to Rochester to attend the New York State Chess Association congress.

1950. Saturday, Binghamton
Duchamp is one of the participants in the New York State Chess Championship Tournament, which commences today at the Arlington Hotel.

1956. Sunday, Basswood Lake
Having corrected the biographical notes for the "Three Brothers" catalogue while on holiday with the Hubacheks in the depths of Minnesota [18.8.1956], Duchamp sends them to Miss Woodward at the Guggenheim Museum asking her to have the notes retyped and sent to his address in New York. If James Johnson Sweeney's introduction to the catalogue has been received, Duchamp writes: "I would appreciate your sending it to me at the same time."

27 August

1929. Tuesday, Les Rousses
From Morez, Marcel sends a telegram to Brancusi at the Hôtel Britannique in Aix-les-Bains announcing his arrival with Mary Reynolds on

Sunday evening from Geneva. As Brancusi's hotel is too expensive for them, Marcel requests the sculptor to reserve a double room in one of the more modest hotels. He lists the alternatives and asks him to confirm by cable.

1936. Thursday, New York City
His train from Cleveland is due in at seven in the morning. On arrival Duchamp has time to go to the Carnegie Hall studio to see if there are any messages for him and to pay Charles F. Biele & Sons $10 for the two strips of glass ordered on 1 August before meeting Miss Dreier, who has stayed overnight at the Colony Club.

Still without funds, the Société Anonyme is never likely to be in a position to care for the works from her collection which Miss Dreier "set aside" nine years ago for its use. As a safeguard, Miss Dreier has had a Trust Agreement drawn up making herself and Duchamp joint trustees of 45 items from her collection, to be held in trust for the Société Anonyme until it can be established somewhere permanently.

In the morning, after discussing the draft Trust Agreement with Dee, Miss Dreier telephones their amendments to William Shaw of Blandy, Mooney & Shipman, who has drawn up the document. In the afternoon Dee and Miss Dreier return by train to West Redding.

1946. Tuesday, Zug
Mary Reynolds and Marcel travel to Zurich, where they plan to stay a few days.

1949. Saturday, Rochester
Opening of the New York State Chess Championship Tournament at the Recreation Building, Kodak Park, in which Duchamp is participating.

1951. Monday, Syracuse
In the morning Duchamp receives a long letter from Miss Dreier and calls Fritz Glarner to arrange a visit to Garden City. "Sunday is the last and most important round in the chess championships here (in the afternoon)", he writes to Miss Dreier, and suggests visiting her on Saturday afternoon. "But if it is not convenient for you," he writes, "I will come Sunday by the 11.30 train."

1961. Sunday, Cadaqués
After spending three months in Cadaqués, Teeny and Marcel leave for Paris.

28 August

1915. Saturday, Spring Lake
In the afternoon John Quinn and his friend Frederick Gregg [24.7.1915] are due to arrive at the Essex Hotel to join Duchamp, who arrived on Wednesday.

1926. Saturday, Paris
Meets Roché for lunch at the restaurant of the Café de la Paix.

1928. Tuesday, Nice
From the Hôtel Saint Louis, Rue de Belgique, where he is staying, Marcel writes to Brancusi saying that although he is losing weight he is feeling better. He tells the sculptor: "Write what you are doing, whether you are coming this way…"

1936. Friday, West Redding
With the help of Carl Rasmussen all day, Duchamp replaces the newspaper bands with 2 glass strips and completes the framing of the Large Glass, which is now repaired and standing in Miss Dreier's spacious library [28.7.1936]. Meanwhile, Miss Dreier types a list of artists whom Dee is to contact about contributing an example of their work to the Société Anonyme.

1951. Tuesday, Syracuse
Following the arrangements made the previous day, Duchamp interrupts his participation in the New York State Chess Championship to visit Garden City, Long Island, and make plans with Fritz Glarner for the cleaning of Miss Dreier's mural in the chapel of St Paul's School.

1953. Friday, New York City
Like the summer before, Duchamp goes to play chess in Cazenovia [23.8.1952], a "delightful place" southeast of Syracuse.

1961. Monday, Paris
Making a stop between Cadaqués and Stockholm, Teeny and Marcel stay overnight with Jackie and Bernard Monnier at 108 Rue du Bac.

30.8.1926

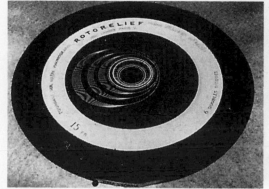
30.8.1935

29 August

1923. Wednesday, New York City
In his article "Cubism: its Development" for the *Freeman*, Walter Pach writes: "In the last canvases that Duchamp did before addressing himself to other mediums, the forms and colours are pure inventions, or so distantly derived from nature as to count as inventions. Their purpose is still to give body to certain deep ideas, and they attain a profound and original beauty."

1927. Monday, Nice
In the last stages of the tournament organized by the local Groupe de Joueurs d'Echecs, Duchamp plays another game "with energy and precision" against G. Renaud [22.8.1927] and wins.

1929. Thursday, Les Rousses
In the afternoon, after having received confirmation of his hotel accommodation in Aix-les-Bains, Duchamp cables back to Brancusi: "Delightful thank you until Sunday evening 9:40 regards = Duchamp."

1935. Thursday, Paris
Busy arranging his "counter" for the Concours Lépine, which opens the following day, Duchamp writes a hasty note to Miss Dreier promising to write soon and send her the "toy".

1936. Saturday, West Redding
To reimburse his transatlantic crossing costing $180, the $10 paid to Charles F. Biele & Sons and the remaining time and materials supplied by Carl Rasmussen, Miss Dreier gives Dee a cheque amounting to $202.50. Apart from repairing the Large Glass during the summer, Dee has also had *Rotative Plaques Verre* [20.10.1920] and *3 Stoppages Etalon* [19.5.1914] taken out of storage. The optical machine now has a new motor and is in working order; the three canvases of *3 Stoppages Etalon* have been mounted on glass and photographed with the rulers [8.7.1918] for Dee's "album" [5.3.1935] using the white weatherboarding of the house as a background.
In the post Miss Dreier receives three copies

of the Trust Agreement [27.8.1936] from Blandy, Mooney & Shipman, which she and Dee are to execute in New York. In a covering letter Mr Shaw recommends that, in view of the terms of the document, the future trustees should each make suitable provision in their will.

1953. Saturday, Cazenovia
This year the New York State Chess Championship [30.8.1952], in which Duchamp is playing, is held at the Cazenovia Junior College.

1956. Wednesday, New York City
In the evening Teeny and Marcel return from their holiday at Basswood Lake in Minnesota, close to the Canadian border, where they have been guests of the Hubacheks [18.8.1956].

1961. Tuesday, Paris
In the morning Teeny and Marcel fly from Orly with Air France on flight 794, which is due to arrive at two-twenty in Stockholm. They plan to visit the exhibition "Rörelse i konsten" [16.5.1961] in which the full-scale replica of the Large Glass constructed by Ulf Linde is on show.

30 August

1913. Saturday, Herne Bay
In reply to his letter, which has been forwarded from Paris, Duchamp writes a note to Elmer MacRae, treasurer of the Association of American Painters and Sculptors, acknowledging receipt of the remaining $600 due to him [2.7.1913] from the sale of his paintings at the Armory Show [17.2.1913].

1914. Sunday, Puteaux
Despite the war, Gaston, who is mobilized in the 21ème Régiment de l'Infanterie, and Raymond, who is an assistant medical officer at Saint-Germain, are both at home today with their wives Gaby and Yvonne. Making a customary dominical visit, Marcel finds Jacques Bon (Yvonne's brother), Robert Gleizes (Albert's brother) and Paul-Napoléon Roinard [17.5.1914] among the visitors. At five in the afternoon Henri-Martin Barzun also calls at 7 Rue Lemaître.

1918. Friday, at sea
After about six days sailing from Barbados, Duchamp crosses the equator in the SS *Crofton Hall* as the ship passes into the southern hemisphere.

1926. Monday, Paris
At noon Duchamp calls to see Roché at Arago.
Later, at three o'clock, Roché is amongst the guests at the screening of Duchamp's film *Anémic Cinéma* in one of the private projection rooms at 63 Avenue des Champs-Elysées.

This extraordinary film, which adds an unsuspected dimension to the cinema, is the result of long hours of shooting at Man Ray's studio in July with Marc Allégret as consultant. Shot frame by frame, millimetre by millimetre, the sequences of nine black discs, each inscribed with a sensuous phrase by Rrose Sélavy (which Man Ray helped Duchamp to glue in spiral form with white letters onto cardboard pasted onto gramophone records), alternate with ten discs, each decorated with a different design based on spiral and circular forms which, in movement, produce a pulsating, erotic effect. Prefaced by the palindromic title only, the final frames of the seven-minute film are signed with Rrose Sélavy's fingerprint, a guarantee for a voyage from the third to the fourth dimension.

1935. Friday, Paris
Opening of the 33rd Concours Lépine, the Salon des Inventions, at the Parc des Expositions, Porte de Versailles, where Duchamp has taken a tiny stand of three square metres [2.8.1935] to exhibit *Rotorelief (Disques Optiques)*. In a joint venture with Henri Pierre Roché [20.7.1935], 500 sets of six coloured cardboard discs have been produced, each one printed recto verso with original motifs drawn by Duchamp, and designed to be placed on a

30.8.1936

gramophone. Turning at a certain speed the discs give an impression of depth, the optical illusion being more intense when viewed with one eye. In addition to the abstract images used for *Anémic Cinéma* [30.8.1926], *Corolles* [5.12.1934], *[Sein-]Cage*, and *Spirale blanche*, with the general public in mind Duchamp has devised some easily recognizable forms: *Œuf à la Coque, Lanterne chinoise, Lampe, Poisson japonais, Escargot, Verre de bohème, Cerceaux, Montgolfière* and *Eclipse totale*.

Situated in alley F, stand number 147 is "a regular carnival" with some of the discs turning horizontally and some vertically. Sandwiched between incinerators and a rubbish-compressing machine on the left and an instant vegetable-chopper on the right, Duchamp's invention, which is awarded an "honourable mention" in the Industrial Arts category, goes practically unnoticed by a public more interested in searching for useful gadgets.

1936. Sunday, West Redding
At eleven o'clock Walter Buschmann is due to return to The Haven [19.7.1936] with his various cameras and enough films or plates to take photographs of the Large Glass [5.2.1923] now installed with *Tu m'* [8.7.1918] in Miss Dreier's library. Duchamp is particularly anxious to have large negatives made of both these works so that the prints from them do not require any enlargement. For one photograph, which includes not only these works but also the collector and the artist, Buschmann seats Miss Dreier at the refectory table and poses Duchamp in his pale cotton pullover standing facing her exactly in the centre of the composition, his back touching the frame on the left side of the Large Glass.

1939. Wednesday, Paris
With the news of mobilization in Poland in the wake of Germany's ultimatum, before his departure the following day Marcel decides to return nine reproductions of *9 Moules Mâlic* [19.1.1915] to Roché, thereby completing the promised set of ten. "For the moment it is better that you have them, years could go by before the three things meet again: you, me and the malic moulds," writes Marcel in an accompanying note. "This evening, it appears that the calm should be more marked: exchange of notes is the contrary of rupture…"

1950. Friday, Binghamton
"Lou and Walter Arensberg ask me to go to Philadelphia and look again with you at the disposition of the rooms that eventually you will consecrate to the collection," writes Duchamp from the Arlington Hotel [26.8.1950] to Fiske Kimball, director of the Philadelphia Museum of Art. As he is staying in Binghamton until 5 September, Duchamp proposes to go to Philadelphia on 7 September if Kimball can see him that day.

1952. Saturday, Cazenovia
Invited as the guest of honour at the New York State Chess Association's convention, Duchamp addresses the members at the banquet:

"It is not very often that anyone is a guest of honour at a chess convention, because chess players are very discriminating critics. I am therefore doubly happy that the great New York State Chess Association has selected me for that honour this year. I am very thankful and most appreciative.

"Of the three main aspects of chess, as I understand it, the first – the contest between two minds – may be the most attractive to the majority of players, as it satisfies, in a peaceful way, the natural instinct of competition in man.

"The second aspect – the application of scientific methods to chess – has for its aim the clarification of ideas in a game already too complex for the limitation of the human mind.

"Personally I have been more interested in the third aspect – the artistic side of chess.

"Objectively a game of chess looks very much like a pen-and-ink drawing, with the difference, however, that the chess player paints with black and white forms already prepared instead of inventing forms as does the artist.

"The design thus formed on the chessboard has apparently no visual aesthetic value and is more like a score of music which can be played again and again.

"Beauty in chess does not seem to be a visual experience as in painting. Beauty in chess is closer to beauty in poetry; the chesspieces are the block alphabet which shapes thoughts; and these thoughts, although making a visual design on the chessboard, express their beauty *abstractly*, like a poem.

"Therefore, the aesthetic source in chess is imagination, inventiveness. The pieces are moved about the board according to strict rules and the winner, following his flights of imagination, brings about the winning pattern. But then again, beautifully elaborated combinations and strategic conceptions tell an ideographic story through a series of moves and become a real *visual* pleasure.

"Actually, I believe that every chess player experiences a mixture of two aesthetic pleasures: first the abstract image akin to the poetic idea in writing, second the sensuous pleasure of ideographic execution of that image on the chessboards.

"From my close contact with artists and chess players I have come to the personal conclusion that while all artists are not chess players, all chess players are artists.

"Thank you."

1962. Thursday, Cadaqués
After three months in Spain, Teeny and Marcel return across the border [1.6.1962] to France on their way back to Paris, where they are invited to stay a month with the Monniers [25.5.1962].

1968. Friday, Cadaqués
Accepts an invitation from Ms Cunningham of the Art Institute to attend a luncheon for the Press in Chicago on 16 October, prior to the members' preview (scheduled for the next day) of the exhibition "Dada, Surrealism and their Heritage" [27.3.1968]. Duchamp also writes to Brookes Hubachek giving him their programme and plans for visiting Chicago.

31 August

1920. Tuesday, New York City
Accompanied by Morris Crawford, the editor of *Women's Wear*, Marcel calls on Beatrice Wood, who is still in desperate financial straits [26.7.1920].

1924. Sunday, Strasbourg
The Championnat de France opens with an official reception at ten in the morning, held in a well-appointed and agreeably decorated room at the Café Broglie, the headquarters of the Echiquier Strasbourgeois, which has organized the tournament. After the roll-call the 13 competitors are invited to sign the Livre d'Or of the

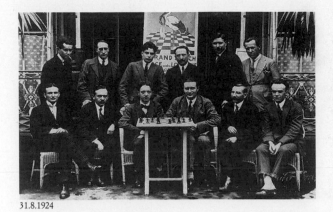

31.8.1924

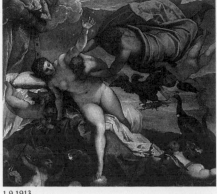

1.9.1913

Fédération Française des Echecs. Georges Renaud from Nice is defending his title.

In the first round Duchamp is forced to abandon his game against André Muffang, the Parisian champion. The second round begins in the evening at eight: Duchamp loses his game against another Parisian, Gibaud [12.7.1924].

1926. Tuesday, Paris
To ensure that Brancusi doesn't miss the boat, Marcel has invited the sculptor to stay overnight with him at the Hôtel Istria. When Roché calls at the hotel at seven in the morning, they are still fast asleep. Brancusi, who is going to New York to prepare his exhibition for Brummer [18.8.1926], is accompanied by his friends to the Gare Saint-Lazare and, with Stoor (the huge dog belonging to Edward Steichen), safely boards the boat-train for Le Havre.

1936. Monday, New York City
The "Los Angeles newshawks" who managed to track down Duchamp at the Arensberg home before he returned east [16.8.1936] have their picture and article, entitled "Cubism to Cynicism", published in *Time* magazine.

Duchamp is quoted as having declared: "My attitude towards Art is that of an atheist towards religion. I would rather be shot, kill myself or kill someone than paint again."

1939. Thursday, Paris
With Mary Reynolds travels to Aix-en-Provence, where they plan to stay a fortnight.

1946. Saturday, Bern
Returning from Zurich on the last stage of their holiday in Switzerland, Mary and Marcel spend two days at the French ambassador's residence [30.7.1946] with their friends Henri and Hélène Hoppenot.

1954. Tuesday, New York City
Writes to Roché at Saint-Robert recounting his visit [23.8.1954] to see the Arensberg Collection in Philadelphia, where "everything is in place: the large glass of Katherine Dreier is positioned right in the middle of an enormous room… It was an extremely sticky operation to install it [19.7.1954]… Brancusi is alone in a large room," explains Marcel, "with about twenty of his things."

Announcing his intention, if their finances permit, "to go for two months to France with Teeny," Marcel asks Roché if they can borrow his apartment in Boulevard Arago, which would be more central "for tourists" than staying in Neuilly with the Crottis or in Puteaux with the Villons.

*

Marcel has never received his copy of *Les Machines Célibataires* [15.4.1954] from Michel Carrouges, but has ordered a copy from Wittenborn and promises André Breton to send him a few lines about the book as soon as he has read it. He requests Breton to send him a copy of Jean Reboul's text if it has been published.

1 September

1904. Thursday, La Bourboule
Almost at the end of his holiday in the Auvergne, after a short tour of the Cantal from Massiac where his grandmother lives, Marcel chooses a card of a snow-covered Puy Mary to send to Julia Bertrand [24.7.1900] in Neuilly.

"Dear Godmother," he writes, "Today we are at La Bourboule… We leave tomorrow for Néris-les-Bains, where Maman is and Saturday for Paris. Regards from all to all, I embrace you, Marcel."

1909. Wednesday, Rouen
Three years after completing his military service [18.9.1906], Duchamp has a medical examination and, found physically unfit, is discharged from further service.

1913. Monday, London
After a month by the sea at Herne Bay, Marcel and his sister Yvonne spend the first four days of the month exploring London.

Continuing his tour of great European muse-

ums [25.8.1912], does Marcel visit the National Gallery with its great collection of Italian masters, which includes *L'Origine della Via Lattea* [The Origin of the Milky Way] by the Venetian painter, Tintoretto?

1915. Wednesday, New York City
Two articles about Duchamp are published today.

One appears in the September issue of *Vanity Fair*, for which Duchamp's portrait photograph was made [28.7.1915]. The journalist says that the artist who painted the "Nude descending a Staircase", the picture which "made such a turmoil here a couple of years ago [17.2.1913]… speaks English like an Englishman" and is not tender about having the artist "card-indexed and thrust into pigeonholes by those who talk about them".

The other, entitled "A Complete Reversal of Art Opinions by Marcel Duchamp, Iconoclast", is published in the September issue of *Arts and Decoration*:

"The American character contains the elements of an extraordinary art," declares Duchamp. "Your life is cold and scientific… In architecture the Florentine palaces here have disappeared with the advent of the skyscraper, with the call of utility, that means. Assuredly, the Plaza Hotel with its innumerable windows, voraciously taking in light, is more beautiful than the Gothic Woolworth Building, but I like the immensity of the latter.

"New York itself is a work of art, a complete work of art. Its growth is harmonious, like the growth of ripples that come on the water when a stone has been thrown into it. And I believe that your idea of demolishing old buildings is fine. It is in line with that so much misunderstood manifesto issued by the Italian Futurists which demanded, in symbol only however, though it was taken literally, the destruction of the museums and libraries."

Commenting on individual artists, Duchamp declares "Velázquez, like Constantin Meunier, is the type of great man. You feel that he asks you to stand by and admire his greatness, his dexterity, his grandeur and he is terrifically suave. That is not so true of Rodin, who is more subtle and thus better able to fool us… Rodin is always sensuous, a materialist, an animal, if you will.

"Greco is the root of Picasso. They call Picasso the leader of the Cubists but he is not a

1.9.1915

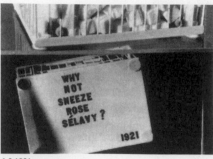

1.9.1921

Cubist strictly speaking. He is a Cubist today – something else tomorrow. The only real Cubists today are Gleizes and Metzinger.

"But that word Cubism means nothing at all – it might just as well, for the sense it contains, have been policarpist. An ironical remark of Matisse's gave birth to it [1.10.1908]. Now we have a lot of little Cubists, monkeys following the motion of the leader without comprehension of their significance. Their favourite word is discipline. It means everything to them and nothing.

"Daumier was good in a caricatural way, selected by himself to be sure, but his irony was not so profound as Goya's. The spirit of Daumier is revived in the Greek cartoonist Galanis, who has lately done some very interesting themes in the manner of the Cubists.

"Gauguin is an impressionist and a romanticist – a great force – Baudelairian, exotic, a traveller, gathering romances out of vague or rare or uncivilized or little known countries.

"Sargent, Simon, Blanche, Cottet, Bernard are impossible. They trade upon antiquity. The prolific Bernard is an especially disgusting parasite. Maurice Denis is a little better. And so in the twentieth century we have what may be called neo-catholicism in art. I do not believe that art should have anything in common with definite theories that are apart from it. That is too much like propaganda. I like Bouguereau better than any of these men, he is so much more honestly an academician. The others pose as revolutionary and their puny little souls cannot know what revolution means. They must have taken their definition out of the dictionary.

"Whistler has a living personality that he could not fully conserve in his pictures. Remove all the evidence of the influence of traditions upon the work of Gustave Moreau and you will find that he is the most isolated figure of his epoch. There is a great sympathy between the work of Redon and Moreau in refinement of colour and sensitiveness. Redon is one of the sources to which Matisse has gone, consciously or not. There is nothing you can take hold of in Matisse's colour, not in the old sense of quality in colour. It is transparent, thin, perhaps, but when you have left his pictures you will see that they have taken hold of you."

With his "red hair, blue eyes, freckles, a face, except for a certain sensitiveness, and a figure that would seem American even among Americans," Duchamp "neither talks, nor looks, nor

acts like an artist. It may be that in the accepted sense of the word he is not an artist," concludes the journalist, who observes that: "in any case he has nothing but antipathy for the accepted sense of any of the terms of art."

1921. Thursday, Paris
"It is really fine here, in spite of being my country," says Rrose Sélavy who has adopted the new spelling of her name [10.7.1921]. She tells the Stettheimer sisters: "[Marsden] Hartley. Man Ray. I've seen. The whole of Greenwich Village is walking up and down Montparnasse. Met McBride by chance at the Rond-Point des Champs-Elysées." Although enjoying the French wine, Rrose hopes, without really knowing why, to return to New York in December: "Paris is deadly dull after a while."

With her camera, Rrose has been searching for "some cinema effects [28.7.1921]…" she tells the sisters. "I hope to bring some footage back to New York."

Having organized, through Albert Gleizes, for Florine to have an exhibition of her paintings at the Galerie Povolozky, Rrose asks her to send fifteen canvases or more to Robinot at the Grand Palais des Champs-Elysées and promises to try to arrange for her to be represented at the Salon d'Automne.

1924. Monday, Strasbourg
In the fourth round of the French chess championship Duchamp loses his game against A. Surén of Colmar.

1929. Sunday, Aix-les-Bains
After their holiday in the Jura [7.8.1929], Mary and Marcel arrive in the evening at the famous French spa by train from Geneva. Before returning to Paris, they plan to spend two days with Brancusi, who has been taking a cure.

1935. Sunday, Paris
"Complete failure" announces Marcel in an express letter to his partner Roché, who is at Saint-Martin-en-Haut on the edge of the Massif Central. After three days open to the public, Marcel has sold only two sets of his *Rotoreliefs* [30.8.1935] to friends, and a single disc to a stranger. Deciding to stop all further expenditure, Marcel says: "I will return the paper taken conditionally (1,350 francs) and we will try to recover the rest of our capital [20.7.1935] by selling in 'artistic' circles."

To avoid having to attend his stand every day during the whole month of the Concours Lépine, Marcel engages a "secretary".

1936. Tuesday, New York City
The eve of his departure, Duchamp accompanies Miss Dreier to the Bank of New York and Trust Company where, witnessed by the assistant secretary, Charles Birney, Jr., they sign the original Trust Agreement for the Société Anonyme [27.8.1936] and two copies of the document, one each for Duchamp and Miss Dreier.

1937. Wednesday, Paris
Roger Caillois reviews *L'Opposition et les Cases conjuguées sont réconciliées* [15.9.1932] by Duchamp and Halberstadt for *La Nouvelle Revue Française*.

1947. Monday, Endicott
Forty players competed in the New York State Chess Championship [23.8.1947], which was won by Albert S. Pinkus. Duchamp takes the class A consolation event.

1958. Monday, Barcelona
From Cadaqués, Teeny and Marcel arrive in the Catalonian capital, where they plan to spend two days.

1960. Thursday, Cadaqués
Having spent July and August on the western shores of the Mediterranean, Teeny and Marcel leave Cadaqués to travel eastwards. From Venice they plan to sail in the Adriatic and through the Corinth Canal to Pireaus, where they will change ships and join Marcel's sister, Suzanne, to explore Crete, Rhodes and Hydra.

1966. Thursday, Cadaqués
Replying to two letters which have arrived from the Seine-Maritime, Duchamp turns his attention to Normandy.

Maître Le Bertre [23.6.1958], who lives in the house where Duchamp was born [28.7.1887], has requested a photograph of *Jardin et Eglise à Blainville* [2.12.1949], which was exhibited recently at the Tate Gallery [16.6.1966]. Having written the same day to Richard Hamilton asking him to be so kind as to have a print despatched, Duchamp tells Le Bertre: "I hope you will receive it soon," and adds, "I have also written to my two sisters to make a short visit to you in Blainville one day at the end of September."

2.9.1915

2.9.1925

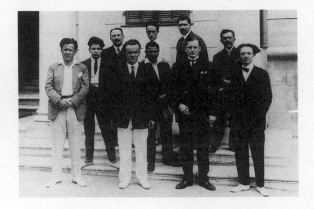

To Olga Popovitch, director of the Musée des Beaux-Arts, who would like to organize an "exhibition of the family", Duchamp promises to come and see her in Rouen to discuss the project and says: "I will telephone you from Neuilly on my return."

2 September

1904. Friday, Néris-les-Bains
From the spa where his mother has been taking a cure, Marcel, who is on his way home, sends a postcard of Le Mont Dore to Ferdinand Tribout in Grand-Couronne to thank him for his letter. "After leaving Massiac," he writes, "we have been via Murat where we climbed the Puy Mary, Vic-s[ur]-Cère, Aurillac, La Bourboule, Le Mont Dore: all that in 4 days…"

1915. Thursday, New York City
On his return from a week at the coast, Duchamp thanks John Quinn for his holiday. "I appreciate the days I spent at Spring Lake," he writes in French. "I am in the best of health. Now I am going to work," he vows, "and retire to bed not so late…"

1925. Wednesday, Nice
Duchamp's poster to publicize the French Chess Championship is described as *hyper-moderne* by Georges Renaud and he is congratulated for its eye-catching effect: defying the laws of gravity a cluster of pale pink and black cubes is confined within the cloche-like silhouette of a chess King.

That morning, the jury led by Alexandre Alekhine, and nine chess players competing for the French championship title (defended by Robert Crépeaux), attend a reception at the Syndicat d'Initiative and are invited to sign the Livre d'Or, which was inaugurated at the chess olympiad the previous year [12.7.1924].

In the afternoon at two-forty a bell rings and a clock is set in motion for each competitor who, by the tournament rules, must play at the rate of fifteen moves an hour. After four hours play, when the afternoon session is finished, Duchamp is still battling against André Chéron from the Cercle de Colombes. Resuming their game at a quarter to nine, after another hour's play Duchamp finally beats his opponent.

1926. Thursday, Paris
Due to leave soon for Monaco, Marcel has lunch with Gaby Picabia and Roché at the Café de la Paix, Place de l'Opéra.

1927. Friday, Nice
The result of the chess tournament organized by the Groupe de Joueurs d'Echecs de Nice [13.8.1927] is as follows: the winner is the Comte de Villeneuve-Esclapon with five and half points; Dr Telling of New York is second with four points; jointly in third place are Duchamp, Brian Reilly and Georges Renaud, each with three and half points.

1932. Friday, La Baule
The casino of this fashionable resort on the Atlantic coast is the setting for the French Chess Championship. In the morning at eleven, the participants gather in the Salle des Ambassadeurs for the draw of the tournament, after which Duchamp makes the announcement that the title of Master has been granted to Messieurs Gromer and Kahn in recognition of their numerous international successes.

The referee of the tournament which starts later the same day is the Grand Master Eugène Znosko-Borovsky, who is also the author of a number of books, one of which Duchamp is translating into French.

1933. Saturday, Cadaqués
"It's really a senseless business this denial of a visa for Spain," writes Marcel to Brancusi, telling him that he believes the same thing happened to Tristan Tzara. Unable, therefore, to accept their invitation [13.8.1933], Marcel supposes that the sculptor has decided "in this heat" to go somewhere else as "Paris must be impossible". Indeed, hearing of his plight, Marina Chaliapine, daughter of the famous singer, who has met with the

same refusal by the Spanish authorities, invites Brancusi to stay at Saint-Jean-de-Luz.

1936. Wednesday, New York City
To return to France, Duchamp boards the *Normandie*, the French counterpart of the English liner *Queen Mary*, which 48 hours earlier garnered the Blue Ribbon for the fastest Atlantic crossing. Miss Dreier has sent Dee a telegram, and her sister Mary has sent him some fruit.

1945. Sunday, West Redding
While spending the day with Miss Dreier at The Haven, Dee tells her that he plans to return to Paris the following March or April. "I shall miss him very much," writes Miss Dreier later to her sister Mary.

1946. Monday, Bern
At the station in the afternoon, prior to the departure of the 5:12 train bound for Paris (for which they have reservations), a young man from the French embassy arrives bearing letters for the customs officials with the result that none of the pieces of luggage belonging to Mary and Marcel is opened for inspection.

1951. Sunday, Syracuse
During the New York State Chess Championship [25.8.1951] which ends today, Duchamp lost the game he played against the new champion J. T. Sherwin. According to the account which is published later in *Chess Review*, it was a lively, dramatic and interesting game.

1957. Monday, Binghamton
After playing nine games in nine days during the New York State Chess Championship [24.8.1957], Marcel has won 3, lost 3 and drawn 3, which he considers "very honourable". During the day he returns with Teeny to New York City.

3 September

1904. Saturday, Paris
At the end of his holiday [1.9.1904], Marcel travels from Néris-les-Bains to the capital, where he stops overnight before returning home to Normandy.

5.9.1911

1919. Wednesday, Paris
While visiting Neuilly Marcel posts a letter to Walter and Magda Pach in New York City telling them that in the month he has been back he has seen all his friends again one by one: "No one has changed, they all live in the same apartments with the same dust as five years ago." Finding Paris attractive in summer, emptied of people, Marcel says that he sees few painters ("same refrain") and, in painting, has seen nothing which interests him except pieces by Georges Ribemont-Dessaignes, Francis Picabia and his brother Villon, who "has worked a lot since his demobilization".

As his brother's widow [7.10.1918] Yvonne, who is working as a nurse, has not yet been demobilized, Marcel has been to visit her at Laon, about 140 kilometres northeast of Paris.

1925. Thursday, Nice
Due to commence at two-thirty, the second round of the French Championship is eight minutes late in starting. Duchamp plays Silbert of Paris, but at a quarter past five has to concede a draw.

1927. Saturday, Chamonix
In the evening at nine o'clock at the Hôtel d'Angleterre those participating in the French Chess Championship are invited to a reception. M. Vincent, the secretary-general of the Fédération Française des Echecs, makes a speech to welcome the players.

1938. Saturday, Paris
Afraid that Man Ray has not received his letter of 25 August, Marcel writes again repeating his questions about the copy of *Anémic Cinéma* [30.8.1926] for the Museum of Modern Art.

1939. Sunday, Aix-en-Provence
Duchamp is on holiday with Mary Reynolds in Provence when, following the invasion of Poland early on Friday by Hitler's troops, France and Great Britain declare war on the German Reich.

1940. Tuesday, Paris
In spite of difficulties in travelling north, Marcel, who has spent more than three months in Arcachon [16.5.1940], manages to return to Paris with Mary Reynolds. After the evacuation of Dunkirk on 4 June, the arrival of the Germans in Paris on 14 June, and Pétain's capitu-

lation on 22 June, the battle between the Royal Air Force and the Luftwaffe, which commenced at the beginning of August, continues to rage in the skies over Britain.

1946. Tuesday, Paris
After five weeks in Switzerland, Mary Reynolds and Marcel return on the night train from Bern, which is due to arrive at the Gare de Lyon at thirteen minutes to six in the morning.

1951. Monday, New York City
In the evening Duchamp returns from Syracuse after "a very restful vacation" playing chess in the New York State Championship [25.8.1951].

1959. Thursday, Paris
Following discussions with Bill Copley, who has just arrived in Paris, Duchamp writes to Denise Roché to tell her that although Fawcus has abandoned the idea, Copley agrees to purchase *A propos de jeune Sœur* [8.3.1915] from the Roché Estate. Duchamp also informs George Staempfli, who recently acquired the miniature window from Marie Sarlet in Brussels, that Copley would like to buy *La Bagarre d'Austerlitz* [22.9.1949] for the stated price of $12,000.

4 September

1904. Sunday, Blainville-Crevon
Returns home after a holiday in Massiac which was crowned with a four-day tour of some of the celebrated places in the Auvergne.

1924. Thursday, Strasbourg
In the ninth round of the French Championship, Duchamp plays victoriously against the president of the Echiquier Strasbourgeois, E. Michel, who resigns after the thirty-sixth move.

1925. Friday, Nice
The third round of the French Championship starts with precision at two-thirty. When M. Vincent announces the closure of the afternoon's play at six-thirty, Duchamp's game against Raoul Gaudin of Périgeux is still in progress. Resuming play at eight-thirty, the game ends in a draw just twenty minutes later.

1927. Sunday, Chamonix
Commencing at two o'clock in the afternoon, Duchamp draws his game against Georges Renaud of Nice in the first round of the French Championship.

1929. Wednesday, Aix-les-Bains
After two days visiting Brancusi, Mary Reynolds and Marcel are due to return to Paris with the sculptor.

1936. Thursday, at sea
"'Rolling' on a very calm sea – wonderful weather," writes Dee aboard the *Normandie*. Thanking Miss Dreier for the telegram and the fruit from her sister, and providing her with the addresses of Piet Mondrian and Roché, Dee says: "Again I think of the wonderful weeks at The Haven…" Then, referring to all his works made a decade or two ago, which he has had a chance to see again while visiting Louise and Walter Arensberg [6.8.1936] and the ones he is satisfied to have repaired and restored while staying with Miss Dreier [29.8.1936], he declares: "this trip has really been a wonderful vacation in my past life. I don't feel like the people who don't dare touch a past for fear of regretting. It was very objective: vacation in past time instead of a new area." Promising to write from Paris, he then adds in French, "*toujours affectueusement*, Dee."

1946. Wednesday, Paris
A couple of days after their return from Bern, Mary Reynolds and Marcel are invited to dine with Violaine, the Hoppenots' daughter. They recount all the "activities at the embassy and *ailleurs*" including, no doubt, dinner the previous weekend at the Hôtel de la Croix Blanche in a village near Fribourg. With the staff off duty at the ambassador's residence, the *maître d'hôtel* Louis was asked to reserve a table. Returning perplexed, he announced that the speciality of the establishment was *pis de vache* or cow's udder. When the astonished ambassador enquired, "Is it good?" Louis, with dignity but evidently shocked, replied: "I have never served anything of the sort yet! I don't commit myself in that way!"

1951. Tuesday, New York City
"In spite of the nervous effort demanded by the games, I find myself in better physical condition than when I left," writes Dee the day after his

5.9.1961

return from Syracuse. "My result (50%) also satisfies my little ambition," he tells Miss Dreier.

Knowing from his telephone call today that Mr Kelly is to meet the dean of St Paul's School on Wednesday to discuss the cleaning of Miss Dreier's mural, Dee has arranged to call him again on Thursday for news.

1967. Monday, Cadaqués
Writes to Richard Hamilton proposing that he and Teeny travel to London on 15 October so that they can "stay and work Monday and Tues-

D'APRÈS marcel Duchamp,

Richard Hamilton

day, and leave for New York from London Wednesday." For this edition [9.8.1967], Marcel says he prefers the formula "*D'après* Marcel Duchamp, Richard Hamilton" instead of "*Après*".

5 September

1911. Tuesday, Veules-les-Roses
After Suzanne's wedding on 24 August the family have returned to the Villa Amélie to continue their holiday by the sea.

Using twice the distinctive Mery profile of his sister Magdeleine, inherited like himself from their grandmother, and combining it with two profiles of Yvonne, Marcel is experimenting with composition in "a very loose interpretation of the Cubist theories". While drawing his sisters' heads in a progression of scale and accentuating differences in rhythm of line as well as playing on great contrasts of light and shade, Marcel chooses a title which is evocative of the chessboard: *Yvonne et Magdeleine déchiquetées*.

On a card with a view of the esplanade and the house of Victor Hugo, a celebrated visitor to the village, Duchamp writes to Dumouchel in Paris: "It's the great man of Veules…"

1917. Wednesday, New York City
Writes to Carl van Vechten at 151 East 19th Street thanking him for the cheque. Marcel has phoned Roché about the title of the articles by Erik Satie, *Mémoires d'un Amnésique*, and suggests that for more information Carl should speak to Roché. And Fania [28.7.1917], enquires Marcel, "Is she working like a negro?"

1925. Saturday, Nice
Duchamp obtains a bye in the fourth round of the French Championship.

1926. Sunday, Mougins
On his way to spend three weeks in Monaco, which he loves for "its lack of mosquitoes and its architecture", Marcel stops to see his sister Suzanne and Jean Crotti. Built opposite Picabia's "Château de Mai" and shaded by old olive trees, the Crotti's house is styled "Minorange".

1933. Tuesday, Cadaqués
"Received your letter. Delighted," writes Marcel to Man Ray [21.8.1933], who has announced his arrival on Friday. Suggesting that he should travel to Toulouse and take the direct train to Figueras arriving at four in the afternoon, Marcel explains that there is an afternoon bus connection to Cadaqués nearly every day except Friday. "If you take a taxi," says Marcel, "that will cost you about 35 pesetas (70 francs)."
In addition to Mary Reynolds' signature, "Mary always," next to Marcel's, Gala adds a long, enthusiastic note telling Man Ray that they are waiting impatiently for him: "Come, there are so many things to do here at Cap Creus." Dali, meanwhile, is dreaming of the photographs of the Gaudí buildings in Barcelona for *Minotaure*.

1946. Thursday, Paris
Marcel's hopes of obtaining a visa rapidly for his return to the United States are dashed when he learns that he must wait a month.
It is Marcel's "night off", but before going out he has asked Mary Reynolds, who doesn't want to delay writing to their friends any longer, to pass on his warm regards and "a thousand things" for Henri and Hélène Hoppenot [31.8.1946].

1950. Tuesday, Binghamton
Returns to New York after attending the annual congress of the New York Chess Association, which terminated on Sunday.

1961. Tuesday, Stockholm
After a week in the Swedish capital, the Duchamps leave by train for Amsterdam [29.8.1961]. During his stay Duchamp was photographed by Lutfi Ozkok at the Moderna Museet with the team who built the replica of the Large Glass: Oscar Reuterswärd, Ulf Linde,

Carlo Derkert and the director of the museum, Pontus Hulten. He has certified the Glass as a true copy, and also the replicas of *Roue de Bicyclette* [15.1.1916] and *Fresh Widow* [20.10.1920], which were all made for the Moderna Museet [16.5.1961].

1963. Thursday, Cadaqués
"Awaiting you Monday evening," reads Marcel's cable to Baruchello [27.7.1963], "Piqueras will be at Barcelona airport if not take taxi to Cadaqués affectionately = Duchamp."

6 September

1908. Sunday, Veules-les-Roses
After a spell of bad weather it is a fine day for another outing. The same band of friends [3.8.1908] have cycled along the coast to Quiberville and visited the lighthouse at the Cap d'Ailly, and on another day they made an excursion inland to the village of Blosseville. Today after a bicycle ride they have found a shady place for a picnic.
The bottles of cider are carefully propped up in the centre of the cloth spread out on the grass, the lunch is unpacked and everyone except Puech is sprawled on the ground when Carmen Cartaya (the new champion of Veules! [23.8.1908]) takes her photograph. Germaine Galuska and Odette Cartaya are sitting on the left next to Lucien Tremlett and Nina Ayza-

6.9.1908

6.9.1967

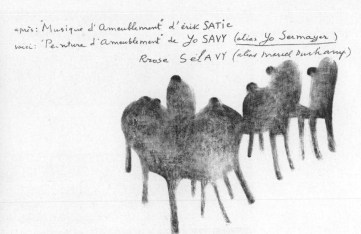

après: "Musique d'Ameublement" d'érik SATie
voici: "Peinture d'Ameublement" de Yo SAVY (alias Yo Sermayer)
Rrose SélAVY (alias Marcel Duchamp)

guer [20.8.1908] reclining in the foreground. On the right Mercedes Cartaya is adjusting her hat, her fiancé Roland Jourdan stretched beside her, wearing his chequered cap. Sporting a white, black-ribboned hat, Marcel is seated in the background between Coco Brown and Marcel Langlois, whose attention at that moment is drawn to Mercedes…

*

Remembering when he was last at the Château de Montigny near Dieppe visiting the Langlois family (close friends of the Duchamps since the days before Blainville, when both families were living in Cany), that Louis and Henry agreed to come to Veules, Marcel writes reminding them of their promise. To the younger brother, Henry, Marcel says: "At the same time as Louis, I remind you that we are counting on you as agreed in Montigny. I hope to see you soon," he scrawls. "Write quickly."

To Louis, Marcel writes: "You promised to come and spend a few days here. Which day are you arriving? We will be leaving here from 15 to 20. So come quickly." Suzanne adds that if they bring their bicycles, rather than going to Saint-Valéry-en-Caux, they should take the train to Saint-Pierre-le-Vigier, only 6 kilometres from Veules. "Take advantage of the fine weather," she writes, "it's so miserable when it rains here."

1925. Sunday, Nice
Duchamp's game against Georges Renaud in the fifth round of the French Championship, "one of the most attractive games played so far," is watched by numerous spectators. After masterly development and an excessively closely-fought battle, Duchamp finally wins the game.

1927. Tuesday, Chamonix
In the Chamonix chess club's headquarters, the fifth congress of the Fédération Française des Echecs opens with a speech by the club's president, M. H. de Noussane.

1935. Friday, Paris
After sending Miss Dreier a set of *Rotoreliefs* [30.8.1935] Dee then writes to say that his invention for the Concours Lépine "is a complete failure commercially speaking", but he has decided to have it copyrighted in the United States, "hoping to sell a few there."

Dee is sorry that Miss Dreier has returned his *Colonne sans fin* by Brancusi to George

Of's storage. "I wish you would like it enough to place it somewhere in your house and enjoy it," he tells her. "If you don't wire I will understand that you have asked Of to bring it again to Redding."

Thanking her for the offer of her studio in New York, Dee replies: "I don't think I can go for the moment," and referring to the reconstruction of the Large Glass, broken in transit after the exhibition at Brooklyn [19.11.1926]: "We will have to wait for the good weather again, in order to work at the glass."

1947. Saturday, New York City
At eight Marcel takes Stefi Kiesler to dinner at the Café Royal.

1949. Tuesday, Rochester
Returns to New York after attending the congress of the New York State Chess Association [27.8.1949], which ended the previous day.

1951. Thursday, New York City
Duchamp telephones Mr Kelly [4.9.1951], who is leaving for a three week vacation but promises to provide a written report of his discussions with the dean of St Paul's School.

1952. Saturday, New York City
"I wrote to Walter [Arensberg] telling him that I would be delighted to restore the back of the King and the Queen," writes Duchamp belatedly [21.8.1952] to Fiske Kimball. "Is the picture in Philadelphia?" he enquires, suggesting to go one day to see the condition of *Le Paradis* [9.10.1912], the picture in question.

1961. Wednesday, Amsterdam
Continuing their train journey from Stockholm, the Duchamps cross the border between Denmark and Germany at Grossenbrode. Their passports are then stamped again at Oldenzaal on the Dutch border before the train arrives in Amsterdam, their destination.

1967. Wednesday, Cadaqués
"Have received your letter safely with the catalogue very good – the colour very successful and the whole very impressive!" writes Marcel to the Savys [21.8.1967], referring to Yo's catalogue for her exhibition due to open on 14 November in New York. "In fact we will speak about 18 Sept[ember] when we toddle back in the Volkswagen."

1968. Friday, Cadaqués
"…I see nothing current that could be put in the 'recent' end of the gallery," says Marcel thanking Simon Watson Taylor for the invitation to participate in the Apollinaire Festival, which he is organizing at the Institute of Contemporary Arts, London.

7 September

1921. Wednesday, Paris
Charles Demuth has sent an express letter to Gertrude Stein asking whether he and Marcel may call to see her in the evening at 27 Rue de Fleurus.

1924. Sunday, Strasbourg
Duchamp returns to Paris after the French Championship, which has been won by the 23-year-old Robert Crépeaux from Grasse. It has been a triumph for the young generation of players. After his performance for the French team in the Chess Olympiad [20.7.1924], Duchamp's result is disappointing: out of thirteen players he is placed eleventh with 4 points.

1925. Monday, Nice
It is not until six o'clock in the evening after playing all afternoon that Duchamp, taking a few quick puffs on his pipe, placidly accepts defeat against Lazard, his sixth-round opponent in the French Chess Championship.

1930. Sunday, Nice
Since he has been staying on the Côte d'Azur [30.7.1930], Dee has been to Mougins and chosen some pictures for the Société Anonyme's exhibition at the New School for Social Research [9.7.1930]. He writes to Miss Dreier to say that he has already selected two canvases by Francis Picabia and two each by Jean and Suzanne Crotti.

1936. Monday, Le Havre
Although the sea was calm earlier in the voyage [4.9.1936], the *Normandie* sailed into a fierce storm in the eastern Atlantic. In the morning a west-northwest gale in the Channel reaches gusts of 120 kilometres an hour. By five o'clock, however, the wind has abated a little

8.9.1931

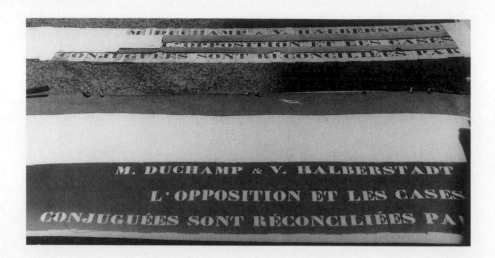

when the pilot is taken aboard the liner from the tug *Minotaure*. A huge crowd has gathered to watch the great ship "manoeuvre magnificently" with three tugs in the harbour, and at five-forty Duchamp is among the 300 passengers who disembark at Quai Joannes-Couvert.

1943. Tuesday, West Redding
Dee visits The Haven for two days to prepare the Large Glass [5.2.1923] for its transfer, on a temporary loan, to the Museum of Modern Art, New York. With Miss Dreier he checks her manuscript on David Burliuk, which she wants to have ready to send to Mr Harry Abrams on Saturday.

1950. Thursday, New York City
Visits Philadelphia to study the alternatives for installation of the Arensberg Collection in the museum, and has lunch with Fiske Kimball [30.8.1950]. On his return Marcel writes to Louise and Walter enclosing tracings he has made of the two solutions.

Marcel now prefers the first solution. He says to the Arensbergs "the next step is for you to see it", and Fiske Kimball is available to devote his time to them. "I, on the other hand, am going to Europe for a month," warns Marcel, who says he would like to be there when they come east. "My old friend Mary Reynolds [9.8.1950] is dying of uremia and her brother has asked me to go and see her... This was a great shock."

He asks the Arensbergs not to mention his trip to France: "As I am scared of the Parisian Crocodiles, I keep my going as mute as possible..."

1951. Friday, New York City
In the morning post receives a cheque and a card from Miss Dreier inviting him to The Haven on 10 September. Dee writes: "I will be very happy to be with you and Mary on Monday, your birthday..." and reports on his telephone call with Mr Kelly the previous day.

1963. Saturday, Cadaqués
"Very happy to receive your news and to hear that all progresses well for the project," replies Duchamp, who now has not only a letter but also a card posted in Hong Kong from the elusive Mr Hopps, to whom he and Richard Hamilton sent an SOS a month ago [3.8.1963].

To Hopps' request for some early works to add to the forthcoming exhibition in Pasadena [3.8.1963], Duchamp says that he cannot borrow anything from his sister, who is gravely ill, but will be able to send by air freight some framed drawings belonging to Roché's widow as soon as he returns to Paris. "I will bring myself one chess set," adds Duchamp, referring to his *Pocket Chess Set* [23.3.1944], "[which] I have just completed in Cadaqués."

1965. Tuesday, Hanover
The first of two openings [17.7.1965] takes place at the Kestner-Gesellschaft of "Marcel Duchamp, même", a travelling exhibition [19.6.1965] principally of readymades, drawings and prints.

8 September

1925. Tuesday, Nice
The public is sparse at two-thirty when Duchamp starts his game against Robert Crépeaux in the seventh round of the French Championship. For four hours Duchamp dominates his opponent until he makes an error, losing a piece, which allows the champion to check him. To the surprise of the crowd which has gathered round the table, Crépeaux doesn't then move his Knight, but secures a rapid victory all the same.

1931. Tuesday, Villefranche-sur-Mer
The chess book with Vitaly Halberstadt is progressing. Man Ray has sent photographs of the two authors which Marcel finds very flattering and is looking forward to seeing the enlargements when he returns to Paris in October. With Brancusi and his camera, the constant sunshine on the terrace is perfect to photograph the shadows cast by the zinc stencils forming the authors' names and title for the cover of the book.

"Here the weather is ideal," Marcel tells Man Ray in Paris, "cool in the evening. But sun all day and every day." On the steep hillside overlooking the Mediterranean, Mary Reynolds is renting the Villa Marguerite with its spacious, sunlit terrace at the first floor. Marcel admits that there are a few mosquitoes in the evening, "but with citronella, and especially

with the mosquito net to sleep under, life is very agreeable..."

Almost neighbours at Col-de-Villefranche, a little further up the hill are Kay Boyle and Laurence Vail, who invite Marcel and Mary to dinner one evening: the other guests are Helen and Giorgio Joyce, Emma Goldman, Alexander Berkman and Robert McAlmon.

1937. Wednesday, Paris
"Two words to announce that all your variations [24.8.1937] are finished and very beautiful," writes Dee to Miss Dreier who has told him that she "is crazy to see them". The *40 Variations* will be shipped to George Of in New York "sometime next week".

1938. Thursday, Paris
In the morning Duchamp writes to André Breton requesting an appointment with him at Denoël, the publishers of *Foyers d'Incendie* by Nicolas Calas. Duchamp is preparing Breton's text of presentation for the book by Calas.

*

Having solved the mystery of the missing copy [3.9.1938] of *Anémic Cinéma* [30.8.1926], Marcel reassures Man Ray that "all is in order. Natacha has found the film and I will send it to Barr immediately."

1951. Saturday, New York City
As the list of items purchased for the Arensbergs between 1935 and 1940 that Marcel made for the Californian tax department was unsigned and appeared to be incomplete [15.8.1951], Walter has sent him a typewritten one, which Marcel has completed and corrected before signing and returning it. "If there should be some other questions," he writes in an accompanying note, "don't hesitate to squeeze my recollections (as vague as they are!) What a nuisance!"

1959. Tuesday, Paris
Duchamp follows his letter to Denise Roché the previous Thursday with another concerning the purchase by Bill Copley of *A propos de jeune Sœur* [8.3.1915].

1963. Sunday, Cadaqués
"The cigar cutter just came!" Marcel writes delightedly to Richard Hamilton [3.8.1963]. "It cuts a beautiful form in my cigars and so neatly! Many many thanks."

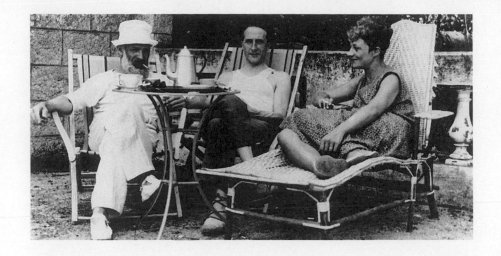

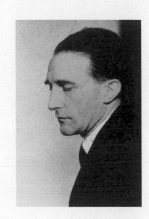

Replying to several queries Hamilton poses about the Large Glass for his lecture, Marcel states that the "lines of the Sieves [3.8.1914] evidently are determined by those basic perspective measurements as is everything in the Bachelor apparatus". At the top of the measured drawing of the Sieves published in the Green Box, Marcel explains that: "In 'D/2' D represents 'Distance points' which are used in orthodox perspective to determine the direction of the different lines in perspective, such direction being different with each different distance from the Spectator. I don't remember why D/2 (meaning half Distance)," he continues, "and I don't remember the explanation of D/2 = 142.6 except that 71.3 x 2 = 142.6."

1964. Tuesday, Cadaqués
As Richard Hamilton (who has recently spent a month in Cadaqués with his family) is in charge of the catalogue for the exhibition opening at Cordier & Ekstrom in January, when Marcel receives a letter from Gianfranco Baruchello with questions from Sig. De Miglio, the printer in Rome, who is preparing the colour cliché of the door 11 Rue Larrey [9.10.1937] for the cover, he forwards them to Richard with the plea: "Please Richard act directly with them and let us not waste time to have my opinion. Finally explain to them that the printing will be done in America as well as the embossing and final gluing."

1966. Thursday, Paris
While Duchamp is still in Cadaqués, an interview he recently accorded Claude Rivière is published in *Combat*. Discussing mainly contemporary art, the journalist's first question is: "What can you say about the direction of art today?"
"I cannot say anything. I do not think, I do not judge. Art is anything. One can choose of course. One starts with a frame of mind, chosen materials, with the subject but in fact the principal factor in art today is boredom."
Does Duchamp think this situation will last long?
"That doesn't matter! This situation exists… What is important to me is to see it existing."
Is today's approach really sincere…?
"Bah! Isn't insincerity often the same thing as sincerity?"
Doesn't he think that artists today take the easy way out by using manufactured objects?

"But what have I done myself? …In music we find investigations parallel to those of painters. John Cage pursues his search for silence, even Erik Satie did not go as far as him. Cage performed a boring repetitive music which lasts for 8 hours [*Vexations* by Satie, in New York on 9–10 September 1963]… There again you see, it's boredom that dominates…"
Claude Rivière remarks that Duchamp has had enormous influence on the present time…
"Who can know the extent of my influence? Not me, in any case, but I am sure that Pop Art was inevitable. It's more interesting than the Op [Art] and, more than [Op], the Pop opens a new vision and affirms a *scission*. It's this scission which is important."
"To me your work appears to be more sumptuous than what you see in Pop Art," claims the journalist.
But someone comes to collect Duchamp and, smiling, he tells Claude Rivière before he goes: "You see art never saved the world. It cannot."

1968. Sunday, Cadaqués
Writes a note to Pierre de Massot inviting him to telephone Neuilly after 17 September to arrange to meet at Givaudan's or elsewhere before he returns to New York.

9 September

1903. Wednesday, Paris
Having signed their marriage contract the previous day, at eleven in the morning Raymond Duchamp-Villon marries the young widow Yvonne Reverchon, née Bon, in a civil ceremony at the *mairie* of the *1ère arrondissement* at 4 Place du Louvre.

1925. Wednesday, Nice
In the eighth round of the French Championship, Duchamp is beaten again by his old rival Casier [18.4.1925] of Caudebec-les-Elbeuf who, according to the reporter from *Le Petit Niçois*, plays a brilliant game.

1929. Monday, Paris
Five days after returning to the Rue Larrey from Aix-les-Bains, Marcel sends a message to

Henri Pierre Roché: "Are you in Paris? I am – a word giving me a rendezvous: would be happy to see you…"

1933. Saturday, Cadaqués
Dee sends Miss Dreier the translations he has made of the texts by Villon and Pevsner for the catalogue of her own exhibition [19.8.1933], with an accompanying note asking her to read them over carefully and to "change whatever sounds bad English, or not clear enough".

1943. Thursday, West Redding
"The Glass is so beautiful where it is that I am sorry that one cannot transport the whole setting on a magic carpet." But, Miss Dreier admits, "it is important for people to see this extraordinary piece even under museum conditions which are never quite favourable…" With four men from the Museum of Modern Art practised in handling fragile works of art, Dee supervises the removal of the Large Glass from the library on the upper floor (where it has been standing since he repaired it [28.8.1936]) into the waiting truck provided by Thorn's removals and he accompanies the precious cargo on its slow journey to New York. The driver has been instructed not to exceed the speed of 15 m.p.h.! Arriving at six o'clock in the evening, the Large Glass is immediately transferred by elevator to the third floor of the museum, where it is to be installed the next day.

1947. Tuesday, New York City
In the evening at six Marcel calls to see Stefi Kiesler at 56 Seventh Avenue.

1957. Monday, New York City
Telephoning from Connecticut Kay Sage enquires whether the Cassandra Foundation has made a decision yet concerning Marcel Jean, who desperately needs funds to visit the United States and collect information for his history of Surrealism.
As Kay thought that the award "was practically a *fait accompli*", Duchamp suggests that she write directly about the matter to Bill and Noma Copley who are at Longpont-sur-Orge in France.

1961. Saturday, Amsterdam
"How can I thank you enough for your invitation to Stockholm and for your eagerness to

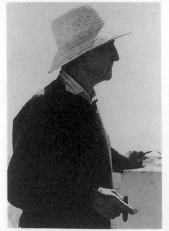

9.9.1963

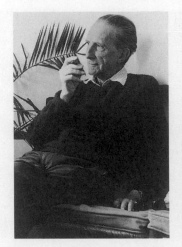

make this voyage a succession of events more delightful from one to another," Duchamp tells Pontus Hulten from the Hotel des Pays-Bas. "Naturally the star turn was the exhibition itself [17.5.1961] which even descriptions made by enthusiastic friends were unable to convey exactly. You must be sad even," Duchamp continues, "to see it evaporate after all the fatigue and emotion it caused you. I hope therefore to see you again soon in Paris or in New York and please believe my admiration for this great adventure…"

Teeny encloses a postcard she has written in gratitude to Anna Lena, Hulten's wife, thanking her in particular for the visit to the "charming theatre which", she says, "I will never forget."

*

After their visit to Amsterdam where they joined the Copleys for a couple of days and found time to see the Rembrandt's at the Rijksmuseum, the Duchamps return to Paris by train.

In the mail awaiting their arrival at the Monniers', Duchamp finds a letter from Serge Stauffer, forwarded from Cadaqués. He replies proposing arrangements for Giovanni Blumer, who wishes to collect two Valises, to meet him at 108 Rue du Bac on either 16, 17 or 18 September.

1963. Monday, Cadaqués
Replies to Beatrice Wood saying that he will be "very happy" to see her in Pasadena and hopes that she will be at the opening of the exhibition on 7 October. "Meanwhile," Marcel writes, "thank you for the news of your prosperity in the art world and delighted…"

*

In the evening Elena and Gianfranco Baruchello arrive from Rome [5.9.1963] to spend three days with Teeny and Marcel. During their visit, Gianfranco photographs Marcel in his wide-brimmed straw hat.

1968. Monday, Cadaqués
Suffering in the last few days from a slight cold and pains in his back, Marcel decides to see the doctor. Later in the day he feels better and Teeny hopes "he improves and that the drive on Saturday won't be too hard on him". Although they have planned to return to Paris, she has decided that "if he is not up to it, we will just stay here a little longer".

10 September

1903. Thursday, Paris
Following the civil marriage of Raymond and Yvonne which took place the previous day, the two families and their friends are invited to attend a service of benediction at the Temple de l'Oratoire, 145 Rue Saint-Honoré.

1925. Thursday, Nice
In the ninth and final round of the French Championship, Duchamp wins his game against Bertrand of the Cercle Philidor, Paris.

In the final results, Robert Crépeaux retains his title, Lazard and Silbert take second place, Chéron and Bertrand tie fourth and Duchamp (ahead of Gaudin, Casier and Renaud) finishes sixth with four points. For his score of 50% Duchamp is awarded the title: Master of the Fédération Française des Echecs.

1927. Saturday, Chamonix
Although there are still matches to play in the next few days, Marcel knows that he is now out of the running for a high placing in the tournament. "Dear Morice," he writes on a postcard to Brancusi, "won't be French champion this year – until 18 in Paris."

*

To celebrate her 50th birthday, members of the Dreier family perform a skit entitled *The Modern Dubs*, which is dedicated to their "beloved sister Katherine Sophie Dreier". Set in an art gallery, one of the visitors is a Patron of Modern Art and to the celebrated air from Gilbert and Sullivan's *H.M.S. Pinafore*, she sings a little verse:

I've paintings of Masters
Which shock holy pastors,
And yet I can never tell why.
I've Duchamp and Manet,
And great Cimabue,
But why are they great, oh, why, why?
Kandinskys and Stella,
Lissitzky – good fella –
But what shall I say, what alas,
When people enquire
What means this, dear Sire,
I feel like a stupid old Ass…

1933. Sunday, Cadaqués
At the same time as receiving word from Brummer, Marcel has received Brancusi's letter announcing the exhibition on 15 November in New York and inviting him to accompany the sculpture across the Atlantic. Giving his agreement, Marcel writes to Brancusi at the western end of the Pyrenees [2.9.1933]: "We can settle all the details on our return to Paris."

1942. Thursday, West Redding
To celebrate her birthday, Miss Dreier has invited Dee and Ethel and Edward Dreier to lunch. Dee has been invited to spend the night at The Haven before returning to New York.

1943. Friday, New York City
As Miss Dreier had feared, some of the pieces of the Large Glass held only by gravity since its repair [28.7.1936] slipped out of position during its transport the previous day. During the morning before the museum men start to install the Glass in one of the rooms of the permanent collection (where it will be shown with works by Calder, Pevsner, Brancusi, Moore and Giacometti), Duchamp puts back the pieces which have slipped.

1947. Wednesday, Milford
"For her 70th summer", Miss Dreier receives from Dee: *Coloriage pour le "Cimetière des uniformes et livrées"*, the model for the miniature colour reproduction [10.7.1938] of *9 Moules Mâlic* [19.1.1915] for the *Boîte-en-Valise* [7.1.1941].

1950. Sunday, New York City
Marcel tells Roché that he has accepted Brookes Hubachek's invitation to go to Paris to see Mary Reynolds [7.9.1950]. "After being assured," he explains, "that Mary will see nothing alarming in my coming… she is back at Rue Hallé… with a nurse and an American friend, also a trained nurse sent 10 days ago by her brother."

Reluctant "to turn out" the Waldbergs [16.11.1945] from Rue Larrey for a month when he arrives on 19 September, Marcel asks Roché if he might have a room at 99 Boulevard Arago. "In any case," he writes, "I will spend the first night at the Hôtel Terminus Gare Saint-Lazare." As a postscript Marcel repeats

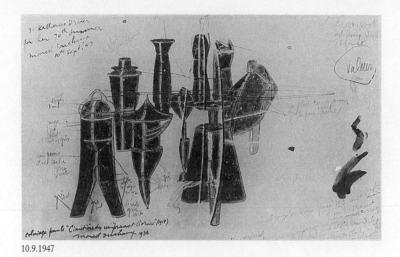

10.9.1947

10.9.1951

the instructions which he gave to the Arensbergs on Thursday: "Keep my arrival to yourself. I want to avoid the Parisian crocodiles as long as possible."

*

When he arrives at Milford in time for lunch, Dee surprises Miss Dreier by bringing her what he calls "two gadgets" which she finds "most enticing".

1951. Monday, New York City
Dee takes the usual train via Bridgeport to Milford where he is invited to lunch with Mary Dreier. For her birthday and in recognition of her lifelong chivalry and defence of modern art, Dee brings Miss Dreier a drawing of his chess Knight [14.6.1949] which he has dedicated: "To Katherine Dreier, Knight of the Société Anonyme…"

1957. Tuesday, New York City
Marcel and Teeny meet Monique Fong.

1961. Sunday, Paris
Finding a reply from Richard Hamilton to his letter of 25 August and one from Nancy Thomas of the BBC on his return from Sweden, Denmark and Holland the previous day, Marcel agrees to them both coming to Paris on 25 September to discuss the interview for the "Monitor" programme. "According to Teeny," writes Marcel to Richard, "we will *both* go to London with you on 26th and do the filming on 27th and 28th."

*

Duchamp's "conversation" with Ulf Linde in Stockholm is published in *Dagens Nyheter*.

1962. Monday, Paris
"I do remember the Blue Bowl and also the painting of the Avenue lined with Elm Trees," writes Duchamp to Mary Dreier, referring to Miss Dreier's paintings. He believes they stayed in the family as they were not part of "the collection scattered among different museums…"

Has she asked her brother Theodore? In case they are at Hahn's Storage, Duchamp promises to look when he returns to New York on 2 October.

*

The Duchamps leave by train for Milan, where they are invited to stay a couple of days with Enrico Baj in Via Privata Bonnet.

11 September

1925. Friday, Nice
In the evening all the competitors are among the fifty guests invited to attend a banquet held at the Café de Paris to mark the closure of the third French Chess Championship.

When the champagne is served, the president of the Fédération Française des Echecs, M. F. Gavarry, invites Baron Buchet, president of the Groupe des Joueurs d'Echecs de Nice, to speak. After his words of thanks to everyone, Georges Renaud rises and proposes a toast to the Fédération, to Alexandre Alekhine and to the French champion; he then reads the results of the tournament and to the accompaniment of much applause proclaims Robert Crépeaux champion of France. When Alekhine speaks next, he pays homage to Renaud who, "as a real apostle of chess, lost his chance as a competitor in sacrificing all his faculties and his talent to organizing the tournament, a marvel of its kind." M. Gavarry then addresses the guests and proposes a toast to the winner and to the "perseverance and union of all" in promoting the cause of chess in France.

*

At the close of the tournament, Duchamp travels to Rome.

1929. Wednesday, Paris
"You have all the rights to be furious, but I have been actually unable to write: I had so many things to decide on… You must understand," Dee tells Miss Dreier, "…It can be no more a question of my life as an artist's life: I gave it up ten years ago; this period is long enough to prove that my intention to remain outside of any art manifestation is permanent.

"The second question is that, according to my attitude, I don't want to go to America to start anything in the way of an 'art' museum of any kind.

"The third question is that I want to be alone as much as possible.

"This abrupt way to speak of my 'hardening process' is not meant to be mean, but is the result of a '42-years-of-age' summing up."

"I am a little sick – physically," he hastens to add, explaining, "my bladder is beginning to speak – so I have to take care of myself – doctors included.

"My opinion is that anything one does is all right and I refuse to fight for this or that opinion or their contrary.

"I don't see any pessimism in my decisions: they are only a way toward beatitude.

"Your life," he reminds Miss Dreier, "has been and is connected with the actions and reactions of so many people that you can hardly approve of my choice between a snail and a butterfly for a disguise.

"Please understand I am trying for a minimum of action, gradually.

"I would never let Waldemar George write anything about me, if it were in my power.

"My brother never said a word… yet to me. All this is very annoying, so let's forget it…"

Closing the letter, he writes: "10000 apologies for this rough letter and *affectueusement* Dee."

1932. Sunday, La Baule
At a lunch held at the Club Baulois to which the fourteen competitors are invited, the president of the Fédération Française des Echecs announces the results of the tournament and declares M. Raizman the new French champion. Scoring seven and a half points (having won five games and drawn five), Duchamp is placed fourth with Barthelemy, Betbeder and Gibaud.

The games against Silbert and Polikier, both of which Duchamp won, are later published in *L'Echiquier*.

On the back of a sheet of paper marking the score of the tournament, Duchamp sketches the head and shoulders of a woman wearing a stove-pipe hat, and a man's head, almost mask-like, with a beard. The sketch is later entitled *The King checked by the Queen*. [For the illustration, see 2.9.1932].

1934. Tuesday, Bois de la Chaise
From the Hôtel Saint-Paul situated in beautiful grounds on the Isle of Noirmoutier where he and Mary Reynolds are staying, Duchamp writes to Brancusi in Paris: "Small wood like Fontainebleau; the island is large and we haven't seen anything yet. It is hot during the day. Announce your arrival with woollies for the evening. Sandy beaches…"

11.9.1963

12.9.1962

1935. Wednesday, Paris
As Roché is now back from Saint-Martin-en-Haut, Totor meets him at Arago. They settle their account for the *Rotoreliefs* [30.8.1935] and discuss their failure [1.9.1935] at the Concours Lépine.

1944. Monday, New York City
Hans Richter has invited Mary Reynolds and Marcel to stay with him in the country. Thanking him, Marcel explains: "You know how hard it is for me to leave N.Y. even in summer – moreover I benefited from the vacations to work in a less disjointed fashion." He asks Richter to let him know when he returns to New York.

1949. Sunday, New York City
"I am delighted to hear that you have finished the first part of your writings," Marcel tells Helen Freeman [15.4.1949], who is composing an "inner description" of him. "I wish you would send me a copy."

He confirms that of the two original drawings entitled *Vierge* [7.8.1912], only one belongs to the Arensbergs, and explains that he "had lost complete sight of it for 25 years" [16.5.1939]. Uncertain whether he put the original in the lid of the *Boîte-en-Valise* [7.1.1941] (which he completed for the Arensbergs in April 1943) or "a *coloriage* by hand of the reproduction in black and white to show the stencil man how to put the colours on the 300 reproductions", Marcel suggests that Helen ask Man Ray to look at it, "to see if the support (black-and-white) is hand-painted or a reproduction."

1962. Tuesday, Milan
At an old Lombard inn, "El ronchett di ran", situated by one of the canals, the Duchamps have lunch with Arturo Schwarz and a group of painters: Enrico Baj, Rodriguez [16.8.1962], Roberto Crippa and Dangelo. It is warm enough to eat outside on the terrace, where the trellis is still covered with flowering plants. During the meal another artist suddenly arrives and presents himself, telling Duchamp that he has come especially to meet him: it is Gianfranco Baruchello from Rome. When he learned from Rodriguez by telephone that Duchamp was in Milan, Baruchello went straight to Rome airport and boarded an aeroplane.

1963. Wednesday, Cadaqués
A telegram to Marcel from Louis Carré on behalf of his sisters and cousin, Dr Robert Jullien [9.6.1963], announces that the funeral of his sister Suzanne, who died at 5 Rue Parmentier earlier in the day from a brain tumour after a short illness, will take place on 15 September.

On the fifth and sixth floors at 5 Rue Parmentier is an apartment and a studio which the Crottis purchased over forty years ago. Suzanne bequeaths the apartment to her sisters Yvonne and Magdeleine, and the studio to Marcel.

As well as many early drawings and some of his sketchbooks, Suzanne also owned certain paintings by Marcel at her death: *Jeune Homme et Jeune Fille dans le Printemps* [24.8.1911] and *Nu Rouge*, a seated nude painted in 1910.

12 September

1915. Sunday, New York City
In the Special Feature section of the *New York Tribune*, Duchamp's comments on Women, Cubism and Official Art are published with a photograph of the artist relaxing in a deck chair. Like other recent press articles [1.9.1915], Duchamp is introduced as the author of the "greatest sensation of all": his "Nude descending the Staircase" [18.3.1912]. On meeting the young French painter a few days previously, the journalist is surprised: "Instead of proving to be a very queer individual, he turned out to be retiring and much more given to listening to the views of those about him than speaking of his own... He is keenly interested in all New York, from the latest musical comedy to Coney Island [24.7.1915]." Duchamp is described as "only twenty-eight, dresses most correctly in the mode, and is quite handsome – one would take him for a well-groomed Englishman [rather] than a Frenchman..."

"The American woman," Duchamp has discovered, "is the most intelligent in the world today – the only one that always knows what she wants, and therefore always gets it... and this wonderful intelligence which makes the society of her equally brilliant sisters of sufficient interest to her without necessarily insist-

ing on the male element protruding in her life, is helping the tendency of the world today to completely equalize the sexes, and the constant battle between them in which we have wasted our best energies in the past will cease..."

Knowing of no other city where he would rather spend the next two years, Duchamp compares New York with cities in Europe: "The capitals of the Old World have laboured for hundreds of years to find that which constitutes good taste and one may say that they have found the zenith thereof. But why do people not understand how much of a bore this is?

"If only America would realize that the art of Europe is finished – dead – and that America is the country of the art of the future, instead of trying to base everything she does on European traditions! ... Look at the skyscrapers: has Europe anything to show more beautiful than these? I have been trying to get a studio in one of their highest turrets, but unfortunately I find people are not permitted to live in them."

"Why this adoration for classic art? It is as old-fashioned as the superstitions of the religions... And this fetish of 'ideals'! There is no such thing. Every single factor of life should have its own individual merit.

"Why do Americans make a God of Rodin? This 'official' art is antediluvian – why always go backward instead of forward?"

As he has discovered that people don't know anything about Futurism, when he is asked what his pictures represent Duchamp says: "It is a little difficult to explain to them that they do not represent concrete material things, but abstract movement."

He declares that, "Cubism could almost be called a prophet of the war, as Rousseau was of the French Revolution, for the war will produce a severe, direct art," Duchamp believes. "One readily understands this when one realizes the growing hardness of feeling in Europe, one might almost say the utter callousness with which people are learning to receive the news of the death of those nearest and dearest to them. Before the war the death of a son in a family was received with utter, abject woe, but today it is merely part of a huge universal grief, which hardly seems to concern any one individual."

Asked to comment on Duchamp's statement, the American painter Mr Kenyon Cox believes that as a result of the war "the people of the

13.9.1920

13.9.1926

European countries will have suffered so much that they will have no use for fads in life… M. Duchamp is right in saying that the future art is a severe one, but it will be the severity of Classicism not Cubism," and that if America is the country of art of the future it is because "its art is more classic than any other art today".

1918. Thursday, Montevideo
The day that the German defences collapse on the Western Front, the SS *Crofton Hall* calls at the capital of Uruguay on the northern shores of the River Plate before sailing upstream towards Buenos Aires.

1927. Monday, Chamonix
During the magnificent gala evening held at the Grand Casino du Mont-Blanc, with dancing to a jazz band until dawn, the results of the tournament are announced. André Chéron of Colombes-sur-Seine retains his title as French champion. Duchamp is placed seventh: out of eight games he has won two and drawn two. However he drew his game against the champion: this, and the game lost to Polikier (runner-up in the tournament) are published later in *L'Echiquier*.

In a gesture much appreciated by the pipe-smokers, the pipe manufacturers of Saint-Claude, Prostet et Sevenier, offer a selection of their best quality pipes to the competitors.

1947. Friday, New York City
After taking one Leon Carroll watercolour from a set of 20 to the Plaza Art Gallery, 9 East 59th Street, where he is told they might fetch approximately $20 each at auction, Dee writes to Miss Dreier: "If you decide to have them sold at auction will you write to them to take the remaining ones (at Of's) and to sell them in different sales…"

1950. Tuesday, New York City
"Yes, I discussed the question of lowering the windows," Marcel tells Lou and Walter Arensberg, who are concerned about the light in two of the rooms under consideration for their collection at the Philadelphia Museum of Art. Knowing that it would be "a very big and costly job", Marcel writes: "My final opinion about it is that you ought not to insist now until you have seen the effect with your own eyes." As an afterthought, Marcel suggests that as the ceilings in the two rooms in question are 19 feet high, it would not be so costly to raise the floor

to within 3 or 4 feet of the windows and provide steps down to the other rooms.

1962. Wednesday, Milan
Having decided to stay on in Milan (after his spur-of-the-moment flight from Rome the previous day), Baruchello invites the Duchamps with Enrico Baj and Arturo Schwarz to lunch at the famous Grand Hotel Villa d'Este at Cernobbio on Lake Como. At a nearby table in the midst of her guests is a bride dressed in white.

So that there is a memento of the occasion, on postcards of the restaurant a diagram of the table is drawn and each person signs at their approximate place; one is given to Baruchello and the other to Baj, which he posts to himself.

1965. Sunday, Cadaqués
Writes to Kay Boyle at the MacDowell Colony, Peterboro, New Hampshire, saying that they "would have loved to see the Colony again" where they stayed "some years ago" [16.7.1956]. Marcel confirms that the Valise belonging to Kay [31.3.1959] was bought by Mrs Sisler, who has a large collection of his work [13.1.1965] "and does not intend to sell anything…"

*

Duchamp informs Louis Carré in Paris that he plans to leave Cadaqués on 17 September and will be arriving in Paris three days later.

13 September

1917. Thursday, New York City
A last evening with their friends, including Marcel and Roché, before Gaby and Francis Picabia go their separate ways: Gaby sails on Sunday for France to join her children and Francis leaves for Spain the following Thursday.

1920. Monday, New York City
An exhibition of 16 paintings by Louis M. Eilshemius [9.4.1917] opens at the gallery of the Société Anonyme, 19 East 47th Street [30.4.1920].

1926. Monday, Monaco
Duchamp has managed to negotiate [21.3.1926] and retrieve his canvas *La Partie d'Echecs* [1.10.1910], from the John Quinn Estate

[28.7.1924]. Duchamp writes to its new owner, Dr Tovell of Brussels, from the Hôtel de Nice giving him some of the history of the picture: it was exhibited at the Salon d'Automne the year he became "*sociétaire*" and, before he sent it to the Carroll Galleries, where Quinn purchased it [5.4.1915], it was reproduced in *Les Peintres Cubistes* [17.3.1913]. "The painting is packed now," confirms Duchamp, "and I will have it shipped as soon as I get back to Paris (Oct 1st) to your office address."

*

Marcel has received Paul Morand's preface to the catalogue [18.8.1926] for Brancusi's exhibition: "I am having it translated and will send it to you," he promises the sculptor, who is at the Brevoort in New York [31.8.1926].

To prevent the 27 pieces by Brancusi belonging to Quinn being auctioned with the rest of the collection, Marcel has agreed with Roché [8.8.1926] and Mrs Rumsey to purchase all of them from the estate for the sum of $8,500: a $4,500 cash down payment with the remainder due within six months. To complete the down payment to Joseph Brummer (who is acting for the Quinn Estate), Marcel instructs Brancusi: "If you see Mrs Rumsey ask her to deposit 1,500 dollars at my bank 530 Fifth Avenue…"

1927. Tuesday, Chamonix
At ten o'clock in the morning, the annual congress of the Fédération Française des Echecs commences and M. R. Gaudin, vice-president of the Fédération, presides.

Meanwhile from Mens, south of Grenoble where she has spent a day with her friend Zette to break the long drive from Cannes, Marcel's young wife takes the wheel again of the Citroën, *cul pointu*, and negotiates alone the difficult and increasingly mountainous roads into the Alps. Although the descent to Grenoble is "worse than that of the Grande Chartreuse", and the foot brake of the vehicle is giving insufficient response, Lydie pilots her car safely to Chambéry and Albertville. The advice she receives – which is to take the most direct route through the Gorges de l'Arly – turns out to be unreliable because the road is virtually impassable.

Undaunted and encouraged no doubt by the thought of being reunited with Marcel, Lydie eventually completes the journey of more than 200 kilometres via Megève and Saint-Gervais to the alpine resort dominated by Mont Blanc.

14.9.1914

14.9.1959

To her dismay she finds Marcel very disheartened. He is thin and exhausted not only by the tournament but also wearied physically by the very cold weather at the high altitude.

1950. Wednesday, New York City
On the eve of his departure to Paris, Marcel replies belatedly to Helen Freeman who has sent him "Aroma", which he finds is "a real conclusion" and "helps the general understanding of the previous notes [20.12.1949]". He has no objection to her reading the text to others, knowing that she will be selective in her listeners.

"And if you want to publish it," he advises, "you must not cut it, or try to make it more 'legible' for the average mind. You are not trying to convince anyone and those who will read it, will have no right to criticize it – it is essentially a poem."

1951. Thursday, New York City
At ten-thirty (in the evening?) Duchamp meets Monique Fong.

1956. Thursday, New York City
As the awaited introduction to the catalogue of the "Three Brothers" has not yet arrived [26.8.1956], Marcel, Lee Malone, the director of the Museum of Fine Arts, Houston decide to cable James Johnson Sweeney who, after a holiday in Ireland, has gone to Yugoslavia. They send a telegram to the Hotel Excelsior in Dubrovnik: "Where is our introduction please mail it directly Staempfli Hallerstrasse Bern stop Lee here with me send greetings Marcel."

1962. Thursday, Milan
Early in the afternoon, Enrico Baj and Arturo Schwarz accompany the Duchamps to the central station where they are to take the ten minutes to three train leaving for Paris from platform 10. As a souvenir Baj, their host in Milan [10.9.1962], addresses himself a postcard of the Piazza Duomo and everyone signs it.

14 September

1913. Sunday, Yport
After his visit to England with Yvonne [8.8.1913], Marcel has spent ten days with his family at Yport and, during this time, has made a watercolour of the house belonging to Madame Haas, known as "the princess".

The same day that Marcel is due to return to Paris, the *Psyché*, a ship with a cargo of wine which had run aground a week ago in a severe storm, is refloated.

1914. Monday, Paris
The day General Helmuth von Moltke is sacked for the German defeat in the battle of the Marne, an agent for the Société du Gaz de Paris leaves a notice at 23 Rue Saint-Hippolyte demanding payment from Duchamp of 7 francs 60 centimes.

1924. Sunday, Paris
"Back since Sunday with a pitiful result," writes Duchamp to Jacques Doucet referring to his performance in the French Chess Championship at Strasbourg [7.9.1924].

Concerning the optical machine, Duchamp says: "I have tried spurring on our mechanic. I have almost (!) finished fitting the striped globe onto the first plate. He is busy (!) with the motor. He has had a triangle made in wood to make the whole thing more stable. In short I am sure of succeeding. It requires your patience and mine... As soon as I have got something presentable," promises Duchamp, "I will ask you to come to Man Ray's..."

*

Forgetting in his first note to mention his quest for black velvet, Duchamp writes again to Doucet: "I would like to glue velvet as a backcloth onto the metal plate which holds the spiral. An English velvet, a silk velvet?? A velvet which resembles the absolutely mat backcloths that one sees in film studios. 70 cms wide by the same length. Maybe you could help me to find this?"

1926. Tuesday, Monaco
After cabling to Brancusi in New York the message: "Cable poste restante Monaco if Rumsey refuses to deposit fifteen hundred Duchamp," Marcel receives by return a reassuring reply: "Fifteen hundred have been deposited Brancusi."

1927. Wednesday, Chamonix
When the Duchamps arrive at Flumet on their way back to Paris, they find that the Gorges de l'Arly, which Lydie negotiated with difficulty the previous day, is now closed. There is no alternative but to cross the difficult Col des Aravis to reach Annecy, their destination for lunch.

The road by Ponts de la Caille and Saint-Julien is in such bad repair that during the afternoon four of the car's leaf springs break. It is six in the evening when they set off again, and the last kilometres of the sinuous road to Bellegarde are lit by the headlights of the car.

*

In Nice, Isadora Duncan dies tragically when one of her long scarves is caught in the wheel of the automobile in which she is riding.

1933. Thursday, Cadaqués
In the morning, after a month in the Casa Lopez [13.8.1933], Mary Reynolds and Marcel leave to spend two weeks in Barcelona.

1943. Tuesday, New York City
Describing the temporary home of the Large Glass which Miss Dreier has not yet seen [10.9.1943], Dee explains: "It is not a very large room but there are vistas front and back of the glass. The artificial light thrown from the ceiling is not too strong."

In addition to the pound of coffee he sent the day before, Dee sends "ten pounds of sugar" to Miss Dreier at 100 West 55th Street: "I thought it was simpler to send you the tickets," he adds, sticking them to the top of his letter. "How do you like your new quarters?" he enquires.

1948. Tuesday, New York City
Awaiting his return to the city in the morning [from Endicott after the close of the New York State Chess Championship which was won by Larry Evans?], Duchamp finds letters from Katharine Kuh requesting a meeting with him on 30 September. "Yes Thursday morning Sept. 30th suits me perfectly," replies Duchamp, "around 11 a.m. wherever you say."

1950. Thursday, New York City
Making the voyage at the invitation of Brookes Hubachek [10.9.1950], Marcel boards the *Queen Mary*, which is due to sail at eleven o'clock in the morning.

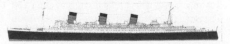

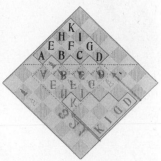

15.9.1932

1957. Sunday, New York City ·
After a long delay in getting the material released from the French customs [7.4.1956], Iliazd is still assembling 30 copies of the *Boîte-en-Valise* [7.1.1941]: "As soon as these 30 boxes are delivered to Lefebvre-Foinet," Duchamp confirms, "you will receive from him the 100,000 francs [10,000 francs at present values], which terminates our contract."

1958. Sunday, Madrid
"How are your troubles? Have you been able to find a relief permitting you to think of other things?" Marcel asks Roché. Announcing his return to Paris and promising to telephone him, Marcel also mentions that he saw their mutual friend the sculptor Etienne Martin this summer in Cadaqués.

1959. Monday, Paris
Leaving Max Ernst's house in Paris where, in the studio over the summer months René Bouché's painting *The Great Obsession* has been burgeoning with the portraits of seven painters (Bill Copley, Dorothea Tanning, Matta, Max Ernst, Marcel Duchamp, Jean Arp and Victor Brauner), the Duchamps travel to London.

*

To mark the publication of Robert Lebel's monograph [6.4.1959] "a little exhibition in honour of Marcel Duchamp in the I.C.A. library" and members' room has been organized by Richard Hamilton at the club's small headquarters in Dover Street, London.

1963. Saturday, Neuilly-sur-Seine
The Duchamps have returned from Cadaqués to attend the funeral of Marcel's sister, Suzanne, who died on 11 September. After the service at the Eglise Saint-Pierre in the morning, as chief mourner Marcel attends the burial at the Cimetière Monumental, Rouen [12.6.1963].

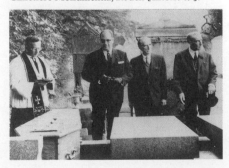

15 September

1919. Monday, Paris
At three-thirty in the morning Marcel is in the apartment at 32 Rue Charles Floquet [9.8.1919] when, attended by the midwife Mlle Gorrel, Gaby gives birth to Picabia's fourth child, a son Vicente. As no one has thought to provide a cradle, the baby is placed in a small valise. From the Rue Emile-Augier, Francis brings Germaine Everling, who is expecting his child in January, to see the baby and it is they, together, who declare the birth at the *mairie* of the *7ème arrondissement*.

1924. Monday, Rouen
Lucie and Eugène Duchamp's golden wedding anniversary is celebrated by the whole family at their home. "The lunch was very merry," affirms Marcel's young cousin Meran, attending with his father Etienne Mellerio of Paris.

Meran recalls that there were two amusing episodes. A frothing white dessert was served and after tasting it, "Villon leaned towards his mother and said: 'It's good, mother, your shampoo!' which made everyone laugh."

"But the last straw," according to Meran, who wore magnificent side whiskers at that time, "was when Crotti with his usual dry, sarcastic air started to talk about the hair that many men have on their bodies.

'Me', said Crotti, 'I have a great bush of hair, quite isolated. Like this', he described with his hands. 'It pleases Suzanne enormously, doesn't it?' he added addressing his wife earnestly. 'You know my bush... (repeating his gestures), you adore that! I'm also telling Mellerio about it.'"

Suzanne was very embarrassed and didn't know how to stop her husband who, naturally, pressed on regardless.

The niece of Clémence (the elderly, lifelong servant of the Duchamps) and her friend, who were serving, couldn't stop giggling, and at the story of Crotti's hair they had to leave the room for fear of dropping the dishes.

1927. Thursday, Bellegarde
To leave the mountains behind them Lydie and

Marcel have another difficult pass to cross in the Jura, "worse than les Aravis" which Lydie negotiated the day before. This costs them another leaf spring before they reach the fertile plains of Bourg-en-Bresse, where they have lunch. In the evening, north of Beaune in Burgundy, the couple stop for the night in Saulieu.

1930. Monday, Nice
After six weeks' holiday "enjoying chess and sun", Marcel leaves for Paris, where he expects "to get all the pictures ready to be shipped by the 1st October" for the 61st exhibition of the Société Anonyme [7.9.1930].

1932. Thursday, Florence
In *L'Italia Scacchistica*, an unsigned article attacks *L'Opposition et les cases conjuguées sont réconciliées* by Vitaly Halberstadt and Marcel Duchamp, recently published by Editions de L'Echiquier, Brussels [20.5.1931], for being nothing but a plagiarism of Rinaldo Bianchetti's book: *Contributo alla teoria dei finali di soli pedoni*, Florence, 1925.

In fact Duchamp and Halberstadt state very clearly all their sources in what they describe as their attempt to "elucidate a question which, for twenty years, has periodically given rise to bitter articles in chess literature". Designed by Duchamp, from cover to cover [8.9.1931], on each double page spread the text in German, English and French runs concurrently in three separate columns with a fourth for the chessboard diagrams. Duchamp has devised diagrams in red and black on transparent paper, printed on both sides, using the principle of superimposition by folding along a dotted line. In a final set of diagrams, the authors "show the consistency of the method of transfer" which has enabled them to make their classification.

1937. Wednesday, Paris
"Evidently it would be better for Shawn [16.6.1936] to have a regular European tour organized by an impresario," Dee advises Miss Dreier in a "hasty letter" which he hopes will catch the *Queen Mary*. Rolf de Maré, whom Miss Dreier will see in New York and "is surely the man to get good information from", has given Dee the address of Mr A. Meckel, who "managed Argentina and other first class dancers". However, "Vaudeville houses like the Casino de Paris or the Ambassadeurs," Dee admits, "would bring him in much closer con-

15.9.1937

16.9.1932

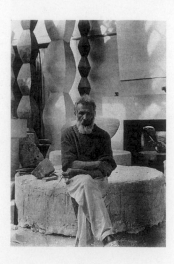

tact with the French public… and would not lower his standing as an artist – especially nowadays, when the 'ballet' has been a little overdone as a private performance."

Regarding the project of a museum [24.8.1937] and a building for it, Dee declines to discuss it for the moment even with Kiesler, "one of the few with whom one could talk," he adds.

1942. Tuesday, Lyons
Although she was due to go to New York in June [27.5.1942], Mary Reynolds, who has been working for the French resistance, only manages to reach Lyons from Paris today, and she does not have an exit visa yet.

1950. Friday, at sea
Aboard the *Queen Mary*, Marcel receives a radio message from Roché offering him the loan of Arago while he is in Paris [10.9.1950].

1951. Saturday, New York City
On receiving another call for help from the Arensbergs regarding the tax demand from the state of California [8.9.1951], Marcel replies: "Your search for the origins of the purchases becomes a regular *casse-tête chinois*. I feel terribly sorry to see you racking your brains and probably losing sleep about it." For information about their purchases from the Modern Gallery, Marcel suggests they contact Miss Ione Ulrich at the Museum of Modern Art. "The Matisses," have been in Europe since July – and are probably not back. If in a hurry, tell me and I will make sure or, tell them to answer your letter."

1957. Sunday, New York City
Promising to send Fawcus a photograph of his portrait by Bill Copley [15.12.1953] for the book soon, Marcel tells Robert Lebel: "My photo-colourings [4.6.1957] are genuinely advancing."

1958. Monday, Madrid
After a round trip in a bus from Madrid: Granada, Córdoba, Seville "at speed", Marcel writes a postcard to Brookes Hubachek telling him he is "so glad the box finally arrived…"

1963. Sunday, Paris
After attending Suzanne's funeral the previous day, Marcel and Teeny fly from Orly to Barcelona on their way back to Cadaqués.

16 September

1917. Sunday, New York City
In the morning Duchamp goes motoring with the Picabias, Roché, and the Baronne del Garcia, but not without a breakdown before lunch.

After an amusing day, they all have an Italian meal together before accompanying Gaby Picabia to the *Espagne*, the ship which is taking her back to France.

1927. Friday, Saulieu
On the last stage of the Duchamps' journey from Chamonix to Paris, the sparking plugs of the Citroën give trouble all day. They drive as far as Auxerre before lunch and eventually reach Paris at seven-thirty in the evening.

If it was cold in Chamonix, the top-floor studio at Rue Larrey is icy, and coal for the stove cannot be delivered until Monday. Worn out from driving, miserable and bewildered, Lydie immediately telephones the house at Avenue du Bois but learns that her mother, after taking a cure at Vichy, has gone to Etretat.

1932. Friday, Paris
Proposing to arrange another Brancusi exhibition [17.11.1926] in December at his gallery in New York, Joseph Brummer has arranged to meet Duchamp at Brancusi's studio today.

1958. Tuesday, Paris
Teeny and Marcel return from Madrid to the Ernsts' apartment at 58 Rue Mathurin-Régnier, which has been lent to them until they fly back to New York on 2 October.

1961. Saturday, Paris
According to the latest letter from Stauffer, Giovanni Blumer [9.9.1961] will not now be in Paris until 26 September which is the day Duchamp leaves for London. Duchamp writes advising Stauffer that he has left instructions with the Monniers to give Blumer the 2 Valises when he calls and that, in advance, he has signed a receipt of payment.

1965. Thursday, Cadaqués
"We are certainly looking forward to meeting you and to our visit in Hanover where I saw Schwitters in the years 1920 [9.5.1929]," writes Duchamp to Dr Schmied, who has just opened the exhibition at the Kestner-Gesellschaft [7.9.1965]. Duchamp confirms his arrival on 28 September and agrees to make a short interview for the television.

17 September

1927. Saturday, Paris
Knowing that the temporary arrangement of living at Rue Larrey with Marcel cannot be prolonged, in the warmth of the Brasserie du Labyrinthe, 64 Rue Monge, Lydie writes a long letter to her mother in Etretat. Since 15 July rent has been paid on the apartment at 34 Rue Boussaingault which, unlike the very spare accommodation at Rue Larrey, has a proper bathroom and is centrally heated. Unsettled by "the makeshift, much too tiring way of life" since her marriage [8.6.1927], Lydie tells her mother: "You must understand how impatient I am to be in my own place."

However, Lydie does not want to move her belongings from the Avenue du Bois until her mother's return, because, she explains, "I would consider that as tactless, an indiscretion and almost a violation of the home that Marcel would not allow me to do either…"

1935. Tuesday, Paris
As no cable has arrived from Miss Dreier following his proposal on 6 September to lend Brancusi's *Colonne sans fin*, Dee cables her at the Colony Club, New York: "Yes thanks."

1949. Saturday, Milford
While Dee is visiting her, Miss Dreier discusses alternative ways of preserving Hans Richter's *Preludium*, a fragile paper scroll dating from 1919. Recently donated to the Société Anonyme by Richter himself, the scroll is an experiment in giving visual structure to sound using Bach's *Well-Tempered Clavier* in part as inspiration.

1951. Monday, New York City
At the Sidney Janis Gallery, 15 East 57th Street, an exhibition opens entitled "Brancusi to Duchamp". Henri Pierre Roché has lent two

17.9.1949

pictures by Duchamp for the show: *Femme nue assise dans un tub* and *Portrait de Chauvel* [2.12.1949], both of which belonged to the group of early paintings found by Jacques Villon at Puteaux [14.11.1949].

1954. Friday, New York City
"For the moment, I am getting better and better," writes Marcel to Jean and Suzanne Crotti, "I have regained more than my normal weight... we will soon be able to compare our two cases [24.6.1954] viva voce because we hope to leave at the beginning of November, and spend two months in Paris."

1963. Tuesday, Cadaqués
Receives a letter from Elizabeth Humes in Rome and a copy of the one she has sent to Brookes Hubachek regarding the shipment to Chicago of art objects, pictures and books bequeathed to her by Mary Reynolds [30.9.1950].

After asking Baruchello to check with the Italian transport company about the packing [27.7.1963], Marcel tells Hubachek: "Everything seems to me perfectly organized! Air freight is certainly the safest mode of transport for the shipment of paintings. Also very important is the direct trip Rome–Chicago. And no duty for works of art..."

1964. Thursday, Paris
The Duchamps board the night train for Milan.

1965. Friday, Cadaqués
After another summer in Cadaqués, the Duchamps leave for Paris where they are due to arrive on Monday.

18 September

1906. Tuesday, Eu
Towards the end of their twelve months with the 39ème Régiment d'Infanterie (with some leave in August when Duchamp went briefly to Saint-Pair (12.8.1906]), the captain in charge of those exempted from further service on account of their profession [16.2.1905] has questioned each soldier about his activity in civilian life. Replying that he is a copperplate

printer, Duchamp realized from the officer's silence, that "the corps of French officers could not have a worker earning seven francs a day in its ranks," and he was not dissuaded from returning to civilian life.

Liberated with a certificate of good conduct, Duchamp is held on reserve by the army.

1915. Saturday, Boston
In the wake of a number of press articles [12.9.1915], the *Boston Evening Transcript* publishes a portrait of Duchamp by Alfred Kreymborg, who is the editor of *Others*, a literary magazine recently founded with financial backing by Walter Arensberg. Like his colleagues, Kreymborg identifies Duchamp as the man who "provided the high-water sensation" of the Armory Show [17.2.1913], when "men and women who could not distinguish between a Rodin and a canary bird's cage passed passionate judgment against such 'quackery', 'self-advertising', 'new-commercialism'," and "the artist and the art critic glared and blared".

"A month ago [15.6.1915]," writes Kreymborg, "a tall, slender, athletic-looking individual of twenty-eight arrived in New York. Word soon flew round that Marcel Duchamp was here... New York gasped. Here was a new sensation. Let us ferret him out, parade him, paint the town with him. But he was not to be found. He had domiciled himself with a friend, a scholarly gentleman who knows New York and the way of New York. Only a sacred few were allowed to meet the 'weird specimen' of 'outrageous Cubism'. Even they expected to meet a wild-eyed, yellow-haired, madly clothed Lothario old in years and the sour wisdom of life, instead, they encountered a young, decidedly boyish human with the quietest air and the most genial simplicity in the world. Mother Nature is still the supreme joke-smith. And New York, as ever, the supreme metal for her anvil.

"He talks in a low, gentle, humorous voice, tinged at unconscious intervals by a serious undertone of quiet enthusiasm. Words are few with him, phrases concise, and they are delivered slowly, even when he uses his mother tongue. He is proud in a gleeful way of his English, of which he can deliver a perfect sentence on rare happily inspired occasions reached with sorely dramatic effort and put forth with arduous emphasis. His blunders are

laughable, but he laughs long before you do, as a matter of fact, you laugh at his amusement, not at him. And he loves to laugh, with a wicked chuckle, especially over a solemn, long drawn-out game of chess, of which he is so fond that he will sit up through the night until the breakfast time arrives. Then he goes to bed, nonchalantly: breakfast can wait, just as every other factor has to wait – in his life... He loves athletics, even to the extent of our American street games! He was taught some of these games during the first week of his arrival: he went at them like a boy of seven and soon out-distanced some of the most dyed-in-the-wool natives. This after a French dinner at the Villa Richard, an old-fashioned inn overlooking the Hudson. In a moment of confidence, he said: 'To play – that is best.'

"But there is a deep seriousness somewhere in the dark. The make of his head, the cut of his face betray him. His eyes are wonderfully intelligent; his nose is sharp, aristocratic challenge; his chin is 'determined', his mouth, exquisitely sensitive... But his tongue leads or tries to lead you astray. Banter is its principal weapon. No discussion, however serious or illuminating, is worthwhile if there is fun in the wind. He has found his New York haunts: one or two out-of-the-way French restaurants, one or two vaudeville houses, one or two groups of people. He loves ragtime and plays it with a distinctly French accent. The very best in music, the very best in painting and literature, is all that can hold him intellectually, but in life, anything will amuse, excite, wring a responsive joy from him, he smokes vile tobacco with the abandon of a connoisseur, he will drink 'red ink' wine with the relish of Bacchus himself; he will seek any one's company if that individual does not indulge in lofty conversation. He loves Americans. 'They are children, like the French. They play with everything, baseball, business, invention, art, architecture.' American architecture is 'the only architecture' of the day. He regrets passionately the influence of European culture. Those who have been abroad, those 'higher up', bring back pernicious influences. The American must, can, will, find himself at home."

"His taste in the arts is, as has been intimated, severely pure. 'Pure' is his favourite monosyllable. He enjoys Wagner and Richard Strauss, but they do not exist in his deeper life; Bach,

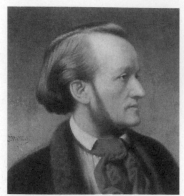

18.9.1915

19.9.1918

Beethoven and the latest European god, Stravinsky, do. He can illustrate on the piano with one stiff dramatic finger the themes of *Le Sacre du Printemps*, which that *enfant terrible* of the ballet, Nijinsky, is to bring to America this fall. This ballet is the only work that interests him in the whole modern theatre repertory [29.5.1913]… Stravinsky stands higher in his belief than does his favourite painter, Seurat, the forerunner of Cézanne. Duchamp confesses his primal indebtedness to Cézanne but acknowledges a greater love for Seurat…

"Duchamp expressed the reason of his preference for Seurat: 'I like Seurat better because he saw deeper and more prophetically into concrete objects and their nature than did Cézanne. Cézanne, as it were, tastes the fruit which Seurat slashes open with precision.' Stravinsky passed 'beyond Seurat', because of the happy accident of living in a later, more enlightened age. The great Russian is influenced by 'Cubism so-called', but he is not 'Cubism'. Duchamp scorns the word; it is merely a convenience for designating a certain group of artists in point of time as opposed to other groups. He hates the word; it is a discordant note in any conversation with him. A man is a man; an artist is an artist; if you can catalogue him under an ism he is no longer man or artist…"

"As to himself, Duchamp will say little or nothing. It is not mock modesty or hypocrisy, or hyper-sensitiveness, or any pose of the dilettante. He simply does not enjoy talking about his own work. 'I am interested in what there is to do, not in what I have done.' The nude is therefore taboo. And all other work of the past…

"There are only half a dozen examples of Duchamp's work in New York. Three of them are on glass. They are amazing studies, and their execution the slow, patient labour of a profoundly simple, fundamentally serious nature… Some master once remarked: 'You need four ears for a Bach fugue.' You certainly need many eyes for Duchamp. But inside your ears and behind your eyes, a simple logical something must be in evidence, call it what you will. For here is harmony, a harmony of inspiration, will and execution that demand on your part, if you hope to understand it to the full, an equal harmony of elements. After all, criticism is the other half of the creative faculty: you have to re-create yourself in the image of the thing looked at or listened to…"

1928. Tuesday, Nice
Feeling a great deal better physically after spending a few weeks on the Côte d'Azur [10.8.1928], Duchamp travels to Marseilles, where he is a competitor in the French Chess Championship. The tournament is to be held at the Palais Indochinois of the Institut Colonial.

1947. Thursday, New York City
Awaiting the return of Kiesler from Paris with photographs of the Surrealist exhibition [7.7.1947], Marcel writes to Elisa and André Breton to confirm that he received a copy of the catalogue about a fortnight ago. Again Marcel asks Breton to consider making an "album-souvenir" [18.7.1947] with photographs of the installation and texts from the catalogue, arguing that it would not be expensive to produce.

1955. Sunday, New York City
After being shown a collection of drawings by the late Henry Toledano, Duchamp writes to Carl Zigrosser at the Philadelphia Museum of Art asking if he would "accept to see the drawings" and give his opinion, as the artist's brother would like to dispose of them.

1964. Friday, Milan
At eight-twenty in the morning the Duchamps are due to arrive on the night train from Paris.

1967. Monday, Neuilly-sur-Seine
Teeny and Marcel are due back at 5 Rue Parmentier after a leisurely journey from Cadaqués in the Volkswagen.

1968. Wednesday, Cadaqués
After postponing their return to Paris a few days [9.9.1968], Marcel is now feeling well enough to travel back to Paris by train.

19 September

1918. Thursday, Buenos Aires
Faring better than the *Lyncée*, which was wrecked off the coast of Ejur *en route* to Buenos Aires [10.6.1912], the SS *Crofton Hall* reaches its destination safely with Yvonne Chastel and Marcel aboard after the long voyage from New York [14.8.1918]. Marcel knows no one in the Argentine capital, "except the parents of a Parisian friend, very nice people," who run a brothel.

1922. Tuesday, Chicago
In the exhibition of the "Arthur Jerome Eddy Collection" at the Art Institute of Chicago, there are two works by Duchamp, both purchased by Eddy from the famous Armory Show [17.2.1913]: *Portrait de Joueurs d'Echecs* [15.6.1912] and *Le Roi et la Reine entourés de Nus vites* [9.10.1912].

1934. Wednesday, Bois de la Chaise
From the island of Noirmoutier [11.9.1934], Duchamp chooses a card of the pier near the hotel to send to Dumouchel in Paris with the message: "Didn't have a minute to ascend to your 7th before my departure. Here until Friday. No need to tell you that I am enjoying superb weather."

1943. Sunday, New York City
"What a surprise to hear from you," writes Marcel to Yvonne, his companion in Buenos Aires [19.9.1918], who has since married and lives in London [16.7.1927]. He has arranged to have lunch today with her son, Peter Lyon, who is in New York for two or three days from Boston.

"I have been here a year and a half," Marcel explains, "Just getting by here – little enthusiasm for painting at the moment as you can well imagine." As for the family, "everyone is well." The last time he saw the Villons and Magdeleine was when he left Paris [23.6.1941]; the Crottis moved to the south of France and, while waiting a year for his visa [21.3.1942], Marcel was in Sanary, where his sister Yvonne lives.

Promising to send her copies of *VVV* [13.3.1943], Marcel asks Yvonne to give greetings to the Penroses, Mesens, Ernestine [?], and Gaby Picabia, who narrowly escaped the Gestapo and is now in London with her daughter Jeannine.

1950. Tuesday, Paris
After disembarking from the *Queen Mary*, Marcel travels on the boat train to Paris. Awaiting him at the Hôtel Terminus Gare Saint-Lazare, where he spends the night, is a letter from Roché in Corrèze renewing the offer of his apartment at 99 Boulevard Arago [15.9.1950].

19.9.1964

21.9.1917

1952. Friday, New York City
Receives a letter from Walter Arensberg, who
is recovering from his third sinus operation.

*

Is invited to have lunch today with Alfred Barr.

1963. Thursday, Cadaqués
Only a few days after their return [15.9.1963],
Teeny and Marcel leave for Paris where they
plan to spend the rest of the month with the
Monniers at 108 Rue du Bac.

1964. Saturday, Bergamo
Following the projection of some 60 films on
and about art from 21 countries in the ancient
Romanesque church of Sant'Agostino, now a
cinema, the jury and critics are unanimous in
awarding the Gran Premio Bergamo to Jean-
Marie Drot's film *Jeu d'Echecs avec Marcel
Duchamp* produced by the Radio-Télévision
Française.
"For fifty minutes," reports M. Brumagne of
the *Tribune de Lausanne*, "the camera makes
coherent jumps in space, captures Duchamp
from all angles, discovers his *œuvre* chronologi-
cally and succeeds in a striking summary by siz-
ing up the artist, the humanist and man who
said: 'There are no solutions because there are
no problems.'"
At the presentation ceremony, Jean-Marie
Drot persuades Duchamp to accompany him
to the platform, where they are congratulated
by Minister Scaglia and the mayor of Bergamo,
Sig. Simoncini, which results in an amusing
confusion of identity between the film director
and the artist.

1968. Thursday, Neuilly-sur-Seine
Receives a telephone call from Arturo Schwarz
concerning an exhibition project "El Espiritu
Dada 1915–1925" in Caracas.

20 September

1917. Thursday, New York City
The day that Francis Picabia sails back to
Spain [4.4.1917], Walter Arensberg, Duchamp
and Henri Pierre Roché have dinner together
at the Petite Bretonne restaurant at 55th and
Eighth.

1947. Saturday, New York City
On the eve of her husband's return from
Europe [27.5.1947], at ten-thirty in the evening
Marcel calls to see Stefi Kiesler at 56 Seventh
Avenue.

1951. Thursday, New York City
"Agreed for 1952 in N.Y. to meet the mahara-
jas," Marcel tells Roché apropos of the Bran-
cusi sculptures at Indore; "saw Liberfield three
months ago at Carré's who wanted also to or-
ganize something of this kind."
Concerning the sculptor's absence at the
Biennale of São Paulo, can Roché ask Jean Cas-
sou why? Did Brancusi refuse or was he not
invited?
So that he can varnish the two pictures cur-
rently on show at the Sidney Janis Gallery
[17.9.1951], Marcel asks for "two small bottles
of crystal mastic varnish" which, he suggests,
Michel Sanouillet [8.7.1951] could bring him
from Paris.

1952. Saturday, New York City
In the morning Marcel receives a letter from
Beatrice Wood saying that although Walter
Arensberg still has pains after his operation, his
colour has returned.

*

"Your letter yesterday was a great relief,"
writes Marcel to Lou and Walter, "not so
much by the 'long details' but the fact that you
are feeling better..." For the work he has
agreed to undertake on *Le Paradis*, the picture
painted on the back of the canvas *Le Roi et la
Reine entourés de Nus vites* [9.10.1912], Mar-
cel requests that Budworth handles it in New
York: "I mean to receive the case," he
explains, "take the painting out and keep the
case in his place; deliver the painting to my
studio without the case – all this because I
have very little room." Marcel also points out
that as his studio isn't fireproof, a special
insurance might be required.

*

Apologizing for his silence, Duchamp writes
thanking Michel Carrouges for his letters and
the chapter from his forthcoming book pub-
lished in the *Mercure de France* [1.1.1952]. "I
am delighted with the idea of the cover for
your book," Duchamp says, "I suppose that
you will easily have a line drawing made of the
glass. In fact it is better that this is done by a
'professional'." After requesting to see a copy

of the cover if it is printed before the book,
Duchamp writes: "I read the manuscript that
Breton lent me in Paris two years ago too
quickly – but I have a very vivid recollection of
it, confirmed moreover by the article in the
Mercure and I await the new book with impa-
tience..."

1954. Monday, New York City
Marcel thanks Roché for agreeing to lend them
his apartment on the Boulevard Arago while
they are in Paris, and informs him that he and
Teeny will probably be sailing on the *Flandre*,
departing 9 November from New York.

1958. Saturday, Sèvres
At five in the afternoon, Marcel and Teeny visit
Roché, recount their holiday in Spain
[14.9.1958] and later enjoy a "magnificent"
dinner of roast veal accompanied by Moët et
Chandon champagne.

1964. Sunday, Milan
In the afternoon after a short visit to Italy
[18.9.1964] to attend the Bergamo festival, the
Duchamps are due to board the train for Paris,
which departs at five minutes to three.

1965. Monday, Neuilly-sur-Seine
Travelling back from Cadaqués [17.9.1965],
Marcel and Teeny are due back at 5 Rue Par-
mentier, where they plan to stay a month
before returning to New York.

1966. Tuesday, Neuilly-sur-Seine
Marcel and Teeny return from Cadaqués to
spend a month at 5 Rue Parmentier.

21 September

1917. Friday, New York City
After dining together at the Café des Artistes,
the Arensbergs invite Duchamp, Roché and
other friends to spend the rest of the evening at
their apartment, 33 West 67th Street.

1921. Wednesday, Paris
Marcel tells Man Ray (who himself has only
recently crossed the Atlantic [22.7.1921] and is
now occupying a room at 22 Rue de la Con-

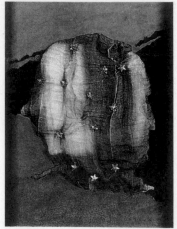

21.9.1944

22.9.1935

damine [25.6.1921]) that he plans to return to New York in January.

The American (who has been doing some photography for Crotti to earn some money) has recently met Paul Poiret, for whom he hopes to do some work, and has an appointment with Picabia the following day to meet Léonce Rosenberg.

1924. Sunday, Rouen
Opening of the Championnat de Haute-Normandie, which is played near the cathedral at the Brasserie Paul, the headquarters of the Cercle Rouennais of which Duchamp is a member. Duchamp's opponents in the tournament (which is played according to the rules of the recent French Championships [31.8.1924]) are Casier (president of the Echiquier Elbeuvien), who also played at Strasbourg [7.9.1924], Lainé (president of the Cercle Rouennais) and Lenormand of the Groupe Havrais des Joueurs d'Echecs.

1934. Friday, Bois de la Chaise
After their holiday on the island of Noirmoutier [19.9.1934], Marcel returns with Mary Reynolds to Paris.

1942. Monday, New York City
"'Perfect' for Thursday 7 p.m. at the Colony Club," replies Dee to Miss Dreier, "I can't answer all the questions mentioned in your letter. It is better to discuss them on the roof." While excusing the "long telegram" and "short letter", Dee remarks: "Definitely cooler here…"

1944. Thursday, New York City
"Your letter which I kept preciously is dated 24 Nov. 43," writes Marcel to Yvonne whom he last wrote to a year ago [19.9.1943]. And he has finally posted the promised *VVV* [13.3.1943] today.

As well as issue no. 2/3, Marcel sends Yvonne a copy of *VVV* no. 4, in which his composition *Allégorie de Genre* is illustrated. Destined originally as a George Washington cover for *Vogue*, which the editors rejected, the profile of the first American president's head is composed of iodine-stained absorbent pads covered in gauze and stuck through with 13 nails, the heads of which are each decorated with a glittering gold star. This gory double image of America's glorious Stars and Stripes,

and the victor of the American War of Independence, is fixed to the flat, black profile of the country set in a very vivid, almost electric sea of midnight blue.

Marcel has not seen the Arensbergs: "They stay in California," he explains, "I cannot afford the luxury of the voyage… They are very isolated and see hardly anybody except foreigners who ask to visit their collection."

Compared with Paris, Marcel says: "New York obviously has been a paradise for me but the human animal is so stupid that one ends up by no longer seeing any paradise."

As only the letters from America destined for the Calvados and the Manche are permitted in France, Marcel asks Yvonne if she knows of anyone either civilian or in the forces who could transmit a letter to Villon. "Be kind enough then to reply to me by return," he requests, "so that I send you a note to forward to the Villons if it's possible."

Marcel anticipates staying "at least a year" more in New York, forecasting that "even if the war ends tomorrow, people won't be allowed to leave easily…" A further detail about New York: "The burlesques have been withdrawn."

1947. Sunday, New York City
The reception party for the architect is the same as the one for his departure [27.5.1947]: with Stefi and her two friends Alice and Lillian, Marcel goes to La Guardia airport to meet Frederick Kiesler, who is due to return on a flight arriving at one-thirty in the afternoon from Paris.

Later that evening, at nine-thirty, Marcel calls on the Kieslers at 56 Seventh Avenue.

1965. Sunday, Neuilly-sur-Seine
Receives a telephone call from Arturo Schwarz, who is concerned that on the etching of the Large Glass which Duchamp made during the summer in Cadaqués [14.7.1965], the nine Shots are missing.

1967. Thursday, Neuilly-sur-Seine
Planning to return to New York via London and having received an "OK for Oct. 15th" from Richard Hamilton, Marcel replies giving their flight number, adding: "and will be delighted to see you at the airport…"

22 September

1918. Sunday, Buenos Aires
Having learned that the *Henrik Ibsen* is sailing tomorrow for New York, Duchamp writes hastily to the Stettheimer sisters. "Pleased on the whole," he declares only a few days after his arrival [19.9.1918], "knowing nothing, nor anybody, not even a word of Spanish, amusing all the same." He is already looking for an apartment to work in.

Finding the city much cheaper than New York, "the food splendid" and butter such as you cannot find on Columbus Avenue, there are "small streets like those behind the Madeleine in Paris" and one broad avenue.

Although he was hardly aware of it, the sea voyage was very "*pericoloso*" [18.8.1918], Duchamp tells the sisters. "Spring here. I will have 2 summers this year," he concludes, promising to write a longer letter soon.

1924. Monday, Rouen
"Your letter seems to have had a magical effect," writes Duchamp to Jacques Doucet, "the mechanic has done in 1 day what seemed to me should take eight." As a result of this sudden progress to the optical machine, he says: "Now we can envisage a trial rotation next week."

However, Duchamp persists with his idea of using velvet [14.9.1924]. "It is the only way," he believes, "to obtain an absolutely mat surface and really black at the same time. But we could experiment. See you soon then if you would like to meet at Man Ray's to see the thing turning. If not finished…"

1935. Sunday, Paris
Responding to André Breton's request for an unpublished work to embellish the cover of *Au Lavoir noir*, Duchamp suggests *La Bagarre d'Austerlitz*, which Man Ray has recently photographed.

Made and signed by Rrose Sélavy in 1921, it is the second small window after *Fresh Widow* [20.10.1920]. With the appearance of being built into a brick wall on one side and set in painted wooden panels on the other, the glass panes are rubbed with flourishes of whitewash.

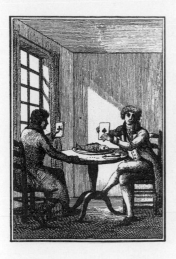

As Duchamp said later: "I could have made twenty windows with a different idea in each one, the windows being called 'my windows' the way you say 'my etchings'…"

The title is evocative of the great Marquis de Bièvre, whose puns uttered at the court of Louis XV are French classics. A number of them translated pictorially were beautifully engraved and presented in a *porte-feuille* or portfolio entitled *Galerie de M. de Bièvre*:

Vue de Carpentras [De carpe entre as]
Le prévoyant [Le pré voyant]
Vendange [Vent d'ange]

However, *La Bagarre d'Austerlitz*, which incorporates the Parisian railway terminus Gare d'Austerlitz (named after the "Battle of the Three Emperors" fought in Moravia in 1805), is similar to the fanciful construction used systematically by the Marquis de Bièvre to write his tragedy *Vercingentorixe*, "the posthumous work of the Sieur de Bois-Flotté."

The words printed in italics in *Vercingentorixe* are those which the Marquis intended should "enrich and multiply the idea" in presenting it so that "the imagination can take off in whichever direction it pleases".

Sylvie's dramatic declaration to Convictolitan in Scene Four of the tragedy is an example:

"Va, nous savons *de Naples* où tu portes tes vœux;
Pars *de gâteau*, cruel! laisse-moi."

1936. Tuesday, Paris
At a meeting with Mrs Alfred Barr, Duchamp has gleaned further information about "Fantastic Art, Dada, Surrealism", an exhibition being organized by her husband in New York. As Mrs Barr has requested that Duchamp have a word with André Breton (who does not wish to participate in the exhibition), Duchamp writes a note to Breton proposing that they meet at noon on Thursday at Lipp's in Boulevard Saint-Germain.

1950. Friday, Paris
Marcel telephones Roché at Saint-Robert and tells him that he is very comfortably installed in Arago [19.9.1950].

1953. Tuesday, New York City
As James Johnson Sweeney, who has just returned from Europe, would still like to orga-nize a Brancusi exhibition at the Guggenheim Museum, Marcel writes again to the sculptor [3.6.1953]: "If you are still not decided, let me say that this exhibition offers all the guarantees that you could insist upon. I promise to be there and to deal with everything if you don't come to America."

1958. Monday, Paris
Uncertain whether Robert Lebel is back in Paris yet, Duchamp decides in the morning to send him an express letter announcing that the "circus" opens the following day at Trianon Press and he would be happy to see the author there. "I will telephone you this evening," writes Duchamp. "We could arrange the interview more easily if you answer the telephone. In any case," Duchamp continues, "Max [Ernst] and Dorothea whom we telephoned in Huismes would like to have you and Nina to dinner with us (58 Mat.[hurin-]Régn.[ier]) Tuesday 30 Sept. So long then…"

1959. Tuesday, London
After completing their second consecutive summer in Europe [9.4.1959] with a week in London spending time with Richard Hamilton working on the typographic version of the Green Box, Marcel and Teeny fly back to New York.

1965. Wednesday, Neuilly-sur-Seine
To remove any shadow of doubt, Duchamp sends a telegram to Richard Hamilton in London: "Expecting you Friday love = Marcel."

1968. Sunday, Neuilly-sur-Seine
"It all seems very well planned," replies Marcel to Brookes Hubachek, who is organizing their forthcoming visit to Chicago, "but we know how hard it is to make the final arrangements and we want you to know that we will adjust with pleasure to whatever you decide." He tells Brookes that he has been unwell recently, "so I

do not want to exert myself too much although I will prepare a few remarks for the dinner," he promises. "What we want to tell you mainly is that we would prefer to be alone with you and the family on the free night."

With great excitement at his discovery, Duchamp writes to Arturo Schwarz: "Just imagine, I have found the book on the anaglyphs in the same bookshop where I had bought it around 1930, while taking a walk on the Boulevard Saint-Germain following a very vague memory – The Vuibert bookshop is still at the same place and the book is still on sale (4th edition). I will show you my sketches [20.8.1968] for the French de luxe edition when you arrive."

23 September

1924. Tuesday, Rouen
At the end of the three-day tournament, Duchamp, who has won five games and drawn one, is declared champion of Haute-Normandie and presented with a small silver-bronze plaque engraved with his name. The new champion "has really deserved his title by his solid and profound game", comments the *Bulletin de la Fédération Française des Echecs*. "His imperturbable composure, his ingenious style, the impeccable way in which he makes use of the slightest advantage, makes him a formidable opponent at all times."

1932. Friday, Paris
The Cercle des Echecs de Lutèce is reconstituted at a general meeting held at the Café Ludo in Rue de la Sorbonne. Duchamp is elected to the committee as a technical adviser.

1949. Friday, New York City
Duchamp thanks Katharine Kuh for the reservation card from Palmer House, where he will stay for the opening of the forthcoming exhibition of the Arensberg Collection in Chicago. "I would appreciate it very much if you took care of the train reservation (round trip). My choice is the Wolverine… but if this is not morning enough I can take an earlier train. I hope everything arrived safely," Duchamp adds, "and that you are having a grand time arranging the show – Until the 19th."

23.9.1958

1950. Saturday, Paris
"At last I have found a few minutes to tell you just how delightful the apartment is to live in," writes Marcel to Roché, following up his telephone call of the previous day. "The sun in the morning and the view onto the trees makes my stay a little less gloomy." Baffled by Mary Reynolds' desperate condition, Marcel tells his friend: "Her brain is so lucid, her heart and her lungs are in an almost perfect state, that one hardly understands that it is impossible to attempt anything in the way of a 'cure'."

1951. Sunday, New York City
At the Arensbergs' request, still in quest of details for their tax demand [15.9.1951], Marcel sends them the address of J. B. Neumann, from whom they purchased a Robert Delaunay. "If I am not mistaken you have had St Severin since before 1935," Marcel writes, adding, "…I can also see [Neumann] if you want me to."

1953. Wednesday, New York City
Marcel thanks Beatrice Wood warmly for giving him "precise news of Lou's health and the result of the operation", which she had a few days ago. "What great sadness to see our dearest friends struck by the inevitable," Marcel laments, "because the shock of a fatal accident does not contain the element of hope upon which a long illness, even ineluctable, makes it possible to speculate. At the same time, science today is too categorical to allow this speculation and the long agony of someone to whom one cannot tell the truth is a torture made of silent, implicit treason."
 "I have been through these moments," Marcel continues, "and I know how much Walter must be suffering after a life of complete communion between Lou and him." He then asks Beatrice: "Tell him all this because I cannot write it to him…"
 *
To both Lou and Walter, Marcel writes, "Dear Lou I sincerely wish you a short convalescence and hope that Walter will find a minute to write me a short note from time to time until Lou is well again." He tells them of his trip to Minnesota [16.8.1953], of chess in Cazenovia [29.8.1953] and then declares: "Ready now to hibernate."

1957. Monday, New York City
"Period of inactivity after the chess tournament [2.9.1957]," writes Marcel to Roché. "I have

received a little book, an English translation of 25 pieces of paper from the green box, by a professor friend at Yale, George Hamilton," he announces. Promising to send Roché a copy of *From the Green Box* published by the Readymade Press, Marcel adds: "Very good layout, pleasing…"
 The book with Fawcus is advancing slowly, but there is "no question of going to Paris this year", Marcel says, "we are still full of Mexico [6.4.1957]."

1958. Tuesday, Paris
At eleven in the morning Duchamp is due to be in attendance, with or without the author, for the opening of what he describes as "the circus" at Trianon Press, to provide some pre-publication publicity for Robert Lebel's book, the text of which is still not printed.

1961. Saturday, Paris
For Jean Larcade [2.8.1961] Duchamp signs a declaration authorizing the Galerie Rive Droite, 23 Faubourg Saint-Honoré, to reproduce eight copies of *Feuille de Vigne femelle* [12.3.1951] in bronze, reserving one copy for himself and one for Man Ray.

1965. Thursday, Neuilly-sur-Seine
To the Kestner-Gesellschaft Duchamp cables: "As agreed arriving Hanover Tuesday morning about nine."

24 September

1928. Monday, New York City
The Fifth Avenue Bank of New York credits Duchamp's account with $100 received from Miss Dreier.

1939. Sunday, Paris
"Well, it had to come. How long will it last?" wonders Dee about the war against Germany [3.9.1939]. "How will we come out of it, if we come out of it?" he speculates in his letter to Miss Dreier.
 Too old for active service, Dee envisages doing "some civilian work to help. What?? Everything is still a mess," he says. Villon and Gaby are staying with Mme Mare in Bernay.

Suzanne is in Nantes. As for himself, Dee says that Paris "is half deserted and black at night", and he is "waiting for the first bomb, to leave somewhere in the country…"
 The promised sale of the Verlaine [16.5.1939] has not gone through because of the war. He wonders whether he should send the book to the United States or try later to sell it to the same people. "I can't say I will see you soon," Dee concludes, "But who knows? in these times."

1942. Thursday, New York City
In the evening at seven, Dee dines with Miss Dreier at a place he is very fond of: the roof on top of the Colony Club [7.7.1942]. Matters to be discussed include George Heard Hamilton's recent proposal to organize an exhibition of the three Duchamp brothers at Yale University Art Gallery, and the question of preparing the catalogue of the Société Anonyme Collection [14.10.1941]. Unable to sell her house, Miss Dreier also asks Dee whether she should let Mr Lion [2.7.1942] sell *Le Poisson* by Brancusi, rather than borrow money from her sister Mary.

1944. Sunday, New York City
"We have been to see all the films of the liberation of Paris – it must have been really something!" writes Marcel to Jean Crotti, now that postal communications with France have been at least partially resumed [21.9.1944]. Saying that Mary Reynolds, who narrowly escaped the Gestapo [2.1.1943], "really regrets having left Paris," Marcel gives his address and asks for news quickly.

1954. Friday, New York City
In the afternoon at five Duchamp meets Monique Fong [21.7.1954], who is going back to Europe for a year.

1964. Thursday, Neuilly-sur-Seine
Thanks Richard Hamilton for his letter and the one to SEPA, the printer in Rome making the cliché for the Cordier & Ekstrom catalogue [8.9.1964]: "Everything very clear for us – but will they understand?" Marcel wonders. "Hope that by Friday Oct. 9th when we arrive in London," he continues, "you will have an answer to your letter," and adds, "Teeny and I both looking forward to being with you and the children."

25.9.1950

1965. Friday, Neuilly-sur-Seine
Richard Hamilton arrives from London for the weekend to discuss details for constructing another replica [5.9.1961] of the Large Glass for the forthcoming exhibition at the Tate Gallery.

*

Duchamp receives a telegram from Dr Wieland Schmied confirming that he will be at the station in Hanover on Tuesday morning.

25 September

1926. Saturday, Monaco
After about three weeks in the south of France [5.9.1926], Duchamp leaves the Hôtel de Nice and returns to Paris.

1930. Thursday, Paris
In the evening at seven Marcel calls at Arago, and Roché takes him to eat escalopes of wild boar at Les Maronniers, 53 bis Boulevard Arago. After dinner they call on Helen Hessel in Rue Ernest Cresson, and find her in bed, wearing pink pyjamas, looking just like a fair-haired boy. They talk a while and when Marcel leaves, Helen becomes agitated, making comparisons, jealous that Marcel is happy with Mary Reynolds.

1950. Monday, New York City
As he is in France [14.9.1950], Duchamp is not present for the installation nor the opening of "Challenge and Defy" at the Sidney Janis Gallery on East 57th Street. For the exhibition, Duchamp supplied in advance a replica of *Fountain* [9.4.1917], the object signed "R. Mutt", which was rejected by the committee of the Independents more than 30 years previously. Exhibited in public therefore for the first time, with paintings by Dali, Magritte and Delvaux for company, the urinal is installed low, in its utilitarian position, near the skirting board in a corner of the gallery, so that "little boys could use it", as Duchamp remarked later...

1951. Tuesday, New York City
"I have been thinking about the nurse condition," Dee writes to Miss Dreier, whose health has been giving grounds for concern for several months. He has received a letter in French from Campendonk and news from George Of,

both of whom have promised to write to Miss Dreier. "Nothing new about the 'cleaning' in Garden City [6.9.1951]," however, but Mr Kelly is due back from his holiday soon.

1961. Monday, Paris
Richard Hamilton, accompanied by Nancy Thomas of the BBC [10.9.1961], arrives from London to discuss the "Monitor" interview with Duchamp.

1968. Wednesday, Neuilly-sur-Seine
Drawing a little plan, Marcel writes a note to Pierre de Massot [8.9.1968], proposing to meet him at four o'clock on Friday at the *café-tabac* situated at the junction of the Boulevard Haussman and the Avenue de Messine, instead of at the Galerie Givaudan.

26 September

1912. Thursday, Berlin
After being based in Munich [1.7.1912] for two months, Marcel has spent the first three weeks in September visiting Vienna, Prague, Leipzig, and Dresden and is now back in Berlin.

"Once again, here I am growing accustomed to life in Berlin," writes Marcel from the Hotel zum Goldenen Löwen, 55 Judenstrasse, to his brothers Gaston and Raymond. "The second impression is better than at first sight. Probably because I have visited a few paintings: always the museums, which are marvels of installation – why is the Louvre so badly arranged?

"And then the Berlin Secession, which finally enabled me to see the face of young French painting abroad. One room was reserved for Friesz, Marquet, Valtat, Herbin and 4 Picassos. It gave me very great pleasure to find Cubism again, it was such a long time since I had seen it. And that went not a little way, to my indulgence for Berlin.

"I take the bus, trams, as if I have always lived here. The metro does not have the same importance here as in Paris. There is only one long line and a transversal, again most agreeable.

"The horse-drawn buses, because there are still a lot of them here, resemble in their small size our Auteuil-Saint Sulpice (with a small exaggeration).

"Les Linden or les Linden!" exclaims Marcel, referring to his mother's first cousin, Armande van Linden, and her family. "The lime trees in question are missing. It's a very wide boulevard and not very long. Only the Tiergarten is nice.

"I received official notice that my drawing [*Vierge* No.1; 7.8.1912] pleased the jury of the Salon d'Automne. Much good it may do me! At last I have found the *Gil Blas* and I hope to follow with interest the opening of the 'automne', by our friend V[au]xelle no doubt.

"I am writing to you from a so-called 'literary' café. There are, above all, lots of women who are not at all 'literary'.

"I hope that my friend [Bergmann?] will join me again here at the beginning of next week and will show me the 'night-life' in Berlin. It's a speciality.

"I hope to return to Paris around the 10th," Marcel says, and tells his brothers that on his way back he will probably stop in Cologne. "I am beginning to have a real need," he declares, "to see some friends' faces again..."

1924. Friday, Paris
"At last I have seen something turning," writes Duchamp to Jacques Doucet [22.9.1924]. As the motor is due to be fitted the following day, Duchamp proposes to take Doucet on Monday to see the optical machine in its "raw state".

1926. Sunday, Paris
His first day back from Monaco, Marcel receives a visit from Roché at the Hôtel Istria. In room 27, to which Marcel has now moved, they discuss their Brancusi business [13.9.1926].

1932. Monday, Paris
"The author of the violent article ('Un plagio', *L'Italia Scacchistica* 15 September 1932) directed against our book *L'Opposition et les cases conjuguées sont reconciliées* must have forgotten to read this book seriously, just as he has forgotten to sign an insulting article," protest Duchamp and Halberstadt in a joint letter to the Italian chess magazine.

"The tone of the article reveals a superficial *parti pris*, which excuses us from a discussion point by point... Nevertheless we wish to correct certain entirely false allegations. In our book (page 3), we acknowledge the importance of R. Bianchetti's theories," and the authors cite the passage referring to Bianchetti's study of 1925.

BERLIN. Nationaldenkmal Kaiser Wilhelms I.

27.9.1912

27.9.1916

"This is enough to prove our honest intention to render to Caesar the things that are Caesars," they argue. "In the spirit of historic justice we must recognize D. Przepiorka as the author of this most important phrase in the article referred to: *l'Opposition est un cas particulier des cases conjuguées*. This was in Munich in 1908!" Claiming that in their book they were not seeking "a new theory but the definitive conciliation of two concepts", Duchamp and Halberstadt say: "those who read Bianchetti's book, which we consider as one of the important steps forward, will also read our book and will see that the superficial attacks against us are groundless."

1945. Wednesday, New York City
At eight o'clock Marcel dines with the Kieslers at 56 Seventh Avenue.

1946. Thursday, Paris
"James Sweeney must have already told you the bad news," writes Marcel to Ettie Stettheimer [9.8.1946] in New York. Unable for a month or two to obtain an American visa, there is no chance of Marcel being in New York for Florine's exhibition [1.3.1946] at the Museum of Modern Art, which opens on 1st October. "I am all the more sorry, as I was looking forward to helping with the presentation of this essential manifestation in memory of the painter she is."

1950. Tuesday, Paris
After learning from the clinic at 50 Avenue du Roule, Neuilly, "contrary to the diagnostics of numerous doctors," that Mary Reynolds "has a dreadful tumour [of the uterus] which no one detected and which cannot now be operated", Marcel asks Gaby Picabia to write immediately to Henri and Hélène Hoppenot in Bern and tell them the truth and the hopelessness of Mary's condition.

1951. Wednesday, New York City
Having just received two long letters from Miss Dreier, before posting his own letter written the previous day, Dee adds a note thanking her and wishing her "a prompt recovery from the tapping (yesterday)".

1954. Sunday, New York City
As their letters have crossed, Marcel writes again thanking Roché for agreeing to lend Arago [20.9.1954]. "All the operations [25.5.1954]

have made a hole," says Marcel, "and I cannot see a rapid way of making gold…" They still expect to sail on 9 November.

1961. Tuesday, Paris
Accompanied by Nancy Thomas of the BBC and Richard Hamilton, the Duchamps fly to London.

1966. Monday, Neuilly-sur-Seine
"We received this morning the big collection of clippings very amusing to read (pro and con)," writes Duchamp to Hugh Shaw, Exhibitions Organizer of the Arts Council of Great Britain, one of those involved in mounting the exhibition at the Tate Gallery [16.6.1966].

27 September

1912. Friday, Berlin
On a card representing the imposing memorial to Kaiser Wilhelm I, Marcel writes to his grandmother Nicolle and the Paulin Bertrands in Neuilly: "This is to give you an idea of the modern Berlin style, a mixture of Greek, rococo and, dominating all architecture, the souvenir of the sovereign of each period. I will be returning to Neuilly in a few days, happy to find the calm there again to work."

1916. Wednesday, New York City
An old friend of Gaby Picabia and Juliette Gleizes, the composer Edgar Varèse, who arrived from France some nine months ago with the idea of making his name as a conductor and creating new instruments for his music, has met with an accident. While waiting for a bus on Fifth Avenue, he was knocked down by a car and is confined to St Vincent's Hospital with a broken foot.
Marcel is one of the many friends who endeavour to relieve Varèse's boredom and frustration by visiting him in hospital. Today he finds a young American girl at the composer's bedside. It is her second or third visit, made at a friend's suggestion, because she speaks French; she is a budding actress at the French Repertory Company, Marcel learns, and her name is Beatrice Wood. Surprised to be *tu-toied* by a stranger, Beatrice senses "an immediate affin-

ity" with Marcel. "He was frail, with a delicately chiselled face and penetrating blue eyes that saw all," she remembers. "When he smiled the heavens opened. But when his face was still it was as blank as a death mask. This curious emptiness puzzled many and gave the impression that he had been hurt in childhood."
Their discussion on modern art provokes Beatrice to shrug her shoulders and remark: "Anyone can do such scrawls." Whereupon Marcel replies dryly: "Try."

1924. Saturday, Paris
Duchamp is due to visit the mechanic to see the motor fitted to the optical machine being constructed for Jacques Doucet.

1928. Thursday, Marseilles
The results of the sixth Championnat de France, which is won by Aimé Gibaud, are announced in a ceremony at the Club Nautique. One of the nine competitors, Duchamp is placed seventh, having won two games and drawn two.
Duchamp is in the group of those photographed on the steps of the Palais Indo-Chinois of the Institut Colonial, where the chess tournament was played.

1946. Friday, Paris
Writes a note to André Breton accepting his invitation to lunch on Monday at 42 Rue Fontaine.

1957. Friday, New York City
Now that Frank Anderson Trapp has returned from abroad, Duchamp informs him of Marceau's concerns for lending to Amherst College [29.6.1957], and wonders whether he can delay opening the revival of the Armory Show, "to have better chances of success with Philadelphia."

1958. Saturday, Paris
As the Ernsts are returning to Paris on Monday, Marcel invites Patrick Waldberg to a "small reunion, family only" at 58 Rue Mathurin-Régnier on Monday evening.

1961. Wednesday, London
Following the interview with Katharine Kuh in New York [29.3.1961], Duchamp is filmed at a second session in conversation with Richard Hamilton for the BBC's "Monitor" programme, directed by Nancy Thomas.

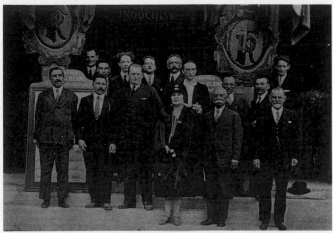

27.9.1928

"What do you feel was your first contribution to painting?" asks Richard Hamilton in the first take.

"Well, that Nude descending [18.3.1912] was one, in my opinion, for the fact that in art in general, motion has never been exploited… In other words, to introduce a movement…"

"How soon was it before the public and the critics realized that it was important?"

"First it was only a *succès de scandale*… Forty years after, people still talk about it, so there must be something else than scandal in it. And I believe so."

"After the completion of this painting, you were beginning to think about vastly different things. You were beginning to embark on *La Mariée mise à nu par ses Célibataires, même* [5.2.1923]. Did you regard this as a departure from any other kind of painting that you'd ever done?"

"I did – in the first place I was glad – at least it was in my personal makeup to look for something else. In other words I was not going to paint many nudes again… This chapter of my life was over and I immediately thought of inventing a new way to go about painting. And that came with the Glass…"

Even thirty years afterwards not many people really appreciate this painting fully. "Is this a disappointment?" asks Hamilton.

"No, I don't know why. I never really did it for the idea of having it in the Louvre or in the National Gallery in London… It was always done for my own satisfaction as a sort of hermit."

"But while you were working on the picture, you were conscious that you were creating a work of high art, a very important—"

"I was not conscious of it," interrupts Duchamp. "I was doing what I wanted to do and consciousness of it never came into my conscious."

In the subsequent take, Duchamp continues: "It was more recopying, copying some sketches that I'd done on glass already, so there was no creativeness there, no invention any more, it was just a translation of a thing already done, to my mind at least, onto glass…"

Hamilton considers that one of the paradoxes of Duchamp's work is that while he was working on this "disciplined major work", at the same time he was producing apparently effortless readymades.

"Yes – that's one of the paradoxes and that wheel [15.1.1916] was the first one, and not even named readymade at the time… Again the idea of movement… And then in 1914, I stopped the idea of movement in that bottle rack [15.1.1916]…"

Later Duchamp returns to the paradoxical side of his activity: "The two are almost schizophrenic – almost," he laughs. "The position where on one side I would work on a very intellectual form of activity, and on the other side killing everything by the more materialistic thoughts."

"Did you regard it as a joke?" enquires Hamilton.

"Of course, humour came in as an element. It was very important for me to introduce humour. Even in the Large Glass there is a great deal of humour, humorous elements in it. And it was really a great philosophical side of it, if you want to call it philosophical, to doubt the seriousness of the work as in a cosmic whole of the world. Our little corner of the earth is so small comparatively… and we have always been anthropocentric, which is a little thing to be mocked."

"Can everyone make a readymade by putting their signature to it?"

"One can," replies Duchamp. "It should be completely impersonal, because if you introduce the choice, it means that you introduce taste, and if you introduce your taste, you go back to the old ideals of taste and bad and good taste and uninteresting taste. And taste is the great enemy of art: A-R-T."

Hamilton says that many people feel that Duchamp's iconoclastic act is a "sort of betrayal of art".

"Yes, it was really trying to kill the artist as a little god by himself…"

"You don't feel that you've committed suicide?"

"No, no, no… But I'm glad if I've contributed to this cessation."

Does Duchamp think there is a gulf between the readymade and a picture like *Nu descendant un Escalier*?

"I wonder. I don't think there is much in common, especially that I fortunately never went into making a readymade a day in the last forty years, which would have been a great mistake… Because, you know, repetition has been the great enemy of art in general, I mean, formulas and theories are based on repetition…"

Is the readymade a "snap judgment" in fact or decided in a "more reflective period"?

"Very often reflective," replies Duchamp, "because generally I added a little sentence on it – a title, so to speak, which never was descriptive; on the contrary, as far away as I could be from the object itself or the things the object could recall. So it was a decision – it could be a long decision too, it could take time to decide… It was all kinds of intellectual connotations and correlations with it. In other words, I'm getting away from the plastic, physical, purely material – materialistic – form of art."

Hamilton asks whether Duchamp considers his readymades to be more trivial than his other work.

"They look trivial but they're not. On the contrary, they're a much higher degree of intellectuality at least. And the one I love most is the one which is not quite – it's a readymade, if you wish, but a moving one. By this I mean three threads, three metres of thread falling down and changing the shape of the unit of length, that metre becomes a curve and repeated three times [19.5.1914]. I was satisfied with the idea of not having been responsible for the form taken by chance. At the same time, being able to use it for other things in my Large Glass, for example."

In the last take, Hamilton says: "Strangely enough, your work, which appears so aggressive, has provoked great love in your admirers – a love not only for your work but also for your personality."

"Yes… I'm delighted to have had that result instead of the opposite."

"Do you feel that your integration with art is still important?"

"Very, very much. I'm nothing else but an artist… The years change your attitude, and I couldn't be very much iconoclastic any more."

1965. Monday, Neuilly-sur-Seine
In the evening the Duchamps travel to the Gare du Nord and take the night train departing for Hanover at five minutes past seven.

1967. Wednesday, Neuilly-sur-Seine
Thanks Arne Ekstrom for transferring $1,000 to his bank, and confirms that he has spoken on the telephone to M. Meunier, who is to collect three Valises from Lefebvre-Foinet and transport them to New York.

28.9.1923

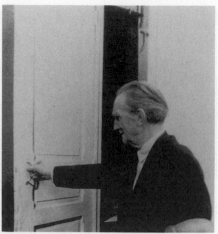

28.9.1965

28 September

1923. Friday, Paris
"Thank you for your express letter and invitation," writes Duchamp to Jacques Doucet, "I will be very happy to have lunch with you on Wednesday," and adds, "I hope that the canvas will give you pleasure," referring to *Deux Nus*, dated 1910. In a haze of greenery, a red-headed model of ample proportions is seated on the left, looking towards her dark-haired companion, whose back is partially masked by the foliage.

On the advice of André Breton, his personal advisor, Jacques Doucet, the founder of one of the first fashion houses in Paris and a discerning patron of the arts, is acquiring two of Duchamp's works.

The principal acquisition, the glass which Duchamp gave to his brother Raymond, Breton described to Doucet as being "the modern trajectory's extreme point in the domain of painting", namely: *Glissière contenant un Moulin à Eau en Métaux voisins* [11.12.1919]. After the *Broyeuse de Chocolat* [8.3.1915] it was the second motif to be elaborated in the Bachelors' domain of the Large Glass [5.2.1923] and Duchamp's first painting using a glass surface.

1927. Wednesday, Paris
"Enchanted bowl enchanting," reads the message on Duchamp's cable to thank Miss Dreier for the wedding present, which she decided not to choose until she received Man Ray's photograph of Lydie [23.7.1927].

"What do you mean by telling me that she is not beautiful!!!" she exclaimed to Dee after seeing the portrait. "Maybe the word handsome is better." Miss Dreier has noted the resemblance to a certain Anne Morgan: "Of course that means that she is very powerful... I know that if she becomes too powerful that out of self-protection you will vanish as you always have... So after seeing the picture I went down to Tiffany and had sent to both of you with my card a bowl which I believe that you will both like."

Upset not to have received a wedding invitation even, Miss Dreier complains: "It was very neglectful, but a mother forgives much... I do feel it is very important to remain your mother," she continues, "I see my duties are not over yet..."

1933. Thursday, Paris
Delighted with his "little" Spain, in the evening Marcel returns with Mary Reynolds from Barcelona, where they have spent the last two weeks of their Catalonian holiday.

1937. Tuesday, Paris
"Today I reread your letter of a year ago (almost to the day) – that is to say how ashamed I am never to have replied," writes Marcel to Walter Pach, who had stated his price for the *Jeune Homme triste dans un Train* [17.2.1913] in his collection. "Naturally I was bowled over by the price that you had decided," explains Marcel, "and I didn't want to discuss it, leaving you every right to attach a value to it."

Although Pach had proposed that Marcel take 20% of the sale price, Marcel would prefer to eliminate the question of a percentage for himself and see the price reduced from $3,500 to between $2,000 and $2,500. "I would be perfectly content with $100 added to this sum," he says, hoping that Pach will not consider this late response as "unpleasant haggling". Pach knows, if it is to leave his collection, how much Marcel would like this painting to join its "brothers and sisters" in California. "I remain convinced," Marcel continues, "that my production, because it is restricted, has no right to speculation, that is to say, to travel from one collection to another, being dispersed..." Arensberg, Marcel believes, has every intention of "making a coherent whole".

Be that as it may, the pressing reason for renewing contact with Pach is that Marcel needs a good photograph of the painting for the "album" [5.3.1935] he is busy preparing and which he requests Pach to send him...

1939. Thursday, Paris
Not separated for so long as he had feared [30.8.1939], Marcel has lunch with Roché at Au Rat, 34 Boulevard Saint-Marcel, and talks about his idea of inviting the painter Jean Marembert (founder with Michel Tapié de Céleyran of the Groupe des Réverbères) and the Ferats to a village of artists in the south of France.

On seeing the photographs of Warsaw after the bombardment, Roché wonders: stay or leave?

1948. Tuesday, New York City
In the morning Dee receives a letter from Miss Dreier which has crossed with his own. Regarding the Paul Klees, Dee confirms that he has made an appointment on Tuesday to see Mrs Batsell.

Edgar Varèse, whom he telephones, has received Wilhelm Maler's music [8.5.1929], "finds it interesting," and says he will write to Miss Dreier's cousin as soon as she provides him with his address.

1959. Monday, New York City
While staying at the Hotel Dauphin [3.4.1959] since their return to New York [22.9.1959], the "run for a new apartment has started".

"We had to wait until we recovered from the 5 hour timequake and the dazzling London days [14.9.1959]," writes Marcel to Terry and Richard Hamilton. "But now we see you we feel you we hear your voice quite clearly – giving us the most wonderful time. Teeny, nevertheless, is still lost between Hornton Street, Hampstead and Coolhurst Avenue," Marcel continues, "and you may come across her one of these days..."

Sending them under separate cover, Marcel has finished the "corrections" for the Hamiltons' (George and Richard) typographic version in English of the notes from the Green Box. "If you find a few difficult points to solve, let me know," he suggests, "and we will go through them again." Included in his comments are preferences for Standard Stops (instead of Standard Stoppages), Handler of Gravity (instead of Director of Gravity)... Proposing "TENDer of gravity" as the translation of "Soigneur de gravité", Marcel remarks: "you can always explain in the introduction of the book that my French being not a slave of grammar or of spelling, also full of neologisms – you intended to transfer the same attitude to the English translation. But do you like my TEND-er?" he enquires.

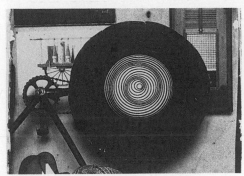

29.9.1924

29.9.1960

1965. Tuesday, Hanover
The North Express train from Paris is due to arrive at nine twenty-two in the morning. Wieland Schmied meets the train and takes the Duchamps to Kastens Hotel in Luisenstrasse, where he has reserved a quiet room for them.

Pleased to find that the hotel is so close to the station, where he will be able to buy the *New York Herald Tribune*, Duchamp explains to Schmied that he is following the eliminating tournament for the World Chess Championship, which is being held in Cuba. Bobby Fischer [16.12.1963] is participating, but as he refused to go to Cuba, the American is playing all his games in Miami and each move is being transmitted by telephone. Duchamp is amused by the idea that Fischer is "present" in the tournament but not "physically present".

It is the final day of the exhibition at the Kestner-Gesellschaft [7.9.1965]. Before the reception at eight in the evening, which has been organized to celebrate Duchamp's visit, Dr Schmied shows his visitors around and Umbo takes photographs. Many young artists, including Wolf Vostell and Konrad Klapheck, come from Cologne and Dusseldorf to the closing party, which lasts late into the night.

29 September

1917. Saturday, New York City
In the evening, while dining with Alissa Franc and Roché at the Metropole, Marcel tells them that he is thinking of leaving New York.

1924. Monday, Paris
In the afternoon at three Duchamp is due to meet Jacques Doucet at Man Ray's studio in Rue Campagne-Première and take him to the mechanic, where he will be able to see the optical machine in its "raw state", the motor having been fitted the previous Friday.

1926. Wednesday, Paris
Marcel meets Roché at noon.

1933. Friday, Paris
The day after his return from Barcelona, Duchamp has promised to call and see Brancusi

[10.9.1933] at 11 Impasse Ronsin at five-thirty in the afternoon.

1936. Tuesday, Paris
"It's a curious thing (again): why I could be so energetic in America and the minute I land in Europe my muscles refuse to function," reflects Dee, who tells Miss Dreier that since he left [2.9.1936] he has "not been able to accomplish anything". After writing about the Villons, Pevsner whom he hasn't seen, Brancusi, Man Ray, the news that he has decided to write to the treasurer of Les Amis de la Bibliothèque, Jacques Doucet, "who might be interested in buying the Verlaine," and that he will enquire about her lithographs [31.7.1936], Dee puts the letter aside... for a week.

1941. Monday, Sanary-sur-Mer
At the Hôtel Primavera in the morning, receives a letter from Victor Brauner. "Don't bother about the shoes any more," Duchamp replies, "I've found others... the same for Hualva, forget about all these pesterers."

*

Writes a note to Georges Hugnet in Paris enquiring whether he can count on him again to deal with payment of the quarter's rent on 11 Rue Larry, which is due in October [20.8.1941].

1943. Wednesday, New York City
Dines at Valeska with Mary Reynolds and the Kieslers.

1951. Saturday, New York City
Duchamp receives a visit from Claudine and her friend from Washington, Monique Fong.

1952. Monday, New York City
Duchamp dines with Monique Fong.

1958. Monday, Paris
By express letter informs Jean Suquet of his lightning visit to Paris.

*

Dorothea and Max Ernst return to Paris during the day, and Duchamp has invited Patrick Waldberg [27.9.1958] to the apartment for nine o'clock that evening.

1960. Thursday, Paris
After a tour in Greece [1.9.1960], which included a visit to the dramatic site of Delphi not far from the crossroads in the mountains

where Oedipus met the Sphinx, Teeny and Marcel arrive at the Monniers' at 108 Rue du Bac. They will be staying in Paris for a couple of weeks before returning to New York.

1961. Friday, Paris
The Duchamps return to 108 Rue du Bac after spending two days in London at the invitation of the BBC.

1965. Wednesday, Hanover
During their very short stay in the city, which Duchamp had visited so many years before [8.5.1929], Dr Schmied takes his guests for a tour in his Volkswagen, stopping to see the Niedersächsisches Landesmuseum, the Wilhelm Busch Museum, and the famous Herrenhäusen Gardens.

Before boarding the train to return to Paris, Duchamp also accords a televised interview to the Norddeutscher Rundfunk in the setting of the exhibition. When the interview is finished, Duchamp nonchalantly wanders across the room and suddenly stumbles: to everybody's amusement it is the *Trébuchet* [6.8.1960], which Schmied has fixed to the floor, that Duchamp has pretended to trip over.

30 September

1897. Thursday, Rouen
Due to start his first year at the Lycée Corneille the following day, Duchamp enters the Ecole Bossuet, 15 Route de Neufchâtel, as a boarder.

1898. Friday, Rouen
As classes at the Lycée Corneille start the following day, in the evening the boarders return to the Ecole Bossuet.

30.9.1911

ENCORE L'ÉCOLE CUBISTE
— Ah! non! ma vieille! pas tous les ans!

1.10.1897

1901. Monday, Rouen
The day before the new scholastic year at the Lycée Corneille commences, Duchamp is due to return to the Ecole Bossuet by eight-thirty in the evening.

1911. Saturday, Paris
The preview of the Salon d'Automne is held in the afternoon at the Grand Palais. The work of the young avant-garde in room VIII echoes that shown at the Salon des Indépendants [21.4.1911], which Apollinaire now describes as Cubist, the term coined by Matisse three years earlier [1.10.1908]. "You must excuse them," teases Métivet in a cartoon he is sending to *Le Rire*, "they are children who are very small, who are not big, and show their cubes to all the passers-by…"

After a medical examination of the Salon by two doctors, the readers of *Fantasio* are warned that some of the people in the pictures have contagious diseases. Looking at Kupka's *Grand Nu*, the doctors are convinced that the public's health is in danger; they recommend salt baths for the deformities of the *Nymphe des bois* by Duchamp-Villon, and regret that the bones of the figures in Léger's *Etude pour Trois Portraits* will have to be broken and reset…

In room VIII, alongside works by Albert Gleizes, Jean Metzinger, Fernand Léger, Henri Le Fauconnier and André de Segonzac, which have been hung by Raymond Duchamp-Villon and Roger de la Fresnaye, Duchamp exhibits two canvases which Apollinaire considers "interesting": *Jeune Homme et jeune Fille dans le Printemps* [24.8.1911] and *Portrait* [or *Dulcinée*].

Painted in August with the intention to "detheorize Cubism in order to give it a freer interpretation", the portrait in pale and delicate colours represents a lady whom Duchamp had apparently seen passing by and loved quixotically. In the five successive positions, painted "in the shape of a bouquet" on the canvas, the Knight of the Doleful Countenance step by step unclothes his Dulcinea, save for the neat hat, which remains jauntily perched on her head.

Although Picabia has exhibited with the Société Normande de Peinture Moderne since the first exhibition [19.12.1909], Duchamp has never met him. Pierre Dumont makes the introductions in front of Picabia's huge canvas *Sur la Plage* (also remarked on by the *Fantasio*

quacks, who diagnose that the child has a congenital hip deformity). "Our friendship began right there," declares Duchamp. "Picabia had an amazing mind… A negator."

1912. Monday, Paris
The day the Salon d'Automne opens Duchamp is in Berlin, but his drawing entitled *Vierge, No.1* [7.8.1912], which he sent from Munich, is exhibited. Although he mentions this "strange" drawing, Apollinaire nevertheless in general regrets the "battle-ground" of recent years and remarks sorrowfully that the Fauves are now quite tame. Even Métivet's cartoon in *Le Rire* suggests that Cubism has become old hat.

The chief attraction at the Grand Palais is the section devoted to the Decorative Arts, notably *La Maison Cubiste* with its façade, 10 metres by 3 metres, built by Raymond Duchamp-Villon. Other collaborators in the project, issuing from the ideals discussed with such passion at Puteaux, include André Mare, Marie Laurencin, Maurice Marinot, Jacques Villon, Georges Ribemont-Dessaignes and Roger de La Fresnaye.

1926. Thursday, Paris
At three-thirty in the afternoon Marcel meets Helen Hessel and Roché at Arago. An hour later Roché, who has just acquired a driving licence and purchased a three-seater Citroën 5CV, takes them in the little car to play tennis. Finding a fourth person, they enjoy a mixed-doubles, and Marcel uses a sliced shot that Roché admires.

Later Roché drives Helen and Marcel as far as the Porte Maillot, returning after dark down the Champs-Elysées, "swimming in the headlights." A game of chess rounds off the day.

1940. Monday, Paris
In reply to the Arensbergs' invitation to go to America "for the purpose of painting a decoration or decorations" for the Francis Bacon Foundation, "to be used in the installation of its art collection," Marcel writes a postcard accepting. As communication with the outside world from the occupied zone is virtually impossible, he addresses the card to Picabia's daughter Jeannine, who finds a way for it to be forwarded in an envelope to Hollywood via Lisbon.

Requesting that Arensberg apply to Washington for a temporary visa to be sent to the American consulate in Marseilles, Marcel says that further correspondence should be sent care of his

brother-in-law Duvernoy, in Sanary, in the unoccupied zone of France. "They will receive your letters in a permanent way," explains Marcel, knowing that it is "useless to write" to him at an address in the occupied zone.

1946. Monday, Paris
At twelve-fifteen Marcel lunches with André Breton [27.9.1946] at 42 Rue Fontaine.

1947. Tuesday, New York City
At seven-thirty Maria Martins and Marcel dine with the Kieslers.

1948. Thursday, New York City
When she visited Hollywood in June, Katharine Kuh successfully persuaded the Arensbergs to exhibit their collection in the autumn of 1949 at the Art Institute of Chicago. Today, in the morning, Duchamp meets Mrs Kuh, who is preparing the catalogue: he answers the queries she has about the collection and they discuss his own work.

Concerning the Large Glass [5.2.1923], Mrs Kuh notes that the Green Box [16.10.1934] is a record of the "associative events", and that Duchamp's approach was from "all possible associative angles. He investigated even the words…" He put everything in words first, "completely interrelated"; he "combined a kind of literature with his art" and considers "actual play on words as important as plastic art".

When he was in his early teens Duchamp apparently wrote about light, and he was particularly interested in the relation of light and colour to form. "Colour, form, shape, design even, and light grow out of the material that's used," notes Mrs Kuh. "Light does not emanate from the surface of a material, it comes from within… [Duchamp] is the only man to handle glass and reflective materials spiritually…"

He mentions his "preoccupation with motion and rest, with inter-relationships etc. like the relativity of speed… Dualism is always necessary – balance and counter balance."

Rrose Sélavy? Because philosophically he believes in anonymity. This was also why he "used wire instead of drawing" when working on glass.

1950. Saturday, Paris
In the early hours at Rue Hallé, Marcel hopes that Mary Reynolds is "not conscious enough

1.10.1909

to add, as torture, the refusal to die to the physical impetus". Three hours later at six, Marcel witnesses Mary's last unconscious minutes.

*

Widowed during the First World War, Mary Louise Reynolds made her home in Paris in 1923 at 14 Rue de Monttessuy, and "took part in the literary and artistic life which was resurrected in France after having been dormant" during the war. Although Marcel had met her before in New York, their friendship, which he described as "a true liaison, over many, many years", began in Paris [19.5.1924]. "Mary Reynolds was an eye-witness of the Dada manifestations and on the birth of Surrealism in 1924," he wrote later, "she was one of the supporters of the new ideas." Likening her collection of books, albums, magazines, catalogues of exhibitions to an "art and letters diary" over 30 years, Marcel believed it was on account of her close friends, many of them important figures of the epoch, that Mary was spurred "to apply her talents to the art of bookbinding". Apart from her own highly original ideas for bindings, such as those for books by Jean-Pierre Brisset and Raymond Queneau, Mary also executed a binding for Roché [10.8.1937]. Marcel designed the bindings for Alfred Jarry's *Ubu Roi* [26.11.1934], for *Anthologie de l'Humour noir* by André Breton, and provided her with the cover for *Rrose Sélavy* [19.4.1939], which is none other than the title on cardboard made for the *Boîte-en-Valise* [7.1.1941]: "de ou par Marcel Duchamp ou Rrose Sélavy."

A very independent woman, generous, and courageous "in her brave own way", during the Second World War she fought in the Resistance and narrowly escaped the Gestapo "by actually walking over the Pyrenees into Spain [2.1.1943]". Marcel considered her "a great figure in her modest ways".

1960. Friday, Paris
Replying to Stauffer's request to meet him in Paris, Duchamp suggests any day of the following week. He asks Stauffer to telephone him as soon as he arrives from Zurich.

1 October

1897. Friday, Rouen
In the morning, after walking down the hill from the Ecole Bossuet in single file with the other boarders, Duchamp starts his first day in the Sixth Form at the Lycée Corneille.

Situated at 4 Rue du Malévrier, just on the edge of the old medieval city, the Lycée is installed in the buildings of a Jesuit college founded in the seventeenth century. Corneille, Cavalier de la Salle, Corot, Flaubert, Maupassant and Alain all attended the school.

1898. Saturday, Rouen
Starting his second year at the Lycée Corneille, Duchamp moves up to the Fifth Form.

1900. Monday, Rouen
In the evening, together with the other boarders, Duchamp is due to return to the Ecole Bossuet.

1901. Tuesday, Rouen
At eight-thirty in the morning Duchamp starts his fifth year at the Lycée Corneille with German, taken by M. Briois until ten. An hour of Geography with M. Guillon follows, and in the afternoon M. Nebout, the professor of Letters, teaches for two hours.

The remainder of the timetable of the Second Form (which includes Duchamp's friends Robert Dacheux, Pierre Dumont [3.10.1899] and Ferdinand Tribout) is as follows: Wednesday, in the morning M. Nebout teaches until ten, an hour of Mathematics with Léon Dumont follows, and in the afternoon there is History with M. Guillon; on Friday, M. Zacharie takes Drawing in the morning and M. Nebout teaches in the afternoon; on Saturday, Mathematics with M. Dumont is followed by German with M. Legrand, and M. Nebout again in the afternoon; on Monday, between the first two hours with M. Nebout in the morning and two more in the afternoon, Arthur Dumont (Pierre's father) is to take Geology in the spring term from ten until eleven o'clock.

1908. Thursday, Paris
On his return to Paris after a summer by the sea at Veules-les-Roses [6.9.1908], Duchamp moves to 9 Rue Amiral-de-Joinville [24.12.1907]. He continues to dabble with the humorists, but affirms his intentions to become a painter by submitting work for the first time to a Salon. Jacques Villon and Raymond Duchamp-Villon are both on the committee of the Salon d'Automne, which was founded in 1903 by their neighbour in Montmartre, the architect and critic Frantz Jourdain, to rival the Salon des Indépendants.

Although the jury, comprising Henri Matisse, Albert Marquet and Georges Rouault, rejects the paintings of L'Estaque by Georges Braque, which Matisse derides as being "made of little cubes", all three paintings by Duchamp are accepted: *Portrait, Cerisier en fleurs* and *Vieux Cimetière*.

The ruined cemetery (subject also of a charcoal drawing by Lucie Duchamp) was painted at Veules: "Under a sky of old-enamel blue rises a ramshackle ruin," observes the critic of *L'Ame Normande*, "where the arch of a window still stands upright, the stones of a chapel fall one by one. Part of the choir only remains and looks like a Roman aqueduct... and grass grows around vigorously, while the last iron crosses lean in the field of the dead, in the field of abandon."

1909. Friday, Paris
The great revelation of the Salon d'Automne held at the Grand Palais is the much admired collection of 24 portraits by Jean-Baptiste-Camille Corot [1796–1875], which include *Agostina* and the portrait of Alphonse Karr.

1.10.1910

Submitting work for the second time to the jury Duchamp has three paintings accepted: *Etude de Nu* (a "nude on a couch" which is sold to the celebrated dancer Isadora Duncan as a present for a friend) and two landscapes painted at Veules-les-Roses [22.8.1909], *Veules (Eglise)* and *Sur la Falaise*.

1910. Thursday, Paris
In spite of the reduction in space for the painters at the Grand Palais due to 18 rooms reserved on the ground floor for the German Decorative Arts, Duchamp has five pictures accepted at the Salon d'Automne: *La Partie d'Echecs, L'Armoire à Glace, Paysage, Nu couché* and *Toile de Jouy*. Having been accepted three years in a row, Duchamp becomes "Sociétaire", with the right in future to exhibit without submitting to the jury.

Painted during the summer months, *La Partie d'Echecs* is composed from a scene in the garden at Puteaux: Duchamp's bearded brothers are concentrating intently on their game of chess while Gaby Villon sits at an adjacent table laid for tea, and Yvonne Duchamp-Villon reclines in the foreground.

But if Cézanne's card players influenced *La Partie d'Echecs*, it is the great pictures by Henri Matisse in this year's Salon, "the large figures painted red and blue," which particularly impress Duchamp.

"As usual, the pictures by Matisse cause a scandal," observes Apollinaire; the two large panels *La Danse* and *La Musique*, he writes, have "a powerful effect".

1922. Sunday, Paris
"Rose Sélavy trouve qu'un incesticide doit coucher avec sa mère avant de la tuer; les punaises sont de rigueur" [Rrose Sélavy finds that an incesticide must sleep with his mother before killing her; bedbugs are *de rigueur*] is one of the "strange puns" sent to Picabia which Breton publishes today in *Littérature*. An essay by André Breton in veneration of Rrose's *alter ego* is illustrated with Man Ray's aerial photograph of the Domain of Rrose Sélavy [20.10.1921], and preceded by *Litanie des Saints*:

Je crois qu'elle sent du bout des seins
Tais-toi, tu sens du bout des seins
Pourquoi sens-tu du bout des seins?
Le veux sentir du bout des seins.

"A veritable oasis for those who are still searching, this name could well prove to be the rallying point for the violent assault necessary to liberate modern consciousness from its terrible fixation mania, which we never cease denouncing in these pages. The famous intellectual manchineel tree, which in half a century has borne the fruits called Symbolism, Impressionism, Cubism, Futurism and Dadaism, is simply asking to be cut down. Today, the case of Marcel Duchamp offers us a very precious demarcation line between the two spirits which are likely to become more and more opposed to one another at the very heart of *l'esprit moderne*, according to whether or not this 'spirit' claims to be in possession of the truth, which is rightly represented as an ideal naked woman only emerging from the well in order to go back and drown herself in its mirror.

*

"A face of admirable beauty, although none of its details is particularly striking, and in the same way anything one might say to the man would have the edge taken off it by coming up against a polished surface that concealed everything going on behind it, and yet a merry eye without irony or indulgence which dismisses the slightest suspicion of seriousness and demonstrates a concern to remain outwardly extremely cordial, elegance in its most fatal form, and over and above the elegance a really supreme ease – this, on his last visit to Paris, was the picture I had formed of Marcel Duchamp, whom I had never seen and whose intelligence, from the little I had heard of it, I expected to be wondrous.

"And in the first place we should note that Marcel Duchamp's situation in relation to the contemporary movement is unique, in that the most recent groups more or less claim to be acting in his name, although it is impossible to say whether or not they have ever had his consent, especially when we see the perfect liberty with which he detaches himself from ideas and movements whose originality was largely due to him, even before they have become systematized, thus putting some other people off them. Could it be that Marcel Duchamp gets to the crux of ideas more quickly than anyone else? At all events, when we consider the rest of his production, it would seem that from the very first days of his adherence to Cubism he was already making some sort of advances to Futurism (1912: *Le Roi et la Reine entourés de Nus vites* [9.10.1912]),

and that his contribution to both was very soon accompanied by reservations of a Dadaist order (1915: *Broyeuse de Chocolat* [8.3.1915]). Dada was no more successful in putting an end to such scruples. The proof is that in 1920, when no more could be expected of it, and when Tzara, who was organizing the Salon Dada, thought he was justified in including Marcel Duchamp among the exhibitors, Duchamp cabled from America the simple words "Nothing doing", which obliged Tzara to substitute for the expected pictures notices reproducing the numbers from the catalogue on a large scale, thus only barely saving appearances.

"Let there be no misunderstanding: we have no intention of codifying the modern spirit or, because we enjoy the riddle, of turning our backs on those who claim to be able to solve it. May the day come when the Sphinx, her riddle guessed, will throw herself into the sea. But so far, any such efforts have only been a mockery. We have met together and we shall meet again, in the hope of witnessing a conclusive experiment. Let us be as ridiculous and as touching as spiritualists, if you like, but let us beware of materializations, my friends, of whatever sort. Cubism is a materialization in corrugated paper, Futurism in rubber and Dadaism in blotting paper. And anyway, I ask you: Could anything do us more harm than a *materialization*?

*

"Whatever you may say, belief in immateriality is not a materialization. Let us leave some of our friends to flounder among these grotesque tautologies and let us come back to Marcel Duchamp, who is the opposite of St Thomas. I have seen Duchamp do an extraordinary thing: toss a coin into the air and say, "Heads I leave for America this evening, tails I stay in Paris." And this without the *slightest* indifference; no doubt he would infinitely have preferred either to go or to stay. But Duchamp is one of the first people to have proclaimed that choice must be independent from individuality, which he demonstrated, for example, by signing a manufactured object: for is not individual choice the most tyrannical of all, and are we not right in putting it to such a test, provided that this does not imply substituting for it a mysticism of chance?

"Ah! if only the coin could take a month, or a year, to fall, then everyone would understand us! Luckily, the decision is made between two breaths – and naturally it must be acted upon

1.10.1943

immediately – and there must be no lack of oxygen to start again at once. (It goes without saying that it will be the privilege of only a few to understand the foregoing, and it is they who will also appreciate – to their great amusement, alas! – the phrase written by a man who, basically, was quite unacquainted with such speculations: Guillaume Apollinaire; a phrase which gives the measure of the prophetic capacity he was so attached to: 'Perhaps it will be the task of an artist as detached from aesthetic preoccupations, and as intent on the energetic as Marcel Duchamp, to reconcile art and the people.')

*

"Writing these lines, in spite of the extremely ambitious title under which I thought I could put them together, I did not in any way promise myself that I would exhaust my subject, namely, Marcel Duchamp. I merely wanted to avoid the sort of errors Apollinaire and Dada made about him, and furthermore to ruin all future systematization of Duchamp's *attitude*, including his love of 'novelty', as it will inevitably appear to simple people. Yes, I know, all Duchamp does now is play chess, and he would be quite happy just to become unrivalled at it one day. Therefore, people will say, he has come down on the side of intellectual ambiguity; he agrees to pass for an artist, if you like, or even for a man who has produced little because *he could not do otherwise*. And so he, who was responsible for freeing us from that old cliché-ridden conception of lyricism-blackmail, which we shall have occasion to return to, would be seen by most people merely as a symbol. I refuse to see this as anything but a trap he has set. For my part, as I have said, what constitutes the strength of Marcel Duchamp, what has enabled him to survive several death-traps, is above all his *scorn for theory*, which will always astonish less favoured people.

"With regard to what is to follow, it would be a good idea, I think, for us to concentrate our attention on this scorn, and in order to do that it will be enough for us to evoke the glass picture to which Duchamp will soon have given ten years of his life, which is not the unknown masterpiece and about which the most amazing legends have already arisen even before it has been completed, or again to recall one or other of those strange puns that their author signs Sélavy and Rose, which demand special scrutiny:

CONSEIL D'HYGIENE INTIME:
IL FAUT METTRE LA MŒLLE DE L'EPEE DANS LE POIL DE L'AIMEE.
[Hint for intimate hygiene:
The substance of the sword must be stuffed into the bush of the beloved.]

*

"For Marcel Duchamp, the question of art and life, as well as any other question likely to divide us at the present time, does not arise."

1923. Monday, Paris
Duchamp spends the first of three days serving on the jury of the Salon d'Automne at the Grand Palais.

1926. Friday, Paris
Marcel lunches with Roché.

1943. Friday, New York City
After living for a year in the room sublet to him by his friends the Kieslers at 56 Seventh Avenue [2.10.1942], Duchamp moves around the corner to 210 West 14th Street. In a converted mid-nineteenth-century town house, on the top floor, reached by four flights of stairs, for $35 a month Duchamp rents the front room, measuring about 17 feet by 20, which is lit by a north-facing, floor-to-ceiling skylight. He shares the bathroom off the hallway with the occupants of the other two small living quarters on the same floor.

1946. Tuesday, New York City
"Anti-reality!" was Duchamp's spontaneous answer to Kurt Seligmann's inquiry, "What about magic..." [30.10.1945]. The quote appears in Seligmann's article "Magic and the Arts", published in the October issue of *View*.

Stranded in Paris and unable to obtain a visa to return to the United States [26.9.1946], Duchamp is not in New York when the memorial exhibition of Florine Stettheimer's paintings, which he helped to organize with Monroe Wheeler, opens to the public at the Museum of Modern Art.

Among the pictures exhibited are *La Fête à Duchamp* [28.7.1917]; *Picnic at Bedford Hills* [9.6.1918] and *Portrait of Marcel Duchamp* [24.10.1926], which Henry McBride describes as one of the most whimsical:

"There was nothing accidental in this, for Marcel in real life is pure fantasy. If you were

to study his paintings and particularly his art-constructions, and were then to try to conjure up his physical appearance, you could not fail to guess him, for he is his own best creation, and exactly what you thought. In the portrait he is something of a Pierrot [9.6.1921] perched aloft upon a Jack-in-Box contraption, which he is surreptitiously manipulating to gain greater heights for his apotheosis. Among the 'outside' portraits this is the best from the point of view of pure painting. It is also the simplest. The most complicated character in the whole range of contemporary art has been reduced to one transparent equation."

1950. Sunday, Paris
Duchamp cables the news of Mary Reynolds' death and details of the funeral arrangements to her close friends Henri and Hélène Hoppenot in Bern.

1959. Thursday, Paris
Publication by Le Terrain Vague of *Marchand du Sel*, writings of Marcel Duchamp, principally the notes of the Green Box [16.10.1934], the notices on the artists of the Société Anonyme [30.6.1950], and epigrams by Rrose Sélavy [19.4.1939], assembled and presented by Michel Sanouillet with a bibliography by Poupard-Lieussou. Glued and folded inside the front cover is a captioned illustration on cellophane of the Large Glass, photographed by Marcel Jean in Philadelphia, which Duchamp has numbered by hand to identify each element [25.10.1958]. The title of the book is inspired by a line from *Rrose Sélavy* by Robert Desnos [1.12.1922].

1960. Saturday, Paris
Worried about the proposed Surrealist exhibition in New York planned at the D'Arcy Galleries [28.7.1960], Duchamp sends an express letter to André Breton saying that he is in Paris for a fortnight and would like to see him.

1961. Sunday, Paris
"As you probably know already, I signed the etchings at Leblanc's a few days ago," writes Duchamp to Enrico Baj, hoping that his letter will arrive before the Italian artist leaves for New York to attend the opening of "The Art of Assemblage" exhibition at the Museum of Modern Art.

The edition that Duchamp has just signed is *Rébus*: returning to a favourite hobby-horse, he

DECOR FOR SATIE'S "SOCRATE" — Calder

1/2.10.1968

plays on "Tous les goûts sont dans la nature" (or "Every man to his taste in the Bush"), where the drawings of main drainage (*tout à l'égout*), a sonorous plait of hair and an ugly sow, represent the syllables of a wry, pungent version of the French expression equating taste with sewage.

1962. Monday, Paris
At the Café de Flore, 172 Boulevard Saint-Germain, Duchamp meets Enrico Baj, gives him copy number 41 of the Green Box [16.10.1934], and dedicates it to him on a slip of the café's printed paper.

1963. Tuesday, New York City
After four and a half months in Europe [15.5.1963], Marcel and Teeny enjoy a "perfect plane trip" on their return from Paris to New York.

1966. Saturday, Paris
In the morning at a quarter to eleven Duchamp is among the hundreds of mourners at the cemetery of Batignolles for the funeral of André Breton, who died at the age of seventy on 28 September.
The card announcing the writer's death bears the epitaph:

JE CHERCHE L'OR DU TEMPS
*
Duchamp is due to meet Louis Carré at twelve-fifteen.

1968. Tuesday, Neuilly-sur-Seine
The Man Rays come for dinner and are seated talking to Marcel when Robert and Nina Lebel arrive. As Teeny greets them, Lebel catches sight of Marcel "abnormally pale", reminding him suddenly of those fine nineteenth-century pictures representing very great men: Socrates, Cato, or Leonardo da Vinci... The vision fades as Marcel rises from his chair.
Man Ray has brought some magnificent photographs, which are handed round, including one of Marcel's birthday cake [28.7.1968].
They have dinner at the studio, Marcel is as frugal as usual with his food. He enjoys the pheasant, taking two helpings, which surprises and delights Teeny.
That afternoon Marcel had gone back to the old bookshop [22.9.1968] where he bought *Les Anaglyphes Geométriques* years before. He was absolutely delighted to find that they still had the same book, and he bought quite a few

of them. At the same time he found a new edition of Alphonse Allais, a favourite author of his, and bought that too.
When everyone has finally left, Marcel goes to his armchair and starts reading Alphonse Allais, while Teeny heats milk for his usual drink before going to bed. While she is in the kitchen she hears him laughing aloud over one of the Alphonse Allais stories. His happiness makes her feel it had been a nice evening.

2 October

1899. Monday, Rouen
The evening before commencing his third year at the Lycée Corneille, Duchamp returns to the Ecole Bossuet.

1900. Tuesday, Rouen
Duchamp commences his fourth year at the Lycée Corneille. His professor of Letters is M. Hamelin, who takes the Third Form from eight until ten every Tuesday morning, followed by Mathematics in the afternoon with M. Girod.
The timetable for the remainder of the week is as follows: on Wednesday at ten M. Vennin takes an hour of German, and in the afternoon M. Jourdan teaches History; on Friday at ten M. Girod takes Mathematics for two hours, and in the afternoon M. Zacharie teaches Drawing; on Saturday an hour of Geography with M. Jourdan is followed in the afternoon by German with M. Vennin until four o'clock; on Monday M. Hamelin teaches from eight until ten and from two until four.

1902. Thursday, Rouen
Returns in the evening to the Ecole Bossuet.

1903. Friday, Rouen
Having passed the first part of the Baccalauréat [21.7.1903], Duchamp returns for his last scholastic year at the Lycée Corneille. The morning commences with an hour each of Mathematics with M. Le Lieuvre, Natural History with M. Arthur Dumont, and Latin with M. Texcier followed by an afternoon of Philosophy, the first hour of which is devoted to the appreciation of authors. The young professor of Philosophy is M. Dominique Parodi.

Arthur Dumont, who taught Geology when Duchamp was in the Second Form [1.10.1901], particularly hates roses. "Is there any flower more ugly?" he asks the boys with his defective pronunciation. "I admit that it smells good, but this lalge cabbage upon a slim stem that plicks, that's leally hollible! The poets who plaised it ale stupid and the paintels who leploduce it have no taste. I have tlied to convince my son [3.10.1899] of it... A waste of effort! Sometimes he paints loses, lalge displopoltionate loses which he plefels – *Dieu sait poulquoi* – to the simple and lavishing dogloses. The wild lose, that's leal beauty."
*
For the rest of the week the timetable is as follows: on Saturday, in the morning, two hours with M. Parodi are followed by an hour of Physics taken by M. Lecaplain and, from two until three, M. Kergomard teaches History; on Monday, M. Parodi teaches until ten, M. Le Lieuvre takes Mathematics for an hour and, after lunch from two until three, M. Montailler teaches German, which is followed by an hour of Natural History with M. Dumont; on Tuesday, commencing at ten, M. Kergomard takes an hour of History, M. de Vesly teaches Technical Drawing until midday and, after an hour for lunch M. Texcier takes Greek until two, followed by two hours of Philosophy with M. Parodi; on Wednesday, after an hour each of Chemistry with M. Buguet, Physics with M. Lecaplain and Latin with Texcier, in the afternoon there is an hour of History with M. Kergomard, and then German taken by M. Montailler until four o'clock; on Thursday morning for two hours, M. Zacharie takes the Drawing class.

1924. Thursday, Paris
Sends an express letter to Jacques Doucet thanking him for the sample of black velvet [22.9.1924] for the optical machine [29.9.1924], which "seems perfect." The next operation is to fit the glass globe to the copper circle; "the whole completed will greatly please me," writes Duchamp, "and you as well I hope."

1928. Tuesday, Paris
The day following the premiere of *Un chien andalou*, a film directed by Luis Buñuel and Salvador Dali, at the Cinéma des Ursulines, Duchamp writes to Mrs Carpenter [18.5.1928] acknowledging the cheque of $200 for the Picabia sold to the Arts Club of Chicago. He

confirms that after speaking to Alice Roullier he has given instructions to George Of in New York permitting Budworth's to collect the Picabia exhibition [2.5.1928], and also gives her a list of prices including the four pictures taken by Alice Roullier from Paris.

1942. Friday, New York City
In the evening Stefi Kiesler prepares the studio-like room with a superb view, its own bathroom and private entrance on the twentieth floor of 56 Seventh Avenue, which the Kieslers are subletting to Marcel for a year.

1948. Saturday, San Francisco
The Société Anonyme lends *Rotorelief (Disques Optiques)* [30.8.1935] to the exhibition "Mobiles and articulated Sculpture" organized by Jermayne MacAgy, which opens at the California Palace of the Legion of Honor.

1950. Monday, Paris
Marcel cables Roché at Saint-Robert announcing the death of Mary Reynolds.

1951. Tuesday, New York City
Duchamp dines at eight with Monique Fong, who observes in him, "at the same time as an infinite concentration, an extraordinary liberty – humour… an all-powerful ease," constituting a man the likes of which, "in searching hard," she considers she is unlikely to meet two or three times in her life.

1958. Thursday, Paris
At 58 Rue Mathurin-Régnier, on the eve of his departure for New York Duchamp is interviewed for a book entitled *Ces peintres vous parlent*, published by L'Œil du Temps.
Regarding art in general, Duchamp observes: "Painting blends more and more with Society. It has become a subject of conversation. The grocer knows Matisse. Before, painting was esoteric and the Cubist revolution did not have the repercussions that it has fifty years later… In time, everything is distorted. It was like it is today: the movement lacked homogeneity. Everything is modified with anecdote…"
Does Duchamp think that painters have become more intellectual than sensitive?
"Rational intelligence is dangerous and leads to ratiocination. The painter is a medium who doesn't realize what he is doing. No translation can express the mystery of sensibility, a word

still unreliable, which is nevertheless the basis of painting or poetry, like a kind of alchemy…"

Je dois malheureusement partir vite j'ai passé 4 mois délicieux en France et en Espagne
Marcel Duchamp

Asked to write a few words for the publication, Duchamp scribbles: "Unfortunately I have to leave quickly I have spent four delightful months in France and Spain."

1960. Sunday, Paris
The Duchamps are invited to attend a cocktail party for the Friends of the Contemporary Art Center, Cincinnati, at the home of Louis Carré in Bazoches-sur-Guyonne near Paris.

1961. Monday, New York City
Opening of William C. Seitz's exhibition "The Art of Assemblage" at the Museum of Modern Art. Duchamp, who has not yet returned from Europe, has 13 works in the show, predominantly his readymades, but also his last painting *Tu m'* [8.7.1918], the Green Box [16.10.1934], and the *Boîte-en-Valise* [7.1.1941].

1962. Tuesday, New York City
In the evening the Duchamps return to Manhattan after a "very warm summer in Spain and beautiful fall days" in Paris.

1966. Sunday, Paris
The day after the writer's funeral, the short film made in homage to André Breton by Adam Saulnier, for which Duchamp was interviewed, is broadcast on the news by the ORTF.

1967. Monday, Neuilly-sur-Seine
At six in the evening, after her visit to the antipodes [29.5.1967], Monique Fong visits the Duchamps.

1968. Wednesday, Neuilly-sur-Seine

M. Duchamp
Born like a light
Lived like a light
Out like a light
And this was the delightful life of
Marcel Duchamp.

…as Sandy Calder expressed it so perfectly.

*

At one in the morning Teeny telephones Dr Robert Jullien [14.12.1961], who lives nearby, and he comes immediately.
By two o'clock she has recalled her dinner guests, and also Jackie and Bernard Monnier, who come to help her.

3 October

1899. Tuesday, Rouen
At the beginning of Duchamp's third year at the Lycée Corneille, the professor of Letters M. Barbé takes the Fourth Form for lessons today and for the rest of the week, except for the hour of German with M. Vennin on Saturday at ten o'clock. Each Monday the Fourth Form has German from eight until ten in the morning, followed by a Drawing class commencing at ten-fifteen with M. Philippe Zacharie, a professor at the Lycée since 1874, who has also been teaching at the Ecole des Beaux-Art now for twenty years.
Like his older brothers before him, Duchamp and his gifted classmates Pierre Dumont and Robert Pinchon will be having regular lessons with this experienced teacher until they leave school. An exhibitor at the Salon and a member of the Société des Artistes Français, Zacharie is a prolific classical painter, with no curiosity for the avant-garde. His most recent mural, *La Ville de Rouen protégeant la jeunesse des Ecoles sous l'égide de la République,* decorates the Patronage Scolaire de la Rue Saint-Lô, and he has a commission from the Lycée Corneille to paint the ceiling of the Salle des Actes.
Completing the timetable, every Monday afternoon from two until four M. Canonville-Deslys teaches the Fourth Form Mathematics.

1902. Friday, Rouen
The timetable at the Lycée Corneille for the boys in Rhetoric, preparing the first part of their Baccalauréat examination in this scholastic year, commences with an hour of Mathematics taken by M. Canonville-Deslys, followed by an hour of History with M. Jourdan [29.7.1901], and in the afternoon M. Roche

3.10.1950

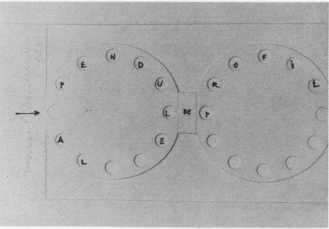

3.10.1964

[30.7.1898], the professor of Letters, teaches from two until four o'clock.

For the rest of the week: on Saturday M. Roche takes the morning class and in the afternoon there is an hour of German with M. Briois and an hour of Geography with M. Jourdan; on Monday, M. Roche takes the first class which is followed by an hour each of German, History and Mathematics; on Tuesday M. Roche teaches all day and also takes the class on Wednesday morning; in the first term only M. Jourdan takes History for an hour before lunch on Wednesday and in the afternoon there is an hour each of German and Mathematics; on Thursday morning, M. Zacharie teaches Drawing for two hours.

1905. Tuesday, Rouen
Within a few months, having successfully obtained his diploma as a copperplate printer, which automatically reduces his military service to one year, Duchamp engages voluntarily in the army [21.3.1905].

After breaking his attendance at the Académie Julian [15.5.1905], at the Imprimerie de la Vicomté in Rouen as an apprentice, Duchamp not only learned how to print his grandfather's plates of the "extraordinary views of old Rouen", but discovered the art and techniques of the typographer. When he presented himself for the examination at Rouen, "the jury was composed of master craftsmen," Duchamp remembers, "who asked me a few things about Leonardo da Vinci. As the written part, so to speak, you had to show what you could do by way of printing engravings. I had printed my grandfather's plate, and offered a proof to each member of the jury. They were enchanted. They gave me 49 out of a possible grade of 50."

1923. Wednesday, Paris
At noon in his office at Rue de la Paix, Jacques Doucet awaits his luncheon guest [28.9.1923], who is coming after his duties in the morning as a member of the jury of the Salon d'Automne at the Grand Palais. André Breton [1.10.1922] described him in a letter to Doucet a year ago as being "the man from whom I would be the most inclined to expect something, if he wasn't so distant and deep down so desperate, the man who alone has kept away from the public and who, up to now, has not wanted to be the hero of any adventure, however brilliant it might be (Cubism, Dadaism), a

mind that one finds at the origin of all the modern movements and which these different movements have not understood at all... His thinking here is a refuge for me."

1928. Wednesday, Paris
Further to his letter of the previous day, Duchamp cables the Arts Club of Chicago: "Sending details Picabia show = Duchamp."

1936. Saturday, Paris
Totor calls to see Roché in Arago and recounts his visit to Hollywood [21.8.1936]. The news of Louise and Walter Arensberg, Beatrice Wood and her pottery [10.8.1936] brings back memories of New York twenty years before...

1938. Monday, Paris
"I have sent a [green] box [16.10.1934] as you requested to your address today," writes Marcel to Naum Gabo in London. "You will have it soon after this letter. If you insist on sending me something," Marcel continues, "send me 100 francs, which more or less represents the discounted price to bookshops..." Having heard reports about Gabo's travelling exhibition in the United States, Marcel says: "I hope that you will prepare your 1940 exhibition during this period of peace (assured at least for a year)..."

1941. Friday, Sanary-sur-Mer
Since obtaining his passport and exit papers [25.8.1941], Marcel has been awaiting news of his American visa. Between them Walter and Louise Arensberg have completed five documents in application for a visitor's visa for Marcel, which have been forwarded via their lawyer to the authorities in Washington. Although René Lefebvre-Foinet, who is now in Los Angeles [25.4.1941], has advised her that no further action is required, Miss Dreier, impatient for results, has made an application for Marcel as well. Brookes Hubachek, to whom Mary Reynolds and Marcel are looking as "banker" [27.4.1941], has told Arensberg that he is mystified by the "number of letters from Marcel giving [him] complicated instructions concerning disposition of funds..."

Marcel confirms to Beatrice and Francis Steegmuller that Villon (who has been receiving the funds via Hubachek) is very happy with their financial assistance, enabling him to work, "although I have heard," writes Marcel, "that life in Paris is more expensive even than in the

unoccupied zone... But, unhappily, there is almost nothing to be found!" he explains, "meat once or twice a week, vegetables, little or no fish. But what will it be like next winter?"

*

Further to his letter on Monday, Duchamp sends a note to Victor Brauner proposing to meet him in Marseilles on Wednesday: "I would like to have Laurette to lunch too if she is in Marseilles."

1945. Wednesday, New York City
Dines with the Kieslers at 56 Seventh Avenue.

1948. Sunday, New York City
Travels to Milford to visit Miss Dreier.

1949. Monday, New York City
"Many thanks for having taken the train tickets [23.9.1949]: the Roomette will be filled with smoke," writes Duchamp to Katharine Kuh, who has made arrangements for him to travel to Chicago on 18 October. "I feel very sorry," he adds, "that the Arensbergs won't be there for the opening. Am writing them."

1950. Tuesday, Paris
At eleven in the morning, Marcel attends the funeral service for Mary Reynolds at the American Church, Avenue George V.

1951. Wednesday, New York City
Receives a letter from Miss Dreier, mentioning that Dr Lee does not object to her having a few visitors. "He does not realize," comments Dee, "that there is as much medication in a friend's visit as in any good drug."

1953. Saturday, Philadelphia
Among those attending the opening of "Before Columbus: Pre-Columbian Sculpture from the Arensberg Collection" at the Philadelphia Museum of Art are Duchamp and Man Ray.

1958. Friday, New York City
After four months in France and Spain, the Duchamps return to 327 East 58th Street.

1961. Tuesday, New York City
The return home from Paris, considers Teeny, "was the least trying yet. It seems like a perfect time to leave and arrive, no traffic getting back to New York, so one can take the Expressway to [Queens] Midtown Tunnel and we were home in a jiffy. No trouble with the customs

4.10.1905

and the Air France personnel and everything was delightful (plane almost empty)…"

1964. Saturday, Paris
Duchamp verifies that the model of the folding paper sculpture which he has designed as an insert in the "de luxe" edition of Lebel's book, *La Double Vue* (due to be published later in the year), is in working order, signs and dates it.

1967. Tuesday, Neuilly-sur-Seine
Duchamp receives a visit from Jiri Padrta, who is preparing a publication in Czech about him.

4 October

1905. Wednesday, Rouen
After signing up the previous day, Duchamp joins the 39ème Régiment d'Infanterie at the Jeanne d'Arc barracks as a second-class soldier.

1950. Wednesday, Paris
Alone, Marcel attends the cremation of Mary Reynolds at Père Lachaise cemetery. According to instructions sent by Brookes Hubachek to Marcel, the ashes are to be sent to Chicago, to be placed in the family burial vault.

*

After telephoning him on his arrival at Sèvres from the Corrèze [2.10.1950], Roché returns at seven o'clock to Arago [23.9.1950] and finds Marcel very thin, tired and starting a cold. As Marcel has chosen Etienne Martin's bed in the apartment, Roché changes the sheets and then they go out to dinner. In the restaurant on the Place Denfert-Rochereau, Marcel shivers a little but Roché thinks that, considering everything, they have quite a good talk together.

1951. Thursday, New York City
"Here in N.Y. very little is happening. Most people are not back yet," Dee says, replying to Miss Dreier's letter which he received the previous day. However "a chess tournament is in the offing", one day a week at his club, and there is a project of an exhibition with Rose Fried. "I suggested a family show," explains Marcel, "…I thought we might call it Duchamp *frères et sœur*, like the sign on a commercial firm in France."

"The world of art coagulating seriously," writes Marcel to Yvonne Lyon [8.1.1949]. "The cliques of artists with prefabricated formulas pullulate, and I am really pleased not to be starting my life today. Unfortunately there is no question of travelling at the moment because the only way to survive is to lie low."

1954. Monday, New York City
As requested by André Breton [31.8.1954], Duchamp comments on Michel Carrouges' book, *Les Machines Célibataires* [15.4.1954] and a text by Jean Reboul, both analysing the Large Glass [5.2.1923].

"Bachelor Machine, in relation to *La Mariée…*, expression describing a group of operations, is only important for me as a partial and descriptive title and not that of a title with an intentionally mythical theme.

"In the Bachelor Machine an erotic desire in action is 'brought' to its 'projection' of appearance and mechanized character.

"In the same way the Bride or the *Pendu femelle* is a 'projection' comparable to the projection of an 'imaginary entity' in 4 dimensions in our world of 3 dimensions (and even in the case of flat glass to a re-projection of these three dimensions on a surface of 2 dimensions).

"Using the green box, Carrouges has brought to light the underlying process with all the meticulousness of a submental dissection. Needless to say that his discoveries, if they constitute a coherent whole, were never *conscious* in my preparatory work because my unconscious is *mute* like every unconscious; that this preparation turned more on the *conscious* necessity to introduce 'hilarity' or at least humour to such a 'serious' subject. Carrouges' conclusion about the atheist character of the Bride is not unpleasant but I would like to add that in terms of 'popular metaphysics' I am not prepared to discuss the existence of God – which means that the term 'atheist' (as opposed to the word 'believer') doesn't even interest me, no more than the word believer, nor the opposition of their quite clear meanings.

"For me there is something other than *yes, no* and *indifferent* – it is for example *the absence of investigations of this kind*. And now Reboul's text taught me to what reactions the glass can lead a mind 'armed with pseudo-scientific clairvoyance'; I say 'pseudo' because psychiatry uses methods similar to those of the artist, methods by which interpretation can rave at will.

"It's a way of telling you that I like his descriptive analysis of *La Mariée…* and above all his paragraph on the 'readymades'.

"I like too his diagnosis of my particular case of schizophrenia. Completely unaware of the gravity of my case, I am not more alarmed, having already passed a good part of my life in this mist behind the glass. Besides, I have in any event at my disposition the *thermometer* of chess, which registers quite precisely my deviations from a line of thought strictly 'syllogistic'… Keep me abreast of the debates in *Médium…*"

*

In the paragraph on the readymades (referred to by Duchamp), Jean Reboul observed that the readymades exhibited by Duchamp have "a homologous aspect to the delirious expression released in the Bride. These objects find themselves repressed from their original, prehistoric world in itself, that of their constituent elements in the raw state, not yet regulated by the world for itself (today shattered) of their 'abductor', barricaded in his autism. Then struck with peculiarity, dehumanized, scoured of affective warmth, which normally should link them to 'our' world, they are reified, 'thingified', *to a second degree,* stricken by the contagious segregation which mutilates man, himself 'thingified'."

1956. Thursday, New York City
"Affectionately and atavistically," Marcel confirms to Roché that the sum for the small glass, *9 Moules Mâlic* [19.1.1915], which Teeny is buying [5.6.1956], has been deposited according to his instructions.

1962. Thursday, New York City
Teeny and Marcel have supper at Denise Hare's.

1963. Friday, New York City
Explaining to Monique Fong that he returned on Tuesday and leaves for Pasadena on Sunday, Duchamp asks: "When are you coming this way again?"

1965. Monday, New York City
Published in the catalogue for the exhibition "New Sculpture by George Segal" at the Sidney Janis Gallery, is the statement: "With Segal it's not a matter of the found object; it's the chosen object. Marcel Duchamp."

5.10.1960

5 October

1916. Thursday, New York City
Soon after their first meeting [27.9.1916], Marcel dines with Beatrice Wood and her journalist friend Alissa Franc at the Dutch Oven.

1917. Friday, New York City
While dining with the Arensbergs and Roché, Marcel announces that he has been interviewed by French officials and is likely to become secretary to a French captain in New York.

1923. Friday, New York City
Dated August 1923, *Love Days* by Henrie Waste [9.6.1921], which is published by Alfred A. Knopf, "[goes] out into the world today."

1930. Sunday, Paris
Having assembled most of the pictures for the Société Anonyme since his return from the Midi [15.9.1930], Dee cables Miss Dreier in New York: "Everything ready to be shipped next week stop except Léger Stella away stop second shipment will follow."

1948. Tuesday, New York City
Duchamp has an appointment with Mrs Batsell [28.9.1948], who is interested in seeing the Paul Klees belonging to Miss Dreier, with a view to selling one.

1950. Thursday, Paris
In the morning Roché thoughtfully brings Marcel his breakfast in bed. Marcel goes out at nine, but in the evening he has dinner with Roché and Elizabeth [Humes?] at Mouton-Duvernet. Afterwards they call at 14 Rue Hallé, so that Roché can see Mary's sitting room again before everything is dispersed.

1951. Friday, New York City
In the afternoon at four o'clock Duchamp meets Monique Fong.

1960. Wednesday, Paris
At one o'clock at La Coupole in Boulevard Montparnasse, Duchamp meets Daniel Spoerri [23.6.1960] and Serge Stauffer, with whom he

has been corresponding since 18 August 1957. While drinking apéritifs at the bar they talk about Greece [1.9.1960], Mexico, Arthur Cravan, Edition MAT [27.11.1959], and the exhibition project "Bewogen Beweging", which is to be held at the Stedelijk Museum, Amsterdam, and the Moderna Museet, Stockholm [21.8.1960].

While eating oysters in the restaurant, Duchamp recalls Massiac [9.7.1958], Puy Mary [1.9.1904], and the Facteur Cheval ("life is a swift charger, my mind will live with this rock"), the architect and builder of the magical Palais Idéal at Hauterives in the Drôme.

While Duchamp dissects a pig's trotter, his companions introduce various subjects: New York, gastronomy, the countryside, Paris, Cadaqués, Salvador Dali, chess in three dimensions, the chess book written with Halberstadt [15.9.1932], Raymond Roussel [10.6.1912], "Expo 58" in Brussels [20.6.1958], Socialist Realism, democracy, competition, the infamy of work, the French philosopher and economist Charles Fourier, the idle society, the German philosopher Max Stirner, language…

After lunch, Duchamp takes Stauffer back to Max Ernst's apartment, 58 Rue Mathurin-Régnier. After talking about Ionesco's play *Rhinocéros* (which opened in Paris on 25 January), Duchamp studies very carefully, page by page, the dummy of the book Stauffer is preparing on the notes for the Large Glass.

1965. Tuesday, Neuilly-sur-Seine
"I utterly agree with you on the election of the new Satrapes [of the Collège de 'Pataphysique] which you propose," writes the Transcendant Satrape Duchamp to His Magnificence the Vice-Curateur Opach, recently elevated to this position following the death of Baron Mollet (former secretary to Guillaume Apollinaire), "and I am happy to salute you in your eminent office…"

1966. Wednesday, Paris
André Parinaud's homage to André Breton [1.10.1966], published in *Arts et Loisirs*, is based on a "kind of meditation" in the company of Breton's "old friend" Duchamp.

"The great thing about Breton," Duchamp tells Parinaud after some reflection, "I have not known a man who had a greater capacity for love. A greater power to love the magnitude of

life, and one understands nothing of his loathings if one doesn't know that, for him, it was a question of protecting the quality even of his love of life, the marvellous of life. Breton loved as a heart beats. He was the lover of love in a world that believes in prostitution. It is there his mark."

Duchamp explains that it was Picabia who introduced him to Breton [22.7.1921], when the group were intensifying their "daring experiences," which included experiments with psychic and hypnotic sleep [1.12.1922], automatic writing, and manifestos.

"I was never associated with the team exploration of these unknown territories," Duchamp declares, "because of a kind of temperamental impossibility of exchanging my most intimate self with anybody. And then, I was fifteen years older than these young men… But none of their attempts to penetrate the gates of mystery left me indifferent or was unknown to me…"

Finally Duchamp asks: "Who more than [Breton] has meditated on the decision of human happiness, has meditated on the causes of conflict and antagonism which can arise, even when the classless society is installed; who better than he has brushed with the great, surreal explanation of life; this total awareness of a limitless truth, who has loved more than he, this drifting world?"

What will remain of Surrealism?
"For me," replies Duchamp, "it embodied the most beautiful dream of a moment of the world."

1967. Thursday, Neuilly-sur-Seine
Receives a telephone call from Monique Fong, who is in Paris.

6 October

1936. Tuesday, Paris
Having received a long letter from Miss Dreier, Dee adds a postscript to his own of 29 September to say that the copy of *Anémic Cinéma* [30.8.1926], belonging to the Société Anonyme, which Catton Rich of the Art Institute of Chicago was enquiring about [25.8.1936], *is* inflammable. "If they want it," writes Dee, "you can ask them $10 for renting it. I would like it not so much for the amount but for the principle…"

 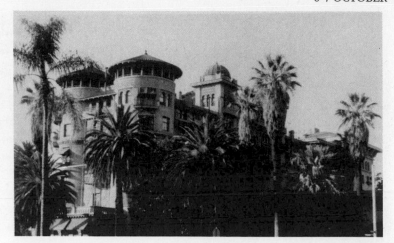

6.10.1963

1947. Monday, New York City
When he hears that the house Arago is "undisturbed" [23.8.1947], Totor writes expressing his relief to Roché.

1950. Friday, Paris
Marcel has a leisurely breakfast in the morning at Arago, talking to Roché until eleven before going out.

1951. Saturday, New York City
"For a whiff of fresh air," Duchamp travels to Town Farm, Woodbury to visit Kay Sage and Yves Tanguy.

1953. Tuesday, New York City
Marcel cables Arensberg that Man Ray was in Philadelphia on Saturday for the opening of "Before Columbus: Pre-Columbian Sculpture from the Arensberg Collection", and sends his love to them both.

1963. Sunday, New York City
At nine-thirty in the morning, Teeny and Marcel leave for Idlewild, where, accompanied by Richard Hamilton and Bill Copley, they depart on an American Airlines flight at eleven forty-five for Los Angeles. Weather conditions are perfect and Marcel, who is sitting next to Richard, "keeps pointing out places of geographical interest, identifying several times the Mississippi…"

Walter Hopps has promised to be at the airport when the plane is due to arrive at two-fifteen to take them to Pasadena. At Marcel's request they are staying a short distance from the museum at the astonishing Hotel Green, a vast Italianate palace of turrets and loggias set in the midst of a flat lawn planted with tall, slender palm trees.

1965. Wednesday, Paris
The series of eight canvases entitled *Vivre et laisser mourir ou la fin tragique de Marcel Duchamp*, painted by Messieurs Aillaud, Arroyo and Recalcati and exhibited in "La figuration narrative dans l'art contemporain" at the Galerie Creuze, induces an immediate reaction.

Marcel has been asked to visit the gallery by his friends, just before the opening. When he sees the painting he isn't at all upset; in fact it rather amuses him. He signs the guest book. However, his friends André Breton, Robert Lebel, André Pieyre de Mandiargues and Arturo Schwarz are among fifty who sign the tract, "Le 'Troisième Degré' de la Peinture," condemning what it refers to as "a loathsome crime disguised as a ritual assassination".

7 October

1918. Monday, Cannes
While working as a surgeon [1.1.1916] treating the wounded at Mourmelon in the Marne in 1916, Duchamp-Villon contracts a streptococcus infection [24.2.1918] through a graze on one of his hands, which results in blood-poisoning; painful abscesses appear on different parts of his body and although he is in the

capable hands of the surgeon Gosset, he is greatly weakened by his suffering and does not survive the operation to remove the eighteenth abscess. At seven o'clock in the evening he dies, at the age of 42 in the military hospital 72, Montfleury. A telegram is sent to 7 Rue Lemaître, which his wife Yvonne [9.9.1903] receives on her return from Cannes after spending leave with her husband.

An assistant medical officer in the 68ème Régiment d'Artillerie à pied at the time of his death, Duchamp-Villon's name is inscribed in the register with the words: "Mort pour la France."

1926. Thursday, Paris
At eleven o'clock in the morning Marcel meets Roché. Later they go to Neuilly, where, together with the Picabias, they are invited to have lunch with M. and Mme Jacques Doucet.

During the day Marcel collects a lens from Demaria which he is to take to New York for Brancusi.

A week before his own departure, Marcel writes to Brancusi in New York to assure him in detail about the transport of his sculptures, and sends him the preface for the catalogue by Paul Morand [13.9.1926]. "*Au revoir* dear Morice, I'm impatient to leave," complains Marcel Morice, "Paris is idiotic…"

1947. Tuesday, New York City
In the evening at seven-fifteen Marcel visits Stefi and Frederick Kiesler at 56 Seventh Avenue.

1948. Thursday, New York City
Duchamp has lunch with Alfred Barr, the director of the Museum Collections at the Museum of Modern Art, who agrees to accompany him to Milford on 19 October.

*

Gives his written authorization for the New York World Telegram to reproduce in an advertising brochure from a black-and-white photograph his *Nu descendant un Escalier,* No.2 [18.3.1912].

1949. Friday, Boston
Duchamp is invited to attend the opening today of the "Jacques Villon–Lyonel Feininger" exhibition at the Institute of Contemporary Art, which includes loans from the collection of the Société Anonyme.

On his way back to New York he has promised to stop at Milford to see Miss Dreier.

1950. Saturday, Paris
At eleven in the evening Roché is at home when Marcel returns to Arago.

1960. Friday, Paris
In the morning at eleven o'clock, Duchamp receives Serge Stauffer [5.10.1960], who presents him with a copy of Henri Arvon's book on Max Stirner. Among the subjects they discuss: *Réseaux de Stoppages* [19.5.1914], photography, language as convention, Wittgenstein, the title of Stauffer's forthcoming book for which Duchamp suggests "Climat Duchamp", the translation of certain passages, the "happiness" of the Large Glass [5.2.1923], *Avoir l'apprenti dans le soleil* [25.12.1949]…

Before Stauffer leaves at one o'clock, Duchamp telephones Man Ray to arrange for Stauffer to collect some documents from him.

*

In the afternoon Duchamp is interviewed by George Charbonnier for a series of radio pro-

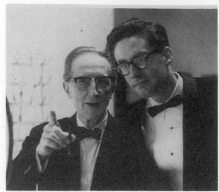

7.10.1963

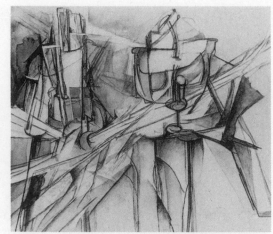

9.10.1912

grammes to be broadcast on France Culture in December and January.

1962. Sunday, New York City
Accepts an invitation from Mrs Selma Rosen to give his lecture "A propos of myself" at the Baltimore Museum of Art on 10 February.

1963. Monday, Pasadena
Duchamp's first major exhibition "By or of Marcel Duchamp or Rrose Sélavy" is installed in rooms surrounding the central courtyard of the Pasadena Art Museum. The first gallery is hung with the early work, the second with pictures and objects relating to chess, and a third is decorated with paintings from Duchamp's Cubist period, including the famous *Nu descendant un Escalier* [18.3.1912]. The replica of the Large Glass lent by the Moderna Museet [5.9.1961] dominates the main gallery, where the readymades are also shown; the optical experiments are reserved until last with Duchamp's own miniature museum: the *Boîte-en-Valise* [7.1.1941].

Orchestrated by Walter Hopps, the evening commences at six when the Duchamps are invited with the president and trustees of the museum and special guests, including the French consul, Richard Hamilton, Bill Copley, and Beatrice Wood from Ojai, to cocktails and dinner at the home of Mr and Mrs H. Leslie Hoffman at 1100 Avondale Road, San Marino.

To the special "black-tie" preview, held from eight-thirty until ten o'clock under the Asian-style turquoise tiled roof of the museum on North Los Robles Avenue, Hopps has invited artists, dealers and other personalities of the Southern Californian art world. Julian Wasser's camera captures Larry Bell, and also Dennis Hopper and Billy Al Bengston with Andy Warhol, who has an exhibition at the Ferus Gallery in Los Angeles.

The celebrations continue afterwards at the Hotel Green, where the first vice-president of the museum, Robert A. Rowan, and his wife Carolyn give a memorable reception which, Teeny says, is "more like a ball with music, champagne and dancing..." Beatrice Wood, who has brought Ram Pravesh Singh, dances indefatigably; before Wasser's camera Edward Ruscha holds a candle for a portrait with Patty Callahan, and all the artists, including Duchamp, sign a pink tablecloth. It is a marvellous evening.

1964. Wednesday, Neuilly-sur-Seine
At midday precisely Marcel is due to meet Louis Carré at 7 Rue Lemaître, Puteaux, (where his brother had lived since 1905) for a last visit before the bulldozers demolish the house. The new urban development of La Défence was postponed by André Malraux, Minister of Cultural Affairs, to enable Jacques Villon to live there until his death [12.6.1963].

Also before going to London on Friday, Marcel provides two lines in manuscript for the announcement of Carré's show in November, "Francis Picabia chapeau de paille? 1921," in which the "masterpiece of the month" is Picabia's *L'Œil cacodylate* [1.11.1921]. Marcel slightly modifies the sentence which he composed more than thirty years ago for Picabia's painting, and with the additional introductory words evokes both Eros and a text by Apollinaire [29.6.1913]:

"...et roses pour
Fr' en 6 π qu'habillarrose Sélavy"

8 October

1916. Sunday, New York City
After trying to see Alfred Stieglitz on two occasions without success, Charles Duncan writes urging Stieglitz to bring Duchamp into the fold of his gallery 291. Arguing that Duchamp and Picasso are "the vital contemporary artists", Duncan thinks it would be interesting to make a comparison of the two artists' work. "The nature of Marcel's sensibility," he believes, "is more particular in experience, which means he is a few centuries more developed as a human animal than our beloved Picasso..."

1917. Monday, New York City
As the result of the interview before the weekend [5.10.1917], Marcel learns this morning that he has been appointed personal secretary to a French captain on a war mission in New York for the French government and, starting tomorrow, he will be working from nine-thirty to five every day.

Announcing this "great change" to the Stettheimer sisters in Tarrytown, who will be expecting him as usual for their French lesson

on Wednesday, Marcel writes: "I ask you therefore to abandon my lessons until they sack me – that will be, perhaps, in eight days or in eight years..." Although he wants to be useful to his country, Marcel regrets becoming "a miserable bureaucrat abandoning everything he has loved and loves in N[ew] Y[ork] for the last two years..."

*

During the day, Marcel removes the small glass, "the funny red figures" as Roché calls it (*9 Moules Mâlic* [19.1.1915]) from his studio, and takes it down to the Arensbergs' apartment.

1924. Wednesday, Paris
From Jacques Doucet Duchamp receives the velvet for the optical machine [2.10.1924] and also an invitation to lunch the following Wednesday, which he accepts by express letter.

1932. Saturday, Paris
Following the Arensbergs' decision to purchase two paintings by Picasso, Marcel cables Walter in Hollywood to say that he has obtained a reduction for the Cubist one, and that it is "fine" for the nude in November.

1935. Tuesday, Paris
Miss Dreier is "overjoyed" to have the *Colonne sans fin* [6.9.1935] to place on the island by the pool at The Haven. "It's the very first column Brancusi did," Dee tells her, "...and Brancusi has a weakness for it."

She wants to buy some sets of the *Rotoreliefs* [30.8.1935] as Christmas presents: "It was a marvellous experience when I put it on the gramophone," Miss Dreier told Dee enthusiastically. Explaining that he sells each set of 6 discs in a black box at $1 a box, Dee mails her 5 sets and proposes subtracting 75 francs from the money he owes her after small transactions related to the subletting of her apartment in the Place Dauphine [5.3.1935].

1941. Wednesday, Sanary-sur-Mer
Duchamp is due to travel to Marseilles, where he has arranged to meet Victor Brauner at the Café Noailles at noon [3.10.1941].

1950. Sunday, Paris
His last morning at Arago, Marcel has an early breakfast with Roché. After going out for a while, he returns to the apartment at ten-thirty to pack his belongings. Further conversation

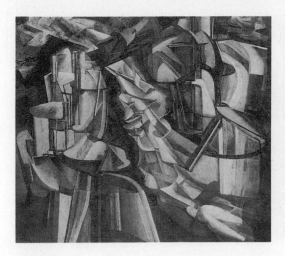

with Roché, who finds it so natural to have Marcel staying with him. They look at an erotic album from China. Since he has decided to stop smoking, Marcel gives all his tobacco to Roché. As if to leave a token of his presence in some way, Roché makes a mannequin with a bronze head by Brancusi, which he lays on the bed that Marcel was using at Arago.

1951. Monday, New York City
Duchamp has received a copy of *Art has many faces*, Katharine Kuh's "wonderful new book". There are illustrations of the famous Nude [18.3.1912], *Mariée* [25.8.1912] and the Large Glass [5.2.1923]. In a chapter entitled "The Machine" she comments that, in his work, Duchamp "mechanizes the human being and humanizes the machine…"

Harper Brothers, the publishers, have now written asking Duchamp for his comments on the book. "If they intend to use them for their publicity," explains Duchamp to Mrs Kuh, "I would rather give them excerpts of an informal letter to you."

He continues: "So refreshing to 'see' an Art book and not read it – an Art book should carry its message through images, not through words. And this, the common error of all art books to 'explain' Art in the very inadequate jargon of the critic has been here successfully avoided, with the result that I hope more people will begin to open their eyes rather than their ears where and when art is concerned."

1957. Tuesday, New York City
Replies point by point to a long letter from Lebel, who is concerned about the slow progress of his book, the proofs in French, and the English translation, neither of which Duchamp has received.

Lebel has now seen the *Boîte de 1914* [25.12.1949] belonging to Dumouchel in Nice, and one of his questions is about the meaning of the sentence under the drawing of a cyclist riding uphill. Duchamp replies: "*Avoir l'apprenti dans le soleil* [25.12.1949] belongs to the moment in my life when I glued together bits of different arts (writing and drawing for ex[ample]) without any descriptive connection with each other (at least as little connection as possible)."

As the fragile 14 hand-coloured transparent photos of the Large Glass for the "super luxes" [4.6.1957], which he has been working on all summer, are almost finished, Duchamp plans to

ask Jackie Monnier to take them with her when she returns to Paris around 1 November.

1963. Tuesday, Pasadena
In the afternoon Joan Smith takes the Duchamps to a tea party organized by Mrs Toby Franklin Wilcox at 1071 Arden Road. With Walter Hopps they linger long enough to watch the television newscast.

In the evening at the crowded public opening of the exhibition, seated in the middle of the gallery, which is arranged with the chess paintings and objects, Duchamp and Hopps concentrate on a game of chess. Julian Wasser, who was in attendance at the preview the night before, is taking more pictures, then suddenly has an idea: he asks a young friend, Eve Babitz, if she would agree to be photographed nude playing chess with Duchamp. With her consent, Wasser then disappears and arranges for the session to take place one morning a few days later.

9 October

1912. Wednesday, Paris
Issuing from the activities of the Société Normande de Peinture Moderne, combined with the energy and ideas generated by the circle at Puteaux, the exhibition opening nine days after the Salon d'Automne is baptized "Section d'Or".

"The few artists whose works are assembled here exhibited last year [20.11.1911] in too small a gallery to show to their advantage," writes René Blum in the preface to the catalogue, "…they have no common direction nor deep affinities between themselves but a unique thought leads them: to disentangle Art from tradition…"

It is curious, all the same, that the invitation to the candlelight opening of the "Section d'Or" at 64 Rue La Boétie is made in Duchamp's name together with Gleizes, Picabia, Dumont and Valensi, when Duchamp has been absent for several months [19.6.1912] and has made no promises to his brothers about the exact date of his return [26.9.1912].

According to the catalogue, Duchamp exhibits six works, four of which are identifiable. After its rejection earlier in the year and

its voyage to Barcelona [20.4.1912], *Nu descendant un Escalier, No.2* [18.3.1912] is shown to the Parisian public for the first time and passes almost unnoticed.

The two works on the chess theme, made after the Nude but before Duchamp went to Munich – a watercolour entitled *Le Roi et la Reine traversés par des Nus en vitesse* and a canvas, *Le Roi et la Reine entourés de Nus vites* – contrast with the earlier chess picture *Portrait de Joueurs d'Echecs* [15.6.1912].

For *Le Roi et la Reine entourés de Nus vites*, Duchamp claims he used the back of the canvas on which he painted *Le Paradis* in 1910

"Adam, and Eve"

because he didn't have anything else available at the time. Compared with the richly coloured, tranquil landscape in which, with a voluptuous Eve, his friend Dumouchel represents Adam, the new painting focuses sharply on two static, sculptural elements; "the right-hand side on top is male, the King, and on the left-hand side is a female, and that was very important," Duchamp explains. "I felt that the line should express it without using the descriptive form of the body." The King and the Queen are beset by two, rapid cross-currents, one of a steely blue. "The swift nudes are a flight of imagination [19.8.1912]," says Duchamp, "introduced to satisfy my preoccupation of movement still present in the painting."

In the first and only number of *La Section d'Or*, the bulletin published by Pierre Dumont for the exhibition, is a rousing text by Apollinaire entitled "Jeunes peintres ne vous frappez pas!", defending the artists from the critics. "Don't forget that shots were fired on Victor Hugo," he warns them. "His glory was not diminished. On the contrary."

1917. Tuesday, New York City
Following confirmation of his appointment on Monday morning, Duchamp starts work as personal secretary to a French captain.

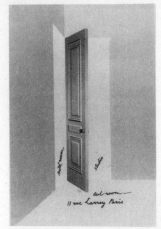

9.10.1937

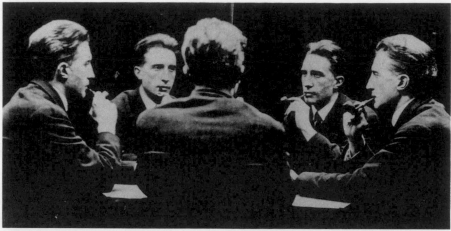

10.10.1917

1926. Saturday, Paris
After seeing Totor at the Café du Dôme, Roché has trouble starting his little car [30.9.1926].

1933. Monday, Paris
From the Oasis in Rue Vavin, Duchamp writes a card to Miss Dreier with Nina and Wassily Kandinsky [10.5.1929], who have recently moved from Nazi Germany and, on Duchamp's recommendation, have settled in Neuilly.

1937. Saturday, Paris
During André Breton's lecture "L'Humour noir" at the Comédie des Champs-Elysées, Marcel Jean is invited to demonstrate on a blackboard the mechanism of Duchamp's door at 11 Rue Larrey. As shown in the pages of *Orbes*, which appeared in the summer of 1933, Duchamp's door contradicts the maxim that a door is either open or closed: "When one opens the door to enter the bedroom, it closes the entrance to the bathroom, and when one opens the door to enter the bathroom it closes the entrance to the studio…"
 Duchamp was compelled to find a way of providing privacy between the studio and the bedroom after Lydie, his fiancée [12.5.1927], on leaving the bathroom one day in a state of undress found herself face to face with Jean Crotti, her future brother-in-law.

1943. Saturday, New York City
At seven o'clock Marcel (who himself has just moved) dines with Mary Reynolds at her new home at 73 Perry Street. Mary has also invited the Kieslers, from whom Marcel was subleasing accommodation until 1 October.

1948. Saturday, New York City
After his lunch with Alfred Barr on Thursday, Dee writes to Miss Dreier asking whether he might come to see her next Saturday prior to his visit to Milford with Barr.

1952. Thursday, New York City
Duchamp outlines in detail a proposition to André Breton on behalf of Fleur Cowles, the editor of *Look* [8.11.1949] and *Flair*, who would like to consecrate about 50 pages of her next "almanac" to the history of Surrealism. As the current almanac for 1952–53 has just been published, Duchamp promises to send a copy to Breton, and requests his "provisional" reactions as soon as possible.

1958. Thursday, New York City
"We have the good fortune to be the guests of Mr & Mrs Washburn during our stay in Pittsburgh," writes Duchamp to Mrs Schilpp, Mr Washburn's secretary, who is arranging accommodation for those on the jury of the Pittsburgh International [1.4.1958]. As requested he gives her the time of their arrival on 16 November.

1964. Friday, Neuilly-sur-Seine
Bernard Monnier comes to say goodbye, and Jackie then takes Teeny and Marcel to Orly for their flight to London. Despite the bad weather, once above the clouds they have "a perfect flight". After landing at 4:15 p.m. they take a taxi from the airport, but the London traffic is "nasty" in the rush hour. It takes two and a half hours to get to Richard Hamilton's house on Hurst Avenue, where they are invited to stay.

1965. Saturday, Neuilly-sur-Seine
In case he has not received an invitation for the exhibition "Hommage à Caïssa", due to open on 8 February for the benefit of the American Chess Foundation, Duchamp invites Daniel Spoerri [10.3.1961] "formally" and asks him either to deposit the work he is donating at the Galerie Iolas or to arrange for International Art Transport to collect it. "In recompense," explains Duchamp, "I will give you an etching [11.5.1965] that I made especially at the beginning of the summer for all the participants."

10 October

1917. Wednesday, New York City
Like Duchamp and Picabia, Roché has a five-way portrait made of himself at the Broadway Photo Shop, 1591 Broadway. Copying the profile on the right of Duchamp's photograph,

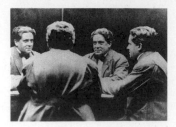

Picabia made a portrait of Duchamp (replacing his pipe with a cigarette) entitled *Métal*, which he published in the July issue of *391*.

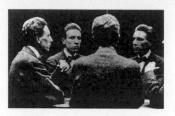

1928. Wednesday, Paris
In the evening after seeing Rita [?] earlier, Marcel writes to Brancusi [28.8.1928]: "It's agreed: not Friday, Monday if you can," and proposes to call at the studio beforehand. After only about ten days back in the capital he complains: "Life in Paris is unbearable. I will soon be going away."

1931. Saturday, Paris
When Marcel, who has been in Villefranche [8.9.1931], arrives at Arago in the evening at seven, Roché finds him: "all smiles, subtle, a little unwell [17.8.1931], clear-headed, adorable." They go to Rue Ernest Cresson to dine with Helen Hessel, who is to have a hip operation and is due to leave for Frankfurt with Roché the following day.
 After dinner, watched by Roché and Helen, Marcel plays chess with Kadi [18.4.1931], who is making progress. He leaves them at eleven o'clock.

1933. Tuesday, Paris
Roché visits Rue Larrey and tells Marcel, who is back from Spain [28.9.1933], of his dramatic rupture with Helen Hessel and the existence of his two-year-old son. Believing that Helen was about to find out about his life with Denise and their son, Roché decided to admit everything himself. On the night of 14 July, when he confessed, Helen tried to kill him with her revolver but he managed to prevent her from firing any shots. "I'll get you," she threatened. "I'll take my time. I know now how to do it – I have to kill you from behind. In France it's a *crime passionnel*: I will be acquitted."
 Fearing for his life, Roché has been hiding. Knowing that Helen has been on the prowl near Bellevue, he is constantly on his guard and

11.10.1912

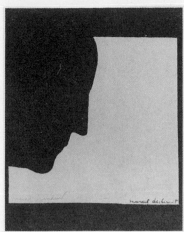

11.10.1958

keeps a revolver in his pocket. Roché hopes that Marcel, who knows Helen well, will eventually be able to tell him how she is.

1943. Sunday, New York City
Acknowledges two letters and a cheque from Miss Dreier. As John Schiff has not yet delivered the photographs, Dee promises to go to collect them on Monday and "mail them immediately".

1945. Wednesday, New York City
For the third consecutive Wednesday evening, Marcel dines with the Kieslers.

1950. Tuesday, Paris
Marcel invites Roché to spend the evening with him at 14 Rue Hallé. After dinner, which Roché finds "very charming and poignant at times", they have a long talk.

1960. Monday, Paris
In his role as chairman of the American Chess Foundation's Arts Committee for American Chess [9.6.1960], Duchamp writes to some friends in Europe asking them to donate a work of art to a special auction in New York, the proceeds of which will be used to help good American chess players participate in international tournaments.

1964. Saturday, London
With Teeny, who has lent a painting to the show, Marcel visits the Miró exhibition at the Tate Gallery.

1966. Monday, Neuilly-sur-Seine
At ten o'clock in the morning Duchamp has an appointment with Arturo Schwarz.

11 October

1912. Friday, Paris
A staunch defender of the artists exhibiting in the "Section d'Or", which opened on Wednesday, Guillaume Apollinaire gives the first lecture at 64 Rue La Boétie, which he entitles "L'Ecartèlement du Cubisme" [the Quartering of Cubism]. Using ideas he is developing for the book he is writing, *Médita-*

tions esthétiques, Apollinaire divides Cubism into four categories: scientific, physical, instinctive and orphic.

Apollinaire wrote to Duchamp in Munich to ask him for a portrait photograph to publish in his forthcoming book, and the document was made by the young photographer Hans Hoffmann, who had taken Franz Marc's old studio at 33 Schellingstrasse, not far from Duchamp's lodgings in Schwabing [1.7.1912]. If Duchamp and Apollinaire had not met previously [10.6.1912], the "Section d'Or" on Duchamp's return from Germany (whenever that may have been [26.9.1912]) was the occasion for them to do so.

1926. Monday, Paris
In the afternoon at three-thirty Marcel meets Roché and Daubas [?].

1941. Saturday, New Haven
At a meeting, the trustees of Yale University agree to accept the donation of the Collection of the Société Anonyme, Inc. (Museum of Modern Art) made by its trustees, Marcel Duchamp and Katherine Dreier [1.9.1936]. Duchamp gave his approval to the donation by telegram from France on 9 August.

1958. Saturday, New York City
Replies to Robert Lebel's letter that he received in the morning explaining the three different works superimposed on the canvas entitled *Réseaux de Stoppages* [19.5.1914]. The pencil tracing "is that of the Large Glass, 'complete' (invisible or almost, with many omissions)," writes Duchamp. "It is rather a sketch for the overall dimensions (to half the scale), the opposite way round from Printemps."

Duchamp has sent Arnold Fawcus about 20 examples of *Autoportrait de Profil*, the profiles [25.3.1957] torn by hand and signed "Marcel dechiravit" for copies of the book in the category "*hors commerce*", and remarks to Lebel that the next stage will be the printing of the text: "Only after that, will we be able to glimpse the end of the tunnel."

1961. Wednesday, New York City
Duchamp is "agreed and delighted" with Simon Watson Taylor's proposal to lunch with him on 19 October. "Telephone me 2 days before to confirm as you suggest."

12 October

1920. Tuesday, New York City
After looking for Alfred Stieglitz at his address in 59th Street and finding that the building is being "remodelled", Duchamp assumes that he has gone to Lake George, and writes to him there from 19 East 47th Street [30.4.1920] asking for a painting by Georgia O'Keeffe for a forthcoming group exhibition at the Société Anonyme gallery.

1926. Tuesday, Paris
Having great difficulty in understanding what the Italian artists are planning for the Société Anonyme exhibition due to open 19 November, and why she is now unable to have any pictures from Carrà [26.5.1926], Miss Dreier has written an SOS to Duchamp. He cables to confirm that in Paris he has only received the work of Dottori and Paladini.

1936. Monday, Paris
At Hans Arp's request, Duchamp mails two copies of the Green Box [16.10.1934] to Mrs Norton in London. Writing to advise her of the minimum sale price in England and the amount she owes him, Duchamp asks Mrs Norton whether she is interested in having some *Rotoreliefs* [30.8.1935], the discs which she may have seen at the Surrealist show in London [11.6.1936].

1947. Sunday, New York City
At midnight Marcel calls at the Kieslers' apartment at 56 Seventh Avenue and stays for an hour.

1958. Sunday, New York City
Receives a telephone call from Monique Fong.

1959. Monday, New York City
Feeling incapable of writing a special text, Marcel suggests to Suzanne that "the famous letter" [17.8.1952] which he wrote to Jean [30.1.1958] could be used for the catalogue of the forthcoming exhibition at the Musée Galliera. If she will send it back to him, Marcel offers to read it again and modify it a little if necessary.

13.10.1963

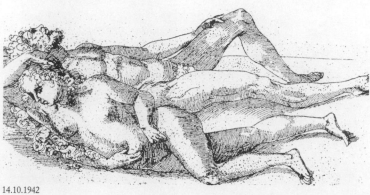

14.10.1942

He tells his sister that they have finally found an apartment, at 28 West 10th Street.

1964. Monday, London
After their experience on Friday, Teeny and Marcel plan to leave 25 Hurst Avenue early to be at Heathrow in good time for their flight to New York, which is due to depart at noon.

1967. Thursday, Neuilly-sur-Seine
Marcel writes to Brookes Hubachek and encloses Ektachromes of two paintings by Jacques Villon, a study for *Les Grands Fonds*, painted at La Brunié [16.7.1940], and a portrait, neither of which has been "on the market". Proposing that the Art Institute of Chicago or one of the trustees might be interested, Marcel explains that Villon gave the pictures to Georges Herbiet [10.6.1963], "a very close friend of the family," who now needs the money.

*

Armed with photographs of the wooden chessmen which Duchamp carved in Buenos Aires [22.6.1919], Arturo Schwarz comes to measure the originals.

*

After her telephone call [5.10.1967], Monique Fong visits the Duchamps at 5 Rue Parmentier.

13 October

1924. Monday, Versailles
At twelve-thirty Marcel is with Roché, Brancusi, Hélène Perdriat and de Zayas.

1926. Wednesday, Paris
After Roché has called to say farewell, Marcel takes the boat train from the Gare Saint-Lazare to Le Havre.
In the evening at eleven o'clock Rrose cables Elsa Triolet at the Hôtel Istria from the maritime station: "Paris leaves in one hour."

1944. Friday, New York City
Writes to Ettie Stettheimer enclosing a copy of the letter he wrote to Monroe Wheeler towards the end of September proposing a memorial show of Florine Stettheimer's paintings [18.5.1944] at the Museum of Modern Art. Wheeler, whom Duchamp saw briefly recently,

has the matter in hand, "But nothing official yet," Duchamp advises Ettie.

1948. Wednesday, New York City
After visiting her family in Chicago, Mary Reynolds has been staying at the Chelsea Hotel before returning to Europe. Describing New York as "untenable", she tells the Hoppenots: "They have invented more noises since 1945, and neon lights blaze everywhere day and night."
Mary finds Marcel "a tired wisp of a chess player", who is "thinner than ever but quite well – the only familiar sight in this bewildering world, and yet more bewildering than the environment."
Today Marcel accompanies Mary from the Chelsea to the ship. "Though I left him with a few pounds added, it wasn't enough," she writes sadly, "and I hated to see him walk off the boat so fragile…"

1950. Friday, Paris
In the evening at seven, Totor calls at Arago. After he and Roché have enjoyed a good dinner at the Balzac, they visit the Ludo, a café with a billiard academy at 13 Rue de la Sorbonne, but Roché is tired and he declines to play.

1954. Wednesday, Philadelphia
In a week of celebration for the Louise and Walter Arensberg Collection [28.12.1950], now installed in the galleries [23.8.1954], inaugurated on Monday with a special press view and open to the public from Saturday, George Widener, the chairman of the trustees of the Philadelphia Museum of Art, gives a magnificent dinner, to which the Duchamps are invited.

1959. Tuesday, New York City
Daniel Spoerri's idea of multiplying "animated works" – his Edition MAT [Multiplication d'Œuvres d'Art] – is progressing: the catalogue is to be printed soon and Jean Tinguely has constructed a unit covered with black velvet incorporating a motor in order that Duchamp's *Rotoreliefs* [30.8.1935] can be hung vertically. Duchamp, whom Spoerri considers as the precursor of his idea, has promised to participate and has started to send him 35 sets of the edition published for Rose Fried [6.12.1953].
"So you will receive 2 packets of boxes," explains Duchamp, "which the *Rotoreliefs* slip into, and on which they are laid when the

boxes are open and stood on a long-spindled gramophone… Afterwards, at different intervals, you will receive 4 packets of *Rotoreliefs* (9+9+9+8=35)." Saying that he hopes that the idea is still going through, as a postscript Duchamp adds: "If possible I would like to receive the equivalent of 10 dollars by *Rotorelief* sold – if, however, that fits in with your general plans."

1962. Saturday, New York City
"The great event of next spring will be a revival of the Armory Show [17.2.1913]," Marcel tells Brookes Hubachek in Chicago. "I have accepted to be of help and expect to be very busy trying to locate the scattered paintings; (there were over one thousand in the 1913 show – happy if we find the half of it). All we hope now," says Marcel, "is to see you sometime either here or there – and tell you about our summer…"

1963. Sunday, Pasadena
Marcel acquired the brown straw hat with a tartan band in Las Vegas during the week. After the opening of the exhibition [8.10.1963], Bill Copley invited Teeny and Marcel to fly to the desert oasis for twenty-four hours with Richard Hamilton, Betty Asher, Walter Hopps and Betty and Monte Factor. "We did have fun," revealed Teeny. "Went to the best hot shows and all the most amusing gambling dens…" A souvenir photograph of the group was taken while they dined at the Stardust and in an hour of

LAS VEGAS, NEVADA

amusement at the Golden Nugget, Marcel (who didn't gamble himself while he was in Las Vegas) directed Hopps' placing of chips on the gaming tables from time to time as they sat chatting. Gradually Marcel became more specific in his instructions and Hopps realized that "winning numbers were coming up with increasing regularity". When Marcel said "it was a nice time to stop", Hopps initial stake of $20 had increased more than a hundredfold.

LA SCIENCE TRIOMPHANTE

M.D. *A la manière de Delvaux* **LE PÉCHÉ ORIGINEL**

The day after returning from Las Vegas, the brown straw hat with a tartan band accompanied Marcel to the early morning photographic session with Julian Wasser at the museum where, in the centre of the room with the Large Glass, he played chess with brave Eve Babitz who willingly stripped bare for him. Hat in hand, Marcel was then interviewed by Francis Roberts in Hopps' office.

During his long conversation with the journalist, Duchamp mentions that *La Broyeuse de Chocolat* [8.3.1915] appears in many places in his work: "Always there has been a necessity for circles in my life, for, how do you say, rotation. It is a kind of narcissism, this self-sufficiency, a kind of onanism. The machine goes around and by some miraculous process I have always found fascinating, produces chocolate."

The brown straw hat is with Marcel again today. On his second visit to Ojai [15.4.1949], Beatrice Wood gives a lunch party for Marcel at McAndrew Road, her home since 1954. As well as Ram Pravesh Singh, who accompanied Beatrice to the special preview [7.10.1963], the guests are Walter Hopps, Betty Asher, Richard Hamilton, a Japanese couple and Harriet von Brerton. Later they have tea at the Esther Baur Gallery, Santa Barbara, before returning to Pasadena.

1966. Thursday, Paris
For a replica of *Pocket Chess Set* as it was exhibited in "The Imagery of Chess" [12.12.1944], Duchamp writes a label for the back of the wooden box: "Seen liked and approved Marcel Duchamp 13 October 1966."

14 October

1923. Sunday, Paris
From his studio [15.7.1923] at 37 Rue Froidevaux, Duchamp writes accepting Jacques Doucet's invitation to meet him on Wednesday.

*

Later in the day Duchamp travels to Rouen where he plans to stay until Tuesday evening.

1926. Thursday, Le Havre
Accompanying some 20 bronzes, marbles and stones by Brancusi stored in the hold as freight,

with all the consulate and customs papers in order, Marcel leaves for New York on the *Paris*, which sails at one-fifteen in the morning.

1935. Monday, Paris
As 300 francs is owed on 15 October for six months' storage of Miss Dreier's furniture, Dee proposes to pay the sum and asks Miss Dreier if she will "charge it on the transportation of the Brancusi column [6.9.1935]".

1941. Tuesday, New Haven
Following the decision made at the meeting of the trustees of Yale University on Saturday, Miss Dreier signs the Deed of Gift and Agreement making the donation of the Collection of the Société Anonyme to Yale University.

The Agreement provides for the addition of works of art to the collection by the Grantors but also for the closing of the collection, "at and upon the death of both Katherine Dreier and Marcel Duchamp." In one clause "the Grantors express the hope that the Grantee will be generous in lending objects in the collection to other public institutions as have been the Grantors in the past," and in another the Grantee agrees to publish a catalogue of the collection when funds are available.

1942. Wednesday, New York City
As announced in the catalogue, the exhibition "First Papers of Surrealism" has an "opening sanctified by children playing, with the perfume of cedar". Held in the Whitelaw Reid Mansion at 451 Madison Avenue for the benefit of the Coordinating Council of French Relief Societies, Inc., the exhibition is the second that Duchamp helps organize in partnership with André Breton [17.1.1938]: Breton is responsible for its "hanging", and Duchamp signs "his twine".

With the help of Sandy Calder and using miles of guncotton, Duchamp has made a Sleeping Beauty's Palace by weaving an intricate web from wall to wall, camouflaging the painted, gilded ceiling and chandeliers. After a frightening false start caused by the spontaneous combustion of their material, which they had attached unwittingly to all the lamps, each alcove of pictures, as well as the ceiling, is finally safely entwined with an impenetrable mesh of string, making the paintings themselves difficult to see.

At Duchamp's request, the Janis' young son Carroll is invited to bring some friends to play

ball during the opening. Should anyone want to throw them out, Carroll is told to reply: "Marcel Duchamp said we could play." Dressed for action in baseball pants, a football jersey and basketball sneakers, Carroll asks the elegantly dressed visitors for a contribution of a dollar to kick the ball.

Working closely with Breton on the catalogue, Duchamp has designed the cover, which features two close-up photographs printed on yellow paper. On the front is a pitted and pebbled section of wall from Kurt Seligmann's barn at Sugar Loaf, into which Duchamp has fired five shots, perforating the cover; on the back, with an impression in dark green for the title of the catalogue, is the more savoury landscape of what appears to be Gruyère cheese.

In the section entitled "On the Survival of Certain Myths and on Some Other Myths In Growth or Formation", the page entitled "Original Sin" has a drawing by Hans Baldung Grien of Adam and Eve, a quotation from Hegel and below it, *A la manière de Delvaux*, a round, photographic collage made especially for the catalogue by Duchamp. In fact the small oval mirror reflecting the breasts of a figure is the central element of a composition by Paul Delvaux around which four, sturdy tree trunks, metamorphosed into four, fair young women are planted in the foreground of a dry and barren landscape: *L'Aurore*, which Peggy Guggenheim purchased from E. L. T. Mesens in June 1938, was brought to New York with the rest of her collection from Grenoble [25.4.1941]. On the page entitled "Science triumphant", the quotation is by Alfred Jarry: "Science with a capital S, or rather, because that is still not imposing enough... SCIENCE with a capital SCYTHE." The sound-wave perceptive bat is juxtaposed with *La bonne et la mauvaise nouvelle* by Puvis de Chavannes, in which the Good News and the Bad News fly, personified, over a hilly, coastal landscape with a telegraph pole and wires in the foreground.

14.10.1966

In the section of the catalogue devoted to the artists and their work, Duchamp and Breton "have thought it best here to resort to the general scheme of 'compensation portraits'..." On the page reproducing *Réseaux de Stoppages* [19.5.1914], Duchamp's "compensation portrait" is by Ben Shahn.

1944. Saturday, New York City
Marcel thanks Yvonne Lyon for having replied so quickly [21.9.1944] and says that he has received a letter from his sister Suzanne (which crossed with his of 24 September?) via an American soldier: "Everyone is alive and the houses are still standing." Not trusting the post, he encloses a letter for Villon to be forwarded and asks Yvonne to write from time to time: "that leads one to believe in peace."

1950. Saturday, Paris
Since 8 October, Marcel has been living at 14 Rue Hallé. With the responsibility after Mary Reynolds' death [30.9.1950] of emptying the house, one of his tasks for her family is to arrange for the books, magazines, exhibition catalogues and pamphlets to be assembled, packed and transported to Mary's brother Brookes Hubachek, who intends making a donation of this valuable collection to the Ryerson Library at the Art Institute of Chicago.
In the morning Marcel receives a telephone call from Violaine [4.9.1946] on behalf of her parents, the Hoppenots, who would like to contact the owner of the house. Marcel has already informed the agent that he would like to leave the place on 15 November, and writes to the Hoppenots: "At any price this house is a gem and can be transformed without great expense." He thanks them "very deeply" for their letter and, he adds, for "your feelings of very close friendship for Mary, whose departure, so rapid and so silent at the same time, still remains an enigma."

1951. Sunday, New York City
In the afternoon at three Duchamp meets Monique Fong.

1963. Monday, Pasadena
At nine-thirty in the morning Duchamp telephones the Francis Bacon Library. Unable to speak to Elizabeth Wrigley [1.2.1954], he leaves a message saying that he hopes to see her when he returns to California at the end of the month.

1966. Friday, Amsterdam
Attends the opening at the Stedelijk Museum of Bill Copley's exhibition, the catalogue of which announces "Tremendous Deliriums"... The camera of Ed van der Elsken captures four masters of twentieth-century art playing the fool: first, posed in an "official" line-up, standing from left to right, René Magritte, Duchamp, Max Ernst and Man Ray, the first three holding a copy of Bill's catalogue; then Ernst turns his back and buries his head so that it disappears while Duchamp puts his finger in and Man Ray raises his cane as if to strike him; the third shot records the amusement of all concerned.

Ad Petersen of the Stedelijk, who also has his camera at the opening, takes a photograph of Duchamp conversing with the Dutch chess champion, Jan Hein Donner.

15 October

1904. Saturday, Paris
The etching by Jacques Villon of Marcel and Suzanne playing chess, the game which their elder brothers taught them, is exhibited today at the Salon d'Automne.

1924. Wednesday, Paris
Jacques Doucet, the collector, is due to call at the Hôtel Istria at noon to take Duchamp to lunch [8.10.1924].

1927. Saturday, Paris
Duchamp is one of the fourteen competitors in the Tournoi Championnat de Paris directed by Vitaly Halberstadt. Commencing today, the tournament is to be played in the different chess clubs of the capital.

1934. Monday, New York City
A touring exhibition, "Eight Modes of Painting," organized by the College Art Association in collaboration with the Société Anonyme, opens at the Junior League Galleries. From her own collection Miss Dreier lends Duchamp's second study for *9 Moules Mâlic* entitled *Cimetière des Uniformes et Livrées,* No.2 [19.1.1915]. The exhibition is to be shown in seven other locations, closing at the Detroit Institute of Arts on 28 May 1935.

1942. Thursday, New York City
"The opening of the Surrealist show took place last night and seems to be quite a success," writes Dee to Miss Dreier. "I was not there, (this is one of my habits)," he continues, "But reports indicate that the children played with great gusto." Suggesting that they visit the exhibition together when Miss Dreier next comes to New York, Dee is keeping a copy of the catalogue for her.

1951. Monday, New York City
Replying to the Arensbergs' enquiry about his two early paintings in the exhibition "Brancusi to Duchamp" [17.9.1951], Marcel says they were among the "some 16 early works" which he sent them photographs of two years ago [18.12.1949]. He promises to enquire about the prices and informs Arensberg that the pictures belong to Roché and not Janis.

Regarding the continuing saga of the tax demand [23.9.1951], Marcel suggests: "If you send me a photo of Miró's *Man and Woman* I can put my memory to delightful torture and find a date and price for it..."

1954. Friday, New York City
Confirming their departure on 6 November for France on the *Flandre*, Marcel replies to Roché's concern for their needs at 99 Boulevard Arago: "No daily help, Teeny is a very good cook."

1955. Saturday, New York City
As adviser to the Cassandra Foundation, in the evening Duchamp meets the artist, Nicolas Carone.

1956. Monday, New York City
Thanks George Heard Hamilton, the curator of the Société Anonyme Collection, for agreeing to lend Villon's *La Table Servie* and Du-

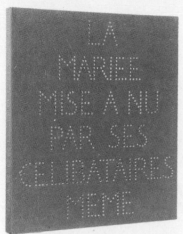

16.10.1934

champ-Villon's *Femme assise* for the "Three Brothers" exhibition due to open at the Guggenheim Museum on 8 January. "I am very flattered to be asked for my prose," Duchamp continues, enclosing a copy of *Rendez-vous du Dimanche 6 Février 1916 à 1 h 3/4 après midi*. He claims that it has only been published in his *Boîte-en-Valise* [7.1.1941], forgetting that it was reproduced in *Minotaure*, No.10 in 1937.

*

Writes to Lee Malone in Houston.

1961. Sunday, New York City
Writes a note to Brookes Hubachek in Chicago to say they are back and "in good shape" [3.10.1961], and mentions Jackie Monnier's arrival in New York on 19 October with a group of French collectors, who will be visiting a number of cities, including Chicago, at the end of the month.

1965. Friday, New York City
On the day that Duchamp returns home with Teeny from Paris, his interview with Wieland Schmied, which was recently recorded in Hanover [29.9.1965], is broadcast by the Norddeutscher Rundfunk.

1967. Sunday, Neuilly-sur-Seine
Accompanied by Teeny, Marcel leaves from Orly airport on Air France flight 816, which is due to depart at two o'clock in the afternoon. Richard Hamilton has promised to meet them on their arrival at London airport.

16 October

1923. Tuesday, Paris
In the evening Duchamp returns to Rue Froidevaux after spending two days in Rouen.

1934. Tuesday, Paris
Since his return to Paris on 21 September, Duchamp has finally launched Rrose Sélavy as a publisher at 18 Rue de la Paix, address of the Travelers Bank.

"Well dear your amazing book has arrived!!!!" exclaims Miss Dreier. "It is one of the most perfect expressions of Dadaism which has come my way. I was terribly amused

at myself," she admits, "how annoyed I was when I saw all those torn scraps – and of course the glass *was* broken!!!!! At first it seemed to me that I just could not bear all those torn pieces of paper – and then I woke up to the fact – how right Dada is to jolt us out of our ruts…"

When Anaïs Nin visited Rue Hallé recently, Duchamp showed her the publication and told her that this form should hereafter replace finished books. "It is not the time to finish anything," he said. "It's the time of fragments."

The circulation of a very distinguished announcement of the limited edition has also commenced. "I am sending you three copies of the subscription form for a book that I have just published about a picture in glass which I made some years ago," writes Duchamp today to Alice Roullier, hoping that "without too much bother" she will find him one or two clients in Chicago for the "de luxe" version which costs 750 francs. "This book," he explains, "is in fact a box containing photographic reproductions of notes written by hand and photos of pictures."

Duchamp gives the green flocked cardboard box the same title as the work to which it is the key: *La Mariée mise à nu par ses Célibataires, même* [5.2.1923]. Also known as the Green Box, it contains a colour plate of *9 Moules Mâlic* [19.1.1915] and ninety-three other items, a selection from hundreds of working notes on scraps of paper, and studies carried out between 1911 and 1915, which determined the composition of the Large Glass. Significantly, Duchamp also includes in the box a reproduction of *Moulin à Café* [20.10.1912], the small grinding machine – a foretoken of the great lovemaking, bachelor machinery comprised in the Glass.

"I thought I could collect, in an album like the Saint-Etienne catalogue," explains Duchamp, "some calculations, some reflexions, without relating them. Sometimes they are on torn pieces of paper… I wanted that album to go with the Glass and to be consulted when seeing the Glass because, as I see it, it must not be 'looked at' in the aesthetic sense of the word. One must consult the book and see the two together. The conjunction of the two things entirely removes the retinal aspect that I don't like. It was very logical."

1935. Wednesday, Paris
Mary Reynolds, Marcel and Roché go together to Lloyds Bank at 43 Boulevard des Capucines.

1936. Friday, Paris
Acknowledges the cheque from Mrs Norton [12.10.1936] and promises to mail her six sets of *Rotoreliefs* [30.8.1935] today.

In a postscript Duchamp mentions that of the 20 "de luxe" copies of the Green Box [16.10.1934], he still has nine available for sale at the price of 750 francs [or 2,500 francs at present values]. He would need the name of the purchaser in order to perforate it inside the box.

1946. Wednesday, New York City
The miniature version which Duchamp made for Carried Stettheimer [23.7.1918] stands in for the original *Nu descendant un Escalier*, No.2 [18.3.1912] in the exhibition "1910–12. The Climactic Years in Cubism" held at Jacques Seligman's gallery at 5 East 57th Street.

1948. Saturday, New York City
Dee is due to travel to Milford to see Miss Dreier, who plans to ask him the current market price for the Paul Klee which she showed recently to Dr Henry Hope at the Museum of Modern Art.

1954. Saturday, Philadelphia
Almost four years after the bequest was made by the trustees of the Francis Bacon Foundation [27.12.1950], twenty-two galleries at the Philadelphia Museum of Art containing the Louise and Walter Arensberg Collection are opened to the public.

Sadly, neither of the Arensbergs have lived to see their collection exhibited in the museum (Louise died on 25 November 1953 and Walter on 29 January 1954), but Duchamp has supervised the installation of the collection in the museum according to the terms of the bequest.

In the heart of this extraordinarily fine collection of modern art is the very important group of works by Duchamp himself. Fulfilling the wishes of Miss Dreier, as one of her executors [29.3.1952], Duchamp arranged for the Large Glass [5.2.1923] to be bequeathed to Philadelphia [6.5.1952]. It now stands in the midst of the collection where it originally belonged.

17.10.1916

17 October

1916. Tuesday, New York City
Thanking Suzanne for emptying his apartment at 23 Rue Saint-Hippolyte [22.10.1913], Marcel tells her that after nine months at the Lincoln Arcade Building [1.1.1916] he is moving back to 33 West 67th Street, where he lived the previous summer [18.10.1915] as the guest of Louise and Walter Arensberg. "I will have a small studio, one room and bath in a very nice house of studios," he tells his sister.

Anxious for news about his *Egouttoir* [15.1.1916], Marcel asks "Have you written the phrase on the readymade – do it – and send it to me (the phrase) indicating how you did it."

Marcel tells his sister that Jean Crotti, one of the Musketeers [4.4.1916], who went to Paris alone, will now have been rejoined by his wife Yvonne. He sends his good wishes to Henriette and to all the friends at the hospital for the blind where she is working as a nurse [12.3.1915]. Suzanne in her uniform, the bearded pharmacist, the round-faced doctor with a moustache, and Paul François, the director of the hospital, were all subjects of drawings made by Marcel before he left for New York [6.6.1915].

1923. Wednesday, Paris
"Quite anxious to see the project of the frame" for *Deux Nus* [28.9.1923], at noon Duchamp is due to meet Jacques Doucet at his office in Rue de la Paix.

1934. Wednesday, Paris
Finding it "impossible to make a quick decision", Marcel has not replied to a long letter from Walter Pach which he received four months ago. Explaining that Alfred H. Barr, Jr., the young director of the Museum of Modern Art, has already made enquiries about borrowing *Nu descendant un Escalier,* No.1 [18.3.1912] for his exhibition "Modern Works of Art", Marcel tells Pach that he has asked its new owner, Walter Arensberg, to refuse to lend it. He requests Pach to take the same position and "refuse with a tame excuse, without acrimony".

Recognizing that a public dispute will only increase Barr's supporters, Marcel maintains

that "the critic's only weapon is silence". He agrees that artists such as Derain and Picasso would never support Pach's point of view, because "the nature of the artist is to devour his neighbour first..." Undertaking to define Barr for those who ask his opinion, "if this doesn't attack him in an obvious way," Marcel believes that sooner rather than later, "his malicious incompetence will automatically turn against him..."

As for those who employ Barr, Marcel says: "in the last ten years the American clients are formed entirely by the dealers on the Rue La Boétie." He considers that the collector, "in spite of himself, or even consciously, has been a speculator similar to buyers of Rembrandt or Raphael, and at this time when gold no longer has a steady value, the oil of paintings holds its own."

Mentioning that his book, the Green Box [16.10.1934], which he has been working on all summer, is finished and that Julien Levy has some copies, Marcel encloses some subscription forms, "just in case any of your friends are interested..."

1954. Sunday, New York City
"I do not intend to give you my reading of *Les Machines Célibataires* in detail but I am anxious to tell you how much I was taken by the multiple facets of your discoveries in the analysis of the comparative themes that you tackled and successfully," writes Duchamp to Michel Carrouges, whose book was published earlier in the year [15.4.1954].

Concerning Breton's "intention to open a general discussion" in his revue *Médium* on these myths in the light of Carrouges' book, Duchamp confirms that "not having available the necessary instruments for a studied view of these questions", he has replied "succinctly" to Breton [4.10.1954].

As the Large Glass is now on view to the public [16.10.1954], Duchamp suggests that the publishers should contact the Philadelphia Museum of Art for promotional and commercial reasons. He announces his voyage to Paris and writes: "I will see you if you are there..."

1956. Wednesday, New York City
In a meeting at the Guggenheim Museum, Marcel and James Johnson Sweeney work out a rough draft of acknowledgments to be included in the "Three Brothers" exhibition catalogue.

1964. Saturday, Milan
A group exhibition entitled "1908–1928" opens at the Galleria Schwarz in Milan, which includes two readymades by Duchamp: *Roue de Bicyclette* [15.1.1916] and *Fountain* [9.4.1917], both replicas edited by the Galleria Schwarz [5.6.1964].

1965. Sunday, New York City
With only the weekend to recover from their transatlantic flight, Duchamp tells Joseph Solomon, whose letter was awaiting their return: "We are leaving again tomorrow... We won't be back before Thursday," and invites him the following Monday at about six. "Let us know by telephone Friday morning if it is OK," requests Duchamp, giving Solomon the telephone number. "Delighted to see you again," he adds.

1966. Monday, Neuilly-sur-Seine
On the eve of his return to the United States, Duchamp writes to Hugh Shaw of the Arts Council of Great Britain thanking him for having sent the photograph to Maître Le Bertre [1.9.1966], and says: "We want to tell you how much we enjoyed meeting you on the occasion of the Tate Gallery show [16.6.1966], whose success was partly due to your devotion."

*

Is due to meet Louis Carré and his lawyer.

18 October

1915. Monday, New York City
In the afternoon after a weekend in the country, Duchamp returns to his room at 34 Beekman Place, the place he has recently moved to on the East River at the bottom of 50th Street. In contrast to West 67th Street, where he was the guest of the Arensbergs during the summer [2.8.1915], the neighbourhood is "nightmarish" according to Juliette Gleizes, who visited Marcel with Albert soon after their arrival from Barcelona.

After a long "terrifying" walk searching for the address, a narrow footbridge swaying high above the rooftops leads vertiginously to Marcel's room. As if to make himself at home, Marcel has already installed a revolving bicycle wheel on the kitchen table between the four legs of an upturned chair.

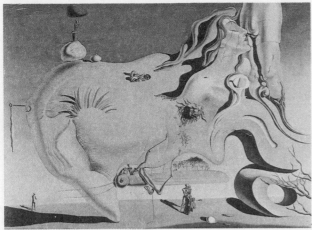

18.10.1938

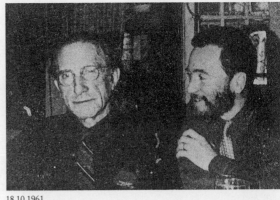

18.10.1961

1935. Friday, Paris
On learning that evening that there is to be an auction of an "interesting collection" on 27 and 28 November, Marcel writes immediately to the Arensbergs, enclosing a page from the catalogue illustrating 2 paintings by Georges Braque. "I like no. 127 very much," says Marcel, "and the auctioneer estimates that the bidding will not reach 10,000 francs. If you find this Braque interesting," Marcel proposes, "I could go to the sale and bid up to the sum that you specify."

1938. Tuesday, Paris
After the annexation of Austria by the German Reich in March, and the Munich pact signed by Hitler, Chamberlain, Mussolini, and Daladier on 30 September, Hitler has now annexed the Sudetenland, thus securing the fate of Czechoslovakia.

Addressing them as "dear children of peace" and happy to know that they are in France, Duchamp tells Gala and Salvador Dali [5.9.1933]: "Mary [Reynolds] has passed the political moments with a disquieting calm... After Munich she has girded her loins."

Unable to give Dali the name of the person who is insuring *Le Grand Masturbateur*, Duchamp suggests that he write to Mlle Rapoport at the Galerie Wildenstein.

1943. Monday, New York City
In the afternoon, Duchamp plans to take the train at a quarter to five which reaches Redding at six-thirty. Miss Dreier has promised to meet the train, which her sister Mary is also due to catch from New York.

1945. Thursday, New York City
Following a conversation with James Johnson Sweeney, Marcel tells Roché that Sweeney would be interested in his notes on New York in 1916 for his monograph. As for Roché's recent idea for artists' private journals [21.8.1945], Marcel writes: "Sweeney is having your *post mortems* project typed and he was very attracted by the idea which I explained to him briefly."

1949. Tuesday, New York City
On the Commodore, which leaves Central Station for Chicago at five-thirty in the afternoon, Duchamp occupies roomette 8 in car number 671, which has been reserved for him.

1950. Wednesday, Paris
Duchamp and Roché are invited to spend the day with Jean Paulhan, the writer and former director of *La Nouvelle Revue Française*, who lives at Luzarches, some thirty kilometres north of Paris.

1951. Thursday, New York City
Dines with Monique Fong at Granada, a Spanish restaurant at the corner of West 3rd Street and MacDougal.

1959. Sunday, New York City
"I simplified the 'testimonial' and I think a small type would make the page look 'fine'," writes Marcel from the Hotel Dauphin to Richard Hamilton [28.9.1959], who has also sent some final queries regarding small details in the translation of the typographic version of the Green Box. Marcel returns Richard's letter annotated, indicating preferences for the words employed.

1961. Wednesday, New York City
At a lunch arranged between distinguished members of the Collège de 'Pataphysique on the eve of the symposium to be held at the Museum of Modern Art, "to enable them to discuss the complex problems of interpretation," the Sérénissime Provéditeur-Général Roger Shattuck, up from Texas, is most privileged to be introduced by the high-flying Sérénissime Provéditeur-Délégataire Simon Watson Taylor to the Transcendant-Satrape Marcel Duchamp. Shattuck, author of *The Banquet Years*, has brought with him a "weighty, cogent and erudite thesis on the subject of 'Juxtaposition in Art'." Duchamp, however, declares "his firm intention of speaking for exactly three minutes..."

1962. Thursday, New York City
In the evening at 28 West 10th Street, the Duchamps give a small party for their friend Rodriguez [11.9.1962].

1963. Friday, New York City
"Back safely from Pasadena after a week of libations and freeways," writes Duchamp to Robert Lebel. Enclosing the Takis [14.4.1962] and Man Ray [31.3.1959] catalogues for Lebel's "addenda", Duchamp also sends him the catalogue made by Walter Hopps for Pasadena [7.10.1963] which, he remarks, "you will see has drunk deeply from you. In any case," he observes, "life starts at 76 with a one-man show..."

1965. Monday, Minneapolis
Making his first visit to Minneapolis to attend the opening of "Not Seen and/or Less Seen of/by Marcel Duchamp/Rrose Sélavy 1904–1964" [14.1.1965], Duchamp arrives in time to enjoy a lobster lunch served in one of the galleries at the Walker Art Center, the fifth American museum to take the exhibition. Sipping a glass of straight bourbon and smoking a cigar, after lunch Duchamp converses with Don Morrison of the *Minneapolis Star*. The journalist, who has had a pre-preview of the exhibition, is not prepared "to make any firm pronouncements upon Marcel Duchamp as an artist", but thinks that "if anyone is handing out laurels for delightful luncheon companions", he wants to nominate "this shrewd, puckish, thoroughly unselfimpressed man". Describing the artist as "78 going on 35", Morrison senses the amusement Duchamp must have felt when his Nude "created such a vituperative critical uproar at the famous Armory Show [17.2.1913]", and decides, while listening to his comments, that "since the days of the Dada movement, Duchamp has made something of a career of needling the pomposities of the art world, of twitting complacent critics and setting explosive charges under comfortably settled aesthetic values."

Morrison discovers that Duchamp "deplores the lack of humour in modern young artists" and their "loss of independence and individuality", which Duchamp thinks "is a product of the lucrative 'art industry' serving 'art consumers' instead of art-lovers". Admitting that he never made much money, Duchamp says: "We took a pride in doing things that wouldn't sell; we did them for fun."

Considerable space in the show is given to the readymades, but Duchamp "refuses to ascribe to them any significance" and tells Morrison: "I don't like the word 'anti'. They are anart, or non-art. I don't look at them, I think about them. I don't look for them, they find me." The journalist learns that Duchamp's "criteria for selecting these objects involve him in apparent contradictions. But even as he explains that contradiction is the whole point," Morrison observes, "you wonder about that wry twinkle, you wonder if he is putting you on and pin-pricking your own assumptions about art."

"I don't choose them for their beauty," explains Duchamp. "Beauty is terrible because we accept it and it becomes commonplace and comfortable. 'Ugly' doesn't mean anything either,

19.10.1948

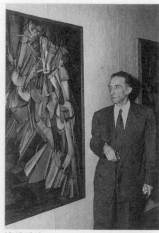

19.10.1949

because it is just beauty with a minus sign."

The readymades, Duchamp continues, "inspire no feeling whatever. It is hard to maintain this. I will keep something around for a long time; then, to my horror, it starts looking beautiful. Out it goes!" Duchamp smiles and adds: "That damned *Hérisson* [15.1.1916] has become a great trial. It has begun to look too good."

*

There is a festive air as 250 guests arrive at the Walker Art Center to take their places for dinner in the first-floor galleries. At nine o'clock another 150 guests arrive to visit the exhibition upstairs. Seated on the staircase landing, the director, Martin Friedman, conducts an "informal conversation-type lecture" with Duchamp for the guests standing on the balcony and in the lobby below; but most of what Duchamp has to say is lost, the crowd is so great, the evening so warm and the conversation so intimate.

1966. Tuesday, Paris
Teeny and Marcel return to New York, taking with them five sets of the two missing prints provided by Jean Brunissen [1.2.1966] (previously Vigier et Brunissen) for the new edition of notes being prepared for Cordier & Ekstrom [28.6.1965]. As these are the only sets he has found, Brunissen advises that a complete reprint be envisaged immediately to replace the missing copies – the reason for the last-minute delay in publication [24.8.1966]?

1967. Wednesday, London
After Marcel has spent two days working with Richard Hamilton on his project for an edition [4.9.1967] of two details of the Large Glass (the Oculist Witnesses and the Sieves), the Duchamps return to New York. Their early TWA flight leaves London at a quarter to eleven on "a clear sunny morning". However, because of poor weather conditions in New York, the aircraft makes an unscheduled stop to refuel in Boston before safely reaching its destination.

19 October

1915. Tuesday, New York City
Confident about the progress he is making with the new language, Duchamp writes his first letter

in English to John Quinn, thanking him for the cheque for \$120 in payment for *Nu descendant un Escalier,* No.1 [18.3.1912], one of the works dispatched from Paris to Walter Pach [2.4.1915].

As he is still anxious to find a job that will give him some regular income but will also allow him time to do his own work, Duchamp is grateful for Quinn's introduction to Miss Greene at the Pierpont Morgan Library. With his training and experience as a librarian [3.11.1913], Duchamp tells Quinn: "With that I hope so much find what I wish exactly," and he adds, "I will be so glad if I can help you about that bronze cast [24.8.1915]."

1923. Friday, Paris
Duchamp returns to Brussels [20.6.1923] to play in the Belgian national chess tournament.

1925. Monday, Paris
After spending "two or three weeks around Rome [11.9.1925], in a district where there were several artists" (at Anticoli Corrado, west of Tivoli, where Mary Reynolds has the use of several rooms in a chateau?), and with just a day in Florence, Duchamp is back at the Hôtel Istria.

"Desnos has asked me, on Breton's behalf, to exhibit the globe [8.11.1924] that you have – telling me that you have already agreed to lend it," writes Duchamp to Jacques Doucet, referring to the first Surrealist exhibition which is due to open at the Galerie Pierre at midnight on 13 November. "To tell you the truth," continues Duchamp, "I would rather not – And I would only do it if you want to. All the exhibitions of painting or sculpture make me feel sick – And I would like to avoid being associated with them." He would also regret if anything but "optics" is seen in the globe. Saying that he would like to call to see him one afternoon to make a decision, Duchamp tells Doucet: "except Thursday, choose the day."

1926. Tuesday, at sea
On the eve of his arrival in New York, Marcel writes a note to Pierre and Madeleine Trémois (ex. Turban [8.1.1918]) at the Librairie Trémois in *Paris* to say that he has made the arrangements with Victorine and gives her address in Le Havre. "Gordon can come to collect the books on board," says Marcel, because while the *Paris* is docked in New York, Victorine is on board every morning until two.

1937. Tuesday, Paris
Resuming his chess column for *Ce Soir* [18.6.1937], Duchamp presents his readers with an unpublished problem by Jos. Boehm, and reports the score of the return match between Euwe and Alekhine for the world championship title, which is being played in Rotterdam.

1948. Tuesday, New York City
In the afternoon Duchamp takes the 3:04 train to Milford, accompanied by Alfred Barr, who has agreed to help raise funds for the catalogue of the Société Anonyme Collection and is visiting Miss Dreier's new home for the first time. "It is so late in the season," laments Miss Dreier, "that my lovely Brancusi in the garden, which one sees through Duchamp's glass, has had to be taken in for the winter, as well as all my lovely rose-coloured geraniums... But my ageratums and French marigolds [are] still gay."

1949. Wednesday, Chicago
After his overnight train journey on the Commodore, which is due to arrive at eight-thirty, Duchamp has time to check in at Palmer House, where he is to stay before attending the Press Conference for the exhibition of "Twentieth Century Art from the Louise and Walter Arensberg Collection" at the Art Institute of Chicago.

Gathered with Duchamp to record an interview in one of the galleries in the East Wing of the museum, where 30 of his own pictures are hung, are Katharine Kuh and Peter Pollack from the Art Institute, Edward Barry from the *Chicago Tribune*, Clarence J. Bulliet from the *Chicago Daily News*, Lou Spence from *Time* magazine and Cloyd Head from the radio station WMAQ.

Barry remarks that Villon is still painting, and asks Duchamp: "What about yourself?"

"Well, no," Duchamp replies. "I don't know whether painting is a profession or should be a profession... I don't believe in eternal gifts; a source of inspiration can be stopped at one time or at least the desire to paint can stop. It is not essential."

He draws their attention to his paintings hanging in a good light and well spaced out. "I'm sure I never saw those colours," he exclaims, "I never saw them... It gives a new life to the pictures. I wish the Arensbergs could see them... They never saw them. I'm not speaking only of my own paintings but of all

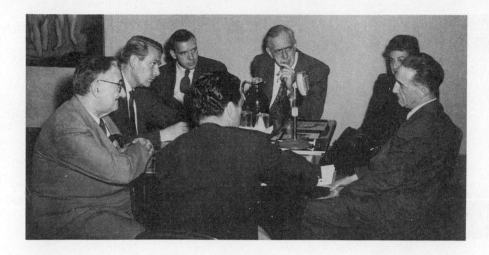

the pictures. Every one…"

The discovery in a Matisse of a little red spot on the cheek of a woman's face is very important. "I only saw it today for the first time," he tells them. "This is very important… it is like an entirely new painting."

Returning to the subject of his work, Duchamp declares, "I am not giving up painting. I am not painting now. It is because I don't agree with the state of affairs of the painting business and I mean even if you can abstract yourself from it, you are in it… no matter what you do yourself.

"A hundred years ago," Duchamp says, "there were a few collectors, a few painters, a few critics… a world of art by itself. Now it's the layman's world… Art has become a thing like baseball: everybody can speak of art… It has deteriorated the finest of these things. At least I think it has." He points out: "the economics of modern life have taken art for the money side of it and deteriorated it or at least distorted it," and that, "it doesn't come into the realm of painting, the realm of art."

Is this why Duchamp stopped painting?

"Well, more or less; I may be lazy, besides. That is maybe an excuse for the laziness. But after all, it takes five minutes to make a painting if you want… The quicker the better, otherwise one loses the inspiration, the subtle thing that comes from the subconscious."

Barry asks Duchamp to tell them "in lay language" what the group that began the innovations before the first war was seeking, what it revolted against, why it changed the direction of modern art so suddenly.

Replying that it was a gradual evolution from Courbet, when Modern Art starts, Duchamp insists: "What we call Modern Art needs a definition, because the word 'modern' means 'modern', which means nothing because they were modern in 1649… In this new form of art, every generation says 'Well I want to be something',"

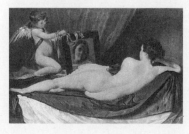

explains Duchamp, "because it is not a totalitarian form of aesthetics like Louis Quatorze or Louis Treize or Napoleon… Courbet, or his period, decided that art should be a free affair and every man has a right to paint as he pleases… At least this art is free, not commissioned or ordered. And so it went on, from generation to generation, adding more ideas, more theories to it, but the theory only came after."

His own contribution, Duchamp says, "was adding intellectual colour… I mean purely cerebral colour, which has no equivalent in the light of the sun. For example, the title was very important." With *Nu descendant un Escalier* [18.3.1912], which he declares is "definitely feminine", Duchamp says: "I had fun finding that title. It was great fun," he continues, "and I said cerebral colour because it adds not in the way of intellectualism, but in the way you make another frame to a painting… the title is enriching."

Cloyd Head asks Duchamp, whom he finds "an engaging personality: slender, with restless sensitive hands and a clear-thinking intelligence," what he thinks of *Mariée* [25.8.1912]. "I love it," Duchamp replies, "I tell you why. Because that was a real departure from any influence in my case. In this case there was no influence… But if you want to see an influence, I'll tell you how it was done. It was Cranach and Böcklin. I was spending three months in Munich when I did it… Böcklin [19.6.1912] was the man who gave me the possibility of it. Looking at it, but not copying… He is one of the sources of Surrealism, certainly."

*

At six-thirty in the evening, the director of the Art Institute of Chicago, Daniel Catton Rich, and his wife invite a few people to an informal dinner with Duchamp at the Cliff Dwellers' Club across the street from the museum. For Walter S. Brewster, the vice-president of the Board of Trustees, Duchamp signs and dates a copy of the catalogue with the exclamation: "Wonderful reunion."

The first public exhibition of "Twentieth Century Art from the Louise and Walter Arensberg Collection" opens at eight the same evening. The very handsome catalogue designed by Paul Rand has a detailed list, established by Katharine Kuh [17.4.1949], of the works exhibited.

Based on an interview [30.9.1948] and their discussions, Mrs Kuh contributes an important essay on Duchamp in the catalogue. "Duchamp's

enormous discipline shows everywhere in his work," she writes. "His pseudo-scientific speculations, partially symbolic, partially rational, are always connected tightly with a central idea. Toward modern science and its machinery he developed a mysterious ambivalence, where his respect was cynically dissipated by humour and doubt… Like Proust, his contemporary, to Duchamp nothing is as it seems. Since Leonardo, no artist has been so consumed with philosophical and technological experiments.

"There is more than technology to Duchamp's probings, there is also poetry. He became more and more concerned with the symbolism of celibacy. For him the celibate life of today's machine-bred man and woman was conceived as a constantly recurring frustration or boomerang. As with his tongue in his cheek he tried to marry technology to art, he at the same time searched for the poetic heart in our scientific instruments… Duchamp's name and work are woven into the fabric of contemporary history. He, in but a few years, reached out and caught single-handed the most elusive facets in the art and life of our time."

1951. Friday, New York City
Before going to Central Park to be photographed, Duchamp takes Monique Fong shopping in Madison Avenue.

1957. Saturday, New York City
After detailing for Roché his results in the New York State Chess Championship [2.9.1957], Marcel encloses a draft letter to James Johnson Sweeney regarding the Brancusis. In a postscript he announces that Jackie and her baby [18.2.1957] have arrived in New York. "I have then somewhat the same experience as you," Marcel explains: "in the form of Step Grandfather, even."

1961. Thursday, New York City
To coincide with his "Art of Assemblage" exhibition [2.10.1961], William Seitz [5.4.1957] organizes a Symposium at the Museum of Modern Art, which is presided over by Lawrence Alloway, "the spiritual mentor of Pop art." The speakers are Richard Huelsenbeck, Robert Rauschenberg, Roger Shattuck and Duchamp. According to a member of the audience, Simon Watson Taylor, "Roger Shattuck spoke learnedly but succinctly, Bob Rauschenberg passionately but incoherently, Huelsen-

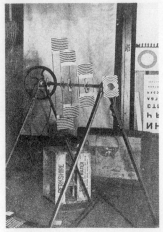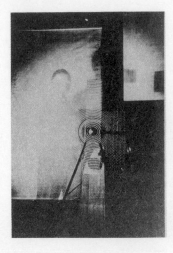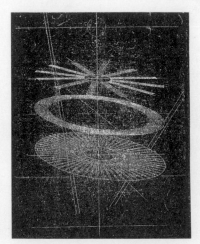

20.10.1920

beck interminably and inconsequentially, and then Marcel arose diffidently, produced his sheet of typed paper, read out his text [*Apropos of Readymades*] in his usual quietly affable voice and sat down again."

"In 1913 I had the happy idea to fasten a bicycle wheel to a kitchen stool and watch it turn.

"A few months later I bought a cheap reproduction of a winter evening landscape, which I called 'Pharmacy' [4.4.1916] after adding two small dots, one red and one yellow in the horizon.

"In New York in 1915 I bought at a hardware store a snow shovel on which I wrote 'In advance of the broken arm' [15.1.1916]. It was around that time that the word 'Readymade' came to my mind to designate this form of manifestation.

"A point which I want very much to establish is that the choice of these 'Readymades' was never dictated by an aesthetic delectation. This choice was based on a reaction of *visual* indifference with at the same time a total absence of good or bad taste... In fact a complete anaesthesia. One important characteristic was the short sentence which I occasionally inscribed on the 'Readymade'.

"That sentence instead of describing the object like a title was meant to carry the mind of the spectator towards other regions more verbal.

"Sometimes I would add a graphic detail of presentation which in order to satisfy my craving for alliterations, would be called 'Readymade aided'.

"At another time wanting to expose the basic antinomy between art and Readymades I imagined a *Reciprocal Readymade*: use a Rembrandt as an ironing board.

"I realized very soon the danger of repeating indiscriminately this form of expression and decided to limit the production of 'Readymades' to a small number yearly. I was aware at that time, that for the spectator even more than for the artist, *art is a habit-forming drug* and I wanted to protect my 'Readymades' against such contamination.

"Another aspect of the 'Readymade' is its lack of uniqueness... the replica of a 'Readymade' delivering the same message, in fact nearly every one of the 'Readymades' existing today is not an original in the conventional sense.

"A final remark to this egomaniac's discourse: since the tubes of paint used by the artist are manufactured and ready-made products, we must conclude that all the paintings in the world are 'Readymades aided' and also works of assemblage."

Duchamp takes very little part in the discussions, but he answers a question from the audience followed by one from Rauschenberg who challenges Duchamp on just how difficult the choice of a readymade really was for him.

Later, before calling a halt to the proceedings, the chairman asks Duchamp a final question, carefully noted by Watson Taylor: "Did you, or do you, really want to destroy art?"

"I don't want to destroy art for anybody else but for myself, that's all," replies Duchamp.

1965. Tuesday, Minneapolis
Profiting from Duchamp's visit to the Twin Cities on the occasion of his exhibition at the Walker Art Center, Carl D. Sheppard, director of the Art Department of the University of Minnesota, invites him to visit the Holman Building. With a small group of students and faculty members behind him, Duchamp makes a tour of the different art classes. "They seemed awed by the presence of this man," observed a journalist, "and it was clear they were doing their best to make a good impression, and in every way treated him like royalty."

While one group of students eyed him with curiosity, "Duchamp picked up a welding torch and made his signature on some sheet metal nearby. This was for the many students he didn't get to meet or shake hands with... One artist had only a wad of clay, and so Duchamp signed his name on that."

1966. Wednesday, New York City
The radio programme "Pour saluer André Breton" [1.10.1966] is broadcast in France by France Culture. In the fifty seconds selected from the interview which he accorded to Jean Schuster, Duchamp says that he first met Breton before Surrealism at the time of Dada [14.7.1921] and that "Breton detested old men... He died without ageing."

20 October

1889. Sunday, Blainville-Crevon
At eight o'clock in the evening a fifth child, Suzanne-Marie-Germaine, is born to Lucie and Eugène Duchamp. Their two eldest sons, Gaston and Raymond, are studying at the Lycée Corneille in Rouen and Marcel is two years old [28.7.1887].

1912. Sunday, Paris
Publication by Eugène Figuière et Cie of *Du Cubisme* by Albert Gleizes and Jean Metzinger, their profession of faith fully illustrated with reproductions of works commencing with a portrait by Paul Cézanne, their master. In addition to their own pictures and those of certain artists exhibiting in the "Section d'Or" [9.10.1912], Marie Laurencin, Fernand Léger, Juan Gris, Francis Picabia and Duchamp, there are illustrations of paintings by artists in the rival camp: Pablo Picasso, Georges Braque and André Derain.

Duchamp is represented by *Sonate* [19.11.1911] and *Moulin à Café*, a small panel made late in 1911 for Raymond Duchamp-Villon, belonging to a group of oils all the same size painted by six or seven friends, including Gleizes, Metzinger, de La Fresnaye, Villon and perhaps Léger, forming "a kind of frieze on the small cupboard doors at ceiling height in the kitchen".

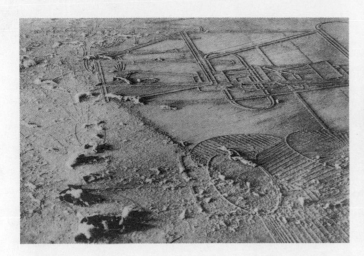

His first painting of a machine "open[s] a window onto something else". The *Moulin à Café* "shows the different facets of the coffee grinding operation and the handle on top is seen

simultaneously in several positions as it revolves. You can see the ground coffee in a heap under the cog wheels of the central shaft which turns in the direction of the arrow on top."

1920. Wednesday, New York City
"I am less bored today than on ordinary days," Marcel tells his sister Suzanne and Jean Crotti, uncertain though of the exact date upon which he is writing to them. After six months' silence he admits that he has something to ask for, and this is why they are receiving a letter. "Nothing new here," Marcel informs them; even the Société Anonyme, "the only interesting thing in N.Y.," exhibits, but doesn't sell and nobody even comes. Walter Arensberg is working "like a madman on his Dante", although Marcel sees less of him because there are not the parties there used to be.

"Actually I don't drink anymore, but in spite of that I don't get any fatter," says Marcel of his life under Prohibition. "I go to bed between 4 and 5h, have great difficulty in getting up before 1:pm; I have lots of lessons [15.1.1918] (the winter season is starting again)."

He has made a "monocle", *Rotative Plaques Verre (Optique de Precision)*. "It's a thing which turns very fast with an electric motor – very dangerous – I nearly killed Man Ray with it…" The first actual machine that Marcel has constructed rather than painted [20.10.1912] is

built to be viewed from about one metre when it is in motion, hence the term "monocle." Interested at that time in making "designs like spirals, giving the idea of a corkscrew [8.7.1918] when it turns," Marcel made the machine with five glass blades each larger than the next and painted with parts of geometrically calculated black circles on a white ground. When the blades turn on their metal axle, continuous concentric circles on one plane are perceived by the observer, but it is only from a precise position that the illusion of a single pattern is created.

Since Marcel moved back to the Lincoln Arcade Building [15.7.1920], he is slowly advancing his episodic work on the Large Glass, which he commenced five years ago [26.1.1916]. Man Ray has recently made an "aerial" photograph of the *Elevage de Poussière*, the result of about three months' accumulation of dust on the lower half of the glass while it has been lying horizontally on trestles in the studio. This dust is required to "be a kind of colour (transparent pastel)" for the Sieves [3.8.1914] to be "fixed" to the glass with varnish.

After carefully cleaning the glass, Marcel has had the area reserved for the Oculist Witnesses silvered (as was the small Argentine glass [4.4.1919]). Using a sharp point on the carbon drawing made by Rose Sélavy, the three circular motifs put into perspective have been transferred onto the back of the silvered area of the glass. "I am scraping the mirror by drawing after the [oculist] chart that Yvonne [Chastel] has at home." Thus the onlooker is introduced to the amorous proceedings of the glass.

And who, by the way, is Rose Sélavy? Her calling card states that she is a specialist in "precision optics" and has a "complete line in whiskers and kicks". Also a sidekick, certainly, because if Rose has been in the shadows for some while, she now has a role to play.

Duchamp, du chambranle, virtuose,
Lui glottine feuille de rose…

Thinking of making a series of windows, Rose has signed and copyrighted *Fresh Widow*, a miniature French window, made to measure and fitted with panes of black leather which, Marcel insists, are to be polished everyday…

Amaurose de l'amoureuse,
O deuil d'une veuve voyeuse…

as if frequenting, one might add, the "Veuve Poignet".

Although Marcel's preoccupation with optics has been extended since the acquisition of a "moving picture camera" six months ago, experiments with cinematic illusion have to be spaced out because of the cost of the film. Indeed the research even leads to an unfinished sequence of Man Ray, with increasing difficulty, endeavouring to shave the pubic hair of Else, Baroness von Freytag-Loringhoven [11.8.1918], much of which is also lost in the development…

"And chess? Superb Superb!" exclaims Marcel to his sister and brother-in-law. "I have made tremendous progress, …not that I have any chance of becoming French Champion, but I will have the pleasure of being able to play with almost any player in one or two years. Naturally it is the part of my life that I enjoy the most." Again as last season, Marcel is a member of the Marshall Club team comprising the eight strongest players; he has been playing against Frank Marshall in his simultaneous exhibitions, when the champion takes on 12 opponents at the same time, and is proud to have won two games.

"I am going to launch a new kind of chess on the market," announces Marcel, who plans to ask the champion if he may call them "Marshall's Chessmen". Making the Queen from a Castle and Bishop combined, and using the same Knight, Pawn and King as the ones he made in Buenos Aires [22.6.1919], Marcel explains: "They will be coloured… the White Queen will be light green, the Black Queen will be dark green." The Castles are to be light and dark blue; the Bishops, light and dark yellow, the Knights, light and dark red; there is to be a White King, a Black King and white and black Pawns. "Please notice," writes Marcel, "that the Queen's colour is a combination of the castle and the bishop (as she is in her manner of moving)."

Suddenly remembering why it is that he is writing, Marcel says that Carl van Vechten has bought a book from the Albert Lefrançois bookshop at 8 Rue de Rome, but it is going to cost 32 francs to post it. Can it be collected and given to someone coming to New York, to save the postage?

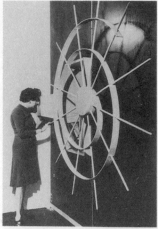

20.10.1942

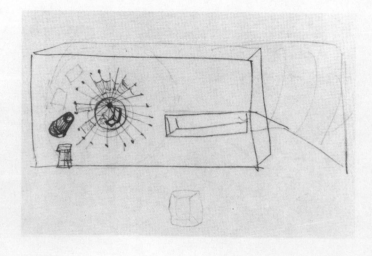

1924. Monday, Paris
To give "the object, even when it's still, a curious appearance" and before copper-hammering it himself, Duchamp takes the outer copper plate of the optical machine to an engraver to have the words "Rrose Sélavy et moi esquivons les ecchymoses des Esquimaux aux mots exquis" engraved around it. "I find the lettering and copper-hammering indispensable especially in order to avoid the kitchen utensil effect which red copper always has," writes Duchamp to Jacques Doucet. "I still haven't put the velvet [8.10.1924] in place," he adds, "and am waiting until everything on the construction side is finished."

1926. Wednesday, New York City
When the *Paris* docks safely at ten o'clock in the morning Marcel is hoping that Allen Norton, with whom he is invited to stay at 111 West 16th Street, will be on the quayside to greet him. As the cases of Brancusi's sculpture are to be liberated from the ship's hold the following day, Marcel disembarks "with nothing important to clear through customs", only a copy of his recently completed film *Anémic Cinéma* [30.8.1926].

Soon after landing, Marcel sees an old friend, Charles Demuth [1.11.1921], for a moment, and no doubt tells him about his concern for transporting the Large Glass [5.2.1923] safely to the Brooklyn Museum, where it is to be exhibited on 19 November. "What one's own time can do to one," reflects Demuth sympathetically. "The future makes it up, usually. But, dear Marcel, having used glass so often seems to have added difficulties for the Future – he would, of course."

1933. Friday, Paris
With his departure only five days hence, Dee writes a hasty note to Miss Dreier to say that he is bringing another Brancusi exhibition to the Brummer Gallery in New York: "62 Brancusis: about all he had in his studio in Paris."

1942. Tuesday, New York City
In the wake of "First Papers of Surrealism" inaugurated the previous Wednesday, Peggy Guggenheim's new gallery Art of this Century at 30 West 57th Street opens with a benefit evening for the American Red Cross. Frederick Kiesler has transformed the space and designed

an elaborate, theatrical showcase for Peggy's collection [22.7.1942]. The catalogue, which André Breton has taken in hand but is not ready in time for the opening, includes Duchamp's English version of his text "SURcenSURE" (originally published in *L'Usage de la Parole*, December 1939).

As well as showing *Jeune Homme triste dans un Train* [17.2.1913], which Peggy has recently acquired from Walter Pach, Kiesler has the privilege of making the first installation of Duchamp's *Boîte-en-Valise* [7.1.1941] for public exhibition. In a glass case which is set into the wall of a corridor opposite a conveyor belt of Paul Klees, Kiesler's idea of presentation recalls the "television" room which he made for the Société Anonyme at the Anderson Galleries [25.1.1927]: to the left of a huge, spoked wheel incorporating a spiral motif is a peephole which, as the wheel is turned, reveals to the viewer, one by one, fourteen images from the Valise.

1943. Wednesday, West Redding
After a short visit to The Haven [18.10.1943] Duchamp is due to return by train to New York, accompanied by Mary Dreier.

1949. Thursday, Chicago
"Wire received opening great success presentation gives new life to the collection..." is Marcel's enthusiastic message to the Arensbergs, who were not present at the exhibition opening in Chicago. The present suitors for their collection are Minneapolis, Philadelphia and Chicago, and Walter has authorized Marcel to discuss the Chicago proposals while he is in the city and report back.

After Duchamp has sent his cable to Hollywood, Sam Marx of the Art Institute of Chicago arranges to see him that same morning with Daniel Catton Rich and Katharine Kuh. The space they have in mind for showing the Arensberg Collection permanently, which they show to Duchamp, is 200 by 58 feet, 28 feet high, with two cathedral portals. For it to be divided into different sized rooms on two or three floors, the trustees of the museum will have to find between $200,000 and $300,000.

*

In the evening Sam Marx gives a dinner party for Duchamp, inviting Bobsy Goodspeed

[11.7.1937] and Alice Roullier of the Arts Club of Chicago. Duchamp and Marx discuss the "pros and cons exhaustively" of the Arensberg collection remaining in Chicago, and are "convinced" that the Arensbergs should come to Chicago to see the pictures while they are hung there and properly lit.

1950. Friday, Paris
In the evening at six, Marcel meets Roché at Arago and they travel together to Puteaux for dinner at Camille Renault's restaurant. While enjoying turbot and partridge, accompanied by bottles of Mâcon and Beaujolais, the subject of their conversation turns to Mary's bookbinding [30.9.1950], and Marcel decides that he will give her tools and material to François Stahly's wife, who had been a friend of Mary's.

1952. Monday, New York City
"The King and the Queen arrived unannounced a few days ago, accompanied by Adam and Eve," writes Marcel to Louise and Walter Arensberg referring to *Le Roi et la Reine entourés de Nus vites* [9.10.1912], which he painted on the back of an earlier picture, *Le Paradis*. Since the donation of the collection to the Philadelphia Museum of Art [27.12.1950], the restoration work on the paintings continues. "I must say that Miss Adler did a splendid job removing all the black paint," Marcel remarks appreciatively, adding that for him to restore Paradise, "all that is necessary is to retouch the nudes on the areas where the paint is actually missing..." Marcel finds the background landscape "in good condition and very luminous".

As Walter had to undergo a third sinus operation recently, Marcel is concerned about his health: "Are you all right for good?" he enquires.

1955. Thursday, New York City
The material which Duchamp sent earlier in the year [22.3.1955] to France for the new series of the *Boîte-en-Valise* [7.1.1941] has not yet been released from French customs. As Iliazd has suggested that the intervention of Jean Adhémar, the head curator of the Bibliothèque Nationale, might obtain results, Duchamp writes to him: "I am more than touched by your intention of intervening with the customs... I hasten to add that all these reproductions were printed in France between 1936 and

 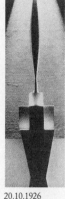 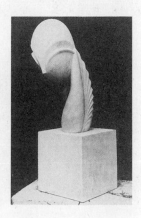

20.10.1926

1940... I fail to understand why the customs are making such difficulties about releasing them…" After thanking Adhémar in advance for his help, Duchamp adds as a postscript that he would be "most honoured to make a gift of one of these boxes (my pocket museum) to the Bibliothèque Nationale, just as soon as Iliazd has assembled a number of them."

1960. Thursday, New York City
After obtaining Julien Levy's opinion on the proposed title of the exhibition, Marcel writes a note to André Breton from the D'Arcy Galleries, where the Surrealist show is due to open on 28 November. With Claude Tarnaud and Maurice Bonnefoy, the director of the gallery, Marcel has looked quickly at the maquette of the catalogue, but he needs further instructions from Breton and asks him to reply rapidly.

At the gallery Marcel also meets the printer who requires four weeks to print the catalogue and agrees to print the "carrot" sign of the French tobacconists in relief on the cover.

1965. Wednesday, Chicago
Between Minneapolis and their return to New York, Marcel and Teeny make a short stop at 3220 Prudential Plaza to see Brookes Hubachek and his son Bill.

21 October

1916. Saturday, New York City
Dines at the Brevoort with Beatrice Wood and Alissa Franc.

1917. Sunday, Tarrytown
Duche and Roché are invited by the Stettheimers for another of "the exciting parties" at the weekend [28.7.1917], which includes playing some pool billiard.

"The summer is over," thinks Ettie sadly, "and we are freezing in our summer house in spite of an enthusiasm for its gardens and a ton of coal a week for its furnace and hot water bottles for its beds…" The three sisters and Mrs Stettheimer plan to return to New York on 5 November, to what Ettie describes as: "the second-class waiting-room, the same stuffy little house, looking out on the Elevated Railroad."

1926. Thursday, New York City
Is it Art? The customs' officials are stumped when they unpack the Brancusi sculpture that arrived with Duchamp on the *Paris* the day before. Under Federal customs law for cultural encouragement, all works of art are admitted into the United States from foreign countries free of duty [24.7.1915]. Whatever the queer-looking pieces of marble, bronze and wood are, the inspectors feel very sure it is not Art.

The "representative" of Brancusi arrives and begins to explain *Bird in Space*, *The Kiss* and *Mme Pogany*, but to no avail. Mr F. J. H. Kracke, the appraiser of the New York Custom House, is called and he also is "unable to see any artistic value in the stuff".

However the official definition of sculpture, as Henry McBride points out, is not exactly foolproof: "A work of art is not necessarily sculpture because artistic and beautiful and fashioned by a sculptor from solid marble. Sculpture as an art is that branch of the free fine arts which chisels or carves out of stone or other solid substance, for subsequent reproduction by carving or casting, imitations of natural objects, chiefly the human form, and represents such objects in their true proportions of length, breadth, and thickness, or of length and breadth only."

Convinced that the Brancusis are not sculpture but commercial objects, the New York officials declare that the 40% duty should be paid, as prescribed by law. However it is decided that for the exhibition at the Brummer Gallery, which is due to open on 17 November, the work is to be admitted in bond and duty is to be levied on each piece that remains permanently in the United States.

1930. Tuesday, Paris
Dee receives a letter from Miss Dreier telling him in detail about the Clavilux, a sound and light machine with a keyboard, coloured bulbs and ground glass discs invented by Thomas Wilfred who has just installed one for her. Hoping that she might persuade Dee to come and try the Clavilux for himself, Miss Dreier says she has imprisoned herself with her lectures [13.6.1930] and admits: "it would also be quite wonderful to have a boost through you – for you are the only one who can quickly get me over the top…"

1949. Friday, Chicago
In the afternoon Marcel boards the train leaving for New York at four o'clock and, from his roomette 6 in car number 681, writes to Louise and Walter Arensberg enclosing a plan of the exhibition which he has drawn for them. "I had a very pleasant time in Chicago and must tell you that the collection in these new surroundings stands out like a block apart from the already classic Impressionists, Bonnard, etc., which the modern section of the museum is made of." Outlining the installation, the lighting and wall surface, Duchamp says: "The general effect was that all the paintings had been cleaned, and in the case of the *Portrait* [30.9.1911], hung in your dining room, all the colours stood out as though the painting had been painted yesterday. The conclusion," he continues, "is that you must see the collection in that presentation… It will help you enormously to discuss the other problems and you will have all kinds of ideas about the possible final arrangements."

Marcel describes the meeting he had the previous day at the Art Institute with Marx, Rich and Katharine Kuh, who are "all enthusiastic about having the collection in Chicago". The Arensbergs' conditions could be met, Marcel believes, but, "the point I insist on," he writes, "is that you must see your collection flying on its own wings."

Comparing two of the cities vying for the collection, Marcel says: "Remoteness and cosmopolitanism are two very important factors – and I feel that Chicago is better, geographically, than Minneapolis. I feel also that a promise to raise funds and to keep their word from the Chicago people can be trusted."

1953. Wednesday, New York City
"I found it very good, without noticing anything abnormal (or unusual) in the offhand manner in which you, as much as I and the others have been treated," writes Marcel to Roché, after receiving his comments on an article which appeared in *Paris Match*.

Regarding his essay, *Souvenirs sur Marcel Duchamp* [1.6.1953] for the monograph being prepared by Robert Lebel, Marcel advises Roché that his modifications will be "very good", and that he should let himself "be guided by circumstances". He is not keen to include the notices, "too short and inadequate," which he wrote for the catalogue of the Société Anonyme [30.6.1950] considering that "they are only possible in the context of the catalogue where they are".

22.10.1913

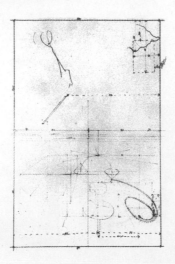

1958. Tuesday, New York City
"Between ourselves, I am losing the kind of enthusiasm I had in Paris for a few weeks," Duchamp admits to Robert Lebel. "The profound indifference of Fawcus," Duchamp predicts, is likely to continue and he is awaiting

instructions before going to see Braziller: "(there again, what indifference!)," Duchamp exclaims, "what beauty of indifference!"

Confirming to Lebel that "little Benoît's etching", *Equilibre*, is an original on celluloid, "but really of no importance," Duchamp begs him not to change the layout of the *catalogue raisonné* just for this item. "Otherwise," he threatens, "I will send you all my daily doodles made while waiting for a telephone number."

Made in June to illustrate a poem written in 1917 by Francis Picabia, which has recently been published in a limited edition by PAB at Alès, Duchamp explains: "if you look at it (the celluloid) in a mirror or against the light, you can barely read 'Et qui libre?'," a pun on the title of the poem: *L'Equilibre*.

*

Opening in Paris of "Le Dessin dans l'Art magique" at the Galerie Rive Droite, for which Duchamp has made a calligram for the cover of the catalogue: "MAGES" is surrounded by selected prefixes, I-MAGES, HOM-MAGES, DOM-MAGES, PLU-MAGES, RA-MAGES, and FRO-MAGES. A copy of the *Boîte-en-Valise* [7.1.1941] is shown in the exhibition.

1960. Friday, New York City
After another discussion with Julien Levy by telephone about the title of the Surrealist exhibition, Duchamp follows his earlier letter with a note to André Breton making another proposal.

1961. Saturday, New York City
"Fine – very well done. O.K." writes Duchamp to Katharine Kuh after reading through a text and correcting a slip. "Bravo and thank you."

1962. Sunday, New York City
"At last I have found a moment to retrace our Milanese and Parisian arabesques," writes Duchamp to Enrico Baj in Milan. "First of all our apartment! your apartment of the Via Privata Bonnet [10.9.1962] with the broken mirrors and a tropical climate *outside*, the perspective behind the altar and the lunch on Lake Como [12.9.1962] and Varese and the family."

Max Ernst's studio is "almost bought, almost rented," remarks Duchamp on hearing the news. With Duchamp's assistance in Paris early in October, Baj is now renting the studio jointly with the painter Maria Luisa de Romans.

1967. Saturday, New York City
After returning from London on Wednesday, Marcel went immediately to see David Mann at the Bodley Gallery. "Everything has arrived safely, canvases, catalogue and curriculum vitae," writes Marcel to Yo and Jacques Savy [6.9.1967], "Mann is very cheerful and finds the catalogue superb." Marcel has accepted the proposal of Mrs Perutz, who is sharing the gallery with Yo, to offer a cocktail the day of the opening: "It is very normal here," he explains. "It was difficult to refuse her."

Teeny then writes two lines to say that she has been to enquire at the hotel around the corner between 9th and 10th Street. "Be kind enough to give us your views on this question quickly," continues Marcel after detailing the prices and orientation of the rooms, "so that we can finally reserve a room for Thursday 9 November, which we spoke of as possibility of arrival…" As a postscript, Marcel suggests: "It would be good perhaps that you give us your ideas on the prices without forgetting the 33% for the gallery."

22 October

1913. Wednesday, Paris
Since his return to Paris after ten days holiday with the family at Yport [14.9.1913], Marcel has moved from 9 Rue Amiral-de-Joinville in

Neuilly [1.10.1908] to a brand new building at 23 Rue Saint-Hippolyte, not far from his friend Dumouchel, who lives at 44 Rue de la Clef in the *5ème arrondissement*. In fact the building is still under construction, and for a while Marcel has to climb a ladder to reach his apartment.

On the new plaster-work, Marcel has started plotting, full-scale, the definitive perspective composition of the Large Glass. Working mainly for the lower half from the focal point on the line of the Bride's Clothes, he accurately plots the essential points of the Bachelor Machine, which is based on the first sketch on cardboard [13.1.1913].

[It appears likely, therefore, that the perspective drawing on tracing paper to the scale of one tenth, entitled *La Mariée mise à nu par ses Célibataires, même*, in which the whole of the Large Glass and its main elements are positioned precisely, was made after the plan on the wall.]

Whilst establishing the composition on the plaster, Duchamp also works on the plan and elevation drawings of the *Appareil Célibataire*, clearly marking all his detailed calculations and measurements.

*

In the afternoon at four o'clock, as his brother's witness, Marcel attends the marriage of Gaston to Gabrielle Charlotte Marie Bœuf which takes place in a civil ceremony at the *mairie* of Puteaux. Giving his new address, Marcel signs the register with the three other witnesses: his brother Raymond, his sister-in-law Yvonne, and her brother Jacques Bon.

1917. Monday, New York City
Roché spends the evening alone in Totor's studio, 33 West 67th Street. He greatly admires the two large pieces of glass, which Totor is slowly working on, describing them as "magnificent, unique".

1930. Wednesday, Paris
To inform her that the shipment for the exhibition [7.9.1930] is on the *De Grasse*, sailing from Le Havre today, Dee cables Miss Dreier and also writes enclosing a list of the 22 paintings which are on their way to her. He has selected work from Francis Picabia, Amédé Ozenfant, Jean Viollier, Jacques Villon, Max Ernst, Joan Miró, Man Ray, Jean Crotti, Suzanne Duchamp, Adriaan Lubbers, Georges Papazoff, Joseph Stella and two Piet Mondrians: *Foxtrot A* and *Foxtrot B*. (For the latter, Lefebvre-Foinet has advised a

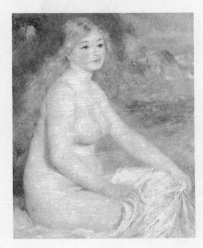

23.10.1965

value of only $20 each, fearing that the American customs will consider them decorative panels and, as in Brancusi's case [21.10.1926], levy duty on them.) Unable to obtain any new pictures from Fernand Léger, Dee suggests that Miss Dreier include those she already has.

"I don't think I can leave Paris now," writes Dee, who is occupied with the chess book he has written with Halberstadt, an extract of which has just been published in the October issue of *Le Surréalisme au Service de la Révolution*. "I am deeply in my book, trying to find a publisher... It is now at the Nouvelle Revue Française... It would be heaven to have them do it." Besides in January he plans to go to Nice for two months, "to play and train with a Grossmeister," but, Dee promises: "making my return coincide with your arrival in Paris."

1940. Tuesday, Paris
"Your sculptures are fine with Mary [Reynolds], who is with them and with me," Marcel assures Roché. A consular notice is pinned to the door at 14 Rue Hallé, but if the house seems to be in danger, the Brancusis could be returned to Arago which is "intact".

Since their return to Paris on 3 September, Mary and Marcel have been to Roché's house at Sèvres to investigate and found that five German soldiers live there, and between 25 and 30 come to eat there every day. Marcel "bravely interrogated", but they were not allowed inside.

1949. Saturday, New York City
Marcel is due to arrive at the Central Station at nine o'clock in the morning on the overnight train from Chicago.

1953. Thursday, New York City
In what appears to be his first visit to Philadelphia since the transport of the Large Glass to the museum [31.12.1952], Duchamp is invited to see the rooms, now finished and ready to receive the Louise and Walter Arensberg Collection.

1956. Monday, New York City
As Ira Haupt is not keen to send the pictures from his private collection "out of town", Duchamp requests loans to the Guggenheim Museum only of his two pictures by Jacques Villon for the "Three Brothers" exhibition due to open on 8 January.

1965. Friday, New York City
In the morning Joseph Solomon telephones to confirm that he will call at 28 West 10th Street on Monday, as Duchamp has proposed, but between five and five-thirty instead of six o'clock.

23 October

1915. Saturday, New York City
As the bronze cast of *Femme assise* by Raymond Duchamp-Villon is now finished [24.8.1915], John Quinn has proposed that Duchamp call at his apartment, 58 Central Park West, this morning at about ten, and motor with him by taxi to Greenpoint, Long Island, to inspect it.

1917. Tuesday, New York City
In the afternoon, Roché comes to collect Marcel from the office in Lower Manhattan, where he is now working regular hours for a French captain [9.10.1917]. They walk the short distance to Battery Place and take some refreshment before going back to 33 West 67th Street, where Roché has a nap for a couple hours on Marcel's bed. Like the previous evening, Roché is enchanted by Marcel's work and finds the "cones" in the lower section of the glass "brilliant".

Later, Marcel, Roché, the Arensbergs, Sophie [?] and Aileen Dresser go to the movies to see Chaplin and Fairbanks.

1926. Saturday, New York City
A few days after his arrival Marcel calls on Beatrice Wood at her small apartment on 46th Street. She shows him some drawings, which Marcel says she should exhibit.

1935. Wednesday, Paris
Following up his letter to the Arensbergs on Friday, Marcel has posted a complete catalogue of the sale, so that it catches the ship sailing for New York today.

1964. Friday, Bern
An exhibition opening at the Kunsthalle groups the works of Marcel Duchamp, Wassily Kandinsky, Kasimir Malevich, Josef Albers and Tom Doyle.

1965. Saturday, Barcelona
The interview which Duchamp accorded recently to Rosa Regas one September evening in Cadaqués is published in *Siglo XX*, illustrated with photographs by Xavier Miserachs.

"Duchamp spends six months every year in Cadaqués," writes the journalist. "One can see him in Meliton's bar or at the village casino playing chess. People think that is the only thing that interests him."

Admitting her nervousness at meeting Duchamp, Rosa's first question is to ask him why he stopped painting?

"By repetition. One can make three or four exceptional things. The rest is repetition. Renoir, for example: one nude, two nudes, three nudes. Afterwards they are all the same."

Does this happen to all painters?

"Not only to painters but to all those who do anything."

Do you think they are conscious that their work is repetitive?

"Obviously the moment of self-criticism comes. Then you have to decide to continue or to stop. If you continue it's only because of money..."

So you think that a man who paints pictures and sells them is like someone selling beans?

"Absolutely..."

You have pictures in different museums in the world... Are you pleased with that or are you indifferent?

"I am pleased, of course."

Rosa admires the big live beetle chained to the lapel of Teeny's suit: a "makeche" from the Yucatán with a jewel-like shell. Their importation is forbidden in the United States for fear of their multiplication and invasion of the country.

"It's the same fear that they have for the blacks," says Duchamp.

They talk about the film by Bardem, *Les Pianos mécaniques*.

"I think it gives a false impression of Cadaqués, as much in the atmosphere as the landscape," considers Duchamp. "Above all it's a literary film. It is not naturalism but stylism."

Has Duchamp read articles in the press about Cadaqués?

"Yes, I think they have no idea what Cadaqués is like... But everything is a job. You have to let them do it, let them criticize... In spite of everything, I think they are sincere."

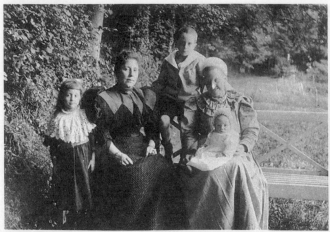

24.10.1953

Do you believe in sincerity?

"Naturally I believe in it as in a mirage. Even liars are sincere. Sincerity is a myth like politics."

Did you vote in the last elections in the United States?

"Yes, I decided to, to please Teeny."

Who did you vote for?

"For Johnson. But we have seen that it was the same thing to vote for one or the other…"

In politics, you have no preference then?

"Everything changes from one day to the next. To seek happiness for the greatest number of people thanks to a good economy; what does that mean? Perhaps there are people who would like or want to live without 10,000 dollars."

Can one say that you are a sceptic?

"Yes, maybe, at the moment. I believe, above all, that a recipe cannot be applied to 30 millions of people."

So no recipe?

"None. Maybe the artists in power," he says laughing. "It is obvious that we would all be poor. But it would be good that they fight amongst themselves, that they know nothing at all of any political tricks. They would be less demanding, less economist and above all more cheerful. That's one thing left to try."

Are you happy in Cadaqués?

"I love Cadaqués. I liked it better when I was here in 1933 with Dali and Man Ray [5.9.1933]. The houses, then, were not painted white like today, but they were the colour of the stone with which they were built, grey…"

Does architecture interest you?

"Not at all…"

What do you do in Cadaqués?

"I am staying. Like that."

Do you like work?

"I understand that one has to do it, otherwise there wouldn't be a place for the majority of the people. It's a brainwashing, an alienation like art or anything else. It's fine like that."

Preparing to leave, Rosa asks a final question: "The attainment of a certain happiness depends on who, in your view?"

Duchamp smiles. Rosa blushes at the absurdity of her question.

"I think that all depends on the smooth running of organic functions, normal sexual relations and perhaps a little of the Mohammedans' dodge, who believe in a god without too many interdictions and with the promise of a luxurious paradise."

As they say goodbye, Duchamp switches on the staircase light. He then declares with a grin: "One tires of everything, happiness included!"

1966. Sunday, New York City
The Duchamps attend a performance in the series of "Nine Evenings – Experiments in Art and Technology" at the 25th Street Armory and meet Monique Fong, also in the audience. The programme that evening is Lucinda Childs, Debbie Hay and Robert Rauschenberg in *Open Score.*

24 October

1915. Sunday, New York City
"French Artists spur on American Art" is the headline of a long article, published in the *New York Tribune*, which includes interviews with the sculptor Frederick MacMonnies and the group of French artists who have come to New York in the last few months. "The effect of this migration," believes MacMonnies, "is likely to be far more far-reaching than even the most enthusiastic now imagine."

The writer, who remains anonymous, declares that "when young Marcel Duchamp… came over, the art world took his journey as a manifestation of curiosity and stood apart in piquant expectancy, confidently waiting for him to express the time-worn disgust with America and its standards generally ladled out to this country by artists. He praised and gloried in the vibrant electricity of this wholly new and young and strong force in the world [18.9.1915]."

After Duchamp came Juliet and Albert Gleizes on their honeymoon, Francis Picabia and Jean and Yvonne Crotti. "And New York

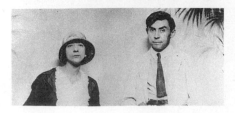

awoke to find that it is witnessing a French invasion." Individually they give their reason for coming to America, which is that "all air, all life [in France] is stifled by war".

The journalist asks Duchamp whether the French artists have forgotten Paris and its Quartier Latin.

"I assure you," replies Duchamp, "the Quartier Latin is a gloomy *endroit* these days! The old gay life is all vanished. The ateliers are dismally shut. Art has gone dusty… But it is a very different life from the happy, stimulating life one used to encounter. Paris is like a deserted mansion. Her lights are out. One's friends are all away at the front. Or else they have been already killed.

"I came over here, not because I couldn't paint at home, but because I hadn't anyone to talk with. It was frightfully lonely. I am excused from service on account of my heart [3.8.1914]. So I roamed about all alone… Nothing but war was talked from morning until night. In such an atmosphere, especially for one who holds war to be an abomination, it may readily be conceived existence was heavy and dull.

"So far as painting goes – it is a matter of indifference to me where I am. Art is purely subjective, and the artist should be able to work in one place quite as well as another. But I love an active and interesting life. I have found such a life most abundantly in New York. I am very happy here. Perhaps rather too happy. For I have not painted a single picture since coming over."

Duchamp is asked whether he is still painting in the same style as the Nude.

"Oh, no… My methods are constantly changing. My most recent work is utterly unlike anything that preceded it."

Will he find a public in America capable of appreciating his work?

"That I cannot say. Pioneers must always expect to be misunderstood. It is a matter of great indifference to me what criticism is printed… I am simply working out my own ideas in my own way… I cannot explain my paintings. Either one grasps their purport or one doesn't… There is nothing static about my manner of working. I am never deceived myself into thinking that I have at length hit upon the ultimate expression. In the midst of each epoch I fully realize that a new epoch will dawn…"

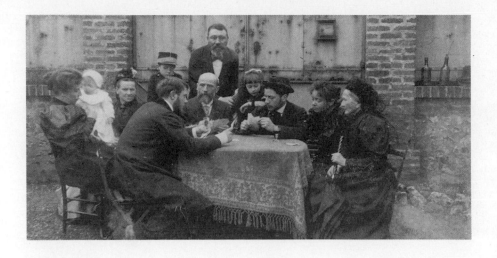

1916. Tuesday, New York City
In the afternoon Duchamp has an appointment at twenty minutes past four to meet a recent acquaintance, Florine Stettheimer, at the Knoedler Gallery on Fifth Avenue where an exhibition of her paintings is being held. For her public début, wishing to introduce the private setting in which she paints and lives, the very shy but decisive Florine has insisted on redecorating the gallery. The *Family Portrait* of herself, her sisters Carrie and Ettie, and her mother, the two canvases of André Brook, their summer residence in 1915, seen both from the front with the family, and from the back with the garden, together with colourful compositions of flowers and figures are presented on walls camouflaged with white-draped muslin. Over one picture, there is a transparent, fringed canopy similar to the one hanging in her bedroom.

Together with Duchamp, who, according to Florine, "looks thin, poor boy," Carrie and Ettie call at the gallery with Elizabeth Duncan, Isadora's older sister. The photographer Arnold Genthe and the Marquis de Buenavista, the Peruvian Ambassador to the United States, who speaks "amusingly, admiringly" about the paintings, are also among the visitors.

1917. Wednesday, New York City
In the evening from Louise Norton's apartment, Marcel telephones Roché to invite him to join them. However Roché has decided to have an early night, and stays at home.

1926. Sunday, New York City
Having told Ettie of his forthcoming visit to the parallel streets of New York [23.8.1926], soon after his arrival Marcel is invited to the Stettheimers', who now live at Alwyn Court, 182 West 58th Street. His movements remind Ettie of a limerick about Einstein's famous theory:

There was a young lady called Wright
Whose pace was faster than light
She left home one day
In a relative way
And returned the preceding night.

Although in the three intervening years since he last saw the sisters [12.2.1923] Marcel has read Ettie's portrait of him [1.1.1924], he has only heard reports [26.7.1923] of the double portrait Florine has painted of himself and Rrose Sélavy.

In a very pale green void, seated comfortably in an armchair, looking pensive and withdrawn, the long fingers of his left hand grasping a sil-

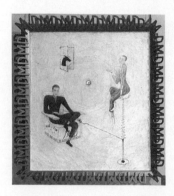

ver-handled crank, Marcel adjusts the height of Rrose Sélavy's spiral-sprung stool.

A silver-thin spiral
Revolving from cool twilight
To as far pink dawn
A steely negation of lightning
That strikes

A solid lamb-wool mountain
Reared into the hot night
And ended the spinning spiral's
Love flight –

[*Duche* by Florine Stettheimer]

Poised to seduce like a flower about to blossom, the shoulders of her rose-coloured body suit forming a heart shape, Rrose gazes with an air of indifference at Marcel, one of her gold-bangled wrists raised in conversational gesture. Above her manipulator is his chess Knight [7.1.1919] framed by a transparent hinged window with a fastening. A shade darker than the surrounding void, a sea-green circle described on the canvas brushes the corners of the window, the back of Marcel's chair and the undulating curves of Rrose. In the centre of this circle, like a target, is a "cosmic clock" with three hands.

1945. Wednesday, New York City
In the evening at seven-thirty Marcel dines with the Kieslers in their penthouse at 56 Seventh Avenue with its magnificent view over Lower Manhattan.

1950. Tuesday, Paris
Dines with Roché at an Italian restaurant near the Opéra Comique [Poccardi, 12 Rue Favart?]. Afterwards they drink beer at the Régence at 161 Rue Saint-Honoré, a café frequented by chess players, including the late Raymond Roussel [1.12.1932], whom Marcel saw there once, many years ago, but did not speak to.

1953. Saturday, New York City
Greatly amused by the two old photographs which Suzanne has sent him, Marcel says he thinks he can date the one of Yvonne as a baby on the knees of Clémence [18.12.1925] in the garden at Blainville to 1895, the year of her birth [14.3.1895]: "…There are leaves on the trees," he writes, "and I don't remember if Yvonne was born in March or in the fall (in which case it would be 1896)." He dates the other photograph taken at Montivilliers around 1900.

Thanking his sister for the etching, his portrait, which she sent via Sidney Janis, Marcel says he likes it very much and doesn't see why she should want to retouch it.

As Suzanne has news of Gustave Candel [25.4.1941], Marcel asks her to thank him for "his enthusiasm". He remembers "vaguely" the

portrait he painted of Gustave's mother, her head and shoulders placed, rather strangely, on a pedestal, which he signed in 1913, and says he would like to have a photo of it.

1956. Wednesday, New York City
In the afternoon at the Guggenheim Museum, Marcel has a meeting with James Johnson Sweeney to review the list of loans for the "Three Brothers" exhibition due to open on 8 January.

1957. Thursday, New York City
Having read the French text "with voracity",

26.10.1912

Duchamp tells Robert Lebel [8.10.1957] that it "pleased me and even amused me enormously. Regarding the English translation," he very much doubts that "the non-anecdotal passages, those which are 'distilled Lebel', could be translated except by an American 'erudite'."

*

Receives a visit from Monique Fong before she flies back to Washington.

1961. Tuesday, New York City
Writes to his sister Suzanne promising that Jackie Monnier, who arrived with a group of French collectors on 19 October, will bring her four copies of "The Art of Assemblage" [2.10.1961] catalogue when she returns to Paris. The show is "*almost* shocking", says Marcel, wondering whether Suzanne has seen Canaday's article in the *New York Times* of 17 October. The short interview for radio which Marcel made recently is to be broadcast on 1 November in New York.

1965. Sunday, New York City
"The stamp on this envelope expresses all my regrets at not being able to attend the [pataphysical] 'Feast of Bosse de Nage's Hat'," [28.10.1965, according to the vulgar calendar] writes the Transcendant Satrape Duchamp to the Transcendant Satrape Jean Ferry in Paris. The stamp in question represents Bartholdi's monument with the words "Liberty for All".

1967. Tuesday, New York City
For the New York exhibition of *Le Cheval-Majeur* by Raymond Duchamp-Villon [22.6.1966], Duchamp, who has recently returned from Europe, holds a belated press conference at M. Knoedler & Co. Inc., now situated at 14 East 57th Street.

"I'm not going to speak, I'll just answer questions," Duchamp tells the journalists. After discussing his brother's work he is soon persuaded to talk about himself. Grace Glueck of the *New York Times* notes his comments about the Paris art scene 50 years ago ("lively, though we didn't sell anything"), dealers and critics ("they have a trade, like grocers"), current art ("I like what the young people are doing") and the secret of his longevity ("not much liquor, but all the women you want").

If he had his life over again, would it be the same?

"I'm happy with what I did. I didn't want to produce too much – it isn't necessary in art. It shouldn't be a rule that an artist's importance is determined by the amount he produces."

What does he feel is his most important contribution?

"The introduction of the random into art. Though, actually, Rubens' technique was just as random as the accidental threads I used to let fall on my canvases [19.5.1914] – but we didn't realize it. We thought he knew just exactly what he was doing."

The conference terminates with Duchamp's thoughts on current work, which he compares to the Fauves: "...they only lasted for 6 or 7 years. But they left their imprint on our memories. You shouldn't try to judge the new art – you should try to love it."

25 October

1916. Wednesday, New York City
After dining together, Beatrice Wood and Marcel call on Salzados, where they find Alfredo Sidès, a business man, who is very good company and, according to Bea, they have "a charming time".

1917. Thursday, New York City
When Totor comes home in the evening he finds Roché, who has been resting an hour on his own in the studio after the tea party at Lou and Walter Arensberg's apartment. Together they join the Arensbergs for dinner at the Café des Artistes, almost next door on 67th Street.

1923. Thursday, Brussels
"From a perfectly happy man," writes Duchamp to Jacques Doucet on a card representing the Japanese Tower and Kiosque at Laeken. In his first important chess tournament, Duchamp's rating is very good and he remarks: "Rrose Sélavy has a *femmes savantes* side to her, which isn't disagreeable." Giving Doucet his address (Hôtel Parisiana, Rue de la Fourche) and the date of his return to Paris, Duchamp hopes that he will not be late for the frame [17.10.1923].

1932. Tuesday, Paris
The letter by Halberstadt and Duchamp of 26 September has been published on 15 October in *L'Italia Scacchistica.* In the same issue Stefano Rosselli Del Turco [17.3.1931], the editor of the Italian chess magazine, has printed his reply and revealed that he himself is the author of the original article, "Un plagio," attacking the chess book by Halberstadt and Duchamp [15.9.1932]:

"We deny that it is sufficient to prove the intention to render to Caesar the things that are Caesar's, and to write: 'we have been particularly encouraged by the work of the Ing. Rinaldo Bianchetti...' in a book which is only a badly made copy of what Bianchetti wrote in 1925," complains Rosselli Del Turco. Perhaps David Przepiorka was the first to pronounce the words *l'opposition est un cas particulier des cases conjuguées',* the editor admits, but he maintains that Bianchetti developed an entirely new process, which Duchamp and Halberstadt have copied without indicating the source.

"It is difficult to prevent M. Rosselli Del Turco calling us plagiarists each time he wants to and to prove it his way," comment Halberstadt and Duchamp in their letter today to the Italian chess magazine. "We only hope that one day maybe M. Bianchetti himself will let us know whether he intends starting a quarrel, of the Berger-Dedale kind, in which neither of the two parties convinces the other..." They declare that at least 100 pages are given to explaining a "new opposition", which they call "heterodox", and applies not only to the position of Bianchetti but also to Locock, Reichhelm and Ebersa. Finally, the authors request an end to the arguments, "before they become too subjective."

1933. Wednesday, Le Havre
Boards the *Ile de France,* which departs in the afternoon at two o'clock for New York. One of Duchamp's fellow passengers is the composer Virgil Thomson, who is travelling with Arnold Schoenberg and his family. Virgil has been spending the summer, with the help of his friend Maurice Grosser, scoring the music for his and Gertrude Stein's opera *Four Saints in Three Acts.* Florine Stettheimer is designing the sets and costumes.

1942. Sunday, New York City
"Yes, very good idea to have the string [14.10.1942] photographed," writes Dee to Miss Dreier, confirming at the same time that he will meet her at 451 Madison Avenue on 30 October. "I would rather lunch with you alone," he adds, "as we have so many things to speak about."

Duchamp, Breton and Kiesler, the three largely responsible for two important current manifestations, "First Papers of Surrealism" [14.10.1942] and Art of this Century [20.10.1942], dine together.

1946. Friday, Paris
Opening of the Alexander Calder exhibition, which Duchamp has helped to organize [24.6.1946], at the Galerie Louis Carré, 10 Avenue de Messine. In the catalogue of mobiles [2.2.1932], stabiles and constellations, there are essays by Jean-Paul Sartre and James Johnson Sweeney.

1947. Saturday, New York City
At nine-thirty in the evening Marcel arrives at 56 Seventh Avenue to play chess with Frederick Kiesler.

1950. Wednesday, Paris
At three-thirty in the afternoon Marcel has help from Roché's wife Denise in his task of sorting out the belongings of Mary Reynolds at 14 Rue Hallé, according to the Hubacheks' wishes [14.10.1950].

1958. Saturday, New York City
"We have received the marvellous photos safely and we look at them three times a day, after meals," writes Duchamp to Lily and Marcel Jean, referring to those taken of the Large Glass at Philadelphia earlier in the year [6.5.1958]. Duchamp wishes to reproduce one of the photographs on transparent paper, as an inset folded in half and glued to the inside cover of *Marchand du Sel*, the forthcoming publication of his writings edited by Michel Sanouillet [31.7.1958]. Using the same method as the one employed for the illustration of the Large Glass in *Le Surréalisme et la Peinture* [2.4.1945], Duchamp says he will add numbers by hand to the photograph before the block is made.

1960. Tuesday, New York City
Attends the opening at the D'Arcy Galleries, 1091 Madison Avenue, of an exhibition of oils and drawings by the young French Surrealist Pierre Demarne.

1965. Monday, New York City
As agreed by telephone on Friday, at about five or five-thirty in the afternoon Joseph Solomon is due to visit Duchamp at 28 West 10th Street.

26 October

1889. Saturday, Blainville-Crevon
Six days after her birth, Suzanne is privately baptized by the parish priest in the collegiate church of the village.

1912. Saturday, Avallon
Breaking their return journey to Paris, Picabia makes a stop in Avallon, where Apollinaire sends several postcards, including one to Louis Marcoussis.

It was the previous weekend after a long drive when Picabia, Apollinaire, Marcel and the chauffeur, Victor, reached the Jura foothills as night was falling. Suddenly a violent electric storm unleashed torrential rain while Picabia, a passionate driver, expertly negotiated the treacherous mountain roads. It was a dramatic climax to their journey and, having survived their battle with the elements and eventually found their destination, the men felt distinctly heroic on arrival.

Gabrielle Picabia was delighted to receive her friends in a region, her own, with so many charms: exquisite local produce (notably, the game, morels, cream, and wine from the hillsides below); "everything which Apollinaire greatly appreciated as well as the atmosphere and customs of the region, the frontier part of which, thanks to Voltaire, had been granted special and favourable excise regulations..."

During their stay in the old fortified farmhouse at Etival, isolated in the mountains some 30 kilometres from the nearest town, "the weather was terrible." On occasions when the rain stopped, they explored this "free" frontier region bordering Switzerland, known as the Zone, with Francis at the wheel and Gabrielle as their guide. Otherwise they stayed indoors, played a great deal of spillikins and talked: Picabia and Apollinaire preoccupied still with *Méditations esthétiques*, the evolution of artistic and poetic values [11.10.1912], and Marcel, no doubt, brooding on ideas for the work commenced in Munich [25.8.1912].

Since meeting Gabrielle [19.11.1911], Marcel has become very close to her and it remains a

secret between them that this is in fact his second visit to the Jura. In one of his letters sent to Gabrielle poste restante, Marcel compared their emotional relationship with that of the characters in *La Porte Etroite* by André Gide. Later in the summer after Marcel had requested repeatedly to see her alone, Gabrielle replied from Etival, giving him the date and timetable of her return journey to see Francis in Paris, leaving her children, Marie and Pancho, behind with her mother. After being driven as far as the railway station at Saint-Laurent on the branch line, at Andelot Gabrielle would indeed be alone for a short while, waiting for the connecting train to Paris.

Much to Gabrielle's surprise, Marcel came from Munich to Andelot, the tiny main-line station buried in the Jura mountains, and was waiting on the platform to meet her. They let the train to Paris go by and, after talking all night, Gabrielle boarded the first train for Paris in the morning and Marcel returned to Germany.

Apollinaire found in Madame Buffet, Gabrielle's mother, an extremely cultivated lady, granddaughter of Jussieu, the famous botanist whose circle included Chateaubriand, Mme Récamier and Lamartine. Taking his cue from Madame Buffet, Apollinaire conversed with her at length, displaying his extreme erudition. Gathered in the drawing room after dinner before a blazing fire, Madame Buffet requested Apollinaire to recite some of his poems. The elderly lady was particularly moved by one retracing his childhood disappointments, and she asked the poet its title. "It's not finished yet," replied Apollinaire, "and has no title yet." Then suddenly, he turned to her and said kindly, "I will call it *Zone*."

In this "mountain décor", thought Gabrielle, "how far we were from the New Spirit, the differences between Cubism and Orphism..."

*

According to Gabrielle, Marcel is unwell on the return journey. Nevertheless, the Jura–Paris road, combined with spices of distant Ejur [10.6.1912], inspires a text that he writes on his return:

"The machine with 5 hearts, the pure child of nickel and platinum must dominate the Jura–Paris road.

On the one hand, the chief of the 5 nudes will be ahead of the 4 other nudes *towards* this

27.10.1951

Jura–Paris road. On the other hand, the headlight child will be the instrument conquering this Jura–Paris road.

This headlight child could, graphically, be a comet, which would have its tail in front, this tail being an appendage of the headlight child appendage which absorbs by crushing (gold dust, graphically) this Jura–Paris road.

The Jura–Paris road, having to be infinite only humanly, will lose none of its character of infinity in finding a termination at one end in the chief of the 5 nudes, at the other in the headlight-child.

The term 'indefinite' seems to me more accurate than infinite. The road will begin in the chief of the 5 nudes, and will not end in the headlight child.

Graphically, this road will tend towards the pure geometrical line without thickness (the meeting of 2 planes seems to me the only pictorial means to achieve purity)

But in the beginning (in the chief of the 5 nudes) it will be very finite in width, thickness, etc., in order little by little, to become without topographical form in coming close to this ideal straight line which finds its opening towards the infinite in the headlight child.

The pictorial matter of this Jura–Paris road will be *wood*, which seems to me like the affective translation of powdered silex.

Perhaps, see if it is necessary to choose an essence of wood. (the fir tree, or then polished mahogany)

Details of execution.
Dimensions = Plans.
Size of the canvas."

1918. Saturday, Buenos Aires
"Because of the Argentinians' way of life, quite different to that of the New Yorkers, it is difficult to become acclimatized," writes Marcel to Jean Crotti about a month after his arrival

[19.9.1918]. "No public dances – the few night clubs correspond with the third rate clubs of Montmartre, infamous hookers." As ladies should not be seen in such places, he explains: "Yvonne finds herself deprived of her night life."

There is no trace of Cubism "or other modern elucubrations" in Buenos Aires, and Marcel proposes to try to organize a small exhibition of Cubists next May or June, bringing 30 pictures from New York including *Le Clown* by Crotti. "To enlighten these good people, critics and others," Marcel finds that *Les Peintres Cubistes* by Guillaume Apollinaire [17.3.1913] and *Du Cubisme* by Albert Gleizes and Jean Metzinger [20.10.1912] would save him "a heap of discourse". He asks Crotti to send him a dozen copies of each book to his apartment at Alsina 1743. As an alternative, if the publisher Figuière sent the books free, Marcel would undertake to distribute and sell them. In addition to these two titles, he asks Crotti to find four or five copies of *Un coup de dés jamais n'abolira le hasard* by Stéphane Mallarmé and a few magazines, such as *Les Soirées de Paris*.

"No intention to have an exhibition myself here," declares Marcel who, in addition to the apartment which he shares with Yvonne, has found a small studio at 1507 Sarmiento. "…I have started a small glass in order to see an effect that I will transfer to the Large Glass when I return to New York."

Marcel asks Crotti, if he has done anything new, to send it to him for the exhibition and to embrace Suzanne. "The recent news," he adds, referring to the war in Europe, "almost made me hope that we might see each other again soon…"

Before posting the letter, Marcel receives a cable from Suzanne announcing the death of their brother Raymond on 7 October in the military hospital at Cannes. "I am very sad at the news," writes Yvonne in a postscript. "…Tell Suzanne my despair at being so far from everyone in such circumstances," requests Marcel, "I cannot believe it, so much the less since I have not seen him for such a long time and he was in good health then. I do hope the family bears up!!!"

1927. Wednesday, Paris
In the Tournoi Championnat de Paris [15.10.1927] Duchamp plays one of his opponents at 90 Rue des Mathurins, and Roché comes to watch.

1937. Tuesday, Paris
Writes a short letter to Miss Dreier saying that the whole edition of her *40 Variations* are on the *Lafayette*, which sailed on Saturday. Regarding Berenice Abbott's photographs [25.6.1937] of the Large Glass, Dee is not sure whether he can use them to make a reproduction for his album, "because they are not 'full face'," he explains, "But we will see."

1942. Monday, New York City
"This letter gives me the impression of having been written three months ago when I arrived," writes Duchamp to Alice Roullier in Chicago. "Because I do not believe myself capable of such a simple lack of effusion than a letter when it is certain that it will arrive at its destination. This literature aside, how are you?" he enquires, mentioning that he has had news of her from Mrs Goodspeed [11.7.1937], "but not enough."

After a word about Roché, his own departure from France, and Mary Reynolds, who is "as stubborn as a horse, who wouldn't leave her house or her cat," Duchamp turns to business. Keen to sell one or two of "the new boxes" (his *Boîte-en-Valise* [7.1.1941]) Duchamp would like Alice to find the collectors as she has done before [22.12.1934]. "The price, evidently, is high," he tells her, $200 a box for the "de luxe" version which is limited to 20 copies. "Write quickly," adds Duchamp.

1947. Sunday, New York City
After finishing his chess game with Kiesler at one in the morning, Marcel returns in the evening at seven-thirty to dine at 56 Seventh Avenue.

1950. Thursday, Paris
At four o'clock in the afternoon Roché calls at 14 Rue Hallé. With Denise's help, Marcel has made a list [of Mary Reynolds' library?] and he invites Roché to choose some books not included in those to be transported to Chicago.

In the evening they meet Jean Suquet [25.12.1949] for dinner at Mouton-Duvernet. While entertaining Suquet, Duchamp treats himself to a dish of frogs' legs in spite of Roché pulling faces.

1966. Wednesday, New York City
Travels to Philadelphia for a meeting with the director of the Philadelphia Museum of Art. On recounting that the Musée National d'Art Moderne in Paris and the Musée des Beaux-Arts in

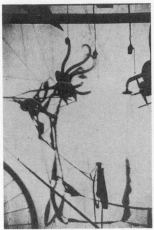

27.10.1964

Rouen would like to borrow from the Louise and Walter Arensberg Collection for an exhibition in April 1967, Duchamp receives a favourable response from Dr Evan Turner, who requests an official letter from the two museums.

27 October

1917. Saturday, New York City
Marcel, Lou and Walter Arensberg, Roché and Sophie [23.10.1917] dine at the Beaux-Arts Café. Later with Walter and Roché, Marcel visits Isadora Duncan in her large, new studio, where they talk late into the night.

1925. Tuesday, Paris
In the morning at the Hôtel Istria, Marcel is with his secretary, the sister of Raymond Radiguet's ex-girlfriend, who is busy typing chess endgames for him when Roché arrives. The two sisters have lunch with them at Le Select, 99 Boulevard du Montparnasse, and Roché notices that Marcel, "quite sweet," is adored by both the girls.

1926. Wednesday, New York City
From Manhattan, Duchamp goes to meet Miss Dreier at the Brooklyn Museum, where the stretching of canvases and the framing is under way in preparation for the opening of the Société Anonyme's "International Exhibition of Modern Art" on 19 November. They decide where to position the Large Glass which, until it was brought to the museum recently, has been in storage for three years [5.2.1923].

1937. Wednesday, Paris
The solution to the chess problem selected by Duchamp in June [18.6.1937] appears in tonight's edition of *Ce Soir*, and a further problem by H. Lange (unsigned) is proposed to readers.

1950. Friday, Paris
Helping to clear the house at 14 Rue Hallé, Roché brings Marcel's stock of [Green] Boxes down from the attic. Slowly he makes a great choice of books for himself, hesitates, and returns some of them. Among the items which belonged to Mary Reynolds, he takes the 1924 *Larousse*, the American novels, the set of six dessert plates decorated with a rebus, the long-handled Turk's

head brush, and the bedside lamp on a spring which, when he tries it at Arago, is still working. Marcel has put aside Mary's coffee grinder and an optician's sign to give to Etienne Martin, a young sculptor friend of Roché's.

1951. Saturday, New York City
After receiving another letter from Walter Arensberg enclosing photographs of *Homme et Femme* by Joan Miró and two paintings by Fernand Léger, *Le Typographe* and *L'Homme à la canne*, Marcel makes a statement that, to the best of his recollection, the three works were bought through him for the Arensbergs prior to 1935. "Have you any more holes in your memory?" Marcel asks Lou and Walter, "I hope not, when I think of the voluminous correspondence you must have had about that stupid tax [15.9.1951]."

1953. Tuesday, New York City
Travels again to the Philadelphia Museum of Art [22.10.1953] to inspect the rooms for the Arensberg collection, which are now finished except for some details in the artificial lighting. However Fiske Kimball remains noncommittal about plans for a "grand opening".

1964. Tuesday, New York City
"Bourgeois Gallery show *was* April 1916 [1.4.1916]," Marcel confirms to Richard Hamilton, who is preparing a catalogue for the exhibition of the Mary Sisler collection due to open on 13 February. "In this catalogue… are mentioned only two Readymades… *without* their title," explains Marcel and he advises Richard: "If I were you I would not jiggle with the dates… I don't actually remember *which* Readymades were at Bourgeois." Referring to the shadows of *Roue de Bicyclette*, *Sculpture de Voyage* and *Porte-chapeaux* photographed in New York [8.7.1918], Marcel declares: "The date [19]17–[19]18 for the photo of 33 W. 67th St. is OK."

1965. Wednesday, New York City
Sandy and Louise Calder come to supper at 28 West 10th Street; it was like old times, according to Teeny, "except that they left at 10.15 to go to bed!"

1966. Thursday, New York City
Writes to both M. Dorival, the director of the Musée National d'Art Moderne, and Mlle Popovitch, the director of the Musée des

Beaux-Arts, Rouen, to inform them of his encouraging visit to Philadelphia the previous day and Dr Evan Turner's willingness to lend works for the exhibitions to be held in France the following April.

1967. Friday, New York City
Writes to the Conseiller Culturel at the French Embassy, M. Edouard Morot-Sir, to inform him of Yo Sermayer's exhibition at the Bodley Gallery, and invites him to the opening on 14 November.

28 October

1917. Sunday, New York City
At three o'clock in the morning, after their long talk with Isadora Duncan, the three men return to 33 West 67th Street and Marcel invites Roché to sleep in his studio.

1926. Thursday, New York City
Responding to the Arts Club of Chicago's interest in taking the Brancusi exhibition, Duchamp cables Alice Roullier [1.7.1926] the dates of the show at the Brummer Gallery and suggests: "we might shorten exhibition here."

1949. Friday, New York City
Hoping to enjoy a little of the Indian summer in the country, Marcel telephones Yves Tanguy at Woodbury but gets no reply.

1950. Saturday, Paris
Leaving Roché to sort out some of the contents of Mary Reynolds' house at 14 Rue Hallé, Marcel goes out at eleven in the morning and returns at two o'clock. The removal van arrives at four and it takes an hour, with very little help from the driver, to load the vehicle with the furniture and books which Roché has chosen to purchase from Mary's estate. Roché accompanies the removal van to Arago and then to Sèvres, where he has agreed to store the stock of Green Boxes for Marcel.

1961. Saturday, New York City
Thanks Richard and Terry Hamilton for the "wonderful time" [26.9.1961] and promises to study the map of London before their next visit.

29.10.1910

31.10.1924

For the Rose Fried Gallery, Duchamp signs a receipt of payment for three copies of the *Boîte-en-Valise* [7.1.1941].

1965. Thursday, New York City
Enjoying an "orgy of movies", after seeing recently the Beatles' second film *Help!*, Peter Sellers in *What's New, Pussycat?* and *The Knack or How to get it*, directed by Richard Lester, in the evening Teeny and Marcel see *The Loved One*, based on the novel by Evelyn Waugh.

29 October

1910. Saturday, Paris
While Marcoussis contributes a cartoon about the current railway strike, the drawing by Duchamp in *Le Rire* today is entitled *La Mode ample*. It resembles *Grève des PTT* [23.3.1910]. The young man perched on a bar stool is in evening dress and wearing a top hat several sizes too large for him: "Tell me now," demands the woman, "when will you stop using your father's hats?"

1916. Sunday, New York City
The Stettheimer sisters take Professor Hirth and Duchamp out motoring to visit the Elizabeth Duncan [24.10.1916] School of Dance on Mount Airy Road at Croton-on-the-Hudson, which Mabel Dodge, also resident on Mount Airy Road, has recently helped to establish. Situated on a high hill overlooking the Hudson, the school "had atmosphere" according to Florine.

1923. Monday, Brussels
Provisionally placed third in the Tournoi National Belge, Marcel writes with pride to Picabia at Le Tremblay-sur-Mauldre, choosing a postcard evoking the French disaster at Waterloo. "Delighted with the visit playing every day from 6 until 8 in the evening – resting like a protégé during the day…"

1925. Thursday, Paris
After meeting Mary Reynolds at the Petit Buffalo, Roché takes her to lunch at Couteau's, 32 Avenue d'Orléans, and learns that she is "happy with Totor". He then sees Totor a little later in the company of some girls at the Café du Dôme.

1949. Saturday, New York City
Dee goes to see Miss Dreier at Milford to resolve a number of questions which have arisen with George Heard Hamilton, their collaborator at Yale University, in preparing the catalogue of the collection of the Société Anonyme. Both Dee and Miss Dreier wish to sign the biographical notices they have written on individual artists, and Miss Dreier believes that they should not be "uniform in system".

1953. Thursday, New York City
Knowing that Louise is now at home after her operation, Marcel writes to the Arensbergs about his visit on Tuesday to Philadelphia and asks them about a date for the opening: "What is your feeling and have you any ideas you want me to give them… I think March could be a good time," he suggests and adds, "Tell me if I should undertake anything with the Philadelphians."

*

"My silence does not prevent me from thinking of you often," writes Marcel to Man Ray in Paris. Wishing to include *Feuille de Vigne femelle* [12.3.1951] in his forthcoming exhibition with Picabia on 6 December at the Rose Fried Gallery, Marcel asks, if it is not too complicated, to send him one or two copies of the limited edition in painted plaster, which Man made from the original.

1955. Saturday, New York City
Having earlier in the week attended one of the previews at the Solomon R. Guggenheim Museum of the Brancusi exhibition which he had helped with in the initial stages [3.6.1953], Marcel posts a letter to Roché saying that the show is a "triumph", and "Sweeney has surpassed himself" in presenting the sculpture.
The other news is that Sidney Janis is "very enthusiastic" about his Cubist exhibition, opening in January. The rushes of the interview with Sweeney [3.8.1955], which Marcel has seen, have already been cut from 2 hours to 40 minutes.
"And great joy to know that your book will be published by Gallimard. When?" enquires Marcel, referring to *Deux anglaises et le continent*, which Roché has completed since the publication of *Jules et Jim* [15.5.1953].

1958. Wednesday, New York City
In a short note to Patrick Waldberg (whose book on Max Ernst is due to appear in December), Marcel agrees to look at the photographs

of M. Cummings, which have not yet arrived, promising to return them without delay.

*

With the pretext of the forthcoming publication of Lebel's monograph on Duchamp (for which there is still no date of publication), Alain Jouffroy met both the artist and the author at Max Ernst's apartment before Duchamp returned to New York on 3 October. This second interview by Jouffroy, accorded after an interval of almost four years [24.11.1954], is published today in the weekly Parisian magazine *Arts*.

Describing Duchamp's close participation in the design and production of the book, the "de luxe" version, Lebel considers, "will be a genuine object by Duchamp." Duchamp smiles and protests: "Lebel quite simply forgets to mention his text and I want to say how much this text satisfies me, certainly not for the praise bestowed on me, but because it helps me to understand myself."

In reading the book, has Duchamp been able to put to the test his theory, which has many enemies, that the artist is unconscious of the real significance of his work and that the spectator must always participate in the artistic creation by interpreting it?

"Without any doubt… on my own works and behaviour [Lebel] provides me with explanations which I had never dreamed of. The real critique of art should be a participation and not, as is in most cases, a simple translation of that which is untranslatable."

As author of one of the key works of modern art, *Nu descendant un Escalier* [18.3.1912], how do you explain that you have had to wait so long before a book is published about you?

"The choice made in this field cannot be explained otherwise than by a kind of mental chance or in commercial advantages… I probably don't offer enough of a hold on these operations concentrated on an individual."

Lebel has spent more than six years on the book, do you consider yourself to be a particularly difficult or esoteric artist compared to Picasso and Braque for example?

Duchamp hesitates before replying: "What may have disorientated certain people in my attitude, is that it was difficult to divide the man and the artist. This was a danger for the biographer that only Robert Lebel could avoid by considering the whole situation."

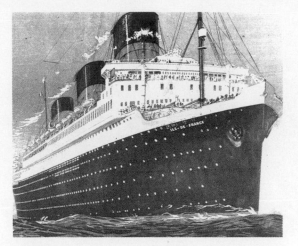

31.10.1933

Lebel declares that in France it is often forgotten that Duchamp is not completely unknown and that he enjoys immense prestige in America. Although as early as 1934, André Breton published an important article [5.12.1934] in *Minotaure*, giving Duchamp his rightful place, "everything was done so that the wider public knew nothing…"

There are more than 200 works catalogued in Lebel's book, but in France it is thought that you have produced nothing, Jouffroy tells Duchamp. As most of the work is in American museums, would it not be the moment to arrange a big exhibition in Paris?

"Histrionic manifestations have never tempted me, but they suit me even less at my age. It would be more practical to organize cut-price excursions to take those who are interested to the museums where my work is to be found. Let the art lovers and critics stir themselves."

Remarking that he has recently made some new works, notably one for the "de luxe" version of the book, Jouffroy suggests that, although it is claimed otherwise, Duchamp has not really abandoned Art.

"If at a certain moment I ceased to paint *physically*," replies Duchamp, "I never pledged anything concerning intentions which could arise by themselves. Lebel's book gave me the occasion to express myself in the opposite way to the painter's routine which is eternally repeated… I am not a painter in perpetuity and since generals no longer die in the saddle, painters are no longer obliged to die at their easel."

1964. Thursday, Paris
Une Révolution du regard by Alain Jouffroy, which includes his third interview with Duchamp [8.12.1961], is published by Gallimard.

30 October

1934. Tuesday, Paris
On the advice of André Breton, Duchamp has already sent subscription forms to Valentine Hugo for *La Mariée mise à nu par ses Célibataires, même*, known as the Green Box [16.10.1934]. In his letter to her today Duchamp refers to the article for *Minotaure,*

which Breton is preparing on the notes for the Large Glass [5.2.1923].

1942. Friday, New York City
"From 11:30 on," Dee is due to meet Miss Dreier at the exhibition "First Papers of Surrealism" [14.10.1942] and afterwards have lunch with her [25.10.1942].

1945. Tuesday, New York City
At seven-thirty Marcel is invited to dinner at Julien Levy's joining Dorothea Tanning, Max Ernst, the Kieslers, Kurt Seligmann and Matta in their ninth reunion to discuss their experiences in magic.

1955. Sunday, New York City
"Thank you for your letter and the marvellous idea you had," writes Duchamp to Iliazd, who suggested that the intervention of Jean Adhémar [20.10.1955] might solve the problem with the French customs.

*

Writes to Lefebvre-Foinet to say that Iliazd will call to put him in touch with M. Jean Adhémar.

1963. Wednesday, New York City
Having spoken to the dealer George Staempfli about the two Renoirs which belonged to the Crottis, Marcel tells Robert Lebel: "He is interested and will go to Paris in December to see them…" Would Lebel, in his capacity as expert, agree to provide a certificate of authenticity, which would make a sale easier? "Tell me as well," requests Marcel, "what % you would like?"

31 October

1917. Wednesday, New York City
Duchamp lunches downtown with Arensberg, Roché, de Journo and Varèse.

1924. Friday, Paris
Having been to the engraver earlier and seen the phrase now inscribed in a circular fashion on the copper plate [20.10.1924], Duchamp tells Jacques Doucet: "…[he] has done a remarkable job for me." As Doucet has not, apparently, quite understood how this piece fits

with the rest of the machine, Duchamp explains with a diagram: "On top of what you saw turning at Man Ray's comes a red copper disk holding the glass globe…" With only the mounting of this part and the velvet remaining to be done, Duchamp writes: "I hope to be able to ask you to come to Man Ray's around the middle of next week. Everything will be finished."

1925. Saturday, Paris
On his way to catch a tram to Fontenay, Roché catches sight of Totor at the Café du Dôme with his usual girls, and a new one, who is busy combing his hair.

1927. Monday, Paris
Having a delicate matter to discuss with Lydie, who is now installed in her own apartment [17.9.1927], Marcel asks her to come to his studio at 11 Rue Larrey. Rapidly he explains to her that he is unable to bear the bond, moral burden and responsibilities of marriage; that it is an absolute necessity for him to regain his liberty and that he wants a divorce. With the assurance that it will not change their relationship, Lydie agrees to cooperate.

1931. Saturday, Paris
In the morning, when Roché arrives at 11 Rue Larrey and sees a Rolls-Royce parked by the entrance, he is sure that it is for Marcel, maybe a high-class "bird". However it is none other than Picabia, who has left his latest motoring piece in the street below while visiting Marcel. After chatting and recalling the times in New York together [20.9.1917], Roché and Marcel have lunch on their own at Les Maronniers, 53bis Boulevard Arago.

1933. Tuesday, New York City
At ten-thirty in the morning the *Ile de France* docks, bringing Duchamp, after seven years' absence, back to America for another Brancusi exhibition [17.11.1926].

Later in the day he dictates a letter to Louise and Walter Arensberg asking them if they would agree to lend *L'Enfant Prodigue* to the show: "Can you ship it as soon as possible to the Brummer Gallery, 53 East 57th Street?" he requests.

1949. Monday, New York City
In today's *Time* magazine, "Be Shocking" is the headline of Lou Spence's account of Duchamp's appearance in Chicago [19.10.1949]. "It isn't

1.11.1921

that modern art is dead," Duchamp is quoted as saying, "it's just finished and gone... Unless a picture shocks it is nothing – a calendar painting." A work of art must express a new idea, he believes, but all the masters of modern art "long ago ran out of ideas... I myself haven't given up painting," Duchamp explains, "I'm just not painting now, but if I have an idea tomorrow I will do it."

1950. Tuesday, Paris
Invited to Arago at eight, Marcel then goes to eat a couscous with Roché and Marie-Thérèse Pinto at the restaurant Ben Aïssa, 83 Avenue Denfert-Rochereau. Roché finds that Marcel and Pinto get along well together.

1954. Sunday, New York City
"The tickets have been bought, the packing started," Marcel tells Roché a week before leaving for Europe. Signing MarTotor and Mar-Teeny, Marcel says that unless he hears to the contrary they will go directly to Boulevard Arago on their arrival in Paris.

1956. Wednesday, New York City
In anticipation of the delivery of *9 Moules Mâlic* [19.1.1915] to their apartment in a day or two, Marcel writes to inform Roché (who has sold the glass to Teeny [4.10.1956]) that the crate is now at the customs.

1961. Tuesday, Boston
In the morning Marcel and Teeny attend the christening of Michael, son of Paul and Sally Matisse. Jackie Monnier, the baby's aunt, who is on a visit to the United States [15.10.1961], is one of the godparents.

*

On his return to Manhattan later in the day, Duchamp replies to James Johnson Sweeney in Houston regarding a "presumed De Zayas Derain" from the period 1917–18 when Marius de Zayas had a gallery in New York.

1963. Thursday, New York City
His return to Pasadena imminent, Duchamp sends a cable to Walter Hopps.

*

To Brookes Hubachek's "bombshell letter" about the shipment from Rome [17.9.1963], Marcel declares: "In spite of my usual fear of shipping monsters, I was overcome by the detailed torture the common species inflicted to those innocent items."

Promising to tell Baruchello about the "abominable handling of the shipment", Marcel hopes that "the repairs can be taken care of without too much trouble..."

1 November

1919. Saturday, Paris
Duchamp does not exhibit at the Salon d'Automne which, this year, pays homage to Raymond Duchamp-Villon [7.10.1918] by presenting 19 of his works dating from 1906 until his death.

1921. Tuesday, Paris
Since his return [25.6.1921], Marcel has graced Francis Picabia's canvas entitled *L'Œil cacodylate* with the pun: "en 6 qu'habilla rrose Sélavy" – a variation on a theme adopting the spelling of Rrose [10.7.1921] – to which he has added his name in capital letters. The inscription is embellished with two small cut-out photographs of Duchamp's head: one with it completely shaved in Buenos Aires [9.3.1919], and the other with the comet (its "tail being an

appendage of the headlight child..." [26.10.1912]) shaved by Georges de Zayas at Ribemont-Dessaignes' property at Les Houveaux, hamlet of Le Tremblay-sur-Mauldre. In this way both Rrose and Marcel, with Madge Lipton on their left and Jean Cocteau on their right, are present with a host of Picabia's friends at the Salon d'Automne, where the picture is exhibited.

One of the many Americans "strolling on the Montparnasse", Charles Demuth's view is that the Salon d'Automne is "dead – about five years dead". He tells Stieglitz that "Marcel, dear Marcel, is doing some wonderful movies [1.9.1921]" and "seems to be the only one really working".

1922. Wednesday, New York City
Illustrated with drawings by Robert Locher, *Vanity Fair* publishes an article in praise of Marcel's close friend, Yvonne George, who has recently joined the Greenwich Village Follies. She has come to New York after working for almost a year at the famous small café in the Rue Dantin, Chez Fisher, where she captivated her audiences with a repertoire of old sad songs of love and death.

1924. Saturday, Paris
On All Saint's Day, following encouraging exploratory results [20.4.1924] Rrose Sélavy as president of the board of directors, and Duchamp as administrator, issue 30 bonds of 500 francs each (2,000 francs at present values) entitled: *Obligations pour la Roulette de Monte-Carlo*. The purpose of the company issuing the bonds, which are redeemable by "artificial drawings" and bear interest of 20%, is firstly to exploit the Roulette of Monte Carlo, and also "Trente et Quarante" and other mines on the Côte d'Azur, as may be decided by the directors. Extracts from the statutes printed on the back of the bond also state that the "system", a cumulative one "experimentally based on one thousand rolls of the ball", is the exclusive property of the board of directors.

Using the roulette table and Rrose Sélavy's words "Moustiquesdomestiquesdemistock" run-together and repeated in fine green italics as a background, the face of the bond is also decorated with an image by Man Ray. His photograph of Duchamp's head lathered with soap and his hair sculpted into the winged head of Mercury, the Roman god of science and commerce, patron of vagabonds and thieves, is cut out and glued within the roulette wheel, except for the bristling mercurial wings.

1926. Monday, New York City
Marcel calls again to see Beatrice Wood [23.10.1926].

1933. Wednesday, New York City
The day after his arrival, Marcel writes to Alice Roullier, who took the previous New York

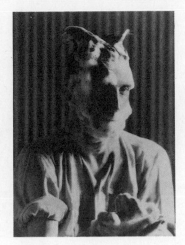

1.11.1924

Brancusi exhibition to Chicago [4.1.1927], giving her, as requested, his address at the Hotel Blackstone, 50 East 58th Street. Will Alice have the opportunity to come to New York soon? "I remember in my last letter I spoke about a possible voyage to N.Y.," Marcel explains, "but in fact I was certain that nothing would happen. Everything was decided so rapidly that I still believe it's a dream. Write to me quickly."

1942. Sunday, New York City
Marcel spends part of the day with his neighbours, the Kieslers [2.10.1942].

1950. Wednesday, Paris
After dining together at the restaurant Au Cochon de Lait, 7 Rue Corneille, near the Palais du Luxembourg, Roché accompanies Totor back to 14 Rue Hallé before returning home.

1952. Saturday, New York City
Duchamp writes three letters to Chicago. Two are to the Art Institute "informally" but in his capacity as an executor of Miss Dreier's estate [29.3.1952]. He asks Katharine Kuh whether "Dan Rich and the Chicago Institute in general would like to receive (as a present) the marble *Leda* of Brancusi…" To Mr Schneewind at the Print Department, Duchamp proposes the gift of about 30 "interesting" etchings by Dürer, Whistler, and others.

"What joy to receive your news," Marcel tells Alice Roullier, who has written for advice about selling a Stella. He gives her the address of a dealer, mentions how busy he is with Miss Dreier's estate and asks her when she might come to New York. "I don't see any opportunity for me to go to Chicago," he adds, "but you never know."

1959. Sunday, New York City
Teeny and Marcel take possession of an apartment they have found in Greenwich Village at 28 West 10th Street: "two enormous rooms and only one flight up…" While the move actually takes place they continue to stay at the Hotel Dauphin a day or two.

Returning the extract from the letter he wrote to Jean Crotti on 17 August 1952, Marcel gives Suzanne permission to publish it, as it is [12.10.1959], in the Galliera catalogue.

Marcel also finds it an auspicious day to give up smoking.

1961. Wednesday, New York City
At seven o'clock in the evening, a short interview recently recorded with Duchamp for "La Voix de l'Amérique", is broadcast on the radio by France III.

1966. Tuesday, New York City
"I have studied your list of works: it seems to be very representative," writes Duchamp to Bernard Dorival, the curator of the Musée National d'Art Moderne. "All the important pieces are there except number 111, *Réseaux des Stoppages* [19.5.1914], which you could perhaps include in your loan request to Mrs Sisler." Using the numbers from the Tate Gallery catalogue [17.6.1966], and making a list by collectors, which he encloses, he suggests including *Eau et Gaz à tous les Etages* [6.4.1959], no.181, and *Boîte-en-Valise* [7.1.1941], no.168. "I have omitted 74, 77 and 169 (really of no interest)."

Now that the exhibition will open at Rouen and go afterwards to Paris in June, Duchamp writes: "I hope therefore that Mlle Popovitch will be happy with your gesture which leaves her to be the first…"

2 November

1919. Sunday, Paris
When Marcel returns to the apartment in Avenue Charles Floquet, Roché is already in conversation with Gaby Picabia and has seen the baby Vicente [15.9.1919]. As Roché sailed for New York on 19 July, returning only a few days ago, and Marcel's ship arrived in London from Buenos Aires on 22 July, they have not met for well over a year [3.7.1918]. Although his shorn head [9.3.1919] lends him rather a consumptive air, Roché finds Marcel has "ripened" and that he is as gracious as ever.

After the three of them have had dinner, other guests arrive: Bordelongue and his wife (who dance so erotically together), Juliette and Albert Gleizes, Jean Cocteau, and a troupe of young dancers. With music, the dancing begins and Roché escapes from the party at eleven.

1923. Friday, Paris
After a delightful and successful visit to Brussels, Duchamp arrives at his studio in Rue

Froidevaux at six in the evening and finds two letters from Jacques Doucet, one enclosing a cheque (for the two works purchased recently [28.9.1923]?).

"I finished third in this tournament, which amply flatters my chess player's vanity," writes Duchamp to the collector. He promises to start cleaning *Glissière contenant un Moulin à Eau en Métaux voisins* [11.12.1919] as soon as he returns from Rouen: "It will take me 2 or 3 afternoons," he calculates. "Tell me how you want to arrange that," he requests Doucet.

1930. Sunday, Paris
Duchamp sends Man Ray a list of sculpture by Brancusi that still belong to him [13.9.1926] and their prices: *Prométhée, Trois Pingouins, Chimère, Torse de Jeune Homme, Torse de Jeune Fille, Adam et Eve, Le Commencement du Monde* and *La Colonne sans fin*. "Except *La Colonne sans fin*, which is in New York, all those belonging to me are at Roché's," declares Duchamp.

1933. Thursday, New York City
"Here I am arrived and settled in perfectly at the hotel chosen by Brummer," writes Marcel to Brancusi, who has remained in Paris. "It is agreed that he pays all my expenses – be reassured on that side." The catalogue for the exhibition, which opens on 17 November, is at the printers and Brummer will wait until the sculpture arrives before deciding the prices. "We are bringing *L'Enfant prodigue* from the Arensbergs [31.10.1933], Clark's bird, Miss Dreier's baby, so that all the important collections are represented (also the Pogany belonging to Mrs Pollack)," says Marcel. Busy planning a visit in the next few days to Philadelphia, he has seen Crowninshield of *Vanity Fair* and will meet Henry McBride the next day. "Everyone is enthusiastic and stunned that such an enormous thing can happen at the moment… Everyone sends you their good wishes – the list would be too long."

1939. Thursday, Palavas-les-Flots
Since his last letter to Miss Dreier [24.9.1939], Duchamp has left Paris and has been searching with Mary Reynolds for somewhere to live, first near Aix-en-Provence; they are now staying for a month by the sea near Montpellier at the Villa l'Horizon.

A letter from Miss Dreier has been forwarded from Paris in which she writes: "I have set my

3.11.1905

3.11.1913

heart on having you at the opening of the big exhibition of a section of the Collection of the Société Anonyme, which the George Walter Vincent Smith Art Gallery is putting on from November 9th…" However Duchamp travels 8 kilometres to Montpellier and cables his reply: "Quite impossible now writing = Duchamp."

1963. Saturday, New York City
While Marcel flies back to California to spend four days "hamming on French television" (a rendezvous which has been made there with Jean-Marie Drot "because Philadelphia has been emptied" for the Pasadena retrospective [7.10.1963]), Teeny makes a short visit to Cincinnati.

3 November

1905. Friday, Rouen
Having retired as *notaire* [27.3.1905] and moved with his wife, three daughters and Clémence to 71 Rue Jeanne d'Arc in the Norman capital, Eugène Duchamp writes to the *préfet* of the Seine-Inférieure presenting his resignation as mayor of Blainville-Crevon [7.11.1895], and that of his deputy M. Alexandre Déquinemare.

As for the rest of the family, his two eldest sons, Gaston and Raymond, have recently moved from Paris to the suburbs at Puteaux, 7 Rue Lemaître, where, within sight of the Eiffel Tower and with Kupka [12.11.1904] as a neighbour, they occupy two new studio houses. Marcel is in army uniform doing his military service [3.10.1905].

1913. Saturday, Paris
After attending classes at the Ecole des Chartes [4.11.1912], Duchamp has been receiving instruction since May in the duties of under-librarian from the staff at the Bibliothèque Sainte-Geneviève, where Picabia's uncle Maurice Davanne is a librarian. It is due to his patronage that Duchamp is engaged on a temporary basis for two months to replace another librarian, M. Mortet, who is on leave. Considering it "a wonderful job" because he has so many hours to himself to continue his plans [22.10.1913] for the Large Glass, Duchamp is to receive 100 francs (or 1,500 francs at present values).

1915. Wednesday, New York City
In the evening Duchamp, who lives at number 34 [18.10.1915], has an invitation to visit his neighbour Walter Pach at 33 Beekman Place. Pach has also invited Albert Gleizes, Jean Crotti, the Prendergasts, George Of and Henry McBride.

1919. Monday, Paris
By one in the morning, Gaby Picabia's party has run dry. Knowing of an all-night bar on the Avenue de Suffren, Marcel offers to go in search of alcohol. Gaby, who is bored stiff, and Juliette, who would like some fresh air, volunteer to accompany him. However, since the war the Parisian street lighting still leaves a lot to be desired. In pitch darkness, the trio have great difficulty in finding their way. Advancing like a sleepwalker, Marcel repeats despairingly: "Oh! what a good time I'm having Avenue de Suffren, what a good time I'm having Avenue de Suffren, what a good time…"

1920. Wednesday, New York City
At a meeting of the Société Anonyme, also attended by Wallace Putnam, Man Ray, Joseph Stella, and Mrs John Bishop, Duchamp declines to continue as president [29.4.1920] and is elected chairman of the Exhibition Committee. Relinquishing her responsibilities as treasurer to Paul Gross, Miss Dreier becomes president; Marsden Hartley is appointed secretary and Mary Knoblauch, head of the library.

1930. Monday, Paris
Following the shipment of paintings sent on 22 October for the Société Anonyme exhibition [7.9.1930], Dee cables Miss Dreier in New York that the pictures by Johannes Molzahn "will be shipped fifth November on SS *France*".

1933. Friday, New York City
In preparation for the Brancusi exhibition on 17 November, Marcel is due to see Henry McBride during the day, he also meets Albert E. Gallatin, who intends purchasing *Le Poisson* in bronze and requests a catalogue of the 1926 Brummer exhibition [17.11.1926] for the library of his museum.

Later Marcel writes to Brancusi for the catalogue saying: "If you prefer to keep the New York catalogues, send me one of Chicago [4.1.1927]."

1934. Saturday, Paris
Clos Vert, alias Dorothy Dudley, writes an article on Duchamp's latest publication, *La Mariée mise à nu par ses Célibataires, même* [16.10.1934], the collection of notes from which the Glass of the same name evolved in New York from 1915 to 1923. "He calls it a book," she declares, "but it is a book such as the publishing world has not seen before." Slipping it out of its ordinary cardboard case, "the book… bound in green suede, is not really a book but a box, and not really a box but a book. A thing to surprise to keep you guessing… The package is like a closed door, yet somehow inviting you to open it. The inside is even more surprising…" She states that the 93 documents inside, "as loose and free as air, money or sin, are irresponsibly beneath the hand to be read or scrutinized as you wish – no binding, no numbering, no indicated sequence. They exist, in fact, at liberty without traditional moorings. Reader and book must find a new manner of attachment to each other, and to the problem called culture."

After describing the contents and the Large Glass [5.2.1923] as described to her, Dorothy Dudley concludes: "You may say this book is nonsense, but it is nonsense that makes sense. Perhaps it is a *retard* in books, a regulator, a corrective, to decorators too exuberant over their modern, for whom surfaces have become more important than structure. In other words the streamline more important than the destination."

1937. Wednesday, Paris
The chess column in *Ce Soir*, unsigned, publishes the solution to one of the problems chosen for the readers by Duchamp [19.10.1937].

1938. Thursday, London
One of the *Obligations pour la Roulette de Monte-Carlo* [1.11.1924], is included with 93 other works in the "Exhibition of Collages Papiers-Collés and Photo-Montages", installed for Peggy Guggenheim by Roland Penrose at her gallery, Guggenheim Jeune.

1950. Friday, Paris
In the evening Totor telephones Roché and they have dinner together at the celebrated Norman restaurant Pharamond at 24 Rue de la Grande Truanderie in Les Halles. With real cider from Normandy to accompany the meal, Totor eats a steaming dish of *Tripes à la mode*

4.11.1942

de Caen, one of the specialities on the menu, and Roché chooses a *brochette* of kidneys.

1959. Tuesday, New York City
"We are moving this evening," writes Duchamp to Robert Lebel, "and our definitive address for many years I hope is: 28 West 10th Street."

Telling Lebel that he has received a long letter from André Breton, busy organizing a Surrealist exhibition, Duchamp agrees to the loan of *With my Tongue in my Cheek* [30.6.1959].

To promote Lebel's book [6.4.1959], which appears officially in New York on 6 November, Duchamp has already been interviewed by *Newsweek*. He has also received the short, poetic text from Jean Cocteau [24.1.1938], which, if Lebel agrees, he will pass on to the American publishers, Grove Press.

Headed "Marcel" and underlined with a flourish, Cocteau declares that he will never forget " the spectacle of elegance" one Sunday at Picabia's, when he saw "three greyhounds enter, of which one is Marcel Duchamp. Marcel invented everything of the 'Great Era' without the inelegance of knowing it," writes Cocteau. "Genius tumbled from his pockets. With a small gold key, he opened a door on a world which was mine without my suspecting it. I will always retain a tender and solemn devotion for him. He remains, in my view, the founder of this unreal realism which will be the keynote of the century, and is symbolized by his Joconde with the moustaches of a musketeer."

1961. Friday, New York City
Writes to Louis Carré and also to Brookes Hubachek. "We received some time ago your wonderful kaleidoscopic gadget," Marcel tells Brookes. "…it's so much more interesting than the old broken, coloured glass kaleidoscope and so much more varied in possibilities!" He is sorry that their planned meeting with Jackie Monnier (whom they saw on Tuesday in Boston) "had turned into a dislocation of dates" [15.10.1961]. "It was our fault," Marcel admits.

1964. Tuesday, New York City
In the evening with Denise and David Hare, Marcel and Teeny watch the results of the presidential election coming in on television.

1967. Friday, New York City
"Here is M. Morot-Sir's reply to my invitation [27.10.1967]," writes Marcel to Yo and Jacques

Savy, "and now Bon Voyage, N.Y. is waiting for you…" The Conseiller Culturel of the French Embassy, who will be returning from Virginia the evening of the opening, 14 November, has asked his wife to represent him. He says, however, that he would very much like to meet the artist at the gallery on 15 or 17 November.

4 November

1912. Monday, Paris
Taking a decision to paint only for himself, Marcel decides to become a librarian and enrols for a course in bibliography at the Ecoles des Chartes. After his brush with the Cubists [18.3.1912], he wants nothing more to do with "professional painters", and needs time to elaborate the project he commenced in Munich.

For Marcel there are two kinds of artists: "the artist that deals with society, is integrated into society; and the other artist, the completely freelance artist who has no obligations." After the Salon d'Automne [30.9.1912], which closes on Friday, he has no further intention of exhibiting in Paris. To release him from "material obligation", a librarian's career, Marcel considers, provides "a kind of social excuse no longer obliging me to expose myself". Besides he finds attending the Ecole des Chartes is "taking an intellectual position as opposed to the manual servitude of the artist".

1915. Thursday, New York City
After being out all day, Duchamp arrives home late at night and finds a special delivery from John Quinn enclosing five letters for translation and a letter from Miss Belle da Costa Greene, Jack Morgan's librarian. Quinn has arranged an introduction and his instructions to Duchamp are to send a note to Miss Greene immediately telling her whether he will go to the J. Pierpont Morgan Library the following day or on Saturday at eleven o'clock, but it is too late for Duchamp to do as Quinn suggests.

1919. Tuesday, Paris
With Miss Dreier, who is now staying for a few weeks at the Hôtel Brighton after visiting her relatives in Germany [12.8.1919], Duchamp and Roché dine at one of the oldest restaurants

in Paris, La Pérouse, situated at 51 Quai des Grands-Augustins.

1942. Wednesday, New York City
"I can't write such letters as your nice last one, but in my telegraphic way I mean the same thing," writes Dee to Miss Dreier at The Haven. "Mr Schiff came and took the strings and will

send you a set of the photographs [14.10.1942]. Hope to see you soon in your tenth floor apartment," he adds, "with a view I hope."

1956. Sunday, New York City
"Bravo – the Glass has arrived unscathed and without any difficulty with the customs [31.10.1956]," Marcel tells Roché, referring to *9 Moules Mâlic* [19.1.1915], which now belongs to his wife and is already installed on the mantelpiece. "Teeny is in the eighth heaven," continues Marcel, "and she is going to write to you 'personally'."

Mentioning the Suez crisis, Marcel comments that Teeny finds that France has a lot of courage… "How is the grandson," he asks Roché adding, "me, I will only be a consort or immaculate grandfather."

1957. Monday, New York City
Concerned about the quality of the English translation of Robert Lebel's manuscript [24.10.1957], Duchamp writes to George Heard Hamilton to ask him whether it would appeal to him to revise passages and certain pages of it.

1958. Tuesday, New York City
It is election day. A cable arrives announcing the birth of a daughter, Catherine, to Jackie and Bernard Monnier. Marcel advises Teeny, who is

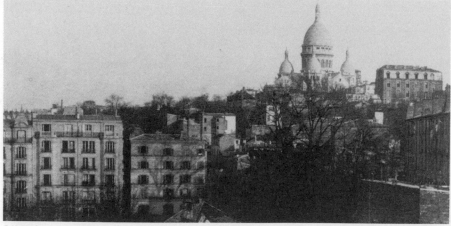

5.11.1906

concerned about Jackie's health, that, as a tonic, his mother drank a certain brew of French stout.

In the evening Peter Matisse comes to supper and stays very late listening to the returns: Nelson Aldrich Rockefeller [12.12.1955], the Republican candidate, defeats Harriman and is elected Governor of New York State.

1964. Wednesday, New York City
In the early hours of the morning, the Duchamps and the Hares learn the results of the election: a landslide victory for Lyndon Johnson over his opponent, Senator Barry Goldwater.

*

Today Marcel has a checkup at White Plains Hospital [31.12.1962].

5 November

1906. Monday, Paris
Liberated from the army [18.9.1906], Duchamp is back in the hub of Montmartre at 65 Rue Caulaincourt, a few doors down from his friend Gustave Candel, the son of a cheese merchant, who lives at 105 with his parents. The view across the Maquis to the Sacré-Cœur and the Moulin de la Galette which Marcel enjoyed from Villon's apartment at number 71 [12.11.1904], is gradually being masked by new development.
Returning to the Académie Julian after more than a year's absence [15.5.1905], Duchamp pays 25.10 francs for four consecutive weeks of morning classes.

1915. Friday, New York City
At eleven o'clock in the morning Duchamp goes to see his neighbour Walter Pach and asks him to telephone Miss Greene and present his apologies. When Pach speaks to Miss Greene, she confirms the appointment with Duchamp in the library at a quarter to four. "I misunderstood your letter [4.11.1915]," writes Duchamp to Quinn afterwards, "I thought I should write to Miss Greene before going to see her... Let me now thank you very much as I hope [to] do that much better very soon."

In the afternoon, at the appointed time, Duchamp arrives at the little Renaissance-style palazzo, 33 East 36th Street, the library built by the late J. Pierpont Morgan adjacent to his residence on Madison Avenue. When Duchamp meets Belle Greene, appointed librarian by the great banker and collector in 1906, he no doubt has Quinn's advice ringing in his ears: "You will find her quite a business-like person. I hope you will get along well with her and that you can come to some satisfactory arrangement... You mustn't be backward in talking to her. She is a brisk American woman but don't let that make you shy. She won't bite you. Good luck to you and let me know how you get along."

Following the interview Duchamp writes again to Quinn. After enquiring how many hours he wanted to work and for what remuneration, Miss Greene decided, says Duchamp, "to ask the president of the French Institute for: 4 hours every afternoon every day (from 2 o'clock to 6) and $100 a month. My hope is surpassed," declares Duchamp, delighted that the work as a librarian, in which he has experience [19.1.1915], will provide him with the "entire freedom" he needs. Starting the translation of the letters for Quinn straight away, Duchamp adds: "I wish you will be pleased by it."

1916. Sunday, New York City
Edgar Varèse, who is now out of hospital [27.9.1916], the sculptor Jo Davidson (with whom the composer has a communicating door at the Hotel Brevoort), and Beatrice Wood dine with Marcel.

1923. Monday, Paris
In the evening Marcel returns from Rouen to his studio at 37 Rue Froidevaux.

1926. Friday, New York City
The Stettheimer sisters give a dinner party at 182 West 58th Street to which Duche is invited. Among the guests are Alfred Stieglitz and Georgia O'Keeffe.

1928. Monday, Paris
"Your two letters announcing the possible stop of activities in the S[ociété] A[nonyme] [29.4.1920] did not surprise me," writes Dee to Miss Dreier. "The more I live among artists, the more I am convinced that they are fakes from the minute they get to be successful in the smallest way.
"This means also that all the dogs around the artist are crooks – if you see the combination *fakes and crooks* how have you been able to keep some kind of faith (and in what?). Don't name a few exceptions to justify a milder opinion about the whole 'art game'. In the end, a painting is declared good only if it is worth 'so much'. It may even be accepted by the 'holy' museums – so much for posterity.
"Please come back to the ground and if you like some paintings, some painters, look at their work, but don't try to change a crook into an honest man, or a fake into a fakir.
"This will give you an indication of the kind of mood I am in – stirring up the old ideas of disgust – But it is only on account of you. I have lost so much interest (all) in the question that I don't suffer from it – You still do."

Dee goes on to tell Miss Dreier that even if Brummer is planning a Duchamp-Villon exhibition in December, another mixed sculpture exhibition in February for which Brummer would invite him to America for two months has not yet been decided. "But please don't see [Brummer] about this," Dee begs her, "because I want him to realize by himself whether he wants me or not. I don't really care personally one way or the other. Seeing N.Y. is always a pleasure but too expensive, even if you are paid to come over..."

1954. Friday, New York City
From his studio, Marcel writes hastily to Yvonne Lyon [4.10.1951] in England saying that he and Teeny are leaving on the *Flandre* the next day. "Will be living at Roché's... If you are in Paris, let me know," he suggests, giving her the address and telephone number. "We will be staying until January."

1956. Monday, New York City
Duchamp meets Monique Fong and her husband Klaus Wust [21.7.1954].

1960. Saturday, New York City
Writes to thank E. L. T. Mesens for the promised gift of one of his collages to be sold at auction for the benefit of the American Chess Foundation [9.6.1960].

1966. Saturday, New York City
In the morning post Marcel receives a cheque from the Cassandra Foundation in Chicago, paying him for the reproduction rights, his

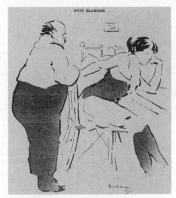
6.11.1909

7.11.1895

advice and collaboration in connection with the replica of the Large Glass [5.2.1923] made by Richard Hamilton for the exhibition at the Tate Gallery [16.6.1966]. "I am really touched by this conclusion," writes Marcel to Bill and Noma Copley, "…I hope we will see you soon and that you will tell me about all the decisions taken with the Tate."

1967. Sunday, New York City
Brookes Hubachek, who is on a visit from Chicago, dines in the evening with Marcel and Teeny at 28 West 10th Street.

6 November

1909. Saturday, Paris
A cartoon by Duchamp entitled *Nuit blanche* is given a full page in *Le Courrier Français* no. 44, with a cover by Villon. Sitting at the dressing table in her underclothes, the frustrated young woman says: "I don't want anything… Leave me in peace." The ageing, balding, portly man, anxious to find some alternative pleasure for her, proposes: "Un piano? Un piano à queue?" (A piano? A *grand* piano? [25.5.1907]).

1919. Thursday, Paris
Duchamp and Roché dine with Miss Dreier in the restaurant at 8 Rue de Valois, near the Palais-Royal.
 The name of the establishment is Le Bœuf à la Mode, one of the Marquis de Bièvre's favourite puns. As he has just come from the Mille Colonnes, Rue de la Gaîté, where he has had a "magnificent talk" with Erik Satie, Roché no doubt recounts his admiration for the composer (whom he finds resembles "his friend Socrates") and his ambition to write a book of their conversations: *L'Exemple de Satie*.

1954. Saturday, New York City
Embarking on their first trip to Europe since their marriage [16.1.1954], Marcel and Teeny board the SS *Flandre*, which sails in the evening at six-forty for Le Havre.

1957. Wednesday, New York City
Duchamp suggests to Robert Lebel that he should telephone Roché about the chesspieces

he had made around 1920 [20.12.1919]. "Also around 1935 I designed and made a pocket chess set with pieces in celluloid, of which Roché or Man Ray should have an example," Duchamp explains. "A maximum of 20 pocket chess sets were made." (In fact Duchamp may have already made a prototype of his *Pocket Chess Set* [23.3.1944] earlier than this, which he showed Roché [7.3.1926]).

1959. Friday, New York City
Publication by Grove Press of *Marcel Duchamp*, the standard edition of Robert Lebel's book [5.5.1959] *Sur Marcel Duchamp*, translated into English by George Heard Hamilton.

1963. Wednesday, New York City
Teeny arrives back from Cincinnati, and Marcel from his second trip to Pasadena [2.11.1963], after being filmed by Jean-Marie Drot.

1966. Sunday, Paris
On the first anniversary of the composer's death, the film by Luc Ferrari, *Hommage à Edgar Varèse* [20.4.1966], is re-broadcast on French television.

7 November

1895. Thursday, Blainville-Crevon
After the death earlier in October of Ferdinand Richard, mayor of Blainville-Crevon, which precipitated an election on 27 October, the new councillors meet to elect their mayor. Eugène Duchamp is elected in the first ballot with seven votes out of ten; Alexandre Déquinemare is voted deputy mayor.

1914. Saturday, Paris
The transport company Pottier has sent a card advising Duchamp that the works being sent to New York by agreement with Walter Pach for the Carroll Galleries will be collected today from 23 Rue Saint-Hippolyte.

1924. Friday, Paris
The optical machine is now finished [31.10.1924] and Duchamp confirms to Jacques Doucet that he will meet him at Man Ray's studio at eleven-fifteen the following morning.

1945. Wednesday, New York City
Dines with Max Ernst and the Kieslers.

1949. Monday, New York City
In reply to Katharine Kuh, who has sent him the press clippings about the Arensberg exhibition [19.10.1949], Duchamp says: "I find [them] very entertaining outside of my personal feeling. I think they give a very good account of the show and the establishment of *very* modern art in the museum life of tomorrow." Duchamp thanks her and Daniel Catton Rich for "the sincere attentions" they "poured" on him and adds: "The visit to Chicago will be in my memory a constant reminder that I did not paint in vain…" Regarding Mrs Kuh's essay in the catalogue, Duchamp tells her: "[it] is read with great interest by all my friends who hardly know me (each one from one angle)."

1950. Tuesday, Paris
After telephoning at six o'clock in the evening Totor and Roché return to Puteaux again for dinner at Camille Renault's restaurant [20.10.1950]. Afterwards Roché accompanies Totor to 14 Rue Hallé.

1958. Friday, New York City
With the elections of the previous day still in mind, on the back of the envelope containing Teeny's letter to Jackie, Marcel writes: "*mes bons baisers pour* Catherine R. Monnier (R stands for Rockefeller), Marcel."

1966. Monday, New York City
In the morning Duchamp receives a letter from Mlle Olga Popovitch, the curator of the Musée des Beaux-Arts, Rouen.

1967. Tuesday, Milan
Two exhibitions open marking the publication of *The Large Glass and Related Works*, Vol. I, by Arturo Schwarz, illustrated with 9 etchings by Duchamp. The book is on display at the Biblioteca Comunale di Milano, Corso di Porta Vittoria; the first and second states of the engravings are exhibited at the Galleria Schwarz, Via Gesù. Also at the same address as the Galleria Schwarz, the Galleria Solaria has an exhibition of early drawings installed by the architect Pierluigi Cerri.
 The etchings for the book, which Duchamp started work on two years earlier [14.7.1965], describe the main parts of the Glass [5.2.1923]:

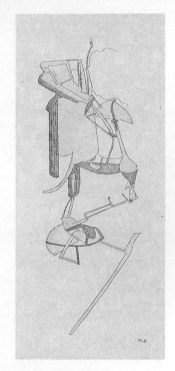

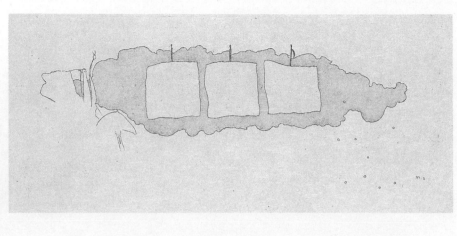

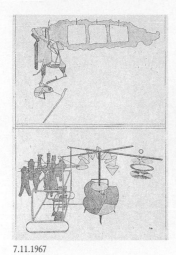 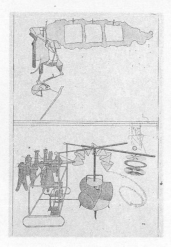

7.11.1967

8.11.1924

The Bride, The Top Inscription, The Nine Malic Moulds, The Sieves, The Oculist Witnesses, The Water Mill and *The Chocolate Grinder.* The remaining two show the whole Glass, one in its unscathed state, *The Large Glass*; the other, entitled *The Large Glass Completed,* reveals it with the intended but never realised elements: Boxing Match, Chute and Planes of Flow.

8 November

1918. Friday, Buenos Aires
"An old Buenosairian already!" exclaims Marcel, telling the Arensbergs that after almost two months [19.9.1918] he knows the town by heart. "Very provincial, very family. Society very important and very closed... At the casino – sort of Arcade Building Theatre – one sees only men... No hotel life as in N.Y. ...There really is the scent of peace, which is wonderful to breathe," he writes, "and a provincial tranquillity, which allows and even forces me to work."

In the room he has rented at 1507 Sarmiento, "far from the comfort" of the studio on 67th Street, Marcel has started the study for the lower-right section of the Glass. "I hope," he says, "that a few months will be sufficient to completely terminate the drawings that I want to bring one day to N.Y. to finish the Glass."

Hoping that Walter will advise on the choice of pictures, Marcel announces his exhibition project [26.10.1918]. Although he wrote to Barzun recently about sending works from New York with Marius de Zayas' help, Marcel advises Walter not to send anything from his own collection. "I myself will exhibit nothing," declares Marcel, "according to my principles." He warns Walter: "It is agreed... that you exhibit nothing of mine, if you want to please me, in the event that you are asked to lend something in N.Y."

Marcel mentions that Miss Dreier, who also fled the warmongering in New York, has been in Buenos Aires a month but has to endure the city: "Buenos Aires does not admit women on their own – it's senseless, the insolence and the stupidity of the men here."

1924. Saturday, Paris
Commissioned in February [28.2.1924], the optical machine, which is baptized *Rotative*

Demi-sphère (Optique de Précision), is now finished and Duchamp presents it to Jacques Doucet in the morning at eleven-fifteen when he comes to Man Ray's studio in Rue Campagne-Première.

It is Duchamp's second optical machine. After completing *Rotative Plaques Verre* [20.10.1920] in New York, for which he used black circles on a white ground, Duchamp experimented with spirals and later filmed these configurations in rotation [28.7.1921]. With this new construction, however, the optical effect is more accessible: the convex wooden hemisphere on which curves in black on white are painted is turned by an electric motor at the turn of a switch. The spirals are in fact created by the combined effect of two circles revolving one above the other on different centres; a third centre is that of the revolving image obtained by the viewer while looking at it with one eye. The broad copper disc, which frames the glass dome covering the hemisphere and rotates with it, is engraved with an inscription by Rrose Sélavy [20.10.1924].

1925. Sunday, Paris
To Miss Dreier, who, on behalf of the Société Anonyme, is organizing a Fernand Léger exhibition at the Anderson Galleries which opens on 16 November, Duchamp sends the following telegram: "Léger wrote November second."

1933. Wednesday, New York City
The *Champlain* docks with 24 tons of Brancusi sculpture in its hold, more than fifty pieces from the Romanian artist's studio for the exhibition at the Brummer Gallery, due to open on 17 November.

1939. Wednesday, Paris
Georges Hugnet composes a poem entitled "Marcel Duchamp".

1947. Saturday, New York City
In the afternoon between two-thirty and six

Marcel poses for Frederick Kiesler. The result, made of a galaxy of rectangles covering eight sheets of paper, is a full-length portrait of Marcel stripped to the waist in a characteristic, relaxed pose, his hands in his trouser pockets.

1949. Tuesday, New York City
As a result of Duchamp's meeting with Fleur Cowles [7.6.1949], short excerpts from discussions at "The Western Round Table on Modern Art" [8.4.1949], edited by Charlotte Devree, are published by *Look* magazine in an article entitled "Modern Art Argument".

1950. Wednesday, Paris
After their telephone conversation in the morning, Marcel meets Roché and Marie-Thérèse Pinto for lunch at one o'clock.

In the evening at seven Marcel telephones Roché and they dine together at Mabillon with Isabelle Waldberg [19.4.1945].

1952. Saturday, New York City
Very busy helping to arrange the Katherine S. Dreier memorial exhibition, which is due to open on 15 December, Duchamp travels to Milford for the day. While he is at Laurel Manor he measures the painting by Max Ernst in the barn.

1956. Thursday, New York City
Writes to Alfred Barr, one of the advisors to the William and Noma Copley Foundation [18.6.1954], proposing the painter Thomas Sills (Jeanne Reynal's husband), as a candidate for the annual Copley Award.

1963. Friday, New York City
Duchamp writes to Maurice Lefebvre-Foinet to enquire about inexpensive storage, and to his sister Yvonne requesting her, on her return to Neuilly at the end of the month, to arrange for the removal of the works by Jean Crotti bequeathed to the Musée de la Ville de Paris and about 100 canvases by Suzanne, so that work can begin in December on the studio in Rue Parmentier that he has inherited from Suzanne [11.9.1963]. There are also the 21 damaged canvases by Crotti, which Lebel has asked the "new restorer" to remove from the studio. Writing to Lebel for confirmation that this has been done, Duchamp enquires whether he can count on an official receipt for the two Renoirs [30.10.1963].

9.11.1945

9.11.1959

As Jackie has agreed to supervise the work on the studio, Teeny has written giving her a list of their requirements for the kitchen and bathroom, and Marcel adds his own note: "Thank you dear Jackie…"

1965. Monday, New York City
Invited to tea or a drink at five-twenty, Monique Fong arrives at 28 West 10th Street and the Duchamps tell her that Robert Rauschenberg has not replied and they do not know if he is coming. "He travels a great deal," explains Marcel, "or he's a Monsieur who doesn't reply to letters…"

The conversation turns to Paris and the "assassination" of Duchamp at the Galerie Creuze [6.10.1965] which, according to Monique, Marcel recounts with his customary grace: "It's the man's right," he declares. André Breton's anger, Marcel believes, is explained by his terror of old age and death.

1966. Tuesday, New York City
"In complete agreement to change the dates and to start with Rouen in April and to finish the Paris exhibition around 15 July [1.11.1966]," confirms Duchamp, replying to Mlle Olga Popovitch. For her official letter requesting loans, Duchamp gives her Dr Evan Turner's correct title, director of the Philadelphia Museum of Art, and adds: "Good luck and please keep me informed."

1967. Wednesday, New York City
When Yo arrives at Kennedy airport, a week before the opening of her exhibition, she has instructions from Teeny to take a porter after going through customs and to tell him that she wants a taxi. Teeny will be waiting in the hall before the taxis, standing under a huge Calder hanging from the ceiling. If they miss each other, Yo is to telephone 28 West 10th Street.

After consulting with Yo, Teeny has reserved room 907 at the hotel nearby [21.10.1967].

9 November

1933. Thursday, New York City
Duchamp keeps Brancusi abreast of preparations for his exhibition by sending him the lat-

est news: the ship arrived the day before with 35 cases of sculpture; delivery should be made to the gallery giving Duchamp 5 days for the installation; he has been to Philadelphia and seen Horter; Romeike has closed down, but the gallery can send press cuttings to Brancusi as they appear, unless the sculptor would prefer to take out a subscription; Walter Pach has written an article for *Nation*; to lift the sculpture into the gallery, Brummer is having a pulley installed on the roof at the back; Mrs Meyer is very active and requests photographs of the exhibition, which Charles Sheeler is unable to provide, so Duchamp is looking for another photographer; Crowninshield will have a page in next month's *Vanity Fair*; he has received the first packet of photographs, and Mrs Rumsey has sent a telegram from Washington. "She is delighted," says Duchamp, "and will come to see me when the exhibition is open."

1937. Tuesday, Paris
In his last chess column for *Ce Soir*, Duchamp selects an endgame by V. Kosek for his readers to study. He gives the solution to the problem posed by H. Lange [27.10.1937], and terminates by announcing that Dr Alekhine is leading in the return match against Euwe for the world title.

1939. Thursday, Springfield
Celebrating five months in advance its twentieth anniversary [29.4.1920], "Some New Forms of Beauty 1909–1936," a selection of the Collection of the Société Anonyme, opens at the George Walter Vincent Smith Art Gallery with a reception and dinner. Duchamp's *Rotative Plaques Verre (Optique de précision)* [20.10.1920] is, according to Miss Dreier, "a delight to most who come." Duchamp's own words quoted in the catalogue describe his machine as "an organization of kinetic elements, an expression of time and space through the abstract expression of motion".

1945. Friday, New York City
In the morning Marcel arranges another window at Brentano's [19.4.1945], this time for *Le Surréalisme et la Peinture* by André Breton. He places an object by Isabelle Waldberg centrally under a tent-like canopy made from an old length of broad paper, found in his studio, which cascades almost like a veil in the window. Copies of the book, with its Magritte cover [2.7.1945], are displayed in front of the sculpture: to the left

is the bust of a mannequin made of wire netting, found ready-made; to the right, a pair of heavy shoes painted by Enrico Donati to resemble those illustrating the cover of the book.

"Naturally Marcel did everything," said Isabelle, "invented everything and executed everything."

This volume of texts by Breton, published by Les Editions Françaises Brentano, includes "Phare de la Mariée" [5.12.1934].

1950. Thursday, Paris
At six o'clock, Totor telephones Roché and they arrange to have dinner "next to the cinema of the Lion [de Belfort]". After enjoying trout and sole, Roché accompanies Totor to 14 Rue Hallé before returning to Arago.

1952. Sunday, New York City
After his visit to Milford the previous day, Marcel writes to George Heard Hamilton and gives him the measurements of the painting by Max Ernst.

Referring to the decision taken by the executors of Miss Dreier's estate [29.3.1952], he explains: "The Franz Marc was offered to and accepted by Mr Duncan Phillips in July [30.7.1952] and I am sorry not to be able to change that. What he will show as a Dreier Unit (as he calls it)," Marcel continues, "will be in fact a cross section of the S[ociété] A[nonyme]. collection…"

1959. Monday, New York City
"I am sending you 2 small aprons designed to protect hands from an excessive heat of pots and pans on the fire. One is male and the other is female," writes Duchamp to André Breton. This *Couple de Tabliers* is none other than two pairs of oven gloves, transformed and dedicated to Eros. Destined for the "de luxe" edition of *Boîte Alerte*, the catalogue which Breton is preparing for the Surrealist exhibition opening on 15 December, Duchamp explains: "They could be made in Paris, in a few days and more cheaply, if you like the idea."

*

Prompted by the launching this week of *Marcel Duchamp* by Robert Lebel, published by Grove Press, the interview which Duchamp accorded recently appears in *Newsweek* with the title "Art Was a Dream…" Referring to Lebel's statement that Duchamp's work "surpasses so to speak the limits of painting", the journalist is

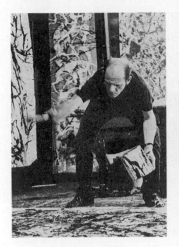

10.11.1916

particularly interested in Duchamp's reasons for not painting any more.

"I became a non-artist... not an anti-artist, as someone said. The anti-artist is like an atheist – he believes negatively. I don't believe in art. Science is the important thing today. There are rockets to the moon, so naturally you go to the moon. You don't sit at home and dream about it. Art was a dream that's become unnecessary...

"Painting since 1914 has been – not exactly superfluous – but superficial... Not an essential production as in Cimabue [17.3.1913], the Renaissance, even the Romantics. They had a credo to express. But ever since Courbet, the emphasis has been on the eye, the retina. Colours and forms only, always on the surface. Someday of course the wheel will turn again and religion and art will come back – maybe if Eisenhower and Khrushchev get together and rule the world!"

How does Duchamp feel about today's Abstract Expressionists?

"Acrobatics, just splashes on canvas. Of course, I think people should be shocked... But the Abstract Expressionists don't shock anybody. The only shocking thing these days is the stupidity of Russian painting." (Duchamp would have seen the work of the Russian painters and Pollock [19.3.1945] in the Brussels exhibition "50 ans d'Art Moderne" [20.6.1958].)

His decision to abandon painting "has never troubled Duchamp for a moment", claims the interviewer.

"I didn't have to sell to live. All my life I've been able to live on very little money. I spend my time very easily, but wouldn't know how to tell you what I do. Let's just say I spend my time not painting. I have a wife and she has children of her own. I have a studio because I refuse to be 24 hours with my wife. There's no problem filling up the time.

"I suppose you could say I spend my time breathing... I'm a *respirateur* – a breather. I enjoy it tremendously."

1962. Friday, Cleveland
Marcel arrives by air from New York on his second brief visit to the city [26.8.1936] in time to lecture in the evening at the Cleveland Museum of Art. As he plans to be away only 24 hours, Teeny does not accompany him.

1965. Tuesday, New York City
Late in the afternoon there is a sudden blackout throughout the city.

"I fortunately was home," recounts Teeny to Jackie, "and I was able to find two candles. It was a spooky feeling, no storm, no reason, just everything black. Marcel was on the 12th floor of a building on 17th Street. They took him down 12 flights by candle light and he walked safely home and was I happy when he walked in at 6.30. It must have been very weird, the moon had not come up yet and the only light was from the cars. Fifth Avenue was so full of people it was like a parade and no one knowing where to go or what to do. He had to push and squeeze his way down till 14th Street. We were supposed to dine at the Copley's but the telephone was numb too so there was just nothing one could do but sit tight. Bless our little transistor, it became a fascinating object and we learned to our amazement it was off from Toronto to Harrisburg (representing the size of all France) and reports started coming in from everywhere, a kind of continuous dialogue about everything and the mystery of how and why it happened. The lights were then announced to go on at 8, then at 10... As night wore on we got more and more amazed and relieved that there were no bad accidents, everyone being rescued from the subways, the elevators and the most frightening places on bridges etc. without incident. The hundreds of planes that couldn't land were getting down safely in New Jersey. It was a kind of miracle multiplied over and over again. There was very little crime and not many fires it seemed too good to be true. Early in the night we heard a description of a reporter who had walked up 20 flights from 80th to the 101st floor in Radio City to interview a group of French tourists that had been stuck up there. He said when the moon came up, the building they were in made a shadow across lower Manhattan as though a finger of God was pointing at it and the people spoke in awe of the beauty of what they saw..."

10 November

1916. Friday, New York City
In the evening Duchamp takes Florine Stettheimer [24.10.1916] to dinner at Eugenie's.

According to Florine, at the restaurant "there was nothing to see – instead I was looked at". They then go to see *A Daughter of the Gods*, a film inspired by the legend of Ondine. Annette Kellermann, who plays the role of the water nymph, wears a daring body stocking adorned with garlands of foliage judiciously placed. Duchamp considers the Fox starlet "ordinary" and Florine thinks: "I shall no longer say I am shaped like [her] – having nothing on it was easy to judge her looks."

1933. Friday, New York City
The 35 crates containing the sculpture for Brancusi's exhibition are removed from the hold of the *Champlain* and transported to Brummer's storage space for inspection by customs.

1942. Tuesday, New York City
As four months of his six month temporary visa have already expired, Duchamp has a meeting at 521 Fifth Avenue with Leo Taub, the lawyer specializing in turning temporary visas into immigration visas, who has helped Yves Tanguy and others in similar situations.

Taub gives Duchamp some documents, which have to be completed by two sponsors.

1945. Saturday, New York City
As Isabelle Waldberg (who helped him the previous day by providing a sculpture for Brentano's widow) is due to leave for France any day now, Marcel gives her some parcels destined for his family, which she has offered to take with her.

1950. Friday, Paris
In the morning around eleven-thirty, Totor telephones Roché and they agree to meet for lunch at the restaurant Au Rat at 34 Boulevard Saint-Marcel [28.9.1939].

1952. Monday, New York City
After learning that Mary Dreier has been operated on for a broken hip and that she "is as satisfactory as can be", Duchamp visits her at the St Clare Hospital, West 51st Street.

1958. Monday, New York City
At 327 East 58th Street, Teeny and Marcel give a party for Hans Arp, whose retrospective exhibition is being held in the Museum of Modern Art, recently re-opened after the fire [15.4.1958].

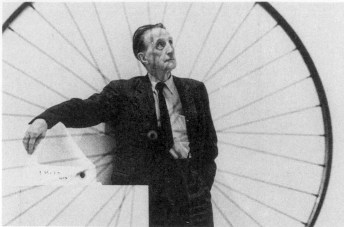

10.11.1961

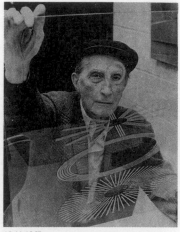

10.11.1967

1961. Friday, New York City
Late morning as arranged, Duchamp meets Marvin Lazarus at the Museum of Modern Art where "The Art of Assemblage" exhibition [2.10.1961] is being held.

"When we came in," recounted Lazarus later, "Duchamp had his hat and coat on. I called over the guard and asked if he could hang them up. He said it would be an honour to. We began shooting. I wanted to move the *Roue de Bicyclette* [15.1.1916] so that I could shoot through it. Duchamp moved it. Meanwhile the guard had changed. He ran over to me and asked if I had moved the object. Before I could answer, with a little smile, Duchamp said quietly, 'No, I did it.' The guard then turned on him and said, 'Don't you know you're not supposed to move things in a museum?' Duchamp smiled again and speaking very softly said, 'Well, I made the object – don't you think it's all right for me to move it a little?'

"The guard looked staggered… It was obvious he couldn't decide whether his leg was being pulled, or whether it really was Duchamp…

"I asked Duchamp what the letters *L.H.O.O.Q.* [6.2.1930] under the Mona Lisa with a moustache mean. He explained, 'It's a pun. You must pronounce the letters. But you must use the French pronunciation, not English, of the letters. The pun comes out,' He had seen polite explanations of the pun in books… 'But I tell you it means only one thing that pun: Hot in the ass. Ass, not bottom, that's exactly what it means… Don't let anybody fool you'."

On leaving the museum, they meet the curator Peter Selz, and Duchamp introduces the photographer to him saying: "Mr Lazarus just took some pictures of me in the exhibit." Selz replies that they already have wonderful pictures of the show.

"You didn't hear what I said," insists Duchamp, "I said Lazarus took pictures of *me* in the exhibit."

Selz is suddenly interested and addresses Lazarus: "I would like a set."

"I'll show you a set," replies the photographer firmly.

1962. Saturday, New York City
"This Neo-Dada, which they call New Realism, Pop Art, Assemblage, etc. is an easy way out,

and lives on what Dada did," Marcel has told his friend Hans Richter, who is writing a history of Dada. Proposing to use Marcel's statement in his book, Richter sends it today in a letter to Marcel: "When I discovered readymades I thought to discourage aesthetics. In Neo-Dada they have taken my readymades and found aesthetic beauty in them. I threw the bottlerack [15.1.1916] and the urinal [9.4.1917] into their faces as a challenge and now they admire them for their aesthetic beauty…"

1965. Wednesday, New York City
After the mammoth blackout the previous afternoon, the electricity supply is resumed at 5:27 in the morning. "Exactly 12 hours," writes Teeny to Jackie, "so we didn't have to reset our electric clock!!"

*

Reminding Victor Brauner about the chess exhibition at Cordier & Ekstrom [15.4.1965], Duchamp requests him (if he wishes to participate) to contact the Parisian company International Art Transport before 15 December.

*

The dinner party which didn't take place at the Copleys' the previous evening with Marcel, Teeny and George Segal [4.10.1965], is reconvened.

1966. Thursday, New York City
Replies to Louis Carré confirming that he will expect to hear from him when he arrives in New York.

1967. Friday, London
The Petersburg Press announces their subscription offer for the *Oculist Witnesses*, a detail of the Large Glass [5.2.1923], which has been prepared by Richard Hamilton in close collaboration with Duchamp [18.10.1967] and signed jointly "*d'après* Marcel Duchamp, Richard Hamilton" [4.9.1967]. The edition of 50 is to be available in December.

11 November

1914. Wednesday, Paris
Absent when the agent of the Société du Gaz de Paris calls at his apartment 23 Rue Saint-

Hippolyte to collect the gas rate amounting to 7.60 francs, Duchamp is served a notice requesting payment on the agent's second visit which will be within five days.

1915. Thursday, New York City
"I have just finished the translations [4.11.1915]," Duchamp tells John Quinn and promises to send them as soon as he has reread them. "Herewith a letter from Miss Greene [5.11.1915]," he continues bravely in English. "You will see in it many hopes."

1916. Saturday, New York City
After her rehearsal Marcel meets Beatrice Wood and they have dinner together. "Feel too sophisticated," thinks Beatrice, "torn feeling, as if the gentleness of life were lost."

1917. Sunday, New York City
After dinner together at the Café des Artistes, Walter Arensberg invites Duchamp, Varèse, Roché and Stella back to his apartment.

1918. Monday, Rethondes
After the retreat of the German armies, the abdication of William II, German Emperor and King of Prussia, and the proclamation of the German Republic, the armistice is finally signed on the western front.
Commenting on the reaction in Buenos Aires to the news of the armistice, Duchamp says dryly: "The town… doesn't stop 'libationing', celebrating, 'demonstrating' – *le jour de gloire est arrivé.*"

1919. Tuesday, Paris
An express letter from Alexandre Archipenko [19.11.1911] is addressed to Duchamp at 32 Avenue Charles Floquet. As the sculptor is going to Switzerland on Thursday, he is unable to receive Duchamp and Miss Dreier at five in the afternoon on that day, but proposes that they visit him between eleven and noon.

1922. Saturday, New York City
After writing to invite Henry McBride, the celebrated art critic, to come on Sunday "at about nine-thirty" to a party at Louise Hellstrom's, where there will be "a lot of amusing people", Rrose Sélavy follows the card with a telegram: "A dinner has been arranged at Louise Hellstrom's 214 East 15th Street will you come at seven o'clock Sunday."

12.11.1904

1933. Saturday, New York City
After clearance by the customs officials, the Brancusi sculpture is due to be taken from storage to the Brummer Gallery at 55 East 57th Street. When each item is carefully examined for insurance purposes, *L'Oiseau dans l'espace*, a piece in white marble belonging to Mrs Rumsey [12.12.1926], is found to be slightly cracked.

1942. Wednesday, New York City
"The Surrealist show [14.10.1942] is over and they are returning your Magritte and my twine with many thanks," writes Marcel to Lou and Walter Arensberg from whom he has had no news for over six weeks. Asking for reassurance immediately, Marcel reminds them: "In one of my letters I was asking you if you were willing to lend most of my things for a one-man show at Peggy Guggenheim's Museum during next Spring?"

Marcel's other preoccupation is the question of his visa: he tells the Arensbergs that he is sending them, under separate cover, the documents given to him by Leo Taub the previous day, which have to be completed by his sponsors, and he hopes that Walter and Kenneth McGowan will consent to help him.

1948. Thursday, New York City
Marcel dines with Stefi and Frederick Kiesler.

1951. Sunday, New York City
In the evening at six Duchamp meets Monique Fong.

1954. Thursday, at sea
"At last we finally decided to leave and we return in January," writes Marcel to the Hoppenots from the *Flandre*. "Good food on board. Good roll…"

1958. Tuesday, New York City
"I received the 800 marked on the small piece of paper," writes Duchamp to Jean Larcade of the Galerie Rive Droite [21.10.1958]. Mystified to have received the sum for 4 Valises when he thought only two had been collected from Lefebvre-Foinet, Duchamp concludes that these were sold from the exhibition "Le Dessin dans l'Art Magique", and the gallery has taken two more. Asking Larcade to let him know, Duchamp adds: "…and also give me news of the 'magic' exhibition (catalogue)…"

1963. Monday, New York City
In the evening at eight Marcel and Teeny are due to meet Louis Carré.

1965. Thursday, New York City
To allow the painters to complete the redecorating at 28 West 10th Street, Marcel and Teeny anticipate taking a room nearby at the Hotel Earle, 103 Waverley Place, just for two nights.

12 November

1904. Saturday, Paris
Since leaving the Lycée Corneille [30.7.1904] and taking a holiday at his grandmother's in Massiac [1.9.1904], with his father's approval Marcel has moved from Blainville to live with his eldest brother, Gaston (known professionally as Jacques Villon), at 71 Rue Caulaincourt. Situated on the northern slope of Montmartre, the apartment overlooks the Maquis, a maze of footpaths, rambling vegetation and humble dwellings, inhabited by scrap dealers, artists and tramps, their patches of garden and assortment of hens, goats, donkeys and other animals enclosed with picket fences, a vestige of the rural village now encircled by the city. Windmills and the new white-domed basilica of the Sacré Cœur are silhouetted against the sky on the summit of the hill.

Its reputation and atmosphere hardly diminished since the heyday of Toulouse-Lautrec at the Moulin Rouge, the cabaret celebrated for the songs of Aristide Bruant and the French cancan, Montmartre attracts artists from far and wide. Amongst the new arrivals and neighbours of Villon and Marcel are Frantisek Kupka from Czechoslovakia, Louis Markous from Poland and the Dutchman Kees Van Dongen. To make ends meet many of the younger artists, like Villon [1.7.1900], draw cartoons for magazines such as *Le Rire*, *Le Sourire*, *Le Courrier Français* or *L'Assiette au Beurre*. One of the haunts of the humorists, whose well-paid stars include Abel Faivre, Lucien Métivet, Adolphe Willette and Charles Léandre, is Chez Manière, a café-brasserie famous for its suppers, just nearby at 65 Rue Caulaincourt.

Having decided to embark on an artistic career like his brothers, Marcel goes to the Académie Julian, 5 Rue Fromentin, to enrol for four consecutive weeks of morning classes commencing on Monday, with live models and the use of an easel and stool, for which he pays in advance the sum of 31.10 francs (or 600 francs at present values).

1915. Friday, New York City
In the morning at ten, Duchamp returns to the J. Pierpont Morgan Library [5.11.1915], where Miss Greene introduces him to the president of the French Institute and Museum of French Art, Mr McDougall Hawkes.

"Mr Hawkes asked me some informations, talked to Miss Greene, who came back after his departure and gave me an appointment for tomorrow," Duchamp tells John Quinn later the same day, adding, however, that "any decision can't be taken before the meeting of the Committee in about a month".

With his note Duchamp encloses the letters from his brother Raymond, Georges Rouault, André Dunoyer de Segonzac, Raoul Dufy and Mme [Auguste] Chabaud all dated 24 August, which Quinn asked him to translate [4.11.1915].

1918. Tuesday, Buenos Aires
Having received a card from Ettie which, he says, "although distant in time and in space put me back amongst you at Bedford Hills," Duchamp writes a long letter to the three sisters, the first since the hasty note he wrote soon after his arrival [22.9.1918].

"Buenos Aires does not exist," he tells Ettie. "Nothing but a large provincial town with very rich people without any taste, everything bought in Europe, the stone for their houses included. Nothing is made here," Duchamp continues, "…I have found French toothpaste that I had completely forgotten about in New York."

Describing the way of life and the various colonies, English, American and Italian, which are "closed", Duchamp remarks: "There is no French colony – the French here more numerous perhaps than in New York are dreadful to see…" Life is cheaper, the food "wonderful and wholesome" but, he claims: "I am not getting any fatter for all that."

"I am basically very happy to have found this entirely different life," Duchamp contin-

ues. "I feel a bit back in the country where one finds pleasure in working."

For three days the town has been celebrating the armistice, and Duchamp imagines what New York must be like: "Although I hate these celebrations," he admits, "I know you all love them and I'm happy that you join in. As soon as... star spangled banner etc."

As for his plans, Duchamp mentions his decision to go to France before returning to New York. He gives Ettie his parents' address in Rouen in case the sisters are in Europe next summer: "If you 'drop' me a line," promises Duchamp, "I will run to see you wherever you are."

For Carrie, Duchamp has questions about the work on her doll's house [23.7.1918] and assures her: "My doll's houses are progressing as well. Out of sight but not out of mind, whatever you have often said..."

Addressing the third sister as "My dear Florine painter of the King", Duchamp describes the artistic climate for her: "Nothing here; not even studios. The painters here are very steady young people who live with their families and use the attic or glazed patio as a studio. Not one interesting painter... Ridiculous galleries. In the middle of all that, I am content because I am working."

1919. Wednesday, Paris
Desiring that Duchamp meet Erik Satie [6.11.1919], Roché arranges a lunch at the restaurant Aux Vendanges de Bourgogne, to which Miss Dreier is also invited. The meeting

of the "two sharp Normans" is a success. While they are eating the dessert, Georges de Zayas (brother of Marius [29.4.1919]) appears. For his forthcoming book of caricatures, in which both Duchamp and Satie are subjects, de Zayas requests Satie to reply to the questionnaire which is also to be published in the album.

1922. Sunday, New York City
At seven in the evening, Rrose Sélavy attends Louise Hellstrom's dinner party at 214 East 15th Street, where she plans to present Henry McBride to the hostess.

1933. Sunday, New York City
After the discovery of the previous day, Duchamp sends a long cable to Brancusi in Paris: "Rumsey bird cracked right round at ten centimetres above the narrowest point stop Cable length of the copper rod stop Can it be stood up without danger stop Crack almost invisible see Pottier for insurance stop Brummer offers to repair and guarantees invisibility rest arrived safely."

*

Replying to Beatrice Wood, Marcel promises to go and see her drawings at the Weyhe Galleries as soon as the Brancusi exhibition is open. Since his letter to the Arensbergs [8.11.1933], *L'Enfant prodigue* has arrived, but he has received no word from them directly. "Do you think there is a small chance of seeing them in N.Y. before I leave," Marcel asks Beatrice. "Obviously if I make some money I could go to see all of you in California. But that is really problematical..."

1945. Monday, New York City.
Marcel has lunch with Isabelle Waldberg.

1952. Wednesday, New York City
Following a meeting with Fleur Cowles on the subject of the almanac [9.10.1952], Marcel replies to André Breton saying that she agrees with the points he has raised. Notably: Breton's new text "encasing" the texts already published (which will remain in their original language), will be translated into English; the layout for the 75% of the publication which Breton is responsible for, is to be made in Paris ready for printing unchanged in New York; the layout for the remainder, which will be under Marcel's supervision, is to be made in New

York but submitted to Breton for his approval; agreement also to include the Heisler alphabet and a historical calendar. However the first important question concerns the reproductions: which? and where are they? Marcel also requires an estimate from Breton in his next letter of the work the project entails and his remuneration.

1954. Friday, at sea
With some delay Marcel replies to Germaine Everling in Cannes saying that he has spoken to Rose Fried [6.12.1953]: "She very much likes the paintings of Francis and could buy them or take them on deposit," he says. "The prices from 100 to 200,000 are very fair and make it possible to build an international market. Don't sell everything," Marcel advises, "...it is probable that in years to come the prices will increase."

Almost a year since Francis Picabia died [30.11.1953], Marcel tells Germaine, "The death of Francis naturally upset me; I saw him in 1950 [17.11.1950] but I thought that he could still live a long time."

As Germaine has kept in contact with Marcel's first wife [8.6.1927], who was remarried during the war, he adds: "I enclose here a letter for Lydie which I ask you to send to her because I was unable to read her new name."

1958. Wednesday, New York City
"Since our return [3.10.1958] the 'day-to-day' matters have multiplied to such a point that I postpone all my letters until the day after next," Marcel tells Roché. Nothing important to report: a voyage to Pittsburgh on 16 November and a granddaughter, Catherine, has arrived [4.11.1958] for Teeny. Of Lebel's monograph, Marcel remarks: "The book has picked up speed to make it to the top of the hill..."

1961. Sunday, New York City
"Am very happy that the valises arrived safely [16.9.1961]," writes Duchamp to Serge Stauffer. Replying to Stauffer's concern that the miniature Glider has "disappeared", Duchamp explains to him that it was impossible to keep the celluloid flat and fit it properly – it is for this reason that there is only a reproduction on paper in the *Boîte-en-Valise* [7.1.1941].

To Stauffer's other questions Duchamp says that in June he saw Charbonnier who was eva-

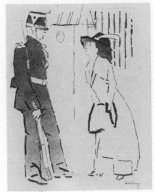

13.11.1909

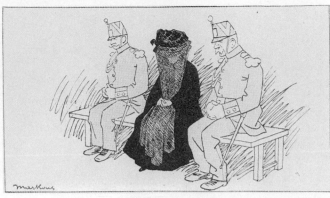

"1909....Toujours très entourée"

sive about the publication of the interviews [13.1.1961]; he does not have a copy of the photograph printed in *Literary Digest* [20.6.1936]; *Mariée* [25.8.1912] is difficult to photograph in colour and he thinks that Albert Skira "is not particularly interested in this kind of thing"; at the Cinémathèque in September, Henri Langlois confirmed that there is a copy of *Anémic Cinéma* [30.8.1926] but only with the "apocryphal section" and that Marc Allégret was consulted, but all the filming was done with Man Ray, "a millimetre for each frame for hours..." Duchamp adds that if Stauffer confirms that *Stéréoscopie à la Main* [4.4.1919] is now at the Museum of Modern Art, he will ask them for a good photograph of it.

*

Informing his sister Suzanne that five catalogues of "The Art of Assemblage" exhibition are on their way to her including one for Jackie Monnier [24.10.1961], Marcel also asks her to see whether Villon has the 1912 catalogue of the Salon des Indépendants [18.3.1912], because he requires the exact date of the opening of that exhibition for the lecture in Detroit on 28 November.

1964. Thursday, New York City
After telephoning Berenice Abbott to tell her that he "did not feel up to the captions" for her album, suggesting Nicolas Calas instead (whom he has also telephoned), Marcel recounts his efforts to Kay Boyle at the Radcliffe Institute: "Let us hope..."

*

Sees Louis Carré who gives him news of Gaby Villon; they discuss the question of a night nurse and Duchamp immediately writes a letter to Dr Viel asking for his approval.

13 November

1909. Saturday, Paris
All France has been agog for the last ten days over the court case in which Meg Steinheil, the widow of the painter assassinated at the Impasse Ronsin in May 1908, is accused of murder. After publishing a cartoon by Markous [12.11.1904] the previous Saturday, today *Le Rire* gives its cover to "The Voluptuous

Meg looking for the attitude of Truth", drawn cynically by Léandre. In this affair, declares *Le Rire* gleefully, there is "love, blood, bad painting, blotted copybooks, money, flowers, soup, pearls, politics, history..."

On the day that the eloquent Antony Aubin obtains an acquittal for the accused, *Le Courrier Français* also has a cover about Meg by Willette. Inside, Duchamp makes his contribution to the quantity of ink expended over Meg with a drawing entitled *Au Palais*. "Est-ce que vous l'avez vue?" enquires the young woman, accosting an embarrassed guard standing on duty before the Palais de Justice, where preferential entry is suspended. (The standard reply to her question is: "Mon cul!")

1915. Saturday, New York City
As agreed the previous day, Duchamp returns to the J. Pierpont Morgan Library in the morning at eleven to meet Miss Greene, who takes him to the Museum of French Art. [In 1915, from separate locations, the French Institute and Museum of French Art moved to Scribner's Building at 597 Fifth Avenue, near 48th Street.] Pending a decision by the Committee, Miss Greene gives Duchamp some provisional work to do for the museum, which he is to commence on Monday.

1917. Tuesday, New York City
In the evening Roché watches Marcel working in his studio at 33 West 67th Street. Later, after dining at the Arensbergs' two floors below, they go to listen to the jazz band at Healy's (which is nearby at the corner of 66th and Columbus).

1945. Tuesday, New York City
Duchamp dines with a number of friends, including Sidney Janis, Max Ernst, Edgar Varèse and the Kieslers.

1947. Sunday, New York City
In the afternoon, from three until seven, Marcel plays chess at the Kieslers', 56 Seventh Avenue.

1952. Thursday, New York City
"Film delightful letter follows," is the message of Duchamp and Hans Richter's telegram to Jean Cocteau, who has sent his contribution as requested for Richter's film: *8 x 8*.

1959. Friday, London
The interviews which Duchamp accorded to the BBC in New York [19.1.1959] and in London [14.9.1959] are broadcast in the series "Art, Anti-Art" on the Third Programme. In an unguarded moment Duchamp reveals publicly one of the underlying themes of the Large Glass [5.2.1923]:

"Eroticism is a very dear subject in my life and I certainly applied that liking or that love to my Glass. And in fact I thought it was the only excuse for doing anything, to give it a life of eroticism which is completely close to life in general and more than philosophy or anything like that. And it's an animal thing that has so many facets that it's pleasing to use it as a tube of paint, so to speak, to inject in your productions. It's there stripped bare. It's a form of fantasy. It has a little to do also... the stripped bare probably had even a naughty connotation with Christ. You know the Christ was stripped bare [21.12.1945] and it was a naughty form of introducing eroticism and religion..."

14 November

1904. Monday, Paris
After enrolling on Saturday, at eight in the morning Duchamp is due to attend his first class at the Académie Julian, 5 Rue Fromentin, which is just a short walk from the Rue Caulaincourt down the Rue Lépic. The students work from the model or a collection of plaster casts, and the tuition given by J. Lefebvre and T. R. Fleury is in the pure classical tradition.

Duchamp loathes these plaster casts, infinitely preferring to play billiards.

13.11.1959

1946. Thursday, Paris
At six in the evening at the Galerie Maeght, 13 Rue de Téhéran, Duchamp is due to meet André Breton, and one or two other friends, including Jacques Prévert, who has also been invited.

1948. Sunday, New York City
Marcel confirms that he has received both a copy of Maria Martins' catalogue for her exhibition at the Galerie Drouin and *Martinique charmeuse de serpents* published by the Editions du Sagittaire. By way of apology, he admits to Elisa and André Breton that he plans to have something printed on his writing paper excusing himself for his laziness in writing.

Since Breton left New York, Marcel remarks that everyone has "hidden" – not least himself – and that Enrico Donati is about the only person he ever sees. After the tragic death of Arshile Gorky, Julien Levy has organized an exhibition: is Breton planning one in Paris?

Troubled after noticing in an exhibition of collages at the Museum of Modern Art that the sea of *Allégorie de Genre* [21.9.1944], which was originally a very powerful deelp blue, has completely faded, Marcel asks Breton if he would like him to repaint the background before the picture is returned to Paris.

1949. Monday, New York City
After receiving the replacement ampoule [29.5.1949] for the Arensbergs, Marcel posts a letter to Roché thanking him and recounting his "very enjoyable" days in Chicago [19.10.1949].

Regarding his early pictures, which Villon has recently unearthed at Puteaux, Marcel agrees to sell some to Roché: "Tell me yourself what you want to pay," he suggests. "I don't think that there will be a great demand in spite of the good advisers who regret that I no longer paint. I live further and further from 57th Street," he continues, "and I play a lot of chess without good results (except a small tournament this summer [27.8.1949] where I won 6 games, but really the opponents were weak)."

1950. Tuesday, Paris
On the eve of his departure from 14 Rue Hallé, Totor telephones Roché at five and takes a suitcase to Arago. Later they dine together in Place Denfert-Rochereau.

1952. Friday, New York City
At five-thirty Monique Fong meets Duchamp, who "is very broke apparently, but in great form". She finds his face: "untroubled, inward and alert under a hat tilted back – this youthfulness which is not of the heart but of the mind – which doesn't radiate, but sparks." Occupied by the death of Miss Dreier [29.3.1952], by social invitations, by chess, Duchamp tells Monique that he is resolved to disappear, to pretend to be abroad to recapture his solitude.

"He showers me with compliments, on my face, my black dress, my sad and free expression, the new charm that I have acquired. With him I try to elucidate the two principal lines of my present life. Sensuality on the one hand… Esotericism on the other…"

"Curiously conversant" with Monique's allusions to esoteric doctrines, Duchamp remarks: "Esotericism should not be mental, it must have ritual." He asks whether Lévi-Strauss is an initiate and whether Monique "really intends to try this discipline".

1954. Sunday, Le Havre
When the SS *Flandre* docks at four minutes past noon, Teeny and Marcel disembark and travel to Paris on the boat train. At three o'clock from 99 Boulevard Arago which is to be their home until January, Marcel telephones Roché at Sèvres to say that they have arrived safely.

1960. Monday, New York City
For "La Passoire à Connerie", an exhibition of Edgar Varèse and Michel Cadoret opening at the Galerie Norval, Duchamp contributes: "Mi Sol Fa Do Re," printed on a small slip of paper and glued inside the front cover of the catalogue.

1964. Saturday, New York City
On receiving news from Jackie Monnier, who has just returned from Milan, Marcel gains time by cabling instructions for the next batch of 25 *Boîte-en-Valise* [7.1.1941] "with a new horizon": "Love red stop Please place final order 25 stop…"

1967. Tuesday, New York City
Marking the great day, Marcel chooses a postcard of his famous *Nu descendant un Escalier* [18.3.1912] to send to Yo's mother Jeanne, in Neuilly [9.12.1966]. Having written the date

and the time, "15h," Marcel underlines the day and then writes: "Dear Jeanne, Later we are going to open the exhibition, affectionately Marcel."

Teeny adds her message: "Very pleased to have Yo here!"

"Very happy to have Jackie here," echoes Yo, which leaves Jackie to conclude: "Very pleased to be here!"

*

The exhibition of the *chaisière* [chair attendant], as Marcel calls her, which is signed Sermayer (the name combining those of Yo's two nominal fathers, Marcel Serre [16.4.1910] and Henry Mayer), opens at the Bodley Gallery, 787 Madison Avenue, at six o'clock. With the sculpture by Dolly Perutz in an adjoining space, Yo's ingenious compositions of furniture, sometimes incorporating human forms, plants or chesspieces, inhabit the rest of the gallery.

With *Conversation* illustrating the cover, inside the catalogue [6.9.1967] there is a reproduction of *World Cup* with a brief introduction by Marcel and Rrose, presenting the godparents of Yo's exhibition:

"après 'Musique d'Ameublement'
d'érik SATIe
voici 'Peinture d'Ameublement'
de Yo SAVY
(alias Yo Sermayer)
Rrose SélAVY
(alias Marcel Duchamp)

15 November

1915. Monday, New York City
After his interview the previous Friday with Mr McDougall Hawkes, Duchamp commences part-time work at the Museum of French Art. He will be working from two until six every afternoon on the tasks set provisionally on Saturday by Miss Greene [5.11.1915].

1918. Friday, Buenos Aires
It is almost summer. With "quantities of mosquitoes and flies" but the doors wide open, Marcel is sitting writing to his friends Walter

14.11.1967

and Magda Pach. Referring first to the news of his brother's death [26.10.1918], he tells Pach: "I know that you will suffer more grief than anyone else, I know the deep friendship and admiration that you had for him. I don't have any details yet – It must have been a terrifying agony after 2 years of suffering."

Although the armistice [11.11.1918] "was the good news", Marcel finds it "useless" to leave for France at the moment and remarks that: "readjustment to peace will require as much time (6 months to a year) as that to war."

Regarding his own work: "I took all the notes for the glass so that I can continue here," Marcel explains, "and I hope to finish the drawings in a few months."

1921. Tuesday, Paris
Upset to hear from the Arensbergs that they have moved to Los Angeles, Marcel asks, "Are you not going to return to N.Y. at all? Stay in California?" He is unable to imagine what they can do there "for 24 hours every day" and remarks: "Nature must repeat itself really often…"

Marcel himself is planning to return to New York and admits: "I have already enough of Paris and France in general… I intend to find a 'job' in the cinema, not as an actor, rather as assistant cameraman," he explains. "…I have made a short piece of film [1.11.1921], which I will take with me." As for his chess, he continues playing, and against some strong players he is managing to hold his own.

As Walter has apparently not read *Poésies* by Lautréamont, a long preface to a book of poems which the poet never wrote, Marcel promises to send him the re-edition published by Au Sans Pareil with a preface by Philippe Soupault: "You will find there all the Dadaïc seeds."

Knowing that his friends are selling certain works from their collection, including Picassos, Marcel offers his services: "I know Rosenberg and could speak to him if you give me instructions."

Ruefully Marcel concludes that he won't see them soon, but instead, as he expresses it: "In January there will be only 4,000 miles between us instead of 8,000…"

1925. Sunday, Paris
The day after the opening of the first Surrealist group exhibition at the Galerie Pierre Loeb (a manifestation with which Duchamp did not wish to be associated [19.10.1925]), an anthology entitled *Le Musée des erreurs* is published by Albin Michel. The texts collected by Curnonsky and J. W. Bienstock include the epigraphs by Rrose Sélavy on the cover of *391*, no.18, published in July the previous year:

Oh! do shit again!…
Oh! douche it again!…

and

Du dos de la cuillère au cul de la douairière!

From the same number of *391*, there is the line written by Pierre de Massot:

Rrose Sélavy s'est fait mal et fait ses malles.

1926. Monday, New York City
At the Brummer Gallery, where the exhibition opens on Wednesday, "the two rooms are beautifully arranged, lighting very fine, a daylight-looking arrangement from overhead…" Beatrice Wood visits the gallery and says that "Marcel was putting the finishing touch, hanging pictures on walls, moving stands. He looked tired, but very lovely, impersonal and had a quality very akin to the statues themselves…"

1933. Wednesday, New York City
Two days before the opening, Marcel sends Mary Reynolds a catalogue of the Brancusi exhibition. Writing the date on the cover he promises: "I will write soon, all's well Marcel."

1942. Sunday, New York City
Marcel joins the Kieslers in their apartment for brunch.

1947. Saturday, New York City
After dinner Maria Martins and Marcel call to see the Kieslers at 56 Seventh Avenue.

1950. Wednesday, Paris
Having completed his task of emptying the house at 14 Rue Hallé after the death of Mary Reynolds [30.9.1950], Marcel moves to the Hôtel Terminus opposite the Gare Saint-Lazare, where he is given room 422.

Between eleven-thirty and noon he has time to see Roché at 99 Boulevard Arago (and collect the suitcase which he left with his friend the previous day?).

1958. Saturday, New York City
"Thanks for having sent me the interview [29.10.1958], which should certainly do the trick if the book appears without delay," writes Duchamp to Robert Lebel. "Otherwise it will be forgotten very quickly." In spite of sending "at least 3 letters" enquiring whether the printing of the text has begun, Duchamp has been unable to prise out of Fawcus a "yes or shit" and he reminds Lebel: "on 31 December 1958 we serve notice on Fawcus to terminate the contract."

"I have solved the problem Péret," declares Duchamp, "I am sending you by air, by the

same post, a fancy waistcoat for which I have 'aided' the 5 buttons to spell P E R E T – the whole 'signed and dated'."

*

After "another hectic week", it is the Duchamps' first evening at home since Monday. "Tomorrow we leave for Pittsburgh," writes Teeny to Jackie, "and Marcel says we are going to bed as soon as I finish this…"

1964. Sunday, New York City
Further to his telegram of the previous day to Jackie concerning the next copies of the *Boîte-en-Valise* [7.1.1941], Marcel writes: "Thank you again for having steered the boat of the Brides so well," and remarks: "Schwarz will be a great help to us to pay everything that has to be paid in Milan and to have the 25 boxes transported to Paris."

Regarding Schwarz's question about the early paintings belonging to Gustave Candel [25.4.1941], Teeny has explained in her letter

17.11.1933

to Jackie that these were acquired by Arne Ekstrom for Mary Sisler's collection and will be exhibited in January. "Nothing to add," remarks Marcel.

1967. Wednesday, New York City
Duchamp writes to Louis Carré.

16 November

1919. Sunday, Rouen
Marcel's father is "tremendously alive at 71", according to Miss Dreier, and he "feels his work is infinitely better than at 50 [27.3.1905]". She describes him as looking "like a very busy alive little bird with eyes like fire". However, "the originality," she considers, "comes from the mother, who is very deaf and sits like an Eastern god – withdrawn, yet there. Absolutely part of the group though she can hear nothing."

On polling day in the first round of the parliamentary elections, Miss Dreier, with Marcel, is visiting the Duchamp family at 71 Rue Jeanne d'Arc. To Eugène Duchamp "the secret ballot means not telling anyone for whom he voted". It is the same for a cousin of Lucie Duchamp's [Jean van Linden?], "an important man of affairs," whom they see every evening while Miss Dreier is in Rouen. Indeed she finds their attitude "amusing" because it is not hard to guess that their sympathies lie to the right, with the very popular Georges Clemenceau, who recently negotiated the Treaty of Versailles [28.6.1919].

Lucie Duchamp takes "a great fancy" to Marcel's American friend: "Her attitude," Miss Dreier found, "was very wonderful to me. They

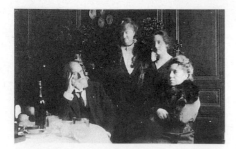

were all kindness themselves," she commented later, "and it was interesting to have so intimate a glimpse into a French family life…" As a souvenir of her visit, a photograph is taken in the dining room, which is decorated with a large gilt mirror and a collection of Rouen china plates. Miss Dreier stands next to Marcel's youngest sister, Magdeleine, with Lucie Duchamp seated on the right; Eugène Duchamp, in a characteristic position [6.5.1911], leans with one elbow on the table, resting his head in his hand.

1937. Tuesday, Paris
Having forgotten to ask for funds to pay for the storage of her furniture when he wrote on 26 October, Dee writes hastily to Miss Dreier.

1945. Friday, New York City
Writes to Patrick Waldberg in Los Angeles, mentioning that for Isabelle [10.11.1945], who sailed for Europe today, he has provided letters addressed to a number of friends in Paris urging them to help her find somewhere to live. His own occupations? "No billiards," writes Duchamp, "but chess quite violently."

1952. Sunday, New York City
"…I beg you not to make any effort in the way of 'homages'," writes Marcel to Roché, who has sent him a copy of "Marcel Duchamp où la Joconde mise à Nu" by Charles Estienne. "I really don't have enough to offer and the danger of the 'too public' life is approaching me."

Recently appointed director of the Solomon R. Guggenheim Museum, James Johnson Sweeney has indicated that he would like to purchase *Adam et Eve* by Brancusi for the collection.

*

As Yale will not be including it in the Memorial Exhibition opening on 15 December, Duchamp wants to make arrangements for the Large Glass [5.2.1923], which is still at Milford, to be transported to Philadelphia [6.5.1952]. "For safety['s] sake," he tells Fiske Kimball, "I would like to be on the truck with the men."

A while ago he received "King and Queen" from Walter Arensberg [6.9.1952]: "… am working on the back," writes Duchamp to Kimball, "'reviving' Adam and Eve."

1958. Sunday, New York City
At three o'clock in the afternoon the Duchamps, who have reservations on the same TWA flight as the Sweeneys and Mary Callery,

fly to Pittsburgh, where they are the guests of Ruth and Gordon Washburn.

1962. Friday, New York City
"The circuit is almost a circus," Marcel tells George Heard Hamilton. "But I enjoyed the *sympathique* audience of Cleveland [9.11.1962]."

If Patricia Matisse, who owns it, cannot supply a photograph of *L.H.O.O.Q.* [6.2.1930], Marcel proposes to give George "a coloured print (collotype process and no screen) from the Valise, which can be photographed like the original".

1966. Wednesday, New York City
At seven-thirty in the evening Duchamp meets Louis Carré, who has recently arrived in New York [10.11.1966].

1967. Thursday, New York City
"Thank you for your letter full of Villons," writes Marcel to Brookes Hubachek, who has found an "unexpected exhibition" of early works by Villon and bought several. As the gallery owner, Mr Johnson, may be interested in the portrait belonging to Georges Herbiet [12.10.1967], Marcel encloses the transparency of it. "In the meantime," he says, "I heard from the shipper in Paris that the little landscape is on its way (by air) to you…"

*

To Pontus Hulten's request for a text for the catalogue of the exhibition "The Machine", which he is organizing for the Museum of Modern Art in New York, Duchamp declines, explaining: "Such a text should be written by a (or several) professional writer with all the objective weight that an (any) artist can't have…" He regrets that Philadelphia has refused to lend *Broyeuse de Chocolat,* No.2 [8.3.1915], "The only possible pull," Duchamp suggests, "would have to come from VIPs in the Museum of Modern Art…"

17 November

1916. Friday, New York City
The neurologist Ernest Southard, one of Arensberg's friends, dictates an account of thoughts he had one evening in a discussion

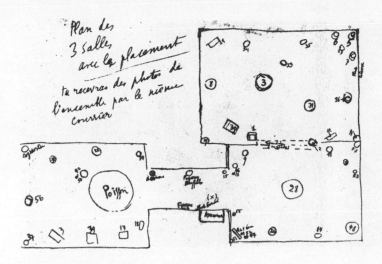

17.11.1958

with Marcel about "Mlle de l'Escalier" [18.3.1912] as Duchamp calls his celebrated painting.

Discussing art with Marcel one night, Southard "inadvertently let fall some words about Diana and her now famous *défi* of the staircase. Whereupon there was nothing for it," Southard recounts, "Marcel burst the usual bonds of his French moderation and descanted at length upon his famous painting. Descant, expatiate, dissect, exfoliate – only by such terms can I fitly recall the phrases of Marcel. The entire rush of ideas from Aphrodite's foam to the red cotton night-cap country was displayed and no decision rendered…"

1917. Saturday, New York City
A painting by Louis Eilshemius [10.4.1917] was purchased for Walter Arensberg at an auction held at the Penguin Club on 10 November; Walter then, three days later, gave the picture to Roché, who in turn arranges for Albert Gleizes to deliver it today to Marcel.

1926. Wednesday, New York City
"The fever of New York prevented me from writing to you earlier," explains Duchamp to Jacques Doucet in a brief note, enclosing two copies of the catalogue which, in addition to the laudatory introduction by Paul Morand [18.8.1926], includes seven aphorisms by Brancusi.

Later, in the presence of the artist, the exhibition, which Duchamp has installed against the background of grey cloth-covered walls, opens in the brightly lit Brummer Gallery at 27 East 57th Street. Augmented by work brought from Brancusi's studio in Paris, which caused such a furore with customs officials [21.10.1926], a large number of sculptures on show are those salvaged by Roché, Mrs Rumsey and Duchamp [13.9.1926] from the late John Quinn's estate.

1933. Friday, New York City
It is the seventh anniversary of the previous Brummer exhibition. Brancusi has remained in Paris but has again entrusted Duchamp with

the installation of his second exhibition at the gallery, which is now situated at 55 East 57th Street. After bringing each piece up in the elevator, "without cutting the cock," Duchamp discovered that "the columns were too long for the gallery" which meant shortening them by 2 centimetres from the top. Since "the question of weight was very serious" Brummer took the advice of a structural engineer and, to install Mrs Meyer's portrait, a wall was built between the two galleries, strengthening the party wall of the two houses. Mrs Rumsey's bird "is upright in the place of honour" and nobody notices the crack, which is practically invisible [12.11.1933]. "…The 58 pieces float very easily in the three rooms. The gallery has been completely whitewashed and the unwaxed parquet gives quite a good neutral tone without polish (rubbed with sandpaper and with acid!)."

According to Duchamp many people come to the opening: "friends old and new, really astounded by the fish, felicitations on the arrangement – really lots of joy in the air."

*

"The exhibition has just opened," writes Marcel in the evening to Alice Roullier, "and I really don't know what is going to happen – 24 tons which I have been juggling with for 8 days." As for the previous Brancusi show, which travelled to the Arts Club [4.1.1927], Alice has invited Marcel to exhibit the sculpture in Chicago. Other than critical success can Brancusi count on anything else? "On the one hand Brummer naturally pays all the expenses, on the other Brancusi would really like to sell something," explains Marcel, pointing out that: "not even a quarter of the costs will be repaid by the eventual sales." Asking for time before sending her the results of his "conversations with Brummer" and his "exchange of emanations with Brancusi", Marcel warns Alice: "You know my personal feelings: they count for very little in the decision to be taken."

1942. Tuesday, New York City
On paper from the Gladstone, 114–122 East 52nd Street, Duchamp acknowledges receipt from Mrs Francis Steegmuller of $170, "being the final portion of the total sum of $420 contributed to Jacques Villon." [9.5.1942]

1950. Friday, Paris
At one o'clock Marcel and Roché meet Francis Picabia.

Later, Roché telephones Marcel between six-thirty and seven and they go to see Pierre de Massot.

1958. Monday, Pittsburgh
At the invitation of Gordon Bailey Washburn, the Carnegie Institute's director of Fine Arts, who has chosen the works for the 1958 Pittsburgh Bicentennial International (excepting the pictures and sculptures from Latin American countries chosen by José Gomez-Sicré), the international jury of award is gathered to select the prizewinners. The six individuals who have accepted the task "consist of a painter, a sculptor, an aesthetician, a collector, a museum director and an ex-artist", according to Washburn, who describes Duchamp as "perhaps the most famous if not the only artist emeritus in the world".

During the next four days Duchamp and his fellow jurors, Raoul Ubac, Mary Callery, Lionello Venturi, Vincent Price and James Johnson Sweeney, each provided with a wheelchair to ease the physical strain, will make their decisions from five hundred and fifty works of art from thirty-one countries.

1961. Friday, New York City
Travels with Teeny to Montreal to participate in a Canadian television broadcast.

1966. Thursday, New York City
At four-thirty in the afternoon Duchamp meets Monique Fong.

18 November

1917. Sunday, New York City
Marcel "is working on his wall" when Roché arrives at his studio. They have dinner at an Italian restaurant and then, with Joseph Stella, Louise Arensberg and others, spend the rest of the evening at Edgar Varèse's where Ernest de Journo recounts his life.

1927. Friday, Paris
Following his wife's petition for a divorce on the grounds of desertion [31.10.1927], Duchamp receives the formal court summons to resume conjugal life with Lydie which he

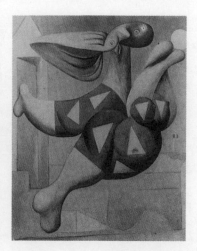

18.11.1933

absolutely refuses to, declaring that he no longer wishes to live with his wife.

1928. Sunday, Paris
At the General Meeting of the Fédération Française des Echecs, held at 30 Boulevard Bonne-Nouvelle, Duchamp is elected as delegate to the organisation of the Coupe de Paris, challenge de la Liberté.

1933. Saturday, New York City
"Marcel Duchamp, Back in America, Gives Interview," is the headline in *Art News*, which is subtitled: "Famous French artist, who has brought Brancusi exhibit to Brummer Gallery, comments wittily on Art."
Refusing to be drawn on Laurie Eglington's first question as to whether the New York customs officials have now distinguished Brancusi's sculpture [21.10.1926] from "de luxe plumbing fixtures", Duchamp is prepared to comment on painting in France:
"In Paris we have inflation in painting, just as you have it over here in dollars, only ours has been going on since the war. Artists, once having found a formula for painting, have used it for making money, selling their stuff like so many beans..."
When he is asked whether he believes in more amateur painting, Duchamp replies that while he holds with "professionalism in painting" he would like to see "more amateurism among dealers".
Duchamp goes on to say: "Painting today, as we all know, shows a return to a form of objectivism – more representation, although in another form. It is a sort of laughing romanticism, a sarcasm toward one's self, a sophistication such as one gets also in conversation. Surrealism, of course, is doing that. For the last hundred years we have been in an era of painting for the sake of painting such as was not known two hundred, nor yet four hundred years back. Fra Angelico, for instance, had no idea of painting for its own sake: he aimed merely at glorifying religion. Recently, however, we are almost totally absorbed in a love of brush stroke. Emotion, even, is today totally subordinated to the hand and everything is concentrated in the success of the brush stroke. What we refer to as *sensibilité* is in the brush stroke rather than through it. The imagination does not ask more than that... it is a sort of humility. It is not any more what I, the artist,

feel... the head is there to translate what the eye sees."

When pressed to name "outstanding" artists in France, Duchamp mentions two Spaniards, Joan Miró and Salvador Dali, "as illustrating the transition from one period of painting to another." He remarks that "there is too much continuation along the lines of the cubist ideas" and insists that "the modern artist must hate Picasso in order to make something new, just as Courbet hated Delacroix. The son must hate the father in order to be a good son. Such hatred seems to be the only means of producing that necessary reaction against the achievements of the previous period..."
Asked to consider contemporary American art, Duchamp observes: "In art it is a case of jumping from one cliff to the next, which is very difficult when one is still on the grass..." He considers that America "has the chance for the future... [and] although it is true that in 1910 Paris was humming with ideas, it is very likely that very little more will come out of France."
The interviewer suggests that contrary to American work, the French have "style".
"Style is just what the French must get away from and the American cease to strive after; for style means following tradition and is bound up with good manners and a standard of behaviour, all completely outside the scope of art. Under such conditions, no new norm can be reached."

Discussing art in general, Eglington writes, "Duchamp intimated that... the trend of events today indicate that this is not going to be a free world much longer and that freedom of art will also come to an end." Duchamp's prediction is that artists will soon be servants of some chief or director and probably no one will look at art anyway "when it is retailed at so much the square yard".
"There is bound to be a wide readjustment of values by posterity," Duchamp reflects. "It is we who discovered Raphael and decided he was a great artist. In his own time he was probably just another artist, much as, in contemporary politics La Guardia is today, whatever he may become, a change from O'Brien."

Duchamp then talks about Brancusi: "He lives absolutely alone with his sculpture, and there is

never any intermediary between him and his lovers. Forms are naturally his obsession. Growing out of the bulky bird, the *Maïastra* of his earlier work, the forms gradually became more elongated until they attain this last shape which we see in the exhibition [17.11.1933]. Brancusi says that he would like to make a projection of a bird large enough to fill all the sky... Brancusi works alone and his only contact with people is with those who love his sculpture. Here is a case where the war between the artist and the collector is non-existent, for no one can find the sculptor's work except at his studio."

Describing the sculptor's method of working, Duchamp continues: "Brancusi penetrates the substance of his material and works with the very molecules and atoms as the Chinese did... he espouses his creations, and lives with them as, again, the Chinese lived with theirs, so that his expression in sculpture produces a coloration of his whole being, and it is difficult to separate Brancusi the man from his *œuvre*. Thus it is that his sculpture takes on with the passage of time an added power to give pleasure."

*

Evoking briefly, in a 12 page report to Brancusi, the success of the exhibition, its beauty, details of the installation and the joyful atmosphere at the opening on Friday, Duchamp tells the sculptor that it is not like the previous show in 1926 when there was the farce with customs: "the press does not operate prior to the opening," he explains, "but this year the things are works of art and they defend themselves. In 2 days more than 500 people without any advertisement."
There is hope for some sales: Gallatin, Mrs Guggenheimer, Mrs Guggenheim (Peggy's mother), Clark, Mrs Meyer... "In a few days I will write to Barnes," says Duchamp, "to ask to see his collection and at the same time I will try to persuade him to come and see the exhibition."
Brummer has advised Duchamp that he will take 10% if total sales are unimportant and 15% if sales are good. "I think that there is nothing to be said about that," comments Duchamp, "given that the whole has already cost him more than 4,000 dollars..."

*

In the evening Dee is due to dine with Miss Dreier.

FÉMINISME
La Femme Curé

19.11.1908

19.11.1911

1945. Sunday, New York City
"You will receive 2 winter underpants from the hands of Mme Waldberg [16.11.1945]," Marcel informs Roché, telling him that his messenger is due in Paris at the end of the month. The other news is that, as Miss Dreier is moving from The Haven, Brancusi's *Colonne sans fin* is now at their disposition again [6.9.1935].

1947. Tuesday, Brooklyn
For the exhibition "American Print-Making", opening at the Brooklyn Museum, the Société Anonyme lends *Rotorelief (Disques Optiques)* [30.8.1935].

1949. Friday, New York City
At one-thirty Duchamp meets Miss Dreier and Alfred Barr at the Museum of Modern Art. Before going for lunch together nearby, they have a look at Miss Dreier's *Abstract Portrait of Marcel Duchamp* which, at Duchamp's suggestion, Barr purchased for the museum in June.

1950. Saturday, Paris
In the afternoon at four-thirty Totor arrives at Arago and spends three hours with Roché who is slightly under the weather with a cold.

1952. Tuesday, New York City
In response to his recent letter [16.11.1952], Duchamp receives a cable from Fiske Kimball proposing transportation of the Large Glass from Milford on Monday.

1953. Wednesday, New York City
Shocked to learn of Roché's emergency abdominal operation, Marcel cables him: "Dear Totor what an episode get better quickly." As requested, he also cables Roché's friend Bouboule at the St Francis Hotel in San Francisco.

1959. Wednesday, New York City
Enclosing the text by Jean Cocteau [3.11.1959], which has been translated by Grove Press, Duchamp tells Robert Lebel that he is going to do a short radio interview live about the book [6.11.1959], "to push sales."

1961. Saturday, Montreal
After his appearance in a television programme, which included Auguste Le Breton, the author of the book from which the film *Du Rififi chez les Hommes* was drawn, Marcel returns to New York with Teeny.

In the evening at Jeanne Reynal's, the Duchamps meet Takis: "not at all what we expected from his book," considers Teeny, "and we liked him!"

1963. Monday, New York City
From Louis Carré, who has had word from his gallery in Paris, Marcel receives up to date news concerning Gaby Villon.

19 November

1908. Thursday, Paris
Women are apparently resolved to "invade" every profession. To the astonishment of *Le Rire,* the female bill-stickers, aviators and painter-decorators have now been joined by three English nurses, who have qualified as deep-sea divers at Tilbury Docks.

In this wave of feminism Duchamp cannot resist drawing his impression of the female priest for *Le Courrier Français*: dressed in a long, black robe and fur hat, solemnly putting on her gloves, she stands by the dressing table in her boudoir, a vaginal injection apparatus hanging prominently on the wall behind her.

1911. Sunday, Paris
Protesting that he has almost no space to talk about the exhibition representing "the different new tendencies of young French painting" at the Galerie d'Art Ancien et d'Art Contemporain at 3 Rue Tronchet, Apollinaire exhorts readers of *L'Intransigeant*: "Go to see it, that would be even more worth while. The most audacious group," he continues, "is well represented by Mlle Marie Laurencin, Albert Gleizes, R. de La Fresnaye, Fernand Léger, Duchamp, making considerable progress, Jean Metzinger..." Stating again his belief that, of present artistic preoccupations, Cubism is the most important, Apollinaire regrets nevertheless the absence of Picasso and Derain in the exhibition.

Francis Picabia [30.9.1911], who persuaded Hedelbert to provide the gallery, sent his wife Gabrielle to deliver the two pictures entitled *Jardin* and a third called *Les Cygnes*. Noticing her descending from a taxi burdened with the canvases, Duchamp gallantly ran to her aid.

The exhibition includes seventeen of the artists who participated in the second exhibition [7.5.1911] of the Société Normande de Peinture Moderne. Among the other twenty-five young artists are the sculptors Alexandre Archipenko and Elie Nadelman, the painters Pierre Girieud and Henri Le Fauconnier. In his preface to the catalogue, René Blum praises the initiative of the organizers to show the "oppositions" and "contrasts" in a whole generation of artists whose significance is lost at the Salons "in the midst of the surrounding mediocrity".

While his brother Duchamp-Villon is represented by his haunting sculpture of *Baudelaire*, Duchamp exhibits *Sonate*, a symmetrical composition, which he commenced in January. A group portrait of the female members of his family, the canvas is dominated by his mother in pale blue, with Yvonne at the keyboard, Magdeleine playing the violin and Suzanne seated in the foreground.

Duchamp cannot have been unaware of Roger Allard's view published in June 1911 that the Cubists "show a single willpower to paint *pictures*: meaning by that works composed, constructed, well-ordered and no longer notes and sketches where the bluff of false spontaneity masks the fundamental emptiness."

In any case, for Duchamp, *Sonate* is a definite turning point and, exploring new avenues, requires "manual adaptation". Having completed *Dulcinée* [30.9.1911], and painted *Yvonne et Magdeleine déchiquetées* [5.9.1911], in September Duchamp decided to rework *Sonate* before exhibiting it.

1916. Sunday, New York City
After rehearsals Beatrice Wood works with Marcel at his studio; they then go to have tea with Alfredo Sidès, who has also invited two stars of the French Theatre where Bea works, Yorska and her leading man, Ruben.

1926. Friday, Brooklyn
Organized by the Société Anonyme, the "International Exhibition of Modern Art", for which over 300 works by 106 artists from 19 countries have been assembled, opens at the Brooklyn Museum. With the ambition of making the event a successor to the Armory Show [17.2.1913], the president of the Société Anon-

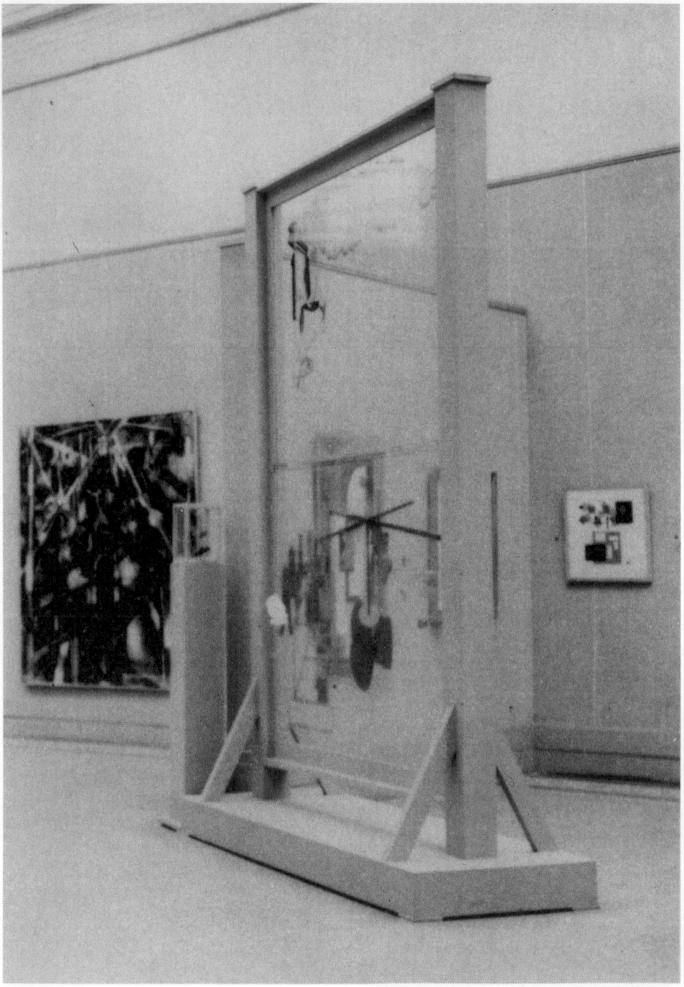

19.11.1926

19.11.1926

yme [3.11.1920], Miss Dreier, in making her selection, "has laid special emphasis on bringing over vital groups with a new vision for the student in America to study." The groups specifically identified in the smaller of the two catalogues published for the occasion are:

"Mondrian from Holland with his international group standing for clarification.

Pevsner and Gabo from Russia standing for depth in sculpture in contrast to mere circumference.

Léger from Paris with his international group working out the problems of the Intérieurs Mécaniques.

De Chirico from Italy and his group working out the problems of his Intérieurs Métaphysiques.

Malevich represented here by Lissitzsky with his group the Suprematists.

And the International Group of Constructivists which also had its beginning in Russia."

Miss Dreier, who is the driving force behind the project, acknowledges the assistance given to her by Kandinsky, Mondrian, Campendonk, Helma and Kurt Schwitters, Bragaglia, Pannaggi and Léger. She gives "special thanks" to Duchamp, who also helped her in Italy [26.5.1926], for his "indefatigable energy" in gathering works in Paris [3.7.1926].

The vast exhibition with its programme of lectures and the concert of modern music at the opening also includes four furnished rooms showing modern art hung in a domestic setting. On exhibition for the first time, well-positioned in one of the spacious galleries, is the Large Glass, *La Mariée mise a nu par ses Célibataires, même* [5.2.1923], which has been framed and installed under Duchamp's supervision [27.10.1926]. Miss Dreier also lends one of the small studies for the Glass, *A regarder d'un Œil, de près, pendant presque une Heure* [4.4.1919], referred to in the catalogue as *Disturbed Balance*.

1936. Thursday, Paris
Duchamp writes to Mrs Norton [16.10.1936] confirming that he is mailing "today and tomorrow 24 sets of discs in 6 parcels of 4 each" and two copies of the Green Box [16.10.1934] separately. He confirms his agreement to the "sale or return" basis proposed by

Mrs Norton. Regarding the *Rotoreliefs* [30.8.1935], Duchamp tells her: "There should not be *any hole* made in the discs," and explains that a disc (with or without the round, black slipcase) should be laid on top of several ordinary gramophone records placed on the turntable. "Also the speed should be reduced to its minimum (35 to 40 turns a minute is best)."

1937. Friday, Paris
Rrose Sélavy's text about the work of Francis Picabia [8.3.1926] is reprinted in the catalogue published for Picabia's exhibition, "Peintures dada, paysages récents," at the Galerie de Beaune.

1940. Wednesday, Hollywood
In response to his request [30.9.1940], the Arensbergs mail Marcel the official invitation from the Francis Bacon Foundation requesting his services for making a decoration with an installation of his works, which he is to supervise. The invitation is in the form of an affidavit, signed by both Walter and Louise, completed by notarial signature. A method considered better than applying for a visitor's visa, Marcel should show the affidavit to the American consul and express his desire to accept the invitation.

1948. Friday, Milford
To assist with the lighting of the Large Glass in the parlour at Laurel Manor, Dee has brought with him from New York the fixtures provided by Barr for Miss Dreier to choose from.

1952. Wednesday, New York City
Responding to Fiske Kimball's telegram, Duchamp telephones him to say that there is not enough time to prepare the Large Glass for transport on Monday. They agree to make a date in January, even at short notice, when the weather is favourable.

1954. Friday, Paris
In the afternoon at four Duchamp is interviewed by d'Orgeix for the magazine *Arts*.

1956. Monday, New York City
Supervising the preparation of the catalogue for the "Three Brothers" exhibition [24.10.1956] due to open on 8 January, Duchamp returns the corrections airmail to

Switzerland and cables Stämpfli & Cie in Bern, instructing them to "hold printing" until James Johnson Sweeney, who is in Paris, has given his final approval.

1958. Wednesday, Pittsburgh
With his fellow jurors, Duchamp is invited to attend an informal panel discussion led by Gordon Washburn, director of Fine Arts at the Carnegie Institute, which is part of the programme organized by the Women's Committee of the Department of Fine Arts.

1965. Friday, New York City
In the evening at seven-thirty Duchamp has a rendezvous with Louis Carré.

20 November

1913. Thursday, Paris
Gabrielle Picabia has written asking Gertrude Stein whether they may bring their friend Marcel Duchamp to the Rue de Fleurus this evening. At about this time, Miss Stein and Miss Toklas find that, while Gabrielle is "full of life and gaiety, Picabia dark and lively", Marcel looks like "a young Norman crusader".

1934. Tuesday, New York City
Because Dee has not written to her lately, Miss Dreier is unaware of his position regarding the loan of his work to Alfred Barr's exhibition [17.10.1934]. His small glass, *A regarder d'un Oeil, de près, pendant presque une Heure* [4.4.1919], is included in "Modern Works of Art", a show opening today which celebrates the fifth anniversary of the Museum of Modern Art.

1935. Wednesday, Paris
After seeing Levis Mano to discuss the means of reproducing *La Bagarre d'Austerlitz* [22.9.1935] for the cover of *Au Lavoir noir*, and promising to bring a maquette to show him in a few days, Duchamp writes to André Breton. The proposal is to print the front and the back of the window on two separate sheets of paper, cut out the windows, and using a sheet of celluloid for the window panes upon which the figure eights are printed in white, to

20.11.1949

mount the three together. Inviting Breton to go and see the maquette and take his decision, Duchamp also says that in sharing the costs he wants to reserve the window for use in his album [5.3.1935].

1936. Friday, Paris
"Thanks for your long letter. This is a business one," Dee announces to Miss Dreier, explaining that a friend of Villon's is interested in buying the bed she has in Paris if it is for sale. "I have been trying to sell Verlaine [29.9.1936]," he continues and he thanks her for proposing to Catton Rich that if he would like to screen *Anémic Cinéma* [30.8.1926], then the Art Institute should have a non-inflammable copy made [6.10.1936] and purchase it from him.

1946. Wednesday, Paris
At seven-thirty in the evening Roché, who has recently returned from New York, has dinner with Mary and Marcel at 14 Rue Hallé.

1949. Sunday, New York City
"...All that," Marcel tells Roché who has sent him photographs of his early paintings [14.11.1949], "reminded me of life well obliterated." *Trois Nus et une Chèvre*, the same combination painted by Louis Morin at Pigall's [22.3.1910], Marcel has decided to give Mary Reynolds, "if she would like it." Roché can have "first sight of and first choice" of certain others: *Clémence*, an intimist-style portrait of the Duchamps' dedicated servant [18.12.1925];

Deux Nus and *Femme nue aux bas noirs*, both painted in 1910 from professional models; *Homme assis près d'une fenêtre*, a portrait of the actor Félix Barré painted at Veules-les-Roses, and *Maison paysanne*. The price "for

friends" is $200 for the canvases and $150 for those on cardboard. "Tell me if that suits you, because my scale is perhaps too American," Marcel requests, adding, "...and don't forget that you have a credit of $300 in the office."

1950. Monday, Paris
Wanting to meet him again [26.10.1950] before sailing on Saturday, Duchamp writes from his hotel to Jean Suquet asking him to telephone.

*

In his short visit to the Roché household at Sèvres (taking the four-twenty train and returning at six-thirty), Marcel gives Roché's son Jean-Claude a chess lesson.

1956. Tuesday, New York City
"The lighting of the glass [4.11.1956] is in my head," explains Marcel to Roché, "and we are waiting for the carpenter, who must fix [the glass] at a slight angle from the wall in order to hang the projector from the ceiling."

1958. Thursday, Pittsburgh
After some "trials and tribulations" the members of the jury who, as Gordon Washburn has discovered since Monday, are "an odd assortment of characters" with little close thought and feeling, have finally established the list of awards for the Pittsburgh Bicentennial International.
The first prize for painting, worth $3,000, is given to "the discovery" of the 1955 Pittsburgh International, the Spaniard, Antonio Tàpies. The other painting prizes go to Afro from Italy, his compatriot Alberto Burri, the Portuguese-born Vieira da Silva, and another Spaniard, Pablo Palazuelo. Camille Bryen from France receives an honourable mention.
The $3,000 sculpture prize is awarded to Alexander Calder. Second prize goes to Henry Moore and the third to César. The Italian Pietro Consagra receives an honourable mention.

His task completed, Marcel returns to New York with Teeny.

1959. Friday, New York City
In the morning on receiving André Breton's letter, Duchamp cables him:

"Je purule, tu purules, la chaise purule. Grâce au râble de vénérien qui n'a rien de vénérable."

The text is to be published in facsimile for the ordinary edition of *Boîte Alerte*, the catalogue of the forthcoming Surrealist exhibition.

"For the signature of the twenty aprons [9.11.1959]", suggests Duchamp in his letter to Breton, "...the simplest would be that I sign on a small ribbon (satin) that is sewn by machine or by hand..."

1961. Monday, New York City
"I have done a bit of retouching to my own words," writes Duchamp to Simon Watson Taylor, who has submitted a French translation of "Apropos of Readymades" [19.10.1961] to the author before its publication by the Collège de 'Pataphysique. "For 'habit-forming' I have only found a distant equivalent," continues Duchamp: *drogue 'à répétition'*, perhaps our pen-pushers will do better."

21 November

1919. Friday, Paris
When Roché arrives at the Hôtel Brighton at one-thirty he finds that Marcel is already with Miss Dreier. The three have lunch together at Madame Prunier's restaurant: oysters, mutton trotters with *sauce poulette*, followed by vanilla soufflé, accompanied by bottles of Sauternes and Barsac.
In the afternoon they travel to Puteaux, where Marcel introduces them both to his brother Villon. Roché much admires Villon and his work, his pretty house, the studio and garden with the view of Paris. Miss Dreier photographs everyone, and takes a snap of Villon and Gaby, with Marcel looking rather solemn between them, standing in the garden by the wall of the studio.

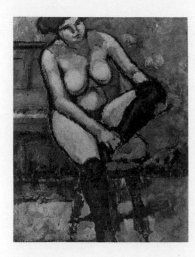

Roché notices that Miss Dreier (whom he finds nice, kind, simple, naive but also stubborn) likes taking Marcel's arm, but that he disengages himself and often gets annoyed with her.

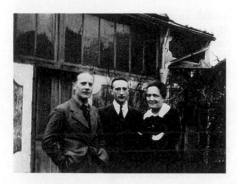

1932. Monday, Paris
Enclosing an invitation card for a Dali exhibition at Pierre Colle's gallery, Duchamp writes to Mme Galka Scheyer, a friend of the Arensbergs visiting Paris, suggesting that he call at her hotel at two o'clock instead of two-thirty on Wednesday afternoon: "Puteaux is a long way," he explains, "(almost an hour by tram) and the light fades quickly…"

1946. Thursday, Paris
Having forgotten about it the previous day, Marcel writes in the morning to André Breton inviting him, Elisa and Aube to dinner on Saturday at 14 Rue Hallé. Roché who is just back from New York has brought with him the title pages from the "de luxe" edition of *Yves Tanguy* published by Pierre Matisse, which Breton as author. Duchamp must sign and return as soon as possible. Using his typographic expertise once more, Duchamp is responsible for the beautiful layout of the book.

1950. Tuesday, Paris
In the evening at six Marcel telephones Roché and meets him and Marie-Thérèse Pinto for dinner at a restaurant in the Rue Mouton-Duvernet.

1954. Sunday, Paris
Deterred from travelling to Paris any sooner on account of the fog, Roché finally makes it from Sèvres to Arago to see the Totors. It is almost exactly four years since he and Marcel last met [25.11.1950].

1961. Tuesday, New York City
Suggesting that it would be better printed rather than reproduced in manuscript, Duchamp sends Arturo Schwarz his proposed "formula" for the book on Enrico Baj:

UNIFORMES ET LIVREES
MILAN
VIA GESU 17
TEL: BAJ 19-61

1962. Wednesday, New York City
In reply to Douglas Gorsline's request for a meeting, Duchamp invites him over on Saturday around eleven-thirty.

1963. Thursday, Waltham
In the jargon of Brandeis University, Duchamp "will speak at a Gen. Ed. S lecture at 7:00 at Olin-Sang". Using slides of his work, Duchamp first discusses his paintings and work relating to the Large Glass, and in the second part of his talk he describes the readymades.

Later replying to a question about the relationship between Pop Art and Dada, Duchamp says that "Pop Art could not possibly simulate Dada, since the latter was an integral part of the postwar European expression of disgust and revolt. Perhaps the most significant difference between the two movements," Duchamp is reported as saying, "is that Pop Art appeals to and is financially supported by members of the class that Dada was expressly reacting against, the upper society – cultured bourgeoisie. Acceptance of Dada was impossible when it flourished…"

1965. Sunday, New York City
"I look at your illustrations-guides with fascination and I am going to reread this *Locus Solus,* which so astounded me 50 years ago!" writes Duchamp to Jean Ferry, whose sketches adorn Pauvert's re-edition of Raymond Roussel's famous novel first published in October 1913.

"The chesspieces could be perfectly edible even to the point that, to express the capture of a piece, the Spaniards use the word 'to eat' (*comar*)," Duchamp explains.

"There have also been chess games where the pieces were represented by glasses filled with different alcohols that the 'capturer' had to drink after capture [12.12.1944]: you can imagine the scene of checkmate after several hours of playing…"

22 November

1916. Wednesday, New York City
Marcel visits Alfredo Sidès and, during the evening, Beatrice Wood joins them.

1939. Wednesday, Palavas-les-Flots
Thinking of making a reproduction of *Nous nous cajolions* for his album [5.3.1935], Duchamp writes to Pierre de Massot requesting a photograph: "…If you are at Pontcharra and the drawing is there, can you send it to me between two pieces of card to Paris (11 Rue Larrey) so that it arrives around 5 or 6 December at the latest."

NOUS NOUS CAJOLIONS

The ink drawing in question made in the 1920s, which represents a nanny with her charge standing by a caged lion, is signed Rrose Sélavy and juxtaposed with a relic of cajoleries saved from the lavatories of the Lincoln Arcade Building [15.7.1920].

1946. Friday, Paris
Mary Reynolds dreams of buying a cottage in the country, and Marcel has accompanied her this week to Dreux. "At least it is a way to escape Paris, which has become my kitchen," she admits.

In the evening Kay Boyle arrives at 14 Rue Hallé with three small children: "A circus," according to Mary. When they leave, Mary and Marcel are "too stunned to go to bed".

1952. Saturday, New York City
Alfred Barr, who was very disappointed that the Large Glass was bequeathed to Philadelphia [6.5.1952], has been successful in his long dis-

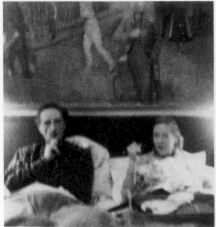

22.11.1958

cussions with Duncan Phillips in Washington to obtain Duchamp's small glass, *A regarder d'un Œil, de près, pendant presque une Heure* [4.4.1919], for the Museum of Modern Art rather than have it go to the Phillips Gallery.

After receiving this news in a letter from Barr, Duchamp telephones, goes to see him, and discovers that a misunderstanding has arisen concerning the proposed Dreier bequest to the American University. Since Duncan Phillips accepted only part of the proposed bequest for the Phillips Gallery [30.7.1952], the executors decided to allocate the remaining items to other institutions and make a new list for the American University.

1955. Tuesday, New York City
As it is more than eighteen months since Marcel applied for citizenship [9.13.1954], and he has heard nothing from the government since, Alfred Barr, who has been following the affair [2.8.1955], decides to write to Nelson A. Rockefeller [9.1.1946]. "I realize that there are factors in Marcel's past such as his association with the Dadaist and Surrealist movements, which may disturb our security investigators," explains Barr, citing a speech by congressman Dondero, who called Duchamp a "red", and accused him of being in the country "to aid in the destruction of [American] standards and traditions". Barr adds that Marcel, who is discouraged and disillusioned, would "greatly appreciate it" if Rockefeller, who is in Washington, could make some inquiries.

1958. Saturday, New York City
"Received your two letters safely and especially the manuscript, which I have begun to read attentively," writes Duchamp to Marcel Jean, referring to his *Histoire de la Peinture Surréaliste.* Promising to send his "impressions" in a few days, Duchamp says: "in the meanwhile, the tachistic photo by Ubac pleases me too and I have just met the said Ubac in Pittsburgh [17.11.1958]." He encloses photographs of Teeny's Miró and a drawing by Balthus; for *La Rue,* (the painting by Balthus which hangs at the head of their bed) Duchamp explains, "Teeny has only an old photo taken by Marc Vaux…"

1960. Tuesday, New York City
"Of course I am very fond of couscous," writes Duchamp to Kay Boyle recalling "a marvellous

mutton couscous at a large luncheon party in Marseilles around December 1941 (?). I also like very much my Steak Tartare," he continues, stipulating that the "best rare beef" should be served with "chopped onions, lots of capers and 2 egg yolks with fresh anchovies".

He regrets that his "favourite food", French-fried potatoes, are "so seldom crisp enough!".

As for the details of Brancusi's famous mutton dish, which Kay has requested, Duchamp has "not enough recollection" to help her.

1963. Friday, Boston
Remaining in Massachusetts after his lecture the previous evening, Marcel is having lunch with Teeny and her son Paul Matisse just off Harvard Square when the news of President John F. Kennedy's assassination in Dallas is announced from loudspeakers. When they return to the Brattle Inn where they are staying, Marcel and Teeny follow the news on television.

1967. Wednesday, New York City
At three o'clock in the afternoon Duchamp has an appointment with Louis Carré.

23 November

1932. Wednesday, Paris
At two in the afternoon, Duchamp is due to meet Mme Galka Scheyer at the Hôtel Castiglione [21.11.1932] and take her by tram to Puteaux to meet his brother Jacques Villon.

1936. Monday, Paris
Having forgotten in his letter on Friday to mention that the buyer of the bed might also want the easel, "businesslike" Dee writes again to Miss Dreier. The Verlaine has not been sold [20.11.1936]: if it goes to auction would $300 be enough, Dee enquires, reminding her that they have to pay 10% on the last bid to keep it.

1946. Saturday, Paris
Marcel calls to see Roché in Arago.
*
Following their turbulent evening with Kay Boyle's children, "what a relief, a French child," exclaims Mary Reynolds after she and

Marcel have entertained Elisa, André Breton and his daughter Aube to dinner. "And Breton, for the first time," Marcel says, "was full of gay humour…"

1950. Thursday, Paris
At a quarter to one Totor and Roché have lunch at the restaurant Au Trotteur, 103 Rue Brancion, near the Abattoirs de Vaugirard, before going to visit Michel Tapié.
*
As arranged by telephone [20.11.1950], at four-fifteen Jean Suquet calls to see Duchamp at the Hôtel Terminus. At about six they descend from his room and take a taxi together as far as the Rue Châteaubriand, just off the Champs-Elysées, where Duchamp has a rendezvous with Gaby Picabia.

1958. Sunday, New York City
Bill Copley, who has seen Richard Hamilton in London, is back in New York and has told Duchamp that he is prepared to help finance the project which started to germinate over a year ago [15.5.1957]: a typographic version of the Green Box in English.

Apologizing for his delay in replying, Duchamp explains to Richard Hamilton: "This delay only means that I am in complete accord with your ideas… Like you, I would like the external aspect of the book to show no signs of 'luxury': an ordinary choice of paper or papers, avoiding, if possible, the glossy paper for the few reproductions…"

1961. Thursday, New York City
To celebrate Thanksgiving, Denise Hare cooks a goose "and all kinds of good things" for the Duchamps and Bob Hale.

1963. Saturday, Boston
Since learning of president Kennedy's assassination the previous day Marcel and Teeny have been constantly listening to the news: "almost glued to the TV, while at the Brattle Inn," and the radio when they return to New York late in the evening.

1964. Monday, Saint Louis
Soon after his arrival from New York, Duchamp (who is to speak at the City Art Museum the following day) is interviewed in his tower room at the Chase Park Plaza Hotel by George McCue for the *St Louis Post-Dispatch.*

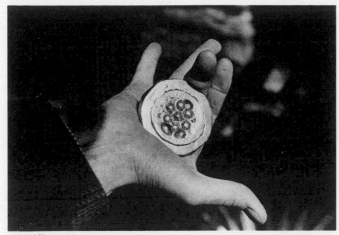

23.11.1967

DERNIÈRE HYPOTHÈSE

LE FUTURISTE. — La prochaine fois ce sera le tour des *Noces de Cana*... Ah! mes amis,
quelle sauce!
Dessin de D.-O. Widhopff.

24.11.1911

"In this century, there has been a double-barrelled kind of art movement," Duchamp explains, puffing on a cigar. "Kandinsky and others created a movement based on nonfigurative ideas before World War I and Cubism and Dadaism explored it further. Then, after World War II, we had more than 20 years of Abstract Expressionism. This has already accomplished its task, so young men are looking somewhere else, purely out of curiosity, I hope, for young men should be curious.

"Dada has an echo in Pop Art. Dada was completely negative and gratuitous; Pop Art is still negative in a sense, but nongratuitous [21.11.1963]. It has integrated the artist comfortably into society. Art movements have no real aim. Each one decorates, and probably illustrates, a period...

"I believe we are returning to a painting of a non-retinal approach. Pop Art painting has passed the retinal barrier, and the intellect wants to come in."

1967. Thursday, New York City
The International Numismatic Agency has recently announced the issue of Duchamp's *Medallic Sculpture* in an edition of 312 copies, 100 each of bronze, stainless steel and silver, and 12 artist's proofs. In fact it is none other than the *Bouche-Evier* which Duchamp contrived in 1964, to plug the waste pipe of the shower in the bathroom of his apartment in Cadaqués. As the original lead stopper proved to be too light for the job, in 1965 Duchamp had a second one cast twice as thick.

"About the medal," Duchamp says in reply to Joe Solomon's enquiry, "I have none for sale but you might write to Mr Neil S. Cooper [president of the International Numismatic Agency] ... He is very nice and might consider a discount."

24 November

1911. Friday, Paris
The poet Guillaume Apollinaire, who was recently accused of receiving statuettes stolen from the Louvre, suspected of collusion with the thief of the *Mona Lisa* [23.8.1911] and incarcerated for a week at the prison of La

Santé before being released, speaks on Cubism in the first of a series of lectures held during the exhibition of the Société Normande de Peinture Moderne [19.11.1911] at 3 Rue Tronchet.

1925. Tuesday, Paris
Totor is with his typist [27.10.1925] when Roché calls at the Hôtel Istria around noon and in fact, because Totor is escorted by two more of his girls, there are five of them for lunch.

1937. Wednesday, Paris
"Marcel Duchamp enjoyed helping these facsimiles look like the forty original variations," writes Dee, who supervised the printing of Miss Dreier's double portfolio of prints entitled *40 Variations* and has sent them to her [26.10.1937].

Marcel Duchamp enjoyed helping these fac-similes look like the forty original Variations —

24 November 1937

1941. Monday, Sanary-sur-Mer
Having received their letter of 20 October and forwarded it to Villon, Marcel writes to Beatrice and Francis Steegmuller confirming that their financial "system" [3.10.1941] can continue, and he confides, as time passes, that he is less and less optimistic about getting to New York.

*

Thanking Georges Hugnet for his news, Duchamp writes on a card that he has stopped smoking almost entirely, except for a few "cigarettes [19.1.1936] made with fag-ends: a tangible form of 'serialism'," and adds: "When I think that I think that I think..."

1942. Tuesday, New York City
Is invited to dinner at Robert Parker's, together with the Kieslers and Jimmy Stern.

1950. Friday, Paris
At nine o'clock on the eve of his departure Marcel dines with Roché and Marie-Thérèse Pinto [21.11.1950] on the Left Bank, Rue Hautefeuille. When they separate, Marcel kisses Marie-Thérèse farewell.

1952. Monday, New York City
In the morning Duchamp receives a letter from Duncan Phillips confirming the news about the small glass, *A regarder d'un Œil, de près, pendant presque une Heure* [4.4.1919], which he learned from Alfred Barr on Saturday.

In his reply to Phillips, Duchamp explains why he changed his mind about the selection for the American University [22.11.1952]: "I felt that the remaining part of the collection (after your personal selection) should be given to institutions which Miss Dreier knew better, and with which she had had closer contact." As these fourteen works have since been accepted, Duchamp proposes another fourteen: "Although less important than the ones on your original list," Duchamp admits, "these works have the same fine quality for which Miss Dreier cared so much," he assures Phillips.

*

To formalize the agreement [6.5.1952], at a meeting of the Board of the Philadelphia Museum of Art it is resolved to accept the Large Glass [5.2.1923] from the estate of Miss Dreier.

1954. Wednesday, Paris
Soon after Duchamp's arrival from America [14.11.1954], Alain Jouffroy decided that he would like to interview him and proposed the idea to André Parinaud. "Who is he?" enquired the editor of *Arts et Spectacles*.

In spite of pointing out that nobody had published an interview with the man in Europe before, and providing a flattering description of Duchamp, Jouffroy managed to obtain the promise of only two short columns on an inside page of the newspaper. With an introduction through Robert Lebel, Jouffroy met Duchamp at 99 Boulevard Arago.

The interview, which is published today, is prefaced with an introduction entitled "Marcel Duchamp, miracle man" by Henri Pierre Roché.

Jouffroy remarks that Duchamp makes statements which seem to be of great personal importance, but which are uttered in a consistently detached and tranquil tone. "An individual," Duchamp says, "can do something else than the same profession from the age of twenty to his death. I expanded the way of breathing."

In awe of his subject, who is seated in front of *9 Moules Mâlic* [19.1.1915], Jouffroy starts

24.11.1962

by enquiring: "How are you?" And then asks: Who are your friends?

"Breton, Max Ernst, Matta, Tanguy, Brancusi, Calder, Donati, Cornell," replies Duchamp. "What I like about them is their intelligence, which I detect through their work. It is not because they are Surrealist or not which interests me... It's their auto-intelligence, if you wish, that is to say, the effort that each of them makes to understand himself. Besides intelligence is a bad word: but there isn't another."

Which books have interested you lately?

"The one by Michel Carrouges about *Les Machines Célibataires* [15.4.1954] and the one by Jean Ferry on Raymond Roussel. To machines imagined and described by Kafka in *La Colonie pénitentiaire,* Carrouges applies all the terminology that I used for *La Mariée...* [5.2.1923]. He sees the Oculist Witnesses and the Top Inscription everywhere. In each machine he finds the same elements: he pushes the analogy to the limit... Ferry's book [*Une Etude sur Raymond Roussel,* published by Arcanes, Paris 1953] enlightened me greatly on Roussel's technique. His game with words had a hidden meaning. But the obscurity of these word games had nothing Mallarméan, nothing Rimbaudesque. It's an obscurity of another kind. What interests me in Roussel is his uniqueness. That he is attached to nothing else."

And painting?

"Since the advent of Impressionism visual productions stop at the retina. Impressionism, Fauvism, Cubism, Abstraction, it's always retinal painting. Their physical preoccupations: the reactions of colours, etc., relegate the reactions of gray matter to a back-seat. That doesn't apply to all the protagonists of these movements. Some of them went beyond the retina. The great merit of Surrealism is to have attempted to be rid of a retinian contentment, of stopping at the retina. By that I do not wish to say that anecdote has to be re-introduced into painting. Men like Seurat, or like Mondrian, were not retinian, even though appearing to be so.

"Painting today is vulgarized to perfection, to the great pleasure of the public who is delighted to enter the arcana of everything that was forbidden before. Everyone has the necessary vocabulary to speak about painting if not to understand it. While nobody dares to butt into a conversation between two mathematicians for

fear of being ridiculous, it is perfectly normal to hear long conversations at dinner on the value of such a painter in relation to another."

Do you attach great importance to artistic production in general?

"No. The production of a period is always its mediocrity. What is not produced is always better than what is produced. Real values are untouchable. Besides I don't see why we give to posterity this prerogative of deciding what is good and what is bad. Especially as this posterity changes every fifty years. Nor do I see why contemporaries can judge better. The idea of judgment should disappear."

*

After their reunion on Sunday, Roché brings Denise to Arago to meet Marcel and Teeny, who have also invited Yvonne [Lyon?]; it is a happy day, according to Roché.

1959. Tuesday, New York City
"You must feel lighter," Duchamp tells Marcel Jean on hearing of the imminent publication of his *Histoire de la Peinture Surréaliste,* which he is looking forward to receiving. "Watson Taylor telephoned me and said that he is translating the History," Duchamp continues (referring to the pataphysician, BOAC steward on the London–New York run, who has just translated Jarry's *Faustroll* for New Directions), "he even asked me to look at the English translation of the passage devoted to chess."

1962. Saturday, New York City
At eleven-thirty in the morning Duchamp receives Douglas Gorsline, who comes to interview him about the influence of photography on his work. Duchamp explains that sometime towards the end of 1911 (prior to painting *Jeune Homme triste dans un Train* [17.2.1913]), when he saw Marey's chronophotography in a magazine, showing fencers and horses, his reaction was "immediate" and he "felt that this visual strategy might be [his]." To allow the "inner" to become the "outer", he forced himself to draw mechanistically. Gorsline records that Duchamp is very proud of his dotted lines and arrows, which he initiated: "One of those moments which repays the creator for his waitings and mistakings..."

Photography generally, Duchamp comments, "represents an even more direct means to art"

and is no more mechanical than the brush and the palette; in its capacity to produce copies at will, it is like etching.

Regarding other sources of his own creativity, Duchamp says that at the time of the Fauves, Impressionism was considered old hat and Van Gogh provided the distortion which destroyed the Impressionist academy. The Cubists, who are giants today, "were considered social pariahs and were glad of this description, it was the Bohemian way and absolutely necessary to their need to be what they wanted to be."

As Gorsline has difficulty equating Duchamp's "pleasant bourgeois origins" with his "ironic attack on these sources", Duchamp argues that he did not hate his social environment but merely wanted to remove himself from it. Displaying what Gorsline considers as a noticeable lack of Freudianism, Duchamp insists that he had a happy childhood. "I had the good fortune to have a good father," he explains. His father, he says, encouraged him to dispose of himself freely: "We search for our valve to escape," observes Duchamp.

*

Promising that on 21 December they will be at the New School to listen to her lecture "open-mouthed", Marcel also tells Kay Boyle: "*Défense d'uriner* is the correct spelling..."

*

"The Utica organizers seem to require absolutism and refuse to show anything which isn't armory-proof," Marcel informs Francis Steegmuller, referring to the forthcoming 50th Anniversary of the Armory Show [17.2.1913]. He prefers not to suggest the Canadian *Baudelaire* by Duchamp-Villon [19.11.1911]: "I *think* that they already have the 'original'..."

1963. Sunday, New York City
After receiving written proposals from Louis Carré concerning the distribution of the proceeds from royalties of Duchamp-Villon's works [17.6.1963], Duchamp telephones Carré and gives him instructions. Payment due to his two sisters, Villon's widow and himself, is to be made directly and not through the intermediary of a *notaire.*

1964. Tuesday, Saint Louis
In the evening at eight Duchamp gives his talk at the City Art Museum entitled "Apropos of Myself" with 30 colour slides of his work.

25.11.1922

26.11.1919

25 November

1922. Saturday, New York City
"Received this morning a note from Crotti accompanied by 50 elucubrations by Desnos," writes Duchamp to André Breton, the editor of *Littérature* [1.10.1922]. "Generally I sleep until noon – have been able to sleep again – What telepathy! or rather 'psychic'. In any case he will be very suitable for *Littérature* – I accept him, eagerly, as correspondent in Paris – Why doesn't he ask for the hand of Rrose? She would be delighted. She has just opened a fashion shop:

La mode pratique – Création Rrose Sélavy
La Robe oblongue, dessinée exclusivement
pour dames affligées du hoquet.
[For practical wear – a Rrose Sélavy creation
The oblong dress, exclusively designed for
ladies afflicted with the hiccups.]

Rrose Sélavy has also gone into another line of business: with Léon Hartl she has bought a dye-shop. Delighted to be able to say: "I am a *teintre* (dyer)!" rather than *peintre* (painter), Rrose keeps the books while Hartl dyes [10.8.1922].

1933. Saturday, New York City
Duchamp dines with the Kieslers and Edgar Varèse, at the Romany Marie Restaurant.

1946. Monday, Paris
Receives a telephone call from Roché.

1949. Friday, New York City
It is of some concern that Walter and Louise Arensberg have not yet visited Chicago to see the exhibition of their collection [19.10.1949], which is a great success. Last Friday the lecture on Duchamp filled the auditorium to overflowing. "Quite a number of people who could not get seats stood during the entire lecture," Mrs Kuh told Duchamp while announcing her visit to New York.
"I will be delighted to see you here," Duchamp replies. "The simplest is to set a date now, Tuesday 6th for lunch, if convenient for you. I could call on you at the Astor around

one o'clock if you tell me exactly in what lobby to meet you."

1950. Saturday, Paris
At four in the afternoon in the hall of the Hôtel Terminus, Roché, Suzanne and Jean Crotti, Villon and Gaby join Marcel for tea before his departure on the 5:37 boat train from the Gare Saint-Lazare.
On arrival in Le Havre, Marcel is handed an unsigned telegram, which he supposes is from Marie-Thérèse Pinto, with whom he dined the previous evening. Due to fog and an adverse tide the *Mauritania* of the Cunard White Star line arriving from Southampton is unable to berth. Like many other passengers waiting to board, Duchamp passes "a half-sleepless night in a harbour station armchair".

1953. Wednesday, New York City
In response to his own telegram [18.11.1953], Duchamp receives a cable from Roché's friend Bouboule: "Mailing check account R."

1959. Wednesday, New York City
In the evening at seven-thirty Duchamp is due to meet Roland Penrose and Lee Miller, who are making a long visit to America.

1962. Sunday, New York City
On a visit to Manhattan, the Chicagoan Brookes Hubachek is invited to dinner at 28 West 10th Street. Teeny has told him: "Come as early as you want to that afternoon. We're both looking forward to seeing you."

1963. Monday, New York City
As he may have to leave New York for a week sometime in December, Duchamp advises Bill Camfield, who has requested a further interview [21.5.1962], to telephone him for an appointment beforehand.

1964. Wednesday, New York City
The Duchamps return from their visit to Saint Louis, which Teeny says was fun: "There were so many people whom I had known when I was young from Biddeford [Pool] and Cin[cinnati], and Marcel's lecture was delightful, everyone seemed to really enjoy it."

1965. Thursday, New York City
At one-thirty on Thanksgiving Day, Louis Carré lunches with Duchamp.

1967. Saturday, New York City
In the evening at eight-fifteen Marcel and Teeny meet Louis Carré at the Côte Basque.

26 November

1919. Wednesday, Paris
After dining again at the Bœuf à la Mode [6.11.1919], Duchamp, Roché and Miss Dreier go to see *C.G.T. Roi* at the Théâtre des Capucines. The stars of the revue are Gisèle de Ryeux, Arletty, Pierre Magnard and Duchamp's friend Mademoiselle Parisys, famous for her naughty little song *Ah! Les Fraises et les Framboises*. Although Curnonsky gave the show a rave review in *Le Théâtre*, possibly Miss Dreier was not amused, because she and her two escorts leave before the end of the first act.

1932. Saturday, Paris
Meets Miss Dreier, who has travelled overnight by train from Berlin, and accompanies her to her apartment at 16 Place Dauphine.

1934. Monday, Paris
In the morning Marcel calls to see Roché in Arago and tells him about the binding he has designed for Alfred Jarry's *Ubu Roi*, which Mary Reynolds is going to execute: with a *U* cut out and forming the back cover, an identical *U* for the front cover, and *B* on the spine, when the book is stood open it reads *UBU*. In addition, on the front black silk fly-leaf, there is to be a gold crown, and on the one at the back, the name of the author.
Marcel also describes his idea for the cover of the next issue of *Minotaure* and they have lunch together at Rosalie's.

1945. Monday, New York City
Writes a quick note to Patrick Waldberg, who is still in Los Angeles [16.11.1945], giving him the address of Walter Arensberg. After short-wave treatment and vitamins, Marcel says his sciatica is now "almost 50% better".

1948. Friday, New York City
Marcel spends the evening with Nelly van Doesburg, who is assisting with the catalogue [1.12.1947] of the Société Anonyme collection.

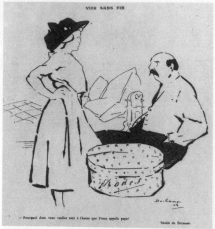
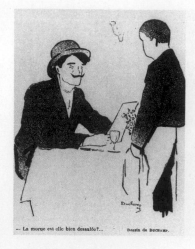

27.11.1909

1950. Sunday, Le Havre
Duchamp boards the *Mauritania* which, after the unexpected delay of 12 hours, finally sails for New York at eight o'clock in the morning.

1953. Thursday, New York City
"Enclosed the cover you asked me for," writes Marcel to Roché, "first page of my Livret Militaire, photo [11.1.1945] which I found in my papers." For Roché's booklet ("Souvenirs sur Marcel Duchamp" [1.6.1953]?), Marcel suggests he uses it as it is, "with the worn edges, on a white ground (or colour)," and specifies coated card, "to really stretch the facsimile."
 Apropos of the funds due from Bouboule [25.11.1953], Marcel warns Roché: "Don't wait too long to give me instructions: I could die in the meantime."

 *

A telegram from Walter Arensberg announces the death of his wife the previous day. Knowing that Louise was terminally ill with cancer, the news is nevertheless devastating. "I know no words to express how stunned I felt on receiving the dreadful news," Marcel replies in French by cable. "Dear Walter even if you had accepted the inevitable stop At the very moment one dies the death of a beloved one all my affection Marcel."

1954. Friday, Paris
At six o'clock in the evening, Duchamp and Roché have a meeting with the publisher Erik Losfeld in Arago.

1958. Wednesday, New York City
For the collection of his writings which Michel Sanouillet is editing [25.7.1958] for Erik Losfeld, Duchamp requests Henri Marceau at the Philadelphia Museum of Art for a set of photostats of the *Boîte de 1914* [25.12.1949]. "It is the badly damaged cardboard box (having belonged to the Arensbergs) which you keep in a small library where Mr Zigrosser works, I believe," explains Duchamp. "If there is a handwritten title with the date on the lid of this box," he continues, "please simply transcribe it by hand and send it to me at the same time as the photostats."

1960. Saturday, New York City
"We are *crazy* about the book," writes Duchamp enthusiastically to Richard Hamilton, who has sent him a first copy of *The Bride*

stripped bare by her Bachelors, even, the typographic version of the Green Box [16.10.1934]. "Your labour of love has given birth to a monster of veracity and a crystalline transubstantiation of the French green box. The translation, thanks above all to your design, is enhanced into a plastic form so close to the original that the Bride must be blossoming ever more."
 Two years since the project finally got under way [23.11.1958], the publishing date of the book both in England and in America is 16 December. Planning to collect his own complimentary copies from Wittenborn, Duchamp tells Richard that he will make sure that George Heard Hamilton, who made the translation, receives his.
 To Richard's news that the BBC television programme "Monitor", which is devoted to items on the arts, wants to make a filmed interview, Duchamp replies, "The ideal solution of the British television's good intentions would be to have you and Terry come to Cadaqués (sent by B. T.) during July or August, when we hope to be there. At least this gives you something to work on in a direction we all would like..."

27 November

1909. Saturday, Paris
Although the Press is still enjoying the aftermath of the Steinheil affair [13.11.1909], Lucien Métivet has turned to another news item. In the previous week's issue of *Le Rire*,

he revealed the astonishing results of protecting certain masterpieces with glass. An observant guard at the Louvre thinks he's gone quite barmy: he sees the reflection of his walrus moustache and goatee in the belly of Ingres' *Source*; in the buttocks of Millet's *Gleaners*; set on a salver like John the Baptist, and even mirrored in the famous face of the *Mona Lisa*!

Completing his November series [6.11.1909], Duchamp publishes two more cartoons. For *Le Courrier Français* his drawing is entitled *Vice sans Fin* in which the young girl, who has just received a stylish hat from her balding lover, enquires: "Why ever did you want me to call you papa earlier?"
 In *Le Rire*, Duchamp's contribution, *La Morue...*, represents a bowler-hatted young man seated at a table in a restaurant: ordering from the menu, his question to the waiter is literally, "Has the salt-cod been well soaked?" [In English his query is better savoured by translating it as: "Is the tart really sharp?"]

1915. Saturday, New York City
In an article entitled "The European Art-Invasion", the *Literary Digest* airs the current opinions on "just what effect the war is likely to

have on American art..." It quotes Harry R. Lachman, a young American painter returned from Paris, who recently declared in the *New York Times* that: "the vagaries of the 'wild men' were killed in the war, and peace would never see their revival, at least in Paris," a view which contrasts with MacMonnies' prophetic declaration published in the *New York Tribune* [24.10.1915]. From the same article in the *Tribune*, lengthy passages are lifted from the interviews with the French expatriates Francis Picabia, Albert Gleizes and Duchamp, each photographed in his respective studio. Duchamp is perched cross-legged on the edge of an armchair, with his canvas *Broyeuse de*

27.11.1960

28.11.1960

Chocolat No.2 [8.3.1915] on his knees, feigning to retouch it.

1919. Thursday, Paris
Duchamp accompanies Miss Dreier again to 7 Rue Lemaître [21.11.1919], where Villon and Gaby have invited their new American friend to a dinner in celebration of Thanksgiving Day.

1924. Thursday, Paris
A quirk of fate plays into the hands of Francis Picabia, master Dadaist. From his vantage point at a nearby bar with Marcel and Man Ray, before slipping away for dinner, Picabia relishes every moment of the pantomime caused by the unexpected closure of the Théâtre des Champs-Elysées on the first night of his ballet, *Relâche.*

RELACHE

Shortly before nine o'clock people start arriving. Jacques Doucet, Roland Dorgelès, Suzanne and Jean Crotti, Tristan Tzara, Nancy Cunard, Brancusi and Fernand Léger are among the many disconcerted by the notice "Relâche" [i.e., "Theatre closed"] posted at the entrance. Jean Borlin, principal dancer of the company and choreographer of *Relâche*, is indisposed and the premiere is postponed until 4 December.

1935. Wednesday, Paris
Duchamp attends the Zoubaloff sale at the Hôtel Drouot and purchases *Violon et Pipe* by Georges Braque for Louise and Walter Arensberg in accordance with their instructions [18.10.1935]. Mary Reynolds, Roché, Suzanne and Jean Crotti are also present.

1959. Friday, Paris
The private view is held at the Galerie Loeb, 53 Rue de Rennes, of "Edition MAT" [13.10.1959], a mixed show orchestrated by Daniel Spoerri. With an illustrated catalogue-cum-order form, the exhibition of multiples by Agam, Albers, Bury, Mack, Rot, Soto, Tinguely and Vasarély also includes Duchamp's *Rotorelief (Disques Optiques)* [30.8.1935] displayed on a motorized wall-mounting designed by Jean Tinguely.

1960. Sunday, New York City
On the eve of the opening at the D'Arcy Galleries Duchamp writes to André Breton in Paris, once again his "co-director" of a Surrealist exhibition [15.12.1959], to tell him that all is well.

Duchamp reports that he, Claude Tarnaud and Alain Bonnefoy have been working very hard for ten days transforming the galleries with some inventions, which are not a repetition of any formulas in previous Surrealist exhibitions. The catalogue is printed and Duchamp hopes that Tarnaud will soon give Breton his own description of the exhibition.

In fact, after telephoning Salvador Dali, who has his own exhibition at the Carstairs Gallery, Duchamp has taken it upon himself to hang the Spaniard's vast grey canvas, more than two metres high, entitled *L'Oreille anti-matière,* or *La Madonne sixtine,* representing – in the style of a Pointillist blow-up photo – a Madonna and Child by Raphael buried in the ear of Pope John XXIII. Tarnaud timidly suggests "that few of the exhibitors will be overjoyed to see their works framing this inordinate picture". Angrily Duchamp replies: "The Surrealists can just piss off! If they want an exhibition they can come and do it themselves..."

1963. Wednesday, New York City
"Your idea of a Jacques Villon exhibition for next January is certainly deeply touching, and I endorse your project wholeheartedly," writes Duchamp to M. Menuisement, who wishes to organize a homage to Villon [9.6.1963] at his gallery in Rouen. Regretting that he will be unable to attend the opening, Duchamp explains: "I live in New York and will perhaps not come to France until next summer."

28 November

1919. Friday, Paris
After writing to request an appointment, Roché takes Miss Dreier and Duchamp to 27 Rue de Fleurus at four-thirty. The visit is not a success. The meeting of Gertrude Stein and Miss Dreier, according to Roché, "is the shock of two heavy masses and Gertrude carried the day easily. Miss Dreier seemed frail by comparison."

1948. Sunday, Milford
Dee spends the day with Miss Dreier.

1953. Saturday, New York City
Before posting his letter written two days earlier to Roché, Marcel adds a postscript with the sad news of Louise Arensberg's death: "...cancer," he explains, "end expected but not so rapidly."

1954. Sunday, Paris
Marcel and Teeny see Roché.

1959. Saturday, New York City
"You must be totally exhausted," writes Marcel to Suzanne, after learning the same morning in a letter from Villon that the opening of the show at Galliera [1.11.1959] is early in December. "All our wishes then, and moral support."

Although they have not yet decided the date, Marcel confirms their project to go with Suzanne to Greece. But before June, Marcel explains: "I don't want to bake in the shape of a tourist."

1960. Monday, New York City
The French tobacconist's sign, a *carotte de tabac,* hanging outside the D'Arcy Galleries, 1091 Madison Avenue, and an electric train set installed in the window signal the "Surrealist Intrusion in the Enchanters' Domain". For the exhibition co-directed with André Breton (at a distance), Duchamp has furnished the four rooms of the gallery with a clock, each one telling a different time; every picture holds a small flag to denote the artist's nationality; a long garden hose meanders carelessly across the floors of the gallery; the tarot, Arcane 17 [19.4.1945], is projected on one of the ceilings and, elsewhere, a ray of light evokes the setting sun.

As part of the installation of the exhibition, there is also a very old-fashioned typewriter, a pair of firedogs holding some partially burned logs without a fireplace, and a punching machine of the sort used in factories to clock workers in and out.

Identified by a notice made with nickel coins, *Coin Sale,* (meaning, if pronounced in French, Dirty Corner), Duchamp has transformed a cupboard in which he has installed (for the duration of the exhibition) three white hens under a dramatic green light.

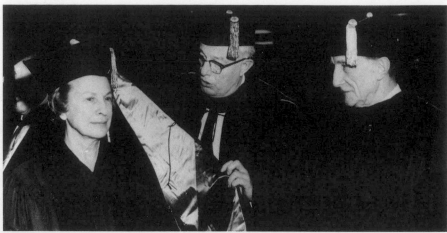

29.11.1961

The discord of the opening, due not only to the decision to hang a Dali of gigantic proportions [27.11.1960] but also to the excruciating sound of a child practising exercises on the piano, is tempered by the professional fortune-teller, who is fully occupied all evening reading cards for the visitors.

The catalogue cover designed by Duchamp is adorned, like the gallery, with the *carotte de tabac*; the imprints of his hand [5.12.1934] and Breton's, mark the first pages. After the historical section devoted to the "enchanters", and texts by the "managers", Edouard Jaguer and José Pierre, follows the catalogue itself in which a few members of the old guard, Ernst, Magritte, Man Ray, Miró, Tanguy etc., are joined by a whole new generation. Duchamp is mentioned as lending the drawing *Discussion dans le Soleil*, given to him recently by Pierre Demarne [25.10.1960], one of the younger artists. For Hans Arp, Duchamp has written "For Arp, art is Arp", his only other contribution, apparently, to the publication.

According to Marie-Louise Aulard reporting for the Collège de 'Pataphysique, late in the evening Dali makes a triumphal entrance and is received royally by Duchamp himself, inimitably throwing the proceedings into further disarray and assuring a certain publicity for the manifestation.

1961. Tuesday, New York City
At the invitation of Mrs Jeanne Levin, a trustee of the Detroit Institute of Arts and chairman of the Modern Art Committee, Duchamp flies with Teeny on American Airlines to Detroit, where he is to receive an honorary degree the following day. At the press conference held at the Institute, Duchamp urges everyone to attend the lecture by Lawrence D. Steefel [21.1.1960] later in the evening.

Due to some technical jinx, which is overcome "after much delightful repartee", the young professor's words are lost to part of the audience at the beginning of his talk.

Steefel discusses just a few works, illustrated with slides to demonstrate how "Duchamp tried to move away from the world of habit, convention, and subservience to material interests into a world of pure poetic consciousness, where events and objects could be dissolved by an aesthetic alchemy into an experience of luminous delight in which far and near, the self and the world would be fused in an ecstatic moment of consummation…" He believes that "to glimpse the true and living presence of the artist, one must dissolve the images he gives us, as one dissolves the printed words in the poem in order to release the magic fluency of the imprisoned thought, which is a mental rather than a physical object, a spiritual rather than a material good…"

As it turned out, with the way the evening was organized, Marcel's talk afterwards, "which would have been too short" for the occasion, "was perfect."

1966. Monday, New York City
As he has been unable to reach Mrs Sisler by telephone, Duchamp mails to her New York address both M. Bernard Dorival's letter and one from Mlle Olga Popovitch concerning loans for the forthcoming exhibitions in Paris and Rouen [8.11.1966].

The French curators are hoping that Mrs Sisler will agree to lend her collection, which includes many of Duchamp's early paintings [13.1.1965].

29 November

1919. Saturday, Paris
At four in the afternoon Duchamp and Roché take Miss Dreier and Yvonne Duchamp to a *thé-dansant* at the Olympia, 6 Rue Caumartin. Yvonne, who is studying for a degree in English

[8.8.1913], is pretty and resembles her brother Marcel. However Roché is puzzled by the young girl and would like to meet her again.

In the evening, Brancusi gives a memorable dinner in his studio. The Romanian sculptor has cooked a dish of goose and cabbage for his guests: Duchamp, Miss Dreier and Roché, who brings Erik Satie [12.11.1919]. According to Roché, the conversations are Homeric. At first Satie doesn't listen much to Brancusi but, as the evening progresses and the wine flows, they recount their stories and take to each other.

1922. Wednesday, New York City
At the Marshall Chess Club, Duchamp plays a simultaneous game against the Cuban chess master, Capablanca and, like 20 out of 24 of his fellow members, is defeated.

1941. Saturday, Sanary-sur-Mer
After meeting a friend of Robert Parker's on vacation from Paris, Duchamp writes to Parker in New York saying: "We became great friends when we discovered your mutual existence in ours."

1942. Sunday, New York City
Spends the afternoon from two until five with the Kieslers at 56 Seventh Avenue.

30.11.1952

1946. Friday, Paris
Believing now that he will obtain his visa to return to America in December [26.9.1946], Marcel accompanies Mary Reynolds to Chartres "on the hunt again [22.11.1946] for that little piece of terra firma" which she still desires.

1949. Tuesday, New York City
Replying to a letter received that morning from the Crottis, Marcel requests the dates of their exhibitions for the catalogue of the Société Anonyme. He also asks Suzanne: "Do you remember in which year I made a large portrait of you in profile, very laboured, at Blainville, I think?"

1960. Tuesday, New York City
In the evening at seven-thirty Duchamp has an appointment with Louis Carré.

1961. Wednesday, Detroit
At the special convocation ceremony commencing at four in the Community Arts Auditorium, both Lydia K. Winston (a collector and trustee of Bennington College and the Art Founders Society of the Detroit Institute of Art), and Duchamp are to receive an honorary doctor of humanities degree.

"Very much moved by the thought of the coming ceremony," Marcel seems nervous on arrival for lunch at the home of Harry and Lydia Winston in Birmingham, but this soon passes. Lydia Winston, who will also make a speech, tells Marcel that she too is nervous!

On their arrival by car at Wayne State University in Detroit, Lydia Winston and Duchamp are escorted by faculty to the robing room, where the Institute's president, Clarence Hillberry, helps them with their caps and gowns.

In the afternoon's programme *Six Chansons* by Paul Hindemith is sung by the Madrigal Singers just before the conferring of the honorary degrees. "Beautifully spoken" by Hamilton Stillwell, Duchamp's citation reads:

"Marcel Duchamp, a native of France, resident of the United States since 1915, internationally renowned as an artist, to the dramatic conceptual change in the arts of our time has made contributions which are beyond measure.

"Severely critical of the sterile traditions of the academies, he has remained revolutionary in spirit, his perceptive wit and insight often serving as catalysts for renewed evaluations of aesthetic philosophies. His experiments with various devices and materials have increased significantly the range of our expressive vocabulary while his intimate knowledge of the psychology of perception has, through the years, provided the matrix in which are set the many facets of his creative energies.

"His pioneering efforts on behalf of the now recognized freedom of artistic expression have placed the worldwide community of present-day artists deeply in his debt.

"In recognition of the significant role of Marcel Duchamp in shaping our heritage in the arts, Wayne State University is proud to add its accolade to his many honours."

After the ceremony Duchamp says: "I am moved and happy to see learning and art being brought together once more," and adds, "I'll be a doctor for the rest of my life now."

1963. Friday, New York City
In the evening Duchamp dines with Louis Carré, who finally plans to settle with him the matter of the royalties from the Duchamp-Villon works [24.11.1963].

1966. Tuesday, New York City
After a luncheon appointment with Louis Carré at Quo Vadis, Duchamp is due to meet the dealer again at four-thirty or five.

30 November

1924. Sunday, Elbeuf
One of the rival chess clubs in the Seine-Inférieure, the Echiquier Elbeuvien, has invited a delegation of ten players from the Cercle Rouennais des Echecs led by Duchamp to play a one-day match. The team members each play two games, except Duchamp and Casier (a participant in the recent championship of Haute-Normandie [21.9.1924]), who is playing for Elbeuf. With Duchamp winning his game on the top board, the result is a victory for Rouen.

1937. Tuesday, New York City
On instructions from Miss Dreier, a banker's draft amounting to 500 francs has been sent by the Bank of New York and Trust Company via the *Queen Mary* to Duchamp in Paris.

1942. Monday, New York City
At Art of this Century [20.10.1942], the *Boîte-en-Valise* [7.1.1941] is featured in the opening exhibition of Peggy Guggenheim's new gallery. The show also includes *Objects* by Joseph Cornell [31.7.1942] and *Bottles* by Laurence Vail.

1952. Sunday, New York City
"Thank you for your letter and your diligence," writes Marcel to Jean Cocteau [13.11.1952], whose participation he invited for Hans Richter's film *8 x 8*. "I have seen your sequence, it strikes just the right note," Marcel continues. "As you request, I will attend to the soundtrack, which could be a series of spoonerisms *recited backwards* on the tape of the recording machine, and then recorded on the film the *right way round*; I don't know but I believe that my 'accent' or at least the cadence of syllables said backwards would make strange music when reproduced the right way round and in consequence very comprehensible, as far as the sense goes." In his postscript, Marcel adds, "An important idea if you find it important: ask Charlie Chaplin to make us a short length (3 minutes) for our film (subject 'chess', if he wishes). I don't know him and he is in Paris."

1953. Monday, New York City
"I will exhibit my copy as you suggest," Marcel tells Man Ray, referring to *Feuille de Vigne femelle* [12.3.1951], "but all the same send 2 others... in case there is a sale." Surprised at Man Ray's calculation of 7,000 francs [700 francs at present values] for the patina, Marcel enquires: "Is that to galvanize them? or for another kind of patina? Here, copper plating costs about $25 but I don't want to do that: I prefer to sell them as *painted casts*."

Regarding the proposed edition with Fleur Cowles [23.5.1953], who has purchased the maquette of the project with Breton, it is not too hopeful, "because it costs the earth even in France." However if Man Ray gives him a list of the documents he wants to retrieve, Marcel promises to speak to Fleur Cowles.

*

After a long illness, Francis Picabia dies at ten minutes past eight in the evening in the house

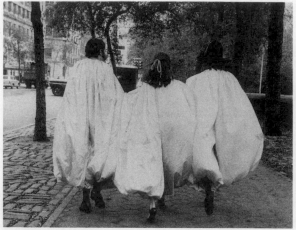

30.11.1967

in which he was born: the top-floor studio that he had once lent to Marcel [7.6.1926] at 26 Rue Danielle Casanova, a part of the Rue des Petits-Champs renamed after the war.

1955. Wednesday, New York City
Thanks Robert Lebel for his letter, "rouser of souvenirs – I have tried to recapture as many as possible, and whatever is missing is of no importance I think." Expecting Lebel in New York at the end of December, Duchamp wishes him "good luck for the book" [7.4.1953].

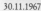

In the evening Duchamp goes to a concert at the Town Hall, which includes a performance of *Déserts* by Edgar Varèse, the premiere of which he attended in Paris [2.12.1954].

1965. Tuesday, New York City
Monique Fong sends the following message to 28 West 10th Street: "To Marteeny. Stop âge étalon. Salons et potages. Stoppons l'étalage. Selon le pelotage."

1967. Thursday, Chicago
At a special meeting the Board of Directors of the Cassandra Foundation resolve to present awards of $2,000 each to eleven individuals in recognition of their past achievements in the field of art. Among the recipients are the composer La Monte Young and the magician-philosopher James Lee Byars, the author of *3 in Pants*. The minutes of the meeting prepared by Barnet Hodes are signed by the four directors: Bill and Noma Copley, Duchamp and Eleanor Hodes.

1 December

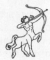

1922. Friday, Paris
In his article entitled "Les Mots sans Rides", appearing in *Littérature* today, André Breton writes:

"I was quite sure that the six examples of wordplay signed Rrose Sélavy in the last but one number of *Littérature* [1.10.1922] deserved the greatest attention quite apart from the personality of their author, Marcel Duchamp. This was because of these two very distinct characteristics: on the one hand their mathematical rigour (the displacement of a letter within a word, the exchange of a syllable between two words, etc.), and on the other hand the absence of the comic element, which used to be thought inherent in the genre but which was enough to depreciate it. To my mind, nothing more remarkable has happened in poetry for many years. At the time, however, neither Robert Desnos nor I foresaw that it was going to give rise to a new and extremely topical problem: Who is it who dictates to the sleeping Desnos the following phrases, of which Rrose Sélavy is also the heroine? Furthermore: is Desnos' brain, as he claims, so closely linked to that of Duchamp that Rrose Sélavy only talks to him when Duchamp has his eyes open [25.11.1922]? As things now stand, this is a question that it is not for me to elucidate. It should be pointed out that in the waking state Desnos, like all the rest of us, is patently incapable of continuing the series of his plays on words even after trying for a long time. But in any case, for nearly a month now our friend has accustomed us to every sort of surprise, and although in his normal state he cannot draw, I have seen a series of his drawings, among them *La Ville aux Rues sans nom du Cirque cérébral* [The town of the Circus of the brain with the streets that have no name] about which I shall say no more today than that they move me more than anything else.

I would like to ask the reader to be content for the time being with these first manifestations of a hitherto unexpected activity. Several of us attach extreme importance to them. And it must be understood that when we talk about wordplay we are playing with our most infallible *raisons d'être*. But words have stopped playing.

Words are making love."

The next eight pages in *Littérature* are devoted to *Rrose Sélavy* by Robert Desnos, poetry transmitted telepathically and transatlantically to him by Duchamp in New York, including the following lines:

La solution d'un sage est-elle la pollution d'un page?
[Is the solution of a sage the pollution of a page?]

Rrose Sélavy propose que la pourriture des passions devienne la nourriture des nations.
[Rrose Sélavy proposes that the putrescence of the passions should become the nourishment of the nations.]

Rrose Sélavy demande si les Fleurs du Mal ont modifié les mœurs du phalle: qu'en pense Omphale?

O mon crâne étoile de nacre qui s'étiole.

Rrose Sélavy connait bien le marchand du sel.

Si le silence est d'or, Rrose Sélavy abaisse ses cils et s'endort.

Au paradis des diamants les carats sont des amants et la spirale est en cristal.

Apprenez que la geste célèbre de Rrose Sélavy est inscrite dans l'algèbre céleste.

Rrose Sélavy met du fard au destin puis de son dard assure ses festins.

La jolie sœur disait: "Mon droit d'aînesse pour ton doigt, Ernest."

L'argot de Rrose Sélavy, n'est-ce pas l'art de transformer en cigognes les cygnes?

Les lois de nos désirs sont des dés sans loisir.

1932. Thursday, Paris
For the preface to the catalogue of Francis Picabia's exhibition of drawings, which opens today at Léonce Rosenberg's gallery, Duchamp has translated the poem by Gertrude Stein, written while Picabia and Olga were visiting Bilignin during the summer.

*

The letter of 25 October from Halberstadt and Duchamp is published in *L'Italia Scacchistica* together with a reply to it from Rinaldo Bianchetti, addressed to the editor, Stefano Rosselli Del Turco, who at the same time declares that the debate is closed.

In a more moderate tone than the one employed by the editor of the magazine and without using the word "plagiarism", Bianchetti says that it is correct that his own theories on endgames hardly differ from those expressed in *L'Opposition et les cases conjugées sont réconciliées* [15.9.1932], but he reproaches the two

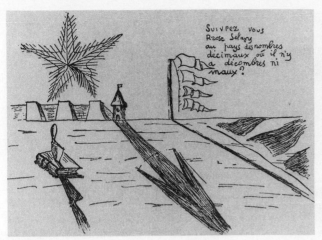

1.12.1922

1.12.1961

authors, all the same, for having developed the methods dating from the beginning of the century with the "careless enthusiasm of youth". Giving numerous illustrations, Bianchetti challenges the general character of "the new heterodox opposition".

*

It is curious to note that after only three months of playing chess (which he started doing in 1932), Raymond Roussel [10.6.1912] has found the endgame formula to bring about checkmate with the Bishop and the Knight, and Tartakover has just published it in the November issue of *L'Echiquier*.

1933. Friday, New York City
Enclosing a "very good" review of the exhibition [17.11.1933], which is open until 13 January, Marcel sends a short message to Brancusi: "Possibility of selling *Mlle Pogany* will know tomorrow morning – A certain number of serious thoughts of purchase. Mme Meyer has not yet come, nor Mme Rumsey. Great great success. Gallery full every day."

1936. Tuesday, Paris
La Nouvelle Revue Française publishes Michel Leiris' comment on *La Mariée mise a nu par ses Célibataires, même* [16.10.1934], the Green Box, which was published by Rrose Sélavy two years earlier. Describing it as a "puzzle", "a marvellous plaything" and a "veritable Pandora's box which cannot be handled without a certain imprudence", Leiris considers that "the only mental technique" with which it can be linked is the 'Pataphysics of Alfred Jarry.

Whether it is a question of Duchamp's "very special attitude regarding sexuality" (Leiris cites Breton [22.12.1934]), regarding "machinism" (Leiris compares Duchamp's use of the machine to that "other extraordinary engineer", Roussel [10.6.1912]), or whether it is a question of "the detached way – comparable, with more lucidity, to that of a child who reconstructs the world with his building blocks – in which he treats the laws of physics", Leiris "finds everywhere the stamp of this stinging negation".

1947. Monday, New York City
In the evening at seven o'clock a meeting is held of the Société Anonyme at the Colony Club, which is chaired by Miss Dreier, with Duchamp as secretary, and attended by the directors, Alfred Barr, Naum Gabo, Eleanor

Williams and Rose Fried. After discussion over dinner, it is resolved unanimously that "an adequate catalogue of the Société Anonyme Collection is urgently needed". The authorities at Yale will be requested "to furnish any necessary data as soon as possible so that the president and secretary may then carry their part of the catalogue to completion."

Originally mentioned in the bequest [14.10.1941], the catalogue was already the subject of discussion when Duchamp returned to New York during the war [24.9.1942].

1948. Wednesday, New York City
Dines with the Kieslers before attending the French Festival.

1952. Monday, New York City
In the morning Duchamp receives a letter from Bernard Dorival, the curator of the Musée National d'Art Moderne, requesting the loan of *Le Roi et la Reine entourés de Nus vites* [9.10.1912] for his forthcoming exhibition: "Le Cubisme." Because of difficulties with the Sweeney show [4.5.1952], Marcel tells Lou and Walter Arensberg that he would prefer them to discuss the matter directly with the Philadelphia Museum of Art.

"I am not doing much to the back of the 'King and Queen'," explains Marcel to Lou and Walter, referring to the same picture which he still has in his studio [20.10.1952]. "I don't think it advisable to wet the canvas for fear the King and Queen might suffer." His plan is to retouch the missing spots on the back, which occurred when the black paint was removed, "to give more unity" to Adam and Eve, "without changing the general effect."

*

In haste, Duchamp writes to Michel Carrouges; he is very pleased with the line reproduction [20.9.1952] of the Large Glass for the cover of *Les Machines Célibataires*; he only has two remarks. "1) one on the drawing: remove 2 small areas on the drawing that do not exist in the present glass. 2) one in the text on the back: add a comma between 'célibataires' and 'même'."

1957. Sunday, New York City
On their way home in the afternoon, after a weekend in Boston with Paul Matisse, Teeny and Marcel call to see the Hamiltons at New Haven. George has only had time to read the

translation of Lebel's manuscript superficially, but "is very unfavourable as far as the quality of the language is concerned" [4.11.1957]. He agrees to consult the French Department at Yale and, within a few days, to write to Marcel proposing different solutions, with an estimate for a completely new translation.

In the evening the Duchamps attend a programme of four ballets by George Balanchine presented by the New York City Ballet at the City Center. The famous *Firebird*, a revival of *Apollo* (which was created for Diaghilev in 1923) and *Orpheus* are performed together with *Agon* which the company recently commissioned to celebrate Igor Stravinsky's 75th birthday.

1959. Tuesday, New York City
Before the exhibition had even opened [27.11.1959], Daniel Spoerri, who is proud of Duchamp's participation, had already sold five sets of *Rotorelief (Disques Optiques)* [30.8.1935] in their new form of presentation. Thanking Spoerri for "the good news", Duchamp agrees to supply his signature. "Enclosed you will find about forty 'original' signatures," he explains, "which you can stick on, either with glue or using quite a hot iron for ten seconds."

1960. Thursday, New York City
Reporting that the exhibition at the D'Arcy Galleries which opened on Monday had a favourable reception, Marcel gives André Breton a written account of the installation.

1961. Friday, New York City
After being "entertained right and left", visiting the Ford Museum, seeing General Motors with its building designed by the Finnish architect Eero Saarinen, writing a special dedication for Lydia [29.11.1961] and Harry Winston in their copy of *Marcel Duchamp* by Robert Lebel and signing his American Airlines baggage tag for insertion as a special item in the Green Box belonging to Jeanne and Isadore Levin, Marcel and Teeny return to Manhattan.

1963. Sunday, New York City
Marcel finds Richard Hamilton's article for *Art International* on the Pasadena retrospective [7.10.1963] "very good and deep" and he asks Richard to let him know when it is published.

1.12.1967

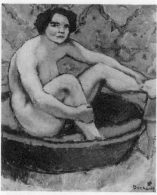

2.12.1949

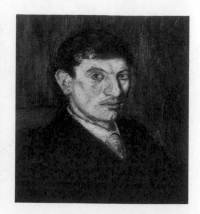

"I had quite a French TV ordeal, both in Pasadena [2.11.1963]... and in N.Y.," he writes, "when they invaded our apartment for a week!! All over now – waiting for Godot..."

It is the second time that Jean-Marie Drot and his crew have filmed at 28 West 10th Street [6.12.1961].

1967. Friday, New York City
"At last we have the enlargements of the photos which Marcel took before the close of the exhibition [14.11.1967]," is the message to Yo in Paris. Both reserved canvases have been sold and David Mann is to deliver *Conversation*, "our picture," say Marcel and Teeny, "that we would be pleased to have at the apartment." Before the exhibition, *Conversation* was hanging in 5 Rue Parmentier.

2 December

1917. Sunday, New York City
With Roché and de Journo, Duchamp is invited to dinner by Alissa Franc at her apartment in Greenwich Village.

1925. Wednesday, Paris
From the Hôtel Istria Duchamp sends Jacques Doucet 50 francs [175 francs at present values], which is the six months' interest due on his Monte Carlo Bond [16.1.1925].

1933. Saturday, New York City
"[Mlle] Pogany sold for $1,500 to H. P. McIlhenny," writes Marcel hastily to Brancusi on a page torn from an engagement book. "All New York is talking of the exhibition [17.11.1933]... I am going to see [Albert C.] Barnes tomorrow in Philadelphia," continues Marcel. "If he buys that will be serious!"

1949. Friday, New York City
"Sold!" is Marcel's reply to Roché's choice of his early pictures. In addition to the proposed *Clémence* and *Deux Nus* [20.11.1949], Roché has chosen *Femme nue assise dans un tub*, dated 1910; *Portrait de Marcel Lefrançois*, and *Portrait de Chauvel*, a very colourful painting of the sculptor [20.12.1909] from Elbeuf, near Rouen, which is painted on cardboard and

needs to be cut to size. (Possibly the canvas entitled *Masque* [18.3.1910]?)

If Mary Reynolds has not chosen one of them, Roché can also have the drawings *Femme-Cocher* [25.5.1907] and *Dimanches*, which represents the dismal scene of a drab couple taking a walk: the man pushes an ornate perambulator with the woman, who is heavily pregnant, at his side.

Mary has accepted *Trois Nus et une Chèvre* [20.11.1949] and *Jardin et Eglise à Blainville*, an Impressionist view of his parents' house which Marcel painted when he was fifteen.

Promising to ask Villon to certify the unsigned pictures, Marcel tells Roché: "As you propose, I would like you to take all that's left on deposit, and to sell eventually, this would remove a burden from Villon." He reminds Roché of the general price scale and states the increased rate for a client: canvases, $500; cardboard $450; drawings $100; (60% for himself, 40% for Roché).

1950. Saturday, New York City
On the arrival of the *Mauritania*, Marcel's postcard is posted to Roché recounting his uncomfortable night before boarding the ship [25.11.1950], and thanking Marie-Thérèse Pinto for her cable, if it was she who sent it.

In the mail waiting for him at 210 West 14th Street Marcel finds a cable from Fiske Kimball dated 3 November, and an invitation to lunch for the coming Tuesday or Wednesday, from Alfred Barr.

1954. Thursday, Paris
Pheasant accompanied by Blanc de Blanc is the luncheon prepared for the Duchamps at Sèvres when they visit Denise and Henri Pierre Roché at half-past twelve. They talk about the paintings of Mimi Fogt, Roché's young friend who is exhibiting for the first time at the Galerie Elsa Clausen. Planning to visit the gallery the following day to see the haunting portraits of Mimi's friends, including the composer Pierre Schaeffer and the writer Jacques Lanzmann, Roché is possessed with the idea of Mimi painting Totor.

At the Théâtre des Champs-Elysées, the premiere of *Déserts* by Edgar Varèse is performed in an evening concert by the Orchestre National conducted by Hermann Scherchen. An electrosymphonic work lasting about twen-

ty-five minutes, *Déserts* is in five parts: two recorded on tape and three composed for an orchestra of woodwinds, ten brasses, piano, a battery of standard percussion instruments, an assortment of rattles and gourds, and even a pair of green cushions to be slapped by a special set of wooden paddles. The recorded industrial noises, which Varèse collected in America and then edited in the studios of "musique concrète" with a team led by Pierre Schaeffer and Pierre Henry, provoke an immediate response. Soon the deafening factory grindings, hammerings and terrifying wails of metal saws are accompanied by a cacophony of shouts, barks, crows and whistles from the audience. "It's certainly the music of the H-bomb," decides one critic. Unperturbed, the conductor and his musicians carry on regardless of the uproar.

Duchamp, who witnessed an earlier tumultuous occasion in the same theatre [29.5.1913], is in the audience.

1957. Monday, New York City
Informing Robert Lebel of George Heard Hamilton's poor opinion of the quality of the English translation [1.12.1957], Duchamp advises that he is writing to Bill Copley, "proposing that he liberates Fawcus completely from a contribution to these new expenses," which include not only the cost of a new translation but also new typesetting, and proofs "sent from Paris, several times, to Hamilton for correction". Duchamp continues: "I deplore this delay but my reaction, and above all Hamilton's, is that a book (on art) so profoundly worked as yours requires an impeccable translation for the English reader."

Promising to send Lebel the details in a few days so that he and Copley can decide, Duchamp concludes: "Your visit in January will be more than 'Welcome' – will help us greatly."

*

Duchamp expects a telephone call from Frank Anderson Trapp of Amherst College, who wishes to arrange a meeting during the week to discuss certain arrangements for his exhibition, "The 1913 Armory Show in Retrospect" [27.9.1957].

1961. Saturday, New York City
Teeny is seated next to Joan Miró and Marcel next to Miró's wife, Pilar, at a luncheon held in the Catalan artist's honour at the National

Institute of Arts and Letters. Among the other guests is Aline B. Saarinen, author of *The Proud Possessors*, who is "so happy" to learn that during the week, when they were in Michigan, Marcel and Teeny visited the building designed by her husband for General Motors at Warren.

1965. Thursday, New York City
Teeny is disappointed that Niki de Saint Phalle and Jean Tinguely (who has been in New York for the occasion of his joint exhibition with Nicolas Schöffer at the Jewish Museum) don't manage to get back for the party at 28 West 10th Street, but Celeste cooks "a wonderful dinner" and they have "a nice time anyway".

1967. Saturday, New York City
The Duchamps attend a performance of the Merce Cunningham Dance Company at the Brooklyn Academy of Music. Opening with the new ballet *Scramble* with sets by Frank Stella, followed by *Place*, the company then performs *How to Pass, Kick, Fall and Run* which is accompanied by John Cage sipping champagne and reading sentences from his life and works.

3 December

1919. Wednesday, Paris
In payment for dental treatment Duchamp "draws" for Daniel Tzanck, his dentist and an

enthusiastic collector of modern art, whose home and surgery is at 177 Boulevard Saint-Germain, a handmade cheque of The Teeth's Loan & Trust Company, Consolidated, 2 Wall Street, New York, for the sum of $115. This

slightly larger-than-life *Chèque Tzanck*, which has the name of the bank repetitively rubber-stamped in red as part of the background and

a serrated edge on the left as if it had been torn from a cheque-book, is "crossed" with the mention ORIGINAL in red.

*

At nine in the evening, Duchamp joins Yvonne Chastel, Miss Dreier, Francis and Gaby Picabia, Roché and others at the home of Georges de Zayas [12.11.1919], 3 Rue Edouard Fournier, to listen to the piano-accompanied version of *Socrate*, a symphonic drama for four sopranos by Erik Satie, which has not yet been performed in public.

De Zayas shows his friends the folder of caricatures to be published later in the month.

1922. Sunday, New York City
"It's a wonderful book," writes Alfred Stieglitz enthusiastically to Henry McBride, who has been consulted by Duchamp at each stage of the production [30.6.1922]. "I can't tell you what pleasure it gives me," he continues, "I pounced upon five copies. The fellows all feel as I do about it – full of glee and admiration." In a loose-leaf format (with index-cum-title) copyrighted by Rrose Sélavy, the Société Anonyme Inc. has published a selection of Henry McBride's articles from those appearing in the *New York Sun* and the *New York Herald* since 1915.

Like a steady crescendo, commencing with Cézanne, the typeface becomes progressively bigger for each article until, from 104 lines to a page, the penultimate page consists of only ten and at the last returns to the small type used at the beginning. *Some French Moderns Says McBride* is illustrated with Charles Sheeler's photographs of works by Brancusi, Matisse, Picasso, Picabia, Derain and Rousseau.

1933. Sunday, New York City
Invited by Albert Barnes to visit his Foundation, which opened as a school at Merion Sta-

tion in 1925, Duchamp travels to Philadelphia for the day. Barnes speaks with enthusiasm of the Brancusi exhibition [17.11.1933] and "is very kind", but Duchamp, who is hoping that Barnes might buy a Brancusi, "is not sure just how far his kindness will go."

In the formidable collection of old masters, antique furniture, objects, and "modern" paintings, including fine examples of Cézanne, Monet, Renoir, Seurat and Henri Rousseau, Barnes has *Femme aux bas blancs* by Gustave Courbet: a provocatively posed, unclothed young woman, semi-reclining against the foot of a tree, who impudently eyes the painter (or onlooker) while she pulls on a pair of white stockings.

1935. Tuesday, Paris
Duchamp meets Michel Leiris at La Nouvelle Revue Française.

1953. Thursday, New York City
Since his telegram to Walter [26.11.1953], Marcel has heard "step by step" from Beatrice Wood "of Lou's fatal journey" and how deeply affected Walter is by his wife's death. "I could not write you any sooner," Marcel explains to Walter. "I felt that you don't want to see anyone or hear any of the polite expressions of sorrow which irritate more than help.

"But you Walter have to face a new reality and do you want to face it? Do you feel the uselessness of accepting the new living conditions in which her absence will beat like a deafening drum? All these questions remain unanswered when they are formulated in words like these," Marcel admits. "The answer must come of itself, unformulated, by breath-

LA PURÉE

4.12.1909

4.12.1917

ing again for her and give the final form to the work that she and you started together.

"When I wrote you about a month agó [29.10.1953], I really hoped that there might be enough time to open the rooms in Philadelphia and let her know that one of her dreams had become a reality. I understand now how useless it was to even hope for that."

Telling Walter that he is not expecting him to reply for some time, Marcel concludes: "Words are too much of a passe-partout approximation and never carry the subtleties of our thoughts – All I want you to know is that I think of Lou and you."

1954. Friday, Paris
At five o'clock after having visited Mimi's exhibition of portraits at the Galerie Elsa Clausen [2.12.1954], Roché calls to see Totor in Arago.

1960. Saturday, New York City
To Serge Stauffer's enquiry regarding a *Boîte-en-Valise* [7.1.1941] for Hans Fischli, the director of the Kunstgewerbeschule and Kunstgewerbemuseum in Zurich, Duchamp replies: "I am having thirty valises made in Paris [3.5.1960]; they will not be ready for several months unfortunately."

Although Duchamp has discovered that he has only one remaining copy of the catalogue "First Papers of Surrealism" [14.10.1942], he sends it to Stauffer "on the express condition" that he returns it as soon as he has studied it.

1965. Friday, New York City
For the series on the French radio entitled "Lewis Carroll, maître d'école buissonnière", directed by J. B. Brunius, Duchamp records his thoughts on the relationship between the game of chess and the theme of the mirror in *Through the Looking Glass*, one of the books he was fond of using for his French lessons fifty years ago [4.12.1916].

*

At eight-thirty in the evening, the Duchamps attend three Happenings at the Filmmakers' Cinematheque: *Moviehouse* by Claes Oldenburg, a sculpture in light, time and space; *Map Room II* by Robert Rauschenberg; and *Prune Flat* by Robert Whitman. According to Teeny it was the "Same old waiting around for hours, not as frightening but nevertheless strange and haunting. Fortunately they let us sit!"

1966. Saturday, New York City
At seven-thirty in the evening Duchamp has an appointment with Louis Carré.

1967. Sunday, New York City
"I am sending you today by air the large book (*The Large Glass and Related Works* [7.11.1967]?) you saw at our apartment when you came 3 weeks ago [5.11.1967] and I hope you will enjoy it," writes Marcel to Brookes Hubachek.

Concerned about the Villon landscape [16.11.1967] Marcel asks Hubachek to tell him if he has not received it and adds: "Hoping it was not lost or forgotten in the warehouse of an Air Line!"

4 December

1909. Saturday, Paris
As the previous Saturday, another of Duchamp's cartoons is published in *Le Courrier Français*. Entitled *La Purée*, the woman asks, "Do you want half of what my Viennese gives me?" Alluding to Viennese bread, the man retorts sarcastically: "I'd rather starve."

1913. Thursday, Paris
Duchamp is invited to the wedding of Dr Fernand Théroude and Germaine Gautier, which takes place at the church of Notre-Dame-de-Grâce-de-Passy at noon.

1916. Monday, New York City
Duchamp accompanies Florine [10.11.1916] and Ettie Stettheimer to dine at the Brevoort. As Duchamp has promised they meet Edgar Varèse, the "composer of futuristic music", Jo Davidson [5.11.1916] and "lots of acquaintances". Varèse introduces them to a Frenchman who arrived from Paris via Liverpool and Philadelphia at the end of October: his name is Henri Pierre Roché, a journalist for *Le Temps*, who knows Leo Stein and Marius de Zayas. Ettie clearly enjoys herself, finding it "very Bohemian and amusing and French".

Without any regular income [26.1.1916], Duchamp finds that he can live by giving French conversation lessons at two dollars an hour: "The French professor! – like Laforgue!

[18.3.1912]" The people he teaches are "charming", taking him "to the theatre, sometimes to dinner". His recent recruits are the stylish Stettheimer sisters, Carrie, Florine and Ettie.

1917. Tuesday, New York City
In the evening Marcel takes Madeleine Turban to meet the Arensbergs. Louise has been singing at the piano for Roché, but his attention is drawn to this pretty girl from Normandy, who arrived in New York on Thanksgiving Day. Estranged from her husband Maurice Turban, a *notaire* in Rouen, Mad has crossed the Atlantic to organize a sale for the Red Cross and she was given Marcel's address by mutual friends, the Hue family, also from Rouen.

Later Marcel and Roché take Mad to see the movie *Tom Sawyer*, starring Jack Pickford.

1919. Thursday, Paris
At the restaurant Vian at 22 Rue Daunou (near the Opéra), Duchamp and Roché have a farewell lunch with Miss Dreier, who sails for New York on Saturday.

1924. Thursday, Paris
Finally a week after the announced date [27.11.1924], Picabia's ballet *Relâche* [28.5.1924] is given its first performance by Les Ballets Suédois at the Théâtre des Champs-Elysées. The choreography is by Jean Borlin and the music by Erik Satie. The film directed by René Clair, *Entr'acte* [28.5.1924] (for which Satie also scored the music), is screened in the interval. The public is advised to bring black spectacles and earplugs.

First-night tickets are hard to come by. Jeanne Léger is without one and Marcel, who plans to attend, has great difficulty at the Hôtel Istria in disengaging himself from Fernand's wife. While Jeanne is engaged with Marcel, two other occupants of the hotel, Kiki and her friend Thérèse Treize, who both have tickets, help themselves to precious items in Jeanne's wardrobe. Thérèse selects a black velvet cape lined with blue and Kiki borrows a fur coat.

After the performance, Picabia, Marcel, Man Ray, Kiki and Thérèse Treize leave the theatre together but Jeanne, already tipsy, is waiting for the two scroungers on the pavement.

"There they are!" Jeanne shouts with a string of obscenities. She grabs Thérèse by the fist, refusing to let go of her while the three men watch with amusement.

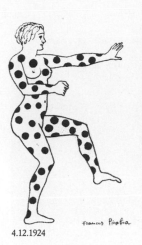

4.12.1924

"There's going to be trouble, don't follow us," Thérèse warns the men. While Man Ray hails a taxi, in the shadows on the other side of the avenue, Jeanne persists in trying to get Kiki and Thérèse to return to the Hôtel Istria with her. Suddenly Thérèse lashes out with her fists and poor Jeanne Léger collapses into the gutter.

1925. Friday, Paris
The Championnat de Paris is over. Out of nine games Duchamp has won three and drawn three.

Before departing for Monaco where he plans to return to the Hôtel de Marseille [12.7.1925], Duchamp has lunch with Roché and Brancusi at Impasse Ronsin. The sculptor is upset by an article by Florent Fels and Roché observes that Marcel is "more jealous or distant, or careful with his appearance in front of Brancusi or Man Ray than with all his 'birds' [24.11.1925]."

1932. Sunday, Paris
In the evening Duchamp writes an express letter to Mme Galka Scheyer at her hotel. "Do you feel up to seeing another part of the family [23.11.1932]," he enquires, proposing to take her to see the Crottis on Tuesday afternoon.

1934. Tuesday, Paris
Regretting his delay in replying, Duchamp acknowledges the cheque of 100 francs [300 francs at present values] received from the Bibliothèque Jacques Doucet for a copy of the Green Box [16.10.1934] and thanks the librarian for the terms in which she gave her impressions. "Jacques Doucet was the friend of a group of ideas to which I remain attached," writes Duchamp, "and I owe a great deal to the confidence he showed in me."

1935. Wednesday, Paris
Replying to Miss Dreier's concern to market his *Rotoreliefs* [30.8.1935] in the United States, and whether he holds the copyright, he sends her a cable with the message: "Copyrighted = Dee."

1942. Friday, New York City
"Thank you for having arranged the presentation of the 'box' so well," writes Duchamp to Alice Roullier [26.10.1942] who has managed to sell a *Boîte-en-Valise* [7.1.1942] at the Arts Club of Chicago and has sent him a cheque. "I

am hastily finishing the valise that I hope to send to Mrs Paepcke during the course of next week," he promises. "I have sold 7. So I have 13 left and you realize that, especially at the moment, they don't sell like hot cakes."

1950. Monday, New York City
Duchamp thanks Fiske Kimball for the telegram (which he found on Saturday on his return from Europe), inviting him to the opening of the Diamond Jubilee Exhibition on 3 November. "I really intend to go to Philadelphia one of these days to see the exhibition," Marcel promises.

1961. Monday, Philadelphia
Having travelled with Teeny from New York earlier in the day, at eight-thirty Duchamp is "guest commentator" at one of the "Art Enjoyment Evenings" organized by the Philadelphia Museum of Art. In the Van Pelt Auditorium he talks about Hans Richter's film *Dreams that Money can Buy* [23.4.1948] before three sequences from it are screened.

Introducing the sequence directed by Max Ernst, Duchamp says: "Joe the dream-merchant sells to Mr A. the bank clerk (who is full of amorous feelings) the story of 'Desire', in which the vagabond subconscious of a sleeping girl materializes through a soliloquy mixed up with fragments of conventional reality. The figure, enacted by Max Ernst himself, follows the lovers as a sort of super-ego, silently witnessing their emotional irresponsibility…"

After the audience has seen the Ernst, which is followed by Fernand Léger's contribution, "The Girl with the Pre-Fabricated Heart," Duchamp turns to the short sequence "composed" by himself and Richter, entitled "Discs and Nudes descending a Staircase".

"The discs are simple flat designs taken from a series of twelve drawings made in 1934 which I called *Rotoreliefs* [30.8.1935]." The one chosen for the film, explains Duchamp, "is a drawing which gives the illusion of a three-dimensional crater, and Richter added a prismatic distortion which multiplies the number of drawings like a kaleidoscope.

"Moving rhythmically across the screen, the *Rotoreliefs* add to their third dimension the illusion of going down. They accompany the nude descending the staircase, repeating it several times to give a stroboscopic impression… A detail we also added to emphasize the illusion of

a downward motion was the unloading of a coal truck into a cellar, interspersed with the procession of female nudes reminiscent of my painting.

"I was very fortunate," Duchamp adds, "to have the music for my sequence especially written for a prepared piano, by John Cage."

5 December

1916. Tuesday, New York City
Learning that Beatrice Wood would like to paint but that she has no room to do so in her parents' apartment on East 63rd Street, Marcel invites her to use his studio on one condition: that she telephones beforehand.

Today after a rehearsal, Bea takes up his offer. Although Marcel is not there, he has left the key for her.

*

Duchamp has consented to be a director of the Society of Independent Artists which is incorporated today. The twenty directors listed include Walter Pach, Man Ray, Morton Schamberg, Joseph Stella and John Covert, who is Walter Arensberg's cousin and has introduced Katherine Dreier.

1917. Wednesday, New York City
At eleven at night, Marcel meets Roché at the Biltmore, where they are joined by Mad (their companion of the previous evening) who is dressed in white. After cocktails, they go to listen to a jazz-band at Healy's [13.11.1917].

1934. Wednesday, Paris
Publication of the sixth number of *Minotaure*, the magazine edited by Albert Skira and E. Tériade, the cover of which is designed by Duchamp. With the photograph *Elevage de Poussière* [20.10.1920] made by Man Ray as a background, Duchamp uses one of the images from *Anémic Cinéma* [30.8.1926] entitled *Corolles*, which is printed in red and black.

In an article entitled "Les Révélations Psychiques de la Main", Dr Lotte Wolff reproduces the imprints of Duchamp's hands, and describes him as someone who "cannot apply himself exclusively to a single talent, because he has too great a number of them. We are bearing

5.12.1967

in mind only those of the writer and born strategist," Dr Wolff continues. "His intuition and sense of orientation surpass even his already considerable intelligence. Notice the strongly marked line of intuition. His craving for liberty in all forms of thought and life is primordial.

MARCEL DUCHAMP

Notice the great space between Jupiter and Saturn and between Apollo and Mercury. Hands of a strategist in the grand style: notice the small triangle on the mound of Jupiter."

Although André Breton (the author of one of the first portraits of Duchamp [1.10.1922]) has not yet seen the Large Glass, except in reproductions, he has studied the notes in the Green Box [16.10.1934] and written "Phare de la Mariée", published in today's issue of *Minotaure*. In the essay, Breton confirms his long held belief that Duchamp is at "the modern trajectory's extreme point" [28.9.1923] and establishes *La Mariée mise à nu par ses Célibataires, même* [5.2.1923] as an important landmark in art.

"Piles of masonry, dumped under a grey sky very slowly turning pink, have just been thrown together in next to no time at some distant point of the globe to produce buildings in a confused, tense colonial style in which the transitory vies with the pompous," writes Breton. "But the inescapable fact remains that, at a certain distance, all this melts into the most conventional setting of modern adventure featuring gold prospectors or suchlike, just as the early days of the cinema helped to fix it – high-stepping horses in the ring, luck, the fire of women's eyes and lips. Although the adventure in question happens to be a purely mental one, this visual image of the greatness and indigence of 'Cubism' rather appeals to me. Anyone who has ever caught himself in the act of believing in the pedantic statements emanating from this movement, or of paying any attention to its scientific claims, or of praising its 'constructive' value, must in fact agree that the whole sum of these putative researches has been a piece of flotsam for the *tidal wave* which very soon

swept it away in the same flood that swallowed up the entire artistic and moral landscape as far as the eye could see…

"The position of Marcel Duchamp at the very forefront of all the 'modern' movements which have succeeded each other during the last twenty-five years has been so unique that it has been a matter for great regret that, until very recently, what is outwardly the most important phase of his work, that accomplished between 1911 and 1918, has guarded its secret rather jealously. When the 'tidal wave' that was to achieve shattering momentum first started to swell, some of us certainly decided that Duchamp must have known quite a lot about its potentialities beforehand, and we had a shrewd suspicion that he must have opened up some mysterious valve to release it. But we scarcely dared hope that we might one day be more fully enlightened as to the part he had, in fact, played. Then the publication in October 1934 of the ninety-three documents he had assembled under the title *La Mariée mise à nu par ses Célibataires, même*, suddenly transformed the crest of this wave into a blade in front of our eyes, and the blade lifted long enough for us to glimpse the incredibly complex components of this vast machinery which drove it…

"Without prejudging the degree of 'exceptional power' which may precisely be the distinguishing mark of a mind such as Duchamp's, those who know him well will agree unhesitatingly that no profounder originality has ever been seen to flow more evidently from any being more obviously committed to a policy of absolute *negation*…

"This refusal pushed to its furthest limit, this ultimate negation, which is essentially ethical, weighs heavily upon all the discussions prompted by the question of a typically modern artistic output… Originality, nowadays, goes hand in hand with rarity. On this point, Duchamp's thoroughly uncompromising attitude, barely disguised by the few human precautions he takes, remains a matter of confusion and envy for the most aware among the poets and painters who are drawn to him…

"It was, indeed, at the end of 1912 that Duchamp underwent the great intellectual crisis which led him gradually to abandon a mode of expression that began to seem vitiated to him. The practice of drawing and painting gave him the impression of being a confidence trick aiming at the stupid glorification of the

hand and nothing else. And if the hand is the main culprit how could one agree to be the slave of one's own hand? *It is preposterous that drawing and painting should still stand today at the point where writing stood before Gutenberg.* The delight in colour, based upon olfactory pleasure, is as wretched as the delight in line, based upon manual pleasure. The only solution, in these circumstances, is to unlearn how to paint and draw, and since that moment Duchamp has never swerved from this purpose. This fact in itself should, I think, induce one to approach with a very special interest the enormous undertaking to which, once such a negation had been formulated, he nevertheless devoted all his energies over a period of ten years. The recently published documents have at last given us an insight into the details of this undertaking, an undertaking without parallel in contemporary history which culminated in the Large Glass… This work represents, at the very least, the trophy of a fabulous hunt through virgin territory, at the frontiers of eroticism, philosophical speculation, the spirit of sporting competition, and the most recent data afforded by the various sciences, by lyricism and by humour."

1952. Friday, New York City
Marcel tells Roché that he agrees to him lending to Dorival's exhibition "Le Cubisme 1907–1914", but fears that Philadelphia will refuse [1.12.1952]. The other news is that Sweeney, whom Marcel saw recently, would like to have an option on *Adam et Eve* by Brancusi [16.11.1952].

1955. Monday, New York City
Although he has received "good news" from Iliazd, before making any payment Duchamp wants to be absolutely certain that the material for the next batch of the *Boîte-en-Valise* [7.1.1941] has, in fact, been released from the French customs [30.10.1955], "…I await now your latest news that the cases are at Lefebvre-Foinet's," Duchamp tells Iliazd, "and I will have Lefebvre-Foinet pay you 150 thousand francs immediately [15,000 francs at present values], half the price of the first 30 boxes."

1961. Tuesday, Philadelphia
After staying overnight and doing "some more rearranging at the Museum" [4.5.1961], the Duchamps return to New York.

6.12.1953

1964. Saturday, New York City
"A few days ago I received the first volume [entitled 'mœurs & coutumes des tableau-istes'] of *L'Envers de la peinture* [Editions du Rocher, Monaco] which I literally lapped up from cover to cover," writes Duchamp to Robert Lebel. "Where has di Dio got to?" he enquires, referring to the publisher of Lebel's other book, *La Double Vue*, which is imminent.

1965. Sunday, New York City
"I hope mayor-elect Lindsay will also do something for the mail in N.Y.," Duchamp comments to Joseph Solomon. "We never get our morning mail before 12 noon – and they lose letters!!"

1967. Tuesday, New York City
At five o'clock an exhibition preview opens at Cordier & Ekstrom, 978 Madison Avenue. In "Polly Imagists", (as opposed to "Mono Imagists", a previous show), Arne Ekstrom exhibits the old-fashioned Spanish greetings card which, after modifying it, Marcel sent him especially for the show from Cadaqués. To the basket of violets upon which are perched two swallows, Marcel has glued part of a colour-plate plundered from the Larousse encyclopaedia illustrating a macaw, two varieties of cockatoo and a budgerigar. He has completed the greeting in Spanish, "many souvenirs from," with the word: *Pollyperruque*.

To reciprocate, Arne has written Marcel a poem:

Merci pour l'exquise Pollytesse
que vous verrez prise
in a squeeze
de Polly-Esther
dans ma volière
ou Polly-plumeuse Kermesse.

*

In the course of the day, Monique Fong calls to see Marcel and Teeny at 28 West 10th Street.

*

In the evening a telegram arrives from Brookes Hubachek saying that he has not yet received the Villon [3.12.1967]. Deciding to send the letter by special delivery, Marcel immediately writes to Lefebvre-Foinet for details of the errant shipment.

6 December

1917. Thursday, New York City
On leaving Healy's in the early hours of the morning, Marcel takes Mad Turban back to 33 West 67th Street where he has invited her to stay with him instead of taking a hotel room, and Roché goes home alone.

*

After an Italian meal, Marcel spends the evening at the Arensbergs with Mad Turban, Roché, Ernest de Journo and Edgar Varèse.

1942. Sunday, New York City
At the dinner party given by Jacqueline Breton at her apartment on 11th Street, the guests include Duchamp, the Kieslers and André Breton, who is now living at 45 West 56th Street.

1951. Thursday, New York City
Jean Dubuffet sends greetings to Henri Pierre Roché on a half sheet of writing paper, to which Duchamp adds his signature in blue ink: Marcel Totor.

1953. Sunday, New York City
At four o'clock the joint exhibition "Marcel Duchamp/Francis Picabia" [30.11.1953] opens at the Rose Fried Gallery, 6 East 65th

Street. In addition to the *Boîte-en-Valise* [7.1.1941], a new edition of *Rotoreliefs* [30.8.1935] (which takes into account the invention of the long-playing record and recommends a speed of 33 rpm on the notice) and the Green Box [16.10.1934], Duchamp exhibits for the first time: *Feuille de Vigne femelle* [12.3.1951] and *Objet-Dard*, its horny male companion piece, the title of which to the French ear blends Art with the notion of sexual excitement. And the sting, *dard* in French, of the Wasp [25.8.1912]?.

1954. Monday, Paris
Duchamp's tribute to Francis Picabia, his old sparring partner [30.9.1911], who died a year ago on 30 November 1953, is published in *Combat-Art*:

NO BECAUSE…
Many people answer with "Yes, but…" With Francis it was always: "No because…" – the incessant discovery of each instant, a multi-faceted explosion which cut short any argumentation. Francis also had the gift of total oblivion which enabled him to launch into new paintings without being influenced by the memory of preceding ones.
An unceasingly renewed freshness makes him "more than a painter".

1961. Wednesday, New York City
At one o'clock nine men and a woman led by Jean-Marie Drot invade the apartment at 28 West 10th Street. "We had forgotten we had told them they could come," Teeny tells Jackie later. "Fortunately Marcel was still here. They turned the place upside-down… it was a joke… when I came home at six I could hardly get in over the wires and camera machines. They had just finished and it took them an hour or more to get everything right side up again…"
While Drot is in America filming his documentary on Sandy Calder, he is also shooting the "journal" of his voyage to New York, which includes these sequences with Duchamp, and is to be the subject of a separate film.

1962. Thursday, New York City
Exactly a year after turning the apartment upside-down to interview Duchamp for his film *Journal de Voyage à New York* [19.4.1962], Jean-Marie Drot returns with two friends to see Duchamp at 28 West 10th Street.

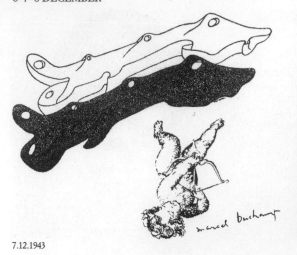

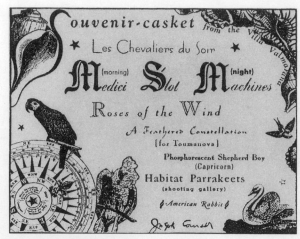

7.12.1943

1965. Monday, New York City
Meets Louis Carré at seven in the evening (or later at eight?)

1966. Tuesday, New York City
"Yes I am in again for 2 shows next year (Rouen and Paris)," confirms Marcel to Brookes Hubachek who has agreed to lend *Jardin et Eglise à Blainville* [2.12.1949]. He suggests that the picture should be insured for $5,000: "This valuation is probably lower than the price the painting might bring at an auction – but it is fair enough I think."

*

"Even if it is long, and with the s of Duchamp(s) on the first line," Duchamp tells Mlle Olga Popovitch that he has decided on the title for the exhibition:
"Les Duchamps, Frères & Sœur:
Jacques Villon, R. Duchamp-Villon, Marcel Duchamp, Suzanne Duchamp-Crotti."
With his sister Yvonne's help, Mlle Popovitch can gain access to the apartment in Neuilly, 5 Rue Parmentier, to choose the pictures by Suzanne; she should also send loan forms to Enrico Donati, Rose Fried and Arturo Schwarz.

1967. Wednesday, New York City
"Maybe the painting was stopped in N.Y. airport waiting to be forwarded to Chicago?" Marcel suggests to Brookes Hubachek, whose cable he received the night before. Expecting an answer from Lefebvre-Foinet by next Monday, Marcel promises to telephone Brookes.

7 December

1923. Friday, Paris
A messenger from Jacques Doucet delivers a cheque for Duchamp to 37 Rue Froidevaux [15.7.1923]. Finding the studio "impossible and cold", Duchamp has in fact now moved nearby to a room at the Hôtel Istria, 29 Rue Campagne-Première, where he enjoys greater comfort.

1931. Monday, Hollywood
Louise and Walter Arensberg send $500 by banker's draft to Duchamp in Paris. (To buy back the precious first example of *Nouveau Né*

in marble by Brancusi, which they had sold to John Quinn in 1922 and was among those salvaged by Duchamp and his partners [13.9.1926] after Quinn's death [28.7.1924]?)

1935. Saturday, Paris
Further to his cable to her on Wednesday, Dee tells Miss Dreier that he has received confirmation of his copyright in the United States of America for the *Rotoreliefs* [30.8.1935]. "As to the price," he explains, "I can't sell them any more than $1.25 the whole set." He doesn't have an agent, but Macy's store in New York, which has purchased a set on approval, "would sell them $3 if they took them... They are only typographical prints on cardboard and have no value as originals," he declares, "(which they are evidently not, not even comparable to etchings)."
At the same time as requesting photographs of the garden and the island so that he can give his preference for the placing of Brancusi's *Colonne sans fin* at The Haven [8.10.1935], Dee asks whether Miss Dreier can arrange for photographs to be made of her "window" (*Fresh Widow* [20.10.1920]) and "the three canvases elongated on which is glued a piece of thread" (*3 Stoppages Etalon* [19.5.1914]), which he needs for his album [5.3.1935].

*

"Am sending you a set of discs for your gramophone, if you have one," writes Duchamp to Henry McBride, supposing that the eminent critic may have seen his *Rotoreliefs* at Julien Levy's gallery in New York. He wonders whether McBride has been to Europe: "I guess not, even though you might [have] escaped me," he concedes.

1943. Tuesday, New York City
Exhibits with Yves Tanguy and Joseph Cornell in a show entitled "Through the big end of the Opera Glass" at the Julien Levy Gallery, 42 East 57th Street. On the folded announcement for the exhibition which he designed, Duchamp has signed a drawing of Cupid which, on the reverse, has a chess problem to be looked at against the light.

1961. Thursday, New York City
The Musée Cantini in Marseilles is organizing a large retrospective exhibition of Francis Picabia's work and has recently requested Duchamp's help to obtain loans from Ameri-

can museums. In order to obtain the large canvas *Edtaonisl* from the Art Institute of Chicago, Duchamp decides to enlist the help of Brookes Hubachek and asks him whether he would telephone the director.
"I hope you are not already engaged in the approaching Christmas festivities," he adds. "Teeny is – as a grandmother should be."

1962. Friday, New York City
Teeny's son Peter comes to supper at 28 West 10th Street. "He seems to open up with Marcel," Teeny observes. "Dear, dear Marcel, he has such an art for keeping things gay and human. I would get lost without him right there."

1964. Monday, New York City
Duchamp is due to meet Louis Carré at one o'clock. To complete "the long and tedious job of filing all the things" at 5 Rue Parmentier following the death of Suzanne [11.9.1963], Carré agrees to have one of his secretaries help Yvonne Duvernoy.

1967. Thursday, New York City
"The cabman on his seat is definitely by me," confirms Marcel to Arturo Schwarz, who is preparing a *catalogue raisonné*. "It's one of a number of sketches (notebook) which belonged to Roché and that I signed for his wife – evidently she sells them separately."

*

At seven in the evening, Teeny and Marcel dine with Louise Varèse and Louis Carré.

8 December

1917. Saturday, New York City
Again Marcel takes Mad with him in the evening and they dine with Ernest de Journo and Edgar Varèse.

1923. Saturday, Paris
Duchamp thanks Jacques Doucet for the cheque delivered the previous day and gives him his new address at the Hôtel Istria. "I am waiting impatiently for news from you concerning the glass," says Duchamp referring to *Glissière contenant un Moulin à Eau en Métaux voisins,* which he offered to clean [2.11.1923]. "I will be working

8.12.1961

at 37 Rue Froidevaux," he explains, "because I do not intend to sublet before 1st January."

1924. Monday, Paris
Having already sold two of the *Obligations pour la Roulette de Monte-Carlo* [1.11.1924], Marcel mails one to Jane Heap, editor of the *Little Review*, who has already promoted the stock company in the magazine and offered to sell the bonds. "Will you show it around and send me the *exact* addresses," Marcel instructs her. "Insist on the serious side of the 20%."

Jane Heap has described the venture and told her readers: "If anyone is in the business of buying art curiosities as an investment, here is the chance to invest in a perfect masterpiece. Marcel's signature alone is worth much more than the 500 francs asked for the share."

*

Miss Dreier, who has heard of Marcel's project "to make 50 francs an hour" at the roulette table, is quite appalled at the news and considers that "the psychological atmosphere in such a place is very bad for a person as sensitive as Marcel". If Paris is too damp for his health, she proposes sending him 5,000 francs [20,000 francs at present values] so that he can go to the south, but only on condition that he promises "to abandon his idea of Monte Carlo". To her, Marcel "is like a small child who doesn't think".

1934. Saturday, Paris
Calls to see Roché at 99 Boulevard Arago.

1946. Sunday, Paris
"The outside of the Lautréamont I don't recall at all, but the typography inside rings a bell," Marcel tells Yvonne Lyon, who has posted him some books from England that he must have left with her many years ago. "It could be the first Lautréamont that I had in 1912 or thereabouts. In any case I would love to keep it as one of the 5 or 6 books which constitute the whole of my library."

Still waiting for his American visa, Marcel adds: "No news since your departure – A bit cold, but I find coal."

1947. Monday, New York City
Following the resolution taken at the meeting of the Société Anonyme the previous Monday, in his capacity as secretary Duchamp writes to George Heard Hamilton to inform him of their decision.

1956. Saturday, New York City
Preoccupied by the Dada exhibition due to open next spring at the Galerie de l'Institut, Marcel tells Suzanne and Jean Crotti, who have enquired about the availability of the *Boîte-en-Valise* [7.1.1941] that, as none will be ready before three months [7.4.1956], maybe Roché will lend his.

"I have no Valise made up," writes Marcel to Roché. "Lend yours if you have good reports of the gallery – don't lend any documents and not the optical machine [8.11.1924] – 'the little sister' [8.3.1915] if need be."

1958. Monday, New York City
"Your little drawings have convinced me," writes Duchamp to Richard Hamilton, who has started [23.11.1958] on the typographic version of the Green Box [16.10.1934]. "I am also in accord with your idea of a textbook-like presentation. The book will then," he continues, "have a unity in its layout which will help the reader." Duchamp agrees to go through the 30 or so drawings when they have been made and suggests that, if it is not too expensive three printings (black, red and blue), "would help in the same way as the original."

For the translation of the notes into English, Duchamp hopes to see George Heard Hamilton before he goes to London.

1961. Friday, New York City
For an article due to appear in *Connaissance des Arts*, Duchamp spends the afternoon being interviewed by Alain Jouffroy [29.10.1958], who is in New York with Jean-Jacques Lebel:

Why have you opted to live in New York since the war, rather than Paris?

"No... I have not opted. From the day I came in 1915, I simply liked this country where I find one lives more agreeably than in Paris, because the people are more hospitable, less 'rat race'. Maybe it's because it is a kind of complete mixture of races. In any case, often the American here is American by option. It's not like the Frenchman who is born in France, and who is chauvinist by tradition!"

Paris is no longer the artistic centre of the world, Jouffroy points out. Perhaps art no longer needs a centre?

"Because of these easy exchanges and voyages from one end of the earth to the other, the question of 'centre' loses its meaning. Even

regionalism has lost its meaning... If regionalism has lost its sparkle, nationalism equally... The Paris-centre or New York-centre of the art world is already over, there is no longer any difference, because even the Japanese are involved. Now, one can talk about Japanese painting, but it greatly resembles the American abstract-expressionist painting."

If the New York School is considered the zenith of the avant-garde, what do you attribute this to?

"Oh! that's very easy. To the fact that during the last war, Breton, Max Ernst, a whole group of Europeans in fact who were here, under the Surrealist banner if you like, influenced Pollock and the others. They admit it themselves. Consequently, the followers of this New York School, the youngest of this school owe a great deal to the influence of this European group here, without being for all that a continuation of Surrealism."

Do you feel related in any way to this New York School?

"Absolutely not, because that is completely contrary to my ideas on the question. I do not believe at all in the physical purity of painting."

In his book [6.4.1959], Robert Lebel describes the Bachelor Machine of *La Mariée mise à nu par ses Célibataires, même* [5.2.1923], as "an incestuous and masculine hell", and places Duchamp "in direct pictorial descent from Hieronymus Bosch". Jouffroy asks whether the Large Glass, like *Le Jardin des Délices* by Bosch has a literary character and whether all painting, pushed further, takes this course?

"The question is slightly different. That is to say when I made this glass, my intention was not to make a painting to look at, but a painting using a tube of paint simply as an accessory and not as an objective. The fact that it is called literary is beside the point, because the word literary has a very wide meaning and not at all convincing. I wanted then to add a book, or rather a catalogue, like the *Armes et Cycles de Saint-Etienne* in which each detail would have been explained – catalogued. And this idea of mixing the two things, in my view, has no literary character at all."

A great many painters continue to work as if painting should be pure, non-literary. What is to blame for this?

"I blame it simply on laziness, the painter's cerebral laziness in general... In any case, the

9.12.1922 9.12.1936

idea of pure painting, born about fifty years ago, was like the outcome of a state of comparatively recent liberty in the status of the artist and dating from the start of Impressionism. Until then the artist was a man more or less in the pay of a king or emperor, or even a group of collectors. One has to add that from 1924 Surrealism had other preoccupations than pure painting."

As Duchamp gave up painting, Jouffroy asks whether his work between 1907 and 1924 contained everything he had to say?

"In fact I made no vow to stop. I never even decided to stop. I stopped partly from laziness, partly from the lack of ideas, because as I told you indirectly earlier, I don't paint in order to paint. I never considered myself as a painter in the professional meaning of the word. Painting was a means amongst others for a certain indefinable objective. I had no intention of judging myself, nor to achieve a precise goal, premeditated or social. I don't want to get to the Panthéon, nor be amongst the tramps... None of that interests me."

You prefer life to the work of art? and you dislike the behaviour of painters?

"Yes... Because it is really not very interesting to be associated with a small group of people who profess to be so idealistic at twenty and who have now become good business men."

Do you think that your legendary behaviour, for certain of your admirers, can be interpreted as an extension of your work?

"Yes, of course. I believe so. I have never made any distinction between my everyday gestures and my gestures on Sundays."

Does humour in general seem to you necessary in creating a work of art?

"An absolute condition. I set great store by it because seriousness is something very dangerous. To avoid seriousness, humour must be introduced. The only seriousness that I could consider is eroticism, because that – that's serious! And I have tried to use it as a platform – for *La Mariée* for example."

"In short," Jouffroy says, "eroticism is the serious part of *La Mariée*, and the humour is the way of presenting it."

"The way of presenting it in liberty, as much as I could. Without too much seriousness either."

Jouffroy returns to the question of abolishing the idea of judgment and asks whether Duchamp means moral or aesthetic judgment?

How can a choice, without judgment, be made between works of art and men?

"I think the mistake is that one believes to be judging when one is simply following a subconscious which is the strongest of all and which makes you *decide* and not judge. Judgment is something on the surface. If you like, it is a superficial expression of the subconscious. It is called judgment because you live in a society where there are judgments, the judged and the judgers."

Because we have to make a choice, how can it be done without accepting everything wholesale?

"Because the subconscious attends to the choice... In reality everything has happened before your decision. But this has no more sense than the true and the false. Moreover, from the moment when you start to speak you talk nonsense, in this order of ideas – and me too. So, to speak of judgment is senseless."

Is it this kind of reflection which rather kept you away from artistic expression?

"A bit. In the same sense that if I had to continue painting, and earn my living by my painting, that would integrate me in a distasteful way for me, to be obliged to become, if you like, one of the soldiers of the question, with the officers and generals who command you."

And yet you continue to exert an influence undoubtedly equal to that which you would have exerted had you continued with your work. That's quite paradoxical...

"Yes, I have my doubts on the result of this behaviour. Even in painting, the individual has lost his rights."

1962. Saturday, New York City
Duchamp's bilingual message of congratulations to the revue is printed on page 26 of *Art News*:

"Bravo for your 60 Ism-packed years
Bravo pour vos 60 ans pleins d'"ismes'."

1963. Sunday, New York City
Acknowledging the certified receipt for the Renoirs [8.11.1963], Duchamp tells Lebel that he will pay the picture restorer, if the *notaire* handling the Crotti Estate is unable to.

He also writes to his sister Yvonne requesting her to keep the restored pictures in a corner of the studio at 5 Rue Parmentier, for the new valuation.

9 December

1916. Saturday, New York City
Four days after their first meeting, Duchamp receives a visit from Henri Pierre Roché, who has been lunching with Marius de Zayas. Discovering the studio at 33 West 67th Street for the first time, Roché notes Duchamp's use of lead wire to draw forms on glass. Later they have tea together at the French Shop.

1922. Saturday, New York City
Marcel has received an invitation from Florine Stettheimer to a tea party at four o'clock in her studio to view the portrait she has just completed of Carl van Vechten [17.12.1916]. Seated on a scarlet chair in the centre of a circular black rug in the middle of his red-carpeted sitting room, the writer is flanked by the corner of a piano on one side and, on the other, his typewriter, the keys of which Florine has used to sign her full name and write the date of the painting. There are three vistas framed by billowing, black fringed curtains: on the left, through the open window, there is a merry-go-round in the brightly-lit street below; in the centre, fantasies of gastronomic delights are detected by a sleek black cat; on the right a small boudoir is dedicated to Carl's wife, the beautiful Fania [7.7.1922].

After Florine has made the tea, her sister Carrie, dressed in her "new blue metal dress", a white turban and white slippers, takes charge of it with Fania and they serve a "very good" hazelnut cake. The other guests include the publisher Alfred Knopf [14.7.1922] and his wife, Blanche, Beatrice and Robert Locher [1.11.1922], Edna Kenton who "seems very happy", the book reviewer Hunter Stagg, and Rita Romilly.

Alfred Stieglitz and Georgia O'Keeffe arrive later – "not by daylight", as they put it, but they come. Everyone misses Ettie, who is out of town. Duche enquires anxiously if she has taken with her "some warm things to wear".

1926. Thursday, New York City
To keep the sculptor abreast of the latest news concerning his exhibition [17.11.1926], Marcel cables Brancusi: "Levy exchanges birds Rumsey orders bronze 1500 have written you."

1929. Monday, Paris
Returning from Villefranche after two months enjoying a milder climate and chess [11.9.1929], Marcel calls in the afternoon to see Brancusi.

1936. Wednesday, New York City
The second of Alfred Barr's exhibitions conceived to illustrate the principal movements of modern art, "Fantastic Art, Dada, Surrealism," opens at the Museum of Modern Art, 11 West 53rd Street. The show has a particularly important historical section, the "fantastic art of the past", commencing with Arcimboldo, Hans Baldung Grien, Hieronymus Bosch and including Odilon Redon and William Blake.

In the modern section, Barr (who has made his peace with Duchamp [15.12.1934]) again presents *Mariée* [25.8.1912], *Cimetière des Uniformes et Livrées* [19.1.1915], and the *Rotoreliefs* [30.8.1935] which were exhibited in "Cubism and Abstract Art" [2.3.1936]. Also on show are three important works by Duchamp that have never been included in an exhibition before: the tiny oil painting *Moulin à Café* [20.10.1912]; *3 Stoppages Etalon* [19.5.1914], which Duchamp recently prepared for presentation together with *Rotative Plaques Verre (Optique de Précision)* [20.10.1920], now in perfect running order [2.9.1936]. Barr also borrows *Le Roi et la Reine traversés par des Nus en Vitesse* [9.10.1912] and *Pharmacie* [4.4.1916] from Man Ray; the little cage, *Why not Sneeze?* [11.5.1935] from Roché and Breton's stock certificate: *Obligations pour la Roulette de Monte-Carlo* [1.11.1924]. Duchamp's first readymade, *Egouttoir* [15.1.1916], is represented by Man Ray's photograph of it.

Lending Duchamp's first optical machine, Miss Dreier is thankful that Man Ray is in New York to assemble it in its allotted place, which is a good, central position, flanked by *3 Stoppages Etalon*, at the entrance to the exhibition. Although the new motor has three speeds, it has been adjusted to one, but at a speed which Miss Dreier finds to be optically unsatisfactory.

As André Breton has refused to participate in the exhibition [22.9.1936], it is Georges Hugnet who has written about Dada and Surrealism for the catalogue.

The final section of the show is devoted to the "art of children" and the insane which Barr believes is "appropriate as comparative material" showing the difference between the Surrealist artists, who "are perfectly conscious of the difference between the world of fantasy and the world of reality, whereas children and the insane are often unable to make this distinction".

1947. Tuesday, New York City
In the evening at nine-thirty Maria Martins and Marcel visit the Kieslers at 56 Seventh Avenue.

1949. Friday, New York City
Dee travels to Milford to see Miss Dreier and brings her the good news that Harry Holtzman, a pupil of Piet Mondrian, is donating two of his own paintings to the Société Anonyme.

With Miss Dreier, Dee carefully goes through all George Heard Hamilton's comments on the "little monographs" being prepared for the catalogue of the Société Anonyme [1.12.1947] and they make notes: some, they decide, should stand as they are.

1960. Friday, Paris
The first of six interviews Duchamp gave to Georges Charbonnier [7.10.1960] is broadcast by the Radio Française on France Culture.

The first question is whether the word "art" has not had quite a different significance for Duchamp?

"In broad terms, that is correct... Art as I understand it is a much more general thing and much less dependant on each period. The blending of taste with the word 'art' is, for me, a mistake. Art is something much more profound than the taste of a period. People don't realize that one can do something other than by taste. We live by our taste, we choose a hat, we choose a picture. Besides the word 'art', etymologically, means 'to make' – to make with the hand, and generally by an individual, which expresses something quite different to what we call taste, and it's an enormous handicap because taste is a source of pleasure and art is not a source of pleasure. It's a source which has no colour, no taste."

But that puts art purely in the artisanal domain?

"Oh! not at all. One can do extremely subtle things that are not at all artisanal. 'To make' doesn't necessarily mean 'to make' artisanally. It can even be made with extremely complicated instruments or even with oil paint... The trou-ble is when you add to the word 'make', the idea of the pleasure of taste, a sensual pleasure in any case. I do not permit that, this intervention of taste. The thing fabricated exists by itself and if it survives, then it has something else more profound than momentary taste."

Have you always held this point of view?

"No, not exactly, but I must have had it in me without knowing. I do not consider that as being the last word either on a very complex question."

One day Marcel Duchamp stopped painting. Why?

"It was not one day, one evening at eight o'clock. It was a slow thing and not even something definitive. If I had sufficient energy still, I would certainly start again... I was simply stopped by the fact that my period, in any case, no longer corresponded to my personal wishes in that sense."

Why not?

"A hundred years ago there were a few painters, a few dealers and a few collectors, and the production of art was an esoteric form of activity... Since, everything has entered the public domain. Everyone talks about painting, not only those who do it, those who buy or those who sell it, but the public at large talks about painting."

Doesn't the esoteric continue to escape the public?

"Agreed. But the esoterics have let the public become initiated, so-called, but [the public] is not at all initiated. This esotericism has become an exotericism. ... You talk about art in general today, the public has something to say and says it. Added to the fact that it brings its money, and that the commercialism in art today has transformed the question from esotericism to exotericism and art is then a product like beans. One buys art as one buys spaghetti."

Should esotericism never be separated from the acquisition of knowledge?

Duchamp laughs: "Esotericism is, after all, something very difficult to define. In all esoteric things, there is a kind of mystery... You cannot define these things. Esotericism still exists, will always exist, but it can be obliterated by a period. In a period like our own, for example, which for a hundred years, in my opinion, has produced nothing in the wider sense of the word, particularly because of the interference of commercialism."

When do you think the crisis started?

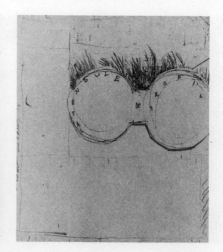

10.12.1950 10.12.1964

"Already in 1900. As soon as the Impressionists, from poor chaps who couldn't live by their pictures, became almost rich... from that moment the wave began and has increased until today to a terrifying point."

You have always been conscious of that?

"It was quite clear. In my personal activity, what I preferred to do was to do something that interested me and especially based on an idea, much more grey matter than physically visual. I could have started again, made a second, a third, a fifth, twenty or so. I was always against that... As it happens I have produced extremely little because I couldn't repeat myself. The idea of repeating, for me, in an artist, is a form of masturbation. Besides, that's very natural. It's olfactory masturbation, dare I say. Each morning a painter, on waking, needs apart from his breakfast, a whiff of turpentine... and if it's not turpentine it's oil, but it's olfactory. A form of great pleasure alone, onanistic almost. It's almost the civil servant side of the artist who works for himself everyday instead of working for the government, don't you see?"

But isn't the phenomenon of painting quite distinct from this attraction?

"Of course! Only it's the conditions into which he is drawn. There is a clear pleasure, a sensory pleasure in any case, if not sensual. And it's very understandable, there is nothing to reproach in it. I have tried to show you the general mechanism, because I have experienced it myself, like everybody. Besides the repetition side of the question which makes a Renoir produce so many nudes until the end of his life, was this need, which was a need by habit to start with. He couldn't prevent himself, it would have been a catastrophe if one had prevented him from painting."

But repetition implies the idea of variation...

"Very little. Much less than you think. There is a fabulous or mythomanic side to artists which one must beware of, they are great liars, in my view."

In disassociating the idea of art from the idea of pleasure, do you think that art is sullied by the pleasure taken?

"Not sullied, but in any case it adds nothing. It's a decoration, very external. In other words, the artist who produces doesn't know at all what he has produced. And it's this way that it can become interesting, when he doesn't know what he is doing. He is the last to be able to judge what he is doing, and if you accept just

this kind of renunciation to understand what you do, you will go much more profoundly into what you do... Not knowing what he is doing, the artist is never responsible for what he does. He does it because he is driven, if he really has something to say, which is more profound than superficial. It's interesting just to be able to say: but who decides? Who decides, is very simple: posterity. One can really excuse this delectation to produce for an artist which leads to the illusion of being a great genius. Each artist has this illusion, which is a marvellous illusion because his life is a great pleasure non-stop."

What can one think of this delectation when considered in relation to the history of art?

"It's of no importance! We are not going to ask how Michelangelo paid his rent. This delectation is of the same order: that he was pleased on 28 May of such a year, doesn't matter to us. What remains of him are not these details of day-to-day life of interest only to biographers. What interests us is what he has left to us..."

The delectation, then, enjoyed by the artist was not a handicap?

"No, not at all. It is never a handicap, on the contrary, it saves you from having these kinds of neurasthenia crises or an inferiority complex which prevents you from working. It's a marvellous thing to have this illusion to be able to do anything and to be sure that it will still be looked at 300 years after your death. This illusion is delightful for the artist and most recommendable."

1963. Monday, New York City
Richard Hamilton would like to include the Picabias that belonged to Suzanne Crotti [11.9.1963] in an exhibition which he is organizing, but Marcel explains that until probate has been granted, he and his two sisters will not be in possession of the pictures.

1964. Wednesday, New York City
The Duchamps give a party at 28 West 10th Street for Lee Penrose.

1966. Friday, New York City
At twelve-thirty Duchamp has an appointment with Louis Carré.

*

"After several gallery visits we have decided upon the Bodley Gallery," writes Marcel to Jeanne Mayer [23.6.1966] who particularly wants an exhibition organized for their daugh-

ter Yvonne [6.2.1911]. "Their first response was no space for this year but possible for November 1967. So I accepted in principle for Nov. 67; that will give us the time to prepare the exhibition in the month of April when we will be in Paris."

Outlining the programme in more detail, Marcel continues: "It is necessary to print a small catalogue in Paris like the one enclosed or larger if Yvonne prefers. For the transport which, like the catalogue, is our responsibility, in the summer we will send 20 or 25 canvases (without frames) by sea freight – we need to allow 2 months for the crossing but it costs very little. We will have nothing to pay for hiring the space and the gallery takes 33% on the eventual sales (oh how many!)."

Jeanne should ask Yvonne to write to him, "if she agrees or has other ideas. Tell her above all," Marcel requests, "to work hard this winter to add a few canvases to those which I showed photographs of to the Bodley Gallery."

10 December

1926. Friday, New York City
Telephones W. S. Budworth & Son to arrange for the packing of the Brancusi sculpture next week after the closure of the exhibition [17.11.1926], which is then to be shipped to the Arts Club of Chicago. For the insurance, Budworth advises that the Arts Club can obtain a better rate but that marble and stone cannot be covered against breakage. Duchamp sends a cable to Alice Roullier of the Arts Club with this information, promising to send her "a list and particulars as soon as Budworth starts packing", and adding that: "150 catalogues will be ready in a week."

1943. Friday, New York City
Although he has a touch of flu, in the evening Dee accompanies Miss Dreier to look at Burliuk's paintings which are in the collection of Arthur Grannick, the viola player. Miss Dreier, who is preparing a book on the Russian artist's life and work [7.9.1943], begs Dee to take good care of himself, and thinks it is "too bad" that he has no telephone, "lives so far down, and so by himself."

11.12.1919

1946. Tuesday, Paris
Duchamp plans to call at the American consulate to see whether he can be given a date, even approximate, of when he can expect to obtain a visa [29.11.1946].

1950. Sunday, New York City
With a copy of the minutes of their meeting held on 30 June at which he was elected an Active Member and Trustee of the Francis Bacon Foundation, Duchamp also receives a form of consent for his agreement to hold a special meeting on 8 December, to discuss the transfer of some art and pre-Columbian items legally to the foundation. He signs the form and encloses it with a letter to Louise and Walter Arensberg. In case they have any special instructions for him, Marcel says that he will wait until the end of the week before going to Philadelphia to see the exhibition [4.12.1950].

1957. Tuesday, New York City
Delighted to learn from Iliazd that 30 copies of the *Boîte-en-Valise* will soon be ready, Duchamp replies by return, saying that he has given instructions to Lefebvre-Foinet to make 120,000 francs available for him instead of the 100,000 he had requested [14.9.1957]. "Your idea for a general label for all the works in the Arensberg collection is excellent," Duchamp says and encloses the proposed text. "As for the printed cardboard with the title Duchamp Sélavy [de ou par Marcel Duchamp ou Rrose Sélavy]," he advises, "don't change it even if it is not quite square."

1961. Sunday, New York City
"Thank you for all the information about the new boxes," writes Marcel to Jackie Monnier, who has already made 30 copies of the *Boîte-en-Valise* and is preparing to make another batch. "If, as Perez promises, we obtain a box without the defects of the previous ones, my opinion is to keep the same green linen already used because even a small difference in the thickness of the new linen or 'plastic' will probably change the general architecture and will introduce new defects."

Liking Jackie's idea to provide a cardboard box to protect the linen until "the client soils the box himself", Marcel has another idea for when the box is completely finished: "to make upon it the marks (dark grey) of 2 dirty hands which hold it before opening it – but we will

talk again about that later."

On the envelope, addressed to Jackie, Marcel affixes an Alfred Jarry stamp issued by the Collège de 'Pataphysique.

1964. Thursday, Paris
Le Soleil Noir publishes Robert Lebel's book, *La Double Vue*, containing two essays, the second of which, "L'Inventeur du Temps gratuit" [The Inventor of Free Time], was previously published in the second number of *Le Surréalisme, même* in spring, 1957. (The short interview with Jean Schuster [8.5.1955] was also included in the same issue.) Erro's portrait painting of the author with a Chocolate Grinder is reproduced on the first inside fold of the cover.

For the "de luxe" edition, Alberto Giacometti has engraved a diptych and Duchamp has realised an idea from the Green Box [16.10.1934] which he jotted down as: "The Clock in profile. and the Inspector of Space." Why do people say that a clock is round, asked Alfred Jarry in *Gestes et Opinions du Docteur Faustroll, pataphysicien*, when, seen in profile, its shape is clearly a narrow rectangle...?

In another note, Duchamp wrote:

"The Clock in profile, with the clock full face, allowing one to obtain an entire perspective of duration going from the time recorded and cut by astronomical methods to a state where the profile is a section and introduces other dimensions of duration."

After a number of working studies [3.10.1964], the final object, entitled *La Pendule de profil*, takes the form of a paper sculpture with the clock-face folded to stand upright.

11 December

1919. Thursday, Puteaux
Squeezed together on the bench seat of the Ford van, Gertrude Stein, Alice B. Toklas and Henri Pierre Roché arrive from Paris at 7 Rue Lemaître. They have come expressly to see the glass, or "the green machine" as Roché calls it, which Marcel gave to his brother Raymond Duchamp-Villon before leaving for New York [6.6.1915].

The *Glissière contenant un Moulin à Eau en Métaux voisins*, a half-moon glass designed to be hung vertically on hinges, was worked on mainly between the months of May and July 1914. The second motif of the Large Glass to be elaborated after the canvas entitled *Broyeuse de Chocolat* [8.3.1915], the Glider was Marcel's first experiment in drawing with lead wire on glass.

"The Glider," Marcel explained, "is also a machine sliding on two runners, the wheel which you see inside is supposed to be activated by a waterfall, which I did not care to represent to avoid the trap of being a landscape painter again."

Placed between the Malic Moulds [19.1.1915] and the Chocolate Grinder in the lower half of the Large Glass, the Glider has a specific role to play in the Bachelor Machine. "The Chariot [Glider] should," as the notes describe it, "while reciting its litanies, go from A to B and return from B to A at a jerky pace, it appears in the costume of Emancipation, hiding in its bosom the landscape of the watermill."

In fact a "lead weight in the form of a bottle of Benedictine" (a brand of sweet liqueur distilled in Fécamp, a port just north of Le Havre in Normandy), was to have activated the Glider originally, but was replaced by the imaginary waterfall. "As the Glider goes and comes," its accompanying litanies are: "Slow life; vicious circle; onanism; horizontal; round trip for the buffer; junk of life; cheap construction; tin, cords, iron wire; eccentric wooden pulleys; monotonous fly wheel; beer professor."

Gaby and Jacques Villon, together with Suzanne (now married to Crotti [14.4.1919]) and Yvonne Chastel (Crotti's ex-wife), who is living in Neuilly since she returned from Buenos Aires [11.3.1919], entertain the visitors to tea. Roché and the two American ladies enjoy their outing together in the van so much, with Miss Stein negotiating the slippery cobbled streets and sounding the horn, that they even envisage making a longer voyage together one day.

1933. Monday, New York City
Marcel is still fully occupied with Brancusi's exhibition at the Brummer Gallery [17.11.1933], which drew 500 visitors on Saturday. Having recently moved from the Black-

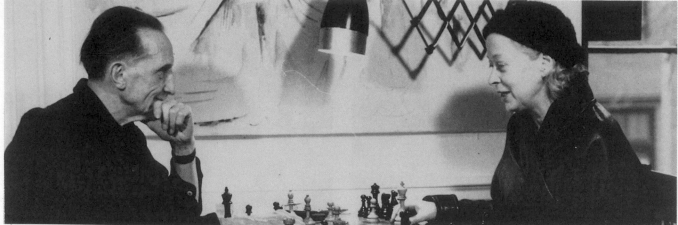

12.12.1959

stone Hotel [1.11.1933] to 645 Madison Avenue, Marcel responds to Brancusi's cable about the installation of the sculptures and gives him his new address. "We have moved the sculptures a little further from the wall," he explains, "but don't forget that the weight forces us to comply with certain architectural laws." As for the hanging of material behind the birds, Marcel says that although it is impossible for Clark's bird, and behind the blue bird it would not be suitable because of a wall, "for Rumsey's bird, white on white is very good, in addition to the fact that the crack is no longer visible at all in all this light."

Marcel is taking care of the collectors as well: he recounts his visit to see Albert Barnes [3.12.1933]; Mrs Meyer has been to the gallery and is "very impressed with her portrait. While looking at it," Marcel tells Brancusi, "she was thinking whereabouts she could put it, which indicates the intention of buying." A. E. Gallatin calls "periodically to look at his little fish in bronze" and there is also a young collector with whom Marcel has become "quite friendly", who seems to have "the intention" of buying.

1956. Tuesday, New York City
At 327 East 58th Street, Hans Richter spends three hours filming the small glass, *9 Moules Mâlic* [19.1.1915] with different lighting

effects for his film *Dadascope*. With Marcel "as fool", holding a sheet of glass up between him and the camera, Richter shoots sequences as Marcel breaks the glass with a hammer.

1959. Friday, New York City
Marvin Lazarus is, perhaps, one of the first to photograph Duchamp in his new surroundings [3.11.1959]. A copy of Richard Avedon's new book *Observations* is on the table and, asking Lazarus about the law on using pictures by photographers, Duchamp shows him Avedon's picture of the Duchess of Windsor, which is hardly

flattering. Does she have any recourse, wonders Duchamp, remarking that, in his opinion, most of the portraits in the book "were too sensational looking". Like the other celebrities in the book, Avedon's two shots of Duchamp have comments by Truman Capote, who visited the Duchamps' previous apartment [3.4.1959], describing it as having: "nothing rain might harm except a small Matisse and a large Miró: as a sanctuary, it speaks of a man who would be himself reasonably free and unbeholden."

Lazarus chatters away as he works and forgets his nervousness. Duchamp seems amused and wants to know all about Severini, where he lives and so on. Wearing a very dark shirt and dark grey flannel trousers secured with a stout pair of braces, Duchamp first sits for Lazarus in the theatrical chair which belonged to Max Ernst. After perching by the Matisses with his pipe in hand, Duchamp stands grinning in front of *Jeune Fille sophistiquée* (a portrait of Nancy Cunard which Brancusi gave to Teeny Duchamp), amused no doubt that the sculpture appears to be sprouting from his head. Lazarus also photographs Duchamp at his chessboard with the canvas by Wilfredo Lam hanging above it between the two windows. When Teeny comes in, Lazarus invites her to sit at the chessboard too so that he can photograph the couple together.

1960. Sunday, New York City
In the face of the Surrealists' strong objections and criticism [28.11.1960], Duchamp writes a short note to André Breton declining to explain or justify his actions. Rather than quibble about the matter, he tells Breton (who is in Paris) that he regrets now having agreed to help organize the exhibition.

1962. Tuesday, Paris
Bill Copley lends three Duchamps to "Collages Surréalistes", an exhibition which opens today at Le Point Cardinal: *Pharmacie* [4.4.1916], *Autoportrait de profil* [11.10.1958] and the 8 of the 9 discs (one was lost) inscribed with puns used for *Anémic Cinéma* [30.8.1926].

12 December

1904. Monday, Paris
At the Académie Julian, 5 Rue Fromentin, Duchamp pays 25.10 francs [a little more than 400 francs at present values] for a further four weeks of morning classes [12.11.1904].

1926. Sunday, Staten Island
Writing from Emerson Hill, where he is staying with Bobby and Beatrice Locher [9.12.1922], Marcel tells Brancusi that the exhibition [17.11.1926] "continues its success". As for sales, "Levy will decide on Wednesday whether he will take the white bird. Several clients have not decided about the small torso and the new born... Stieglitz isn't taking the fish, even at 500 dollars... he doesn't feel rich enough."

Mrs Rumsey, on the other hand, has at last made a decision: she would like a bronze bird like Steichen's for $1,500 and has chosen *Torse de Jeune Fille* for $800. Duchamp will repay his debt to her [13.9.1926] by giving her the *Torse de Jeune Fille* and by giving Brancusi $700 towards the commission of the bronze bird (Mrs Rumsey paying the remainder). Marcel's instructions to the sculptor are clear: "Work and send it to her."

1941. Friday, Montélimar
When Totor's train arrives at three o'clock in the afternoon, Roché, who has come by bus on receiving the news by telegram, is at the station to meet it. With a better complexion, pink against the green shirt he is wearing, Totor has also put on weight. His eyes, Roché learns, are completely cured [21.8.1941] and he has started smoking again.

After a walk they play their habitual game of chess, which Roché wins, Totor having given him a Rook. While enjoying a good dinner, including snails, at the Relais de l'Empereur,

13.12.1919

where they have taken rooms, Totor talks about his exhibition projects in Switzerland.

1944. Tuesday, New York City
Duchamp has organized a special evening performance for the opening of "The Imagery of Chess", a group exhibition of paintings, sculpture, newly designed chessmen, music and miscellany at the Julien Levy Gallery, 42 East 57th Street. With Duchamp acting as the referee, the world champion of blindfold chess, George Koltanowski, plays five simultaneous games blindfold against Alfred Barr, Max Ernst, Frederick Kiesler, Julien Levy, Dorothea Tanning and Dr Gregory Zilboorg.

A number of artists have made new chess sets for the show, notably Max Ernst, Calder, Noguchi, Man Ray and Tanguy. The chessboard devised by André Breton is chequered with small squares of deforming mirrors, and its chessmen are glasses of various sizes filled with different beverages: beer, liqueur, sugar, etc.

Duchamp, who has also designed the catalogue, provides a *Pocket Chess Set* [23.3.1944], presented with a rubber glove in a box.

1945. Wednesday, New York City
With the Kieslers and a number of other friends, Marcel dines at the Brettown restaurant.

1949. Monday, Chicago
After his short visit to meet Walter and Louise Arensberg, who have travelled from Hollywood to see the exhibition [19.10.1949] and hear the proposal from the trustees of the museum to keep the collection permanently, Duchamp goes from the hotel to the Art Institute of Chicago to say good-bye before flying back to New York.

1952. Friday, New York City
Having had no response to his letter of 12 November, Marcel cables André Breton.

1955. Monday, Washington
On being informed today by the Washington office of the Immigration and Naturalization Service that it has instructed the New York office to process the naturalization of Duchamp before the end of the month, Nelson A. Rockefeller sends the encouraging news in a note to Alfred Barr [22.11.1955].

1956. Wednesday, New York City
Promising to send him some prints of Richter's

photographs taken the previous day, Marcel requests Roché to "lend as little as possible to this Dada exhibition [8.12.1956] which", he predicts, "will be a hotbed of jealousies and problems."

13 December

1919. Saturday, Paris
The publication of *Huit peintres, deux sculpteurs et un musicien très modernes*, with caricatures by Georges de Zayas [3.12.1919], illustrations of a short story by M. [Edmond Sailland] Curnonsky, is announced today in *Comœdia*. One of the subjects of de Zayas' eleven lithographs, Duchamp is caricatured at the chessboard in the act of moving his Bishop (one from his own chess set [22.6.1919], with an almost disdainful expression on his face, his head still closely shaved [9.3.1919].

The ten artists and "a very modern" musician [12.11.1919] are woven into Curnonsky's tale, entitled "Le Voyage de M. Dortigois, nouveau riche, au Pays des Volumes", inspired possibly by the voyage of a certain M. Perrichon and his adventures in Switzerland…

Desiring to become a patron of the arts, Anatole Dortigois dreams of founding a literary salon; at a chance meeting, Boulingrot, who has become a rich, famous painter and founder of the Presentist School, proposes his services and advises him to buy the Avant-Garde. Boulingrot promises an introduction to his friend Picabia, providing Dortigois has read Coquiot and "Préface" by Gabrielle Buffet [a text which appeared in *Camera Work*], the best guides to Modern Art.

On the appointed day Dortigois and his

wife, who assume that Cubists dress like harlequins and live in boxes, are surprised to find themselves "in a vast apartment, furnished with perfect taste, [with] kind hosts, courteous and unpretentious guests, and the most gracious reception. Around a good fire, there was Picabia, the great master Picasso, the ironic Ribemont-Dessaignes, the cunning and sharpwitted Marcel Duchamp, the elegant and discreet Metzinger, the famous whimsical musician Erik Satie and the charming Brancusi."

Dortigois enquires why there are no Picabias on the walls. "I only exhibit outside," replies his host and offers to show him the picture he sent to the Salon d'Automne, which is lying under the piano. His friends eagerly reach for the panel and prop it up on a chair. "I entitled it *L'Enfant Carburateur*," declares the artist. "But Duchamp, the rascal, has put it upside down. Besides it's of no importance."

On their way home the Dortigois ask Boulingrot if they were not too ridiculous? "A client is never ridiculous" he replies and suggests that they invite the artists to dinner. "They will all come, except Matisse, who never goes out and Mme Marie Laurencin, who is abroad. And after dinner we will play a little game called *Confidences…*"

The nine artists accept the Dortigois' invitation. After dinner there is dancing, "because the pretty girls have not been forgotten. Picabia does imitations of nervous tics, Gleizes discusses the fourth dimension with Metzinger while Duchamp holds the women in check to explain the different ways of obtaining checkmate in ten moves, Erik Satie plays his score of *Parade* on the piano, Picasso dances, and Brancusi tells Romanian stories to Mme Dortigois." At midnight Boulingrot cleverly profits from the fun to circulate his questionnaire, *Confidences*, for the artists to complete.

Duchamp makes the following replies:
Who are your favourite painters?
"Louis Eilshemius." [9.4.1917]
In which country do you prefer to work?
"Nowhere."
In your opinion, what will be the evolution of painting?
"That doesn't interest me at all."
Do you believe it is necessary to paint with colour?
"I don't think so."
Do you play any sport?
"I don't believe so."

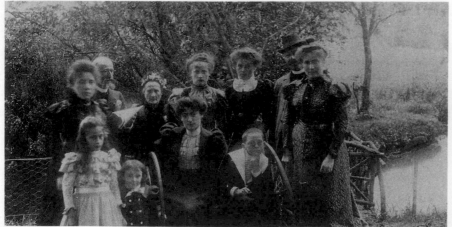

14.12.1961

What do you think about love?
 "I do it as little as possible."
Have you a nationality?
 "Unfortunately."
Do you see a difference between a drawing, a watercolour, an oil painting?
 "I am incapable."
What do you eat?
 "Fillets of sole."
What do you think of the influence of the war on the Arts?
 "I don't add potatoes to shit."

When the guests have gone, Boulingrot and the Dortigois read the replies, but the *nouveau riche*, believing he is being made a fool of, decides that he will buy according to his own taste. "My God," wails his wife, "If you follow your own taste we will be living in a Museum of Horrors!"

Dortigois buys all sorts of bad paintings: "the hunter meeting a milkmaid on a wooden bridge; the young pastry cook playing marbles with the telegraph boy; the choirboy drinking the Communion wine; the Cardinals playing chess in the room of a furnished hotel…" The Dortigois' mansion becomes a Museum of Horrors, and is famous. The collector's name is known worldwide. Dortigois is decorated by the Ministre des Beaux-Arts for his "indirect contribution to aesthetic education of democracy. His mansion is declared to be of public inutility."

The Countess Natol d'Ortigois, who is pretty enough for her word to be believed, persuades certain critics that her husband "did it on purpose" and the Count is finally considered as the greatest whimsical collector in Europe. Boulingrot is appointed curator of the Musée d'Ortigois – and he makes one or two good deals…

1920. Monday, New York City
By arrangement with Fania Marinoff, one of the stars of the show, Marcel has no difficulty obtaining his tickets at the Empire, on Broadway at 40th Street, for the performance tonight at eight-thirty of *Call the Doctor*, Jean Archibald's "scintillating comedy" which, after closing at the end of the week, is to go on tour.

1922. Wednesday, New York City
On her return to New York after eighteen months abroad visiting China and then Europe, where she buys numerous works for her growing modern collection, Miss Dreier presides over a meeting of the Société Anonyme, which

has continued operations in her absence [31.5.1922]. She reports that Vasily Kandinsky, whom she saw at the Bauhaus in October, has accepted to be first honorary vice-president.

1935. Friday, Paris
Opening of an exhibition of Surrealist drawings, which includes works by Duchamp, at the gallery Aux Quatre Chemins, 99 Boulevard Raspail. In the catalogue of texts by various artists is: "Teinturerie Rrose Sélavy: robe oblongue pour personne affligée du hoquet." [25.11.1922]

1941. Saturday, Montélimar
Although their rooms at the Relais de l'Empereur face south, the temperature is so icy that Roché and Totor have slept with almost all their clothes on. They appreciate the warmth of the brasserie facing the park by the station. As Roché has only one packet of tobacco left, Totor gives him a cigar and the rest of his own tobacco.

Even after a surfeit of nougat, they have another fine lunch together and plenty of good talk. At four in the afternoon they say farewell at the station: Roché returns home by bus and Totor continues his journey by train.

1958. Saturday, New York City
Duchamp requests Carl Zigrosser to make an additional set of photostats [26.11.1958] of the *Boîte de 1914* [25.12.1949] for George Heard Hamilton who has agreed to translate the notes into English for Richard Hamilton's typographic version [8.12.1958] of the Green Box.

1961. Wednesday, New York City
Requesting her to telephone him from the hospital, Marcel wishes Kay Boyle "especially good luck with the operation…"

1962. Thursday, New York City
The Duchamps send a message of sympathy to Richard Hamilton, whose wife Terry died in a car accident on 6 November.

*

In the evening the Duchamps attend a Pop Art panel discussion at the Museum of Modern Art, which Teeny finds "very spicy".

1964. Sunday, New York City
"Here the headache of the catalogue of my exhibition," writes Marcel to Elena and Gianfranco

Baruchello, who have written announcing their visit in January for the opening at Cordier & Ekstrom. "SEPA," he continues, "has made a very beautiful reproduction of the door (11 Rue Larrey) for the cover [24.9.1964]." Delighted that they will have Dore Ashton's house Marcel wonders exactly when they will arrive.

"We are still under the spell of our zig-zag [21.6.1964]," says Marcel , "and we often speak of all your care and 'friendlinesses'."

14 December

1920. Tuesday, New York City
At three in the morning Marcel writes a note to Fania Marinoff thanking her for the theatre tickets. "I enjoyed myself very much and also the friend who came with me," he says. "I had never seen you act before (except in a film 4 years ago [Fania starred with Holbrook Blinn in *McTeague*, 1915]) – I am always an excellent audience for that sort of play."

1926. Tuesday, New York City
Further to his telegram on Friday, Duchamp cables Alice Roullier again at the Arts Club of Chicago giving her the value of the Brancusi shipment for insurance purposes: "6200 for nine marbles stop 6300 for one stone seven woods one painting twenty one drawings and two bases stop do you need more accurate information."

1933. Thursday, New York City
"Your photos are a great success with all my friends," writes Marcel to Carl van Vechten. "I continue to prefer no. XVIII P:5 and would like to send some to the family. Can you make me 3 or 4 prints of this number?" he requests.

1935. Saturday, Paris
Totor calls at Arago to have a talk with Roché, whose white stove is roaring on this very cold wintery day.

1946. Saturday, Paris
With tickets for *La Putain respectueuse*, a new play by Jean-Paul Sartre, Marcel returns to the Théâtre Antoine [10.6.1912] accompanied by Mary Reynolds.

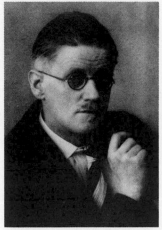

15.12.1936

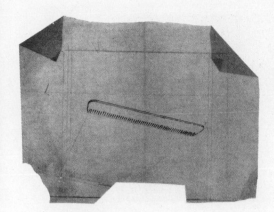

1952.Sunday, New York City
Replies hastily to Roché about *Adam et Eve* for the Guggenheim and the loans to Dorival in Paris [5.12.1952].

1953. Monday, New York City
The two Spanish shawls that Mary Dreier has decided to give to Suzanne Crotti and Gaby Villon in memory of her sister Katherine [29.3.1952], are delivered to 210 West 14th Street for Marcel to forward.

1954. Tuesday, Paris
The Duchamps dine at the home of Louis Carré. The other guests are Dorothea Tanning, Max Ernst, Denise and Henri Pierre Roché who, with Carré, had tried to organize a homage to Duchamp two years ago [10.6.1952].

1961. Thursday, New York City
The ripples caused by the New York Surrealist exhibition [28.11.1960] have not affected Marcel's relationship with André Breton [11.12.1960]. After seeing him during the summer in France, at Breton's request Marcel has made some discreet enquiries about the market for certain paintings in his collection: works by Rivera, Gorky and Tanguy. To continue his investigations, however, Marcel tells his friend that he will require photographs of the pictures and their dimensions.

*

Enclosing with his letter a set of *Rotoreliefs* [30.8.1935] which he hopes will amuse them, Marcel says to Jeanne and Isadore Levin. "We are still under the spell of our Detroit expedition…" [28.11.1961]

*

To Lydia and Harry Winston, Marcel remarks: "How much our visit with you, our 'common' ceremony [29.11.1961], has opened new vistas full of your gracious and warm hospitality." Also enclosing a set of discs, and, confirming that he received the photographs of the ceremony, Marcel comments: "You certainly seem completely at ease in your new 'humanity'."

*

"Wonderful, Wonderful!" exclaims Marcel to Jackie, with whom he has been discussing the fabrication [10.12.1961] of another batch of the *Boîte-en-Valise* [7.1.1941]. "I accept everything you propose and I choose the *green* Resylux… instead of the previous green linen," he says, and instructs her to go ahead and order the boxes.

Writes to Suzanne confirming that he has sent a cable of condolence to Dr Robert Jullien, whose mother, Marie-Madeleine, has recently died. Sister of Marguerite [24.5.1896] (the mother of Meran Mellerio [15.9.1924]), who died in 1956, and Gabrielle, Marie was the youngest of Mery Duchamp's three attractive daughters, who often visited the Duchamps at Blainville-Crevon.

On one occasion (c. 1897) when their grandmother had come from Massiac to Normandy, the three sisters were placed in the centre of the group for a family photograph in the garden: Marguerite sat next to Marcel, with Marie and Gabrielle behind them; on the left, Suzanne and Yvonne posed in front of their parents, Lucie and Eugène who, deep in his newspaper, stood next to his mother, Catherine Duchamp.

1962. Friday, New York City
For the poster of the exhibition celebrating the 50th Anniversary of the Armory Show, Duchamp has made a maquette "using a small part of a reproduction" of *Nu descendant un Escalier*, No.2 [18.3.1912], which he has "cut out in an almost unrecognizable way". Concerned about the violation of reproduction rights, the organizing committee have requested Duchamp to obtain a letter of authorization from the Philadelphia Museum of Art.

Writing to Henri Marceau, Duchamp concludes: "I hope that you will smile on reading this letter and will see only an easily accepted formality."

*

Prior to the American Chess Tournament, which starts on Sunday, the Duchamps are invited to a cocktail party to meet the ten participants including Bobby Fischer and Reshevsky.

*

The Duchamps are also invited later in the evening to a party at Robert Motherwell's.

15 December

1926. Wednesday, New York City
When the Brancusi exhibition closes at the Brummer Gallery [17.11.1926] sales exceed $7,000 which Duchamp considers "a success."

1933. Friday, New York City
"[Mrs Meyer] did not ask the price of her portrait," writes Marcel to Brancusi. "So you can reply as you wish. If she comes back [11.12.1933] I will pass on your idea regarding the price." Marcel has still not seen Mrs Rumsey, but he is going to Philadelphia tomorrow which he hopes will be productive.

1934. Saturday, Paris
"I have been very lazy lately that is to say concentrating on the sale of my box [16.10.1934] which by the way is almost a success," writes Dee to Miss Dreier. He tells her of *Minotaure* [5.12.1934] and promises to send her a copy next week.

"On the other hand I am sorry to have been lazy to write you," he continues, "as I had asked Levy and Pach [17.10.1934] not to lend anything of mine to Mr Barr. So you did and were right. But you do remember my telling you about the arrogance of the gentleman and you know that my only attitude is silence. But please keep that for yourself," Dee requests, "and write what you know of the show [20.11.1934]. It's all very unimportant…"

1936. Tuesday, Paris
"Well we won't sell!" confirms Dee referring to pieces of Miss Dreier's furniture that a friend of Villon's was interested in buying [23.11.1936]. Miss Dreier hopes to get between $250 and $300 for the Verlaine, but an appraiser has estimated that it might fetch $250 in a sale. Before giving it to an auction, Dee proposes to "try 2 or 3 possible people who might buy it without waiting for a sale".

A result of the slow work on his album [5.3.1935] is a cover for *Transition,* which Dee tells Miss Dreier she might see.

*

Although Duchamp has not yet started the colour reproductions of the Nude [26.8.1936] for his album, the one for *Peigne* [17.2.1916] is ready. And even if he declined to write anything [15.7.1936], Duchamp has agreed to design the cover of *Transition* no.26: using the same image of the silvered metal comb standing almost vertically on a mat, grey-green ground, the title of the review laid next to it, in the same perspective, is printed in gold.

James Joyce's reaction when he sees Duchamp's cover is to tell Sylvia Beach that the comb is the one he will use to "comb out"

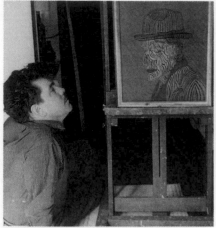
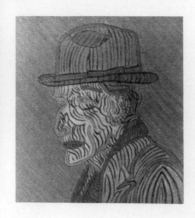

15.12.1953

his *Work in Progress*, some pages of which are published in the same number of *Transition*. Other contributors to this issue include Raymond Queneau, Man Ray, and Alexander Calder.

1950. Friday, New York City
From Hollywood Walter Arensberg advises Marcel by cable that there is nothing for him to do in Philadelphia because Fiske Kimball is in California until after Christmas; the form for his consent to a another special meeting [10.12.1950] and the agenda is being sent by special delivery.

1952. Monday, New Haven
At the Yale University Art Gallery, Duchamp attends the opening of the exhibition "In Memory of Katherine S. Dreier, 1877–1952: Her Own Collection of Modern Art", organized with Duchamp's help before the works are scattered amongst a number of institutions, including the Art Institute of Chicago [1.11.1952], the Phillips Gallery, Washington [24.11.1952], and the Museum of Modern Art, New York [22.11.1952].

1953. Tuesday, New York City
Writes to Mary Dreier to thank her for the shawls, which arrived the previous day.

*

To Fiske Kimball Marcel expresses his concern about Walter Arensberg who, since the death of his wife [26.11.1953], "has completely retired in his work and refuses to communicate with the external world. Lou was too much a part of himself," Marcel believes, and concludes: "I am very sad that he does not seek refuge in his friends."

*

Marcel asks Roché to choose the 12 illustrations for the publication [26.11.1953] himself, "I request only that you do not forget *3 Stoppages Etalon* [19.5.1914] which, although not very photogenic, are very dear to me."
As Bill Copley has sent a photograph of the portrait he has painted of him in profile wearing a pork-pie hat, Marcel also asks Roché to thank Bill and tell him he will be writing.
"I learned of Picabia's death [30.11.1953] rather late," Marcel writes gloomily. "The series continues and will go on accelerating – and especially no more fooling with your occlusions [18.11.1953]."

1959. Tuesday, Paris
The eighth of its kind, the "Exposition inteRnatiOnale du Surréalisme", which, as the typography suggests, is dedicated to Eros, opens at eleven in the evening at the Galerie Daniel Cordier, 8 Rue de Miromesnil. "Produced" by Cordier, the "direction" is again assured by Breton and by Duchamp, who has collaborated from across the Atlantic, and does not attend.

Duchamp's ideas have been partially carried out. From under the palpitating pink satin ceiling into which a shapely pair of lips are set to evoke the breath of Botticelli's *Primavera,* the 200 guests penetrate gradually into the succeeding "grottoes of love" via a narrow ogival aperture. The pictures are massed on moss-covered walls. With sand underfoot, silence reigns among the visitors, better to capture the soundtrack which is broadcast of a woman's sighs, moans and cries as she makes love. Strange perfumes permeate the air.
A small shrine of objects including *With My Tongue in My Cheek* [30.6.1959] is arranged in an alcove covered with black fur. In the remaining room, Meret Oppenheim has set out a feast: six guests are seated around a table tucking into a multitude of fruits, vegetables, lobsters and other delicacies heaped upon a naked Sleeping Beauty who, apart from the gentle movement of her breathing, remains quite immobile.

The "de luxe" catalogue in the form of a green letter box marked *Boîte alerte* contains numerous papers and a telegram from Rrose Sélavy [20.11.1959].
Duchamp devised the *Couple de Tabliers* [9.11.1959] to be included in the special *Boîte alerte* numbered from I to XX.

1960. Thursday, New York City
Writes to Pierre de Massot.

1964. Tuesday, New York City
Duchamp signs his Last Will and Testament.

*

In the afternoon, the travelling Duchamp exhibition which has come from Bern [23.10.1964] opens in London at Gimpel Fils, 50 South Molton Street.

1965. Wednesday, New York City
At the request of Jacques Barzun, dean of Columbia University, Duchamp writes a trib-

ute to Edgar Varèse, who died on 6 November, which Barzun quotes in his own homage to the composer this evening at the McMillin Theater:

"With a deep feeling of nostalgia I remember 1915 when Varèse and I arrived in New York and the group of friends we made or met here at that time: Walter and Louise Arensberg, Picabia, Gleizes, Crotti, Henri Martin-Barzun and Louise Varèse who has been his devoted companion ever since.
A bientôt cher Varèse…"

1967. Friday, New York City
In the evening at seven Duchamp has an appointment with Louis Carré.

16 December

1917. Sunday, New York City
After having tea at the Arensbergs', Marcel invites Roché to his studio until eight o'clock, when they are due at the Vanderbilt. Roché passes the time before dinner reading *Anatol* by Arthur Schnitzler.

1919. Tuesday, Paris
Marcel attends another of Gaby Picabia's parties [2.11.1919] at 32 Avenue Charles Floquet. Among the guests are Juliette and Albert Gleizes, Yvonne Chastel and Henri Pierre Roché. In an aside, Marcel tells Roché that he has had his lungs X-rayed [by Dr Tribout?].

1922. Saturday, New York City
After being closed for eighteen months during Miss Dreier's absence abroad [13.12.1922], the Société Anonyme reopens its gallery at 19 East 47th Street with an exhibition of paintings by Villon.

1926. Thursday, New York City
After the closure of the Brancusi exhibition at Brummer's the previous day, Duchamp supervises the packing and removal of the works to be forwarded by Budworth & Son to Chicago and then sends a detailed list to Alice Roullier proposing that he unpack the cases personally when he arrives on 2 January.

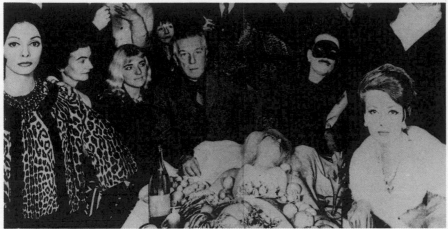

15.12.1959

1933. Saturday, New York City
Invited to lunch by Sturgis Ingersoll, Duchamp travels to Philadelphia where he meets a number of collectors who are "very enthusiastic" about Brancusi's work currently on exhibition at the Brummer Gallery [17.11.1933]. Ingersoll and another collector of Brancusi's work, Maurice Speiser [27.1.1927], tell Duchamp that they will try to arrange the purchase of an important sculpture for the Philadelphia Museum of Art by a group of collectors.

1947. Tuesday, New York City
Aimé Maeght, in whose gallery the Surrealist exhibition was held [7.7.1947], is in New York. Duchamp joins the Donatis, the Kieslers, the Mattas and Leo Castelli for dinner at the Brittany.

1951. Sunday, New York City
Duchamp meets Monique Fong, who is in New York from Washington.

1954. Thursday, Paris
While Duchamp is in Paris, the interview accorded to Michel Sanouillet in his New York studio at 210 West 14th Street is published in *Les Nouvelles Littéraires*.

The huge glass window of Duchamp's room on the rooftops and the modest rent, Sanouillet finds, are the only similarities to a traditional studio. "It is a large dusty room full of corners, encumbered with strange objects of uncertain utility. But not a single paintbrush in sight, nothing hung on the walls, no paint-spattered palette; instead of the characteristic smell of turpentine, a subtle, penetrating perfume of black tobacco." In spite of being in America, there is no radio, television or telephone. On the other hand, a massive chess table with a large double chess clock set in it, dominates the centre of the room.

Sanouillet starts by asking whether Duchamp will help him demolish the extraordinary Duchamp legend?

"With the greatest of pleasure," is the reply.

Asked to explain how it came about, Duchamp recounts how, at 11 Rue Larrey, he built the door [9.10.1937] that demonstrates the inexactitude of the proverb saying that a door must always be either open or shut. "But the practical reason which dictated this measure has been forgotten and only the Dada challenge retained."

Referring to the legend of Duchamp giving up painting in order to devote himself to chess, Sanouillet says the impression is one of a Rimbaud-like conversion: down with literature, painting and art, and long live life...

"Nothing is more untrue," asserts Duchamp: "Since my childhood, I never stopped playing – in the proper meaning of the word – chess, with my brothers, my friends. For me it's a hobby which is as good as another, that's all."

But why did you suddenly stop in 1923?

"I had not made a vow, heaven forbid! I could have taken up the paintbrush again overnight, if I had had a mind to..."

Do you mean that you had lost inspiration?

"No. The idea of changing myself into a Sunday painter was as unbearable as the prospect of doing painting as a profession."

Why?

"Because an amateur can never dominate his art. And the professional must renounce revitalizing. One cannot change styles more than two or three times in a very full life. And the successful painter must produce – he paints apples, more apples and always apples. It's extremely annoying."

But Picasso, then, or Picabia?

"Picabia's different. It was impossible for him not to change his style every spring. Moreover he is the only one to have put grey-matter into his canvases. ... These square kilometres of painted surface in the galleries make me giddy: contemporary painters are intoxicated with turpentine."

You refuse to be called a painter... What is your profession?

"Why are you all for classifying people? What am I? Do I know? A man, quite simply, a 'breather'..."

Did Duchamp cease all literary and artistic production after 1923, persists Sanouillet?

"Practically, yes," replies Duchamp, who then mentions his "cinematographical experiences" and optical experiments. "The truth is that I have nothing to say: at the moment I am experiencing the greatest embarrassment in writing, at Breton's request [4.10.1954], a review of Carrouges' book *Les Machines Célibataires* [15.4.1954]. Besides, you know, all my work, literally and figuratively, fits into a valise..."

Where are the originals?

"They have just been grouped in a perma-

nent exhibition of the Arensberg Collection at Philadelphia [16.10.1954]... In the middle of the room stands my Large Glass [5.2.1923], which I still have pleasure seeing again, even though it is not finished or even intended to be looked at. It certainly isn't *L'Embarquement pour Cythère* [by Antoine Watteau]. It isn't even a picture, it's a mass of ideas."

If one accepts your definition of the Large Glass, why did you feel the need to write all the notes which are found in the Green Box [16.10.1934]?

"Certain ideas, to prevent betrayal, call for a graphic language: that's my glass. But a commentary, the notes can be useful, like captions which accompany photos in a catalogue of the Galeries Lafayette. That's the *raison d'être* for my Box." Duchamp then explains that twelve years after "shelving" the Large Glass, he wanted to reconstitute "as exactly as possible" a hundred or so scraps of paper, his working notes. "So I had all these thoughts lithographed with the same ink as the originals," he continues. "To find paper of absolutely identical quality, I had to scour the most improbable corners of Paris. Then three hundred copies of each litho had to be cut out, using zinc templates which I had trimmed against the periphery of the original papers. It was tremendous work and I had to hire my concierge..."

1957. Monday, New York City
Having "conferred" again with George Heard Hamilton [1.12.1957], Duchamp promises to let Lebel know as soon as he receives Hamilton's proposals, "financial and otherwise", and a page of the proofs retranslated by him. "But particularly," repeats Duchamp [2.12.1957], "I am expecting you in person in January."

1960. Friday, New York City
For the construction of a replica in Stockholm to be exhibited in "Rörelse i Konsten", Marcel asks George Heard Hamilton at Yale University to provide two exact measurements of *Rotative Plaques Verre* [20.10.1920]: the length and width of the largest glass and the length of the central bar holding all the glasses. "Those two measures," explains Marcel, "should be sufficient with a good photo which they have."

*

In his second interview broadcast on France Culture [9.12.1960], Georges Charbonnier commences by asking Duchamp whether the

16.12.1960

present commercial aspect of the work of art by its nature eliminates the notion of a work of art.

"No, not at all. The question, for posterity, is to know what choice to make from the production of a whole century. I even have ideas of what people could probably say in two or three hundred years' time: that our century will be, may be, a kind of eighteenth century. They are not alike at all, but there was a kind of lightness, a certain frivolity which is not really to the credit of eighteenth-century art. One can like Fragonard and all that, but it does not go very far. The twentieth century will be a little frivolous, maybe not important as compared to the Renaissance, the Middle Ages, the Ancient Greeks…"

Will the Surrealist Revolution disappear?

"Yes. It won't have the importance it claims. For all that they introduced things like the possibilities of automatism, things which are extremely interesting… But in any case they are the only ones who have reacted against the general tendency which exists since 1880."

Does all conscious intervention of intelligence in elaborating a work of art appear to you to be desirable?

"Very desirable! I think one has to agree on the word 'intelligence'. It is difficult for us to define. We must accept a certain flexibility in what we desire. There is one thing, certainly, which exists, that is to say to leave the door open. Instead of controlling all one does with words in explaining what one is going to do… to explain nothing and to let it happen."

But it seems to me you want the intervention of the mind by the unconscious, by the unconscious way?

"No. To try to canalize it in a conscious form that, at least, one can enjoy a little. To know what is happening, but in a very, very respectful way, and not by imposing words to define what comes out of this unconscious. From the moment you put words there, you spoil everything. I have a horror of words, you know."

One is bound to agree when you have defined what you are talking about, Charbonnier says a little later.

"Yes. If you have found the universal remedy to paint, there is no longer the individual. … I think it is the individual who remains important in the work of art. Each painter, or each artist is, in spite of everything, the *deus ex machina* of the question."

Is it still worth painting?

"In music, each time a new instrument was invented, a new music was created. It was, nevertheless, another facet of the same thing from a metaphysical point of view. If oil painting is abolished completely, it would be replaced by something else, but it would always be the expression of an individual or a group of individuals who would let their unconscious emerge."

Is it desirable to do it, or not to do it?

"It bothers me a little bit, the number of people who call themselves artists, who are or who believe they are. There will be a fantastic waste in a production like ours today. Attics are never big enough to keep everything. Even today all those poor Bouguereau's are in the cellars of all the world's museums. … They are never exhibited. So in a few more centuries they will deteriorate, disappear. In short, the death which exists for all things…"

That would be a pity from the historic point of view.

"Only! But in fact history is another story."

But it would be a pity in so far as Bouguereau expressed something of his time…

"Yes. In every period there are individuals who had an unconscious to express in a remarkable way and who were never able to emerge either for reasons of personal health or being unlucky. The great artist generally has a lot of luck; also, when he emerges, the conditions of society help him to emerge."

But one has to distinguish between the man and his work, because one can conceive that a man's work can be almost entirely posthumous.

"Yes, yes, I agree. But it is conserved sufficiently for a posterity to take care of it. But there are those who have been destroyed by life itself, who have not been able to produce. And it is those whose absence I regret, because we have all those who have remained often by luck: such and such a king liked them a lot, he put them in the Louvre and at Versailles [such as *Bataille d'Austerlitz* by Gérard] and in spite of the bad times which passed over them they have stayed there."

If I understand correctly, promotion plays a great role in art?

"Enormous. Particularly in monarchical times, obviously."

Is there a difference between producing art in the United States and in France?

"No, no. There is no longer any difference… There are no longer the barriers that there were a hundred years ago in all domains. In the domain of art, there is no difference in the attitude, even in the way of speaking, thinking, except that the language is different, but it's the same approach."

When you come from the United States to France, do you find a different world of forms?

"Yes. One changes universes. There is still something left. Bricks are not the same shape and, goodness knows, if a brick isn't a brick in every country of the world. In any case the way to stack bricks is a little different, sufficiently different to give this almost regional character. But it's in the architecture more than sentiments or the way of speaking or the ways of approaching a subject. A street is a different production in each country. That exists even between Spain and France: a Spanish village is not the same as a French village. Even in the towns, the big cities, there are differences which still exist, they continue to exist particularly because of the ancient monuments – and it's a pleasure! Because if the world became really uniform with petrol stations everywhere like in the United States or on the main roads in France, that would be rather unpleasant to look at."

1963. Monday, New York City
Following his request for a third interview [25.11.1963] to discuss Picabia and the period in Paris between 1910 and 1915, Duchamp receives Bill Camfield and his wife at 28 West 10th Street.

*

The United States Chess Championship, which Duchamp is following with keen interest, is already under way. In the second round, commencing in the evening at seven, Bobby Fischer wins his game against Evans.

17 December

1916. Sunday, New York City
As Carl van Vechten has asked through Avery Hopwood if he may see his portrait, Florine Stettheimer organizes a tea party at her studio, 8 West 40th Street, and invites van Vechten, his wife Fania, Duchamp and Roché, whom she met recently at the Brevoort [4.12.1916],

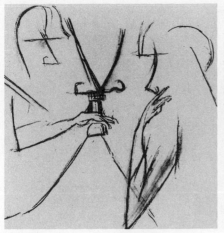

17.12.1959

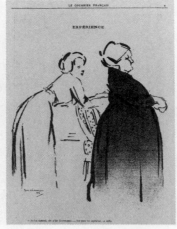

18.12.1909

Marie Sterner, who organized her exhibition [24.10.1916], the Marquis de Buenavista and Florine's two sisters Ettie and Carrie.

1919. Wednesday, Paris
The morning after the party, Marcel drinks tea with Gaby, her cousin Marguerite Buffet, and Roché, who has aroused himself from the cushions on the floor of the drawing room where he has spent the night alone.

*

Following the excursion to Puteaux the previous Thursday to see the *Glissière contenant un Moulin à Eau en Métaux voisins* [11.12.1919], Marcel accompanied by the Villons and Roché (who has been that afternoon with amorous intentions to visit Yvonne Chastel in Neuilly), is invited by Gertrude Stein and Alice B. Toklas to dine at 27 Rue de Fleurus. Although Roché regrets being rather sleepy, he finds the evening friendly and interesting.

1927. Saturday, Paris
"Can you come to the Dôme at about midnight tonight," Duchamp asks Robert Desnos [1.12.1922] in an express letter which he sends at five in the afternoon. "We will talk about your business and Malkine's which seems to me less feasible," he continues, adding: "Also I have a favour to ask of you."

1929. Tuesday, Paris
Totor calls to see Roché in Arago and they then cross Paris to have lunch together at the Pomme à Tell, 32 Rue d'Hauteville, near the Excelsior. Roché learns that to improve his concentration for chess, Totor has given up smoking. After lunch they visit a shop specializing in chess.

1935. Tuesday, Paris
Sends a note to Breton enclosing an unfinished reproduction of *La Bagarre d'Austerlitz* [22.9.1935]. Duchamp promises Breton that he will post another one to him on Wednesday when the cutting out of the windows [20.11.1935] is finished.

1944. Sunday, New York City
"After two years of silence we can at last exchange a few words," Marcel tells Roché, from whom he has received a reassuring card. Sparing him the details of the life of "great luxury" in New York compared to the conditions he left behind in France, Marcel says:

"Friends Tanguy, Léger, Seligmann, Ernst stick to their post and are working," but unlike the first days of exile, there are fewer reunions. "Breton is the only one that I see quite often," Marcel continues, "he has talked for almost three years and still speaks on the radio several times a day."

The other news is that Peggy Guggenheim opened her museum [20.10.1942]; René Lefebvre, who is in Hollywood, comes to New York 2 or 3 times a year, "is still adorable"; and Mary Reynolds is impatient to return to France but, explains Marcel: "except to the military, the government does not issue passports; even I, as a Frenchman, couldn't go back – besides I have no great desire to."

To assist financially, Liberfield gave Marcel $500 when he arrived in New York, part of which he used to repay Alec Ponisovsky [29.4.1942]. Marcel asks Roché whether he knows "what happened when [Alec] was taken away by the Germans", where he was, and what happened to his family.

"Painting sells moderately," says Marcel, "I still don't do any – I have done several covers for friends' books and magazines. I have also perfected a pocket chess set [23.3.1944] with pin heads which catch the pieces of cellulo[id] and prevent them from falling – but the labour is too expensive and I am not continuing on a commercial basis."

Marcel asks Roché to tell him what he needs most hoping to be able to send him regular parcels soon. He also decides to send a cable so that his friend doesn't have to wait too long for news from him...

1949. Saturday, New York City
Having taken Mrs Kuh's manuscript with him to Chicago the previous weekend, but forgotten to give it to her the morning of his departure [12.12.1949], Duchamp returns it by post saying: "Well there it is with my thanks; very good too," and adds: "I was sorry, after leaving Chicago, that you felt uneasy about the visit of the Arensbergs... I am sure that the exhibition [19.10.1949] gave them a wonderful objective reaction to their own collection."

1956. Monday, New York City
To Georges Hugnet's request for his participation in the Dada exhibition being prepared in Paris, upon which he has already exchanged views with Roché [12.12.1956], Duchamp sug-

gests laconically: "an *Egouttoir* [15.1.1916], if you find one (perhaps Man Ray has one). Valise: none ready, in a few months I hope to have a new batch [7.4.1956]... For the exhibition you will certainly find one to borrow. Green Box [16.10.1934], the same if it fits into your plan. No pictures really Dada. Maybe you could find something at Roché's. No desire to do the cover (for the exhibition) because from the purely ethnological point of view, I was not a period-born Dada."

*

In his letter to Claire and Gilles Guilbert [12.7.1938], Duchamp enquires: "How is the wonderful studio? and the travelling?" With news of them from Guy Weelen [26.6.1955], Duchamp says: "I reply to him through you because he did not put his address and I am unable to remember it."

1957. Tuesday, New York City
Having spoken to Barnet Hodes of the Cassandra Foundation, who accepts the financial conditions to make a new translation, Duchamp has given the go-ahead to George Heard Hamilton and follows up his letter to Lebel of the previous day with another. "Really the 6 enclosed pages translated by Hamilton completely change the book (in English)," declares Duchamp, who also sends copies to Arnold Fawcus the publisher.

1959. Thursday, New York City
Invited by Bamberger's store of Newark to dress a window during the period of the annual art show in the first fortnight of February, Duchamp's idea is to give some publicity to Robert Lebel's book [6.11.1959]. He asks Henri Marceau if the Philadelphia Museum of Art would agree to lend three works from the collection to Bamberger's: *Nu descendant un Escalier*, No.3 [29.4.1919], the copy of the famous picture made for Arensberg; *Etude pour les Joueurs d'Echecs*, a charcoal and ink study for the painting [15.6.1912] and *Vierge*, No.2 [7.8.1912].

1960. Saturday, New York City
For the chess game to be played as part of the forthcoming exhibition, "Bewogen Beweging," at the Stedelijk Museum, Duchamp suggests in his letter to Daniel Spoerri: "When you go to Amsterdam, ask to meet M. Max Euwe ex-world champion of chess and explain your problem to him; he will find you someone of

18.12.1925

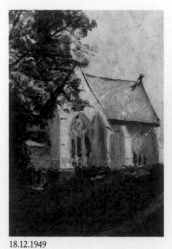
18.12.1949

19.12.1909

medium strength so that I am not too easily beaten. Also the question of telegraphic language is important to transmit the moves. An official code exists which Euwe knows – in any case I would like to arrange all these details by letter with my opponent before commencing."

Duchamp agrees "willingly" to sign a hundred facsimiles of *Cœurs volants* [16.8.1936] for the "de luxe" edition of the catalogue.

18 December

1909. Saturday, Paris
After a fortnight [4.12.1909] *Le Courrier Français* publishes another cartoon by Duchamp, entitled *Expérience*: The mother tells her daughter firmly, "The little lieutenants, not flipping likely; ...your father's a captain, that's enough."

1916. Monday, New York City
Having heard from Villon that the sum of 1,080 francs [12,000 francs at present values] is still owed from the sale of his paintings to John Quinn at the Carroll Galleries two years ago, Duchamp writes to Quinn first confirming that, concerning the recent transaction [18.8.1916], he has sent Gaby Villon the second draft of 1,350 francs, which he has only just received and then respectfully reminds him about the earlier amount that is still outstanding. "Please let me know if I am wrong about it," requests Duchamp, "so that I may write to my brother to explain to him."

1917. Tuesday, New York City
Marcel meets Roché.

1925. Friday, Rouen
At four-thirty in the afternoon, unable to adjust to life after the death of her mistress [29.1.1925] and master [3.2.1925], Clémence Lebourg throws herself in desperation into the Seine from the bank near the Boulevard de Croisset. A young worker pulls her from the water and the municipal ambulance takes her to the Hôtel Dieu. Efforts to save her life are in vain and Clémence dies that night at eleven-thirty, aged seventy-three.

Clémence was born in Cany-Barville and probably joined the Duchamp household sometime between 1879 and 1883, when Eugène Duchamp was employed at the Register Office of her home town. With her wonderfully warm smile and kindly expression, it was Clémence who helped Madame Duchamp bring up the four youngest children born at Blainville: Marcel, Suzanne, Yvonne and Magdeleine. She remained a devoted servant to the Duchamps and moved with them to Rouen when Maître Duchamp retired from his practice at Blainville. Greatly loved by all the family, Clémence appears in various early drawings and paintings by Gaston and Marcel.

1930. Thursday, Paris
"The apartment is all painted in that blue white as near as possible [to] the colour we had at the 1st Société Anonyme [30.4.1920]," Dee informs Miss Dreier referring to the work he is supervising for her at 16 Place Dauphine [13.6.1930]. "It is very clean, very clear; the furnace *is* in the kitchen but leaves space for the gas stove; the partition has been taken out so that you have a kitchen opened on the infinite – the whole thing looks very attractive. Studio like open air."

As La Nouvelle Revue Française has turned down the chess book [22.10.1930], Dee has been to Brussels to show it to Edmond Lancel of the Edition de l'Echiquier. Lancel "wants to do it in 3 languages, German, English and French in the same book," which Dee thinks is an excellent idea.

Asking Miss Dreier, "if the market permits it," whether she can "think about" making monthly deposits to his New York bank account, half to Villon for the etchings and half towards *Maïastra* [10.7.1930], Dee tells her that from this sculpture (which is made up of several elements) "the marble bird and the soft stone piece" should be removed from the garden for the winter.

1933. Monday, New York City
As there has been no response, it now seems unlikely that the Arts Club of Chicago will accept the conditions for taking the Brancusi exhibition [17.11.1933] and, before the show closes at the gallery on 13 January, Joseph Brummer would like a decision concerning the plaster casts of 5 pieces of sculpture. Marcel asks Brancusi: "Do you wish them sent back to you or do you wish to give them to museums in America?"

In a separate letter to Brancusi, Marcel recounts his visit on Saturday to Philadelphia and on the possible sale comments: "It's a very serious hope, but a hope." Otherwise there is a "small collector in New York who has amorous eyes for *La Sorcière*", and Marcel insists that the sculptor decide immediately whether he wants the instalments to be paid in francs or in dollars.

1935. Wednesday, Paris
After his visit on Saturday, Totor calls again to see Roché in Arago.

1947. Thursday, New York City
Replying in haste by telegram, Dee confirms to Miss Dreier that the letter to Hamilton [8.12.1947] was mailed a week ago, that he is in favour of "a contribution toward the Yale Building" and that he will go to the Plaza auction gallery [12.9.1947] tomorrow.

1949. Sunday, New York City
"My plane made Chicago–N.Y. in less than 3 hours [12.12.1949]," Marcel tells Louise and Walter Arensberg. "This makes me wonder if some day our grandsons (!!) will casually say: 'I am going to Chicago yesterday'." He encloses the photographs of his early pictures recently unearthed by Villon [2.12.1949] including *L'Eglise de Blainville*, one of his first oils. In a deft Impressionist style, it was painted when he was fifteen from the garden of his home: viewed across the grassy bank, the ancient walnut tree masks the spire of the church where Marcel was baptized [7.7.1888].

1950. Monday, New York City
On receiving the document announced in Walter Arensberg's telegram [15.12.1950], Duchamp gives his formal agreement to a Special Meeting of the Board of Trustees of the Francis Bacon Foundation to be held at 7065 Hillside Avenue. He also consents "to the proposed action to give to the Philadelphia Museum of Art a part of the property belonging to the Francis Bacon Foundation, Incorporated."

1952. Thursday, New York City
In the morning a parcel containing wild rice arrives from Brookes Hubachek. "It is very welcome," Marcel says, thanking his friend, "and I will have it cooked for some friends who love it." Knowing from Brookes' wife that he has had a "very hard autumn", Marcel advises: "Try

to take it easy even if you feel it is impossible."

He informs Brookes that from the Dreier Estate the Art Institute of Chicago has accepted *Leda* by Brancusi "with enthusiasm" and the etchings, "nothing remarkable but an exchange value for the Print Department." [1.11.1952]

1953. Friday, New York City
Marcel and Enrico Donati have seen Fleur Cowles and learnt that *Flair* magazine has indeed folded. For financial reasons Mrs Cowles no longer wants to go ahead with publishing André Breton's "astonishing" document [23.5.1953]. It falls to Marcel to announce the bad news to Breton and tell him that the maquette is his and, if he wishes, that he is completely free to discuss it with other publishers.

Enthusiastic about Breton's new review, *Médium*, which he finds is packed with ideas and news, Marcel is glad to see that something other than conventional art exists in Paris. He suggests, plagiarizing Jarry, that the present academicism could be opposed by "PatArt", and regrets that Picabia is no longer around [30.11.1953] to "patArder". Various articles which have appeared about Picabia, Marcel comments, show how: "the kick of the mule can take the form of the caress for a dog."

1961. Monday, New York City
In spite of his "prompt action", Brookes Hubachek has been unable to influence the decision about *Edtaonisl* for the Musée Cantini [7.12.1961]. "Too bad! too bad!" laments Marcel. "That large Picabia would have looked well in Marseilles!"

"But we have the rice," he continues. "Your wild rice came some days ago – which delighted Teeny and me as much as ever. Thank you a thousand times, and the best holidays for the whole family."

19 December

1909. Sunday, Rouen
Four of the exhibitors, Duchamp, Eugène Tirvert from Blainville, Alfred Le Petit and Pierre Dumont, Duchamp's talented contemporary at the Lycée Corneille [3.10.1899] and president of the new Société de Peinture Moderne

which was founded in May, have each made original posters announcing the association's first exhibition. Made from a sketch representing a gentleman in a top hat surveying the paintings on show, Duchamp's poster vies for attention with the fancy goods displayed in the "Caprice" shop window at 81 Rue Grand-Pont, situated between the River Seine and the great cathedral.

Grouping the work of younger members of the Ecole de Rouen with certain of Dumont's Parisian friends, including Francis Picabia, the exhibition opens in the afternoon at the Salle Boieldieu, 65 Rue Ganterie. In addition to the two landscapes already shown at the Salon d'Automne [1.10.1909], Duchamp exhibits *Bords de Seine* and *Saint Sébastien*, the subject of which is one of the painted wooden statues in the chapel dedicated to the Virgin in the ancient church of Veules-les-Roses. In the section reserved for humorist drawings, Duchamp shows three cartoons: *Nuit Blanche* [6.11.1909]; *Digestion* [10.5.1908]; and *Belle-Mère* which one critic finds most amusing but hardly flattering!

1916. Tuesday, New York City
It is their fourth meeting [4.12.1916] and Roché decides that his new friend Duchamp is charming.

1927. Monday, Paris
The last time they met was the day that Roché came to watch one of the games Marcel played in the Tournoi Championnat de Paris [26.10.1927]. In addition to obtaining a very good position in the tournament – fourth out of fourteen competitors – Marcel has been awarded the Brilliancy Prize for his game against A. Baratz (the winner of the tournament).

Today, on a bitterly cold morning, Roché calls at 11 Rue Larrey, Marcel tells him about his divorce proceedings [18.11.1927] and then they have lunch together nearby at the Brasserie du Labyrinthe [17.9.1927].

1936. Saturday, Paris
A telegram from Alice Roullier informs Duchamp that his exhibition at the Arts Club of Chicago is scheduled to open on 5 February. She requests shipment by Lefebvre-Foinet of *Le Roi et la Reine traversés par des Nus en Vitesse* [9.10.1912], which belongs to Man Ray, "and anything else you wish…"

(In fact this watercolour belonging to Man

Ray is on loan to the Museum of Modern Art [9.12.1936]).

1946. Thursday, Paris
Totor calls at Arago to see Roché and they have lunch together on the Avenue des Gobelins.

1947. Friday, New York City
Dee is due to visit the Plaza auction gallery on business for Miss Dreier [12.9.1947].

20 December

1909. Monday, Rouen
The day after the opening of the first exhibition of the Société de Peinture Moderne, the *Journal de Rouen* considers that if certain pictures shocked the public "at the first or even second approach – because really too original", there were others, which interested, even captivated the visitors.

Tirvert, Le Petit, and Buttler (the son-in-law of Claude Monet), are highly praised. While Pierre Dumont is described as an "ardent and responsive colourist", Duchamp, writes the journalist, "seeks his impressions in grey tonalities which are not without charm. *Bords de Seine* [19.12.1909] and his *Eglise de Veules* [1.10.1909] particularly stand out."

Camille Lieucy's decorative still-life arrangements attract attention, as does the landscape painting by Picabia: *Bords de la Sedelle Crozant*. The critic declares that the only sculptor in the group, Georges Chauvel, "deserves to be encouraged."

1919. Saturday, Paris
Totor is still in bed when Roché calls at 32 Avenue Charles Floquet to return his wooden chesspieces [22.6.1919]. Finding them very handsome and not wanting them to "disappear", Roché recently took the set to be cast: thankfully the operation is successful and the pieces have reproduced very beautifully. In Picabia's old studio [9.8.1919] Roché sits on Totor's bed and they have a long talk.

1926. Monday, New York City
Marcel invites Henry McBride to come to the Fifth Avenue Theatre at ten minutes past six

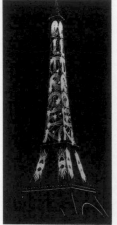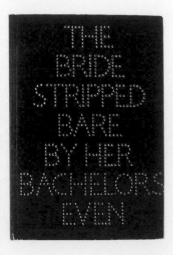

20.12.1959

21.12.1908

on Wednesday: "My film *Anémic Cinéma* [30.8.1926] takes 8 minutes," he explains. "Hope to see you."

1949. Tuesday, New York City
Goaded by Louise Arensberg to do so when they met briefly in Chicago [12.12.1949], Marcel posts his reactions to Helen Freeman's writings [11.9.1949]. "Obviously I as ego was very little concerned and objectively I enjoyed the reading thoroughly," he claims. After reading this "inner description" which is Helen Freeman's very personal and passionate view of his contribution to art, Duchamp says: "I found myself realizing a wonderful non-dimensional, timeless continuum where wordless thoughts through paints are the only apparition transferable to another 'human being'.

"Now if you accept, for a moment," he continues, "the complete disassociation of the signer of this letter and the hero of your perception, I can tell you that it is very sad for the artist in general, not to be conscious of what his work carries or implies and not to be able to realize that what he wants to express has nothing and *can't* have anything to do with the inner significance. This complete divorce that you divulge so rightly, makes me think of the unimportance, of the nonsensical entity of the artist as opposed to the all mighty position of the work, in relation to which the artist is only a blind medium.

"*Bête comme un artiste* seems to apply perfectly," Marcel concludes, "long live the works, superior animals in a timeless and a-dimensional world."

1959. Sunday, New York City
"Thank you for the Alloway article, I must say, not too happy over 'Our' accomplishments," writes Duchamp to Anthony Hill, referring to the sarcastic review of Robert Lebel's book [14.9.1959] in which he is described as a kind of "Duke of Windsor" of art.

"Received yours," Duchamp continues, "and [Andrew] Forge's pleasantly flattering, not polemicky [Duchamp highlights the 'k'] and full of meat" (the talk broadcast by the BBC and published in the *Listener*).

*

Looking forward to receiving the tape of the BBC interview broadcast on 13 November, Duchamp tells Richard Hamilton: "also received most of the good articles (mainly the *Listener*) even Alloway's, a little hard to swallow…"

Concerning Hamilton's work on the typographic version [18.10.1959] of the Green Box, Duchamp adds: "Bravo for the Citroën, the title page you sent me is perfect…" (In 1925 the French car manufacturer displayed its name in 250,000 light bulbs on the Eiffel Tower.)

*

"OK for the 2 cabarets," decides Duchamp referring to the proposal to use the *Rotoreliefs* [30.8.1935] for Bernardin's shows at the SOHO and the Crazy Horse Saloon in Paris. He instructs Daniel Spoerri, however, to "tell Tinguely to supervise the execution (enlargement). It would be good also that we don't do all this for nothing… I leave you, as well as Tinguely, to decide on the amount to ask for."

1964. Sunday, New York City
Thanking Richard Hamilton for the "very beautiful" photo, Marcel says: "although the small one is already printed, we may have time to change it… Catalogue *almost* ready." The reproductions by SEPA [13.12.1964] have arrived, confirms Marcel. "Embossing not finished yet but soon… All is well."

1965. Monday, New York City
In the afternoon Duchamp cables the director, Evan Turner, requesting an afternoon meeting with him at the Philadelphia Museum of Art on either 28 or 29 December.

21 December

1908. Monday, Massiac
Catherine Méry, Marcel's paternal grandmother, dies at the age of 87. Catherine was the daughter of Louise and François Méry, a ropemaker, who lived at Brassaquet near Brassac, about 30 kilometres north of Massiac in the Auvergne. At Brassac on 28 July 1841, shortly after her twentieth birthday, Catherine married Jean, a saddler from Massiac, son of the innkeeper Antoine Duchamp. The eldest of their four sons, Pierre, who became a postmaster in Paris, was born the following year; Méry, Marcel's godfather [7.7.1888], was born in 1844; Jean-Baptiste, who was born in 1845, died when he was twenty; their youngest son Eugène, Marcel's father [28.7.1887], was born in 1848.

After the death of her husband on 31 January 1874, Catherine continued to run the Café de la Paix, situated by the bridge where the main road from Paris to Perpignan crosses the River Alagnon, whence her nickname "Duchamp du pont".

As well as receiving the family at Massiac [1.9.1904], Catherine Duchamp herself visited Blainville regularly, and was often photographed with the family in the garden. She gave a missal to each of her grandchildren on the occasion of their first communion. Among Marcel's early watercolours are those of his grandmother sewing or crocheting, and he also etched a very fine portrait of her.

1916. Thursday, New York City
Duchamp and Roché are among the guests at a dinner party given by Louise and Walter Arensberg.

1934. Friday, Paris
Receives a letter from Alice Roullier enclosing a cheque in payment for copies of the Green Box [16.10.1934].

1942. Monday, New York City
At eleven o'clock in the morning Joseph Cornell [30.11.1942] calls to see Duchamp at 56 Seventh Avenue [2.10.1942]. The room is "a mess with débris" according to Cornell, but he is impressed with the view.

They talk for a couple of hours and, before Cornell leaves, Duchamp presents him with an on-the-spot readymade: a glue carton "gimme strength".

1945. Friday, New York City
In a discussion, Alfred Barr asks Duchamp a number of questions about his work. Duchamp mentions an analogy between his *Nu descendant un Escalier* [18.3.1912] and Sir Edward Burne-Jones' picture, *Golden Stairs*, which leads Barr to enquire whether Duchamp was aware of an analogy between the Large Glass and the As-

Wind—for the draft pistons

Skill—for the holes

Weight—for the standard-stops

to be developed—

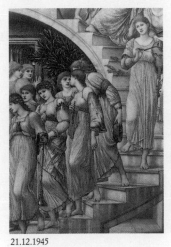

21.12.1945 22.12.1923

sumption of the Virgin. Duchamp replies "No", not while he was working on it, but a religious element nevertheless appears in the title of the work. *Mise à nu*, he points out, is the same expression used in one of the Stations of the Cross, when Christ is stripped bare.

Asked why he used accident and chance in the Glass, Duchamp says that it was one of two ways of avoiding "the personal subconscious element in art", the other being the mechanical way of drawing the objects. The methods of creating accidents in the Glass, Duchamp explains, were gravity (*3 Stoppages Etalon* [19.5.1914]), wind (*Piston de Courant d'Air* [21.5.1914] for the Milky Way), and skill when he used a toy cannon to position the holes made by 9 Shots.

1946. Saturday, Paris
"Thank you my dear Lebel, I am not free on Christmas Eve – unfortunately," writes Duchamp. "Excuse me for having replied to your 2 express letters so late. I have my visa [10.12.1946] and expect to leave in January."

1954. Tuesday, Paris
At five in the afternoon Roché calls to see Totor in Arago and they discuss plans for an exhibition [of Roché's collection] at the Galerie Creuze [?].

1957. Saturday, Washington
Gathered in the capital for a symposium on modern art, Duchamp, Hans Richter and Sir Herbert Read give an informal press conference at the home of Robert Richman, the director of the Institute of Contemporary Arts. Paul Sampson of the *Washington Post* refers to the three men as "veterans of the Surrealist wars" who agree that art has become such big business that it should be included in the Dow Jones index.

"Art is a marvellous investment for people who would rather buy a painting than Standard Oil," asserts Duchamp. He refers also to the change in the attitude of the general public: "Before, a layman would go to the Louvre, take his hat off and look at the pictures. Now he goes and says I like this and I don't like that."

Both Richter and Duchamp tell the reporter that they would prefer to be called individuals rather than Surrealists. When questioned about Salvador Dali, one of the most flamboyant artists, Duchamp comments: "Dali made a very sincere attempt at nonconformity. It's very simple to be newly reintroducing the old

techniques. A great principle in Dali's life is contradiction. What he says on Wednesday he doesn't believe on Thursday."

1962. Friday, New York City
In the evening, Duchamp has promised to attend Kay Boyle's lecture at the New School, starting at eight-fifteen [24.11.1962].

1963. Saturday, New York City
Duchamp writes a letter each to Robert Lebel and Bernard Monnier, his son-in-law, concerning the payment to M. Marquère, who has restored the 21 damaged pictures by Crotti, and the transport of the remaining 175 works to Odoul's storage [8.11.1963]. To both of them he remarks that Christmas is "la foire au pin des pisses" [Duchamp's pun on "la foire au pain d'épices"].

*

In the evening the "famous projects" for renovating the studio at 5 Rue Parmentier [8.11.1963] arrive which "look perfect".

1965. Tuesday, New York City
Further to his telegram the previous day, Duchamp makes an appointment by telephone to see Evan Turner at three o'clock on 5 January.

1967. Thursday, New York City
For the first time a spaceship with a man aboard circles the moon. Before they go to Virginia for Christmas, in the evening Monique Fong and her husband Klaus Wust call to see the Duchamps at 28 West 10th Street.

In the midst of a happy, relaxed conversation there is a lull and Duchamp suddenly asks: "Who is going to die next year?"

No one speaks. He continues: "Last year it was Breton, this year Magritte, next year—"

Klaus interrupts him with a lighthearted remark, but it is not enough to dispel their fears.

On leaving, Monique notices on the mantelpiece a letter with foreign stamps and an address that she recognizes. "Have you received a letter from the ambassador?"

"Yes," replies Duchamp, inviting Monique to read it. It is a short letter from Octavio Paz, the Mexican ambassador to India, announcing that the French edition of his essay, *Marcel Duchamp ou Le Château de la pureté*, translated by Monique [7.5.1967], is due to be published in January and that there will also be an English version. Paz explains that it is Nathaniel Tarn, a

young poet introduced to him by Monique, who is responsible for the publication…

"You know who is Nathaniel Tarn?" questions Monique, "It's M. T., the pedagogue [7.3.1953]."

"It's amusing," remarks Duchamp.

22 December

1923. Saturday, Paris
After having lunch with Man Ray, Duchamp replies to a note from Jacques Doucet enquiring about pictures by Georges Seurat. "His *poudreuse*, I believe, belongs to an American collection," says Duchamp. "*Le Chahut,* which is, I think, his best – I have no idea where it is." He has heard that Paul Signac or Lucie Cousturier, "those infamous *pasticheurs*," had some in their collections, otherwise he doesn't think any of the "ten or twelve important things that he did are in a museum".

1926. Wednesday, New York City
"I am too stupid!" exclaims Rrose Sélavy afterwards, "or too moved! in showing the movie…" Jane Heap and another "soul" were on the fourth floor waiting for a signal from Rrose (which never came) to attend the screening of *Anémic Cinéma* [30.8.1926] at ten past six in the Fifth Avenue Theater. "With love and desolation," Rrose promises them "a special performance" on her return from Chicago in January.

1933. Friday, New York City
"Thank you dear Carl for the avalanche of good photos [14.12.1933]," writes Duchamp to van Vechten.

1934. Saturday, Paris
Marcel has discovered that the quickest way now to send the two "de luxe" copies of the Green Box [16.10.1934] and the ordinary copy, which is a gift from him to Alice Roullier, is by the *Champlain* leaving on 3 January. By arranging for a New York "broker" to collect the parcel from customs and forward it express to Chicago, Alice should receive her order around 14 January.

"Now thank you for having worked so well," Marcel tells Alice, whose cheque arrived the day before.

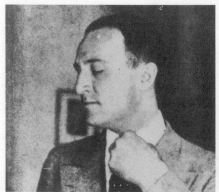

23.12.1960

24.12.1907

"Of course it's remarkable in our times to still find some friends for unnecessary expenditure. Let's hope that in showing the book [the Green Box], other enthusiasts will make up their minds." Marcel has sold 10 "de luxe" copies so far and the others are selling "pretty well".

At the request of Skira, Marcel wonders who might distribute *Minotaure* in Chicago. Would the Arts Club be interested? Marcel encloses a recent issue [5.12.1934] in his parcel for Alice.

1939. Friday, Paris
Back at Rue Hallé after two months' absence [2.11.1939], Mary Reynolds and Marcel call on Roché. From their discussions, Mary does not appear to have enjoyed being in the south very much during this period of war [3.9.1939].

1944. Friday, New York City
At three-thirty in the afternoon Duchamp and Frederick Kiesler have a meeting at *View* magazine to discuss a special Duchamp issue. As reproductions of his work will be published, Duchamp cables Arensberg in Hollywood asking him to wire the address of Sam Little, who photographed his pictures before the war.

1951. Saturday, New York City
Duchamp spends the evening with Monique Fong, whom he saw the previous Sunday. They discuss MT, particularly in relation to Monique; Duchamp believes that they will be married but that "the difficulties will not be resolved for so little". He advises Monique to be less reserved.

1952. Sunday, New York City
Cabling Henri Marceau to ask whether the Large Glass (now formally accepted by the museum [24.11.1952]) could be transported to Philadelphia [19.11.1952] on 30 December, Duchamp adds: "Four strong men needed."

*

Having finalized André Breton's contract with *Flair* magazine [12.12.1952], Marcel writes to Breton explaining that the basis is now 30 pages for the almanac instead of 50; the deadline for the maquette is 1 March, which Marcel hopes can be met; the translator will be Lionel Abel. Meanwhile Marcel requests Breton to send him a list of the proposed reproductions as soon as possible.

1961. Friday, New York City
"It gave me much pleasure to reread what you showed me at Seillans, as well as the new texts

for me on Man, Arp, etc." writes Marcel to Patrick Waldberg, whose book *Mains et Merveilles* has been republished. Marcel thanks him for this "private" copy, "and also for the perspicacious and microscopian contents."

1966. Thursday, New York City
Robert Lebel has written to say that he has "persuaded" Dorival [1.11.1966] to mount a Duchamp exhibition in Paris after the one of "Brothers and Sister" to be held in Rouen. For this "first" in France, Lebel says that he and Dorival would prefer not to repeat the Tate Gallery's "error" [16.6.1966] of including the replicas made by Schwarz and Hamilton. Have the loans from Philadelphia been confirmed? Could the loan be extended of *Tu m'* [8.7.1918], presently in the exhibition at the Musée National d'Art Moderne: "Dada 1916–1966"?

Duchamp supposes that Evan Turner, who "in principle was not against" lending [26.10.1966], is waiting for a decision from his committee. "In theory," emphasizes Duchamp, "everything at Rouen in April goes to Paris in May." Although he has written to Andrew Ritchie at Yale for *Tu m'*, it would be advisable for Dorival to request an extension officially. "Impossible for the glass: the Malic Moulds [19.1.1915] – they are senile and no longer travel." As for the early works, Duchamp is still trying to contact Mary Sisler [28.11.1966].

*

The Duchamps receive a short visit from Monique Fong.

1967. Friday, New York City
On a piece of card from the parcel sent from Pasadena containing 20 reproductions of *3 Stoppages Etalon* [19.5.1914] destined for the *Boîte-en-Valise* [7.1.1941], Marcel asks Jackie Monnier if she has been able to obtain the missing magazine reproductions in colour of Dumouchel.

23 December

1916. Saturday, New York City
As a result of his visit at the beginning of the month to the Carroll Galleries to enquire about the sum owed to Villon, Duchamp receives a note from Miss Bryant, the director

of the gallery enclosing a draft for 1,080 francs.

1944. Saturday, New York City
Having declined the invitation to join the Dreier family Christmas gathering on Monday, Dee has lunch with Miss Dreier today. He talks a lot about his family and, with the alarming news of the German offensive in the Ardennes, voices his fears that the Germans may enter Paris again and this time not spare it.

1952. Tuesday, New York City
Duchamp receives a reply from Marceau to his cable of the previous day advising him that a truck will pick up the Large Glass from Milford on 30 December, weather permitting.

1958. Tuesday, New York City
"Thanks a thousand times for sending the photostats [13.12.1958]," writes Duchamp to Zigrosser. "They are remarkably done and thanks too for sending them to George Hamilton."

1960. Friday, Paris
Asked at the beginning of the third interview with Georges Charbonnier [16.12.1960], which is broadcast on France Culture, for his judgment on the whole of the Surrealist period, Duchamp replies that although the Surrealists don't like to speak about their Dada origins very much, it is interesting to look at the passage from one to the other.

And yet a certain number of Dada members were members of the Surrealist movement, remarks Charbonnier. Tzara, Picabia…

"Completely. The members were exactly the same: Breton, Aragon, Eluard, Rigaud (who later committed suicide), Soupault naturally… Picabia and me, we were old already. We understood that even to laugh, even to mock, even to destroy becomes boring after a while when it has become a habit. Any habit can become boring. In the end, after being Dada for four or five years, they needed a change. To pass from one habit to another. The Surrealist habit, which was born in 1924, still exists. So it is more solid, more general. It is clear that when you destroy something rapidly, you cannot continue to destroy it."

The repercussions were not yet known…

"Not at all, even." Duchamp explains that while "it had a vein of Dada", Surrealism did not "rebuild on the Dada debris" but had the idea of "taking into consideration the unconscious

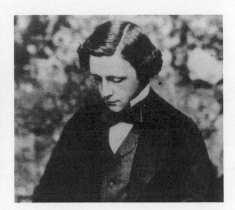

24.12.1917

which Dada had not touched at all. And that," declares Duchamp, " was really the basis of Surrealism: the state of hallucination, dreams, phenomena of the unconscious that few artists before, or few writers, had even thought of mentioning or using. Obviously the existence of Freud is not without good reason in all that. But it is natural that a work like Freud's can have an echo in the domain of art." Naturally in a fairly large group of ten or twelve principal characters, there was not only agreement but sometimes differences. "Then they had to deal with politics, or at least to have an attitude without being squarely on one side or the other, on the contrary, they tried to create a new political formula or new society themselves. Not that they went very far in this domain but it was their intention.

"So, this Surrealism which started as a literary movement, became a much more general movement and that's why it still exists. ... Cubism, after all, was a painting movement, exclusively so to speak. There was very little Cubist literature, also very little Cubist sculpture. Whereas Surrealism was a movement which encompassed all sorts of activities which have almost nothing to do with painting or the plastic arts."

Why is it that very few were drawn from Cubism to Surrealism?

"Age. The difference in age, and then the war... Surrealism was created by young people aged 17, 18, 19, 20 – really a big generation gap which did not even have an antithesis. It was not a revolution essentially against Cubism, not at all."

Charbonnier thinks that there is now a mixture of influences and, taking a shop window as an example, he believes it would be difficult for the general public to tell whether the Surrealists or Fernand Léger were responsible for the style of the display.

"As soon as decorative art, like the shop window, takes over an idea like Surrealism or Cubism, first it damages it completely and makes something vulgarized of it, which only very vaguely echoes the Cubist or Surrealist origins of the question. This public application of these movements is really hardly interesting." Duchamp points out that whereas the Cubist influence was limited to the Cubist forms given to objects, "there is no Surrealist form, there is a Surrealist spirit."

The Dadas and Surrealists didn't think of destroying Cubism?

"Yes. In a theoretical way. They did not destroy it, but they stopped it. After 1920 the Cubist movement was continued, but all the Cubists changed their style – all of them. And each one became a name. Each one is spoken of as having started in the Cubist movement and having developed into an individual."

That is the case of Picabia, Villon, Braque...
"Exactly."

What about Picasso?

"Obviously Picasso, with his great vision, was able to encompass Cubism, Surrealism, as well as other forms for which we have no names but which we call Picasso. It is always the individual that interests me more than the movements, which simply serve to group the young."

Our language no longer provides us with precise enough symbols. To rely on something solid, we can no longer rely on language. Were the Surrealists conscious of this?

"Certainly. Every 50 years, or every 30 years there is a need of complete change, in language above all... It's clearer in our period, more glaring. Our period demands more of language than other periods. A reproach that I make – completely personal – is this need to use words whether new or old to translate consciousness or, if you prefer, what happens in us. It is a formula in which I don't believe at all, that language or words can translate in an exact or precise way everything that really happens in the world, that is to say what happens within the individual and not outside the individual. The translation by words of these phenomena is very approximate, more than approximate and often untrue. ... The word has taken a position of king. The power that the word has taken in modern life, and we see it even in advertisements – the vocabulary of advertisements, is an extraordinary thing. If you compare the advertisements of 1920 and the advertisements of 1960, you are flabbergasted. Me arriving from another country, America, I don't understand most of the words that I read. Newly made words which are of Greek origin, but which have been made in the last ten years, exist in all countries; this deformation or reconstruction, I think is greater now in the last twenty years than it has ever been."

1962. Sunday, New York City
"I read your letter with amazement and tried to recall my 1911 activities," writes Duchamp to Gorsline, who has sent him the notes of

their meeting [24.11.1962]. "I still have a visual recollection of looking at an illustrated magazine (if not *L'Illustration*) but I can't decide where I was when I looked at these diagrammatic photos of Marey or maybe of Eakins and Muybridge." Saying that in 1911 he had no knowledge of their names, Duchamp says: "I suppose I saw the photos and did not pay much attention to the names or name."

As Gorsline is going to France to continue his research, Duchamp suggests he telephone Suzanne Crotti, but doubts "whether she will remember any important detail".

1965. Thursday, New York City
The Duchamps post Naum and Miriam Gabo a card of Charlie Chaplin in *Modern Times* to wish them a merry Christmas and happy 1966.

24 December

1907. Tuesday, Paris
Marcel has engraved the menu for his Christmas Eve party: a nude is sitting in a giant glass of champagne tilting a bottle to her lips and downing the last dregs from it. At 73 Rue Caulaincourt, his address since he moved in the summer from number 65 [5.11.1906], Marcel provides his guests with oysters to start with, hors d'œuvres followed by a seasonal stuffed turkey as the main course, salad and various pâtés. The desserts in plural are heralded by "Plump pudding" [sic], a tradition with Marcel, who always provides one at Christmas time for his friends Tribout and Dumouchel. Wine, liqueurs and champagne are in plentiful supply.

The party rages on for two days, much to the dismay of the neighbours. As a result Marcel's tenancy at number 73 is short-lived: his landlord gives him six months' notice to quit.

1917. Monday, New York City
"Merry Xmas my kindest thoughts of you take good care of Mad," is Jean Crotti's cable to Marcel.

Since Marcel issued the invitation [6.12.1917], Mad Turban has been staying at 33 West 67th Street. While he has his hours to put in for the French Mission [9.10.1917], guaranteeing his punctuality every morning with an effi-

24.12.1957

24.12.1963

cient but complicated multiple alarm system set in plates filled with coins, Mad works for the Red Cross. In the evenings, Marcel gives French conversation lessons using his Lewis Carroll text books and introduces Mad to some of his pupils: Miss Dreier is suspicious when Marcel introduces her as his sister Magdeleine…; one of the prettiest is Jane Acker, an actress working for Metro Pictures. Louise Norton often accompanies them to dine with Joseph Stella in various downtown trattorias. Invariably the evenings end at the Arensbergs' apartment and with chess until the early hours of the morning.

1926. Friday, New York City
"Merry Christmas dear Miss Roullier," writes Duchamp, confirming his arrival in Chicago on 2 January. "If, in spite of Sunday, you can have a man to open the cases [16.12.1926] that would be perfect and I could do a lot of work Sunday afternoon and evening." He has decided to send an additional case containing a bronze bird, the most recent made by Brancusi, which "will be one of the important centres of the exhibition".

Thinking that it is not necessary for him to stay in too expensive a place, Duchamp says that he counts on her to find him "a medium-scale hotel".

1942. Thursday, New York City
Stefi Kiesler has been working all day preparing her Christmas Eve party, which is attended by a number of friends including Marcel, Matta, Louise and Edgar Varèse, Robert Parker and his wife, Howard Putzel and John Cage, who brings a dancer [Merce Cunningham?].

1946. Tuesday, Paris
"I think it is still unwise to trust things to the uncertainty of post," Duchamp advises Jean Brun and promises that when he sees Matta in New York he will try to make different arrangements. Bellmer should give his things to someone coming to Paris, "this someone," explains Duchamp will hand them to Mary Reynolds who will do the rest…"

1947. Wednesday, Milford
After the snowstorm the day before, there is "perfect sunlight and sparkling snow and no wind" when Dee arrives from New York to have lunch with Miss Dreier.

In the sun room, Miss Dreier has hung a festive wreath against the garden door and built her

crèche on the long table against a background of balsam branches. As the room gets very cold at night, she decides to hold their short Christmas celebration at five, "just at twilight."

The climax to their "grand Christmas dinner" after the turkey is "English Plum pudding with burning blue flames caused by the French brandy and sugar poured over it". Dee has brought a half bottle of 1934 Veuve Cliquot, which Miss Dreier confesses is delicious.

"It was lovely having Dee," Miss Dreier tells her sister Mary, "and he was made very happy by your gift. As always we had a lot to talk about in relation to Art. He really is very profound."

When Dee goes to bed, Miss Dreier returns to the piano to sing some Christmas carols.

1951. Monday, New York City
Writes to thank Alfred Barr for stating the position regarding the royalties due to Villon [25.6.1951], and adds: "Everything is fine as you have arranged it and I am very grateful to you."

1952. Wednesday, New York City
"Everything OK for *Adam et Eve*," Marcel tells Roché and confirms that he has written to Dorival about the refusal for the painting King and Queen [14.12.1952]. "For your glass, have it carried by someone, upright, as we did for the Surrealist exhibition at Wildenstein's [17.1.1938]."

1956. Monday, New York City
After seeing the rushes of the 16mm film shot by Richter on 11 December, Marcel promises Roché that he will send him a reel of it.

*

Marcel gets home early to be with Peter, Paul and Teeny at five o'clock, the time when a call has been booked to Jackie, Teeny's daughter, in Paris. At five-thirty a friend telephones and Teeny decides on the spur of the moment to invite her to dinner with two others, instead of them staying on their own.

Later in the evening, the call to Paris has still not come through. Teeny serves "a most beautiful baby pig! Stuffed with barley, chestnuts and sausage," and Marcel carves it, "like a master."

1957. Tuesday, New York City
Early in the morning Paul Matisse arrives to decorate Teeny's "little alive tree", bringing "an apparatus to hold a lot of candles, with stars on the end to balance them".

At noon the telephone rings and it is a tele-

gram from Jackie, but Teeny asks the cable company to make the call again at eight that same evening, when Peter Matisse and the Hares have arrived. "It was perfect timing – great fun."

David Hare brings "an extraordinary crown", a repetition of the one he had made for Marcel's 70th birthday in East Hampton [28.7.1957]. Denise Hare takes a photograph of Marcel wearing it, as the one taken in July did not come out.

1958. Wednesday, Boston
Paul Matisse who is to be married on 27 December has invited his brother Peter, Teeny and Marcel to celebrate Christmas Eve, just the four of them, at his apartment.

1959. Thursday, New York City
In the late afternoon Duchamp receives a telegram from Jean Cocteau [3.11.1959] in Saint-Jean-Cap-Ferrat: "Devoted wishes full-face and profile."

1960. Saturday, New York City
A card from Marjorie and Brookes Hubachek arrives with their gift of wild rice.

1961. Sunday, New York City
Teeny and Marcel have "a very nice and quiet Christmas Eve" all by themselves. But they have an unexpected guest. While Denise Hare is away, Teeny is looking after her magpie, who is "very entertaining and talks a funny language from another planet".

1963. Tuesday, New York City
Marcel is very sad at the news of Tristan Tzara's death in Paris at the age of 67. They had last met in Rome during the summer [20.5.1963]. Marcel keeps repeating: "Poor Tzara, he was so young…"

*

A beautiful white azalea, "like a tree," has arrived from Jackie and Bernard Monnier, "with the Christmas greens the room really looks lovely." To celebrate Christmas Eve, the Duchamps have invited their friends Gardie [6.8.1954] and Mike.

1965. Friday, Boston
In the afternoon Teeny and Marcel arrive from New York to spend Christmas with Paul Matisse and his family. They visit the Gallery of Contemporary Art where Paul is exhibiting his *kalliroscope* in a show called "Art turned on".

25.12.1960

25 December

1916. Monday, New York City
Having finally received the draft of 1,080 francs from Miss Bryant on Saturday with a note saying that Quinn had spoken to her about it, Duchamp writes to thank Quinn and adds: "I am very sorry to have disturbed you with such stories [18.12.1916]."

1918. Wednesday, Buenos Aires
Christmas in a heat of 90° F "is a novelty" for Marcel.

1929. Wednesday, Paris
With the caveat "Impossible to write" at the top of a piece of ruled ledger paper, Dee replies concisely to letters from Miss Dreier which he found on his return from Nice [9.12.1929] and a cable that arrived a week earlier. Although he plans to go back to the Côte d'Azur at the end of January, his return to Paris in the spring, he says, "seems to coincide with the end of your trip to Germany." He mentions that he is "working a lot" and declares: "I have stopped smoking entirely and gained 5lbs in 2 weeks!! Maybe my mind will also gain (not in weight!)."

1943. Saturday, New York City
Dee spends Christmas with Miss Dreier at her apartment at 100 West 55th Street. He is very touched by the gift awaiting him with a card from Mary Dreier.

1947. Thursday, Milford
After staying overnight and spending Christmas Day with Miss Dreier, Dee returns to New York.

1948. Saturday, Milford
Dee spends Christmas with Miss Dreier.

1949. Sunday, New York City
"Received your letter safely and almost at the same time the long text, which filled me with joy," writes Duchamp to Jean Suquet, who has been working on his project since the summer [9.8.1949]. "Certainly you know that you are the only person in the world to have reconstructed the gestation of the Glass [5.2.1923] in

its detail, with the numerous intentions, never executed even. Your patient work enabled me to relive a long period of years when the notes of the Green Box were written while the glass was taking form; and I admit that, not having read these notes for a very long time, I had completely forgotten many points, not illustrated on the glass, which still delight me."

Duchamp tells Suquet what a revelation it was for him to see a performance at the Théâtre Antoine of *Impressions d'Afrique* [4.6.1912]. "Even today," says Duchamp "I consider Raymond Roussel more especially important as he has no followers."
Duchamp invites Suquet to reproduce whatever he considers necessary for his "illuminating" text including the enigmatic drawing from the *Boîte de 1914*, which also comprises 16 manuscript texts.

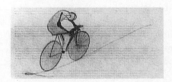

"*Avoir l'apprenti dans le soleil* if I remember exactly the phrase accompanying the silhouette of a cyclist climbing a hill, belonged to a series of short texts in a box for photographic plates (1912 or 1913?); I am happy that you were able to see a copy (there were only 3) at Villon's…
"An important point also that you have sensed very precisely relates to the idea that the Glass in fact is not made to be looked at (with 'aesthetic' eyes); it should be accompanied by a text of 'literature' as amorphous as possible, which never took form; and the two elements glass for the eyes, text for the ears, should be complementary and above all prevent one or the other from taking an aesthetico-plastic or literary form. Finally, I owe you more than I can repay for having stripped bare my stripped bare…"

*

Remarking that it is years rather than months without contact, Marcel tells Breton that he remains externally inactive but that current stupidi-

ties, however, petrify him spiritually. He praises Jean Suquet's precision and perception and declares that the publication of the text would clarify his "pseudo-obscurities" for a lot of people.
After hearing of Breton's present state of affairs from Donati, Marcel proposes to see whether an American review would publish a monthly column on European affairs and asks Breton what he thinks of the idea and what level of remuneration he would require. If Breton is prepared to part with anything from his collection, Marcel suggests that with photographs he could approach museums or collectors.

1950. Monday, New York City
"Because we live too long, we are condemned to see others die," writes Marcel to Suzanne and Jean Crotti, who have announced the death of a friend.
Since he returned to New York [2.12.1950], Marcel has seen Elizabeth Humes and Mary's brother Brookes Hubachek: "He is really very distressed," Marcel says, "and showed considerable gratitude to me for having done what I could to arrange Mary's affairs [14.10.1950]."

1953. Friday, Lebanon
Marcel spends Christmas in the country with Alexina Matisse, who is known to everyone as Teeny, and her three adult children, Jacqueline, Paul and Peter. Teeny, who was divorced from Pierre Matisse in 1949, lives about an hour and a half's drive due west of New York. They bought the farmhouse in New Jersey for themselves and the children as a place to spend the summers during the war.

1956. Tuesday, New York City
Peter Matisse has already left to attend midnight mass, but it is such a delightful party that everyone else stays until three in the morning.

Throughout Christmas Day, Teeny keeps trying to telephone her daughter Jackie, but in vain.

1957. Wednesday, New York City
Receives a fake tap from Bob Hale as a Christmas present, which he glues to the fireplace wall.

1960. Sunday, New York City
Writes to Mary Dreier on a card of Gentile da Fabriano's *Adorazione dei Magi*: "Even the years have decided to go faster and faster. May 1961 be another good one for you."

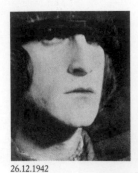

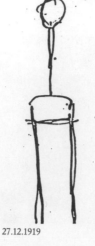

26.12.1942 27.12.1919

"Teeny rejoices at the thought of her favourite game dish," writes Duchamp on a card illustrated with Villon's, *Le Pigeonnier normand*, thanking Marjorie and Brookes Hubachek for the wild rice which arrived the day before.

1961. Monday, New York City
In the evening the Isaacs, Levins and Djuna Barnes come to dinner at 28 West 10th Street.

1962. Tuesday, New York City
As the Museum des 20. Jahrhunderts, Vienna, has returned the replica of *Egouttoir* [15.1.1916] after the closure of the exhibition "Kunst von 1900 bis heute" on 4 November, Werner Hofmann has written to enquire whether Duchamp has another which could be shown permanently in the museum. "Unfortunately I only possess the one replica," is Duchamp's reply. "I suggest that you might buy a bottle rack in Paris at the Bazar de l'Hôtel de Ville, where, I think, they still have the same model."

1963. Wednesday, New York City
Christmas lunch at Denise Hare's is "a pagan feast. A whole pig surrounded by squabs…" When the Duchamps return home at seven-thirty in the evening, Teeny tries unsuccessfully to telephone Jackie, who sent her a white azalea and ties for Marcel.

1966. Sunday, Paris
"Lewis Carroll, maître d'école buissonnière," is broadcast by the ORTF. Directed by Jacques B. Brunius with the collaboration of Paul Chavasse, the television programme includes an interview with Duchamp.

26 December

1923. Wednesday, Paris
In the morning Duchamp telephones M. Ruaud and makes an appointment to meet him at his studio the following afternoon at two-thirty.
"I hope that the framing will be painless," Duchamp writes to Jacques Doucet in the evening. He promises to let the collector know if the case for the glass, *Glissière contenant un Moulin à Eau en Métaux voisins* [11.12.1919],

can be used to return it to him [8.11.1923]. As he is vacating his studio at 37 Rue Froidevaux at the end of the month, Duchamp asks Doucet whether he wouldn't like to have the glass back before his departure for Rouen on Saturday.

1942. Saturday, New York City
At Kay Boyle's request, Duchamp goes to see the drawings of the artist who is to exhibit with Wols in March. "It will go very well together," he declares to Kay, thanking her at the same time for "such a good evening". Asking when she returns from Monte Carlo, he adds: "It's a pity that Rrose Sélavy did not accept to be your nurse, even dry…"

1956. Wednesday, New York City
When Paul Matisse comes in from his father's party in the early hours he, Marcel and Teeny stay up talking until about four o'clock.

*

Marcel and Teeny are enjoying "a delicious breakfast in bed" when the telephone rings. It is Jackie at last [24.12.1956] and Teeny feels her "Christmas is complete, and a very happy one".

1958. Friday, Boston
Marcel presents his wedding gift to Paul Matisse, who is to be married the following day: it is a green woollen waistcoat, more sober than the one chosen for Benjamin Péret [15.11.1958], the buttons of which bear the letters of his bride's name, S A L L Y.

1965. Sunday, New York City
After spending Christmas with Paul Matisse and his family, Marcel and Teeny return from Boston in time to be at the Fischer [28.9.1965] versus Reshevsky chess game.
"What excitement it was," according to Teeny. "Reshevsky got a terrific position at the beginning and from then on it was a bloody fight, Fischer still managed not to be mated (by a hair's breadth) when they adjourned after 5 hours…"

27 December

1919. Saturday, Le Havre
Before boarding the *Touraine*, due to sail for New York at ten in the evening, Duchamp

writes to Brancusi from the Grand Café Prader, 15 Place Gambetta. "In passing by Rouen, my family gave me a cable from Miss Dreier telling me to buy the sculpture in wood, which I asked you the price of, do you remember which one?" Duchamp draws a diagram of *Little Girl* and asks the sculptor to send it imediately to Miss Dreier. "As soon as I arrive in New York, I will tell Miss Dreier that I have bought this sculpture for her and she will send you 6,000 francs…" [35,000 francs at present values].

As a present for Walter and Louise Arensberg, Duchamp is bringing *Air de Paris*: a small glass ampoule emptied of its "physiological" serum (but still labelled) and resealed by the pharmacist at the corner of the Rue Blomet and the Rue de Vaugirard in Paris.
The *Touraine* finally sails from the harbour at ten minutes to midnight.

1920. Tuesday, New York City
The works of Archipenko have arrived safely for his one-man exhibition, due to open on 1 February at the gallery of the Société Anonyme. Duchamp has already recommended Archipenko's work to the Daniel Gallery and asks the sculptor, one of the first artists to be invited to exhibit by Miss Dreier [8.4.1920], for further guidance on prices.

1923. Thursday, Paris
At two-thirty in the afternoon at his studio at 37 Rue Froidevaux, Duchamp has an appointment with M. Ruaud. Now that the glass has been cleaned [2.11.1923], *Glissière contenant un Moulin à Eau en Métaux voisins* [11.12.1919] is to be placed in its special hinged frame so that it can be hung vertically, enabling the glass to be moved from side to side, casting its shadow according to the angles of the light and its position.
The previous day Duchamp promised Doucet that after this delicate operation he would report to him and inform him whether the glass still fits into its case. Is it at this moment, now that the glass is framed, but before it is delivered to Doucet, that Man Ray photographs it on its side with Duchamp stretched out on his back, behind it on the table, holding it firmly upright with both hands?

1950. Wednesday, New York City
At one-fifteen at the Colony Club, Duchamp is invited to lunch with Miss Dreier, who has also

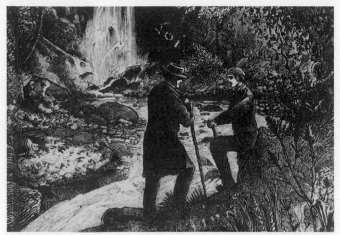

27.12.1955

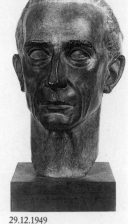

29.12.1949

invited Alfred Barr, the director of the Museum of Modern Art. Miss Dreier has brought with her three panels of drawings of the dancer Adeline Genée by Claire Avery as a gift for the Dance and Theatre Collection of the museum.

*

At three-thirty in Los Angeles, California, as president of the Francis Bacon Foundation, Walter Arensberg signs the Agreement presenting the Louise and Walter Arensberg Collection to the Philadelphia Museum of Art. Louise Arensberg witnesses her husband's signature and the director, Fiske Kimball, witnessed by Julius Ziegst, signs on behalf of the museum. The Foundation agrees to keep the collection until space is available in Philadelphia to receive it and not to remove it from 7065 Hillside Avenue without written permission from the museum. The museum has agreed that the collection will be shown in specified galleries on its own for a period of not less than twenty-five years.

Cock-a-hoop, Kimball sends an ecstatic cable from the Bel-Air Hotel to Henri Marceau in Philadelphia.

1952. Saturday, New York City
"Your letter came like a bombshell and I can only thank you which is a small tribute to your thought," writes Marcel to Brookes Hubachek, who has sent him a cheque for $3,000 in memory of Mary Reynolds [30.9.1950]. While mentioning that he has frequently thought of Marcel "at odd times" and hopes that the world is treating him all right, Brookes comments: "In many respects you have confounded life, for which I congratulate you."

Marcel promises to have the cheque in the bank on Monday and to "start operations" according to Brookes' instructions.

"The Pecans also appeared and are very good and tender as usual," Marcel continues. "It is curious how these festive days give, in America, a feeling much closer to world peace possibilities than in Europe (as I recall them). Dear Brookes, many thanks again for your friendship," Marcel concludes, wishing the Hubacheks "a good, good 1953. After all we can't expect or promise for more than one year ahead nowadays…"

*

In reply to Marceau's cable [23.12.1952], Duchamp announces: "Will arrive Milford before noon Tuesday stop expecting to ride back on truck *bonne année*."

1954. Monday, Paris
After the wedding of Teeny's daughter Jackie Matisse to Bernard Monnier at the Protestant church at 19 Rue Cortambert, the bride and groom are invited by Marcel and Teeny to dine at La Pérouse, the famous old restaurant at 51 Quai des Grands-Augustins.

1955. Tuesday, New York City
Posts a letter to Roché announcing an exhibition project with the collaboration of Louis Carré of the three Duchamp brothers, to be held in Houston and at the Guggenheim Museum early in 1957. "I'm in charge officially," declares Marcel. As James Johnson Sweeny, the director of the Guggenheim, would like to include *9 Moules Mâlic* [19.1.1915], Marcel asks Roché, if he agrees to lend the glass, to make it transportable.

As a Christmas present, Marcel and Teeny have chosen an address book for "Denise and Totor a year after such a good visit to Paris" [6.2.1955]. While the back is covered with the personal columns from a newspaper, the front is decorated with an old print of two gentlemen standing under an arch of a bridge, by a stream, with a waterfall in the background. There are several words scratched in gold on the print; on the arch, *santé*; by the waterfall, *joie*; and on the bank by the two men *affection*.

1958. Saturday, Boston
Marcel and Teeny attend the wedding of Paul Matisse to Sarah Barrett.

1965. Monday, New York City
Sends a note to Donald Gallup at the Beinecke Rare Book and Manuscript Library, Yale University, authorizing Bill Camfield to read his letters, "to make notes or copies of them and to quote passages from them for his work on Picabia [16.12.1963] and modern art in general." Duchamp sends a copy to Camfield and wishes him good luck.

28 December

1925. Monday, Paris
In the morning Marcel returns from Monaco [3.12.1925] – where he has been busy writing

his "roulette system", continuing his stock-exchange transactions by telegram, playing chess and even searching for a piece of land – to attend the wedding of his youngest sister, Magdeleine, who in a civil ceremony at the *mairie* of Neuilly-sur-Seine marries Jacques Edouard Dagnet, an architect from Rouen.

1933. Thursday, New York City
Duchamp has two important pieces of news for Brancusi. A friend of the Meyers, Mr Behrman, has purchased *Le Chef*; and Mrs Rumsey has finally visited the exhibition [17.11.1933] twice and would like to buy *La Muse endormie*. To reassure Brancusi about *L'Oiseau*, Marcel writes: "[Mrs Rumsey] made no remark expressing regret of a fracture, it's like a flaw in the marble accentuated by the transport."[11.11.1933] Should she wish to buy it, Brummer has written to Mrs Meyer about the price of her portrait [11.12.1933].

1948. Tuesday, New York City
Having purchased the Davidson 120 and 50 binders for the Hoppenots for $69.95, Marcel has consulted a shipping agent and discovered that it will cost a further $25 to send them to Bern. "Do you know someone travelling to Switz-erland or to Paris who could bring you the in-strument for nothing," Marcel asks the Hoppenots. "Also," he suggests, "could the French consul send it in a box to you in the diplomatic bag?"

1954. Tuesday, Paris
Roché shows Totor a picture by the American painter Patrick Henry Bruce and a Modigliani.

29 December

1923. Saturday, Paris
At five Duchamp leaves Montparnasse to spend the New Year with his parents in Rouen.

1934. Saturday, Paris
Totor calls to see Roché in Arago and gives him news of Helen Hessel [10.10.1933] with whom he and Mary Reynolds had dinner recently. Helen is well and her son Kadi "superb".

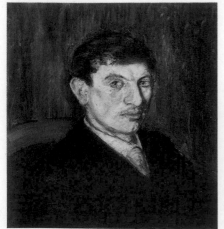

29.12.1949

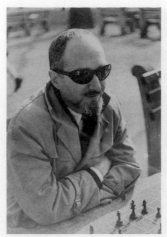

29.12.1964

1949. Thursday, New York City
"I told you that a sculptor, very likable and without any modernist intention, made a bust that was purchased, I believe, by the Musée [National] d'Art Moderne Paris," writes Marcel to Roché. Although he is uncertain whether the bronze is exhibited yet, Marcel "would like to know the comic effect of this bust in", what he considers is "an unattractive *ambiance* for it..."

To Roché's enquiry about the Valise [7.1.1941], Marcel says that he has sold the 20 "de luxe" copies, but that Patricia Matisse, who assembled a certain number, may still have some of the "ordinary" version in a box (without the leather case and without an original), which sell for $100 each.

*

As requested by Marcel, on the back of certain early paintings found at 7 Rue Lemaître including *Portrait de Marcel Lefrançois* and *Portrait de Chauvel* [2.12.1949], Villon certifies that they were painted by his brother.

The portrait of Marcel Lefrançois, nephew of Clémence [18.12.1925] and a friend of Marcel's, which was painted at Blainville in about 1904, "was already a reaction against the Impressionist influence," explains Marcel. "In this painting I wanted to try out a technique of the Renaissance painters consisting in painting first a very precise black and white oil and then, after it was thoroughly dry, adding thin layers of transparent colours. This technique of precision was deliberately in contrast with my first attempts at oil painting and it helped me to keep my freedom of development instead of sticking to one formula. Nevertheless, I abandoned it very soon to direct my research towards all sorts of unsuccessful tries marked by indecision and finally discovered the importance of Cézanne."

1952. Monday, New York City
Receives a cable from Marceau to say that as they will have help in Milford tomorrow, the truck will bring three men instead of four [23.12.1952] permitting Duchamp to ride back with them as far as New York.

1958. Monday, New York City
In the evening at seven-thirty Marcel and Teeny are due to meet Louis Carré at the Stanhope.

1960. Thursday, New York City
A satrapic banquet takes place at Michel Cadoret's [14.11.1960] and it is reported that the

Transcendant Satrapes Marcel Duchamp and Eugène Ionesco, as well as the composer Edgar Varèse, confer on the supreme interest of 'pataphysics in various worlds, including this one.

1961. Saturday, New York City
Writing a Christmas letter to Jackie in Paris, Teeny requests her daughter to keep Marcel's dressing gown: "I never can make him wear it," she comments, "he prefers a raincoat!"

1964. Tuesday, New York City
Duchamp has written on a memorandum slip: "La vache à lait lèche Arman, songe-je," which is published today in the catalogue of Arman's exhibition at the Sidney Janis Gallery.

1967. Friday, New York City
Writes to Louis Carré.

30 December

1920. Thursday, New York City
Duchamp is invited to a tea party which Miss Dreier has organized to introduce her friends to the Chicago-born sculptor John Storrs, and his wife Marguerite. Among those also invited are Florine Stettheimer, Louise and Walter Arensberg, Marsden Hartley, Joseph Stella, Miss Dreier's sisters Mary and Dorothea, Mr and Mrs James Daugherty and Henry McBride. Storrs, who lives in France, is visiting New York for his first one-man exhibition in America at the Folsom Gallery.

1922. Saturday, New York City
In the evening Marcel attends a party given by the Stettheimer sisters, whose guests include Marie Sterner, Pitts Sanborn, Hugo Seligman and Carl van Vechten [9.12.1922].

1933. Saturday, New York City
"Mrs Rumsey has been to the exhibition a third time [28.12.1933] and at last decided to buy *La Muse endormie*," writes Marcel to Brancusi. A deal has been agreed to give her the marble sculpture in exchange for the same subject in plaster, which she already owns, for $1,000.

As the Brooklyn Museum or the Philadelphia Museum of Art [18.12.1933] might be

interested in *La Colonne du Baiser*, Marcel asks Brancusi to let him know by letter immediately if it could be made in cement or some artificial stone and be sold for $1,000, the price for the sculpture in plaster.

1936. Wednesday, Paris
Has a session with Roché at the apartment in Boulevard Arago, to discuss the Brancusis.

1941. Tuesday, Montélimar
Walking past the Bar du Ciné, Totor hears a shout: it is Roché. Having learnt the previous day that Totor is planning to stop in Montélimar on his way to Montpellier, Roché has taken the midday bus into town and is waiting for him. In good spirits, Totor has news of Jules Bublin, their banker friend in Geneva. Worried about how Totor will live, Roché would like to support his friend even for a limited period of time, but he is nervous about committing himself to an "adoption". Discussing a possible exchange, Totor mentions his concept "infra-visible" [a variation of *infra-mince*?] but wonders how he will find a means to express it; otherwise he can propose the tiny model of the urinal which he made to reproduce *Fountain* [9.4.1917] in the *Boîte-en-Valise* [7.1.1941]. Not very keen on the subject of the latter, Roché declares that he would prefer drawings. Totor retorts sarcastically: "Why not watercolours of the Riviera?" He would be driven to it perhaps, he adds morosely, to avoid dying of starvation.

The tension between "creator" and "sleeping partner", however, is short-lived. They have an enjoyable meal at the Relais, followed by a game of chess with an ample supply of chocolate truffles. Applying himself and with the advantage of Totor's Knight, Roché has a clear-cut win. They move to a well-heated brasserie for the second game, which Roché loses in spite of Totor giving him the advantage again of a Knight.

Afterwards Totor accompanies his friend to the bus before setting off for Montpellier, where he is invited to see in the New Year.

1952. Tuesday, Milford
Before noon Duchamp arrives from New York to supervise the loading of the Large Glass onto the truck, which has come to 130 West River Street with three strong men from the Philadelphia Museum of Art. When the Glass is safely on board, Duchamp rides back with the cargo as far as New York.

30.12.1959

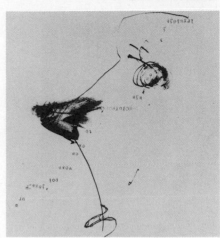

31.12.1915

1955. Friday, New York City
Following his petition sponsored by Alfred Barr Jr. and James Thrall Soby [9.3.1954] and the intervention of Nelson A. Rockefeller [22.11.1955], Duchamp finally becomes an American citizen.

1959. Wednesday, New York City
"Watson Taylor delivered 'your Blessed Sacrament' personally!" Duchamp tells Marcel Jean, explaining that "even before reading it", he finds "the muscular aspect" of *Histoire de la Peinture Surréaliste* imposing. "First of all your wardrobe is so appropriate to open the book!" continues Duchamp, referring to the cover photograph. "Finally everything, colours, photos – details and then the grey matter."

"On the rebound" a dummy arrived in the morning from the publisher which Duchamp considers, "is an object to put on the mantlepiece…"

For the English edition, Duchamp has already put the two chess games into specialized English with Watson Taylor [24.11.1959].

1960. Friday, Paris
Duchamp spends the greater part of his fourth interview with Charbonnier, which is broadcast on France Culture, discussing his interest in movement, the idea of the readymades and his enjoyment of language. Charbonnier admits that he was "excessively disconcerted" the day he was confronted with "nus vites" [9.10.1912].

"It's very simple, it's just a pleasure to play with the words. You know what I think about words [23.12.1960], but as soon as you add poetry, or at least you transform the word of communication into a poetic word, the word becomes like another colour, if you like. I did not invent the word *vite* because it existed then as an adjective: it was said that Mr So-and-So who raced from Paris to Roubaix was *vite* [swift]. It was a semantic novelty at the time. I used it also with the idea, and very important, of introducing laughter in the best sense of the word. Not coarse laughter or mockery, but humour. I considered that all the past, except Rabelais and Jarry, was made of serious people who considered that life was serious and that serious things had to be produced so that serious posterity comprises all that these serious people of that time had made. I wanted to be rid of all that as well…"

In the title *La Mariée mise à nu par ses Célibataires, même* [5.2.1923], Charbonnier asks why Duchamp used the possessive "*her* Bachelors, even".

"What bride has several bachelors at her disposal? Nobody knows. You can, if you wish, call it poetic, it's an idea. It directs your mind in an unexpected way. And what is more interesting to me is the word *même* which follows. It's not the Bachelors themselves, it's 'even', an adverb with no meaning. That greatly interested Breton and all the Surrealists because they used it again afterwards precisely because of this indecision, imprecision. … It is not even nonsense, but it gives a direction."

A very disquieting direction, remarks Charbonnier.

"Very disquieting. It's a vein which I enjoyed exploiting very much or that I tried to exploit. I did it in that title and in the execution of the Large Glass, it was the same idea: to obtain effects which fly off at a tangent, from a translation or from a normal acceptance of things, like the window closes, the door opens, etc. which have been too familiar for too long and that we should never speak about again."

What role has movement played in your preoccupations?

"From 1912, parallel with Futurism, it interested me a lot. It was an interesting idea because it had never existed in the sense of using movement as an instrument, and not as an ideal. It can be said of the little statue near the Medicis' fountain [Jardin du Luxembourg], the three nude girls with a bronze veil which floats very well: that's movement. And one can even say the *Homme qui marche* by Rodin has movement. That was the static conception of movement. One could be allowed, as an artist, to present the idea of movement in a different way… but it had never been permitted to imitate or to want to imitate the cinema."

Were you thinking deliberately of the cinema?

"Inevitably because the idea of a nude descending a staircase came from the fact that I had seen photographs called 'chronophotographs' in *L'Illustration*. At that time there were a lot of experiments, photographs repeating each movement, and giving the diagram of movement. You could argue that doesn't give any idea at all of movement. Indeed it doesn't, but it describes it. After all a picture is a diagram of an idea… If it had never been done, perhaps it would be interesting to do. Each period has

difficulty in finding things that haven't been done and that is one of the things which has had a great influence in the last fifty years."

The idea of the first readymade is attributed to you.

"Yes certainly. It was me who invented the word. The idea came by chance, like all things that have any value. Choice is the principal thing in painting – you want to go to Gennevilliers this morning, nobody stops you if you want to go there. The idea of choice interests me in a metaphysical way, as much as that. And that was the beginning: the day I bought a bottle rack [15.1.1916] from the Bazar de l'Hôtel de Ville and I brought it home. It was the first readymade. What interested me too was to give it a kind of flag or a colour that did not come out of a tube of paint. I obtained this colour by writing a phrase on the readymade in question, which had to be of poetic essence, and often without normal meaning. It is not the idea just of a work of art at all, it's the idea that it was chosen, it's sacred because chosen…"

Duchamp explains that the great difficulty of "choice became quite delicate to avoid choosing those things recalling an aesthetic past, or even future. It's easy," he observes, "to choose something you like, this 'like' is based on your traditions, your idea of taste and things like that. It was necessary to choose something without taste, insipid. It's difficult. Even if you find a bottle rack nice to look at, it is definitely insipid. It clearly doesn't have taste, it fulfilled exactly what I wanted. It starts from a humoristic formula which is a necessary foundation of the readymade. It must not be a serious thing, the gaiety of the choice must intervene."

31 December

1915. Friday, New York City
Using his Smith Premier typewriter, pen and ink, squiggles and blots, Marcel makes a lively portrait in profile of Fania Marinoff [2.8.1915].

1917. Monday, New York City
For several days the temperature in the morning has been minus 20 degrees Centigrade, or thereabouts, freezing the bottles of milk to a solid block of ice.

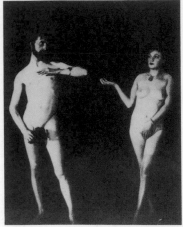

31.12.1924

1.1.1910

At four in the afternoon Marcel has a visit from Roché who then goes downstairs to the Arensbergs' apartment, where he and Walter make a number of telephone calls to arrange the New Year's Eve celebrations.

In the evening at the restaurant with the Arensbergs, Louise Norton and Edgar Varèse, the Meyers, Aileen Dresser and Roché, Mad Turban and Marcel, the atmosphere is festive with shrieks, whistles and carnival hats. One of the menus is handed round which the women in the party cover with kisses in deep red lipstick. As Lou Arensberg has left her imprint on it, Roché keeps it as a souvenir.

Afterwards at the Arensbergs', in the studio lit just by a blazing log fire, Lou serves champagne and more friends arrive: Joseph Stella, Mabel Dodge, the French film director Léonce Perret and his wife, and Alissa Franc.

1924. Wednesday, Paris
On the last night of their season at the Théâtre des Champs-Elysées, after performing *Relâche* [4.12.1924] the Ballets Suédois present *Cinésketch*, written specially for the occasion by Francis Picabia and directed by René Clair.

The stage is divided into three spaces, a bedroom and a kitchen separated by a corridor, which are lit individually and successively from above. Dressed in "black-and-white city clothes giving the appearance, as much as possible, to photography" and with "exaggerated comic make-up" the characters in the sketch are: a woman, her husband, her lover, the lover's wife (to be played by Yvonne George [1.11.1922]), the maid, a masked thief and a policeman, played by Jean Borlin. The farce is performed at the speed of a Keystone comedy and the lighting is switched on and off, according to the action, with the precision of an "edited" movie.

Each section of the story has a title which is announced on the loudspeaker: *One evening...* the woman reads in bed and goes to sleep; *A thief* enters the kitchen from the corridor, he tastes the cake; the woman hears him; the thief leaves the kitchen; the woman powders herself, the thief enters the bedroom, the woman signals him to wait and she fires her revolver six times while the thief takes a step forward at each shot... *The woman's lover* is in the corridor; the lover enters the bedroom and the woman fires six more shots while her lover advances and she escapes... to the kitchen,

where panic-stricken she runs round the laundry tub before picking up the cake ready to throw it; the lover's wife arrives in the corridor... *The lover's wife and the woman*: in the bedroom the thief makes the lover sit down; on entering the kitchen, the lover's wife has the cake thrown at her by the woman; the thief starts reading aloud *La Fille née sans mère* by Picabia and the lover faints. End of Act One.

Act Two commences with the arrival of the husband, attired for the automobile, accompanied by the policeman, and culminates in a classic chase with the lights being turned on and off very rapidly. Loving every moment, the audience punctuates the madness on the stage with shouts, whistles and roars of laughter.

When the lights go up for Act Three, in the kitchen there is a *tableau vivant* of Lucas Cranach's *Adam und Eva*: before the shadowy tree of life with its forked-tongued serpent, are two slender nude figures, the male bearded, both standing motionless in exact exchange of gesture and regard.

It is an apparition only. René Clair controls the light from high in the rigging loft. Brogna Perlmutter (with whom he has fallen in love) plays Eve to Duchamp's Adam. The Cranach is the one which Duchamp saw and was moved by in the museum at Leipzig [25.8.1912].

The policeman, who doesn't understand, wants to arrest everybody... He paces up and down while everybody argues in the bedroom; the husband kisses the maid in the kitchen; music calms everyone down and the policeman executes a humoristic dance; they gradually move from the bedroom to the corridor, and then to the kitchen where the maid tries to kiss the policeman who disappears into the laundry tub full of suds followed by everyone else. The light fades and the clock strikes midnight. A soft light illuminates the bedroom where the woman is sleeping; she suddenly wakes up and looks around, sits up, takes her book and sleeps again, book in hand.

1926. Friday, New York City
After cabling Brancusi that Joseph Brummer is arranging to advance him money on the sales of the exhibition [17.11.1926], Marcel writes to the sculptor confirming the two sales (*L'Oiseau dans l'Espace* to Mrs Meredith Hare and *Le Coq* to Earl Horter), and also the deal with Mrs Rumsey [12.12.1926]. He asks Brancusi if he can find out whether the bronze bird for Mrs Rumsey can be sent to the port of Bal-

timore or Philadelphia, which "would avoid trouble with the customs in New York [21.10.1926]".

*

Miss Dreier gives Dee the three etchings by Meryon [27.4.1926] to take with him to Chicago.

1934. Monday, Paris
Dee first deals with certain accounting matters between himself and Miss Dreier before proudly announcing to her the success of the Green Box [16.10.1934]: "I have sold ten 'luxes' and 35 ordinary copies without much advertising. I have almost my publishing money back."

1937. Friday, Paris
Signs a receipt for an advance of 10,000 francs [25,000 francs at present values] from Roché against the cheque due to them from the Museum of Modern Art.

1941. Wednesday, Montpellier
Spends New Year's Eve with Caroline Dudley Delteil [22.4.1930].

1945. Monday, New York City
"Sciatica 105% cured (short-wave treatment)," writes Marcel to Roché, adding: "Mary [Reynolds] told me that Cocteau cured his with a session of acupuncture!"

Marcel believes that Sweeney is busily trying to help Roché with his "Post Mortems" idea [21.8.1945], however he promises to have the text returned to him. "You should speak to the Carnegie Institute," suggests Marcel.

1949. Saturday, New York City
Confirming that he is not making a catalogue of his work, Marcel thanks his sister for the packet of photographs. He is surprised that Suzanne doesn't remember the large oil painting he made of her in profile [29.11.1949] and makes a little

sketch of the composition. Using the same technique as the *Portrait de Marcel Lefrançois*, "this canvas was made at Blainville around 1902," he believes, "like the drawing you sent me."

1.1.1913

For the short text he is writing on Emile Nicolle [15.8.1894] for the catalogue of the Société Anonyme, Marcel asks Suzanne to tell him what she knows about their grandfather. He has also asked for Gaston's help.

1951. Monday, New York City
Duchamp celebrates New Year's Eve with Monique Fong at the German restaurant Luchow's near Union Square. As Monique has given him a miniature Christmas wreath, Duchamp brings her a bottle of port. As usual, their conversation turns to André Breton and MT [22.12.1951].

1952. Wednesday, New York City
It has snowed abundantly in the night. Duchamp travels to the Philadelphia Museum of Art to supervise the unloading of the Large Glass, which was brought safely by truck the previous day from Milford.
From the Katherine S. Dreier Estate, Duchamp proposes the "enormous painting by an unknown German, in the enormous golden frame", still in the garage at Milford, to Henri Marceau, who accepts it and agrees to pay the transport.
While he is at the museum, Ingersoll and Marceau take Duchamp to see the rooms for the Arensberg collection which are "ready to receive the final coatings on the walls and the installation of the floors".

1956. Monday, New York City
Max Ernst and Dorothea Tanning have spent a fortnight with the Duchamps at 327 East 58th Street and have now returned to their "chateau" in Arizona [25.4.1949]. As another guest, Robert Lebel, was expected in December but has not turned up, Duchamp cables him in Paris to enquire when he will arrive and sends best wishes for 1957.

*

On receiving news from Marcel Jean about difficulties encountered with the organizers of the Dada exhibition, Duchamp replies that he also "predicted to Hugnet [17.12.1956] a great number of headaches concerning the opening of the old trunk".
To help with the history of Surrealism which Marcel Jean is writing, Duchamp thinks that the Copley Foundation should be able to award him a travel grant for his research in America: "The American institutions don't

usually look favourably on Surrealism," Duchamp explains.

1957. Tuesday, New York City
On New Year's Eve Teeny and Marcel don't go to a party, but treat themselves to caviar and champagne: "very private and nice."

1958. Wednesday, New York City
As Marcel has a touch of flu, the Duchamps have a very quiet New Year's Eve.

1960. Saturday, New York City
"Many many thanks for your season's greetings and your very nice present," writes Duchamp to Mary Dreier, saying that he and Teeny would like to see her whenever she finds it convenient.

*

Thanking him for his enclosure concerning chess, in exchange Duchamp sends E. L. T. Mesens an "echo" of his work included in the current Surrealist exhibition [28.11.1960].

1961. Sunday, New York City
In preparation for the "informal talk" he has been invited to give in Palm Beach on 15 February, Duchamp sends Henri Marceau a list and says: "I would like to know how many colour slides you have at the Museum of Philadelphia to illustrate this lecture." In addition to the slides, Duchamp also wants to purchase a photo of *Glissière contenant un Moulin à Eau en Métaux voisins* [11.12.1919]. "Tomorrow is 1962," he adds, "with my best wishes."

1962. Monday, White Plains
The surgeon for Marcel's second prostate operation [24.6.1954] is Dr Kaare Nygaard, whose secretary previously worked for Teeny's father, an eye surgeon. Also a keen sculptor, Nygaard is inspired later to make a bronze bust of Duchamp.
After a spinal anaesthetic at eight o'clock in the morning, Marcel is out of the recovery room at one. By the evening he is feeling well enough to smoke a cigar. Teeny is so relieved, she declares: "This was my best New Year's Eve…"

1967. Sunday, New York City
"Your letter filled me with joy," Duchamp tells Simon Watson Taylor [20.11.1961]. Referring to the enclosures, Duchamp says: "the text of your translation of 'Lighthouse'… [5.12.1934] is a faithful illustration of the perspicacious

world of André Breton." Watson Taylor has translated an excerpt from *Le Savon* by Francis Ponge for the Penguin publication which he has also edited: *French Writing Today*. Duchamp promises enthusiastically to read it and "for 68", wishes Simon, "the Oscar of best-sellers which you deserve…"

1 January

1910. Saturday, Paris
Le Courrier Français publishes a drawing by Duchamp of an item to be included in a "catalogue of New Year's gifts for old men". An outsize doll, pulling along a musical toy rabbit on a string, has "I walk, you talk" inscribed on the skirt of her dress. Using the wording from the catalogue of the Parisian department store, the Grands Magasins de la Samaritaine, which has a page of beautiful dolls on offer, she is described as a "Walking baby, with sleeping lashes, sends kisses with both hands, completely articulated, bonnet, silk dress, lace-trimmed chemise, 'can be undressed'."

1913. Wednesday, Rouen
Wondering what has become of his friends Dumouchel and Tribout, on the first day of the new year Duchamp sends them a card of the Hôtel Dieu (where Flaubert spent his childhood) to 44 Rue de la Clef. "I will be in Paris around Tuesday," he tells them rather vaguely. "Perhaps I will go to Place Monge on Monday at three-thirty."

1916. Saturday, New York City
After only about three months at 34 Beekman Place [18.10.1915] Duchamp has moved to Room 512 at 1947 Broadway, "a sort of studio which is comfortable enough." Thanks to an introduction from John Quinn, each afternoon Duchamp works in the library at the Museum of French Art [15.11.1915], but this temporary job has yet to be confirmed.
Sending his New Year's greeting to Quinn, Duchamp says: "I have good news from my brothers. They are still on the front both of them; Raymond Duchamp-Villon is a surgeon in the *artillerie lourde* – He is safer than Jacques Villon, who is now on the first trenches line."

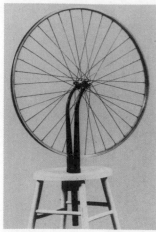
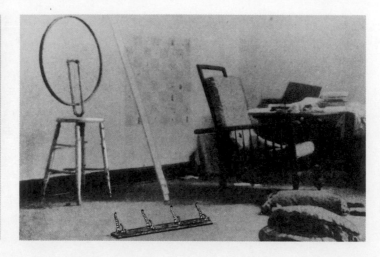

2.1.1951

1918. Tuesday, New York City
In the first minutes of the New Year at the Arensbergs' apartment, 33 West 67th Street, the gentlemen kiss all the ladies and more champagne is served.

After the exchange of New Year's greetings, Marcel and Mad join Perret and Meyer in the dining-room to play poker. In the studio, Roché throws himself full-length face downwards in front of the fire, providing a convenient footrest for Mrs Meyer and Aileen. As Aileen talks to Alissa, Roché's attention is drawn irresistibly to Lou's hands, "so wonderful to touch," which are delicately peeling an apple for him. While Madame Perret and Mabel Dodge reminisce, Joseph Stella and another guest have each found a sofa to sleep on. Roché is lost in admiration for Lou, whom he considers an admirable hostess and quite unselfconscious.

At four o'clock on another bitterly cold morning, Roché gallantly sees Alissa home.

1924. Tuesday, Rouen
Having learned from Turro when they had lunch together before Christmas that Susanna wants to know what has become of him, Pierre Delaire, on the Feast of Circumcision in the calm of Rouen, turns his thoughts to her. "Don't expect the autobiography," he warns her, "because nothing, nothing has happened to me. I have hair and I won't tell you why [9.6.1921]. I am very respectably bored."

Stating that he has only read the pages of *Love Days* [5.10.1923] concerning himself, Pierre says: "It is always charming to have a portrait of oneself even when one only serves as background…" To the author's claim that she hasn't really treated him very kindly, Pierre considers that it is not for him to say whether or not that is so. "That's of secondary importance," he believes. "But I suppose that you use Susanna as an incomplete double or intentionally deceptive so that your real self is even more mysterious. What strange confessions you would write!"

Of himself, Pierre recounts that he gives a few French lessons to Americans, makes very few puns ("there seems to be a slowing down in the production") and plays a lot of chess: "I will die," he declares, "before tiring of that hobby." As far as he knows, there is no new activity in Paris.

"Wherever I am," Pierre observes, "I am under the impression of being in a waiting room. It's tiring because the train is always behind schedule."

Will she come to France, maybe? Or will Pierre return to America? "I dream constantly of voyages to N.Y.," he admits and, after giving New Year's greetings to the family, signs himself "Stone of Air".

1926. Friday, Paris
While in Monaco [28.12.1925], Marcel visited Francis Picabia, Germaine and their son Lorenzo, recently installed at the Château de Mai above Mougins, and purchased some 80 canvases and watercolours from various periods of his friend's work. Today, as requested, Roché comes direct from Fontenay to the Hôtel Istria to advise Marcel on German collectors.

1927. Saturday, New York City
In the afternoon Duchamp boards the five-o'clock train bound for Chicago.

1928. Sunday, Paris
Duchamp has lunch with Lydie [18.11.1927].

1931. Thursday, New York City
At 66 West 10th Street the "Special Exhibition Arranged in Honor of the Opening of the New Building of the New School" comprises seventy contemporary works of art. Although Duchamp himself is not represented in this show organized by the Société Anonyme, at Miss Dreier's request [9.7.1930] he chose paintings by a certain number of European artists [22.10.1930] which he sent to America for the exhibition.

1936. Wednesday, Paris
"Happy new year and many happy returns," writes Dee to Miss Dreier thanking her for the trouble she is taking to find someone in America to promote his *Rotoreliefs* [30.8.1935]. "An amazing detail," he recounts, "I showed it to scientists (optical people) and they say it is a new form, unknown before, of producing the illusion of volume or relief." He is to show the discs to a Professor of Optics, "and maybe have a scientific account written by him for the Academy of Sciences… That serious side of the play toy," continues Dee, "is very interesting."

As Miss Dreier, who is trying to locate *Rotative Plaques Verre (Optique de Précision)* [20.10.1920], has found four boxes in store "which look like bookcases", Dee describes the box as he remembers it and the contents: "The 5 glass blades were piled up in the box with the motor and the iron frame (taken to

pieces)." For the reproduction of this work in the album he is preparing, Dee intends using a "very good photograph" which he found recently at Man Ray's. Also for the album, he enquires whether Miss Dreier can have the *3 Stoppages Etalon* [19.5.1914] photographed.

1942. Thursday, Montpellier
Duchamp spends "a good new year's day" with Caroline Dudley Delteil.

1943. Friday, New York City
Marcel is invited to a luncheon given by Carrie and Ettie Stettheimer for their sister Florine. The party is to celebrate the inclusion of the portrait of Ettie and the double portrait of Duchamp and Rrose Sélavy [24.10.1926] in the "Twentieth Century Portraits" exhibition at the Museum of Modern Art. Amongst some twenty guests are Kirk and Constance Askew, Virgil Thomson to whom the double portrait belongs, Maurice Grosser, Monroe Wheeler, Ossip Zadkine and Georgia O'Keeffe.

*

At seven-thirty Marcel dines with the Kieslers at 56 Seventh Avenue and plays chess with his host until after midnight.

1945. Monday, New York City
In the afternoon at two-thirty Marcel meets the photographer Percy Rainford and Frederick Kiesler, who is devising some pages for the special Duchamp issue of *View* magazine [22.12.1944].

1946. Tuesday, New York City
Marcel spends the evening with Stefi and Frederick Kiesler at 56 Seventh Avenue.

1949. Saturday, New York City
At seven o'clock Marcel is invited to dine with the Kieslers.

1952. Tuesday, Paris
Prior to publication of the book by Michel Carrouges, an extract entitled "La machine-célibataire selon Franz Kafka et Marcel Duchamp" is published in *Mercure de France*.

1961. Sunday, New York City
For the book that she is preparing with Rudi Blesh, Marcel forwards to Harriet Janis three photographs of collages by Suzanne, which he has just received from his sister.

3.1.1943

2 January

1905. Monday, Paris
Although he has paid for the classes [12.12.1904], Duchamp is marked today as absent in the register of the Académie Julian.

1927. Sunday, Chicago
At two o'clock in the afternoon Duchamp is due to arrive by train from New York. As requested [24.12.1926], Alice Roullier has asked Frederick Miller to work in the evening at the Arts Club to open and unpack the cases containing the Brancusi sculpture in Duchamp's presence.

1943. Saturday, New York City
Since 15 September when Mary Reynolds reached Lyons but then failed to obtain her visa to leave France before the Germans invaded the unoccupied zone, Marcel feared that she had been trapped and put in a concentration camp. The first news came ten days ago when Mary sent word to her brother Brookes in Chicago that she had arrived in Madrid. Today Marcel is relieved when he himself receives a telegram from Mary to say that she is in Lisbon and hopes to board a Clipper to fly to New York on 6 January.

1944. Sunday, New York City
Duchamp thanks Mary Dreier for her "Christmas card" [25.12.1943] and encourages her to stay in the sun as long as she can declaring that "N.Y. is no place to enjoy the winter".

1951. Tuesday, New York City
Duchamp authorizes another replica of a readymade for the next in the series of historical exhibitions at the Sidney Janis Gallery. After the replica of *Fountain*, which was shown in "Challenge and Defy" [25.9.1950], Janis has the privilege of being the first to exhibit the talismanic *Roue de Bicyclette* [15.1.1916] in "Climax in XXth Century Art: 1913". Duchamp has assembled the two elements which Janis purchased recently in Paris, but since the fork supporting the wheel is slightly curved, this third version is not an exact copy of the one made by Duchamp

for his studio at 33 West 67th Street.
Also included in the exhibition is *3 Stoppages Etalon* [19.5.1914] from Miss Dreier's collection.

1958. Thursday, New York City
Teeny and Marcel are invited to Denise and David Hare's freshly painted house, and have "a very delicious supper".

1959. Friday, New York City
In the evening Bob Hale plays chess with Marcel at 327 East 58th Street.

1962. Tuesday, New York City
"Very good idea," Duchamp tells Serge Stauffer who has proposed to try solving the problem of the Glider [12.11.1961] with the help of his printing students and to produce enough to be included in future copies of the *Boîte-en-Valise* [7.1.1941]. Saying that 200 examples would be sufficient and offering to assist financially, Duchamp confirms that he has ordered a photograph from Philadelphia. He also promises to send Stauffer a photograph of *Stéréoscopie à la Main* [4.4.1919] and, although he does not have a single copy of the *Architectural Record* [25.6.1937], to send documents with details of the Large Glass if he finds them again.

3 January

1922. Tuesday, Rouen
"It's very difficult to write even with the left hand," Duche demonstrates to Ettie before using his right hand to send "seasonal greet-

Rouen 3 Janvier
C'est très difficile
d'écrire même de
la main gauche.
Je reprends ma droite.

ings to all the Stettheimer family" and to thank her for the news.
Disappointed, like Gleizes, that Florine has not come to Paris [1.9.1921], Duche asks: "has she at least arranged to exhibit at the Indepen-

dents?" As he has fixed his return to New York, Duche announces: "The *Aquitania* leaves with me on 28 January… Farewell," he writes, "and this time it is not paper but my hand that you will be touching, another month and I will be passing along Columbus Avenue in the shadow of the Elevated."

1943. Sunday, New York City
"Everything is tempting, Frida [10.3.1939] and Rivera, Mexico, life as I like it, the material advantages – and your description of all that is a masterpiece of diabolism," concedes Marcel, who has taken 3 months to answer Walter Pach's letter. However, "in spite of the temptation," Marcel has decided not to move from New York. He explains to Pach that he has a temporary visitor's visa and "could only obtain a visa to return to the USA with great difficulty…" Besides, he has settled into the accommodation sublet to him by the Kieslers [2.10.1942] and he has sold enough copies of the *Boîte-en-Valise* [7.1.1941] to live on for the time being.
After mentioning that he has been busy with Mme Elsa Schiaparelli and André Breton for the Surrealist show [14.10.1942] at Peggy Guggenheim's gallery "which for its interior architecture is a great success (Kiesler *fecit*) and the collection looks very good in these surroundings" [20.10.1942], Marcel tells Pach the good news he received on Saturday from Mary Reynolds.
Sending his best wishes to Rivera and, if Pach sees them, to the Paalens and Benjamin Péret, Marcel says, "Embrace Frida for me and tell her that if I see the possibility of visiting Mexico I will jump at it."

1950. Tuesday, New York City
Believing that the Chicago Art Institute is "one of the very few places in the world" for the Arensberg Collection, Marcel was disappointed when the Arensbergs informed him a few days ago that they had declined to accept the proposal made to them on their recent visit to Chicago [12.12.1949]. Marcel tells Brookes Hubachek that the Arensbergs have not given him any special reason for their decision and suggests "maybe [they] will reconsider that wonderful opportunity".

1953. Saturday, New York City
Duchamp informs Mary Dreier that "the operation" on Tuesday and Wednesday to move the Large Glass from Milford to Philadelphia

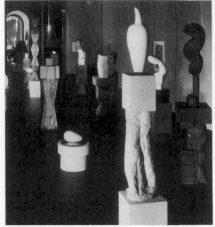

4.1.1927

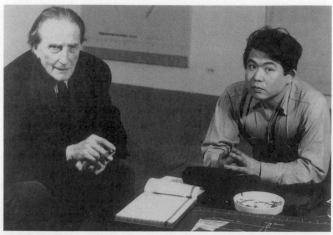

4.1.1966

"was a success" and he asks for her approval before shipping the "enormous painting" in the garage to the Philadelphia Museum. "It would be a simplifying solution," he explains, "to help you [with] emptying the house little by little" and adds encouragingly: "Hope you are feeling better and better in this new year."

1956. Tuesday, New York City
Both *Nu descendant un Escalier*, No.1 and No.2 [18.3.1912] hang in the loan exhibition "Cubism 1910–1912", which opens at the Sidney Janis Gallery that afternoon at four o'clock.

1959. Saturday, New York City
In the evening the Donatis are invited to 327 East 58th Street.

1962. Wednesday, New York City
Duchamp plans to visit the Museum of Modern Art to order a photograph of *Stéréoscopie à la Main* [4.4.1919] for Serge Stauffer.

4 January

1927. Tuesday, Chicago
The opening at four in the afternoon of the Brancusi exhibition, which Marcel has installed since his arrival on Sunday, is a "great success". The very spacious exhibition room measuring 13 by 7 metres is situated at the premises of the Arts Club, 410 North Michigan Avenue. Like the installation of the exhibition at the Brummer Gallery [17.11.1926] Marcel has had the walls hung with grey cloth. Poised in the centre is Steichen's bird, at each end the golden bird and *Maïastra*, and between Steichen's bird and the golden bird the column. In his letter from the Racquet Club at eleven that evening, Marcel tells Brancusi: "Around these four centres I have grouped the rest. The effect is really satisfying."

1942. Sunday, Sanary-sur-Mer
"Returned safely to Sanary after Montpellier [1.1.1942]," writes Marcel to Roché. "Generally this voyage did me a great deal of good and I will write to you soon at greater length on this subject." But he regrets not having visited Roché's wife and son: "Next summer will be more propitious for such adventures…"

The arrival of a letter dated 1 December from René Lefebvre-Foinet in California saying that the long-awaited American visa [1.7.1941] will very soon be issued, far from raises Marcel's hopes. "It was written before the 7th," (the day of the attack on Pearl Harbour and the declaration of war by the United States, Great Britain and Holland on Japan) he tells Roché.

1952. Friday, New York City
At four in the afternoon Duchamp meets Monique Fong, with whom he saw in the new year.

1958. Saturday, New York City
While Bill and Noma Copley have been in New York, Marcel has had long discussions with Barnet Hodes and Bill about the English translation of Lebel's book [17.12.1957]. "I have just reread the translation (excellent) that Copley made of your contribution to the book," writes Marcel to Roché.
"Prompted by 1958" to reply to Roché's questions, Marcel says he has a dozen copies of the Green Box [16.10.1934] in New York and doesn't believe that he left any in Roché's attic [11.2.1951]; the new batch of 30 *Boîte-en-Valise* [7.1.1941] being assembled by Iliazd should be ready soon [10.12.1957]; he has no more copies of *L'Opposition et les Cases conjugées sont reconciliées* [15.9.1932] and suggests that Roché write to the publisher Edmond Lancel in Brussels to find out how many copies are left, and at what price.

1959. Sunday, New York City
The Duchamps are invited to supper by Denise and David Hare.

1966. Tuesday, New York City
In the afternoon at one, before the opening of Arakawa's [11.2.1963] exhibition, Duchamp visits the Dwan Gallery and chats with the artist until four-thirty.

5 January

1916. Wednesday, New York City
On the day that Marius de Zayas opens an exhibition at the Modern Gallery of Picabia's "machine" pictures (which have titles inspired

by Latin tags lifted from the pink pages of the *Petit Larousse*), Duchamp writes a note to John Quinn who has requested Villon's correct address. He reminds the lawyer that the promised letter and draft to his brother, in present circumstances [1.1.1916], would best be addressed to Madame Gaston Duchamp, as "'Jacques Villon' is entirely a pen name", and offers to translate the letter.

1927. Wednesday, Chicago
In between many social engagements, Duchamp finds time to meet Paul Gaulois, a young artist Miss Dreier is assisting financially, who is "trying to create a place where artists that are not established can exhibit their work". Planning to see more of Gaulois while he is in Chicago, Duchamp writes later to Miss Dreier: "I am treated like a male Cecile Sorel – opera every night – Dinners – Teas."

1928. Thursday, Paris
Marcel and Lydie have an appointment at the Palais de Justice at two o'clock [18.11.1927].

1934. Friday, New York City
Marcel sends a telegram to Brancusi with the news that for the sum of $2,000 Philip L. Goodwin offers to purchase *La Négresse blonde II* from the exhibition [17.11.1933] and to donate it to the Wadsworth Atheneum. Brummer recommends that the offer be accepted.

1942. Monday, Sanary-sur-Mer
From the Hôtel Primavera, Duchamp writes a card to Georges Hugnet in Paris, remarking: "Ces mites sont un mi(s)tère." To replace "the motheaten stoppage", Duchamp instructs Hugnet to ask Maurice Lefebvre-Foinet to accompany him to 11 Rue Larrey where he has the remaining stock [25.4.1941] of reproductions for the *Boîte-en-Valise* [7.1.1941]. At the extreme left end of the shelf marked "4", Hugnet will find two packets: one containing the "stoppages"and one with the rulers [29.8.1936]. Duchamp invites him to take one of each.

1943. Tuesday, New York City
Following a suggestion made by Duchamp the work of 31 women artists, selected by André Breton, Jimmy Ernst, Max Ernst, Peggy Guggenheim, Howard Putzel, James Thrall Soby, James Johnson Sweeney and also Duchamp, is exhibited at Art of this Century [30.11.1942].

5.1.1916

At six-thirty in the evening Kiesler and Du-champ visit André Breton.

1946. Saturday, New York City
"Sinking more and more into a delay in reply-ing to you," writes Marcel to Tristan Tzara in Paris, "I met Maria Jolas who told me that she had replied to most of your questions…" Apart from Brentano's, he thinks that other bookshops will be importing the books which interest Tzara. After information about *VVV* [13.3.1943], *Art of this Century* [20.10.1942] and *View* [15.3.1945], Marcel tells his Dada friend: "As you can imagine I am continuing my life in Sanary [2.7.1941] here only consent-ing to a few appearances at enforced exhibi-tions. Besides," he explains, "the group of exiles, at first compact 3 years ago, has quickly changed into an 'every man for himself' with the customary feuds and scoldings." Léger and Masson have gone home, Breton is in Haiti for three months lecturing, Max Ernst and Peggy Guggenheim "are separated if not divorced", and "Tanguy is completely settled in the coun-try not far from N.Y.". Although he plans to go to Paris in April, it is nevertheless "without much joy – the rat race", Marcel says, "doesn't attract me – here on the contrary daily life has a tranquillity which allows me to work if I wanted to."

[Although Marcel was unsure of the date when writing to Tzara in Paris, the stamped envelope is franked early in the morning at seven-thirty.]

1950. Thursday, New York City
"Villon told me that he has given you all the canvases [29.12.1949] and countersigned them," writes Marcel in a short note to Roché, referring to the batch of his very early paint-ings found at Puteaux [14.11.1949].

1956. Thursday, New York City
"I have known Varèse since 1915," writes Duchamp to Merle Armitage, and says that on hearing *Déserts* again recently [30.11.1955] he considers the composer "Still *avant* avant-garde".

1959. Monday, New York City
"I am not for selling your important things (by auction) in N.Y.," is Marcel's advice to Roché. "You could be the victim of a dealers' ring as Walter Pach was a few years ago…"

However Marcel has a buyer for *Deux Pin-gouins* by Brancusi, the sculpture that Roché bought from him [17.2.1937] to provide funds for the *Boîte-en-Valise* [7.1.1941].

1966. Wednesday, New York City
In reply to Bill Camfield, who is now at the Art Department of the University of St Thomas in Houston [27.12.1965], Duchamp says that he is not sure that the glass *Les Forces mécaniques de l'amour en mouvement* by Crotti (which was exhibited at the Montross Gallery [4.4.1916]) is still in Neuilly. He promises to check on this and the picture by Suzanne Duchamp entitled *Un et une menacés* on his return to Neuilly in April. "When is your article coming out?" enquires Duchamp. "Can you wait until April for the photos?"

6 January

1915. Wednesday, Paris
After examination by military doctors Duchamp is again declared unfit to serve in the army [1.9.1909].

1920. Tuesday, New York City
The *Touraine* bringing Duchamp back to the United States [14.8.1918] docks at five-thirty in the afternoon. In addition to *Air de Paris* [27.12.1919] for the Arensbergs, Duchamp has brought with him a Japanese paper edition of *Huit peintres, deux sculpteurs et un musicien très modernes* [13.12.1919] for John Quinn.

1928. Friday, Paris
Duchamp confirms to Miss Dreier that the problem with two pictures by Otto Carlsund, a Swedish painter who exhibited with Léger's group in the Brooklyn exhibition [19.11.1926] has now been resolved and that he has paid Lefebvre-Foinet. "Many of the exhibitors," ex-plains Duchamp, "have asked Foinet to keep their works – and when there is trouble, I'd rather trust Foinet than the artist."

Saying that he will have Foinet receive the shipment of paintings by Dorothea Dreier and Louis Eilshemius, Duchamp promises to "try to find a way of exhibiting them". At the end of the month he intends to send Stieglitz 10

pictures by Picabia in Legrain frames for an exhibition in New York.

After his visit the previous day to the Palais de Justice, Duchamp can happily tell Miss Dreier, who had doubts about the marriage [28.9.1927]: "Divorce is advancing… I am leav-ing for the south in a week for a month or two – on that account."

1936. Monday, Paris
Invited by André Breton to participate in the exhibition at Charles Ratton's gallery, Duchamp proposes the little window [22.9.1935] belonging to Marie Sarlet in Brus-sels, *Why Not Sneeze?* [11.5.1935] belonging to Henri Pierre Roché and the replica of *Egouttoir* [15.1.1916] recently photographed by Man Ray for *Cahiers d'Art*.

As Breton has requested, Duchamp has enquired whether *Why Not Sneeze?* is for sale: Roché's price is 5,000 francs [15,000 francs at present values].

1937. Wednesday, Paris
Duchamp writes to André Breton that if it is convenient he will come at nine on Saturday evening to return the Alphonse Allais.

1953. Tuesday, New York City
Marcel hopes that Brookes Hubachek "started 1953 in the perfect mood…"

In another letter, he wishes Roché "a tailor-made 1953", thanks him for taking *9 Moules Mâlic* [19.1.1915] to the Musée National d'Art Moderne for "Le Cubisme 1907-1914" as requested [24.12.1952], and discusses further the option on *Adam et Eve* by Brancusi.

1961. Friday, Paris
In the fifth interview broadcast on France Cul-ture [30.12.1960], Georges Charbonnier com-mences by asking Duchamp whether the situa-tion in which the readymade is placed has an importance with regard to the definition of a readymade. "No, not at all," replies Duchamp. "I gave it a kind of personality of mine: gener-ally there was an inscription which added a colour… There were also amusing things with the readymades, to decide a certain time, a cer-tain day to choose a readymade. It was a ren-dezvous then with destiny. I did that with a steel comb [17.2.1916] for dogs. I marked the exact time, the day, it's written on it."

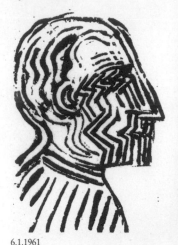

6.1.1961

Isn't silence the conclusion of the ready-made?

"Yes, probably. I would not think of choosing a readymade today, it doesn't interest me. I have done enough for my satisfaction and I do not wish to do it with the idea of a public which benefits or enjoys it. It's silence in that way. The silence is the best production that one can make because one doesn't sign it. Everyone benefits, one knows what silence is. It exists and it is even propagated faster than electric light," says Duchamp laughing. "It's interesting in that way."

Charbonnier remarks that he is struck by the affinity between Duchamp and Picabia.

"Oh, we were great friends – great, great friends."

There was a great affinity between your frame of mind and his?

"Enormous. We were great friends between 1911 and 1914 in particular. For us it was an explosion, almost like two poles each adding something and detonating the idea because there were two poles, [5.5.1914]. If he had been alone, I had been alone, perhaps less would have been produced in both of us."

He considered you as the great Surrealist.

"We tried to be more general than Surrealism, much more independent if you like, because Surrealism wanted to be something that fitted into the framework of society X or Y. But with us, there was not even this idea of fitting in anywhere. We were much more Dada than Dada because, if we could have, we would have destroyed Dada. There was simply the idea of not fitting in anywhere and not to seek any notoriety. You never manage it, these are pseudo-dreams."

Did you and your brothers have interests in common? What were your discussions and reunions like?

"Oh, it was very simple, very family to start with, but also mixed with other Cubists who came at that time to Puteaux where my brother has lived since 1905. He made a kind of Sunday at Puteaux where everybody came; the Cubists of this period came: La Fresnaye, Gleizes, Metzinger, Léger. So there were amusing Sunday afternoons, we played... practised archery. There was a garden, so it was pleasant particularly in summer. Naturally discussions followed, completely theoretical like in the

agora. It was a kind of agora and most interesting. For me, I was quite young at that time, it was really a most salutary source of inspiration. Apollinaire often came. It really was an interesting meeting of minds."

Jacques Villon seems to have kept his distance from Surrealist preoccupations.

"He liked to remain a painter and whole painter... as one refers to bread," laughs Duchamp.

Did Breton think that you took Surrealism seriously enough?

"A great sympathy with Breton, there was a sympathy like the one for Picabia. It was a sympathy man to man rather than theory to theory. In other words it was a sympathy of individuals. There could have been the same sympathy that one has for a good concierge," laughs Duchamp. "It's not that I'm his concierge," he continues laughing, "nor him mine, I mean the fellow feeling of a sensual kind, but not necessarily intellectual. That exists as well, but I do not consider myself as a Surrealist... I do not approve of his way of thinking, and particularly Breton who can change his mind like his shirt. He has his chameleonisms of mind which one must accept. You know very well that something he has said could be contradicted, and the contradiction belongs to the Surrealist system. You must be able to contradict yourself with alacrity which is not at all a bad thing. I am in favour of contradiction, and particularly with oneself. There never was, as I told you, this kind of friendship as with Picabia which was a man to man friendship. One could even see a homosexuality in it, if we were homosexuals. We are not, but it comes back to the same. I mean that it could have changed into homosexuality instead of Surrealism." Duchamp then mutters: "If he hears that, old chap!"

Continuing to talk about Breton, Duchamp explains that at the very beginning, at the moment of Dada, "it was very important for [Breton] to have the support of an Aragon, an Eluard. All that was dissolved in '30, '35 when there were separations and he was left on his own. He himself probably wanted this solitude... I think that is what motivated the separations more than the reasons given which were of political origin or something else. I believe that Breton is a phenomenon of extraordinary egoism, of egotistical ambition, a kind

of Nero... a marvellous dominator in that sense. My relations with him did not bother him because I am not a Surrealist in the real meaning of the word, nor even ambitious in that way. Because there is nothing that would bore me more than to be leader of a school, which is really a strange ambition to maintain for 40 years... You have to have an incredible nerve to do it." Laughing, Duchamp adds: "And he does it very well!"

Have you ever been excommunicated?

"Never. I am one of the only ones, and Péret I think. But it was difficult to excommunicate me because I never signed their petitions. I was never asked to sign and I never offered to sign, it was something that never interested me."

Charbonnier asks when Duchamp first went to the United States?

"In 1915... Perhaps I had the spirit of expatriation, if that's a word. It was part of a possibility of my going out in the traditional sense of the word: that is to say from my birth, my childhood, from my habits, my totally French fabrication. The fact that you have been transplanted into something completely new, from the point of view of environment, there is a chance of you blossoming differently, which is what happened to me. It is certain that it helped greatly to rid me of the traditional dross of the individual who is born in his village and who never leaves it. It is a different country, at least it was very different then. Now it is less so because all countries," laughs Duchamp, "are starting to look alike. One will need to go to the moon to change."

In the intellectual and artistic field, what did you find in the United States?

"In every country an elite, or intelligent people, exist... and those in the United States were sympathetic because their relationship from individual to individual was very agreeable, particularly in my case."

The broadcast terminates with Duchamp explaining the importance of the Armory Show [17.2.1913] which he considers, "revolutionized the United States from an artistic point of view... All these people who became museum curators or art critics," says Duchamp, "were formed by this exhibition of 1913. When Surrealism arrived, they did not accept Surrealist ideas, because they had been formed by a norm which they didn't want to depart from. So, like here, there was the same opposition on

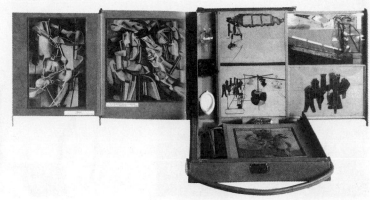

7.1.1941

the part of curators or art critics etc., who stayed in their soft option which they had established since 1913. Then there was the same battle to place Surrealism; and now, after at least twenty years, it's completely accepted, even more than accepted."

1967. Friday, New York City
Monique Fong dines with Teeny and Marcel at 28 West 10th Street and among other subjects they talk about Octavio Paz, the Mexican Ambassador to India, and discuss his essay on Duchamp.

7 January

1919. Tuesday, Buenos Aires
"Apart from a few tangos, there is nothing other than the theatre, with foreign companies, often French (which is too much of a reminder that I understand French well)," writes Marcel to Lou Arensberg, explaining his reason for

working. Although he is planning to join a chess club, for the time being Marcel plays alone: "I have cut out forty of Capablanca's games," he says, "which I am going to play over." In addition he has had a set of rubber stamps made and encloses an example for Walter of how he uses them to mark the games.

By the same post, Marcel is sending Walter an oculist's chart, used for eye testing. "I have used oculist charts recently," he mentions, "And I hope that this one could be useful for Walter."

Thanking Lou for her description of a few "happenings" in New York, Marcel enquires whether they have seen Barzun as he is awaiting news, mid-February, about the exhibition project [8.11.1918]. He signs his name and stamps the paper with the amusing ass-like head he has designed for the chess Knight.

1926. Thursday, New York City
Prior to auctions in New York and Paris, the "John Quinn 1870–1925" memorial exhibition, showing only a selection of his collection of paintings, watercolours, drawings and sculpture, opens at the Art Center. The four pictures by Duchamp are exhibited: *A propos de Jeune Sœur* [8.3.1915], *Nu descendant un Escalier*, No.1 [18.3.1912], *La Partie d'Echecs* [1.10.1910] and *Peau brune* [19.1.1915].

1941. Tuesday, Paris
"Thank you for your letter of 19 Nov. The late reply," Marcel explains to Roché, is due to the fact that "one thinks only of eating". The telephone at Melun has been cut off but he continues to keep an eye on Arago for Roché [22.10.1940] and confirms that his works of art "are safe in Mary's cellar" and everything is in good condition. As Mary Reynolds wants to pay 2,000 francs to her landlady Mme Fribourg who lives in Cannes, Marcel enquires whether a reciprocal service might be possible if Roché has payments to make in Paris or the occupied zone. He also requests Roché to cable Arensberg asking him to send money to him via an American citizen such as Peggy Guggenheim.

"My new box is finished," announces Marcel, "I am reserving one for you." Originally conceived as an "album", he has been working on the idea steadily for nearly six years [5.3.1935]. The box containing lilliputian reproductions of 69 works, almost everything Marcel has produced to date, has become a Valise: the leather case when opened reveals ingenious unfolding and sliding panels presenting his major works. Inside the lid of this portable museum (limited at first to 20 "de luxe" copies) is the place for an original work. Opening in a similar fashion to the lid, the central panel holds the miniature Large Glass in celluloid; on its left placed vertically one above the other are three readymades: *Air de Paris* [27.12.1919] at the top opposite the Bride's ethereal domain; the skirt, or hood-like ...*Pliant... de Voyage* [1.4.1916] is placed next to the horizon or Bride's clothes; and at the bottom masculine *Fountain* [9.4.1917] accompanies the Bachelors' territory in the lower half of the Glass.

A folded panel sliding out to the left from behind the Glass exposes *Nu descendant un Escalier*, No.2 [18.3.1912] and when opened shows *Mariée* [25.8.1912] and *Le Roi et la Reine entourés de Nus Vites* [9.10.1912]. The sliding panel on the right is divided into two: *9 Moules*

Mâlic [19.1.1915] (also in celluloid), standing next to the Bachelor machine of the Glass, occupies the lower half; the upper half exhibits the last painting, *Tu m'* [8.7.1918], and appropriately the image of *Peigne* [17.2.1916] borrowed from *Transition* [15.12.1936]; a third celluloid miniature, the Glider [11.12.1919], is taped to the upper outside edge of the panel enabling it to be folded outwards at right angles to the panel for display. Apart from the difference in scale, the full deployment of the panels echoes the ritual opening of medieval altar pieces, a hinged form which Marcel once considered in his notes for the Large Glass.

Placed at the bottom of the Valise is a cunning, 3-dimensional evocation of *Why not Sneeze?* [11.5.1935] and a folded card reproduction of the rulers and threads of *Trois Stoppages Etalon* [19.5.1914]. Next to these two works on top of a pile of loose sheets and paper folders on which reproductions of the remaining pictures and objects are glued, each carefully labelled, are three pictures mounted on stiff card: *Sonate* [19.11.1911], *Broyeuse de Chocolate*, No.2 [8.3.1915] and *Moulin à Café* [20.10.1912].

Published for the first time in the Valise is Marcel's *Recette* dated 1918 which consists of:
3 pounds of quills (feather or pen)
5 metres of string (weight 10 grams)
25 candles of electric light.

In addition to her own works also included in the contents of the box, is a four page folio of phrases by Rrose Sélavy which are written in copperplate and printed on lined music paper. Co-authors of this new box, Rrose and Marcel have entitled it the *Boîte-en-Valise*.

1955. Friday, Paris
Teeny and Marcel return to Arago after being away at the New Year.

With the idea of producing an improved standard version of the *Boîte-en-Valise* [7.1.1941] compared to the ordinary Box which Rose Fried has been selling [25.2.1952], Duchamp has met the publisher and book designer Ilia Zdanevitch, known as Iliazd, who has proposed structural changes to the design of the Box.

In the afternoon Duchamp informs Iliazd by express letter that on Monday at three o'clock he wants to bring Bill Copley, "who should deal with getting the Valises into production," to show him the new ideas for the construction.

9.1.1918

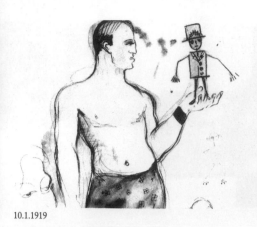

10.1.1919

1958. Tuesday, New York City
Robert Lebel's arrival in New York has been postponed until 19 January. Hoping that his letter will reach him before Lebel leaves Paris, Duchamp writes: "Awaiting you with impatience because it is necessary to end all these discussions and ridiculous quarrels [17.12.1957]."

1962. Sunday, New York City
In the morning Denise Hare comes to collect the magpie, which spent Christmas at 28 West 10th Street. In spite of having to call the Bronx Zoo vet when the bird had too many sunflower seeds, "that he loved so much he ate them all up in one afternoon and they made him very sick," Teeny says that they "loved him and will miss hearing his silly talk".

1963. Monday, New York City
The Allan Gallery organizes a small exhibition of Duchamp, Picabia and Schwitters in collaboration with the Galleria Schwarz, Milan.

1965. Thursday, Columbus
The Duchamps attend the opening of the exhibition "Jean Crotti in Retrospect" at the Columbus Gallery of Fine Arts.

1968. Sunday, New York City
"I don't recall if I ever spoke to you about my epitaph," writes Marcel to his old friend from the Lycée Corneille, Dumouchel. "Your letter reminds me:
　…Et d'ailleurs, c'est toujours les autres
　　　　qui meurent.
[…And besides it's always the others who die.]
I hope that Teeny won't forget it on my casket of 'incinerated'," he adds. "Don't take this offhandedness too seriously because, like you, I sense the inanity of everything surrounding us, alive or dead, and wish that you outlive me so that my epitaph is written for you for a long time yet."

1918. Tuesday, New York City
With Marcel, Roché, and Aileen Dresser at the Arensbergs in the evening, are Jean Crotti and Yvonne Chastel who has taken her maiden name after obtaining a divorce from Crotti on 29 December in Paris. Both of them have just returned to New York [17.10.1916], and Yvonne was desperately upset when she visited 33 West 67th Street and discovered Mad Turban living with Marcel [24.12.1917]. For those wondering what the future may hold for them, Yvonne reads the cards.

1927. Saturday, Chicago
Duchamp cables Miss Dreier in New York for the correct spelling and address of Mrs Kuppers in Germany.

1947. Wednesday, Paris
"Marcel is ready to leave when he gets a bunk and on a boat," writes Mary Reynolds sadly to her friends the Hoppenots in Bern. "It seems he may only get a day's notice which makes it almost like the plane as far as mental anguish is concerned." They have been for a last excursion to the Loir-et-Cher to look for a cottage [29.11.1946] but "only found the dreariest structures representing the anxious economies of thrifty little people…"
In a postscript to Mary's letter, Marcel writes: "This is a farewell on departure for this America that you don't detest either – China is better," he adds referring to the book by Paul Claudel illustrated by Hélène Hoppenot, the presentation of which Marcel says "is worthy of the photos".

1949. Saturday, New York City
"I wanted to get a sweater and tell you what colour it was," explains Duchamp to Mary Dreier, belatedly thanking her for the Christmas present. "I have not bought it yet – it will probably be navy blue."

*

"Yes, what is becoming of us?" Marcel wonders. "I've somewhat the impression to have withdrawn to the country, in a distant province; because that's the life I lead in New York," he reveals to Yvonne Lyon [13.1.1947] in London. Claiming that he sees very few people and has only sporadic contact with the Arensbergs, Marcel finds that there is "a general lassitude… it's true to say," he says, "that the majority prefer war to peace."
Having searched in vain for her coffee percolator, Marcel asks whether she wants something similar and also enquires: "Do you want coffee or tea, rice…"
He speculates whether in London there is "the same debacle in painting" as in New York and in conclusion writes: "There, my dear Yvonne. Nothing as usual. Chess as much as possible: at least chess players don't talk… Write from time to time, you are one of the rare people to whom one can speak freely."

1950. Saturday, New York City
Dee is due to visit Miss Dreier in Milford to review the week's work on the catalogue of the Société Anonyme and to take with him the biographical material he has received from Harry Holtzman (a close friend of the late Piet Mondrian [18.5.1943]), who has donated two of his own works to the Société Anonyme.

1952. Tuesday, New York City
After lunching together Duchamp takes Monique Fong to the Henri Matisse exhibition at the Museum of Modern Art. "Retinal painting," says Duchamp.

1957. Tuesday, New York City
The opening of the "Three Brothers" exhibition is postponed until 19 February.

1958. Wednesday, Philadelphia
The Duchamps attend the opening of the Picasso exhibition at the Philadelphia Museum of Art.

1962. Monday, New York City
Monique Fong lunches with "Duchamp the incomparable", as she notes in her diary.

1918. Wednesday, New York City
Duchamp posts his letter to Miss Dreier thanking her for the $100 cheque. He has seen George Of about the panel which will be ready a week on Thursday. As the painting has been commissioned to fit the long, rectangular space above the bookcase in Miss Dreier's apartment at 135 Central Park West, Duchamp informs her: "I told [George Of] to try it first on the wall. So he will take it to your place and bring it to mine afterwards. I am thinking about the interesting part of it," Duchamp continues, "and have already several ideas among which I intend to select later on."

10.1.1946

1920. Friday, New York City
While Marcel is visiting Lou and Walter Arensberg at 33 West 67th Street, Beatrice Wood arrives with Aileen Dresser and Mr Meyles.

1934. Tuesday, New York City
Four days before the Brancusi exhibition [17.11.1933] closes, Marcel is at the gallery when Mrs Meyer [28.12.1933] visits again with her third daughter. Later he outlines progress regarding sales to Brancusi. "On the whole the exhibition went well and if you realized the state of things here, you should be satisfied pecuniarily. From the point of view of general success, everyone is agreed that it is the best exhibition of the year and by far."

1937. Saturday, Paris
At nine in the evening, as agreed [6.1.1937], Duchamp visits André Breton and returns the book by Alphonse Allais, one of the authors to be included in the *Anthologie de l'humour noir*, which Breton is preparing.

1946. Wednesday, New York City
At noon, Duchamp is due to call at the Museum of Modern Art to collect copies of two letters concerning his American visa. As it appears that renewal of the visa is unlikely, Nelson A. Rockefeller, the first vice-president of the Board of Trustees of the museum, has written to the Service of the U.S. Department of Justice, Immigration and Naturalization at 70 Columbus Avenue informing the district director that as Duchamp is supervising the forthcoming Florine Stettheimer exhibition [13.10.1944] he hopes it will be possible "to extend Mr Duchamp's visa until his services to the Museum can be completed".

1952. Wednesday, New York City
On learning from Miss Dreier of Frances Kellor's death, Duchamp writes with his "deep affection" to Mary Dreier. "Between the illness of the three people closest to you, you have been a wonderful helping companion to each one. So it is the lot of those who live longer to bear the burden of confronting death again and again with no satisfying reply to their 'why'."

1958. Thursday, New York City
With the approach of Lily and Marcel Jean's visit (sponsored by the Cassandra Foundation [31.12.1956]), Duchamp wonders whether they are arriving "by air, by water or by land

(Bering Straits)" and invites them to stay at 327 East 58th Street for a week or so. "We have a little room in the apartment which is sunny enough to dispel your eventual home sickness. That will allow you to make your plans without panic," suggests Duchamp.

1960. Saturday, New York City
Printed on the announcement of Bill Copley's exhibition at the Alexander Iolas Gallery, 123 East 55th Street, which opens today, is Duchamp's observation:

"Cops pullulate, Copley copulates."

1961. Monday, New York City
Teeny and Marcel go to the opening of Bill Copley's exhibition at the Alexander Iolas Gallery and then "escape" to attend the first night of Ionesco's play *Rhinocéros*.

1964. Thursday, New York City
Bill and Noma Copley are invited to dinner at 28 West 10th Street. The small portable television set which Noma gave the Duchamps for Christmas is a great success. "Although we don't use it very often," admits Teeny, "it gives a new dimension to our bedroom and I'm delighted with it."

1966. Sunday, New York City
Duchamp attends the presentation by John Cage of Baruchello's film, *La Verifica incerta* [30.4.1965], at the Solomon R. Guggenheim Museum.

10 January

1905. Tuesday, Paris
After missing the previous week's classes at the Académie Julian, Duchamp pays for a further four consecutive weeks of tuition [12.12.1904].

1918. Thursday, New York City
Although he gives a French lesson regularly every Tuesday evening to Miss Dreier [24.12.1917], Duchamp has arranged to give another at eight-thirty this evening.

1919. Friday, Buenos Aires
After writing to Lou on Tuesday, Marcel has

received a letter from the Arensbergs posted in New York on 5 November. From it, he learns of Morton Schamberg's sudden death from flu on 13 October. Reminded of his own brother's death [7.10.1918], Marcel wonders, in a postscript to his letter, "where this wave of death is coming from" and says that he has heard from France that Apollinaire also died from Spanish flu on 9 November.

Marcel has seen no sign in Buenos Aires of either Arthur Cravan [20.4.1917], last seen in Mexico, or Mina Loy, who has been searching for her husband.

"I am waiting impatiently for Charlie in *Soldier's Life*," writes Marcel who has seen several of Chaplin's old films while in Argentina where the famous comic is greatly appreciated. He asks the Arensbergs to remember him to Dr Southard [4.5.1917] and also "the pretty Beatrice [Wood]" whom, he says, "I will undoubtedly see here one day on the screen."

1927. Monday, Chicago
At eleven-thirty in the morning, Walter Pach gives the first of two lectures at the Arts Club of Chicago where Brancusi's sculpture is on exhibition [4.1.1927].

1940. Wednesday, Paris
Although André Breton has been sent to Poitiers as an auxiliary doctor, Duchamp has arranged to take Peggy Guggenheim to 42 Rue Fontaine to see the Miró that Breton would like to sell. They are also interested in an oil painting by Max Ernst, which Jacqueline Breton believes her husband would sell. Peggy is particularly taken with the Dali hanging above the bed, but it seems less likely that the Bretons could be persuaded to part with it.

1943. Sunday, New York City
Marcel visits the Kieslers.

1946. Thursday, New York City
Marcel tells André Breton, who is in Haiti, that he has seen the engraver, and work on the cover for *Young Cherry Trees secured against Hares* is progressing. For this volume of poetry by Breton (being published by View Editions), Marcel has planned that the black-and-white photograph of the author's head on the hard cover will appear through the aperture cut from the face of the Statue of Liberty printed in red, green and blue on the jacket.

10.1.1950

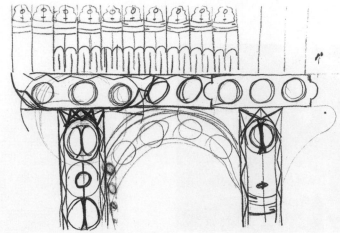

11.1.1927

Planning to leave for Europe mid-April, Marcel hopes that before he leaves the Bretons will be back in New York by the beginning of April when the book should be finished.

1947. Friday, Paris
Marcel telephones Mary Reynolds to warn her that he may have a berth on a ship leaving on Monday. By the evening when he dines with her, his passage is arranged.

1950. Tuesday, New York City
On behalf of Harry Holtzman [8.1.1950], Duchamp invites André Breton to contribute an article, "Science and Surrealism," to the Abstract artist's new review *Transformation*.

As Breton wants to reproduce the small, untitled canvas belonging to Gaby Villon in the *Almanach Surréaliste du demi-siècle*, Marcel decides to baptize the painting: *Courant d'Air sur le Pommier du Japon*. The setting for the buddha-like figure, inspired by the same model called "the Japanese", who posed for *Peau brune* [19.1.1915], is the garden at 7 Rue Lemaître, Puteaux.

1955. Monday, Paris
In the afternoon at three Duchamp is due to visit Iliazd with Bill Copley [7.1.1955].

*

At six o'clock Teeny and Marcel arrive at Sèvres to spend the evening with Roché and his family. Jean-Claude is proud to have found Duchamp's two chess problems published in *Le Figaro*. During the evening Teeny, Marcel, Roché, and Jean-Claude play a game of Kriegspiel.

1958. Friday, New York City
Informing Frank Anderson Trapp [2.12.1957] of Teeny's willingness to lend a Matisse to his exhibition "The 1913 Armory Show in Retrospect", Duchamp encloses a few lines to accompany his Nude in the catalogue:

"For over 35 years I have been completely overshadowed as an artist by 'that' very painting which took all the credit and notoriety.
Even lately I am surprised when my name is mentioned without a reference to 'that' painting.
Nevertheless I have a tender feeling for it, very much as though it were my prodigal daughter."

*

In "an orgy of theatre" Marcel and Teeny have recently seen *Purple Dust* by Sean O'Casey.

Tonight, accompanied by Denise and David Hare and Polly and George Heard Hamilton, they go to see *The Chairs* and *The Lesson* by Eugène Ionesco. *The Lesson* was "beautifully acted by a very young English girl", comments Teeny, "We all loved it." Next week they have tickets for *Endgame* by Samuel Beckett.

1963. Thursday, New York City
To illustrate an article being prepared for the Italian art magazine *Metro*, Duchamp has been requested to provide photographs of *In advance of the Broken Arm* [15.1.1916] and *Tu m'* [8.7.1918]. He orders them from George Heard Hamilton at Yale saying: "Terribly sorry to be such a pest…"

1967. Tuesday, New York City
John Cage, who has just had lunch with Monique Fong and her husband, calls to see the Duchamps.

11 January

1918. Friday, New York City
In the absence of Lou Arensberg (who has gone to Boston), there is a large crowd tonight at 33 West 67 Street including Marcel, and Charles Sheeler, who tells Roché that he is planning to make movies. Afterwards Roché has a talk with Mad Turban and Marcel.

1927. Tuesday, Chicago
In reviewing the Brancusi exhibition at the Arts Club [4.1.1927], C. J. Bulliet of the *Chicago Evening Post* reports that, according to Duchamp, "Brancusi has in his mental and emotional make-up a strong strain of mysticism … and this mystical tendency, combined with an intellect capable of developing an idea, and a really marvellous technical skill that can 'visualize' it, 'explains' Brancusi sufficiently."
"M. Duchamp – what is he doing? Nothing," Bulliet informs his readers, "just loafing and enjoying life in Paris, he will tell you, with amused indolence. Why isn't he painting, and renewing the renown that came to him with his Cubistic nudes? Because if he should paint again, he would merely repeat himself, so what's the use. All painters should be pensioned at 50,

he observes, and compelled to quit work. The government should see to it that the retired painters live on their pensions, and do not work clandestinely and secretly. Another sideline job for the prohibition enforcement department, says M. Duchamp…"

*

At eleven-thirty in the morning Walter Pach delivers his second lecture at the Arts Club of Chicago.

Brancusi in Paris receives a cable from Duchamp: "Club buys golden bird two drawings sold not finished."

1937. Monday, Paris
To help André Breton find photographs of Alphonse Allais [9.1.1937], Marcel has telephoned his friend Dr André Thibault who knows

the theatre critic Pierre Varenne. Although Marcel has not been able to find the critic's telephone number, he gives Breton his address. Thibault may be able to help, Marcel suggests, if Breton would prefer to telephone Varenne.

1940. Thursday, Paris
Marcel speaks on the telephone to Roché early in the morning, and at eleven o'clock accompanies Peggy Guggenheim [10.1.1940] to 99 Boulevard Arago. After concluding the sale of an Arp to Peggy, Roché, Mary Reynolds and Marcel have a "very jolly" lunch together at the restaurant Au Rat, 34 Boulevard Saint-Marcel.

1945. Thursday, New York City
For Kiesler's contribution to the special issue of

APPLICATION DES EXERCICES PRECEDENTS ET RÉCAPITULATION 3

mon âme, manière, rose, axes.

mon âme, manière, rose, axes.

mon âme, manière rose axes

mon â me manière rose axes

mon âme manière rose, axes

12.1.1894

View in preparation [22.12.1944], he and Percy Rainford have a second session [1.1.1945] with Marcel at 210 West 14th Street. The photographs show Marcel sitting at his cluttered table, his head turned in profile before a chessboard propped up against a wall pinned with notes, letters and telegrams. There are shots of the opposite side of the room, where tiers of shelves are strewn with papers and various odds and ends including, on the summit, part of Marcel's invention for the cover of *View*: a bottle of Bordeaux with a tube curling from its neck, through which a puff of smoke can be blown. They also photograph the part of the room where a press lies on the sill of the ceiling-high windows and a wastepaper basket scatters its overflowing contents of crumpled newspaper, empty cartons and torn card onto the floor.

In the evening, Marcel dines with the Kieslers at 56 Seventh Avenue.

1948. Sunday, New York City
In the afternoon at five, Marcel calls at 56 Seventh Avenue and spends a couple of hours with the Kieslers.

1960. Monday, New York City
Just after ten o'clock in the morning Duchamp telephones the Philadelphia Museum, but Henri Marceau is not available immediately. Giving his new address and telephone number [1.11.1959], Duchamp leaves a message asking Marceau to call him back in the next fifteen minutes.

1964. Saturday, New York City
"Many thanks for your first thought in 1964, which is a great present and a very pleasant one," writes Marcel to Brookes Hubachek, "I can't find the words to thank you enough."

Replying to his Chicago friend's question about Steinlen, Marcel explains: "although I never met him [he] used to live in Montmartre around 1905–06 when Villon took me under his wing [12.11.1904] at the beginning of my 'career'!! He is very well known for his cats. He drew at least a million of very beautiful cats."

Teeny and Marcel expect Brookes in New York the week beginning 20 January: "save us a night," requests Marcel, "and come for dinner."

1965. Monday, New York City
Richard Hamilton arrives from London for the opening of Marcel's exhibition at Cordier & Ekstrom on Wednesday.

In the afternoon the Duchamps attend the opening of an exhibition by Rodriguez [18.10.1962] who also reached New York today.

1966. Tuesday, New York City
The Duchamps go to the opening of Gianfranco Baruchello's exhibition at Cordier & Ekstrom, which Salvador Dali also attends.

1968. Thursday, New York City
In order to make a replica of the glass door which he made for Gradiva [18.4.1940], Duchamp writes to Georges Hugnet, whose bookbinding workshop was in the same courtyard at the time, asking whether he still has any photographs of the door, above all ones showing the shape of the two figures. Remembering that the glass was chequered, like the squares of a chessboard, Duchamp asks whether the squares were transparent or mirrors; whether the squares were glued together at the back, and therefore not transparent; or whether in fact the glass had been frosted.

12 January

1894. Friday, Blainville-Crevon
In a handwriting lesson at the village school Marcel, who is now six and a half, signs and dates his Reverdy exercise book number three. In the book he practises writing a series of words including "*mon âme, manière, rose...*"

1916. Wednesday, New York City
In the afternoon, while working at the Museum of French Art, Duchamp receives a visit from Miss Greene, who pays him $120, his salary for two months [15.11.1915]. Miss Greene says that she will be writing to him, but Duchamp doubts that the museum needs him as a librarian on a permanent basis.

1917. Friday, New York City
Duchamp has an "exquisite" lunch at Manguin's with Roché.

1927. Wednesday, Chicago
"The exhibition [4.1.1927] is a great success," Dee tells Miss Dreier. "I almost see all the expenses paid (of my undertaking) – meaning yet that the capital is still to come in, but we have 15 or 16 [Brancusi] pieces for that capital [13.9.1926]." As they have decided to extend the exhibition by a few days, Dee plans now to arrive in New York on 25 January.

Miss Roullier has studied the Meryon etchings [31.12.1926], but the values she has given Dee seem to be rather low and he has arranged to have one of them mounted properly.

1940. Friday, Paris
After his visit with Peggy Guggenheim on Wednesday to 42 Rue Fontaine, Duchamp writes to André Breton in Poitiers to say that of the three paintings, Peggy prefers the Dali. He asks Breton, if he has no sentimental reason for wanting to keep it, to tell him at what price he would sell it and the same for the Max Ernst. They have already agreed on the price of the Miró, but Duchamp suggests that to close the deal, Breton might propose a figure for the three pictures.

As the reproduction of *Mariée* is missing from Breton's copy of the Green Box [16.10.1934], Duchamp promises to deliver one to Rue Fontaine on his next visit and leave it on the table.

1947. Sunday, Paris
On the eve of Duchamp's departure to America, Breton finishes writing a letter to the Surrealist artists inviting their participation in another international exhibition to be held at the Galerie Maeght in Paris during the summer. Elaborated

12.1.1952

12.1.1962

in discussions with Duchamp, his partner for previous exhibitions in Paris [17.1.1938] and in New York [14.10.1942], Breton describes the concept and form of the project in some detail.

The 21 steps of the staircase to the upper galleries are to appear like "the spines of books carrying 21 titles corresponding in signification to the 21 major arcanes of the Tarot". Taking the visitor through various stages of "initiation", Duchamp envisages the Room of Superstitions as a white grotto; he has devised the Rain Room in which a billiard table is to be the main feature, and has also planned the Labyrinth, a long rectangular room to be divided into twelve octagons, each with an altar dedicated to "a being, a category of beings or an object susceptible of being endowed with mythical life". After this voyage, material sustenance for the visitor is to be provided in a Surrealist kitchen. On the ground floor there is to be a "retrospective" entitled "Les Surréalistes malgré eux", including Bosch, Arcimboldo, Blake and Rousseau, and contemporaries whose orbit has left the movement such as de Chirico, Picasso, Dali and Magritte.

Duchamp has agreed to coordinate operations in New York with the help of the architect Frederick Kiesler, Matta and Enrico Donati.

1950. Thursday, New York City
Mr and Mrs Earle Miller who go along with Henry McBride to a cocktail party given by Pierre Matisse "are thrilled to meet Salvador Dali, Marcel Duchamp and some of the others of the great".

1952. Saturday, New York City
After their outing together on Tuesday, Duchamp spends a long evening with Monique Fong, first at 210 West 14th Street and then at a small Italian restaurant on the corner of 4th and 10th Street. Their conversation revolves round the same components of the game: André Breton, Alfred Jarry, Patrick Waldberg, MT, etc. but, according to Monique, "the game recurs infinitely." Worried about her tendency towards depression and perseveration, Duchamp writes in her notebook: "Please stop 'this' nervous depression." He advises her to write all kinds of things – a manifesto, Surrealist or not, the story of her tacit love for Breton, etc.

Monique considers it worth the long journey from Washington just to share "Duchamp's friendship, his absolute clairvoyance, his liberty".

1955. Wednesday, Paris
Marcel has a conversation with Roché on the telephone.

1956. Thursday, New York City
While *Nu descendant un Escalier*, No.2 [18.3.1912] is on exhibition [3.1.1956] at the Sidney Janis Gallery, today Sam Falk photographs Duchamp, pipe in hand, sitting by his famous painting.

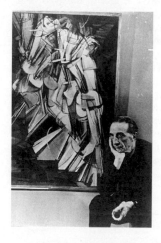

1959. Monday, New York City
"All is well." Marcel tells Roché that the sale of Brancusi's *Pingouins* has been concluded [5.1.1959], and that Teeny is taking an interest in *Cariatide*.

1962. Friday, South Hadley
Having had to cancel his previous engagement [10.4.1961], Duchamp's visit to Mount Holyoke College at Dorothy Cogswell's invitation is rescheduled for today and he arrives from New York in time to have lunch with a small number of students.

The informal discussions during the day are based on a list of questions provided a year ago by Dorothy Cogswell, which Duchamp has brought with him. While he talks to a group of art students in the Kingsley Room, Duchamp is photographed sitting in front of a picture by Elizabeth Henry, who is seated on his left.

At four o'clock Duchamp has tea in the gallery at Dwight Hall, with students taking a course on Picasso. Mr and Mrs Leonard Brown, who have also been invited, have lent a small exhibition of Duchamp's work from their

valuable collection of Dada and Surrealism. Jean Brown, who selected the exhibition, has included a small watercolour by Francis Picabia that Duchamp never even knew existed. Entitled *Pharmacie Duchamp$ Transatlantique* [13.5.1958] the work represents a shop front with two traditional flasks, one red and one green, standing in the window.

Later during dinner a student sitting next to Jean Brown asks Duchamp what he thinks about the exploration of space. "Why do we not go down below the earth's surface?" is his reply.

In the car with the Browns, who have offered to take Duchamp to Springfield to catch a train back to New York, the discussion focuses on how Art, in becoming a consumer product, is losing all its spiritual values. "What will happen to serious artists who hope to retain these qualities in their work," Jean Brown wonders. "They will go underground," [20.3.1961] declares Duchamp.

And how does he feel about his marriage [16.1.1954]? Duchamp says: "It is like gaining another self."

1964. Sunday, New York City
To celebrate their tenth wedding anniversary [16.1.1954], Teeny and Marcel have "a very intimate party" with the three Hales and Denise and David Hare. "We can hardly believe it," says Teeny. "The time has gone so quickly."

1965. Tuesday, New York City
On the eve of Duchamp's show at Cordier & Ekstrom, another guest arrives from abroad: Arturo Schwarz.

A telegram from Olga and Louis Carré is delivered to the gallery: "Hurrah for the genius of the century period with you in spirit congratulations to all."

13 January

1913. Monday, Paris
Duchamp and his brother Jacques Villon, Pierre Dumont and many other friends attend the funeral of Gaston Gosselin at the church of Sainte-Marie-des-Batignolles, 63 Rue Legendre. Born in Sotteville-les-Rouen in 1882, a young

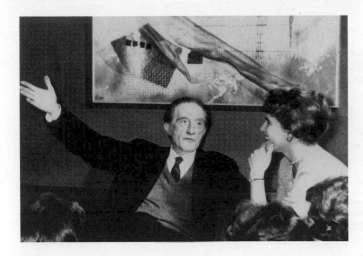

painter of great promise and member of the Société Normande de Peinture Moderne, Gosselin died on 11 January after a long illness.

*

Since his return from Etival [26.10.1912], Duchamp has made considerable progress with the work which commenced with the first Munich drawing: *La Mariée mise à Nu par les Célibataires* [7.8.1912]. In November, as a counterpoint to the Bride [25.8.1912], Duchamp made studies of elements for a Bachelor Machine. The graphic arrangement of these two principal elements of the composition is to be the Bride above, the Bachelors below: "The Bachelors serving as an architectonic base for the Bride," Duchamp wrote in a note, "the latter becomes a sort of apotheosis of virginity."

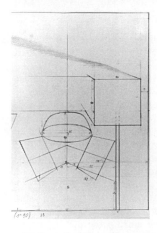

By the end of December Duchamp had incorporated the various parts of the Bachelor Machine in a large perspective sketch drawn in black and red on a piece of cardboard measuring approximately one metre by 70 centimetres high: *Esquisse de la Machine Célibataire en perspective.*

1917. Saturday, New York City
According to Roché, Marcel dines with him and a couple of friends, but according to Beatrice Wood, after dinner with Sidès and Foucher, Marcel takes her to meet the Arensbergs who live just two floors down from his own studio at 33 West 67th Street.

When Lou and Walter meet the young actress they give her a warm welcome and make her feel at ease in the large duplex apartment, the sitting room of which is beautifully furnished with early American furniture, oriental rugs and comfortable sofas and chairs. On the walls of every room, however, hang the paintings of Picasso, Braque, Matisse, Rousseau, Gleizes and Duchamp, all of which horrify her and make her "head spin in disbelief".

Bea, who has "sat down in a state of shock", finds herself near a soaring Brancusi bird standing on a pedestal; quite relaxed in his armchair, Marcel observes her reactions throughout the evening. The Arensbergs' house is open regularly to their wide circle of friends: writers, poets, critics, painters, philosophers and actors. At midnight there is a customary pause in the discussions around the grand piano, games of chess and diverse conversations when Lou serves drinks, hot chocolate, pastries and éclairs.

1918. Sunday, New York City
Having failed to wish the Stettheimer sisters a happy New Year "in any form or manner", Duche telephones Ettie to make amends but receives a rather cold reception. "I am very *blesséd*," he declares ambiguously. Standing her ground, Ettie considers privately that "he's a washrag, or seems to be…"

1919. Monday, Buenos Aires
Continuing a letter of New Year wishes to the Stettheimer sisters, Duche addresses each of them in turn.

From Florine's long letter, he has been able to visualize one of their dinner parties in detail: "I see Sidès and Nadelman vying for who dances the more often with Ettie by the end of the evening." After mentioning that he feels like a prisoner of war because the Argentinian soldiers are dressed like Germans, Duche cites a prognostic [his own?] for the Peace Conference which envisages "Europe in small pieces" without war for 50 years.

Duche thanks his "chèreEtt" for the funny article from the *Tribune* which he has declared a readymade. "I have signed it but not written it," he says, and wishes that he had collected more of the same kind. Missing her lotion for his hair, Duche insists that he never had wavy hair "except at the age of 5" and signs himself "your immense baby".

And Carrie's doll's house? "A photo of the state of construction would please me," he tells her. "And your new chauffeur: what kind?" Duche enquires, "the fish shop on Columbus Ave is [it] still well stocked?"

1923. Saturday, New York City
The Stettheimer sisters throw a large party [celebrating the American show organized by John Wanamaker for Belmaison?], which is attended by numerous artists and friends including Marguerite and William Zorach, Marion and Louis Bouché, Duchamp, Mr and Mrs Joseph Hergesheimer, Charles Brackett, Pitts Sanborn, Florine Oppenheimer, Hilda Hellman, Gilbert Cannon, Henry McBride, Louis Bernheimer, Abraham Walkowitz, Andrew Dasburg, Marie Doro, Professor Edwin Seligman and his wife, and Carl van Vechten.

Later Dasburg takes a group down to Louise Hellstrom's [12.11.1922] where they find Joseph Stella, Jane Heap, Margaret Anderson and Eva Gauthier.

1926. Wednesday, Rotterdam
At six o'clock Duchamp writes a card informing Brancusi that "everything has arrived safely free of charge". He adds: "will be in Paris tomorrow evening – I don't promise to come and see you if the train arrives after midnight."

1927. Thursday, Chicago
"I forgot about helping you on 23rd when I accepted to have the Brancusi show until 23rd here," explains Dee guiltily to Miss Dreier whose Société Anonyme exhibition opens in New York on 25 January.

*

On her "only free evening" from social events, Rrose Sélavy [20.10.1920] draws her conclusions about "Chicago City" for Ettie Stettheimer's benefit: "I go to the opera every night; I have at least a lunch a day and a tea as well – and it is a real delight to see myself swimming in these social perfumes. Knowing that this will not last a lifetime, I am perfectly satisfied."

In spite of this round of engagements, Rrose has managed to avoid dancing. "My rose (rrose) shirt astonishes the Chicagoans," she tells Ettie. Giving love to the whole family, Rrose mentions that she is wearing Florine's tie this evening after wearing Carrie's stockings yesterday…

1939. Friday, Paris
Thanking Henri Parisot for sending him his collection "Biens Nouveaux", Duchamp comments: "I find it very interesting. The choice of pieces contributes enormously." He invites Parisot to 11 Rue Larrey on Monday at four unless the editor would prefer to meet him in a café near Alésia.

13.1.1961

026 Z 691

13.1.1965

1947. Monday, Paris
In order to catch the boat-train at the Gare Saint-Lazare, Marcel leaves Mary at 14 Rue Hallé at the crack of dawn.

Before leaving Paris, Duchamp has confirmed that Isabelle Waldberg [16.11.1945] may have his studio at 11 Rue Larrey, and (although he has not seen the proofs) he has also left with her his contribution to *Le Memenot Universel Da Costa*, known as "Washington" for short on account of "D.C.". As the publication takes the form of an encyclopaedia, Duchamp has provided a short entry signed with his initials:

"SENSES. One can look at seeing. Can one hear hearing, scent smelling, etc. ...?"

Later in the day when the SS *Washington* has sailed from Le Havre, Marcel writes to Yvonne Lyon [8.12.1946] and posts the letter when the liner calls at Southampton. Commenting that he has eight days at sea before him, and dormitory accommodation as anticipated, Marcel concludes: "Farewell, dear Yvonne, another leap ended."

1953. Tuesday, New York City
Marcel informs Louise and Walter Arensberg that he has finished retouching Adam and Eve [20.10.1952] and that Budworth is shipping the painting immediately to Philadelphia. Describing the progress being made with the building work at Philadelphia [31.12.1952] which he finds is "very well done", Marcel comments that "the ensemble gives a feeling of an architectural unit".

1954. Wednesday, New York City
"I will of course go to Philadelphia when you ask me and follow your instructions in my interview with Fiske [Kimball]," Marcel assures Walter Arensberg, who is dismayed by the proposal of having a "general opening of a Modern Museum" at the same time as their collection [3.12.1953] when an opening in March had been suggested [29.10.1952], before the death of Louise.

1961. Friday, New York City
Duchamp has completed his *Anagramme pour Pierre de Massot*, which is a drawing of the phallic street urinal inscribed "de Ma Pissotierre j'aperçois Pierre de Massot" [from my

street urinal I perceive Pierre de Massot]. He posts it to Robert Lebel for the auction at the Hôtel Drouot on 17 March, the proceeds of which are for the benefit of the one-time manager of *391* [10.7.1921].

*

In a letter of condolence to Charles Covert Arensberg, following the death of his cousin, John Covert [19.4.1917], Duchamp writes: "I have always kept nice memories of 1915–16–17 when I was closer to him. During these few years he joined forces with the pioneers of the new art movement and became an outstanding figure in the group formed around Walter Arensberg."

*

Duchamp declares that he doesn't know himself when a work of art comes into existence, nor who makes it, when the sixth and final interview with Georges Charbonnier is broadcast in Paris on France Culture [6.1.1961].

"I believe that the artist doesn't know what he does. He knows what he does physically and even his grey matter thinks normally, but he is incapable of assessing the aesthetic result. This aesthetic result is a phenomenon with two poles. The first is the artist, who produces, and the second pole is the spectator. By spectator I mean the whole of posterity and all those who look at works of art who, by their vote, decide that a thing should survive... The artist has produced without knowing it; and I insist on that because artists dislike being told that. The artist likes to believe that he is completely conscious of what he does, why he does it, how he does it and the intrinsic value of his work. I don't believe that at all. I sincerely believe that the picture is made as much by the onlooker as by the artist. Therefore the spectator is as important as the artist in the art phenomenon."

Cannot the artist over a period of time have this kind of dialogue with himself and his work of art, asks Charbonnier.

"No, because the onlooker, by his interpretation, adds what the artist never even thought of doing. He not only adds, but he deforms in his way, according to his authority, and God knows, it is powerful this authority when it concerns posterity which in fact decides what is put into the Louvre... Like electricity, there are two poles: the positive and the negative. The one is as indispensable as the other. I attach even more importance to the spectator than to the artist."

"[Posterity] is very important because, in the end, it makes history. History is made by the people who come afterwards, who interpret it and often distort it. We know nothing about what really happened under Louis XV; there are written things which are interpreted, but the facts themselves have not always been recorded in a precise way and, God knows, that in every period historians make great novels of past history. In the domain of art it's the same thing."

Drawing on his experience of the previous summer [1.9.1960], Duchamp takes the Ancient Greeks as an example.

"There are so few documents that there is a fantastic fabulation. There are three theories at once for the same site."

Did you think about this when you painted?

"More or less. More or less. When you do something, what the others see in it always astonishes you."

If you thought that when you painted, did it not reduce a certain faith in painting which one expects in the artist?

"No, on the contrary. If as an artist one has this attitude to what one does, one hopes to come out of oneself without knowing it... that the thing which comes out will be something independent of your will, your intelligence, your sense, everything. It's a thing much more profound than the unconscious. And only posterity can discover it!"

But isn't that a typically Surrealist attitude?

"Not only Surrealist... The profound value of art cannot be detected in a temporary fashion. It's a much more profound thing and much more durable... I believe the centuries can have this profound perception of a thing that the artist, in making it, cannot imagine. In other words, we each smoke a cigarette, there are two ways of smoking, yours and mine. There's no comparison even if, apparently, we are smoking in the same way."

Charbonnier turns to the price of painting and asks how the notion of price can be attached to a work of art.

"Impossible to understand, and completely ridiculous. It's paradoxical because the work of art does not have a value, none. It's a thing which is essential only by its presence. This presence is such that it passes from century to century and is preserved as a unique thing which has no price. More than ever, money has taken the form of divinity. Is it because God has

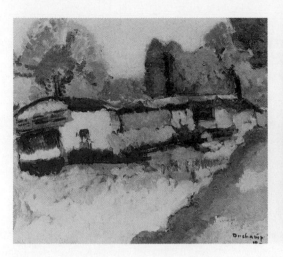

diminished in importance? It was necessary to find another? And money has been found as a divinity which is hardly spoken about, but which is thought about all the time. There is a temptation for the buyer as well as for the artist to use this thing which helps satisfy the speculative need because it's a form of competition. After all we live in a competitive world. You kill your neighbour. You have to kill your neighbour to survive, don't you? Otherwise you don't survive, it's you who dies. It's a choice."

1964. Monday, New York City
"Teeny and I are walking on air since the arrival of the Parmentier estimate [21.12.1963]: it will make a fine 'bachelor apartment'," writes Marcel to Bernard Monnier, who has also advised him of the arrival of the first of three payments from Arturo Schwarz.

*

Writes a belated note to Francis Roberts [13.10.1963], returning the manuscript of the interview accorded in Pasadena with a few corrections.

1965. Wednesday, New York City
The invitations to the preview dinner of "NOT SEEN and/or LESS SEEN of/by MARCEL DUCHAMP/RROSE SELAVY 1904–1964" are each adorned with a playing-card sized illustration of Leonardo's *Mona Lisa* pasted to them. Underneath the illustration, in addition to *L.H.O.O.Q.*, Duchamp has written *rasée* [shaved], a reminder that the lady once had a goatee and moustache [6.2.1930]. Guests are

invited at eight o'clock to the black-tie preview and a sumptuous, colourful dinner, which is theatrical in its presentation at Cordier & Ekstrom, 978 Madison Avenue. A tiered wedding cake

with small effigies of Teeny and Marcel on the summit is stuck with messages from Rrose Sélavy. The noble Collège de 'Pataphysique is represented by the Provéditeur-Délégataire Simon Watson Taylor, who presents Duchamp with the first copy of the *Selected Works of Jarry*, which he edited with Roger Shattuck.

Apart from the New Yorkers, many friends have come from Europe to celebrate the opening of the mysterious Mary Sisler's almost exhaustive collection of Duchamp's early works not yet seen, accompanied by those less seen. For many years Duchamp himself refused to allow his early pictures to be handled indiscriminately or exhibited out of context [11.4.1952].

Here, a complete set of readymades [5.6.1964] is presented in contrast with drawings and paintings for decades in the collections of Duchamp's close friends Gustave Candel [24.10.1953] and Henri Pierre Roché [15.4.1959]. One such picture given to Candel and never exhibited is the little Fauve style landscape of 1910 entitled *Bateau-Lavoir*, which was painted from the banks of the Seine near the Pont de Neuilly.

It is also the first appearance in New York of *Rotative Demi-sphère (Optique de Précision)* [8.11.1924].

The catalogue with the door which is open and shut at the same time [9.10.1937] on the cover [20.12.1964], contains a foreword and texts on the works exhibited written by Richard Hamilton [11.1.1965].

*

Duchamp talks to the Press earlier in the day. The first question is why such a gifted artist should have decided to give up painting? The answer, noted by Emily Genauer of the *Herald Tribune* is that "he stopped painting but not making art. Thereafter he concerned himself with 'conceptions' … which he holds more important than mere technique possessed by any artisan."

Duchamp is "lean, lively and jauntily clad in corduroys and suede shoes", and to Grace Glueck of the *New York Times* looks "not at all like a figure from Art History". Asked about the value of *Nu descendant un Escalier* [18.3.1912], Duchamp says airily: "All that's over my head," and looks off into space for a moment. "The trouble is, artists can't shock people any more. Everything's accepted. The only thing that shocks today are the Russian paintings by their complete return to academicism."

Grace Glueck also records Duchamp's view on the future for art: "I don't think oil painting will last another 50 years. It'll cease to be, like illuminated manuscripts. New forms of life and new techniques are springing up. As for museums," Duchamp continues, "they'll probably go on collecting things, but they may store them on tape. You may be able to see an art show in Tokyo simply by pushing a button."

Does Duchamp still play chess?

"I didn't get far enough with it, so I no longer take it quite so seriously. What do I do though? At a certain stage of life, it's enough to sit in a chair and meditate. For me that's an occupation."

1967. Friday, New York City
"Your sad note about the welcome which Paris is reserving for me reminds me of the tenor or the coloratura who is to sing for the first time at the opera of Toulouse or Rouen," says Marcel and, playing with the name of the famous Russian bass, asks Robert Lebel: "Should I be scared or: *(Où il y a) cha(t) (i)l y a pine…*

"I can't lay my hands on Mary Sisler," he continues, "she has disappeared [22.12.1966]. On the Phila[delphia] side, Dr Turner is late in replying definitely."

As another auction is to take place for the benefit of Pierre de Massot [13.1.1961], Marcel has asked Jackie Monnier to collect a copy of his etching, *Les Joueurs d'Echecs* [11.5.1965], from 5 Rue Parmentier and give it to Robert Lebel for the sale.

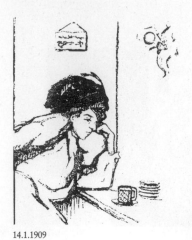

14.1.1909

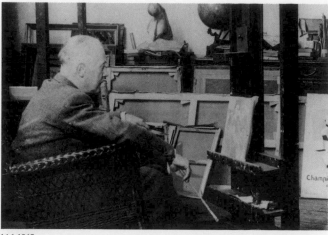

14.1.1965

14 January

1905. Saturday, Blainville-Crevon
A banquet is held in honour of Eugène Duchamp, who has been mayor of the village for the last ten years [7.11.1895]. To illustrate the menus, Gaston has etched a portrait of his father incorporating a view of Blainville. *Notaire* since December 1883, Eugène Duchamp plans to retire from his practice at the end of March and move to Rouen., where he can be more actively involved in regional affairs.

1909. Thursday, Paris
Duchamp's drawing *Le Lapin* [25.5.1907], which was exhibited at the Salon des Artistes Humoristes in 1907, is published today in *Le Courrier Français*; in this version the woman who has been stood up regrets that she didn't restrict her drinks to just one half pint.

1920. Wednesday, New York City
Marcel takes Walter Arensberg and Beatrice Wood to the studio of Louis Eilshemius, the artist he "discovered" at the Independents [9.4.1917].

1922. Saturday, Paris
Invited to lunch at the Conrans', Duchamp finds that one of the other guests is Roché, whom he has not seen for several months [28.7.1921]. Their meeting brings back memories of New York and they talk about Louise Norton, Beatrice Wood and the Arensbergs.

1926. Thursday, Rotterdam
Travels back to Paris by train.

1965. Thursday, New York City
At the Parke-Bernet sale of the Ira Haupt Collection [22.10.1956], *Portrait de Marcel Duchamp* by Jacques Villon is sold amid much competition to a New York collector for $23,000. It is one of a series: in the autumn of 1950 Marcel posed in the artist's studio at Puteaux seated in one of the wicker garden chairs.

1966. Friday, New York City
Marcel writes to Brookes Hubachek thanking him for his New Year gift. "I hope Hawaii will at least offer you an exotic picture of nature (feminine and otherwise) to adorn the non-monkey business," he tells Brookes, who is planning to take a well-earned break from his "load of heavy work".

*

On Friday evenings John Cage comes to play chess with Marcel and, for the occasion, Teeny cooks "all kinds of extraordinary things". But the sequence will be interrupted for a while because Cage is going "on circuit" for a month.

15 January

1916. Saturday, New York City
"Thank you enormously for attending to all my affairs," writes Marcel to his sister Suzanne who has agreed to empty his studio in Paris at 23 Rue Saint-Hippolyte [22.10.1913]. "Now that you have been up to my place you have seen a bicycle wheel and a bottle rack in the studio. I had bought it as a ready made sculpture," he explains, "and I intend to do something with the said bottle rack..."
Explaining first the basis of his new concept to Suzanne, Marcel says that in New York he has purchased objects "in the same flavour", treats them as "readymade", signs them and adds an inscription in English. "I will give you some examples," he continues. "For example I have a large snow shovel at the foot of which I have written: *In advance of the broken arm...* don't struggle too much to understand the meaning, romantic or Impressionist or Cubist – that has nothing to do with it; another 'readymade' is called: *Emergency in favour of twice...*"
After this short explanation, Marcel offers his sister the symmetrical, spiny object purchased at

the Bazar de l'Hôtel de Ville in 1914, which he left behind in Paris, and with her assistance proposes to make a "Readymade at a distance". He instructs her to "inscribe at the bottom, inside the bottom circle in small letters painted with an oil paint brush in white lead paint the inscription which," he says, "I will give you afterwards and you will sign it with the same writing as follows: [d'après] Marcel Duchamp."
Making a replica of his talismanic *Roue de Bicyclette* is not so difficult [18.10.1915], but to find the curious free-standing circular rack called an "égouttoir" – quite common in France – is certainly impossible in New York. Hence the "Readymade at a distance". But the inscription is lost and the original *Egouttoir* (or *Porte-bouteilles*, or *Hérisson*, as Duchamp refers to it) disappeared too. However, this manufactured iron object, designed to drain (*égoutter*) bottles after they have been washed, is the epitome of non-taste. After all, the word *égoutter* sounds much like *égoûter*, the French for "to remove taste".

1918. Tuesday, New York City
On Tuesday evenings, Duchamp gives French lessons to Miss Dreier and Bertha [von Zastrow?]. Miss Dreier has told her sister Mary how Duchamp "speaks wonderful French" and that "his pronunciation is so beautiful". Mary can join the class by paying for the nights she comes. "It is $1.50 a person if there is more than one – $2.00 for single lessons [10.1.1918]," Miss Dreier explains. "We are reading a very amusing French story which I am afraid will shock you, so you must be prepared... It is very humorous, but quite French in a naughty way."

1921. Saturday, New York City
At a quarter to five in the afternoon Duchamp is due to collect Miss Dreier and accompany her to the Manhattan Trade School where, that evening, she is to give the first in a series of three lectures on Modern Art. They hang seven pictures and place two sculptures on exhibition for the lecture, entitled "Rebels in Art", which commences at eight-thirty. Joseph Stella and Duchamp attend and answer questions afterwards.

1928. Sunday, Paris
On the eve of his departure for Nice, Duchamp informs Alfred Stieglitz that, as they discussed last year, he has arranged to send on his own

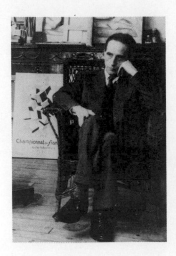

15.1.1916

15.1.1956

account with George Of in New York, eleven Picabias framed by Pierre Legrain. "Will you look at them," he requests, "and see whether you can show them…? These things are recent and show a shade of Picabia that you know and probably expected to come out."

Duchamp explains that he is "going south for 2 months to recover from a divorce [5.1.1928]," and adds, "So I am afraid you'll never see me married." He comments: "Life here is a bit more European and I loaf a lot."

*

Thanking Miss Dreier for "the wonderful table" which arrived after he wrote on 6 January, Dee says delightedly, "it is just the kind of furniture that fits in my studio." Although he will be away when the shipment of paintings by Dorothea Dreier and Eilshemius arrives, he has decided to write to some people suggesting that, in the meantime, they go to see the pictures at Lefebvre-Foinet.

1937. Friday, Paris
Delighted to hear that they are being sold successfully, Duchamp mails a further six sets of *Rotoreliefs* [30.8.1935] and two copies of the Green Box [16.10.1934] to Miss Strettell in London and requests payment for the 30 sets mailed on 16 October and 19 November last.

1945. Monday, New York City
Further to their photographic session on Thursday, today Marcel has lunch with Kiesler.

1952. Tuesday, New York City
Duchamp visits the Rose Fried Gallery and finds Miss Fried and Fritz Glarner hanging the new show, "Coincidences," which apart from "the very good title" includes "good examples of Malevich, Rodchenko etc".

"Duchamp Frères & Sœur" [4.10.1951] is coming next on 25 February and Duchamp suddenly discovers that his "peaceful life has been changed into a publicity machine". Rose Fried tells him that in addition to the interview in the *Art Digest* tomorrow "as a forerunner of the show", *Life* is interested and also "Talk of the Town" in the *New Yorker*.

*

"The circus continues," Dee tells Miss Dreier, promising to send her a copy of the *Art Digest*. "Hoping to receive a little note from you telling me the last news of your village," writes Dee, "I am sending you my best wishes from my village."

1955. Saturday, Paris
With Max Ernst and Dorothea Tanning, Marcel and Teeny are invited to dinner by Lily and Marcel Jean, 17 Rue Hégésippe-Moreau. They gossip gaily about their friends – notably Yves Tanguy and his wife Kay.

At the age of fifty-five, Yves Tanguy dies suddenly at his home in Connecticut from a cerebral haemorrhage.

1956. Sunday, New York City
Produced and directed by Robert D. Graff, the thirty minute film *A Conversation with Marcel Duchamp*, which was shot at the Philadelphia Museum of Art [3.8.1955] the previous July during two very hot days, is broadcast by NBC Television in the series: "Conversations with the elder wise men of our day."

Accompanied by James Johnson Sweeney, the director of the Solomon R. Guggenheim Museum, in the opening sequence Marcel is looking at the Large Glass [5.2.1923], which stands like a monument in the galleries of the Louise and Walter Arensberg Collection [13.10.1954]. "Yes, the more I look at it the more I like it. I like the cracks, the way they fall," says Marcel and goes on to explain how the Glass was broken [26.5.1936] after the exhibition of the Société Anonyme at the Brooklyn Museum [19.11.1926].

They look at various early canvases by Marcel including *Portrait de M. Duchamp père, assis* [6.5.1911] and Sweeney remarks that he looks like a patient man. "He was always very understanding and always helped us out of scrapes," Marcel admits. "He told us 'All right, I'm going to give you what you want, but listen: there are six of you. Anything I give you while I'm alive I will deduct from your inheritance.' And when he died [3.2.1925] these amounts had been deducted… Not so stupid, actually, that idea: it helped us all manage."

Explaining the transition from the portrait of his father to Cubism, Marcel declares: "I decided to get away from all the influences I had been under before. I wanted to live in the present, and the present then was Cubism… I became a Cubist painter and gradually came up with the Nude [18.3.1912]."

After the event of the Armory Show [17.2.1913], which Marcel argues, "could have been just an explosion," he explains: "I had done what I could with Cubism, but now it was time to change… I could have done ten other nudes at that time if I had wanted to. But the fact is I did not want to. But I went on immediately to another formula, the formula of the *Chocolate Grinder* [8.3.1915]."

Sweeney asks what it was that particularly interested Marcel in the machine that so fascinated him in Rouen.

"The mechanical aspect of it influenced me then, or at least that was also the point of departure of a new form of technique. I couldn't go into the haphazard drawing or the paintings, the splashing of paint. I was beginning to appreciate the value of exactness, of precision, and the importance of chance."

Sweeney supposes that the *Chocolate Grinder* heralded something in his work, something of that "break" which Marcel has often talked about.

"Yes, it was really a very important moment in my life. I had to make big decisions then. The hardest was when I told myself: 'Marcel – no more painting, go get a job.' I looked for a job in order to get enough time to paint *for myself*. I got a job as a librarian in Paris in the Bibliothèque Sainte-Geneviève [3.11.1913]… I didn't want to depend on my painting for a living."

Even if he ignores the broad public, Marcel paints for the ideal public, Sweeney suggests.

"It is only a way of putting myself in a right position for that ideal public. The danger is in pleasing an immediate public that comes around you and takes you in and accepts you and gives you success and everything. Instead of that, you should wait for fifty years or a hundred years for your true public. That is the only public that interests me."

Sweeney recalls Roché's comment that Marcel is always careful to find a way to contradict himself.

"You see the danger is to 'lead yourself' into a form of *taste*, even the taste of the *Chocolate*

17.1.1938

Grinder. Repeat yourself often enough and it becomes taste."

Sweeney asks how he found the way to get away from good or bad taste in your personal expression.

"By using mechanical techniques. A mechanical drawing has no taste in it."

Then does this divorce from all human intervention in drawing and painting have a relationship to the interest in the readymades?

"It was naturally, in trying to draw a conclusion or consequence from the dehumanization of the work of art, that I came to the idea of the readymades [15.1.1916]."

Marcel then shows Sweeney the birdcage readymade, *Why Not Sneeze?* [11.5.1935]. "It weighs a ton, and that was one of the elements that interested me when I made it, you see. It is a readymade in which the sugar is changed to marble. It is a sort of mythological effect."

He then picks up *A Bruit secret* [23.4.1916]. Explaining that Arensberg put something in the ball of twine before he finished it, Marcel says: "It was a sort of secret between us... Listen to it. I don't know. I will never know whether it is a diamond or a coin."

Returning to the Large Glass, Sweeney comments that it remains "a sort of unfinished epic" and supposes that there is something broader in Marcel's concept of what art is than just painting.

"Yes. I consider painting as a means of expression, not an end in itself. One means of expression among others... In other words, painting should not be exclusively retinal or visual: it should have to do with the grey matter, with our urge for understanding. This is generally what I love. I didn't want to pin myself down to one little circle and I tried to be as universal as I could. That is why I took up chess. ... I took it very seriously and enjoyed it because I found some common points between chess and painting. Actually when you play a game of chess it is like designing something or constructing a mechanism of some kind by which you win or lose. The competitive side of it has no importance, but the thing itself is very, very plastic, and that is probably what attracted me in the game."

They look at the *Boîte-en-Valise* [7.1.1941], which Marcel describes was "a new form of expression" for him. Rejecting the idea of a book in which to reproduce his work, he says:

"I thought of the idea of a box in which all my works would be mounted like in a small museum, a portable museum, so to speak, and here it is in this Valise."

To sum up, Marcel declares: "I am interested in the intellectual side, although I don't like the word 'intellect'. For me 'intellect' is too dry a word, too inexpressive. I like the word 'belief'. I think in general that when people say 'I know', they don't know, they believe. I believe that art is the only form of activity in which man as man shows himself to be a true individual. Only in art is he capable of going beyond the animal state, because art is an outlet towards regions which are not ruled by time and space. To live is to believe; that's my belief, at any rate."

1961. Sunday, New York City
Immediately after having lunch with Teeny and Bill Copley at 28 West 10th Street, Marcel goes to help Harold Phillips with a chess book project, which is his occupation at the moment every Sunday afternoon.

Bob Hale comes to play chess with Teeny and stays for supper.

1962. Monday, New York City
"We too are delighted that we actually are on our way to Florida," writes Duchamp to Jeanne and Isadore Levin [14.12.1961], whose idea originated when they were together in Detroit [28.11.1961]. After giving details of their travel arrangements on 12 February, Duchamp adds: "As for filling our time, we are inclined to take it easy and lazy."

1963. Tuesday, New York City
Writes to thank Brookes Hubachek for his New Year gift. "The Tower is going up rapidly," Marcel remarks, "the view from the top is getting wider and wider – Thanks to you, the architect [27.2.1951] – Even the sky seems not to be the limit."

Commenting on Brookes' views about the French president, Marcel says: "Your reaction to the article on de Gaulle is absolutely correct. The political business is too complicated in France and one can only judge characters and, wrong or right, de Gaulle is made of strong metal..."

1966. Saturday, New York City
"Thanks for the slides giving a good idea of your impeccable technique," writes Marcel to Richard Hamilton, who is working on a replica

of the Large Glass in Newcastle-upon-Tyne. He gives Richard Maria Martins' address in Sussex, where she will be staying "for a month or two".

1967. Sunday, New York City
"As pleasures go," says Marcel to Brookes Hubachek, thanking him for his gift, "we are quits, but I will never tell you enough of my gratitude."

*

Monique Fong visits the Duchamps with her daughter Barbara, who plays chess with Teeny.

1968. Monday, New York City
Duchamp sends Marcel Jean a copy of an advertisement for the second edition of his book, *The History of Surrealist Painting* [30.12.1959], which he saw by chance in the *New York Times* of 7 January.

*

In the morning the Duchamps travel to Philadelphia by bus, "now the best way, for the train is so frustrating," according to Teeny. They have lunch in the country with Bonnie Wintersteen and get back to New York "just in time" for a friend who comes to supper.

16 January

1925. Friday, Paris
Having spoken to Jacques Doucet about the issue of *Obligations pour la Roulette de Monte-Carlo* [1.11.1924] the previous day, Duchamp sends the collector certificate number 15 by registered post. He has worked hard at the system since his "bad experience" the previous year [31.3.1924]. "Don't be too sceptical," requests Duchamp, "because I believe in this case to have eliminated the word chance. I want to have forced roulette to become a game of chess." Telling Doucet that he very much wants to pay the dividends, Duchamp promises to call on him before departing for Monaco.

1928. Monday, Paris
Departs for Nice.

1932. Saturday, Paris
Louis Aragon is charged with incitement to disaffect after the publication of his poem "Front

Rouge" in *Littérature de la Révolution mondiale*. With 300 others including Paul Fort, Francis Picabia, and Giacometti, Duchamp puts his signature to the petition requesting that the charge (which carries a possible sentence of five years in prison) be dropped immediately.

1948. Friday, New York City
In connection with preparations for the celebration on 5 March, Duchamp sends a statement about the Société Anonyme [30.4.1920] by telegram to Miss Dreier in Milford, which reads: "Already 1920 need for showing modern art still in chaotic state of Dada in non commercial setting to help people grasp intrinsic significance stop aim of SA to show international aspect by choosing important men from every country unknown here Schwitters Mondrian Kandinsky Villon Miró."

1951. Tuesday, New York City
Marcel tells Louise and Walter Arensberg about his recent visit to Philadelphia. He saw Fiske Kimball, now back from the West Coast [27.12.1950], who told him the news of the donation with ecstasy and, after a few hours discussion, Marcel says, "I heard all I wanted to know. First of all, the period of 25 years is really comforting."

Suggesting some modifications to the galleries reserved for their collection, Marcel thinks that "a gentle disorder" in the hanging would be preferable to "a geometric 'balancing' in the disposition of the paintings". As for the Large Glass [5.2.1923], "I had already spoken, some time ago, to Miss Dreier," he explains, "and she is perfectly willing to give the glass to Phila[delphia] – I announced it to Fiske, who accepted promptly."

Marcel stresses to the Arensbergs that they must both: "get in fine shape around springtime and come up to Phila[delphia] to see the space and decide about some final points."

Referring to *Nu descendant un Escalier*, No.2 [18.3.1912] currently on exhibition in Philadelphia [4.12.1950], Marcel declares: "The 'nude' is holding its own among the masterpieces of the Jubilee, *says I*."

1952. Wednesday, New York City
Providing some publicity for the forthcoming Duchamp family exhibition at the Rose Fried Gallery on 25 February, "A Marcel Duchamp Profile" is published in the *Art Digest*.

"Like Heraclitus," commences the article, "who, centuries ago, declared that 'all is flux', Marcel Duchamp believes that life is predicated on change." Tracing the different stages in his career, the journalist concludes that: "Anti-aesthetic, rebellious, defiant, Duchamp has spent a good part of his 64 years shocking people out of their apathy towards tradition in art."

"Change is necessary," says Duchamp. "Humanity can't stand more than 30 or 40 years of anything. I still have a decided antipathy for aestheticians. I'm anti-artistic. I'm anti-nothing. I'm revolting against formulating."

1954. Saturday, New York City
Since spending Christmas at Lebanon, Marcel has asked Teeny Matisse to marry him and he has chosen the Feast of Saint Marcel for the ceremony. As his wedding gift Marcel presents Teeny with *Coin de Chasteté*; a small sculpture of two interlocking parts: a wedge of galvanized plaster inserted into the cleft offered by a piece of pink dental plastic.

On arrival at City Hall on this very cold day, Marcel and Teeny discover they need a witness. Quite by chance a young man sees Marcel in the ante-chamber and asks him what he is doing there. "I'm getting married like you!" replies Marcel. He has no difficulty in persuading his friend, a chess player, to be their witness. After the ceremony, they take a taxi uptown to the corner of 60th Street and Lexington where Teeny's daughter Jackie offers them a glass of champagne in her small apartment.

At five o'clock a long telegram in French from Paul Matisse, a poetic expression of his joy, arrives at 327 East 58th Street. On the top floor at this address is the apartment which Teeny and Marcel have taken over from Max Ernst and Dorothea Tanning, now living in France.

In the evening Teeny and Marcel drive out to the farmhouse at Lebanon where they stay for a few days.

Teeny first met Marcel in 1923 when she was seventeen at a ball in Paris given by Mr and Mrs Heyworth Mills. Mariette Mills was a childhood friend of Teeny's mother, and when Teeny was sent to Paris by her father, Dr Robert Sattler, a prominent eye-surgeon from Cincinnati, Mariette became her guardian. While at school in Neuilly, Teeny attended drawing and sculpture classes at the Grande Chaumière.

Mariette, who had studied sculpture with Bourdelle, had a beautiful studio and house in Rue Biossonnade, where the ball was held. Fernand Léger, Francis Picabia, Brancusi and Mina Loy were among the guests. During the evening, Bob McAlmon and Marcel arrived completely drunk, and when they peed down the stairwell, Heyworth Mills hid Teeny and Joella Lloyd (Mina Loy's daughter) from the scene.

Later with Pierre Matisse, Teeny met Marcel in Paris and again many times when he came to New York during the war.

The romance started one evening in 1951 when Marcel asked Teeny to have dinner with him at a restaurant in Central Park. Soon afterwards he invited her to lunch near his studio. As she had not played much chess since she was a child, Teeny took a chess course with Horowitz at the New School of Social Research and learned chess notation. Marcel and Teeny enjoyed analysing games together, but she decided that she would never play him competitively.

1961. Monday, New York City
On their seventh wedding anniversary, Teeny and Marcel are invited to cocktails at the Ernsts before attending the preview of David Hare's exhibition at the Saidenberg Gallery, which is being celebrated with a concert.

1962. Tuesday, New York City
In reply to Richard Hamilton, Marcel sends him Ulf Linde's address for Nancy Thomas [27.9.1961].

1968. Tuesday, New York City
On their fourteenth wedding anniversary, the Duchamps invite Bill Copley, who is editing a new magazine called *S.M.S.*, and their friends Denise and David Hare to dinner at 28 West 10th Street.

17.1.1956

17 January

1922. Tuesday, Paris
At four o'clock Roché calls to see Mad Turban and Marcel [at 37 Rue Notre-Dame-de-Lorette or 22 Rue de la Condamine?]. Roché admires the beautiful set of painted chessmen [20.10.1920], and they reminisce about old times in New York.

1938. Monday, Paris
By ten in the evening when the first Parisian "Exposition Internationale du Surréalisme" is opened by André Breton, Duchamp (the "Generator-arbitrator" of the event) has already escaped to London.

Access to the exhibition held at the Galerie Beaux-Arts, 140 Rue du Faubourg Saint-Honoré, is down a long corridor baptized "Rue Surréaliste" hung with Parisian street signs chosen for their significance; lining the way, a collection of ravishing life-size mannequins have been contributed by different artists. For his evocation of Rrose Sélavy [20.10.1920] in Rue des Lèvres, Duchamp has selected a model with the wax features of Simone Simon, the star of *Lac aux Dames*, film by Marc Allégret [30.8.1926]: her golden curls are covered with a gentleman's felt hat, she wears Duchamp's shoes, shirt and tie but no trousers; the breast pocket of the jacket holds a red light bulb.

The corridor leads to a central grotto where Duchamp has hung twelve hundred coal sacks from the ceiling. This *ciel de roussettes* would seem to place the Surrealist works firmly beneath the highly combustible sky of Breton in homage to "Psst", Breton's Dada poem published in *Cannibale* No.2 [25.5.1920]. Under the sacks gleaned from La Villette, bulging with newspaper and still shedding black dust, stands a glowing brazier fuelled electrically, which the insurers have refused to approve, but which the organizers have decided shall stay where it is. The pond in the grotto has been created by Dali; Wolfgang Paalen, who is charged with creating "water and undergrowth", has provided a mossy, leaf-strewn carpet underfoot. Beds have been lent from Ribemont-Dessaignes' father's

shop in the Faubourg Saint-Antoine. As the flickering brazier is the only source of illumination, Man Ray, the appointed "master of light", has decided that visitors who wish to see the pictures will be supplied with an electric torch. In a corner, coffee beans roasting on a small grill fill the grotto with a marvellous aroma.

Duchamp's other invention for the exhibition is the installation of revolving doors upon which to hang drawings and objects.

The fragile glass *9 Moules Mâlic* [19.1.1915] has been carried to the gallery by Roché, who has also lent *Rotative Demi-sphère* [8.11.1924]. There is an unspecified readymade, probably the replica [22.5.1936] of *Egouttoir* [15.1.1916]; Man Ray has provided *Pharmacie* [4.4.1916] and for the first time one of Rrose Sélavy's windows, *La Bagarre d'Austerlitz* [22.9.1935], is exhibited.

1939. Tuesday, Paris
Remarking on the "eternity" between their meetings, Duchamp sends an express letter accepting André Breton's invitation on Thursday. Regarding the text of presentation [8.9.1938] for Nicolas Calas, the paper and blocks are at the printers and, before his intervention, Duchamp is waiting to receive some stitched copies of the book. [*Clé* No.2, the monthly bulletin of the Fédération Internationale de l' Art Révolutionnaire Indépendant?]

1941. Friday, Paris
Marcel repeats the instructions concerning funds "succinctly" to Roché, and also the news that he has finished his Box [7.1.1941]. "I sell them 4,000 francs each [6,000 francs at present values]," Marcel tells his friend in Grenoble, "and I am having difficulty in finding the skins to make the outer valise."

Life in Paris is like the back of beyond: "One never goes out in the evening. We have had coal until now – but it's the end – we hope a few hundred kilos more to finish winter." As for food, "although difficult, the supply has nothing in common with famine."

*

To André Breton at Villa Air-Bel in Marseilles, Duchamp writes an Inter-zone card permitted by the authorities for personal correspondence. His message reads:

"Mary and I in good health scarcely tired. Have received news from you thanks. I am working on my Box which is finished. If you

go to New York find me an artistic (sic) mission so that I can spend some time there. Fondest thoughts, Kisses and all from two of us to you two."

1943. Sunday, New York City
At five o'clock Kiesler and Duchamp call to see Marie Cuttoli.

1956. Tuesday, New York City
A guest of the Duchamps since she arrived from Paris determined to find a gallery to give her an exhibition, Mimi Fogt has brought a number of canvases with her, including the one of Marcel which he posed for with his pipe on a number of afternoons in her tiny studio at 3bis Place de la Sorbonne.

One of the celebrities much taken with her exhibition at the Galerie Elsa Clausen [2.12.1954], and particularly with Mimi herself, was Maurice Chevalier. Tonight after his "Great New American Triumph", the King of Hearts is presiding over a Gala Charity Dinner on the Starlight Roof of the Waldorf-Astoria. Disregarding the famous women in New York with whom his name has been linked, Chevalier has invited Mimi to be his personal guest.

In an atmosphere of excitement and great amusement at 327 East 58th Street, Mimi prepares to join Chevalier privately in his hotel suite, as he has already planned it, to make a grand entrance together with Mimi on his arm. She wears the one long evening dress she possesses, but it is agreed that the camel-hair coat is "not possible", and Teeny lends Mimi her fur coat. Just before she leaves, Marcel plies Mimi with Daiquiris, to give her courage.

Mimi, mon beau petit bout de chou de rien du tout est-ce que tu m'aimes?
Mimi, mon tout petit roudoudou d'un sou je t'aime plus que moi-même
Mimi, si mes baisers valaient deux sous la paire tu serais Mimi millionaire...

1961. Tuesday, New York City
Teeny and Marcel have invited Henri-Martin Barzun [6.6.1953] and his old friend Edgar Varèse to dinner at 28 West 10th Street.

1965. Sunday, New York City
In the morning John Canaday's bitter-sweet article, "Leonardo Duchamp," appears in the *New York Times*.

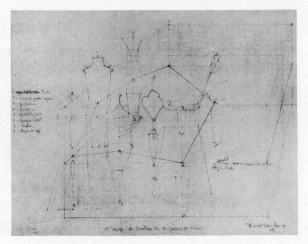

19.1.1915

In the afternoon at three-thirty, Richard Hamilton delivers a lecture entitled "The Large Glass in Perspective" at the Solomon R. Guggenheim Museum.

1967. Tuesday, New York City
"I hope you have received the letter from the Bodley Gallery accepting to make an exhibition of about 25 of your canvases in Nov. 67 or January 68," writes Duchamp to Yvonne Savy, further to the letter he wrote to her mother [9.12.1966]. "Besides I hope that you have worked again this winter and increased the choice of 25 canvases."

Duchamp requests Yvonne to reply in French to David Mann of the gallery: "without completely committing yourself," he advises, "until we know where the transport and catalogue costs lead us. Besides he will be in Paris in May and will come to see you."

18 January

1934. Thursday, New York City
Signs and dates a typed statement for Miss Katherine S. Dreier: "I have found few speakers on Modern Art in any country who can present the subject with a feeling of deep understanding and a touch of lightness more successfully than Miss Dreier."

*

Following the closure of the exhibition on Saturday, a statement of sales is prepared for Brancusi. Five sculptures have been sold and the sum due to Brancusi is 65,173.97 francs [approximately 200,000 francs at present values].

1953. Sunday, New York City
Duchamp attends the opening of Jacques Villon's exhibition at the Rose Fried Gallery, 6 East 65th Street.

1956. Wednesday, New York City
On learning of the death of Mary's brother, Henry Edward Dreier, on 24 November 1955, Duchamp sends his condolences and thanks her for her "good thoughts for 1956".

1961. Wednesday, Providence
A *Boîte-en-Valise* is exhibited in "The World

of Dada", which opens at the Rhode Island School of Design.

1963. Friday, New York City
Duchamp responds to an express letter from Jean Larcade and confirms the sale price of $750 for a *Boîte-en-Valise* [7.1.1941] and a minimum of $450 for the Green Box [16.10.1934]. As with previous transactions [12.3.1962], Duchamp requests Larcade to pay the amount due to him through a New York bank.

1968. Thursday, New York City
The weather has been so bad the last month that Marcel and Teeny dream of going back to Mexico [25.2.1965] to see their good friends the Tamayos, Wolfgang Paalen, Mimi Fogt and her husband Alberto, and Octavio Paz. They are happy, though, to stay at home now – Marcel working or playing chess with friends, and Teeny reading or cooking and just being there.

Tonight, however, Marcel crosses the street to play a game at the Marshall Chess Club, situated exactly opposite their apartment.

19 January

1915. Tuesday, Paris
With time on his hands at the Bibliothèque Saint-Geneviève where his life as a librarian for a few hours each day [3.11.1913] is easier than in peacetime, Duchamp replies to a letter full of good news from Walter Pach. He congratulates Pach on his recent fatherhood, and wishes a long life to the infant Raymond, named after Duchamp-Villon. Delighted with the sale of some prints and John Quinn's purchase of *Peau brune*, a watercolour of the model known as "the Japanese", who also posed for Eve in *Le Paradis* [9.10.1912], Duchamp tells his friend: "We are happy if your efforts have not been in vain."

Villon is still near Amiens, only about 20 kilometres from the front line, where he has been given leave for a fortnight from fighting in the trenches; Duchamp-Villon is still at Saint-Germain-en-Laye [30.8.1914] and Yvonne is a nurse at the hospital and "wouldn't give her place for an empire (of Germany)"; Gaby Villon, also a nurse, will probably be going to the north of France soon, pleased that this might

enable her to see her husband, but Duchamp says that this is less likely. "I have been before the discharge board [6.1.1915]," he tells Pach, "and I am condemned to remain a civilian for the whole length of the war. ... I am not upset by this decision: as well you know."

"So I am still working regularly," Duchamp continues, "not many hours a day, tired out at the moment. I haven't yet finished my red thing on glass... I think it will be completed at the end of February."

Duchamp is referring to his small study on glass: *9 Moules Mâlic*. The first drawing for these Malic Moulds, dated 1913, is entitled *Cimetière des Uniformes et Livrées*. The Eros matrix or "group of uniforms or hollow liveries destined to receive the illuminating gas" number eight Moulds at this stage: Priest, Department store delivery boy, Gendarme, Cuirassier, Policeman, Undertaker, Flunkey and Chasseur de café [Messenger boy]. Drawn in perspective with the position of the head and feet established, each Mould is cut by an imaginary horizontal plane at the point called the "point of sex", forming a "polygon of sex".

Early in 1914, while continuing to plot his full-scale plan in perspective on the wall of his studio [22.10.1913], Duchamp decided to add the Stationmaster between the Priest and the Policeman, making the final group of Moulds nine.

The figuration enshrined in *Réseaux des Stoppages* [19.5.1914] (an operation using his new unit of measurement, *3 Stoppages Etalon* [19.5.1914]), provided Duchamp with the 9 Capillary Tubes, the conduit for the gas. A photograph of this Network, taken from an almost horizontal angle, proved too inaccurate, so Duchamp squared the canvas and then, by drawing the squares again in perspective, obtained the form of the Capillary Tubes so that each one touches a different hat of the Malic Moulds.

Before starting work on the small glass itself, Duchamp made another precise drawing:

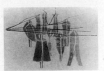

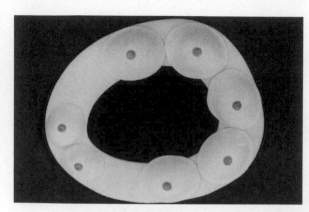

20.1.1957

Cimetière des Uniformes et Livrées, No.2, including the Stationmaster and the Capillary Tubes, but which is drawn in reverse for its transfer to the glass. He is using fuse wire glued with varnish to the back of the glass to outline each shape and has noted "not to forget the imaginary polygon of sex, probably engraved with acid on the other side of the glass"; for the colour of the Malic Moulds, Duchamp stated: "They are provisionally painted with red lead while waiting for each one to receive its colour, like croquet mallets."

1936. Sunday, Paris
In the evening, Duchamp sees Georges Hugnet.

1937. Tuesday, New York City
Upset by Barr's comparison of Surrealist artists with children and the insane, Miss Dreier has decided to withdraw all her loans from the travelling version of the exhibition "Fantastic Art, Dada, Surrealism" [9.12.1936]. The announcement of her decision is made at a press conference at the Great Northern Hotel. Later Miss Dreier cables Duchamp in Paris: "Threw bombshell."

1939. Thursday, Paris
At seven-fifteen, Duchamp dines with André and Jacqueline Breton at 42 Rue Fontaine.

1959. Monday, New York City
George Heard Hamilton, currently working on the English translation [13.12.1958] of the Green Box (and the translator of the text [17.12.1957] of Robert Lebel's forthcoming book), interviews Duchamp for BBC radio. Hamilton wants him to talk about the readymades [15.1.1916], which "so many people want to know about these days". After Duchamp has described several of them, Hamilton asks whether there is any way in which a readymade can be thought of as a work of art.
"That is a very difficult point," replies Duchamp, "because art first has to be defined. All right, can we try to define art? We have tried, and every century there is a new definition of art. I mean that there is no one essential that is good for all centuries. So if we accept the idea that trying not to define art is a legitimate conception, then the Readymade can be seen as a sort of irony, or an attempt at showing the futility of trying to define art, because here it is, a

thing that I call art. I didn't even make it by myself; as we know, art means to make, to hand make, to make by hand. It's a hand made product of man, and there instead of making, I take it ready made, even though it was made in a factory. But it is not made by hand, so it's a form of denying the possibility of defining art.
"You don't define electricity; you see electricity as a result, but you can't define it. I remember that a professor of physics always said that you cannot define electricity. You can't say what it is but you know what it does. You see, that is the same thing with art: you know what art does but you don't know what it is."
The actual intention in choosing and selecting, does that not give them some kind of possibly intellectual value?
"It has a conceptual value, if you want, but it takes away all the technical jargon. You don't know whether you should take it as a work of art, and that is where the irony comes in..."
Turning to the Large Glass [5.2.1923], Hamilton asks whether it is a Dada work.
"I wouldn't say that, even though I tried in that big glass to find a completely, personally new expression, the final product was to be a welding of mental and visual reactions. In other words the ideas in the Large Glass are more important than the actual realization."
But this sounds almost contradictory because a work of art is primarily a visual experience.
"Yes. But the welding of two different sources of inspiration gave me a satisfactory answer in my research for something that had not been previously attempted... In that quest my research was to find some way of expressing myself without being a painter; without being a writer; without taking one of these labels, and yet producing something that would be a product of myself."
Do you think people understand it the way you would like them to, or is it subject to interpretations, like so many works of modern art?
"I don't think people take time to understand it; it is not an attractive subject for the public today. Collectors take a different attitude today: they regard art as a commodity, a thing they put on their walls, a conversation at table... But in the Large Glass there is nothing to converse about, unless you make an effort to read the notes in the Green Box, but who cares? I mean, it is not interesting for the public today, it has no public appeal."

Mr Duchamp, if your works are ironic reflections upon the difficulties of defining art as a function, a process, is it wrong to exhibit them in art museums?
"No, it is not wrong because, after all, even if they are supposedly ironical, they still belong to the same form of human activity. Whether you object to their conception, they are still in the same medium. They are not scientific, they are artistic, even if they are against art in this way."

1963. Saturday, New York City
"The chess wallets are perfect and Marcel says to thank you very profusely," writes Teeny to her daughter Jackie, who has procured seven from the Maroquinerie Stany in Paris, for an additional number of his *Pocket Chess Set* [23.3.1944].
Commenting on his recent spell in hospital [31.12.1962], Teeny says: "Marcel was a very good patient: never any pity for himself, ignoring gloom, and always just himself. He has the most extraordinary way of accepting realities, simply, and not letting them change his way of being himself. He has a better appetite than ever and as he is too busy here to go to his studio I have been cooking more and more! He is working on his two next month lectures and I try to do all his errands and typing and we are as busy as bees. Lots of visitors sometimes almost round the clock."

1964. Sunday, New York City
Having received news from Bernard and Jackie Monnier about progress at 5 Rue Parmentier [21.12.1963], Teeny tells them: "We don't know how to thank you for the ordeal you are both going through in that DADA ATELIER of ours."
After further instructions about the apartment relayed by Teeny, Marcel adds his own postscript: he thanks Bernard for advising him of the "round sum" received for the sculptures of Duchamp-Villon [24.11.1963]; tells Jackie that he does not want to have an exhibition at the Galerie Louis Carré "because of the difficulties of obtaining the things from Philadelphia – they only lend from museum to museum" and, referring to Cadaqués, announces: "This morning received the good news that Rosita accepts us for the months of July, August and September..."

1967. Thursday, New York City
Taking her second daughter, Sassie, to introduce to the Duchamps, Monique Fong collects a tape recorder from 28 West 10th Street to

21.1.1909

21.1.1923

make a spoken translation of *Marcel Duchamp o el castillo de la pureza* by Octavio Paz [6.1.1967], which the ambassador completed in Delhi on 25 October 1966.

*

Further to his letter written on Tuesday, "Be reassured," Duchamp tells Yvonne Savy, "the letter has finally arrived safely and thank you for the good news and resolutions." Explaining that "the American postman often confuses the 1 with the 7" because the seven isn't crossed in the USA, Duchamp thinks that her letter must have gone to 70th Street by mistake.

As an afterthought on the envelope he adds: "Photos very good, pictures as well."

20 January

1923. Saturday, New York City
"Naturally it vexes me," Marcel writes to Francis Picabia, referring to the proposed Dada exhibition. "I cabled you so that you didn't have to prepare unnecessarily – Refrain, I beg you. I have done nothing since I left you [28.1.1922]," he protests, "except a kind of album [3.12.1922]… I will send it to you."

Introduced to Darius Milhaud by Yvonne George [1.11.1922], Marcel says the French composer "has a lot of success" in New York. With his greetings to Germaine Everling and Breton [14.7.1921], Marcel adds: "Thank you all the same," and signs MarSélavy.

1934. Saturday, New York City
Exactly a week since the successful Brancusi exhibition [18.1.1934] closed at the Brummer Gallery, Duchamp boards the *Champlain*, which sails for Le Havre shortly after midday.

1936. Monday, Paris
Writes to André Breton on behalf of Benjamin Benno, an American artist who needs a recommendation for a prize from an American foundation.

If he can, Duchamp hopes to see Breton just before the meeting of "Contre-Attaque" (the group founded by Breton on 7 October 1935 after the split with the Communists), which is to be held at nine o'clock the following evening at the Grenier des Augustins, 7 Rue

des Grands-Augustins. Members of the group include Benjamin Péret, Georges Bataille and Maurice Heine.

1957. Sunday, Bridgewater
In the depths of the Connecticut countryside, the Duchamps attend the marriage of Jean McLaughlin Davis to Julien Levy.

Using an old-fashioned book mark, Marcel has indicated that the wedding present from Teeny and Rrose is "For sitting only". A spongy collar, the shape of a toilet seat, is decorated with seven falsies, like those used for *Prière de toucher* [7.7.1947], the nipples of which are tinted pink: a "*seins-siège*" in other words [or Saint-Siège].

1961. Friday, New York City
It is very cold and there has been another deep fall of snow, which Teeny (whose birthday it is) helps to shovel away in front of the house.

In the evening Max Ernst and Dorothea Tanning, who have recently arrived from Paris, come to dinner at 28 West 10th Street.

1965. Wednesday, New York City
Marcel shows his exhibition at Cordier & Ekstrom [14.1.1965] to Monique Fong and her husband Klaus Wust.

1967. Friday, New York City
It is Teeny's birthday. Having learned from his sister Yvonne that Mlle Popovitch has been to Neuilly and selected the paintings by Suzanne to be exhibited in Rouen [6.12.1966], Duchamp proposes two more canvases by Suzanne, in New York: the portrait of Villon (which belongs to himself) and an oil from the Dada period belonging to Enrico Donati.

"Still the Sisler mystery," he remarks to her, referring to the uncertainty of loans for the exhibition, "and the Philadelphia half-mystery [13.1.1967]."

21 January

1909. Thursday, Paris
Le Courrier Français [14.1.1909] publishes a drawing by Duchamp: watching her elegant daughter stepping into a cab the mother enquires: "Am I to come with you… today?"

1923. Sunday, New York City
In what is now becoming almost a tradition for a new painting [9.12.1922], at four o'clock, with Carl van Vechten, Claggett Wilson, and a number of other guests, Duchamp attends the tea party to celebrate Florine Stettheimer's portrait of Henry McBride [3.12.1922]. Dressed in a black coat over his tennis whites, the critic is poised on a chair set in the middle of the canvas on a circular red rug. The green of the Sea Bright tennis club on one side, his gardening green on the other, fill the lower part of the canvas; behind McBride's head and shoulders is Florine's evocation of his artistic domain, a turbulent and brightly coloured cityscape incorporating, at its edge, the statue of a nude by Gaston Lachaise.

1940. Sunday, Paris
In the morning Duchamp telephones the Café des Deux Magots hoping to find André Breton.

SAINT·GERMAIN·DES·PRÉS

The *dame cabinet* thinks that Breton is not in Paris, and there is no reply when Duchamp tries telephoning Rue Fontaine.

1953. Wednesday, New York City
Responding to Brookes Hubachek's new year wishes that he will continue "to baffle fate and confound man's natural enemies", Marcel writes: "I promise that I will fight man's natural enemies not only for my benefit but for my closest friends' benefit also."

*

Wanting to arrange for a permanent display of Katherine and Dorothea Dreier's paintings, Duchamp writes to Miss Lochridge of the George Walter Vincent Smith Art Museum [9.11.1939]. He also mentions that he will enquire to see whether their sister Mary Dreier is willing to present the plaster cast of the rider on horseback, an Italian piece which stood on the big chest in Miss Dreier's living room at Laurel Manor.

21.1.1961

22.1.1929

Duchamp then writes to Mary about this proposed tribute to the memory of her two sisters as artists, concluding: "Let's hope they will give some space and you will give them the paintings."

1954. Thursday, New York City
A large envelope arrives from Walter Arensberg enclosing copies of his recent letters to Fiske Kimball and a draft of the last one which has not been sent. In a short note to Marcel, Walter says that he is too distracted to write himself and has asked his secretary, Elizabeth Wrigley, to explain the reasons for his dejection. After outlining the problems related to the proposed catalogue and the delayed opening of the Arensberg galleries, in the final paragraph of her letter, Mrs Wrigley states: "Mr Arensberg would like you to go to Philadelphia as soon as possible and to be quite firm about the situation."

Duchamp sends a cable to Kimball: "Intend to take 11 am train tomorrow Friday," and adds, "will call you up before leaving New York."

1961. Saturday, New York City
The reproduction [2.2.1960] of *Nu descendant un Escalier,* No.2 [18.3.1912] has now appeared, but as he has not received a copy Duchamp asks Henri Marceau to mention the oversight to the New York Graphic Society.

*

Thanking Brookes Hubachek for his new year gift, Marcel confirms that he has already telephoned James Johnson Sweeney about the picture, *Portrait of the Artist's Father* by Villon, purchased for the Guggenheim Museum. Due to what he calls a "historical mechanism", Brookes missed buying it himself, and he would like in some way to retrieve it. Sweeney is unable to assist because the purchase was made by his trustees, and Marcel thinks that Mr Harry Guggenheim is unlikely to want to part with it or even sell it. Should Marcel try to "get it back" introducing a sentimental note? Might it be better for him to propose an exchange with another Villon? Otherwise Brookes should perhaps write directly to Harry Guggenheim, stating his request and reminding him of his donation of the Calders to the Guggenheim Museum…

*

Duchamp has finished reading the thesis of Lawrence D. Steefel, Jr. and "enjoyed it like a new 'perspective' vision" of himself. "It is a rare privilege," he writes to the Princeton graduate, "to look at oneself as though you were your own cousin with many hidden facets and enough of obvious identification as to be sure it is yourself nevertheless."

*

For Kay Boyle, Duchamp gives a valuation for insurance purposes of a drawing which has been lost.

1967. Saturday, New York City
On receiving a telephone message from Mrs Sisler's secretary saying she neglected to reply to his letters, Duchamp promptly writes "a sort of ultimatum" to Mrs Sisler [13.1.1967] "asking for a yes or a no in writing" for loans to Rouen and Paris. As he has not posted his letter of the previous day to Mlle Popovitch, Duchamp adds a postscript with this information.

1968. Sunday, Paris
Philippe Collin's interview with Duchamp at the Galerie Givaudan [21.6.1967] is included in the French television programme "Images et Idées" produced by Jean-Michel Meurice and André Fermigier.

22 January

1917. Monday, New York City
At a lunch with Duchamp, Roché meets John Quinn [for the first time?]. In the evening Duchamp dines with Roché, who starts calling him Victor…

Victor.

1929. Tuesday, La Lucette
In the afternoon a dreadful accident occurs in the gold and antimony mines situated not far from Laval, the birthplace of the Douanier Rousseau and Alfred Jarry. On learning of a fire at the foot of one of the shafts, some 260 metres deep, the director of the Mines de la Lucette, M. Marcel Douxami [5.5.1917], goes to the rescue taking with him two of his men. However, overcome by the gas, the three men perish with the miners already trapped underground.

1936. Wednesday, Paris
"Sweet" as always, Totor calls to see Roché in Arago, and amicably they redivide the remaining Brancusi sculptures [13.9.1926] between themselves.

1940. Monday, Paris
Peggy Guggenheim has decided to wait before buying the Miró and the Max Ernst [12.1.1940]. Having missed Breton at the weekend and wanting to discuss this matter directly with him, Duchamp writes asking when he will be on leave again.

1947. Wednesday, New York City
On a bitterly cold morning, the SS *Washington* docks after an unpleasant passage across the Atlantic [13.1.1947]. With no cargo in the hold, the ship rolled badly and most of the passengers were seasick. Because disembarkation formalities are extraordinarily slow, Duchamp has to endure five hours on the jetty in freezing conditions.

1953. Thursday, New York City
With the Katherine S. Dreier Memorial exhibition [15.12.1952] drawing to a close, Duchamp has the task of writing about transport arrangements to Katharine Kuh of the Art Institute of Chicago concerning *Leda* by Brancusi [1.11.1952], and to Duncan Phillips concerning the groups of works bequeathed to the Phillips Gallery and the American University in Washington [24.11.1952].

Duchamp explains the procedure to both Mrs Kuh and Phillips and requests them to liaise with the Yale University Art Gallery.

*

At seven Duchamp dines with Monique Fong at Port Arthur, Chinatown; he buys her a paper dragon and a jar of kumquats for her sister. Monique finds Duchamp "weary" and misses his "bursts of silent laughter" when she first knew him [29.9.1951].

At eleven they meet Michel Cadoret.

23.1.1917

1954. Friday, New York City
As stated in his cable of the previous day, Duchamp telephones Philadelphia in the morning at ten o'clock. However Fiske Kimball is in New York and can be contacted at the Chemical National Bank after twelve-thirty. A cable from Kimball confirms this and they manage to meet later in the day.

As a result of their discussions, Kimball agrees not to make any mention of a "Modern Museum"; not to relate the opening of the Arensberg Collection with anything else; to open the collection as early as possible and not to wait until October; to aim for "dignified publicity"; to simplify the framing to save time; not to try to have the catalogue ready for the opening, and to "spend all the time necessary to make it a 'monument'."

Fiske has asked Henry Clifford to edit the catalogue and suggests that he submit some pages to Walter Arensberg for his approval. Marcel proposes that James Thrall Soby write the introduction.

1958. Wednesday, New York City
After a discussion with Lebel, who is now in New York [7.1.1958], Marcel writes to Roché about his text. "As all political or religious allusions have been avoided in the book generally," would Roché consider replacing "the Creation" by "creative ingenuity", requests Marcel, and correcting the final proofs in the French text? If he agrees then Marcel will write to Bill Copley in Mexico and ask him to correct the English translation.

23 January

1917. Tuesday, New York City
Roché makes his second visit to the studio [9.12.1916] of Victor, as he nicknamed Duchamp the previous day. He looks at the pictures, particularly the portraits (*Yvonne et Magdeleine déchiquetées* [5.9.1911]?), and they talk about exhibitions.

*

The day after Woodrow Wilson's speech defending the rights and privileges of small nations of the world, six citizens of the small nation of Greenwich Village decide to take action.

"The hour of midnight approached and," according to John Sloan, "as the conspirators gathered in the shadow of the great arch a fine snow fell... Solemnly, and in manner befitting the seriousness of the occasion, we ascended to the highest point of vantage within the open space of the Square and there, with suitable rite and ceremony, did declare our independence and in token thereof did sign and affix our names to the parchment, having the same duly sealed with the Great Seal of the Village.

"For protection against the weather, precautions in the shape of hot water bags and steamer rugs had been taken. Indeed, for the space of one hour our proceedings were sorely delayed. Those who had previously been dispatched to bring to the rendezvous such warming liquids as might be readily obtainable were compelled to stalk warily about the Square while blue-coated guardians of the peace beguile the watches of the night with small talk and laughter.

"Now it is not generally known that in the left leg of the arch which is set at the entrance to Washington Square there lies a small door. It leads up to a great chamber where twenty men might lie hid with ease. Beyond that is the roof which, being surrounded with a high buttress or coping, did provide us with an assembly room most suitable and sequestered.

"Deployed to other quarters, the blue-coated denizens at length departed, whereupon right speedily did our fellow conspirators ascend and warmly were they welcomed...

"Filled with a vast content, our little band pledged themselves forever to the service of the State of Greenwich, solemnly drank to her continued prosperity, vowed eternal constancy to aforementioned ideals of autonomy, [and] affixed red, white and blue balloons to the ramparts" before descending from the summit of the monument. John Sloan's fellow arch conspirators are Gertrude Drick, Charles Ellis, Duchamp, Betty Turner and Allen Russell Mann.

1924. Wednesday, Rouen
At the annual general meeting of the Cercle Rouennais des Echecs, it is noted that Marcel Duchamp has become a member.

1925. Friday, Paris
Hoping that she will be able to sell some, Duchamp posts one of his *Obligations pour la Roulette de Monte-Carlo* [1.11.1924] to Marie Sterner in New York. "I have already sold ten bonds," he explains in his letter, "and I am very confident."

1927. Sunday, Chicago
Extended for four days, the Brancusi exhibition finally closed at the Arts Club on Saturday. Today Marcel is supervising the packing before returning to New York on Monday and he writes to Brancusi in Paris announcing that the Arts Club is buying *L'Oiseau d'Or* for $1,200 and that two drawings have been sold. "I am pleased with the result," he explains, "because lots of people who have loved certain things will buy in Paris." Marcel tells Brancusi that Rue Carpenter, the dynamic president of the Arts Club and wife of Chicago composer John Alden Carpenter, is in Egypt.

1928. Monday, Hyères-les-Palmiers
Duchamp is one of the nine chess players competing for the Coupe Philidor which commences today at the Hôtel des Palmiers. The tournament has been organized for the fourth Congress of the local chess club.

1946. Wednesday, New York City
Following Nelson A. Rockefeller's intercession [9.1.1946], Duchamp is informed by the Immigration and Naturalization Service that he has been granted an extension of his visa to 20 April 1946.

1950. Monday, New York City
As the Arensbergs have chosen to purchase two of Marcel's very early paintings, *L'Eglise de Blainville* [18.12.1949] and *Portrait de Marcel Lefrançois* [29.12.1949], for $500, Marcel writes to ask Roché if he would mind exchanging the portrait chosen by Walter for *Femme nue aux bas noirs* [20.11.1949]. "In my opin-

24.1.1965

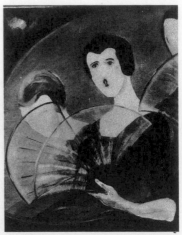

25.1.1927

ion," says Marcel, "these two things will add above all the earlier dates to those pictures of mine in his collection."

To Roché's proposal of an exhibition at La Hune in Paris, Marcel declares that he is not interested, still for the same reason [9.5.1949]: "The public would too easily take advantage of these things of youth which are only amusing in their relationship with what came afterwards." He doesn't consider that his later pieces in Roché's collection are sufficient in number "to give an idea to the 'general' public".

1952. Wednesday, Milan
The Green Box [16.10.1934] is exhibited by the association of the Amici della Francia.

1954. Saturday, New York City
Following a detailed summary of his previous day's conversation with Fiske Kimball, at the foot of the sixth page of his letter Marcel tells Arensberg: "Another mere piece of news is that I married last Saturday Teeny Matisse, the ex-wife of Pierre." He concludes: "In growing old, the hermit turns devil…"

1959. Friday, New York City
After reassuring him on the sale of the Brancusi sculpture [12.1.1959], Marcel tells Roché that, as the new landlord of 327 East 58th Street has decided "to make alterations to the whole house", including their apartment, they will probably be coming to France around June.

1962. Tuesday, New York City
Marcel thanks Hubachek for his "wonderful" present: "I can't tell you, dear Brookes, how grateful I am to you to allow me to live in my free way, although not quite orthodox, yet consistent."

He encloses a reply from Louis Carré agreeing to Hubachek's idea "of having a good representation of the graphic work in the large Villon show in Chicago".

24 January

1917. Wednesday, New York City
In the evening Marcel dines with Beatrice Wood, who considers that they "get along nicely".

1918. Thursday, New York City
Sometime in the three months while it has been at the Arensbergs' [8.10.1917], *9 Moules Mâlic* [19.1.1915] was cracked: propped momentarily against an armchair on castors, it fell when the chair rolled away. Today the small glass moves to a new home: Henri Pierre Roché takes it from 33 West 67th Street back to his apartment.

1927. Monday, New York City
From Chicago Duchamp returns to stay with Allen Norton [20.10.1926]. He has promised Miss Dreier to assist her with the final touches to the International Exhibition of the Société Anonyme, which is due to open at the Anderson Galleries the following day.

1928. Tuesday, Hyères-les Palmiers
Having left Paris by car on Sunday, Lydie reaches Hyères late in the afternoon after a long drive, pleased to be rejoining Marcel. It is the eve of the hearing for their divorce [18.11.1927] and Marcel comes to the hall of the Hôtel de Paris when Lydie arrives. He instructs the hotel porter not to bring in his wife's luggage and, saying that the chess tournament is not yet over, tells Lydie that he has reserved her a room in a neighbouring hotel.

1938. Monday, London
The officers of His Majesty's Customs & Excise at Croydon were so shocked by the pubic hair drawn on the figures, even though Cocteau had pinned leaves to the appropriate places, that Peggy Guggenheim and Marcel had to go to Croydon to get the work released. As a result the offending drawing made on a linen bed sheet entitled *La Peur donnant ailes au Courage*, in which one of the five almost naked figures is a portrait of Jean Marais [13.7.1937], hangs "privately" in Peggy's office at the gallery.

Today Guggenheim Jeune opens at 30 Cork Street with an exhibition proposed by Marcel of Jean Cocteau's drawings and the furniture which were designed for *Les Chevaliers de la Table ronde*. Marcel, who flew from Paris with Mary Reynolds straight after finishing the installation of the Surrealist exhibition [17.1.1938], has also hung the show.

1952. Thursday, New York City
As an active member and trustee of the Francis Bacon Foundation, Duchamp gives his written consent to a Special Joint Meeting to be held

the following day in Hollywood. He also consents to the proposed sale of shares belonging to the foundation and any other business as may come before the meeting.

1955. Monday, Paris
Marcel and Teeny go to Sèvres again to have dinner with Roché [10.1.1955].

1957. Thursday, New York City
In the morning Duchamp calls to see George Wittenborn at 1018 Madison Avenue to show him the catalogue [19.11.1956] of the "Three Brothers" exhibition (the opening of which has been postponed until 19 February); Wittenborn orders 200 copies.

*

As Robert Lebel has sent a cable announcing his visit at the beginning of February, Duchamp writes asking him a favour: "If it is not too late nor too difficult, could you bring me *Lolita* by Nabokov, which is 'forbidden' apparently."

*

Duchamp also writes to Georges Hugnet authorizing him to use the spiral of *Rotative Demi-sphère* [8.11.1924] (which has already been reproduced in *391* [2.7.1924] and on the cover of the *Little Review* in 1925) for the cover of his forthcoming book, *L'Aventure Dada*.

1960. Sunday, New York City
In the evening Brookes Hubachek visits the Duchamps and they take him to dinner at Henry's. Marcel has two lamb chops, Brookes and Teeny "a marvellous steak".

1961. Tuesday, New York City
In addition to the photos which he sent to Harriet Janis [1.1.1961], Marcel sends another, "quite a good one too," to Rudi Blesh for their joint publication, *Collage*.

*

In the evening Saul Steinberg and a friend are invited to supper at 28 West 10th Street.

1965. Sunday, New York City
Ten days after the opening [13.1.1965], the show at Cordier & Ekstrom is still newsworthy. Accompanied by a recent portrait photograph of Duchamp by Niki Ekstrom, an article by Grace Glueck in the *New York Times* reveals that the entire exhibition, property of Mrs Mary Sisler, is to be donated eventually to a museum. However, the collection will first travel to a number of

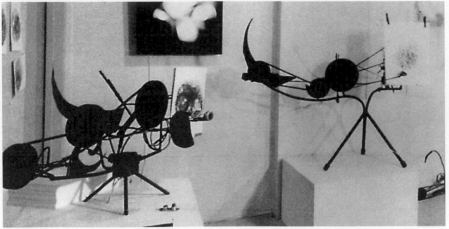

25.1.1960

American museums, starting with Houston on 23 February. Concerning the identity of the "mysterious" Mary Sisler, the journalist states that she is the widow of William Sisler, son of the founder of the Firestone Tire & Rubber Co.

In a long article for the *New York Herald Tribune*, examining "Pop's Grandada", Emily Genauer wonders: "Is Duchamp, even now, putting us on?"

Duchamp told her when they met that he stopped painting, but he didn't stop being an artist.

"It's a Renaissance idea that a work of art has to be a painting on canvas or a sculptured figure." Duchamp goes on to say that his role as an artist lies in his vision and selection – more important, he insists, than the technician's ability merely to fabricate.

He tells his interviewer that it is absurd that artists like Cimabue and Rembrandt should be enjoyed for their "look". Cimabue was serving his God humbly, he said. He should not be enjoyed as a designer. Rembrandt was a man of profound ideas.

But isn't it the form, the technique, which makes possible the communication of concept?

"Yes," replies Duchamp, "but we mustn't be so self-important as to think that we can necessarily judge what is good form."

25 January

1920. Sunday, New York City
Marcel and Allen Norton are visiting Aileen Dresser [9.1.1920] when Beatrice Wood calls by for an hour.

1927. Tuesday, New York City
Just back from Chicago, Duchamp attends the opening at the Anderson Galleries of the "International Exhibition of Modern Art", a selection of works from those shown by the Société Anonyme at the Brooklyn Museum [19.11.1926]. Too late to include in the catalogue (the cover of which is illustrated with Miss Dreier's painting, *At a Stravinsky Program*), Frederick Kiesler has built the model of a "modern room", or "television room" for the visitors to the exhibition. The model represented a small

dark room, according to Miss Dreier, "where in turning a button, the *Mona Lisa* from the Louvre would appear, or if pressed again, Velázquez' *Venus* from London, or a Rembrandt from the Rijksmuseum would be lighted."

1928. Wednesday, Paris
Lydie Duchamp's petition for divorce is heard in public in the third chamber of the Tribunal de Grande Instance de Paris [4.1.1928]. As both parties wanted the divorce, judgment is not required. The divorce is pronounced *de plano*.

1947. Saturday, Milford
Dee comes for the day from New York and, after his unpleasant transatlantic crossing and icy reception [22.1.1947], is surprised when Miss Dreier tells him he is looking well.

George Heard Hamilton's idea to hold an exhibition at Yale of work by the directors of the Société Anonyme, they consider would not only be excellent but delightful, and with plans to reopen the Société Anonyme for membership, there is a lot to discuss.

1953. Sunday, New York City
Concerning the loan [6.1.1953] of *9 Moules Mâlic* [19.1.1915] to the forthcoming exhibition "Le Cubisme 1907–1914", Marcel tells Roché that he would prefer the glass to be presented on a base.

1958. Saturday, New York City
Tonight Marcel and Teeny have tickets for Marcel Marceau, the extraordinary French mime artist.

1960. Monday, New York City
After dining at the de Menils', Marcel and Teeny attend the opening of Jean Tinguely's exhibition, "Kinetic Constructions and Drawing Machines," at the Staempfli Gallery. "Lots and lots of champagne and fun."

1962. Thursday, New York City
Although he is still waiting for his order from the Museum of Modern Art [3.1.1962], Duchamp sends Serge Stauffer the photograph of the Glider, which has arrived from Philadelphia for him [2.1.1962].

1963. Friday, New York City
"We are having another cold spell and this morning our hot water pipes burst," Teeny

tells Jackie. "Fortunately it didn't bother us as we love excuses not to use water."

After his operation [31.12.1962], Marcel has transferred his studio activities temporarily to 28 West 10th Street. "You should see our living room," says Teeny, "papers and books, acids and tools on every table. No place left to eat but on our laps but it's a wonderful mess and I will miss it when it goes…"

1965. Monday, New York City
In the afternoon, Marcel and Teeny are the witnesses for the marriage of Denise and David Hare at City Hall. While waiting in the antechamber before the brief ceremony, Marcel is recognized as a "celebrity" by members of another wedding party also waiting their turn, which causes a momentary diversion.

Invited to a champagne dinner in the evening at 28 West 10th Street are the Hares, Muriel Oxenburg and Enrico Baj.

1967. Wednesday, New York City
Sending his greetings to the Dumouchels in Nice, Marcel confirms the "festival in Rouen" on 15 April and says that Mlle Popovitch has announced "that there will be a plaque on 71 R[ue] Jeanne d'Arc and the inauguration of a street J. Villon and a street Raymond Duchamp-Villon, or else a single street for them both. Me," Marcel declares, "I will have (later) only a public toilet or underground W.C. in my name."

The other news is the chess tournament in Monte Carlo starting on 24 March, "with the world champion and our Bobby Fischer." At Prince Rainier's request Marcel transmitted the invitation to Fischer who is delighted. Planning to attend the event which also includes the best players in Europe, Marcel promises to send "Mouchel" a telegram on their arrival around 23 March. "Be kind enough to tell me what you read in the newspapers of Nice to inform us exactly of the date of the tournament."

*

Before they go out to supper, Marcel adds a postscript at the end of Teeny's letter to Jackie requesting her to telephone Editions Pierre Belfond to enquire whether the publication of his six interviews with Pierre Cabanne [9.6.1966], which he read and corrected [25.8.1966] while in Cadaqués, has appeared yet and to let him know.

*

In fact, *Entretiens avec Marcel Duchamp* by Pierre Cabanne, in which Duchamp expresses

27.1.1921

535. CHERBOURG — Le paquebot « AQUITANIA »
de la Cunard Line
Longueur, 274 m 60 – Largeur, 29 m 60
Tonnage, 45,647.

Le Goubey, Édit, St-Pierre-Église

28.1.1922

modestly and in some considerable detail his life and work, is published by Editions Pierre Belfond today.

26 January

1916. Wednesday, New York City
Two weeks have passed since Duchamp saw Miss Greene at the Museum of French Art [12.1.1916] and he has still not had his position as librarian confirmed. Duchamp writes to John Quinn [5.11.1915] about the situation and offers again to do some translations. "I spend these free days in working hard," Duchamp declares boldly in English. "I have almost finished that big glass you have seen when I began it."

1927. Wednesday, New York City
After hearing on his return from Chicago the American government is demanding that duty amounting to $200 [21.10.1926] on *L'Oiseau dans l'espace* by Brancusi, Duchamp has seen Edward Steichen, to whom the sculpture belongs. Having agreed that they should fight the decision, Duchamp meets Albert Gleizes' brother-in-law, Maurice Speiser, a lawyer from Philadelphia, who agrees to act for Brancusi.

*

Duchamp deposits $225 in Brancusi's New York Bank account, the proceeds of the sale of two drawings in Chicago [23.1.1927].

*

Miss Dreier has arranged for the Large Glass [5.2.1923], which has been packed in a case, and other works identified with a yellow tag (signifying that they were not selected for exhibition at the Anderson Galleries), to be collected by Yaccarino from the Brooklyn Museum [19.11.1926] and transported to the Lincoln Warehouse.

1942. Monday, Sanary-sur-Mer
On his return from a trip to Monte Carlo (where he happened to meet an old friend from New York, an eminent chess player), Marcel informs Roché that, as Alec Ponisovsky has helped him out with funds for the time being, he will not need to bother him too much [30.12.1941].

Meanwhile Peggy Guggenheim has cabled the news that the shipment of her art collection [25.4.1941] has arrived in New York and Marcel is to give the remaining 2,500 francs to Nelly van Doesburg [20.4.1941] in Lyon. Can Roché arrange that?

"It's terribly difficult to put one's hand on a 'tangible' idea," Marcel tells Roché, referring to the subject he mentioned shortly before the New Year. "I am going to give *infra-mince* a trial," he explains, applying it, he says cryptically, "to a production which is no longer manual but *coudique* (as in 'elbow')."

Concerning the model of the miniature *Fountain* [30.12.1940], Marcel proposes to send it to Denise and Roché for "trial", to decide "if it is worth keeping".

1946. Saturday, New York City
Dee accompanies Miss Dreier to Milford "with George the painter and paperer", who announces that he is prepared to start redecorating Laurel Manor in two weeks. Because a chimney has been removed and a partition taken down, the house is in a dreadful mess and there are piles of debris in the yard. Miss Dreier however has great fun riding up and down in her "marvellous play-toy", the elevator in the hall which works like a dumbwaiter: "the weights are in the cellar and the machinery up in the attic."

1954. Tuesday, New York City
In reply to his letter of 23 January, Marcel receives two cables from Walter Arensberg. One concerns the author for the introduction to the catalogue of the collection: "Don't think I like Clifford," says Walter. "What do you think about Kahnweiler?" The second reads: "Congratulations! All happiness to the bride [16.1.1954]."

1964. Sunday, New York City
Duchamp signs the receipt of loans that he and Teeny made personally for his retrospective exhibition [7.10.1963], which have now been returned by railway express from the Pasadena Art Museum.

1965. Tuesday, New York City
Mails a copy of the "Not Seen and/or Less Seen of/by Marcel Duchamp/Rrose Sélavy 1904–64" exhibition catalogue [13.1.1965] to Robert Lebel in Paris.

27 January

1920. Tuesday, New York City
Beatrice Wood dines with Marcel, who endeavours to explain chess to her but she admits that she doesn't understand.

1921. Thursday, New York City
At eight-thirty in the evening the painter Joseph Stella gives a lecture at the gallery of the Société Anonyme, 19 East 47th Street. The journalist Margery Rex speaks to Stella and also interviews Miss Dreier, Duchamp, and Man Ray for an article to appear in the *New York Journal.*

1926. Wednesday, Paris
Having undertaken with Maître Bellier to arrange an auction at Drouot in March of the Picabia paintings that he has recently purchased [1.1.1926], Duchamp has had the works framed and they are now in his room at the Hôtel Istria. As he would like to show the pictures to Jacques Doucet, Duchamp writes asking the collector to propose a rendezvous as soon as he can, "except Saturday afternoon."

1927. Thursday, New York City
Marcel breaks the news to Brancusi about the government's decision concerning the import duty, and reports on his meeting the previous day with Speiser, who has been instructed to fight the case. "In any case," Marcel says, "I advise you to wait before sending Mrs Rumsey's bird [12.12.1926] until the decision is taken concerning Steichen's bird."

The twelve crates of sculpture from Chicago [23.1.1927] have arrived safely in New York and are at Mrs Rumsey's. To economize on the cost of the return transport to Europe, Marcel will also see if he can persuade Brummer, Mrs Rumsey and Miss Dreier to each keep one or two pieces of sculpture.

1931. Tuesday, Cannes
When Totor steps from the train, Roché is waiting to greet him. Roché has not heard about the recent death of Frau Hessel, the mother of Franz, and learns that when Helen [25.9.1930] left Paris for Berlin about ten days ago, it was

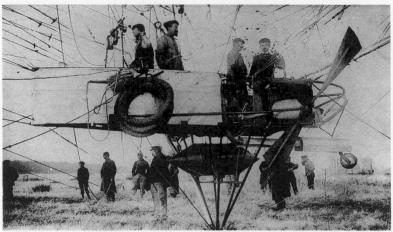
29.1.1909

Totor who accompanied her to the station.

Before continuing his rail journey at five o'clock, Totor meets a friend of Roché's, another Marcel, at the station bar.

1934. Saturday, Le Havre
At four in the afternoon the *Champlain* docks after an unpleasant crossing [20.1.1934]; Duchamp disembarks and returns to Paris.

1951. Saturday, Philadelphia
Duchamp is invited to the Museum Directors' Conference at the Philadelphia Museum of Art which is attended among others by Sir Philip Hendy of the National Gallery, London, and Francis Taylor of the Metropolitan Museum. When the president of the museum, Sturgis Ingersoll, introduces the speakers, he refers to the recent gift of the Arensberg Collection [27.12.1950] in terms of "great appreciation". This was to have been the official public announcement of the gift, had the news not been scooped by the Californian press on 17 January.

After the conference Duchamp goes to a tea party given by Fiske Kimball [16.1.1951] and tells him of Miss Dreier's intention to give a number of works to the museum from her personal collection in addition to the Large Glass. Delighted with the news, Kimball agrees to visit Milford early in spring to discuss the donation with her.

1954. Wednesday, New York City
Replying by return to Walter's telegram requesting his opinion about Kahnweiler writing the introduction to the catalogue of the Arensberg Collection, Marcel says that he is not in favour. "Kahnweiler, in my opinion, is too much one-sided," he explains. "Having discovered Cubism in Picasso, Braque, Gris, [he] never considered anything else *as worthy* of his attention." Marcel doesn't see how even from photographs he could do justice to the collection without having seen it. "I don't see anyone better than Soby," he states.

28 January

1922. Saturday, Le Havre
After spending seven months in France [16.6.1921], Duchamp embarks on the *Aquitania* of the Cunard Line to return to New York.

1927. Friday, New York City
"Very sincerely I have a memory in a class of its own of my visit to Chicago," writes Marcel to Alice Roullier of the Arts Club, "and I blame you for the good times I had there." Confirming to her that the Brancusi shipment has arrived safely and also the cheque for the drawings [23.1.1927], Marcel says: "Be kind enough to send me this small present for your family in Paris and any message I can take them. When you come to Paris," he promises, "we will arrange something with Roché because I count on knowing what your Denning Place apartment would like."

1933. Saturday, Paris
In the morning Dee receives an express letter from Miss Dreier, who returned very early that morning to her apartment at 16 Place Dauphine and was rather surprised not to find him at the station. Sending an express letter in reply, explaining that the letter from Berlin with the time of her arrival had never reached him, Dee promises to call on Miss Dreier at five o'clock.

1938. Friday, Paris
Back from his short visit to London with Mary Reynolds [24.1.1938], Totor speaks on the telephone to Roché, who has already been with Denise to see the "Exposition Internationale du Surréalisme" [17.1.1938] and read the catalogue by Breton and Eluard: *Dictionnaire abrégé du Surréalisme.*

1951. Sunday, New York City
After giving an account of his visit to Philadelphia the previous day and announcing Miss Dreier's intended bequest to the museum, Marcel has another piece of news for the Arensbergs.

"While in Paris, I tried to see my old friend Dr Dumouchel, but he does not live in Paris any more." After finding his address, Marcel wrote to him and Dumouchel has now replied agreeing to sell his portrait to the Arensbergs for $800 which, Marcel says, is his tentative price.

Stating that this canvas, and *La Partie d'Echecs* [1.10.1910], which they have just bought from Walter Pach [24.6.1950], are the two important paintings of 1910, Marcel writes: "The portrait is very colourful (red and green) and has a note of humour which indicates my future direction to abandon mere retinal painting."

Marcel replies belatedly to a letter from Pierre de Massot enquiring about the availability of reproductions for a book he is working on. With the recent gift of the Arensberg collection to Philadelphia [27.12.1950], Marcel tells de Massot, "we can photograph galore."

1953. Wednesday, New York City
Duchamp writes two letters to the Philadelphia Museum of Art. One is to Henri Marceau confirming that he has had the Achenbach painting in the huge gold frame [31.12.1952] sent "cash on delivery" as requested. To Fiske Kimball, who has received delivery of the "King and Queen" after their trip from California via his studio [16.11.1952], Duchamp writes: "I have signed the second painting on the back [*Le Paradis*] so that you could, if you wish to show it, mount it all on a hinge."

1959. Wednesday, New York City
In a letter to Roché, Marcel says that *Cariatide* by Brancusi [23.1.1959], the sculpture which he gave him in exchange for help in financing the Green Box so many years ago [18.5.1934], has been purchased by George Staempfli.

Marcel has received Patrick Waldberg's book on Max Ernst published by the Editions Jean-Jacques Pauvert, and also a letter from Fawcus to say that, regarding Lebel's book, only the index remains to be printed. "Everything happens one day," he concludes.

1961. Saturday, New York City
At the news of the arrival of another grandchild born on 25 January Teeny and Marcel send a cable to Jackie and Bernard Monnier in Paris: "Bravo and our wishes of good luck for Antoine Blaise."

1962. Sunday, New York City
As Brookes Hubachek [23.1.1962] is in town, Marcel and Teeny have invited him to 28 West 10th Street.

29 January

1909. Friday, Neuilly-sur-Seine
To send his apologies to Carmen Cartaya [6.9.1908] at 27 Rue de Longchamp, Paris,

29.1.1910

29.1.1925

Duchamp chooses a wonderful postcard illustrated with the gondola of the airship *Patrie* which is ready to take off with four passengers.

"All my excuses and all my regrets at not having been able to come to your place yesterday," writes Duchamp. "Georges [Ayzaguer] who stood me up besides, was coming to pose. My compliments to Mr and Mrs Cartaya. Remember me to Mercedes," adds Duchamp, referring to Carmen's sister.

1910. Saturday, Paris
As well as one by Villon in the same issue, another cartoon by Duchamp entitled *Objets et Mont-de-Piété* is published in *Le Courrier Français* [1.1.1910]. While the young artist is pulling on his boots to go to the pawnshop, his wife sits up in bed and says: "Oh! no, Jules not mother's watch."

"Why not?" he replies, "it's not leaving the family."

1917. Monday, New York City
Marcel has lunch with Lou Arensberg, Beatrice Wood and John Covert. Talking about the forthcoming exhibition being organized by the Society of Independent Artists [5.12.1916], the men decide to enlist Bea's help.

1919. Wednesday, Buenos Aires
With no news from New York about plans for sending a group of Cubist pictures to the Argentine [7.1.1919], Duchamp sends a telegram to Henri-Martin Barzun at 110 West 78th Street which reads: "Cable what chances exhibition when shipment."

1921. Saturday, New York City
Illustrated with Duchamp's *Nu descendant un Escalier*, No.2 [18.3.1912], Margery Rex's article, "Dada will get you if you don't watch out; it is on the way here" (which was written after her visit to the Société Anonyme gallery on Thursday) is published in the *New York Journal*.

1925. Thursday, Rouen
At six-thirty in the morning at her home at 71 Rue Jeanne d'Arc, Lucie Duchamp dies from cancer at the age of sixty-eight. It is four months since the family were in Rouen to celebrate Lucie and Eugène Duchamp's fifty years of marriage [15.9.1924].

The eldest daughter of Marie Sophie Eugénie Gallet and Emile Frédéric Nicolle

[15.8.1894], Marie Caroline Lucie was born in Rouen on 23 October 1856. A son, Henri, was born in 1858 and a daughter, Ketty, in 1863, but in August 1867, three days after giving birth to her fourth child Zélie, Lucie's mother died, aged thirty-six.

Lucie's family was unusually artistic: her father was an eminent artist [7.3.1908]; her mother adeptly filled sketchbooks with drawings of picturesque scenes in the Pays de Caux, the fertile plateau lying between Dieppe, Le Havre and Rouen in Normandy. Not far from Yvetot, Sophie Gallet drew the churchyard of Allouville where the hollow trunk of an ancient oak tree accommodates two tiny chapels one above the other.

Many of Sophie's sketches were drawn in the park of the Château de la Viézaire at Saint-Gilles-de-Crétot. The chateau was the seat of the de Brihon family, descended from the de Brihon who held the appointment of *franc-bouteiller* to William the Conqueror. When Lucie's mother visited the chateau, it was the residence of her aunt Adèle Pillore (the grandmother of Julia [24.7.1900]) who, as a small child, often visited in Rouen her uncle Alexandre Forfait, Minister of the Navy: one day she found herself in her uncle's study sitting on

Napoléon's knee during an interminable discussion about the invasion of England, which Forfait (who was a naval engineer) believed would succeed with a great flotilla of small barge-like

vessels carrying troops and heavy armaments.

Also living in the Château de la Viézaire was Adèle's elderly maiden-aunt Octavie Pillore, whose great tragedy in life was to have composed an opera, *Protogène*, with a libretto by Eugène Scribe, which was apparently jealously suppressed by the influential Scribe and never performed.

Lucie's aunt Marie Estelle Gallet was also married to an artist, Léonce Lelarge [28.6.1919], who was celebrated for his portraits in pastel; one of his subjects was the great friend of Flaubert [7.7.1888], the poet Louis Bouilhet.

On 15 September 1874, Lucie Nicolle married Eugène Duchamp in Rouen. From her mother, inherited from the wealth of the Gallets and Pillores, Lucie had a rich dowry.

From the marriage there were seven children. On 31 July 1875 at Damville, Lucie gave birth to a son, Emile Méry Frédéric Gaston; the following year, Pierre Maurice Raymond was born on 5 November. Their third child, Jeanne Marie Madeleine, was born at Cany-Barville on 25 June 1883 (a few months before the Duchamps settled at Blainville-Crevon), but she died from the croup on 29 December 1886. Marcel [28.7.1887] and his three sisters, Suzanne [20.10.1889], Yvonne [14.3.1895] and Magdeleine [22.7.1898], were all born at Blainville-Crevon.

29.1.1954

Suffering from a progressive deafness since childhood [16.11.1919], Lucie was apparently placid to the point of indifference. However, like her parents, she enjoyed drawing and painting, and over a number of years Lucie designed in detail the different items of a whole dinner service in the style of Strasbourg, with every leaf and petal of the floral design careful-ly worked out like an embroidery which was never actually realized. She remained closest to her two youngest children, her favourites.

1928. Sunday, Hyères-les-Palmiers
"It is raining like in Normandy at Hyères, but it is not so cold," writes Duchamp to Brancusi. "Perhaps I will be second," he tells the sculp-tor, pleased with his progress in the chess tournament [23.1.1928], and gives his address in Nice from next Thursday.

Disclosing his whereabouts to Mad and Pierre Trémois [19.10.1926], Marcel admits in retro-spect: "I took it upon myself to get married and immediately afterwards took it upon myself to be divorced [25.1.1928]. It's too much for a bachelor."

1929. Tuesday, Paris
For the electricity supply consumed at 11 Impasse Ronsin in the fourth quarter of 1928 and which was invoiced on 5 January to Du-champ, the amount of 144.75 francs is paid to the landlord, the Imprimerie de Vaugirard.

1941. Wednesday, Dieulefit
On receiving Marcel's second letter [17.1.1941] of instructions [7.1.1941], Roché writes to the Arensbergs, but not without emotion because he has not had any contact with them for over twenty years.

1949. Saturday, New York City
Replies to the Hoppenots concerning the tape recorder [28.12.1948].

1952. Tuesday, New York City
"Thank you, I received the cheque safely and the long letter very comforting for one who worries about your health and morale [12.1.1952]," writes "Monsieur Duchamp" to Monique Fong in Washington.

After commenting on the news about André Breton, "Monsieur Duchamp" enquires: "When are you passing by New York to see your grandfather who gives you such good ad-vice. Write again and try to come soon, affec-tionately, Monsieur Duchamp."

1954. Friday, New York City
Duchamp receives a telegram from Elizabeth Wrigley in Hollywood announcing the death of Walter Arensberg from a heart attack. He was seventy-five.

Neither Louise (who died on 25 November) nor Walter lived to see their collection, their life's work (which was donated on 27 December 1950), installed in the new galleries being built for it at the Philadelphia Museum of Art. The number of works by Duchamp, which the Arensbergs began to acquire soon after Walter Pach brought the young Frenchman to their apartment on 15 June 1915, became not only the largest but the most representative group of his work held anywhere.

Although they met regularly in New York until Duchamp went to Buenos Aires [14.8.1918], in 1921 the Arensbergs settled in California [15.11.1921] and, when he had ceased work on the Large Glass [5.2.1923], Duchamp returned to France.

Nevertheless, they corresponded and Du-champ assisted them with acquisitions pro-posing his own works when the occasion pre-sented itself. In the summer of 1936 Duchamp had the opportunity to visit his friends in Hol-lywood [6.8.1936]; he went again to California [17.4.1949] a few months before the Arensberg Collection was shown at the Art Institute of Chicago [19.10.1949], and he joined them for a day or two in Chicago, when they travelled to see the exhibition and discuss giving their col-lection to the museum [12.12.1949].

A trusted friend, Duchamp represented the Arensbergs on a number of occasions, helping to negotiate satisfactory terms for the gift of the collection. Duchamp was even sent to Holly-wood by the Metropolitan Museum for a long weekend [25.4.1950] which was the last time he saw them.

1958. Wednesday, New York City
After receiving a request from the city of Tours for the loan of *Nu descendant un Escalier*, No.2 [18.3.1912] for an exhibition entitled "Œuvres qui ont fait Scandale", Duchamp forwards the letter to Henri Marceau in Philadelphia. He also thanks Marceau for the Picasso catalogue [8.1.1958].

1959. Thursday, New York City
Before leaving for London, George Heard Hamilton has sent Duchamp the list of Richard Hamilton's questions concerning the transla-tion of certain terms in the notes [8.12.1958].

"I am all for Tree-type," declares Duchamp in the list of his replies. He and George admit they are defeated by "Pendu femelle", due to the fact that Pendu is always masculine in

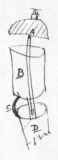

French, "even if it is a hanged woman. In my glass," says Duchamp, "my animal (le Pendu) is a female." He agrees to "branded bottles", proposes that the reflexive pronoun is included "either way" in "The Bachelor grinds (himself), his own chocolate (himself)", which "gives the finicky tone of the French", and agrees that "commercial slogan" is better than "motto".

1960. Friday, Newark
At Bamberger's store, Duchamp finishes the installation which will remain *in situ* for a fort-night to publicize Lebel's book [6.11.1959]. A giant frame almost fills one of the display win-dows and behind it, Duchamp places *Nu descen-dant un Escalier*, No.3 [29.4.1919] on a draped stand so that it appears in the upper left hand corner of the frame. Five naked articulated shop mannequins with neither wigs nor arms step gracefully one behind the other from the edge of the picture down several steps. The drawing, *Por-trait de Joueurs d'Echecs* [17.12.1959] (the second of the two works of art lent by the Philadelphia Museum of Art [17.12.1959]) is placed centrally at the foot of the frame with an illustration of *Cœurs Volants* [16.8.1936] and *Eau et Gaz à tous les Etages* [6.4.1959] to the right. In front of the frame several copies of *Marcel Duchamp* by Lebel are laid open and six copies of the dust-jacket illustrated with the double-exposure portrait photograph by Victor Obsatz are placed in a ver-tical column to the right of the frame.

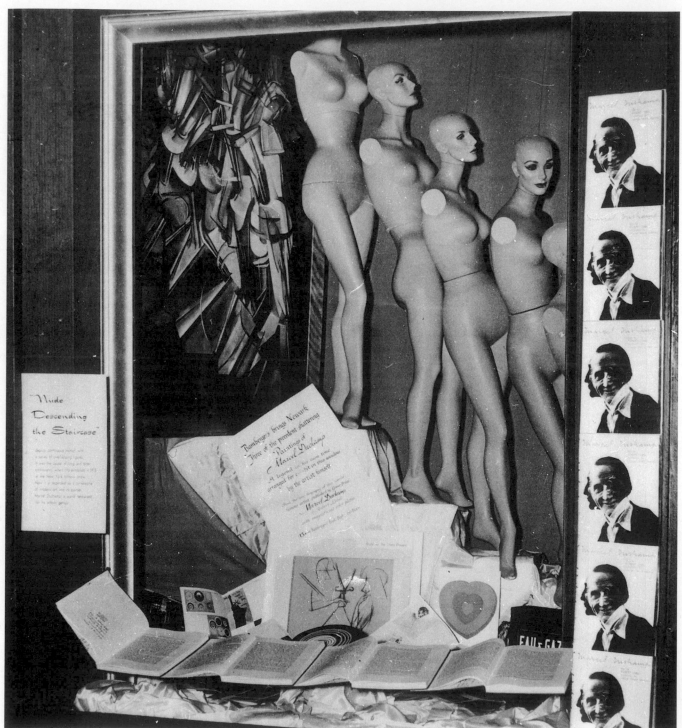

29.1.1960

29.1.1967

While he is working, Duchamp notices a small crack in the glass at one of the corners of the Nude's frame.

1961. Sunday, New York City
The weather has been bright and sunny but very cold; snow has been lying on the ground for weeks. As the exhibition, "Surrealist Intrusion in the Enchanters' Domain", [28.11.1960] has finally closed, Marcel and Teeny go to the D'Arcy Galleries to bring their belongings home. "The chickens that have become everyone's pet will be greatly missed," says Teeny in her letter to Jackie, referring to the occupants of *Coin Sale*, one of Marcel's ideas for the show.

Before going to Denise Hare's for supper, Marcel adds a few lines to Jackie: "First of all my compliments for the happy birth [28.1.1961]. Thanks to you, thanks to Bernard the human race is not in danger of extinction. Thanks as well for the 12 boxes," he continues, referring to the completed Valises [3.5.1960], which he finds wonderful. "I am arranging to have the 2 missing 'items' printed," Marcel adds.

1966. Saturday, New York City
In response to a request from Mlle Olga Popovitch, curator of the Musée des Beaux-Arts in Rouen, who wishes to organize an exhibition of the three Duchamp brothers, Duchamp explains that, due to a clause in the deed of gift it is impossible for items from the Arensberg Collection to be away from Philadelphia for more than four months at a time. Therefore, the works which are to be lent to the exhibition taking place in June at the Tate Gallery will have to return across the Atlantic, and another show will have to be mounted at a later date.

"During my visit to France in the spring, I could visit you in Rouen to discuss all the details of this difficult enterprise," Duchamp proposes. "I would also like to ask you," he continues, "if you would accept the gift to the museum of Rouen of a certain number of paintings, watercolours, drawings, by my sister Suzanne Duchamp-Crotti?"

1967. Sunday, New York City
On learning from Dorival that the Philadelphia Museum of Art has accepted to lend seven of his works to Paris but has refused Rouen [13.1.1967], Duchamp writes to Dr Evan Turner to ask him whether he might reconsider his decision. "My point is that Rouen is as important as Paris under the circumstances," explains Duchamp. "As you know Rouen is my home town and the municipality is having a festival in honour of the four Duchamps. For the occasion they are also naming two streets after Jacques Villon and Raymond Duchamp-Villon [25.1.1967]."

Duchamp also points out that the paintings would be away no more than three months, even with the two shows, and adds: "The museum in Rouen was built around 1880 and is a stone building of a type of architecture which offers all the guarantees of safety."

30 January

1904. Saturday, Rouen
Although the feast day falls on 28 January, the University of Caen has directed that the Feast of Saint Charlemagne will be celebrated today, and in veneration of the founder of universities, all colleges and *lycées* are closed.

1936. Thursday, Paris
Michel Leiris inscribes a copy of his book *La Néréïde de la Mer Rouge* to Marcel Duchamp.

1947. Thursday, New York City
At two-thirty in the afternoon, Duchamp and the Crottis are due to meet Miss Dreier at the Centre d'Etudes Supérieures, 934 Fifth Avenue, where Jean Crotti's "Gemmaux" are being exhibited by the French Embassy.

1953. Friday, Paris
Opening of "Le Cubisme 1907–1914" at the Musée National d'Art Moderne, an exhibition organized by Bernard Dorival which provokes the wrath of André Breton. With fifteen "ratatouilles" by Gleizes, twelve pieces of "lard" by Lhote, Breton criticizes the imbalance of the show and declares that "authentic" artists such as Gris, Laurens, Metzinger and Marcoussis are poorly represented. As for the three works by Duchamp, *Les Joueurs d'Echecs* [7.5.1952] lent by Villon, *A propos de jeune Sœur* [8.3.1915] and *9 Moules Mâlic* [19.1.1915] both lent by Roché [25.1.1953], Breton says that these are: "relegated disgracefully to a corridor above the fire-fighting equipment – quite unintentional humour." A "scandalous" exhibition.

1957. Wednesday, New York City
Marcel has finally persuaded Teeny to reserve a place on a flight to Paris so as to be present at the arrival of her first grandchild.

In a letter, Marcel tells Roché that when Teeny comes on 15 February she will bring a copy of the film with Sweeney [15.1.1956], and Richter's film if it is ready [24.12.1956].

1958. Thursday, Neuilly-sur-Seine
At 5 Rue Parmentier in his eightieth year, Marcel's brother-in-law Jean Crotti dies suddenly. By strange coincidence Jean's elder brother André dies on the same day.

1961. Monday, New York City
Writes to Peter Steefel [21.1.1961] in Wisconsin saying that after reading the books (which he plans to mail tomorrow) he has left all his "paper markings" at places where he found French misspellings. "In other words you must go over all the French quotations with the original text," Duchamp advises, "to avoid stupid remarks from the reader."

1964. Thursday, New York City
With Arman's recommendation, Duchamp asks Georges Véron to make an ektachrome of a canvas by Fernand Léger belonging to his cousin, Dr Robert Jullien in Paris.

1965. Saturday, New York City
Arturo Schwarz has been working every morning with Duchamp on the *catalogue raisonné* of his work. Today he leaves for Chicago to study the Mary Reynolds Collection [20.6.1956].

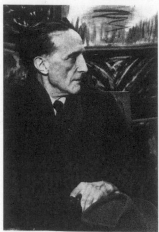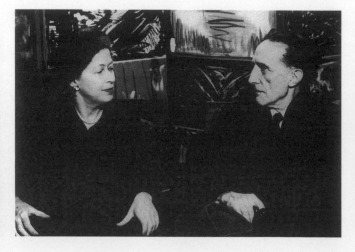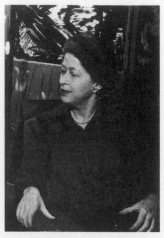

31.1.1954

31 January

1920. Saturday, New York City
Dines with Aileen Dresser and Beatrice Wood.

1953. Saturday, New York City
Henri-Martin Barzun has written to postpone dining with Duchamp until 7 February, but as Duchamp will be out that day and may not return until late, he writes to Barzun suggesting 8 February and adds: "Confirme encore ou infirme encore..."

*

As soon as he received André Breton's request for more time to produce the layout of the almanac [22.12.1952], Marcel telephoned Mrs Cowles' secretary, who promised to send Breton a cable according him an additional three weeks. Giving Breton a list of the photographs which could be made in New York, Marcel says that the *Art News* annual which Breton was looking for will be forwarded by second-class post with a longer letter.

1954. Sunday, New York City
Catching up on some letter-writing, Marcel announces to Jean and Suzanne Crotti the deaths of Louise and Walter Arensberg [29.1.1954] and his recent marriage. "Since 16 January I am married to Teeny Matisse; no children yet except the 3 readymade." He adds cryptically: "Louis XVI and St Marcel," referring to the date of the wedding, anniversary of the day when the French king was fatally condemned to espouse the *Veuve*, and his own saint's day.

After informing Mary Dreier that he has sent the enquiry for tax exemption of her donations to Yale, Duchamp declares of his marriage: "This shows clearly that bachelors are unpredictable."

And to Roché he remarks: "Everything happens one day."

1958. Friday, New York City
Richard Avedon captures Duchamp in his lens, just his head with the brow wrinkled from his raised eyebrows and his hands, one on each side of his face placed almost symmetrically, the long fingers extended, one from each hand touching the side of his nose by the corners of his eyes.

In the evening after lunching with friends, the Duchamps hear a very exciting concert with Aaron Copland conducting an outdoor overture and his Third Symphony.

According to Teeny, neither of them liked it as much as the Webern, which they heard a few weeks previously.

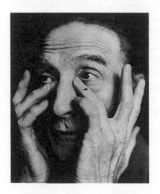

1 February

1921. Tuesday, New York City
Alexander Archipenko's exhibition, which Duchamp has been instrumental in organizing

[27.12.1920], opens at the Société Anonyme, 19 East 47th Street. Providing some unusual publicity for the Russian sculptor's first one-man show in America, Duchamp is author of an advertisement for the "Archie Pen Co.", appearing in the February–March edition of *Arts*. Describing it as "a brilliant caricature of a modern magazine advertisement", the editor of *Arts* regrets that the well-known artist who drew it refused to sign his work.

1923. Thursday, New York City
In the evening at a quarter to eight, Marcel is invited to dinner at the Stettheimers'. Among the other guests are Mr and Mrs Alfred Knopf, Fania and Carl van Vechten, Alfredo Sidès and Edward Steichen.

1947. Saturday, New York City
Since his return to New York [22.1.1947], Duchamp has seen Donati, Kiesler, Matta and Max Ernst concerning their participation in the proposed Surrealist exhibition [12.1.1947]. As Kiesler will take care of the Room of Superstitions, Duchamp asks Breton to send the architect a list of half a dozen examples.

Matta is willing to make an altar for the Labyrinth; the two large walls in the Rain Room could be hung with a large canvas by Matta and one by Ernst. Stating that he is quite prepared to follow his co-director's line of thinking, Duchamp asks Breton whether he agrees to these proposals.

Next week Duchamp plans to visit Connecticut to establish the prints for the catalogue.

1954. Monday, New York City
Duchamp replies to Elizabeth Wrigley's cable [29.1.1954] saying that he "did not know Walter was so far gone and always hoped he would somehow overcome his grief". He offers Mrs Wrigley his assistance in carrying out Arensberg's last decisions about Philadelphia [22.1.1954].

1966. Tuesday, New York City
Having difficulty in finding a system to trim the edges of the items printed by the Maison Vigier et Brunissen in Paris for the White Box, which is to be published by Cordier & Ekstrom [28.6.1965], Duchamp writes to Brunissen to ask whether he would be willing to lend his machine to the gallery for a month. If Brunissen accepts, the machine could be sent air-freight by I.A.T. As an afterthought Du-

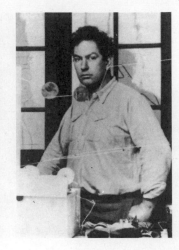

2.2.1932

champ adds: "Perhaps this machine is made in America that too would simplify the work."

2 February

1917. Friday, New York City
After Roché has dictated his article for *Le Temps*, he and Marcel have dinner with the Stettheimers.

1918. Saturday, New York City
Invited to dine at the Stettheimers' in the evening, Marcel and Roché find Leo Stein [28.7.1917], in one of his depressed moods, among the other guests.

1925. Monday, Rouen
On a bitterly cold day, the family and their friends gather at the church of Saint-Godard [24.8.1911] for the funeral service of Lucie Duchamp, who died on Thursday. Grief-stricken at the loss of his wife, Eugène Duchamp is determined to follow the hearse on foot to the cemetery on the hillside above the city. Halfway up the very steep avenue, members of the family persuade Maître Duchamp, who is evidently exhausted from the long, strenuous walk, to ride the rest of the way in one of the funeral cars. At the Cimetière Monumental, the coffin is placed in the tomb next to the one sheltering the remains of Lucie's father, Emile Nicolle [17.8.1894], her sister Zélie, who died in childbirth, her brother-in-law Fortuné Guilbert (Ketty's first husband), and her infant daughter Madeleine.

1926. Tuesday, Paris
Marcel is busy preparing the public auction of his 80 Picabias [27.1.1926], when Roché calls to see him at the Hôtel Istria.

1928. Thursday, Hyères-les-Palmiers
Duchamp wins the Coupe Philidor [23.1.1928] jointly with Halberstadt and O'Hanlon. Described by Georges Renaud as "the most striking" game of the tournament, Duchamp's win against H. Smith in the second round is considered likely to be awarded the Brilliancy Prize. At the close of the chess congress Duchamp travels to the Marigny Hotel, Place Gambetta in Nice.

1932. Tuesday, Paris
Duchamp and Mary Reynolds are invited to dine with the Calders, 14 Rue de la Colonie. Thanks to Duchamp, Sandy Calder is preparing a one-man show for Marie Cuttoli of his "mobiles", the word invented by Duchamp to describe the American sculptor's objects with moving elements, some of them motorized. The show is due to open at the Galerie Vignon in April.

1935. Saturday, Paris
Totor calls to see Roché in Arago.

*

On meeting Hans Arp, Duchamp learns of the existence of an important Surrealist exhibition in Copenhagen.

1950. Thursday, New York City
Marcel thanks Roché for accepting the exchange of paintings [23.1.1950] which he says will make life easier for him.

1953. Monday, New Haven
At the Yale University Art Gallery, following the close of the exhibition "In Memory of Katherine S. Dreier, 1877–1952" [15.12.1952], Duchamp supervises the shipment [22.1.1953] of all the donations to various museums, thus accomplishing his task as one of the executors of the estate.

In agreement with Mary Dreier, Duchamp asks George Heard Hamilton to select two modern paintings from those belonging to Miss Dreier. He chooses a small Campendonk and a Schwitters.

1955. Wednesday, Sèvres
The day before their departure, Marcel and Teeny return to 2 Rue Nungesser-et-Coli to see Roché once more [24.1.1955]. After lunching together, Roché's wife Denise is to accompany them back to Paris. At three o'clock when they leave, Roché is alone at the window watching them in the street below: he fears that he may never see Marcel again.

1957. Saturday, New York City
Marcel informs the Crottis that when Teeny goes to Paris [30.1.1957] on 15 February she will bring the paintings for Jean from Rose Fried.

1958. Sunday, New York City
After the death of Jean Crotti on Thursday, Marcel writes a letter to his sister Suzanne, which Teeny also signs.

"When we saw him in New York last year," says Marcel, "he was still the same Jean that I have always known and whose warmth in his friendship I always appreciated."

1960. Tuesday, New York City
Duchamp thanks Henri Marceau for lending the pictures to Bamberger's store [29.1.1960] and informs him of the cracks in the glass, which he noticed on Friday.

Following the request to the museum from the New York Graphic Society to make a reproduction of *Nu descendant un Escalier*, No.2 [18.3.1912], Duchamp tells Marceau that he accepts with pleasure the sum to cover all his rights on the reproduction. He enquires about the dimensions of it and adds: "I would also like them to be interested one day in reproducing the Large Glass [5.2.1923] in an interesting way."

At the end of his letter Duchamp says that he hopes Marceau will have lunch with them on Monday when they come to Philadelphia.

*

Proposed by Edgar Varèse and seconded by Stuart Davis and Louis Bouché, Marcel Duchamp is elected as a member of the National Institute of Arts and Letters.

Varèse proposes Duchamp "as one of the important painters of our time, internationally known, and a legendary figure in the world of art. Besides his prestige as an artist," asserts Varèse, "Marcel Duchamp has the further distinction of being a man of wide culture and for good measure possesses a personality of great charm."

1968. Friday, New York City
As Joe Solomon would like to obtain posters of the exhibitions held last year in Rouen [15.4.1967] and Paris [6.6.1967], Duchamp sends him the names and addresses to write to. Regarding his numismatic piece, Duchamp says: "There is no special name for the medal [23.11.1967] unless they gave a title indicated in their leaflet."

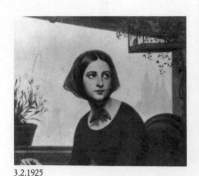

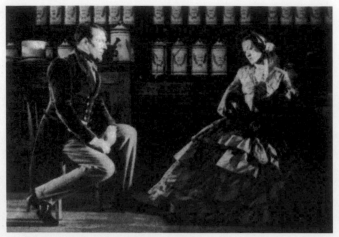

3.2.1925

3 February

1925. Tuesday, Rouen
In the afternoon at three o'clock on the day after his wife's funeral, Eugène Duchamp collapses suddenly and dies at his home, 71 Rue Jeanne d'Arc. He was almost seventy-seven.

Born on 16 February 1848 at Massiac in the Cantal, Justin Isidore, known as Eugène, was the youngest son of Jean and Catherine Duchamp [21.12.1908]. After studying at the Petit Séminaire in Saint-Flour, thirty kilometres south of Massiac, in 1868 Eugène started his career as a supernumerary in the register office at Fontainebleau. With the outbreak of war in 1870 he served as a lieutenant in the army of the Loire and was held prisoner at Stettin in distant Pomerania. Returning to the administration after the war, Eugène was receiver in the register office at Ganges, near Montpellier, at the time of his father's death on 31 January 1874. On 7 April 1874 Eugène was appointed to the register office at Damville in Normandy, just a few months prior to his marriage to Lucie Nicolle in September the same year.

After five years at Damville, on 2 October 1879 Eugène Duchamp was posted to Cany-Barville, a small market town in the Seine-Inférieure, where he brought his wife and two young sons to live. While in Cany, the Duchamps became close friends of the *notaire*, Maître Langlois and his English wife, who later moved to the chateau of Montigny at Bailly-en-Rivière near Dieppe [6.9.1908].

In December 1883 Eugène Duchamp acquired the practice of *notaire* at Blainville-Crevon, a small village northeast of Rouen just a few kilometres from Ry, the setting of Flaubert's *Madame Bovary*. Delphine Couturier, the model for Emma Bovary, was born in Blainville. As her marriage contract to Delamare was in the archives of the *notaire*, it amused Maître Duchamp to show the document from time to time to his visitors.

During his twenty-two years at Blainville, Maître Duchamp played an active role in village and cantonal affairs. He became a municipal councillor [6.5.1888] and later was elected mayor [7.11.1895], an office which he held exactly ten years [3.11.1905] until he retired as *notaire* [27.3.1905] and moved to Rouen.

After life in his country practice at Blainville, Rouen undoubtedly offered more scope for his talents and the honorary *notaire* continued to serve the city and region with energy, devotion and great administrative competence for twenty years until his death. In 1909 he was nominated to the Conseil de Famille des Pupilles de l'Assistance Publique de la Seine-Inférieure and, with his particular interest in agriculture affairs, held responsibilities in the Caisse Régionale du Crédit Mutuel Agricole de la Haute-Normandie and the Société Centrale d'Agriculture de la Seine-Inférieure. His important nomination as administrator of the Hospices Civils in Rouen was approved unanimously and by prefectoral decree Maître Duchamp was made a member of the Commission Administrative on 7 December 1909.

In recognition of his work, on 8 April 1910, the year in which Marcel painted his portrait [6.5.1911], Maître Duchamp was made Officier de l'Instruction Publique; he was promoted to the rank of Chevalier de la Légion d'Honneur on 31 August 1923. Greatly loved and respected by his family and the community, Eugène Duchamp was remembered as "a small, alert old man, who kept a twinkle in his eye" and had "always an outstretched hand and courteous word" for any who approached him.

1935. Sunday, Paris
After learning from Arp the previous day of the Surrealist exhibition in Copenhagen, but unaware that it has already closed, Duchamp writes to Breton asking whether he should send a copy of the Green Box [16.10.1934], requesting the address of the organizers and some details about the show. Having participated in various Surrealist exhibitions [7.6.1933], Duchamp is surprised no doubt that Breton, author of "Phare de la Mariée" [5.12.1934], seems to have forgotten him.

1939. Friday, Paris
Max Bill inscribes a copy of *Quinze Variations sur un Thème.* for Duchamp.

1943. Wednesday, New York City
At noon, the curtain is raised on the window of Brentano's bookshop on Fifth Avenue, which has been decorated by Duchamp and Kurt Seligmann for Denis de Rougemont's new book: *La Part du Diable*.

Duchamp's black, open umbrellas, the significance of which he said mysteriously, "All women will understand," are hanging by their handles from the ceiling like the formidable wings of giant bats. Masking Brentano's red velvet, Seligmann has painted diabolic emblems dating from the sixteenth century on a white backcloth. Devils of all sizes from fifteen different countries now inhabit the little space, and a black table is alive with handfuls of jumping beans.

Intrigued to see the reactions of the public, de Rougemont and Breton stand at a discreet distance on the edge of the wide pavement. The first passer-by who stops to look is a negro: he smiles broadly. As soon as he sees the large Tibetan devil standing in the left corner of the window, he starts jumping up and down, gesticulating, making faces, and swearing at the devil at the top of his voice. In a final gesture the man sticks out his tongue and then suddenly slips away, leaving behind him the crowd that has formed.

1955. Thursday, Cherbourg
In the afternoon Marcel and Teeny are among the 271 passengers boarding the *Queen Mary* to return to New York [6.11.1954]. Under the command of Captain Sorrel, the liner sails from the safety of the harbour into a rough sea.

1965. Wednesday, New York City
Hoping that he will agree to sign it, Mr and Mrs Phillip Bruno have sent Duchamp a copy of his recent catalogue [13.1.1965] into which they have affixed the press reviews of the exhibition. Duchamp notices that above the illustration of the *Chèque Tzanck* [3.12.1919], the Brunos have tipped in a blank cheque. As it is situated opposite *L.H.O.O.Q.* [6.2.1930], after dating it Duchamp makes the cheque payable by the

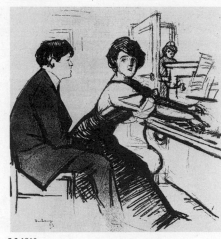

5.2.1910

"Banque Mona Lisa" to Philip Bruno for an "unlimited" number of dollars and signs it.

4 February

1926. Thursday, Paris
After his visit on Tuesday, Marcel returns to the Hôtel Istria to see Totor, who is continuing preparations for the Picabia sale with his secretary. When he is questioned about whether he thinks the sale of eighty drawings, watercolours and paintings from different periods of Picabia's work will be a success or not, Roché says that he is optimistic.

1951. Sunday, New York City
As no trains are running, Dee has to cancel his visit to Miss Dreier at Milford.

1952. Monday, New York City
With no news from them for several months [27.10.1951], Marcel writes to Louise and Walter Arensberg about "Duchamp Frères & Sœur", due to open on 25 February. "The art magazines are very keen about the idea of a 'family of artists'," explains Marcel, "and I have to go through interview after interview [15.1.1952]."
Concerned by Philadelphia's long silence [13.4.1951], Marcel asks: "What do you know about the appropriation and the preparations for the rooms? They are a bit slow to my taste."

1953. Wednesday, New York City
Sending a borrowed copy of the *Art News* annual [31.1.1953], Marcel encloses some comments for Breton about the project for *Flair*. As there are only 30 pages and room therefore for only one illustration per person, Marcel suggests that the drawing by Maurice Henry which was published in the *Almanach Surréaliste du demi-siècle de la Nef* might be used.
He emphasizes how useful Donati has been in liaising with *Flair*, gives Breton further information about Louise Bourgeois who was on the list of names in his last letter [31.1.1953] and also reminds him that Xenia Cage is the wife of the composer. Does Breton accept Lionel Abel as translator?
Marcel would like an illustration of the

Large Glass [5.2.1923] in colour, but as it is still in storage at Philadelphia, pending the installation of the Arensberg Collection, he proposes to colour by hand a good black-and-white photograph instead.
As he severed relations completely with Kiesler [8.11.1947] about two years ago, Marcel requests Breton to contact the architect directly about his reproduction for *Flair*.

1958. Tuesday, New York City
When the Duchamps telephone Lebel at nine o'clock in the morning he still doesn't know how he is returning to France. Half an hour later he calls back to say that he is sailing on the *United States*.
Wasting no time, Marcel leaves with the Valise for Jackie's *Boîte-en-Valise*, which has been especially made and which Lebel has agreed to transport and deliver.

1962. Sunday, New York City
Although they will be in Florida when Jean Dubuffet arrives in New York, Duchamp thanks him for the "good news" and says: "hoping that you will still be in N.Y. when we get back around 23 *and then what a ball!*"

1966. Friday, New York City
Puzzled by Hubachek's enthusiasm to acquire some prints for the Art Institute of Chicago from the catalogue which he has sent to him, Marcel tells his friend: "A few subjects are entertaining, and if you want me to tell you the one I would choose I am inclined to name Mona Lisa, maybe because she is closest to me."

5 February

1910. Saturday, Paris
Today *Le Courrier Français* publishes a cartoon by Duchamp – the third since the beginning of the year [29.1.1910] – entitled *Musique de Chambre*. Although her piano stool is closer to her companion's chair than the piano, with outstretched arms the girl manages to resume playing some notes of music when she hears someone at the door. She warns the young man: "Button your jacket – it's the maid."

1917. Monday, New York City
Roché and Duchamp return to Manguin's for lunch [12.1.1917].

1920. Thursday, Paris
In the sixth number of *Bulletin Dada*, which also serves as the programme of the Matinée Dada at the Salon des Indépendants, Duchamp appears in the long list of "Quelques Présidents et Présidentes".
"Marcel Duchamp," declares Louise Margueritte, "doesn't make art any more, having discovered a new checkmate of the Queen, [a] checkmate made with twine and a rubber bathing cap [8.7.1918]."
Marcel Duchamp's published reply is: "Walter Conrad Arensberg has not yet discovered this checkmate he is happy at the moment to checkmate the King."

1921. Saturday, New York City
The first of three lectures given by Miss Dreier, entitled "Modern Art", each of which are to be delivered in a different venue, takes place at the Heterodoxy Club of New York. Joseph Stella and Duchamp have agreed to attend and answer questions after each lecture.

1923. Monday, New York City
Confirming in writing to pay Louise and Walter Arensberg $1,000, half of the agreed sum (the rest of which is to be paid in instalments over two years), Miss Dreier acquires *La Mariée mise à nu par ses Célibataires, même*, known as the Large Glass. The Arensbergs, now settled in California [15.11.1921], have

5.2.1923

decided that the Glass is too fragile to risk shipping it to the West Coast. It will be transferred from the Lincoln Arcade Building [15.2.1922] to Miss Dreier before Duchamp's departure for France on 10 February.

Duchamp has now decided to abandon this monumental work comprising two rectangular sheets of glass superimposed, a project which he has been working on from time to time since 1915 [26.1.1916]. The elements, which were planned but never executed, are: the spiralling Toboggan or Planes of Flow, the Boxing Match and the mysterious Handler or Tender of Gravity.

Although the Glass was realized in New York, its genesis dates from 1912 when, in the wake of the refusal of *Nu descendant un Escalier*, No.2 [18.3.1912] at the Salon des Indépendants, and of his disenchantment with painters, Duchamp was searching for new criteria upon which to base his work.

It was a writer who showed him the way. Attending a performance of *Impressions d'Afrique* at the Théâtre Antoine [10.6.1912], Duchamp realized that the process used by Raymond Roussel could be applied pictorially. Taking himself away from Paris during the summer, certain forms and ideas germinated in Munich [7.8.1912], notably the Bride [25.8.1912], the figure destined to hang in the upper section of the Glass.

Duchamp's plan developed above all from notes such as those composed after his journey to the Jura [26.10.1912], while at Herne Bay [8.8.1913] and in Normandy [3.8.1914]. Irony, humour and eroticism were the primary colours on his palette. "It was always in my intentions," declared Duchamp, "to reduce the glass to an illustration as succinct as possible to all the ideas of the [notes]." Determined to avoid being invaded by things of the past, Duchamp said: "it was a constant battle to make an exact and complete break."

In December 1912, on his return from the Jura, Duchamp composed the lower half of his

"illustration" on a large sheet of cardboard [13.1.1913]; later the whole composition was plotted full-scale in mathematical perspective on the fresh plaster wall of his new studio at 23 Rue Saint-Hippolyte [22.10.1913].

Desiring to incorporate chance in different ways, Duchamp used his new "gravitational" or weight-determined unit of measurement, *3 Stoppages Etalon* [19.5.1914] to establish the position of the nine Bachelors in the lower section of the Glass. The wind dictated the shape of the Draft Pistons [21.5.1915]. A degree of skill played its part in the position of the holes for the Shots fired from a toy cannon.

And while he was working he had in mind "the idea of a projection, of an invisible fourth dimension, something you couldn't see with your eyes". As touch is the only one of our senses which might have a "quadridimensional application", the erotic act is the "perfect situation quadridimensional", Duchamp said: "a tactile sensation which envelopes every side of an object."

Before leaving for America [6.6.1915], Duchamp made two small but full-scale studies on glass of certain elements of his composition, experimenting with his new materials: first *Glissière contenant un Moulin à Eau en Métaux voisins* [11.12.1919] and then *9 Moules Mâlic* [19.1.1915]. Later when he was in Buenos Aires, Duchamp completed a study for the lower right-hand area of the Glass: *A Regarder d'un Œil, de près, pendant presque une Heure* [4.4.1919].

Other elements forming part of the Bachelor Machinery in the lower part of the Glass were also subjects of separate studies such as: the Chocolate Grinder [8.3.1915], the Sieves [3.8.1914] (later coloured with dust [20.10.1920]) and the Oculist Witnesses [20.10.1920].

As for the contents of this "delay in glass", Duchamp maintained he was mixing "story, anecdote... with visual representation" and that he was "welding language and form". The childhood memory, when he was at the Lycée Corneille in Rouen, of booths at the ancient Saint-Romain Fair, where patrons were invited to throw missiles at the Bride, Groom, Priest, Policeman, Soldier, etc. was one starting point. Even a detail in the title was important. In a note, Duchamp wrote: "La mariée mise à nu par *ses* célibataires même to give a sense of

continuity to the picture and not incur the objection of having only described a fight between social dolls [12.11.1918]. *The bride possesses her partner and the bachelors strip bare their bride.*"

1924. Tuesday, Paris
Apologizing for not replying sooner, Duchamp sends an express letter to Jacques Doucet accepting his invitation to lunch on Thursday. "Thank you very much," writes Duchamp, "very happy also to see Roché again, who is so seldom to be seen."

1937. Friday, Chicago
Three separate exhibitions of paintings by Kees van Dongen, André Derain and Marcel Duchamp open at the new premises of the Arts Club of Chicago situated in the South Tower of the Wrigley Building, 400 North Michigan Avenue. For Duchamp, who will be fifty in July, it is his first one-man show.

Making a selective choice of just nine

important paintings by Duchamp from the period 1911–1914, Miss Roullier has borrowed five from the Arensbergs, one from Man Ray [19.12.1936] and two from Walter Pach. Although *3 Stoppages Etalon* [19.5.1914] and *Fresh Widow* [20.10.1920] were sent to Chicago by Miss Dreier, only the watercolour belonging to her, *Cimetière des Uniformes et Livrées* No. 2 [19.1.1915] is exhibited.

The only one of the three artists in Chicago for the occasion, Van Dongen may have stolen the limelight at the opening, but C. J. Bulliet, reviewing the exhibitions for the *Chicago Daily News*, dismisses the Dutchman as a "suave flatterer".

Unimpressed by the extract "dripping with mysticism" from Julien Levy's book, *Surrealism*, included in Duchamp's catalogue, Bul-

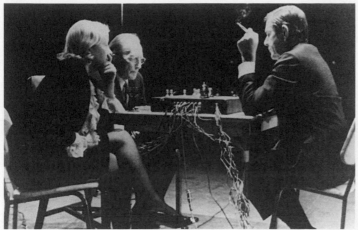

5.2.1968

liet writes bluntly: "Duchamp had the lightest touch of all the Cubists. He played airily with the ideas that were being taken so seriously by Braque, Gleizes and even Picasso...

Duchamp's 'Nude descending the Stairs', with its dramatic expression of motion, had lurking in it the twinkle that was to break later into a grin with the advent of 'Dada'...

Making a comparison between two contemporaries: "Duchamp here, and elsewhere, is dynamic, energetic," observes Bulliet. "Picasso has always, in his Cubism as well as naturalistic phases, veered towards the static, the placid. Duchamp is at home in Chicago's loop, on New York's Broadway. Picasso, you can imagine exploring the tombs of Egypt or the catacombs of Rome."

1953. Thursday, New York City
In the morning Duchamp receives a letter, from Mary Dreier. In his reply he recommends that Mary Dreier accept the proposal from the George Walter Vincent Smith Art Gallery [21.1.1953] to make a selection of 10 pictures by her sister Katherine, to be "on view a good part of the time". Duchamp has also been to see Miss Church at the American Arbitration Association about the Carroll paintings, which, in his opinion, they can keep if Mary Dreier decides so. He agrees that the remaining Carrolls in the tool house at Milford could be sold at auction, together with any other pictures: "This can be decided a little later," suggests Duchamp.

Reporting on his visit to New Haven on Monday, Duchamp says: "I have fixed it with Mr Hamilton... He was very happy." Referring to the shipping of the bequests from the estate, Duchamp comments: "Finally that part of Kate's desire has been accomplished – as she meant it, *I hope.*"

1968. Monday, Toronto
In the afternoon Teeny and Marcel arrive in Ontario from New York. From their room at the Windsor Arms, Duchamp telephones Michel Sanouillet requesting that he drive him over to the theatre at the Ryerson Institute straight away, because "he knows nothing about what's going on tonight". About a fortnight ago, "on a whim," reports Robert Fulford for a Toronto newspaper, Duchamp to everyone's surprise agreed to take part with John Cage in "Sightsoundsystems", a festival of art and technology.

In the evening at eight-thirty Duchamp walks onto the stage which, to the music critic William Littler, resembles a cross between an electronic factory and a movie set. Participating in a work entitled *Reunion*, Duchamp is at the Ryerson Theatre, not only to play chess for four hours with Cage, but to make music. Each square of the chessboard is a contact microphone; each time a chesspiece is moved the connection with the board is broken and the electronic sound in the auditorium subtly altered. David Behrman and Gordon Mumma placed on the right and David Tudor and Lowell Cross on the left, are in the shadows: "at work before tuners, amplifiers and all manner of electronic gadgetry, turning dials, blowing on things and filling a couple of TV screens with scrambled oscilloscopic images."

Cage and Duchamp, who are joined later by Teeny Duchamp, "took things casually... simply smoked, drank some wine and played chess." Occasionally they would turn to look at one of the screens, or greet a friend. Four hours later, "none of the cameramen and few of the curious remained."

Recounting the event later to Monique Fong, Duchamp said it went "very well, very well, it began about eight-thirty. John played against me first then against Teeny. It was very amusing." Asked whether there was any music, he replied: "Oh, yes – there was a tremendous noise."

6 February

1911. Monday, Paris
At a quarter to nine in the evening at the clinic, 89 Rue d'Assas, Jeanne Marguerite Serre [16.4.1910] gives birth to a daughter, Yvonne Marguerite Marthe Jeanne.

1916. Sunday, New York City
Covering four postcards Duchamp types a cryptic text in French entitled *Rendez-vous du Dimanche 6 Février 1916*, which he addresses to Mr and Mrs Walter C. Arensberg at 33 West 67th Street.

In addition to the exacting work [26.1.1916] on the Glass at his studio at 1947 Broadway, Duchamp has spent hours on this "painful construction" of a text with no beginning or end, typing the maximum number of letters across each card and cutting the words irrespective of the rules of hyphenation. "The verb was meant to be an abstract word acting on a subject that is a material object; in this way the verb would make the sentence look abstract." Duchamp

6.2.1930

refined the sentences until the text finally reads: "Without any echo of the physical world."

1923. Tuesday, New York City
As Duchamp sails for France on Saturday, Miss Dreier hopes that the monthly meeting of the directors of the Société Anonyme will be a full one. Although the meeting is scheduled to start at a quarter to nine, at seven-thirty Miss Dreier has offered dinner at her home at 88 Central Park West, for those "to whom it would be a pleasure or a convenience".

1925. Friday, Rouen
Following the funeral of Lucie Duchamp on Monday, the family returns to the Norman capital for the funeral of Eugène Duchamp [3.2.1925]. In recognition of his services as vice-president of the Commission Administrative des Hospices, a magnificent wreath decorated with a blue-and-red ribbon, the colours of the city, has been placed on the coffin by the municipality. Leading the official mourners at the church of Saint-Godard is the *préfet* of the Seine-Inférieure, members of the Commission Administrative des Hospices, and M. Vaudour representing the mayor of Rouen. Many municipal councillors, delegations from various municipal services, are also present.

Afterwards at the Cimetière Monumental, funeral orations are delivered by the director of the Services Agricoles du Département and the president of the Commission de Surveillance des Etablissements Départementaux d'Assistance. Finally M. Vaudour deputizing for the mayor traces the career of Maître Duchamp and praises his competence in administrative matters, his capacity for work, his integrity and independence. In his role as administrator of the hospitals, Maître Duchamp brought "a depth of view and spirit of moderation", he says, "which gave his counsel particular authority."

The coffin is placed in the tomb sheltering the remains of Lucie Duchamp, Lucie's brother Henri Nicolle, her mother Marie Sophie Eugénie Gallet, her grandfather Jean-Baptiste Gallet, and her great-uncle Marie David Stanislas Gallet, both naval men.

1930. Thursday, Villefranche-sur-Mer
After failing to telephone him before leaving Paris, Marcel writes to Jean Crotti to say that he has made a "Joconde" for Louis Aragon similar

to the original that he made in Paris in 1919, belonging to Man Ray. In fact Marcel has made a larger version of *L.H.O.O.Q.* for Aragon, taking a reproduction of Leonardo's *Mona Lisa*, and adding in pencil a moustache, goatee and the *risqué* title pronounced in French: "Elle a chaud au cul" [She has a hot arse].

Aragon is writing the preface to the catalogue of an exhibition of collages at the Galerie Goemans, 49 Rue de Seine; both the replica and the original are to be included in the show. Duchamp will also be represented by *Pharmacie* [4.4.1916], one of the *Obligations pour la Roulette de Monte-Carlo* [1.11.1924], and *Belle Haleine, Eau de Voilette*.

Belle Haleine is a bottle of Rigaut perfume, "un air embaumé," upon which Rrose Sélavy [20.10.1920] has affixed her own label decorated with one of her portraits by Man Ray. Fashioned in New York early in 1921, the object was used to illustrate the cover of Duchamp and Man Ray's *New York Dada* [8.2.1921].

…Et embaume à chaque toilette –
O secret de veille coquette
Sa voile en gaze qui allume
De Rigaut, l'eau qui la parfume…

1950. Monday, New York City
After reading the as yet unpublished text, *Les Machines Célibataires*, which includes a chapter comparing his Bachelor Machine with that of Franz Kafka, Duchamp tells Michel Carrouges: "If I am indebted to Raymond Roussel for making it possible for me, from 1912, to think of something else than retinal painting… I must admit I have not read the Penitentiary, and the metamorphosis only a very few years ago. Just to tell you the circumstantial events which led me to the Bride [5.2.1923]." Saying that he is

"enchanted" with the comparison, Duchamp nevertheless marks his detachment from it.

"My intentions as a painter, which, besides, have nothing to do with the underlying result which, I cannot be conscious of, were directed towards problems of an 'aesthetic validity' obtained principally in the abandon of visual phenomena, as much from the retinal rapport point of view as from the anecdotal point of view."

As for "the introduction of a basic theme explaining or provoking certain 'gestures' of the Bride and the Bachelors", Duchamp denies that they ever crossed his mind. "But it is possible that my ancestors made me 'speak', like them, of what my grandsons will also say."

1955. Sunday, at sea
After a dose of penicillin administered by the ship's doctor, Marcel's slight fever caused by a heavy cold has abated and he is feeling better. "What good memories we are leaving behind us," writes Marcel to Roché, "and you are the ones responsible!!"

1959. Friday, New York City
"We have received and read your brilliant prose: 'Max stripped bare for 50 years'," writes Marcel to Patrick Waldberg. "The book [28.1.1959] is, I believe, everything that you hoped for, total success." He asks Waldberg if there will be an English translation and mentions the difficulties in this respect with Fawcus and Robert Lebel's book. Enclosing the *New York Times* obituary on W. Hoppe, Marcel comments: "I remember having seen him play around 1925."

1961. Monday, New York City
The Duchamps attend the private view of "Paintings from the Arensberg and Gallatin

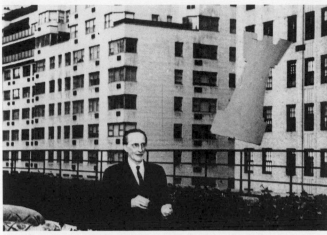

7.2.1966

Collections of the Philadelphia Museum of Art" at the Solomon R. Guggenheim Museum and are invited to dine with Mr Harry F. Guggenheim afterwards.

1965. Saturday, New York City
Duchamp is the subject of a lengthy profile entitled "Not seen and/or less seen" by Calvin Tomkins in the *New Yorker*.

7 February

1917. Wednesday, New York City
In the evening Marcel has dinner with Beatrice Wood and Joseph Stella.

1924. Thursday, Paris
At his residence in Avenue du Bois, Jacques Doucet has invited Duchamp to lunch with Henri Pierre Roché and Louis Aragon. One of their subjects of conversation is *La Bohémienne endormie*, a most astonishing painting by the Douanier Rousseau, previously in the collection of the critic Louis Vauxcelles, and which is now at Kahnweiler's. Busy trying to persuade John Quinn to buy it and sending him cables to New York everyday, does Roché think that an opinion by Doucet might convince the American of the importance of the canvas? Doucet agrees to go and see it. Only the previous day, Roché tells his companions, Brancusi was fascinated by this picture of a lion standing over a sleeping woman. When it was first exhibited in 1897, a notice on the frame read: "Although ferocious, this feline hesitates to spring on its prey which, worn-out with fatigue, has fallen into a deep sleep."

Duchamp is looking handsome, notes Roché, who has not seen him for months [20.7.1923]; "His smile is at once ironic and kind, and impartial."

1934. Wednesday, Paris
In the morning at eleven, the day after violent clashes between the police and demonstrators at the Place de la Concorde, in which sixteen people died, Marcel meets Roché for an hour.

The Place Denfert-Rochereau is the scene of further demonstrations with clashes between masses of students, fascists and police. Madame Langlois, the elderly widow of a well-

known professor of physiology, while on her way to Rue Hallé to play bridge with General Filloneau, Mary Reynolds and Duchamp, is warned by a gendarme not to leave the pavement. "I walk where I choose," she replies firmly, and calmly crosses the road.

1948. Saturday, New York City
Sends a cable to Robert Lebel at the Berkshire Hotel agreeing to meet him on Monday.

1954. Sunday, New York City
Writing to Fiske Kimball, whom he saw recently in New York [22.1.1954], Marcel says: "I never expected [Walter Arensberg] to die of a heart attack [29.1.1954], and yet it is the weapon I would choose if I were asked." Grieved that Arensberg did not live to see their remakable collection of twentieth-cantury art installed at Philadelphia, Marcel insists: "we must listen to him *dead* or *alive*."

Stating quite clearly that he doesn't like the "Modern Museum" idea, which suggests "a dissociation of the two Institutions on the same location", Marcel asks Kimball why he doesn't have three separate openings: the Gallatin Collection in the spring, the Arensberg Collection in October, and the Modern Museum later.

1960. Sunday, New York City
Cables Marceau announcing the time of his arrival in Philadelphia on Monday.

1966. Monday, New York City
A star-studded list of more than forty artists have agreed to participate in "Hommage à Caïs-

sa", an exhibition held at Cordier & Ekstrom for the benefit of the Marcel Duchamp Fund

[18.5.1961] of the American Chess Foundation. In gratitude for the donations, Duchamp gives each artist a copy of *Les Joueurs d'Echecs* [11.5.1965], an etching he made specially in Paris at Stanley Hayter's studio.

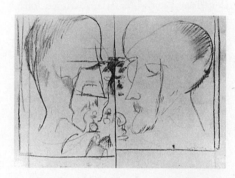

On the roof of 978 Madison Avenue above the gallery, David Hare has devised an airborn sculpture of chesspieces and balloons which, to the surprise of the guests, explode one by one. Among the works of art exhibited in the gallery

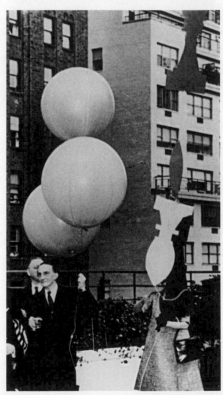

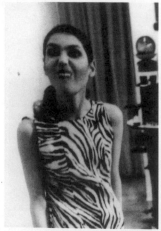

7.2.1966

itself are the beautiful chess sets made by Max Ernst and Man Ray, and one by Salvador Dali in which fingers have become the chessmen. At the opening Duchamp plays chess with Dali.

While Niki Ekstrom has invited top model Benedetta Barzini, who is wearing a long, sleeveless, tiger-patterned dress, Andy Warhol has brought Velvet Underground to the opening.

"Andy's coming to this show was like a guerrilla attack," comments Nat Finkelstein, who was at the gallery to take photographs while Warhol filmed Duchamp. "So these people who were with Duchamp *acted* like defenders, who made sure that none of us would run over and bite him in the ankle…" Marcel let Warhol "arrange" him here and there with an amused smile.

8 February

1921. Tuesday, New York City
For the Dada publications that he and Man Ray have sold in New York, Duchamp sends Picabia a cheque made out in his name this time. Insisting that the first one was not a joke, Duchamp says: "I simply forgot to look at it before sending it to you."

After a paragraph to Germaine Everling saying that he cannot be in Paris before June, Duchamp has a message for Tristan Tzara: the "authorization" which Tzara sent for publication in *New York Dada* (being prepared with Bessie Breuer and Man Ray) will be translated so that everybody can "understand".

Duchamp then declares that his ambition is to be a professional or "*anti* fesses Lionel" chess player. Adding a postscript for Picabia he proposes a translation for the "inscription" in *Jésus-Christ Rastaquouère*:

Les cirages les plus lymphatiques
Jonchent ceux: conne, colle et pâte.

1953. Sunday, New York City
Pursuing the project for *Flair* magazine [4.2.1953], Marcel replies by return to a letter from André Breton about the choice of the size of the plates. It is for Breton anyway to decide, but Marcel wonders nevertheless whether it would be

possible to include some very small black-and-white reproductions of "forgotten" names.

*

Henri-Martin Barzun [31.1.1953] is due to call at 210 West 14th Street at seven o'clock.

1957. Friday, Sèvres
Inspired by reading *Toutes les femmes sont fatales* by Claude Mauriac, Roché writes in his diary: "The subject is thrilling. It's mine; it's about the mystery of sex and orgasm… It makes me think about the book, probably my last, that I will perhaps still write, either on M or Totor and me… I start the ball rolling and begin writing straight off the first page of my novel 'Victor' (provisional title) – or, Victor and François…"

1960. Monday, New York City
"I feel very honoured by the news of my election as a member of the Department of Art in the National Institute of Arts and Letters [2.2.1960]," writes Duchamp to the president, Glenway Westcott, thanking him for the insignia and the yearbook of the institute.

*

Teeny and Marcel take the train for Philadelphia which leaves New York at a quarter to twelve.

1961. Wednesday, New York City
Giving Kay Boyle his consent to whatever she decides regarding the missing drawing [21.1.1961], Marcel adds enigmatically: "Make mine mink."

1966. Tuesday, New York City
"This is not a letter – only to ask you to put in the post airmail to our address, a tube (or 2 if necessary) containing in all 3 numbered copies and 2 artist's proofs of the chess engraving [11.5.1965]," writes Marcel to Jackie Monnier in Paris. "You will find the packet of prints in the 2nd drawer (starting from the top) of the print cabinet in the studio," he continues with precision, explaining that the tubes are on the balcony of the apartment at 5 Rue Parmentier. "Teeny will write to you soon. Thanks if you can do it quickly… Great success of the chess opening [7.2.1966]. Affectionately to you both from both of us Marcel."

1967. Wednesday, New York City
The Hares and the Wusts are guests for dinner at 28 West 10th Street.

9 February

1926. Tuesday, Paris
At Marcel's suggestion, he and Mary Reynolds have lunch with Roché at Couteau's [12.2.1924] after meeting at twelve-thirty for an apéritif at the Petit Buffalo at 132 Avenue d'Orléans. Mary is curious to find out from Roché whether Nancy Cunard has bought anything. Roché regrets having left Helen Hessel behind at Arago, but suspects that Mary would be afraid of his German friend.

1927. Wednesday, New York City
In the evening at the first session of the public auction of the John Quinn Collection which is conducted by Mr D. Bernet and Mr H. H. Parke at the American Art Galleries on Madison Avenue at 56th Street, item no. 51, *Peau brune* [19.1.1915], is sold to Alfred Stieglitz.

1937. Tuesday, Paris
"Bombshell all right," replies Dee to Miss Dreier's decision to publicize the withdrawal of her loans from Alfred Barr's exhibition [19.1.1937]. Saying that he finds her statement clarified the situation for the public, Dee thinks that it will make the public "more conscious of the importance of what is going on".

Even though Miss Dreier asked him to follow her example, Man Ray has decided not to give more "unnecessary publicity" to the Museum of Modern Art. "The thing criticized always profits by any criticism," comments Dee. "As long as you made it a clear statement it is perfect. If it becomes a fight there should be a winner," he argues. "And the win has no more to do with right or wrong – it is a gamble." Asking Miss Dreier to keep his letter private, Dee advises her: "And now get ready for your trip."

1948. Monday, New York City
At one o'clock Duchamp is due to meet Robert Lebel at the Berkshire Hotel, 21 East 52nd Street.

1951. Friday, New York City
The Arensbergs are delighted to have the opportunity of purchasing the portrait of Dr Dumouchel, [28.1.1951] and Marcel replies: "I

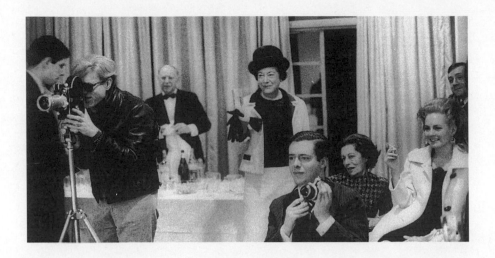

am very glad because it is again a painting which expresses some of my new intentions at the time." As Dumouchel lives in Nice during the winter and the painting is at Saint-Cyr-sur-Loire, Marcel promises to enquire whether Lefebvre-Foinet can organize transport now or whether they will have to wait until the end of March when Dumouchel returns to Saint-Cyr. In any case Marcel would prefer the shipment to go directly to Hollywood: "I am sure the canvas needs the good care of Miss Adler," he writes, "and also I would like you to live with it."

Replying to their question about the colour photograph [24.6.1950] of *Jeune Homme triste dans un Train* [17.2.1913], Marcel confirms that he ordered it in September before leaving for Paris: "Since that, nothing happened!" He promises to write to the photographer again.

*

To Dr Dumouchel, Duchamp reports that he is "rather thin – prostate the same as twenty years ago", but tells his old friend, "I suffer no more no less from it [11.9.1929]." As for his recent visit to France [26.11.1950], Duchamp says: "What I saw of Paris convinced me to return here where I live like a false hermit; delighted, moreover, by the little sides of life, to breathe, to be warm, etc. I have become a great lover of milk [15.7.1920] which, in my opinion, has been my saving for the eight years that I have been here."

Regarding the painting which Dumouchel has agreed to sell to the Arensbergs, Duchamp writes: "I don't remember if I told you that the Arensberg Collection has been given to the Philadelphia Museum [27.12.1950] – so it's there where we will repose together, as far as the subject of immortality is concerned."

1953. Monday, New York City
At the recent opening of the Guggenheim Museum, *Adam et Eve* by Brancusi (which has been acquired for the collection [5.12.1952]) was "in the place of honour", Marcel tells Roché. "The whole arranged by Sweeney," he considers, "is very alive and is not museum (even modern)."

1955. Tuesday, New York City
After a rough crossing from Cherbourg [3.2.1955] on the *Queen Mary*, the Duchamps arrive back in New York.

1965. Tuesday, New York City
"Thank you for the book, which I read with delight (and pride)," writes Marcel to Robert

Lebel, referring to *La Double Vue* [10.12.1964].

Concerning Lebel's request on behalf of Alexandre Iolas, who would like to organize Duchamp's first one-man show in Paris, Marcel replies: "Nothing doing," and goes on to explain that although the Museum of Modern Art might participate, Philadelphia will not lend to a gallery outside America. "But the worst is that the *whole* Ekstrom exhibition [13.1.1965] (the catalogue of which you have [26.1.1965]) is now the property of Mary Sisler, a newcomer among the brood of collectors." Adding (with slight exaggeration) that there is not a single piece which belonged to either Gustave Candel or Henri Pierre Roché left in France, Marcel says that the show will now be touring [24.1.1965]: "A real merry-go-round."

10 February

1923. Monday, New York City
Having decided to abandon living in New York and having arranged for the Large Glass [5.2.1923] to be delivered to its new owner, Miss Dreier, Duchamp embarks on the *Noordam*, a ship of the Holland-America Line, sailing for Rotterdam.

Before departure, he writes a card of the ship addressing it to "Stettheimers III", with the Chekhov-inspired message: "Au revoir Cherry Orchard and mother," and signs it Rrose. [The card is postmarked two days later.]

1927. Thursday, New York City
On the second day of the Quinn sale, during the second session at two-fifteen in the afternoon, Duchamp purchases item no.159 entitled *Nude Study*, an ink drawing by Pablo Picasso.

At the third session that evening at eight-fifteen Duchamp purchases item no.283 *Study of a Man*, a wash drawing attributed to Picasso; it

is described as a: "Bust… with arms folded, the head modelled in a Cubistic manner and vigorously outlined."

1934. Saturday, Paris
Totor has an appointment with Roché in the morning at between eleven-thirty and a quarter to twelve.

1946. Sunday, New York City
"I found the sweater of my dreams," writes Duchamp delightedly to Mary Dreier. "Fine hairy wool, navy blue, very warm … May the sunshine be with you every day of this ending winter."

*

Duchamp attends a meeting of the officers of the Société Anonyme at 100 West 55th Street chaired by Miss Dreier. The nominations proposed on 10 December last to appoint Man Ray as first vice-president and Heinrich Campendonk as second vice-president, replacing Wassily Kandinsky, who died in December 1944, are accepted unanimously. In addition to other business, it was decided to invite Miss Rose Fried and Miss Eleanor Williams to serve on the board.

1950. Friday, Paris
Published in the catalogue of Hans Richter's exhibition opening today at the Galerie des Deux Iles, is the following text (in French) by Duchamp:

"Amateur terminologists, artists, like negroes, are partial to nearly new words.
Hans Richter cinetizes the dynamic but doesn't go so far as to believe that the bottle knows the taste of the wine."

1963. Sunday, Baltimore
Taking the train at eleven in the morning from New York, the Duchamps arrive in Baltimore soon after two o'clock. At Teeny's request Mrs Selma Rosen [7.10.1962] has arranged for a place where Duchamp can have a rest for an hour before giving his talk, "A propos of myself."

The lecture hall at the Baltimore Museum of Art is "jammed" at four o'clock. Teeny comments later that Marcel "really does have an irresistible way of reaching his audience. They seemed to love him."

The Duchamps are persuaded to stay to dinner afterwards before returning to New York.

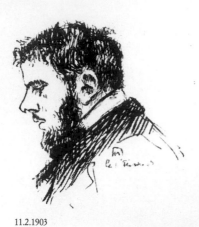

11.2.1903

11.2.1909

1967. Friday, New York City
Following his letter to Dr Turner [29.1.1967], Duchamp receives a favourable response from the Philadelphia Museum agreeing to lend to the show in Rouen as well as the one in Paris.

11 February

1903. Wednesday, Rouen
During classes at the Lycée Corneille [3.10.1902], Duchamp makes an ink drawing of Robert Pinchon's head in profile. In the previous year's class photograph [31.7.1902], Pinchon stands in the second row on the far right.

1909. Thursday, Paris
Le Courrier Français [21.1.1909] publishes a drawing by Duchamp entitled *L'Accident*. The passengers on the top deck of an omnibus peer down into the street where passers-by have gathered to stare at the accident, which is invisible from the artist's viewpoint.

1927. Friday, New York City
On the third day of the Quinn sale, in the afternoon during the fourth session, Duchamp purchases item no.413, *Study of a Woman's Head* by André Derain, a sanguine drawing outlined in black.

1942. Wednesday, Sanary-sur-Mer
On his return from Marseilles, Marcel informs Roché of an important auction to be held at Aix-en-Provence on 24 and 25 February, "where all the dealer tribe (Paris and the coast) will be meeting," which he plans to attend.

So that the miniature urinal is not damaged in transit, Marcel is searching for a small wooden box suitable for packing it in [26.1.1942].

1950. Saturday, Milford
Miss Dreier has requested the printer of the catalogue of the Société Anonyme [8.1.1950] to run off a proof of his own idea for the title page as well as Duchamp's proposal, so that she and Duchamp can study them, together with other proofs, before George Heard Hamilton and Mr Sawyer arrive at three o'clock. She has warned the gentlemen that Duchamp "is in a very severe mood".

1951. Sunday, New York City
Since Marcel left Paris and returned to America [26.11.1950], Roché has continued to help with matters following Mary Reynolds' death [30.9.1950]. Confirming that the shipment of three enormous cases of reproductions for 180 copies of the *Boîte-en-Valise* [7.1.1941] has arrived safely in New York, Marcel thanks Roché for giving him a depository at Sèvres [28.10.1950] and for dealing with Mary's last notes and her correspondence, at least a part of which Roché has returned to the senders.

Marcel agrees to Roché lending his *Rotoreliefs* [30.8.1935] to the bookshop, La Hune.

*

Visits Miss Dreier at Milford.

1961. Saturday, New York City
"I have just had an idea after reading your letter," writes Marcel to Brookes Hubachek concerning *Portrait of the Artist's Father* by Villon [21.1.1961]. "Could you persuade the Art Institute [of Chicago] to exchange a painting (by Villon or by another painter) for the portrait of my father?" Although the Duchamps had dinner with Harry Guggenheim on Monday and became "acquainted", there was no opportunity to raise the question of the Villon with him.

1962. Sunday, New York City
To Marc Le Bot, who is writing a book on Francis Picabia, Duchamp writes: "The very varied group that spent Sunday afternoons at Puteaux was far from being homogeneous except in the domain of friendship. One always forgets that at this time nobody was famous and everything happened in almost juvenile good spirits... Picabia and I already had our opposing attitude to the idea even of a valid theory, knowing how far lips are to the gray matter.

"At the same time the *Nu descendant un Escalier* [18.3.1912] made in January 1912 is quite a different Cubist interpretation from *Procession à Séville* made a few months later, because we had no intention of settling into a common technical formula. The proof is in the pictures of 1913, where there again there is little fraternal technique between the two of us."

1963. Monday, New York City
In the morning Duchamp receives a telephone call from Shusaku Arakawa, who has already corresponded with him and who has just arrived

in New York. Duchamp proposes to meet the artist at one o'clock by the chess tables in Washington Square. After chatting a while in the open air, they walk to 14th Street and have a fifty-five cent meal of spaghetti together.

*

On the advice of André Breton, Jane Graverol (another newcomer to New York) has written to Duchamp. After telephoning Maurice Bonnefoy, who agrees to look at her work, Duchamp replies suggesting that she should also contact Colette Roberts, a French journalist who has a gallery called The Grand Central Moderns. Mentioning *Texticules* by Raymond Queneau, which arrived safely about a month ago, Duchamp tells Jane Graverol: "I find it really *plus-que-parfait*."

1966. Friday, Lyons
In the catalogue of the exhibition "U.S.A. Nouvelle Peinture", which opens at the Musée des Beaux-Arts, Robert Lebel comments that as "no artist has been less of a prophet in his country" than Duchamp, typically it is Lyons which shows the first interest in his work and not his native Normandy. Since the rejection of *Nu descendant un Escalier* [18.3.1912], "Marcel Duchamp has found only small groups in France to understand and defend him: first Dada, then the Surrealists," writes Lebel. "The official circles have snubbed him and continue to snub him since the Musée National d'Art Moderne owns only a small sketch by him, whereas much more important works were still available recently in Paris, before being acquired by the Americans [9.2.1965]."

1967. Saturday, New York City
While announcing the good news, which arrived from Philadelphia the day before, Duchamp also has to break some bad news to Mlle Popovitch concerning the Sisler collection [21.1.1967]: "Nothing doing. Today I saw the curator of the collection, who was full of apologies for the delay and he explained to me that the whole collection is already on its way to Australia, New Zealand, Tokyo, etc. In short, unwillingness mixed with indifference on the part of Mrs Sisler."

Duchamp encloses a black-and-white photograph of a dry-point by Villon dated 1904, *Marcel et Suzanne jouant aux échecs*, which he proposes should be used to illustrate the back cover of the catalogue.

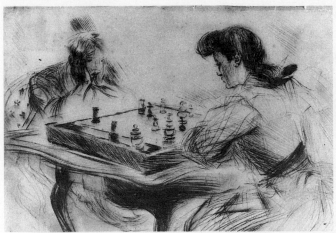

11.2.1967

12 February

1918. Tuesday, New York City
Roché calls on Marcel and finds he has company: Joseph Stella and Mad Turban, who now has a room of her own at 28 West 63rd Street. After living more than a month with Marcel [24.12.1917], Mad's alarming experience one night when Isadora Duncan, very drunk, made a dreadful scene at 33 West 67th Street, was decisive. Mad was also aware of being the cause of Yvonne Chastel's distress [8.1.1918].

1924. Tuesday, Paris
Calling for Marcel at the Hôtel Istria, Roché visits the "neat" little room [7.12.1923] where Marcel, so he says, works on his chess each night from midnight until four in the morning.

They have lunch at Couteau's, 32 Avenue d'Orléans near Denfert-Rochereau, and afterwards go to Arago. Discussing the re-framing of *9 Moules Mâlic* [19.1.1915], Marcel suggests using metal, the material used for the recent framing [27.12.1923] of the glass *Glissière contenant un Moulin à Eau en Métaux voisins* [11.12.1919].

1927. Saturday, New York City
In response to Brancusi's cable asking him to protest energetically against the decision of the customs, Marcel assures the sculptor that the matter is in the hands of Speiser [26.1.1927].

To reduce the return transport to only seven or eight crates, Marcel has arranged for *Maïastra* and the *Pingouins* to be put into storage; Brummer will keep *Torse de jeune fille* for which he has a buyer; *Mlle Pogany* is being sent to Buffalo at the request of Mr Hekking; although Mrs Rumsey categorically refused to purchase *La Colonne sans fin*, it can stay in Rumsey's studio; as for the various bases made by Brancusi, a wooden one and a white, cross-shaped stone have been left with Steichen for his Bird, the other big base has gone to Mr Levy.

Confirming that the crates will accompany him on the *Paris* leaving on 26 February and that he will bring the photographs, Marcel repeats his advice [27.1.1927] to Brancusi which is not to send the bird to Mrs Rumsey

until he gets back: "That's wiser," he writes, "and she is not in a hurry."

1930. Wednesday, Nice
From Villefranche [6.2.1930] (where he has been staying with Mary Reynolds?), Duchamp travels the short distance along the coast to Nice, where the International Chess Congress opens today. One of the present joint-holders of the Coupe Philidor (with Halberstadt and O'Hanlon [2.2.1928]), Duchamp is facing eleven very strong players in the tournament, organized this year by the Cercle de Nice at the Palais de la Méditérranée on the Promenade des Anglais.

1952. Tuesday, New York City
Accepting Fiske Kimball's invitation to look at the distribution of the Arensberg Collection on the working drawings for the galleries [4.2.1952], Duchamp proposes going to Philadelphia on 18 February.

*

After reading all her letters and manuscripts, Marcel finally posts a letter to Helen Freeman Corle [13.9.1950]. "I am definitively convinced," he writes, "that I have nothing to do with all that: paintings and your thoughts evoked by these paintings." Stating that "the linear flow of time (1912–1952) is not a justification for the identicity of MD 1912 with MD 1952," Marcel says: "on the contrary I believe that there is constant dissociation." He explains that without any "interior echo" guiding him, he read the text as if he was a stranger to these things. "You yourself wrote these words without intention of meaning, syntax, explanation – compared with language your words are rather like the aroma of a dish compared to its taste."

1959. Thursday, New York City
"This hope by pipette is very titillating," writes Duchamp to Robert Lebel as the "de luxe" version of the monograph is slowly nearing completion. "I still don't understand why it is impossible to varnish the wretched label (Eau et Gaz), having tried myself," he complains. "But so as not to delay any further, I prefer 'to give up and in'."

Hoping that Lebel will make his visit to New York coincide with the opening at the Sidney Janis Gallery on 6 April, Duchamp says he is still worried about the chances of an English

edition of the book. Concerning the exhibition at La Hune in Paris at the beginning of May, he is all for "esotery", i.e., just reproductions and no original paintings.

Duchamp concludes by mentioning that he has received the book on Max Ernst, "winning the race," and comments that Patrick Waldberg [6.2.1959] "has really laid a lion's egg."

1962. Monday, New York City
Teeny and Marcel fly to Florida for ten days. Until 16 February they will be the guests of Jeanne and Isadore Levin [15.1.1962], who live at 316 Garden Road, Palm Beach, "a most attractive house with a beautiful garden and swimming pool."

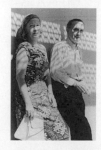

Marcel's only request of his hosts is to provide him a copy of the *New York Times* at eight o'clock every morning so that he can study the day's chess game with his breakfast coffee.

1966. Saturday, New York City
At the request of Richard Hamilton, who is making a replica of the Large Glass [5.2.1923] for the exhibition at the Tate Gallery, Marcel measures the length of the longest Capillary Tube on his small glass, *9 Moules Mâlic* [19.1.1915]. Making a small diagram, Marcel confirms to Richard the measurement is exactly 33 and fifteen sixteenths of an inch, or almost 34 inches.

1968. Monday, New York City
Since Richard Hamilton is due to come to New York sometime in March, Marcel proposes they decide then when he signs "the new babies". Following the edition made of the *Oculist Witnesses* [10.11.1967], Richard and Marcel are preparing an edition of the Sieves also on glass. Possible dates for a visit to London would be either "first stop" on their way to Monte Carlo or later in April from Paris, Marcel suggests.

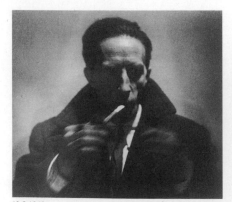

13.2.1948

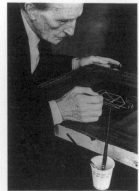

14.2.1967

13 February

1926. Saturday, Paris
"I receive your letter this morning, I reply at midday," writes Marcel to Brancusi, who is in New York for exhibitions at the Wildenstein Galleries after a "dreadful" sea voyage. Marcel says he will telephone Roché and ask him to cable Jeanne Foster's address as requested. In the sculptor's absence, Marcel is attending to the mail at 8 Impasse Ronsin and has paid the rates. "Don't worry about anything in Paris," Marcel assures him, "Stay as long as you like and sell a lot."

1930. Thursday, Nice
In the first round of the International Tournament, Duchamp plays well enough against B. Kostich to be assured of a draw until his thirty-second move, when he misses a continuation, gets himself into trouble, and is forced to resign.

1948. Friday, New York City
In his report prepared for the Museum of Modern Art as holder of a fellowship [1.3.1947], Duchamp describes the part he played in helping to organize "Surréalisme en 1947" [7.7.1947] and adds: "I have spent the winter months doing my creative work in painting and drawing."

His plans for the forthcoming year are "to compose the script" of a film by Hans Richter on different periods and aspects of modern art, and assist with organizing an exhibition of his own and his two brothers' work at the Museum of Modern Art.

1967. Monday, New York City
Monique Fong calls to see Duchamp concerning the essay by Octavio Paz [19.1.1967].

14 February

1927. Monday, New York City
Having been introduced by Alfred Stieglitz, Duchamp is due to meet Mrs Wertheim, who is interested in buying a Brancusi sculpture.

1930. Friday, Nice
In the second round of the International Tournament, Duchamp wins his game against A.J. Maas [23.3.1924], a member of the club at Hyères, who donated the Coupe Philidor in 1925.

1943. Sunday, New York City
At three-thirty in the afternoon Marcel has a late lunch with the Kieslers at 56 Seventh Avenue.

1953. Saturday, New York City
Forwards to Roché a receipt of payment for five pictures purchased by Mary Batsell.

1954. Sunday, New York City
Expressing his condolences to Fiske Kimball, whose father has died, Marcel comments: "We are entering the season of our life when the leaves begin to fall rapidly around us."

He thanks Fiske for the "good news" of progress in the work for the Arensberg Collection. Unable to furnish Fiske with the information he needs on Walter Arensberg for his foreword to the catalogue of the collection, Marcel gives a separate list of Arensberg's close friends. Saying that Walter never gave him anything about Dada, Marcel suggests that Fiske consult the volume *Dada Painters and Poets* edited by Robert Motherwell, and he encloses a copy of *391* [no. VII?] in which a *poëme en prose* by Walter is published.

1962. Wednesday, Palm Beach
At noon Duchamp receives the local Press at the home of the Levins where he and Teeny are staying; in the evening he delivers his lecture, "Of or by Marcel Duchamp," illustrated with colour slides, to members of the Palm Beach Institute of Art at the Norton Gallery.

1964. Friday, New York City
Writes to Louis Carré asking about the situation with Jean Crotti's bequest to the Musée d'Art Moderne de la Ville de Paris and encloses a catalogue of "Jacques Villon, Master Printmaker", a large exhibition held at the Seiferheld Gallery.

1967. Tuesday, New York City
At five in the afternoon an exhibition at Cordier & Ekstrom, 978 Madison Avenue, celebrates the publication of a further collection of 79 fac-

simile notes by Duchamp dating from 1912 to 1920, presented in a Plexiglas box and entitled *A l'Infinitif*.

Also known as the White Box, inside its transparent lid is a silkscreen print on vinyl of the *Glissière contenant un Moulin à Eau en Métaux voisins* [11.12.1919].

As opposed to the Green Box [16.10.1934] which relates mainly to the Large Glass [5.2.1923] the notes in the White Box are on various subjects which Duchamp has grouped as follows: Speculations, Dictionaries and Atlases, Colour, Further References to the Glass, Appearance and Apparition, Perspective, and finally The Continuum.

In the folder labelled Speculations, one of the notes is written on the back of a small publicity card from Hershey, "The Chocolate Town" (situated between Harrisburg and Lebanon in Pennsylvania), home of the Hershey Chocolate Company.

With Duchamp's collaboration, the young painter Cleve Gray [28.6.1965] has translated the notes into English.

15.2..1913

15.2.1963

15 February

1913. Saturday, Rouen
On the day of the marriage of Ferdinand Tribout's younger sister Odette-Jeanne to Marcel Lebailly, Duchamp inscribes an ink drawing to the bride: framed in a triangular mount, it is the sketch for the male figure in *Vous êtes juif?* [9.4.1910], the cartoon published in *Le Témoin* three years ago.

1922. Wednesday, New York City
On his return to New York [28.1.1922] Marcel has settled again at the Lincoln Arcade Building [15.7.1920] and occupies room 312. He still has some work with lead wire to do on the Large Glass.
 "No I have really no wish to open horizons," writes Marcel firmly to Roché, in answer to his friend's proposal for earning money by making a reproduction of one of his works. Marcel says that he doesn't want the nuisance of showing it publicly. "I am sick of being a painter or filmmaker. The only thing which could interest me now is a position which made me play chess *divinely*. That would excite me."

1927. Tuesday, New York City
Following their discussions in Chicago, Duchamp writes to the critic, C. J. Bulliet [11.1.1927], enclosing the photographs of two enormous pictures that are for sale in Europe: *Visite de Dionysos et sa suite à un Mortel* by Ribera, the composition of which is inspired by a bas-relief in Naples; and *Venus pleurant la mort d'Adonis* by Rubens.
 The third painting, a portrait painted in 1910 or 1911 by Picasso, which his brother-in-law Jean Crotti wants to sell, Duchamp says is: "one of the most beautiful Picassos I have ever seen."
 If the matter is to be taken further, Duchamp suggests that Bulliet contact Walter Pach, who spoke to the director of the Art Institute Mr Harshe when he was in Chicago [11.1.1927], and knows about the first two paintings. Pach is better place to act between the parties, and "can do the European end of the business", Duchamp advises.

1928. Wednesday, Nice
Duchamp to Alice Roullier enclosing a letter from Suzanne Crotti to Mrs Herbert Bradley in Chicago, which he asks her to forward. "Happy too to say hello and to announce, if you haven't heard already, my divorce since 25 January." Expecting to see her again in Paris [23.7.1927] soon: "All my good wishes to Chicago," writes Duchamp, "don't forget [C]atherine Dudley [3.6.1922] and fondest wishes to you…"

1930. Saturday, Nice
Playing against J. Araiza in the third round of the International Tournament, Duchamp makes "an unbelievable blunder" at the twenty-eighth move and "loses the results of his fine play". His opponent seizes the opportunity to force a draw.

1934. Thursday, Paris
Duchamp had already returned from America [27.1.1934] when the letter from Youki Desnos arrived asking for assistance to retrieve pictures from the dealer Paul Reinhardt. Unless she has already done so, Duchamp recommends Youki to enquire at the American Embassy. "It is possible that the sight of a paper forwarded by the Embassy would be enough to put the wind up Reinhardt," he says, "Come and see me one day with Desnos at the beginning of the afternoon, I am usually at home, or write in advance."

1947. Saturday, New York City
When Marcel takes Suzanne and Jean Crotti to Milford to see Miss Dreier, they have an "eventful train trip". Instead of the usual hour and a half, the journey takes six hours…

1957. Friday, New York City
Teeny flies to Paris for a fortnight to be with her daughter Jackie at the birth of her first child.

1958. Saturday, Cambridge
On their way to Amherst in Massachusetts, Marcel and Teeny spend the day with Paul Matisse and his wife.

1963. Friday, New York City
Illustrated with one of the fine portrait photographs of Duchamp by Alexander Liberman, *Vogue* publishes an interview just prior to the 50th anniversary of the Armory Show [17.2.1913] entitled "What's happened to Art?" by William Seitz, curator at the Museum of Modern Art and director of "The Art of Assemblage" exhibition [2.10.1961].
 Discussing first the effect of the Armory Show in America, the different attitudes to the *Nu descendant un Escalier* [18.3.1912] in Paris and America, and his own reactions to these events, Duchamp then declares that he has been refining the idea of shocking. "Not only the public but myself," he says, "I've been all my life in that attitude. I never do anything to please myself. None of the few things I have done in my life ever were finished with a feeling of satisfaction."
 Did this have any connection with the decision later not to paint anymore?
 "The decision is more general than that, and it was not a decision in the first place; painting for me was a means to an end but not an end in itself. To be a painter for the sake of being a painter was never the ultimate aim of my life, you see. That's why I tried to go into different forms of activity – purely optical things and kineticism – which has nothing to do with painting.
 "Painting was only a tool. A bridge to take me somewhere else. Where, I don't know. I wouldn't know because it would be so revolutionary in essence that it couldn't be formulated."
 Your kind of revolutionary activity apparently was never political. What adjective would you use to describe it? 'Aesthetic'? 'Philosophical'?
 "No. No. 'Metaphysical' if any. And even that is a dubious term. Anything is dubious. It's pushing the idea of doubt of Descartes, you see, to a much further point than they ever did in the School of Cartesianism: doubt in myself, doubt in everything. In the first place never believing in truth. In the end it comes to doubt 'to be'. No doubt to say 'to be or not to be' – that has nothing to do with it. There won't be any difference between when I'm dead and now, because I won't know it. You see the famous 'to be' is consciousness, and when you sleep you 'are' no more. That's what I mean – a state of sleepingness; because consciousness is a formulation, a very gratuitous formulation of something, but nothing else. And I go further by saying that words such as truth, art, veracity, or anything are stupid in themselves… I mean language is a great enemy, in the first place. The language and thinking of man, if man exists. And even if he doesn't exist."

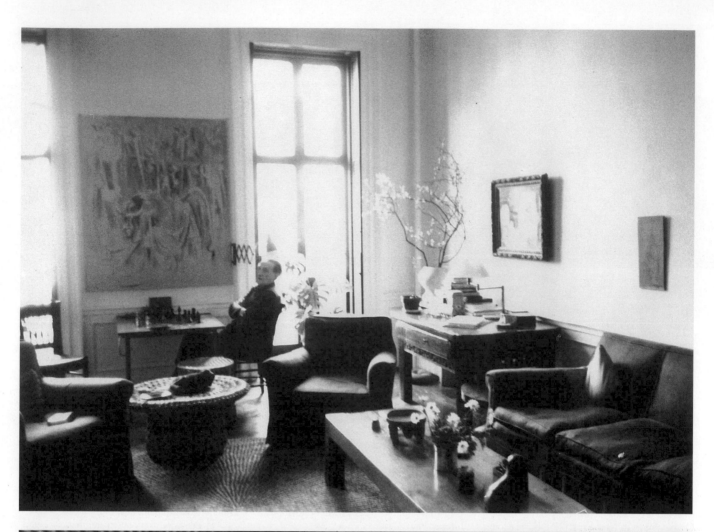

15.2.1963

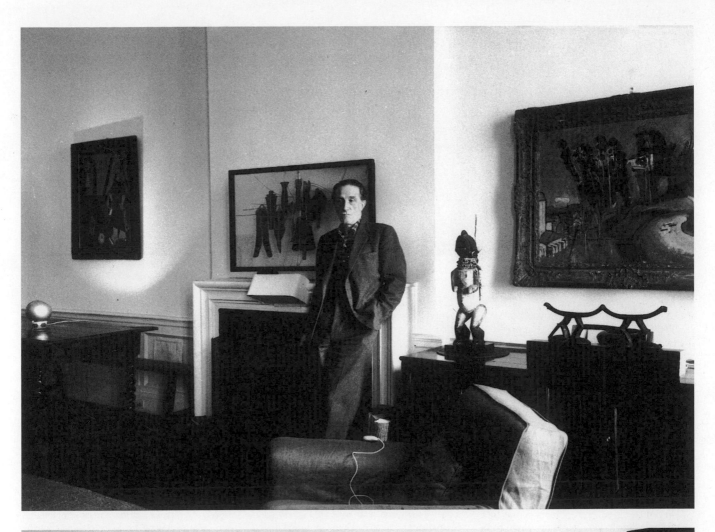

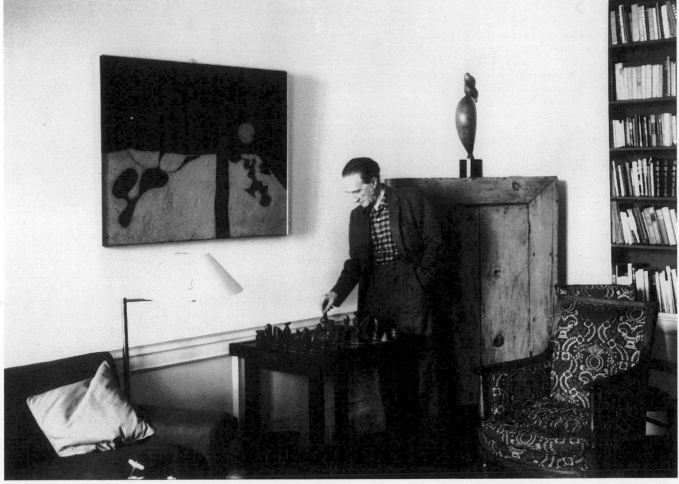

 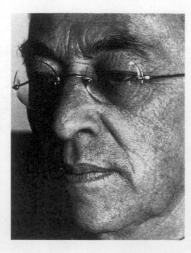 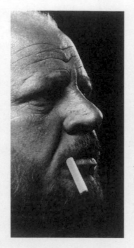

15.2.1963

How would you compare the 'revolutionary' artists of 1963 with those of your youth?

"Well, for one thing, at that time – 1910 – Kandinsky and Kupka produced abstract or 'non-figurative' works; then came the Cubist period, and then a second wind of nonfigurativeness appeared between the two wars. A man a thousand years from now – even two hundred years from now – will see it as much more compact. As one piece. It will be Kandinsky *and* Pollock. Together."

Would you agree that, after the Armory Show, the most important art-historical event in New York was the period after the Second War? It was the first time when the movements from Europe began to be…

"Terminated, yes. But all this comes to a very simple conclusion, you know: there is no art; there are only artists. In other words the school has absolutely no importance. It's only a few names, a few men who are so powerful in themselves that they impose their work. …If you are 'Pop' you're somebody today. But that doesn't mean you're the great artist of tomorrow. In other words it's just like the newspapers appearing every day with the news."

True history of art is the history of individual men?

"Yes, *uniquement*; that's the only thing that counts."

And the young artist in society today?

"But today the integration of art into society forces the artist to submit to its demands. In 1913 the zero – the economic level at which an artist could subsist – was so low that Bohemian life was possible. You didn't have to think every week of having to pay your rent or anything. You didn't pay your rent. Now the zero is too high. You can not afford to be a young man who doesn't do a thing. Who doesn't work? You can't live without working, which is a terrible thing. I remember a book called *The Right to be Lazy*: that right doesn't exist now. You have to work to justify your breathing."

The integration of art: isn't this precisely what modern artists, teachers, dealers, collectors, and museum people have been seeking?

"Oh, yes. It's a marvellous thing from a certain angle. But it has the opposite effect, too, if the mediocritization of the rest results. In other words, there are so many buyers and so many artists that the aesthetic part will become completely nonexistent because it will be completely levelled from the bottom up."

Can you conceive of yourself now as being twenty-six, with the aspirations you had [in 1913]?

"I don't know what I'd do except that I know that there was no money consideration at that time. I didn't expect to make a living. In other words the money question was not included. It didn't exist when I took that painting off the wall in the Independents show.

"The idea was to give up any collaboration with the Cubists. I was a member of the Cubists and I just pulled out of it, rather than integrate myself into Cubism. So that's one form of revolution, or revolt, at least! Today I don't know whether I would have the same considerations. Of course I would hate the mixture of art and money as water in your wine. It's a very good comparison because it dilutes into mediocrity. Water in wine. The bouquet disappears.

"The pitfalls are extremely numerous and hidden for a young man of twenty. How is he to guess that making too much money is a sin? And that doesn't make him an artist either. He could be a great person in himself and be completely annihilated by accepting what society offers him."

Could he be corrupted without knowing it?

"Yes. Artists very often are, because they are not intelligent enough to make sense of the life they live or the society they were born in. I feel there are many geniuses that are lost by that, you see. In other words a genius could very well be corrupted. So he won't be a genius anymore. He'll be lost; he won't come through."

"Another point that I want to bring out is the life and death of a work of art: the short life of a work of art… There are different things; history of art is one thing, very simple: century after century, year after year, movements after movements, et cetera. This is a marvellous classification for man in the world as we are. But if we accept the idea of an aesthetic 'smell' or 'emanation' from a work of art. Suppose we accept it: an aura, almost like a smell; a material transubstantiation. Emanation, right.

"I think that emanation doesn't last more than twenty or thirty years and the work dies. Especially in painting. The time is difficult to estimate: twenty, thirty years more or less. I mean, for example, that my 'Nude' is dead, completely dead. The noise made around it has nothing to do with aesthetic emanation."

What if confronted with [it], a given spectator feels a tremendous emanation – you

couldn't refute this because it's his experience.

"No. But I don't care. It's an illusion that he has. Through the thing he has learned, he is imagining the emanation himself. Physically speaking the smell of the flower is gone. That disappears after twenty years, or when things have happened to it – a hole in it, or something else. A change even in your vision. The 'soul' of the thing is gone. This is purely my own idea, and I don't care if it's true or not, but it helps me make a distinction between aesthetics and art history. That's what happens to a dead man, too. That's why the comparison with life and death is good – it gives the same feeling.

"… I believe in life being the expression of an individual today. Even if in two hundred thousand years we will be a mass conglomeration of souls having to do everything that the other fellow does. I don't care for that society."

And your most powerful interest is not in art, but in great human beings.

"Exactly, that's right."

16 February

1918. Saturday, New York City
In the evening Marcel is invited to Mad's apartment [12.2.1918] for dinner with Joseph Stella and Roché.

1920. Monday, New York City
Duchamp acknowledges John Quinn's payment of $15 for the Japan paper edition of *Huit peintres, deux sculpteurs et un musicien très modernes* [13.12.1919] and confirms that he has already forwarded the cheque to Georges de Zayas in Paris. "I am very pleased with New York again," writes Duchamp who, since his arrival [6.1.1920] has taken the basement of a brownstone building at 246 West 73rd Street. "In spite of the few changes New York is still the same old New York. Paris seemed dull to me during the few months I was in France."

1921. Wednesday, New York City
At eight-thirty in the evening the Société Anonyme holds "A Symposium on the Psychology of Modern Art and Archipenko [1.2.1921]" at 19 East 47th Street. The speakers are Dr Phyllis Ackerman (Professor of Philosophy at

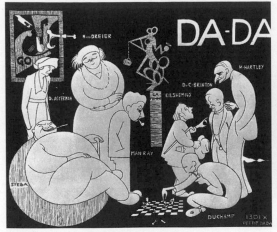

16.2.1921

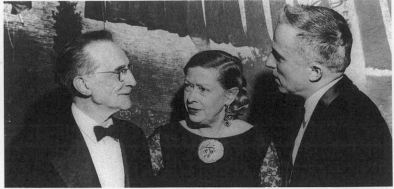

16.2.1963

the University of California), Dr Christian Brinton, Marsden Hartley and Man Ray.

To commemorate the event, Richard Boix draws a composition of the main participants who, in addition to the speakers, are Miss Dreier, Joseph Stella, Eilshemius and Duchamp sitting cross-legged on the floor playing chess and smoking his pipe.

1930. Sunday, Nice
In the fourth round of the International Tournament, Duchamp plays against Tartakover. In notes written after the game, Tartakover comments that "owing to [Duchamp's] good opening play it is only by simplification that one can hope to obtain more than a draw." However, towards the end of this long game, in which he continues his "fine play with a draw well in hand", Duchamp falls into a simple trap and as a result resigns. "Really an unmerited defeat," concludes Tartakover.

1951. Friday, New York City
Duchamp spends the evening with Brookes Hubachek, who has arrived today from Chicago, and Elizabeth Humes, who leaves for Italy the following day.

1958. Sunday, Amherst
On the eve of the 45th anniversary of the most auspicious event in American art history, Duchamp who is accompanied by his wife, visits the Mead Arts Building at Amherst College where Frank A. Trapp has installed his exhibition: "The 1913 Armory Show in Retrospect." In less than a year [27.9.1957] Mr Trapp, who is a member of the Fine Arts Department, has managed to locate and borrow 62 examples of paintings and sculpture shown in the original exhibition, including *Nu descendant un Escalier* [18.3.1912], for which Duchamp has provided a "few words" in the catalogue [10.1.1958].

Arising from a simple proposition made by Professor Kendall Birr to assemble photographs and reproductions of works exhibited in the Armory Show for the American Studies Course, which had decided, for the first time, to turn to the visual arts, and modern art at that, it was soon agreed that to collect a selection of the actual works would be "more exciting". Students will be asked to discuss a group of four contemporary works, shown separately from the main exhibition, "in terms of the heritage of the 1913 originals."

Duchamp spends time with a group of students and during his visit makes himself available to anyone who wants to talk to him. Later he and Teeny return to New York.

1960. Wednesday, New Haven
Duchamp has dinner with George Heard Hamilton, who has been "working like a beaver" on the proofs of the typographic version [28.9.1959] of the Green Box [16.10.1935]. George considers that "they are absolutely magnificent and read like one of the most fascinating texts in science-fiction imaginable". As Duchamp likes to take an early train back to New York, there is not time to go through George's questions, so they agree to meet in New York on Friday.

1962. Friday, Hobe Sound
Leaving the Levins at Palm Beach, Teeny and Marcel go to stay for four days at the home of Diddie and Nick Carter [18.4.1954]: "a dreamy place," describes Teeny to Jackie, "a big beautiful lawn opening down to the river… It's a long narrow island with a magnificent beach all along one side and a river on the other, and sort of jungle forests in between. There is a road going down the middle and from it all one sees are the name signs of the people who own the places. You see no houses and it looks much less inhabited than it is. There is not a hotel or a store in the whole island."

1963. Saturday, Utica
In the evening at the invitation of Edward H. Dwight, director of the Munson-Williams-Proctor Institute, Duchamp is one of the six artists present amongst the 200 guests attending the black-tie preview of the "Armory Show – 50th Anniversary Exhibition", organized by Joseph S. Trovato. More than three hundred works, over a quarter of those in the original exhibition [17.2.1913], have been patiently tracked down and brought to the museum. The walls of the galleries, hung with garlands of laurel leaves, have been repainted to simulate the burlap covered partitions at the 1913 event in New York.

On 5 April the show returns to the original premises: the 69th Regiment Armory on 25th Street and Lexington Avenue.

1964. Sunday, New York City
Having read Richard Hamilton's article "Duchamp", about the Pasadena show

[7.10.1963] in the January issue of *Art International*, "Marcel feels quite transparent now… as some fish are, showing their bones and everything," writes Teeny to Richard.

1965. Tuesday, New York City
Since his visit to New York for Marcel's show at Cordier & Ekstrom [13.1.1965], when the idea of making another replica [5.9.1961] of the Large Glass [5.2.1923] for the forthcoming exhibition at the Tate Gallery was first discussed, Richard Hamilton has been doing some calculations. On 5 February in separate letters to Marcel and the Copleys, who are prepared to commission the replica, Richard states the cost of the year's work on the Glass and proposes to double that figure so that Marcel receives a royalty.

In his reply, Marcel accepts this proposal but insists that Richard take whatever he needs from his royalty in order that the total estimated cost is not exceeded.

17 February

1913. Monday, New York City
In the evening at the 69th Regiment Armory on Lexington and 25th, the Association of American Painters and Sculptors opens its "International Exhibition of Modern Art". The Armory Show, as it is known, has been organized with private funds by a small group of artists with the specific intention of breaking American complacency and apathy to Modern Art.

The atmosphere is festive. The regimental band, playing melodies from *Carmen* from time to time, serenades four thousand visitors in fabulous evening dress, who are massed into the vast, brightly lit hall elegantly partitioned into eighteen octagonal spaces and festooned with swags of greenery.

After a fanfare of trumpets and a few words from the president of the association, Arthur B.

17.2.1913

17.2.1916

Davies, it is the lawyer John Quinn, counsel to the association, and a major lender to the exhibition, who delivers a triumphant speech from the balcony to the attentive crowd below. "This exhibition," he predicts, "will be epoch-making in the history of American art. Tonight will be the red-letter night in the history not only of American but of all Modern Art." Stating that the association believes that "in the domain of art, only the best should rule", Quinn says that the members "felt that it was time the American people had an opportunity to see and judge for themselves concerning the work of the Europeans who are creating a new art".

Francis Picabia, an exhibitor who has travelled with his wife from Paris, is the only artist from Duchamp's circle of friends who is present to witness the event.

A third of the 1,300 works exhibited are from Europe. Crossing the Atlantic the previous September to make the selection, Walt Kuhn visited a number of European capitals and was then joined by Arthur Davies in Paris, where their colleague Walter Pach guided them in a whirlwind tour of the studios, galleries and collectors early in November.

When the Americans visited 7 Rue Lemaître, they chose nine paintings by Jacques Villon and five works by Duchamp-Villon including *Torse d'un Jeune Homme*, a portrait of Duchamp inspired by the young warrior – armless, eagerly striding forward – a fragment of the pediment of Athena's temple, Aegina, which is conserved at the Glyptothek in Munich.

Davies was particularly impressed by the work of the youngest brother and commented: "That's the strongest expression I've seen yet!" In Duchamp's absence (he had just enrolled at the Ecole des Chartes [4.11.1912]) four of his canvases were selected: *Le Roi et la Reine entourés de Nus vites* [9.10.1912]; *Portrait de Joueurs d'Echecs* [15.6.1912]; *Nu descendant un Escalier*, No.2 [18.3.1912] and *Jeune Homme triste dans un Train*.

The latter is a full-length self-portrait (entitled *Nu* in the catalogue) of Duchamp travelling alone on a train from Paris to Rouen; he has identified himself by including his pipe and his cane [13.5.1911], which are quite clearly drawn in the composition based on the relativity of objects in movement.

"First, there's the idea of the movement of the train, and then that of the sad young man

who is in a corridor and who is moving about; thus there are two parallel movements corresponding to each other... It was a formal decomposition," explained Duchamp, "that is, linear elements following each other like parallels and distorting the object. The object is completely stretched out, as if elastic. The lines follow each other in parallels, while changing subtly to form the movement, or the form of the young man in question." Duchamp used the same procedure for *Nu descendant un Escalier*.

The comprehensive presentation at the Armory Show of the European movements including Post-Impressionism, Fauvism and Cubism, creates an exceptionally strong impact on this receptive audience, eager and willing to be initiated in the mysteries of Modern Art. The painting that steals the show, however, and captivates the American public is Duchamp's *Nu descendant un Escalier*.

1916. Thursday, New York City
On the morning of the third anniversary of the Armory Show, following the procedure established with previous readymades [15.1.1916], Duchamp takes an ordinary steel dog-comb and inscribes along the edge of it the following sentence in white paint using small capital letters:
"3 OU 4 GOUTTES DE HAUTEUR N'ONT RIEN À FAIRE AVEC LA SAUVAGERIE" [3 or 4 drops of height have nothing to do with savagery].
Considering it rather like a rendezvous [6.2.1916], Duchamp paints his initials on the lower left end of the comb, dates it, adds very precisely "11 a.m." and entitles it *Peigne* which, as well as meaning "comb" in French, is also an homonym of the subjunctive of the verb *peindre*, to paint.

1918. Sunday, New York City
After a tea with Miss Dreier in her apartment overlooking Central Park and a discussion of Patrick Henry Bruce's paintings which Miss Dreier has recently acquired, Marcel and Roché together with Joseph Stella spend the evening with the Arensbergs. Lou plays Chopin and Debussy on the piano.

1930. Monday, Nice
In the fifth round of the International Tournament, Duchamp wins his game against J.J. O'Hanlon [12.2.1930] after gaining the initiative in the early stages.

1935. Sunday, Paris
Because he particularly liked it, Duchamp regrets that the sale of a picture for André Breton has fallen through, and he doesn't think the price was too high. As they did not manage to make any progress with the "boutique" when they met one evening recently, Duchamp sends a note to Breton advising him that he will be at the *Minotaure* offices at 25 Rue La Boétie, on Wednesday at about five-thirty. Maybe they could meet there?

1937. Wednesday, Paris
Mary Reynolds and Marcel, who is working on the reproduction of the *Broyeuse de Chocolat*, No.2 [8.3.1915], have invited the Rochés to lunch at 14 Rue Hallé but, as his son is unwell, Roché comes on his own. To provide funds to meet the printing costs of his "album" [5.3.1935], Roché agrees to buy Marcel's share of *Deux Pingouins* by Brancusi.

1960. Thursday, New York City
"The general view is already impressive," writes Marcel to Richard Hamilton about the proofs for the book. After his visit to George Heard Hamilton the previous day, Marcel promises to send the "complete corrections" on Saturday. Thanking Richard for the tape of the interview broadcast by the BBC on 13 November which he has listened to at WBAI New York, Marcel asks Richard to enquire from the BBC whether this tape can be broadcast over the WBAI station or whether an "official" copy has to be sent from London.

1963. Sunday, Utica
After attending the preview dinner the previous evening, Duchamp is in demand by the

17.2.1963

Press on the day "The Armory Show – 50th Anniversary Exhibition" opens to the public at the Munson-Williams-Proctor Institute. In addition to the local newspaper reporters, Lyle Bosley interviews Duchamp for WKTV and Dimitri Popescu, editor of the Language Service of the Voice of America, records his comments for a radio broadcast in Europe.

At three-thirty in the afternoon Duchamp has consented to give an illustrated lecture entitled "Recollections of the Armory Show". As the auditorium is already packed thirty minutes before the lecture is due to start, a loudspeaker system and chairs are arranged in the nearby rooms to accommodate the crowds.

"The reaction in 1913 of contempt and caricature is hard today to imagine," declares Duchamp. "The Armory Show followed similar exhibits in Europe although the reaction was mild compared to the megaton explosion in New York. Certainly we are not shocked today. A feeling of reverence with nostalgic overtones will prevail by current aesthetic standards."

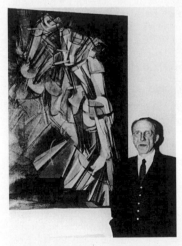

Commenting that it is a *tour de force* to have collected more than 325 of the works that were in the 1913 show, Duchamp adds: "Having heard so much of the Armory Show, all my life, I am thrilled to at last see it, for my Columbus Day was June 15, 1915."

1964. Monday, New York City
On receiving news from the Galerie Menuisement of the success of their Villon exhibition in Rouen [27.11.1963], Duchamp writes: "All these homages, well-merited besides, are a gentle con-

solation and assurance, for us of the family, that posterity will take care of Villon, whom we called 'grandfather' when he was 25 years old. Thank you again, and I hope to have the pleasure of seeing you in Rouen on my next voyage."

1966. Thursday, New York City
"...For two months we have lots of secret things going on," writes Teeny to her daughter Jackie. "The house where Marcel's studio is was sold to the Spanish grocer down the street... so he had but one idea to get out as soon as he could. Today Grosso comes for the last load so the clearing out, packing and moving is almost over. Marcel has worked like a dog since Christmas, squeezing it all in with everything else and I have helped as much as I could. You can imagine after being in the old place for over 24 years [1.10.1943] what it was like and there wasn't one studio there were two! He has taken a tiny place at 80 E[ast] 11 St[reet]. A kind of office building with elevator and service. The man who owns it seems awfully nice and Marcel's name is not on the board so no one knows he is there, which is what he wants. You are again the only person I'm telling because I feel someone in the family besides me should know it. Remember only to all others it's a secret.

"All in all I think it is for the best lately he hated walking so far on very cold days and climbing 4 straight flights up, and now that it is almost over we are both so relieved and pleased. I just hope that it has not tired him too much. He has been absolutely wonderful and worked like a young man and accomplished everything he wanted to do.

"The sky is blue blue and we are beginning to feel Spring in the air...

"PS The *gravures* [8.2.1966] have just arrived!! Marcel says 'Many many thanks to Jackie for her diligence'."

1967. Friday, New York City
Sending Mlle Popovitch the insurance values of Suzanne's paintings, Duchamp says that he forgot to show her a landscape painted by his sister in 1910, a view over the garden of the museum from 71 Rue Jeanne d'Arc with the spire of the cathedral, which he would like included in the exhibition.

"Very important," he underlines in his letter, "I have not received the loan forms." He awaits a signal from her before sending the two paintings from New York to Rouen [20.1.1967].

1968. Saturday, New York City
"I thank you for having put our Gradiva adventure so well into the present," writes Duchamp to Georges Hugnet [11.1.1968], regretting that his "stupid" and "unintentional" use of the conventional "vous" in his last letter was misinterpreted. "One never hears 'tu' in English except in Mr Shakespeare," says Duchamp, "and a kind of contamination infects you and spreads from language to language. I am reviving the door [18.4.1940] in milky Plexiglas this time for an exhibition of doors at Cordier & Ekstrom. I will omit the bellows and the camera."

18 February

1918. Monday, New York City
In the evening Roché calls to see Marcel at 33 West 67th Street. While Roché goes downstairs to see Walter Arensberg, Marcel falls asleep. Later Marcel and Roché dine together before spending the rest of the evening at the Arensbergs'.

1930. Tuesday, Nice
Duchamp has another win in the sixth round of the International Tournament. Znosko-Borowsky finds that Duchamp's opening against the English player Brian Reilly develops in very much the same manner as Dr Alekhine's in the thirty-second game of the Capablanca match.

1947. Tuesday, New York City
Writes belatedly to Mary Dreier to thank her for the Christmas present, which was forwarded to him in Paris by her sister Katherine. "Here I am again," Duchamp says, "happy to be in N.Y. [22.1.1947] where one can set aside the useless worries of all the politically-minded Europeans."

1951. Sunday, New York City
As a director of the Francis Bacon Foundation, Marcel has received from the Arensbergs the minutes of the last two meetings, which he acknowledges.

After calling at An American Place to see Miss Doris Bry, Marcel tells the Arensbergs in his letter that she has "accepted in the name of O'Keeffe" the price offered for a watercolour which interests them.

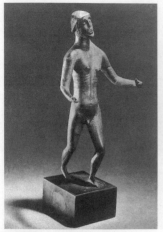
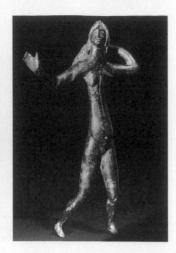

18.2.1955

Regarding the portrait painting, Dumouchel [9.2.1951] would prefer to wait until he returns to Saint-Cyr-sur-Loire to hand over the canvas to Lefebvre-Foinet himself as "he does not trust the neighbours".

1952. Monday, New York City
In the morning Dee writes to Miss Dreier after receiving a telegram from Mary who has gone to Milford to be with her sister. He is anxious to know what the doctor from the medical school said about her condition and promises to telephone Mary if she returns to New York during the week.

"I am hanging the show on Sunday," explains Dee, referring to "Duchamp Frères & Sœur" opening on 25 February, "and if you feel like having me up in Milford before, Saturday would be a good day for me."

*

Travels to Philadelphia to meet Fiske Kimball who has offered to show him the proposed distribution of the Arensberg Collection on the drawings of the galleries [12.2.1952]. The plan is to give "a room to each artist represented by a certain number of works" and to present the outstanding pieces in the large central room, which Duchamp finds "very satisfactory".

1955. Friday, Paris
Opening of "Pérennité de l'Art Gaulois" at the Musée Pédagogique, 29 Rue d'Ulm, which presents coins, medals, bronze and ceramic objects from earliest times, as well as an important modern section organized by André Breton and Charles Estienne. Duchamp is represented by *A propos de jeune Sœur* [8.3.1915], *Rotative Demi-sphère* [8.11.1924] and *9 Moules Mâlic* [19.1.1915] lent by Roché, and *2 Nus: un fort et un vite* [19.8.1912] lent by Edmond Bomsel.

In his essay entitled "Présent des Gaules" written for the catalogue, Breton quotes the passage from the interview published in *Arts et Spectacles* [24.11.1954], in which Duchamp criticizes art which stops at the retina, relegating the reactions of grey matter to a back seat.

Recently appointed photographer to the museum, Jean Suquet [23.11.1950] takes a photograph of *Rotative Demi-sphère* in motion while it is on exhibition.

1957. Monday, New York City
"So Robert and Teeny were punctual for their appointment," writes Marcel to the young par-

ents, Jackie and Bernard Monnier [15.2.1957], whose son was born on Sunday. "The stars have intervened and the event augurs the best future for this youngster determined to be swift – and you two, still flabbergasted, enter this new dimension with joy."

1958. Tuesday, New York City
A letter from Marcel Jean [9.1.1958] announces the dates of his research trip to the United States. "April is perfect for us," replies Duchamp warmly, "and we have recruited promises of lodging from Julian Levy (Bridgewater, Conn.) who will have a lot to tell you about American Surrealism." Supposing that Marcel Jean will have arranged to see Kay Boyle, Duchamp says that he has spoken to Hans Richter, "who has other angles to offer you."

Duchamp points out how close Connecticut is from New York. "I count on you going to Philadelphia too (Arensberg Collection)," he writes, which is also one and a half hours from New York by train. "Washington is a little further, 4 hours (train). Boston too. Chicago is too far (unless the plane amuses you) 3 hours by air." It is the "beginning of a programme", he adds.

1959. Wednesday, New York City
"Many thanks for Parker Tyler's book on Florine Stettheimer, which I read with great interest and find a remarkable account of the life of the proud artist she was," he writes to J. Solomon

1964. Tuesday, New York City
Replies to a long letter from Baruchello, who wonders whether he is blamed in some way for the delay in the publication of *Metro*, with Marcel's drawing for the cover [18.6.1963]. Denying that he ever dreamed of such a thing, Marcel declares "*Metro* is something quite separate from our friendship and our mutual affection... I have the misfortune or good fortune of detaching myself as soon as projects fall through," explains Marcel, "and to forget they have ever been formulated. So I hope to wake up one day with the No.9 on my bed but without ever waiting for that day to arrive."

Marcel agrees that the drawing for the cover of *Metro* can be exhibited at Cordier & Ekstrom next year: "It will be needed," remarks Marcel, "because the majority of the things will be dated from 1910 or even before."

The prospect of their studio in Neuilly and the plans for the summer are much more preoccupying subjects. "Concerning our tour in

Italy," writes Marcel, "we are waiting to see you here to make exact plans... so come quickly."

1968. Sunday, New York City
Thanking him for finding a buyer for the Villon landscape [12.10.1967] and confirming that he has sent Georges Herbiet's address to the purchaser, Mrs Kovler, Marcel asks Brookes Hubachek about his recent trip to Basswood at the coldest time of year: "Did you shoot any polar bears?" he enquires.

"We have been glued to the T.V. for the Winter Olympics in Grenoble," Marcel continues. "Marvellous: enjoyed Peggy Fleming our gold medal and Killy the French ace."

19 February

1930. Wednesday, Nice
At the beginning of the seventh round of the International Tournament which is just past the halfway mark, Duchamp is lying in fifth place with the same number of points as Colle and Seitz. However he loses his game against the Belgian champion, E. Colle.

1935. Tuesday, Paris
Marcel visits Brancusi at 11 Impasse Ronsin, where they are joined by Roché.

1936. Wednesday, Paris
Mary Reynolds and Marcel travel to London.

1939. Sunday, Paris
"Very curious the letter from Poissonnier," remarks Dee to Miss Dreier. "Vaguely heard his name, but I will find out where he got the drawing and how much he wants for it." Not wanting her to spend money unless she cares for the drawing, which is *Vierge*, No.2 [7.8.1912] made in Munich, Dee says: "I will tell you more about it when I have seen the original and the man."

The reproduction of the Large Glass which he is working on "is a terribly long job. Now the black is printed on the Cellophane. It had to dry 2 months before I could attack the colouring problem," explains Dee. "Now I am making a model with the colours, that means I have started five and will go on until I find the

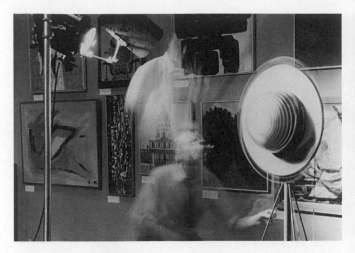
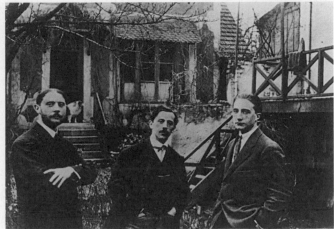

19.2.1957

satisfactory colours." Admitting that he is a "pig" for not having thanked Mr Coates for the photographs [14.7.1938], Dee promises to send him a copy of the reproduction "in progress".

As for the Verlaine manuscript [24.8.1937], Dee says he will try again to sell it.

1944. Saturday, New York City
The exhibition "Color and Space in Modern Art since 1900", which has been organized by Robert Lebel, opens at the Mortimer Brandt Gallery on 57th Street. The *Boîte-en-Valise* [7.1.1941] and two paintings lent by Walter Pach, *La Partie d'Echecs* [1.10.1910] and *Le Passage de la Vierge à la Mariée* [7.8.1912], are shown in one of the spacious rooms of the gallery, which is devoted to the work of the three Duchamp brothers. In another, objects by Isabelle Waldberg are surrounded by several paintings by Matisse, early de Chiricos and drawings by Matta and Miró, In the third, Calder's sculpture is juxtaposed with pictures, including a very large Picasso entitled *L'Atelier*, and canvases by Braque.

1953. Thursday, New York City
Writes to Hélène and Henri Hoppenot enclosing an invitation to a "très cornélienne" event, and says that he will arrange the long-promised lunch with Djuna Barnes.

1957. Tuesday, New York City
Opening two days after it was due to close (the catalogue gives the dates of the show as January 8 to February 17), the "Three Brothers" is finally inaugurated at the Solomon R. Guggenheim Museum, 7 East 72nd Street, at three o'clock. The delay is due to certain rooms not being ready in the temporary museum. The exhibition of paintings and sculpture by Jacques Villon, Raymond Duchamp-Villon and Marcel Duchamp has been organized by James Johnson Sweeney and Duchamp [27.12.1955] with the collaboration of Douglas MacAgy in Houston. The show will now open in Houston on 22 March.

Duchamp has planned and designed the catalogue which has his and Villon's signatures and the ex-libris of Duchamp-Villon on its cover. Chosen for the frontispiece is a photograph of himself, Gaston and Raymond seated in the garden at Puteaux in 1912.

1960. Friday, New York City
As agreed when they met on Wednesday, George Heard Hamilton has a working session in the evening with Duchamp at 28 West 10th Street. Both have gone over every word, each by himself, and now they go over them together, making the final corrections to the proofs of the typographic version in English of the Green Box. George agrees to post the proofs back to Richard Hamilton from New Haven the following day.

1961. Sunday, New York City
As Rose Fried wishes to buy one of the new Valises [29.1.1961], Marcel sends Jackie specific transport instructions for Lefebvre-Foinet

20 February

1923. Tuesday, at sea
As she enters the English Channel, the *Noordam* passes the Lizard, the southernmost point of Great Britain, bringing Duchamp to Europe from New York [10.2.1923].

1930. Thursday, Nice
Having reached sixth place at the beginning of the 8th round of the International Tournament, Duchamp plays against the leader, Sir George A. Thomas, who is ahead of the two Russian players Znosko-Borovsky and Tartakover. Although Duchamp handles his opening very well

and obtains a better game, after a slip Duchamp loses his advantage and later resigns.

1935. Wednesday, Paris
Duchamp plans to go to the *Minotaure* offices at Editions Skira around five-thirty, where he hopes to see André Breton [17.2.1935].

1937. Saturday, Paris
To settle the financial matter agreed at lunch in Rue Hallé on Wednesday, Marcel goes to see Roché at Arago.

1947. Thursday, New York City
Duchamp meets Alfred Barr, who assists him in writing a report on the work he has accomplished during the year from 1 March 1946 as holder of a fellowship granted by the Southern Educational and Charitable Trust. The report, signed by Duchamp, is to be forwarded to Washington with the museum's application.

During the year, states the report, Duchamp was guest director of the Florine Stettheimer exhibition [1.10.1946]; made a trip to Paris [1.5.1946] where he "collected information and documents for the catalogue of a retrospective show" of his paintings to be held at the Museum of Modern Art, and organized an exhibition of Alexander Calder's sculpture at the Galerie Carré [25.10.1946]; he then returned to the United States [22.1.1947] "to select the works of American artists for a large Surrealist exhibition to be held in Paris during the summer months of 1947 [12.1.1947]."

In addition the report indicates Duchamp's plans for the year commencing 1 March. He intends returning to Paris to work with Breton on mounting the Surrealist exhibition, and to study and edit the notes made by James Johnson Sweeney in his conversations with him [21.8.1945].

*

In fact some of Duchamp's conversations with Sweeney have been published recently in the *Bulletin of the Museum of Modern Art*, Volume XIII, no. 4–5, 1946. In an article entitled "The Great Trouble with Art in this Country", Duchamp declares that "there is no spirit of revolt" and he compares the climate among artists in New York 30 years ago with that of today.

"Dada was an extreme protest against the physical side of painting," said Duchamp. "It was a metaphysical attitude. It was intimately and consciously involved with 'literature'. It was a sort of nihilism to which I am still very sympa-

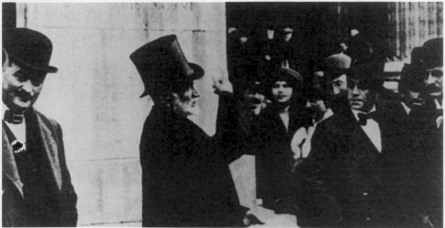

20.2.1957

thetic. It was a way to get out of a state of mind – to avoid being influenced by one's immediate environment, or by the past: to get away from clichés – to get free. The 'blank' force of Dada was very salutary. It told you 'don't forget you are not quite so blank as you think you are!'

"Dada was very serviceable as a purgative. And I think I was thoroughly conscious of this at the time and of a desire to effect a purgation in myself. I recall certain conversations with Picabia along these lines. He had more intelligence than most of our contemporaries. The rest was either for or against Cézanne.

"Brisset and Roussel were the two men in those years whom I admired for their delirium of imagination. [Jean-Pierre] Brisset's work was a philological analysis of language – an analysis worked out by an incredible network of puns. He was a sort of a Douanier Rousseau of philology… Roussel was another great enthusiasm of mine in the early days. The reason I admired him was because he produced something I had never seen. That is the only thing that brings admiration from my innermost being – something completely independent – nothing to do with the great names or influences. Apollinaire first showed Roussel's work to me. It was poetry… It was fundamentally Roussel who was responsible for my glass, *The Bride Stripped Bare by Her Bachelors, Even* [5.2.1923]. From his *Impressions d'Afrique* [10.6.1912] I got the general approach. This play of his, which I saw with Apollinaire, helped me greatly with one side of my expression. I saw at once I could use Roussel as an influence. I felt that as a painter it was much better to be influenced by a writer than by another painter. And Roussel showed me the way. My ideal library would have contained all Roussel's writings – Brisset, perhaps Lautréamont [8.12.1946] and Mallarmé."

1957. Wednesday, New York City
On behalf of Robert Lebel in New York [24.1.1957], Duchamp writes to Henri Marceau asking whether in the papers left by Arensberg he has found two items: firstly, the manuscript dated October 1915, written when he was learning English in New York [19.10.1915], in which the word "the" is replaced with an asterisk [text published in *Rogue* magazine, 1916]; secondly, the *Boîte de 1914* [25.12.1949]. For the monograph, which Duchamp says is about to be published, Lebel would like a photostat of *The*, and a bibliographic description of the Box.

"The show at the Guggenheim [19.2.1957] wonderful," adds Duchamp, "I hope that you will call to see it."

1963. Wednesday, New York City
"I wonder how the exhibition is coming along," Duchamp enquires of Thomas Leavitt, director of the Pasadena Art Museum [12.4.1962]. The photographic facsimile of *9 Moules Mâlic* [19.1.1915], which has been ordered by David Hayes for the retrospective, "is taking shape nicely" but, as it is not clear who is to pay for it, Duchamp requests Leavitt to contact the photographer.

Pointing out that the "revival" of the Armory Show [17.2.1963] doesn't close until 28 April, Duchamp wonders whether Pasadena can receive his three Armory Show paintings in time

to open on 5 May? "The reason I prefer this date," explains Duchamp, "(May 5th instead of May 12th) is because Teeny and I want to leave for Europe as soon as possible and at the same time we would love to take advantage of your nice invitation to go to Pasadena for a few days."

1964. Thursday, New York City
Before leaving for Boston, Marcel posts a letter to Robert Lebel saying that "for more than a month and a half Teeny has been gathering odds and ends old and recent…" and he promises to send them to him very soon.

*

In Boston, Duchamp is the guest of honour at the preview of the exhibition "Jacques Villon, master of graphic art" at the Museum of Fine Arts, which is held from five until seven o'clock in the Print Galleries. Later accompanied by Paul and Sally Matisse, the Duchamps are "champagned and dined".

1965. Saturday, New York City
Writes to Louis Carré giving him the dates of their voyage to Mexico via Houston and a contact address care of Mimi Fogt [18.4.1957].

1968. Tuesday, New York City
For the Museum of Modern Art's Collection Records, Duchamp completes, signs and dates nine questionnaires providing the following information:

3 Stoppages-Etalon [19.5.1914] is the original which belonged to Katherine S. Dreier; Duchamp mentions that he "used the design in *Tu m'* [8.7.1918]" and that the work was his "first use of 'chance' as a medium".

Roue de Bicyclette [15.1.1916] is the replica made for the exhibition "Climax in 20th Century Art, 1913" [2.1.1951], but the inscription in green oil paint on the inner rim of the wheel was not added by Duchamp until the occasion of another exhibition at the Sidney Janis Gallery in 1959. [6.4.1959?]

Paysage, painted in Neuilly in 1911, was given "to a Dr Nagel of New York in payment for medical services" and was later acquired by Miss Dreier. (The landscape resembles the distant background in the top left-hand corner of *Le Paradis* [9.10.1912]).

Stéréoscopie à la Main [4.4.1919] is a drawing on a photograph, or "study of a stereoscopic effect in a handmade drawing", which was sold directly to Katherine S. Dreier.

20.2.1968

A regarder d'un Œil, de près, pendant presque une Heure [4.4.1919] is the study for the Large Glass made in Buenos Aires and also sold directly to Miss Dreier.

Designs for Chessmen are drawings [25.6.1921] which Duchamp believes he made in New York and gave to Miss Dreier; very similar to the set of rubber stamps made in Buenos Aires [7.1.1919], the Knight was chosen as the symbol of the Société Anonyme [30.4.1920].

Fresh Widow [20.10.1920] "was made at the time of Dada" and was again sold to Miss Dreier.

Why not Sneeze? [11.5.1935] is unnumbered, but is in fact the ninth replica, one made in addition to the Schwarz edition of eight [4.6.1964] especially for the museum, and a gift of the dealer.

Coin de chasteté [16.1.1954] is the copy given to Sacha Maruchess, the chess friend who provided Duchamp with the pink dental plastic for the object. After the death of Maruchess, this example passed to Mr and Mrs Solomon Ethe, who gave it to the museum after the pirate edition, which Mrs Ethe had made for the Gertrude Stein Gallery, was destroyed by Duchamp. Only two examples were not destroyed: one was sold, the other was this example, which Mrs Ethe promised never to sell.

21 February

1923. Wednesday, Rotterdam
On disembarking from the *Noordam* [10.2.1923], Duchamp travels to Brussels where he intends living for a while rather than returning to Paris.

1930. Friday, Nice
In the ninth round of the International Tournament, Duchamp loses his game against G. Maroczy.

1943. Sunday, New York City
Marcel spends part of the day with the Kieslers at 56 Seventh Avenue.

1952. Thursday, New York City
As Miss Dreier is prevented from receiving visitors after a bad fall the previous week, Dee is unable to go to Milford on Saturday as planned

[18.2.1952]. "I was mortified when I saw the printer's mistake in the catalogue," Dee writes, referring to the transposition of Miss Dreier's name and another collector's who have both lent to "Duchamp Frères & Sœur", due to open on 25 February. He has had an errata slip printed and pasted on the offending page.

"The next lines I consider out of place and I beg of you to discard them altogether if you judge them so," Dee ventures cautiously. He explains that James Johnson Sweeney has asked him to help organize "L'Œuvre du XXe Siècle" to be shown in Paris and London. "His great idea is to have the large glass included in the exhibition," continues Dee. "You can imagine my brainstorm when he first spoke of it." Although he is not against the idea, Dee admits that his "side weighs very little as compared with the trouble both physical and mental" that the question may bring Miss Dreier. "So please don't hold it against me," says Dee, "if you feel that I have been stupid enough to even suggest it."

*

Expressing his satisfaction with the installation plan which he has seen [18.2.1952] for their collection at Philadelphia, Marcel also broaches the question of Sweeney's project to Walter and Louise Arensberg. "The idea is to show in Europe the important landmarks of the last 50 years which have not been seen there for a long time," he explains. "Sweeney wants to know whether you can make an exception to your no lending decision [27.12.1950] in this case of exceptional importance... I know that without your Matisse, the Chagall, the de Chirico, the Rousseau and 2 of my own paintings the show would be incomplete."

If the Arensbergs have no objection in principle, Marcel says that he will ask Sweeney to write to them officially.

1958. Friday, New York City
George Heard Hamilton feels "rather up in the air" with no confirmation from Fawcus about the translation [17.12.1957] of Robert Lebel's manuscript. "What about us?" wrote Lebel, signing himself "your montgolfierist", on his return from New York [4.2.1958] after finding that the publisher had disappeared to Davos for a skiing holiday.

"Received 'around the world' safely," replies Duchamp, "and your corrections that I found on the whole correct – while waiting to review all that with Hamilton..." Satisfied that the

translation is in hand, Duchamp outlines Braziller's proposal for publishing the English edition. "I even think (confidentially) that if we could be rid completely of our chap," writes Duchamp, "we would immediately do a deal and a fast deal with Braziller. So our problem is to see the photogravure finished," he argues, "I hope therefore that F[awcus] will be tempted by the payment of this work by Chicago, if only payment could be made directly to the printer."

1964. Friday, Boston
Duchamp is interviewed by Russell Connor for the television programme "Museum Open House with Marcel Duchamp", produced by WGBH in Boston. Also while he is in the city, Duchamp speaks to over 100 students at the museum's Design School, "all impromptu and full of charm and humour."

1965. Sunday, New York City
Last December Joseph Solomon inquired whether Duchamp had another portrait of Florine Stettheimer, apart from the charcoal drawing owned by Virgil Thomson (dated *c.* 1925 in 1952, but possibly made earlier?).

"Distressed" that he has not, and declining to make one "without the presence of the model", Duchamp explained: "I so rarely made portraits anyway and later came to doubt it as a true expression of mine."

Today as he has been unsuccessful in telephoning Virgil to discuss the purchase of the drawing, Duchamp has written to the composer. In his letter to Solomon, Duchamp says: "You might, if you feel inclined to do so, telephone [Virgil] and see what his reaction is."

1967. Tuesday, New York City
"I have just been to see the painting at Mrs Jane Wade's," writes Marcel to Brookes Hubachek. He tells him that the painting which he saw at Francis Steegmuller's some

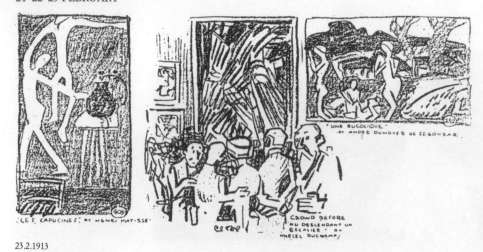

'LES CAPUCINES' BY HENRI MATISSE

CROWD BEFORE 'NU DESCENDANT UN ESCALIER' BY MARCEL DUCHAMP

23.2.1913

years ago "is in perfect condition and a very good colourful example of Villon's paintings of 1913". Mrs Wade also has the dry point made after the painting, a mirror image of it, which Marcel indicates in a sketch. His verdict on the painting: "Authentic and beautiful."

22 February

1917. Thursday, New York City
After calling to see Juliette and Albert Gleizes, Marcel and Roché take Louise Norton to a dinner dance.

1925. Sunday, Monaco
"I only left Paris 8 days ago, dear Monsieur Doucet [16.1.1925]," writes Duchamp on a card illustrated with an aerial view of the Casino and Hôtel de Paris. Busy verifying his roulette system [1.11.1924], Duchamp says "it's working very well." But at the height of the winter season Monte Carlo is too crowded for him: "I am returning to Paris on Tuesday 3 March," he writes, "in order to come back and play in April."

1930. Saturday, Nice
By the tenth round, the two Russians have overtaken the Englishman [20.2.1930] in the International Tournament. Duchamp plays the leader, E. Znosko-Borovsky, and both players, according to a commentator, content themselves with a friendly draw.

1947. Saturday, New York City
In spite of a snowstorm the previous day, Dee visits Miss Dreier at Milford, and organizing a small publicity drive they finalize the text announcing the re-opening of the Société Anonyme for membership [25.1.1947]. There is already one $100 member "to help pay the printer's bill".

1955. Tuesday, New York City
Posts a letter to Roché concerning the proposed monograph by Robert Lebel [7.4.1953], confirming that he has received the colour scale from Skira for printing *Nu descendant un Escalier* [18.3.1912] and *9 Moules Mâlic* [19.1.1915], and that he is requesting Lebel to contact "Copley's publisher, Mr Fawcus, 19 Rue Rousselet".

1965. Monday, New York City
The Duchamps fly to Houston, where they are the guests of Mr and Mrs John de Menil for three days.

1967. Wednesday, New York City
Replying to Richard Hamilton's letter about Editions Alecto's "prints-replicas", Marcel requests more details about the project before 22 March, the date when he leaves for Europe.

1968. Thursday, New York City
"Our apartment does not have the extra room that we could have lent you," writes Duchamp to Lily and Marcel Jean, who is invited to give a lecture in New York on 26 March. Teeny has asked for the weekly tariff of two hotels near Washington Square, and Duchamp suggests enquiring at the City University of New York whether they rent rooms for their lecturers. He also alerts Marcel Jean to cheaper travel rates in the spring if the air ticket is purchased in Europe.

23 February

1913. Sunday, New York City
In the group of drawings entitled "What Cesare saw at the Armory Show" [17.2.1913] published by the *Sun*, which includes cartoons of works by Matisse, Gauguin and Dunoyer de Segonzac, Cesare has sketched his impression of the crowd before *Nu descendant un Escalier* [18.3.1912].

1920. Monday, New York City
Marcel has lunch with Beatrice Wood.

1929. Saturday, Gibraltar
Duchamp meets Miss Dreier and her Scottish companion, Mrs Thayer, whose ship arrives today from New York.

1930. Sunday, Nice
At the beginning of the final round of the International Tournament, Sir George Thomas and the two Russians, Tartakover and Znosko-Borovsky are level with 8 points each, promising an exciting finish.

The tournament is won by S. Tartakover after what he terms "a tragical end" for his opponent, Znosko-Borovsky who has to abandon the game; Sir George Thomas, whose game against his compatriot Brian Reilly ends in a draw, is runner-up. Drawing his game against Dr A. Seitz, Duchamp finishes ninth.

1941. Sunday, Paris
Using thinly disguised language, Marcel writes to Roché in the unoccupied zone: he confirms that Lef[ebvre-Foinet] has returned Roché's pieces of sculpture to Arago [22.10.1940]; he encloses his reply to Walter [Arensberg], which he asks Roché to read before posting; with Walter's Affidavit [19.11.1940] commissioning a decoration for his museum at Holly[wood], Marcel says he is doing the maximum to obtain his exit visas; where should he send the "boîte de conserves" (*Boîte-en-Valise* [7.1.1941]) for Peg[gy Guggenheim] who has ordered one? Regarding Roché's box, which should be finished in a fortnight, would he like it sent to Arago? Before going to Lyons and Grenoble at the end of April, Marcel wants to find a way "to send one or 2 cases containing 50 boxes (in pieces)" which will accompany him in due course to America, but will be provisionally addressed care of his sister at Sanary-sur-Mer.

Mentioning that he and Mary Reynolds are managing to obtain provisions, chickens, veal, eggs, butter and cheese at Les Halles where his friend Candel [10.4.1910] is a cheese merchant, Marcel revises his accounts yet again [17.1.1941] with Roché in some detail translating French francs and dollars into kilograms. As an afterthought, he decides to send Peggy's box to Roché's "more permanent address" and says: "You will give it to her when you see her."

1942. Monday, Sanary-sur-Mer
Travels to Aix-en-Provence, where Tristan Tzara is living, to attend an important auction of paintings [11.2.1942].

1947. Sunday, New York City
At Miss Dreier's request, Duchamp writes to Alfred Barr to inform him that changes were

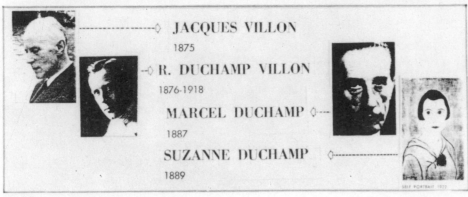

24.2.1952

made the previous day to the text of the Société Anonyme announcement and that, although Miss Dreier would have liked his approval, "she is going ahead with the printing." Miss Dreier hopes, nevertheless, to see Barr when she goes to the Museum of Modern Art on Tuesday afternoon.

1962. Friday, Hobe Sound
Teeny and Marcel's last four days in Florida have been spent, a "few places down the road" from Dr and Mrs Noland Carter [16.2.1962], at "an old boathouse so beautifully done over and perfect that it's like a Brancusi inside". Mrs Essie Johnson "rarely goes out" and the Duchamps "had a lovely quiet time just doing nothing... walking and bathing and just drinking in the beauty of the gardens... no parties".

A flight by jet brings them back in two hours to the cold and rain of New York.

1965. Tuesday, Houston
At eight o'clock in the evening the director of the Museum of Fine Arts, James Johnson Sweeney, Mrs Sweeney, Mrs Mary Sisler (whose foundation owns the contents of the exhibition), and the Duchamps attend the champagne preview of "Not Seen and/or Less Seen of/by Marcel Duchamp/Rrose Sélavy 1904–1964" [13.1.1965] which is held in the Cullinan Hall and the South Garden Gallery of the museum. The show's next stop is Baltimore on 11 May.

1966. Wednesday, New York City
"If you still have some room," writes Duchamp to Gabriel White of the Arts Council of Great Britain, who is organizing the loans for the Tate Gallery, "I would like you to ask Mr Arturo Schwarz... for a drawing (sketch for the *Chèque Tzanck* [3.12.1919]) and a Waistcoat I made for Benjamin Péret [15.11.1958] a few years ago." He adds that Schwarz also has "a great number of bibliographical documents" that he would be willing to lend if there is to be "a department of documents in the show".

1967. Thursday, New York City
Enclosing the loan forms which he has signed for 19 of Suzanne's pictures [17.2.1967] to be exhibited in Rouen, Duchamp informs Mlle Popovitch that he is instructing Lefebvre-Foinet to collect the 17 from Neuilly on 23 March, and the remaining two will be sent on 28 February air-freight from New York to France.

"Very good, agreed for the poster with a reproduction of the Musée d'Art Moderne's picture of the 2 brothers playing chess [7.5.1952]," writes Duchamp.

24 February

1918. Sunday, New York City
Duchamp apologizes to John Quinn for not having acknowledged the book on Ezra Pound, and enquires: "Who is the author?" Having heard recently from Walter Pach about Quinn's purchase of the *Coq Gaulois* by Duchamp-Villon, Duchamp says how pleased he is and relates the latest news brought from France by Jean Crotti [8.1.1918] of his brothers: Raymond has been in hospital with blood poisoning and has been unwell for a year; Villon is in the camouflage unit near Paris.

"I should like to see you again, as it is such a long time that I did," writes Duchamp, unaware that Quinn is in hospital recovering from a serious intestinal operation. "I am now working as a good clerk from 9.30 to 5.30 [8.10.1917] – going to bed earlier than the previous years."

*

In the afternoon Marcel has a crowd of visitors at 33 West 67th Street. Although Crotti has just sailed for France, Yvonne (now divorced from him [8.1.1918]) has remained behind; she and Mad Turban read Mrs Cram's hand. After a "rehearsal" of Mad's screen test, witnessed by the "ineffable" Stella, Roché and de Journo, they are joined at the Italian restaurant by Varèse, Louise Norton and the Dressers.

1923. Saturday, Paris
At the Annual General Meeting of the Salon d'Automne, Duchamp is one of 26 members drawn by lottery to serve on the jury responsible for selecting non-members' works for inclusion in this year's exhibition.

1929. Sunday, Malaga
Having negotiated the hire of a Packard (registration number GBZ 886) with a chauffeur named Juan Martinez for their holiday in Spain, Duchamp, Miss Dreier and Mrs Thayer make the Hotel Caleta-Palais at Malaga their first stop from Gibraltar.

1942. Tuesday, Aix-en-Provence
Attends the first day of an important picture sale.

1952. Sunday, New York City
The day before the opening, Duchamp installs the exhibition "Duchamp Frères & Sœur, Œuvres d'Art" at the Rose Fried Gallery, 40 East 68th Street, and uses the showcase made by Naum Gabo to exhibit a copy of the *Boîte-en-Valise* [7.1.1941].

1953. Tuesday, New York City
Having read the manuscript of Roché's article for *La Nouvelle Nouvelle Revue Française*, which is to be published on 1 June, Marcel sends him this cable: "Perfect."

1959. Tuesday, New York City
For the exhibition at the Sidney Janis Gallery to mark the publication of the "de luxe" edition of Robert Lebel's book [12.2.1959], Duchamp writes to Henri Marceau requesting the loan of three works from the Philadelphia Museum of Art: *Nu descendant un Escalier*, No.3 [29.4.1919], *Mariée* [25.8.1912], and *Cimetière des Uniformes et Livrées*, No.1 [19.1.1915]. Duchamp adds that the English edition of the book is due to appear shortly and he wonders if the museum would be interested in having a certain number of copies at the wholesale price.

1961. Friday, New York City
"Thank you, thank you for the large green box and the large green plant," writes Duchamp to Cleve Gray. Inviting Cleve to contribute to the Chess Auction for the benefit of the American Chess Foundation, Duchamp says: "We have already collected more than fifty works – even Villon has sent a fine portrait of a man." As the sale is planned to take place in April, he asks Cleve: "Can you bring us your 'kindness' on your next voyage to New York."

1964. Monday, New York City
For an article in the April issue of *L'Œil*, which Robert Lebel is preparing, Duchamp has written to Pasadena for a photograph of *Aéroplane* [19.8.1912] belonging to Beatrice Wood [13.10.1963]. He dispatches two packets of illustrations to Lebel with the instructions: "Keep these documents preciously and return them to us in Paris when we arrive at the end of April."

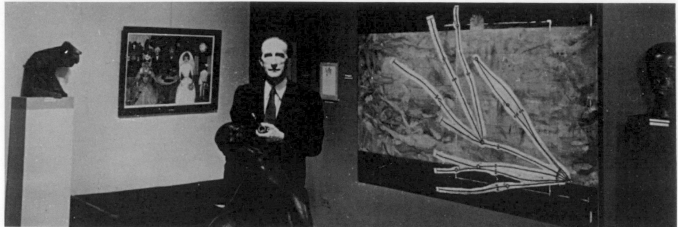

25.2.1952

1965. Wednesday, Houston
In the evening, Duchamp is the guest of hon-our at a reception held at the home of Mr and Mrs John de Menil, 3363 San Felipe Road, for members of the Art Associates of the Universi-ty of Saint Thomas.

25 February

1937. Thursday, Paris
On returning to his studio late in the evening, Duchamp finds an express letter from André Breton inviting him to 42 Rue Fontaine the fol-lowing evening. He replies by return, happily accepting, as there is much for them to discuss.

1942. Wednesday, Aix-en-Provence
On the final day of the auction which Duchamp attends, the pictures make good prices.

1950. Saturday, Milford
After another working session with Miss Dreier [11.2.1950] on the catalogue of the Société Anonyme Collection, Dee returns to New York with a set of galley proofs and cuts to start pasting.

1952. Monday, New York City
Duchamp represents the family at the opening (which is very well attended) at the Rose Fried Gallery, 40 East 68th Street. The idea of "A fam-ily of artists", title of Walter Pach's preface to the catalogue, has caught the imagination of the Press. Duchamp, who conceived the title of the show [4.10.1951], "Duchamp Frères & Sœur, Œuvres d'Art", as if it were a "family firm", has been in great demand for interviews [4.2.1952].
 As the gallery is very small, there is only space for three or four pieces by each member of the family. Duchamp shows his *Boîte-en-Valise* [7.1.1941], *Réseaux de Stoppages* [19.5.1914] lent by Mr and Mrs Pierre Matisse, and a num-ber of works on paper, notably: *Sieste éternelle* [18.3.1912]; *Cimetière des Uniformes et Livrées*, No.2 [19.1.1915]; *Knight* [10.9.1951] and *La Mariée mise à nu par ses Célibataires, même* [22.10.1913], the first precise perspective draw-ing on tracing paper for the whole composition of the Large Glass [5.2.1923].
 As Henry McBride remarks, "in France family

ties are like hoops of steel," and the "reluctant Marcel" has been "inveigled into an exhibition by Miss Fried on the pretence of it being a family affair". The critic reminds the readers of *Art News* that thirty years ago, or more, Marcel's opponents, "those who thought him a menace to all standards, moral or aesthetic" said, "he was *capable de tout*; and that of course is no compli-ment," says McBride. "And strangely unjust; for to those who knew him well, Marcel is as inca-pable of actual sin as he is incapable of being undistinguished. His crime, if it be a crime, con-sists in being inscrutable. From the moment of his arrival in America he began mystifying us and he will go on mystifying us, I believe, to the end of the chapter. It is simply that the sincerity of a creative artist is past the comprehension of the general; and Marcel is sincere. But to the mob his every move has been suspect. His enthusiastic discovery of Eilshemius [9.4.1917]," McBride recalls, "was hailed as an uproarious joke, and it was some years before the world got to see the real Eilshemius pictures and saw that they were good and that Duchamp was right." Comment-ing that there is nothing "provocative" in Duchamp's contribution to the show, McBride doesn't think that the original drawing for *La Mariée mise à nu par ses Célibataires, même*, for example, "will catch the eye of an alarmist." At least he sincerely hopes it won't.

1954. Thursday, New York City
Congratulates Roché on his "wonderful" arti-cle about the *Rotoreliefs* [30.8.1935] entitled "DISKOPTIKDEMARCELDUCHAMP" in the January issue of *Phases*:
 Marcelduchampsaystomelik ehowaboutit
 we'llmakeadealbothofus
 you'llputupthemoneyandi'll
 furnishtheopticaldiscstherotoreliefs
 likeIcallthemwe'llexhibitthematthe
 inventors'fairandwe'llsplitthetakeif
 thereisanyokitellhimwe'llmake
 adirectpitchtothepeopleandwe'llsee…

1962. Sunday, New York City
In reply to Serge Stauffer's question about cut-ting out the miniature Glider after printing the celluloid [2.1.1962], Duchamp suggests two methods which he explains in detail. He promises to chase the Museum of Modern Art [25.1.1962] for the photograph of *Stéréoscopie à la Main* [4.4.1919].

*

"Bursting with plans and projects" (one of them *End of the World*, No.2, in the Nevada Desert), Jean Tinguely, accompanied by Niki de Saint Phalle, spends the evening with Mar-cel and Teeny at 28 West 10th Street.

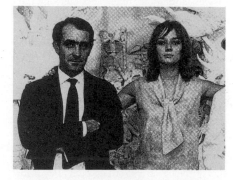

1965. Thursday, Houston
Teeny and Marcel fly to Mexico City to spend three weeks with their friends Mimi Fogt and Alberto Capmany at 63 Calle Antonio Sola. They have the little house in the garden with a bedroom decorated with paintings by Mimi, including a large canvas: *Amantes de Mazatlan*. During the day, the garden is the domain of two small multicoloured parrots and two yel-low and green Spanish-speaking parrots known as Monsieur and Madame, who are great mimics – Madame in particular.

During their stay a number of excursions are planned. One by air to Palenque, thence to

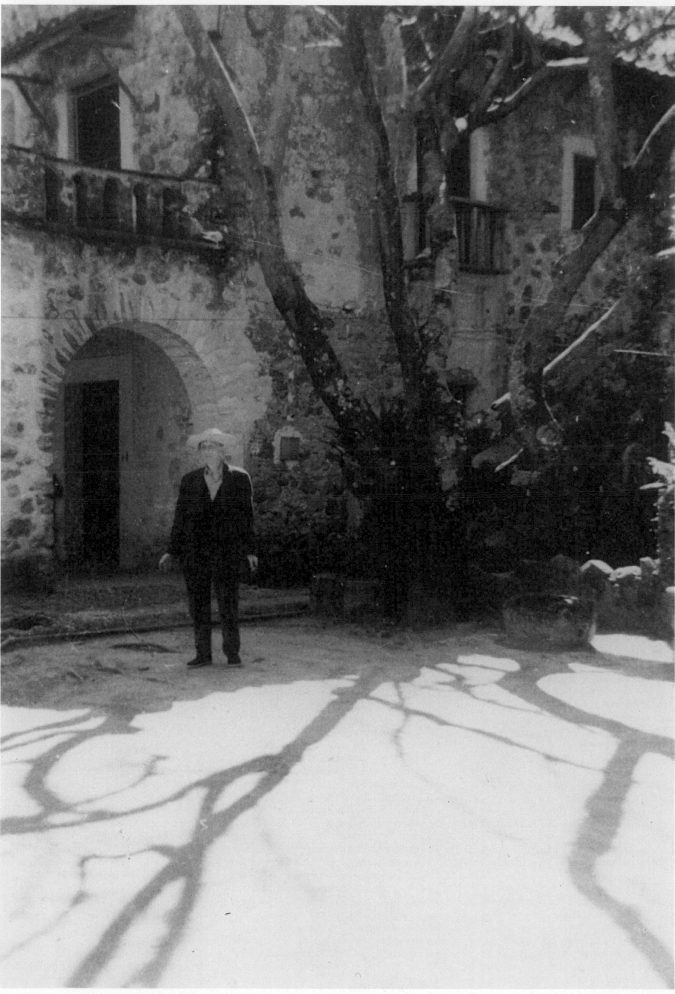

25.2.1965

26.2.1927

Villahermosa, capital of Tabasco, to see the monumental stone sculptures in the jungle-like park of La Venta. Another in the second-hand, olive-green Plymouth with burgundy upholstery, called "Submarine", which will transport Teeny, Mimi, Marcel and Alberto to the hacienda near Taxco, once belonging to Alberto's grandfather. Here, Marcel is shaded by a sombrero borrowed from the house in Mexico City, while Teeny bathes in the pool built of old flagstones, which is filled from the

ancient aqueduct nearby. Mimi the portraitist will also no doubt persuade Marcel to sit for her a third time [6.4.1957].

26 February

1917. Monday, New York City
At midday Victor [23.1.1917], who has now become "Totor", calls to see Roché and they have lunch together at Polly's, the popular "Bohemian" restaurant on West 4th Street.

1918. Tuesday, New York City
Dines with Roché and Mad Turban at Kalama's, 11 West 47th Street.

1920. Thursday, New York City
Gaby Picabia has arrived from Paris with the idea of selling some dresses designed by Nicole Groult, Paul Poiret's sister. She is stay-

ing with Marcel at 246 West 73rd Street while de Journo, who is helping her financially, is setting up the company.

Writing to Yvonne Chastel about Gaby's plans, Marcel mentions that Preston Sturges, (son of Mary Desti with whom Yvonne is staying in London) gave him a bed and a mattress: "He wanted to give me yours," explains Marcel, "but I insisted, this one is metallic and very good. I have not needed anything else."

America has gone completely dry since 17 January when the prohibition amendment to the Constitution came into legal effect. "One doesn't drink here any more and it's quiet, too quiet," says Marcel.

1924. Tuesday, Paris
Acknowledges Jacques Doucet's kind note and confirms the meeting with him at Man Ray's studio for the following morning.

1927. Saturday, New York City
In the morning before the *Paris* sails at eleven o'clock, Marcel writes a note to Alice Roullier in Chicago to say that she hasn't sent the small present for her family [28.1.1927] and giving his address in Paris. "The Brewsters are on the *Paris* and heaps of acquaintances," Marcel tells her. One of the passengers is Julien Levy, the son of Edgar A. Levy, who purchased the white bird by Brancusi [12.12.1926] from the Brummer exhibition [17.11.1926]. Marcel has undertaken to introduce Julien to Man Ray, whose movie camera and studio in Paris could be secured to make the film for which Julien has been writing the scenario.

With the controversy raging about the decision of the American government to levy duty on Steichen's bird because it is not art, [26.1.1927], Duchamp's departure on the Paris with fifteen Brancusi sculptures in the hold is newsworthy. Photographed with Léon Hartl [25.11.1922] and his wife on the deck of the liner in the magnificent racoon coat acquired in Chicago as protection against the severe winter climate, Duchamp is interviewed for the *New York Times*. He tells the reporter that the Brancusis are to be exhibited in Berlin: "This does not mean that Brancusi has abandoned his efforts to have his works admitted without duty. An appeal has been made [12.2.1927] which will ultimately be carried to Washington. To say that the sculpture of Brancusi is not art is like saying an egg is not an egg."

1928. Sunday, Hyères-les-Palmiers
After his success in the Coupe Philidor [2.2.1928], Duchamp returns with the team from Nice to play a chess match against the local team, which is won by the visitors.

1929. Tuesday, Malaga
After spending a couple of days in Malaga which has given Duchamp the opportunity to see Tristan Tzara, the chauffeur Martinez drives Duchamp, Miss Dreier and Mrs Thayer along the coast and then northwards over the Sierra Nevada to Granada. Miss Dreier takes two photographs of Duchamp, one while he is seated on the ledge of a white-façaded building, and one in the same location standing by the Packard, his coat round his shoulders.

1937. Friday, Paris
At about a quarter to eight in the evening, Duchamp is due at 42 Rue Fontaine to dine with André and Jacqueline Breton.

1942. Thursday, Aix-en-Provence
After spending "three very pleasant days" seeing Tristan Tzara and attending the picture sale, Duchamp travels back to Sanary via Marseilles.

1949. Saturday, New York City
Duchamp cables Douglas MacAgy in San Francisco accepting his invitation to participate in the "Western Round Table on Modern Art", which is being organized as a rebuttal to *Life*'s Round Table, held at the Museum of Modern Art in New York the previous year.

1952. Tuesday, New York City
"Well the vernissage of the Duchamp family [25.2.1952] was quite a success," reports Dee to Miss Dreier, writing with the new pen she gave him, which is still a little stiff. "The Villons from Carré gave a wonderful illumination to the show and Suzanne was a revelation to many. But I think Raymond was the most admired. His 4 bronze pieces showed no signs of 'fatigue'. They are actually ageless."

1955. Saturday, New York City
Duchamp forwards to Lebel a packet and letter he has received from Skira [22.2.1955].

1958. Wednesday, New York City
Informs Lebel of Fawcus' letter from Munich appearing to accept George Heard Hamilton

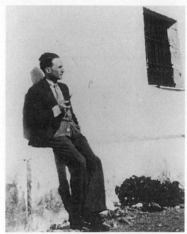

26.2.1929

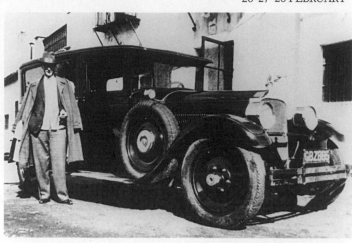

as translator [21.2.1958]. According to Fawcus the photogravure is at an advanced stage and the French edition of the book should appear well before Christmas. Duchamp suggests that Lebel should call to see the printer and check on progress for himself.

*

After news from Lefebvre-Foinet that 30 copies of the *Boîte-en-Valise* [7.1.1941] have been delivered and are very beautiful, Duchamp writes to compliment Iliazd and to thank him for having completed this long work [7.1.1955].

27 February

1909. Saturday, Rouen
Braving the cold and flurries of snow, a great number of people turn out to attend the opening of the third exhibition of the Société des Artistes Rouennais, which is held in the Salle des Concerts at the Musée des Beaux-Arts. After the *Marseillaise* has been played by the band of the 74th Regiment, Marcel Delaunay, the president of the young society, makes a short, passionate speech.

For the exhibition, two young sculptors Chauvel and Galimard have transformed the concert hall with a sculptural decoration: four great pilasters, one at each corner, adorned with female heads are linked by a series of arcades decorated with medallions and insets in the modern style.

With his two brothers who are also exhibiting, Duchamp is represented by *Vieux Cimetière* [1.10.1908], which the critic Georges Dubosc describes as having "character and strength".

1920. Friday, New York City
In the afternoon Marcel has tea with Beatrice Wood.

1924. Wednesday, Paris
In the morning Duchamp has an appointment with Jacques Doucet at Man Ray's studio in Rue Campagne-Première. Duchamp presents his idea for another optical machine [20.10.1920] and Doucet, who already owns two of his works [28.9.1923], agrees to finance the project.

1926. Saturday, Paris
Having heard from Roché that Jacques Doucet has mislaid the catalogue of 80 Picabias to be sold at auction on 8 March [4.2.1926], Duchamp sends the collector another one and says that he is sending two more under separate cover. "As you advised, I have not put the 4 collages in the sale," writes Duchamp, "and I am very pleased. I have already sold a series of drawings and watercolours…" Feeling confident about the outcome, Duchamp tells Doucet that he thinks Picabia's recent pictures and ones from his Orphic period will attract bids.

1944. Sunday, New York City
In the afternoon, Marcel plays chess at Julien Levy's with Frederick Kiesler and Alfred Barr.

1950. Monday, New York City
Opening of "20th Century Old Masters", the first of a series of historic exhibitions organized by Sidney Janis at his gallery, 15 East 57th Street. *La Partie d'Echecs* [1.10.1910] by Duchamp is lent by Walter Pach.

1951. Tuesday, Chicago
Date of the Trust Indenture made in the City of Chicago, Cook County, creating a trust primarily for the benefit of Marcel Duchamp, which is signed by Duchamp as the donor and Frank Brookes Hubachek, Jr. as the trustee.

A keen collector and benefactor of the Art Institute of Chicago, Hubachek was deeply grateful for Marcel's help in settling Mary Reynolds' estate in France [25.12.1950] and he decided to make this generous arrangement in memory of his sister [30.9.1950], thus assuring Duchamp a regular income during his lifetime.

1957. Wednesday, New York City
"So glad you will be here for a few days," writes Marcel to Katharine Kuh. "Will you call us up when you are installed in your Dorset and we will arrange probably a dinner *à la maison*." The "Three Brothers" exhibition [19.2.1957], Marcel tells her, is open until 10 March.

1961. Monday, New York City
The Duchamps attend a grand dinner held in the guest house of the Museum of Modern Art to celebrate the opening of a retrospective exhibition of Max Ernst's work, 1909–1961, which has been organized by William Lieber-mann. Among the guests is Lefebvre-Foinet,

on his way to California, who confirms that the Valise ordered for Rose Fried [19.2.1961] is on its way…

28 February

1924. Thursday, Paris
After receiving an express letter from Jacques Doucet in the morning, Duchamp telephones Picabia, who agrees to speak to Doucet to clarify a detail concerning the agreement reached the previous day whereby Doucet will finance Duchamp's second optical machine.

"I am very happy that you have settled the question of money with [Picabia]," writes Duchamp later in an express letter to Doucet. "It was difficult for me to tell you that I needed about 600 [francs], because I consider this as an exchange and not a payment. I would like to be able to make you a present of this hemisphere. So I am entirely at your service to attend to the assembling and presentation." Referring to Doucet's second express letter, Duchamp confirms that he will meet the collector at Man Ray's studio the following afternoon.

1925. Saturday, Monaco
"I return to Paris Tuesday morning," writes Rrose Sélavy on a postcard to Dr Dumouchel. "Delighted with my 'research', haven't played at all [22.2.1925]."

Rrose Sélavy

1929. Thursday, Granada
"I don't think that we will be going through Malaga [26.2.1929] again on Sunday," writes Duchamp to Tristan Tzara enclosing "el Defensor de Granada of 28 February" for his collection. In case there is an opportunity to see Tzara again, Duchamp says that they plan to be in Ronda on Monday and to reach Seville on Tuesday evening.

Nous. Marcel Duchamp,

déclarons à toutes fins utiles que le porteur du présent

Certificat Inaliénable et Intransmissible

est Docteur Agrée et Agrégé du recueil de poèmes de

29.2.1964

1934. Wednesday, Paris
At about eleven-thirty, Marcel calls to see Roché in Arago and they have lunch together.

1946. Thursday, New York City
Sending him braces, socks and a hot-water bottle, Totor tells Roché that he will be in Paris before Roché goes to America. "In fact I am thinking of leaving around 15 April," he writes. "I am in the middle of packing already, wanting to sort out and bring as many things as possible."

1949. Monday, New York City
"Delighted at the news!" writes Duchamp to Douglas MacAgy after cabling him on Saturday accepting the invitation to the "Western Round Table on Modern Art".

As the conference organized by *Life* magazine at the Museum of Modern Art in New York was particularly controversial and gave a lot of publicity to the denigrators of Modern Art, Duchamp asks for details of the symposium: the place, whether *Life* magazine is involved, what kind of questions will be raised, who the chairman is, whether Arensberg will attend, which day he should arrive, and by which airline. "I want to book my reservation as soon as possible," explains Duchamp and enquires whether he can use his return ticket from Hollywood. "I want naturally to go down visit the Arensbergs, Man Ray and maybe Max Ernst on the way back."

1956. Tuesday, New York City
Writes to Roché about the prices for Brancusis, gives him the address for books on chess at 13 Rue Saint-Jacques in Paris, and says that NBC have given him a copy of Robert D. Graff's film [15.1.1956]. No plans to go to Europe this year!

1959. Saturday, New York City
On receiving Richard Hamilton's request for photographs of certain works to illustrate the English typographic version of the Green Box [16.10.1934], Duchamp writes to Henri Marceau at the Philadelphia Museum of Ar, asking whether the museum can supply them.

1967. Tuesday, New York City
By air-freight, Duchamp sends two canvases by Suzanne Crotti to the Musée des Beaux-Arts, Rouen [23.2.1967].

29 February

1924. Friday, Paris
Following their exchange of express letters the previous day, at about two-thirty in the afternoon Duchamp has another meeting with Jacques Doucet at Man Ray's studio about building the "hemisphere".

1940. Thursday, Paris
With the proviso that the gift also has Miss Dreier's approval, Duchamp agrees to giving "the collection of works of art gathered for the Société Anonyme Inc. since its foundation [29.4.1920] as a museum of Modern Art to the country museum in Redding, Conn[ecticut]." He stipulates however that "this consent will be effective only when the country museum is established [8.8.1939]".

1960. Monday, New York City
With the stock of the *Boîte-en-Valise* [7.1.1941] made by Iliazd [26.2.1958] almost exhausted, Marcel asks Jackie if she will start proceedings for ordering more boxes. "But there is a detail before making a firm order," warns Marcel, "it's the frame in wood which should contain the celluloid of the large glass," and suggests that Jackie ask Robert Lebel to lend her his copy.

1961. Wednesday, New York City
The Duchamps give a dinner party for Max Ernst [27.2.1961] and Dorothea Tanning at 28 West 10th Street.

1964. Saturday, New York City
A "non-transferable and inalienable certificate" which identifies the bearer as an "endorsed and examined reader of the collection of poems by Arturo Schwarz entitled *Il reale assoluto*" and confers the privilege of reading these poems freely for the sum of 1,000 Lire, is signed by Duchamp. The wording of the certificate is printed in the centre of a lithograph by Duchamp: *Four Readymades.* In each corner of the paper is a thumbnail sketch of a readymade: *Roue de Bicyclette* [15.1.1916], *Egouttoir* [15.1.1916], *In advance of the Broken Arm* [15.1.1916], and *Fountain* [9.4.1917]. An origi-

nal signed certificate is included in each volume of the limited edition and published in the ordinary paperback edition.

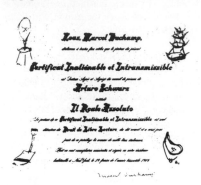

1968. Thursday, New York City
Monique Fong dines with Teeny and Marcel at 28 West 10th Street.

1 March

1910. Tuesday, Neuilly-sur-Seine
In the afternoon Paul Barbarin [or Barbazin who was at the Lycée Corneille?], a young French teacher and friend of Duchamp, brings Max Bergmann, an art student from Munich, to Rue Amiral-de-Joinville.

Bergmann, who arrived in Paris only two weeks ago, is relieved that Duchamp speaks to him slowly and clearly in French so that he understands most of what he says. For his artistic studies, Duchamp recommends the Académie Julian [12.11.1904] or La Palette to Bergmann and offers to take him to see some exhibitions. Bergmann readily accepts, and Duchamp promises to call for him on Friday afternoon.

1913. Saturday, Albuquerque
On his return by rail to San Francisco after visiting the Armory Show [17.2.1913] in New York, an art dealer Frederick C. Torrey of Vickery, Atkins & Torrey, has second thoughts, disembarks from the train and swiftly sends a telegram to Walter Pach: "I will buy Duchamp nude woman descending stairway please reserve."

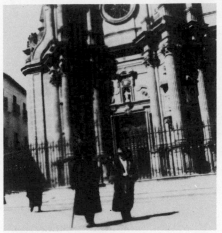
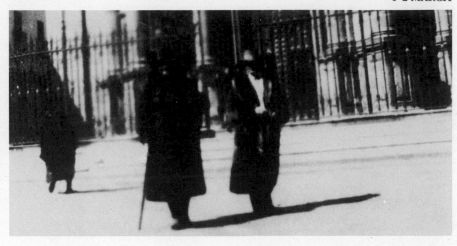

2.3.1929

In New York on the same day, Arthur Jerome Eddy buys *Portrait de Joueurs d'Echecs* for $162 [15.6.1912]. "[Eddy] was the first man in Chicago to ride a bicycle," noted Duchamp, "and the first to have his portrait painted by Whistler. That made his reputation! He had a very important law practice and collection of paintings."

1917. Thursday, New York City
In the evening Marcel has a visit from Beatrice Wood who comes to paint, and Isadora Duncan's brother [Augustin?] also calls. Something in Beatrice's attitude causes Marcel to be very firm with her; this makes her unhappy but she knows that he is right.

1930. Saturday, Nice
"Tournament finished [23.2.1930], not bad, not too bad," writes Marcel to Brancusi. "Unfortunately the weather is dreadful." Asking for news, Marcel says that he will be returning to Paris in a fortnight.

1940. Friday, Paris
Fascinated at hearing Marcel's "explanation" of Peggy Guggenheim, Roché recalls the day they met [11.1.1940] and agrees how pleasant the contact can often be with women who have rather unattractive faces but beautiful bodies which they must show off and use "or be deprived of any life".

1945. Thursday, New Haven
Opening of "Duchamp, Duchamp-Villon, Villon", an exhibition organized by George Heard Hamilton at the Yale University Art Gallery. In addition to Duchamp's own works, two portraits of him are exhibited: the celluloid construction by Antoine Pevsner [3.7.1926] and a canvas painted by Miss Dreier in 1918: *Psychological Portrait of Marcel Duchamp* (also known as *Abstract Portrait of Marcel Duchamp*).
At Miss Dreier's request, Duchamp has provided a replica of *In advance of the Broken Arm* [15.1.1916] which, like the original in his studio at 33 West 67th Street, is hung from the ceiling in the exhibition.

1946. Friday, New York City
Invited as guest director of the Museum of Modern Art [9.1.1946] to select the paintings for the Florine Stettheimer memorial exhibition [13.10.1944] to be held in the fall, and with a recommendation from the museum, Duchamp

is awarded a fellowship for a year from the Southern Educational and Charitable Trust.

1947. Saturday, New York City
On the basis of his report [20.2.1947], Duchamp's fellowship from the Southern Educational and Charitable Trust is renewed for a further year.

1961. Wednesday, Milan
The *Rotoreliefs* [30.8.1935] and *Couple de Tabliers* [9.11.1959] are exhibited in "L'Oggetto nella pittura" at the Galleria Schwarz.

2 March

1913. Sunday, New York City
After his purchase from the show yesterday, for $324 Arthur J. Eddy buys another Duchamp from the Armory Show [17.2.1913]: *Le Roi et la Reine entourés de Nus vites* [9.10.1912].

1917. Friday, New York City
After the episode the previous evening, though remaining "like a knife", Marcel ensures that the situation with Beatrice returns to normal.

1924. Sunday, Rouen
Duchamp attends a banquet at the Cercle Rouennais des Echecs which is presided over by the Radical-Socialist *député*, Maurice Nibelle. In the afternoon Victor Kahn plays simultaneous games on 17 chessboards, including one against Duchamp, which Duchamp wins.

1929. Saturday, Granada
With Miss Dreier and Mrs Thayer, Duchamp makes an excursion to Guadix, a town notable for its cathedral and dwellings carved into the hillside. Then they drive fifty miles northeast of Guadix as far as Baza before returning in the evening to Granada.

1936. Monday, New York City
Alfred Barr's exhibition, "Cubism and Abstract Art", opens at the Museum of Modern Art. *Nu descendant un Escalier*, No.2 [18.3.1912] has been lent by the Arensbergs, and *Mariée* [25.8.1912] by the Julien Levy Gallery. Miss Dreier has provided *Cimetière des Uniformes et*

Livrées, No.2 [19.1.1915] and a photograph of *A regarder d'un Œil, de près, pendant presque une Heure* [4.4.1919], which was exhibited in a previous show [20.11.1934]. At Miss Dreier's suggestion, Barr has also included a set of Duchamp's *Rotoreliefs* [30.8.1935].

1946. Saturday, New York City
Before the notary public, Max Levite, Duchamp certifies the death of Arthur Cravan as follows: "I the undersigned, Henri Robert Marcel Duchamp, Artist, thereby affirm that I knew about Fabian Lloyd whose disappearance in 1918, caused a flutter in the art world. We expected a great deal of his poems the manuscript of which was lost with him. I knew him well and only death could be the cause of his disappearance [10.1.1919]."

1959. Monday, New York City
The invitation card for the opening of René Magritte's exhibition at the Alexander Iolas Gallery, 123 East 55th Street, is adorned with Duchamp's aphorism: *Des Magritte en cher, en hausse, en noir et en c uleurs*.

1961. Thursday, New York City
The Duchamps have an appointment with the manager of Parke-Bernet, the famous auction house, to discuss the sale for the benefit of the American Chess Foundation. Since beginning his campaign [9.6.1960], Duchamp has managed to collect about 65 works "mostly drawings and small things", which have been given by the artists. It is proposed that the sale be termed for "the Marcel Duchamp Chess Fund" and held in May with other modern paintings.

1962. Friday, New York City
Posts the photograph of *Stéréoscopie à la Main* [4.4.1919] to Serge Stauffer with the note: "At last. M.D." [25.2.1962].

1963. Saturday, New York City
Replying to Richard Hamilton (whose typographic version of the Green Box has just been re-printed [26.11.1960]), Duchamp promises to show the silk-screen print of one of Richard's paintings to Leo Castelli [4.3.1962]. He announces the date of their arrival in Spain as 20 June, and says: "From that date on we will be in Cadaqués for three months and would love to have you visit us, we have a room for you in our little apartment."

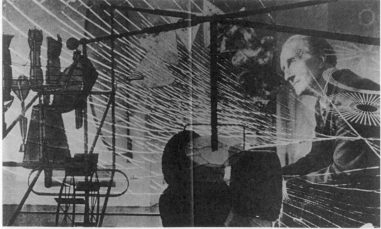

2.3.1967

1967. Thursday, New York City
"Filled with horror" when he learns that Baruchello has been plagiarized, Marcel recommends his young Italian friend to avoid any discussion and, as he would do himself, firmly ignore it.

*

Responding to Brookes Hubachek's "two million, five thousand thanks" for a copy of *The World of Marcel Duchamp* recently published by Time-Life, Marcel takes a "DON'T FORGET" pad and, crossing out "DON'T", adds underneath in large letters: "ABOUT IT." Marcel

explains to the mystified Brookes, who claims that he's "getting so darn old and senile" that he can't remember whether he ordered the book himself or not, "I got a few copies and am delighted that you were among the first ones to see it… I joined the senile society long ago," adds Marcel, "so cheer up."

1968. Saturday, New York City
"The months pass by in the cold still," write Marcel and Teeny to Yo and Jacques Savy in Paris. "After having hesitated about leaving New York [18.1.1968] we decided to stay quite simply in the warmth of our apartment."

They confirm that three of Yo's paintings which were exhibited at the Bodley Gallery [14.11.1967] will be hung in the Museum of Modern Art at the time of the forthcoming Dada and Surrealist exhibition.

Announcing the date of their arrival in Neuilly on 31 March, Marcel and Teeny add that, "in order to keep in training," they play chess regularly at the London Terrace Chess Club.

3 March

1918. Sunday, New York City
At six in the evening Marcel receives some visitors: Roché, Mary Sturges and Yvonne Chastel. On leaving, Roché embraces the two women and Marcel.

1925. Tuesday, Paris
In the morning (on arrival by a night train?) Duchamp returns to the Hôtel Istria after spending a couple of weeks studying his martingale in Monaco [22.2.1925].

1934. Friday, Paris
At eleven-thirty in the morning, Marcel has an appointment at Arago with Roché.

1939. Friday, Paris
When Gaby and Jacques Villon come to dine with Mary Reynolds and Marcel at 14 Rue Hallé, they meet the Mexican painter Frida Kahlo, who is wearing her beautiful native costume. Wife of Diego Rivera, Frida came to Paris at the invitation of André Breton, but when she became seriously ill, it was Mary and Marcel who had her transported to the American Hospital, and Mary who invited her to stay afterwards.

An exhibition of her work is due to open in Paris on 10 March.

1960. Thursday, New York City
"Certainly I will be very happy when I come to Paris to have a quick look at Pierre's journal," writes Marcel to Denise Roché, referring to the hundreds of notebooks and diaries in which almost daily Roché jotted down all his thoughts and activities for nearly sixty years [15.4.1959]. Marcel warns Roché's widow, however, that he will not be in Paris before the end of September, after their holiday in Greece, because they will be at Cadaqués in July and August.

1964. Tuesday, New York City
"Always a pleasure to read your Sévignéries and [I] regret not knowing how to play tennis in ball pens," Duchamp writes to Monique Fong. Explaining that their earlier departure from New York this year is on account of the studio apartment they have inherited in Neuilly [8.11.1963], Duchamp says: "So, dear Monique, no visit in N[ew] Y[ork] in May, but perhaps in Neuilly at the end of April."

1967. Friday, New York City
"Bodley Gallery (Mr Mann) told us about your reply," writes Duchamp to Yvonne Savy [19.1.1967], "and we are very happy that the show looks promising for November. He has even arranged to have a woman sculptor (incidentally a friend of ours) at the same time as you.

The gallery is large enough so that you each have your 'privacy'." A meeting is to be arranged with Mr Mann who will be in Paris around 18 May when the Duchamps will already be in Neuilly after their visit to Monte Carlo. "Might you be tempted, perhaps, you and your husband to come as far as Monte Carlo at that time," suggests Duchamp. "We will be at the Hôtel Hermitage on 23 March in the evening."

1968. Sunday, New York City
In the afternoon at about two, Jasper Johns calls for Duchamp at 28 West 10th Street to take him to see the set that he has made for Merce Cunningham's ballet, *Walkaround Time*, before it is sent to Buffalo. Roberta Bernstein who has been helping Jasper with finishing touches all morning waits in the cab which will take the three of them to the studio at 343 Canal Street.

Using silk-screens of the separate elements of the Large Glass [5.2.1923], Jasper has had each motif printed onto the front and back of transparent inflatable plastic boxes held rigid by aluminium rods. Although voluminous, the boxes (like gigantic building blocks) are extremely light in weight so that the dancers will be able to move them around the stage. "Duchamp liked the set very much," recalls Roberta. "He asked Jasper how it was done and what Merce was going to do with it… Jasper asked for suggestions and Duchamp said he thought some of the pieces should be suspended from the ceiling." They discuss how the set should be credited in the programme and, although Jasper doesn't want his name mentioned, Duchamp insists that it is.

After finding a cab, Jasper and Roberta accompany Duchamp back through the Soho area to 10th Street. Duchamp remarks "how much he loves this area of New York, especially when it is deserted" as it is today.

4 March

1910. Friday, Paris
As arranged on Tuesday, at about two-thirty in the afternoon Duchamp calls for Max Bergmann at his lodgings at 13 Rue Bonaparte, and takes him to see "different exhibitions

3.3.1968

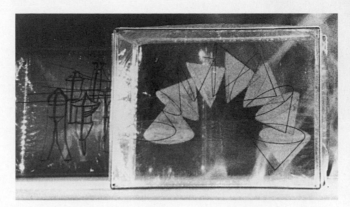

4.3.1929

where the most modern Parisian painters" are represented. Bergmann considers that with Duchamp he makes progress not only in the language but also in the question of painting: he realizes for the first time what Professor Herterich (his professor at the Akademie) meant when he said that French artists were only concerned with "sensory perception" in their artistic values.

1923. Sunday, Paris
During a short visit to France, his first since he returned to Europe [21.2.1923], Duchamp has looked up a number of friends and also been to see his parents in Rouen.

In the evening before returning to Brussels where he is living at the moment, Duchamp meets Francis Picabia and André Breton [1.10.1922]. On renewing his acquaintance, Breton finds Duchamp "as always charming and superior, so much better than I remember him..."

1927. Friday, Le Havre
After her transatlantic crossing, the *Paris* docks at nine in the evening. During the voyage Marcel spent a lot of time in the lounge with his young friend, Julien Levy, talking, "smoking, drinking moderately, beer or Cinzano *à l'eau* until the time Marcel would find himself a chess game." Many hours were passed discussing the film they planned to make [26.2.1927], until a message was flashed from a ship steaming westwards that Man Ray had been called to New York and the project seemed postponed or shelved.

"Marcel toyed with two flexible pieces of wire, bending and twirling them, occasionally tracing their outline on a piece of paper," relates Julien. "He was devising a mechanical female apparatus... He thought of making a life-size articulated dummy, a mechanical woman whose vagina, contrived of meshed springs and ball bearings, would be contractile, possibly self-lubricating, and activated from a remote control, perhaps located in the head and connected by the leverage of the two wires he was shaping. The lines of the wires when they are shaped to give just the leverage needed and then removed from their function as messengers between the head and vagina, they become *abstractions*. You understand? And to no apparent purpose... The apparatus might be used as a sort of *machine-onaniste* without hands."

When Julien suggested that the machine "could be equipped with a mechanism by which the lower half of her body was activated by one's tongue thrust into the mouth in a kiss, "Marcel unbent, giggled for the first time," and admitted him "to his inner circle of friends".

1929. Monday, Granada
While staying in Granada [26.2.1929] Miss Dreier's party has visited the Alhambra and the Cartuja, a small convent a little way out of town, with some imposing steps leading to the entrance.

Today, on the next stage of the journey, Martinez drives Duchamp, Miss Dreier and Mrs Thayer in the Packard to the Hotel Reina Victoria at Ronda, overlooking the spectacular ravine of the Guadalevin.

1937. Thursday, Paris
Invited by the editor Louis Aragon to be a regular contributor, Duchamp publishes his first chess column in *Ce Soir*, the new evening newspaper which made its début on Monday. For the issue which is dated 5 March, this new fortnightly column is headed by an eye-catching chequered motif incorporating the black chess Knight.

In view of the development of chess internationally since the war, Duchamp announces that he will be giving an important place to news of chess events "thus reaching not only

the specialized player, the strong player but all players... Our ambition," writes Duchamp, "is to attract those who do not know how to play and to show them why this international game, so fertile in combinations is nevertheless easy to learn." To the chess problems and annotated games, Duchamp promises to include, from time to time, articles of a general nature accessible to everybody.

While mentioning certain events planned for 1937 including a tournament at Easter in Margate; the International Team Tournament in Stockholm; the match for the women's world championship title in Austria; a return match for the world title between Alekhine and Euwe in Holland; the Championnat de France and the Championnat de Paris, Duchamp expresses the hope that an international tournament will be organized for the occasion of the Exposition Internationale de Paris.

After reminding readers that the world's first chess review was published in France by Louis-Charles Mahé de La Bourdonnais in 1835, Duchamp presents a chess problem devised by Pierre Biscay and dedicated to *Ce Soir*. The solution requiring checkmate in two moves will be given in a fortnight. Finally Duchamp comments on the game opening with the Nimzovitch Defence, which was played in Hastings recently by W. Winter and A. Reynolds.

1946. Monday, New York City
After lunching with Alfred Barr, Duchamp joins Miss Dreier in inviting Barr (until recently director of the Museum of Modern Art) to become a director of the Société Anonyme. "We felt the time had come to again become active for under the Deed of Gift to Yale [14.10.1941] the collection will grow," writes Miss Dreier. "We hope to begin to operate this coming fall..." Barr's appointment will be the third new directorship, following acceptances from Eleanor Williams and Rose Fried to join the board [10.2.1946].

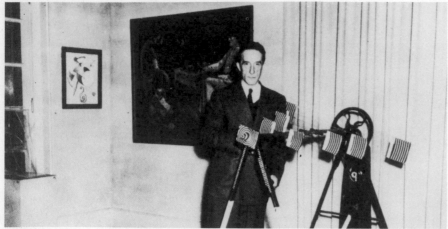

5.3.1948

1950. Saturday, Milford
After working again with Miss Dreier on the catalogue of the Société Anonyme, Dee returns to New York with the galleys of 27 artists for proofreading and pasting [25.2.1950]. Miss Dreier is due to post him another 18 on Tuesday which brings the corrected artists' entries to 154 leaving a balance of 15.

1952. Tuesday, New York City
"Very good," is Marcel's opinion of the show at the Rose Fried Gallery [25.2.1952]. "The people here as you know adore the family idea, the babies are kings here," he explains to Jean and Suzanne Crotti. As Rose Fried, he says, is keeping the press clippings, "You will see therefore what reception this new kind of show received... It remains to sell something. Let's hope, the month of March is long."

Marcel informs them that "Dreier is still valiant," and adds: "I believe she lives only by the will to live, because the doctors don't have a cure for her illness... Happily, she doesn't know the gravity of her condition."

1955. Friday, New York City
"Arrived safely [9.2.1955] with lumbago which lasted 3 weeks," writes Marcel to Jean and Suzanne Crotti. "In short, all is well, even the cold [6.2.1955]." In addition to advising his sister and brother-in-law that Enrico Donati has given their address to a collector, Mr Wertheimer of Chanel & Bourgeois, who would like to see their painting by Soutine, Marcel requests them to lend the portrait drawing of Lucie Duchamp by Villon (c. 1895), to the New York dealer Lucien Goldschmidt, who is organizing an exhibition of Villon's etchings.

1959. Wednesday, New York City
Duchamp sees Arnold Fawcus who shows him Robert Lebel's book, *Sur Marcel Duchamp*, which is now finished in its different French editions: three variations of "de luxe", and the ordinary edition. Duchamp is very pleased with the result. It now remains for Fawcus to find an American publisher, the reason for his visit to New York.

1962. Sunday, New York City
"[Leo] Castelli is very well disposed and would like to see you and your work when he goes to London between June and September," writes

Marcel to Richard Hamilton. Suggesting that Richard should write the dealer a short note and collect as much material before the summer, Marcel says: "Castelli is a very open mind and the best of the daring dealers here."

1964. Wednesday, New York City
"Arne Ekstrom is preparing for Nov[ember] 64 a show of my early works (those outside of Philadelphia) and found some that never were exhibited," Marcel announces to Richard Hamilton, who is preparing a show of his own work at the Hanover Gallery. "He has asked me to ask you if you would accept to compose a catalogue ('genre' Pasadena [7.10.1963], a little less important) for that show – it could be printed in England if you prefer – but entirely under your supervision." Stating that Ekstrom will pay for Richard's work, Marcel writes: "After your answer to this, you may expect more elaboration."

5 March

1917. Monday, New York City
After meeting Roché at Manguin's for lunch, Marcel spends part of the evening at Roché's apartment before going with him to the Arensbergs, 33 West 67th Street. In his absence, Beatrice Wood works on a poster at Marcel's studio for the Rogue's Ball.

1929. Tuesday, Seville
In the evening, after driving from Ronda, Miss Dreier, Duchamp and Mrs Thayer arrive at the Hotel Bristol. They plan to spend several days in the birthplace of Velázquez, the Andalusian city watered by the Guadalquivir where the navigators Amerigo Vespucci and Magellan prepared their great expeditions across the ocean.

1935. Tuesday, Paris
"I have been very busy with two new ideas," writes Dee to Miss Dreier explaining his silence [31.12.1934]. Encouraged certainly by the success of the Green Box [16.10.1934], Dee declares: "I want to make, sometime, an album of approximately all the things I produced." As it will be expensive, Dee proposes to start by making ten colour reproductions of his "better

works" employing the same painstaking process [18.5.1934] he used for the reproduction of 9 Moules Mâlic [19.1.1915] for the Green Box. By selling these he says: "I hope to get enough money to do the complete album. Then I will ask you to have a photograph (in black and white) made of every painting or object of mine you possess. But this won't come before 6 months from now." As it is now impossible to photograph the Large Glass [5.2.1923] which was broken in 1931 while in transit between the Lincoln Warehouse [26.1.1927] and The Haven, where Miss Dreier wished to install it, Dee explains: "I will make an interpretation (for the colours) from the other paintings made for it."

The second idea occupying Dee is to make a "playtoy with the discs and spirals" from *Anémic Cinéma* [30.8.1926]. "The designs will be printed on heavy paper and collected in a round box," Dee writes. "I hope to sell each box 15 francs [50 francs at present values] and many – (each disc is to be seen turning on a Victrola). This second project is less expensive than the other and I am working very seriously at it. Please don't speak of this, as simple ideas are easily stolen."

Following the subletting of the studio at 16 Place Dauphine [12.4.1931] in September, Dee tells Miss Dreier exactly what she owes him for the cost of the removal and storage of the furniture (including "a moth disinfection before springtime").

1940. Tuesday, Paris
In the morning at eleven-fifteen Marcel has an appointment with Roché at Lloyds Bank to sign documents.

1943. Friday, New York City.
Further to Walter Arensberg's enquiry on behalf of a friend who would like to buy a 1914 abstract Picasso, Marcel proposes one belonging to Mary Callery. "I will send a photo," he promises, "if the price $9,000 is (as I think) not too high."

At the same time, Marcel asks Walter if he knows the work of Wilfredo Lam, who had a show recently at the Pierre Matisse Gallery. "Well, he is very much appreciated by Breton who has a few of his large watercolours... and would like to sell one of them for $100 for immediate need of money. Let me know if you want a photo."

1946. Tuesday, New York City
Duchamp and Miss Dreier visit the studio of Burgoyne Diller, an artist whose work stems from the philosophy of Mondrian. They purchase a painting, *Composition*, No.21, and fourteen drawings to add to the Société Anonyme Collection.

1947. Wednesday, New York City
Spends the evening with Maria Martins, Mary Callery, Miró and Kiesler.

1948. Friday, New Haven
To mark Katherine Dreier's seventieth birthday [10.9.1947] and the work she has accomplished through the Société Anonyme [30.4.1920], George Heard Hamilton has organized an exhibition of "Painting and Sculpture by the Directors of the Société Anonyme" at the Yale University Art Gallery. Drawn mainly from the Société Anonyme Collection, Miss Dreier's personal collection, or the artists themselves, each director (Campendonk, Miss Dreier, Duchamp, Naum Gabo, Kandinsky and Man Ray) is well represented. Duchamp has ten works in the show including *La Partie d'Echecs* [1.10.1910] (lent by Walter Pach), which is hung next to *Rotative Plaques Verre* [20.10.1920].

In addition to the exhibition, three lectures are to be delivered during March on the founding of the Société Anonyme. Organized under the auspices of the Thomas Rutherford Trowbridge Art Lecture Foundation, the first lecture entitled "'Intrinsic Significance' in Modern Art" [16.1.1948] is delivered this afternoon at four o'clock by Miss Dreier. (The other two lectures are to be given by James Johnson Sweeney and Naum Gabo.)

For the occasion Miss Dreier has pinned to her dress a beautiful white orchid which Alfred Barr, unable to attend, has sent her.

1957. Tuesday, New York City
While asking his sister Suzanne which photographs by John Schiff she would like and how many, Marcel mentions that he will be speaking soon on French radio one evening, in the programme "Voix de l'Amérique".

1959. Thursday, New York City
After seeing Fawcus the previous day, Marcel tells Roché that Lebel's book is "pleasing and complete". Although his plan is to fly to Europe after the show in honour of the publi-

cation at the Sidney Janis Gallery on 6 April, Marcel says firmly that he has "no intention" of being at La Hune for the presentation of the book in Paris, where the authors, he insists, should be the guests of honour.

1967. Sunday, New York City.
Catching up on some correspondence, Duchamp writes three letters to France.

Thanking Pierre Cabanne for his greetings, Duchamp says that although he wrote in January, their publisher Belfond has not deigned to reply. "Hope all the same that the appearance of the book [25.1.1967]," he declares, "will bring him out of his (pecuniary) silence."

*

"It's possible that this portrait of father by Villon belongs to Dr Robert Jullien," Duchamp tells Mlle Popovitch, who is preparing the exhibition in Rouen [23.2.1967]. If it belongs to his sister Yvonne, it seems unlikely that she will reply. Regarding Suzanne's painting, *Readymade malheureux*, Duchamp doesn't remember signing the loan form: "In any case the picture belongs to Schwarz," he explains, "and you can without fear ask him for it for the show."

*

Thanking Robert Lebel for having obtained the loan of George Washington [21.9.1944] from André Breton for the exhibition in Paris, Marcel writes: "After the defec(a)tion of Mary Sisler [11.2.1967], Dorival had the good idea to give me Raymond Duchamp-Villon – the two of us will barely fill the Paris M.O.M.A. and there will be many spatial silences: Reposing." However, Dorival (who has been criticized in the past for his attitude to Duchamp's work [30.1.1953]) has refused to exhibit the readymades.

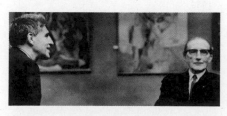

Lebel hopes with Claude Givaudan to engineer an exhibition of the readymades and has also promised Monique Fong that he will try to find a publisher for the essay on Marcel by Octavio Paz [19.1.1967]. Marcel thinks this will be quite difficult, "because the text is too long for an article in a magazine and really

short for a booklet (except in 3 languages)."

Responding to Lebel's request for information about *A l'Infinitif* [14.2.1967], Marcel encloses a clipping from *Art in America* and a copy of "the translation of the torn papers just as it is in the white box".

6 March

1917. Tuesday, New York City
In the evening Marcel visits the Arensbergs and, with Beatrice Wood, they play twenty-one.

1918. Wednesday, New York City
With the Arensbergs, Edgar Varèse, Louise Norton, Roché, Mary Sturges and Yvonne Chastel, Marcel spends the evening at the home of Aileen and Lawrence Dresser, 5 West 16th Street.

1924. Thursday, Paris
At Ruppaley's, a supplier of electrical medical equipment, Duchamp finds and buys a metal stand for the optical machine commissioned by Jacques Doucet [28.2.1924]. Afterwards he goes to Mildé's and makes an appointment to meet the engineer on Saturday at Man Ray's studio.

At midnight Duchamp writes an express letter to Doucet reporting progress. Expecting Mildé's estimate for the globe and other work on the machine early the following week, Duchamp tells the collector: "So I will not be leaving before Wednesday or Thursday and I would like to see you before [then]."

1940. Wednesday, Paris
At eleven o'clock Marcel and Roché meet Peggy Guggenheim at her apartment, 18 Quai d'Orléans on the Ile Saint-Louis, and take her on an expedition to Melun. After showing Peggy *9 Moules Mâlic* [19.1.1915], they have lunch at the Grand Veneur, on the edge of the forest of Fontainebleau not far from Barbizon. It is four o'clock when they start their return journey to Paris.

1964. Friday, New York City
Receives a telephone call in the morning from Louis Carré who arrived in New York the previous day.

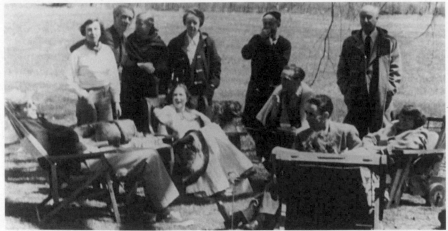

7.3.1957

8.3.1915

7 March

1908. Saturday, Rouen
Opening of the second exhibition of the Société des Artistes Rouennais at the Musée des Beaux-Arts, which includes an important retrospective exhibition of paintings, drawings and prints by the late Emile Nicolle [15.8.1894]. Duchamp-Villon has lent the portrait bust which he made in memory of his grandfather.

Making his début in Rouen, Duchamp exhibits three paintings: *Etude d'Enfant*, *Sur le Balcon* and *Paysage d'Automne*, a study of autumn trees described as "a pretty patch of gold on a blue ground". His two humoristic drawings, *Scène de ménage* and *Femme cocher* [25.5.1907] are deemed "original" by Morel, the critic of the newspaper *Dépêche de Rouen*.

1910. Monday, Paris
At about two o'clock Duchamp calls to see Max Bergmann who, following the recommendation [1.3.1910], signed up that morning for four weeks of art lessons at La Palette. After talking for an hour and a half, Duchamp then takes Bergmann to the opening of the Bonnard exhibition at Bernheim-Jeune, 15 Rue Richepanse.

1926. Sunday, Paris
At ten-thirty on the eve of the sale, Duchamp has arranged a private visit for Jacques Doucet and Henri Pierre Roché to see the exhibition of 80 Picabias at the Hôtel Drouot, which is to be opened to the public in the afternoon.

Later Roché introduces Marcel to Helen Hessel [9.2.1926], who has come with her husband Franz to live at Fontenay[-aux-Roses?] on the outskirts of Paris. Marcel shows them his little red pocket chess set.

1940. Thursday, Paris
After their excursion to Melun the previous day, at eleven Peggy Guggenheim, Mary Reynolds and Marcel visit Roché at 99 Boulevard Arago. Peggy looks at the Brancusis: the marble *Princesse X* and *Eve*, the sculpture carved in oak, which she particularly likes. Roché notices the way she touches the rounded forms at its base. Afterwards they have lunch together at the restaurant Au Rat, 34 Boulevard Saint-Marcel.

1949. Monday, New York City
Writes to Hélène and Henri Hoppenot in Bern concerning his "radiophonic research" for them and about sending them a projector.

Duchamp also replies to Douglas MacAgy's long letter giving him details of the "Western Round Table on Modern Art" [28.2.1949]. Having made enquiries about his flight, Duchamp gives his proposed dates (arriving 6 April and leaving 12 April) and writes: "TWA tell me that I can take the plane back from Phoenix (if I want to see Max Ernst) and stop also at Los Angeles without difference in the price of the ticket." Regarding the programme in San Francisco, Duchamp says: "I will attend all social functions if necessary and avoid them when possible." He also warns MacAgy that when he receives the provisional list of questions, these "may lead to some suggestions" on his part. "I certainly hope to spend a few unofficial hours with you both," Duchamp continues, and mentions that he has just received a letter from the Arensbergs, who are expecting him after the conference.

1952. Friday, New York City
Writes to Miriam and Naum Gabo about the sculpture of Gabo's that he has attempted to sell to collectors in Brazil.

*

As a trustee of the Francis Bacon Foundation, Duchamp gives his written consent for the Annual General Meeting to be held in Hollywood on 14 March.

1953. Saturday, New York City
Duchamp has lunch with Monique Fong (who is on one of her regular visits from Washington) [22.1.1953] and tells her categorically that, regarding MT, she is a fool.

1957. Thursday, New York City
The invitation to the preview of Hans Richter's film, *8 x 8*, in the auditorium of the Museum of Modern Art at eight-thirty, is decorated with Duchamp's Cupid [7.12.1943] and related chess problem. Screened for the benefit of *Film Culture*, the motion picture magazine, *8 x 8*, a chess sonata in 8 movements, is described as "a fairy tale for grownups, mixing Freud and Lewis Carroll with Venice, Venus and Old Vienna".

With the collaboration of Arp, Calder, Cocteau, Max and Dorothea Ernst, and Kiesler, who filmed sequences independently it has taken Hans Richter four years to cpmplete his "new Surrealist film poem".

In Richter's sequence Duchamp is disguised with a long beard and a crown as the Black King; Richard Huelsenbeck in heavy armour as the Black Castle is overcome by the White Queen, Jackie Matisse, until Julien Levy playing the role of the Black Knight shoots her with a bow and arrow, despite Tanguy's presence as the White Knight. This chess fantasy was filmed by Arnold Eagle during the summer of 1952 on Richter's farm in Southbury, Connecticut.

1966. Monday, New York City
Writes to Louis Carré.

1967. Tuesday, New York City
Duchamp receives by post the loan forms for the works he is lending to the exhibition at the Musée des Beaux-Arts, Rouen, which he signs: they are for the charcoal drawing, *Pour une Partie d'Echecs* [15.6.1912], the oil paintings *Femme nue assise dans un Tub* and *Portrait en buste de Chauvel* [2.12.1949], and *Portrait de J. Villon* by Suzanne Crotti, his sister.

8 March

1896. Sunday, Blainville-Crevon (?)
In remembrance of his family, Marcel (who is eight years old) makes a drawing of a cavalryman, unmounted, his horse galloping away. At each corner of the small sheet of paper he writes *La Cavalarie*, and notes in the centre: "NOTA: this image should only go into the hands of the Duchamp family."

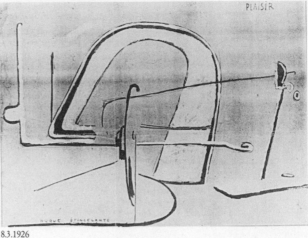

8.3.1926

1915. Monday, New York City
Thanks to his American friend, Walter Pach [19.1.1915], Duchamp is well represented in the "Third Exhibition of Contemporary French Art" at the Carroll Galleries, 9 East 44th Street, which opens today. Five paintings which were shipped by Pottier [7.11.1914] to New York are exhibited: *Portrait* [30.9.1911], *La Partie d'Echecs* [1.10.1910], *A propos de jeune Sœur*, *Broyeuse de Chocolat*, No.1, and *Broyeuse de Chocolat*, No.2.

The study of his thirteen-year-old sister Magdeleine, *A propos de jeune Sœur*, was painted in 1911 at his parents' house in Rouen. Although the seated, red-headed figure with dark shoes and stockings is apparently the main subject of the picture, the flowing lines and shapes of the figure have all been tied to a detail of the chair. Placed exactly in the centre of the canvas, one of these ornate, symmetrical wooden forms, a vertical extension from the front leg of the chair, provides a decorative support between the arm and the seat. In fact it is a chair which appears in other drawings: *Suzanne, assise dans un fauteuil*, dated 1903, and a cartoon entitled *Future Belle-maman*. This intricate detail of the chair is the only "realistic" element in what is an almost abstract painting and is, as such, a forerunner of the brass knob of the banister [1.4.1912] in *Nu descendant un Escalier*, No.2 [18.3.1912] and the attributes of *Jeune Homme triste dans un Train* [17.2.1913].

The two more recent canvases entitled *Broyeuse de Chocolat* are studies for the central mechanism in the lower part of the Large Glass. After planning the whole of the Bachelor apparatus [13.1.1913], Duchamp then concentrated on making studies of each detail [19.1.1915]. The first element he worked on in 1913 was the Chocolate Grinder inspired by the one in Gamelin's shop in Rouen, which fascinated him as a school boy [1.10.1897]. Established since 1835 in the Rue Beauvoisine, north of the cathedral, the chocolate manufacturer reserves one side of his double-fronted shop for the chocolate-making process so that it can be seen from the cobbled street. With the energy generated by the steam engine installed in the basement at the back of the shop, a mill grinds the cocoa beans to a smooth paste. After adding sugar, the mixture is then refined to a smooth, delicious chocolate by the three heavy, drum-like rollers set into the circular basin of the machine. With a burner gently heating the basin from below, the aroma of pure hot chocolate wafts enticingly into the street.

Adding a circular Necktie above the rollers, and a Bayonet, Duchamp then incongruously placed his machine on a Louis XV chassis with three delicately carved legs. Determined to make an image "purified of all past influences", the first painting depicts the machine sculpturally in a very dramatic light: the title and date are printed on a piece of leather and glued to the top right-hand corner of the canvas.

In the second canvas painted in 1914 (which also has its title printed on a piece of leather and glued in the bottom left-hand corner), Duchamp removed all shadows and placed the object on a rich, almost black background made by mixing Prussian blue with a touch of vermilion. While altering the proportions of the machine slightly and making it less squat, the lines of the three rollers are drawn with threads glued to the canvas and sewn at each intersection. "The general effect is like an architectural, dry rendering of the chocolate machine," remarks Duchamp.

"Through the introduction of straight perspective and a very geometrical design... I felt definitely out of the Cubist straitjacket."

1924. Saturday, Paris
In the afternoon at Man Ray's studio, Duchamp meets the man from Mildé's and explains his requirements for the optical machine [6.3.1924]. The engineer promises to deliver an estimate for the work to Duchamp on Tuesday morning and they agree to meet later the same day so that Duchamp can communicate his decision before leaving for Nice.

At five o'clock, after the engineer has left, Duchamp writes an express letter to Jacques Doucet proposing to meet him before his next appointment at Mildé's: "I could meet you wherever you wish on Tuesday from two o'clock. If you would be so kind, I would also like to leave with another two thousand francs in my pocket."

1926. Monday, Paris
At eleven in the morning Duchamp goes to see Roché in Arago; they meet again at the Hôtel Drouot just prior to Duchamp's sale of "80 Picabias", which commences at two in the afternoon. In the preface to the catalogue, Rrose Sélavy announces that it is a "Sale uniting different states of Picabia's work". Describing briefly the various periods represented and citing examples, Rrose Sélavy concludes: "The gaiety of the titles, the collage of everyday objects show [Picabia's] desire to abandon the established church, to remain a non-believer in divinities too lightly created for social needs."

The auction is very well attended: Tzara, Desnos, and Heyworth Mills are among the personalities in the crowd as well as Doucet, Roché and Breton who take the opportunity to buy. Maître Bellier's hammer knocks down the colourful Ripolin canvas, *Les Rochers à Saint-Honorat*, to Jacques Doucet for 4,100 francs. Roché buys six "machine" watercolours and *La Nuit espagnole*, an example of "the Dadaist campaign" painted in 1922. André Breton's purchases include *Procession à Séville*, from Picabia's Orphic period (which was exhibited at the "Section d'Or" [9.10.1912]), *Catch as catch can*, dated 1913, *Prenez garde à la Peinture* from 1919, and two more recent pictures painted brightly with Ripolin: *Les Amoureux* and *Femme à l'Ombrelle*, "full of ironic marks." For 350 francs Duchamp himself buys *Plaisir*, a pastel on cardboard.

8.3.1956

Although Duchamp declares that the financial result is "not important", he is nevertheless on the whole satisfied with the outcome. After the sale he accompanies Mary Reynolds, Roché and Helen Hessel to a café. When Marcel and Mary talk about going on to the Bœuf sur le Toit, home of the painting *L'Œil Cacodylate* [1.11.1921], Roché and Helen decide to hurry back to Fontenay.

1932. Tuesday, Paris
Duchamp receives a cable from Arensberg instructing him to take the Roger de La Fresnaye [the canvas entitled *Nu?*] "at best possible reduction".

1938. Tuesday, Paris
In case André and Jacqueline Breton stop in New York for a few days on their way to Mexico in April, Dee writes asking Miss Dreier when she will be opening The Haven and whether Breton (the author of "Phare de la Mariée" [5.12.1934]) could come to West Redding to see the Large Glass [5.2.1923]. "Would you mind very much having him and his wife come up for tea in the afternoon and show them your collection," he enquires.
Dee also alerts Miss Dreier to his need, as soon as he has found "a real commercial photographer", for "a simple good photograph taken of the glass" sometime during the summer for his "album" [5.3.1935].

1947. Saturday, New York City
Duchamp meets Alfred Barr and Miss Dreier, who has come specially from Milford with a package of drawings, watercolours and prints submitted by Rose Fried for the membership drive of the Société Anonyme [22.2.1947]. The works they select, which include prints by Hayter, Albers and Gottlieb, will be given according to the subscription rate paid by members: $100, $50 or $25.

1948. Monday, New York City
After seeing John Ployardt, a friend of Man Ray's from California, who is opening a gallery in Hollywood with William Copley, Marcel writes to Breton. Ployardt would like Breton's permission to make a de luxe edition illustrated with photographs of his poem, *Union Libre*, and to make a new translation. Requesting his news, Marcel also asks Breton to address him a separate letter for Ployardt quickly.

1949. Tuesday, Washington
Duchamp is invited by Duncan Phillips to visit the Phillips Gallery and select a painting by Arthur Dove for donation to the Société Anonyme Collection.

1956. Thursday, New York City
Addresses a letter to Jehan Mayoux, the author of articles in *Bizarre* Nos 1 and 2 (dated May and October 1955) condemning *Les Machines célibataires* by Michel Carrouges [15.4.1954].
"I am a great enemy of written criticism," writes Duchamp, "because I see these interpretations and these comparisons as an occasion to open a faucet of words. Every 50 years El Greco [11.3.1929] is revised and re-adapted more or less to the taste of the day. It is the same with all works which survive, and this leads me to say that a work is made entirely by those who look at it or read it and make it survive through their acclamation or even their condemnation.
"I refuse to think about the philosophical clichés renovated by each generation since Adam and Eve in all corners of the planet. I refuse to think of it and to speak of it because I do not believe in language, which instead of expressing subconscious phenomena in reality creates thought by and after the word. (I willingly declare myself a 'nominalist', at least in that simplified form.)
"All this twaddle, the existence of God, atheism, determinism, liberation, societies, death etc., are pieces of a chess game called language, and they are amusing only if one does not preoccupy oneself with 'winning or losing this game of chess'. As a good nominalist, I propose the word 'patatautology', which, after frequent repetition, will create the concept of what I am trying to explain in this letter by these execrable means: subject, verb, object, etc."

1961. Wednesday, New York City
Thanking her for dealing with the *Boîte-en-Valise* [7.1.1941] for Rose Fried [19.2.1961], Marcel informs Jackie Monnier that Arturo Schwarz will be coming shortly to collect three Valises from Lefebvre-Foinet in Paris. Regarding the missing items, Marcel suggests: "Leave a black double page so that they only have to be glued when they are printed."
Writes at the same time to Lefebvre-Foinet.

1963. Friday, New York City
"We are very sorry that the change of dates makes it quite impossible for us to go to Pasadena for the opening as we leave N.Y. on May 15th," writes Duchamp to Walter Hopps who needs to postpone the opening until 11 June on account of obtaining loans from Philadelphia.
Regarding Hopps' proposals to make some facsimiles for the exhibition with David Hare's collaboration, Duchamp agrees to four copies of *9 Moules Mâlic* [19.1.1915]: one each for Pasadena, Yale, Stockholm and himself. He agrees in principle to the same proposition for *3 Stoppages Etalon* [19.5.1914], "yet we would have to discuss the method," writes Duchamp, "since the threads are not covered by glass in the original. The canvas support of the threads is pasted on glass and also the 3 rulers made of wood, if only photographed, could not be called 'facsimile'." Concerning the *Rotoreliefs* [30.8.1935], Duchamp explains that he has already started an edition himself which has a black background with a motor for the discs. And finally Duchamp is against making a facsimile of the small glass, *A regarder d'un Œil, de près, pendant presque une Heure* [4.4.1919], "which could only be too far from the original on account of the important breaks which cannot be satisfactorily reproduced."

1967. Wednesday, New York City
Having signed the loan forms the previous day, Duchamp posts them to Mlle Popovitch in Rouen and comments on the latest proposal for the Musée National d'Art Moderne [5.3.1967]: "It now seems that the whole show from Rouen will go to Paris in May – what a family!!"

9 March

1910. Wednesday, Neuilly-sur-Seine
After lunch Duchamp receives a visit from Max Bergmann who has spent the morning working at La Palette. At six they take a walk for an hour and then Duchamp accompanies Bergmann back to Paris.

1918. Saturday, New York City
In the evening Duchamp meets Roché at Miss Dreier's apartment 135 Central Park West and

9.3.1965

together with a friend of Miss Dreier's, they attend a performance of *King*, a comedy by Gaston-Arman de Caillavet, first performed in Paris in 1908. They have supper afterwards at Jack's.

The night is still young: Duchamp and Roché have invitations to a masked ball at Marie Sterner's, where they find the three Stettheimer sisters among the guests.

1919. Sunday, Buenos Aires
Before Yvonne Chastel's ship sails on Tuesday, Marcel writes a letter for her to deliver to Jean Crotti. Although he has tried to dissuade her from leaving, Marcel explains that Yvonne has made up her mind to return to France. With no social life, Marcel says: "I have been able to work a lot... I have plunged into chess. I belong to the club here and spend numerous hours of the day there." As the Cubist exhibition is unlikely to take place [29.1.1919], Marcel plans to return sooner to Paris, probably in June. "I have the impression that this visit will be short," he writes. "I am thinking then to leave again for N[ew Y[ork]."

Thinking of his friend's own experiments with glass, Marcel asks Jean whether he has had the time "to vitrify his imaginations?" And has Suzanne worked? "I am longing to see you all again," writes Marcel, "and all quite changed in 4 years. I have aged a little. I lost my hair a while ago but an energetic treatment by Yvonne and my close-shaven cut seems to have saved it for a while."

In a postscript he thanks Crotti for the books on Cubism [26.10.1918] and says he is "happy that Figuière didn't send others as all these projects to cubify B.A. have shattered..."

1924. Sunday, New York City
The day before the opening of Charles Sheeler's exhibition of works by Pablo Picasso, Marcel Duchamp, Marius de Zayas and Georges Braque at the Whitney Studio Club, Henry McBride announces in the *New York Herald* the "Reappearance of Duchamp's *Nude descending a Staircase*". After the uproar surrounding the canvas [18.3.1912] at the Armory Show [17.2.1913], McBride says that today "it comes quietly and will be viewed quietly. This picture and the others by Picasso, Braque and de Zayas already have the air of classics. They have reticent greys and browns and the whole atmosphere of the rooms has become thoughtful and serious. So much for the process of

time! It is strange how dreadful a mere idea can be to those unaccustomed to ideas, and it is strange how innocent the monster may become when robbed of unfamiliarity."

1926. Tuesday, Paris
Grateful for his support, Duchamp writes to Jacques Doucet thanking him for attending the "80 Picabias" auction the previous day.

1928. Friday, Nice
After receiving a notice of the law-court session from Brancusi, Marcel writes to the sculptor: "I think that you will soon have final news on the trial [25.5.1927]." Saying that he is thinking of returning to Paris around 15 April, Marcel announces two pieces of news: "We won against the Hyèrois [26.2.1928]. Jeanne Léger is here!"

1933. Thursday, Paris
Delighted at the news that a Mrs Glaeser is interested in taking over the lease [13.6.1930] of the double studio apartment at 16 Place Dauphine for a year, at one o'clock in the afternoon Dee sends an express letter to Miss Dreier giving her the address of Mr Brisac [the landlord?]. "The sun shines!" he exclaims, "until Saturday."

1942. Monday, Sanary-sur-Mer
From the Hôtel Primavera, Duchamp writes again to Georges Hugnet in Paris [5.1.1942] thanking him belatedly for paying another quarter's rent [29.9.1941] on his studio at Rue Larrey, which was due on 15 January.

"I went to see Tzara in Aix [26.2.1942]," recounts Duchamp. "Little to eat here but lots of sun... I am trying to finish a box in leather [7.1.1941] – I am still short of the lock and the saddler..."

1944. Thursday, New York City
On receiving a cable from the Cincinnati Art Museum asking for his help in obtaining the loan of *Nu descendant un Escalier*, No.2 [18.3.1912] for their exhibition, "Pictures for Peace," selected works from the Armory Show [17.2.1913], Duchamp sends a telegram to Arensberg stating the museum's request and adds: "I don't want to interfere if you have already made up your mind."

1946. Saturday, New York City
Duchamp meets Kiesler and the accountant Bernard Reis at the Sweeneys'.

1954. Tuesday, New York City
At the height of Senator Joseph McCarthy's drive to eradicate Communism and anti-Americanism from the country, Alfred Barr and James Thrall Soby accompany Duchamp to the office of the Immigration and Naturalization Service at 70 Columbus Avenue to sponsor the petition for his final citizenship papers. Duchamp is told that he will be notified shortly, "maybe a couple of weeks," of the date when he should return for the administration of his Oath of Citizenship.

1957. Saturday, New York City
With James Johnson Sweeney, Duchamp records four minutes for "La Voix de l'Amérique", a programme broadcast on French radio.

*

L'Aventure Dada by Georges Hugnet, published by the Galerie de l'Institut, has on its cover the drawing of the spiral motif and epigraph of *Rotative Demi-sphère* [8.11.1924], which was first published in *391* [2.7.1924] and also decorated the cover of the *Little Review*, Spring 1925.

1958. Sunday, New Haven
Duchamp attends a lecture delivered by George Heard Hamilton and makes an appointment with him, the following week in New York, to go through the first four chapters again of the English translation [26.2.1958] of Robert Lebel's manuscript. Hamilton tells Duchamp that he is "most agreeably surprised" by Lebel's corrections, which he finds "remarkable".

1959. Monday, New York City
Confirming what he said to Roché [5.3.1959], Marcel writes to Lebel: "The whole pleases me greatly and pleases all those who have seen it here." Janis has already organized his "exhibition-presentation" to open on 6 April: "I am really counting on you arriving in time," Marcel tells the author. "Fawcus has seen Wittenborn, Abrams and Graphic Society, all three of which are begging him to let them do the American edition. I am bombarding F[awcus] with incitements to have done with it on the dotted line and he has promised me to have a complete result before returning to France."

1965. Tuesday, Milan
Premiere of Richter's film *Dadascope* at the Galleria Schwarz. Made between 1956 and 1961, this anthology of Dada poems spoken by the authors includes 3 sequences with Duchamp.

10.3.1929

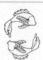

In the first entitled "Carte Postale", Richter uses the images of Duchamp breaking a sheet of glass with a hammer which were shot at 327 East 58th Street [11.12.1956] while, on the soundtrack, Duchamp reads *Rendez-vous du Dimanche 6 février 1916* [6.2.1916].

A dozen aphorisms by Rrose Sélavy spoken by Duchamp accompany "Puns", filmed in Connecticut: Duchamp is seated in a hollow tree in his shirtsleeves, speaks animatedly into a paper loud-hailer held in one hand while gesticulating vigorously to an imaginary audience with the other.

In the sequence entitled "Observations", Duchamp reads three notes from the Green Box [16.10.1934] to the image of coloured string being coiled slowly into a haphazard pile and then slowly uncoiled and lifted away again. The notes are "L'idée de la fabrication…"; "Peinture de précision, et beauté d'indifférence"; and "Etants donnés…"

1967. Thursday, New York City
At five in the afternoon, the Duchamps have an appointment with Monique Fong.

10 March

1918. Sunday, New York City
In the evening a number of friends meet at Marcel's studio before going out to dinner. Roché, who slept late that morning after the masked ball, decides to stay behind alone with the picture that Marcel is painting for Miss Dreier [9.1.1918], which he finds beautiful.

Nevertheless Roché does visit the Arensbergs later, and returns upstairs to Marcel's studio before accompanying Yvonne Chastel back to her small flat at 1 East 56th Street.

1923. Saturday, Brussels
Giving his new address, Duchamp posts a card illustrated with the imposing facade of the Musées Royaux des Beaux-Arts to Picabia [4.3.1923] at the Maison Rose, Le Tremblay-sur-Mauldre.

"I am living at 22 Rue de la Madeleine," he says, "and if you don't write it to 9 of your friends within 24 hours great misfortune will fall upon you…"

1925. Tuesday, Paris
Saying that he is delighted with his results "on paper" at Monte Carlo [3.3.1925], Duchamp tells Jacques Doucet: "I would very much like to see you one afternoon." As he has to go to Rouen on Friday, Duchamp suggests that it would be better to wait until Monday or any day that week to suit Doucet.

1926. Wednesday, Paris
Roché calls to see Marcel at the Hôtel Istria and they review the auction of "80 Picabias" [8.3.1926]. Later after meeting at Le Select in Montparnasse, they visit Pierre Legrain who is to make some frames for the recent pictures by Picabia which Duchamp kept for himself and decided not to put in the sale.

1929. Sunday, Seville
After a few days in Seville [5.3.1929] where Miss Dreier photographed Duchamp in the cloister of the museum (which has a fine collection of pictures by Velázquez, Murillo and Zurbarán), and where they were both photographed with the doves in the Parque Maria Luisa, Juan Martinez drives his party north to the Sierra de Guadalupe in the heart of conquistador country. In this ancient place of pilgrimage, Duchamp, Miss Dreier and Mrs Thayer visit the famous monastery which dominates the village.

1939. Friday, Paris
"The only one amongst the painters and artists from here that has his feet on the ground and his brains in their place," according to Frida Kahlo [3.3.1939], Duchamp has extracted her paintings from customs and ensured their exhibition at Pierre Colle's gallery [7.6.1933]. Breton has nevertheless put his stamp on the show, entitled "Mexique", by surrounding Frida's seventeen canvases with pre-Columbian sculpture, photographs by Manuel Alvarez Bravo and other things which Frida calls "all that junk".

"There were a lot of people on the day of the opening," Frida remembers, "great congratulations to the *chicua*, amongst them a big hug from Joan Miró and great praises for my painting from Kandinsky, congratulations from Picasso and Tanguy, from Paalen and from other 'big *cacas*' of Surrealism…"

1952. Monday, New York City
In the morning Marcel receives a letter from Fiske Kimball saying that the museum agrees to lend *Nu descendant un Escalier*, No.2 [18.3.1912] and *Head of a Horse* by Duchamp-Villon to Sweeney's exhibition, "L'Œuvre du XXe Siècle." Reminding them that nothing of his has been exhibited in Paris and London for over thirty years, Marcel writes again to the Arensbergs [21.2.1952]: "Would it be possible to include the *Mariée* [25.8.1912] oil which I like so much and which is already in Philadelphia." He suggests that as the Museum of Modern Art will be lending *Le Cheval* by Duchamp-Villon, "we could leave the *Head of a Horse* in its stable."

Marcel hopes too, to persuade the Arensbergs to reconsider their decision about the Matisse, Chagall and Metzinger. "This is not an imploring letter," he writes, "but it is an exact translation of my feelings toward an art manifestation worthy of help." If Philadelphia manifests the "rather cautious and indifferent feeling", Marcel hopes that the Arensbergs "will see it from a broader angle". Reminding them that they are still the legal owners of the collection, he argues: "*We* are still capable of human reactions – which is not the case of 'anonymous' museums."

1953. Tuesday, New York City
"I was wondering if you could have your glass reframed in a manner more solid and definitive," writes Marcel to Roché referring to *9 Moules Mâlic* [19.1.1915], which has a frame by Legrain [9.8.1926]. He believes that plastic glues exist whereby the pieces of glass could be stuck together without moving them. Putting the glass face downwards and then removing the metal frame and the back piece of glass, the broken glass would be left exposed enabling it to be cleaned and the pieces glued before covering it again with the glass. Turning the whole thing over, the same procedure would be repeated. The final operation would be to cement the three pieces of glass together in the metal frame with a special mastic. "Leave the mastic to dry several months," recommends Marcel, "without moving the glass."

1957. Sunday, New York City
Thanking Henri Marceau warmly for sending the documents to him for Lebel [20.2.1957] Duchamp adds: "Obviously I am wondering in what state this *Boîte de 1914* must be," and says he will ask to see it one day, "if it is not too difficult to find in the numerous papers of the Arensberg Collection."

10.3.1968

Informs Roché of his plans to fly to Houston on 2 April followed by a trip to Mexico, and tells him about the interview with Sweeney recorded the previous day: Crotti may know the day it is to be broadcast [5.3.1957].

1959. Tuesday, New York City
Unsure which edition of the *Boîte-en-Valise* [7.1.1941] he gave her [2.7.1943], Marcel writes to Kay Boyle at Rowayton to enquire whether she has an original one in a leather valise, because the Rose Fried Gallery is interested in purchasing it. "You can telephone me in the morning," adds Marcel, "not too early."

1961. Friday, New York City
The day of the opening of the exhibition, "Bewogen Beweging," at the Stedelijk Museum in Amsterdam, Duchamp receives a telegram from Daniel Spoerri [17.12.1960]. He is advised that the chess game organized with Euwe for the show is a great success, the newspaper, *Het Parool*, is publishing the game that he has agreed to play against three young champions, and that the draw has decided that Amsterdam commences with white; their first move is E2E4 and they are awaiting his response by return.
In reply Duchamp cables white's first move followed by his own: 1E2E4C7C5.
"Will you please ask my three opponents," writes Duchamp in a letter to Spoerri, "if I may also have two friends to play the game with me and also I hope that I am not dealing with *great* champions!" After requesting Spoerri to send him some details about the exhibition, in a postscript Duchamp suggests how the correspondence by cable can remain extremely simple, even when chesspieces are captured, by indicating only the two squares forming the move.
In order that the public can follow the game, a giant chessboard has been hung vertically on a wall in the exhibition, upon which the chessmen will be moved each day.

1963. Sunday, New York City
"Our voyage in Italy is taking shape," writes Duchamp to Baruchello, the young artist who, just six months ago, appeared out of the blue in Milan [12.9.1962]. Outlining their plans to spend two weeks in Sicily, with a few days in Rome and Naples beforehand, and a couple of days in Rome on their return, Duchamp enquires: "Will you be in Rome at these times (20–23 May and

10–12 June)? We would have great pleasure in seeing you and following your advice for a rapid visit (a medium hotel, central, etc.)."

*

In the evening Duchamp speaks on the radio, and Teeny's son Peter, who is helping to make a set of black, motorized backgrounds [8.3.1963] for a new series of *Rotoreliefs* [30.8.1935], comes to dinner at 28 West 10th Street.

1968. Sunday, Buffalo
Duchamp attends the first performance of *Walkaround Time*, a ballet with choreography by Merce Cunningham, which has been programmed in the second Festival of the Arts Today. The music *...for nearly an hour...* is by David Behrman, played by the composer with John Cage, Gordon Mumma and David Tudor; the décor after the Large Glass is by Jasper Johns. Starting at eight-thirty in the Upton Auditorium at the State University College, *Walkaround Time* is preceded by a performance of *Winterbranch*, a ballet to music by La Monte Young with costumes by Robert Rauschenberg.
After the performance, Duchamp is persuaded to take a curtain call with the dancers. Linking hands in front of the plastic boxes imprinted with the motifs of the Large Glass (the Milky Way and the Bride suspended as he suggested [3.3.1968]), Duchamp stands between Merce Cunningham on his left and Carolyn Brown on his right. "I remember seeing Marcel Duchamp," said Cunningham later, "coming up to the stage, eyes bright, head up, none of that looking down at the steps. He walked to the centre... and held our hands, bowed and smiled as though he were greeting guests. He was a born trouper."

11 March

1919. Tuesday, Buenos Aires
After accompanying Marcel to Argentina [14.8.1918], Yvonne Chastel sails for France, taking with her a letter from Marcel to Jean Crotti [9.3.1919], her ex-husband [8.1.1918].

1924. Tuesday, Paris
After receiving Mildé's written estimate [8.3.1924] in the morning, Duchamp consults

Jacques Doucet before going to Mildé's at five o'clock to discuss it. The engineer is not surprised that Doucet has rejected the estimate. He explains that the mould to make the glass globe for the optical machine alone costs 300 francs [1,200 francs today], and each cast 100 or 150 francs, and that he will need special fibre gears, etc. Duchamp cuts him short, declaring that the maximum sum available to cover all the work is 2,500 francs [10,000 francs at today's value]; no doubt a glass globe, available commercially, could easily be adapted for their needs, and a belt-drive system would avoid a costly system of gears. It is left that if a way can be found of bringing the estimate within the budget, the engineer may contact Duchamp, but without any commitment by either party.

1927. Friday, Paris
A week after his return from New York, Marcel has an appointment at four-thirty to see Roché in Arago.

1929. Monday, Guadalupe
After an overnight stop, Miss Dreier, Duchamp and Mrs Thayer are driven to Toledo via Talavera la Reina, which is famous, Miss Dreier notes, "for its ancient potteries and silk weaving."
At Toledo, the adopted city of El Greco, they visit the ancient chapel: Christo de la Luz. When Alfonso VI entered the city, the horse of the Cid, first governor of the Alcazar who

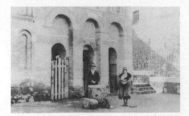

was accompanying the King, suddenly fell to its knees before the wall of the chapel, refusing to advance any further. At that place, inside the wall of the building, a Christ still illuminating a Visigothic lamp was discovered.

1931. Wednesday, Nice
On the first day of the second International Chess Tournament at Nice [23.2.1930], which is being played in private club rooms at 15 Rue de Russie, Duchamp draws his game against Znosko-Borovsky.

12.3.1910

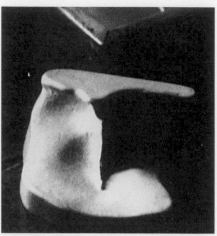

12.3.1951

1933. Saturday, Paris
Dee is due to meet Miss Dreier, who has been endeavouring to sublet her double studio apartment at 16 Place Dauphine [9.3.1933].

1936. Wednesday, Paris
Soon after his return from a visit to London [19.2.1936] with Mary Reynolds, Marcel meets Roché and tells him that *Glissière contenant un Moulin à Eau en Métaux voisins* [11.12.1919], which belonged to the late Jacques Doucet, has been sold by Madame Doucet to Louise and Walter Arensberg.

1941. Tuesday, Paris
After receiving a telephone call in the morning from Georges Hugnet and accepting an invitation to lunch with him on Friday, Duchamp suddenly remembers that he already has an engagement for lunch that day. "I must have still been asleep," writes Duchamp hastily to Hugnet at eleven the same morning. "Would you like to postpone our rendezvous until Saturday?"

1950. Saturday, Milford
Miss Dreier is expecting another visit from Dee to continue their work on the Société Anonyme catalogue [4.3.1950].

1957. Monday, New York City
On Sunday, while the painting was being prepared for Budworth to collect from the Guggenheim Museum, the *Nu descendant un Escalier*, No.2 [18.3.1912] was slightly torn. Examining it with the picture restorer Sheldon Keck, Duchamp finds that the damage is not serious: there is a thin tear about an inch long in one of the dark areas of the picture and some of the paint is missing. Keck assures Duchamp that it can be restored invisibly, but meanwhile, so that the painting can be sent to Houston with the rest of the "Three Brothers" exhibition [19.2.1957], he proposes making a temporary repair.

12 March

1910. Saturday, Paris
A drawing by Duchamp entitled *Le Maestro dans ses Œuvres* is published in *Le Courrier Français*. In domestic surroundings a violinist plays for a man and woman; the caption reads "...pour mourir dans un pianissimo" [...dying away in a pianissimo].

1915. Friday, Paris
Replying to a letter from Walter Pach, Duchamp confirms that he received the newspaper clipping reproducing one of his drawings (*Vierge*, No.1 [7.8.1912], exhibited in December 1914 at the Carroll Galleries in the "First Exhibition of Works by Contemporary French Artists"?) and a copy of Pach's catalogue for the Matisse exhibition at the Montross Gallery.
"Here the war goes on and on," writes Duchamp gloomily. The news of Villon at the front, however, is good: "He astonishes all of us by his endurance." Unable to share the current optimism of a decisive outcome in the spring offensive, Duchamp remarks: "I remember too well the same confidence in the month of August and all I see is badly regulated civilian imagination."
Since his last letter to Walter Pach [19.1.1915], Duchamp has spent a fortnight in Rouen with his family "for a change of air": although in the capital there is hardly any impression of war, it is quite the contrary in the provinces. Often visiting the Duchamp-Villons who are both still working at the hospital in Saint-Germain-en-Laye, Duchamp says, when they play poker together "we believe we are really far from events". Gaby Villon and Suzanne are delighted with their work as nurses at the Hôpital des Jeunes Aveugles, situated on the Boulevard des Invalides at the corner of the Rue de Sèvres.
Since returning from Rouen, Duchamp has been working hard to finish his two small studies on glass (one of the Malic Moulds [19.1.1915] and the other of the Glider), and preparing the upper part of the Large Glass. "I am particularly pleased to finish these few small things before starting another part," he writes.
Admitting that he is not in touch with artistic life in Montparnasse, Duchamp says that he has no news of Picasso, Braque and Derain either. On the other hand, he tells Pach: "I absolutely must go to see Brancusi."
Duchamp asks after Mrs Pach and their son Raymond: "Fortunately for him, he won't remember the bad times that witnessed his birth." Promising to write more often, Duchamp fears that, because of the German submarines, his letter will take a long time to reach Pach in New York.

1924. Wednesday, Paris
Duchamp reports to Jacques Doucet on his meeting at Mildé's the previous day. "I see perfectly now," writes Duchamp confidently, "that on my return it will be easy for me to direct operations and that you will be as satisfied as me with the machine."

1928. Monday, Nice
"I have been going to the Post Office almost every day expecting to get a letter from you," writes Dee to Miss Dreier. "Anyway I just weighed myself, the result being a gain of 4 pounds in 2 months. I needed them very badly." Now that he has obtained his divorce [25.1.1928], Dee is living "bachelorly" in Nice and admits: "I enjoy every minute of my old self again." As his ex-wife Lydie is still in Saint-Raphaël, they see each other "every other week".
Acknowledging Miss Dreier's recent payments to his bank in New York, Dee declares: "I am living quite cheaply here – and don't seem to care what is going to happen after September." He is playing a lot of chess and, mentioning his success at Hyères [2.2.1928], says: "Chess is my drug, don't you know it!"
Dee is concerned that he has had no news of either the Dreier–Eilshemius shipment [15.1.1928] nor his shipment of Picabias to Stieglitz [15.1.1928]. As he does not intend returning to Paris until 15 April, he requests Miss Dreier to write directly to Nice, and signs, "*affectueusement*, Dee (Vorced)."

1930. Wednesday, Nice
"I hope you are enjoying your trip to Germany," writes Dee to Miss Dreier, telling her that, following the chess tournament [23.2.1930], he is returning to Paris on 18 March. He hopes to see her after Munich: "Let me know in Paris when you arrive so that I can meet you at the station."

1931. Thursday, Nice
In the second round of the International Chess Tournament, Duchamp plays against Dr A. Seitz and resigns after the twenty-second move.

1935. Tuesday, Paris
Duchamp's letter is forwarded to André Breton in the Gers, where he is staying with Max Ernst at the Château de Pouy near Auch. Having received from Salvador Dali a contribution of 250 francs to printing the bulletins [intended for

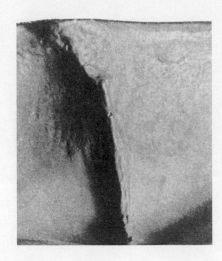

12.3.1957 12.3.1959

the "Cycle systématique de conférences sur les plus récentes positions du surréalisme"?] which he has given to the printer, Duchamp asks Breton what he is to do about the 650 francs still owed, and enquires where to deliver the order.

1937. Friday, Paris
In his second contribution to *Ce Soir*, Duchamp has chosen one of the 80 chess problems devised by the ex-champion of France, André Chéron [12.9.1927], which have been published by Payot, Lausanne: *Miniatures stratégiques françaises*. He comments on a game played at a recent tournament in Stockholm between R. Fine and S. Landau illustrating the Slav Defence, and reminds his readers of the events celebrating the 10th anniversary of the Echiquier Russe Potemkine, one of the strongest chess clubs in Paris.

*

Open from five o'clock until the early hours of the morning, at the Bar La Cachette, 150 Avenue Emile Zola, is a small but unusual exhibition organized by the magazine *Orbes* presenting works by Duchamp, Francis Picabia, Camille Bryen, Jean van Heeckeren, Jacques-Henry Lévesque and others. A set of Duchamp's *Rotoreliefs* [30.8.1935] are revolving silently in a corner, and the Bride of the Green Box "spreads her virginity" in a vitrine. At nine o'clock an orchestra of the best hot jazz musicians in Paris starts to play and "the public, caught in the crossfire, could only be disappointed for want of space". The line up is Philippe Brun on trumpet, Alix Combelle on tenor-sax, Pierre Fouad on drums, Stéphane Grappelli on violin and piano, and Jerry Mengo on drums, etc., etc.

*

In the evening at eight o'clock, a great crowd has gathered in the hall lent by Les Amis du Populaire, 14 Rue Magellan, to watch the Grand Master Dr O. Bernstein playing 58 simultaneous chess games which Duchamp is reporting for *Ce Soir*. Organized by the Fédération Sportive et Gymnique du Travail, the event is attended by M. Léo Lagrange, Ministre des Sports et Loisirs, who makes a speech. Playing rapidly, in four and a half hours Bernstein obtains the "marvellous result" of 45 games won, 5 lost and 8 drawn.

1951. Monday, New York City
On the deck of the *De Grasse*, Duchamp, wearing a broad-rimmed felt hat, is photographed

with the Man Rays and Bill Copley [9.5.1949] by Gloria de Herrera. Duchamp has come to bid farewell to Man Ray, who has decided to leave Hollywood and return to live in Paris.

In the privacy of Man Ray's cabin, Duchamp presents his old friend with a parting gift: *Feuille de Vigne femelle* made of galvanized plaster, resembling an imprint of the human vulva.

1952. Wednesday, New York City
In the morning after receiving a letter from Mary Dreier reporting on her sister's health, Dee sends Miss Dreier some news of the show at the Rose Fried Gallery [25.2.1952]: a Villon has been sold and some orders have been taken for the *Boîte-en-Valise* [7.1.1941]. "All in all that exhibition is very satisfactory in many aspects," Dee writes, "and the people, in general, see it as it was intended to be."

1955. Saturday, New York City
"I hope to see Beatrice very soon – and won't speak to her about the cover of her catalogue," writes Duchamp to the director of The American Gallery in Los Angeles, who is organizing an exhibition of Beatrice Wood's pottery. Enclosing one of the *Rotoreliefs* [30.8.1935] – a goldfish turning in a glass bowl – Duchamp adds: "Please reproduce the design in black and white or in colour if you think it fit for the catalogue."

1957. Tuesday, New York City
After inspecting the damage to *Nu descendant un Escalier*, No.2 [18.3.1912] the previous day, Duchamp reports in writing to Henri Marceau at Philadelphia.

*

"Djuna Barnes has asked me to help her dispose of the M[anu]s[cript] writings of Baroness von Freytag-Loringhoven," Duchamp tells George Heard Hamilton. Explaining that Djuna would like to will them to Yale with some of her own manuscripts, Duchamp asks George, if he thinks this is feasible, to give him the name of the curator at Yale to whom Djuna can write directly about the gift.

One of the most colourful and genuinely eccentric artistic personalities in New York during the First World War and in the early twenties, Elsa (Baroness) von Freytag-Loringhoven worked, according to Jane Heap, "unhampered by sanity." Elsa described Duchamp, not only in her poems [11.8.1918] and paintings (often on celluloid), but also in fantastic sculptures. A looped assemblage of lead drainage pipes standing vertically in a mitre box, entitled *God*, may have been among them. A beautiful object by Elsa, *Portrait of Marcel Duchamp*, photographed for posterity by Charles Sheeler, was published in the Winter 1922 issue of the *Little Review*: standing on a saucer, a long-stemmed glass overflows with an assortment of feathers and small toothed wheels and springs plundered from unknown mechanisms. Rising from the centre of this strange bouquet is a slender rod, upon which a few additional tiny pieces have been skewered or entwined.

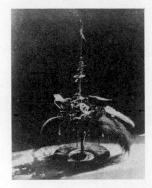

1959. Thursday, New York City
At Richard Hamilton's request Marcel sends about a dozen photographs which he has been busy collecting to illustrate the typographic version [29.1.1959] of the Green Box [16.10.1934]. Arnold Fawcus [9.3.1959] has promised to supply a photograph of the *Moulin à Café* [20.10.1912] on his return to Paris early in April.

Having identified the Louis XV leg of the Chocolate Grinder for Richard which he was looking at upside down, Marcel declares: "Everything else seems in perfect order of march and I have no suggestion to make except that I would prefer to leave the binding as you planned it: 'The Bride...' drawn in white dots with a superimposition of black dots on a green background and forget about my designing anything for it."

13.3.1943

1962. Monday, New York City
On hearing from Lefebvre-Foinet that Jean Larcade [2.8.1961] has collected another copy of the *Boîte-en-Valise* [7.1.1941] from him, Duchamp writes agreeing to the conditions but advises Larcade that he has decided to increase the price. "These Valises are starting to draw towards the end of the 300 (original edition) and it seems to me quite fair that we benefit a little after twenty years of twiddling thumbs." Requesting payment in September when he plans to be in Paris, Duchamp adds: "Be kind enough to confirm your decision."

13 March

1917. Tuesday, New York City
John Covert, Secretary of the Society of Independent Artists [5.12.1916], has called a meeting of the directors at four in the afternoon at Walter Arensberg's apartment, 33 West 67th Street. Termed as "a very important meeting", the subject of the reunion is undoubtedly arrangements for the exhibition which is due to open on 9 April.

1925. Friday, Paris
After an appointment at eleven-thirty with Roché who has just returned from New York, Marcel goes to Rouen for twenty-four hours.

1929. Wednesday, Toledo
On the next stage of their journey from Gibraltar [23.2.1929], Juan Martinez drives Duchamp, Miss Dreier and Mrs Thayer from Toledo to the Savoy Hotel in Madrid, where they plan to stay six days.

1931. Friday, Nice
In the third round of the International Tournament, Duchamp resigns his game against A. Baratz [19.12.1927], member of the Echecs du Palais Royal, who held the title in 1926, and was the winner of the Paris tournament in 1927.

1937. Saturday, Paris
To celebrate the tenth anniversary of the Echiquier Russe Potemkine, at two in the afternoon at the Grand Véfour, Palais Royal, S. Tartakover plays ten simultaneous games of

chess blindfold. As Duchamp reports later in his column for *Ce Soir*, the Grand Master wins six games, loses three and draws one.

1943. Saturday, New York City
"15 Early 15 Late Paintings," an exhibition organized at short notice by Max Ernst's son, Jimmy, opens at Art of this Century [5.1.1943]. Although the other artists are represented by both an early and a late work, just an early canvas by Duchamp is hung: *Jeune Homme triste dans un Train* [17.2.1913] from Peggy Guggenheim's own collection [20.10.1942].

The exhibition replaces one based on the magazine *VVV* organized by André Breton which was cancelled when Breton insisted that an advertisement for Art of this Century in *VVV* should be paid for and Peggy Guggenheim refused. Edited by David Hare with Breton and Max Ernst as editorial advisors, the first issue of *VVV* appeared in June 1942 with a cover by Max Ernst.

In the current number entitled "Almanac for 1943", it is Duchamp, now the third editorial advisor, who has designed the cover. On the front, overprinted with the title of the magazine, Duchamp has used a readymade print, *Allegory of Death*: a "bizarre horseman", armed with a scythe, wears a doublet decorated with the stars and stripes; his mount has the characteristics of both a globe and a horse, incorporating the sun above it and a crescent moon below.

The back cover has been fashioned with the assistance of Frederick Kiesler: a female torso in profile, drawn by Duchamp, has been cut

out and wire netting inserted in the opening. On the last page, opposite the inside back cover, there is a photograph of Peggy's daughter, Pegeen Guggenheim, showing readers how to perform the "Twin-Touch-Test": "Put the magazine flat on the table, lift back cover into vertical position, join hands on both sides of the wire screen towards you."

Twin-Touch-Test

Inside Duchamp has contributed a version of his rebus, *Nous nous cajolions* [22.11.1939], redrawn especially for this publication.

1957. Wednesday, New York City
Requests Roché in Paris to deposit Richter's piece of film [24.12.1956] with Carl H. Strauss at 22 Place Vendôme.

14 March

1895. Thursday, Blainville-Crevon
At ten o'clock in the evening Lucie Duchamp gives birth to a daughter, Marie Madeleine Yvonne, her sixth child.

1931. Saturday, Nice
In the fourth round of the International Tournament, Duchamp plays against Sir George Thomas and resigns after the 27th move.

1952. Friday, Hollywood
With Duchamp's written consent [7.3.1952], the Annual Meeting of the Active Members of the Francis Bacon Foundation is held in the morning at eleven. The president announces that Duchamp's term of office as an Active Member [30.6.1950] will terminate with the adjournment of the meeting; Mrs Carol Baker is nominated and subsequently elected to succeed Duchamp.

1958. Friday, New York City
Informing Robert Lebel of his visit the previous Sunday to New Haven and his concern

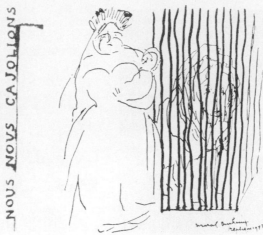

about the unsatisfactory terms of the contract between Fawcus and George Heard Hamilton for the English translation of Lebel's text [26.2.1958], Duchamp says that he is writing to Fawcus by the same post requesting him to make a definite refusal to the previous translator by registered post. Since the publisher is promising that the French edition will appear in June, Duchamp has also asked to see the proofs of the photogravure. If Lebel has spoken to Fawcus about Braziller [21.2.1958], Duchamp says he could see Braziller again and try to get a contract signed for the English edition. When Bill Copley returns to New York on 19 March, Duchamp will see that the legal contract with Hamilton is tied up and that payment is made to Fawcus if the photogravure is more than just begun.

*

In the evening at 327 East 58th Street, while Teeny is writing to her daughter Jackie, she hears the door bell ring: "Here comes Marcel now, he always rings three times."

1963. Thursday, New York City
In great demand at the moment, which Teeny believes is a stimulant for him, Duchamp speaks again on the radio [10.3.1963], something he enjoys doing.

15 March

1912. Friday, Neuilly-sur-Seine
On receiving three canvases from his sister Suzanne in Rouen which are destined for the Salon des Indépendants, and having looked at them, Marcel writes encouragingly to her. Remarking that compared to her earlier paintings the drawing is "more hidden beneath the colour harmonies", he agrees with her that the colour relationships in her portrait, for example between the blue background and the pink blouse, interest her as such and not in order to create atmosphere. "But I believe that the relation from colour to colour, because it is only optical, expresses the artist less than the drawing," Marcel writes, citing the Impressionists as an example.

In her portrait and in the painting of her sisters, "there is composition and drawing," he explains, "these are your qualities, I believe,

and you will inevitably develop them." Stating that "there is no plastic difference between the drawing on paper and the painting on canvas", Marcel declares that whether made with colours or in a harmony of black and white (also colours), this harmony is "fundamental". He asks her not to take these comments as advice: "It's only what I was thinking in front of your canvases."

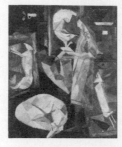

As he has learned from Charly, Suzanne's husband [24.8.1911], that she plans to come to the opening on Tuesday, Marcel promises to collect her invitation cards and send them to Rouen. He plans to deliver the paintings to the Quai d'Orsay on Sunday morning.

1916. Wednesday, New York City
"Do you know we are going to have an exhibition on the 1st of April at Bourgeois Galleries," writes Duchamp to John Quinn. "There will be some paintings by Seurat, Cézanne, Van Gogh, Rouault, Dufy, Villon." Wanting a sculpture by Duchamp-Villon to be included, Duchamp asks Quinn whether he would agree to lend *Femme assise*, either the plaster or the bronze [24.8.1915]. "I work very much, for the present," Duchamp adds, inviting the collector to his studio at 1947 Broadway to see what he is doing.

1917. Thursday, New York City
In the afternoon at two, Duchamp, Roché, de Zayas and Beatrice Wood attend a lecture given by the actor and writer, Jacques Copeau, founder with André Gide and Jean Schlumberger of *La Nouvelle Revue Française*, and also founder with a group of young actors of the Compagnie du Vieux-Colombier.

1923. Thursday, Brussels
While Lucie Duchamp in Rouen is writing to Miss Dreier that she has seen Marcel

[4.3.1923] and finds him in better health and stronger, although she anxious that he finds some work and settles down, Rrose Sélavy writes from the Taverne Royale to the Stettheimer sisters.

Having seen the gallery in Paris in Rue des Pyramides, Rrose cannot recommend it to Florine, but Albert and Juliette Gleizes have promised that Florine's painting, *Asbury Park South* (a souvenir of 4 July 1920), which was exhibited in the Salon d'Automne, is being sent back to New York. "I spent a few days in Rouen," writes Rrose, "a few others in Paris (quite dreary) and I am here hunting for a possible job…"

Rrose threatens to send the sisters some postcards of the Grand'place and the Church of Sainte-Gudule, and requests "indolent" Ettie to recount how New York is without her. "Of you three," conjectures Rrose, "I believe that it is Ettie I will see the first in Paris this summer…"

1927. Tuesday, Paris
Just before noon Marcel has arranged to meet Roché and have lunch with him at the Restaurant l'Ermitage, 4 Rue de Quatrefages, just around the corner from 11 Rue Larrey.

1931. Sunday, Nice
In the fifth round of the International Tournament, Duchamp resigns his game against J. Mieses.

1945. Thursday, New York City
From five-thirty until seven, the editors of *View*, Charles Henri Ford, Parker Tyler and John Myers, give a cocktail party at 1 East 53rd Street. Their guests are invited to meet Duchamp, the subject of a special issue of the magazine which has just been published.

The cover itself is by Duchamp, the result of an ingenious "bricolage" with a bottle of Bordeaux [11.1.1945], the content of which was enjoyed beforehand at a dinner one evening with André Breton. For the background, Duchamp used complex, inventive operations, including those with little half-tone screens, to create the desired effect of outer-space. Labelled with a page from his Livret Militaire,

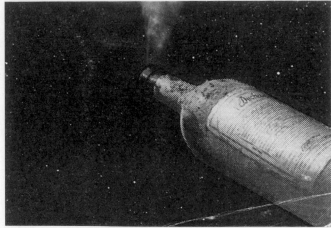

15.3.1945

the vessel is more futuristic than the *Rochambeau* [6.6.1915] to blast Duchamp from the Old World across the Milky Way to the New!

On the back cover is a message composed in letters of various sorts and sizes: "Quand la fumée de tabac sent aussi de la bouche qui l'exhale, les deux odeurs s'épousent par infra-mince." [When the tobacco smoke also smells of the mouth which exhales it the two odours are married by infra-thin.] Does the smoke from the bottle also smell of the wine?

In his introduction entitled "Testimony 45" (which is followed by the first publication in English of "Phare de la Mariée" [5.12.1934]), André Breton declares that since the Large Glass [5.2.1923], Duchamp's interventions "continue to bear witness to the absolutely exceptional span of his imaginative compass and mark his unshakable fidelity to the sole principle of *invention, mistress of the world.* I say that Marcel Duchamp's journey *through the artistic looking-glass*, determines a fundamental crisis of painting and sculpture which reactionary manoeuvres and stock-exchange brokerages will not be able to conceal much longer."

James Thrall Soby contributes an essay, "Marcel Duchamp in the Arensberg Collection," and although he does not mention it in his text, on page 36 together with *Air de Paris* [27.12.1919] and sentences by Rrose Sélavy [10.7.1921], appears *Apolinère enameled*, an unexhibited, unpublished readymade dated 1916–1917. Using a small publicity panel of a young girl painting a bedstead, with the wording "Sapolin enamel paint, manufactured by Gerstendorfer Bros.", Duchamp made a sign for Guillaume Apollinaire. Obliterating certain letters and adding others, the name of the

paint becomes the name of the poet:
 -APOLINèRe ENAMELed
and the name of the company becomes a poem:
 -ANy -ACT-RED BY
 hER-TENOR-Epergne
which translated literally into French becomes: "N'importe quel acte qu'elle lit, contenu surtout," and the homophone of it re-translated reveals this erotic message: "Any act, any bed, cunt held above all."

In this issue there is also an English translation of Gabrielle Buffet's essay "Cœurs Volants" [16.8.1936]; an extract from "Rrose Sélavy" by Robert Desnos [1.12.1922] illustrated with a drawing by Max Ernst, *Le Marchand d'Ucel (C'est la Vie)*; an article by Harriet and Sidney Janis, and one by Nicolas Calas. Between *A Watch-case for Marcel Duchamp* by Cornell, Florine's double portrait [24.10.1926] and Ettie's poem [30.7.1922] on one side, and some Duchampiana by Man Ray, Robert Parker, Julien Levy, Henrie Waste [9.6.1921] and Mina Loy on the other, is the central six-page spread designed by Frederick Kiesler.

emeritus
for chronic diseases of the Arts

Finding that "there seems to be a definite though unintentional correlation between the daily utilities of the artist's environment and the inner structure common to all his work", Kiesler illustrates his ideas in a *Poème Espace* dedicated to "H(ieronymus) Duchamp". The unfolding triptych is based on three photographs of the 14th Street studio [11.1.1945] upon which several works by Duchamp are cleverly superimposed. The text running across these three panels, "Du mirage des réseaux circonflexes en peinture / du mirage de la cédille aux échecs – Fous, Cavaliers et Rois – Marcel D. né 1887 artiste-inventeur – R. Roussel né 1877 artiste-inventeur," links Duchamp directly with Roussel [1.12.1932] whom Tartakover described as the "author of many strange works, the powerful fantasy of which is based particularly on a new conception of movement".

1949. Tuesday, New York City
"I have no photograph of the glass before it was broken, at hand," writes Duchamp to Katharine

Kuh who has requested one for the exhibition catalogue of the Arensberg Collection (even though the Large Glass no longer belongs to it [5.2.1923]) which is to be shown in the autumn at the Art Institute of Chicago. He suggests working from a good reproduction in *Art News*: "Miss Dreier has it," he explains, "and will let me photograph it… Can you wait 2 weeks?"

1952. Saturday, New York City
Telling Roché of the success of the Duchamp family exhibition [25.2.1952], Marcel announces his intention of making 25 copies of the *Boîte-en-Valise* [7.1.1941]: "I hope to be rid of them quite quickly, if so I will have 25 more made and at that time we could consider leaving one on deposit with Mme Collinet and one with Gheerbrandt." Disliking the system of sale or return, especially as the dealer's price for the Valise is only $70, Marcel says: "I find that the dealer can take this risk instead of me…"

*

"Enclosed the result of my squeezed lemon," writes Duchamp to Marcel Jean [9.10.1937], the artist, who has embarked on the task of writing a history of Surrealism. Inviting him to pose other questions, Duchamp remarks: "Yet it is curious to notice how frail memory is, even for the important periods of life. Moreover that explains the blissful fantasy of history."

Among his replies, Duchamp states that he doesn't think Erik Satie was with him, the Picabias and Apollinaire when they saw *Impressions d'Afrique* [10.6.1912]; that he never went to Munich before 1912 [21.6.1912]; that in Munich he "saw lots of reproductions in shop windows of Kandinsky and the French Cubist group"; "The Jura–Paris Road" [26.10.1912] was written after Munich "because the title was suggested by a voyage with Apollinaire, Picabia and Gabrielle Picabia after the Section d'Or [9.10.1912]"; that the "canvas *Mariée* [25.8.1912], given to Picabia in 1912, was sold later (or exchanged) to Eluard… Eluard exchanged it for a canvas belonging to Breton – who sold it to Julien Levy, who sold it to Arensberg in 1935, 36 or 37"; that he arrived in New York on 15 June 1915; that he met Man Ray as soon as he arrived in New York; that Man Ray made the photograph for the label of *Belle Haleine, Eau de Voilette* [6.2.1930] and did the lettering; that he and Man Ray made the single issue of *New York Dada* [8.2.1921], and together built *Rotative*

Plaques Verre [20.10.1920]; that *Tu m'* [8.7.1918] was his last painting on canvas and is "a dictionary of the main ideas of the years preceding 1918 – Readymades [15.1.1916] – *Stoppages-Etalon* [19.5.1914], tear, bottle-brush, cast shadows, perspective"; that his "readymades were exhibited in the umbrella stand at the exhibition entrance" in the Bourgeois Galleries [1.4.1916]; that Rrose Sélavy appears for the first time in *L'Œil Cacodylate* [1.11.1921]; that three of his paintings were included in "L'Epoque héroïque du Cubisme" at the Galerie Jacques Bonjean [23.4.1932]; that Ratton kept the door for *Gradiva* [18.4.1940] in his garage for a long time before, by common consent, it was destroyed; and that *Anémic Cinéma* [30.8.1926] was shot at Man Ray's studio.

1964. Sunday, New York City
Duchamp is one of the thirty-one guests invited to a meal by the maker of "tableaux-pièges", Daniel Spoerri [10.3.1961]. The places set at the table are identical, but transformed by each guest while eating and the end result is exhibited at the Alan Stone Gallery. When Duchamp leaves the table, beside his rather messy plate is a coffee cup and saucer with a spoon, another small spoon lying on the table, three wine glasses, a crumpled serviette and two ashtrays, the smaller one containing the stub and ashes of his cigar.

As well as "31 Variations on a Meal", Spoerri realizes one of Duchamp's ideas for a readymade, that of using a masterpiece on canvas as an ironing board. The resulting assemblage in which *Mona Lisa* is incorporated rather than a Rembrandt, Spoerri puts into the category: "piège à mots" [word trap].

1966. Tuesday, New York City
With John Cage, who dines and plays chess at 28 West 10th Street every week, the Duchamps attend a performance of the Japanese Bunraku Puppet Theatre. Also in the audience the same evening are Arakawa [4.1.1966], Jasper Johns, Susan Sontag and Yoshiaki Tono.

16 March

1910. Wednesday, Paris
At six in the evening Duchamp calls for Max Bergmann at his new address, the Hôtel des Mines, 125 Boulevard Saint-Michel, and takes him to Montmartre. After spending some time in a café frequented by artists, Duchamp introduces his German friend to the Bal Tabarin, Rue Victor-Massé, a lively music-hall decorated with delightful frescos by Willette. Bergmann is particularly taken by the dancing of 8 Parisian girls.

1918. Saturday, New York City
In the afternoon, after visiting Miss Dreier's studio, the park and her apartment (where he makes the acquaintance of the parrot), Roché accompanied by Miss Dreier, calls on Marcel at 33 West 67th Street.
As Marcel's work on it advances, the long rectangular painting [10.3.1918] continues to impress Roché.

1927. Wednesday, Paris
After lunching together the previous day, at two o'clock in the afternoon Marcel has another appointment with Roché.

1931. Monday, Nice
In the sixth round of the International Tournament, Duchamp draws against D. Noteboom.

1945. Friday, New York City
At one o'clock Duchamp and Miss Dreier catch the *Yankee Clipper*, due to arive at New Haven at twenty-five past two. George Heard Hamilton is at the station to meet them and drives them in his car to the Yale Art Gallery where they visit the exhibition of the three Duchamp brothers "Ducamp, Duchamp-Villon, Villon" [1.3.1945].

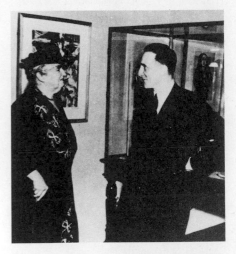

Miss Dreier finds that the exhibition reveals "the very interesting non-material attitude of Duchamp towards art... The fact that he never repeats himself, on principle," she believes, "has kept his mind very fertile and young..." Looking at the little chess sets in the show (not listed in the catalogue), she thinks: "Whatever Duchamp does or touches becomes art."

1953. Monday, New York City
After the serious fire in his home, André Breton has written to Duchamp requesting a further extension of the deadline [31.1.1953] for *Flair* magazine [8.2.1953]. Having obtained extra time from Fleur Cowles, Duchamp writes to Breton.

16.3.1957

1957. Saturday, Paris
At two o'clock in the morning Constantin Brancusi dies at the age of 81 in his studio at 11 Impasse Ronsin. He had settled in Paris after walking all the way from Romania in 1904.

Both Marcel and Teeny had been friends of Brancusi's for very many years. Teeny met the sculptor in 1923 through Heyworth Mills [16.1.1954]. At this time she spent weekends with Mills and his wife at their home in Clairefontaine near Rambouillet, and there were memorable walks in the park of Le Pavillon with Brancusi and Joella Lloyd. Once Brancusi suddenly climbed into a tree and from this vantage point he told extraordinary stories to his young companions.
During their long friendship Brancusi gave Teeny many photographs including one of *Le Nouveau né* inscribed: "Quand nous ne sommes plus enfants, nous sommes déjà un peu mort."

On one occasion before World War I, Duchamp and Brancusi visited the annual Salon de la Locomotion Aérienne at the Grand Palais with Fernand Léger. After walking in silence among the fragile pioneering aircraft, their motors of metal and great wooden propellers, Duchamp suddenly turned to Brancusi and declared: "Painting is finished. Who could do better than this propeller? Tell me, can you do that?"

1958. Sunday, New York City
Having decided to fly to Paris on 30 May to spend the summer in Europe, Marcel gives Roché an outline of their plans and then turns to business.
"The 30 Valises have at last been delivered to Lefebvre-Foinet [26.2.1958] and the price for an eventual buyer from your friends is 100,000 francs [10,000 francs at today's value]," says Marcel explaining that the price for dealers and bookshops is 80,000 francs.

1959. Monday, New York City
The Duchamps attend a dinner party given by Mrs George Henry Warren at her home, 55 East 66th Street. After dinner the guests, among them the Sweeneys, Henry McBride and Earle Miller, attend the opening of the Miró exhibition at the Museum of Modern Art.

17 March

1912. Sunday, Neuilly-sur-Seine
Marcel is due to deliver his sister's three canvases [15.3.1912] to the Salon des Indépendants, which is being held, like the previous year, in temporary huts situated by the river on the Quai d'Orsay. Anxious to avoid the ribald comments and embarrassing questions at the city tollgate through which he would have to pass at the Porte Maillot, Marcel has decided to take his own canvas off its stretcher, roll it up and transport it by rowing boat from Neuilly upstream to the Pont d'Alma. After restretching the canvas and delivering it to the Salon, Marcel returns in the boat to Neuilly.

1913. Monday, Paris
Les Peintres Cubistes by Guillaume Apollinaire is published by Eugène Figuière. The collection of essays is subtitled *Méditations esthétiques*, the author's preferred title for the book. Developed from his recent lectures [11.10.1912] and revised over a period of several months [26.10.1912], Apollinaire discusses the work of ten artists including Duchamp.
"Marcel Duchamp's pictures are still too few in number, and differ too much from one another, for one to generalize their qualities, or judge the real talents of their creator," states Apollinaire. "Like most of the new painters, Marcel Duchamp has abandoned the cult of appearances... To free his art from all perceptions which might become notions, Duchamp writes the title on the picture itself [18.3.1912]. Thus li-

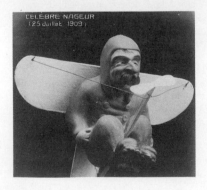

CÉLÈBRE NAGEUR
(25 juillet 1909)

terature, which so few painters have been able to avoid, disappears from his art, but not poetry."
Remarking that Duchamp "is the only painter of the modern school who today (autumn 1912) concerns himself with the nude," Apollinaire declares that his technique, "the energy of a few lines (forms or colours)... can produce works of a strength so far undreamed of. It may even play a social role... Just as Cimabue's pictures were paraded through the streets, our century has seen the aeroplane of Blériot, laden with the efforts humanity made for the past thousand years, escorted in glory to the [Musée des] Arts et Métiers. Perhaps it will be the task of an artist as detached from aesthetic preoccupations, and as intent on the energetic as Marcel Duchamp," concludes Apollinaire, "to reconcile art and the people."

1916. Friday, New York City
John Quinn has agreed to lend the *Femme assise* in bronze by Duchamp-Villon [15.3.1916] to the Bourgeois Galleries, and has invited Duchamp to dine with him at the Hotel Brevoort this evening at seven.

*

At four in the afternoon, while reading the latest number of *Mercure de France* in the trenches at Le Bois des Buttes, Guillaume Apollinaire is wounded when shellfire pierces his helmet.

1927. Thursday, Paris
In the morning at eleven Marcel has another appointment with Roché.

1930. Monday, Toulon
Before starting his return journey back to Paris at midday, Marcel writes a postcard to Brancusi.

1931. Tuesday, Nice
In the seventh round of the International Tournament, Duchamp resigns his game against Sig.

17.3.1960

Rosselli Del Turco. With rather damp humour, the commentator for the *British Chess Magazine* explains what happened: "My good friend Duchamp is a heavy drinker of Vichy water when playing serious chess, and it appears that the barmaid in the Club Rooms was short of Vichy water on this day and had been serving Duchamp with Evian water during the play. Therefore because of this change in waters another good game of chess went wrong when (after a drink of Evian water) Black played 26 - /Lf6? and White, who is not a drinker of water, continued by 27 Lxe6+/dxe6; 28 Dxe6+/Kh8; 29 TxLe6, and Black's attacking position has been converted into a lost game."

1934. Saturday, Paris
Marcel calls to see Roché in Arago.

1950. Friday, New York City
In the evening Marcel attends what Henry McBride describes as an "unusual" dinner party at the Sweeneys'. After cocktails when they are moving to the dining table, McBride apologizes to Marcel for mentioning in his recent review of the Italian sculptor Marini that most of the praise "had in reality been levelled at Paris in reproach for not having recently produced anything comparable". Someone remarks, probably Salvador Dali who is also present, that "the obvious retort of Paris would be instantly to produce a new genius to confute them".

Smiling cynically, Marcel replies that geniuses

are never produced by prestidigitation in any country: "Besides," he adds, "we in France have no immediate need for new ones being so very content with the large supply we still have... You speculators think the time has come to say *au revoir* to Picasso, Matisse, Braque, Dufy et al., and you are eager to make acquaintance with the new boys who will astonish us and, of course, shock us in some new and unexpected fashion. You know that theoretically the revolution is due and you are impatient for it, but I am here to tell you that there won't be one. Revolutions are *démodé*. There is no real need for them. They did not use to have them. They are modern inventions."

There is a chorus of protest at this declaration. Wearily agreeing that Delacroix had been revolutionary in his time, Marcel refuses to accept "any earlier art rebels", and insists that revolutions have been overdone, "stylized like modern business tricks," and do not bear intelligent analysis. "This is a time of peace," says Marcel, "why not prolong it?"

McBride is sceptical that revolutions are obsolete. "To me it looks merely like wartime fatigue," he counters, "as soon as we all get our breath, the Old Nick that is within us human beings will begin to stir again, altercations will arise, fists will bang the tables in cafés none of us have heard of before, and eventually several winners in the arguments will be recognized as heroes..."

1955. Thursday, New York City
"I telephoned Goldschmidt and asked him to write to you, because he prefers not to exhibit the photo of the drawing [4.3.1955] (mother's portrait)," writes Marcel to the Crottis.

1960. Thursday, New York City
For a self-constructing and self-destroying work of art in which an army of saws was planned in the original scenario, Duchamp has written:

*Si la scie scie la scie
et si la scie qui scie la scie
est la scie qui scie la scie
il y a suissscide métallique.*

[If the saw saws the saw
and if the saw sawing the saw
is the saw sawed by the saw
there is metallic Swissscide.]

Duchamp's contribution is one of several by various authors printed on the invitation to *Homage to New York* by Jean Tinguely, which is due to start in the evening at six-thirty.

On the cold, wet morning of Saint Patrick's Day, white-painted components of the huge machine which Jean Tinguely has been busy building for the last three weeks in the Buckminster Fuller dome at the Museum of Modern Art, are brought down by the museum's workmen to the sculpture garden. With the assistance of Billy Klüver, Robert Breer, the workmen and others, Tinguely spends the day patiently preparing his work which has been constructed with a multitude of rusty bicycle wheels, pieces of scrap-iron rifled from city dumps and old motors selected from shops in Canal Street. Robert Rauschenberg brings the promised mascot: a money-thrower containing a dozen silver dollars.

The public starts arriving while the construction work is being completed. The Duchamps are accompanied by Mimi Fogt [18.4.1957] and Alberto Capmany. By six there is a power line to the machine and all the circuits are connected. At seven-thirty Tinguely gives the signal for the machine to be set off. As smoke billows out from a basinet, three notes from the piano are playing. A first meta-matic comes into action followed by a radio which is inaudible and the piano starts burning. When the money-thrower goes off in a great flash, the fan motor starts beating on the washing machine and another meta-matic starts working: armed with a sponge, it makes a long black streak on the paper provided. While the piano is burning, the suicide carriage (needing a little help from Tinguely) rolls feebly towards the pool, and the arms of the addressograph machine start beating on empty oil drums. The large balloon floating above the

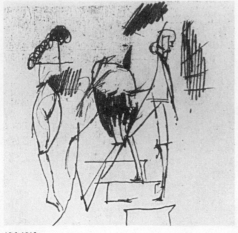
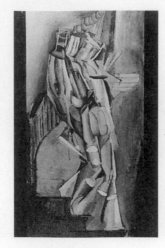
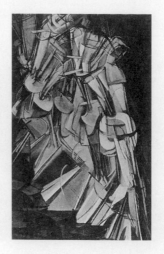

18.3.1912

fracas fails to explode because the compressed air bottle is empty. Becoming anxious that the fire extinguisher in the piano might explode in the heat, Tinguely tries to persuade a fireman to put out the flames but to no avail. When the artist's instructions are finally obeyed, a fireman wielding an extinguisher is almost lynched by members of the audience. The fire dampened, looters descend on the remains and carry off souvenirs.

1961. Friday, Paris
At the auction held for the benefit of Georges Bataille and Pierre de Massot, which starts at nine o'clock in the evening at the Hôtel Drouot, *Anagramme pour Pierre de Massot* [13.1.1961] is sold for 2,600 francs [15,000 francs at today's value].

1967. Friday, New York City
Giving her details of his movements after 22 March, Duchamp tells Mlle Popovitch [8.3.1967]: "You would certainly have more chance than me in managing to obtain a nude from Philadelphia. In short it is as if I were in prison and my works are not at liberty either."

*

"Thank you for the copy of our book ," writes Duchamp to Pierre Cabanne [25.1.1967]. Having read it and also read the article by Otto Hahn in *L'Express* entitled "Saint Marcel Duchamp", Duchamp declares: "'I am beatified'. Our interviews, I believe, come just at the right moment for the show at the Musée [National] d'Art Moderne [8.3.1967]."

18 March

1910. Friday, Paris
Barely a month ago it was the Seine inundating the place; now it is the turn of more than ten thousand visitors to flood into the temporary huts on the Cours-la-Reine for the opening of the Salon des Indépendants. Among the six thousand works exhibited are four paintings by Duchamp, hung in Room 16: two canvases entitled *Etude de Nu* – both considered by Apollinaire as "very ugly" – a portrait "strangely resembling an Apache" called *Masque*, and *Nature Morte*.

Declaring the Salon to be the rout of Impressionism, Apollinaire writing for the evening newspaper, *L'Intransigeant*, says that the most significant works can be seen in Room 18 where the artists include Henri Matisse, Othon Friesz, Henri Manguin, Jean Puy, Maurice de Vlaminck, Albert Marquet, Pierre Girieud, Marie Laurencin, Raoul Dufy, Jean Metzinger and Robert Delaunay, and also in Room 21, domain of the Neo-Impressionists: Ker-Xavier Roussel, Pierre Bonnard, Maurice Denis and Paul Signac.

The undoubted sensation of the Salon, however, is the new school baptized Excessivism. With a published manifesto, the founder, Joachim-Raphaël Boronali, exhibits one picture, which is listed on three numbers in the catalogue, thus dividing the title into three parts:

604. *Et le soleil s'endormit,*
605. *Sur l'Adriatique,*
606. *Marine.*

1912. Monday, Neuilly-sur-Seine
On the day of the press preview of the Salon des Indépendants, Marcel receives an unexpected visit from his two elder brothers solemnly dressed. He learns that Albert Gleizes and Jean Metzinger, members of the hanging committee, think that his Nude destined for the Cubist Room has "too much of a literary title, in the bad sense – in a caricatural way. A nude never descends the stairs – a nude reclines..." Even the Cubists little revolutionary temple, Marcel discovers, cannot understand that a nude could be *descending* the stairs.

"The Cubists think it's a little off beam," explain Villon and Duchamp-Villon. "Couldn't you at least change the title?" But as the title written in capital letters at the bottom left hand corner of the canvas, *Nu descendant un Escalier*, is an integral part of his painting, Marcel says nothing.

As soon as his brothers have gone, he immediately takes a taxi to the Quai d'Orsay, collects his picture and takes it home.

*
Encore à cet Astre

Espèce de soleil! tu songes: – Voyez-les,
Ces pantins morphinés, buveurs de lait
 d'ânesse
Et de café; sans trève, en vain, je leur caresse
L'échine de mes feux, ils vont étiolés! –

– Eh! c'est toi, qui n'as plus que des rayons
 gelés!

Nous, nous, mais nous crevons de santé, de
 jeunesse!
C'est vrai, la Terre n'est qu'une vaste ker-
 messe,
Nos hourrahs de gaîté courbent au loin les
 blés.

Toi seul claques des dents, car tes taches
 accrues,
Te mangent, ô Soleil, ainsi que des verrues
Un vaste citron d'or, et bientôt, blond
 moqueur,

Après tant de couchants dans la pourpre et
 la gloire,
Tu seras en risée aux étoiles sans cœur,
Astre jaune et grêlé, flamboyante écumoire!

This mockery of the sun and its fate is by the Symbolist poet Jules Laforgue. "There is only art; art is desire perpetuated," wrote Laforgue in "Pan et la Syrinx", one of the prose poems published in *Moralités Légendaires*, a book Duchamp particularly liked for its humour and called admiringly "an exit from Symbolism". However, "perhaps less attracted by Laforgue's poetry than by his titles," *Encore à cet Astre* inspired Duchamp to make a small sketch in which one element is a figure mounting three steps.

Planning to illustrate ten of Jules Laforgue's

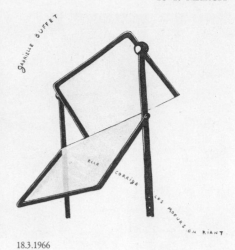

18.3.1966

poems, Duchamp also made a drawing for *Sieste éternelle:*

> …
> Et comme un piano voisin rêve en mesure,
> Je tournoie au concert rythmé des encensoirs.
> Tout est un songe…

Repeating the motif supporting the keyboard in *Sieste éternelle,* a third drawing made to illustrate *Médiocrité* also incorporates spirals: a locomotive with a string of cars attached behind it, coming out of a curve, is at a turning point like the crucial one reached by the steam engine stoked by Arthur Gough in *Le Surmâle* by Alfred Jarry.

> …
> La plupart vit et meurt sans soupçonner l'histoire
> Du globe, sa misère en l'éternelle gloire,
> Sa future agonie au soleil moribond.
>
> Vertiges d'univers, cieux à jamais en fête!
> Rien, ils n'auront rien su. Combien même s'en vont
> Sans avoir seulement visité leur planète.

Preceded by a small study of the same subject painted on cardboard the final version, *Nu descendant un Escalier,* No.2, was painted in January 1912. Reversing the movement of the figure in *Encore à cet Astre,* the painting has a nude descending a staircase.

"The final version," explains Duchamp, "was the convergence in my mind of various interests among which the cinema, still in its infancy, and the separation of static positions in the photochronographs of Marey... Painted as it is in severe wood colours, the anatomical nude does not exist, or at least cannot be seen, since I discarded completely the naturalistic appearance of a nude, keeping only the abstract lines of some twenty different static positions in the successive action of descending."

1930. Tuesday, Paris
At five o'clock in the morning, Duchamp arrives from Toulon after several weeks on the Côte d'Azur [6.2.1930].

1931. Wednesday, Nice
In the eighth round of the International Tournament, Duchamp plays against Brian Reilly and resigns after losing his Queen.

1935. Monday, Paris
Now that the circular is printed, Duchamp sends two copies of it by post to the Château de Pouy [12.3.1935] and asks André Breton for an appointment as soon as he returns to Paris.

1936. Wednesday, Paris
"After adding and subtracting" Dee has finally decided that he probably will go to New York towards the end of May for two months. During this time he plans to repair the Large Glass [5.2.1923] which Miss Dreier discovered had been shattered in transit when it was brought from storage at the Lincoln Warehouse [26.1.1927] to West Redding in 1931; waiting until her next trip to Europe, Miss Dreier broke the news to Dee one day while they were having lunch in Lille. Seeing how upset she felt about it, Dee remained quite calm and just said quietly: "That's too bad. Too bad."
"Are you sure I won't be too much in your way if I stay at the Haven while I work – and then a few weeks in N.Y. at your studio?" Dee asks Miss Dreier in his letter. He plans to put the glass between two sheets of plate glass and, like Roché's small glass [12.2.1924], have it framed in two iron frames, one for each half: "although very heavy, [it] would make a solid piece of furniture when in place." With regard to cost, Dee enquires whether Miss Dreier can afford the expense of the plate glass and the frames, the approximate cost of which should be estimated before he leaves. "There would not be any more expenses attached to the repairing as I would do it all myself," he confirms, "except occasional help for handling the big glasses." Asking her to think it over and to let him know, Dee asks Miss Dreier when she plans to go to The Haven for the summer: "I am sure it will be lovely," he predicts.

1949. Friday, New York City
Replying to Miss Eilers, who is making arrangements for the "Western Round Table on Modern Art" [7.3.1949], Duchamp confirms that, through TWA in New York, he would like a pre-paid round trip ticket departing on 6 April, and that he would prefer to stay in a hotel.
In a postscript to MacAgy, Duchamp enquires whether the conference will be broadcast in Europe or not, and thanks him for sending the list of questions.

1951. Sunday, New York City
"You do well to stop smoking if it has such an effect on your heart," writes Marcel to Roché, admitting that he himself started smoking again in earnest on the *Mauritania* [2.12.1950]. He has seen Fautrier, but found the French artist was "not a nice person to meet".
Provided any publicity is avoided, Marcel is willing for Madeleine Castaing to exhibit *Rotative Demi-sphère* [8.11.1924] now without the broken glass globe. "A cover could be made in plastic," suggests Marcel. If it cannot be made in Paris, he promises to make enquiries in New York: "Give me the exact diameter and also the depth if it is not a complete hemisphere."

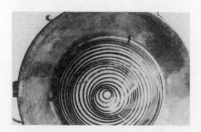

1966. Friday, New York City
After learning that Arne Ekstrom has bought the watercolour *Elle corrige les mœurs en riant,* signed "le fidèle Picabia", which was exhibited fifty years ago at the Modern Gallery [5.1.1916], Marcel writes to Gabrielle Buffet on the dealer's behalf asking whether she knows where it was made and whether she remembers any interesting details about it.

19 March

1917. Monday, New York City
Marcel has lunch again at Manguin's [5.3.1917] with Roché. After dinner with Juliette and Albert Gleizes, they go on to the Arensbergs', where they discuss a bulletin for the forthcoming Independent Artists' exhibition [13.3.1917].

1931. Thursday, Nice
In the final round of the International Tournament, which is won by Brian Reilly, Duchamp draws his game against A. Vajda.

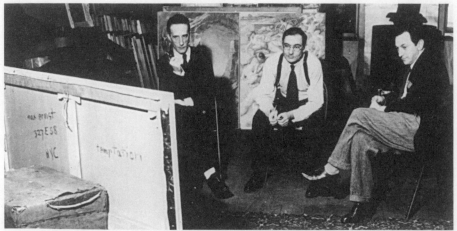

20.3.1946

1944. Sunday, New York City
Marcel has tea with Beatrice Wood who has come east for her exhibition of ceramics which opens on 24 March at America House. It is the first time they have met since Marcel visited the Arensbergs in Hollywood [20.8.1936].

1945. Monday, New York City
In the catalogue of the second Jackson Pollock [18.5.1943] exhibition opening at Art of this Century, there is an invitation to see the twenty foot mural at Peggy Guggenheim's apartment, 155 East 61st Street. "I had a vision," said Pollock of the painting which he made one night in fifteen hours. "It was a stampede... Cows and horses and antelopes and buffaloes. Everything is charging across that goddam surface." The day he came to install it in the hallway of Peggy's house, the artist discovered that it was too long. He telephoned frantically to Peggy, asking her to return home and help him install the canvas. Eventually Peggy persuaded Duchamp and David Hare to come to the rescue. In this type of painting those eight inches of canvas were not needed, declared Duchamp, and the superfluous strip of mural was cut off.

1948. Friday, New Haven
On the day that Naum Gabo gives his lecture "On Constructive Realism" at the Yale University Art Gallery [5.3.1948], a meeting of the directors [1.12.1947] of the Société Anonyme takes place at which Duchamp and Miss Dreier's proposed layout of the catalogue which they made in 1942 [24.9.1942] is presented.

1951. Monday, New York City
After telephoning Philadelphia in the afternoon and finding that Fiske Kimball is away, Duchamp writes to him concerning their proposed trip to Milford [27.1.1951]. Miss Dreier has asked him to organize any day, except Tuesdays and Thursdays, in the first fortnight of April. "If you want to travel by train, the better day would be Saturday," explains Duchamp, "when there is a train leaving Grand Central at 12:50pm arriving in Milford 2:30." If Kimball prefers to go by car, Duchamp suggests meeting him in New York at eleven-thirty or noon, so as to be with Miss Dreier at about two-fifteen.

1957. Tuesday, Paris
The funeral service for Brancusi, who died on 16 March, takes place in the afternoon at the small Romanian church in Rue Jean-de-Beauvais, which Marcel remembers visiting once at Christmas time with the sculptor. Requested by Marcel and Teeny to take some flowers, Jackie Monnier chooses some white cherry blossoms for Brancusi. They feel that "Paris will never be quite the same without him".

1958. Wednesday, New York City
To establish a final draft of Hamilton's contract for the translation [14.3.1958], Duchamp attends a conference with Bill Copley, George Heard Hamilton who has come specially from New Haven, and Barnet Hodes on the telephone in Chicago.

After their discussions, two important points remain outstanding. One is whether Fawcus had a written contract with Warwick, the previous translator, and if so whether it includes a clause whereby Fawcus has agreed that Warwick's translation of Lebel's manuscript is the only one. The second is that although Fawcus has written to Hamilton saying that he wishes to retain all the subsidiary rights himself, Hamilton intends in his contract to reserve a small percentage of these rights on the use of his translation.

It is agreed that Copley will take the cheque of $2,000 with him when he goes to Paris on 22 March, but that he will only give it to Fawcus after assurance from Robert Lebel that the photogravure is indeed more than just commenced.

1968. Tuesday, New York City
The chocolate-and-cream-coloured poster-cum-invitation to the exhibition "Doors" at Cordier & Ekstrom, 978 Madison Avenue, is adorned with a white insert in which the form of the door for *Gradiva* [18.4.1940] has been cut out. With precious details gleaned from Georges Hugnet [17.2.1968], Duchamp is represented in this mixed exhibition with a replica of the door which is made of Plexiglas and forms the entrance to the exhibition.

20 March

1913. Thursday, New York City
Nu descendant un Escalier [18.3.1912] continues to inspire the cartoonists [23.2.1913].

Today the *New York Evening Sun* publishes J. F. Griswold's drawing, *Rude Descending a Staircase*, subtitled "Rush Hour at the Subway". The cascading sequence of lines and geometrical interlocking shapes brilliantly pastiches the original painting's evocation of movement.

Not everyone agrees that the Nude gives the viewer a sense of progressive movement. J.N. Laurvik for his pamphlet, *Is it Art?*, writes that "...one is simply conscious of a series of flat figures, one overlapping the other, the sum total of which remains no less fixed than each separate unit and the attempt to achieve an illusion of motion without the concomitant physical and mechanical means employed by a moving picture results in an amusing failure, very entertaining as a new kind of parlour game but of very little value as art." Even if to some people it produces a sensation of movement, Laurvik declares: "It must be conceded that this, regarded as an end in itself, is a very puerile use of art and in no sense an amplification of its possibilities."

1917. Tuesday, New York City
Marcel meets Beatrice Wood at Henri's.

1918. Wednesday, New York City. -After dinner together at Miss Dreier's, 135 Central Park West, Marcel, Roché and Mrs Simon share a taxi.

1920. Saturday, New York City. -Marcel and Gaby Picabia [26.2.1920] meet Beatrice Wood for tea at L'Aiglon, 25 West 55th Street.

20.3.1961

1937. Saturday, Paris
In the third of his regular weekly chess columns for *Ce Soir*, Duchamp gives the result of the first chess problem [4.3.1937] and selects a new one by Kubbel of Leningrad. He comments on the game played by correspondence between the twenty-year-old champion of Estonia, Paul Keres, and Dr Schapiro, which in a brilliant finish was won by Keres. In the news items, Duchamp reports on the simultaneous games played by Dr O. Bernstein [12.3.1937] and the events celebrating the tenth anniversary of the Echiquier Russe Potemkine [13.3.1937].

1946. Wednesday, New York City
Alfred Barr, Sidney Janis and Duchamp, the judges of the *Bel Ami* Award sponsored by Loew-Levin Productions, meet at Budworth's where the eleven pictures under consideration for the $3,000 prize are gathered.

All confined to the same theme, "The Temptation of Saint Anthony," the paintings are by Ivan Albright, Eugène Berman, Leonora Carrington, Salvador Dali, Paul Delvaux, Max Ernst, Louis Guglielmi, Horace Pippin, Abraham Rattner, Stanley Spencer and Dorothea Tanning. It takes the judges three hours of hard deliberation before finally giving the award to Max Ernst.

The winning painting will be used in technicolour sequences in the film based on Maupassant's novel, *Bel Ami*, the production of which is due to start in April.

1958. Thursday, New York City
Marcel replies to a long, sad letter from his sister Suzanne who, instead of carrying out her plans for a "posthumous reunion of all the family in Rouen", has been alone to Switzerland to bury her husband [30.1.1958].

Teeny has found a purchaser for Suzanne's Miró, the Perls Galleries on Madison Avenue. Marcel thinks the offer is fair and reminds her: "If you want to find a collector who could offer more, you will probably lose a lot of time."

*

Recounting in detail to Lebel the conference of the previous day, Duchamp states the two important points which remain to be settled and warns the author not to underestimate the importance of the subsidiary rights which Fawcus wants to retain for himself. "That's not on," writes Duchamp, "because it means that if a 'paperback' edition, a television programme, or

(why not) a film from the book appears in a few years, you the author, if you haven't reserved your 'subsidiary rights' with Fawcus in writing, you won't see a penny of the vast sums that these ventures can turn over."

Finding the new proof [1.8.1957] of *Moulin à Café* [20.10.1912] "very, very good", Duchamp recommends that "a very thin coat of transparent varnish" is added to it.

"What a bloody mess!" he exclaims in conclusion.

1959. Friday, New York City
Agreeing to her proposal to come to 327 East 58th Street the following Thursday, Marcel asks Kay Boyle, if possible, to bring the Valise [10.3.1959] with her.

1961. Monday, Philadelphia
In the evening, with Katharine Kuh as moderator, Duchamp, the sculptor Louise Nevelson, and two painters, Larry Day and Theodoros Stamos, are members of a panel to discuss "Where do we go from Here?" at the Philadelphia Museum College of Art.

Of the panellists, Duchamp is the only one to make a brief, prepared statement.

"To imagine the future, we should perhaps start from the more or less recent past, which seems to us today to begin with the realism of Courbet and Manet. It does seem in fact that realism is at the heart of the liberation of the artist as an individual, whose work, to which the viewer or collector adapts himself, sometimes with difficulty, has an independent existence.

"This period of liberation rapidly gave birth to all the 'isms' which have followed one another during the last century, at the rate of one new 'ism' about every fifteen years.

"I believe that to try and guess what will happen tomorrow, we must group the 'isms' together through their common factor, instead of differentiating them.

"Considered in the framework of a century of modern art, the very recent examples of Abstract Expressionism clearly show the ultimate in the retinal approach begun by Impressionism. By 'retinal' I mean that the aesthetic pleasure depends almost entirely on the impression on the retina, without appealing to any auxiliary interpretation.

"Scarcely twenty years ago the public still demanded of the work of art some representative detail to justify its interest and admiration.

"Today, the opposite is almost true... the general public is aware of the existence of abstraction, understands it and even demands it of the artists.

"I am not talking about collectors who for fifty years have supported this progression towards a total abandon of representation in the visual arts; like the artists, they have been swept along by the current. The fact that the problem of the last hundred years boils down almost entirely to the single dilemma of the 'representative and the non-representative' seems to me to reinforce the importance I gave a moment ago to the entirely retinal aspect of the total output of the different 'isms'.

"Therefore I am inclined, after this examination of the past, to believe that the young artist of tomorrow will refuse to base his work on a philosophy as over-simplified as that of the 'representative or non-representative' dilemma.

"I am convinced that, like Alice in Wonderland, he will be led to pass through the looking-glass of the retina, to reach a more profound expression.

"I am only too well aware that among the 'isms' which I have mentioned, Surrealism introduced the exploration of the subconscious and reduced the role of the retina to that of an open window on the phenomena of the brain.

"The young artist of tomorrow will, I believe, have to go still further in this same direction, to bring to light startling new values which are and will always be the basis of artistic revolutions.

"If we now envisage the more technical side of a possible future, it is very likely that the artist, tired of the cult for oils in painting, will find himself completely abandoning this five-hundred-year-old process, which restricts his freedom of expression by its academic ties.

"Other techniques have already appeared recently and we can foresee that just as the invention of new musical instruments changes the whole sensibility of an era, the phenomenon of light can, due to current scientific process, among other things, become the tool for the new artist.

"In the present state of relations between artists and the public, we can see an enormous output which the public moreover supports and encourages.

"Through their close connection with the law of supply and demand the visual arts have become a 'commodity'; the work of art is now a commonplace product like soap and securities.

21.3.1905

21.3.1942

"So we can perfectly well imagine the creation of a union which would deal with all the economic questions concerning the artist... we can imagine this union deciding on the selling price of works of art, just as the plumbers' union determines the salary of each worker... we can even imagine this union forcing the artist to abandon his identity, even to the point of no longer having the right to sign his works. Would the total artistic output controlled by a union of this kind form a sort of monument to a given era comparable to the anonymous cathedrals?

"These various aspects of art today bring us to look at it as a whole, in terms of an over-developed exoteric. By that I mean that the general public accepts and demands a lot from art, far too much from art; that the general public today seeks aesthetic satisfaction wrapped up in a set of material and speculative values and is drawing artistic output towards an enormous dilution.

"This enormous dilution, losing in quality what it gains in quantity, is accompanied by a levelling down of present taste and its immediate result will be to shroud the near future in mediocrity.

"In conclusion, I hope that this mediocrity, conditioned by too many factors foreign to art per se, will this time bring a revolution on the ascetic level, of which the general public will not even be aware and which only a few initiates will develop on the fringe of a world blinded by economic fireworks.

"The great artist of tomorrow will go underground."

1962. Tuesday, New York City
On behalf of Pontus Hulten and Ulf Linde who would like to follow the Movement in Art exhibition [16.5.1961] by organizing a "Brancusi-Duchamp-Mondrian" exhibition, Duchamp writes to Henri Marceau of the Philadelphia Museum of Art to enquire whether the museum accepts the idea in principle. "They will find Mondrians in Europe," explains Duchamp, "so, for you it is only a matter of the question Brancusi-Duchamp."

*

For the catalogue of Georges Hugnet's exhibition at the Galerie de Marignan in Paris, Duchamp has written:
Il arrange or, jus n'y est.
The phrase is a homophone of "Hilarant Georges Hugnet".

1964. Friday, New York City
For the decoration of the studio at 5 Rue Parmentier [19.1.1964], Marcel suggests putting "a little blue or lamp black" in the white paint, a recommendation which Teeny passes on in her letter to her daughter Jackie.

21 March

1905. Tuesday, Blainville-Crevon
Marcel paints a watercolour of his six-year-old sister Magdeleine standing sideways to him with her hands clasped behind her back. She is wearing black stockings, a knee-length full skirt, and a red hood, the colours of which he notes in pencil. Writing the precise date, Marcel also adds his signature, in monogram style, the one he prefers at the moment.

*

The reduction of French military service from three years to two, voted by the Assemblée on 21 February and by the Sénat on 16 March, is proclaimed law today and will apply to all conscripts from 1907. The law of 1889, now repealed, selected conscripts for three years' service by the drawing of lots, but also exempted certain professions, such as lawyers, doctors, printers and engravers, from serving more than one year. As he belongs to the "Classe 1907", Duchamp is directly affected by this law.

1926. Sunday, Paris
In the wake of the "80 Picabias" auction [8.3.1926], Duchamp is relieved to have found a buyer for "the Spaniards, *en bloc*, at the prices fetched in the auction rooms..."

Now that Legrain has framed the two Picabias which he decided not to put in the auction, *Midi – Promenade des Anglais* and *Plumes*, both extravagant collages of feathers and macaroni, Duchamp would like to show them to Jacques Doucet [9.3.1926]. He writes inviting the collector to his room at the Hôtel Istria between eleven and midday on Tuesday morning and mentions that he would also like to talk to him about his "project" to buy back his three pictures from the John Quinn Estate [28.7.1924] (*La Partie d'Echecs* [1.10.1910], *A propos de jeune Sœur* [8.3.1915] and *Peau brune* [19.1.1915]). Duchamp has just learned

from a friend in New York that he can buy them at reasonable prices.

1935. Thursday, Paris
As he has still not heard from André Breton [18.3.1935], Duchamp writes to say that the circular will be ready on Tuesday or Wednesday and repeats his previous questions [12.3.1935]. Who is going to pay for the collotype printing? Where is the order to be delivered? And is Breton pleased with the result?

1942. Saturday, Sanary-sur-Mer
Thanking Desnos, who is in Paris, for news of "la Sonde" [provisional title of his novel *Le Vin est tiré...*], Marcel requests a favour: "Can you find me a copy of *Corps et biens* and have it sent to me by Mary [Reynolds, also still in Paris]... Your *contre songeries* are there, aren't they? ... I would like to see them again [1.12.1922]."

Marcel hasn't any news of Picabia in Cannes; as Desnos probably knows via Frank [?], Tristan Tzara is also in the unoccupied zone at Aix-en-Provence [23.2.1942].

*

Arensberg's lawyer receives a letter from the State Department saying that an American visa for Duchamp has been granted.

1949. Monday, New York City
"I don't think I will be too tired Wednesday night (the 6th) to spend the evening with you," writes Duchamp to Douglas MacAgy [18.3.1949], "I feel on the contrary that I will need some friendly voices that evening." He suggests a topic "that might or might not be of interest to the symposiumists" in the forthcoming "Western Round Table on Modern Art" in San Francisco: "Art for all or Art for the few?"

1956. Wednesday, New York City
After speaking to Henri Marceau on the telephone about making three colour transparencies for the "Three Brothers" catalogue [27.12.1955], Duchamp telephones the photographer Peter Juley and makes an appointment with him at the Philadelphia Museum of Art on 29 March. Duchamp then confirms the arrangements in writing to Marceau.

1959. Saturday, New York City
For George Staempfli, a "great friend, passionately fond of Brancusi", Duchamp writes a letter of introduction to Henri Pierre Roché,

22.3.1910

and draws him a plan showing the way from Sèvres station to Roché's house at 2 Rue Nungesser-Coli.

1965. Sunday, New York City
While Duchamp was in Mexico, Evan Turner has been trying to contact him regarding the "ultimate disposition" of Mrs Sisler's collection [13.1.1965]. Excusing his delay in replying, Duchamp invites Turner, who is now in Europe, to telephone him on his return.

1966. Monday, New York City
Teeny and Marcel dine with Bill and Noma Copley, without any other guests.

1968. Thursday, New York City
In the presence of three witnesses, Gerald Fitzgerald, Walter E. Warner, Jr. and Clay Moser, Duchamp signs a Codicil to his Will dated 15 December 1964 bequeathing to Frank B. Hubachek of Chicago the oil painting "representing a Nude in a Tub" [2.12.1949] which is at 28 West 10th Street.

22 March

1910. Tuesday, Paris
Following their outing together the previous Wednesday, tonight Duchamp plans to introduce Max Bergmann to "la vraie vie parisi-enne". At six-fifteen Duchamp and Annequin collect Bergmann and take him to Montmartre. They start with a square meal at the Café-Restaurant des Artistes run by "la mère Coconnier" at 11 Rue Lepic, where Eugène Duchamp came monthly from Normandy to pay his eldest son's board when Gaston first moved to Paris. After supper they visit a Munich-style tavern before climbing the Rue Lepic as far as the Moulin de la Galette. The joyful atmosphere of dancing, drinking and amusement evoking impressions of Renoir, inspires Bergmann to make a few drawings in his sketchbook.

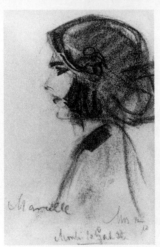

At the Bal Tabarin [16.3.1910], their next port of call, Annequin realizes that Duchamp intends making a night of it with Bergmann and decides to go home.

1917. Thursday, New York City
After dining together, Marcel, Beatrice Wood and Roché call on the Arensbergs.

1937. Monday, Paris
"Well there you are in European waters again," writes Dee to Miss Dreier, who is crossing the Atlantic on the SS *Europa* and due to arrive at Cherbourg on 24 March. Since he and Villon want to be at the station to meet her, he asks Miss Dreier to wire him her expected time of arrival at the Gare Saint-Lazare.

1955. Tuesday, New York City
To Iliazd [7.1.1955] in Paris, who is assembling a third version of the *Boîte-en-Valise*

[7.1.1941] with a new wooden frame and more protective outer casing, Duchamp sends two lists, one of the labels and the other of the reproductions which he is having packed into 5 or 6 crates and sent to Lefebvre-Foinet for delivery sometime in April.

1957. Friday, Houston
After the Guggenheim Museum [19.2.1957] the "Three Brothers" exhibition opens at the Museum of Fine Arts of Houston.

1967. Wednesday, New York City
Teeny and Marcel fly to Paris.

1968. Friday, New York City
"I totally agree," writes Duchamp to Pierre Cabanne [16.7.1967]. "Be kind enough to telephone me in Neuilly (SAB 4634) on Monday morning 1st April before noon and we'll chat."

23 March

1910. Wednesday, Paris
In the early hours of the morning, Duchamp takes Bergmann from the Bal Tabarin to the Taverne Olympia, a fashionable café and restaurant at 28 Boulevard des Capucines not far from the Gare Saint-Lazare. Extravagantly decorated with gilded mirrors and sumptuously lit, the famous American bar was the setting for one of Duchamp's cartoons: *Grève des P.T.T.* [Post office strike]. To the young man comfortably perched on a bar stool, the woman

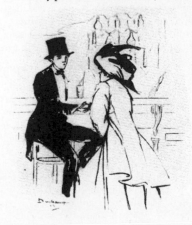

23.3.1910

enquires with surprise: "You didn't receive my express letter then?"

After being badgered by a group of German floozies at the Taverne Olympia, the two young men return to Montmartre. They visit Severini's favourite haunt, Monico's at 66 Rue Pigalle and another cabaret, the Royal. But Duchamp has kept a really special place in reserve until last.

A small doorway at the top of the Rue Pigalle leads to two steep flights of narrow stairs, the second turning at right angles to the first. Decorating the right hand wall are three ornate, gold frames on each flight. Climbing the staircase, the visitors can view the girls of the establishment, or parts of each one, in the form of a live, erotic picture gallery.

At the top of the stairs there is a large bar.

On the left a wide entrance leads to a comfortable rectangular room which, at one end, has a small stage with four wreathed columns. Opposite the entrance there is a small semicircular bar with a mirrored bow window behind it. On the walls hang tall mirrors in highly ornamented gilded frames; garlands of flowers decorate the central motif: a beautifully carved female breast. Louis Morin has painted the panels on the walls and ceiling, which are also elaborately framed in gold. In one, a nude damsel stretched on her back turns happily to pour a glass of champagne into the mouth of a prostrate satyr; in another a naked blonde holding a fan is lying on a gigantic salver which is being carried aloft by a servant of Bacchus and a smirking, bare-chest-

ed giant who has three butcher's knives strapped ominously to his waist; in a third, three nude girls play with a prancing goat: watched by the blonde, while the redhead holds the excited animal, the brunette reaches out for its defiant horns. In the largest panel, which hangs between the bar and the stage, a mad-eyed satyr, life size, carries off an unconscious naked girl through a leafy undergrowth.

Max Bergmann considers that Pigall's is the most incredible place that he has ever seen.

At seven-thirty in the morning Bergmann leaves Duchamp and takes the metro home. It has been a very expensive night and as Duchamp has paid for most of their entertainment, Bergmann proposes to reimburse him in April.

1914. Monday, Paris
At 15 Avenue Foch, in an evening devoted to Saint-Pol-Roux, the Théâtre Idéaliste, which was founded by Carlos Larronde presents *Les personnages de l'Individu, Tristan la vie* and *L'Ame noir du Prieur blanc*. The bill attracts a number of avant-garde painters and writers: Henri-Martin Barzun, Fernand Divoire, René Ghil, Albert Gleizes, Olivier Hourcade, Jacques Reboul and Marcel Duchamp.

1924. Sunday, Hyères-les-Palmiers
With the costs and estimates for Doucet's optical machine agreed [12.3.1924], Duchamp

is pursuing his passion for chess in the south.

Now belonging to the Groupe de Joueurs d'Echecs de Nice, Duchamp plays as a member of the team with Renaud, Reilly, de Smirnoff, and Clérissi, in a match today against the team from Hyères: Maas, de Pampelonne, de Bovies, Chambourlier and Gaudron. The visitors win 5–0.

1926. Tuesday, Paris
In the morning before Jacques Doucet arrives at the Hôtel Istria [21.3.1926], Duchamp receives a visit from Roché, who has decided to purchase *A propos de jeune Sœur* [8.3.1915] from the John Quinn Estate [28.7.1924]. Roché is concerned however that the French franc has gone down in value.

1944. Thursday, New York City
The evening before the opening of the exhibition at America House where Beatrice Wood is showing some of her ceramic work, Marcel invites her to dinner at Michael's. He shows her the miniature chess set he has designed, the size of a leather wallet. To perfect the pocket chess set [7.3.1926] Marcel has added a pinhead to each square and designed the celluloid chessmen with a small hole so that they can be held in place and prevented from falling. Bea thinks it is a wonderful idea and suggests he market it to make some money. "What would I do with money?" Marcel replies. "I have enough for my needs... If I had more money I would have to spend time taking care of it and that is not the way I want to live."

1958. Sunday, New York City
"Today is Sunday," writes Teeny to Jackie in Paris, "cold for spring but the first sun we've seen for ages. Bob Hale is playing chess with Marcel and tonight Mimi [Browne Cohane] and friend are coming for another session."

1959. Monday, New York City
For the exhibition of the Spanish Surrealist Eugenio Fernandez Granell which opens today at the Bodley Gallery Duchamp has written:

> Granell en son
> Domaine d'
> Adultère pour
> Adultes et de
> Presbytères pour
> Presbytes

23.3.1914

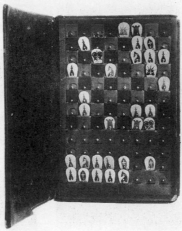

23.3.1944

23.3.1962

1961. Thursday, New York City
Duchamp has two copies of the *Boîte-en-Valise* available in Paris which he reserves for M. Fischli and Serge Stauffer at the latter's request. He gives his approval for an edition of 30 copies, "hors commerce," of the *Boîte de 1914* [25.12.1949] to be made by Stauffer [which was never realized] and agrees to his proposals concerning Daniel Spoerri's book.

1962. Friday, New York City
Knowing how much Brookes Hubachek likes the etching *Portrait de Monsieur Duchamp père* by Jacques Villon, Duchamp posts a copy to him as a present "to make up for the bad luck" he had with the painting *Trois Nus et une Chêvre* [20.11.1949], which was accidentally destroyed in 1956. The etching, Duchamp considers, "carries on the feeling one gets from the portrait" which he painted of his father in a similar pose [6.5.1911]. "[Maître Duchamp] with a brow and all that he needs for thinking, but a bit anxious," were Roché's observations on the portrait, deducing that "perhaps his five [sic] prodigious children were on his mind".

1964. Monday, New York City
"We got your letter late at night," writes Teeny to Jackie, "I read it aloud to Marcel and it just delighted him." Barely a month before Teeny and Marcel are due to move into the studio at 5 Rue Parmentier in Neuilly, Jackie is busy trying to get everything finished [20.3.1964].
"A tray for that first breakfast is indispensable!" agrees Teeny, "a *poubelle*! and broom, etc… Things are really buzzing here and Marcel is fantastic in his activity."

1966. Wednesday, New York City
Louis Carré and his wife, full of news of the Paris art world and the David Thompson sale which they attended, dine at 28 West 10th Street.

1967. Thursday, Neuilly-sur-Seine
In the morning Lefebvre-Foinet comes to the apartment at 5 Rue Parmentier to collect 17 canvases by Suzanne Duchamp [23.2.1967] for the exhibition of the Duchamps at the Musée des Beaux-Arts, Rouen.

*

At three o'clock Teeny and Marcel fly to Nice and then travel to Monte Carlo where the

Grand Prix International d'Echecs is about to start. While they follow the progress of Bobby Fischer [26.12.1965] in the tournament, Teeny and Marcel are staying at the Hôtel Hermitage.

24 March

1913. Monday, Chicago
Just a week after its tumultuous closing ceremony in New York, 634 works from the celebrated Armory Show [17.2.1913], including the four by Marcel Duchamp, *Le Roi et la Reine entourés de Nus vites* [9.10.1912], *Portrait de Joueurs d'Echecs* [15.6.1912], *Nu descendant un Escalier*, No.2 [18.3.1912] and *Jeune Homme triste dans un Train* [17.2.1913], are on display again. An afternoon reception is held for members of the Art Institute which is followed by a gala in the evening, attended by society in force, for the benefit of the Municipal Art League.

Hanging in gallery 53, reserved for the Cubists, Duchamp's Nude is the one picture the public wants to see and it is the first illustration in the catalogue. The public flock to see the "Art Institute Circus", as it is dubbed by the *Evening Post* and revel in their bafflement, shock, hilarity or even fury roused by the new art.

1926. Wednesday, Paris
In the company of Roché and Helen Hessel [8.3.1926], Marcel dines with Mary Reynolds at her apartment at 14 Rue de Monttessuy. It is a "very friendly, simple, almost bourgeois" evening, and Roché admires Mary's remarkable collection of earrings.
After dinner they play two games of chess: Marcel beats his opponent easily but Roché knows that, at the same time, he received a good lesson.

1930. Monday, Paris
With no news from Miss Dreier since his return from the Côte d'Azur, Marcel sends her a telegram at the Regina Palast Hotel, Munich: "Back here telegraph date and hour of arrival in Paris will be at station = Duchamp."

1949. Thursday, New York City
Wishing to correct Katharine Kuh's explanation of Rrose Sélavy [20.10.1920] in a text she is writing for the forthcoming exhibition of the Walter and Louise Arensberg Collection at the Art Institute of Chicago, Duchamp explains in a letter:

"Rrose Sélavy was born in N.Y. in 1920. The name evolved from a (clever? – I would say commonplace) pun on French words: C'est la vie, Sélavy
Rose being the most commonplace feminine name I could think of – (French taste of the period)…"

As for the sentence he wrote for Picabia's *Œil Cacodylate* [1.11.1921]:

"The 'a' of 'habilla' gave me the idea to continue punning: arrose (the verb 'arroser' takes two r's); and then I thought very clever to begin a word, a name with 2 Rs – like the 2 lls in Lloyd.
But I think this is too far-fetched for a serious catalogue."

*

Writes to Mr Swift, president of the San Francisco Art Association, accepting his invitation to dine with the participants of the "Western Round Table on Modern Art" on 7 April.

1960. Thursday, Paris
Because Villon has been gravely ill after the operation for his hip, which he fractured in a fall on 24 February, Teeny and Marcel are in Paris for a few days to be at his bedside while he slowly regains strength.

*

In the evening Marcel meets Roland Penrose.

1966. Thursday, New York City
Attends a party for Japanese artists at the Museum of Modern Art.

1967. Friday, Monte Carlo
At nine-thirty in the morning before taking a taxi from the Hôtel Hermitage, Marcel writes a note to Arturo Schwarz inviting him to join them at the Hall du Centenaire where the pairings for the chess tournament will take place at ten o'clock. "We will stay there until noon," he says. "If you miss us, rendezvous here at the hotel at one."

25.3.1909

In composing the inscription for the wall plaque at 71 Rue Jeanne d'Arc, Duchamp unites the family for posterity under his father's roof:

"Ici a vecu entre 1905 et 1925 une famille d'artistes normands:

Jacques Villon	1875 - 1963
Raymond Duchamp-Villon	1876 - 1918
Marcel Duchamp	1887 -
Suzanne Duchamp	1889 - 1963"

This proposed wording is addressed in a letter to Mlle Olga Popovitch, which Duchamp signs: "With my souvenir *à la roulette*."

25 March

1909. Thursday, Paris
The Salon des Indépendants opens at the Orangerie des Tuileries. Duchamp exhibits two canvases (the maximum allowed for each artist), *Saint Cloud*, which is sold for 100 francs [2,000 francs at present values], and *Paysage*.

Also in the exhibition are two pictures by Wassily Kandinsky, *Nuages rouges* and *Nuage bleu*; the double portrait of Apollinaire and Marie Laurencin entitled *La Muse inspirant le Poète* by the Douanier Rousseau, and two works by Duchamp's neighbour Georges Ribemont-Dessaignes, who lives at 141 Rue Perronet in Neuilly.

1910. Good Friday, Neuilly-sur-Seine
When Max Bergmann arrives at 9 Rue Amiral-de-Joinville after lunch, Duchamp, who has been enjoying some success with publishing his humoristic drawings – notably in *Le Courrier Français* – asks Bergmann to pose for him.

In the evening Duchamp accompanies his German friend back to Paris on the metro.

1917. Sunday, New York City
In the evening Duchamp, Roché, Gleizes and Arensberg dine together with "lots of girls".

1935. Monday, Paris
When Duchamp calls at the Impasse Ronsin,

Brancusi is not feeling well enough to go with him to the concert given by the pianist Gilles Guilbert that evening. Marcel goes on his own, but "suffers" throughout his friend's performance. Immediately after the concert, at eleven-fifteen, Duchamp writes to Guilbert at the Hôtel Claridge.

"It seems to me that it is too much for you to endure the public. The feelings, above all, come from such riffraff that they make you lose confidence in yourself. You must eliminate the public," advises Duchamp, "by crushing it with your superiority."

1937. Thursday, Paris
In his weekly chess column Duchamp has selected an unpublished problem by J. Bokkm, which is dedicated to *Ce Soir*, for his readers. Giving the solution to the problem by André Chéron [12.3.1937], Duchamp comments on the game played by R. Spielmann and E. Zinner in the match between Vienna and Brno. He announces that Dr Alekhine is making a tour of provincial chess clubs in France before playing in the forthcoming International Tournament at Stockholm. The Cercle du Palais-Royal is resuming its sessions of simultaneous games which will be held on Sundays commencing at three o'clock.

1950. Saturday, Milford
While Dee is up from New York to visit her, Miss Dreier reads him Fritz Glarner's lecture entitled "Relational Painting", which in their opinion "is full of meat" and shows "an interesting and serious approach" to the artist's work.

1953. Wednesday, New York City
As Duchamp is unable to meet Henri-Martin Barzun on a Saturday for five or six weeks because he will be playing chess those evenings for his club's team in the Metropolitan League, he sends a telegram and a letter to Barzun asking him to suggest another day. "On the whole Wednesday is not bad for me," Duchamp proposes. "Such difficulties for two to meet, what will it be for 3 or 4 people!!"

1957. Monday, New York City
According to Robert Lebel, now back in Paris after his recent visit to New York, Arnold Fawcus has "excellent" impressions of their layout for the book and their ideas for the "de luxe" edition.

As Fawcus has pointed out that a "de luxe" edition also includes a few copies which cost even more on account of a "special attraction", Lebel has suggested that for the "super de luxe" version Duchamp might hand-colour the remaining 13 sheets of cellophane made for the stencil of the Large Glass – like the one he gave Lebel as a present – which is based on John Schiff's photograph taken at Milford in 1948. Duchamp agrees, "Marcellus coloriavit," and draws a diagram to show how the cellophane could be mounted on black paper on the inside cover of the book opposite the profile.

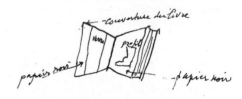

Hoping that the value of the sculpture by Brancusi [16.3.1957] can remain steady, Duchamp writes to Roché: "Since the death of our dear Morisse I'm afraid you may change your prices."

1960. Friday, New York City
Teeny and Marcel fly back from Paris after their short visit to see Jacques Villon.

1965. Thursday, New York City
Gorsline has written from Valescure to tell Duchamp that he has found the solution to his bottle rack by signing it himself [28.7.1964] and to enquire whether he could sublet the studio at 5 Rue Parmentier. Duchamp replies that they "are not in the mood to rent or sell the Neuilly apartment".

*

In reply to William G. Anthony, Duchamp writes declining to write a comment for the dust jacket of a book saying that it is a principle of his not to write "this kind of criticism however appreciative it might be".

1966. Friday, New York City
Marcel is delighted that Brookes Hubachek has agreed to lend *Jardin et Eglise à Blainville* [2.12.1949] and *Clair de Lune sur la baie à Basswood* [21.8.1953] to his exhibition at the Tate Gallery and, to reassure him, writes to explain the expression "nail to nail": the in-

26.3.1910

26.3.1963

surance covering the pictures from the moment they are removed from his wall until they are returned to exactly the same place.

As the Duchamps would love to see Hubachek's wife and daughter when they are in Paris in mid May, Marcel gives Brookes the telephone number and address at 5 Rue Parmentier. "Not Paris but 5 minutes from the Place de l'Etoile," adds Marcel, "and no problem to find us."

1968. Monday, New York City
To allow the exclusive black-tie opening of "Dada, Surrealism and their Heritage" to take place unhindered by demonstrations, the police are out in force on 53rd Street barricading the entrance to the Museum of Modern Art. As the guests arrive, some 300 hippies cry: "Surrealism means revolution, not spectator sports," and a member of a group calling itself The Transformation declares that they are "carrying on the spirit of Dada by being here instead of in the museum... We're part of a spiritual and cultural revolution that's going on all over the world."

Meanwhile in the Founders Room on the sixth floor, Duchamp, who has 13 works in the exhibition, is amongst the 250 guests gathered for drinks and Chicken à la Ritz to celebrate the opening. He is reported as saying: "Certainly I approve of the demonstrations as long as they are not violent."

26 March

1910. Saturday, Paris
In the evening Duchamp takes Max Bergmann to the Palais de Glace on the Champs-Elysées, where they stay until eleven-thirty. It is one of Duchamp's favourite haunts although he never skates.

1917. Monday, New York City
Florentine costumes are *de rigueur* for the Arts Ball at the Vanderbilt. Accompanied by Beatrice Wood, Louise Norton and other friends, Roché wears a gentleman's costume with a doublet fashioned by Bea from a grey vest belonging to her brother, and Marcel is disguised as an astronomer.

1918. Tuesday, New York City
In the morning Roché visits Marcel who is on his own and they have a good talk. While they have brunch, which consists of scrambled eggs, tea and grapefruit, Marcel declares that nothing new has been written since *Un Coup de dés jamais n'abolira le hasard* by Stéphane Mallarmé, and in music nothing has happened either since Debussy. They discuss *Les Chants de Maldoror* by Lautréamont. Roché notices on the wall that the painting for Miss Dreier [16.3.1918] is now well advanced.

1925. Thursday, Paris
Sends one of the *Obligations pour la Roulette de Monte-Carlo* [1.11.1924], on which stamp duty has been paid, to Ettie Stettheimer in New York.

1926. Friday, Paris
The Galerie Surréaliste, 16 Rue Jacques Callot, opens with the exhibition "Tableaux de Man Ray et objets des Iles". The preface to the catalogue is composed of sentences about birds by various authors including Apollinaire, Desnos, Diderot, Lautréamont and the Venetian poet Giorgio Baffo. The melancholic *Portrait de Rrose Sélavy*, its title indicated with a rosebud, the words "cela vit" painted on the canvas, and its background inspired by the web-like *Témoins oculistes* [20.10.1920] (which belongs to Man Ray), finds companions from strange, distant lands. One of these is the squatting Niassan, whose erection displayed in the gallery window shocks the public and scandalizes the Press.

1942. Thursday, Geneva
While in Geneva, Marcel posts an envelope containing a card which the Villons (who are in the occupied zone) have addressed via Marcel to the Steegmullers [24.11.1941] in New York. "I believe my [American] visa has been granted [21.3.1942]," adds Marcel on the card.

*

On his way to Switzerland, Marcel stopped at Montélimar again to meet Roché (probably staying overnight at the Relais de l'Empereur [30.12.1941]), and told him the news about his American visa. Marcel plans to leave, therefore, but Mary Reynolds has decided to stay in France for the time being. "It's a new turning point in Marcel's life," thought Roché, wondering when he might see him again.

Before parting company, Marcel gave Roché the original miniature version of *Fountain*, which is in terracotta and varnished. (The series for the *Boîte-en-Valise* [7.1.1941] was fired by a professional artisan in 1939.) Delighted with his new acquisition, Roché finds it "a small masterpiece of humorist sculpture, the colour of cooked shrimp, with such absurd and carefully made tiny holes".

Marcel also gave Roché some of his "tobacco": a substitute which has been boiled in water laced with snuff powder.

1957. Tuesday, New York City
Marcel writes to Yvonne Lignières (the widow of his brother Raymond), to ask whether she still has "the little Metzinger... If it has not been sold," he tells her, "and you are interested in a possible sale, Sidney Janis would like to know the price."

1959. Thursday, New York City
Marcel is expecting Kay Boyle [20.3.1959] to call at 327 East 58th Street with her *Boîte-en-Valise*.

1960. Saturday, New York City
At the final proof stage Marcel has two last corrections to make to the English translation of the notes which Richard Hamilton has sent him. The first is on the Brasserie de l'Opéra page with the drawing of the Sieves [3.8.1914], where the word "butterfly" should be in the plural. The second concerns a measurement indicated on the General Plan – the drawing of the Glass in perspective – where Duchamp finds "48,5 short" for "48,5 faible", is "better than feeble".

*

Duchamp receives a telephone call from Louis Carré (recently arrived in New York), who gives him reassuring news of Villon.

1963. Tuesday, New York City
Photographs by Marvin P. Lazarus taken over the last three years at 28 West 10th Street [26.5.1960], including one made at the Museum of Modern Art during the "Art of Assemblage" exhibition [10.11.1961], are shown in "The Many Faces of Marcel Duchamp" at the East Hampton Gallery, 22 West 56th Street.

Two tough-looking guards provide security for one of the particularly valuable exhibits which represents a curious scene in the Louvre.

27.3.1902

28.3.1902

1968. Tuesday, New York City
The day after the private view of "Dada, Surrealism and their Heritage", Duchamp attends the first session, which is on Dada, of the three-day symposium commencing at one-thirty at the City University of New York. Other participants include Roger Shattuck [19.10.1961], Richard Huelsenbeck, Marguerite Arp and Marcel Jean.

Afterwards Duchamp stops by at Wally's on 44th Street and Madison Avenue, where he buys a supply of cigars before his departure for Europe.

27 March

1902. Thursday, Blainville-Crevon
Suzanne's doll's pram is a subject for both the eldest and the youngest brothers. Villon entitles his etching *La vie n'est pas un roman*, while Marcel chooses for his drawing in ink, *Parva Domus, Magna Quies*; both are chapter titles from *Jack*, a novel by Alphonse Daudet.

"Parva Domus Magna Quies"

1905. Monday, Paris
After an absence of seven weeks, Marcel returns to the Académie Julian and pays for four consecutive weeks of morning sessions, which are held from eight o'clock until midday.

*

Maître Duchamp, who has been *notaire* at Blainville-Crevon for twenty years, signs his last notarial documents. In retiring from his practice and moving with his wife and three daughters to Rouen, Eugène Duchamp plans to pursue an active career in the Norman capital participating in regional affairs and acting for various community organizations.

1917. Tuesday, New York City
After further examination by French military doctors [6.1.1915], Duchamp is again considered unfit for active service.

1921. Sunday, New York City
With Marsden Hartley, Charles Demuth and other friends, Marcel is invited by Carl van Vechten to come after lunch to his apartment at 151 East 19th Street. Van Vechten's luncheon guests include the painter Andrew Dasburg and Ettie Stettheimer, but Fania is away on tour with Belasco's success: *Call the Doctor* [13.12.1920].

1925. Friday, Paris
Sending Marcel a "laconic" cheque in payment for one of his Monte Carlo bonds [1.11.1924], Ettie Stettheimer has drawn attention to the fact that she has had no news from him for more than a year. Marcel replies to say how surprised and how ashamed he is: "For several years I have been writing to you very often in my thoughts. Don't hold it against me."

First business: he thanks her for joining his scheme and explains that the bond he posted to her the previous day is the only one with any value because stamp duty has been paid on it. It is on this bond that Ettie will receive 20% interest. "My statistics give me full confidence. I spent a month in Monte Carlo last year and proved that I was not a gambler," writes Marcel. "I am going to play there in this frame of mind: a mechanized mind against a machine. Nothing romantic in the venture, nor luck." If Jane Heap has sent her an unstamped bond, Marcel advises her to "keep it as a work of art".

After spending the last two years in Paris "I think of New York in a dreamy way", Marcel admits, "because I cannot see any possibility for me to live there as I did." He tries to tempt the sisters to come to Paris with the description of a furnished house, similar but smaller than their own in 76th Street, with a large studio on the ground floor, which can be rented for 2,500 francs a month. Florine could exhibit the numerous portraits she has painted, and Carrie has surely had enough of housekeeping?

With greetings to Mrs Stettheimer and asking Ettie to embrace Carrie and Florine, he signs the letter: "RroseMarcel."

1952. Thursday, New York City
"I feel very guilty to have brought so much trouble in your life by the loan to Sweeney's

show [10.3.1952]," writes Marcel to Lou and Walter Arensberg. "First of all let me thank you *du fond du cœur* for having made it possible to have two of my things in the exhibition."

On giving their agreement to make the additional loan of *Mariée* [25.8.1912] to "L'Œuvre du XXème Siècle" which James Johnson Sweeney is organizing for the Congrès pour la Liberté de la Culture in Paris, Walter nevertheless reminded Marcel: "You gave your whole-hearted approval to the restrictions which we made at the time of the gift [to the Philadelphia Museum], and I also recall that long ago when we first loaned anything of yours we always felt obliged to obtain your permission first, and this because of your own reaction to lending [8.11.1918]."

Marcel reveals to his friends that Beatrice Wood has written asking him when he will come to live in California, and confesses: "I can't imagine myself playing chess with the Prophets in Ojai!"

1967. Monday, Monte Carlo
Turning his attention from the chess tournament in full swing, Marcel writes to Arne Ekstrom that, while in Monaco, Arturo Schwarz has decided to buy the marble by Arman, exhibited in "Hommage à Caïssa" [8.2.1966]: would he please arrange for the piece to be sent by sea to Schwarz in Milan.

1968. Wednesday, New York City
In the afternoon Duchamp attends the second day of the symposium which commences at the Museum of Modern Art at three-thirty. The panellists discussing Surrealist Art are David Hare, the critic Hilton Kramer and Nicolas Calas.

28 March

1902. Friday, Blainville-Crevon
Marcel makes a drawing of his sister Suzanne as she grips her tennis racket vertically at arm's length before her. The ball she has knocked into play is suspended in midair.

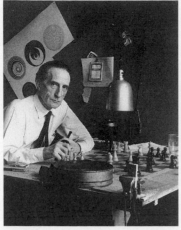

28.3.1956

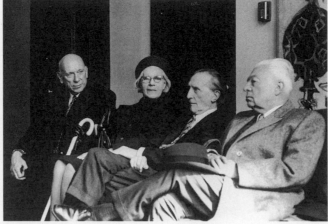

28.3.1968

1918. Thursday, New York City
In the evening at the Arensbergs', Marcel plays chess with Ernest Southard [4.5.1917].

1926. Sunday, Paris
Invited by Roché and Helen Hessel to lunch, Mary Reynolds and Marcel take the train to Fontenay. After the meal, with Cinzano as an apéritif and Benedictine served with the coffee, Marcel plays chess with Helen's sons: first a game with Kadi and then one against Uli.

At four-thirty, as Mary and Marcel are wanting to return to Paris, Helen and Pierre accompany them to the station.

1929. Thursday, Biarritz
On the last stage of their motoring tour from Gibraltar [23.2.1929], Duchamp, Miss Dreier and Mrs Thayer arrive at the Grand Hotel and Bellevue-Palace for Easter weekend.

1944. Tuesday, New York City
Marcel visits the exhibition of Beatrice Wood's ceramic work at America House on 53rd and Madison Avenue, and compliments her on some of the conventional bowls. Afterwards at the restaurant of the Museum of Modern Art, Marcel introduces Bea to Mary Reynolds and they have lunch together.

1950. Tuesday, New York City
Has an initial meeting with Francis Taylor of the Metropolitan Museum, who is anxious to discuss the donation of the Arensberg Collection. It is suggested that Duchamp should represent the Arensbergs at a special committee meeting to consider the terms of the donation.

1956. Wednesday, New York City
At 210 West 14th Street, Sidney Waintrob photographs Duchamp looking straight at the camera, seated at his chessboard, his pipe in his left hand, with a partial sheet of *Rotoreliefs* [30.8.1935] pinned to the wall behind him.

1960. Monday, New York City
To assist Douglas MacAgy, now director of the Dallas Museum, who is organizing an exhibition of lesser known artists, Duchamp writes to Marceau of the Philadelphia Museum of Art. Has he any knowledge of the request made to Henry Clifford at the museum for loans from the Arensberg Collection, namely the painting by John Covert and four Morton

Schambergs? Duchamp reminds Marceau: "[MacAgy] and his wife, you know undoubtedly, have always organized interesting exhibitions in San Francisco [8.4.1949], Houston [22.3.1957] etc."

1963. Thursday, New York City
Believing his first letter to have gone astray, Duchamp writes to Jean Larcade [18.1.1963], care of Lefebvre-Foinet.

1965. Sunday, New York City
After three years' silence [2.1.1962], Serge Stauffer has written to Duchamp enclosing the unique result of his long and patient trials with the printer in Zurich to create a miniature version on stronger celluloid of *Glissière contenant un Moulin à Eau en Métaux voisins* [11.12.1919]. Duchamp finds it very satisfactory, and adds: "Of course I would have liked to have a hundred copies for the recent edition of the *Boîte-en-Valise*."

He then replies specifically to three questions posed by Stauffer, who is preparing a lecture on Duchamp's work for his students at the Bath Academy of Art, where he is teaching for six months. The first is whether, like Roussel, Alfred Jarry was "responsible" in any measure for the elaboration of the Large Glass [5.2.1923]. Duchamp declares that there was no direct influence: "Only an encouragement found in Jarry's general attitude towards what one called Literature in 1911."

The second query concerns the different interpretations given by Robert Lebel and Ulf Linde of *Témoins oculistes* [20.10.1920] and whether he agrees with either of them. Duchamp admits that he is highly amused by the various interpretations of the Large Glass but that each opinion is entirely the author's. He adds: "My preoccupations ... in the Large Glass were, above all, as disparate as possible and leave the door open to all interpretations of others."

To Stauffer's question "Why is eroticism serious?" Duchamp answers: "Have you ever tried to laugh while making love?"

1968. Thursday, New York City
Duchamp attends the final day of the symposium "Dada Surrealism" sponsored by the City

University of New York. At one point in the proceedings, the moderator announces that Duchamp is present and adds: "We should feel very privileged to hear Mr Duchamp, if he cares to address us." Duchamp replies quite simply: "I don't care to."

While Duchamp is seated on a bench talking to Marguerite Arp, Richard Huelsenbeck and Marcel Jean, Michel Sanouillet takes a photograph.

29 March

1899. Wednesday, Rouen
At ten, after the morning class with M. Ligeret, Marcel and his comrades are released from the Lycée Corneille for the Easter holidays.

"Intelligence and taste is developing," states Marcel's end-of-term report, "the child follows his class very well and is gaining a great deal. His level is much higher; his progress is very marked."

1904. Tuesday, Rouen
History with M. Kergomard starts at ten o'clock and is followed with an hour's Drawing in plan and section as applied to exact science supervised by M. de Vesly. After lunch M. Texcier takes Greek between one and two, which is followed by two hours of Philosophy with M. Dominique Parodi, the last class before the beginning of the Easter holidays.

1917. Thursday, New York City
As the date approaches of the exhibition of the Society of Independent Artists [13.3.1917] which they are helping to organize, Roché and Beatrice Wood come to work with Marcel in his studio. Later they visit the Arensbergs together.

1918. Friday, New York City
With Roché, Mary Sturges, Joseph Stella and Alissa Franc, Marcel goes to see *Let's Go*. Seated in the front row of the gods, Roché is delighted by the revue and its negro orchestra, but the others in the party are not so enthusiastic. After the theatre, Mary, Marcel and Stella go on to Ziegfeld's.

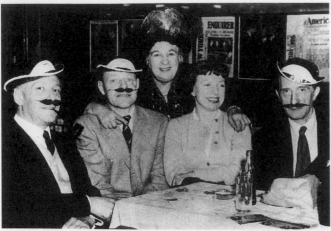

30.3.1960

1937. Monday, Paris
Dee gently chides Miss Dreier for never telling him that she was going to Germany for a month before coming to Paris. It appears that she realized her mistake when Dee's letter, making it clear that he was expecting her on 24 March, was delivered to her on the SS *Europa* when the ship called at Cherbourg.

As Miss Dreier is alarmed by the recent very violent clashes in Clichy between the partisans of Colonel de La Rocque and the Communists, Marcel reassures her: "Don't worry... There is too much interest attached to the success of the international Exposition to allow trouble."

His present activities, he tells Miss Dreier, are: writing a chess column for *Ce Soir* (appearing every Thursday evening [4.3.1937] for which he is earning 600 francs a month), and printing more reproductions for his "album".

1952. Saturday, Milford
After months of suffering Katherine Dreier dies at her home aged seventy-four. "It is really a hard experience to be unable to show your feelings to someone in complete ignorance of the inevitable character of the situation," Duchamp reflects. "Fortunately we all have in us a curious animal belief in eternity, as though Time would stop in our personal case."

An artist and arch-defender of Modern Art, Miss Dreier became a loyal supporter of Duchamp when she met him through John Covert at the foundation of the Society of the Independent Artists [5.12.1916]. In her at-tempt to persuade Duchamp not to resign over the Richard Mutt case [11.4.1917], she wrote to him: "It is a rare combination to have originality of so high a grade as yours, combined with such strength of character and spir-

itual sensitiveness." Later with Duchamp and Man Ray she founded the Société Anonyme Inc. [30.4.1920], the first Museum of Modern Art in the United States, which continued its strenuous work of organizing exhibitions and promoting artists' work and ideas through lectures and publications, even after the collection had been given to Yale University [14.10.1941].

Although Duchamp lived in France between the two world wars except for occasional visits to New York, his allegiance to the Société Anonyme was constant. If Miss Dreier was the

driving force in the society's activities and knew exactly what she wanted to buy for the collection, she greatly admired Duchamp and relied on him for advice and spiritual strength as well as for his practical help as a partner in their ventures.

Busy as she was with the Société Anonyme, Miss Dreier found time for her own painting. She made two portraits of Duchamp both of which were painted in 1918. One was an abstract composition [1.3.1945], the other a figurative study: Duchamp, who poses on a stool in his belted overcoat, holding a pipe and felt hat, helped Miss Dreier by painting the abstract forms of his shadow cast on the background panel of the canvas.

Not as vast as the Arensbergs' collection of Duchamp's work, Miss Dreier nevertheless owned some of his key works including the Large Glass [5.2.1923]. As one of the three executors of her will, Duchamp has the responsibility of placing in institutions the works of art belonging to Miss Dreier's personal collection which remained separate from the gift of the Société Anonyme to Yale.

1956. Thursday, Philadelphia
As agreed with Henri Marceau [21.3.1956] Duchamp is due at the museum at three o'clock to prepare for the arrival at four of Peter Juley, who is to make colour transparencies of *Nu descendant un Escalier*, No.2 [18.3.1912] and *Le Roi et la Reine entourés de Nus vites* [9.10.1912]. About seven in the evening, when it is dark Duchamp and Juley have permission to go up to the gallery to photograph the Large Glass [5.2.1923] in colour by artificial light.

1961. Wednesday, New York City
For the BBC's television programme "Monitor", Duchamp is interviewed by Katharine Kuh.

1963. Friday, New York City
Jackie Monnier has completed 30 more copies of the *Boîte-en-Valise* [7.1.1941] and delivered them to Lefebvre-Foinet. Thanking her Marcel says that they will talk about the next 30 Boxes when he comes to Paris in May.

Because of television commitments for the Armory Show anniversary, Marcel himself is working "in slow motion" on the second edition of the *Pocket Chess Set* [23.3.1944]. "Affectionately to you two," writes Marcel to Jackie, "and to the 3 pawns of your chessboard."

1968. Friday, New York City
Michel Sanouillet and his wife, who are in New York for the exhibition and symposium on Dada and Surrealism [25.3.1968], are invit-

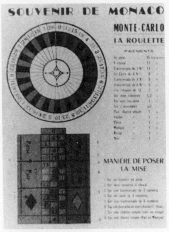

30.3.1967

ed to 28 West 10th Street. Monique Fong calls by and Sanouillet takes some colour photographs of Duchamp.

30 March

1909. Tuesday, Rouen
On the last day of the Salon des Artistes Rouennais [27.2.1909] the *Journal de Rouen* announces that with the help of a grant from the municipal council to the Société des Artistes Rouennais 17 pictures have been acquired as prizes for the tombola, one of which is *Vieux Cimetière* [1.10.1908] by Duchamp. The draw is to be held on 8 April, after which the paintings may be collected from the museum.

1927. Wednesday, Paris
Duchamp, Picabia and Roché are invited to lunch by Jacques Doucet, 46 Avenue du Bois, [with Mr and Mrs John Alden Carpenter from Chicago?].

1928. Friday, Nice
On 19 April in New York, Alfred Stieglitz will open an exhibition of the eleven Picabias (all framed by Pierre Legrain) which Duchamp has shipped to him at the Intimate Gallery [15.1.1928]. After sending a telegram with the message "mailing introduction", Duchamp writes to Stieglitz from the Grand Café de la Poste, Place Wilson: "Very glad you like the pictures. You will find here an Introduction that Picabia had written by Miss Guinness... I hope it will do."

1935. Saturday, Paris
Acting as go-between for Howard Putzel in San Francisco, Duchamp informs Kandinsky that the American dealer proposes returning the watercolours on 29 April at the latest, but would like to keep one or two, "if there are buyers who do not decide immediately."

*

Jacques Villon and Marcel visit 99 Boulevard Arago. Villon brings Roché "a beautiful landscape", Marcel shows him his "optical discs" [5.3.1935]. Roché finds the discs "admirable", but as he has forgotten to bring the gramophone, they cannot watch them turning.

1942. Monday, Montélimar
On his way back from his short visit to Switzerland, Marcel makes another overnight stop to see Roché, who has come to meet him from Dieulefit. Marcel is full of news of his banking friend Bublin in Geneva [26.3.1942] and recounts his visit to Basel. He presents Roché with a packet of real tobacco and gives him a new recipe for a substitute, which is boiled with herbs instead of snuff.

Roché says how pleased he and Denise are with the miniature *Fountain* [26.3.1942], and also writes a recommendation for Marcel in case he needs it to go to New York. They enjoy some very good games of chess before retiring to their adjoining rooms at the Relais de l'Empereur: number 35 for Roché and number 36 for Marcel.

1949. Wednesday, New York City
As he has had no reply from Miss Eilers concerning his plane ticket and accommodation [18.3.1949], Duchamp writes to MacAgy and enquires at the same time whether the conference in San Francisco will be broadcast to Europe as "some friends in Paris would like to listen".

1957. Saturday, New York City
The dealer George Staempfli would like to buy the Brancusi entitled *Le Commencement du Monde*, one of the sculptures Duchamp and Roché purchased from the John Quinn Estate [13.9.1926]. Marcel writes to Roché again hoping that he will agree to a "stable" price, not an inflated one [25.3.1957].

1958. Sunday, New York City
"Seventy years ago, Young Gargantua," writes Marcel in French, "you constructed the Eiffel Tower... Since then you have played many other tricks just as towering."

The text is to be published in the catalogue of Hans Richter's exhibition opening at the Institute of Contemporary Arts, Washington, D.C., on 6 April.

1960. Wednesday, Reims
Le Cosmorama de Jean Dubuffet of today's date, which has been prepared by Noël Arnaud for the Collège de 'Pataphysique, includes a historic document of Transcendant Satrape Jean Dubuffet, the Satrapesse Dubuffet and Transcendant Satrape Marcel Duchamp at the Bow-

ery Follies in New York with the proprietress in her ostrich-plumed hat. In fact the moustachioed Satrapes in their paper hats were also accompanied to this place of entertainment by Enrico Donati who, in the original photograph, is seated on the left of the group.

1961. Thursday, New York City
Inviting Bill Camfield to see him on 3 April, Duchamp gives him his telephone number, ALgonquin 4-8692, in case he should want to change the date.

1963. Saturday, New York City
In accepting Gianfranco Baruchello's invitation to go to Rome on 20 May, Duchamp writes: "We will contact you from Paris to confirm our arrival."

1967. Thursday, Monte Carlo
In a pause from following the Grand Prix International d'Echecs, which is in its final stages, François Le Lionnais [25.6.1965] invites Duchamp to add his signature to a number of postcards he has written to Oulipians: Noël Arnaud, Jean Queval and Paul Braffort, reminding them that their next meeting of Oulipo [OUvroir de LIttérature POtentielle] is on 14 April.

1968. Saturday, New York City
The day before leaving for Europe, Marcel writes to Brookes Hubachek in Chicago giving him their summer schedule which starts with a flight to Paris, followed by a fortnight in Monte Carlo. "No gambling," Marcel assures Brookes.

31 March

1924. Monday, Nice
"The climate suits me perfectly, I would love to live here," writes Duchamp to Jacques Doucet from the Hôtel des Etrangers, Rue du Palais. Apart from chess he has been playing *trente-et-quarante*, tried numerous systems and

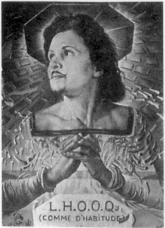

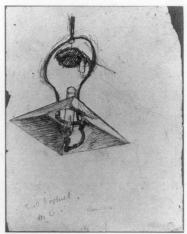

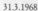

31.3.1961 31.3.1968

been losing "like a novice". Now with experience his results are better: "I play without placing a stake." The best result, for Duchamp, is the discovery that he is not in the least a gambler. "I spend afternoons in the casino without the slightest temptation... Naturally all this leads to the inevitable conclusion, I really need my last two thousand." This sum is part of the arrangement with Doucet for building the optical machine [28.2.1924].

Although Picabia has left Cannes for Paris today, Duchamp will remain in Nice until Easter to play in a chess tournament.

1926. Wednesday, Paris
Busy making contacts and plans for the Société Anonyme's international exhibition due to open in Brooklyn at the end of the year, Duchamp writes to Pablo Picasso, 23 Rue La Boétie, requesting an appointment for himself and Miss Dreier while she is in Paris. Duchamp suggests that they meet at two-thirty on 5 April at the Café de la Régence, 161–163 Rue St Honoré, near the Palais Royal, and reminds Picasso that two years ago Jean Pougny's wife had already tried to arrange for Miss Dreier to meet him.

*

At three o'clock in the afternoon, Marcel and Roché are at the Gare Saint-Lazare to meet Brancusi on his return from New York.

1927. Thursday, Paris
In the morning at eleven-thirty Roché calls to see Totor at the Hôtel Istria.

1930. Monday, Paris
For his important exhibition "Cubism 1910–1913" which he is organizing at the Seligmann Galleries in New York, de Hauke has flown to see the Arensbergs in California to request the loan of *Nu descendant un Escalier*, No.2 [18.3.1912]. Wanting the artist's agreement too, Jacques Seligmann, who is in Paris, arranges to meet Duchamp and then cables Arensberg on Duchamp's behalf: "Willingly consent to loan of Nu escalier cubism exhibition affectionately Marcel Duchamp."

1942. Tuesday, Montélimar
In the morning the hotel porter wakes Duchamp at six-fifteen instead of a quarter to six. Furious at having to leave in a hurry, he nevertheless catches his train south to Sanary.

1950. Friday, New York City
Invited by Fiske Kimball to speak at the "Diamond Jubilee", Duchamp declines saying that "since a deplorable experience dating from 1916" he has made it a rule never to speak in public. Explaining that he agreed to attend the "Western Round Table on Modern Art" [8.4.1949] because "the sessions were private and limited to a friendly discussion", Duchamp declares, "I remain true to the saying: 'stupid as a painter' and I apply it willingly to artists who believe that they can say something otherwise than in their ideographical language."

1952. Monday, New York City
For the funeral of Miss Dreier, which takes place at two o'clock in the Episcopal Church of St Matthew and St Timothy on 84th Street, Duchamp has arranged for flowers to be sent. On the accompanying card he has written: "From the Duchamp family, Jacques Villon and Gaby, Suzanne Duchamp, Jean Crotti, Marcel Duchamp."

1953. Tuesday, New York City
Following the disappearance in February of Gabo's model for *Construction in Space with Balance on Two Points* from a shipment of objects belonging to the Dreier Estate destined for the Guggenheim Museum, Duchamp consoles Yale University Art Gallery: "Miss Dreier, I am sure, would accept it as a manifestation of fate since we can't see any valid explanation."

1955. Thursday, New York City
Receives the press cutting from *Arts* reviewing the exhibition "Pérennité de l'Art Gaulois" [18.2.1955]. "Very cheering," remarks Marcel to Roché.
 Referring to the Guggenheim Museum's forthcoming Brancusi exhibition which Sweeney has been wanting to organize for a long time [22.9.1953], Marcel tells Roché: "Lend everything. The museum is very serious."

1959. Tuesday, New York City
Suggests to Kay Boyle [20.3.1959] that they meet at the Iolas Gallery, 123 East 55 Street, around noon on 6 April. As there is an opening at the gallery that day, Iolas will certainly be there. Marcel adds that he has left her *Boîte-en-Valise* [7.1.1941] with Mr Thaw at the New Gallery, 601 Madison Avenue.
 Published in the catalogue of Man Ray's exhi-

bition at the Institute of Contemporary Arts, London, is Duchamp's definition of his friend: "Man Ray, n. m. synom. de Joie jouer jouir."

1961. Friday, Reims
Marie-Louise Aulard's account of the exhibition "Surrealist Intrusion in the Enchanter's Domain" [28.11.1960] is published in "La Tichomonase" the *Dossier du Collège de 'Pataphysique*, No.14.
 "Le Surréalisme prend un nouveau tournant T.S. Marcel Duchamp" is the title of the article about the event which, the author claims, breaks refreshingly with the "rather conventional academism of this kind of manifestation". In the eyes of the "connoisseur", the opening night orchestrated by Duchamp with the arrival of Dali had a particularly pataphysical value and was surrealist in the best sense.

Referring to the publication in the first days of December of the bilingual tract *We don't EAR it that way* (which is illustrated with the divine Gala in a pastiche of *L.H.O.O.Q.* [6.2.1930]), Marie-Louise Aulard remarks that that Parisian Group appears to have appreciated Duchamp's initiative exactly as it should: "Inspired by the Marchand du Sel's subtle conduct, this text is an acute mystification and very delicate humoristic reaction, of which the Surrealist past has few examples." With this "ingenious pastiche", which in her opinion is the "most intelligent satire", the author says "one can consider that the Surrealism, a little late in the day, manages at last to look at its activity 'on another level' and to think pataphysically."

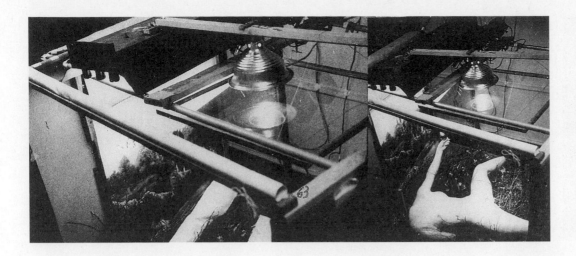

After discussing the relationship between "subversion" and "conformism", Marie-Louise Aulard concludes that with this impressive turning point in Surrealism, "it seems now that the inclusion of the Surrealist Group in the college is only a question of days."

1963. Sunday, New York City
Writing to Gorsline (who is continuing his research [23.12.1962] in France), Duchamp refers to the book by Marey, *Le Mouvement*, published in 1894 which a Yale student has shown him. "I suppose that what I saw in 1911 in the magazine was taken from that book partly at least," Duchamp says.

1964. Tuesday, New York City
After the opening of Gianfranco Baruchello's exhibition at Cordier & Ekstrom (which Marcel does not attend), the Duchamps invite Baruchello to dinner at 28 West 10th Street.

1968. Sunday, New York City
On opening the ordinary modern door to Room 403 at 80 East 11th Street, the view of the small studio inside is blocked by a massive object. Hidden behind a curtain and temporarily framed by three panels of fake bricks is a heavy wooden door with two small holes at eye-level. On looking through these apertures the eye is directed through a gap in a brick wall to a sunlit scene. Just beyond the breach in the wall, a nude on her back lies provocatively on a heap of dry twigs. She is resting with one leg stretched straight towards the onlooker, the other spread out to the right with the knee raised slightly. In the hand of her outstretched left arm she holds up a small, glowing gas lamp. Although some locks of fair hair are visible, the bricks in the foreground mask her head from the onlooker. Far beyond, on the right, under a blue sky broken by some fair-weather clouds, is a wooded hillside with a waterfall glinting in the sunlight as it cascades over the rocks.

This peaceful and magic tableau, which Duchamp has worked on secretly for twenty years (between 1946 and 1966), is entitled *Etant donnés: 1° la chute d'eau, 2° le gaz d'éclairage*. The title is the same as that used in a notice and also a preface to the Large Glass, both of which are found in the notes of the Green Box [16.10.1934]:

"Given 1st the waterfall
 2nd the illuminating gas,
we shall determine the conditions for the instantaneous state of Rest (or allegorical appearance) of a succession [of a group] of facts seeming to necessitate each other under certain laws, in order to isolate the sign of the accordance between, on the one hand, this state of Rest (capable of all the innumerable eccentricities) and, on the other, a choice of Possibilities authorized by these laws and also determining them…"

These energy sources – the waterfall and the illuminating gas – remained quite imaginary in the Large Glass. The landscape of the water mill, which Duchamp described as "hiding" in the bosom of the Glider [11.12.1919], also remained imaginary. However, on peering through this ancient door, the landscape of the water mill with the waterfall, the burning gas lamp and the "Bride desiring", are suddenly revealed in a timeless apparition.

It was in the summer of 1946, when he was at Puidoux [5.8.1946], that Duchamp decided upon the landscape for *Etant donnés*. He already knew the breathtaking view of the Alps from the great vineyards of Lavaux [2.8.1945], which his friend Denis de Rougemont believed to be the centre of the world. But instead of this grandiose panorama, Duchamp's attention was drawn to the scene nearby of the small ravine dividing Puidoux from the village of Chexbres. A photograph taken from the corniche of the waterfall cascading past the mills with a tall poplar in the foreground provided him with the basis for the background of *Etant donnés*. Later, using a photographic enlargement of the scene, he hand-coloured the wooded hillside on the right half and, to complete the left half, collaged in more trees and wilderness.

The gas lamp held aloft by the nude is none other than a Bec Auer, the same kind of incandescent burner with a green light which Duchamp drew for Serge Stauffer when he replied to his questions [6.8.1960].

As a boy, Duchamp first drew the gas lamp in its suspended form when he was at boarding school in Rouen [30.9.1897]. Entitled *La Suspension de l'Ecole Bossuet*, the carefully worked drawing (which he dated c. 1902) illustrates how the slender glass cylinder containing the fragile mantle, penetrates the circular base of the lamp's metal framework from which the rectangular shade is hung.

Like the waterfall, traces of the gas lamp appear in the early notes for the Large Glass. In a sketch for the Pendu femelle, the cylindrical form with its decoratively crenellated base – similar to that of the Bec Auer – contains the "filament substance [which] in its meteorological extension (part relating the pendu to the handler) resembles a solid flame…"

Duchamp made several studies for the torso: in addition to the one mounted in velvet that puzzled Richard Hamilton at the Tate Gallery [16.6.1966], Duchamp also gave Maria Martins a pencil drawing of the nude entitled *Etant donnés: Maria, la chute d'eau et le gaz d'éclairage*.

As if to demonstrate the "arbour-type of the Bride", in a collage of photographs, *Study for Etant donnés*, the nude is placed vertically in the landscape, almost embracing the towering poplar.

In a later *Preparatory study for the Figure in Etant donnés* on a sheet of transparent Plexiglas, Duchamp drew the exact outline of the torso in gouache, and perforated it, pinpointing the form of the moulded figure.

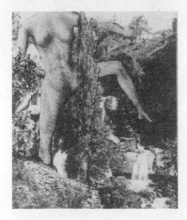

Over the years Duchamp made the different parts of this complicated construction at 210 West 14th Street. The work was long and, from time to time, there were setbacks to overcome.

When the plaster form of the torso was covered with pigskin, it was held in place with hundreds of pins – the only way to secure it without marking the skin. Duchamp then found that he was unable to colour the surface of the skin,

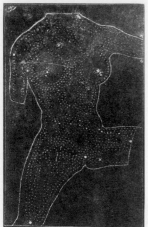
31.3.1968

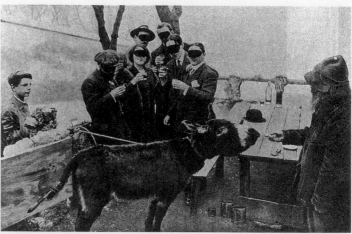
1.4.1910

and that the flesh colour could only be obtained from underneath, by transparency. This meant carefully breaking the plaster mould of the torso and removing it – a long, very delicate operation. To complete the nude, Marcel made a plaster cast of Teeny's left arm and hand.

Because of the difficulty of maintaining ideal atmospheric conditions, the skin of the torso split in one place and Duchamp had to slightly alter the position of the nude in relation to the view of the onlooker. Before leaving for Europe in the summer months, he took the precaution of covering the fragile torso with a plastic bag and hanging it in the cupboard in the studio with an electric heater.

In La Bisbal, a town near Cadaqués, Duchamp found at the entrance to an old building a wooden door, which already had a keyhole and a crack at eye level. The bricks to frame the door of *Etant donnés* in its final installation were also Spanish: Duchamp ordered them one summer from the main builder of Cadaqués, Emilio Puignau [30.6.1962].

To collect the twigs and leaves to place under the nude, Teeny drove Marcel in the old station wagon to Lebanon (before the farmhouse was sold in 1956): bundles were also gathered on excursions up the Hudson River. Nearer to home, in New York, they found material to build the wall. On their way home in the evenings, armed with small shopping bags, they looked for old, discarded bricks along the streets.

When Duchamp was asked to move from the studios at 14th Street because the building was to be renovated, he found a small room in an office building with an elevator at 80 East 11th Street. The construction was carefully disman-tled and slowly transferred to the new room, where the final adjustments to the tableau were made. Once, for the larger pieces and heavy door, which he himself had cut down to size, Duchamp engaged a removal firm [17.2.1966], otherwise he carried everything himself, piece by piece, to the new location Remarkably, he never met anyone that he knew on the street and the secret remained intact.

While at 14th Street, Duchamp had already started to prepare an instruction manual for *Etant donnés*. He chose a ring binder for all his notes and photographs, describing with great precision the fifteen main operations to be fol-lowed, from laying the black-and-white che-quered lino on the floor to the final adjustment of the lighting and, with a clothes peg, anchor-ing the blond hair of the nude. As a guide for the first operations, Duchamp made a scale model in cardboard, which he folded and insert-ed in the first page of the instruction book.

However, the question of the ultimate presen-tation of *Etant donnés* preoccupied Marcel. He finally decided that the one person who might help him solve this problem was Bill Copley. When Marcel first told him the story of the piece Bill could not wait to see it, and readily accepted to present the "demountable approximation" in the name of the Cassandra Foundation to the Philadelphia Museum of Art, if the trustees would accept it.

With the question of *Etant donnés* now set-tled, Marcel leaves 28 West 10 Street with Teeny to spend the summer in Europe.

*

Around midnight the Duchamps arrive at 5 Rue Parmentier, Neuilly, where they will stay for a couple of nights before continuing their journey to Monte Carlo.

1 April

1910. Friday, Paris
Today *Fantasio* reveals the identity of Joachim-Raphaël Boronali, the leader of Excessivism, a new school of painting [18.3.1910]. Illustrated with photographs and the affidavit made by the process-server who witnessed the creation of the masterpiece in Montmartre on 11 March 1910, the article declares that the pic-ture exhibited at the Salon des Indépendants was in fact painted by Lola with her tail! "I am only a donkey," she cried quite openly to the witnesses, who included Roland Dorgelès, André Warnod, Pierre Girieud, Genty and the singer Coccinelle, before the Père Frédé led her back to her stable at the Lapin Agile.

1912. Monday, Paris
Readers of *Fantasio* beware! Monsieur the crit-ic, signing himself "Le Dévernisseur", unwit-tingly setting a trap for the unwary on April Fool's Day, writes in his witty review of the Salon des Indépendants that there is a "cubic" painting entitled *Nu descendant un Escalier* [18.3.1912] in which one can see neither the nude nor the staircase. "But," he adds obser-vantly, "the knob of the banister is perfect."

1916. Saturday, New York City
Since his arrival in New York [15.6.1915] Du-champ has not yet exhibited any of his work in public, but this month he participates in two

mixed exhibitions. The first is "Paintings, Drawings and Sculpture arranged by a Group of European and American Artists". The show which includes Cézanne, Duchamp-Villon [15.3.1916], Dufy, Rouault, Van Gogh and Villon is held at the Stéphane Bourgeois Gal-leries, 668 Fifth Avenue.

In addition to the two canvases entitled *Broyeuse de Chocolat* [8.3.1915], Duchamp pre-sents three drawings which have never been

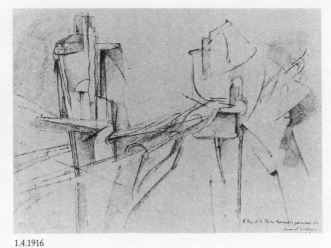

1.4.1912 1.4.1916 1.4.1948

exhibited: *Ustensile célibataire* [the drawing referred to on 2.4.1915?], *Le Roi et la Reine traversés par des Nus vites*, made prior to the large oil painting *Le Roi et la Reine entourés de Nus vites* [9.10.1912], and *Combat de Boxe*, which is a study for the extreme right-hand side of the lower half of the Large Glass.

From his newly invented category of art works, the readymade, which already includes *Peigne* [17.2.1916], and *In advance of the Broken Arm* [15.1.1916], Duchamp selects two, but it is not recorded which ones. ...*Pliant... de Voyage*, an Underwood typewriter cover, is likely to have been one of them. The name of the famous typewriter manufacturer printed on the soft cover removed from its functional context, permits Duchamp to play with "sous-bois" which, like "landscape" and "marine", was of course a popular category in the Salon exhibitions.

1917. Sunday, New York City
Abandoning his crutches for a cane [27.9.1916], Edgar Varèse makes his début in New York as a conductor. Conceived as a Palm Sunday memorial to the soldiers of all nations who have fallen in the war, the *Requiem Mass* by Hector Berlioz is performed by 300 members of the Scranton Choral Society and an orchestra of 150 musicians at the Hippodrome on Sixth Avenue which seats an audience of 6,000.

After the concert, which ends at ten-thirty in the midst of tremendous ovations, Roché and Duchamp go to the Café des Beaux-Arts.

1929. Easter Monday, Biarritz
Their "beautiful trip" through Spain over, Miss Dreier considers that "certainly mortals could not have asked for more". Thankful that Duchamp looked after everything for her, Miss Dreier is astonished to find that the five weeks' motoring from Gibraltar to Biarritz, visiting Malaga [24.2.1929], Granada [26.2.1929], Ronda [4.3.1929], Seville [5.3.1929] and Madrid [13.3.1929] has cost only $50!

Today the three travellers "are all scattered": Miss Dreier's train leaves for Paris in the morning at eleven; Mrs Thayer stays in the south, and Duchamp goes to Nice for ten days to play chess.

1946. Monday, New York City
At the Museum of Modern Art, Duchamp supervises the removal of the Large Glass [5.2.1923] from the sculpture gallery in preparation for its return to Miss Dreier on 6 April. James Johnson Sweeney is sorry to be losing this major work by Duchamp which has been on loan to the museum since 9 September 1943.

1948. Thursday, New York City
Bill Copley and John Ployardt, who are opening a "surrealist" gallery in Beverly Hills, are in New York. They have asked Marcel if he would find out from Roché whether Francis Picabia's painting *La Nuit Espagnole*, which is in his collection, is for sale and at what price.

Knowing that Roché has had news via the dealer René Drouin, and that "everything that has happened [in New York] in the last 3 months has passed by the ears and eyes of Drouin", Marcel feels less guilty about not having written for such a long time. He asks Roché about *La Nuit Espagnole* and then adds that Maria Martins, who is in Brazil, has had pneumonia followed by pleurisy, but has recovered quite quickly.

1958. Tuesday, New York City
"Greatly honoured," Duchamp accepts "with many thanks" Gordon Washburn's invitation to serve on the jury of the 1958 Pittsburgh International. "I hope you will be back from Europe before we leave (May 29th)," Duchamp says, "otherwise we will see you at the Deux-Magots in June."

1962. Sunday, New York City
"This is not a first of April hoax!" Marcel assures Jackie Monnier. Concerning the accident to 9 of the Rhodoids for the Boxes he insists that "it's of no importance at all..." and gives her instructions for their replacement. "The cost," Marcel adds, "will be on my account of course."

1964. Wednesday, New York City
In the wake of the exhibition at the Museum of Fine Arts, Boston [20.2.1964], a show of Jacques Villon's drawings and watercolours opens at Lucien Goldschmidt's gallery at 1125 Madison Avenue. Louis Carré, who has been in the United States since 5 March, attends the opening and Duchamp, proud of the homage paid to his late brother, considers that "every piece is Villon at his best".

1967. Saturday, Monte Carlo
The rock with Prince Rainier's palace, dwarfed by the Tête de Chien in the background, decorates the card Marcel sends to Yo and Jacques Savy in Paris. He underlines the date and starts in English "Wish you were here" (disappointed no doubt that they are not at Menton where they have a house) and continues in French: "Superb weather, snow on the mountains."

*

Gianfranco Baruchello's article "Duchamp mis à nu", a review of *Entretiens avec Marcel Duchamp* by Pierre Cabanne [25.1.1967], is published in *La Quinzaine Littéraire*, no. 25.

2 April

1915. Friday, Paris
After visiting the American consulate with his brother Raymond, Duchamp sends Walter Pach the papers for the transport of Duchamp-Villon's wooden sculpture and three works of his own which have been at Picabia's: *Nu descendant un Escalier*, No.1 [18.3.1912], *Le Passage de la Vierge à la Mariée* [7.8.1912] and the large drawing on cardboard of the Bachelor Machinery [13.1.1913]. The shipment is due to leave for New York on the *Espagne* from Bordeaux on 10 April, but Gaby Villon plans to dispatch with it some prints, and Ribemont-Dessaignes may add some small canvases. Pach is invited to choose one of Duchamp's paintings for himself, either from the two on their way to him, or *A propos de jeune Sœur* [8.3.1915], which is already in New York.

In strictest confidence, Duchamp tells his American friend that he has decided to leave France. He would like to live in New York on condition that he could earn his living and he asks Pach: "Do you think I could easily find a job as a librarian or similar, leaving me great freedom to work," and warns him: "I do not speak English..." As he has not yet spoken to his family about this idea, Duchamp asks Pach

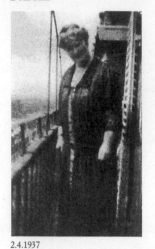

2.4.1937 3.4.1945

to reply on a separate sheet of paper so that his brothers don't find out his plans until he has definitely made up his mind.

"I work a little, disturbed a great deal by a mass of people whom one never sees in peacetime... As for the war, there is no significant news. No important move forward, no move backward. A hopeless equilibrium."

1917. Monday, New York City
The day that Congress votes in favour of the United States of America joining the Allied Forces in the war against Germany, Duchamp and Crotti are featured in an article about the New Art entitled "Sometimes we dread the Future" published in *Everyweek*. As if the famous *Nu descendant un Escalier* [18.3.1912] was not shocking enough, the journalist discloses that Duchamp, the "Whistler of Cubism", is preparing another bombshell: the portrait of a chocolate grinder! Even if the photograph of Duchamp is rather out of date [27.11.1915], the publicity is excellent for the forthcoming exhibition of the Society of Independent Artists, which opens a week from today.

*

Late in the evening, Marcel joins Charles Demuth, Roché and Louise Norton for a "bistro night".

1930. Wednesday, Paris
Miss Dreier has invited a friend of hers, Marcel, Suzanne and Jean Crotti, Man Ray, Jacques Villon and Roché to have dinner with her at Prunier's. Gathered at seven o'clock in one of the restaurant's private rooms, Miss Dreier "with candour and infectious freshness" requests Roché to order the meal, which he does. Accompanied by a riesling-Riquewihr and first-class champagne, clams are served first followed by lobster *Thermidor*, and then chocolate soufflé.

1935. Tuesday, Paris
As Marcel has had no word from Alice Roullier in Chicago since he advised her that he was sending three copies of the Green Box by the *Champlain* on 3 January [22.12.1934], he is worried that either the parcel has gone astray or her letter acknowledging receipt of it has. He writes and enquires at the same time if she will be coming to Europe this summer lamenting that it is an "eternity" since they last met.

1937. Friday, Paris
As promised, Marcel writes to Miss Dreier in Berlin about hotel accommodation [29.3.1937]. The Brighton, where she has stayed a number of times in the past and where they once photographed each other on the balcony overlooking the Rue de Rivoli, can offer a room with a view of the Tuileries for either 125 francs or 150 francs a day. On the left bank, the Voltaire has a large room without bath on the fourth floor, with a balcony on the Seine costing 30 francs a day. Marcel recommends the Voltaire, but tells Miss Dreier that it is her decision and that she should reply as soon as possible so that he can reserve the room for 20 April.

Concerning her lithographs, *40 Variations*, Marcel explains that the initial outlay before seeing a proof in colour is the cost of the paper and the whole print run of the black design. He specifies that the print will be the same size as the original, using exactly the same paper. He proposes to take her to see the technician who will execute the colour printing by stencil, a process much used in Paris, and who will show her examples of his work.

*

In his fifth chess column prepared for *Ce Soir*, Duchamp has selected the problem which won first prize in a competition organized recently by the *British Chess Magazine*. He comments on the game played by Fine and Loudovitch on 14 March in Moscow, and completes the column with some news items: the Parisian interclub championship will start on 5 April, the international congress has just opened at Margate in England, the tournament in Moscow has been won by the American R. Fine, and the ex-world champion Lasker who lives in Moscow has just commenced a lecture tour of the USSR.

1940. Tuesday, Chicago
Walter Pach has lent *Jeune Homme triste dans un Train* [17.2.1913] to the exhibition "Origins of Modern Art" which opens at the Arts Club of Chicago.

1949. Saturday, New York City
"Plane ticket received thanks," cables Duchamp to MacAgy [30.3.1949].

1952. Wednesday, New York City
Replies to Roché concerning an unlimited loan to the Museum of Modern Art of *Adam et Eve*, one of the Brancusis which James John-

son Sweeney has always liked [24.4.1946] and has chosen for his forthcoming exhibition "L'Œuvre du XXème Siècle". Marcel also quizzes his old friend about the price he would put on *A propos de jeune Sœur* [8.3.1915], which he purchased from the John Quinn Estate [6.4.1926], and *Rotative Demisphère* [8.11.1924], which was given to Roché by Mme Jacques Doucet [22.4.1930].

1954. Friday, New York City
In reply by cable to Fiske Kimball's request for him to "come over" to Philadelphia before Easter, Duchamp proposes to arrive at the Museum on Monday around noon.

1957. Tuesday, New York City
The Duchamps travel to Houston, Texas, to attend the American Federation of Arts' annual convention which commences the following evening at the Shamrock Hilton. Making an exception to his rule [31.3.1950], Duchamp has accepted to be one of the guest speakers.

1958. Wednesday, New York City
On returning home after the game in the chess tournament in which he is playing has been adjourned, Duchamp finds Lily and Marcel Jean [18.2.1958] installed at 327 East 58th Street. Teeny has been to collect them from Hoboken, New Jersey, where their ship from Le Havre docked earlier in the day.

1962. Monday, New York City
At their house, Mr and Mrs John de Menil hold a party for Max Ernst, which the Duchamps attend.

1963. Tuesday, New York City
"This is a circus week for me – TV for breakfast, TV for lunch and Radio for dinner," Marcel tells Brookes Hubachek. The exhibition celebrating the 50th Anniversary of the Armory Show is opening with a gala evening on 5 April: "So please find time to see it," he requests Brookes, "and come for dinner." Marcel found the Utica prelude [16.2.1963] "very encouraging" and hopes that "the architecture of the original Armory will add still more colour to it".

1964. Thursday, New York City
At one o'clock in the afternoon Duchamp has an appointment with Louis Carré.

4.4.1916

1965. New York City
"Thank you for your long, long letter full of incidents and new things – what a work! what a business!" exclaims Marcel to Gianfranco Baruchello, who is busy finishing his film *La Verifica incerta.* "So I'm longing to see you in Paris," he says, between 20 and 30 April, "but finish the film calmly."

1968. Tuesday, Neuilly-sur-Seine
Teeny and Marcel travel from Paris to the Hôtel Hermitage, Monte Carlo. Like the year before, they have come to follow the Grand Prix International d'Echecs.

3 April

1910. Sunday, Neuilly-sur-Seine
Duchamp has sent an express letter to Max Bergmann inviting him to come to 9 Rue Amiral-de-Joinville at three o'clock to meet six of his friends. After an enjoyable afternoon in congenial company, Bergmann returns to Paris accompanied by Duchamp's friends.

1917. Tuesday, New York City
Marcel, Louise Norton, Roché and Charles Demuth spend the evening together at a cabaret.

1945. Tuesday, New York City
Duchamp takes the Chilean artist, Roberto Matta, to New Haven and by chance they meet George Heard Hamilton. As Hamilton is interested in Matta's painting *The Bachelors Twenty Years later*, he has an opportunity to talk to the artist about it.
The painting was included as one of the illustrations in *Duchamp's Glass:...An Analytical Reflection* by Katherine S. Dreier and Matta which was published by the Société Anonyme in 1944.

1949. Sunday, New York City
At their request, Marcel sends the Hoppenots a Webster's dictionary. He is off to California for three weeks the day after next and cannot believe his good fortune: "Two days of work [7.3.1949]," Marcel says, "and the rest in Hollywood and the Painted Desert!"

1956. Tuesday, New York City
Following the session on Thursday at the museum, Peter Juley would like to have the two oil paintings transported to New York. Duchamp has alerted Marceau by telephone but has forgotten to mention the question of costs. Not knowing whether Juley intends paying or not, Duchamp tells Marceau that "in any case" he personally will pay for the return transport. He adds that the colour transparency of the Large Glass, which is to be used for the "Three Brothers" catalogue, "is very, very beautiful."

1959. Friday, New York City
Teeny and Marcel move from their top floor apartment at 327 East 58th Street, which they have occupied for the last five years [27.5.1954]. Until their departure for Europe, they have taken a room for a week at the Hotel Dauphin on Broadway at the corner of 67th Street, not far from the Arensbergs' old apartment.

1962. Tuesday, New York City
After making an appointment by telephone and announcing himself as "Juan Ennui", Marvin Lazarus calls at 28 West 10th Street, but Duchamp has gone to the funeral of Henry McBride.

4 April

1913. Friday, Chicago
Manierre Dawson, a young artist friend of Arthur Jerome Eddy's [2.3.1913], buys *Jeune Homme triste dans un Train* [17.2.1913] from the Armory Show, which opened in Chicago on 24 March. It was the only one of Duchamp's four paintings in the exhibition not yet sold.

1916. Tuesday, New York City
"M. Marcel Duchamp and M. Jean Crotti, both of Paris, will meet all comers for the world championship as exponents of the eccentric and the new in art," announces Nixola Greeley-Smith in the *Evening World*. The article provides some lurid publicity for their exhibition today at the Montross Gallery, held jointly with Gleizes and Metzinger, the "Bouvard and Pécuchet" Cubists, as Francis Picabia wittily calls them.

Duchamp exhibits five works dating from before his arrival in America. *Vierge*, No.1 [7.8.1912], the drawing he made in Munich, and three canvases, *Paysage* [1.10.1911?], *Yvonne et Magdeleine déchiquetées* [5.9.1911] and *Dulcinée* [1.10.1911].

The idea for the fifth work came to Duchamp at dusk one day in January 1914 when he was travelling by train from Paris to Rouen. To three copies of a chromolithograph representing a sentimental winter landscape by the Swiss artist, Sophie de Niederhausern, which he claimed to have purchased in an artists' supply shop, Marcel has merely painted over two little lights in the background, colouring one red and one yellow, like flasks in a chemist's shop, called it *Pharmacie* and signed it.

(...)
"Et le pharmacien sur le blême trottoir,
Fait s'épandre les lacs des bocaux verts ou rouges
Phares lointains de ceux qui s'en iront ce soir..."

(Autres Complaintes by Jules Laforgue)
*
When she visited the studio recently at 1947 Broadway which Crotti and Duchamp share, it was Marcel's readymade *In Advance of the Broken Arm* [15.1.1916] suspended from the ceiling, which attracted the journalist's eye. From Crotti's declaration that this snow shovel is the most beautiful thing he has ever seen, Greeley-Smith deducted that the object hardly interested them as a utensil – it is quite new; from the

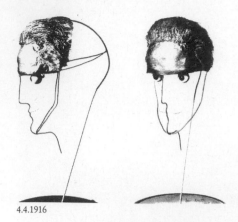

4.4.1916

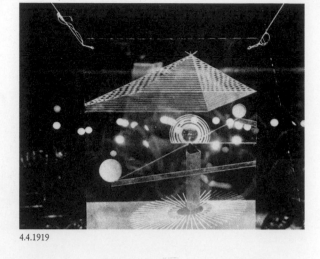

4.4.1919

standpoint of art, it would appear that they find it a much superior subject to Crotti's pretty wife, Yvonne, who was also present in the studio.

The journalist quizzed Marcel about his *Nu descendant un Escalier* [18.3.1912]: is it male or female? Resigned to discussing his "Frankenstein" once again, Marcel was unable to disguise his utter boredom: "Is it a woman? No. Is it a man? No. To tell you the truth, I have never thought which it is. Why should I think about it? My pictures do not represent objects but abstractions. *Nu descendant un Escalier* is an abstraction of movement."

However it was Crotti's abstract "masterpiece", *The Mechanical Forces of Love*, composed of sheets of painted glass and metal, which was presented to the young lady when she was invited to sit down. Crotti, in his intrepid, guileless manner, went to great lengths to explain its meaning. Greeley-Smith endeavoured to relate this ambitious representation of Love with her own experience. The interview started to founder when Yvonne interrupted and accused "the Americans" of caring a great deal for "the little bird sort of sentiment", feelings which Greeley-Smith candidly admitted to enjoying. Duchamp then interrupted: "The thing which has struck me most in this country, which has undoubtedly the most beautiful women," he said gallantly, "is the lack of really strong emotions in your men. An American, for instance, if he has to choose between an important business appointment and an engagement with the woman he loves, he rings her up on the telephone. 'Hello, dear,' he says. 'I can't see you today, I must go to the bank instead.' To a Frenchman that seems very stupid."

*

At the Montross Gallery, 550 Fifth Avenue, the "Four Musketeers", exiles and rivals of the American group promoted by Stieglitz and 291 are far from representing a united front. Incensed by the Greeley-Smith interview, Albert Gleizes (dubbed "Judge of the Cubist Court" by Picabia) attacks Crotti for the titles he has given his work, such as *Of Course, That Depends* or *Because*. Gleizes accuses Crotti of looking for scandal and fears that he himself will be contaminated by all this dubious publicity and that their rivals will use it to their advantage. Gleizes' authoritarian attitude has not changed since he tried to censor the title of Duchamp's *Nu descendant*

un Escalier [18.3.1912], but Crotti stands his ground: he agrees, as a small concession, to cover only one wall label with a slip of paper.

One of Crotti's works is an astonishing portrait of Duchamp made of three lengths of fine wire: one to draw the profile and shape of the head, another to describe horizontally the volume from the line of the brow to the back of the skull, and the third to define the jaw from the chin to each temple. To complete what is an extraordinary likeness, Crotti has modelled in detail a demi-scalp – a hollow forehead to which only half a head of hair and glass eyeballs with their penetrating gaze are attached. It is in the forehead and the eyes that Crotti finds the character of his friend is "most strikingly shown". The sculpture's subtitle "sur mesure", a neat reply to Duchamp's "readymade", implies that the dimensions are the same as those of the subject.

1917. Wednesday, New York City
After an absence of nine months, Francis and Gaby Picabia return to New York from Barcelona.

1919. Friday, Buenos Aires
It has been extremely hot but now the Indian summer is marvellous. After days of delay, the SS *Vauban* finally sails for New York. Miss Dreier and her new companion Koko, a sulphur-crested cockatoo, are among the passengers. Marcel has entrusted Miss Dreier with the small glass study he has made relating to the lower part of the Large Glass: *A regarder d'un Œil, de près, pendant presque une Heure*.

Residing for the last seven months by the Rio de La Plata, a vast "river of silver", Marcel chose to experiment with the Oculist Witnesses' domain, just to the right of the Scissors in the Large Glass: applying a mercury ground, as for a mirror, he drew each form by scratching away the silver… The central ball is in fact a magnifying lens glued to the surface of the glass through which the Voyeur is to observe eventually the ultimate moment of the Bride stripped bare. The spy-glass is poised on a pointed column rising from a circular tilted plane of radiating argentine lines, inspired by panels used for testing eyesight [7.1.1919]. Above hovers a flattened and elongated pyramid defined by areas of thin yellow, green and red horizontal parallel lines, which dazzle as

they overlap. In perspective and aligned with the central spy-glass are two balls poised on the extremities of the Scissors. In the Large Glass, when the Scissors are opened the Illuminating Gas escapes forming a "sculpture of drops" which "blinds" the Oculist Witnesses.

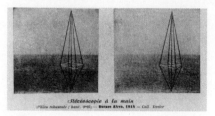

Stéréoscopie à la main
(Photo rehaussée; haut. 0"05) — **Buenos Aires, 1918** — Coll. Dreier

Marcel's other optical experiment, *Stéréoscopie à la Main*, which Miss Dreier also takes to New York, uses a plain view of a vast expanse of calm water. A small boat is only just distinguishable beneath a uniform sky upon which Marcel has drawn an almost identical polyhedron on both photographs. When viewed stereoscopically, the pyramid appears buoyant, floating on the water.

*

Miss Dreier is also entrusted with Marcel's letter to the Arensbergs thanking them for the cheque and replying to Walter's ultimatum, "exhibit or not exhibit" [8.11.1918]. For the exhibition at the Arden Gallery in New York, which opens on 29 April, Marcel is now doubtful about finding financial support for it to be transferred to Buenos Aires [15.11.1918] and thinks that the chance of any sales is extremely remote. As he plans to leave the Argentine in the first part of June, all Marcel can do is to put Marius de Zayas in touch with his contacts in Buenos Aires.

"I have been playing chess solidly," writes Marcel to Walter, "and I have joined the club where there are some very strong players

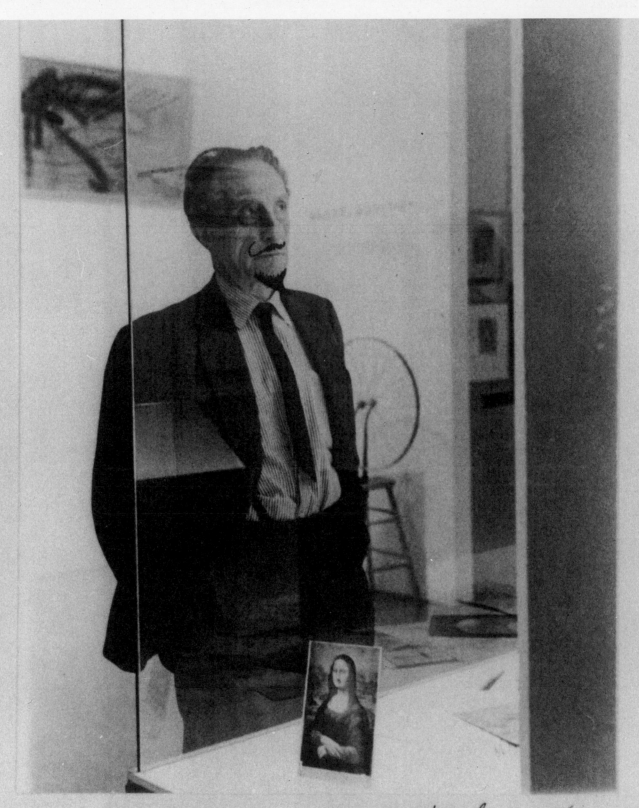

March 12, 1962

Dear Rrose,
 Here's one on you, oui?
 Regards,
 Juan Ennui

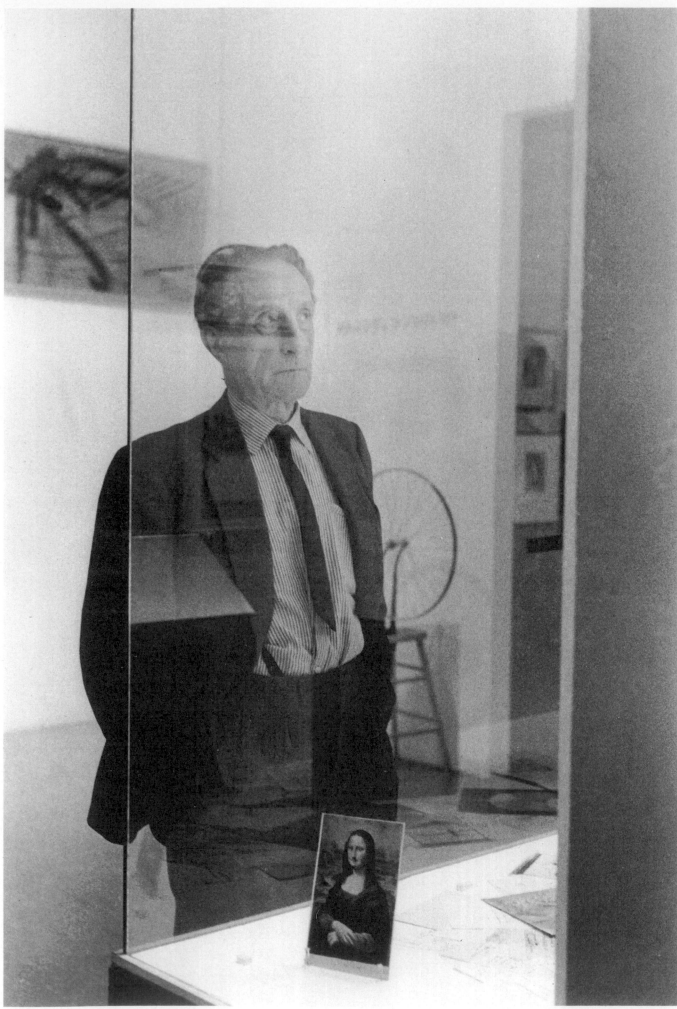

4.4.1962

4.4.1962

ranked by category." He is taking lessons with the club's best player, "who is an excellent teacher and is improving my 'theory'," says Marcel, but he only plays against those in the 2nd or 3rd category and hasn't yet been honoured with a ranking. Marcel proposes that the Gringmuth notation would be a cheap method for them to play chess by cable when he is back in France. Walter may receive a bizarre cable, Marcel warns him, which will be the opening move of a chess game.

1931. Saturday, Paris
After talking awhile at Arago, Marcel and Roché go to Rue Ernest Cresson, the home of Helen Hessel, who is translating Marcel and Halberstadt's chess book into German. Marcel offers to give chess lessons to Helen, her son Kadi and Roché. Returning to the Boulevard Arago to dine all together at Les Marronniers, Marcel sits on Roché's knees in the little car – the Citroën 5CV? [30.9.1926]

1935. Thursday, Paris
At noon Marcel calls for Roché at Arago and they have lunch together at Les Marronniers. Later they return to the apartment where Roché has arranged for Marcel to meet Roland Penrose, who just the previous week saw *Rotative Demi-sphère* [8.11.1924] when he visited Arago.

1950. Tuesday, New York City
As Lou and Walter Arensberg's representative, Duchamp attends a luncheon meeting with a special committee formed of the Metropolitan Museum's president, Roland L. Redmond, Francis Taylor and a trustee, Elihu Root, Jr. to discuss the possible donation of the Arensberg Collection to the Metropolitan.

The committee proposes to guarantee that the Arensberg Collection be exhibited "in three adjacent galleries, each approximately 20 x 40 feet" for five years, after which it would be "consolidated" with the general collection of the museum "but each object... would be appropriately labelled as the gift of Mr and Mrs Arensberg". At Duchamp's request, the committee agree to prepare an *aide mémoire* covering the points discussed at the meeting.

1961. Tuesday, New York City
At George Heard Hamilton's request, Duchamp receives one of his Yale graduate

students, Bill Camfield, who has chosen to write his Master's thesis on the "Section d'Or" [9.10.1912]. The idea for such a manifestation of Cubism arose from the long discussions at 7 Rue Lemaître in Puteaux, where his brothers Villon and Duchamp-Villon lived. Duchamp describes the group being in general agreement but the discussions were long and, on some subjects, very heated. He confirms that there was no contact between Braque and Picasso – whose art was more instinctive – and the Puteaux group who, on the contrary, were keen to inject a measure of reason into art and gain recognition for the directions they were exploring in Cubism. It was probably Francis Picabia, Duchamp believes, who was responsible for securing the sumptuous space where the exhibition was held at 64 Rue La Boétie.

Duchamp tells Camfield that mathematics, the fourth dimension and Bergson were regular subjects of discussion. He himself was interested in these matters and read Lobachevsky and Riemann, the fathers of the two systems of non-euclidian geometry. Metzinger's great passion was mathematics: he retained a great deal of what he read and then "bamboozled" everyone with his quotations. Duchamp's impression of the "golden section" is that it was more "in the air than on the canvas" at that time, but said it is possible that Duchamp-Villon used it for *La Maison cubiste* [30.9.1912].

Regarding the role of chance in art and in an artist's fame Duchamp chooses the example of his *Nu descendant un Escalier* [18.3.1912] and *Le Roi et la Reine entourés de Nus vites* [9.10.1912]. Both interested him equally, but the notoriety of one quite outshines the other.

Duchamp points out that the role of the critic and art historian is important because the artist is the last person to realize what he has done. Different methods, such as Robert Lebel's psychoanalytical approach [6.1.1961], Duchamp considers, almost always lead to worthwhile results.

Of his old sparring partner, Duchamp stresses Picabia's independence and tells Camfield that his varied styles were never undertaken either slavishly or with any facetiousness. Picabia was a real painter, Duchamp adds, "who loved the smell of oil paint," which he himself never did.

1962. Wednesday, New York City
When Lazarus calls to see him, Duchamp apologizes for being absent the day before. The photographer remarks that he hadn't heard of McBride's death, that there had been no publicity. "You know, when a man lives beyond 65," says Duchamp philosophically, "there is no publicity because everyone assumes they've been dead for years..."

Although the pretext of his visit is an autograph for his copy of Robert Lebel's book [6.11.1959], in fact Lazarus also wants Duchamp's reaction to the photograph he mailed to him signed "Juan Ennui". Duchamp has difficulty in following the rather obscure pun, but when it is spelled out to him he enjoys it: Lazarus has added a moustache and goatee to Duchamp himself, who is seen through the glass case in which *L.H.O.O.Q.* [6.2.1930] is exhibited [10.11.1961]. "Dear Rrose," Lazarus wrote on 12 March, "Here's one on you, *oui*? Regards, Juan Ennui."

Talking about *Fountain* [9.4.1917], Lazarus asks Duchamp whether it was done as a joke or not, and whether he expected the "riot" that followed.

"What is a joke?" Duchamp asks. "Anything can be. A serious thing can be. It all depends how you look at it. If the religion of the Catholic church were invented today – it would be a huge joke. Burning incense; long robes, and the theatrics of invoking God. But it's not funny only because of history."

Duchamp explains that the urinal was introduced to see how far one can push art and he did not expect it to be rejected. "It was not a new idea," continues Duchamp, and he tells Lazarus about Boronali [1.4.1910], the donkey whose picture was accepted at the Salon des Indépendants in Paris.

And why did he stay in America? In reply to this classic question, to which Lazarus supposes

4.4.1966

Duchamp has a classic reply, Duchamp says, that he likes American artists better than the French ones, who are "vicious – a basket of crabs". Until recently this remained true but, Duchamp declares, "ever since de Kooning demonstrated that artists could be rich, American artists have all changed and are driving for success."

1964. Saturday, New York City
Marcel sends Brookes Hubachek a catalogue of the Jacques Villon exhibition which opened at Lucien Goldschmidt's gallery on 1 April. "Choose any from the photos," Marcel encourages his friend, "you won't be disappointed." He offers to return to the gallery if Brookes needs any help.

1966. Monday, New York City
Duchamp finds himself visiting the New York University Medical Center as the result of a conversation with Brian O'Doherty about suicide. Dr O'Doherty asked Duchamp whether he had ever considered it, which provoked his reply, "*Je suis respirateur* – a breather." The doctor then enquired whether Duchamp would agree to him taking an electrocardiogram and signing it as a portrait, to which Duchamp promptly replied: "If you sign it M.D.".

As O'Doherty takes the electrocardiogram, Duchamp is relaxed and his heart is unperturbed, neither speeding up nor missing a beat. They talk about age and the lack of correlation between chronological and physiological age. In spite of his 78 years Duchamp declares sharply, "I'm not old. We'll do this again in twenty years and we'll say: remember how we did this twenty years ago?" His heartbeat registered for posterity, Duchamp stands up, bows and with an air of mock seriousness says, "Thank you from the bottom of my heart."

5 April

1915. Monday, New York City
For five hundred dollars the celebrated lawyer and avid collector John Quinn [17.2.1913] purchases his first picture by Duchamp, *La Partie d'Echecs* [1.10.1910] from the Carroll Galleries.

1918. Friday, New York City
After dinner Marcel arrives very drunk at the apartment of Mary Sturges, 1 East 56th Street, where he finds Roché and Yvonne Chastel.

1940. Friday, Paris
Mary Reynolds and Marcel have invited the Rochés to lunch at 14 Rue Hallé. Mary serves her guests chicken and Roché finds the hospitality perfect. He is captivated by the fat tomcat and its size, the sitting room with its "surrealist mixture" and the butcher's table. However, the green liqueur served after the meal makes him feel a little drunk.

1954. Monday, Philadelphia
At the invitation of Fiske Kimball, who would like him to look again at the proposed arrangement of the Arensberg Collection [27.10.1953] prior to its being hung, and the proposed site for the installation of the Large Glass, Duchamp arrives at the museum at about noon.

1957. Friday, Houston
The American Federation of Arts Convention is into its second day session of inquiry, and "The Creative Act – How style evolves in the creative mind" is the subject of the morning's proceedings. Duchamp and his fellow panellists meet for breakfast at the Shamrock Hilton, the headquarters of the convention. Having had virtually no experience of speaking in public [31.3.1950], Duchamp has decided, as he stated later, to approach it as a game and to see what he can do in front of 500 people without being ridiculous.

At ten o'clock in the Shamrock Room, Stanley Marcus, chairman of the convention, welcomes the guests and asks Mrs Otto Spaeth, chairman of the Extension Services Committee, to introduce the panel. After presenting William C. Seitz, artist, art historian and author, as moderator for the session, Dr Gregory Bateson [7.4.1949], visiting professor at Stanford University, and Dr Rudolf Arnheim of the Psychology Department at Sarah Lawrence College, Mrs Spaeth turns to Duchamp and says: "there are times when a cliché ceases to be a cliché and becomes a necessity... Marcel Duchamp needs no introduction. Ever since that woman walked down those stairs and into our show, Americans have known Mr Duchamp."

Seitz opens the proceedings by describing aspects of contemporary creative activity which separate it from those of the past and by trying to define the creative process of the present time. He then invites Duchamp to make his address. In his short speech written in January, Duchamp states his long-held beliefs about the artist, ideas which he expounded at the "Western Round Table on Modern Art" [8.4.1949].

"The Creative Act. Let us consider two important factors, the two poles of art creation: The artist on the one hand and on the other the spectator, who later becomes posterity.

"To all appearances the artist acts like a mediumistic being who, from the labyrinth beyond time and space, seeks his way out to a clearing.

"If we give the attributes of a medium to the artist, we must then deny him the state of consciousness on the aesthetic plane about what he is doing or why he is doing it. All his decisions in the artistic execution of the work rest with pure intuition and cannot be translated into a self-analysis, spoken or written, or even thought out.

"T. S. Eliot, in his essay on 'Tradition and Individual Talent', writes: 'The more perfect the artist, the more completely separate in him will be the man who suffers and the mind which creates; the more perfectly will the mind digest and transmute the passions which are its material.' Millions of artists create; only a few thousands are discussed or accepted by the spectator and many less again are consecrated by posterity.

"In the last analysis, the artist may shout from all the rooftops that he is a genius; he will have to wait for the verdict of the spectator in order that his declarations take a social value and that, finally, posterity includes him in the primers of Art History.

"I know that this statement will not meet with the approval of many artists who refuse this mediumistic role and insist on the validity of their awareness in the creative act – yet Art History has consistently decided upon the virtue of a work of art through consideration completely divorced from the rationalized explanations of the artist.

"If the artist, as a human being, full of the best intentions toward himself and the whole world, plays no role at all in the judgment of his own work, how can one describe the phenomenon which prompts the spectator to

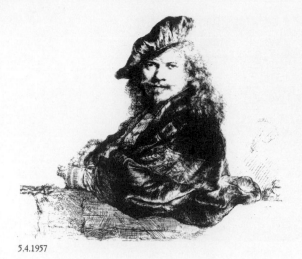

5.4.1957

react critically to the work of art; in other words, how does this reaction come about?

"This phenomenon is comparable to a transference from the artist to the spectator in the form of an aesthetic osmosis taking place through the inert matter, such as pigment, piano or marble.

"But before we go further, I want to clarify our understanding of the word art – to be sure without any attempt at a definition.

"What I have in mind is that art may be bad, good or indifferent but whatever adjective is used, we must call it art, and bad art is still art in the same way as bad emotion is still an emotion.

"Therefore, when I speak of 'art coefficient' in the following explanation, it is to be understood that I never refer to 'great art' only, but am trying to describe the subjective mechanism which produces art *à l'état brut* – bad, good or indifferent.

"In the creative act, the artist goes from intention to realization, through a chain of reactions totally subjective. His struggle toward the realization is a series of efforts, pains, satisfactions, refusals, decisions which also cannot and must not be fully self-conscious, at least on the aesthetic plane.

"The result of this struggle is a difference between the intention and its realization, a difference which the artist is not aware of.

"Therefore, in the chain of reactions accompanying the creative act, a link is missing. This gap representing the inability of the artist to express fully his intention, this difference between what he intended to realize and did realize, is the personal 'art coefficient' contained in the work.

"In other words, the personal 'art coefficient' is like an arithmetical relation between the unexpressed but intended and the unintentionally expressed.

"To avoid a misunderstanding, we must remember that this art coefficient is a personal expression of art *à l'état brut* to be 'refined' as pure sugar from molasses by the spectator after the revelation of the aesthetic osmosis, and the digit of this coefficient has no bearing whatsoever on his verdict. The creative act takes another aspect when the spectator experiences the phenomenon of transmutation: through the change from inert matter into a work of art, an actual transubstantiation has taken place and the role of the spectator is

to determine the weight of the work on the aesthetic scales.

"All in all, the creative act is not performed by the artist alone. The spectator brings the work in contact with the external world by deciphering and interpreting its inner qualifications and thus adds his contribution to the creative act. This becomes even more obvious when posterity gives its final verdict and sometimes rehabilitates many a forgotten artist."

After the applause, Seitz asks Dr Arnheim to speak on his subject, "A Comment on Inspiration," which is then followed by Dr Bateson's topic: "Creative Imagination."

Dr Arnheim opens the discussion by pointing out that three of the speakers have used the term "mediumistic" in different ways. He disagrees with Duchamp's concept because he considers that media are passive people which is "to neglect the very essence" of what is called the artistic process.

Duchamp explains that he did not mean to make a medium of the artist but to compare him to the status of a medium in relation to "the lack of control, conscious control, of intellectual control…"

Seitz wonders whether Duchamp wasn't suggesting that the artist begins with an intention?

"Of course, yes, yes," replies Duchamp. "We create all the time, great artists or not."

"But," queries Seitz, "what the artist creates is not what he intended?"

"No, of course not. That's the point."

"And he doesn't understand then what he did create," persists Seitz.

"No, of course not," says Duchamp.

There is a long discussion about the unconscious processes and levels of conscious control, the self and the outer world. Duchamp is not drawn until Dr Bateson claims that for the artist there are two important worlds, his subject matter and what he sees on the one hand and on the other his canvas and paint.

"Yes," interrupts Duchamp, "but there's the case of the Abstract Expressionist."

Dr Bateson continues: "We can concentrate this now between himself and the canvas."

"It's a different formula," Seitz argues, "a different equation."

Duchamp drives home his point: "In other words you can't standardize what you say

because there are the Abstract Expressionists."

Dr Arnheim then questions Duchamp about his "intriguing term of the art coefficient". Duchamp says he is correct in understanding it as a quotient or a proportion in which on the top of the line is that which is expressed without conscious intention and below the line, what is intended but not expressed.

The larger the coefficient, the larger the raw material of the artistic process, "then the better?" enquires Dr Arnheim.

"Not better," replies Duchamp, "more of it. Quantitivity, not qualitivity. And always there is qualitivity of aesthetic on the aesthetic plane – [that] is the role of the spectator, not of the artist. The artist produces bad art as well as good art, and it's art. You see, when we speak of art, it's always Rembrandt, Raphael. And there are everyday artists who produce bad art, and we never speak of it as raw product. And this exists. And it will be refined by society in the form of the spectator or posterity, that refines it, and as I said, as sugar from pure molasses."

Dr Arnheim then jokes: "But isn't that like sending the molasses out and let the customer refine the molasses?"

Seitz turns to Dr Bateson's point about perception and asks Duchamp whether he agrees that an image in the mind is art.

"Not at all." replies Duchamp firmly, "It has nothing to do with art. Art, if I'm not wrong, is 'to make' from the Latin. To make, that's all. You have to make, to do it, to do… To form. And anything that is not formed or made by man I suppose is not art. I mean, nature is not art. It's evident."

Dr Arnheim returns later to the question of the role of the spectator and says that he has seen the "Three Brothers" exhibition [22.3.1957] and was struck by the "absolute precision and finality" of the pictures. He did not think there was any necessity for "refining". He asks Duchamp whether he would not have found it impertinent to go up to him and say: "Now, I'm going to do the refining!"

Duchamp explains that he is using the words symbolically. "There is no refining in that way except pragmatically. In other words, my point, what's more important is that a creative act is performed half way by the public or the spectator or posterity. And not only decide or refine; the refinement or refining is a creative

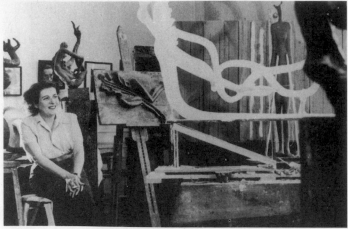
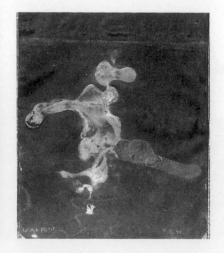

6.4.1946

act. Because you decide whether it's good, bad or indifferent and it's the end of a painter if you say 'bad', you never see him again."

"No," disputes Dr Arnheim, "you decide that."

"Oh, no," Duchamp insists, "No, indeed. I mean I decide that. I believe in that. What happens in fact in the Louvre, and you know that El Greco was forgotten for centuries and reactivated only fifty years ago."

"Was he no good in the meantime?"

"Very medium, yes," puns Duchamp and there is applause and laughter from the audience. "He did all right, having no more than many of us who are not going to be good again."

Then Dr Arnheim wonders whether El Greco's work had not continued "to be good in itself regardless of whether anybody saw it as good".

"Exactly." rejoins Duchamp, "But that's where the point comes in – when you have to consider society and posterity and the spectator in the problem... If the world did not exist, the painter wouldn't exist, ipso facto. There wouldn't be any creation if there was nobody to look at it. In other words, half of the creation is done by these onlookers [18.9.1915]."

There follows discussion about the state of the mind in the creative process and the psychotic in which William Blake is used as an example. Seitz cites the Expressionists and Surrealists and wonders whether these artists were not commenting on their pain "in mass form or unmass form sometimes".

Duchamp intervenes with: "It's again the subject matter, not the value of the product. The quality of his painting again... it's his action of painting. He paints surrealistically instead of otherwise, but it has nothing to do

with the analysis of his mind... Blake used the serpent, and a Surrealist uses something else."

As time is almost up, Seitz refers back once more to Duchamp's statement and asks him, in relation to the quotation from T.S. Eliot, whether he considers there is "a distinction of quality between Expressionist art and art which is more transmuted?"

Duchamp adamantly denies this and explains: "It is a state of affairs in the artist himself when he produces. That's what Eliot says... the whole essay is wonderful on that. I should have quoted it all instead of my own text. If you'll remember it's about that the artist is absolutely absent from real life, daily life, when he produces. He forgets himself and is another, that's why I said medium – introduced the idea of mediumistic role; not a medium, but a mediumistic role, which is different or like mediumistic."

Seitz grasps Duchamp's argument and closes the session by saying: "In other words, expressionist or no, his pain, his anguish would be transmuted from *l'état brut* to pure material by the process of the artist," while Duchamp interjects his agreement.

1962. Thursday, New York City
After receiving a long letter from Carl Zigrosser explaining the difficulties presented by Pontus Hulten's proposed exhibition of "Brancusi – Duchamp – Mondrian" in Stockholm, Duchamp replies to say that he has written to Hulten. "I have not done enough things in my life," he tells Zigrosser, "to ask you to agree to run the risks with my pictures by this travelling (particularly abroad)..."

*

Max Ernst and Dorothea Tanning, who are returning to Arizona on Saturday, have supper with Teeny and Marcel at 28 West 10th Street.

1963. Friday, New York City
The reporter sent by *Vogue* to cover this "nostalgic lark", noted that it was almost as if Duchamp himself was giving the party. After its successful preview at Utica [16.2.1963], two thousand guests have come to celebrate the 50th Anniversary of the Armory Show at its original premises, the 69th Regiment Armory on 25th Street and Lexington Avenue. Even the decor of burlap covered partitions and swags of greenery has been copied to create something of the original atmosphere.

1965. Monday, New York City
"After three days in Houston [23.2.1965]," writes Marcel to Brookes Hubachek, "we eloped to Mexico where we had the 3 best weeks of sun imaginable. And now back to the gusts of wind signed New York."

Informing Brookes of their plans for the summer and their departure on 20 April, Marcel says: "This is a written goodbye unless you come here before the 20th to make it in the flesh."

6 April

1909. Tuesday, Rouen
The draw of the lottery organized by the Société des Artistes Rouennais [30.3.1909] is made at the *hôtel de ville*. The winning ticket holders are invited to collect their prizes from the chief museum attendant at the side entrance of the Musée des Beaux-Arts, Rue Thiers, from between one o'clock and three each afternoon.

1917. Friday, New York City
Duchamp has been elected head of the Hanging Committee of the exhibition organized by the Society of Independent Artists [5.12.1916] and is faced with the task of installing 2,500 works in three days. To avoid any pre-conceived idea of grouping, Duchamp's suggestion that a democratic formula should be imposed on the arrangement of the show has been adopted. The works will be hung, commencing in the north-east corner of the main gallery in the Grand Central Palace, according to the artist's surname in alphabetical order.

In the morning at the exhibition hall, witnessed by Roché and Beatrice Wood, the letter "R" is drawn from a hat, which determines for Marcel the works to be hung first.

Later Marcel takes Bea to have lunch with him at Polly's [26.2.1917].

1918. Saturday, New York City
In the evening, for an hour, Marcel receives a visit from Roché who is accompanied by Alissa Franc, Mary Sturges and Yvonne Chastel.

1926. Tuesday, Paris
On the day that Roché purchases *A propos de jeune Sœur* [8.3.1915] from the John Quinn

Estate, Marcel has lunch with him at Couteau's, 13 Avenue d'Orléans.

*

Continuing their selection of work for the exhibition of the Société Anonyme [31.3.1926], Duchamp and Miss Dreier find themselves in Montmartre near Max Ernst's studio, 22 Rue Tourlaque. Miss Dreier would like to introduce Duchamp to Ernst – she has always thought they have so much in common – but he is out. However the cleaning lady admits them to the studio so that they can look at the paintings.

On their way downstairs Duchamp and Miss Dreier meet Hans Arp with whom they have a long talk and they arrange a provisional appointment to visit him and Ernst on 12 April.

1944. Thursday, Compiègne
At the transit camp of Royallieu where he has been incarcerated since 20 March, Robert Desnos [10.5.1942] writes *Printemps*, a sonnet evoking Rrose Sélavy, his erstwhile transatlantic muse [1.12.1922].

1946. Tuesday, New York City
At eight in the morning a truck arrives at the Museum of Modern Art to collect the Large Glass, which was removed from exhibition on 1 April, to return it to Miss Dreier in Milford. Two men from the museum accompany the precious Glass to 130 West River Street, where it is to be installed in the bay window of the sitting room.

*

For the sculptress Maria [Martins], Duchamp signs and dates one of the "de luxe" copies of his *Boîte-en-Valise* [7.1.1941]. The original work, which he has placed inside the lid, is entitled *Paysage fautif*: the fluid shape "painted" on the transparent surface of Astralon, which is backed with black satin, has been formed with ejaculated semen.

1947. Easter Sunday, Milford
Dee comes from New York for the day. After the heavy rain on Saturday it is a "heavenly balmy" day and warm enough for Dee and Miss Dreier to sit on the porch.

1949. Wednesday, New York City
In the morning Duchamp flies to San Francisco by TWA on the *Constellation*, leaving New York at nine o'clock. Making his second visit to

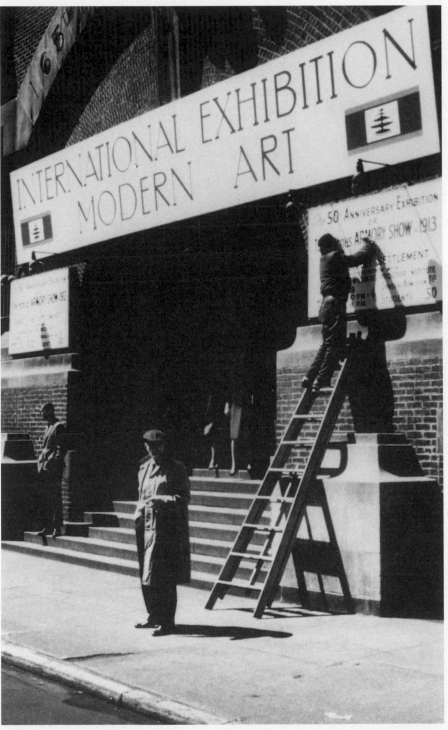

5.4.1963

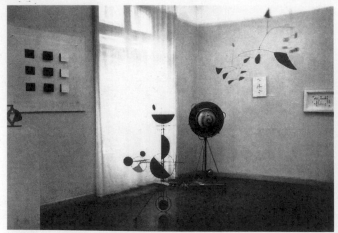

6.4.1955 6.4.1959

the West Coast [5.8.1936] Duchamp is due to arrive in the city of the Golden Gate at ten past six in the evening. He is staying in the Hotel Saint Francis, on the corner of Powell and Geary, and is invited to spend the evening with Douglas MacAgy and his wife Jermayne [2.10.1948].

1955. Wednesday, Paris
From the exhibition, "Perennité de l'Art Gaulois," at the Musée Pédagogique [18.2.1955], *Rotative Demi-sphère* [8.11.1924] is installed at the Galerie Denise René, 124 Rue La Boétie. Its neighbours in the exhibition, "Le Mouvement," are works by Agam and Soto; from the ceiling hangs a mobile by Calder and on the floor stands *Taxi I*, a meta-mechanical sculpture by Tinguely. Works by Bury, Jacobsen and Vasarély are also included in the show; texts by Roger Bordier, Pontus Hulten and Vasarely are published on a broadsheet.

1957. Saturday, Houston
The Duchamps say farewell to Mrs Cecil Hudson, their hostess for the last three days, and fly to Mexico City where they are the guests of Rufino Tamayo and his wife at Calle Malintzin 20. The evening of their arrival Mimi Fogt [17.1.1956], who is now living in Mexico, joins them for dinner.

*

With the *Nu descendant un Escalier* [18.3.1912] Duchamp "peaked" and then "tapered off over the next ten years" according to Geoffrey Hellman of the *New Yorker*. Comparing Duchamp to two undistinguished authors who gained notoriety before abandoning their pursuits and passing into obscurity, Hellman asks Duchamp what he has lived on all his life.

"It's perfectly proper to ask an artist how he gets along. It is not proper to ask a business man, because he doesn't get along; he borrows from other business men. You live and you don't know how to live. You just don't die. I have never had more than two or three hundred dollars ahead of me. I have never gone without a meal. People always ask artists how they live. They don't have to live. They just breathe."

Duchamp goes on to explain that his father, a *notaire*, had given him financial help when he was young. He started painting aged thirteen and the family was full of artists, his grandfa-

ther, his mother, his two brothers, his sister and brother-in-law… After the lycée in Rouen, he went to the Académie Julian [12.11.1904] in Paris when he was seventeen and at that age "was already disgusted with the cuisine of painting". After his success at the Armory Show [17.2.1913], apparently Knoedler's considered offering Duchamp a ten-thousand-dollar-a-year contract.

"I never would have considered it. Dealers can ruin artists, and besides I was almost through with painting."

He then found a job as a librarian [3.11.1913] for a dollar a day. When he went to New York, he supported himself by giving French lessons to friends [4.12.1916] at two dollars an hour.

As for his first marriage [8.6.1927] Duchamp says: "I didn't have enough money for the household, so, very amicably, we got a divorce. No alimony. Nothing. The things life forces men into – wives, three children, a country house, three cars! I avoid material commitments. I stop. I do whatever life calls me for."

"I don't think much of the state of painting today," he discloses. "I am not too much in accord with the crop of young painters. When I painted, no one spoke about it except painters, collectors and dealers. Now we have critics vulgarizing the language by talking about dynamism! When painting becomes so low that laymen talk about it, it doesn't interest me. Do we dare to talk about mathematics? No! Painting shouldn't become a fashionable thing. And money, money, money comes in and it becomes a Wall Street affair."

1959. Monday, New York City
At noon Duchamp is due to meet Kay Boyle at the Alexandre Iolas Gallery [31.3.1959].

*

The box is decorated with the blue enamel plaque *Eau & Gaz à tous les Etages*, sign affixed to Parisian buildings after the installation of these modern conveniences, and key elements in Duchamp's *œuvre*. At five in the afternoon, to mark the appearance of the "de luxe" version of *Sur Marcel Duchamp* by Robert Lebel, Sidney Janis opens a small show in his gallery presenting a number of original paintings and documents as well as the items reproduced in the box.

In addition to the main texts by Lebel, the book also includes: "The Creative Act" by Duchamp [5.4.1957], "Phare de la Mariée" by Breton [5.12.1934] and "Souvenirs sur Marcel Duchamp" revised by Roché [1.6.1953] to incorporate additional observations in his inimitable style.
For example, on Duchamp himself:
"His smile inspired daring and a sense of confidence."
On the Large Glass [5.2.1923]: "Desire! Is there anything stranger than this stuff? Duchamp has expressed it in his own way."
On women: "He lets none into his confidence, but he does spoil them systematically with his fantasies."
On the Green Box [16.10.1934]: "Creation is always inexplicable even when we are shown the tools."
On *L.H.O.O.Q.* [6.2.1930]: "When he drew the elegant moustaches on the Mona Lisa, he was saying, 'Don't let yourselves become hypnotized by the smiles of yesterday, rather invent the smiles of tomorrow'."
And he sums up: "[Duchamp's] finest work is the use of his time."

7 April

1910. Thursday, Paris
At about two-thirty Duchamp arrives at the Hôtel des Mines, 125 Boulevard Saint-Michel, just as Max Bergmann is leaving for La Palette. There has been a misunderstanding. Duchamp told his German friend that if he couldn't make

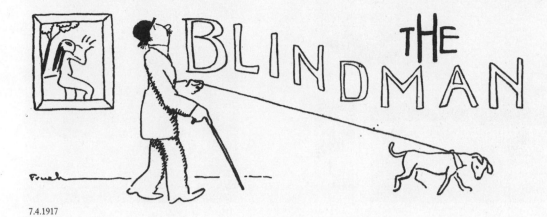

7.4.1917

Tuesday at seven he would come on Thursday at two, but Bergmann had understood the opposite. Instead of spending the afternoon drawing, he willingly accompanies Duchamp to the Panthéon, which is within walking distance from his hotel. After a tour of this grand building decorated, notably, with scenes from the life of Sainte Geneviève by Puvis de Chavannes, and which shelters in its crypt the tombs of certain illustrious Frenchmen including, Jean-Jacques Rousseau, Voltaire, Victor Hugo, and Emile Zola, they take an omnibus across the city to the Parc Monceau.

Not far from this "Chinese Garden" with its "illusions" and many architectural fantasies, is the Musée Cernuschi, 7 Avenue Velázquez, devoted to Chinese arts, which they also visit.

1917. Saturday, New York City
While Marcel is hanging the Independent Artists' exhibition at the Grand Central Palace, Beatrice Wood and Roché work until late at night in his studio. It is they who are producing the bulletin [19.3.1917] for the exhibition entitled *The Blind Man*, which comprises their texts and one by Mina Loy. An old friend of Roché's, the American cartoonist Alfred J. Frueh has made a drawing for the cover.

1918. Sunday, New York City
In the evening Marcel, the Arensbergs and another friend are invited to Mary Sturges' apartment where they join Yvonne Chastel, Alissa Franc and Roché. Dining together nearby, everybody starts with two cocktails and they return to Mary's afterwards.

1926. Wednesday, Paris
When he saw Francis Picabia's collage of feathers, macaroni, cane and corn plasters entitled *Plumes* at the Hôtel Istria on 23 March, Jacques Doucet decided to purchase it. The restoration to the picture has now been attended to and Duchamp sends a telegram to Doucet in Avenue du Bois: "Macaroni repaired is ready for Thursday will write affectionately Duchamp."

1930. Monday, New York City
With consent obtained by Jacques Seligmann from Duchamp himself in Paris [31.3.1930], Walter Arensberg lends *Nu descendant un Escalier*, No.2 [18.3.1912] to the exhibition "Cubism 1910–1913" at Seligmann's premises,

3 East 51st Street, which have been re-named the de Hauke Galleries for the occasion. The exhibition comprises important pictures by Picasso, Braque, Léger, Juan Gris, de La Fresnaye, Gleizes, Metzinger, Marcoussis and Jacques Villon. Maurice Raynal [9.10.1912] has written the preface to the catalogue.

1943. Wednesday, New York City
Invited for one o'clock Marcel, who is still living at 56 Seventh Avenue [2.10.1942], lunches at the Kieslers with André Breton.

1946. Sunday, New York City
The painter Arshile Gorky invites Duchamp and the Kieslers to dinner.

1949. Thursday, San Francisco
At eight o'clock with the other participants of the "Western Round Table on Modern Art", Duchamp attends an informal stag dinner, presided over by Henry F. Swift, held at the Family Club, 545 Powell Street. At the dinner Duchamp is seated next to one of the panellists, the anthropologist Gregory Bateson.

1953. Tuesday, New York City
Catching up on correspondence, Duchamp writes three letters destined for Paris.

"Two words only of great pleasure to have dipped into your book," writes Duchamp to Marcel Jean, who has sent him the first chapters [14.7.1952] including the one on himself. "I am waiting to have dissected it carefully to give you a report of my reading."

Replying to the first of Robert Lebel's two "serious" matters – which of his works should be reproduced in the forthcoming publication *Le Premier Bilan de l'Art actuel* – Duchamp says that if Lebel finds *9 Moules Mâlic* [19.1.1915], belonging to Roché "photogenic", this would be his choice rather than *A propos de jeune Sœur* [2.4.1915]. The important news that Lebel has been commissioned to write Duchamp's biography is the second "serious" matter: may he, like Marcel Jean, address a questionnaire to him? And what would Duchamp's reaction be to publishing, at the same time, a complete catalogue of his work?

Repeating his instructions [10.3.1953] for strengthening *9 Moules Mâlic*, Marcel explains

to Roché that the small glass, *A regarder d'un Œil, de près, pendant presque une Heure* [4.4.1919], was successfully repaired with an invisible glue. "If the glass must travel, it is essential that it arrives in perfect shape 'for centuries to come'."

1954. Wednesday, New York City
After his visit to Philadelphia on Monday Duchamp writes suggesting to Henri Marceau that the Large Glass should not be positioned exactly in the middle of the gallery but nearer the windows. He draws a sketch plan and offers, as soon as they have found another aluminium pillar, to return to the museum and assist with the exact positioning of the Glass.

As requested Duchamp also sends Marceau a photograph of how the Large Glass was installed at Milford, drawing attention to the way it is framed.

1956. Saturday, New York City
Duchamp has learned from Robert Lebel that customs clearance of items for the standard version of the *Boîte-en-Valise*, which he thought had been obtained in December [5.12.1955] following the intervention of M. Jean Adhémar [20.10.1955], has not yet been obtained. As a last resort, Lebel and Lefebvre-Foinet envisage redirecting the shipment back into Switzerland and bringing the items back into France as samples in small parcels. Duchamp replies thanking Lebel for giving him some hope to seeing an end to this "unbounded idiocy".

le surréalisme, même 1
directeur : André Breton

Referring to Lebel's comment that André Breton's new review with a Duchampian title is progressing slowly behind the cover featuring *Feuille de Vigne femelle* [12.3.1951], Duchamp closes his letter with the exclamation: "Vive le surréalisme, même!"

8.4.1926

1959. Tuesday, New York City
"The deed is done," writes Marcel to Lebel, exactly six years since the project for the biography and catalogue began [7.4.1953]. Fawcus is due to sign a contract with Grove Press the following day for the American edition of 2,500 copies to be published in September. Following Lebel's advice, Marcel agrees that, for the presentation of *Sur Marcel Duchamp* (the French edition) at the Galerie La Hune in May, he will only exhibit drawings.

1966. Thursday, New York City
"Many thanks for the photo of your beautiful work in progress," writes Marcel to Richard Hamilton, who has almost completed the replica [16.2.1965] of the Large Glass. "Happy to see it in the last stages already!"

Replying to Richard's queries regarding loans to the exhibition at the Tate Gallery, Marcel has telephoned Andrew Ritchie at Yale University and has spoken to George Heard Hamilton, curator of the Société Anonyme Collection, to pave the way for an agreement to lend *Tu m'* [8.7.1918], which poses transport difficulties on account of its protruding bottle brush.
Marcel doesn't consider he would be successful in obtaining *Le Roi et la Reine entourés de Nus vites* [9.10.1912], from the Philadelphia Museum of Art because the painting is in very poor condition, but he may try for the *Broyeuse de Chocolat*, No.2 [8.3.1915]. He suggests leaving out *Nu descendant un Escalier*, No.3 [29.4.1919], which is the photographic copy he retouched.
Although he is not in favour of the glass, *A regarder d'un Œil, de près, pendant presque une Heure* [4.4.1919], travelling from the Museum of Modern Art, he will speak to Dorothy Miller about the canvas *Le Passage de la Vierge à la Mariée* [7.8.1912].
As for *3 Stoppages Etalon* [19.5.1914], there is a copy in Mary Sisler's collection, and he promises to follow up Breton and Lebel by writing to the latter.

"On the other side of the picture," Marcel asks Richard whether he thinks, "it would be a good idea to invite to the dinner on 16 or 20 June Mr and Mrs Arne Ekstrom and George and Mrs Hamilton – they seem to want to come."

8 April

1917. Easter Day, New York City
Taking a break from the task of hanging the show at the Grand Central Palace, Duchamp lunches with Walter Pach, Arnold Friedman, Walter Arensberg and Beatrice Wood. During the day, Roché calls by to look at the exhibition and admires the three paintings by Bea.

1920. Thursday, New York City
Although the Société Anonyme is not yet formed legally, its first exhibition is due to open at 19 East 47th Street on 30 April. With Miss Dreier, Duchamp is organizing a continuous programme of exhibitions changing every six weeks. Already looking ahead to the autumn, Duchamp drafts a letter to Archipenko, whom Miss Dreier met on her last visit to Paris [11.11.1919], inviting him to exhibit a group of his work in October.

On behalf of Miss Dreier, Duchamp explains to Archipenko that the intention is to show contemporary art, particularly work not seen in commercial galleries, but in a non-commercial context. Sales will take place directly between the artist and the buyer, or through the main dealers in New York. With a plan of the gallery, Archipenko can choose what he wants to send and even decide how he wants his sculpture installed. In order to avoid tax levied on the sculpture, Archipenko should contact C.B. Richards & Co. to organize the transport and insurance which will be paid for when the shipment arrives in New York. Correspondence is slow but Miss Dreier hopes to have an early, favourable reply together with a short introductory biographical notice. Duchamp himself adds a personal postscript: "Dear Archipenko, do make this shipment. New York needs to see what you have done these last years and many people here would be very happy to be able to appreciate them."

1926. Thursday, Paris
"I hope that feathers and macaroni have arrived safely," writes Duchamp to Jacques Doucet. He tells the collector that in the auction on 8 March

two other works by Francis Picabia, "not at all in the same vein," were acquired by Tristan Tzara and the Galerie Pierre. There is also a portrait of a man on exhibition in Dresden and another due back from America.

Duchamp himself has kept three Picabias: *Retour des Barques*, a collage of shoe soles and stretcher wedges; *Midi – Promenade des Anglais*, a landscape of feathers, macaroni and leather [21.3.1926]; and *Femme aux Allumettes*, a female portrait made with a variety of small objects including matchsticks, coins and hairpins. "My intention," he tells Doucet, "is not to sell mine except in conditions guaranteeing the precious side of these things."

1949. Friday, San Francisco
A special exhibition of Modern Art, which includes the famous *Nu descendant un Escalier*, No.2 [18.3.1912], has been arranged

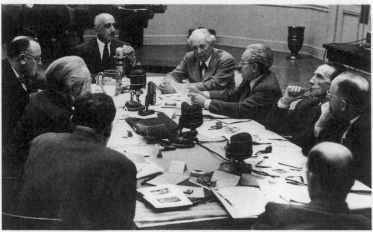

8.4.1949

in the San Francisco Museum of Art for the occasion of "The Western Round Table on Modern Art", sponsored by the San Francisco Art Association.

The event has been organized by Douglas MacAgy, director of the California School of Fine Art, with the intention of countering the negative result of "A *Life* Round Table on Modern Art", which was held in New York the previous autumn. He has invited George Boas, philosopher and professor at Johns Hopkins University, to chair the discussions. The other distinguished participants are: Gregory Bateson, cultural anthropologist and lecturer at the University of California Medical School, Kenneth Burke, literary critic, philosopher and professor at Bennington College, Marcel Duchamp, Alfred Frankenstein, music and art editor of the *San Francisco Chronicle*, Robert Goldwater, associate professor of art at Queens College, Darius Milhaud [20.1.1923], composer and professor of composition at Mills College, Andrew Ritchie, director of the department of painting and sculpture, Museum of Modern Art, the artist Mark Tobey, and the architect Frank Lloyd Wright. Arnold Schoenberg, the composer, was also invited but is prevented by ill-health from attending.

The closed session on why artists create art commences at two o'clock in the Members' Room of the museum. Boas is at the top of the table with Frank Lloyd Wright on his left; Duchamp is seated between Burke (who is next to Wright) and Frankenstein. Introducing Duchamp early in the session as "really one of the oldest masters of modernism", Boas invites him to speak.

"Art can never be adequately defined," Duchamp declares, "because the translation of an aesthetic emotion into a verbal description is as inaccurate as your description of fear when you have been actually scared."

In raising his topic "Art for All, or Art for the Few" [21.3.1949] Duchamp makes a sharp distinction between "taste" and what he terms the "aesthetic echo". In art for all, he says, "we mean that everybody is welcome to look freely at all works of art and try to hear what I call an aesthetic echo. We also imply that art cannot be understood through the intellect, but is felt through an emotion presenting some analogy with a religious faith or a sexual attraction – an aesthetic echo." Having described how the aesthetic emotion manifests itself, Duchamp

affirms: "Taste gives a sensuous feeling, not an aesthetic emotion. Taste presupposes a domineering onlooker who dictates what he likes and dislikes, and translates it into beautiful and ugly... Quite differently, the 'victim' of an aesthetic echo is in a position comparable to that of a man in love or a believer who dismisses automatically his demanding ego and, helpless, submits to a pleasurable and mysterious constraint. While exercising his taste, he adopts a commanding attitude; when touched by the aesthetic revelation, the same man in an almost ecstatic mood, becomes receptive and humble."

After a short recess, Frank Lloyd Wright demands a definition of a work of art, but the discussion leads to the question of beauty.

"Is there a beautiful?" asks Duchamp, "and what is it? Define beauty if you can't define art."

In reply to Boas, who wants to know why the artists make "these things", Duchamp says simply: "It's an urge. It's not explicable in any way... We don't emphasize enough that the work of art is independent of the artist. The work of art lives by itself, and the artist who happened to make it is like an irresponsible medium."

"Now, Mr Duchamp," says Bateson, "what you are saying is that the artist is the picture's way of getting itself painted. That is a very serious and reasonable thing to say, but it implies that, in some sense, the work of art exists before it is there on the canvas."

"It's a kind of race between the artist and the work of art," summarizes Duchamp.

Frank Lloyd Wright considers that "every artist worthy of the name has his feet on what he considers principle and from that his work, his utterance, his feeling... proceeds." To the architect's belief that man doesn't make principle and that principle is: God is principle, Duchamp says: "That also can be discussed."

Boas asks Duchamp if he wants to discuss it. "No," replies Duchamp, "I want to get away from principles; away from truth, from all these metaphysical concepts which don't belong to our discussion." Using Mallarmé as an example, Wright maintains that the poet "did everything possible to destroy this sense of principle and he could only destroy it by destroying himself".

After extensive discussion on the question of principle, Duchamp says: "There are several kinds of basic principles: first, the basic princi-

ples that change with every generation, like the concept of the 'beautiful' – then the basic principles that belong to the technical side of the work of art like gravity in architecture. But I don't believe in the existence of eternal laws governing art metaphysically."

Bateson asks Duchamp whether there are common elements between his Nude and the reproduction of a Matisse which they have in front of them. "This leads to the more general question," he replies, "I think the quality common to all modern works of art since the Impressionists when the word modern art was first applied is based on a common aestheticism which I call 'retinal'." Agreeing with Bateson that it is "a metaphorical way of putting it", Duchamp continues: "Nevertheless this retinal quality is actually the dominant quality in an Impressionist, Pointillist, Expressionist, Fauvist, Cubist or abstract painting – only the Surrealists have reintroduced the 'grey matter' quality in painting."

*

At eight o'clock the evening session, which is held before an invited public in the Auditorium of the museum, is on the role of the critic. Boas is seated at a separate table on the left of the platform where he can see the audience and also the panellists, who are sitting in a row at the long table.

After hearing the three other artists' views on the subject, Duchamp states: "Criticism against Modern Art is a natural consequence of the freedom given to the artist to express his individualistic view. Moreover, I consider

8.4.1959

9.4.1910

the barometer of opposition a healthy indication of the depth of individual expression: the more hostile the criticism, the more encouraged the artist should be."

Adding a warning note, Duchamp says: "The critic transposes, translates an emotion into another medium, the medium of words – and I wonder if such translation can at all express the poetic 'essentials' of that other language commonly called art."

Boas asks Duchamp what he expects a critic to do, what he expects a critic to say?

"Nothing much," says Duchamp, "Whatever the critic may say, the work makes the grade by itself."

"But what would you like the critic to do?" persists Boas.

"I don't care," replies Duchamp.

1951. Sunday, New York City
As Louis Carré is planning to open a Kupka exhibition in his New York gallery in May, Duchamp asks the Arensbergs whether they would agree to lend *Disques de Newton, Etude pour la Fugue à deux couleurs*, the only Kupka in a private American collection, and explains: "This is a parenthetic letter! – more of real ones later."

1952. Tuesday, New York City
"Chère Monique, Chère Seulique and in good French, Chère Unique," writes Duchamp to Monique Fong in Washington after receiving a second letter from her in the morning. During her next weekend in New York, Duchamp proposes that Monique either call on Saturday between five and seven in the evening or on Sunday from six o'clock when they can dine together. "Without a reply from you I will put in an appearance at the above hours. Bring your chatterbox well oiled," he requests, "because my ears have need of an orgy," and signs himself "Ducreux".

1959. Wednesday, New York City
The *Village Voice* prints Jerry Tallmer's interview with the headline: "A toothbrush in a lead box – would it be a masterpiece?." For the journalist, it was as if he were going to interview Beethoven. One morning, before the presentation of Lebel's book at the Janis Gallery [6.4.1959], Tallmer visits Duchamp at his apartment at 327 East 58th Street, and discovers the "living legend" in his shirtsleeves

hip-deep in cartons and crates. "We're moving," says Duchamp. "Where to?" enquires Tallmer. "To a warehouse," is the reply, "I mean we're going to Europe for five months."

Knowing of the popular myth that Duchamp took a vow 30 years ago never to put his hand again to art, Tallmer says that he has heard that there will be some new things at the Janis show. "Not new. There are a few pieces of sculpture I made in '53 or '54. I don't call that new. People get the wrong idea about my not painting. It's true and it's not true at the same time. But I did not make a vow. That's all nonsense."

"Then the myth is a myth?"

"Yes, a myth. I am ready to paint if I have an idea. But it's the idea that counts. In any event I am not one of your physiological painters who does it for the love of the smell of turpentine." Duchamp glances over at the fireplace. "We used to have a faucet there on the fireplace a while ago [25.12.1957]. I considered it a work of art, but not public art. Art: what is a work of art? Your whole life, a producing mind, can be a work of art. Even action can be art. Even a grocer can be – *can* be – an artist."

After talking about the old days of Dada and Surrealism, Tallmer asks Duchamp if he will say anything about the Abstract Expressionists for publication.

"Well, they have a school you see," Duchamp replies with a slow smile. "The only danger is of it becoming an academy... The danger of any new movement is academicism, the adoption of new canons – especially with the addition now of money transactions. These things sell nowadays. The Impressionists and the Cubists did not sell. That's the difference. If it's a good thing, I don't know."

Duchamp declines to name those he considers the foremost artists of his lifetime. "I was never interested in judging people. It's enough to find yourself. That takes all your time... An artist," he repeats, "is merely a medium. He doesn't know what he does. He thinks he knows but he doesn't. It takes the art critic to tell him – to tell him, for instance, that he's produced a masterpiece."

And in his own work, what did Duchamp think had been most worthwhile? "The glass. The Large Glass [5.2.1923] for me is the only thing that I think shows no direct influence. Any artist in his lifetime produces only four or five things actually worth anything. The rest is filling up time, sketching for new projects, or doing

the same things over again for money." Then returning to the previous question: "I have really a very derogatory opinion of my times. The 50 years I have been seeing paintings – I am afraid it may go down as a whole era of commercialism. It seems to me we've merely moved from esoteric to exoteric, to the public domain... Mr Bouguereau sold for $100,000 in 1910. Where is he now? I have a feeling that if you put something in a lead box and dropped it in the river with a note on it: Open in 500 years, this is a masterpiece – and if you put a toothbrush in there, or a typewriter – well all these schools of Africa, isn't that the same thing? That's where my doubts come. There is no criterion."

Where had Duchamp most enjoyed living?

"Here in New York. Artists in Paris are, as a group, more demanding. Here the artists have more respect for your privacy."

And newspapermen?

Duchamp says he didn't mean those sort of demands, but "personal things, demands for help. But then I'm not an active artist... I once wanted to open a home for lazy people. It's not so easy as you think. The problem is your inner activity, that you cannot stop. You'd be ousted as soon as you worked – and this inner activity is work. The nature of man is that he could not do nothing."

Then why the exhibition at the Janis Gallery?

"Oh, that's not I. That's commercial, to sell a book."

"But you gave your agreement."

"Oh, I give my agreement every time. If I'm compromised every time, I don't care. You have to pay one way or another."

Tallmer is then intrigued as to how Duchamp has made a living all these years.

"I decided at the age of 20 that I couldn't be an organized citizen. I went on a strict economy plan, modest living quarters, no luxuries, to make it last. And it has."

"Then you have to be awfully lucky in your... in your..."

Duchamp saves the journalist from his embarrassment: "Yes, when you're a young man full of sex and everything, you have to be lucky that way. I have been very fortunate in my – encounters. Sure I was lucky. That's the truth for everybody: you've got to be lucky."

The arrival of Teeny Duchamp signals the end of the interview. Duchamp accompanies his visitor to the door. Tallmer notices that

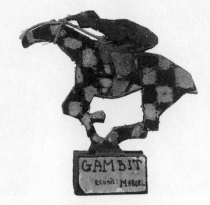

extending from and adding leverage to the knob of the lock is an ordinary teaspoon. He fingers it appreciatively. "There," says Duchamp, "isn't that art?"

1963. Monday, New York City
Having accepted an invitation to stay with the Baruchellos on 20 May [30.3.1963] at the beginning of a holiday in Italy, Duchamp thanks his young Italian friends for thinking of their return to Rome from Palermo on 10 June. As they plan to go by train to Florence the following day Duchamp suggests: "It seems simpler to me to go to a hotel rather than bother you."

1967. Saturday, Neuilly-sur-Seine
In the morning Duchamp immediately answers a letter from Mlle Popovitch confirming his preferred wording for the cover of the catalogue, "Les Duchamps..." followed by the name of each sibling. He has seen Mourlot, who will bring him a set of proofs and he hopes that the covers will be in Rouen before he himself arrives on Wednesday morning.

9 April

1910. Saturday, Paris
Two of Duchamp's cartoons appear in the press this morning. *Triplepatte*, the drawing which Bergmann probably posed for [25.3.1910], is published full-page in *Le Courrier Français*. A young couple in a hallway are about to embrace: the girl, struggling to disrobe, complains: "Help me then to take off my jacket," and the young man mutters, "There's no doubt I shall never know just when one should embrace women."

In the same issue there happens to be another "three-handed" phenomenon: a drawing of Boronali painting with his tail [1.4.1910] by Widhopff!

The other drawing by Duchamp, for which he was never paid, appears in Paul Iribe's review, *Le Témoin*. A sophisticated couple is sitting at a table, the man in evening dress leans back with a broad smile, a lighted cigar in his hand, "Sorry: there's no idiotic *métier*..." he replies to the girl who has enquired whether he is a Jew.

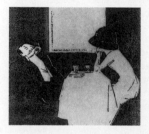

In the afternoon Max Bergmann, alias Triplepatte, calls to see Duchamp at Neuilly and stays to supper. In the evening, with Duchamp's friends, they play "petits chevaux", a game with dice for which Duchamp himself has made some of the horses and painted the cloth, based on the steeplechase course at Auteuil. Bergmann wins 25 francs and then loses 1.50. At about midnight they walk from Rue Amiral-de-Joinville as far as the Porte Maillot, where Bergmann takes the metro home.

*

In Rouen the Société des Artistes Rouennais opens its fourth exhibition at the Musée des Beaux-Arts. Duchamp, "so timid previously," disturbs the critics with his *Etude de Nu* (possibly one of those exhibited at the Salon des Indépendants [18.3.1910]?). Although the drawing of the woman's torso is "pure, the colour spoils everything", writes one critic, commenting that "wine rather than blood" must be running in the model's veins.

1917. Monday, New York City
The discord amongst the officers and directors of the Society of Independent Artists [5.12.1916] dominates the atmosphere at the Grand Central Palace until the opening hour of the exhibition. The subject of the dispute is *Fountain*, the entry sent by Richard Mutt from Philadelphia, who has paid his $6 membership fee and has the right to exhibit. Its defenders maintain that there is nothing immoral in the sculpture and to refuse it would be against the very principles upon which the exhibition has been organized: "No jury, no prizes." Its

detractors led by William Glackens, president of the society, who considers it the product of "suppressed adolescence", believe the object to be indecent and certainly not a work of art. Reminded of the cartoon strip characters Mutt and Jeff, George Bellows suspects that someone has sent it as a joke.

Standing on the top of a black pedestal, the smooth and shiny white enamel form causing all the argument is none other than a male urinal turned on its back.

Finally a meeting is called of those directors who can be mustered at short notice. Mutt's defenders are voted down by a small margin and *Fountain*, say the majority in their statement released to the Press, "may be a very useful object in its place, but its place is not in an art exhibition, and it is, by no definition, a work of art."

No doubt finding a disturbing parallel with the refusal by the "orthodox" Cubists of his *Nu descendant un Escalier* [18.3.1912] from the Parisian Salon des Indépendants in 1912, Duchamp immediately resigns from the Society in protest.

In spite of the drama during the day, the private view in the evening is "gorgeous and gay" according to the critic Henry McBride. Mrs Whitney heads the reception committee and a brass band plays while the guests await the arrival of the mayor, who never turns up. Finding that the show has the look of a real salon, McBride is complimentary about the way the space has been used, the hefty pillars reduced in volume by the astute placing of the partitions. He compares the scene to the foyer of the Opéra in Paris on a Ballets Russes night.

Duchamp's idea for hanging the show in alphabetical order presents a challenge and it is generally heavily criticized. McBride finds his way in easily enough to peruse the 2,500 works, which he estimates the proportion of inoffensive to offensive (meant in the complimentary sense) as being about ten to one, but has difficulty finding his way out. He makes four unsuccessful circuits of the labyrinth and each time he goes round he bumps into the poet and pugilist, Arthur Craven who is billed to give a lecture in the exhibition on 19 April.

"I am glad I do not owe you money." declares the poet to the critic, " What an awful

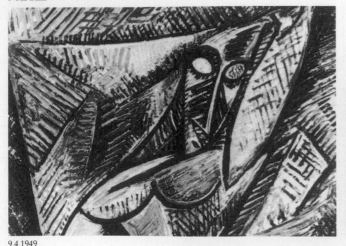

9.4.1949

9.4.1950

place this would be to escape from a creditor. When you turn these corners you don't know what you're getting into!"

Duchamp's apparently fortuitous hanging arrangements result in what Arensberg describes as "the beauty of chaos". There is an eclipse of the European "stars", such as Matisse, Derain, Delaunay, Picasso, Picabia and Gleizes, their dispersion rendering them totally defenceless, while the crowds are fascinated by the sultry and bespangled nude painted by George E. Lothrop, which completely overshadows Mina Loy's entry hung next to it. One of Beatrice Wood's contributions, *Un peu d'eau dans du savon*, fabricated under Marcel's tutelage in his studio, with it's real bar of soap in the form of a scallop shell nailed strategically to the canvas is a hit. Gentlemen leave their calling cards wedged into the frame. Another great attraction and one of the finds of the show according to Duchamp, is the *Claire Twins* by Miss Dorothy Rice. Everyone laughs when they see this bold painting of two creatures resembling pantomime dames but they admire it. Even Marius de Zayas of the Modern Gallery is glued to the floor in front of it.

Duchamp is alone in considering that the other discovery of the show is *Supplication* by Louis Eilshemius. It was "one of the thousand or two paintings" that McBride "merely glanced at in passing", but Duchamp has shaken his judgment and he agrees to look at the canvas again.

The only person who notices a picture, ex-catalogue, purporting to be Duchamp's contribution, is the journalist Jane Dixon. Referring to *Tulip Hysteria Co-ordinating*, whose very title evokes a climacteric movement of the tumultuous can-can, she declared: "Those were the most hysterical tulips I ever saw in my life. So hysterical were they that every vestige of resemblance to their former symmetrical selves had been lost and they were merely lurid splotches of colour running wild all over the canvas."

1918. Tuesday, New York City
The news from France is that Paris was bombarded the previous day by Big Bertha.
After attending a concert of Mexican songs at the Aeolian Hall and dinner, Roché visits Marcel at his studio and they spend the rest of the evening at Yvonne Chastel's with Mary Sturges.

1937. Friday, Paris
In his sixth contribution to *Ce Soir*, as well as giving news of tournaments in Berlin and Leningrad, Duchamp presents his readers with the chess problem which won the *Arbeider Magasinet* competition in 1936, and publishes the astonishing game which Dr Alekhine lost against the young English amateur, V. Buerger, in the present international tournament at Margate.

1949. Saturday, San Francisco
On the second day of the "Western Round Table on Modern Art", the subject of the closed session, which starts at one o'clock in the Members' Room, is why people collect and why museums organize exhibitions.
After returning to the question of retinal art, which he introduced in the first session, Duchamp becomes the focus of an attack by Frank Lloyd Wright, who doesn't believe that Duchamp still regards *Nu descendant un Escalier*, No.2 [18.3.1912] as "a great picture".
"I beg your pardon, sir," replies Duchamp, calmly defending his painting. "On the other hand," he points out, "forty years have gone by, and Time, after all, is an important factor in the decision whether a thing is good or bad."
Wright admits that when he made his first architecture he didn't know whether it was going to be good or not and was "learning to walk".
"So was I," comments Duchamp.
"Now that you walk, Marcel Duchamp, do you still regard it as a great picture?" persists Wright.
"More so," says Duchamp firmly.
Making a general attack, Wright refers to Picasso's inspiration from Negro sculpture and says that "…If Picasso is a great artist – that degeneracy does loom…"
"Why do you call it degeneracy," asks Duchamp. "The artist seeks in the primitive what might be good to take."
"And healthy," interjects Milhaud.
"Would you say that homosexuality was degenerate?" challenges Wright.
"No… I believe that the homosexual public has shown more interest or curiosity for Modern Art [than] the heterosexual," replies Duchamp, "so it happened, but it does not involve modern art itself."
Later Duchamp declares: "The word 'forward' implies the acceptation of progress, and progress, of course, does not exist in art that I

know of. There is no progress in art.
Wright doesn't agree, arguing that Duchamp has left out the factor of changed circumstances: "The way we live today compared with the way that same age lived."
"That doesn't apply to the aesthetic emotion," says Duchamp.
Boas then gives Duchamp the opportunity to repeat his ideas expressed the previous day, which differentiate taste and the aesthetic echo. In conclusion Duchamp says: "Generally speaking, very few people are capable of an aesthetic emotion or an aesthetic echo. While many people have taste, only a few are equipped with aesthetic receptivity."
"Does that mean that taste really represents the accumulated or established standards of the period…?" enquires Ritchie.
"Yes," replies Duchamp.
If Duchamp is right "that it is only possible for the great mass of people to follow established opinions", argues Ritchie, then "we may be… on the wrong track altogether in having museums…"
Goldwater wonders how the observer makes the jump from the beginning of education in the museum to the appreciation of the aesthetic echo.
"Well, you have it, or you don't have it," says Duchamp. "I am not a mathematician, and I would never dream of understanding mathematics or think mathematics, because I have not the natural tools for it. Neither, I think, has the layman the tools for art. Only a few people are privileged and their group form the third term of a trinity: artist, work of art, recognition."
"Nevertheless, you would have the privilege, if you so desire, of education in mathematics," observes Goldwater.
"Never," insists Duchamp, "if you haven't the brains for it."
When Ritchie asks Duchamp to define the relation between feeling and taste, Boas proposes he does it by way of an example.
"The absence of an aesthetic echo in many people is best illustrated by colour blindness," suggests Duchamp. "A man who is colour blind will never dream of a red or a green or anything like that. It's the same kind of physical deficiency."

Towards the end of the three-hour session, Bateson asks whether Modern Art contains a sense of magic that could transform the onlooker.

10.4.1910

10.4.1945

"I think the work of art has magic at all times," declares Duchamp, "and in 1949, we have our own magic, haven't we?"

"I think we have," agrees Bateson.

"And we can't help it, I think," adds Duchamp.

1950. Sunday, New York City
After declining the invitation to speak in Philadelphia [31.3.1950], Duchamp has received another letter from Fiske Kimball enquiring whether he will not reconsider his decision. "Your insistence touches me profoundly," says Duchamp, "but doesn't manage to convince me. I cannot speak in public because I don't believe in it." Excusing himself, Duchamp begs him to pardon "a topsyturvy prima donna" and signs himself "Sarah Bernhardt alias Marcel Duchamp".

1959. Thursday, Lisbon
Marcel and Teeny arrive by air from New York to spend a few days in Portugal before travelling to Cadaqués.

10 April

1910. Sunday, Paris
Max Bergmann arrives at Rue Amiral-de-Joinville at twelve-fifteen, in time for lunch with Duchamp. Afterwards they visit the Salon des Artistes Indépendants [18.3.1910] and as they wander amongst the 6,000 exhibits, they meet Gustave Candel, a close friend of Duchamp's from the days when they were neighbours in Montmartre [5.11.1906]. The two Frenchmen will certainly ensure that Bergmann doesn't miss Boronali [1.4.1910] nor Room 18 – the climax of the show – with the Matisse, the canvases by Pierre Girieud and the astonishing masterpiece by the Douanier Rousseau, who has confounded all with his painting of Yadwigha reclining on her Louis-Philippe canapé in the midst of a lush tropical forest.

At half past five Duchamp leaves Bergmann in Candel's hands for the evening. They have plans to explore Paris for a couple of hours on foot as far as Montmartre, to go to the cinema and play a game of billiards.

1929. Wednesday, Paris
It is just over six weeks since Duchamp went to meet Miss Dreier and her secretary, Mrs Thayer, in Gibraltar [23.2.1929]. On his return to the capital from Nice [1.4.1929], he finds a letter from Mrs Jarvis, the assistant secretary at the Arts Club of Chicago, asking for instructions concerning the return of Picabia's paintings [2.10.1928], to which he replies.

1935. Wednesday, Sèvres
Has an amusing day at the Rochés' with some friends [the Mills?].

1945. Tuesday, New York City
The catalogue cover for Man Ray's exhibition "Objects of my Affection" at the Julien Levy Gallery, 42 East 57 Street, is by Duchamp. Using a close-up frame of noses and lips, which Levy describes as "the first real kiss in the annals of the cinema", Duchamp has processed it mechanically until the image, reduced to a primitive organization of regular dots, presents a ground-figure conundrum ambiguous to read.

1949. Sunday, San Francisco
After two days of intense debate at the "Western Round Table on Modern Art", an additional session is organized to enable those panellists who can attend to review certain topics. In this final session, which is attended by Bateson, Burke, Duchamp, Goldwater and Milhaud, Frankenstein replaces Boas as moderator.

Returning first to the question of the function of the critic, Duchamp agrees with Goldwater that "one of the prime functions of the critic is simply to serve as a method whereby the observer is arrested on a work of art for a longer time than, unaided, that work of art could hold his attention…"

"And when the critic tells the public, 'please, now, get your emotions out of yourself'," says Duchamp, "it is also a great help… In fact the public is completely ignorant, or should be, and needs help. In fact, whether the public will ever feel anything is doubtful, and as I said before, I think that only a few people are not colour blind. By colour blind, I mean incapable of an aesthetic echo. And I don't think it could be developed."

Goldwater asks whether in Duchamp's mind the aesthetic echo is "something which is immediate and instantaneous" in approaching the work of art.

"Yes. It is immediate and direct, but you can make a man conscious of its 'existence'," Duchamp explains to the critic. "You can almost describe the taste of an orange, and when the man tastes an orange, he will see what you meant."

In reply to a further question from Burke about the appreciation of a work of art, Duchamp explains: "What you see is not what I see. We get just as much of an emotion, you and I, and it's not the same emotion, because your emotion is never my emotion anyway; so it doesn't have to be one single emotion, a formulated emotion. You have your own interpretation and your own emotion and it's all right, as long as you have an emotion.

"Why is it so difficult to admit that of the two entities, the artist and his masterpiece, the latter is more important (although inanimate)?" asks Duchamp. "The artist is only the mother, in other words."

At the end of the session. Robert Goldwater asks if Mr Duchamp would return to expand on precisely the relation of taste and the aesthetic echo to the collector.

"There are all sorts of collectors," Duchamp explains, "the real collector – the one I oppose to the commercial collectors, who have made Modern Art a Wall Street affair – the real collector, in my opinion, is an artist *au carré*; he selects paintings and puts them on his wall, in other words, he 'paints a collection'.

"… People today often buy paintings as an investment. It seems to me that a hundred years ago, fewer painters, fewer collectors, fewer critics and fewer dealers made a little world outside the great public and gave preference to qualitative evaluation – with little or no speculation."

Has the commercial influence directed any broad style or direction in contemporary art, asks Goldwater.

"No, I don't think it has any essential importance," replies Duchamp and then observes: "The very fact that Modern Art is so much liked and disliked is sufficient proof of its vitality."

1953. Friday, New York City
What is to be done with the paintings from the Katherine Dreier Estate [29.3.1952] which are still at the American Arbitration Association? Duchamp replies to Mary Dreier reminding her that these paintings belong to

11.4.1906

her and may be disposed of as she pleases [5.2.1953]. As she will be returning to New York around 21 April, Duchamp offers to discuss the matter with her then.

1957. Wednesday, Mexico City
On receiving a letter from Louis Carré sent to him care of Rufino Tamayo [6.4.1957], Duchamp immediately forwards the information about *Le Grand Cheval* and *Maggy* to Katharine Kuh at the Art Institute of Chicago, and adds: "After enjoying Houston we are *éblouis* by Mexico."

1960. Sunday, New York City
Before leaving for Atlanta, Duchamp writes a note to Leon Kroll confirming that Kroll should contact Alfred Barr about the loan of *Le Passage de la Vierge à la Mariée* [7.8.1912] for exhibition at the National Institute of Arts and Letters [8.2.1960].

*

The guests of honour at a reception held at four-thirty at the Atlanta Art Association are the judges of the Painting-of-the-Year contest Dr William M. Milliken, director emeritus of the Cleveland Museum of Art (whom Duchamp last met twenty-four years earlier [26.8.1936]), Dr Russell A. Plimpton, director of the Society of the Four Arts, Palm Beach and Duchamp himself. The judges' task has not yet commenced, but they have been invited to attend the presentation of a scholarship award which is presented by Arthur Harris, vice-president of Mead Packaging Inc., to Conroy Hudlow of Chattanooga, Tennessee, a third-year art student at the Atlanta Art Institute. He will receive a year's study in Paris and in exchange a French art student will be given a year's study at the Atlanta Art Institute. After the ceremony tea is served.

1961. Monday, New York City
Instead of going to Mount Holyoke College in Massachusetts to give a talk, Marcel (whose back is much better) "is sitting peacefully at home". The cable chess game against the young Dutch players, organized by the Stedelijk Museum [11.3.1961], is still going on. "It makes our nights endless," says Teeny, "and it becomes too engrossing to be real fun."

1965. Saturday, New York City
From Cordier & Ekstrom, where the exhibition is to be held, Duchamp writes inviting a number of artists to take part in a show next spring for the benefit of the American Chess Foundation. "The show of about thirty works will be called CHESS," explains Duchamp, "and each work should be related to chess in a manner as close or as far-fetched as you wish…"

Each artist taking part will receive a copy of the etching, personally inscribed, which Duchamp is making exclusively for the occasion.

1967. Monday, Neuilly-sur-Seine
For a show of readymades at the Galerie Givaudan to run concurrently with the exhibition at the Musée d'Art Moderne planned in June, Marcel writes to ask Arne Ekstrom if he will lend him the original photograph taken in his New York studio [8.7.1918] of the shadows cast by the readymades, which was shown at the Tate Gallery, so that he can have an enlargement made to exhibit.

*

The interview which Duchamp accorded to Jeanne Siegel in February, is broadcast in New York on WBAI as part of a series "Great Artists in America Today".

11 April

1899. Tuesday, Rouen
The new President of the Republic, Emile Loubet, who was elected following the death of M. Félix Faure, has accorded a day's holiday to all the school children in France and so the beginning of the summer term at the Lycée Corneille is delayed 24 hours. Like his fellow boarders, Duchamp returns to the Ecole Bossuet in the evening; M. Ligeret's class at the Lycée Corneille commences at eight o'clock the following morning.

1906. Wednesday, Eu
After six months service with the 39ème Régiment d'Infanterie at their barracks in Eu – the

Norman town rescued from insignificance by the popular song *Le Maire d'Eu* – Duchamp is promoted to the rank of corporal.

1917. Wednesday, New York City
In a carefully worded and neatly handwritten note, Duchamp writes to Miss Dreier regretting that because of his resignation [9.4.1917] from the board of directors of the Society of Independent Artists, on account of "serious disagreement with the ruling spirit", he has been unable to help her decorate the tearoom at the Grand Central Palace as he had originally promised.

In a much hastier letter he asks his sister Suzanne to relay the anecdote to the family in this way: "The Independents have opened here with great success. A friend of mine, using a masculine pseudonym, Richard Mutt, sent a urinal in porcelain as a piece of sculpture. It wasn't at all indecent – no reason to reject it. The committee decided to refuse to exhibit this thing. I resigned and it's a row which will count in New York." He adds that he wanted to make an exhibition of rejects from the Independents but that would have been a pleonasm and the urinal would have been lonely.

1936. Saturday, Paris
At twelve-fifteen, Marcel has an appointment at Arago to meet Breton and his wife Jacqueline. Roché shows them the works by Duchamp, Brancusi, Picabia and Calder which he is proposing to lend to the Surrealist exhibition opening in London on 11 June.

1941. Friday, Paris
Having a great deal to do before his imminent departure for Grenoble via Lyons, Duchamp writes a note to Georges Hugnet: "Mary [Reynolds] asks you to postpone this afternoon's appointment until next week… so telephone her one day (morning) and arrange something."

1952. Friday, New York City
Deciding to wait before exhibiting his early paintings [23.1.1950] (due to his unwillingness to show them out of context or to put them on the market), Marcel asks Roché to stop all his efforts in this respect. He says: "The sales game is really a dealers' game and neither you or me know how to do it. The buyers of my paintings in the past," Marcel points out, "have always disregarded the dealers' skilful denigration."

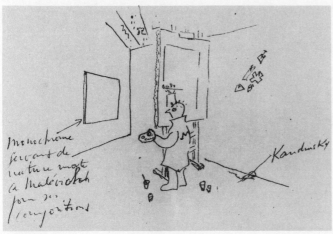

11.4.1961

However Catton Rich and Katharine Kuh of the Art Institute of Chicago are wanting to acquire a major work of his for the museum and have made enquiries through the dealer Rose Fried. Unable to think of anything else of importance, Marcel asks Roché if he would consider selling *9 Moules Mâlic* [19.1.1915], while keeping it during his lifetime?

1953. Saturday, New York City
In the evening, while waiting for the uptown bus on the corner of 14th Street and Eighth Avenue, Marcel catches sight of Léon Hartl, his dye-shop partner [25.11.1922], whom he has not seen for many years. Although he is in a hurry, Marcel greets his friend with a smile and they chat for a few minutes until the bus comes along.

1959. Saturday, Lisbon
Marcel writes postcards to Robert Lebel in Paris and Richard Hamilton in London confirming that Fawcus has signed with Grove Press for the American edition of *Sur Marcel Duchamp* [6.4.1959], which is to be published in September. For Lebel he chooses a card decorated with an extravagantly sculptured eighteenth-century coach, used by the Marquis de Fontes in Rome. On a card representing the mountains at Sintra, Marcel asks Richard to pass the news on to George Heard Hamilton.

1960. Monday, Atlanta
Faced with some 900 works of art submitted from artists living in Georgia, Alabama, Louisiana, Mississippi, North and South Carolina, Tennessee, Virginia and Florida the three judges Dr Milliken, Dr Plimpton and Duchamp commence their arduous task of selection: they must choose about 75 pictures for exhibition at the Atlanta Art Association and the prize-winners of the Painting-of-the-Year Competition. Each work is studied and some are marked "perhaps", or "perhaps maybe" and others "definitely in" or "definitely out". The sixth event of its kind, this year there is a preponderance of abstracts. The weeding out process is due to be completed on Tuesday.

1961. Tuesday, New York City
For Madame Legros, who is preparing a *catalogue raisonné* of Jean Arp's work, Marcel is searching for the whereabouts of a wood relief by Arp, which he had written about to the sculptor some ten years ago. He asks Brookes

Hubachek in Chicago to enquire whether it was in Mary Reynolds' collection. Can Brookes check with the Art Institute of Chicago?

If he comes to New York before 18 May, Marcel offers to show Brookes the oil sketch of Pulitzer by Villon which is among the works to be auctioned for the benefit of the American Chess Foundation. He promises, in any case, to mail him a catalogue when it is published at the beginning of May.

*

Both Jean Tinguely and Yves Klein are in town for their exhibitions: Tinguely's machines have been turning noisily at the Staempfli Gallery since the previous Tuesday and today "Yves Klein le Monochrome" opens at the Leo Castelli Gallery. "[Yves] and his beautiful little German wife came to see us the other night," Teeny tells Jackie. "With us he was quiet and his mind was fascinating and we listened until early morning."

1967. Tuesday, Neuilly-sur-Seine
"Naturally I would be delighted to see your exhibition of your new models 'Marcel'," writes Duchamp to Dino Gavina [11.6.1965], asking the designer to let him know when and where the presentation will take place.

*

"I remember the drawing in *Le Rire* (*La Mode ample* [29.10.1910])," writes Duchamp to Otto Hahn, enquiring whether the date is on the magazine. "I'm not proud of it however."

12 April

1917. Thursday, New York City
The "whole gang" goes to the Rogue's Ball [5.3.1917].

1918. Friday, New York City
In the evening after dinner at the Arensbergs', Roché goes up to Marcel's studio and plays chess with Mary Sturges on the board fixed to the wall, while Yvonne Chastel helps Marcel with the canvas commissioned by Miss Dreier [9.1.1918]. She is painting a colour scale of lozenges. Later Roché accompanies Yvonne home on foot through the melting snow.

1931. Sunday, Paris
In the evening Dee and Miss Dreier drive out to the Bois de Boulogne and dine together at the celebrated restaurant, the Grande Cascade. Although spring is late this year and the forsythia just in full blossom, the weather has been "heavenly" since Miss Dreier's arrival from America a week ago. Until moving into her apartment at 16 Place Dauphine [18.12.1930] on Thursday, Miss Dreier is staying at the Hôtel Brighton.

1949. Tuesday, San Francisco
After attending the "Western Round Table on Modern Art", Marcel travels south to Hollywood where he is invited to stay with Louise and Walter Arensberg, whom he has not seen since his last visit to California [21.8.1936].

*

On his arrival at 7065 Hillside Avenue, Marcel makes an inspection of the house with Louise and Walter, as if it were his first visit. He examines all the paintings and objects carefully without comment giving the same attention to each piece whether it is one of his own or another's. When he comes to *Le Roi et la Reine entourés de Nus vites* [9.10.1912] he remarks: "This one still holds up."

1950. Wednesday, New York City
Duchamp receives the *aide mémoire* of the meeting held at the Metropolitan Museum on 4 April together with a letter from Roland Redmond. The executive committee of the trustees approves the suggestion that Duchamp should travel to California at the museum's expense to discuss their proposals with the Arensbergs for the acquisition of their collection.

A telegram from Francis Taylor, who initiated the present negotiations and is anxious to see him before he goes to California, invites Duchamp to lunch on either 17 or 18 April.

*

In the evening, after receiving a letter from Arensberg, Marcel cables Walter the time of his arrival in Hollywood on 19 April.

1952. Saturday, New York City
As promised in his letter to her on Tuesday, Duchamp waits for Monique Fong between five and seven at his studio 210 West 14th Street.

After her visit, Duchamp has a quick supper before the appointment he has at eight o'clock to play "a serious chess game".

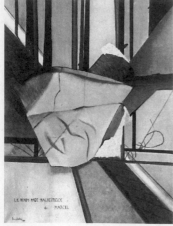

14.4.1919

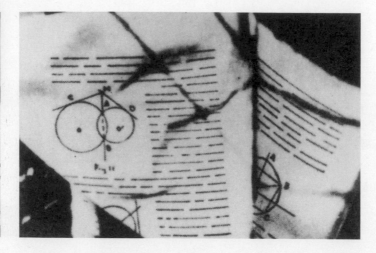

1958. Saturday, New York City
After ten days as guests at 327 East 58th Street, Lily and Marcel Jean go to Connecticut for a week.

1960. Tuesday, Atlanta
The three judges, Dr Milliken, Dr Plimpton and Duchamp, select two Florida artists for the top awards in the Painting-of-the-Year Competition. Tony Scornavacca of Miami wins the $1,000 first prize for his painting *Still Life with Chairs*, and the special $750 watercolour prize goes to Fred Messersmith of Deland for *Shore Birds*. Second prize is won by Edward Ross of Roswell and a cash award is given to Pat Herrington of Atlanta. Five works are selected for honourable mentions.

Their task completed, the judges meet the journalists. Replying to Barbara Bright, Duchamp declares that the artist who wants to be a genius has the world against him today. "The priest-like life of an artist was easier 100 years ago. Then you didn't have to eat... but no one has the right to be Bohemian today because people won't let you."

Duchamp's advice to young artists is: "decide whether you want to make a living or be a genius." For the genius art is a great risk and "you often have to be dead to be called a genius".

Duchamp is also interviewed by Robert E. Simmons, who is covering the event for the *Atlanta Journal*. "Young artists take themselves too seriously today," Duchamp declares. "In my day – when I was in my 20s – we had gay ideas. We were idealists. If we could breathe, it was all we needed. That, and a little food here and there... There is not enough vitality in people of today to start a revolutionary art movement... Dadaist art was started as a negative movement. It was an objection to principles of previous forms of art."

With a quick smile, Duchamp remarks that he is now "retired" as an artist. "Retired like a businessman who never did business."

*

At eight o'clock Duchamp returns to the Atlanta Art Association to speak to a gathering of students and faculty members of various institutions including the Atlanta Art Institute, Emory University, Oglethorpe University, Agnes Scott College, Georgia State College. He has agreed to answer questions from the audience which have been submitted to him in advance.

Asked about the source for *Nu descendant un Escalier* [18.3.1912], Duchamp replies that, in *L'Illustration*, he saw a trick photograph of a fencer with his rapier in many mechanical positions, showing movement, and he decided to portray artistically what the camera caught literally.

1962. Thursday, New York City
After an initial approach by William Seitz [19.10.1961], Thomas W. Leavitt, director of the Pasadena Art Museum, formally proposes to arrange an exhibition of Duchamp's "most important paintings and other work in this country". As the majority of his works are in the Philadelphia Museum of Art, the possibility of assembling such an exhibition depends on their cooperation and Leavitt has already written to Henri Marceau.

In reply to Leavitt's query about other collections of his work in the United States, Duchamp claims that there are not many. Yale University Art Gallery has a few works, the Pierre Matisse Gallery has the large canvas *Réseaux des Stoppages* [19.5.1914], and Jeanne Reynal owns the first drawing in perspective [22.10.1913] of the Large Glass. As the proposed dates for Pasadena, 12 May to 23 June 1963, coincide with a "revival" of the Armory Show at the Munson-Williams-Proctor Institute, Duchamp suggests they be revised.

1963. Friday, New York City
A week after the opening of the "50th Anniversary of the Armory Show", Harold C. Schonberg's interview conducted while playing chess with the "hero (or the villain)" of the original exhibition, is published in the *New York Times*. As he played Pawn to Queen four, Duchamp "with his spare figure and ascetic face", writes Schonberg, "looked like what St Thomas must have looked like."

He denies that he gave up painting to concentrate on chess: "I have been interested in chess since I was 13 years old. My brothers showed me the moves. But I am not of master calibre. For that, eight hours a day, nine hours a day, are necessary. One must devote one's life to chess to be a good player."

Duchamp sets up a Queen's Gambit and says that he was in Paris at the time of the Armory Show [17.2.1913]: "I heard about the scandal about my *Nu descendant un Escalier* [18.3.1912]. This I found very pleasant."

He swings his Queen to Rook four, attacking his opponent's Bishop's Pawn: "...After all my aim was not to please the general public. The scandal was exactly in my program, you might say."

By picking off the Bishop's Pawn, Duchamp breaks up his opponent's Queen's side. "There is a great correlation between chess and art," he says. "They say chess is a science but it is played man against man and that is where art comes in. Check."

His opponent respects the check while Duchamp continues: "Both chess and music are visual arts coupled to mechanics. Both are arts of movement. The beauty of a chess position is that it is not static. The beauty is in the arrangement and in the inherent possibilities."

Interrupting his train of thought, Duchamp tactfully points out that his opponent must, in his position, lose a piece. "In art as in chess there must be new movements... Take the New York School or the advent of Pop Art. This is good... that a group of young men do something different. The deadly part of art is when generation after generation copies one another..."

Duchamp's opponent, putting off the moment of resignation, looks round the room at the early Matisse, the Miró and Tanguy. "They were revolutionaries," explains Duchamp. "Today the artist has been integrated into our society. I doubt very much if there could be ever again such a scandal as occurred with the Nude in 1913. Today we see the complete democratization of art. Everything is accepted." His next move causes his opponent to resign, a decision, Schonberg admits he should have taken five moves earlier.

"There was more excitement in 1913," Duchamp says. "...I was present at the world première in Paris of Stravinsky's *Sacre du Printemps* [29.5.1913]. I will never forget the yelling and the screaming." He invites the journalist to another game, sets up the pieces and opens with a Nimzovitch Defence.

"I stopped painting in 1923 because there was too much commercialism. I did not like the mixture of money and art. I like the pure thing. I don't like water in wine."

162. Puissance d'un point par rapport à un cercle. — Le produit constant M A × M B s'appelle *puissance* du point M par rapport au cercle.

Exercice

57. — Si deux cercles O et O' se coupent en A et B, les tangentes aux deux cercles, issues d'un même point de la corde commune A B prolongée, sont égales. Examiner le cas où les circonférences deviennent tangentes.

LIGNES PROPORTIONNELLES DANS LE CERCLE

57. — *Si deux cercles* O *et* O' *se coupent en* A *et* B, *les tangentes aux deux cercles, issues d'un même point de la corde commune* A B *prolongée, sont égales. Examiner le cas où les circonférences deviennent tangentes.*

DÉMONSTRATION: Soient M C et M D deux tangentes issues d'un point M quelconque situé sur le prolongement de B A (fig. 227).

Dans la circonférence O', on a:

$$\overline{M C} = M A \times M B.$$

Dans la circonférence O', on a:

$$\overline{M D} = M A \times M B.$$

d'où $\overline{M C}^2 = \overline{M D}^2$

ou M C = M D

Si les circonférences O et O' deviennent tangentes, la droite M N devient la tangente commune; les tangentes menées de tous les points de cette droite sont égales.

On peut d'ailleurs remarquer que l'on a des tangentes à une circonférence issues d'un même point; on sait qu'elles sont égales.

1965. Monday, New York City
In the evening at seven-thirty, Duchamp is due to meet Louis Carré, who is staying at the Regency.

1967. Wednesday, Rouen
In the morning, Duchamp arrives from Paris to supervise the hanging of the exhibition, "Les Duchamps," at the Musée des Beaux-Arts. Smiling and relaxed, the survivor of the artists in the family decides the exact position of each work in the show with the curator, Mlle Olga Popovitch.

At four o'clock in Mlle Popovitch's office, Jean-Paul Deron of *Paris-Normandie* meets Duchamp whom, the journalist recalls, is the man that André Breton considered the most intelligent of the 20th Century and also "for many, the most annoying". He discovers the artist wearing a bright blue woollen tie on a striped shirt with a green waistcoat, and there is a hint of surprise when Deron finds that Duchamp transforms the interview into a conversation covering a wide range of subjects which he treats with wit and sensitivity but without the slightest compromise. Deron summarizes their exchange, first concerning Duchamp's brothers, Villon and Duchamp-Villon.

"We were extremely good friends, even though we had different ideas. They launched me… We didn't know that we would become important. Braque and Picasso didn't know either."

Duchamp lights a cigar.

"Cubism? Undoubtedly, of the three, I was the first to be interested in it. My brothers followed within a few months. We would listen to theories, to precepts. It is better to do something and not talk about it."

Duchamp smiles: "Me, I'm the father of nothing at all."

The cigar moves from one hand to the other.

"There is nothing more boring than repetition. Anything which is not unusual, or *insolite* which is a very nice word, falls into oblivion. Even now the unusual wins. It is not negation. It is difference, clear difference."

The future of art: "One can forget oil painting. It discolours. It needs repairing all the time. Yes, one can find something else. Oil painting has no *raison d'être*."

The beautiful and the ugly: "The most ugly thing, kept religiously for 40 years, penetrates

your taste and becomes aesthetic."

Duchamp is hard on artists who want to be rich.

"They should work during the week and paint on Sundays, but not wreck the products of their imagination by selling them…"

Son of a *notaire*, Duchamp expresses his hostility to the realm of property.

"For example, to barter, it's horrible. Wednesday, I take; Thursday, I give. The notion of equality in the exchange seems to me a disgrace. I favour a world of tenancy. Possession should be forbidden."

Duchamp is happy that his work is exhibited in Rouen.

"I love museums. At Philadelphia I have been in the museum for 20 years…"

13 April

1917. Friday, New York City
In the early hours of the morning after the Rogue's Ball, some of "the gang", Mina Loy, Roché, and Beatrice Wood spend the rest of the night at the Arensbergs where they have breakfast together.

Later after taking a bath in Marcel's studio, Roché stretches out on the couch and looks at the paintings.

1930. Sunday, Paris
At their Annual General Meeting, which is conducted in a calmer atmosphere than last year, members of the Fédération Française des Echecs elect Duchamp to their committee. The meeting regrets Dr Alekhine's resignation as a member and hopes that the world champion will reconsider his decision.

1945. Friday, Beauvallon
Henri Pierre Roché makes a page of notes for writing a life of Marcel Duchamp.

1950. Thursday, New York City
Replying to Arensberg's letters (including the one written on 11 April), Marcel promises to put Walter's suggestions to Francis Taylor and to report his reactions when he goes to see them on 19 April.

Redmond's *aide mémoire* of the meeting on 4

April makes it clear "how much and why" the Metropolitan Museum would like to have the Arensberg's collection but the "litigious point", which Marcel asks Louise and Walter to consider before his arrival, concerns the length of time they promise to show the collection as a whole.

1951. Friday, New York City
Boarding the William Penn train at Pennsylvania Station at eleven in the morning, Duchamp joins Fiske Kimball in one of the through coaches from Philadelphia to Boston. On their arrival at Bridgeport they take a taxi the short distance to Milford where Miss Dreier has invited them to lunch. After looking at Miss Dreier's collection, which is the reason for their visit [27.1.1951], to return to New York, Kimball has proposed they take the three-twenty train from Milford, which arrives at the Grand Central Station at just before five o'clock.

During the day Duchamp has the opportunity to ask Kimball about the arrangements being made for the Arensberg bequest [27.12.1950] to be installed at Philadelphia. Kimball replies that architectural drawings are in preparation "to be presented for adequate appropriation".

1963. Saturday, New York City
Teeny and Marcel leave early in the morning to spend Easter with Paul and Sally Matisse at Concord.

14 April

1918. Sunday, New York City
After they have dined together, Roché, Mary Sturges and Yvonne Chastel call at Marcel's studio. Roché finds that the painting for Miss Dreier [12.4.1918] "is becoming more and more magnificent". The four of them then go to watch late-night movies at Loew's until after midnight.

1919. Monday, Paris
At the *mairie* of the *17ème arrondissement,* Jean Joseph Crotti marries Suzanne Marie Germaine Duchamp. Crotti was granted a divorce from his second wife Yvonne Chastel on 29 December 1917, and Suzanne was divorced from Charles Desmares [24.8.1911] on 21 February 1913.

MINA'S POEMS À 2
DIMENSIONS ½ :
HAUTS-RELIEFS ET
BAS-FONDS, Inc...,
MARCEL DUCHAMP (ADMIRAVIT)

14.4.1959

Par conséquent Takis,
gai laboureur des
Champs magnétiques et
indicateur des chemins
de fer doux

14.4.1962

OSEUR D'INFLUENCE

AUX HEURES D'AFFLUENCE

MARCEL DUCHAMP

ENRICO DONATI
la gaia pittura
introduction au sourire
Copulation versus masturbation
marcel Duchamp
1952

15.4.1939/1952

From Buenos Aires, Marcel sends his sister and her husband a recipe for a wedding present which, as it is entitled *Readymade malheureux*, could be considered an ambiguous gift for a happy man: *mâle heureux*.

Suzanne has instructions to tie a geometry book with string to the balcony of her apartment, 22 Rue de La Condamine. The wind will blow through the book, choose its own problems, turn and tear out the pages gradually destroying them. Later from a photograph taken of the principles in the process of erosion, Suzanne paints a canvas entitled *Le Ready-made malheureux de Marcel*.

1926. Wednesday, Paris
Having enjoyed a lunch with champagne at Madame Prunier's restaurant, Marcel, Miss Dreier and Roché go to the Cercle Interallié, where "all the Duchamps, sisters and brothers", are united.

1936. Tuesday, Paris
After a telephone call from Georges Hugnet, Duchamp writes to André Breton, whom he saw on Saturday, about the choice of works to be included in the Surrealist exhibition in London. Rather than lend *Cimetière des Uniformes et Livrées* [19.1.1915] which he is hoping to sell when he goes to America next month, Duchamp proposes the canvas belonging to Roché. Since it has no real title and to avoid using terms such as "portrait" or "study", Duchamp baptizes the painting *A propos de jeune Sœur* [8.3.1915].

In the next two weeks Duchamp is going to be busy with the cover for *Cahiers d'Art* at the Imprimerie Ramlot, but he asks Breton, if he has the opportunity, to suggest a time when they could meet.

1959. Tuesday, Cadaqués
Marcel and Teeny arrive in Cadaqués and settle into the apartment on the edge of the sea which they had seen and liked the previous summer. On the sixth floor the apartment has two bedrooms, a sitting room and a large terrace which dominates the bay. On the left the great Es Cucurucuc rock protrudes from the sea, and in the distance on the right is the Sa Sabolla lighthouse. From their bedroom window Marcel and Teeny can see the large church of the old village.

It is a very cold day in the little windswept port and there is no heating in the apartment.

However, the owner of the house, Rosita Casadevall, comes to the rescue and lends the Duchamps a large copper brazier which they put in the sitting room under the table covered with a cloth descending to the floor.

*

Before flying to Europe, Marcel has composed some lines for Mina Loy. They are reproduced in facsimile in the catalogue of her exhibition opening today at the Bodley Gallery, New York.

1962. Saturday, Milan
A note by Duchamp appears in the catalogue published for the Takis exhibition at the Galleria Schwarz: *Par conséquent Takis, gai laboureur des Champs magnétiques et indicateur des chemins de fer doux.* [Thus, Takis, gay labourer of magnetic fields and indicator of soft railways.]

1967. Friday, Neuilly-sur-Seine
"Don't take umbrage, you have been victim of professional idiosyncrasy and that you must always expect," Duchamp advises Baruchello following the publication of his article in *La Quinzaine Littéraire* [1.4.1967].

*

Sends Pierre de Massot an invitation to the exhibition "Les Duchamps", which opens the following day in Rouen.

15 April

1922. Saturday, New York City
At four-thirty, Duche is invited to Florine Stettheimer's studio for tea; the other guests are her two sisters, Ettie and Carrie, Baron and Baroness de Meyer, Henry McBride, Carl van Vechten and Claggett Wilson.

1927. Friday, Paris
Before going to Normandy for Easter weekend, where he plans to play chess in Rouen and visit Lydie Sarazin-Levassor at Etretat, Marcel meets Roché.

1928. Sunday, Paris
After his prolonged stay in Nice [16.1.1928] for chess and a change of scene [6.1.1928], Duchamp returns to his 'eyrie' at 11 Rue Larrey.

1936. Wednesday, Paris
In order to obtain papers from the American consulate for his visit to Connecticut to repair the Large Glass, Dee asks Miss Dreier if she would send him an invitation to stay for over 3 months so that he can apply for a six-month visa. He wonders whether mid-May for his arrival is too early. Will she be back at The Haven then? What will be his address at her studio if he stays for a while in New York?

Dee is delighted at the prospect of his voyage and adds: "So glad to see you again and to leave my political shores!"

1939. Saturday, London
Publication in the *London Bulletin*, No. 13 of the following lines by Duchamp:

Oseur d'Influence aux Heures d'Affluence

and also (in French):

"Determine the difference between the volumes of air displaced by a clean shirt (ironed and folded) and the same shirt when dirty. Coincidental fitting of objects or parts of objects; the hierarchy of this kind of fitting is directly proportional to the 'disparate'."

1941. Tuesday, Grenoble
On his arrival from Paris via Lyons where he met Peggy Guggenheim and Laurence Vail, Marcel telephones Roché at Beauvallon. With great joy, Roché agrees to meet Marcel in Grenoble at the Hôtel Moderne on Friday evening.

1949. Friday, Ojai
Helen Freeman drives Marcel, Lou Arensberg and Bill Mercer from Hollywood to Beatrice Wood's new home, where they are invited to lunch. The house, incorporating a studio for her ceramic work, has been built to her own plans on the edge of the village in a beautiful valley of orange groves. From the barren plot, without a blade of grass, Bea has planted cactus, two eucalyptus trees and a forest of vines and roses. Inspecting the house, the garden and the rock walls, Marcel is enchanted. He is encouraging and tells Bea how wise she was to come to Ojai.

1951. Sunday, New York City
As there has been no news from Roché for several weeks, Marcel wonders whether he is ill or

15.4.1953

perhaps away and requests a few words of reassurance. "Here nothing but the routine of pseudo-modern life – and lots of chess," writes Marcel. "Last night I lost a game and I paid for it in interminable analysis, post-mortem, all day today. Where will I direct my ambition?"

1952. Tuesday, New York City
For the invitation card of Enrico Donati's exhibition at the Alexandre Iolas Gallery, Duchamp has written:

la gaia pittura
introduction au sourire
copulation vs. masturbation

1953. Wednesday, New York City
"DADA 1916–1923," opens at the Sidney Janis Gallery, 15 East 57th Street. It is Duchamp who has nonchalantly masterminded this first show of international Dada in America, suggested the artists, planned the installation, designed the catalogue and supervised the hanging. Structuring the exhibition territorially, the artists are grouped by city: Zurich, Hanover, Cologne, Amsterdam, New York, Paris and Berlin. There are more than 200 works of art and documents, many of them gathered in Europe by Marguerite Hagenbach and Jean Arp for the exhibition. Huelsenbeck and Hans Richter helped prepare and hang the Swiss and German sections.

Separated by the doorway to the exhibition, are two Picabias: *La Femme aux Allumettes* and *Le Beau Charcutier.* Above the door, screwed upside down to the casing and with a sprig of mistletoe dangling provocatively from its belly, is the replica of Mutt's *Fountain* [9.4.1917]. Echoing the doorway from the wall beyond is *Fresh Widow* [20.10.1920] by Rose Sélavy. This miniature French window, *Tu m'* [8.7.1918], and *A regarder d'un Œil, de près, pendant presque une Heure* [4.4.1919] have been lent from the Katherine S. Dreier Estate [29.3.1952].

A tissue-weight broadsheet measuring 2 x 3 feet designed by Duchamp serves as catalogue. The texts by Arp, Tzara, Huelsenbeck and Lévesque are composed in four contrasting typefaces in narrow columns. Each text is then cut into blocks of varying sizes which, starting at the top left-hand corner of the poster, run diagonally across and down it in four cubistic cas-

cades. The catalogue numbers in bold, but with numerical groups out of sequence, are laid at right-angles on the left or on the right in columns of diminishing lengths, to fill the remaining space. A pale transparent orange ink is used to overprint the title and the surrounding frame composed of the letters D and A.

When this poster-like catalogue was delivered to the gallery, Duchamp took one of the sheets in both hands and crumpled it into a ball. "Mail it this way," he advised Janis. His orders were obeyed. At the opening, a wicker laundry basket standing at the entrance is filled with the crumpled catalogues and visitors are invited to help themselves. One of the first guests to arrive is Edgar Varèse, who is delighted when he takes a ball of paper and discovers its purpose.

1954. Thursday, Paris
With Duchamp's permission [20.9.1952] a line drawing of the Large Glass illustrates the cover of *Les Machines Célibataires* by Michel Carrouges, which is published today by Arcanes.

1956. Sunday, New York City
In a quick note to Anthony Hill, who is preparing a book on Cubism with Adrian Heath for Alec Tiranti, Duchamp apologises for his procrastination but is delighted to give him permission to quote from the notices he wrote for the catalogue of the Société Anonyme [30.6.1950].

1958. Tuesday, New York City
After having lunch with Marcel, Teeny takes a bus as far as 53rd Street to go to the library for Marcel and is shocked by "the horrible sight" of the Museum of Modern Art. Earlier that afternoon the second floor caught fire destroying a mural by Monet and a number of smaller canvases.

*

"Someone in Paris [Poupard-Lieussou] is preparing a bibliography of *études* on my very august person," writes Duchamp to Henry McBride, wondering whether the critic can provide him with the reference of an article which appeared in 1915, 16, or 17.
"We saw and loved *Endgame* of Beckett [10.1.1958]," Duchamp adds.

*

In the evening at seven, Duchamp is due to meet Louis Carré.

1959. Wednesday, Cadaqués
When Marcel goes to the post office to collect his mail he learns of the death of Henri Pierre Roché on 9 April.

One of his closest friends, Marcel first met Roché during the First World War in New York [4.12.1916]. Roché was immediately fascinated by Marcel and his work, noting observations in his diaries which became his main source as a writer, not only for *Jules et Jim* [15.5.1953] and *Deux Anglaises et le continent* [5.6.1956], but also for *Victor*, the unfinished manuscript about "Totor" in the early New York days [8.2.1957]. Like Marcel, Roché adored women and they shared many amorous adventures.

Roché was also an enthusiastic collector and enjoyed dealing in art. On account of their great admiration for Brancusi, Roché and Marcel decided to go into partnership to save from auction [13.9.1926] 27 of the Romanian's sculptures belonging to the late John Quinn. Over the next thirty years they carefully placed each piece in selected private collections or museums, thus retaining the precious quality of the work.

As the "sleeping partner", as he called himself, Roché also took a close interest in several of Marcel's own projects. After advancing funds [18.5.1934] for the Green Box and helping him with the *Rotoreliefs* [30.8.1935], Roché also assisted with the *Boîte-en-Valise* [7.1.1941] which to produce required an important initial outlay [17.2.1937]. After the war, Marcel resisted Roché's attempts to persuade him to show his work in Paris [26.4.1952] but, on the other hand, found his friend's essay, *Souvenirs sur Marcel Duchamp,* "perfect" [24.2.1953].

*

Later in the day, in a letter to Lebel, Marcel reflects that Roché, whose essay is republished in *Sur Marcel Duchamp* [6.4.1959], "at least saw a 'de luxe' and I am beginning to reckon the chances I have of seeing the 'ordinary' in the window of the bookshops."

For the forthcoming exhibition at La Hune [7.4.1959], Marcel agrees to sign the posters, but wonders how to do it without losing them in the Spanish post.

As for providing three illustrations to accompany a text which Lebel has been asked to write (neither of them is to know what the other is doing), Marcel accepts in principle and wonders, "will I have the pleasure of pleasing both of us?"

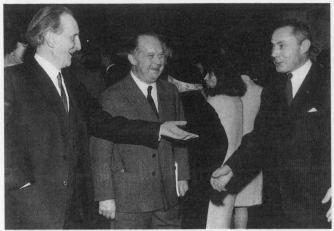
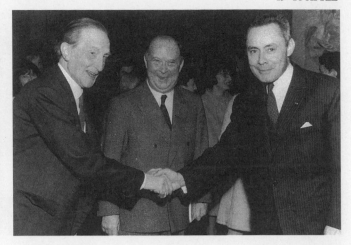

15.4.1967

1967. Saturday, Rouen
At ten o'clock Duchamp is in attendance at "Les Duchamps", an exhibition of the work of the three brothers and their sister, Suzanne, which is installed at the Musée des Beaux-Arts. Among members of the Press is Jean Dalevèze from Paris on a mission for *Les Nouvelles Littéraires* who has arranged to meet Duchamp and discuss the question of a broadcast. At twelve-fifteen Duchamp, accompanied by Teeny and his sisters Yvonne and Magdeleine, is invited to meet the mayor, Bernard Tissot, at the *hôtel de ville* and have lunch afterwards at the Régent at 5 Quai de la Bourse.

The official opening of the exhibition is at three o'clock in the imposing entrance hall of the museum. At the foot of the columns before the grand staircase, M. Quoniam, Inspector General of the Musées de France, makes the first speech, the second is by Dr Rambert, councillor with responsibility for the city's cultural affairs, the third by Mlle Popovitch, and it falls to M. Bernard Dorival, curator of the Musée National d'Art Moderne, Paris, to deliver the final address. The mayor of Rouen and the *préfet*, M. Chaussade, are among the guests.

16 April

1910. Saturday, Paris
In the afternoon, Duchamp accompanies Jeanne Serre to the Salon de la Société Nationale des Beaux-Arts, which has just opened at the Grand Palais. As he has arranged to meet Max Bergmann at two o'clock to visit the exhibition, Duchamp introduces him to Jeanne. Bergmann finds Duchamp's "new conquest" a very interesting young lady. Jeanne, who is twenty, adores the artistic world, not as a painter but as a model. She is small, high-waisted, her long back carried erect, elegantly, as if to compensate for the fact that she walks with a slight limp. Her face with its strong, square jawline is framed by long, dark hair which is plaited and coiled in place over each ear. Her liaison with Duchamp draws her from the orbit of Forain and traditional portraitists to the group at Puteaux, whose revolutionary spirit is in tune with her own irreverent and combative temperament.

Before their marriage, Jeanne and Marcel Serre were both living in Pontoise with their parents. Jeanne's mother, Mme Chastagnier, was against her daughter marrying Serre, a young insurance

broker for the company Le Soleil, who is unable to work on a regular basis because he suffers from glandular tuberculosis. Soon after their marriage in June 1908, Jeanne learned that Serre had a mistress. Her illusions shattered, Jeanne resolved to live her own life. Recently the Serres moved from Pontoise to 132 Rue Perronet, just opposite 9 Rue Amiral-de-Joinville, Duchamp's home [1.10.1908].

After a tour of the Salon, where the Blanches, Boutet de Monvels, Carolus-Durans, and La Gandaras reign supreme, Duchamp and Bergmann take Jeanne home. But as it is the last day of the Othon Friesz exhibition at the Galerie E. Druet, 20 Rue Royale, the two men return to Paris to visit the show: it has been well reviewed by Apollinaire and includes some studies of snow and skaters painted in Munich.

1917. Monday, New York City
In the evening Marcel takes Mina Loy with him to visit Roché who is preoccupied by the mixed reception of the *Blind Man* [7.4.1917], which he published for the Independent Artists' Exhibition [9.4.1917]. The Arensbergs have voiced their disappointment with it and few copies were sold.

1926. Friday, Paris
Duchamp accompanies Miss Dreier to see Roché at his apartment 99 Boulevard Arago. While declining to take works by either Laurens or Prunas, she chooses some watercolours by the Bulgarian artist Georges Papazoff for the Société Anonyme exhibition.

In the evening while Duchamp and Miss Dreier are discussing the exhibition, it is decided that Miss Dreier should write to ask John Storrs [30.12.1920], whom she met the previous day, to send his "very best things" including both of the new brass sculptures.

1937. Friday, Paris
"Well well – of course I will be at the Gare de l'Est Wednesday morning at 10:10," writes Dee in reply to Miss Dreier and he promises to reserve her a room at the Hôtel Voltaire.

A few copies of her lithograph [2.4.1937] have been printed in black which he is taking to the colourist so that a trial stencil can be made from one of the watercolours. He hopes to be able to show her the result on Wednesday.

*

The youngest competitors of the tournament, Reuben Fine and Paul Keres, are the laureates of the competition which has just finished at Margate, Duchamp announces in *Ce Soir*. As well as presenting the chess problem by J. Telkes, Duchamp comments on the game played by Keres and Alexander at Margate. He informs his readers that both Fine and Keres are competitors in the tournament just starting in Ostend, and reviews the French edition of Dr Alekhine's book, *Deux cents parties d'échecs*, which has just been published by the Fédération Française des Echecs.

1958. Wednesday, New York City
"Received your letter this morning," writes Marcel to his sister Suzanne. "Enchanted with the idea of spending 10 or 15 days at Ste Maxime with you."

Planning to arrive in Paris on 30 May, Marcel explains that they won't be able to arrive in Sainte-Maxime before 15 July because from Paris on 1 July they plan to hire a car and visit Lascaux in the Dordogne, Massiac [21.12.1908], and Fleury in the Beaujolais, where Teeny's half-sister and her family live.

"We would also like to spend a day or two in Sanary," adds Marcel. They will fly from Nice to Barcelona and spend August in Cadaqués before returning to New York mid-September. While in Paris they have been invited to stay in the little house belonging to Max Ernst.

*

In the evening Marcel and Teeny go to play chess at their club.

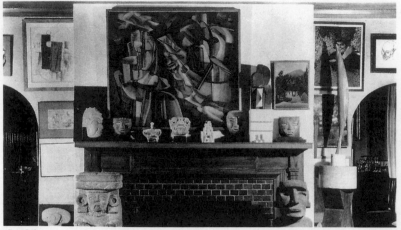

17.4.1949

1962. Monday, New York City
In the morning post there is a note from the Télévision Française to say that Jean-Marie Drot's film, *Journal de Voyage à New York*, in which Duchamp appears [6.12.1961], is now scheduled to be broadcast on 19 April.

Teeny sends the news to Jackie and mentions two plays by Eugène Ionesco: "If *Chemises de nuit* is amusing maybe Marcel and I can see it when we are in Paris, we also want to see *Amédée où comment s'en débarrasser* we've always missed it everywhere..."

1965. Friday, New York City
Bill Lieberman, who, like Duchamp, is an advisor to the Cassandra Foundation, has slides of work by Shinohara, an artist he met recently in Japan, which he shows to Duchamp at the Museum of Modern Art. Lieberman would like the artist to be recommended for an award.

*

In the evening while busy packing, Marcel writes to Noma and Bill Copley regarding the Cassandra Foundation and supporting Lieberman's proposal. He also encloses a letter he has received from a New York artist, Allan Hugh Clarke, whom he met recently at Cordier & Ekstrom. Duchamp doesn't have time to see his work but would they care to do so?

1968. Tuesday, Monte Carlo
The drawing which Marcel wants to give to Jasper Johns, who made the décor inspired by the Large Glass for the ballet *Walkabout Time* [10.3.1968], happens to be in New York. He asks Arne Ekstrom to tell Johns that he will have to wait until October for it. As an afterthought he mentions that Teeny lost the $10 Ekstrom gave her to gamble with on 14 17.

17 April

1917. Tuesday, New York City
In the evening Marcel sees Roché and Albert Gleizes.

1927. Easter Day, Rouen
At the Cercle Rouennais des Echecs, chess players from the Nord and Pas-de-Calais play a team from the Seine-Inférieure, which also includes members from the Echiquier Elbeuvien and the Echiquier Havrais. As a member of the Cercle Rouennais, Duchamp plays Joseph Bertrand (pseudonym of André Muffang) from Valenciennes. Although Duchamp resigns his game against the French Master, the Seine-Inférieure is victorious with six and a half points, as opposed to four and a half for the team from the Nord and Pas-de-Calais.

1928. Tuesday, Claremont
As a personal favour to the professor of Art History, Joseph Pijoan, the Arensbergs agree to lend *Nu descendant un Escalier*, No.2 [18.3.1912] just for the day, from ten until four, to Pomona College.

1931. Friday, Paris
After spending "a nice morning" together doing some banking, Roché and Marcel have lunch together at Laborde's, which reminds them of Manguin's in New York [5.2.1917].

1949. Sunday, Hollywood
After his working stint in San Francisco, Marcel is staying for twelve days with the Arensbergs [12.4.1949]. His visit coincides with that of Katharine Kuh, who is preparing a final list for the exhibition of the Arensberg Collection, excluding the pre-Columbian sculpture, which is planned to open in mid-October at the Art Institute of Chicago. Duchamp has promised to help her this afternoon with dates – particularly the Brancusis.

Apart from the beautiful group of Brancusi sculpture, there are more than thirty key works by Duchamp belonging to the Arensbergs in their extraordinarily fine collection of Modern Art, which numbers more than 200 items. Marcel is well aware of the indecision concerning the future of the collection which, like a beautiful princess, has many suitors. The Arensbergs have no children, and they are both now over seventy.

Walter's office, where his secretaries are engaged on the Francis Bacon research, is on the first floor. Walter is excited, depressed, frequently changes his mind and races up and down the stairs. Louise, who is shy and nervous, often argues with Walter. Tension reigns in the household but both the Arensbergs are extremely kind. Mrs Kuh is struck by Duchamp's cool composure and how remote he is with his hosts as he is with everyone else.

One lunch time, when Margaret the maid has provided a particularly spartan menu of cheese, dates and nuts, Walter and Marcel discuss the accidental in art, a phenomenon which Marcel considers basic and which he raised at the "Western Round Table on Modern Art" [8.4.1949]. Walter is not entirely convinced by Marcel's argument, believing the accidental only appears accidental and that it is in fact predetermined, even if unconsciously. Using his *3 Stoppages Etalon* [19.5.1914] as an example, Marcel asks whether this demonstration of allowing threads to fall horizontally and then using the result as an anti-artistic arrangement doesn't prove his point. The way the threads fell, Walter admits, was accidental, but the impulse to create the accident was not chance. The discussion goes on and on, both men taking pleasure in exploring every aspect of the question. Mrs Kuh notices that, daily, Walter becomes positively regenerated by Marcel's presence.

An outing to see the Frank Lloyd Wright buildings in Los Angeles may also have been provoked by Marcel's account of the conference which the architect attended. Considering Wright an impostor, Walter's driving becomes progressively worse and increasingly erratic as his fury mounts. Although Mrs Kuh fears for their safety, Marcel remains attentive, responsive and totally unperturbed throughout.

From time to time during his stay, Marcel slips discreetly out of the house to see Man Ray, who lives at 1245 Vine Street nearby, but who is currently out of favour at Hillside Avenue.

1950. Monday, New York City
Walter Arensberg and his wife have already told Marcel that they are unhappy about the

17.4.1958

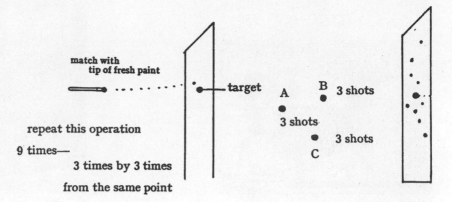

match with
tip of fresh paint

→ target

A · · B 3 shots

3 shots

· 3 shots

C

repeat this operation

9 times—

3 times by 3 times

from the same point

Metropolitan Museum's proposal which, they consider does not offer enough space, nor is five years sufficient to prove the worth of keeping the collection together. A firmer telegram from Walter today states that he considers the offered conditions are so remote from what they expected as to leave no room for further discussion, and they therefore withdraw.

The same day Francis Taylor of the Metropolitan sends a telegram in response to Arensberg suggesting that Duchamp fly to California on Wednesday as planned because the museum believes that "areas of disagreement are capable of being resolved by direct negotiation..."

1957. Wednesday, Ixtapan de la Sal
Reporting to Suzanne and Jean Crotti that the Convention in Houston was "worth its weight in gold", Marcel writes: "I gave my little speech of 8 minutes, we debated in front of more than 500 ladies and gentlemen, three days of this kind of circus, all in cordiality."

*

In Paris, approximately two minutes of the interview Duchamp recorded previously with Pierre Crenesse in New York are broadcast by France 3 in André Parinaud's half-hour programme, "Revue des Arts," which today is devoted to *L'Aventure Dada*, Georges Hugnet's recently published book [9.3.1957].

Instead of defining Dada, Duchamp declares that it was due to his pictures such as *Nu descendant un Escalier*, No.2 [18.3.1912], *Le Roi et la Reine traversés par des Nus vites* [1.4.1916], and preparatory work for *La Mariée mise à nu par ses Célibataires, même* [5.2.1923], that he entered the Dada circle...

1958. Thursday, New York City
Still shocked by the catastrophe, at one-thirty in the morning on their way home from the chess club, Marcel and Teeny stop to look at the Museum of Modern Art which was damaged by fire on Tuesday.

*

Stauffer's typographic transposition of a text from the Green Box [16.10.1934] meets with Duchamp's approval, but he suggests that Stauffer try adding blue where blue crayon was used.

In reply to Stauffer's question as to whether there is a topographical relationship in the composition of the Large Glass between the axes of the Malic Moulds and the 9 Shots, Duchamp says no. The position of the Malic

Moulds depended on the limitations of the defined surface (the crown of each Malic Mould already connected to the *Réseaux des Stoppages* [19.5.1914]), and also on the careful placing of them in perspective preventing one form from hiding another. The position of the 9 Shots was a question of dexterity – with a toy canon and matches dipped in fresh paint, the person shooting, whatever his ability, could never hit the bull's-eye.

The exact time of his birth? Duchamp replies: "As far as I remember the maternal declarations, I was born at 1h in the morning, 28 July 1887." [In fact he was born at two o'clock in the afternoon.]

The exhibition "50 Ans d'Art Moderne", which has been organized for "Expo 58", opens at the Palais International des Beaux-Arts in Brussels. Three paintings by Duchamp have been lent to the show: *Le Passage de la Vierge à la Mariée* [7.8.1912]; *Broyeuse de Chocolat*, No.2 [8.3.1915] and *Réseaux des Stoppages* [19.5.1914].

58

**50 ANS
D'ART MODERNE**

1961. Monday, New York City
In reply to Henri Marceau who has asked if it would amuse him to visit the Philadelphia Museum of Art when the Arensberg–Gallatin pictures are returned from the Guggenheim [6.2.1961] and give him the benefit of his advice about any changes in the hanging, Duchamp writes: "I am very flattered and accept with pleasure," and proposes sometime during the week commencing 1 May.

1963. Wednesday, New York City
Following the version of the *Rotoreliefs* [30.8.1935] mounted by Jean Tinguely for Daniel Spoerri's Edition MAT [27.11.1959], Peter Matisse is working on backgrounds for a set with a motor to be sent to Arturo Schwarz in Milan [10.3.1963] and he comes to supper at 28 West 10th Street for the second evening

in succession. "Marcel is a prestidigitator," observes Teeny, "in manoeuvring Peter to get 5 backgrounds finished..."

1965. Saturday, New York City
Marcel tells Richard Hamilton, who is starting to assemble a major Duchamp exhibition for the Tate Gallery, that Arne Ekstrom will be answering the main points in his letter. However, in Philadelphia recently, Marcel saw Dr Evan Turner who has not yet heard from the Tate.

18 April

1910. Monday, Neuilly-sur-Seine
Max Bergmann, whose throat is still sore but better, decides it is too fine a day to work. Instead he takes the tram after lunch to visit Duchamp. As a token of his friendship, Duchamp gives Bergmann his *bilboquet*. On the heavy ball which is pierced with a thumb-sized hole and attached by string to the decoratively turned wooden handle fashioned with a spike to impale the ball, Duchamp carves the following dedication:

Bilboquet
Souvenir de Paris
A mon ami M. Bergmann
Duchamp printemps 1910.

In the evening they have supper together in Neuilly and then take the tram to the Porte Maillot where they sit and draw in a café until about eleven o'clock.

1917. Wednesday, New York City
After tea at the Arensbergs', Louise Arensberg, Marcel, Roché, Joseph Stella and Beatrice

18.4.1929

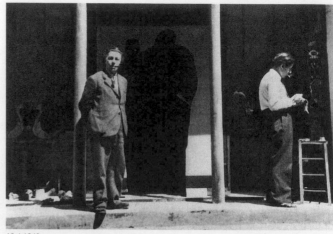

18.4.1940

Wood go to Barnum's circus. They then call on Alfredo Sidès at 12 West 44th Street and take him to meet the Picabias [4.4.1917].

Later Marcel takes Roché for the first time to 110 West 88th Street and they spend a "beautiful night" making love with Louise Norton.

1918. Thursday, New York City
Marcel is slowly getting dressed for dinner when Roché calls for him at 33 West 67th Street. On arrival at the Stettheimers' they find that the sculptor Jo Davidson and his wife are also guests of the three sisters.

1922. Tuesday, New York City
Duchamp meets Paul Gross and promises that on Sunday he and Joseph Stella will help him hang the Société Anonyme exhibition at the MacDowell Club.

1928. Wednesday, Paris
"You don't seem to have ever grasped my relationship with Stieglitz," Dee tells Miss Dreier. "I arranged with Stieglitz to have that show of Picabia because he used to like Picabia, and I thought it was the only way to show these things in N.Y. – I don't really expect any financial returns from it."
As for Herwarth Walden, Dee believes Miss Dreier owes the Berlin dealer nothing and his talk is "pure bluff". Although the sale was made in New York, his sister-in-law Yvonne should pay Walden commission on Miss Dreier's purchase at the Brooklyn exhibition [19.11.1926] of the Duchamp-Villon, *Femme assise*. "It had been impossible for ten years to get it back from Berlin to Paris," Dee argues. "It was only a happy accident that you should be in Berlin, and had the kindness to ship [it] to N.Y."
Villon is overwhelmed at the news that 15 of his paintings were sold on the first day of his exhibition at the Brummer Gallery. Other news: the Dreier–Eilshemius shipment has arrived [12.3.1928] but is still in customs; and Brancusi is building a new studio, not far from the old one [25.8.1927] at 11 Impasse Ronsin, which will be ready in a couple of months. Dee concludes by thanking Miss Dreier for the $250 which have arrived at his bank.

1929. Thursday, Paris
At the Bœuf à la Mode [26.11.1919] everyone signs the card, a picture pun on the name of the establishment, as a souvenir of their reunion:

"For Miss Dreier with kind regards from Jacques Villon, Magdeleine [Duchamp], H. P. Roché, Suzanne Duchamp, Jean Crotti, M. Duchamp and very great affection."

LE BŒUF A LA MODE

RESTAURANT Fondé en 1792

8, RUE DE VALOIS, PARIS

1931. Saturday, Paris
In the evening after dinner, Marcel visits Helen Hessel and Roché at Rue Ernest-Cresson. The chess game that he plays with Kadi [4.4.1931], Roché finds "enthralling": the boy has a perfect memory, is consistent, has imagination and is obviously very talented. Afterwards Helen, advised by Marcel, plays against Roché, who knows he will lose, but they enjoy themselves enormously.

1940. Thursday, Paris
Duchamp sends André Breton some reproductions and his proposal for the cover of *Anthologie de l'Humour noir*, due to be published by Sagittaire. Does Breton have any objection to him installing the door of *Gradiva* in the museum which Peggy Guggenheim [22.1.1940] is organizing? Duchamp refers to the glass entrance he designed for the short-lived gallery which opened at 31 Rue de Seine in May 1937. To cross the threshold, the visitor stepped through a large glass panel from which the merged silhouette of a man and a woman arm in arm had been cut out. The heroine of Wilhelm Jensen's book, the Roman virgin Gradiva, whose motionless pose of stepping forward bewitched the young Norbert, personifies for Breton "the beauty of tomorrow, still masked to the greatest number…"
The location of the museum has not yet been found, but Duchamp has already spoken to Louis Bomsel, the *notaire* who financed the gallery. With three potential owners of the door, Duchamp remarks to Breton that it is not easy to know to whom it belongs, making it as curious as his own at Rue Larrey [9.10.1937] which is open and shut at the same time.

1941. Friday, Grenoble
As arranged by telephone on Tuesday, Roché makes the long expedition from Beauvallon

via Montélimar and Valence and arrives by train in Grenoble at four-thirty in the afternoon feeling nervous and tired. After putting Denise and Jean-Claude on the tram for Les Muriers, he is liberated. At seven Roché is reunited with Marcel at the Hôtel Moderne. They have dinner together and a great talk.

1954. Sunday, Cincinnati
While the Duchamps are staying in the country near the city with Olga Carter – a great friend of Teeny's – and her husband Nick, who is a surgeon, Marcel has a sudden attack of appendicitis. The emergency operation is supervised by Nick Carter.

1956. Wednesday, New York City
Marcel advises Roché to accept $7,000 for Brancusi's *La Colonne sans fin* which stood for so long in the garden at The Haven [8.8.1939] because since he saw it, it has split badly and the "restorers" have painted it black! "Please," implores Marcel, "don't breathe a word to the Queen Mother of the Impasse Ronsin."

There is concern for the safety of the glass, *9 Moules Mâlic* [19.1.1915], which Marcel wants to include in the "Three Brothers" exhibition [28.12.1955]. Rather than the glass travelling twice across the Atlantic, would Roché consider selling it in America?

As he has agreed to Georges Mathieu's request to analyse his chess book *L'Opposition et les Cases conjuguées sont réconciliées*, [15.9.1932] for a magazine, Marcel asks Roché if he will lend Mathieu the book with *carte blanche*.

1957. Thursday, Ixtapan de la Sal
The holiday in Mexico with the Tamayos [6.4.1957] has given Marcel the opportunity to see Bill and Noma Copley frequently and discuss the problems of Lebel's book. After reassurances, Bill has decided to participate financially to the order of $6,000, but Marcel has advised him to insert a deadline in the contract with Fawcus: 31 December 1957.

*

"After 3 days of Convention in Houston," Marcel tells Roché, "we have arrived in the Mexican phantasmagoria which, in fact, has given us colic (something quite normal; in Spanish it is known as *'la tourista'*)."

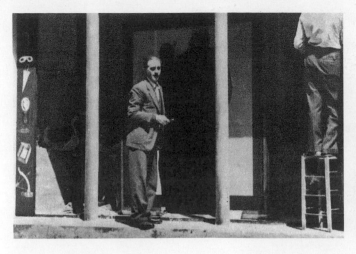

19.4.1901

At this attractive spa where they are staying a week, Teeny is taking baths for her sciatica. Next week Mimi Fogt will accompany them for two days to Oaxaca, an old colonial town with a colourful market and the birthplace of Rufino Tamayo. After returning to Mexico City for a few days, the Duchamps then plan to visit the Yucatán before flying from Mérida to New York via New Orleans.

1958. Friday, New York City
Lily and Marcel Jean return to 327 East 58th Street [12.4.1958] for about a week before going to stay with Kay Boyle.

1963. Thursday, New York City
With Teeny and a group from Philadelphia, Duchamp makes a tour of the "50th Anniversary of the Armory Show" [5.4.1963].

19 April

1901. Friday, Blainville-Crevon
Behind the Duchamps' house to the west the ground slopes away and a stony path meanders down the length of the garden, which is bordered on the south by a long, steep bank of trees and on the north by the River Crevon. On the trunk of one of the beeches planted at the top of the bank some distance from the house, Marcel meticulously carves his name and the date.

1917. Thursday, New York City
With the intention of enlivening the programme of events organized by the Society of Independent Artists during its first exhibition [9.4.1917], Francis Picabia and Duchamp have invited Arthur Cravan, an improbable Englishman proud of his uncle Oscar Wilde, to give a

lecture on "The Independent Artists in France and America". The name of this astonishing personality, announced to the unsuspecting American public as director of the Parisian revue *Maintenant*, poet, French amateur boxing champion and art critic, is already causing a stir in the city. He is an awesome but gentle giant over six feet tall, with a powerful, well-proportioned body and handsome head. Francis and Marcel, remembering Cravan's scurrilous review of the French Independents show in 1914 (pronouncing Metzinger a failure, Gleizes without talent, Suzanne Valadon an old bitch, and declaring that Marie Laurencin needed a good spanking, etc. etc.), are counting on him not to pull his punches in New York.

At three o'clock in stifling heat on the mezzanine floor of the Grand Central Palace, half Greenwich Village awaits the event. Cravan is late. When eventually he arrives with his seconds, he staggers through the very smart crowd to the podium where he sways vertiginously, silently. The expectant intelligentsia holds its breath while Cravan stares happily. He lists dangerously, then suddenly strikes the lectern with such tremendous force the sound of the blow resounds in Lexington Avenue. The smile returns to Cravan's lips and, oblivious to the peril of the Sterner painting hanging behind him,

starts gesticulating wildly. He decides to remove his jacket. The puzzled audience remains indulgent at the prospect of the orator's first utterance. Cravan however is concentrating on unbuttoning his waistcoat. When he is free of his waistcoat he detaches his collar and then he ties a handkerchief round his neck. Without uttering a sound his next gesture is to slip the silk braces from his shoulders. Interrupting the adjustments to his appearance, Cravan concentrates his gaze to the wall across the room. By now the *Who's Who*-er than ever crowd is murmuring uneasily but everyone turns inquisitively to find out what has attracted his attention. It is a painting in the exhibition representing a very beautiful, almost naked woman. Still mesmerized by the picture, Cravan leans forward across the lectern and with the loudest cry he can muster hurls one of the most insulting obscenities in the English language at the audience. To prevent the situation from deteriorating any further, almost instantaneously a few exhibition guards – no doubt under instructions from the organizers – encircle Cravan from behind and handcuff him, but not without some difficulty and damage to their uniforms. In the uproar, Cravan is hustled out by the entrance on 46th Street and driven away in a waiting car.

At the Arensbergs later in the evening, Marcel beams with pleasure and exclaims: "What a wonderful lecture!"

*

Alfred Stieglitz writes inviting Henry McBride to call at 291: "I have, at the request of Roché, Covert [5.12.1916], Miss Wood, Duchamp and Co., photographed the rejected *Fountain* [9.4.1917]... It will amuse you to see it. The *Fountain* is there too."

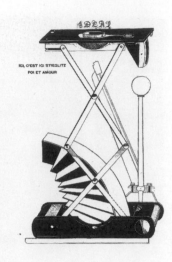

19.4.1917

1939. Wednesday, Paris
Publication day of *Rrose Sélavy*, an anthology of "poils et coups de pied en tous genres". This opuscule, printed in an edition of 515, appears in the collection "Biens Nouveaux" edited by Henri Parisot [13.1.1939] and published by GLM, a one-man enterprise founded by the poet Guy Lévis Mano, 6 Rue Huyghens.

"BIENS NOUVEAUX"

MARCEL DUCHAMP

*Rrose
Sélavy*

G.L.M 1939

1941. Saturday, Grenoble
As the *Boîte-en-Valise* [7.1.1941] for Peggy Guggenheim, which he sent from Paris several weeks ago, has not yet arrived in Grenoble [23.2.1941], Marcel cannot show it to Roché. Instead he draws him a diagram showing its construction and how the box opens out to display the different items in miniature of his work and the folders of reproductions.

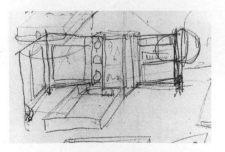

After lunching together at Le Bœuf à la Mode, Marcel and Roché send some cables and do some shopping together. Marcel introduces Roché to his chess partner in one of the cafés in the town.
In the evening René Lefebvre-Foinet and his

girl friend join Marcel and Roché for dinner at the Rex Bar.

*

Giving as his place of domicile "Grenoble Hôtel Moderne", Duchamp makes a formal application to the Ministère de la Défense Nationale for an exit visa to the United States via the Antilles. The motive for his visit to Mr Arensberg in Hollywood is the "organization of a room of French Art in a Los Angeles museum" [19.11.1940]. He deposits his application at the Commissariat Central with a money order amounting to 43.40 francs.

1945. Thursday, New York City
To promote André Breton's book, *Arcane 17*, Breton and Duchamp have made another window display for Brentano's [3.2.1943], but it is dismantled after attracting bewildered crowds and fierce objections from the League of Women and the Society for the Suppression of Vice.

Today Breton and Duchamp take the offending material from Brentano's bookshop on Fifth Avenue and reinstall it in the window of the Gotham Book Mart. Matta [3.4.1945], who illustrated the de luxe edition of the book with four *lames de tarot*, has provided a large drawing depicting a bare breast. Duchamp's headless mannequin, cradling two open, down-turned volumes of the book in her arms, stands naked but for a dainty maid's apron tied to her waist and, as Bacchus sprang from Zeus, a stout bath tap emerges from her thigh. As Rrose Sélavy so aptly says:

Parmi nos articles de quincaillerie paresseuse, nous recommandons un robinet qui s'arrête de couler quand on ne l'écoute pas.
[Among our articles of lazy hardware we recommend a faucet which stops dripping when nobody is listening to it].

In front of the mannequin, surrounded with a framed photograph of Breton and copies of the book which are open displaying Matta's illustrations, is an inkwell by Isabelle Waldberg in the form of a starfish evoking the seventeenth tarot "The Star", emblem of hope and resurrection, the theme of *Arcane 17*.

1951. Thursday, New York City
Walter Arensberg has told Marcel that "the request for the loan of the Kupka puts us on a spot" [8.4.1951].
Since the donation of their collection to Philadelphia [27.12.1950] they have decided not to lend and they cannot make an exception for Louis Carré.

After his visit to Milford with Kimball [13.4.1951] Marcel tells Walter that he is resigned to the fact that the Philadelphia Museum of Art does not want the whole of Miss Dreier's collection.
He suspects that Kimball and the trustees like very little including the Large Glass [5.2.1923]. "I have a hunch," he confides to Walter, "that broken glass is hard to swallow for a 'museum'."

Concerning the bundle of articles by Nicolas Calas including "Hieronymus Bosch's Garden of Delights" (*Life*, 14 November 1949), which Walter has returned to him, Marcel remarks: "If his imagination has a fascinating facet, he might introduce too much 'selfishness' in an interpretation of texts and his congenital limitations with the English language can't be tolerated in your research."

1952. Saturday, New York City
Commenting on her verses written on the recent death of her sister Kate, Duchamp tells Mary Dreier: "I was very touched. They show with such a deep feeling the image of Kate's deliverance after her Calvary of unbearable suffering [29.3.1952]. Our mourning should not be too selfish," he continues kindly. "We would wish her to be with us still, but is that not asking too great a sacrifice? She tried hard enough to stay longer, when I would have given up long before."
Mary needs to recover from the sad months she has been through and Duchamp encourages her to "take full cups of the Florida sun every day…"

19.4.1945

1957. Friday, Ixtapan de la Sal
On a card illustrated with the floating gardens of Xochimilco near Mexico City, Duchamp writes to Friedl and Hans Richter: "The Conventional 3 days in Houston [2.4.1957] were great fun, and Bernard Reiss spoke to encourage the little collector as against the big prices."

1962. Saturday, Paris
The first part of Jean-Marie Drot's film *Journal de Voyage à New York*, sub-titled "New York de jour, êtres de jour" and including sequences with Duchamp [6.12.1961], is broadcast by French television at nine-thirty in the evening.

1966. Tuesday, New York City
In the morning Marcel and Teeny fly to Paris and then go to their studio at 5 Rue Parmentier, Neuilly.

1968. Friday, Monte Carlo
The Grand Prix International d'Echecs [2.4.1968] terminated, the Duchamps return to Neuilly. Among the friends also attending during the fortnight was Brian Reilly, director of the *British Chess Magazine*, whom Marcel first met when they both played for Nice [23.3.1924].

20 April

1912. Saturday, Barcelona
Although the Spanish public has the privilege of being the first to see *Nu descendant un Escalier*, No.2 [18.3.1912], the painting passes apparently without comment. Having withdrawn it from the Salon des Artistes Indépendants, Duchamp has sent it together with *Sonate* [20.11.1911] to the "Exposición de Arte Cubista" opening today at the Galerie Josep Dalmau.

In his preface to the catalogue, Jacques Nayral writes that it is the mathematical which seems to dominate Duchamp's mind and that some of his pictures are "pure diagrams" motivated by the desire to prove and to synthesize. He considers Duchamp "conspicuous by his extreme and speculative audacity" and that the *Nu descendant un Escalier* is an example of his endeavours to explore a "double dynamism,

subjective and objective". But these abstract qualities are subdued in *Sonate* which, he writes, is of quite "Verlainian refinement".

1917. Friday, New York City
Prior to the fancy dress ball organized by the Society of Independent Artists at the Grand Central Palace in aid of the American Red Cross, the Arensbergs give a dinner party at their apartment, 33 West 67th Street. Among the guests are Marcel, who has invited Mina Loy to accompany him, Beatrice Wood, Henri Pierre Roché, Aileen Dresser, Clara Tice, and Arthur Cravan who, after numerous imploring telephone calls to him, arrives alone. The reckless lecturer of the day before does not disappoint his friends with his choice of disguise. Wearing his habitual heavy shoes, he is draped in a white sheet pulled from his bed at the last moment, with a white towel fixed turban-fashion on his head.

In the midst of some two hundred revellers prepared to dance throughout the night, the Arensberg party sits rather bored round a table. Marcel has abandoned his partner and is flirting with another girl under Mina's nose. Cravan, who has not yet exchanged a word with Mina, takes the chair next to her and, already naked to the waist, puts his huge arm round her bare shoulders. His expression is one of gloom and disgust as if the events of the last couple of days have confirmed his preference for the boxing society to that of the art world.

1924. Easter Day, Monaco
After chess in Nice [23.3.1924] and days at the casino of Monte Carlo concentrating on perfecting his system, Marcel leaves the principality to return to Paris.

It is Rrose Sélavy who has described to Francis Picabia these experiments with very little capital: "I have been winning regularly every day – small sums – in 1 hour or 2... It's a delightful monotony. Not the slightest emotion. The problem is, in fact," explained Rrose, "to find the red and black figure to counteract the roulette. The martingale has no importance. They are all good and all bad. But with the right pattern – even a bad martingale could be valid – and I believe I have found a good pattern. You see," she declared, "I have not ceased to be a painter, I am drawing now with chance."

1941. Sunday, Grenoble
After an early lunch, Marcel and Roché walk up to Les Muriers to see Denise and Jean-Claude. They have tea together and then the two men go back to Grenoble. Returning to the Rex Bar with René Lefebvre and his girlfriend, Marcel and Roché are also joined for dinner by Nelly, the widow of Theo van Doesburg.

1947. Sunday, New York City
Miró, who is in New York for his exhibitions at the Museum of Modern Art and the Pierre Matisse Gallery, is celebrating his fifty-fourth birthday. Duchamp gives him a tie as a birthday present.

1952. Sunday, New York City
As he plans to spend the night at New Haven on Friday before going to Milford the following day with Fritz Glarner, Marcel writes suggesting to George Heard Hamilton that they have dinner together on Friday.

1959. Monday, Cadaqués
Complimenting Richard Hamilton for the proofs of the first pages of his typographic version of the Green Box [16.10.1934], Duchamp explains that, as he has not brought a copy of the Green Box with him, he will have one sent to him from Paris so that he can "follow more closely the progress of the printing".

1963. Saturday, New York City
In a letter to Hubachek, whose secretary has seen him on television, Marcel says: "This Armory Show is making me into a real clown."

1965. Tuesday, Paris
While still in the air on an Air France flight from New York, about an hour before landing, Teeny writes a note on the menu card to Jackie in Cadaqués saying that they had a "good departure – no last-minute rush". Marcel adds: "*Bonjour, bonjour* until Sunday from above England, Marcel."

When they arrive at Orly, Bernard Monnier is waiting to take them to 5 Rue Parmentier, Neuilly.

1966. Wednesday, Paris
The film by Luc Ferrari and S.G. Patris, *Les grands répétition. Hommage à Varèse* for which Duchamp was interviewed [by telephone?] in New York, is broadcast on French television.

21.4.1911

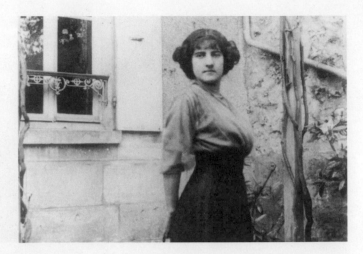

Suddenly finding himself speaking to Pierre Schaeffer [2.12.1954], whom he visited some years ago, Duchamp said he remembered their discussions very well: "You know, painters don't listen to much music and musicians don't look at many pictures. But still there was a tacit understanding [with Varèse], if I may say so."

1967. Thursday, Paris
After Jean Dalevèze's visit to Rouen on Saturday, his article about the Duchamp family and the exhibition is published in *Les Nouvelles Littéraires*.

21 April

1911. Friday, Paris
Installed in temporary sheds erected on the Quai d'Orsay, the Société des Artistes Indépendants opens its 27th exhibition, which includes an important retrospective of the Douanier Rousseau, who died the previous summer. Nearby hangs the work of the younger generation: in addition to paintings by Gleizes and Metzinger, Robert Delaunay exhibits his vertiginous *Tour Eiffel* and Léger's canvas, *Nu dans un Paysage*, is filled with cylindrical forms which Apollinaire sees as a heap of car tyres.

Duchamp shows three paintings, two of which are landscapes entitled *Falaise* and *Paysage*. The title of the third canvas, which he says he "added and treated like an invisible colour", is *Le Buisson*. Duchamp stresses that he "did not, in the painting illustrate a definite theme, but the disposition of the three elements evoked... the possibility to invent a theme for it afterwards."
 The relation between the brilliant blue vaporous form of the hieratic bush and the two contrasting-coloured female nudes, one standing the other kneeling, according to Duchamp satisfied his "desire to introduce some anecdote without being anecdotal": he was "looking for some *raison d'être* in a painting otherwise than the visual experience".
 The model for the kneeling figure was Jeanne Serre [16.4.1910].

1917. Saturday, New York City
After an evening at the Brevoort, Marcel and

Roché return to spend a night with Louise Norton, taking Aileen Dresser with them.

1924. Easter Monday, Paris
At noon, Marcel is due back from Monte Carlo.

1936. Tuesday, Paris
"I am awfully happy that you can have me at The Haven and I certainly will enjoy the Thermos bottle and the sun in the window," writes Dee to Miss Dreier. "It will be splendid," he says, thinking of the work ahead [15.4.1936], "to have the glass right there and your carpenter to help me from time to time."

Favouring the *Normandie*, which sails on 20 May, Dee confirms that he has arranged for Lefebvre-Foinet to roll the paintings by Paul Gaulois [4.5.1929] so that he can bring them with him as Miss Dreier has requested. He needs to know about the times of the trains, whether he should spend a night in New York before travelling to West Redding and the telephone number of The Haven so that he can call her when he disembarks on 25 May. As Miss Dreier has proposed to lend him her studio at Carnegie Hall in New York, permitting him to come and go as he pleases, Dee asks her for the address so that he can have his mail sent there.

1937. Wednesday, Paris
In the morning Dee is due to meet Miss Dreier, who is travelling on an overnight train from Germany arriving at the Gare de l'Est at ten minutes past ten.

1941. Monday, Grenoble
Following Duchamp's application for a visa on Saturday, the central inspector of police makes an enquiry and gives a favourable recommendation. The dossier has then to be forwarded to the *préfet* of the Isère.

*

In the morning, Marcel and Roché go to the Prefecture and do some shopping. They return to the Hôtel Moderne and, although he hasn't seen it yet, Roché decides to order a "de luxe" copy of the *Boîte-en-Valise* [7.1.1941]. He is fascinated by what he refers to as "the chess player's organization" displayed by Marcel. Nelly van Doesburg joins them for lunch at the hotel and then Roché goes to the station with Marcel who is returning to Marseilles.

1946. Easter Day, Milford
Dee arrives from New York in time for dinner with Miss Dreier who moved into Laurel Manor only a week ago [26.1.1946]. As they are going to New Haven the following day, Miss Dreier has arranged for Dee to stay overnight with her neighbour across the street, Mrs Weston.

1947. Monday, New York City
At seven-thirty Marcel dines with the Mattas and Kiesler, with whom he is planning the Surrealist exhibition, which is to take place in Paris in July [1.2.1947].

1958. Monday, New York City
After cocktails at Zadok's, Marcel and Teeny take Peter Matisse and Ann Carter to see the Moscow State Dancers.

1960. Thursday, New York City
At one o'clock, Duchamp has an appointment with Louis Carré at the Carlyle.

*

After speaking to Wittenborn, Duchamp writes to Richard Hamilton [26.3.1960] in London to confirm that the hard cover of his typographic version of the notes for the Large Glass is to be, as he suggests, exactly like the Green Box [16.10.1934]: green with the lettering, *The Bride stripped bare by her bachelors, even*, in white dots.
 The usual design of Wittenborn's general series of books will be restricted to the dust jacket.

1964. Tuesday, Neuilly-sur-Seine
Teeny and Marcel arrive on a flight from New York and move into their studio at 5 Rue Parmentier.
 During the winter, while Marcel and Teeny have been in America, the top-floor studio has been refurbished with the help of Bernard and Jackie Monnier [8.11.1963]. After fifty years' absence, Marcel is once more back in Neuilly [22.10.1913].

1967. Friday, Paris
Duchamp is interviewed by Bernard Dorival about "Les Duchamps" [15.4.1967] for the programme "L'Art Vivant", which is to be broadcast by France Culture on 24 April. Also an article about the exhibition by P.-M. Grand is published today in *Le Monde*.

23.4.1916

Piggy Bank (or Canned Goods)
Make a readymade with
a box containing something
unrecognizable by its sound and
solder the box

already done in the semi Readymade
of copper plates
and a ball of twine

22 April

1927. Friday, Paris
Marcel has female company when Roché calls to see him at noon. Visiting 11 Rue Larrey for the first time, Roché observes the ingenious way the small space on the seventh floor which Totor leased the previous October has been partitioned into three rooms with Man Ray's help. There is a small studio on entering with a large window and a coal-fuelled stove, and beyond it a room, just wide enough to take a double bed, which is lit by a south-facing window overlooking the street. Occupying space taken from the bedroom, the bathroom has a raised floor so that the plumbing executed by Antoine Pevsner runs into the gutter on the roof.

1930. Tuesday, Paris
Marcel visits the Dudley sisters at 13 Rue de Seine. Only Dorothy and Catherine [15.2.1928], who looks after her elderly mother, her nieces Ann Harvey and Sophie Reagan, and her nephew Jason Harvey, are at home because Caroline (the sister responsible for bringing Josephine Baker to Paris in 1925) has gone to

Berlin with Joseph Delteil. As well as meeting the ex-mayor of Chicago, Mr Harrison, Marcel finds Roché who, he is delighted to hear, has just received delivery of *Rotative Demi-sphère* [8.11.1924]. In memory of her husband, Madame Doucet has given Roché the "machine à dormir" which stood in Jacques Doucet's bedroom. After the valet and chauffeur had brought the optical machine up to the apartment, Roché found that the motor was in working order. He watched the "vertiginous" hemisphere turning with its "belly-dance movements", and thought how good it looked with his Brancusis!

On leaving the Dudleys, Roché walks as far as the lion of Belfort, Place Denfert-Rochereau, with Marcel, who is going to play chess at the brasserie, the headquarters of his club.

1946. Monday, Milford
With Mrs Weston and another friend, Miss Dreier and Duchamp travel to New Haven to visit the exhibition "Plastic Experience in the 20th Century, Contemporary Sculpture: Objects, Constructions" at the Yale University Art Gallery. After their visit, Duchamp accompanies Miss Dreier back to New York.

1961. Saturday, New York City
Replies to Henri Marceau confirming his visit to Philadelphia [17.4.1961] with Teeny on 4 May and asks him to reserve a hotel room, "not too expensive, and particularly not far from the museum."

1962. Easter Sunday, Boston
Teeny and Marcel visit Paul and Sally Matisse and their children: "fine, quiet and sweet as ever".

1963. Monday, New York City
Teeny and Marcel cable Isadore and Jeanne Levin in Palm Beach [12.2.1962] inviting them for dinner on 30 April while they are in New York.

23 April

1910. Saturday, Neuilly-sur-Seine
In the afternoon, first Annequin [22.3.1910] arrives to see Duchamp and then Max Berg-

mann, whose wish it is to see the chateau at Versailles. As it would be extremely crowded on a Saturday, Duchamp offers to organize the excursion with his young German friend on Tuesday. Wanting to make the most of the remainder of his stay in Paris, Bergmann also arranges with Annequin (who promises to get the tickets) to go to "La Pie qui chante", a cabaret at 159 Rue Montmartre.

1916. Easter Day, New York City
Duchamp assembles an object made with a ball of twine placed between two rectangular brass plates, and secured at each corner by four long brass screws. He has composed three, short enigmatic sentences of English and French words which he has written in white paint on the plates but replacing certain letters with a dot, rather like "signs from which a letter has fallen off…" Starting on the lower plate and continuing to the plate on top, the three sentences are written horizontally on three lines one underneath the other, each letter in a rectangle, so that those replaced by a dot can be identified by their correspondence with those in the same column.

Duchamp shows the object to Walter Arensberg, cryptographer *par excellence* whose talent is concentrated on the works of Dante and proving that Sir Francis Bacon wrote the plays and poems usually attributed to Shakespeare. Passionate of all things mysterious, Arensberg says that he will loosen the brass plates and secretly slip something small inside the ball of twine so that the hidden message, when shaken, is accompanied by an indefinable sound. Duchamp agrees, gives the object its title, *A Bruit secret*, and presents it to his accomplice as a gift.

1922. Sunday, New York City
With Joseph Stella's help, Duchamp hangs the group exhibition of the Société Anonyme at the MacDowell Club, 108 West 55th Street.

1926. Friday, Paris
Marcel and Roché help Brancusi in his search for a piece of land to build his own studio. Only recently returned from New York [31.3.1926], the sculptor is threatened by his landlord with expulsion from 8 Impasse Ronsin.

1932. Saturday, Paris
"L'Epoque héroïque du Cubisme (1910–1914)" opens at the Galerie Jacques Bonjean, near Rue

23.4.1948

La Boétie. Three pictures by Duchamp are exhibited: *Mariée* [25.8.1912], *Le Passage de la Vierge à la Mariée* [7.8.1912], and *Les Joueurs d'Echecs*, a sketch on canvas for the larger oil entitled *Portrait de Joueurs d'Echecs* [15.6.1912].

1937. Friday, Paris
In his chess column for *Ce Soir*, Duchamp selects a problem by F. Lazard and, giving the results of the Ostend tournament, comments on the game played in the first round by P. Keres and R. Fine. He gives details of the international tournament in Prague, which has just commenced, and also the competition of simultaneous games in Holland, which is to be played in 6 different towns, starting on 26 April.

1948. Friday, New York City
"The film tells the story of seven people in the office of a heavenly psychiatrist. He looks into their eyes and finds there on the inside of the retina the images of their dreams and wishes. They come to him to escape, for a short moment, the terrible struggle for survival which is breaking against the office door. They must go back finally – but with the satisfying doubt of whether the inner world is not just as real (and more satisfying) as the outer one."
Based on ideas contributed by five artists, Duchamp, Fernand Léger, Max Ernst, Man Ray and Sandy Calder, with musical accompaniments by contemporary composers and filmed by Arnold Eagle, Hans Richter's *Dreams that Money can Buy*, which he commenced in 1944 and which progressed "at a snail's pace", is given its world premiere at the 5th Avenue Playhouse, 66 Fifth Avenue. Produced by Art of this Century Films, Inc., Peggy Guggenheim supplied most of the financial backing. For Duchamp's episode Peggy also provided her staircase, stipulating that the shooting be finished that day by six o'clock, the time when she expected to return home. As it was undoubtedly quite a complicated "dream" to realize, four nudes were still descending the staircase when Peggy walked in at six with her guests…
The staircase episode, a *tableau vivant* of Duchamp's famous *Nu descendant un Escalier* [18.3.1912], which was filmed in black and white, contrasts with the spiralling forms of the *Rotoreliefs* [30.8.1935] and a truck-load of coal being tipped into a cellar. Duchamp wrote of this sequence, which is accompanied by John Cage's music for a "prepared piano", that he

was "delighted to have worked with the gangster who 'dreams'."

1949. Saturday, Los Angeles
In his article published today in the *Daily News*, Kenneth Rose compares the visits of two famous artists to Hollywood: Duchamp, "who never made a business of notoriety" and slipped into town unannounced [12.4.1949]; and Salvador Dali, who characteristically made a spectacular media performance of his arrival. Having tracked him down at the Arensbergs', Kenneth Rose asks Duchamp the "inevitable" question: will he ever paint again?
"I don't know. I have never taken a vow not to. I do not believe that everything has been said."
And the contemporary scene?
"Today art is big business, a public enterprise in which the layman evaluates, with a cursory glance, the life work or a single major effort by an artist, yet they do not pretend to pass judgment on the conclusions of the scientist or mathematician… People condemn Modern Art, but offer nothing in its place. It is here: a part of this age. One might just as well scoff at aeroplanes and the radio. It all depends on how we use them."

Although Kenneth Rose considers that *Nu descendant un Escalier* [18.3.1912] will be counted in the 100 important pictures of the first half of the century, he believes that rather than as a painter Duchamp will be remembered as "the man who had the strength to cling quietly and unpretentiously to some spiritual and intellectual values in a crazy commercial world".

1953. Thursday, New York City
Like Duchamp, Fleur Cowles is so enchanted with the layout of André Breton's project for *Flair* [16.3.1953] that she wants to publish it separately from the annual. Duchamp writes to ask Breton if he would agree to supervise the printing of it in France and obtain estimates. In the meantime, from the list given to him by Breton in his previous letter, he will arrange for the eight colour photographs to be made.
Enclosing Mina Loy's signed and certified declaration authorizing him to make decisions concerning Breton's book on Arthur Cravan, Duchamp mentions that if the project goes ahead he will transfer his full powers to Breton.

1962. Monday, New York City
In the afternoon Marcel and Teeny return from their weekend in Boston.

24 April

1917. Tuesday, New York City
Marcel and Roché have lunch with two girls at Manguin's.

1939. Monday, Paris
Thanking him for the copy of *Rrose Sélavy* [19.4.1939], which he finds "very good", and also for his persistence, Duchamp asks Henri Parisot if he would retrieve all his complimentary copies when he next goes to GLM. "I will collect them from you," Duchamp writes, "requesting you (both) to have lunch with me that day."

1946. Wednesday, New York City
Following a decision made at a meeting of the subcommittee responsible for acquisitions at the Museum of Modern Art, James Johnson Sweeney, who is the director of the Department of Paintings and Sculpture, requests Marcel to help with finding paintings and sculpture which might be of interest to the museum while he is in Europe.
In addition to requesting a report on the two large Picabias belonging to Gaby Picabia, *Udnie* and *Edtaonisl*, Sweeney would like to find a Delaunay *circa* 1912. Although Roché has promised to offer him *Adam et Eve* when he decides to sell it [21.8.1945], Sweeney is still anxious to find other good examples of Brancusi's work.
Due to leave New York on 1 May, Duchamp has also agreed to investigate for Sweeney the possibility of arranging an exhibition in Paris: "Painting in New York, 1939–1945."

1951. Tuesday, New York City
As Miss Dreier is not well, Duchamp writes jointly to Katharine Kuh thanking her for the article in the April issue of the *Magazine of Art* giving "such a comprehensive account" of the catalogue of the Société Anonyme [30.6.1950]. "You have written so many catalogues yourself," says Duchamp, "that you realize perfectly how precise and at times tedious that kind of work is."

24.4.1964

25.4.1941

Duchamp mentions that, "if nothing interferes," he has been invited to Chicago on 8 May for a few days by Brookes Hubachek.

1954. Saturday, Cincinnati
A week after the removal of his appendix [18.4.1954], Marcel tells Roché that he is feeling "as fit as a fiddle" and hopes to return to New York on 4 May.

1958. Thursday, New York City
In the evening, the Duchamps attend a cocktail party given by Dominique de Menil.

1961. Monday, New York City
Replying to Pontus Hulten's invitation to the opening in Stockholm on 16 May and his request to use *Corolles* [30.8.1935] for the cover of the gramophone record he is editing for the exhibition, Duchamp sends the following telegram: "Thousand thanks but impossible to come to opening stop agreed for Corolles stop all my wishes."
The record produced by the Moderna Museet and Swenska AB Philips, is a selection of recorded documents from the history of kinetic art and includes readings by Marinetti and Gabo and the sounds of Jean Tinguely's *Hommage à New York* [17.3.1960].

1963. Wednesday, New York City
Much in demand in connection with the 50th Anniversary of the Armory Show [5.4.1963] an interview with Duchamp for radio is broadcast on Voice of America at seven o'clock in the evening. It is to be repeated the following day.

1964. Friday, Neuilly-sur-Seine
For the exhibition, "Le Surréalisme, sources, histoire, affinités," organized by Patrick Waldberg at the Galerie Charpentier, Ulf Linde's replica of the Large Glass has been brought to Paris on its way back from Pasadena [7.10.1963] to Stockholm. As well as a copy of the Green Box [16.10.1934] to marry with the Glass, and a copy of the *Boîte-en-Valise* [7.1.1941] both lent by Lefebvre-Foinet, Duchamp is also represented by *Feuille de Vigne femelle* [12.3.1951], lent by Man Ray, and *Coin de Chasteté* [16.1.1954].

1968. Wednesday, Neuilly-sur-Seine
Referring to the recent poster [19.3.1968], Duchamp writes to Joseph Solomon: "Hope the door inscribed will reach you safely."

25 April

1917. Wednesday, New York City
In the evening Marcel dines at the *rôtisserie* [Parisienne?] with Roché, Beatrice Wood, Francis Picabia, Albert Gleizes and Louise Norton. They discuss the plans for a second number of the *Blind Man* [7.4.1917], and later enjoy some "very good dancing".

1920. Sunday, Paris
In the second issue of Picabia's magazine *Cannibale*, Duchamp's *Chèque Tzanck* [3.12.1919] is reproduced with the title *Dessin Dada*.
In the "Carnet du Cuculin" on the same page, is the announcement: "Marcel Duchamp is better, he drinks cod's liver oil; there are lots of women in America and little whisky."

1931. Saturday, Brussels
Glissière contenant un Moulin à Eau en Métaux voisins [11.12.1919], Duchamp's first study on glass, is exhibited for the first time in "L'Art vivant en Europe", an international exhibition held at the Palais des Beaux-Arts. The work which used to hang in the bathroom of Jacques Doucet [28.9.1923] has been lent by Doucet's widow.

1937. Sunday, Paris
Duchamp accompanies Miss Dreier, who is staying at the Hôtel Voltaire [21.4.1937], to visit Hans Arp at Meudon.
Later Roché arrives and takes them both by car to 24 Avenue de Bellevue in the neighbouring suburban town of Sèvres where he lives with his wife, Denise. They have "a good friendly short talk" and Roché shows them the photographs and drawings of his son Jean-Claude, who is nearly six years old.

1941. Friday, Marseilles
With Léonor Fini, Max Ernst, André Pieyre de Mandiargues and Peggy Guggenheim, Marcel signs a postcard addressed to Meret Oppenheim in Basel. The card is illustrated with a little red devil looking for the "moon" through a long telescope which, at the big end, has a flouncy can-can dancer in full flight.

Marcel learns from René Lefebvre-Foinet that the *Boîte-en-Valise* [7.1.1941] ordered by Peggy Guggenheim did finally arrive in Grenoble at René's address and, as Peggy wishes to take it with her to America, he immediately forwarded it to Marseilles. Informing Roché of this in a letter, Marcel says how much he regrets that, due to "the hitch", Roché did not see the Valise when they were in Grenoble [21.4.1941].

Now that he has obtained a three-month permit as a commercial traveller representing the cheese retailer Gustave Candel [23.2.1941], Marcel can start his "missions" ferrying the contents of almost 50 *Boîte-en-Valise* from occupied Paris to Grenoble in the unoccupied zone. The items for the Valises will join Peggy Guggenheim's art collection which is being packed in the sanctuary of the museum by René Lefebvre-Foinet for shipment to New York.

*

With a letter of recommendation by André Farcy of the Musée de Grenoble, Duchamp's request for an exit visa [19.4.1941] is forwarded today by the Prefecture of the Isère to Vichy.

1947. Friday, New York City
Maria Martins and Marcel dine at the Café Brittany with Matta and the Kieslers [21.4.1947].

1949. Monday, New York City
Duchamp is due back from his trip to the West Coast, after having visited San Francisco [6.4.1949] and spent twelve days with Walter and Lou Arensberg [12.4.1949]. On his way back east, Duchamp flew to Phoenix to see Dorothea Tanning and Max Ernst at Sedona, their self-built Capricorn Hill set in a red world varied with desert blooms and dominated by Cathedral Rock, Courthouse Rock, and to the west, Cleopatra's Nipple.

*

Louis Carré, who is hoping very much that Duchamp will be back in time to be present, opens an exhibition of paintings by Jacques Villon at his gallery, 712 Fifth Avenue.

1950. Tuesday, Los Angeles
His mission to the Arensbergs on behalf of the Metropolitan Museum [17.4.1950] completed, Duchamp returns to New York by air bringing with him photographs of the pre-Columbians: a selection of objects from the Arensberg Collection.

26.4.1910

The trip is "very beautiful" and Duchamp has a good view as the plane circles over the Grand Canyon. During the flight, which takes nine and a half hours, the pilot gives his passengers a running commentary about what is happening inside and outside the aircraft.

1961. Tuesday, New York City
Following Bill Camfield's visit on 4 April, Duchamp replies by letter to a number of further questions about the exhibition "La Section d'Or" [9.10.1912].

Concerning the watercolour, *Le Roi et la Reine traversés par des Nus en vitesse* [9.10.1912], Duchamp says: "The title and the introduction of themes like King, Queen, nudes, speed without actually painting them were among my artistic preoccupations, using the themes mostly in an a-political, a-romantic but humorous way." He reminds Camfield that during the Fauve period, "a poetic title to a painting was an anathema and despised as 'literature'."

1968. Thursday, Neuilly-sur-Seine
Georges Herbiet [12.10.1967] presents Duchamp with a copy of his typewritten manuscript *L'Intime Jacques Villon* which he has dedicated to Duchamp.

26 April

1910. Tuesday, Neuilly-sur-Seine
Duchamp rises early in order to be at the Hôtel des Mines, 125 Boulevard Saint-Michel, at nine o'clock to collect Max Bergmann and his Norwegian friend, Schwensen. From the Gare Montparnasse, they take the train to Versailles, where they spend the day visiting the splendours created by Louis XIV, his palace, the Grand Trianon, the Petit Trianon, built by Louis XV, and the famous gardens of Le Nôtre. Bergmann has been looking forward to this day since it was planned, and is greatly impressed.

Not leaving the palace until six, on their return to Paris the young men find a café and drink absinthe, which makes them very merry. Afterwards, in Montmartre, Marcel's friend Jeanne Serre [16.4.1910] joins them for the rest of the evening. Supper at Madame Coconnier's [22.3.1910] is followed by some refreshment in a brasserie. At ten Duchamp and his friends go back to a favourite haunt, the Bal Tabarin [16.3.1910], where they amuse themselves until midnight.

1917. Thursday, New York City
In the evening Marcel and Roché are invited to the Stettheimers' at 102 West 76th Street.

1927. Tuesday, Paris
At one o'clock Marcel meets Roché at the Brasserie du Labyrinthe for lunch. As Mrs Carpenter [23.1.1927] has arrived in Paris, and is interested in the work of Brancusi, Marcel hopes that he may see her tomorrow.

1930. Saturday, Paris
"You must know that Yvonne George is really dead this time," writes Marcel to Brancusi in the morning. As the cremation is to take place at four that afternoon, Marcel proposes to call for him around three o'clock.

*

With Roché invited to lunch at 11 Rue Larrey, Marcel has requested his elderly charwoman to cook them some fish.
Roché also knew Yvonne George, whose voice had moved the rowdiest of music hall audiences to silence [1.11.1922], until she became too ill to perform. He would like to go to the funeral just to see Marcel and Brancusi at Père Lachaise; his macabre advice to Marcel is to watch the entry of the coffin and then see the "dazzling bones" coming out.

1939. Wednesday, Paris
Henri Parisot has been to collect Duchamp's copies of *Rrose Sélavy* [19.4.1939] from the publisher and has suggested they meet on Thursday for lunch. As Duchamp already has an engagement that day, he sends a message to Parisot proposing Friday instead.

1950. Wednesday, New York City
The day after his return from Hollywood, Duchamp telephones Francis Taylor. Although he is in a meeting when Duchamp calls at the Metropolitan Museum, Taylor leaves it for fifteen minutes to hear Duchamp explain why the Arensbergs decided to withdraw [17.4.1950]. To emphasize the problem of space, he tells Taylor that when the collection was shown in Chicago [19.10.1949], the Art Institute provided 1,100 running feet without the pre-Columbian pieces. Taking the photographs of the pre-Columbians which Arensberg has provided, Taylor hopes to convince the trustees to agree to these conditions. This new proposal however, as Duchamp points out, does not necessarily imply that the Arensbergs will accept.

1952. Saturday, Milford
Duchamp has arranged with Fritz Glarner [20.4.1952] to photograph all the rooms at Laurel Manor, just as Miss Dreier left them [29.3.1952].

*

Spread over ten pages, four of which are in colour, the tribute to Duchamp, "Dada's Daddy" and the "pioneer of nonsense and nihilism", by Winthrop Sargeant is published today in the issue of *Life* magazine dated 28 April. One of the illustrations is a fine chronophotograph by Eliot Elisofon of Duchamp himself descending the stairs.

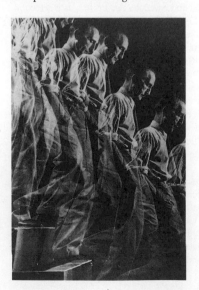

Sargeant considers that those at the opening of the exhibition at the Rose Fried Gallery [25.2.1952] were celebrating the "historical eminence" of Duchamp and he describes the Dada revolution at length. It was "inevitable and completely logical", he writes, that Duchamp should have "given up art altogether". The result of this "admirable tenacity for

nearly thirty years" is Duchamp's "almost oracular position" today amongst Manhattan's artists, dealers and critics.

Sargeant's visit to the "garret-like" studio at 210 West 14th Street, where Duchamp has been living since 1943, is confirmation of this uncompromising independence. Paying a rent of only $40 a month, Duchamp avoids the commercial rat race. He has no telephone, which means that people who want to reach him must write or send telegrams. Duchamp tells Sargeant firmly, "My capital is time, not money."

Duchamp is adept at avoiding traps. Ambition, when it leads to competitive activity is one. Domesticity is another trap which Duchamp cannot understand: "You can go without food and umbrellas alone, but with a wife and children you can't." He is concerned about a new trap attached to his application for American citizenship: jury duty. "Who am I and who is any man that he can bring judgment on another man? I just don't want to do it." Even art itself is a trap for Duchamp. "I have always had a horror of being a 'professional' painter. The minute you become that you are lost. I was never passionate about painting. I never had the olfactory sensation of most artists. They paint because they love the smell of turpentine. Personally, I used to paint for two or three hours a day and I couldn't get away fast enough."

The studio is dominated by the chessboard and piles of material to assemble and fill the *Boîte-en-Valise* [7.1.1941]. The journalist observes Duchamp sitting "smoking pipeful after pipeful of strong Cuban tobacco". Why a suitcase? Sargeant, searching for deeper meanings, tries to trap Duchamp into giving him some clues. Duchamp smiles and sidesteps his question: "What would you consider the proper solution? Obviously there can be no solution when there is no problem. Problems are inventions of the mind. They are nonsensical."

*

Still preoccupied by the destiny of *9 Moules Mâlic* [19.1.1915] Duchamp writes to Roché again [11.4.1952] on his return to New York. Knowing "the bandits" with whom Roché's successors would have to deal Marcel would prefer that they settle the matter themselves. At the same time he again begs Roché to avoid any form of publicity as far as he is concerned:

"I want to be left alone. The family exhibition [25.2.1952] pointed out the danger of my showing my face."

1956. Thursday, New York City
For Mrs Gordon Washburn, wife of the director of the Carnegie Institute of Pittsburgh, and Mr G. D. Thompson, a collector from Pittsburgh, who would like to visit Henri Pierre Roché at 2 Rue Nungesser et Coli, Sèvres, Duchamp writes a note of introduction.

1958. Saturday, New York City
As the Duchamps will fly to Paris on 29 May, Marcel tells Roché that he would prefer to discuss the Brancusi matter with him when he sees him then.

1959. Sunday, Cadaqués
As there is a daily bus service between Figueras and Perpignan, Duchamp proposes in a letter to Lebel that he travel to the Hôtel de France, Perpignan, to sign the posters for the exhibition at La Hune [15.4.1959].

1961. Wednesday, New York City
[Although George Downing, chairman of the art department of Brown University, wrote an article about "The World of Dada" [18.1.1961], which was published in the *Brown Daily Herald* of 18 April announcing Duchamp's talk on 28 April, Duchamp has told Henri Marceau [17.4.1961] that he is going to visit Brown University at Providence, Rhode Island, on 26 and 27 April.]

1965. Monday, Neuilly-sur-Seine
At ten in the morning Duchamp is expecting a visit from Arturo Schwarz at 5 Rue Parmentier.

27 April

1915. Tuesday, Paris
In the morning, at Rue Saint-Hippolyte, Duchamp receives two letters from Walter Pach in New York, one for his personal attention, as Duchamp had requested [2.4.1915] about his intended move to New York, the other for general circulation to the family. He decides to go to Saint-Germain-en-Laye that very day with Pach's

letter, but before taking the train from the Gare Saint-Lazare, he stops at the Café-Restaurant Mollard opposite the station. In the sumptuous ceramic décor of the café, conceived by the architect Edouard Niermans, Duchamp asks for some stationery and replies to Pach. He tells his friend how determined he is to leave Paris and how much he wants to shed the artistic life, which he has disliked since before the war. He is happy that Pach has sold the canvases for him, but he "refuses to envisage an artist's life in search of glory and money". He considers that his father has done enough for him and he wants to find work when he comes to New York so that he doesn't "end up being in need to sell canvases, in other words, to be a society painter".

Hoping to leave on 22 or 29 May from Bordeaux, Duchamp still wants Pach to keep his decision a secret, knowing that his departure will be very hard on his brothers, also his father and sisters.

1917. Friday, New York City
In the early hours of the morning following the party at the Stettheimers', Marcel invites Roché to sleep in the studio at 33 West 67th Street.

*P.B.T. tout les initiales de :
Pierre
(Roché)
Béatrice
Wood
éditeur du magazine
Totor
Duchamp,
surnom donné
par Roché)*

Later that morning, after a "good night", Roché works with Beatrice Wood on "P.B.T." (the initials of the editors: Pierre, Beatrice and Totor), the second number of the *Blind Man*, which was discussed on Wednesday. They meet Picabia at the printer's, lunch together and see Marcel later in the evening.

1926. Tuesday, Paris
In the last few days Dee has been fully occupied with jobs for Miss Dreier who, after her visit to Paris [16.4.1926], is now in Germany collecting work for the International Exhibition of the Société Anonyme which is to be held in Brooklyn at the end of the year. He has bought the Braque collage, *Verre et Musique*, and arranged

27.4.1926

for it to be sent from the Galerie Loeb to the packers; he has been to check the Meryon prints at the Bibliothèque Nationale, and compared the dealers' prices; he has seen a distressed Theo van Doesburg, whom Miss Dreier missed when she was in Paris, who would like to be included in the exhibition; he has written to Vantongerloo in Menton and to another Dutch friend of Mondrian's in Holland about exhibiting and he has received a representative of the Buffalo Museum to show him the Cézanne...

*

In the afternoon Duchamp sits for Antoine Pevsner. The sculptor has promised Miss Dreier, who commissioned the portrait, that he will try to produce "a miracle" for her in order to gain her friendship.

1941. Sunday, Marseilles
With his newly acquired pass permitting him free passage between the occupied zone and unoccupied zone [25.4.1941], Marcel can not only put into operation his own plans for transferring the contents of the Valise from Paris, but can also, while outside the occupied zone where communications are censored, act as go-between for the benefit of his family.

As Beatrice and Francis Steegmuller in New York have sent money to Villon, Marcel writes to suggest a simpler solution of helping his brother financially. If the Steegmullers send dollars to Brookes Hubachek, Mary Reynolds' brother in Chicago, then Mary will give the equivalent in francs to the Villons who have now returned to Puteaux after their prolonged stay at La Brunié [16.7.1940]. Marcel and Mary see them regularly, either at Rue Hallé, or in Puteaux. Although Marcel is hoping to be ready to travel to New York in July, Mary does not wish to leave Paris just yet.

1950. Thursday, New York City
Following Mary Reynolds' laconic note announcing her admittance to the American Hospital at Neuilly, Marcel has received a letter from Suzanne and Jean Crotti giving him more details of Mary's condition. As she is very weak and can hardly write, Marcel asks the Crottis to telephone Mary for news and to keep him informed.

1959. Monday, Milan
Feuille de Vigne femelle [12.3.1951] and a copy of the *Boîte-en-Valise* [7.1.1941] are

shown in an exhibition of Surrealist artists, which opens today at the Galleria Schwarz.

1963. Saturday, Stockholm
A small Duchamp exhibition opens at the Galerie Burén as a result of Ulf Linde's having obtained written permission from Duchamp to include exact replicas of every readymade in the show. Two of the replicas, *Roue de Bicyclette* and *Fresh Widow*, were signed by Duchamp "certifié pour copie conforme" when he visited Stockholm [5.9.1961], the others have been made by Linde since that date.

1965. Tuesday, Neuilly-sur-Seine
Expecting the Baruchellos [2.4.1965] from Rome, Marcel meets them at the Hôtel Montalembert, near Rue du Bac in Paris, and they have lunch together. Finally the long-awaited number of *Metro* [18.2.1964] with the cover designed by Duchamp [18.6.1963], the April issue, has now been published.

1967. Thursday, Neuilly-sur-Seine
Duchamp confirms to Arne Ekstrom that he has received the photograph he requested [10.4.1967] which now belongs to Dieter Keller of Stuttgart; he also writes to Pierre de Massot proposing to meet him on Saturday afternoon at the Bar des Artistes.

1968. Saturday, Neuilly-sur-Seine
There are two events which Marcel wants to attend on his return to the United States in the autumn, the opening of an International Festival of Short Films in Philadelphia on 18 October and the opening in Chicago on the following day of "Dada, Surrealism and their Heritage".

He accepts Mrs Wintersteen's invitation to be a sponsor for the film festival, and writes to Brookes Hubachek to say that he and Teeny have decided to take an early flight to Chicago on 19 October.

28 April

1919. Monday, Paris
On his return from Switzerland, Picabia continues writing poetry: his long poem, *Pensées sans Langage*, published today by Figuière, is

dedicated to Gabrielle Buffet, Marcel Duchamp, Tristan Tzara and Georges Ribemont-Dessaignes, on account of their "elective congeniality".

1923. Saturday, Neuilly-sur-Seine
Marcel returns from Brussels to attend the marriage of his sister Yvonne to Marie Eugène Alphonse Duvernoy, a controller of Customs and Excise in Indochina. The civil ceremony, conducted by M. Villeneuve, takes place at ten minutes to ten at the Mairie and the register is signed by the bride and groom, the bride's parents (who have come from Rouen), and the witnesses, Georges Delacour [24.8.1911] and Auguste Bluysen.

*

In the evening Marcel visits a close friend from New York, baptized "Tigre" by Roché, who has arranged a small supper party and laid the table for seven. Just before midnight, Roché arrives with Man Ray and Kiki. As none of them have seen him recently, they make a great fuss of Marcel, "charming, subtle, shrewd," according to Roché, who is immediately reminded of their nights in New York with Louise [21.4.1917].

28.4.1967

1930. Monday, Paris
Since Miss Dreier sailed back to New York, Dee has dealt with a number of matters on her behalf including negotiating the lease of an apartment at Place Dauphine.

As Miss Dreier has agreed to buy Brancusi's *Maïastra* for $1,000 (paying by instalments), the cases are to be brought out of storage [12.2.1927] and shipped to The Haven. In his letter Dee reminds her, with a diagram, that the sculpture is in four parts.

1941. Monday, Marseilles
Since his application dated 19 April for a passport with an exit visa is for the United States of America, Duchamp is required to complete two copies of a special application form.

1946. Sunday, New York City
After dining with the Kieslers at seven-thirty, Marcel returns again to their apartment at 56 Seventh Avenue, at eleven.

1960. Thursday, New York City
"[I am] really very happy that you would like to help me in this bizarre enterprise," writes Marcel to Jackie Monnier, who has offered to assemble a new series of the *Boîte-en-Valise* [7.1.1941] based on the model made by Iliazd [26.2.1958].

1961. Friday, New York City
"In our busy life I have not had the time to go to see my valise, which Rose Fried finds absolutely marvellous!!" Marcel tells Jackie, who has been busy in the last twelve months assembling copies of the *Boîte-en-Valise* [7.1.1941].

"I hear too that the last valise for the Chess Foundation has just arrived... As for the idea of you keeping at Rue du Bac all the reproductions and plates that Lefeb[vre] Foinet would like to send to Montrouge, that would give me great pleasure, if you assure me that all these packets (even in boxes) don't take up too much space in your apartment."

1965. Wednesday, Paris
The Duchamps and the Baruchellos meet again and enjoy a dinner together of *crevettes grises*, the small shrimps native to the Channel waters.

1967. Friday, Rouen
In addition to the exhibition "Les Duchamps" presently at the Musée des Beaux-Arts [15.4.1967], the city marks the Duchamp fami-

ly's connections with Rouen in a more permanent fashion: a plaque [25.1.1967] has been set into the wall at first floor level of the house at 71 Rue Jeanne d'Arc where Eugène Duchamp went to live with his wife Lucie and their young daughters, Suzanne, Yvonne and Magdeleine, when left Blainville-Crevon [3.11.1905].

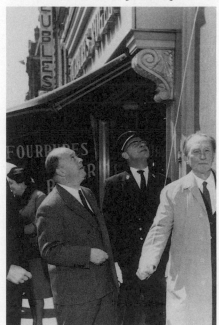

Just before noon, M. Bernard Tissot, mayor of Rouen, M. Feydel, Secrétaire-Général of the Préfecture, M. Blaise Gautier, Inspecteur de la production artistique des Arts et Lettres, and Mlle Olga Popovitch, curator of the Musée des Beaux-Arts, gather on the busy pavement before the house. Accompanied by Teeny, his sisters Yvonne Duvernoy and Magdeleine Duchamp, his step-daughter Jacqueline Monnier and Mme Louis Carré, Duchamp is invited to unveil the plaque, which is inscribed:

Ici a vécu,
entre 1905 et 1925
une famille
d'artistes normands;
Jacques Villon
(1875–1963)
Raymond Duchamp-Villon
(1876–1918)
Marcel Duchamp
(1887–)
Suzanne Duchamp
(1889–1963)

Following the brief ceremony, the mayor invites those present to lunch at the Couronne, one of the oldest hostelries in France on the Place du Vieux-Marché, where Joan of Arc, prisoner of the English, was burned at the stake.

In the afternoon the Duchamps, Mlle Popovitch and her assistant Mlle Le Guéroult, Mme Louis Carré and M. Blaise Gautier visit an exhibition of engravings by Jacques Villon at the Galerie Menuisement [17.2.1964].

29 April

1910. Friday, Paris
In the evening Duchamp meets Gustave Candel [10.4.1910] and Max Bergmann at the Grande Taverne Pousset, 14 Boulevard des Italiens, to make a tour of his favourite night spots [22.3.1910]. After calling at the Taverne Olympia the three young men return to Montmartre. Visiting Monico's, Pigall's, the Taverne Royale and Beauclaire, Bergmann gets so drunk that it will take him the whole weekend to recover.

1917. Sunday, New York City
At his studio at 33 West 67th Street, Marcel installs Beatrice Wood on an upright chair in the middle of the room to make a drawing for the poster announcing the Blind Man's Ball on 25 May. When she has finished all her sketches, Marcel spreads them out over the floor and to Bea's surprise he chooses a high-stepping stick figure thumbing his nose, which she executed in just a few deft strokes.

At four o'clock, Roché arrives and finds the posters "beautiful". After visiting Isadora Duncan's studio, Roché, Marcel and Bea have supper together, and later at the Arensbergs' they see Allen Norton and Mina Loy.

1919. Tuesday, New York City
"Evolution of French Art," a historic exhibition of works on paper dating from Ingres and Delacroix, which has been organized by Marius de Zayas, opens at the Arden Galleries, 599 Fifth Avenue. Following an affirmative reply to his ultimatum [4.4.1919], Walter Arensberg lends three of Duchamp's works to the exhibi-

29.4.1942

30.4.1920

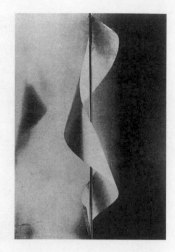

tion: *Nu descendant un Escalier*, No. 3, the photographic copy of his celebrated canvas which, to assuage Arensberg's regret at not possessing the original, Duchamp coloured and worked over by hand for him in 1916; and two drawings, *Combat de Boxe* [1.4.1916] and *Le Roi et la Reine traversés par des Nus vites* [1.4.1916].

1920. Thursday, New York City
The day before the opening of its first exhibition, and after several months of careful planning, the first officers sign the Certificate of Incorporation of the new "Société Anonyme". The signatures of the three founders, Miss Katherine Dreier, treasurer, Duchamp, president, and Man Ray, secretary, are joined by those of Miss Dreier's lawyer Andrew McLaren, and Henry Hudson. It is the New York Secretary of State who, during the process of incorporation, adds the superfluous "Inc." to the name. Whereas Miss Dreier had originally proposed "The Modern Ark – A Private Museum" as a title for the association, and agreed to "Société Anonyme" suggested by Man Ray – which Duchamp liked – she nevertheless gave the organization its subtitle: Museum of Modern Art.

1923. Sunday, Paris
Soon after midnight when Marguerite Buffet arrives, Tigre's guests sit down to supper but there is one empty place at the table. Suddenly Jacques Rigaut [22.7.1921] – the seventh guest – arrives, exuberant, drunk, upsetting the quiet supper by bringing with him half a dozen strangers. While Tigre is occupied with the unexpected guests, Marcel talks to Roché and Marguerite, but Rigaut quite at ease, gay and confident has upset Kiki, who objects to the interruption of supper. After ice-cream they continue drinking sherry and whisky.

The strangers finally go. Tigre is on the sofa talking to herself, her head lowered, eyes glazed, suffering from hiccups. Using the old cure, Marcel and Roché try to give her a fright, but are unsuccessful. Eventually they take her to bed. She talks awhile and goes to sleep. Roché tenderly envelops her in the bedspread and covers her with a fur coat.

When they return to the drawing room, Rigaut starts a bombardment of oranges: one strikes Kiki on the nape of the neck and she bursts into tears. Rigaut departs and Roché returns to Tigre, watching her and caressing

her without waking her. Having known both Anne and Tigre intimately in New York, Marcel remarks to the others in the drawing room that the two [sisters?] have nothing in common: Tigre cannot help it, she spends her life trying to do otherwise; Anne acts by vocation.

Around four o'clock in the morning after leaving Tigre, Marcel, Marguerite Buffet, Man Ray, Kiki and Roché arrive at the Gare Montparnasse on a night bus. In vengeance for his invasion of the supper party, Marguerite has stolen Rigaut's bunch of keys and goes with Roché to hide them under the doormat of Rigaut's apartment.

Mission accomplished the five of them find a bar and order onion soup and beer. Kiki is now very sleepy, Marcel and Marguerite are still on form, Man is gentle and calm and, because earlier the invader went off with the wrong hat, Roché has Rigaut's on his head.

1930. Tuesday, Paris
The committee of the Fédération Française des Echecs meets to elect its officers. Those elected unanimously are the president, M. L. Tauber; the vice-presidents, Messrs J. Conti, E. Pape and G. Gompertz; the secretary, M. E. Convert; and the treasurer, M. A. Gromer. By a large majority, Duchamp is elected this year's delegate at the Fédération Internationale des Echecs.

1942. Wednesday, Sanary-sur-Mer
All Marcel's papers are in order for his departure to the United States, his passage is reserved, and he has made arrangements with Alec Ponisovsky in Monte Carlo to reimburse Roché his loan of 20,000 francs by telegram. To ensure that there are no hitches, Marcel sends Roché Ponisovsky's address and tells him that he plans to go to the Hôtel de Paris in the Rue Colbert, Marseilles, two days before his departure (which is unlikely to be before the middle of the following week). "In principle this is my last letter," writes Marcel, adding that Roché can leave messages at the hotel in Marseilles.

The parcel which Marcel is also sending Roché contains Bachelard's book on Maldoror, the Siemens machine for sharpening Gillette blades, which he purchased in Geneva [30.3.1942?], and an enlargement of a rugged photograph of himself. Wearing a thick pullover, a woollen scarf around his neck, Marcel stands with his hands in his pockets before a tree used as a bot-

tle rack, with the shadows of its branches cast dramatically on his face by the winter sunlight.

1950. Saturday, New York City
"It was good to see you again," writes Marcel to Louise and Walter Arensberg, "I enjoyed this long 'weekend' with you." He reports on the short meeting with Taylor on Wednesday – the day after his return from Los Angeles – and says that he has consulted his lawyer friend Phillips about how to ensure that clauses in a contract are respected. The common solution, Marcel understands, is to name a trustee, who is in charge during his lifetime and who names the successor of his choice.

1961. Saturday, New York City
Writing to Pontus Hulten in Stockholm, Duchamp regrets that he is unable to attend the opening of "Rörelse i Konsten" [Movement in Art] at the Moderna Museet on 16 May on account of his involvement in the Chess Auction, which takes place in New York on 18 May. As Hulten would like to organize a chess game during the show, Duchamp suggests that a Swedish Grandmaster play a game by telegram against Nicholas Rossolini in New York. "After all," he adds, "a chess game of this kind belongs to a form of motion in art!"

1964. Wednesday, Paris
In the afternoon Duchamp and Louis Carré have an appointment with Maître Lesguillier.

1967. Saturday, Paris
In the afternoon at four-thirty Marcel is due to meet Pierre de Massot at the Bar des Artistes.

30 April

1920. Friday, New York City
While the Metropolitan is celebrating its 50th anniversary, the first exhibition organized by the newly-formed Société Anonyme, Museum of Modern Art, (officially incorporated the previous day) opens at its headquarters, on the top front floor of a brownstone building situated at 19 East 47th Street. The small selection of Modern Art by American and European artists beginning with the Post-Impressionist school

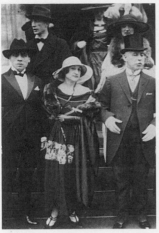 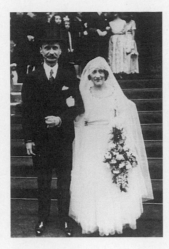 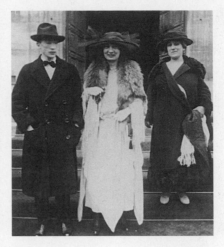

30.4.1923

includes Van Gogh, Villon, Vogeler, Stella, Ribemont-Dessaignes, Picabia, Man Ray, Bruce, Schamberg, Juan Gris, Duchamp, Daugherty and Brancusi.

"Duchamp took complete charge of the decoration of those galleries," wrote Miss Dreier. "The walls were lined with white oilcloth and we had removed all the moulding so that the simplicity of the room stood out. The large closet we turned into a little reference library, and we had comfortable chairs, where people could linger and study the new forms of art."

Man Ray installed the lighting which, with the reflected light cast from the buildings across the street, gives a bluish illumination inside the gallery. Providing an eccentric unity to the exhibition, Duchamp masks each picture frame with a lace paper edging.

As its symbol, the Société Anonyme has adopted Duchamp's rubber stamp chess Knight [7.1.1919]. In contrast to the commercial galleries it is a place "where one exhibits without selling", says Duchamp, "it costs 25 cents entrance." His first idea was to make the critics pay 50 cents...

In addition to regular exhibitions changing every six weeks, Miss Dreier envisages organizing programmes of lectures, both at the gallery and elsewhere. She wants to circulate works of art by arranging travelling exhibitions, and also to build up the library and even publish a quarterly review to promote a better understanding of Modern Art.

1923. Monday, Neuilly-sur-Seine
Following the civil ceremony on Saturday, Marcel attends the marriage of Yvonne to Alphonse Duvernoy at the church of Saint Jean-Baptiste.

After photographing the bride and groom as they descend the carpeted steps outside the church, M. Vaillant-Tozy's camera captures other members of the Duchamp family: Magdeleine, her face hidden under a deep cloche hat decorated with ostrich feathers;

Jean Crotti wearing a top hat; Suzanne on the arm of her cousin, the dramatist Meran Mellerio; and behind them Marcel, who escorts a lady with a very broad brimmed hat.

1936. Thursday, Paris
Marcel speaks to Roché on the telephone about the loan of *Chimère* by Brancusi to the forthcoming International Surrealist Exhibition in London [11.4.1936].

1937. Friday, Paris
In his chess column for *Ce Soir*, Duchamp publishes a problem from the *Cincinnati Times* for his readers, and comments on a game played in the Paris Interclub tournament on 26 April between a member of the Rive Gauche and a member of the Cercle Russe.

1949. Saturday, New York City
Following instructions from the Arensbergs [17.4.1949], Duchamp writes to Fiske Kimball of the Philadelphia Museum of Art. "They asked me to see you about the collection," explains Duchamp, "and I will be delighted to go to Philadelphia whenever it is convenient for you."

1950. Sunday, New Haven
On the day of the thirtieth anniversary of the Société Anonyme, the Associates in Fine Arts at Yale celebrate the occasion with a tea party to which the officers of the association are invited. One of the guests, Alfred Barr, reads a letter from Mr Nelson A. Rockefeller, president of the Museum of Modern Art, which warmly acknowledges the services rendered by the Société Anonyme.

In the evening at the New Haven Lawn Club, Miss Dreier and Duchamp host a dinner in honour of Mr and Mrs Seymour prior to the dissolution of the association.

1953. Thursday, Paris
"Dada pas mort à New York," is the headline of an article by Jacques de Montalais, published in *Combat*. Reporting on the "flashy" Dada exhibition at the Sidney Janis Gallery [15.4.1953], the journalist tells his readers that Duchamp, author of the Large Glass, disappeared with Dada, "crushed by Surrealism and the stature of André Breton. Marcel Duchamp having found his foster-father," continues de Montalais sarcastically, "the New Yorkers have had the scoop – in the New

World – of stale gadgets..." Describing the crushed catalogues in the laundry basket, the journalist says most visitors dared not take one: "They wondered whether the balls were going to explode in their face. Come," concludes de Montalais, "the New Yorkers have had their little shiver – and Marcel Duchamp his little curtain call."

1955. Saturday, New York City
Marcel who is advising Guy Weelen on loans for an exhibition on movement in art which he is organizing at the Musée Cantonale des Beaux-Arts, Lausanne, has learned from Weelen that there have been problems with *Rotative Demi-sphère* [8.11.1924] at the Galerie Denis René [6.4.1955].

"I told Weelen to ask you to lend your *Boîte-en-Valise* for Lausanne," writes Marcel to Roché, "but do so only if you like the idea." Concerned that he has had no recent news from Roché, Marcel tells him that the plans for the Brancusi exhibition at the Guggenheim are progressing [31.3.1955]. And is Brancusi out of hospital now [9.2.1955]?

1963. Tuesday, New York City
For Man Ray's exhibition at Cordier & Ekstrom Inc., 978 Madison Avenue, which opens with cocktails from five until seven, Duchamp has written a poem for the invitation card:

LA VIE EN OSE

on suppose
on oppose
on impose
on appose
on dépose
on repose
on indispose
et Finalement une dose de Ménopause
AVEC osmose
sclérose
et ankylose
MAIS la chose qui ose.

*

Isadore and Jeanne Levin, the New York and Palm Beach collectors, come to dinner at 28 West 10th Street at seven-thirty.

1965. Friday, Paris
At nine-thirty in the morning, Gianfranco Baruchello has arranged a private screening for

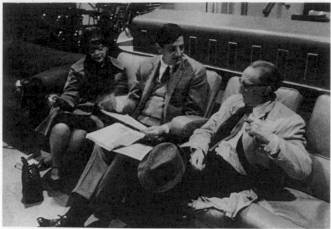

30.4.1965

Duchamp of his recently completed film, *La Verifica incerta*, which he has co-directed with Alberto Grifi.

*

In the evening the Duchamps visit the house where they spent several weeks in the summers of 1958 and 1959: Max Ernst's old address, 58 Rue Mathurin-Régnier [30.5.1958]. Now belonging to Milvia Maglione and Lucio Del Pezzo, it is here where a disparate group of artists have organized "La Fête à la Joconde". Described as the "Jocondologue" on the poster, "Sa Transcendance, Grand Maître de l'Ordre de la Grande Gidouille Marcel Duchamp [11.5.1953]" is photographed by André Morain arriving at the house and also before one of the exhibits, *Hommage à Marcel Duchamp* by Enrico Baj.

The other artists taking part in the show include André Balthazar, Ernest Pirotte and Emmett Williams, who have contributed texts for the poster, Pol Bury, Camille Bryen, Eric Dietman, François Dufrêne, Robert Filliou, Maurice Henri, Léa Lublin, Rotella, and Sarkis.

Also at the opening are André Pieyre de Mandiargues and, representing the Collège de 'Pataphysique, Noël Arnaud.

1967. Sunday, Neuilly-sur-Seine
"I received your packet of photos with great joy," writes Duchamp to Dieter Keller in Stuttgart, who now possesses the photograph of the shadows cast by the readymades at 33 West 67th Street [8.7.1918]. As his photographer now has the elements to make an enlargement one metre high for the show at the Galerie Givaudan which is due to open on 7 June, Duchamp returns the tiny original print to the German collector. "So I will keep the enlarged negative," he continues, "and the large proofs on paper."

Also enclosing a catalogue of "Les Duchamps" [15.4.1967], Duchamp says he looks forward to meeting Mr Keller and his wife on 6 June at the Musée National d'Art Moderne.

1 May

1892. Sunday, Blainville-Crevon
Voting for the municipal council takes place in the *mairie* from eight until six in the evening. Marcel's father, one of the candidates, is re-elect-

ed as councillor for a second term of office with 159 votes from the 169 electors in the village.

1904. Sunday, Blainville-Crevon
In the first poll, Eugène Duchamp and ten other candidates are re-elected to the municipal council by a clear majority. A second poll will be held on 8 May to elect the twelfth councillor.

1917. Tuesday, New York City
Marcel dines with the Picabias, Louise Norton, Beatrice Wood and Albert and Juliet Gleizes.

1946. Wednesday, New York City
Aboard the SS *Brazil* of the Cunard Line, sailing today for France, Duchamp finds a telegram wishing him "Bon voyage speedy return" from James Johnson Sweeney [24.4.1946]. The majority of the passengers are families of American military personnel stationed in France and Belgium.

1965. Saturday, Paris
Duchamp lunches with Baruchello.

1968. Wednesday, Neuilly-sur-Seine
Duchamp writes to Arne Ekstrom in New York to say that he and Teeny will be in Rome between 8 and 11 May.

2 May

1921. Monday, New York City
Marcel is invited to a small gathering at Florine Stettheimer's studio in the Beaux-Arts Building on Bryant Park. With her sister Ettie, the other guests are Marsden Hartley and Alfred Stieglitz whom Florine met for the first time at Hartley's exhibition at the Anderson Galleries the previous week. Discussing her picture *Heat*, Stieglitz claims it was the "only painting" in the "First Retrospective of American Art", an exhibition organized by Marie Sterner at the American Fine Arts Society, and says the "most pleasant things" generally about Florine's work.

1928. Wednesday, Paris
The Picabia exhibition at the Intimate Gallery [30.3.1928] has been a success and brought some reward [18.4.1928].

"Wonderful of you," comments Duchamp in his telegram requesting Stieglitz to deposit the funds due to him at the Fifth Avenue Bank.

1940. Thursday, Paris
Jacques Villon and Gaby, who have been staying at the home of Mme Charlotte Mare and her mother Mme Merlin at Bernay, are once more guests at 14 Rue Hallé. Mary and Marcel insist that Gaby adjust slowly to life again in Paris, but Villon misses Rue Lemaître and, inspired by Proust, complains ruefully that Paris is the realm of *Temps perdu et à perdre*.

1942. Saturday, Sanary-sur-Mer
"I'm achieving my aim after a year on holiday," writes Duchamp to Georges Hugnet [9.3.1942], alerting him of his departure in two weeks for New York via Casablanca. "I much regret that your spoonerisms have not yet appeared, I would have taken some [copies] with me." As Mary Reynolds has the details of a 48-hour service, Duchamp suggests that Hugnet could still send an express parcel with a few brochures.

1945. Wednesday, New York City
"I don't think you *locked* the valise," replies Duchamp to George Heard Hamilton's SOS. "The snap does not lock – you need a turn of the key to lock it," he explains, offering if necessary to go to assist the young curator of Modern Art at Yale University Art Gallery.

As a souvenir of "Duchamp, Duchamp-Villon, Villon" [1.3.1945], "this beautiful show", Duchamp asks Hamilton to accept the second chessboard as a gift; the first board and the *Chèque Tzanck* [3.12.1919] should be sent to Miss Dreier, 100 East 55th Street.

1949. Monday, New York City
In prompt reply to his letter posted on Saturday, Duchamp receives a wire from Fiske Kimball proposing a meeting in Philadelphia the following morning. At twelve-forty Duchamp telephones Kimball and they agree to meet on Friday morning instead.

1951. Wednesday, New York City
The canvas entitled *Baptême* [16.6.1935] which, via Marcel, the Arensbergs purchased from the widow of Dr Tribout in 1937, is being restored by Miss Adler. As the inscription on the back, which reads "Au cher Tribout carabin j'offre ce Baptême", has caused some puzzlement, Marcel explains: "*carabin* is the slang word for medical student." In the same letter to the Arensbergs, Marcel confirms that Dumouchel's portrait [9.2.1951] is now with Lefebvre-Foinet and will be shipped to them immediately.

1958. Friday, New York City
Having received confirmation of their reservation of an apartment in Cadaqués for the month of August, Marcel replies in haste to Suzanne about their plans for the summer in Europe [16.4.1958]. He agrees to Suzanne joining them in Spain and says that they will decide with her about Sainte-Maxime when they arrive in Paris on 30 May. "If you write to me again," adds Marcel in his postscript, "give me your telephone number again, and Gaston's, which I have lost."

1960. Monday, New York City
George Heard Hamilton meets Duchamp in New York to show him his text, "Inside The Green Box," which is to be published as one of the appendices in the typographic version of the notes [21.4.1960] for the Large Glass. After Duchamp has read and approved it, Hamilton returns to New Haven and posts it to Richard Hamilton in London.

1968. Thursday, Paris
As the student unrest escalates in the city, the Duchamps travel to Italy.

3 May

1896. Sunday, Blainville-Crevon
Not six months since he was elected mayor [7.11.1895] following the death of his predecessor, Eugène Duchamp and his fellow councillors face the regular municipal elections. In the first ballot all 12 councillors are elected with a clear majority with Marcel's father polling 132 votes from an electorate of 137.

1905. Wednesday, Paris
After a week's absence, Duchamp returns to the Académie Julian and pays for a further four weeks of morning sessions, which are held from eight o'clock until noon, with the use of an easel costing 25.10 francs.

1917. Thursday, New York City
The editors of the *Blind Man*, who are preparing the second issue of the magazine [27.4.1917], dine together and afterwards call on the Arensbergs.

1919. Saturday, Buenos Aires
"I play day and night and nothing interests me more in the world than to find the right move," writes Duche, his absorption in chess being his excuse to the Stettheimers for not writing for so long [13.1.1919]. "So forgive a poor idiot, maniac. I know you are good enough to forgive."

"Nothing transcendental is happening here," he continues. "strikes, lots of strikes…" Painting appeals less and less; he has met Robert C. Brown, a friend of Max Eastman's, and they gossip about New York.

And what of Ettie, Florine and Carrie? "I would so much like to receive your news," Duche tells them, "but naturally out of sight, out of mind… is a superb 'bromide'." Have they held many dinner parties this winter? Ettie mentioned Gaston Lachaise. "An excellent sculptor in the Nadelman sense…" Marcel remarks. He met him once or twice and likes him but doesn't agree with the religious attitude he has to his work which, he believes, is common to many sculptors and musicians and spoils the "manufacture" of their work.

"Silence and reverence," writes Duche, "are their watchwords, something of importance will be created etc.."

Do the sisters see Roché from time to time or is he out of favour? Marcel chides them for being so particular and considers himself "very happy" to have not displeased or wearied them. Where is Leo Stein with his aesthetic enquiries? "I can only ask you questions," he claims, "I have only question marks around me."

Imagining that the doll's house must be nearly finished Duche would like Carrie to tell him about the elevator. And what "groups" has Florine painted since his departure? To describe her work, Duche says he likes the word "group", which is not so deadly as "composition". He explains its aspect of being "mobile", concluding that the whole canvas should not be "left to the imagination but regulated by optical necessities, common to almost all individuals".

With these words, "le Duche" bids the sisters farewell and asks them to write to his parents' address in Rouen: when his letter reaches them he will have left Buenos Aires.

1935. Friday, Paris
With the intention of having it assembled and photographed for an exhibition at the Museum of Modern Art, Miss Dreier has opened the case in which *Rotative Plaques Verre (Optique de Précision)* [20.10.1920] has been packed since Dee left it with her before returning to Europe [10.2.1923]. In the same case as the pieces for the machine, there is also *3 Stoppages Etalon* [19.5.1914], the three wooden rulers which Duchamp used when he painted *Tu m'* [8.7.1918] for Miss Dreier, and this is the cause of the confusion. With diagrams, Dee sends her clear instructions for reassembling his first motorized machine, which com-

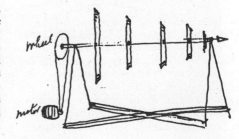

3.5.1958 4.5.1959 5.9.1967

prises five panels of glass painted with black and white arcs, an iron horse and shaft, a wheel and motor with connecting cord and two wooden beams.

Remembering the incident with Man Ray in 1920 when they were building the machine, he warns Miss Dreier that when the machine is turned on, it should not be made to go too fast: a resistance should be put on the motor to control the speed.

1946. Friday, at sea
On the third day's sailing from New York, a large parcel is delivered to Duchamp "with a vague indication: H. Waste [5.10.1923]". The surprise gift from Ettie Stettheimer is a case of champagne which Marcel has the joy to invite Virgil Thomson and other friends on board to share with him immediately. But he puts some bottles aside for the family.

1952. Saturday, New York City
"Thanks yes Totor," is his reply by cable to Roché's proposal that a small exhibition entitled "Hommage à Marcel Duchamp" be held for a week at the Galerie Carré in Paris.

1954. Monday, Cincinnati
Marcel writes a card to Naum and Miriam Gabo announcing his recent operation [18.4.1954] and saying that they hope to be back in New York by 15 May, and Teeny adds her own message.

1958. Saturday, New York City
Thanking him for the "beautiful" photograph, Duchamp tells Henri Marceau that he was unaware of this "portraitist-poet" side of him. "I see with what love you play with an often intractable instrument," he comments. In case there is a chance to see him, Duchamp informs Marceau that he is meeting Marcel Jean [18.4.1958] at the museum on Tuesday.

1960. Tuesday, New York City
"The simplest solution," Marcel tells Jackie, who has embarked on a new series of valises [28.4.1960], "is that you do as you wish for the green paper…" With confidence in the framer, Marcel advises: "In fact the more you can have made by Perez, the better." So as not to lose time he also tells Jackie: "I beg you not to hesitate to take decisions which you think good

without worrying about my preferences, and above all thank you. *Carteblanchement* to you and Bernard, affections too, Marcel."

4 May

1917. Friday, New York City
With Roché and Beatrice Wood, Marcel goes to the printers to make the final corrections and pass to press the second number of the *Blind Man*. Afterwards they lunch together at Old Times.

*

After the lecture on Cubism by Dr E. Southard [17.11.1916] at the Independents [9.4.1917] the evening is spent at the Arensbergs'.

1924. Sunday, Rouen
As a member of the Cercle Rouennais, Duchamp plays on the first chessboard in a club match against the Echiquier Elbeuvien and wins both his games.

1929. Saturday, Paris
After accompanying the American painter Paul Gaulois [5.1.1927] to see Léonce Rosenberg and show the dealer his work, Dee reports in his letter to Miss Dreier: "Rosenberg was delightful – he is actually interested."
Giving his travel plans to Miss Dreier (whom he is meeting in Hanover on 8 May), Dee adds delightedly: "The suit is great."

1943. Tuesday, New York City
Miss Dreier and Duchamp have lunch with Robert Parker and the Kieslers.

1947. Sunday, New York City
In the evening at seven, Marcel visits the Kieslers at 56 Seventh Avenue.

1952. Sunday, Paris
Opening of James Johnson Sweeney's exhibition "L'Œuvre du XXème Siècle" at the Musée National d'Art Moderne, which has been organized under the auspices of the Congrès pour la Liberté de la Culture. Although in principle since the donation of their collection to the Philadelphia Museum of Art [27.12.1950], nothing can be lent to exhibi-

tions, Duchamp has obtained Louise and Walter Arensberg's agreement to lend two of his canvases [27.3.1952]: *Mariée* [25.8.1912] and *Nu descendant un Escalier*, No.2 [18.3.1912]. The exhibition, which comprises over a hundred pictures and a dozen sculptures, travels afterwards to the Tate Gallery, London.

1959. Monday, Perpignan
Robert Lebel has sent the posters for La Hune, as suggested, to the Hôtel de France at Perpignan [26.4.1959], and Duchamp has come from Cadaqués to sign them. Having returned the package containing the signed posters to the post office, Duchamp turns the confirmation of his deed into a pun, which he cables to Lebel at La Hune in Paris: "Fais sous moi = Marcel Duchamp."

With the illustrations for Robert Lebel in mind [15.4.1959], Duchamp's attention is drawn to Bonnevie's shop window, the pâtissier at 5 Place Jean-Jaurès.

1961. Thursday, Philadelphia
Having agreed to advise on the rehanging of the Arensberg Collection [22.4.1961] Marcel arrives from New York City with Teeny. Henri Marceau has arranged for them to stay overnight at 2601 Parkway, an apartment house just across the road from the museum.

5 May

1914. Tuesday, Paris
In his article entitled "La Critique des Poètes" published in *Paris-Journal*, Guillaume Apollinaire replies to Gaston Thiesson's views expressed in his article "Le Salon des Indépendants et les critiques" which appeared in *L'Effort libre* the previous month. Responding to Thiesson's question as to who Francis Picabia had influenced, Apollinaire writes that maybe he is wrong to search for the influences which painters may effect or be subjected to, but he believes that "it is undeniable that Picabia has affected two interesting painters who explore: Marcel Duchamp and Jacques Villon, of whom the former has a real and great talent".

TALE BY ERIK SATIE
*I had once a marble staircase which was
so beautiful, so beautiful, that I had it
stuffed and used only my window for get-
ting in and out.*

*Elle avait des yeux sans tain
Et pour que ca n'se voie pas
Elle avait mis par-dessus
Des lunettes a verres d'ecaille.*

S. T., E. K.

1917. Saturday, New York City
The second number of the *Blind Man* is pub-
lished today by P.B.T. [27.4.1917]. The con-
tents include Mina Loy's interview with
Duchamp's discovery, Louis Eilshemius
[9.4.1917], letters of encouragement from
Frank Crowninshield, editor of *Vanity Fair*,
and Alfred Stieglitz, poems by Walter Arens-
berg, Francis Picabia, Charles Demuth, Charles
Duncan [8.10.1916] and Frances Simpson
Stevens, an article on Marie Laurencin by Ga-
brielle Buffet, a drawing by Clara Tice
[20.4.1917], and a short contribution by Erik
Satie.

The burning issue, however, addressed
bluntly and firmly in the guise of an editorial,
is "The Richard Mutt Case". How could Mr
Mutt's fountain be refused exhibition on the
grounds of immorality or vulgarity when it is
commonly displayed in plumbers' showrooms?
It cannot be a plagiarism, because Mr Mutt
chose it, gave it a new title and in doing so,
gave it a new thought, thus removing its utili-
tarian significance. To refuse it as a "plain
piece of plumbing", the editorial concludes, is
absurd: "The only works of art America has
given are her plumbing and her bridges."

Louise Norton discusses the case of *Fountain*
[9.4.1917] in social and philosophical terms
under the "neutral" but "perversely" penned
title of her article "Buddha of the Bathroom".
Citing Rémy de Gourmont's essay *La Dissocia-
tion des Idées*, she points out how sacred is the
marriage of ideas we inherit and that, in
accepting them without question, "our eyes are
not our own." How valuable it would have
been for Art itself if *Fountain* had been exhib-
ited and installed with on one side an estab-
lished masterpiece from the past, and on the
other side "almost any one of the majority of
pictures now blushing along the miles of wall
in the Grand Central Palace..." To reply to the
critics who say that if the object is Art, it can-
not be Mr Mutt's because he didn't make it,
Louise Norton declares that: "*Fountain* was
not made by a plumber but by the force of an
imagination," and it is this, above all, that has
caused the commotion. To the question, "Is he
serious or is he joking?" she suggests that "per-
haps he is both!" and that the spectator must
judge. After all, isn't there a certain bitter irony
for the artist to observe the hypocrisy in this
"over-institutionalized world" which at the

same time worships "Progress, Speed and Effi-
ciency" rather "like a little dog chasing after its
own wagging tail that has dazzled him"?

To illustrate "The Richard Mutt Case", Alfred
Stieglitz photographed *Fountain* at his gallery
[19.4.1917]. By choosing his angle carefully
and casting a veil-like shadow on its form,
Stieglitz emphasized the Buddha or madonna
aspects of the offending object. For the back-
ground he chose a canvas by Marsden Hartley,
The Warriors, the central form of which is curi-
ously similar to that of the porcelain silhouette.

*

One of the readers of the *Blind Man*, Marcel
Douxami, a mining engineer serving in the
auxiliary services of the French army, who is
on mission in New Brunswick, loses no time to
write to the editors. He has also received a set
of *391*, Picabia's rival magazine, published in
Barcelona [4.4.1917], and is seriously rattled.
Picabia in particular has irritated him. Is it
really the painter or an impostor? If anyone
can solve the urinal dilemma, it is surely Louise
Norton, although she will probably need to
call Bergson to her rescue.

The thesis of Max Goth, the philosopher of
391, who divides the world into two spiritual
families – the children of Adam, who believe in
apparent and superficial realities, and the chil-
dren of Abraham, who are concerned uniquely
with essential and arcane realities – leaves
Douxami perplexed. How can the mind of
Abraham find anything in common between a
flower and the combustion engine, a line and
an idea, a colour and a memory, love and a
chemical phenomenon, etc.?

Douxami thinks that Picabia would make a
good industrial draughtsman, but his mechani-
cal mind in the field of art is infuriating
because there is nothing aesthetic in it. As for
Picabia's poetry, it resembles the work of René
Ghil, which he read in the madness of his
youth, and American music... In listening to
one or reading the other, Douxami is reminded
of lines from Lord Byron's *Childe Harold*,
which he quotes from memory scrambling the
first two lines:

There is a pleasure on the lonely shore.
There is a rapture in the pathless woods.
There is society where none intrudes.

1936. Tuesday, Paris
"Can't arrive before 25," cables Dee to Miss
Dreier at The Haven [21.4.1936], suggesting
that Villon, who went to America on 15 April,
could take the *Normandie* to return to France.

*

Since their meeting earlier in the year
[19.1.1936], Duchamp has designed for
Georges Hugnet the cover of his forthcoming
book: *La Septième Face du Dé*. "I am seriously
accelerating the printing of the cover," writes
Duchamp to Hugnet. "The background colour
will probably be printed Thursday evening. So
if on Thursday you could give me the finished
plate of the title, we will have the cage and the
title printed on Friday and the embossing will
be done on Monday."

1949. Thursday, New York City
The lectures by Miss Dreier [5.3.1948], James
Johnson Sweeney and Naum Gabo delivered at
Yale University under the auspices of the
Thomas Rutherford Trowbridge Art Lecture
Foundation are being published as a book,
Three Lectures on Modern Art, by the Philosoph-
ical Library.

At Miss Dreier's request, Dee calls to see
Mrs Rose Morse at the Philosophical Library,
15 East 40th Street, to discuss the size of the
book and the illustrations.

1959. Tuesday, Paris
Just a month after Sidney Janis' manifestation
[6.4.1959], cocktails are served at the Galerie
La Hune to celebrate the publication of the
"de luxe" version of Robert Lebel's book *Sur
Marcel Duchamp*, which is accompanied by a
small exhibition of documents. The ordinary
editions of the book, both in French and Eng-
lish, have yet to appear. For the little show
Man Ray has provided a blow-up photograph
of *Elevage de Poussière* [20.10.1920]. Just the
previous day "on pilgrimage" to Perpignan,
Duchamp signed a certain number of posters
and posted them back to Paris.

1961. Friday, Philadelphia
After spending two days advising Henry Gar-
diner on the rehanging of the Arensberg
Collection in the museum, Marcel returns to
New York with Teeny.

1966. Thursday, Neuilly-sur-Seine
Although the Tate Gallery's retrospective exhi-

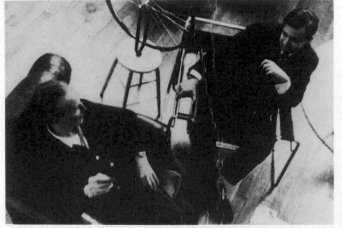

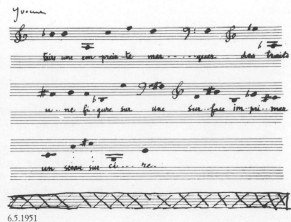

5.5.1966 6.5.1951

bition opening in London on 17 June will not be shown in Paris, to mark the occasion of his first major exhibition in Europe, Pierre Cabanne interviews Duchamp for *Arts & Loisirs*. It is the period when the young artists of Pop, Op, Neo-Dada and New Figuration consider Duchamp as their Master. What does he think of this unexpected veneration?

"I don't think anything about it! One accepts it... I take it with simplicity, without attaching any importance, or even drawing any conclusions... I suppose that all these young generations need a prototype. In that case I play the role of the prototype... nothing more than that. There is no obvious similarity between what I did and what they have done. And I did as little as possible. All that has nothing to do with today's attitude. The attitude today, on the contrary is to produce as much as possible and to earn as much money as possible."

Is Pop Art still very important in the States?

"It's important," replies Duchamp, "but it will be short-lived, like every other movement..."

Cabanne asks whether he is shocked that artists have the right to Social Security? Duchamp explains that as an American who is over 70, he has the right to $57 a month, even though he has not paid much in the way of contributions. It has nothing to do with being an artist or not, but is simply a question of age.

And why did Duchamp choose to be American? "I didn't choose," he explains, "I found myself there from 1915 to 1918 without intending to stay, and then I stayed because the atmosphere was extremely agreeable. It was not the Parisian rat race. I have always thought that if there were people who would shoot you in the back, it is certainly here... The French were completely icy, closed in their aims; their aesthetic theories were lamentable. Either one was fundamentally Fauve or one was Cubist."

Does Duchamp have the impression of being better understood in America, than in France?

"Yes, a little because there was *Nu descendant un Escalier* [18.3.1912]. People knew the picture [17.2.1913], but they didn't know me. For forty years my name was unknown."

Does it bother Duchamp that most of his work is at the Philadelphia Museum of Art where the public is relatively limited?

"No. On the contrary, I prefer it because those people really interested in me will go there. It's not at the ends of the earth..."

Why hasn't there been a Duchamp exhibition in France?

"I have no idea... François Mathey wanted to organize one last year at the Musée des Arts Décoratifs, but he told me: 'I have no money.' Transport and insurance are expensive."

Is his statement: "a picture that doesn't shock is not worth the trouble," a justification of himself?

"No, not exactly. In an artist's production there are only four or five paintings that count even if the artist is called Leonardo da Vinci... There are only certain things that made his name. One cannot produce all the time. To believe that... a 'genius', each time he touches a pencil, does something brilliant, is real stupidity."

What impelled you in your choice?

"Nothing... Indifference. Indifference in the aesthetic sense, indifference in the sense of taste. An attack against taste. You like something because it is blue or yellow... or it is a shape which interests you. I tried – I don't intend to say that I succeeded – to suppress the idea of taste and the idea of attraction."

What is the proportion of game?

"Total, naturally. It doesn't interest me to make something definitive, eternal."

Is Duchamp tired of being labelled an iconoclast?

"Oh, no! because I couldn't care less. The way I live doesn't depend on what others say about me... I don't owe anybody anything and nobody owes me anything."

Has he ever suffered from ceasing to paint physically?

"Not at all. During the forty years that I haven't touched a brush or pencil, I have been really unfrocked in the religious sense of the word. It sickened me... But I have nothing against painting, believe me; I don't want to demolish everything; everyone has the right to live and to do as he pleases."

Commenting on Henri Pierre Roché's statement that his best work is the use of his time, Duchamp denies that he makes his life a work of art. "That people say so, or believe it, I am not against it, but I cannot really see the reason... You believe that you see yourself, and you see nothing at all. In fact you see yourself

inside out. It's the same thing with the question you raised to have an aesthetic life as such. Perhaps. But, in the end, what does that really mean? What will be left? Two years after my death, no one will say anything more! I have had an absolutely marvellous life... I had luck, fantastic luck. I never had a day without eating, and I have never been rich either. So, everything turned out well!"

6 May

1888. Sunday, Blainville-Crevon
A prospective candidate in the municipal elections for the first time, Marcel's father is elected to the municipal council with 167 votes by an electorate of 180.

1900. Sunday, Blainville-Crevon
Eugène Duchamp, mayor of the village, offers himself for re-election in the municipal elections. In the first ballot, 128 out of 171 electors cast their vote and ten councillors obtain a clear majority, including Marcel's father, who is returned with 122 votes. A second ballot will be held the following Sunday to elect the remaining two councillors.

1911. Saturday, Rouen
In the afternoon at two-thirty the second exhibition in Rouen [19.12.1909] of the Société Normande de Peinture Moderne opens in an old fifteenth-century building situated at 141 Rue de la Grosse-Horloge. As a member of the Hanging Committee with Duchamp-Villon, Pierre Dumont (president of the society), Maurice Louvrier (secretary), Robert Pinchon and Eugène Tirvert, Duchamp has been involved with the show's presentation.

In a short preface to the catalogue, the committee states that in its view "each generation contributes a new form of thought expressed in a new language. We have brought together Norman painters and sculptors who, in their work, have understood and felt this need and applied all their efforts to think for themselves... The Société Normande de Peinture Moderne wishes, in a liberal way, to bring to light and to present the aesthetic thought of its

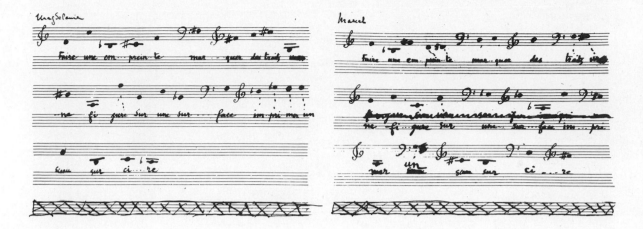

generation and hopes that its visitors will bear this in mind in judging this second exhibition."

Duchamp exhibits three canvases all painted in 1910 during the period when he was influenced by Cézanne and became acquainted with the Fauves' strident colours. Reporting later for *Rouen-Gazette*, Pierre Maridort greatly admires *Portrait de M. Duchamp père, assis*, in which Duchamp's father is captured in one of his favourite attitudes. Qualifying the canvas as "quite simply admirable", Maridort finds "the drawing is simple, energetic, without hardness; the shadows and the greenish and purple colours are harmonious".

La Partie d'Echecs [1.10.1910], which was exhibited at the previous Salon d'Automne, "offers the same qualities of simplicity, reality; the composition is very good and the colours well arranged." Maridort also refers to "a Nude study by Marcel Duchamp called *Figure* – I know not why – of which the breasts particularly are very beautifully painted."

1917. Sunday, New York City
After the busy day on Friday followed by an evening at the Arensbergs', and his attendance on Saturday in the rain at the parade on Fifth Avenue, Roché went home early on Saturday night. When Marcel telephones at two in the morning inviting Roché to join him at Louise Norton's, Roché declines: he is "sleeping too profoundly".

1920. Thursday, New York City
Engaged by Miss Dreier to handle the publicity campaign to promote the recently opened gallery of the Société Anonyme [30.4.1920], Russel M. Crouse interviews Duchamp. Commenting on the declining interest in Modern Art since the excitement caused by the Armory

Show in 1913, Duchamp says: "People took the Modern Art movement seriously when it first reached America because they believed we took ourselves very seriously. They would view a painting and murmur 'Wonderful! Exquisite!' because they thought they were expected to. The probability is that they were looking at a picture that was meant to be humorous.

"A great deal of Modern Art is meant to be amusing... But a great many people seek to treat it all so seriously and solemn-faced. We thought people would laugh with us at our defiance of convention. Instead they tried to be serious about it all – they laughed at us, not with us.

"A better understanding is coming now. If people will just remember the far-famed American sense of humour when they see our pictures and do a little thinking for themselves, instead of trying to get someone to interpret for them, Modern Art will come into its own."

Crouse considers that he has "some very good lines", but Duchamp, reticent about the personal publicity, refuses to let the journalist use his name in the article.

1940. Monday, Paris
At about six in the evening Marcel, Mary Reynolds and Gaby Villon are due to meet Villon at Gaby Picabia's apartment, 11 Rue Chateaubriand, a stone's throw from the Champs-Elysées. Gaby's daughter Janine is leaving for the front to drive an ambulance and Pancho Picabia is just back on leave.

After an hour or so with Gaby, whom Villon finds "really picturesque", Mary, Marcel and the Villons depart for Neuilly where Suzanne and Jean Crotti are expecting them for dinner at 5 Rue Parmentier.

1949. Friday, Philadelphia
As arranged on Monday, Duchamp has an appointment with Fiske Kimball at eleven o'clock at the Philadelphia Museum of Art. After Kimball has shown Duchamp around the museum, they are invited to lunch with Ingersoll. Their discussions, which continue in the afternoon when they return to the museum, turn on the question of space and Duchamp makes detailed notes on the architecture of the different rooms. Kimball also shows him the library and proposes that a special room could be provided for Arensberg's library and the continuation of his work on Sir Francis Bacon.

1951. Sunday, New York City
Replying to Anthony Hill in London, who is preparing an article on music and Dada, Duchamp recalls New York when they were "the happy exiles" in 1915–1918; "Nearly every evening we would meet at the Arensbergs!" says Duchamp, "In fact I think that is where Varèse met Louise [Norton], his wife. We had our iconoclast fun without knowing that there was to be a word for it in Zurich, and certainly Varèse's music was the right song to it."

Describing *Erratum Musical*, the musical score included in the Green Box [16.10.1934], Duchamp says that it was made in 1913 with his two youngest sisters in Rouen. "Each one of us drew as many notes out of a hat as there were syllables in the dictionary definition of the word: *imprimer*," he explains. This musical experiment with chance (an earlier example of which is Mozart's *Musikalisches Würfelspiel*) was also performed by the family trio.

Zahlentafel

1. Walzerteil

	I	II	III	IV	V	VI	VII	VIII
2	96	22	141	41	105	122	11	30
3	32	6	128	63	146	46	134	81
4	69	95	158	13	153	55	110	24
5	40	17	113	85	161	2	159	100
6	148	74	163	45	80	97	36	107
7	104	157	27	167	154	68	118	91
8	152	60	171	53	99	133	21	127
9	119	84	114	50	140	86	169	94
10	98	142	42	156	75	129	62	123
11	3	87	165	61	135	47	147	33
12	54	130	10	103	28	37	106	5

2. Walzerteil

	I	II	III	IV	V	VI	VII	VIII
2	70	121	26	9	112	49	109	14
3	117	39	126	56	174	18	116	83
4	66	139	15	132	73	58	145	79
5	90	176	7	34	67	160	52	170
6	25	143	64	125	76	136	1	93
7	138	71	150	29	101	162	23	151
8	16	155	57	175	43	168	89	172
9	120	88	48	166	51	115	72	111
10	65	77	19	82	137	38	149	8
11	102	4	31	164	144	59	173	78
12	35	20	108	92	12	124	44	131

1952. Tuesday, New York City
After learning that Duchamp is one of the executors of Miss Dreier's estate, the director of the Philadelphia Museum of Art, Fiske Kimball, writes reminding Duchamp of their visit to Milford [13.4.1951] and indicates as he did last year [19.4.1951] that it is really only the

6.5.1958

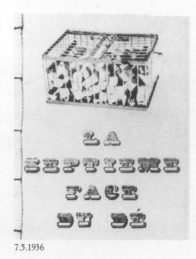

7.5.1936

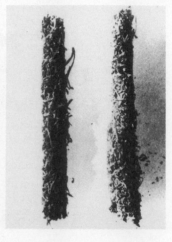

Large Glass which he would like to see join the Arensberg Collection.

In his reply Duchamp confirms that the executors intend offering the Glass to Philadelphia and says: "Miss Dreier always had it in mind, and she actually spoke to me about it only a few weeks before she died."

Referring to Kimball's reference in an earlier letter to the article in *Life* magazine [26.4.1952], Duchamp comments: "It would be hypocritical to say that my 'farther' ego was not pleased…"

*

Knowing that it will please them, Marcel sends the news about the Large Glass and Philadelphia to Lou and Walter Arensberg.

1958. Tuesday, Philadelphia
In the afternoon at three Duchamp has arranged to meet Lily and Marcel Jean [18.4.1958] at the Philadelphia Museum of Art. Making his first visit to the museum, Marcel Jean takes a number of photographs, notably of the Large Glass [5.2.1923], which he plans to use in his book on Surrealism.

1963. Tuesday, New York City
Writes to Douglas Gorsline [31.3.1963] proposing to meet him at one for lunch at the café-brasserie of the Hôtel Lutetia, Boulevard Raspail, on 16 May the day after his arrival in Paris. "Don't telephone unless you want to change it," advises Duchamp.

1967. Saturday, Neuilly-sur-Seine
In a telephone call from Claude Givaudan, who has just received a letter from Octavio Paz, Duchamp learns that for the French edition of *Marcel Duchamp o el castillo de la pureza*, the author recommends Monique Fong as translator [19.1.1967].

7 May

1936. Thursday, Paris
For the loan of *Chimère* by Brancusi to the International Surrealist exhibition due to open at the New Burlington Gallery, London, on 11 June, Duchamp signs a statement giving a value but declaring that the sculpture is not for sale and is to be returned to him after the exhibition.

In the evening at nine o'clock, Duchamp is due to meet Georges Hugnet, who has the plate for the title of *La Septième Face du Dé* which is now required for the printer [5.5.1936]. The front cover, which is illustrated with *Why not Sneeze?* [11.5.1935] and has a very ornate alphabet for the title of the book, is to be printed the following day. The back cover has an enlarged photograph of tobacco compacted in the form of two cigarettes with their paper removed.

1937. Friday, Paris
Giving the solution of Fred Lazard's problem, Duchamp selects one by O. Nemo for the readers of *Ce Soir*. He comments on a game by correspondence between players in Stockholm and Riga, before completing his chess column with several short news items.

1947. Wednesday, New York City
At a recent dinner party given by the Sweeneys in honour of Simone de Beauvoir, to which Duchamp was also invited, an excursion to Connecticut was proposed to the French writer, who is on a lecture tour in America. Duchamp has arranged an invitation to Milford, having diplomatically reminded Miss Dreier beforehand that Simone de Beauvoir "is the second head of Existentialism (Sartre being the first)".

In the morning when the Sweeneys, Duchamp and their French guest set off for the country, it is Mrs Sweeney who drives the vast station wagon with its wooden coachwork, the speed of which surprises Simone de Beauvoir. Finding Yves Tanguy's bright yellow house at Roxbury in the labyrinth of wooded lanes, "where milestones and signposts are as parsimonious as in the Far West," is easier said than done. When eventually they arrive, Tanguy offers them raspberry-pink rum cocktails followed by an "excellent" lunch.

Simone de Beauvoir regrets that they cannot visit the nearby studio of Sandy Calder, "with its fauna and flora of softly murmuring mobile metal," because that day the sculptor happens to be in New York. Instead she discovers "Miss Dreier's residence in the heart of the quiet village of Milford, with its painted wooden houses scattered on lawns where a stream flows". Among the Chinese vases, eighteenth-century knick-knacks and Spanish retables are the most

rare pieces of Modern Art, one of which is Duchamp's Large Glass [5.2.1923]. Although broken, Simone de Beauvoir finds that "the fine grooves of glass harmonize with the planned drawing, they add more to the truth of this strange object standing at the border of the imaginary world and the real world".

In addition to *Fresh Widow* [20.10.1920], "a false window perfectly imitated of reduced size," Simone de Beauvoir remarks on "an elevator which resembles so exactly a real elevator that the elderly lady uses it to go up from one floor to another [23.6.1946]".

A question from Miss Dreier – what is the most distant memory retained from her anterior existences – leaves Simone de Beauvoir embarrassed for an answer.

On their return, Mrs Sweeney takes the parkway snaking through the country far from the built-up areas. Approaching New York, they drive along the banks of the Hudson with Washington Bridge before them in the distance. The sun is setting behind the Empire State Building as the interchanges become more frequent and complicated. Relieved that Mrs Sweeney makes no error in her pathfinding, Simone de Beauvoir returns safely to the Brevoort.

1951. Monday, New York City
An exhibition devoted to the work of Kupka, Villon's neighbour first in Montmartre [12.11.1904] and then at Puteaux, opens at the Louis Carré Gallery, 712 Fifth Avenue. In a small catalogue containing many tributes to the artist, is a short one written specially for the occasion by Duchamp:

"Almost fifty years ago Kupka gave a memorable New Year's party at his studio at the Rue Caulaincourt and shortly thereafter he began to see 'abstract' as one calls it nowadays. For the word was not yet in the dictionary of that happy time. Apollinaire used the word 'Orphism' when he spoke about these things. …And now the search for the father is conducted by the father-candidates themselves, who do not, (however), believe in any polypaternity of this gigantic child."

1952. Wednesday, New York City
Since sending a telegram to Roché on 3 May, Marcel has been giving some thought to the proposed exhibition of his to be held at Louis

7.5.1947

THE LITTLE REVIEW
CALENDAR YEAR **1** p. æ U.

8.5.1922

Carré's gallery in Paris around 20 May depending on the opening of Sweeney's "L'Œuvre du XXème Siècle" at the Musée National d'Art Moderne.

"A maximum of three or 4 things seems to me the best idea," writes Marcel to Roché, listing the works: *9 Moules Mâlic* [19.1.1915], *Rotative Demi-sphère* [8.11.1924], *Les Joueurs d'Echecs* [23.4.1932], and the *Rotoreliefs* [30.8.1935] if a system can be found to turn them at 30 rpm. The *Boîte-en-Valise* [7.1.1941] could be displayed in a vitrine.

Rose Fried has been instructed to start a dialogue with the Art Institute of Chicago with regard to *9 Moules Mâlic*, which is in Roché's collection. "I do not wish your glass in the Guggenheim Collection at any price," Marcel tells Roché.

*

Knowing that there is little enthusiasm in Philadelphia [19.4.1951] for the remainder of Miss Dreier's personal collection, Duchamp has decided to offer the group of works to Duncan Phillips, who purchased a fine Juan Gris from Miss Dreier [24.7.1950] in October 1950. Duchamp writes to Phillips requesting a meeting in Washington the following week to discuss the matter with him.

1966. Saturday, Bazoches-sur-Guyonne
At their country residence near Montfort-l'Amaury, west of Paris, Louis Carré and his wife organize a small dinner party to which M. and Mme Jean Cassou and M. and Mme Marcel Duchamp are invited.

Cassou, retired director of the Musée National d'Art Moderne, is delighted with the evening, which has been arranged "really intimately" so that they can "in all liberty and attentiveness, relax in the pleasure of the intercourse of minds".

1967. Sunday, Neuilly-sur-Seine
Further to Claude Givaudan's telephone call the previous day, Duchamp informs Monique Fong that she has been chosen to translate the essay by Octavio Paz, *Marcel Duchamp o el castillo de la pureza*.

"There is no question of having the book ready for the exhibition [30.4.1967]," he writes, "because I must deal with the illustrations – but if your trip to Japan is not too long – the translation, knowing you, will be ready quite quickly."

8 May

1916. Monday, New York City
On his return to Manhattan after an absence of a week, Duchamp finds three letters waiting for him. Two are from John Quinn, dated 1 and 3 May requesting translations [26.1.1916] of two letters, one from Duchamp-Villon and another from Georges Rouault; the third is from the artist Morton Schamberg, who is organizing an exhibition in Philadelphia in collaboration with the Bourgeois Gallery [1.4.1916] and would like to include a work by Duchamp and *Femme assise* by Duchamp-Villon, which belongs to John Quinn [15.3.1916].

1922. Monday, New York City
At the offices of the *Little Review*, 27 West 8th Street, Duchamp learns that Margaret Anderson and Jane Heap are awaiting money from Francis Picabia before publishing his special number. While in the office, he writes to Picabia on their behalf suggesting that maybe the opera star Marthe Chenal, who is a good friend, might write something in collaboration with Francis and send some photographs of herself which would be excellent publicity. "Naturally endeavour to persuade her to send a large cheque," suggests Duchamp. The cover has not yet been decided, but the *Little Review* would like to have something striking…

Due to appear in the same number, with financial support from the Société Anonyme, is the first part of Mrs Knoblauch's translation of Apollinaire's *Les Peintre Cubistes* [17.3.1913].

1926. Saturday, Paris
Writing from Berlin Miss Dreier has asked Duchamp to look at the work of Marcelle Cahn, who would like to be included in the Société Anonyme's exhibition [27.4.1926]. Fernand Léger has told Duchamp that Miss Cahn has been studying with him and Amédé Ozenfant and that Léonce Rosenberg has some of her canvases in his gallery. Today Duchamp visits her studio at the Hôtel Farnèse, 32 Rue Hamelin, and chooses two paintings "entirely abstract" which he thinks will help make the Léger group important in the exhibition.

1929. Wednesday, Paris
With a new suit and an air ticket, gifts from Miss Dreier [4.5.1929], Duchamp leaves 11 Rue Larrey early in order to be at Le Bourget for a morning flight to Cologne. In conjunction with Lignes Farman, Lufthansa has a regular flight at eight o'clock, arriving at Butzweiler Hof just before noon local time, which gives Duchamp comfortable time to reach the centre of the city for his lunch appointment.

At the Dom Hotel by the great cathedral, Duchamp is due to meet Miss Dreier's cousin, Willi Maler, who is a composer and conductor, and possibly Heinrich Campendonk, professor at the Düsseldorf Academy and a director of the Société Anonyme. After lunch, Duchamp can board the train leaving at two-forty from the central station nearby.

Arriving in Hanover at seven, Duchamp joins Miss Dreier in time for dinner at the renowned Kastens Hotel.

1945. Tuesday, New York City
The day after the signature at Eisenhower's headquarters in Reims of unconditional surrender, today the German surrender is also signed at the Soviet headquarters in Berlin. To celebrate the armistice, André Breton, Man Ray and Duchamp dine together, and choose a German restaurant on 14th Street.

1949. Sunday, New York City
In the morning Marcel writes a lengthy report to Louise and Walter Arensberg about his visit to Philadelphia on Friday. Attaching his own sketch plans of the space proposed by Fiske Kimball for their collection, Marcel writes: "The difficulty will be now to divide the space offered so that it does not look like an ordinary museum collection." He also suggests that when they go to Chicago [17.4.1949] and before making the final decision, they should see the museum in Philadelphia.

1951. Tuesday, New York City
As Alfred Barr was too busy last week he has proposed that Duchamp meet him at the Museum of Modern Art for lunch today. Duchamp's planned visit to Chicago [24.4.1951] has been postponed until the following week.

1955. Sunday, New York City
"I find it very clear in that it applies to very diverse and less known sides," writes Duchamp

"ROTORELIEF"

241720. — M. p. désigner des imprimés, papiers et cartons, papeterie, librairie, articles de bureau, encres à écrire, à imprimer et à tampon, reliure, articles de réclame, instruments pour les sciences, l'optique, la photographie, phonographes, cinématographes, poids et mesures, balances, disques d'optique, déposée le 9 mai 1935, à 15 heures, au greffe du tribunal de commerce de la Seine (n° 301095), par M. *Duchamp (Marcel)*, 11, rue Larrey, Paris.

9.5.1935

to Jean Schuster, who has sent him a copy of his text "M.D. vite", which has yet to be published. "One must hope," Duchamp adds, "that another *Médium* will appear for it."

Returning the biography and bibliography of Jean-Pierre Brisset, whose work he much admires [20.2.1947], Duchamp says that he has spoken to Bill Copley about a new edition of his works. Copley agrees to discuss the question with Schuster and the publisher, Arnold Fawcus [26.2.1955].

9 May

1916. Tuesday, New York City
"I was out of town until yesterday, that's why you didn't hear from me," writes Duchamp from 1947 Broadway to John Quinn, promising the translations of the letters [8.5.1916] by Friday or Saturday.

For Morton Schamberg's exhibition in Philadelphia which is due to open mid-May, Duchamp asks Quinn whether he will lend *Femme assise* by Duchamp-Villon [24.8.1915] allowing Stéphane Bourgeois to send it with a selection of other works from the recent exhibition [1.4.1916].

1929. Thursday, Hanover
During a busy day with the group of young avant-garde artists in the city, friends of Miss Dreier's, Duchamp meets Kurt Schwitters and Carl Buchheister, both natives of Hanover. At Kasten Haus, Duchamp also attends Miss Dreier's lecture, "Modern Art in America," at a meeting of "Die Abstrakten Hannover" which is presided over by Carl Buchheister.

1935. Thursday, Paris
In the afternoon at three, Duchamp registers the trademark, ROTORELIEF, at the Greffe du Tribunal de Commerce de la Seine (n° 301095).

The trademark number 241720 is for designating "printed matter, papers and cardboards, paper trade, book trade, office material, inks for writing, printing and stamping, bookbinding, advertising material, scientific instruments, optics, photography, phonographs, cinematographs, weights and measures, scales, [and] optical discs [30.3.1935]…"

1942. Saturday, Sanary-sur-Mer
Before moving to Marseilles to await his departure for Casablanca, Duchamp writes to Victor Brauner [3.10.1941], who also wants to leave France: "Will you be in Marseilles? If not send me a note which I will give to Peggy [Guggenheim] giving her as complete a description as possible of your desires… It's your turn," he tells the artist, "and I will do my best so that Barr and Peggy overcome the difficulties."

*

Since his last message to them from Geneva [26.3.1942] Marcel has forwarded the Steegmullers' cards and recent cable to his brother. With his papers in order and passage arranged, Marcel hopes to be in New York around 20 June. "I am bringing you a painting from Villon," writes Marcel to Bea and Francis, "let us hope that both of us will get over safely."

1946. Thursday, Le Havre
Although the first contingent of American soldiers' families arriving on the SS *Brazil* today will stay aboard until transport for them is arranged to Reims, Compiègne and other towns in Provence and Belgium, Duchamp and

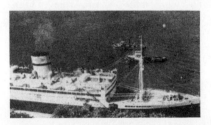

Virgil Thomson are amongst the thirteen passengers going to Paris who disembark from the ship. Bringing with them gifts of all kinds for family and friends, Virgil, who is returning to his apartment on the Quai Voltaire, has "ten trunks of consumer goods: transparent music paper for composer friends, plain music paper for students at the Conservatoire, old suits of clothes for everybody, nylon stockings, Turkish towels, quantities of soap, toilet paper, razor blades, cigarettes and all kinds of packaged edibles…"

1949. Monday, New York City
Standing firm against the Galerie Maeght's advances, Marcel prefers Roché not to exhibit *A propos de jeune Sœur* [8.3.1915] on its own. "The real reason is that I have less and less wish to show off and condone the little Parisian (and

New York) stock exchange game with painting." For Marcel "all this charlatanry of taste" almost obliterates that there is "something else" other than a "more or less lucrative profession. It is also for that (a great deal)," he insists, "that I live a long way from the Paris commodity."

As Walter Arensberg has broken the original *Air de Paris* [27.12.1919], Marcel requests Roché to purchase an identical replacement, suggesting that he return to the same pharmacy if it still exists.

"Saw Copley in Calif[ornia]," adds Marcel in a postscript, explaining that as the gallery in Beverly Hills [1.4.1948] has closed after financial losses, there is little chance of selling *La Nuit Espagnole*, "but perhaps later."

1960. Monday, New York City
Marcel thanks Richard Hamilton for the layout of *Erratum Musical* [6.5.1951], which he finds "just like it". The typographic version of the Green Box is nearly finished [21.4.1960]: "Now that you tell me how close you are to your end of it," Marcel tells Richard, "I am getting jittery (also). When do you think we will see the first copy?"

1961. Tuesday, New York City
"My reply for Smith College is no," writes Marcel to Kay Boyle at the MacDowell Colony. "Unfortunately I am unable to give lectures – at best can I reply to questions at the fireside." Thanking her for the invitation to Rowayton, Marcel says that their visit and "also the bottle of champagne" will have to be deferred until the autumn because they leave for Spain on 29 May.

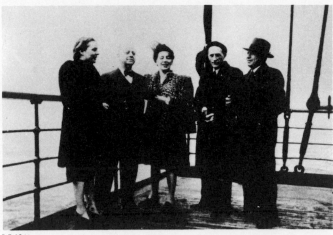

9.5.1946

1964. Saturday, Neuilly-sur-Seine
At 5 Rue Parmentier Duchamp receives Douglas Gorsline [6.5.1963], who has a list of further questions for him.

10 May

1908. Sunday, Paris
A welcome distraction from the municipal elections, the second Salon des Humoristes [25.5.1907] organized by *Le Rire* at the Palais de Glace opens to the public. With entry to the exhibition at one franc (one franc for wags and half-price for idiots! says Willette), the turnstiles work overtime. Among the comic portraits of the famous by Sem and Léandre, the poetic posters by Willette, the pretty pastels by Cappiello, Forain's models, Gustave Doré's caricatures and Métivet's rumpled beds with all sorts of couples in various uniforms and different states of undress, Duchamp exhibits four cartoons entitled: *Digestion*, *American Bar*, *Gigolo de luxe* and *Croquis*.

1917. Thursday, New York City
In the evening, between seven and midnight, Marcel and Roché have a long talk with Beatrice Wood.

1929. Friday, Hanover
Duchamp and Miss Dreier travel by train to Dessau where the Bauhaus [18.8.1924] has been installed since 1925. Nina Kandinsky is waiting at the station and takes them to the Goldener Beutel Hotel.

In the evening, when he has finished his classes at the Bauhaus, Vasily Kandinsky and his wife entertain Duchamp and Miss Dreier at their home.

1935. Friday, Sèvres
After registering the trademark the previous day, Marcel goes to see Roché at 24 Avenue de Bellevue to discuss the project he has in mind for his optical discs.

1942. Sunday, Sanary-sur-Mer
As requested [21.3.1942], a copy of *Corps et Biens* has arrived for Duchamp at the Hôtel Primavera. Duchamp writes a card to Robert

Desnos in Paris saying: "I found the same pleasure in 'Rrose Sélavy' [1.12.1922] as many years ago."

Duchamp's departure from Marseilles is now scheduled for either Thursday or Friday.

1946. Friday, Paris
The day after his return to France, at five o'clock in the afternoon Marcel calls to see Roché at 99 Boulevard Arago.

1961. Wednesday, New York City
As the oil sketch by Villon presented by Louis Carré for the auction in aid of the American Chess Foundation interests Brookes Hubachek, Marcel tells him what Carré considers the normal minimum price. "I would not bid more than $3,100," advises Marcel, "with a chance to get it."

Marcel also informs Brookes that he has telephoned Mr Guggenheim [11.2.1961] and made an appointment to see him on 16 May.

1962. Thursday, New York City
Because of his departure for Europe at the end of the month, Duchamp writes to Bill Camfield at Yale University proposing an appointment at 28 West 10th Street on 22 May at five in the afternoon.

1967. Wednesday, Paris
"Salute to Man Ray," an evening discussion in the presence of the artist, takes place at the American Center for Students and Artists. Duchamp, Alain Jouffroy, Roland Penrose, and Patrick Waldberg are members of the panel, which is chaired by David M. Davis. As reported by Mary Blume for the *New York Herald Tribune*, Man Ray recalls the day in 1915 at Ridgefield, New Jersey, when he first met Duchamp and the only English words Duchamp knew were "yes" and "no".

"I brought out a couple of old tennis rackets, and a ball, which we batted back and forth without a net," says Man Ray. "I called the strokes to make conversation – 15, 30, 40, love, to which Duchamp replied each time with the word "yes".

"We understood each other very well, we sort of had confidence in each other," Man Ray continues. "Most painters are arrogant."

"I wasn't," says Marcel Duchamp.

"No, you weren't," Man Ray agrees. "Those who are sure of themselves never are."

The unfortunate Mr Davis then asks Duchamp why he stopped painting.

"Because I've stopped everything," replies Duchamp, who then stops talking for the rest of the evening.

11 May

1917. Friday, New York City
In the early hours of the morning after taking Bea home, Marcel and Roché decide to visit Louise Norton at 110 West 88th Street.

*

Public fervour for France has been rising since Wednesday when the French Minister of Justice, M. Viviani and Maréchal Joffre narrowly escaped a rail accident on their way back from Kansas City to Washington. To participate in what Ettie calls the "joffreing", Mrs Stettheimer's chauffeur drives the three sisters Ettie, Carrie and Florine accompanied by Marcel to the vicinity of the city hall, where the French mission is to be received officially. The streets are already too densely crowded for them to see anything, but Ettie notices that the large glass windows on the upper floor of Monroe's outfitters are almost empty.

They enter and request an invitation to use the perfect vantage point, which is gallantly accorded by the young manager. Overhearing this exchange, the young man's boss intervenes and it is only with persistence that Ettie gets her way.

"We have a gentleman with us," she argues, "but he's a Frenchman."

The shopkeeper relents, "All right, hats off to the Frenchman!" Knowing Duchamp's views on the war, Ettie is amused by the man's reply.

They watch the whole show. In front of the "quaint colonial-looking City Hall", there are "troops of schoolgirls waving flags, khaki boys built up on a pyramid, soldiers in khaki, and the old guard and the veterans, all colonial in appearance…" Ettie notices that Joffre keeps looking up at the skyscrapers.

*

In the evening, Marcel dines at the Arensbergs' with Beatrice Wood.

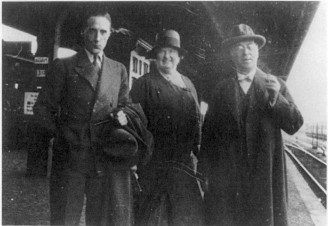

11.5.1929

11.5.1935

1929. Saturday, Dessau
"Delightful aero," writes Marcel on a postcard to Villon, referring to his flight on Thursday, "one thinks again of painting landscapes. I speak German less and less badly, not enjoying myself enormously – too much painting. Back on Thursday or Friday until Sunday..."

At the Kandinskys', after Miss Dreier has written in the visitor's book, Duchamp also signs his name with his good wishes and the date.

When it is time for them to leave Dessau, the Kandinskys accompany their guests to the railway station and Nina takes photographs of Duchamp, Miss Dreier and Kandinsky on the station platform.

1935. Saturday, Tenerife
The opening at the Ateneo de Santa Cruz in the Canary Islands of the "Exposición surrealista" is attended by André Breton, who wrote the preface to the catalogue. Several small items by Duchamp are exhibited, including *Pharmacie* [4.4.1916], and *Spirale*, one of his optical discs [5.3.1935]. *Why not Sneeze?*, signed Rose Sélavy, is a little cage without a canary. It contains a thermometer, cuttlefish, a tiny porcelain dish and is weighted with white marble cubes the size of sugar lumps. The object greatly upset Dorothea Dreier, who agreed in 1921 to give Duchamp the commission *carte blanche*. Even Katherine Dreier, her sister, was unable to accept it and it was acquired by Henri Pierre Roché.

"It is funny that the sugar is not sugar," remarks Duchamp. "That the sugar is marble, and this marble is cold generally, so there is a thermometer to indicate it. It is a mental pun... I introduced the pun by using marble and all this goes into a cage naturally. It is a queer unexpected relation. An unexpected meeting."

O sucrier 'A la Perruche',
Notre raison se tait, trébuche,
Fais qu'en son bain l'oiselle sneeze:
Marbre de canne ou bien de Nice?

1936. Monday, Paris
After receiving a letter from Miss Dreier giving him the timetable of trains from New York to West Redding, Connecticut, Dee replies immediately to confirm that his ship is due to dock

on 25 May and that he will telephone to say whether he will be on the 15:35 train or not. Wanting to see Villon if he is still in New York for a few days [5.5.1936], Dee requests Miss Dreier to ask his brother to write to the ship. "This is my first summer in America for *years!*" Dee tells Miss Dreier, "It will be grand."

*

Pierre Charnay dedicates a copy of *De toutes les Heures*: "To Marcel Duchamp Souvenir of a poet."

1937. Tuesday, Paris
Five days ago the Hindenburg airship exploded on its arrival in New York, killing 34 people. Miss Dreier, who might have been on board, is returning to the States by sea and

Dee is relieved to write to her "on an earthly boat, for if we all miss catastrophic trains, very few control the taking of a dirigible".

Dealing with some small matters for Miss Dreier in Paris, Dee has arranged for her trunk to be picked up and for some pottery to be delivered to Lefebvre-Foinet. He thanks her for the cheque which Man Ray will change for him and confirms that the printing of her lithographs [16.4.1937] has started.

1946. Saturday, Paris
Following their discussions the previous afternoon, Marcel returns to Arago at four-thirty for a couple of hours. He signs a paper to the effect that, due to the disappearance during the war of documents relating to his company with Roché, and having sold all his Brancusi sculptures, in the future he has no further rights on the Brancusis mentioned in previous lists.

1947. Sunday, New York City
Marcel dines with Maria Martins at the Blue Danube Restaurant, where they also meet the Kieslers and Nelly van Doesburg.

1953. Monday, Paris
To mark the Fifth Anniversary of the foundation of the Collège de 'Pataphysique [6.8.1952] on 22 palotin 80 (today's date according to the calendar of Alfred Jarry), His Magnificence the Vice-Curator-Founder of the Collège de 'Pataphysique has deigned to put his signature to the list of Promotions and Nominations.

Those promoted to the Corps of Satrapes are as follows:
Camille Renault, Sculptor at Attigny,
Marcel Duchamp, Entity,
Max Ernst, Official Painter to His Majesty the Emperor,
G., C., and H. Marx Brothers, Economists and Sociologists,
Madame the Fourth Republic, woman of the world,
Jacques Prévert, manufacturer...
Ergé, Boris Vian, Pascal Pia, and M. the Baron Jean Mollet (ex-secretary of the late Guillaume Apollinaire).

1956. Friday, New York City
In reply to Roland Monteyne in Oostham, Belgium, Duchamp says that as far as he knows, Henri Pierre Roché has not written his biography. However, as Roché will reply with pleasure to his questions, Duchamp gives him the address at Sèvres. "[Roché] is preparing a re-edition of pieces about me [1.6.1953]," writes Duchamp, "to appear together with other things by Breton and Lebel."

1959. Monday, Cadaqués
Duchamp sends Serge Stauffer the information he requests about the *Rotoreliefs* [30.8.1935], and suggests that the typographic version of the notes in the Green Box being prepared by the two Hamiltons, which is due to appear in the autumn, will help him in his work.

*

Hoping that the posters he signed in Perpignan on 4 May have arrived safely and are all sold, Duchamp asks for Lebel's opinion "au clair, de la Hune!" He has started to think about the three illustrations [15.4.1959]...

1965. Tuesday, Neuilly-sur-Seine
"It's not a *poire à tabac* but a *carotte à tabac* – in English, a tobacco shop sign [28.11.1961]," writes Marcel to Arturo Schwarz, who is continuing his work on the *catalogue raisonné* [30.1.1965].

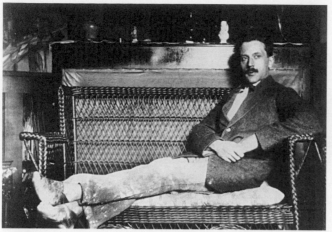

11.5.1965

Denying that *Informations* is his portrait, Marcel says he doesn't remember having a model for the drawing: "At the very most it could be an ambition of personal elegance realized subconsciously." But according to Carmen Cartaya, the model for the drawing dated 1908 was Georges Ayzaguer, who used to pose for Marcel [29.1.1909]. The wicker seat in the drawing is very similar to the one at 7 Rue Lemaître which appears in a photograph of Duchamp-Villon, his trousers spattered with plaster. In the background of the photograph, hanging on the wall to the left, is the watercolour *Le Roi et la Reine traversés par des Nus en vitesse* [9.10.1912].

Having decided that he and Teeny would like to spend 24 hours in Basel on their return from Italy in June, Marcel requests Schwarz to arrange their air tickets, Paris–Rome and Rome–Milan only. "Because we would like to take the train Milan–Basel if it exists direct," explains Marcel, "and do Basel–Paris by train also."

Finally Marcel tells Schwarz the recent piece of news: "The etching has started with Hayter."

Using his drawing in charcoal of the heads of Duchamp-Villon and Villon in confrontation, the first study for the painting *Portrait de Joueurs d'Echecs* [15.6.1912], Marcel is working on a print to give to each participant in an exhibition project [10.4.1965] to benefit the American Chess Foundation.

Wanting to thank Jackie Monnier for so beautifully arranging the apartment at Neuilly for their occupation [21.4.1964], Marcel inscribed the original drawing, *Etude pour les Joueurs d'Echecs*: "Pour Jackie, la fée Parmentière Marcel 1964."

12 May

1916. Friday, New York City
Duchamp thanks John Quinn for agreeing to lend *Femme assise* by Duchamp-Villon to the exhibition in Philadelphia [9.5.1916] and encloses the translations as promised. In the letter from Rouault, Duchamp has had to add some words in parentheses and comments: "Even so, I think you will not quite understand some phrases which have a doubtful sense in French also."

1917. Saturday, New York City
In the afternoon, Beatrice Wood takes Joseph Stella and Marcel with her to buy a hat.

After having dinner at an Italian restaurant, Louise Norton, Aileen Dresser, Roché and Marcel return to 110 West 88th Street.

1927. Thursday, Paris
In March, soon after his return to Paris from New York [4.3.1927], Marcel met Lydie Sarazin-Levassor at a dinner party with Germaine and Francis Picabia at the Grand Veneur in Rue Pierre Demours. The introduction was made by Germaine Everling, a childhood friend of Lydie's father, who knew that Henri, son of the famous automobile constructor, was searching earnestly for a husband for his twenty-four-year-old daughter.

Today M. and Mme Henri Sarazin-Levassor celebrate the engagement of their daughter Lydie to Marcel Duchamp with an afternoon tea party at their home at 80 Avenue du Bois de Boulogne, close to the Arc de Triomphe.

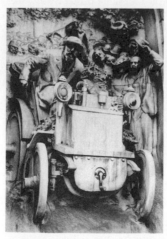

Respecting convention, Marcel has sent Lydie a magnificent basket of flowers; he had searched in vain for a black diamond, suitable for mounting on a platinum ring – the ordinary ring, which they chose instead, the Sarazins found too modest and it was exchanged for a more flamboyant, large pearl.

1935. Sunday, Paris
Dee's letter [3.5.1935] explaining that there are two separate works, *3 Stoppages Etalon*

[19.5.1914] and *Rotative Plaques Verre* [20.10.1920], stored in one box, has not eliminated the confusion. On reception of Miss Dreier's cable which reads: "Never received any other box. Saw glass panels thought these only Revolving Glass which I bought. Now find 3 Stoppages Etalon. How do we exhibit them. Where is Revolving Glass," Dee decides to cut the matter short and replies: "Useless exhibit Stoppages."

1943. Wednesday, New York City
Mary Reynolds and Marcel dine with the Kieslers and Howard Putzel.

1947. Monday, New York City
Maria Martins and Marcel dine with the Kieslers and Le Corbusier at Monte's Restaurant.

1961. Friday, New York City
Paul Matisse comes to see Teeny and Marcel before their departure for Europe on 29 May.

1965. Wednesday, Neuilly-sur-Seine
After sorting out the papers and paintings of his late sister and brother-in-law, Duchamp has made arrangements with Lefebvre-Foinet for a "gemmail", a small canvas by Jean Crotti, and a portrait of Jean by Suzanne to be sent to Claude Blancpain [1.8.1958] in Fribourg hoping that for him and his family these works will be "a constant presence of two good friends lost".

Duchamp has also given instructions to Lefebvre-Foinet to allow a French friend of Joseph Solomon's to collect a *Boîte-en-Valise* [7.1.1941].
*

In the evening, at seven o'clock, Duchamp has an appointment with Louis Carré.

13 May

1911. Saturday, Rouen
In its May issue, the arts magazine *Rouen-Gazette* publishes a caricature of Duchamp at his dandiest, sitting cross-legged on a stool, with cane, spats, bow tie and broad-brimmed felt hat, quietly smoking his pipe. The author is

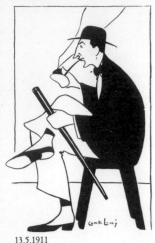

13.5.1911

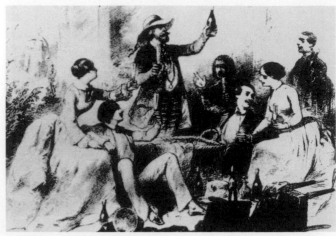

13.5.1960

Camille Lieucy, a cartoonist and also a member of the Société Normande de Peinture Moderne [6.5.1911].

1917. Sunday, New York City
After their night together, Aileen, Roché and Marcel have breakfast at Louise's.

Later there is a "grand evening" at the Arensbergs' with a Russian dancer.

1922. Saturday, New York City
With Henry McBride, Carl van Vechten, Beatrice Locher, Ettie and Carrie, Marcel attends a tea party given by Florine Stettheimer at her studio, 80 West 40th Street.

1927. Friday, Paris
Marcel visits Roché at Arago and announces his engagement to Lydie which was celebrated the previous day. While they are working on their Brancusi papers, Helen Hessel arrives. Almost as if she were Mary Reynolds' shadow, Roché notices that Marcel is "rather cold" with Helen.

1947. Tuesday, New York City
In the evening while he is at Maria Martins' apartment, 471 Park Avenue, with his collaborators for the Surrealist exhibition – Kiesler, Matta and Donati [1.2.1947] – Marcel tries unsuccessfully to telephone André Breton in Paris.

1958. Tuesday, Bern
In addition to a set of *Rotoreliefs* [30.8.1935], estimated at 500 Swiss francs, which is up for sale in the two-day auction held by Klipstein & Kornfeld, is a copy of the *Blind Man*, No.2 [5.5.1917] and a small gouache by Francis Picabia entitled *Pharmacie Duchamp$ Transatlantique.*

1960. Friday, Hempstead
Lorraine Hansberry, Gilbert Seldes, and Duchamp are the guest speakers at the symposium entitled "Should the Artist go to College – and Why?", an event at the first Contemporary Arts Festival, which celebrates the 25th Anniversary of Hofstra College. Commencing in the morning at ten-thirty with a speech of welcome delivered by the President of Hofstra College, Dr John Cranford Adams, the symposium, held in the Hofstra Playhouse is chaired by Dr Malcolm H. Preston. After the introductions, Duchamp delivers a short prepared speech.

"Ladies and gentlemen, 'Dumb like a painter, *bête comme un peintre*.' This French saying dates back at least to the time of *La Vie de Bohème* by Murger around 1850, and is still used as a joke in our discussions. Why should the artist be considered less intelligent than the average man? Could it be because his technical skill is essentially manual and has no immediate relationship with the intellect? In any case, it is generally accepted that the painter needs no special education to become a great artist. But these considerations are no longer valid. Today, the relationship between artists and society has changed since the day when, at the end of the last century, the free artist asserted himself. Instead of being an artisan, employed by a monarch, or by the church, the artist today paints freely, and he is no longer in the service of the Maecenas; on the contrary, he imposes his own aesthetics. In other words, the artist is now completely integrated in the society. Emancipated for more than a century the artist today presents himself as a free man with the same prerogatives as the ordinary citizen and speaks on equal terms to the buyer of his works. Of course, this liberation of the artist has a counterpart, in some of the responsibilities which could be ignored during his status of a pariah or of an intellectual inferior. Among these responsibilities, one of the most important is the education of the intellect, even though professionally, the intellect is not the basis of the formation of the artistic genius.

"Clearly the profession of artists has taken its place in today's society at a level comparable to the level of learned professions, and is not as before, a sort of superior artisanship. In order to remain at this level, and to feel on equal terms with lawyers, physicians, etc., the artist must receive the same college education. Furthermore, the artist in modern society plays a role much more important than the role of an artisan or that of a jester. He finds himself facing a world based on brutal materialism, where everything is valued in the light of physical well being, and where religion, after losing much ground, is no more the great dispenser of spiritual values. Today, the artist is a curious reservoir of para-religious values, absolutely in opposition to the daily functionalism for which science receives the homage of a blind worship. I say blind because I do not believe in the supreme importance of these scientific solutions which do not even touch the personal problems of a human being. For instance, interplanetary travel seems to be one of the very next steps of the so-called scientific progress; and yet, in the last analysis, it is no more than an enlargement of territory at the disposal of man. I can't help seeing this as only a variant of the present materialism which takes the individual further and further away from the search toward his inner self.

"This brings us to the important concern of the artist today which is, I believe, to keep informed and be aware of the so-called material daily progress. With a college education as ballast, the artist need not fear to be assailed by complexities in his relations with his contemporaries. Thanks to this education he will possess the very tools which permit him to oppose this materialistic state of affairs through a cult of the ego in an aesthetic frame of spiritual values. In order to illustrate the position of the artist in the economic world today, it is obvious enough that every ordinary job is more or less remunerated according to the number of hours spent on it. While in the case of a painting whatever time is spent to make it is not taken into consideration when determining its price, and this price varies with the acclaim of each artist. Internal or spiritual values, mentioned above, and of which the artist is so to speak the dispenser, concern only the individual singled out in opposition to the general values which apply to the individual as part of a society. And under the appearance, I am tempted to say, under the disguise of a member of the human race, the individual, in fact, is quite alone and unique. And the characteristics common to all individuals *en masse* have no relationship whatsoever with the solitary explosion of an individual facing himself alone.

"Max Stirner, in the last century, very clearly established this distinction in his remarkable book, *Der Einzige und Sein Eigentum* (*The Ego and His Own*) and if a great part of the education applies to the development of these general characteristics a part, just as important, of college education, develops the deeper faculties of the individual, the self-analysis and the knowledge of our spiritual heritage. These are the important qualities which the artist acquires in college, and which will allow him to

MODERATOR BOAS: The distinction that Mr. Duchamp is making is that, between the direct effect of the picture upon an observer, and then the reflections that an observer might make upon it which could be called esthetic. Have I got that correct?

MR. DUCHAMP: ~~the man~~ *off taste* ~~trusts his preestablished likes and dislikes~~ The man who gets the esthetic shock — it's a shock — is not master of himself. He ~~is submitted, he is~~ *submits* ~~exclusively to no taste~~ *and becomes humble.*

14.5.1950

keep alive the great spiritual traditions with which even religion seems to have lost its contact. I believe that today, more than ever before, the artist has this para-religious mission, to keep lit the flame of an inner vision of which the work of art seems to be the closest translation for the layman. It goes without saying that to feel such a mission the highest education is indispensable."

1962. Sunday, Paris
In the evening at a quarter to ten, the second part of Jean-Marie Drot's film *Journal de Voyage à New York* [19.4.1962], which is subtitled "New York de nuit, êtres de nuit", is broadcast by French television.

After watching the film "on the screen of sport and politics", Jean-Jacques Lebel writes a card to Duchamp, "painter and philosopher", saying: "Suddenly we saw and heard you. Stupidity was eclipsed and thanks to you, for a moment, we believed that 'all is not lost', that life has, perhaps, even a meaning." Man Ray who is with Jean-Jacques adds: "And your pupil – Man."

1963. Monday, New York City
Acknowledging Brookes Hubachek's message of "bon voyage", Marcel writes: "The reports on Villon's health have not been very good recently and we are anxious to see him."

*

An irregular limerick composed in English by Duchamp for Bill Copley is published today in *Iris Time Unlimited*:

There was a painter named Copley
Who never would miss a good lay,
And to make his paintings erotic
Instead of brushes, he simply used his prick.

14 May

1903. Thursday, Rouen
The "Exposition internationale des beaux-arts", an important show of Impressionist paintings organized by the Société des Amis des Arts de Rouen opening today, includes two canvases by Duchamp's friend, the young Robert Pinchon [11.2.1903].

1927. Saturday, Paris
After their engagement party on Thursday, Marcel dines at 80 Avenue du Bois de Boulogne with his future parents-in-law. Lydie wants a traditional white wedding, Marcel, who would have preferred less fuss, has stipulated a short engagement. As the marriage is to take place on 8 June, there is much to organize in a very short time.

1937. Friday, Paris
Instead of a chess problem, Duchamp publishes a study by Halberstadt composed specially for *Ce Soir*, and comments on the game between Panov and Ioudovitch on 18 April in the USSR championship, which is currently being played at Tbilisi, the Georgian capital. In the news items, Duchamp gives the results of various tournaments, including the "brilliant victory" of the young Estonian champion, Keres, at Prague.

1942. Thursday, Marseilles
After lunching with Victor Brauner [9.5.1942], Jacques Hérold, and Henriette Gomez, Duchamp boards the *Maréchal Lyautey*, which is to take him to Casablanca on the first stage of his voyage to New York. As a souvenir, he gives Hérold one of the series of miniature urinals made for the *Boîte-en-Valise* [7.1.1941]. Before the ship sails, Duchamp is photographed on the bow of the ship, waving farewell to his friends on the quayside.

Since applying for his French passport over a year ago [19.4.1941], and finally obtaining it [25.8.1941], Duchamp had to wait many months while the Arensbergs made applications to Washington on his behalf before he learned that his American visa had been granted [26.3.1942].

1946. Tuesday, Paris
At one o'clock Marcel returns to see Roché at Arago [11.5.1946].

1947. Wednesday, New York City
Duchamp dines at the Mattas' with the Kieslers, and their discussions continue until after midnight.

1950. Sunday, New York City
With news that Wittenborn and Schultz are planning to print the digest of the "Western Round Table on Modern Art" [8.4.1949], Duchamp gives his written permission to Douglas MacAgy to publish his text of the conversations in the corrected form [7.6.1949], which MacAgy sent to him in November.

1958. Wednesday, New York City
Progress is being made on Robert Lebel's book. Duchamp has seen Braziller, who has cabled his agent in Paris to obtain the French dummy from Fawcus so that he can take a decision about the American edition, and George Heard Hamilton has countersigned the contract for the translation of Lebel's text into English [20.3.1958].

In fact the English translation of the last two chapters has just been completed and Duchamp promises to Lebel to forward them. As he wishes to finalize the English text with the author before returning them to Hamilton, Duchamp requests Lebel in his letter to him today to keep them until he arrives in Paris on 30 May.

15 May

1904. Sunday, Blainville-Crevon
At eleven-thirty in the morning, a week after the second ballot, the members of the new municipal council hold a meeting. First, the name of each elected councillor is registered in the order of the number of votes obtained in the ballot. M. Alexandre Déquinemare, the senior councillor presides over the meeting and M. Eugène Duhamel is chosen as secretary. The council then proceeds to elect the mayor. Each councillor is called in turn to give the president the name of their candidate written on a piece of folded white paper. Eugène Duchamp receives ten votes and is elected mayor for another term of office. Receiving seven votes, Déquinemare is elected deputy mayor by the same procedure.

1905. Monday, Paris
Having decided to interrupt his classes, Duchamp commences his last week of study at the Académie Julian [3.5.1905]. To avoid having to serve two years in the army which, if he waits to be called up in 1907, would be ob-

15.5.1965

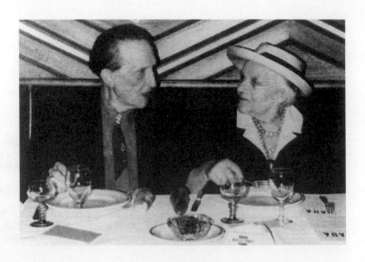

ligatory for him following the repeal of the law [21.3.1905], Duchamp has decided to obtain the necessary qualifications as a copperplate printer and then engage voluntarily in the army immediately. Thus he will benefit from the exemptions available under the old law of 1889 which effectively reduces three years' military service for certain professions to only one year. He will serve his apprenticeship at the Imprimerie de la Vicomté, Rouen.

1917. Tuesday, New York City
In the evening Marcel, Roché, and Beatrice Wood go to Alissa Franc's for dinner.

1922. Monday, New York City
Marcel dines with Walter Pach and Beatrice Wood.

1926. Saturday, Paris
Duchamp has some new works by Francis Picabia which he would like to show to Jacques Doucet. He writes to the collector inviting him to the Hôtel Istria on either 17 May at three-thirty or 18 May between eleven and noon.

1933. Monday, Paris
Three of Duchamp's notes for the Large Glass [5.2.1923] are published today in *Surréalisme au service de la Révolution*, No.5. In the summary printed on the cover of the review, Breton draws attention to the "considerable value" of the unpublished notes of the Large Glass on account of the "entirely new light that they cast on their author's preoccupations".

1941. Thursday, Lyon
Marcel telephones Roché at Les Muriers to announce that he is on his way back to Grenoble.

1946. Wednesday, Paris
In the afternoon at two o'clock, Marcel calls to see Roché again at Arago.

1953. Friday, New York City
"I have received and read most of *Jules et Jim* and with pleasure," writes Marcel to Roché, whose novel, published by Gallimard, was awarded the Prix Claire Belon on 16 April. "A small masterpiece," remarked Raymond Queneau on hearing the news. Roché's deliberately simplified style, Marcel finds "quite irresistible";

the autobiographical content adds "bite", recounting as it does the adventures in the 1920s of Franz Hessel alias Jules, Roché alias Jim and the beautiful women in their lives, particularly Franz's wife, Helen alias Kathe. "Continue," advises Marcel, "but without passing through the Académie Française…"

"Now that I have meant to write you long ago and did not, I hope, at least, that this word will find you on the way to complete recovery," Marcel writes to the Arensbergs, after hearing from Beatrice Wood of Louise's recent operation. The Dada exhibition [15.4.1953] at the Sidney Janis Gallery, Marcel tells them, "was a very amusing experience of re-living some good years."

1955. Sunday, New York City
Writes to Poupard-Lieussou referring to the *Rotoreliefs* [30.8.1935], *Anémic Cinéma* [30.8.1926] and his optical machine (*Rotative Demi-sphère* [8.11.1924]?).

1957. Wednesday, New York City
After spending time making an analysis of the Large Glass by borrowing "on extended loan" the Green Box [16.10.1934] belonging to Roland Penrose, Richard Hamilton, who teaches at the University of Durham, wrote to Duchamp on 27 June 1956 enclosing a diagram which he had used in a Duchamp evening at the Institute of Contemporary Arts in London on 19 June. He is convinced of the need for an English translation of the notes in the Green Box, a kind of "skeleton key" which, he believes, would be invaluable to students. Discouraged by past experiences of projects coming to nought, Duchamp has never replied. However, a recent contact with Henry Steiner, a student of George

Heard Hamilton's at Yale University, who has translated 25 of the notes, prompted Duchamp to show George Hamilton the letter and diagram. As George Hamilton would like to work on the publication of a translation, Duchamp writes to Richard Hamilton saying that he has given George Hamilton his address.

1963. Wednesday, Paris
The Duchamps arrive at night on a flight from New York.

1965. Saturday, Paris
Marcel Duchamp is the guest of honour at the Rrose Sélavy dinner held at the Restaurant Victoria, 6 Rue Blaise-Desgoffe, near the Gare Montparnasse. Organized by the Association pour l'Etude du Mouvement Dada, the dinner is presided over by Michel Sanouillet. Duchamp, who is seated with Gabrielle Buffet-Picabia on his left and Jacques Fraenkel on his right, has an urn inscribed with Rrose Sélavy's signature on the table before him into which he can deposit the ashes of his cigar.

Towards the end of the dinner attended by some thirty members of the association, the president reads out a certificate attesting to the contents of the urn which, at Duchamp's request, is then burnt in the urn.

1968. Wednesday, Paris
On their return to France after spending ten days in Italy [2.5.1968], the Duchamps find Paris in turmoil. Following the general strike and massive demonstrations on Monday, today some 2,500 students are occupying the Théâtre de l'Odéon with the blessing of its director, Jean-Louis Barrault.

At three in the afternoon Duchamp has an appointment with Louis Carré.

16 May

1907. Thursday, Rouen
The Duchamp family are invited to the first communion of Pierre Delacour, son of George Delacour, Lucie Duchamp's first cousin. Villon provides the menus, etched with numerous putti and signed "Jacques Villon rubenixt".

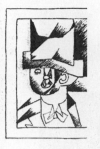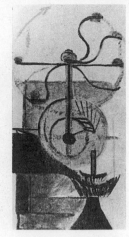

16.5.1916

1916. Tuesday, Munich
A cartoon by Olaf Gulbransson entitled *Bei den Futuristen* appears in today's issue of *Simplicissimus*. In a gallery of paintings, a wounded German soldier contemplates a large canvas the composition of which is dominated by an infernal machine – none other than Duchamp's *Moulin à Café* [20.10.1912] – gruesomely ejecting human legs and an ear into the air. The soldier exclaims: "'The War' they call this picture? Well, it's not as dreadful as that!"

Flanked by two other paintings: the one to the left contains elements characteristic of Kandinsky, and the one to the right is *Portrait d'Homme* by Juan Gris which, like *Moulin à Café*, Gulbransson saw in *Du Cubisme* [20.10.1912].

1939. Tuesday, Paris
The present discontent with the Museum of Modern Art in New York, Miss Dreier believes, might create a swing of support back to the Société Anonyme. To raise money she plans to ask certain artists to donate a special edition of an etching, a copy to be given to each subscriber. Dee promises to speak to Villon about the project.

Returning to matters in his previous letter [19.2.1939]: "Will try seriously to sell Verlaine," writes Dee, "I ought to get $200 – I think."

As requested by Miss Dreier, Dee will also have a print made of the Large Glass, as photographed by Mr Coates, and send it to Kiesler.

He has been to see Bernard Poissonnier, the owner of the mysterious drawing which turned up in Paris, and found that the work in question is *Vierge*, No.2 [7.8.1912]. Poissonnier wants $1,000 for it. "I told him he was crazy," recounts Dee, "but he seems to think he will get that much or almost."

1940. Thursday, Paris
"I am leaving for Arcachon fifteen days I hope. Mary [Reynolds] is staying here," writes Marcel to Roché the day after Holland fell to the advancing German army. He delivers the note to Arago together with ten rhodoids of the Large Glass [5.2.1923] destined for the Valise, nine of which are already framed.

1941. Friday, Grenoble
Taking short cuts, Roché has walked down from Les Muriers in the rain to meet Marcel at the Hôtel Moderne. On his first mission from Paris representing Gustave Candel [25.4.1941],

Marcel has not only brought Roché some cheese but also one of his suits. The lunch is not appetizing but afterwards they enjoy some excellent chocolates.

After shopping, calling at the post office and other errands in the afternoon, they have dinner together in a bar in Place du Marché. To end the day they play a couple of games of chess: giving Roché his Queen, Marcel loses but when he gives him a Castle, he wins.

1947. Friday, New York City
Having tried in vain since Tuesday to telephone André Breton in Paris, Duchamp sends a cable giving Breton the essential news and telling him not to expect a call.

1961. Tuesday, New York City
In the morning when he is received by Mr Harry F. Guggenheim in his downtown office Duchamp explains in a few words that his mission is on behalf of Mr Hubachek [10.5.1961], the collector and benefactor, whose love for the painting by Jacques Villon, *Portrait of the Artist's Father*, is such that he would like to buy it, keep it during his lifetime and then donate it to the Art Institute of Chicago. Mr Guggenheim, who is very friendly, does not refuse to consider the possibility and seems to understand Hubachek's sentiments for the painting, which he shares. He says that as the museum is a foundation he has to consult the trustees and he promises to do so.

Later in the day Marcel writes to Brookes Hubachek and suggests, as he is not very optimistic about the outcome of his meeting, that his friend might consider asking Mr Guggenheim for the painting on loan and that it be returned to the Guggenheim museum after his death?

*

The exhibition held at the Stedelijk Museum [10.3.1961] opens at the Moderna Museet of Stockholm under the title "Rörelse i Konsten". In addition to the works by Duchamp shown in Amsterdam, the first replica of the Large Glass [5.2.1923], which has been made for the show by Ulf Linde, is exhibited for the first time.

1962. Wednesday, New York City
Duchamp sends a telegram to Bill Camfield at Yale University [10.5.1962]: "Can you change 5 p.m. Monday to 2 p.m. Monday. Please telegraph. Sorry."

1963. Thursday, Neuilly-sur-Seine
Duchamp is due to visit his brother Villon [13.5.1963] and, unless he hears to the contrary, have lunch with Gorsline [6.5.1963] at the café-brasserie of the Hôtel Lutetia in Boulevard Raspail.

When he sees Louis Carré later in the day, Duchamp mentions that William Agee is preparing a thesis on the sculpture of Raymond Duchamp-Villon.

1965. Sunday, Neuilly-sur-Seine
Sometime during the last week in April, Duchamp visited the studio of the Polish sculptress Alina Szapocznikow at 32 Rue Alphonse Bertillon in Paris, on behalf of the Cassandra Foundation. Learning that the Copleys are due back on 10 June while he and Teeny are in Italy, Duchamp writes to Alina Szapocznikow suggesting that she contact the Copleys at the Hôtel Pont-Royal on their arrival.

17 May

1896. Sunday, Blainville-Crevon
A fortnight after the first ballot of the municipal elections when Eugène Duchamp and his fellow councillors were all safely re-elected [3.5.1896], a council meeting is held at ten-thirty to elect the mayor. Edouard Papillon, the senior councillor presides and Georges Cottard is chosen as secretary. Eugène Duchamp receives ten of the eleven votes cast, one councillor being absent, and is re-elected mayor of Blainville-Crevon. Alexander Déquinemare is elected deputy mayor.

1914. Sunday, Puteaux
With the date corrected by hand, the invitations, which have been etched by either the poet himself or Jacques Villon, announce to a small circle of friends that "Paul-Napoléon Roinard will read privately... his melodrama in verse *La Légende Rouge* – a synthesis of revolutionary ideas.

You are invited to attend this reading which will take place at 7 Rue Lemaître, Puteaux, from one thirty precisely until six... *R.S.V.P.*"

17.5.1914

The Duchamp brothers and all the usual friends, according to Henri-Martin Barzun, are gathered at the appointed hour in Villon's studio. Guillaume Apollinaire is disappointed that, in the midst of pictures by Villon and sculpture by Duchamp-Villon, there is nothing by Duchamp. Jacques Bon who, in the morn-

ing, set up a trestle table in the studio with glasses and refreshments and arranged the chairs, notices that a number of the poet's guests, many of them humble workers with their families, become restless, unused to sitting for so long, or hearing such rhetoric.

The temperature in the studio rises and claps of thunder interrupt the reading. When the children in the audience lose patience, they are released into the garden much to the dismay of all the cats.

Albert Gleizes and Jacques Bon, who have been charged by Roinard to signal any inconsistencies, notice that it is not a quill that Danton, the principal character, throws down on the table in anger, but the poet's own fountain pen.

1917. Thursday, New York City
In the evening, Marcel dines in China town with Francis Picabia, Edgar Varèse and Beatrice Wood.

1922. Wednesday, New York City
Alfred Stieglitz has asked Duchamp to write, even in a few words, his opinion of photography. Although he is not really happy to do so, Duchamp replies to Stieglitz saying that he would like to see photography "make people despise painting until something else will make photography unbearable".

1930. Saturday, Paris
Without losing a single game, the popular champion Znosko-Borovsky wins the Tournoi Internationale de Paris organized by the Cercle Russe Potemkine. In this tournament of very strong players, Duchamp drew his games against both the winner and M. Romi.

1941. Saturday, Grenoble
It is a sunny day. Marcel and Roché take the cable car and have an excellent lunch at the Restaurant Gras with its fine panorama. While discussing Roché's "memoirs project", the accounts of famous artists' lives, Marcel is full of encouragement.

In the afternoon Marcel takes Roché with him to the Préfecture to enquire about his passport [21.4.1941]. Later at the museum, Marcel gives André Farcy the first batch of items for the *Boîte-en-Valise* [7.1.1941] which he has brought from Paris. The sets of reproductions are to be stored at the museum with Peggy Guggenheim's collection [25.4.1941] until shipment is made to New York.

The small restaurant where they have supper is full of students. Like the night before, they play chess with the same results: giving Roché his Queen, Marcel loses; giving up a Castle, Marcel wins.

1947. Saturday, New York City
In the morning Marcel receives a cable from Aimé Maeght, who has been unable to find a place on a plane to New York.

Following his own telegram the previous day, Marcel writes to André Breton about the forthcoming Surrealist exhibition. Kiesler hopes that Breton can find an assistant for him and would like a hotel near the gallery with modern facilities; *Boogie Woogie* by Mondrian is not available from the American collector, but maybe Carré or someone else in Paris may be able to lend one; and the shipment by sea is due to leave in the next day or so. Reminding Breton to include one of his Picabias in the show, Marcel is still concerned about the date of the opening: although 27 June gives them more time, is it enough?

Marcel also requests that Enrico Donati's collaboration with the catalogue be acknowledged. When they started preparing the covers recently in Donati's studio, there were 999 foam-rubber breasts on the floor to be glued separately by

hand. "By the end," recalled Donati, "we were fed up but we got the job done. I remarked that I had never thought I would get tired of handling so many breasts, and Marcel said, 'Maybe that's the whole idea'."

1949. Tuesday, New York City
"I certainly will be there," replies Duchamp to Katharine Kuh, who has sent him the invitation from the Art Institute of Chicago to attend the opening of the Arensberg Collection on 19 October. "I am not so keen about speaking in public especially on my own work," he writes, declining with apologies to address the Society for Contemporary American Art.

"Did you finally get all the data for the catalogue?" enquires Duchamp, remembering Mrs Kuh's task at the Arensbergs' a month ago [17.4.1949].

1950. Wednesday, New York City
Walter Arensberg has already had conversations about the collection with officials of the National Gallery. On reception of a telegram from Arensberg requesting him to postpone his meeting with Duncan Phillips in Washington until he has received his letter, Marcel cables back: "Have not yet arranged appointment waiting for your letter."

In addition to proposals from the Metropolitan [26.4.1950], earlier discussions with Philadelphia [6.5.1949], and those with Chicago which were terminated [3.1.1950], the Arensbergs have now also been approached by Dallas and Mexico City.

1960. Tuesday, New York City
"I have taken a long time to reply to you because I didn't know how to attack your problem," writes Duchamp to Claire and Gilles Guilbert [21.6.1958]. "Finally Teeny went to Georges Keller, owner of the Carstairs Gallery," he explains, "[and] she spoke to him about your Cézanne..." Keller could visit them in June or, Duchamp suggests, they could write directly to the dealer themselves.

1963. Friday, Paris
At four o'clock in the afternoon, Marcel and two of his sisters, Suzanne Crotti and Yvonne Duvernoy have a meeting with Louis Carré who is looking after Villon's affairs. Villon's health is giving great cause for concern and he is to be admitted to the Hôtel Dieu.

17.5.1964

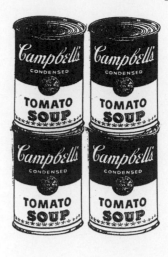

1964. Sunday, Neuilly-sur-Seine
Following a request from Dr Beeren, the curator of the Gemeentemuseum at the Hague, to include *Roue de Bicyclette* [15.1.1916] in the exhibition of New Realists that he is organizing, Duchamp suggests that he write to Arturo Schwarz who will have one available after 5 June. "He is making an edition of 8 copies and would give his consent to you, I'm sure, to lend one for your exhibition," Duchamp explains. "I will be in Milan on 4 [June] to sign them."

Confirming to Richard Hamilton that he has written to the Hague, and announcing at the same time the Schwarz edition, Duchamp promises that he has not changed his mind about signing a special Bicycle Wheel for him. He instructs Hamilton to "make it and keep it in London until I sign it *to you*".

*

In New York, the *New York Herald Tribune* Sunday Magazine publishes an article by Rosalind Constable entitled "New York's Avant Garde, and how it got there" in which the journalist quotes Duchamp's comments on the difference between Dada and Pop Art.

"The humour of Pop Art is not the same. They seem to feel that in a democracy they should have a more reverent attitude towards a garbage can, go lower and lower in the means used to express the art of their day. Instead of Ophelia they will take a prostitute, or something like that. The lower the material used the better. Reverence in reverse. But it's reverence anyway."

"Pop Art," Duchamp considers "is a return to 'conceptual' painting, virtually abandoned, except by the Surrealists, since Courbet, in favour of retinal painting... If you take a Campbell soup can and repeat it 50 times, you are not interested in the retinal image. What interests you is the concept that wants to put 50 Campbell soup cans on a canvas."

And how does Duchamp feel today about the Large Glass [5.2.1923]?

"I like it very much," he replies. "In my career, if I may call it that, it has been a key painting for me, decidedly. There was hardly a trace of tradition in it. I consider that big glass painting of mine something which you don't have to look at to like. That was one of the ideas behind it. You should look at it as at a Sears & Roebuck catalogue. You look at part of it and say: 'This was intended to do this and that.' I intended to do a book that would show reduc-

tions of what was on the glass, and why – and not from the retinal image again, but from the conceptual. That is the idea before and the execution later. But of course I never did the book..."

1965. Monday, Paris
At five-thirty in the afternoon Duchamp has an appointment with Louis Carré.

1966. Tuesday, Paris
On behalf of the Cassandra Foundation, Duchamp visits the studio of Jean Hélion at 4 Rue Michelet. Duchamp has known Hélion since 1930: after his escape from a prison ship near Stettin, in 1942, Mary Reynolds hid Hélion in Paris for a while until he could travel to Marseilles. There, he joined Duchamp, Tzara, Brauner and Hérold, to await a passage to America.

Hélion tells Duchamp that he has always refused honours and prizes, but he does know of a writer who would write a book on his work. As the Cassandra Foundation never gives awards to writers, Duchamp suggests that Hélion should take the award and pay for the publication of the monograph himself.

18 May

1917. Friday, New York City
With the Picabias and Beatrice Wood, Marcel calls on Roché.

In the evening Marcel and Roché dine with Aileen Dresser.

1926. Tuesday, Paris
In the evening Duchamp leaves by train for Venice.

1927. Wednesday, Paris
At five o'clock in the afternoon Marcel goes to Arago, where he and Roché continue revising their Brancusi papers [13.5.1927].

1928. Friday, Paris
Delighted that the Picabia exhibition was arranged so quickly [2.5.1928], Duchamp tells Alfred Stieglitz: "I love the catalogue." As Mrs

Carpenter, who is in Paris again [27.5.1927], would like to have the show at the Arts Club of Chicago in October, Duchamp is writing to George Of to arrange storage until September. Sending his love to the "Intimates", Duchamp hopes that "in the way of simplification" everything in the show will be sold.

1934. Friday, Paris
Since his return from America [27.1.1934], Marcel has been busy preparing a selection of his notes and documents relating to the Large Glass [5.2.1923] for publication in facsimile to be presented in a cardboard box. He also plans to reproduce the principal paintings and drawings which served as studies for the Glass and include them in the box with the notes. To finance the publication, the printing of which is expensive, Marcel has obtained support from Roché in exchange for the *Cariatide* by Brancusi; he has also the prospect of money from a legacy, and six subscribers for "de luxe" copies of the edition.

"I have been 3 or 4 times to your place with my stencil man," writes Marcel to Roché in Arcachon. "We are having a lot of difficulty and I must make another tracing for him of all the stencils," he continues, referring to the reproduction of *9 Moules Mâlic* [19.1.1915] for the box.

As the estimate for the collotype work is quite steep, Marcel plans to look elsewhere before making a decision. Knowing that he will have to pay the printer within two months and that the legacy is unlikely to be paid in time, Marcel requests the loan of a further 5,000 francs from Roché with *Promethée* or another Brancusi as guarantee.

1941. Sunday, Grenoble
While in the unoccupied zone Duchamp writes on behalf of the Villons to Mme Charlotte Mare [2.5.1940], who is staying with her daughter Anne-Françoise at La Brunié [16.7.1940], summarizing the main points of a letter addressed to her from her mother, Mme Merlin. Because of her great age and fear of leaving the house unoccupied, Mme Merlin has decided to stay at Bernay [2.5.1940] in Normandy.

"Gaby [Villon] has given me the suit, which I will send you from Marseilles in a few days," promises Duchamp, "she has put away the boots and found no trace of mustiness... we are

Photographic Credits

We are very grateful to the following private collections and institutions for making available works in their possession.

The publishers apologize for any accidental omissions from this list; amendments will be made to forthcoming editions.

Akademie der bildenden Künste, Munich

Alpenland Lichtbildwerkstätte, Vienna

Arakawa, New York

Archivio Gruppo Editoriale Fabbri, Milan
(Photos Piero Baguzzi)

Archivio RCS Rizzoli Libri, Milan

The Art Institute, Chicago

Association Internationale des Amis et Défenseurs de l'œuvre de Man Ray (TMR, Collection L. Treillard), Paris © by SIAE Man Ray 1993

The Barnes Foundation, Merion Photograph © Copyright 1993

The Beinecke Rare Book and Manuscript Library, Yale University, New Haven

Bibliothèque Littéraire Jacques Doucet, Paris

Bibliothèque Nationale, Paris

Osvaldo Böhm, Venice

© Centre National d'Art et de Culture Georges Pompidou (Photo Philippe Migeat), Paris

Delaware Art Center, Wilmington

Jacques Faujour, Paris

Fondazione Solomon R. Guggenheim, Venice

Lou Hammond & Associates, Inc., New York

The Menil Collection
(Photo Hickey-Robertson), Houston

Ugo Mulas, Milan

Musée Ingres, Montauban

Musée National Fernand Léger, Biot

Musées royaux des Beaux-Arts de Belgique
(Photo Speltdoorn), Brussels

Museum der bildenden Künste, Liepzig

The Museum of Modern Art, New York

The Museum of Modern Art, Toyama

The Newberry Library, Chicago

Northwestern University Library
(Music Library), Evanston

Philadelphia Museum of Art, Philadelphia

Foto Renard, Venice

The John and Mable Ringling Museum of Art, Sarasota

Service Photographique de la Réunion des musées nationaux, Paris

Staatsgalerie Stuttgart, Graphische Sammlung, Stuttgart

Staatens Konstmuseer, Stockholm

Tokoro Gallery, Tokyo

The World Ship Society, Manchester

Yale University Art Gallery
(Objects Gift of Katherine S. Dreier), New Haven

Zindman-Fremont, New York

and also

Enrico Donati, New York

Pablo Volta, Paris

Marvin Lazarus Archives

Richard Hamilton, London

Paris-Normandie, Rouen

Jean-Jacques Lebel, Paris

Daniel Bunen, Paris

Gianfranco Baruchello, Rome

Ursula and Klaus-Peter Bergmann, Haimhausen

André Morain, Paris

Bibliothèque Nationale, Paris

Dino Gavina, Bologna

Daniel Pype, Paris

Kunstmuseum, Basel

Galerie Louis Carré, Paris

Collège de 'Pataphysique

François Lespinasse, Rouen

Mme Alexina Duchamp Archives

Descharnes & Descharnes, Paris

George Staempfli, New York

Beatrice Wood, Ojai

The Francis Bacon Library, Claremont

Arturo Schwarz, Milan

Ecke Bonk, Düsseldorf

Lufti Ozkok, Stockholm

Archives du Musée nationale de l'Art Moderne, Centre Georges Pompidou, Paris

Richard Lusby

Sidney Janis Gallery, New York

Kestner-Gesellschaft, Hannover

Julien Wasser

Ed van der Elksen, Amsterdam

Ad Petersen, Amsterdam

John Schiff Archives

Lilian Kiesler, New York

Alain Mounier, Paris

Musée de Montmartre, Paris

Museum of the City of New York, New York

James Lee Byars, New York

Henri Cartier-Bresson, Paris

Cordier & Ekstrom, New York

Denise Hare, New York

Arman, Paris

Monique Fong, New York

Mount Holyoke College, South Hadley

Richard Avedon, New York

Nat Frikelstein

Jeanne Levin, Palm Beach

Jean Suquet, Paris

Eliot Elisofon, New York

Harry Ransom Humanities Research Center, Austin

Bibliothèque Municipale, Rouen

The Andy Warhol Foundation for the Visual Arts, Inc.

Alexander Liberman, New York

Mimi Fogt, Sintra

Francesco Turio Böhm

Nicolle de Zayas, New York

Niki Ekstrom, New York

and additional documentation from the Duchamp archive of the Académie de Muséologie Evocatoire, Warelevast.

Synchronopticum

SELECTED FILMOGRAPHY

La Fayette! We come! 1918
35mm (1800 metres), black and white, silent
M.D. in a secondary role [8.7.1918]

Entr'acte, 1924
22', 35 mm, black and white, silent (1968 version with soundtrack, conducted by Henri Sauguet)
Director: René Clair assisted by Georges Lacombe
Scenario: Francis Picabia
Photography: Jimmy Berliet
Minuted music: Erik Satie
Includes sequence of M.D. and Man Ray playing chess [4.12.1924]
Production: Rolf de Maré

Anémic Cinéma, 1926
7', 35 mm, black and white, silent
Copyright Rrose Sélavy
Shot frame by frame by M.D. and Man Ray [30.8.1926]

Le Mariage de Duchamp, 1927
35 mm rushes, black and white, silent
Camera: Man Ray [8.6.1927]

The Witch's Cradle, 1943
16 mm rushes black and white, silent
Director Maya Deren [15.8.1943]: unfinished film

Dreams that Money can Buy, 1944-47
80', 16 mm, Kodachrome
Director: Hans Richter assisted by Miriam Reaburn
Photography: Arnold Eagle
From the 7 dreams one is by M.D. with music by John Cage: Discs (demonstrating Rotorelief), and Nudes descending a staircase [23.4.1948]
Production: Art of this Century Films, Inc.

8 × 8, 1955-57
70', 16 mm
Kodachrome
Director: Hans Richter
Photography: Arnold Eagle
Includes sequence with M.D. as the black King [7.3.1957]

Dadascope, 1956-61
41', 16 mm, colour
Director: Hans Richter
Photography: Arnold Eagle
Includes sequences with M.D. [9.3.1965]

Duchamp (in Cadaqués), 1961
54', 16mm, black and white, silent
Cameraman: Rolf Schneer
Gaumont Actualités archives
Grand Prix, Festival du Film d'Art, Bruxelles 1963
Gran Premio Bergamo, 1964 [19.9.1964]

A Conversation with Marcel Duchamp, 1955
for the television series "Conversations with the Elderly Wise Men of Our Day"
Director: Jean-Marie Drot
Voice of François Chaumette for the commentaries
Includes sequences with M.D. [6.12.1961]
Broadcast by RTF, Paris; part one "New York de jour, êtres de jour" on 19 April 1962 and part two "New York de nuit, êtres de nuit" 1965 Broadcast by NDR on 15 October 1965

In November 1961, M.D. appears in the same programme with the French writer Auguste le Breton. French-speaking TV, Montreal

Monitor, 1966
Interview by Katharine Kuh
Includes sequence with M.D.
Broadcast by BBC on 24 June

Screen test for Marcel Duchamp, 1966
film shot by Andy Warhol at the opening of "Hommage à Caïssa" [7.2.1966]
Copyright: the Andy Warhol Foundation for the Visual Arts, Inc.

Jeu d'échecs avec Marcel Duchamp, 1963
for the television series "L'Art et les Hommes"
Director: Jean-Marie Drot
Broadcast by RTF, Paris on 8 June 1964

Journal de voyage à New York, 1964
Director: Jean-Marie Drot

Museum Open House with Marcel Duchamp, 1964
30', video, black and white
Director: Russell Connor [21.2.1964]
Production: WGBH

Les expositions, 1966
Interview by Adam Saulnier on the death of André Breton
Broadcast on the ORTF news, Channel 1 [2.10.1966]

Rebel Ready Made, 1966
for the series "New Release"
Director: Tristram Powell
20', 16 mm, black and white
Broadcast by BBC on 23 June 1966

Les grandes répétitions: Hommage à Varèse, 1966
Directors: Luc Ferrari and S.G. Patris
With M.D.'s participation from New York
Broadcast by ORTF, Channel 2 [20.4.1966]

Ausstellung Marcel Duchamp in Hannover, 1965
9', video, black and white
Interview by Wieland Schmied [29.9.1965]
Eigenproduktion

Art Actualité, 1967
on the exhibition at the Musée national d'art moderne, Paris
Broadcast on the ORTF news, Channel 1 [2.7.1967]

Images et idées – Trois Hommes – Trois Peintres, 1968
60', 16mm, colour
Producers: Jean-Michel Meurisse and André Fermigier
Includes M.D. interviewed by Philippe Collin [21.6.1967]
Broadcast by ORTF, Channel 1 on 21 January 1968

Late Night Line Up, 1968
Includes M.D. interviewed by Joan Bakewell
Broadcast live by the BBC on 5 June 1968

Signe des Temps
33', 16 mm, black and white
Interview by Jean Antoine (Paris, 1966)
Broadcast by the French speaking Belgian TV in 1971

Grimaces, 1962-67
45', 16 mm, black and white
A film by the artist Erro
M.D. makes one of the 160 "grimaces"
Production: Givaudan
Soundtrack by the artist François Dufrêne

(List established with the collaboration of Carlo Montanaro)

SELECTED BOOKS OF REFERENCE (established in collaboration with Evelyne Pomey)

Including books published since 1968 which do not appear in the Bibliography.

Catalogues Raisonnés

LEBEL, ROBERT, *Sur Marcel Duchamp*, a study of Duchamp's life and work followed by a catalogue raisonné. Paris and London, Trianon Press & New York, Grove Press, 1959. (All texts by R. Lebel on M.D. are published in Robert Lebel. *Marcel Duchamp*, Les dossiers Belfond, Paris 1985, 270 p.)

SCHWARZ, ARTURO, *The Complete works of Marcel Duchamp*, London, Thames and Hudson & New York, Abrams, 1969, XXII-630 p. (2nd edition revised, 1970). 3rd edition to be published in the Fall 1993.

Collected interviews

STAUFFER, SERGE, *Marcel Duchamp. Interviews and Statements*, Stuttgart, Graphische Sammlung Staatsgalerie, 1992, 254 p.

Selected exhibition catalogues

D'HARNONCOURT, ANNE & McSHINE, KYNASTON, *Marcel Duchamp*, The Philadelphia Museum of Art, 22.9.-11.11. 1973; New

York, The Museum of Modern Art, 3.17.1973-10.2.1974; The Art Institute of Chicago, 9.3.-21.4.1974. Published as a book: London, Thames and Hudson, 1974.

HULTEN, PONTUS & CLAIR, JEAN, *L'Oeuvre de Marcel Duchamp*, Paris, Musée National d'Art Moderne (CNAC George Pompidou) 31.1.-2.5.1977. Vol. 1: Jennifer Gough-Cooper & Jacques Caumont, 'Plan pour écrire une vie de Marcel Duchamp'; Vol. 2: Jean Clair, catalogue raisonné;

Vol. 3: *Abécédaire*; Vol. 4: H.P. Roché, *Victor*, unfinished novel.

MOURE, GLORIA, *Duchamp*, Barcelona, Fundació Joan Miró, Feb.-March 1984; Madrid, Fundació Caixa de Pensions, April-May 1984; Köln, Museum Ludwig 27.6.-19.8.1984.

DANIELS, DIETER & FISCHER, ALFRED M., *Übrigen sterben immer die andenen: Marcel Duchamp und die Avantgarde seit 1950*, Köln, Museum Ludwig, 15.1.-6.3. 1988.

On *Etant donnés*

D'HARNONCOURT, ANNE & HOPPS, WALTER, *Etant donnés: 1° la chute d'eau... 2° le gaz d'éclairage..., reflections on a new work by Marcel Duchamp*, Philadelphia, The Philadelphia Museum of Art, 1987, 64 p. (First published in *Philadelphia Museum of Art Bulletin*, 2nd Semester 1969).

D'HARNONCOURT ANNE, *Manual of Instructions for Etant donnés: 1° la chute d'eau; 2° le gaz d'éclairage...* (facsimile), Philadelphia, The Philadelphia Museum of Art, 1987.

BONK, ECKE *Marcel Duchamp, Die Grosse Schachtel* (The Making of the Boîte-en-Valise de ou par Mar-

cel Duchamp ou Rrose Sélavy), München, Schirmer/Mosel, 1989, 324 p.

NAUMANN, FRANCIS M. *The Mary and William Sisler Collection*, New York, The Museum of Modern Art, 1984. pp. 106-219.

150, 155, 165, 172, 176, 186, 191.

FERDIÈRE, GASTON, *Les mauvaises fréquentations, Mémoires d'un psychiatre*, Paris, éd. Jean-Claude Simoën, 1978, 302 p. With the assistance of JEAN QUEVAL. See on M.D. pp. 79-80, 136.

GHEERBRANT, BERNARD, *À la Hune. Histoire d'une librairie-galerie à Saint-Germain des Prés*, Paris, éd. Jean-Pierre de Monza, Coll. "Art Vif", 1991, 230 p. See on M.D. pp. 25, 57, 68, 69, 167, 179-80, 182, 184-5, 186, 188, 189, 190-1, 193-5, 196-7, 198, 203-4, 210, 214, 224, 225. See also "cahier iconographique", pp. 12, 14.

GUGGENHEIM, PEGGY, *Out of This Century. Confessions of an Art Addict*, London, éd. André Deutsch, 1980, 396 p. Preface by GORE VIDAL. Introduction by ALFRED H. BARR, JR. See on M.D. pp. 50-1, 65-6, 140-1, 160-2, 165-7, 198, 204-5, 208, 209, 216, 232, 233, 256, 271-2, 273, 276, 279, 281-4, 293, 295, 296, 299, 307.

HAJICKA, ALICE, *Hier (Souvenirs)*, Paris, éd. du Pavois, 1946, 304 p. See on M.D. pp. 113-4, 169. Passage on pp. 113-4 is reproduced in: *Gazette des Lettres*, 2e année, no. 24, 9 nov. 1946, p. 15.

HUELSENBECK, RICHARD, *Mémoires of a Dada Drummer*, New York, éd. The Viking Press, coll. "The Documents of 20 Century Art." See on M.D. pp. 82-4, 108-12, 113-5.

HUGNET, GEORGES, *Pleins et déliés, Souvenirs et témoignages 1926-1972*, La Chapelle s/ Loire, éd. Guy Authier, 1972, 430 p. See on M.D.: pp. 156-7 "Marcel Duchamp" poème de la suite "Neuf Sons", 1977.

JEAN, MARCEL, *Au galop dans le vent*, Paris, éd. ... See on M.D. ... "L'exposition internationale du surréalisme en 1938." Also see pp. 28-9.

KANDINSKY, NINA, *Kandinsky und ich*, München, Kindler Verlag, 1976. French edition: *Kandinsky et moi*, Flammarion, 1978, 286 p. Translated from the German by JEAN-MARIE GAILLARD-PAQUET. See on M.D. pp. 171-2, 201.

LACAN, JUDITH, ALBUM JACQUES LACAN. *Visages de mon père*, Paris, éd. du Seuil, 1991, 158 p. See on M.D. p. 69.

LEBLANC, GEORGETTE, *La machine à courage. Souvenirs*, Paris, éd. J.B. Janin, 1947, 232 p. Preface by JEAN COCTEAU. See on M.D. pp. 98-9.

LEIRIS, MICHEL, *Journal 1922-1989*, edited and prefaced by JEAN JAMIN, Paris, Gallimard, 1992, 958 p. See on M.D. pp. 100, 101, 107, 293, 299, 316-7, 370, 501, 511, 535, 676, 689, 694, 764, 776, 814, 825, 828.

LEVY, JULIEN, *Memoir of an Art Gallery*, N.Y., ed. G.P. Putnam's Sons, 1977. See on M.D. pp. 18-9 "Duchamp"; pp. 20-7 et 30 "Duchampiana"; pp. 31-5 "Joella"; pp. 28-9 "The Duchamp's Disc" reproduced from *Art News*, Sept. 1958 (review of *From the Green Box*, by G. H. HAMILTON).

LOSFELD, ERIK, *Endetté comme une mule ou la passion d'éditer*, Paris, éd. P. Belfond, 1979, 226 p. See on M.D., pp. 105-6. New edition, Bibliothèque Belfond, 1991, 272 p.

MAGRITTE, RENÉ, *Écrits complets*, Paris, Flammarion, Coll. "Textes", 1979, 766 p. Edited by ANDRÉ BLAVIER. On M.D. see texts nos.: 5, 42, 62/1, 128, 133, 148, 161, 190. See also nos. 1, 78, 99, 136, 145, 168, 183, 201, 204.

MALET, LÉO, Interview with JACQUES BAUDOU "Treize questions à Léo Malet" OULI.PO.PO, *Enigmatika* 18 Spéciale 81, Paris, éd. de la Butte aux Cailles, 1982, 224 p. See on M.D. pp. 21-22. Reproduced in *La Vache enragée*, s.l., éd. Hoëbeke, 1988, 248 p. See on M.D. pp. 120 et 125. First edition: *Enigmatika*, no, 18, mai 1980, pp. 3-9. See on M.D. p. 9.

MAN RAY, *Autoportrait*, Paris, Robert Laffont, 1964, 360 p. See on M.D. pp. 63, 72-4, 76, 83-5, 87-8, 91-2, 93-4, 97, 100-2, 107-17, 219, 234, 273, 335-6.

MASSON, ANDRÉ, *Les Années surréalistes. Correspondance 1916-1942*, edited by FRANÇOISE LEVAILLANT, Paris, La Manufacture, 1990, 576 p. See on M.D., p. 302 (Letter to M. Leiris, 5 janv. 1936)(Letter to R. Caillois, 4 août 1942). See also note p. 532.

MASSOT, PIERRE DE, *Marcel Duchamp, Propos et souvenirs*, Milano, Galleria Schwarz, 1965. Edition: total of 35 copies which enclose a signed and numbered replica of LHOOQ.

NIN, ANAÏS, *The Diary of Anaïs Nin, 1931-1934*, San Diego, Harvest, 1966; Italian edition: *Il diario, volume primo 1931-1934*, Milano, Bompiani, 1977, edited and prefaced by GUNTHER STUHLMANN, translation from the English by DELFINA VEZZOLI.

NIN, ANAÏS, *The Diary of Anaïs Nin, 1934-1939*, San Diego, Harvest, 1967. Italian edition, *Il diario, volume secondo, 1934/1939*, Milano, Bompiani, 1977, edited and prefaced by GUNTHER STUHLMANN, translation from the English by DELFINA VEZZOLI.

NIN, ANAÏS, *The Diary of Anaïs Nin, 1939-1944*, San Diego, Harvest, 1969. Italian edition, *Il diario, volume terzo, 1939/1944*, Milano, Bompiani, 1979, edited and prefaced by GUNTHER STUHLMANN, translation from the English by DELFINA VEZZOLI.

PACH, WALTER, *Queer Thing, Painting. Forty years in the World of Art*, New York and London, Harper Brothers pub., 1938, 335 p. See on M.D. pp. 22, 47, 139, 147, 155-63, 195, 223, 231, 234, 317.

RIBEMONT-DESSAIGNES, GEORGES, *Déjà jadis, ou du mouvement Dada à l'espace abstrait*, éd. Julliard, Coll. "Les Lettres Nouvelles", 1958, 302 p. See on M.D. pp. 29, 31, 33-4, 37-8, 43, 47, 48-9, 52-3, 56, 63-4, 82-3, 84-5, 98, 103, 123, 161, 163, 176-7, 275. On M.D. See no. 33, déc. 1955, pp. 732-53.

ROUGEMONT, DENIS DE, *Journal d'une époque. 1926-1946*, Gallimard, 1968, 598 p. On M.D. See pp. 562-71 (3 août-9 août 1945). See also le *Journal des deux mondes*, Gallimard, 1948, 240 p.

SALMON, ANDRÉ, *Souvenirs sans fin (1920-1940)*, Paris, Gallimard, 1961, 402 p. See on M.D. pp. 58 et 99.

SARAZIN-LEVASSOR, LYDIE, *Le récit de Lydie*, in *Rrosopopées*, 12e année, no. 19-20, mars 1989, pp. 473-508.

STEIN, GERTRUDE, *The Autobiography of Alice B. Toklas*, New York, ed. Harcourt Brace and Co, 1933, 312 p. See on M.D. pp. 164, 258.

TANNING, DOROTHEA, *Birthday*, Santa Monica-San Francisco, The Lapis Press, 1986, 185 p. See on M.D. pp. 142-3, 222.

THIRION, ANDRÉ, *Révolutionnaires sans Révolution*, Paris, Robert Laffont, 1972, 584 p. See on M.D. pp. 100, 280-1.

THOMSON, VIRGIL, *Virgil Thomson*, New York, Da Capo Press, 1966, 424 p. + XIII. See on M.D. pp. 58, 86, 164, 173, 204, 205, 243, 284, 337, 371, 374, 375.

VARESE, LOUISE, *A looking-Glass diary*, Vol. I: 1883-1928, New York, Win Norton and Co, 1972, 290 p. See on M.D. pp. 124, 125, 132, 133, 134, 135, 202, 203, 220.

WALDBERG, PATRICK, *Mains et merveilles. Peintres et sculpteurs de notre temps*, Paris, Mercure de France, 1961, 264 p. Foreword GEORGES SALLES. See pp. 149-70: "Marcel Duchamp. L'unique et ses propriétés".

WALDBERG, PATRICK ET ISABELLE, *Un amour acéphale. Correspondance 1940-1949*, edited by MICHEL WALDBERG, Paris, éd. de la Différence, 1992, 488 p. See on M.D. pp. 72, 80, 128, 140, 159, 197, 215, 293, 297, 300, 306, 321, 331-3, 417, 421, 437, 439, 442.

WILLIAMS, WILLIAM CARLOS, *The Autobiography*, New York, New Directions, 1967, 402 p. See on M.D. pp. 134, 135-6, 137, 140, 153, 194, 318.

WOOD, BEATRICE, *I Shock Myself*, Ojai (Ca) Dillingham Press, 1985, 181 p. See on M.D. pp. 22-7, 29-33, 37, 46-7, 49, 53, 82, 118-9, 134, 135, 136, 138, 144, 156, 164, 165.

BIBLIOGRAPHY

"Une rue Jacques Villon", Paris Normandie, 1er juin 1967.

CHASTEL, ANDRÉ, "Marcel Duchamp au M.N.A.M. Un hommage à Méphisto", Le Monde, 9 juin 1967.

CALONI, PHILIPPE, "Vive la mariée", Pariscope, 14 juin 1967, pp. 18-9.

ELGAR, FRANK, "Raymond Duchamp-Villon (trop tôt disparu) Marcel Duchamp (depuis longtemps inactif)", Carrefour, Paris, 14 juin 1967.

"Exposition [Les frères Duchamp], Loisirs Jeunes, 15e année, no. 606, 14 juin 1967, p. 14.

M.B., "M.D. maestro-dada", Il Giornale del Mezzogiorno, (Roma), 15 Giugno 1967.

MARCHAND, SABINE, "Au Musée d'Art Moderne, les frères Duchamp", Le Figaro, 15 juin 1967.

LÉVÊQUE, JEAN-JACQUES, "La Génération en colère", L'Information (Paris), 16 juin 1967.

HAHN, OTTO, "Duchamp et Duchamp-Villon", L'Express, 19 juin 1967.

PLUCHART, FRANÇOIS, "Duchamp l'incorruptible", Combat, 19 juin 1967.

BAROTTE, RENÉ, "Il y a 54 ans, la foule faillit lacérer un nu de M.D. Aujourd'hui...", Paris Presse - L'Intransigeant, 20 juin 1967.

CUTLER, CAROL, "A Belated Homage to Marcel Duchamp", Herald Tribune (Paris), 20 June 1967.

MAZARS, PIERRE, "Le retour des frères Duchamp", Le Figaro Littéraire, no. 1106, 26 juin 1967, p. 42.

1968

Entretiens sur le surréalisme, edited by FERDINAND ALQUIÉ. Actes du colloque de Cerisy 10-18 juill. 1966. Paris-La Haye, éd. Mouton, 1967, pp. ...

"Duchamp arrive", Tribune de Lausanne, 11 juin 1967.

PIERRE, JOSÉ, "Tu m'....", Opus, no. 2, juill. 1967, pp. 102-4.

WEBER, GERHARD W., "Mona Lisa mit Bart", Die Welt, 25 Juli 1967.

"2 Duchamp Art Works get the realisme", New York Post, 26 July 1967.

SPIES, WERNER, "Marcel Duchamp, der dadaistische Oldtimer", Frankfurter Allgemeine Zeitung, no. 171, 27 Juli 1967, p. 22.

SOLOMON, ALAN, "The new York", Vogue, 1er août 1967, pp. 102-7, 135-7, 140.

KENEDY, R.C., "Chronicles, Paris. M.D. Galerie Givaudan", Art International, Vol. XI, no. 7, 20 Sept. 1967, p. 62.

SHIREY, DAVID L., "The gayest of us all", Newsweek (N.Y.), Vol. LXX, no. 18, 30 Oct. 1967, p. 63.

RAGON, MICHEL, "L'Armory Show. Les débuts de l'art moderne aux États-Unis", Jardin des Arts, no. 156, nov. 1967, pp. 75-82.

BAROZZI, PAOLO, "La distanza metafisica di M.D.", Communità (Milano), no. 148-149, dic. 1967, pp. 69-72.

VALLIER, DORA, "M.D. et son frère Raymond", XXe Siècle, nouvelle série, 19e année, no. 29, dec. 1967, pp. 99-102.

CABANNE, PIERRE, "Le mois le plus long, Marcel Duchamp-Raymond Duchamp-Villon (MNAM)", 1968, 568 p.

PIERRE, JOSÉ, "Le surréalisme des peintres", pp. 246-59. See on M.D. pp. 248-9 + discussion: p. 261.

ARNAUD, NOËL, "Dada et surréalisme", pp. 350-69. See on M.D. p. 365.

PAZ, OCTAVIO, Marcel Duchamp, Mexico, édition Era, 1968. Portfolio de 6 dossiers:
1. Marcel Duchamp o el castillo de la pureza,
2. M.D. "Textos"
3. El Gran Vidrio,
4. Tres Láminas en color,
5. Un sobre con nueve reproduccions de Ready-made,
6. Album fotográfico; Carto autografico, Nota biografica. Carto auto-grapho, Nota biografica. Layout by VICENTE ROJO in Marcel Duchamp's style.

Translation Paz, OCTAVIO, Marcel Duchamp or the Castle of Purity, translated from the Spanish by DONALD GARDNER, London, Cape Goliard Press, 1970, n.p., and New York, Grossman, 1970.

SCHWARZ, ARTURO, Le Grandi Monografie: Duchamp, Milano, Fratelli Fabbri Ed., 1968, 212 p. Duchamp, Paris, Hachette-Fabbri, 1969, 218 p., coll. "L'art de notre temps".

LE BOT, MARC, Francis Picabia et la crise des valeurs figuratives, 1900-1925, Paris, éd. Klincksieck, 1968, (janv.), 208 p. See on M.D. pp.: 48-52, 61, 63, 87, 91, 106-7, 116, 119, 122-4, 126, 128, 129, 133, 173, 183, 184. Repr. h.t.: Nu... et Mariée...

PASSERON, RENÉ, Histoire de la peinture surréaliste, Paris, Le Livre de Poche, série Art, 1968, (1er trimestre), 382 p., ill. See on M.D. pp.: 15, 25-30, 27, 28, 32, 33, 34, 37, 38, 63, 65, 85, 86, 95, 193, 196, 200, 223, 252, 253, 258, 265, 277, 278, 282, 283, 284, 294, 295, 301, 306.

LEBRUN, ANNIE, "L'humour noir", pp. 99-113. See on M.D. pp. 100, 101, 104, 109-10, 111-2, 113.

SAUVY, ALFRED, "Sociologie du surréalisme", pp. 486-504. See on M.D. pp. 488, 500-1.

CHRISTIAN, "Origine", Cahiers Dada Surréalisme, no. 2, 1er trim. 1968, pp. 199-201.

BUZZATI, DINO, "Il grande Venerdì", Corriere della Sera, 10 genn. 1968.

ROUGEMONT, DENIS DE, "Marcel Duchamp mine de rien", Preuves, no. 204, fév. 1968, pp. 43-7.

HECHT, YVON, "Chef-d'oeuvre de la sculpture cubiste 'Le cheval majeur'", Paris Normandie, 17 fév. 1968.

"Hippies protest at dada preview", New York Times, 26 March 1968.

REIF, RITA, "Marcel Duchamp: Where art has lost, chess is the winner", New York Times, 27 May 1968.

GLUECK, GRACE, "A Rainy Taxi, a Tea Cup of Fur", New York Times, 24 March 1968.

BAJ, ENRICO, Automitobiografia, Milano, Rizzoli, 1983, 198 p. See on M.D. pp. 18, 80, 98, 100, 101, 103, 104, 109, 110, 111, 112, 114, 124, 127-34, 182-4, 187.

BEAUVOIR, SIMONE DE, L'Amérique au jour le jour, Paris, éd. Paul Morihien, 1948, 392 p. See on M.D. pp. 37, 342-3.

BON, JACQUES, Promenades d'hier en aujourd'hui de Paris à Puteaux 1905-1952, Puteaux, 1959, 60 p. Edition of 1000 copies. See especially, pp. 35-6.

LONDON, JOHN, "Monsieur Marcel has no more shocks", The Evening News (London), 7 June 1968, p. 4.

"New etchings from Duchamp", The Observer, 9 June 1968, p. 40.

YALKUT, JUD, "Towards an Intermedia Magazine", Arts Magazine, Vol. 42, no. 8, June/Summer 1968, pp. 12-4.

SOUTHARD, ELMER ERNEST, "Melle de l'escalier" (17 Nov 1916), in Frederick P. Gay, The Open Mind. Elmer Ernest Southard 1876-1920, Normandie House, 1938. Appendice "F", pp. 315-6.

Memorial Volume of and by ETTIE STETTHEIMER, N.Y., ed. Alfred A. Knopf, 1951, 646 p. See pp. 94-103.

ROCHÉ, JULIETTE, La minéralisation de Dudley Craving Mac Adams, in La Vie des Lettres (Paris), Vol. VIII, 1922: no. 1, fév., pp. 23-34, no. 2, avril, pp. 145-56, no. 3, juin, pp. 264-71. Reprinted in book format under same title, Paris, 1924, 33 p.

WITKIEWICZ, STANISLAS I, Papierek Lakmusowy, Manifest (Festmani), Zakopane [1921], 8 p.

LEPRETTE, PHILIPPE, "Le 'Cheval majeur' de Ryamond Duchamp-Villon installé hier à la préfecture", Paris Normandie, 27 sept. 1968.

See also:

BOYLE, KAY, Collected poems of Kay Boyle, Port Townsend (Wa), Copper Canyon Press, 1970. See pp. 61-2 "A Complaint for Mary and Marcel".

Memories of Marcel Duchamp

ARP, JEAN, Jours effeuillés, Poèmes, Essais, Souvenirs 1920-1965. Foreword by MARCEL JEAN. Paris, Gallimard, 1966, 672 p. See on M.D. pp. 184, 309, 506.

BOYLE, KAY and McALMON, ROBERT, Being Geniuses Together 1920-1930, ed. Michael Joseph, 1970. New edition, London, The Hogarth Press, 362 p. 1984. See on M.D. pp. 34, 67, 92, 111, 19 et 275.

BUÑUEL, LUIS, Mon dernier soupir, Paris, Robert Laffont, 1982, 324 p. See on M.D.: p. 223.

CALDER, ALEXANDER, An Autobiography with pictures, New York, Panther Books, 1966. French edition: Autobiographie, Maeght éd., 1972, 212 p. Translated from the English by JEAN DAVIDSON.

CLERT, IRIS, Iris Time (l'artventure), Paris, Denoël, 1978, 368 p. See on M.D. pp. 135, 177, 178, 198, 259, 271, 277, 333, 339.

COCTEAU, JEAN, Le Passé défini, t. 1, 1951-1952, Paris, Gallimard, 1983, 468 p. See on M.D. pp. 334, 340, 368-9, 383, 393, 424-5.

DEMARNE, PIERRE, Art, Artistes, Essais, Souvenirs 1920-1965, Paris, U.N.P.F., 1977, 288 p. See pp. 82-8. "M.D. la vie intérieure". See also pp. 15, 112, 139, 140, 144, 208, 253, 264.

DUHAMEL, MARCEL, Raconte pas ta vie, Paris, Mercure de France, 1973, 624 p. See on M.D. 297-8, 306, 307.

ERNST, JIMMY, L'Écart absolu. Un enfant du surréalisme, Paris, éd. Balland, 1984, 350 p. Translated from the English by NICOLE MENANT. See on M.D. pp. 277, 288,

EVERLING, GERMAINE, L'Anneau de Saturne, Paris, Fayard, 1970, 206 p. See on M.D. pp. 9, 79, 87, 102, 103, 123, 136, 140,

Hoog, Michel, "Quelques précurseurs de l'art d'aujourd'hui", *La Revue du Louvre et des Musées de France*, Paris, 16e année, no. 3, 1966, pp. 165-72. Repr. p. 170: *Boîte-en-valise* (boîte ouverte, album fermé); p. 171: *Boîte-en-valise* (album ouvert).

Tzara, Tristan, [Notes biographiques - Dadaglobe], *Cahiers Dada Surréalisme*, no. 1, 1966, pp. 120-2. Reprinted in *Œuvres Complètes*, t. 1, Paris, Flammarion, 1975, p. 582. Edited and prefaced by Henri Béhar.

Lebel, Robert, "Aperçu de Marcel Duchamp", exhibition catalogue, *USA nouvelle peinture*, Lyon, Musée des Beaux-Arts, 12-26 fév. 1966.

Roberts, Colette, "Mirage des échecs", *France Amérique*, 17 fév. 1966, p. 15.

Gray, Cleve, "Spéculations. Marcel Duchamp", *Art in America*, March/April 1966, Vol. 54, no. 2, p. 72.

Hahn, Otto, "Qu'est-ce que le happening?", *Arts Loisirs*, no. 30, 20 avril 1966, pp. 50-1.

Lucie-Smith, Edward, "The happening?", *The Times*, 7 June 1966.

Russell, John, "The man who knew when to stop", *Sunday Times Magazine*, 12 June 1966.

"The remarkable evolution of Marcel Duchamp", *The Times*, 18 June 1966.

Seddon, Richard, "Duchamp at the Tate", *Birmingham Post*, 18 June 1966.

"Growing up absurd", *Observer*

Anti-art), Michel Sanouillet: an extract from *Marchand du Sel*, pp. 343-4, 1966.

Marshall, William, "Marcel Duchamp: il n'y a que des choses auxquelles je ne crois pas…", *Paris Normandie* (Rouen), 30 sept. 1966.

"Marcel Duchamp at the Tate", *Art International*, Vol. X, no. 6, Summer 1966, pp. 101-4. Iconographical notes by A. Schwarz "The Mechanics of the Large Glass".

Robertson, Bryan, "The complete works", *Spectator*, 24 June 1966.

Art and Artists, N.Y., Vol. I, no. 4, July 1966, M.D. Number, with: "Introduction", p. 4. Hahn, Otto, "Passport no. G255300", interview, pp. 6-11. Breton, André, "Crise de l'objet", pp. 12-15. Lebel, Robert, "The Ethic of the Object", pp. 16-9. O'Doherty, Brian, "Duchamp's Cardiogram", pp. 20-1. Hamilton, Richard, "Son of the Bride Stripped Bare", interview, pp. 22-6. Hamilton, George Heard, "In Advance of Whose Broken Arm?", pp. 29-31. Watt, Alexander, "Dadadate with Man Ray", pp. 32-5. Watson Taylor, Simon, "A propos of Readymades", p. 46. Mussman, Toby, "Anémic Cinéma", pp. 48-51. Finch, Christopher, "… and Picabia", pp. 52-3. Man Ray, Hommage à Marcel Duchamp, 1966, cover.

Melville, Robert, "Marcel Duchamp", *New Statesman* (London), Vol. 72, no. 1842, 1 July 1966, p. 25.

Fermigier, André, "L'oracle et la sibylle", *Nouvel Observateur*, no. 89, 27 juil 1966, p. 34-5 (Tate Gallery Exhib.).

Schurr, Gérard, "Le mouvement Dada", *La Galerie des Arts*, no. 39, déc. 1966, pp. 26-9.

1967

Paz, Octavio, *Marcel Duchamp ou le Château de la pureté*, Genève,

Week End Review (London), 19 June 1966, p. 23.

Hecht, Yvon, "Marcel Duchamp", *Mirror* (London), 19 June 1966.

"Riopelle, Duchamp-Villon" *Art News*, Vol. 65, no. 6, Oct. 1966, p. 17.

Lebel, Jean-Jacques, [An article on Picabia includes a short note on M.D.'s philosophical realm], *La Quinzaine Littéraire*, Paris, no. 13, 1er oct. 1966, p. 6.

Rougemont, Denis de, "André Breton", *Preuves*, Vol. 16, no. 189, nov. 1966, p. 15-7. See on M.D. P. 17. Also in *Encounter* (London), Aug. 1967, p.68.

Ducreux, A., "Marcel Duchamp ou l'Art et les Echecs", *Paris Normandie*, 6 nov. 1966.

Cabanne, Pierre, "Après Picasso, qui?", *Arts Loisirs*, no. 61, 23 nov. 1966, pp. 34-7.

Weidle, Wladimir, "L'herbe a repoussé sous les pas de ce cheval d'Attila", pp. 38 et 40. Bousquet, Jean-Claude, "Ils étaient cinq cavaliers de l'apocalypse", pp. 40-1 et 44-5. Restany, Pierre, "Ils ont donné au siècle son second souffle", pp. 45-6. These three texts under the general title: "Dada 1916-1966)" in *Arts Loisirs*, no. 62, 30 nov. 1966.

Schwarz, Arturo, *The Large Glass and Related Works*, Milano, Galleria Schwarz, T.I 1967 and T.II 1968.

ed. Claude Givaudan, 1967, 106 p. Translated from Spanish by Monique Fong-Wust. Edition of 600 copies. Copies from 1 to 100 are signed by Duchamp and Paz and include a series of transparent shadows. Reprinted in: O. Paz, *Deux transparents: M.D. et Cl. Levi-Strauss*, no. 156, 1970, 192 p.

Pierre, José, *Le Futurisme et le Dadaïsme*, Lausanne, éd. Rencontre, 1967, 208 p., 20e volume de la collection "Histoire générale de la peinture". Introduction by Philippe Soupault: on M.D. pp. 7-8, 9. See on M.D. pp. 29, 39, 53-7, 59-60, 63-5, 67-9, 81, 82, 83, 84, 87, 88, 89, 91, 95, 114, 125-9, 131, 134, 142, 155, 156, 159, 160, 161, 176, 178, 188, 189, 190, 192, 193, 203. "Dictionnaire": numerous entries concerning M.D. pp. 147, 154, 163-4, 193, 202.

Kuhns, Richard, "Art and Machine", *Journal of Aesthetics* (Baltimore), Vol. 25, Spring 1967, pp. 259-63.

Paz, Octavio, "André Breton ou la recherche du commencement", pp. 606-19. See on M.D. p. 616 and Soupault, Philippe, "Souvenirs", pp. 660-71. See on M.D. pp. 668, 670. *N.R.F.*, no. 172 "André Breton et le mouvement surréaliste", 1er avril 1967.

New York: The New Art Scene. Photographs by Ugo Mulas. Text by Alan Solomon, N.Y., Holt Rinehart Winston, 1967, 346 p. See pp. 70-9: "Duchamp".

Roberts, Colette, "Exposition Duchamp 'A l'infinitif'", *France Amérique*, 23 fév. 1967.

"Marcel Duchamp (Cordier and Ekstrom)", *The New York Times*, no. 2068, 20 avril 1967, p. 9.

Grand, P.-M, "Les Duchamp à Rouen", *Le Monde*, 21 avril 1967.

"Saint Marcel Duchamp", *L'Express*, 13 mars 1967.

"Un événement de portée internationale: Marcel Duchamp, Jacques Villon et Raymond Duchamp-Villon", *Paris Normandie*, 8 avril 1967.

Hecht, Yvon, "La grande exposition 'Les Duchamp'. Aujourd'hui, à Rouen, Marcel Duchamp participera à la mise en place des œuvres", *Paris Normandie*, 12 avril 1967.

Deron, Jean-Paul, "Marcel Duchamp dispose ses œuvres au Musée des Beaux-Arts", *Paris Normandie*, 13 avril 1967.

Hecht, Yvon, "Marcel Duchamp lui-même a ouvert l'exposition 'Les Du-

champ'", *Paris Normandie*, 17 avril 1967.

Dalevèze, Jean, "Les Duchamp à Rouen. Une révolte en formes", *Les Nouvelles Littéraires*, 29/30 avril 1967.

"Hommage à Jacques Villon: Rouen rappelle son séjour à Rouen", *Paris Normandie*, 1967.

Cluzeau-Ciry, H., "L'Anti-peinture: Marcel Duchamp", *Planète*, Paris, no. 34, mai-juin 1967.

Jacobs, Jay, "Prose and Cons. The World of M.D.", *Art in America*, Vol 55, no. 3, May-June 1967, p. 120.

Fong, Monique, "Marcel Duchamp", *Les Lettres Nouvelles*, mai-juin 1967, pp. 70-6.

Warnod, Jeanine, "Les Duchamp à Rouen", *Le Figaro*, 4 mai 1967.

Cabanne, Pierre, "Marcel Duchamp: le voyage au bout du scandale", *Galerie des Arts*, no. 45, juin 1967, pp. 4-7.

Blume, Mary, "Man Ray, Honored Guest", *New York Herald Tribune* (Paris), 12 May 1967, p. 12.

Clay, Jean, "Marcel Duchamp le dynamiteur", *Réalités*, no. 257, juin 1967, pp. 80-3. Reproductions p. 82-3.

Duparc, Christiane, "Duchamp: A l'assaut d'une légende", *Nouvel Adam*, Paris, juin 1967, pp. 76-7.

Jouffroy, Alain, "Duchamp prince de l'insolence", *Arts Loisirs*, no. 87, juin 1967, pp. 20-1.

Lévêque, Jean-Jacques, "On verra en juin…", *Arts Loisirs*, no.

Roubaix". *La Quinzaine Littéraire*, Paris, no. 25, 1er avril 1967, pp. 16-7.

Baruchello, Gianfranco, "Duchamp mis à nu", *La Quinzaine Littéraire*, Paris, no. 25, 1er avril 1967, pp. 16-7.

Cabanne, Pierre, "Entretien avec Marcel Duchamp, de Pierre Cabanne", *Paris Normandie*, 7 avril 1967.

Schwarz, Arturo, "The Mechanics of the Large Glass".

Lebel, Robert, "André Breton et la peinture", *L'Œil*, no. 143, nov. 1966, pp. 2-9.

Hecht, Yvon, "Riopelle, Duchamp-Villon"

Sers, Philippe, "Marcel Duchamp", *Gazette Médicale de France*, t. 76, no. 1, 5 janv. 1967, pp. 48-51.

"In Copertina", *L'Italia Scacchistica*, Milano, anno 57, no. 736, feb. 1967, p. 37 (cover: repr. "Giocatori di scacchi").

J.P., "Marcel Duchamp's (Cordier and Ekstrom) 14 Feb.-4 March 1967)" *Art News*, Vol. 65, no. 10, Feb. 1967, pp. 12-3.

Schwarz, Arturo, "The Mechanics of the Large Glass", *Ca-*

Sedton, Richard, "Duchamp at the Tate".

Schwarz, Arturo, "The Mechanics of the Large Glass", *L'Express*, Paris, 8 août 1966, p. 30.

there", *New York Herald Tribune* (Sunday Magazine), N.Y., 17 May 1964, pp. 7-10.

KAISSERLIAN, GIORGIO, "I ready mades di M.D.", *Il Telegrafo*, (Livorno), 24 Giugno 1964.

"VII gran premio bergamo internationale del film d'arte e sul-l'arte"; "Assegnati con obiettività. I premi a concorso", *La Rivista di Bergamo*, special issue, anno XV, nos. 8-9, agosto-settembre 1964, pp. 21-4, 29-31.

BRUMAGNE, N.M., "Le Festival de Bergame", *Tribune de Lausanne*, 26 Oct. 1964.

F.M., "Duchamp", *Domus*, no. 420, nov. 1964, p. 35.

"Les signataires de L'Oeil caco-dylate", in exhibition catalogue Galerie Louis Carré, *Francis Picabia, chapeau de paille ?* Paris 4 nov./4 déc. 1964, 18 p. + folder. See pp. 10, 13, 17.

BENAYOUN, ROBERT, *Erotique du surréalisme*, Paris, éd. Jean-Jacques Pauvert, 1965. Republished: Société des Editions Pauvert, 1978, 192 p. See on M.D.: pp. 43, 44, 46-50, 138, 163, 164 (+ 5 reproductions).

TOMKINS, CALVIN, *The Bride and The Bachelors: The heretical courtship in Modern Art*, London, Weidenfeld and Nicolson, 1965, 246 P; New York, The Viking Press, 1965. See M.D. pp. 2, 5, 6-7, 9-68, 94, 143, 148, 150, 167, 235. Published in Penguin Books, 1976.

McCUE, GEORGE, "M.D. says new art requires the viewer to think", *Saint-Louis Post Dispatch*, 24 Nov. 1964.

DORFLES, GILLO, "Il Ready Ma-de di Duchamp", *Art International* (Lugano), VIII, no. 10, déc. 1964, pp. 40-2. (Repr. of 10 readyma-des).

LEBEL, ROBERT, "Une révolution du regard par Alain Jouffroy", *L'Oeil*, no. 120, déc. 1964, pp. 51, 82.

PIPER, FRANCES, "Duchamp Gallery visit scheduled", *Columbus Dispatch*, 13 Dec. 1964.

1965

BRETON, ANDRÉ, *Le surréalisme et la peinture*, revised edition 1928-1965, Paris, Gallimard, 1965, 432 p. See on M.D. pp. 57-59, 63, 64, 74, pp. 85-99: "Phare de la Mariée", 189, 191, 209, 221, 224, 226, 251, 280, 336, 351, 360, 371, 383, 412. 17 repr. M.D.'s works + photo.

SANOUILLET, MICHEL, *Dada à Paris*, Paris, éd. J.J. Pauvert, 1965, 648 p. See on M.D. pp. 16-7, 21, 24-32, 44, 45, 52, 61, 72, 81, 111, 115, 116, 117, 143, 146, 149, 161, 165, 167, 179, 180, 182, 208, 212-3, 218, 226, 227, 235, 252, 268, 274, 275, 279-80, 289, 290, 291, 295, 297, 298, 308, 330, 336, 344, 353, 355, 357-8, 362, 371, 377, 383, 392, 413, 414, 416, 424, 429, 433, 434, 458, 490, 491, 499, 517, 521, 523-4, 526, 531, 533-4, 536, 552, 553, 602, + Bibliography: pp. 607, 609, 611, 616, 619, 620, 622.

"Marcel Duchamp. The Mysti-que of his Career Revealed in New York", *Pictures on Exhibits*, Jan. 1965, pp. 4-5.

GLUECK, GRACE, "Ready Ma-de", *The New York Times*, 10 Jan. 1965.

NEFF, JOHN H., "Gothic to Pop to Op", *Wesley on College Argus*, 15 Jan. 1965, pp. 2, 4.

THINESSE, ANNE, "Importante rétrospective Marcel Duchamp à New-York", *Le Monde*, 15 janv. 1965.

PRESTON, STUART, "Duchamp retrospective covers wide area", *The New York Times*, 16 Jan. 1965.

CANADAY, JOHN, "Leonardo Du-champ", *The New York Times*, 17 Jan. 1965, p. 19.

ROBERTS, COLETTE, "Marcel

RICHTER, HANS, autobiography on the artist. Introduction by HERBERT READ, Neufchâtel (Suisse), éd. du Griffon, 1965, 132 p. See on M.D. pp. 118, 119, 123.

SEUPHOR, MICHEL, *Le style et le cri, Quatorze essais sur l'art de ce siècle*, Paris, éd. du Seuil, 1965, 288 p. See on M.D. pp. 27, 35, 74, 78, 85-6, 88, 93, 94, 180, 181, 225.

JOUFFROY, ALAIN, "Les objec-teurs", *Quadrum* (Bruxelles), no. XIX, 1965, pp. 5-32. See on M.D.: "La 'distance infinie' de Duchamp", pp. 6-9.

SADOUL, GEORGES, "Souvenirs d'un témoin", *Etudes Cinématogra-phiques*, nos. 38-39 "Surréalisme et cinéma, I", 1er trimestre 1965, pp. 9-28. See: "Anémic Cinéma", pp. 17-8.

HESS, THOMAS B., "J'accuse Marcel Duchamp", *Art News*, T. LXIII, no. 10, Feb. 1965, pp. 44-5, 52-4 (6 repr. + photos).

KOZLOFF, MAX, "Art. Du-champ", *The Nation*, Vol. 200, no. 5, 1 Feb. 1965, pp. 123-4.

BARBER, WALTER, "Duchamp's Retrospective in New York", *Herald and The Arts*, 7 Feb. 1965.

"Pop's Dada", *Time*, 5 Feb. 1965, pp. 78, 85.

"Rose Sélavy may sneeze: Du-champ show this week", *The Hou-ston Post*, 21 Feb. 1965.

"Duchamp Preview", *The Hou-ston Post*, 23 Feb. 1965.

EWING, BETTY, "French is the-me at stock show party", *Houston Chronicle*, 23 Feb. 1965.

HONHOLT, EDITH, "Duchamp at Museum", *The Houston Post*, 23 Feb. 1965.

HOFMANN, WERNER, "Marcel Duchamp und der Emblematische Realismus", *Merkur*, t. XIX, no.

Duchamp, chef d'époque", *France-Amérique*, 21 janv. 1965.

GENAUER, EMILY, "Duchamp - Pop's Granddada", *New York He-rald Tribune*, 24 Jan. 1965, pp. 31-2.

GLUECK, GRACE, "To lend or not to lend", *The New York Times*, 24 Jan. 1965.

HUELSENBECK, RICHARD, "Mar-cel Duchamp. Eine retrospektive interview, *L'Oeil*, no. 126, juin Ausstellung", *Frankfurter Allge-meine*, no. 23, 28 Januar 1965, P. 24 Jan. 1965.

COATES, ROBERT M., "The Art Galleries. Marcel Duchamp", *The New Yorker*, 30 Jan. 1965, p. 92.

PRICH, MARGARETE, "Man Ge-nop den vek mit Andacht. Vater der 'Antikunst', M.D. in Museum Hans Lange", *Rheinische Post* (Düsseldorf), 21 Juni 1965.

KLAPHECK, ANNA, "Vater des Ready-Made". Ausstellung M.D. im Krefelder Museum Hans Lan-ge, *Rheinische Post* (Düsseldorf), 8 Juli 1965.

PLUNIER, Eo, "Nicht Asthetik, sondern Energie. Marcel Du-champ, legendärer Vorläufer der Moderne. Unfassende Ausstel-lung in Krefeld", *Die Welt*, 16 Juli 1965.

DANIEL, CONSTANCE, "Fall sea-son opens at Art Center - and it's a 'Smash'", *The Milwaukee Jour-nal*, 10 Sept. 1965, pp. 2-3.

Revue de l'Association pour l'E-tude du Mouvement Dada, no. 1, Oct. 1965 Includes: photography of M.D.'s 'urn' p. I, cover; photo-graph of M.D. at Rrose Sélavy dinner, 15 may 1965, p. II, cover; "L'urne de M.D.", p. 2.

GENAUER, EMILY, "Duchamp M. Duchamp to Descend on Wal-Magazine, t. XXXIX, no. 6, March 1965, pp. 53-4.

CALAS, NICOLAS, "Again and Again, Duchamp", *The Village Voice*, 15 April 1965, pp. 14, 27.

JOUFFROY, ALAIN, "Arman", in-1965, pp. 25-7, 48-9. See on M.D. 1965.

ASHTON, DORE, "M.D. brico-leur de génie", *XXe Siècle*, 27e an-née, no. 25, juin 1965, pp. 97-9. Translation of an English text by MADDY BULYSSE "D. Sublime bri-coleur". Repr. of 3 works.

SHERMAN, JOHN K., "Du-champ's early work shown", *The Minneapolis Tribune*, 24 Oct. 1965.

MORRIS, MARGARET, "About people", *Minneapolis Tribune*, 20 Oct. 1965.

MORRISON, DON, "2 Cent's Worth", *The Minneapolis Star*, 19 Oct. 1965.

McCONAGHA, AL, "Grand Dada ker", *Minneapolis Tribune*, 17 Oct.

"Artist Marcel Duchamp visits U classes, exhibits at Walker", *Minnesota Daily*, 22 Oct. 1965.

JUDD, DONALD, "Marcel Du-champ and/or Rrose Sélavy", *Arts*

1966

BOSQUET, ALAIN, *Entretiens avec Salvador Dali*, Paris, éd. Pierre Belfond, 1966, 190 p. On M.D. see 9th interview, p. 159.

TOMKINS, CAVIN, *The World of Marcel Duchamp*, New York, Time Life Books, 1966, 192 p. French Edition: *Duchamp et son temps* 1887-1568, N.Y.: Time Inc.

DIEHL, GASTON, *La peinture mo-derne dans le monde*, Paris, éd. Flammarion, 1966, 220 p. See on M.D. pp. 57, 63, 88, 114, 165.

SCHWARZ, ARTURO, *I Maestri del Colore, Duchamp*, Milano, Fratelli Fabbri Editori, 1966.

L'Arte, Milano, Vol. VII, no. 55 to 63, 1966, includes. MICHEL SA-NOUILLET, "Le origini del dada: Zurigo, New York" pp. 81-120 (photo and reproductions). "Il da-da in Germania e a Parigi. Diffu-sione del dadaïsme" pp. 121-60. ROBERT LEBEL, "La prima genera-zione surrealista" pp. 201-240 (reproductions). HANS RICHTER, "Duchamp e il Ready Made", pp. 342-3 (extract from *Dada, Art and*

BIBLIOGRAPHY

Scott, Hugh, "Master of Shock has Mellowed", *The Philadelphia Inquirer Magazine*, 19 March 1961.

Aulard, Marie-Louise, "Le surréalisme prend un nouveau tournant grâce au T.S. Marcel Duchamp", *Dossiers du Collège de 'Pataphysique*, no. 14, 9 clinamen 88EP (31 March 1961), pp. 73-4.

Brady, Frank R., "Duchamp", *Art and Chess*, *Chess Life* (N.Y.), vol. XVI, no. 6, June 1961, pp. 168-9.

K.[url] K.[atharine], "Landmarks of Modern Art", *Saturday Review*, vol. 44, no. 23, 10 June 1961, p. 34.

Linde, Ulf, "Marcel Duchamp", *Louisiana Revy*, (Humlebaek, Danemark), no. 1, Sept. 1961, p. 6-7.

Linde, Ulf, "Framf? och bakom Glaset", *Konstrevy* (Stockholm), vol. 37, no. 5/6, nov./déc. 1961, pp. 162-5.

"U" honors art world luminaries" *Wayne State U*, 30 Nov. 1961.

Grafly, Dorothy, "The Art World", *Philadelphia Pa Bulletin*, 4 Dec. 1961.

Watson Taylor, Simon, "La Science à New York", *Dossiers du Collège de 'Pataphysique*, no. 17, 22 sable 89EP (22 Dec. 1961), pp. 85-8.

C.R., "Peinture, gastronomie et Bottin mondain", *France-Amérique*, 24 déc. 1961.

Noël 1961, special issue "Pour un bilan du siècle".

Gindertael, R.V., "Le refus", pp. 13-20 (see on M.D. 19) p. 18, repr. *Roue de bicyclette*.

Habasque, Guy, "Art et Technique: la cinétique", pp. 81-92 (repr. *Rotative plaque verre, 1920*).

Chevalier, Denys, "Les animateurs", pp. 137-43; On M.D. p. 142.

1962

Crespelle, J.P., *Montparnasse vivant*, Paris, Hachette, 1962, 332 p. See on M.D. pp. 22, 23, 246-8, 250, 253, 267, 273.

Lebel, Robert, *Anthologie des formes inventées, Un demi-siècle de sculpture*, Paris, éd. de la Galerie du Cercle, 1962, 94 p. On M.D.: pp. 11-2, 14, p. 76: "Duchamp Marcel"; p. 12: repr. *Apollinère*... (1916-17); *Appareil rotatif* (1920). + plate 14: *With my tongue*... (1959).

Janis, Harriet and Blesh, Rudi, *Collage*, Philadelphia, New York, London, Chilton Book Co, 1962. Revised edition, 1967.

1963

Brown, Milton W., *The Story of the Armory Show*, published by the Joseph H. Hirshhorn Foundation, New York Graphic Society Distributors (the New Spirit), 1963, 320 p. See on M.D. pp. 48, 50, 100, 102, 103, 104-5, 108, 109-12, 115, 119, 145, 147, 161, 173, 175, 182, 240.

Cabanne, Pierre, *L'Épopée du Cubisme*, Paris, La Table Ronde, 1963, 432 p. See on M.D. pp. 101, 111, 132, 133, 134, 155, 162, 168, 169, 186, 187, 188, 196, 199, 203, 206, 213, 216, 217, 232, 245, 249, 281, 283, 286, 319.

Kyrou, Ado, *Le surréalisme au Cinéma*, Paris, Le Terrain Vague, revised edition, 1963. Republished, Paris, éd. Ramsay, coll. "Ramsay-Poche-Cinema", no. 14, 1985, 310 p. See on M.D. pp. 12, 93, 172, 174, 176, 178-80, 181, 198-200.

Tyler, Parker, *Florine Stettheimer, A Life in Art*, N.Y., Farar, Straus and Co, 1963, 194 p. See M.D. pp. 5, 6, 11, 15, 40-1, 54, 69-70, 71, 85-6, 91, 94, 107, 117,

no. 3, May 1962, pp. 38, 52 (p. 39: repr. *Nu..., no. 1*).

Ashbery, John, Foreword (Paris, 14 Sept. 1962) to exhibition catalogue, *New Realists*, Sidney Janis Gallery, N.Y., 31 Oct.-1st Dec. 1962 and S.[idney] J.[anis], "On the Theme of the Exhibition".

Steefel, Lawrence D., "The Art of M.D.", *Art Journal* (N.Y), vol. XXII, n. 2, Winter 1962-63, pp. 72-9.

127, 145, 165, 173, 184, M.D., h.t. between pp. 66 and 67: *Portrait of Florine Stettheimer, 1925*. Rept., of a number of works by Florine in which M.D. appears: *Picnic at Bedford Hills, 1918*; *Asbury Park South, 1920-30*; *La fête à D*, 1917.

Jouffroy, Alain, "Pourquoi le collage? Pourquoi l'objet?", *Metro* (Milano), n. 8, 1963, pp. 88-91.

Sachs, Samuel, II, "Recontructing the 'Whirlwind of 26th Street' (Armory Show)", *Art News* (N.Y.), V. 61, n. 10, Feb. 1963, pp. 26-9, 57-8. P. 26, photo of the exhibition room with two works by M.D. (1913).

"200 attend preview of Armory Art Show"; "Duchamp Leads a quiet life", *Utica Observer Dispatch* (N.Y.), 17 Feb. 1963.

Lucy, William, "Duchamp paints Uncle Sam as top 'Modern Collector'"; "Duchamp's Explosive' work analyzed", *Utica Daily Press*, 18 Feb. 1963, p. 17.

Dali, Salvador, "Why they attack the Mona Lisa", *Art News* (N.Y.), V. 62, n. 1, March 1963, pp. 36, 63-4.

Bracker, Milton, "Armory Art Show of 1913 revived, revered", *New York Standard*, 10 March 1963, p. 80.

Canaday, John, "1913 Armory Art Show is back for Anniversary", *The New York Times*, 5 April 1963.

"Game worth scandal", *Newsweek*, 22 April 1963, p. 57.

"Duchamp + Villon = Villon-Duchamp", *Tribune de Lausanne*, 14 juill. 1963.

"The Art galleries. The Art object", *New Yorker*, 10 Aug. 1963.

Schumach, Murray, "Pasadena to see Art of Duchamp", *Pasadena*, 13 Aug. 1963.

Matthieu, Mary, "They came, they saw... Duchamp conquered", *Los Angeles Times*, 7 Oct. 1963. "Society and Art worlds converge", *Los Angeles Times*, 9 Oct. 1963.

Hansen, Barbara, "Famous Artist here; Created 1913 Uproar", *Herald Examiner* (Los Angeles), 9 Oct. 1963 (interview with Madame Duchamp).

Dann, Frode N., "Duchamp remained gadfly after the Nude Descended", *Independent Star News*, 13 Oct. 1963.

"Gen ed S Features 'Dadaist' Duchamp", *The Justice*, 19 Nov. 1963.

Solman, Paul, "Why not sneeze Rose Selavy ?", *The Justice*, 26 Nov. 1963.

1964

Crespelle, J.P., *Montmartre Vivant*, Paris, Hachette, 1964, 286 p. See en M.D. pp. 30, 31, 34, 189.

Encyclopédie des Farces et Attrapes et des Mystifications, François Caradec and Noël Arnaud, eds. Paris, éd. Jean-Jacques Pauvert, 1964, 576 p. See en M.D. pp. 270, 293, 357, 374, 375.

Goldaine, Louis and Astier, Pierre, *Ces peintres vous parlent*, Paris, éd. du temps, coll. "L'Oeil du Temps", 1964, 200 p. Foreward by Pierre Restany. See on M.D. pp. 46-8. P. 48, "Impressions graphologiques".

Hopps, Walter, Linde, Ulf, Schwarz, Arturo, *Marcel Du-

champ, Ready-Mades, etc* (1913-1964), Milano, Galleria Schwarz, Le Terrain Vague, Paris. Trilingual edition: Italian, French, English.

Jouffroy, Alain, *Une révolution du regard. A propos de quelques peintres et sculpteurs contemporains*, Paris, Gallimard, 1964, 266 p. See en M.D. pp. 9, 26, 27, 46, 98, 126, 127, 141, 176, 186, 188, 190, 191, 193, 196, 198, 199, 216, 225-6, 233, 234, 236, 239.

Lebel, Robert, *L'Envers de la peinture*, Monaco, éd. du Rocher, 1964, 122 p. See en M.D., pp. 12-3, 15, 26, 88.

Sanouillet, Michel, *Picabia*, Paris, éd. du Temps, coll. "L'Oeil du Temps", 1964, 176 p. See on M.D. pp. 12, 13, 23-5, 26, 30, 34, 40, 41, 44, 46, 47, 48, 52, 62, 63, 64, 116.

Cage, John, "26 statements re Duchamp", *Art and Literature*, no. 3, 1964, pp. 9-10.

Reuillard, Gabriel, "L'extraordinaire famille Duchamp Villon", *Paris-Normandie*, 25 janv. 1964.

Nordland, Gerald, "M.D. and common object art", *Art International*, vol. VIII, no. 1, Feb. 1964, pp. 30-2 (on the Pasadena retrospective).

Dhainaut, Pierre, "Raymond Roussel oseur d'influence", *Bizarre*, no. 34-35 spécial Raymond Roussel, 2e trimestre 1964, pp. 73-4.

Kozloog, Max, "Johns and Duchamp", *Art International*, vol. VIII, no. 2, 20 March 1964, pp. 42-5.

Lebel, Robert, "M.D. hier et demain", *L'Oeil*, no. 112, avril 1964, pp. 12-9.

Constable, Rosalind, "New York's avant-garde and how it got

CALAS, NICOLAS, "The Brothers", *Time* (N.Y.), 8 April 1957, pp. 74, 77.

LEBEL, ROBERT, "M.D. Liens et ruptures. Premiers essais, le cubisme, le Nu descendant un escalier", *Le surréalisme, Même*, no. 3, automne 1957, pp. 21-31.

SAMPSON, PAUL, "3 Surréalists See Art Shifts", *The Washington Post and Times Herald*, 22 Dec. 1957.

1958

COURTHION, PIERRE, *L'Art Indépendant*, Paris, Albin Michel, 1958, 320 p. See on M.D. pp. 81, 100, 187, 188, 191-2, 267. Planche 42: M.D. Nu..., 1912.

HAUSMANN, RAOUL, *Courrier Dada*, Paris, Le Terrain Vague, 1958, 160 P. See on M.D. pp. 9, 46.

MAZUR, MICHAEL, "Mead Armory Show recaptures Excitement and Flavor of 1913 Revolution in Art", *The Amherst Student*, 20 Feb. 1958, pp. 3, 8.

WAYNE, C. SMITH, "Armory Show Originals now at Amherst College", *The Springfield Sun*, 23 Feb 1958, p. 6.

WOLF, HOWARD, "Duchamp cites Artists' role in Society, use of Symbols", *The Amherst Student*, 27 Feb. 1958.

LEVEQUE, JEAN-JACQUES, "Entretiens avec Man Ray", *Temps Mêlés*, nos. 31/33, mars 1958, pp. 83-8.

"The New Spirit: the 1913 Armory Show in retrospect", *Art News*, vol. X, n. 4, April 1958, pp. 2-6.

HUGNET, GEORGES, "L'exposition internationale du surréalisme en 1938", *Preuves*, n. 91, sept. 1958, pp. 38-47.

Observations: photographs by byrinthe de verre", *Les Lettres Nouvelles*, n. 63, sept. 1958, pp. 277-84. See on M.D. pp. 281-2.

1959

JEAN, MARCEL, *Histoire de la peinture surréaliste*, avec la collaboration de ARPAD MEZE, Paris, éd. du Seuil, 1959, 384 P. See on M.D. pp.: 22, 26, 29, 31-7, 53, 57, 58, 59, 60, 62, 75, 81, 82, 85-8, 90, 91-2, 94-6, 98, 99-114, 119, 120, 121, 123, 124, 126, 127, 137, 144, 177, 193, 219, 229, 232, 234, 251, 252-4, 255, 256, 260, 264, 270, 273, 281, 282, 286, 293, 295, 301, 304, 312, 313, 315, 317, 318, 319, 321, 323, 326, 328, 329, 330, 341, 342, 343, 344, 350, 352, 356, 357, 361. Translated by S. WATSON TAYLOR, *The History of Surrealist Painting*, London, Weidenfeld & Nicolson, 1960. On M.D., see pp. 100-12 et al.

LEBEL, ROBERT, *Sur Marcel Duchamp*, Paris, éd. Trianon Press, 1959, 194 p.; *Marcel Duchamp*, London, Trianon Press, 1959, 194 p. Translated by GEORGE HEARD HAMILTON; with chapters by M.D. "The Creative Act" pp. 77-8, ANDRÉ BRETON "Light House of the Bride" pp. 88-94, H.P. ROCHÉ "Souvenirs on Marcel Duchamp" pp. 79-87. Catalogue raisonné pp. 154-176. R. LEBEL, new revised and enlarged edition, Paris, éd. Belfond, 1985, 270 p. Republished, *Duchamp: von der Erscheinung zur Konzeption* (Duchamp: from the vision to the concept). R. Lebel, with essays by A. BRETON, H.P. ROCHÉ, M. DUCHAMP. Köln, G.F.R.: DuMont Schauberg (1972), 234 p.

GEORGE, WALDEMAR, *Jean Crotti et la primauté du spirituel*, Genève,

ve, éd. Pierre Cailler, 1959, 60 p. + 122 illustrations. See on M.D.: (La Mariée mise à nu...)", *Dossiers du Collège de 'Pataphysique*, no. 7, 11 Gidouille 86EP, (25 June 1959), pp. 75-9.

CHARBONNIER, GEORGES, *Le Monologue du peintre*, Paris, Gallimard, 1959. Republished, Guy Durier, 1980, 416 p. See on M.D. pp. 98-9 interview with Jacques Villon.

HABASQUE, GUY, "L'Armory Show", *L'Oeil*, n. 50, fév. 1959, pp. 10-7, 39.

THARRATS, JOAN J., "Artistas de hoy, M.D.", *Revista*, 14 fev. 1959, p. 17.

ROCHÉ, HENRI PIERRE, "Adieu, brave petite collection !", *L'Oeil*, n. 51, mars 1959, pp. 34-41. (Repr.: *A propos de petite soeur* and *La cage à sucre*, coll. Roché).

DALÍ, SALVADOR, "The King and the Queen Traversed by Swift Nudes", *Art News* (N.Y.), vol. 58, n. 2, April 1959, pp. 22-5.

TALLMER, JERRY, "A Toothbrush in a Lead Box; Would it be a Masterpiece", *Village Voice* (N.Y.), vol. IV, no. 24, 8 April 1959.

LAMBERT, JEAN-CLARENCE, "Un labyrinthe de velours vert", *France-Observateur*, 17 déc. 1959.

B.[ONNEFOI], G.[ERMAINE], "8e exposition internationale du Surréalisme ou Le Cabinet des Mirages érotiques", *Les Lettres Nouvelles*, série hebdomadaire, no. 34, 16 déc. 1959, pp. 24-6.

LEIRIS, MICHEL, "A propos d'une oeuvre de M.D. (La Mariée mise à nu...)"

"Matières nouvelles", pp. 17-23, "Rotative demi-sphère, 1925 (coll. H.P. Roché). Neuf moules mâlic, 1914. HUGNET, GEORGES, "La forme humaine à l'infini", pp. 27-8. Supplement "Chroniques du jour": ROBERT LEBEL, "M.D. Une gifle à Paris ?". Repr.: Nu...

1960

APOLLINAIRE, GUILLAUME, *Chroniques d'art 1902-1918*, Paris, Gallimard, 1960, 526 P. Texts edited and prefaced by L.C. BREUNIG. See on M.D. pp. 79, 200, 204, 252, 258, 262, 265, 274, 281, 345, 365, 420.

LIBERMANN, ALEXANDER, *The Artist in his Studio*, text and photo by A. LIBERMANN, ed. Thames and Hudson, 1960, 72 p. text + 145 photos.

MELLQUIST, JEROME, *Les Caricatures de Jacques Villon ont la marge de l'Indulgence*, Genève, éd. Pierre Cailler, 1960, 40 p. + cahier iconographique. Translated from the English by BERTHE VULLEMIN. See on M.D. pp. 9-10, 12, 15.

SANOUILLET, MICHEL, "Francis Picabia et 391", 391, Paris, éd. Erik Losfeld, 1960, 160 p.; pp 8-16; Foreword. See on M.D. pp. 9, 10, 15, 16.

BRETON, ANDRÉ, "Marcel Duchamp", *Arts*, 27 janv. 1960.

HENRY, MAURICE, "L'humour de l'art", drawing, *Arts*, 27 janv. 1960.

"Tea to Fête Art Contest Judges; French to present scholarship", *The Atlanta Journal*, 10 April 1960.

"Plimpton, Duchamp and Milliken 'Painting of Year' Judges", *The Atlanta Journal*, 11-12 April 1960.

SAUCET, JEAN, "Cette photo explique le plus scandaleux tableau moderne", *Paris-Match* (photo by Eliot Elisofon), no. 584, 18 juin 1960, p. 107.

JOUFFROY, ALAIN, "Biographie des peintres", M.D. p. 54; and HOCTIN, LUC, "La peinture moderne (1905-1940)", M.D. p. 21 (two repr.) in *Jardin des Arts* (Bruxelles), no. spécial, [juill 1960].

LEBEL, ROBERT, "Sur Marcel Duchamp" (extracts), *Le Jardin des Arts*, no. 69, juill. 1960, pp. 37-44.

M.R., "Surrealists (D'Arcy Galleries, Nov. 12-Dec. 17)", *Arts News*, vol. 59, no. 7, Nov. 1960, p. 67.

RUBIN, WILLIAM, "Reflexions on Marcel Duchamp", *Art International*, vol. 4, no. 9, Dec. 1960, pp. 49-53.

CANADY, JOHN, "Nostalgia and the Forward Look. Duchamp Surveys Surrealism and Dali Forges Ahead in all Directions", *New York Times*, 4 Dec. 1960.

"Surrealistic Sanity", *Time*, vol. 76, no. 24, 12 Dec. 1960, p. 81.

JOHNS, JASPER, "The green box", *Scrap* (N.Y.), 23 Dec. 1960, p. 4.

1961

RICHTER, HANS, *Dada Profile*, Zürich, Verlag die Arche, 1961, 116 p. See on M.D. pp. 8, 78, 92, 93; and "M.D. le magicien" pp. 31-4.

SEITZ, WILLIAM, in exhibition catalogue, *The Art of Assemblage*, M.O.M.A., N.Y., distributed by Doubleday and Co., 1961, 176 p. See on M.D. pp. 10, 14, 17, 23, 32, 37, 39, 44-7, 72, 73, 76, 83, 87, 88, 89, 123, 149 + rept.

"A Family Affair", Time, N.Y., vol. 59, 10 March 1952, p. 82.

"Miss K.S. Dreier Dead; Painter a leader in Modern Art", New York Herald Tribune, 30 March 1952.

SARGEANT, WINTHROP, "Dada's Daddy: A new Tribute is paid to Duchamp, pioneer of nonsense and nihilism", Life Magazine, vol. 32, no. 17, 28 April 1952, pp. 100-11.

BRETON, ANDRÉ, "Ferments de liberté. 125 œuvres de haut vol au Musée d'Art Moderne", Arts, no. 359, 15 mai 1952, p. 12. [List of works exhibited. Repr. of Nu...; and Mariée...]. Extract reprinted in Le surréalisme et la peinture, 1965.

CARROUGES, MICHEL, "La machine-célibataire selon Franz Kafka et M.D.", Mercure de France, no. 1066, 1er juin 1952, pp. 262-81.

KYROU, ADONIS, "Hans Richter, Max Ernst, F. Léger, Marcel Duchamp et Calder vont montrer à Paris ce que peut être aujourd'hui le cinéma surréaliste", Arts, no. 365, 26 juin 1952, p. 3. (On the film Not for sale).

"Surviving spirit of Dada", Life Magazine, 15 April 1953.

CHASTEL, ANDRÉ, "Cubism: discovery to decor", Art News, vol. 52, no. 2, April 1953, pp. 26-9, 67. See on M.D. p. 28.

SOLIER, RENÉ DE, "Le cubisme (1907-1914)", Nouvelle N.R.F., no. 3, 1er mars 1953, pp. 539-43, h.t.

CARROUGES, MICHEL, Les Machines célibataires, Paris, Arcanes, coll. "Chiffres", 1954, 248 p. cover by M.D., La Mariée... See on M.D. pp. 27-59: "Kafka et Duchamp".

ESTIENNE, CHARLES, "Marcel Duchamp ou la Joconde mise à nu", Octobre (Galerie Craven), Paris, oct. 1952.

"Acquaforte. Esagerazioni", le Arte (Firenze), anno I, nov./déc. 1952, no. 3, pp. 64-5. (Repr. La entourés de nus vite.

"Plis et repris", Medium, Informations surréalistes, no. 1, nov. 1952.

DEGAND, LÉON, Art d'Aujourd'hui, Paris, juin 1953: "La peinture cubiste" pp. 9, 19, 30, 31. See M.D. p. 30. Repr.: Nu..., Roi et Reine

LEVESQUE, JACQUES-HENRI, "Picabia et Dada", Fixe (Barcelona), published by the Dau Al Set, Agost-Setembre 1952.

MONTALAIS, JACQUES DE, "...pas mort... à New-York", Combat, 30 avril 1953, p. 3.

"Dadadadada", Time (N.Y.), 27 April 1953, p. 93.

ROCHÉ, HENRI PIERRE, "Souvenirs sur M.D.", N.R.F., no. 6, 1er juin 1953, pp. 1133-6.

ROCHÉ, HENRI PIERRE, "Souvenirs sur M.D.", N.R.F., no. 13, janv. 1954, pp. 161-2.

GOLDWATER, ROBERT, "The Arensberg Collection for Philadelphia", Burlington Magazine, vol. 96, 1954, pp. 350-3.

ROCHÉ, HENRI PIERRE, "Di-skoptiksdemarcelduchamp", Pha-

"Kat. Dreier artist, dead at 75", New York Times, 30 March 1952, p. 92.

1953

HAMILTON, GEORGE HEARD, "Anonyme no longer", Art News, vol. 51, no. 9, Jan. 1953, p. 36-7, 58-60.

BRETON, ANDRÉ, [Le cubisme au Musée d'Art Moderne], Medium, Informations surréalistes, no. 4, fév. 1953.

1954

BRUNIUS, JACQUES B., En marge du cinéma français, Paris, éd. Arcanes, coll. "Ombres blanches", 1954, 192 p. Cover: Rotative Noire", Journal intérieur du Centre d'études métaphysiques, Paris, no. 1, juin-juillet 1954, pp. 12-20.

CARROUGES, MICHEL, Les Machines célibataires, Paris, Arcanes, coll. "Chiffres", 1954, 248 p. cover by M.D., La Mariée... See on M.D. pp. 27-59: "Kafka et Duchamp".

ESTIENNE, CHARLES, "Hommage à Picabia", Combat-Art, no. 12, 6 déc. 1954, [p. 1].

Mariée..., Le Roi et la Reine inversés, Broyeuse, Apolinère). Unsigned biographical article.

1953

Premier bilan de l'art actuel, edition d'or", P. 74-6. P. 80, photo: M.D.; Picabia and Béatrice Wood, N.Y. 1916. Document
Premier bilan de l'art actuel, edited by ROBERT LEBEL, Paris, Le Soleil Noir. Positions, nos. 3-4, 1953 [mai]. M.D., p. 16: Témoins oculistes, Dessin, 1920. Foreword by LEBEL: "Confrontations" pp. 10-6. On M.D., ROBERT LEBEL: "Le surréalisme en 1953" pp. 94-6. On M.D., p. 11; "La porte de M.D.", p. 11", p. 12. In Medium. Communication surréaliste.

BRETON, ANDRÉ, "Par infra-mince", no. 1, nouvelle série, nov. 1953, p. 15, and "La porte de M.D.", p. 11", p. 11", p. 12. In Medium. Communication surréaliste.

BUFFET, GABRIELLE, "La Section d'or", photo: (20th century section), Philadelphia, Museum of Art, 1954.

CLIFFORD, HENRY, "Introduction" at The Arensberg Collection (20th century section), Philadelphia, Museum of Art, 1954.

1954

VALLIER, DORA, "La vie fait l'œuvre de Fernand Léger", Cahiers d'Art, 29e année, II, 1954, pp. 133-72. See on M.D. p. 140 [C'est fini la peinture...]. Also in exhibition catalogue, Musée des Arts Décoratifs, F. Léger, juin-octobre 1956, 415 p. + ill. See on M.D. pp. 30-1. Reprinted in Dora VALLIER, L'Intérieur de l'Art. Entretiens avec..., Paris, éd. du Seuil, 1982, 158 p., pp. 53-89. See on M.D.

REBOUL, JEAN, "Machines célibataires. Schizophrénie et Lune Noire", Journal intérieur du Centre d'études métaphysiques, Paris, no. 1, juin-juillet 1954, pp. 12-20.

ROCHÉ, HENRI PIERRE, "La vie de M.D.", La Parisienne, no. 24, janv. 1955, pp. 63-9.

"Révélation de l'art gaulois", Arts, no. 503, 16 fév. 1955, p. 14, in Cahiers d'Art, 1936.

BOUROTTE, RENÉ, "Toiles en pièces détachées et statues qui marchent toutes seules !", Paris-Presse, 19 avril 1955.

MAYOUX, JEHAN, "Les machines célibataires", Bizarre, no. 1, mai 1955, pp. 73-83; and no. II, oct. 1955, pp. 80-96.

RIBEMONT-DESSAIGNES, GEORGES, "Avant Dada", Les Lettres Nouvelles, Paris, no. 32, nov. 1955, pp. 535-48; no. 33, déc. 1955, pp. 733-53.

1955

VALLIER, DORA, "Intelligence de Jacques Villon", Cahiers d'Art, 30e année, I, 1955, pp. 33-94. See on M.D. pp. 50-2, 58, 82. Photo: La maison de Blainville p. 41. Repr.: Villon, Mon frère Marcel, huile sur toile, 81 × 60 cm, p. 115.

SANOUILLET, MICHEL, "Dans l'atelier de M.D.", Les Nouvelles Littéraires (Paris), no. 1424, 16 déc. 1954, p. 5.

1955

ses, Paris, no. 1, janv. 1954, p. 14. (Two repr.).

Reprinted in Dora VALLIER, L'intérieur de l'art. Entretiens avec..., Paris, éd. du Seuil, 1982, 158 p.; pp. 91-123. On M.D., pp. 102-3, 108, 117.

VILLON, JACQUES, Cahiers d'Art, 30e année, I, 1955, P. 226 (on Brancusi's Exhibition organized by M.D.).

DEGAND, LÉON, "Le mouvement, nouvelle conception de la plastique", Aujourd'hui, no. 3, 1955, p. 15 [Gal. Denise René].

ALLEAU, RENÉ, "Des fictions et des jeux", pp. 31-2 [on Machines Célibataires].

SOBY, JAMES THRALL, "The Arensberg Collection", [Fine Art] Saturday Review, 6 Nov. 1954, pp. 60-1.

HANTAI, SIMON and SCHUSTER, JEAN, "Une démolition au platané", pp. 58-62 (see on M.D. p. 61-2), Medium. Communication surréaliste, no. 4, nouvelle série, janv. 1955.

1956

BLESH, RUDI, Modern Art USA. Men, Rebellion, Conquest 1900-1956, New York, Alfred A. Knopf, 1956, 295 p. + X. See on M.D. pp. 71, 72-3, 74-9, 91, 95, 99-100, 109-10, 200-1.

"New York: la mostra di Jacques Villon, Raymond Duchamp-Villon e M.D.", Emporium, vol. CXXV, 1957, pp. 220-7.

HABASQUE, GUY, "L'art français dans les collections américaines", Médecine de France, no. 79, 1956, pp. 17-32 (repr.).

CHANIN, A.L., "Then and now", The New York Times Magazine, 22 Jan. 1956, pp. 22, 25.

SEIZ, JEAN, "L'avant-garde aux cheveux blancs", Les Lettres Nouvelles, no. 39, juin 1956, pp. 895-8. [Dreams that money can buy].

1957

BRETON, ANDRÉ, L'Art Magique, Paris, Club Français du Livre, 1957, 238 p. On M.D. see pp. 44-5. Republished, Paris, Phébus/Adam Biro, 1991. See on M.D. pp. 81, 87-9, 187, 242, 247, 249-51, 281, 287, 294, 295, 319, 332.

BUFFET-PICABIA, GABRIELLE, Aires abstraites, Genève, éd. Pierre Cailler, coll. "Les problèmes de l'art", 1957, 186 p. See on M.D.

HUGNET, GEORGES, L'Aventure Dada (1916-1922), Paris, Galerie de l'Institut, 1957, 101 p. + cahier iconographique. Cover by M.D.; introduction by TRISTAN TZARA. Reproduction of four works by M.D. + photos. New enlarged edition, Paris, éd. Seghers, 1971, 240 p.; cover by M.D. See on M.D.: pp. 30, 35, 36-7, 39-43, 44, 45, 52, 86, 87, 88, 98-9, 104, 112, 113. Ill. pp.

LEBEL, ROBERT, "L'humour absurde de M.D." XXe Siècle, no. 8 ("Art et humour du XXe Siècle"), janv. 1957, pp. 9-12.

BIBLIOGRAPHY

HAMILTON, GEORGE HEARD, "Duchamp, Duchamp-Villon, Villon", *Bulletin of the Associate in Fine Arts at Yale University*, vol. XIII, no. 2, March 1945, pp. 1-5.

B[AZIN], G[ERMAIN], "Marcel Duchamp", *L'Amour de l'Art*, 25ème année, II no. spécial "L'école de Paris à New York", juill. 1945, p. 37. Repr. "Homage to the Salon d'Automne 1944", "La 'Valise-poème' ouverte".

McBRIDE, HENRY, "Florine Stettheimer: A Reminiscence", *View*, Series V, no. 3, Oct. 1945, pp. 13-5.

1946

LEIRIS, MICHEL, "Arts et Métiers de M.D." ; *Fontaine*, no. 54, été 1946, pp. 188-93. Reprinted in *Brisées*, Paris, Mercure de France, 1966, 304 p., pp. 114-9.

SWEENEY, J.J., "Alexandre Calder", in *Mobiles, Stabiles, Constellations*, exhibition catalogue Galerie Louis Carré, 25 oct.-16 nov. 1946, pp. 21-35. See on M.D. p. 31.

1947

ROBSJOHN-GIBBINGS, T.H. *Mona Lisa's Mustache. A Dissection of Modern Art*, N.Y., Alfred A. Knopf, 1947. See on M.D., pp. 189-91.

WEINBERG, HERMAN G., "Payez-vous deux sous de rêves", *La Revue du Cinéma*, no. 7, été 1947, pp. 10-4. [On Hans Richter's film, *Dreams that money can buy*.]

ESTIENNE, CHARLES, "Surréalisme et Peinture", *Combat*, 16 juill.

1947. On the 1947 Surrealist Exhibition see also: GEORGES LIMBOUR, *Action*, 25 juill. 1947. JACQUES LASSAIGNE, *La Bataille*, no. 134, 16 juill. 1947. GÉO LONDON, pp. 41, 42, 43, 44, 45, 49, 50, 51, review of the exhibition, *La Bataille*, 16 juill. 1947. CHARLES ESTIENNE, *Combat*, 8 juill. 1947.

GUERRE, PIERRE, "L'Exposition internationale du Surréalisme", *Cahiers du Sud*, no. 284, 2ème semestre 1947, pp. 129-31.

MARCHAND, JEAN-JOSÉ, "Réflexions à propos de l'exposition surréaliste...", *Paru*, no. 34, sept. 1947, pp. 677-81.

1948

NADEAU, MAURICE, *Documents Surréalistes*, Paris, éd. du Seuil, 1948, 400 p. See on M.D., pp. 136, 316, 368.

PACH, WALTER, *The Art Museum in America*, N.Y., ed. Pantheon Books Inc., 1948, see p. 100.

ROUGEMONT, DENIS de, *Journal des deux Mondes*, Paris, Gallimard, 1948, 220 p.

OLIVIER, "Le surréalisme en 1947", *Paru*, no. 38, janv. 1948, pp. 61-3.

DREIER: pp. 1-30. See on M.D. pp. 5, 7, 21. See also pp. 70, 71, 81, 86, 90, 112, 114, 120. J.J. SWEENEY: pp. 31-62. See on M.D. NAUM GABO: pp. 63-87. See also M.D., P. VI.

SADOUL, GEORGES, *Histoire du Cinéma Mondial*, 9th edition, revised and enlarged by HENRI LANGLOIS, Paris, Flammarion, 1949, pp. 197, 202. See on M.D., pp. 196-8.

1950

De Picasso au surréalisme, textes by MAURICE RAYNAL, JACQUES LASSAIGNE, WERNER SCHMALENBACH, ARNOLD RUDLINGER, HANS BOLLIGER, Genève-Paris, Skira, 1950, 212 p. See: p. 87, "Les expériences personnelles de M.D."; pp. 111-12, "M.D. et Picabia à New York". See also: pp. 10, 11, 38, 61, 69, 76, 77, 78, 86, 88, 89, 106, 121, 150, 154, 175, 177, 193-4. Two colour reproductions, pp. 88, 112.

CARROUGES, MICHEL, *André Breton et les données fondamentales du surréalisme*, Paris, Gallimard, coll. "Les Essais", no. 43, 1950, 336 p. Republished, coll. "Idées", no. 121, 1971, 384 p. See on M.D., pp. 11, 13, 58, 66, 120, 243, 303-4, 305, 315.

DREIER, KATHERINE S., "Marcel Duchamp" in *Collection of the Société Anonyme*, New Haven, Yale University Art Gallery, 1950, 224 p.; pp. 148-50.

JANIS, HARRIET and SIDNEY, "M.D. Anti-Artiste", *Horizon* (London), vol. XII, no. 70, Oct. 1947, pp. 196-8.

McBRIDE, HENRY, "Florine Stettheimer", *View*, Series V, no. 3, Oct. 1947, pp. 13-5.

MARCHAND, JEAN-JOSÉ, "Réflexions à propos de l'exposition surréaliste...", *Paru*, no. 34, sept. 1947, pp. 677-81.

Two letters concerning the Swiss Government concerning the seizure of a copy of *Surréalisme en 1947*, "comme étant d'un caractère immoral" (cover by M.D.), *Derrière le Miroir*, no. 16, janv. 1949.

PUEL, GASTON, "Lettre à M.D. Constructeur" [p. 3], "Lettre à Raymond Roussel" [p. 2], *Néon*, no. 5, printemps 1949.

"Beauty and the Bubble" *Time*, vol. 53, no. 16, 18 April 1949, p. 72.

Ros, KENNETH, "Duchamp, whose 'Nude' once rocked nation, visiting in L.A." *Daily News* (Los Angeles), 23 April 1949, p. 5.

BOSWELL, PEYTON, "Comments: Words in San Francisco", *Art Digest*, Vol. 23, no. 15, 1 May 1949, p. 7.

BARRY, EDWARD, "Arensberg Art goes in View Today: 200 Modern Items shown in Collection", *Chicago Daily Tribune*, 20 Oct. 1949, p. 16.

LOUCHHEIM, ALINE B., "Arensbergs bought Cubists then", *New York Times*, 23 Oct. 1949.

"Be Shocking", *Time* (N.Y.), Vol. 54, no. 18, 31 Oct. 1949, p. 42.

KUH, KATHARINE, "Four Versions of 'Nude descending a Stair-

case", *Magazine of Art* (N.Y.), Vol. 42, no. 7, Nov. 1949, pp. 264-5.

LEBEL, ROBERT, "Picabia et Duchamp ou le pour et le contre", *Paru*, no. 55, nov. 1949, pp. 141-3.

"Modern Art Argument", *Look*, Vol. 13, no. 23, 8 Nov. 1949, pp. 80-3.

McBRIDE, HENRY, "Conversation Piece", *Art News*, N.Y., vol. 49, Sept. 1950, pp. 20-1. Reprinted in *Flow of Art. Essays and Criticism*, Atheneum Pub., 1975, pp. 425-8.

1951

MOTHERWELL, ROBERT ed., *The Dada Painters and Poets: an Anthology*, N.Y., Wittenborn and Schultz, 1951, XXXVI + 390 p. See on M.D., pp. XVII, XXVI-XXVIII, XXX, XXXI, XXXIII, XXXIV, XXXVI, 13, 14, 15, 104, 111, 136-40, 166, 185-6, 196, 204, 207-11, 213, 214, 255-63, 306-15, 320, 321, 323, 356-7.

KUH, KATHARINE, *Art has many faces. The Nature of Art presented Visually*, N.Y., Harper and Brothers "Publishers", [1951]. See M.D., pp. 128, 148-50.

A.Z., "Marcel Duchamp" *Il Tempo* (Milano), 30 genn. 1952.

PACH, WALTER, "A Family of Artists", in exhibition catalogue *Duchamp frères et soeur*, N.Y., Rose Fried Gallery, 25 Feb.-March 1952.

SUQUET, JEAN, "Le signe du Cancer", *La Nef*, special issue 63-64 "Almanach surréaliste du demi-siècle", mars 1950, pp. 99-105 (republished, éd. Plasma, 1978).

"The great Armory Show of 1913", *Life*, vol. 28, no. 1, 2 Jan. 1950, pp. 58, 60.

ROSS, KENNETH, "L.A. lays golden egg, but Philadelphia takes it back home to hatch", *Los Angeles News*, 20 Jan. 1951.

"Philadelphia gets $ 2,000,000 in Art" (Arensberg Collection), *New York Times*, 18 Jan. 1951.

JEAN, MARCEL, "Les Quinzaines héraldiques" ibid., pp. 63, 65. "Bonanza for Philadelphia", *Time*, vol. LVII, no. 7, 12 Feb. 1951, p. 73.

LECOMTE, MARCEL, "Anthologie de l'humour noir, par André Breton" *Le Journal des Poètes*, no. 3, mars 1951, p. 2.

Art d'Aujourd'hui, t. I, no. 7/8, York 1951", *Art d'Aujourd'hui* (Paris), série 2, no. 6, juin 1951, pp. 4-14.

SEUPHOR, MICHEL, "Paris-New York 1950: GABRIELLE BUFFET-PICABIA "Dada", pp. 27-30. M.D. repr.: *Apollinère, Nu..., La porte du 11 rue Larrey, LHOOQ*, P. 31: Photo: Exposition surréaliste Paris 1938. P. 32: Georges Hugnet, "Surréalisme". Repr.: *Roi et Reine* of the Société Anonyme", *Magazine of Art*, no. 44, 28 Nov. 1951.

KUH, KATHARINE, "Collection..." *La Valise de M.D.*

1952

BRETON, ANDRÉ, *Entretiens (1913-1952)*, Paris, Gallimard, coll. "Le Point du Jour", 318 p. 1969. See "Point du Jour", pp. 20-1. Revised edition, coll. "Idées", 1973, 320 p. See on M.D., pp. 24, 59, 60, 64, 68, 76, 90, 103, 163, 182, 184, 196, 197, 208, 220, 228, 246, 301.

GAFFE, RENÉ, *Peinture à travers Dada et surréalisme*, Bruxelles, éd. des Artistes, 1952, 92 p. See on M.D. pp. 10-1, 15-6, 19-21, 62.

POITTEMANS, ELEANOR, "Mural on glass panel" *Art in Modern Architecture*, N.Y., Reinhold Publ. Corp., 1952. See p. 154.

BUFFET-PICABIA, GABRIELLE, "Dada et l'Esprit 'Dada'", *Preuves*, no. 11, janv. 1952, pp. 46-7.

"La vie à Paris", *Vogue*, Christmas no. 1950, pp. 63-5.

Three lectures on Modern Art, N.Y., The Philosophical Library, 1949, VII + 92 p. by KATHERINE

KUH, KATHARINE, "Four Versions of 'Nude descending a Stair-pommier du Japon" (1910), p. 159.

JEAN, MARCEL, "Les Quinzaines héraldiques", ibid., pp. 63, 65. "Courant d'air sur le Breton" *Le Journal des Poètes*, no. 3, mars 1951, p. 2.

"Marcel Duchamp", *Vanity Fair*, July 1934, p. 22. Reprinted in DIANA EDKINS *Vanity Fair. Photographs of an Age. 1914-1936*, New York, ed. Clarkson N. Potter, 1982, 203 p, pp. 152-3.

1935

WOLFF, DR LOTTE, "Les révélations psychiques de la main", *Minotaure*, no. 6, hiver 1935, pp. 38-44.

BRETON, ANDRÉ, "Phare de la Mariée", id, pp. 45-9. Reprinted in *Le Surréalisme et la Peinture*, N.Y., Brentano's, 1945, 204 p. + illus. p. 107. See also 1965.

LEVESQUE, JACQUES-HENRY, "Préface. Marcel Duchamp", pp. 1-2.

MASSOT, PIERRE DE, "La Mariée... par Marcel Duchamp", pp. XVII-XXII, (text dated: 20 nov. 1935), *Orbes*, 2ᵉ série, no. 4, hiver 1935-6. Cover by M.D. Cover p. II: advertisement for *La Mariée...*; éd. Rrose Selavy.

1936

LEVY, JULIEN, *Surrealism*, New York, The Black Sun Press, 1936, 192 p. See M.D. pp. 4, 10, 15-7. Reproductions pp. 100, 127-8.

BULLIET, C.J., *The Significant Moderns and Their Pictures*, New York, Halcyon, 1936. See pp. 130-2; repr.: *Nu...*

BUFFET, GABRIELLE, "Coeurs Volants", *Cahiers d'Art*, no. I-II, 1936, pp. 34-44. See al-so note by M.I. KITROSER on the "Roto-reliefs", p. 34. Cover and reproductions of eight works by M.D.

JEAN, "Le dadaïsme et le surréalisme", p. 316, Cassou, "Notice historique sur Dada et le surréalisme", pp. 341-2; "Marcel Duchamp", p. 343.

1936

[MERCHANT, FRANK], "Restoring 1000 glass bits in panels", *The Literary Digest* (N.Y.), vol. 121, no. 25, June 1936, pp. 20, 22.

"Artist Must Die To Be Great, Frenchman Says", *The Berkshire Country Eagle*, 17 June 1936.

"Cubism to Cynicism" *Time (The Weekly Magazine)*, N.Y., vol. 28, no. 9, 31 August 1936, p. 22.

1937

HUGNET, GEORGES, *Cartes Postales Surréalistes*, Paris, Georges Hugnet, 1937. 21 cards 142 × 92, black on pink ground. See no. 1; M.D.: "L'Air de Paris".

PAULHAN, ANDRÉ, "Marcel Duchamp", *Triptyque*, no. 107, avril 1937, pp. 28-32.

KIESLER, FREDERICK J., "Design-Correlation", *The Architectural Record*, May 1937, pp. 53-60.

BRETON, ANDRÉ, "Cabezas de tormenta", *Sur* (Buenos-Ayres), no. 32, mayo 1937, pp. 7-40. Includes Duchamp's note on *Anthologie de l'Humour Noir* (1940).

CAILLOIS, ROGER, "Jeux et Techniques; l'opposition et les ca-ses conjuguées sont réconciliées", *N.R.F.*, no. 288, 1er sept. 1937, pp. 511-4.

BUFFET, GABRIELLE, "Rencontre avec Apollinaire", *Le Point*, 2ᵉ année, no. V, pp. 184-99, nov. (P. DRIEU LA ROCHELLE).

1938

BRETON, ANDRÉ and ELUARD, PAUL, *Dictionnaire Abrégé du surréalisme*, Paris, Galerie Beaux-Arts, 1938, 76 p. See M.D. entry, p. 10. New edition, éd. José Corti, 1969, 78 p. see also "Objet" pp. 18-9). Reprinted in *Œuvres complètes de Paul Eluard*, t. 1, Gallimard, Pléiade, 1968, pp. 719-96.

ZERVOS, CHRISTIAN, *Histoire de l'art contemporain*, Foreward by Henri Laugier, Paris, éd. Cahiers d'Art, 1938, 452 p. On M.D. see chapter "Au-delà de la peinture" p. 351, and repr.: *Le Roi et la Reine entourés de nus vites*, 1912, p. 352; *Broyeuse...*, 1914, p. 353; *La Mariée...*, 1915-1923, p. 354. On M.D. see chapter "Dada", p. 407, and repr.: *La Mariée...*, 1912, p. 409; *Verre peint*, 1917, p. 410.

McMORRIS, D., "Marcel Duchamp's Frankenstein", *Art Digest*, N.Y., vol. 12, no. 7, 1st Jan. 1938, p. 22.

PETITJEAN, A.M., "A propos de l'exposition surréaliste", *N.R.F.*, no. 294, 1er mars 1938, pp. 515-6.

BRETON, ANDRÉ, "Some Passages from the Lighthouse of the Bride", *London Gallery Bulletin* (London), no. 4/5, July 1938, pp. 17-9. Translated by H.[umphrey] J.[ENNINGS]. Repr.: *The Bride...* P. 16.

ROLAND DE RENNEVILLE, A., "Le surréalisme en 1938", *N.R.F.*, no. 299, 1er août 1938, pp. 302-6. See M.D. p. 306. On the 1938 Surrealist Exhibition see also: *Aux Écoutes*, 22 janv. (ANDRÉ SALMON); *Vendémiaire*, 26 janv.; *Grin* May 1942, p. II.

"Artist descending to America" *Time (The Weekly Magazine)*, N.Y., vol. 40, no. 10, 7 Sept. 1942, pp. 100, 102.

1939

BIDDLE, GEORGE, *An American Artist's Story*", Boston, Little Brown and Co, 1939. See on M.D. and Else Freytag-Loringhoven, pp. 137-41.

1940

BRETON, ANDRÉ, *Anthologie de l'humour noir*, Paris, éd. du Sagittaire, 1940, 264 p. See on M.D. pp. 221-2. New editions, Le Sagittaire, 1950: Paris, J.-J. Pauvert, 1966, pp. 329-31; and au Livre de Poche, 1970, pp. 354-6.

CROWNINSHIELD, FRANK, "The Scandalous Armory Show of Anonyme Inc., 1913", *Vogue*, 15 Sept. 1940, pp. 68-71.

"To and from America", *View*, N.Y., vol. I, no. 3, Nov. 1940, p. 1.

1941

HUGNET, GEORGES, *Marcel Duchamp*, Paris, published by the author 1941. Poem dated 8 nov. 1939. 8 p. brochure, edition of 200 copies, 20 of which on havane de Montval and 6 on japon nacré.

1942

BRETON, ANDRÉ, "Genesis and Perspective of Surrealism", *Art of this Century*, exhibition catalogue, N.Y., 1942, pp. 13-27. See 1945 and 1965 editions.

New Press, (Santa Barbara), 24 May 1942, p. II.

1943

VVV, no. 2/3, March 1943: Cover by M.D. p. 86: Photos: Window display for *La part du diable* and *Souvenir de l'exposition Surréaliste de 1942*, p. 133; Kurt Seligmann, "Surrealist bibliography. Duchamp": p. 137.

1944

DREIER, KATHERINE S. and MATTA ECHAURREN, *Duchamp's Glass, La Mariée mise à nu par ses célibataires, même: An Analytical Reflection*, New York, Société Anonyme Inc., 1944 (May), 3 repr., Edition: 250 copies (Museum of Modern Art, 1920).

JANIS, SIDNEY, *Abstract and Surrealist Art in America*, N.Y., Reynal and Hitchcock, 1944. See pp. 126-7. Repr. p. 10, *Large Glass*. p. 131, *Boîte-en-valise*.

1945

BRETON, ANDRÉ, *Le Surréalisme et la Peinture*, N.Y., Brentano's, 1945, 204 p. Repr.: *Phare de la Mariée*, pp. 107-24. *Genèse et perspective du surréalisme* pp. 84-5.

NADEAU, MAURICE, *Histoire du Surréalisme*, Paris, éd. du Seuil, 1945, 366 p. + h.t. See on M.D. pp. 41-2, 48, 50, 172, 182, 212, 231.

JEWELL, EDWARD ALDEN, "Surrealists open Display Tonight", *New York Times*, 14 Oct. 1942.

RIBEMONT-DESSAIGNES, GEORGES, "De Dada à Bifur". *L'Age d'Or*, no. 1, 1945. Reprinted in *Pages Françaises*, no. 6, oct. 1945, pp. 51-7.

BRETON, ANDRÉ, "Genèse et perspective artistiques du Surréalisme", *Labyrinthe*, no. 5, 15 fév. 1945, pp. 10-1. Repr.: *Jeune homme dans un train*, 1912, p. 10. *La mariée...*, 1915-23, p. 11.

View, Marcel Duchamp number, Series V, no. 1, March 1945, with: LINDAMOOD, PETER, "I cover the cover", p. 3; FORD, CHARLES HENRI, "Flag of Ecstasy", p. 4 (printed on photo of MAN RAY); BRETON, ANDRÉ, "The Point of View: Testimony 45", p. 5; BRETON, ANDRÉ, "Light House of the Bride", pp. 6-9, 13; SOBY, JAMES THRALL, "M.D. in the Arensberg Collection", pp. 10-2; BUFFET, GABRIELLE, "MagiCircles", pp. 14-6 et 23; DESNOS, ROBERT, "Rrose Sélavy (1922-1923)", p. 17; JANIS, HARRIET and SIDNEY, "M.D. anti-artist", pp. 18-9, 21, 23-4, 53-4, CALAS, NICOLAS, "Cheat to Cheat", pp. 20-1; WASTE, HENRIE, "Pensée-cadeau", p. 22; KIESLER, FREDERICK, "Les larves d'Imagie d'Henri Robert, Marcel Duchamp, poème espace dédié à H(ieronymus) Duchamp" pp. 24-30; MAN RAY, "Bilingual Biography", pp. 32 et 51; PARKER, ROBERT A., "America discovers Marcel", pp. 32-3, 51; LEVY, JULIEN, "Duchampiana" pp. 33-4; WASTE, HENRIE, "A Portrait", pp. 34-5, 51; LOY, MINA, "O Marcel: or I too have been to Louise's" pp. 35, 51 (from *The Blind Man*); KOCHNITZKY, LEON, "M.D. and the Futurists", pp. 41, 45.

neum Pub., 1975, pp. 156-8; and *The Dial. An Anthology of Writings from the Dial Magazine 1920-1929*, 1981.

BONDON, W.G., "Société Anonyme Has Third Show of Modern Art", *Evening World*, 4 Aug. 1920.

1921

TZARA, TRISTAN, "Dans le catalogue du salon Dada..."; "Tzara envoie à M.D...", *DadauanGran dAir* (Dada au Tirol), Paris, no. 8 [1921], [p. 1].

FUNNY GUY [F. PICABIA], "Mon cher Confucius"; *Le Pilhaou-Thibaou*, (Paris), 10 juill. 1921, p. 9.

1922

STEIN, GERTRUDE, *Geography and Plays*, Boston, The Four Seas Cy Publ., 1922; Introduction by SHERWOOD ANDERSON. See pp. 405-6, "Next Life and Letters of M.D.". Reprinted N.Y., Something Else Press, 1968.

TZARA, TRISTAN, "Nous connaissons Totor...", *Le Cœur à Barbe*, Journal Transparent, [no. 1], avril 1922, [p. 7]. Reprinted in *Œuvres complètes*, t. 1, Paris, Flammarion, 1975, p. 586 and reprint J.M. Place, 1981.

APOLLINAIRE, GUILLAUME, "Aesthetic Meditations", *Little Review*, (N.Y.), vol.IX, no. 2, 1922, pp. 49-60. See on M.D. pp. 56-7, + reprod. h.t.: *Nu...*; Translated by Mrs Ch. KNOBLAUCH, for the Société Anonyme. See other chapters in vol. VIII, no. 2, Spring 1922, pp. 7-19, and vol. IX, no. 3, Autumn 1922, pp. 41-59.

PICABIA, "Picabia dit dans *Littérature*, nouvelle série, no. 4, 1er sept. 1922, p. 18.

Little Review, vol. IX, no. 3, Autumn 1922, Stella Number. See p. 17: M.D. and Stella, photo by Man Ray pp. 32-33: STELLA, M.D.: pp. 60-61: Rayograph, *Rose Sel a Vie*.

BRETON, ANDRÉ, "Marcel Duchamp", *Littérature*, Paris, nouvelle série, no. 5, 1er oct. 1922, pp. 7-10. Republished, éd. J.M. Place, 1978. Reprinted in *Les Pas Perdus*, 1924, pp. 141-6.

1923

BRETON, ANDRÉ, "Les mots sans ride", *Littérature*, nouvelle série, no. 7, déc. 1922, pp. 12-4.

FREYTAG-LORINGHOVEN, BARONESS ELSE VON, "Portrait de Marcel Duchamp", *The Little Review*, (N.Y.), vol. IX, no. 2, Winter 1922, h.t. pp. 40-41.

DREIER, KATHERINE S. *Western Art and the New Era. An Introduction to Modern Art*, New York, Brentano's, 1923, 140 p. Dedicace: "To Dee". See p. 110, "Portrait of M.D." by JOSEPH STELLA; p. 111, "Portrait of Tu'm". See also: pp. 70, 71, 81, 86, 90, 112, 114, 120.

BRETON, ANDRÉ, "A Rrose Sélavy" poème de *Clair de Terre*, Paris, Collection Littérature, 1923. Reprinted in *Œuvres complètes*, Coll. "Pléiade", 1989, p. 189.

DESNOS, ROBERT, "L'Aumony-me", *Littérature*, nouvelle série, no. 10, 1er mai 1923, pp. 18-9.

PACH, WALTER, "Modern Art Cubism: Its Development", *The Freeman* (N.Y), vol. VII, no. 181, 29 Aug. 1923, pp. 591-3.

RIBEMONT-DESSAIGNES, GEORGES, "Dada Paintings or the Oil-Eye", *Little Review*, vol. IX, no. 4, Autumn-Winter, 1923-1924, pp. 10-2.

1924

BRETON, ANDRÉ, *Les Pas Perdus*, Paris, Gallimard, 1924, 212 p. See on M.D. pp. 141-6 et 194. New revised edition, Coll. "Soleil", 1969, 176 p.: See pp. 111-5; "Marcel Duchamp". See also on M.D. pp. 35, 99, 108, 119, 129, 133-4, 152-3, 154, 161. Republished coll. "Idées", no. 205. See M.D. pp. 117-21; 36, 105, 113, 126, 137, 140, 141, 159, 162, 169.

MASSOT, PIERRE DE, *The Wonderful Book. Reflections on Rrose Sélavy*, Paris-Passy, Imprimerie Ravilly, 1924, [20 p.].

McBRIDE, HENRY, "Reappearance of Duchamp's 'Nude descending a Staircase'", *The New York Herald*, 9 March 1924, p. 13. Reprinted in *The Flow of Art. Essays and Criticisms*, 1975, pp. 189-90.

"Gallery Notes" *New York City World*, 24 oct. 1926 (Brancusi Exhibition).

DE MASSOT], P[IERRE], "Rrose Sélavy s'est fait mal...", *391*, Paris, no. 18, juill. 1924, p. 3.

PICABIA, FRANCIS, "Journal de l'Instantanéisme (Portrait de Rrose Sélavy)", *391*, Paris, no. 19, oct. 1924, p. 1.

"Entr'acte", *Comoedia Illustré*, 1er nov. 1924, Texts by Picabia and R. Clair.

P.M., "Relâche", *Ville de Paris*, 28 nov. 1924.

1925

OZENFANT and JEANNERET, *La Peinture Moderne*, Paris, éd. Cres, catalogue: *The Cubist Spirit in its Time*, London Gallery, 1947.

 OZENFANT and JEANNERET, *La Peinture Moderne*, Paris, éd. Cres, catalogue: "L'Esprit Nouveau", 1925, 172 p. + h.t. See M.D. p. 92 (The Cubists at the 1911 Salon).

ACHARD, PAUL, "Picabia m'a dit... avant *Cinésketch* au Théâtre des Champs-Élysées", *L'Action*, 1er janvier 1925, p. 4 (Interview).

ACHARD, PAUL, "Soirs de Paris. Les Derniers Moments de...", *Paris-Midi*, 2 janv. 1925. (Cinésketch).

"Erotisme" *Journal Littéraire* (Paris), 10 janv. 1925. (Cinésketch).

1926

MAN RAY, "Portrait de Rrose Sélavy", (1923), exhibition catalogue *Tableaux de Man Ray*, Paris, Galerie Surréaliste, 26 mars-10 avril 1926.

DREIER, KATHERINE S., Catalogue: *International Exhibition of Modern Art*, arranged by the Société Anonyme for the Brooklyn Museum, N.Y., Nov.-Dec. 1926. See M.D. p. 23.

1928

OZENFANT, *Art. Bilan des Arts Modernes en France*, Paris, éd. Jean Budry, 1928, 318 p. See M.D. pp. 30, 58, 121-2. Repr.: p. 121, *Vitre et étain*, p. 122, *La Mariée...*

PACH, WALTER, "For Jacques Villon", exhibition catalogue Villon, Brummer Gallery, New York, 26 March-21 April 1928.

1929

JANNEAU, GUILLAUME, *L'Art Cubiste. Théories et réalisations*, Paris, éd. d'Art Charles Moreau, 1929 (mai), 116 p. See M.D. pp. 21 et 24. Reprinted in exhibition catalogue: *The Cubist Spirit in its Time*, London Gallery, 1947.

1930

"Current Exhibitions of Interest" *Parnassus*, vol. II, no. 4, April 1930 [de Hauke Galleries].

FORBES, WATSON, "In the Galleries. The de Hauke Galleries", *The Arts*, vol. XVI, no. 8, April 1930, pp. 586, 588 et 590.

"Cubists Revised at de Hauke Galleries", *Art News*, 5 April 1930.

SALMON, ANDRÉ, "Marcel Duchamp Villon", *Gringoire*, (Paris), 11 avril 1930.

TERIADE, E., "Documentaire sur la jeune peinture. III. Conséquences du Cubisme", *Cahiers d'Art*, 5e année, no. 1, 1930, p. 17, 22. See p. 24: "A regarder d'un œil..."

"Exhibition of Cubism (Galerie de Hauke, New York)", *Documents*, Paris, 2e année, no. 5, 1930, pp. 302-3 (repr. *Nu...*).

GEORGE, WALDEMAR, *Jean Crotti et le démon de la connaissance*, Paris, éd. Graphis, 1930, (edition: 565 copies). See reproduction *Portrait sur mesure de Marcel Duchamp*.

LEVESQUE, JACQUES-HENRY, "La porte de Duchamp" *Orbes*, II, no. 2, été 1933.

ARAGON, LOUIS, *La Peinture au défi*, Paris, Galerie Goémans, 1930. Edition: 5 copies on Japon Impérial, 15 copies on Hollande Van Gelder, 1000 copies on papier Bouffant. Reprinted in ARAGON, *Ecrits sur l'Art Moderne*, Paris, Flammarion, 1981, 380 p.; Preface by JACQUES LEENHARDT. See M.D. pp. 30-5 et 46; 189, 257, 335.

MASSOT, PIERRE DE, "Extraits d'un cahier noir", *Orbes*, 1er série, no. 4, hiver 1932-1933, pp. 119-25. See M.D. p. 123.

1931

RIBEMONT-DESSAIGNES, GEORGES, "Histoire de Dada (fragments)", *NRF*, no. 213, juin 1931, pp. 867-79 and no. 214, juill. 1931, pp. 39-52.

1932

BRETON, ANDRÉ, "The Bride stripped bare by her own Bachelors" (Presentation) *This Quarter*, Paris, vol. V, no. 1: Surrealist number p. 189, sept. 1932.

1933

BRETON, ANDRÉ, "La Mariée mise à nu par ses célibataires mêmes" (présentation) *Le Surréalisme au Service de la Révolution*, no. 5, 15 mai 1933, p. 1.

MASSOT, PIERRE DE, "Lu le soir. L'opposition et les cases conjuguées sont réconciliées, par M.D. et V. Halberstadt", *Orbes*, 2e série, no. 2, été 1933, pp. 15-7.

LEVESQUE, JACQUES-HENRY, "a ne mic cine ma", *Orbes*, 2e série, no. 2, été 1933, p. 23.

1934

Petite Anthologie poétique du surréalisme, introduction by Georges HUGNET, Paris, éd. Jeanne Bucher, 1934. Total edition 2028 copies. See M.D. pp. 11, 26, 33. h.t., repr.: *La mariée...*

HUGNET, GEORGES, "Dada à Paris", *Cahiers d'Art*, 9e année, no. 1-4, 1934, pp. 109-14. See p. 109, "Tableau dada 1920".

BIBLIOGRAPHY

CABANNE, PIERRE, "D.: j'ai une vie de garçon de café", *Arts Loisirs*, no. 75, 1er mars 1967, pp. 10-1.

LEBEL, ROBERT, "M.D. maintenant et ici", *L'Œil*, no. 149, mai 1967, pp. 18-23, 77. Photo reportage by MARC LAVRILLIER.

RUSSELL, JOHN, "Exile at Large. Interview", *Sunday Times* (London), 9 June 1968, p. 54.

GLUECK, GRACE, "Duchamp parries Artful Questions", *New York Times*, (N.Y.), 25 Oct. 1967, P. 37.

ROBERTS, FRANCIS, "I Propose to Strain the Laws of Physics", (Interview at Pasadena Oct./Nov. 1963), *Art News*, Vol. 67, no. 8, Dec. 1968, pp. 46-7 to 62-4.

NORMAN, DOROTHY, "Interview with ..." (1953), *Art in America*, Vol. 57, no. 4, July-August 1969, p. 38. Extract of this interview in D. NORMAN, *Alfred Stieglitz : An American Seer*, N.Y., Random House, 1973, p. 128.

ROBERTS, COLETTE, "Interview with..." (April 1968) *Art in America*, Vol. 57, no. 4, July-Aug 1969, p. 39.

HAHN, OTTO, "Marcel Duchamp", *VH101* (Zürich-Paris), no. 3, automne 1970, pp. 55-61.

STAUFFER, SERGE, *Marcel Duchamp, Interviews und Statements*, gesammelt, übersetzt und annotiert von Serge Stauffer, Stuttgart, Graphische Sammlung Staatsgalerie, 1992, 254 p.

Books, parts of books and articles devoted to Marcel Duchamp until 2 october 1968

1908

[Salon des Artistes Rouennais], *Journal de Rouen*, 8 mars 1908.

MOREL, E., [Salon des Artistes Rouennais], *La Dépêche de Rouen*, 17 avril 1908.

"Lawn-Tennis: les championnats de Veules-les-Roses", *L'Auto* (Paris), 20 août 1908, p. 5.

1909

GOSSEZ, A.M., "L'Art à Rouen en 1908-1909; la troisième exposition des Artistes Rouennais", *L'Âme Normande*, 5e année, no. 40/41, fév-mars 1909.

D[ubosc], G., "Le Salon des Artistes Rouennais", *Journal de Rouen*, 27 fév. 1909.

["Clôture de l'exposition"], [*Journal de Rouen*, 30 mars 1909] (list of works purchased by the Société for the Lottery).

[result of the lottery draw], *Journal de Rouen*, 8 avril 1909.

"Les affiches de l'Exposition de Peinture Moderne", *La Dépêche* (Rouen), 19 déc. 1909.

"Exposition de Peinture Moderne", *Journal de Rouen*, 20 déc. 1909.

1910

APOLLINAIRE, GUILLAUME, "Au Salon des Indépendants - Le vernissage", *L'Intransigeant* (Paris), 19 mars 1910.

DUBOSC, G., "Le Salon", *Journal de Rouen*, 9 avril 1910.

"A propos de Boronali et des Indépendants de Paris", *Avant-garde de Normandie*, 15 mai 1910.

1911

"Exposition de la Société Normande de Peinture Moderne", *Journal de Rouen*, 8 mai 1911.

MOREL, E., "Beaux-Arts. Société Normande de Peinture Moderne...; 41: Le Roi et la Reine...; [38: Joueurs d'é]checs; 39: Nu...; 40: Jeune homme...; 41: Le Roi et la Reine...; Paris, *La Dépêche de Rouen*, 8 mai 1911.

MARDORT, PIERRE, "Beaux-Arts. Deuxième Exposition de la Société Normande de Peinture Moderne", *Rouen Gazette*, 2e année, no. 19, 13 mai 1911 (with a caricature of DUCHAMP by CAMILLE LIEUCY); and no. 20, 20 mai 1911.

1912

GLEIZES, ALBERT and METZINGER, JEAN, *Du "cubisme"* (Paris), éd. E. Figuière, coll. "Tous les Arts", 1912, 44 p. + iconographic text (repr.: *La Sonate* and *Le moulin à café*) Reprint 1947 éd. Compagnie Française des Arts Graphiques, 82 p. + 10 pl. h.t.

LE DEVERNISSEUR, "Au Salon des Indépendants", *Fantasio* no. 137, 1er avril 1912, p. 619.

NAYRAL, JACQUES, foreword catalogue *Esposicio d'Art Cubista*, Barcelona, Galeries Dalmau 20 abril-10 maig 1912.

DUBOSC, GEORGES, "Exposition de la Société Normande de Peinture Moderne", *Journal de Rouen*, 17 juin et 12 juill. 1912.

RAYNAL, MAURICE, "Exposition de la Section d'Or", *La Section d'Or* (Paris), special issue devoted to the exhibition no. 1, 9 oct. 1912 [pp. 2-3].

1913

APOLLINAIRE, GUILLAUME, *Les Peintres Cubistes. Méditations esthétiques*; Paris, éd. Eugène Figuière, coll. "Tous les Arts", achevé d'imprimé 20 mars 1913; éd. Athéna, 1922. Limited edition; Genève, éd. Pierre Cailler, 1950, 142 p. See also M.D. pp. 74-6 Plate 37; 38: *Joueurs d'é...* Photo of M.D.; 38: *Joueurs d'é...*

"A Near Futurist Painting" (cartoon), *Chicago Daily Tribune*, 4 March 1913.

"What Cesare saw at the Armory Art Show", *The Sun*, 23 Feb. 1913.

GATSWOLD, J.F., "The Rude Descending a Staircase", *New York Evening Sun*, 20 March 1913, (cartoon: *Nu...*)

B[uffet], G[abrielle], "A propos du vernissage", *Les Soirées de Paris*, no. 19, déc. 1913, p. 5.

1914

EDDY, ARTHUR JEROME, *Cubists and Post-Impressionism*, Chicago, A.C. McClurg and Co, 1914, 210 p. See also M.D. pp. 68, 70-2, 164-5. Colour repr.: *Joueurs d'échecs*, p. 64 and *Le Roi et la Reine entourés de nus vites*, p. 72.

APOLLINAIRE, GUILLAUME, "Une Gravure qui deviendra rare", *Paris-Journal*, 19 mai 1914.

1915

LOCHER, ROBERT, "Prudes descending a Staircase", (Cartoon: *Nu...*), *Rogue* (N.Y.), no. 5, May 1915, p. 3.

"Marcel Duchamp visits New York", *Vanity Fair*, no. 5, Sept. 1915, p. 57.

1917

"Sometimes we dread the Future", *Every Week*, (N.Y.), 2 April 1917, p. 14. Photographs by PAUL THOMSON.

McBRIDE, HENRY, "Opening the Independents", *The Sun*, 15 April 1917. Reprinted in HENRY McBRIDE, *The Flow of Art. Essays and Criticisms*, selected, with an introduction by DANIEL CATTON RICH, Prefatory essay by LINCOLN KIRSTEIN, N.Y., Atheneum Pub., 1975, 462 p.; pp. 121-5. See also M.D. pp.: 9, 11, 19, 21-2, 54, 151-2, 156-8, 173, 189-90, 264, 289, 292, 335, 369, 372, 425-8, 430.

NORTON, LOUISE, "Buddha of the Bathroom", *The Blind Man*, (N.Y.), no. 2, May 1917, pp. 5-6. Reprinted in LOUISE NORTON, *Marcel Duchamp in Perspective*, edited by Joseph MASCHECK, New Jersey, Prentice Hall, 1975, 184 p.; pp. 70-2.

H.P.R., "The Richard Mutt Case", [p. 5], *The Blind Man*, no. 2, May 1917.

DEMUTH, C., "For Richard Mutt", p. 6, *The Blind Man*, no. 2, May 1917.

LOY, MINA, "Free Verse...", p. 12; "O. Marcel...", pp. 14-5, *The Blind Man*, no. 2, May 1917.

PICABIA, FRANCIS, "M.D. Professeur de Langue...", *391* (N.Y.), no. 5, juin 1917, p. 8.

1918

FREYTAG-LORINGHOVEN, BARONESS ELSE VON, "Love-Chemical Relationship", *The Little Review* (N.Y.), vol. V, no. 2, June 1918, pp. 58-9.

APOLLINAIRE, GUILLAUME, "Le cas de Richard Mutt", *Mercure de France*, 16 juin 1918.

McBRIDE, HENRY, "Florine Stettheimer at the Independents", *The Sun*, 28 April 1918. Reprinted in *The Flow of Art. Essays and Criticisms*, 151-2.

1919

CURNONSKY, *Huit Peintres, deux sculpteurs et un musicien très modernes*, caricatures by GEORGES DE ZAYAS, Paris, s.l.é., 1919. Edition: 160 numbered copies of which 10 on Japon. "Le Voyage du M. Dorigois. Nouveau riche au pays des volumes" pp. 1-10. See also M.D. pp. 4, 5. Préface de G. de Zayas; 11 lithographs by de Zayas, including one of Duchamp.

PHARAMOUSSE, [F. PICABIA], "M.D. parti à Buenos Ayres..." "Pierre Roché veut faire...", *391* (Zürich), no. 8, fév. 1919, p. 8.

PICABIA, FRANCIS, *Pensées sans langage*, Paris, éd. Eugène Figuière, 1919. Dedication: "Chers amis Gabrielle Buffet, Ribemont-Desaignes, Marcel Duchamp, Tristan Tzara, je vous dédie ce poème en raison de votre sympathie élective."

1920

SERNER, Dr, "Carnet du docteur Serner", *391* (Paris), no. 11, fév. 1920, p. 4.

LOUISE MARGUERITTE et puis puis, "M.D. ne fait plus d'art...", *Bulletin Dada*, Paris, no. 6, 5 fév. 1920 [p. 3].

McBRIDE, HENRY, "Modern Forms-The Walter Arensbergs", *The Dial*, vol. LXIX, July 1920, pp. 61-4. Reprinted in *The Flow of Art. Essays and Criticisms*, Athe-[neum]...

PICABIA, FRANCIS, "M.D. continue...", *Dadaphone*, Paris, no. 7, mars 1920, [p. 4].

no. 4, Dec. 1922, p. 2; reply to "Can a Photograph Have the Significance of Art?"

SUQUET, JEAN, New York, 9 août 1949, New York, 25 déc. 1949 in JEAN SUQUET, Miroir de la Mariée, Paris, Flammarion, 1974, 270 p.; pp. 243-4, 246-7.

TZARA, TRISTAN, see "Écrits de Duchamp", 1958.

VAN DER MARCK, JAN, Cadaqués, 11 July 1967 in S.M.S. (N.Y.), no. 1, Feb. 1968, n.p.

WATSON TAYLOR, SIMON, Cadaqués, 11 juin [1961], Dossier du Collège de 'Pataphysique, no. 15 Gidouille 88EP (29 June 1961), p. 71.

WOOD, BEATRICE, [Jan. 1954], Spain [April 1959] in BEATRICE WOOD, The Autobiography of Beatrice Wood. I Shock Myself, Ojai (Ca): Dillington Press, 1985, 181 pp.; pp.135, 144. See also, p. 119, letter to American Gallery, Los Angeles, dated 12 March 1955.

Interviews with Marcel Duchamp

"A Complete Reversal of Art Opinions by Marcel Duchamp, Iconoclast", Arts and Decoration (N.Y., Vol 5, no. 11, Sept. 1915, pp. 427-8 and 442. Reprinted in Studio International, Vol. 189, no. 973, Jan.-Feb. 1975, p. 28.

[McBRIDE, HENRY], "The Nude Descending a Staircase Man Surveys U.S.", The New York Tribune, 12 Sept. 1915, p. 2.

KREYMBORG, ALFRED, "Why Marcel Duchamps Calls Hash a Picture", Boston Evening Transcript, 18 Sept. 1915, p. 12.

MACMONNIES, FREDERICK, "French Artists Spur on an American Art", New York Tribune, 24 Oct. 1915, pp. 2-3.

GREELEY-SMITH, NIXOLA, "Cubist Depicts Love in Brass and Glass. More Art in Rubbers Than in Pretty Girl!", Evening World (N.Y.), 4 April 1916, p. 3. Reprinted in Washington Post, 9 April 1916, p. 7.

CURNONSKY, Huit peintres, deux sculpteurs et un musicien très modernes, caricatures by GEORGES DE ZAYAS, Paris 1919. Édition: 160 numbered copies of which 10 on Japon. Préface by GEORGES DE ZAYAS. See p. 6: "Confidences", M.D. answers to 10 questions.

[REX, MARGERY], "Dada will get you if you don't watch out; it is on the way here", + Photograph of Nu ..., no. 2, New York Journal (N.Y.), 29 Jan. 1921, p. 3.

BULLIET, C.J., "Artless Comment on the Seven Arts", Chicago Evening Post, 11 Jan. 1927 (Brancusi Exhibition).

PUTMAN, SAMUEL, "Brancusi doth make E-Heggs of us all", Chicago Post, 18 Jan. 1927. "Brancusi bronzes defended by Cubist", New York Times, 27 Feb. 1927.

EGLINGTON, LAURIE, "M.D. Back in America, Gives Interview", Art News, (New York), Vol. 32, no. 2, 18 Nov. 1933, pp. 3, 11.

SWEENEY, JAMES JOHNSON, "Eleven Europeans in America", Bulletin of the Museum of Modern Art, (N.Y.), Vol. XIII, no. 415, 1946, pp. 19-21.

SANOUILLET, MICHEL, "Dans l'atelier de M.D.", Les Nouvelles Littéraires, Paris, no. 1424, 16 déc. 1954, p. 5.

SCHUSTER, JEAN, "M.D. vite", Le Surréalisme même, no. 2, printemps 1957, pp. 143-5.

HELLMAN, GEOFFREY, "M.D.", New Yorker, (N.Y.), Vol. 33, no. 7, 6 April 1957, pp. 25-7. (From the column "The Talk of the Town", pp. 23-7.)

SWEENEY, JAMES JOHNSON, Wisdom. Conversations with the elder wise men of our days, ed. by JAMES NELSON, New York, W. Norton and Co, 1958, 274 p. + 16 pp. ill. See M.D. pp. 89-99.

THARRATS, JOAN J., "M.D. Interview", Art Actuel International (Lausanne), Vol. 1, no. 6, 1958, p. 1 et 19. Reprinted in Revista, 14 fév. 1959, p. 17.

JOUFFROY, ALAIN, "M.D. nous déclare : il n'est pas certain que je revienne à la peinture", Arts, no. 694, 29 oct. 1958, p. 12.

"Art was a Dream", Newsweek, Vol. 54, no. 19, 9 Nov. 1959, pp. 118-9.

"Interview de M.D. à la B.B.C. le vendredi 13 nov. 1959" (extract), Bief, première série, no. 1er déc. 1959, [p. 3].

SCHONBERG, HAROLD C., "Creator of 'Nude Descending' Reflects After Half a Century", New York Times (N.Y.), 12 April 1963, p. 25.

Western Round Table on Modern Art, "Modern Art Argument", Look, Vol. 13, no. 23, 8 Nov. 1949.

"The iconoclastic opinions of M. Marcel Duchamps concerning Art and America", Current Opinion (N.Y.), Vol. 59, no. 5, Nov. 1949.

B. K[RASNE], "A Marcel Duchamp Profile", Art Digest, (New York), Vol. 26, no. 8, 15 Jan. 1952, pp. 11, 24.

"The European Art Invasion", Literary Digest, Vol. 51, 27 Nov. 1915, pp. 1224-7.

JOUFFROY, ALAIN, "Interview exclusive de M.D." "M.D.: l'idée de jugement devrait disparaître", Arts, no. 491, 24 nov. 1954, p. 13. Reprinted in Une révolution du regard.

"Artist has world against him, says Duchamp", The Atlanta Journal, 12 April 1960.

GENAUER, EMILY, "Art. Dalí and Some Surrealist 'Enchanters'", New York Herald Tribune (The Lively Arts), 4 Dec. 1960, p. 19.

CREAN, HERBERT, "Dada", Evidence (Toronto), no. 3, Fall 1961, pp. 36-8.

CANADAY, JOHN, "Whither Art?", New York Times, 26 March 1961, p. 15.

ASHFORD, BARBARA, "Artists can't shock people today, M.D. says", The Evening Bulletin (Philadelphia), 10 May 1961, p. 56.

LINDE, ULF, "Samtal med M.D." Dagens Nyheter, (Stockholm), 11 Sept. 1961, p. 5.

KUH, KATHARINE, The Artist's Voice, Talks with seventeen Artists, New York and Evanston, Harper and Row, 1962, 248 p. See M.D. pp. 81-93 (with 7 repr.).

KEYES, EMILIE, "Artist Duchamp Decries Routine", Palm Beach Daily News, 15-16 Feb. 1962.

BORSICK, HELEN, "Duchamp: The 'Bizarre' Painter of Famed 'Nude'", Plain Dealer (Cleveland), 18 Nov. 1962.

JONES, WILL, "Duchamp's Ready mades are neutral, Unesthetic Duddy", Minneapolis Tribune, 24 Oct. 1965.

STEEGMULLER, FRANCIS, "Duchamp: Fifty Years later", Show Nothing", Show Oct. 1965.

CABANNE, PIERRE, "Marcel Duchamp: je suis un détroqué", Arts-Loisirs, no. 35, 25 mai 1966, 16-7.

SEITZ, WILLIAM, "What's Happened to Art?", An Interview with M.D. on Present Consequences of New York's 1913 Armory Show. Vogue, (N.Y.), no. 4, 15 Feb. 1963, pp. 110-113, 129-31.

ASHTON, DORE, "An Interview with M.D.", Studio International, (London), Vol. 171, no. 878, June 1966, pp. 244-7.

GOLDAINE, LOUIS and ASTIER, PIERRE, Ces peintres vous parlent, Paris, éd. du Temps, 1964, 266 p. See "Conversations avec M.D.".

HAIN, OTTO, "Entretien. M.D." L'Express, no. 684, 23 juillet 1964, pp. 22-3.

RIVIÈRE, CLAUDE, "M.D. devant le pop art. "C'est l'ennui qui préside actuellement ...", Combat, (Paris), 8 sept. 1966, p. 9.

FLEMMING, H. Th., "Immerspielt Magie hinen. Interview mit M.D.", Die Welt (Essen), no. 242, 18 Okt. 1965, p. 7.

GLUECK, GRACE, "Duchamp opens display today of 'Not seen and/or less seen'", New York Times, 14 Jan. 1965, p. 45.

TOMKINS, CALVIN, "Profiles. Not seen and/or less seen", The New Yorker (N.Y.), Vol. 41, 6 Feb. 1965, pp. 37, 93.

PARINAUD, ANDRÉ, "André Breton", Arts Loisirs, no. 54, 5 oct. 1966, pp. 4-7. (Interview with M.D. on André Breton's death). Reprinted in three languages in exhibition catalogue. A. Breton, Milano, Galleria Schwarz, 17 Gen.-14 Feb. 1967, pp. 19-20, 24, 29-30, 33-6, 41-6. Italian translation: LUCIA MARIZZI; English translation: HENRY MARTIN. Extract in L'Archibras, no. 1, avril 1967, p. 17. Extract in ALAIN and ODETTE VIRMAUX, André Breton. Qui êtes-vous?, Lyon, La Manufacture, 1987, 160 p. See pp. 107-8.

RIVIÈRE, CLAUDE, "M.D. devant le pop art. "C'est l'ennui qui préside actuellement ...", Combat, (Paris), 8 sept. 1966, p. 9.

D.[ESCARGUES], P.[IERRE], "Duchamp dévoile le cheval majeur" Tribune de Lausanne, 3 juill. 1966, p. 8.

REWALD, ALICE, "M.D.: c'était le pays de Cocagne", Gazette de Lausanne, 4-5 mai 1963.

SELDIS, HENRY J., "Gamesmanship of Art and Life. M.D. Style", Los Angeles Times, 13 Oct. 1963.

[on the Tate Gallery exhibition], Sunday Telegraph, 3 July

Art and Artists, London, Vol. 1, no. 4, July 1966, M.D. Number, "Passport no. G255300", Interview by Otto Hahn, pp. 6-11. "Son of the Bride Stripped Bare", Interview by Richard Hamilton, pp. 22-6.

do Museum's Patrons", New York, 19 June 1966, p. 15.

CABANNE, PIERRE, Entretiens avec Marcel Duchamp, Paris, éd. Belfond, 1967, 222 p. Dialogues with M.D., London, Thames and Hudson, 1971, 136 p. Translation by Ron Padgett; Introduction by Robert Motherwell; Preface by Salvador Dalí. New edition, Belfond, 1977, Coll. "Entretiens", 1977, 220 p. Dialogues with Marcel Duchamp, N.Y., Da Capo Press, 1987, 136 p. Introduction by Robert Motherwell; Preface by Jasper Johns.

SCHMIDT, DANA ADAMS, "London Show pleases Duchamp and so...

BRIGHT, BARBARA, "Genius like...

delphia Museum of Art, 1987. Dist. in Europe by Schirmer/Mosel, Münich. Facsimile. Manual of instructions.

12 déc. 1926, p. 177; 31 déc. 1926, pp. 177-8; 4 jan. 1927, p. 180; 23 jan. 1927, p.180; 27 jan. 1927, p.14; 30 jan. 1927, p. 181; 8 juin 1927, p. 181; [1928], "Je dois beaucoup d'admiration ...", in MARCEL JEAN, Au galop dans le vent, Paris, éd. Jean-Pierre de Monza, Coll. "Art Vif", 1991, 230 p., cover p. IV.

Duchamp's name also appears in the following documents: Dada soulève tout, 12 janvier 1921, Manifeste dimensioniste, magazine Plastique, 1938, La parole est à Pére, 28 Mai 1943.

Marcel Duchamp
Letters to:

ADHÉMAR, JEAN, New York, 20 Oct. 1955, in ECKE BONK, The Portable Museum. The Making of the Boîte-en-Valise, de et par Marcel Duchamp or Rrose Sélavy. Inventory of an Edition, London, Thames and Hudson, 1986, 324 p.; pp. 178, 194.

ARENSBERG, WALTER, 1940, pp. 157-8, 162, New York, 22 July 1961 (extract) p. 225 in ECKE BONK.

ARENSBERG, WALTER and LOUISE, 25 Aug. 1917; 20 Aug. 1918; 8 Nov. 1918; 7 Jan. 1919; March 1919, 15 June 1919; Fall 1921; 15 Nov. 1921 in Dada/Surrealism, no. 16 "Duchamp Centennial", 1987, pp. 203-27 "M.D.'s letters to Walter and Louise Arensberg, 1919-1921". Introduction, translation and notes by FRANCIS M. NAUMANN. New York, 5 July 1942 in NAUMANN, New York, 21 July 1942 in BONK, pp. 165-6.

BAJ, ENRICO, Paris, 1er oct. 1961 (facsimile), New York 21 Oct. 1962 in I libri di Baj, Milano, ed. Electa, 1990, 164 p., pp. 58-9.

BRANCUSI, CONSTANTIN, 13 fév. 1926, p. 171; [oct. 1926], p. 174;

BRAUNER, VICTOR, Sanary, 9 mai 1942 in La Planète affolée. Surréalisme, dispersions et influences. Flammarion et Musées de Marseille, 1986, 344 p., p. 57.

BRETON, ANDRÉ, Carte Interzone, Paris, 17 janv. 1941 in View, no. 7-8, Oct.-Nov. 1941, p. 5, rubrique "Cords and Concord". [New York, Nov. 1953], extract in Medium. Communication Surréaliste, nouvelle série, no. 2, fév. 1954, p. 12. New York, 4 oct. 1954 in Medium. Communication Surréaliste, nouvelle série, no. 4, janv. 1955, p. 33. New York, 25 Nov. 1922 in André Breton, Œuvres complètes, t. I, Paris, Gallimard, coll. "La Pléiade, no. 346", 1988, 1872 p., p. 1315; 25 juin 1938 (extract), p. 239; 2 juill. 1945 (extract), p. 363; 9 nov. 1959 (extract), pp. 421-2; 12 janv. 1940 (extract), p. 346; Pneumatique, nov. 1959, p. 422 in exhibition catalogue André Breton. La beauté convulsive, M.N.A.M., Centre Georges Pompidou, 25 avril-26 août 1991.

CARROUGES, MICHEL, in Les Machines Célibataires, Paris Arcanes 1954. Reprint.

COCTEAU, JEAN, New York, 30 nov. 1952 in Le passé défini, t. I: 1951-1952, Paris, Gallimard, 1983, 468 p., pp. 394-5.

COLLÈGE DE 'PATAPHYSIQUE (S.M. OPACH), Cadaqués, 15 sept. 1965, télégramme, in Subtidia Pataphysica, no. 1, 29 sable 93EP (29 Dec. 1965), p. 22.

CROTTI, JEAN, 17 août 1952 in exhibition catalogue Jean Crotti, Paris, Musée Galleria, 11 déc. 1959-11 janv. 1960, n.p.; "Affectueusement, Marcel", Ten letters from Marcel Duchamp to Suzanne Duchamp and Jean Crotti: fév.-mars 1912: [15 janv. 1916]; 17 oct. 1916; 11 avril 1917; 8 juill. 1918 (also see BONK, p. 236); 26 octobre 1918; 9 mars 1919; [20 octobre 1920]; 19 mai 1921; 17 août 1952 in Archives of American Art Journal, New York, (Smithsonian Institution), Vol. 22, no. 4, 1982, pp. 3-19; 17 août 1952 in exhibition catalogue Tabu Dada. Jean Crotti et Suzanne Duchamp 1915-1922, ed. by WILLIAM A. CAMFIELD and MARTIN, JEAN-HUBERT, Kunsthalle Bern 22 Januar-27 Februar 1983, p. 8; Paris, M.N.A.M. Centre Georges Pompidou 6 avril-30 mai 1983; and Huston and Philadelphia. Télégramme, New York, 1 June 1921 in MICHEL SANOUILLET, Dada à Paris, Jean-Jacques Pauvert éditeur, 1965, 648 p., p. 280.

DONATI, ENRICO, Cadaqués 29 juin 1961 in Pleine Marge (Cognac) no. 7, juin 1988, p. 33.

DOUCET, JACQUES, Extract from letters: 26 oct. 1923; 7 mars, 8 mars, 16 mars, 4 avril 1924; Undated; 3 juill., 8 avril, 15 août 1924; Undated; 15 sept., 22 sept., 3 oct. 1924; Undated; 21 oct. 1924; Undated; 31 oct. 1924; [19 oct. 1925]; Undated [1924]; 16 janv. 1925; 2 déc. 1925 in Duchamp du signe edited by MICHEL SANOUILLET, Paris, Flammarion, 1975, 318 p., pp. 264-8 and 269-70; 25 oct. 1925, extract in BONK, pp. 250, 22 déc. 1923, extract. Telegram 7 avril 1926 in FRANÇOIS CHAPON, Mystère et splendeur de Jacques Doucet, 1853-1929, Paris, éd. Jean-Claude Lattès, 1984, 416 p., pp. 296 et 331.

DREIER, KATHERINE S., Telegram 16 Jan. 1948, p. 1; 5 Nov. 1928, p. 13 (Extract); 11 Sept. 1929, p. 14 (Extract); 9 Feb. 1937, p. 18 (Extract); 3 May 1935, p. 763 in The Société Anonyme and the Dreier Bequest at Yale University. A Catalogue Raisonné, ed. by ROBERT L. HERBERT, ELEANOR S. APTER, ELISE K. KENNEDY, published for the Yale University Art Gallery by Yale University Press, New Haven and London, 1984, 791 p. Letters extracts: 5 March 1916; 11 avril 1917; 8 juill. 1918 (also see BONK, p. 236); 26 oct. 1918; 9 mars 1919; [20 octobre 1920]; 19 mai 1921; 17 août 1952 in Archives of American Art Journal, New York, (Smithsonian Institution), Vol. 22, no. 4, Oct. 1937, p. 199; Paris, 26 Dec. 1936, p. 152; Paris, 25 juin 1937, pp. 152, 199; Paris, 26 juin 1937, p. 199; Paris, 8 March 1938; Paris, 22 May 1938, p. 200; Paris, 10 July 1938, p. 200; Paris, 14 July and 27 July 1938, p. 200; Paris, 9 Feb. 1939, pp. 228, 230; Paris, 19 Feb. 1939, p. 201 in Bonk.

DUCHAMP, SUZANNE, New York, 15 Jan. 1916 in BONK, p. 233. See also: CROTTI.

FOGT, MAURICE, Le Tignet, 9 août 1959 in Burlington Magazine, Vol. CXIX, no. 896, Nov. 1977.

HAHN, OTTO, 11 avril 1967, 17 mai 1967 in VH101 (Zürich-Paris), no. 3, automne 1970, p. 61.

HEROLD, JACQUES, Letter included in a work by JACQUES HÉROLD, Objet votif à Marcel Duchamp, 1951 and published in the exhibition catalogue After Duchamp, Paris, Galerie 1900-2000 S.A., "Poésie - Prose - Editions rares", no. 11, 1964, p. 100 (cat. no. 265). 22 nov. 1939 (extract) in BONK, p. 155.

ILIAZD, New York, 26 fév. 1958 in exhibition catalogue Iliazd, Paris, M.N.A.M., Centre Georges Pompidou, 10 mai-25 juin 1978, p. 71. Paris, 1955 - pneumatique pp. 175-6, 194; New York, 22 mars 1955, pp. 177, 194; New York, 30 oct. 1955, pp. 177, 194; New York, 5 déc. 1955, pp. 178, 194; New York, 10 déc. 1957, pp. 179-80, 194 in Bonk.

ITALIA SCACCHISTICA, Milano, 26 sept. 1932. Letter signed by M.D. and VITAL HALBERSTADT, and New York [1923] telegram; New York 8 mai [1922] in The Société Anonyme and the Dreier Bequest at Yale University. A Catalogue Raisonné, adressed to the chess magazine, L'Echiquier (Bruxelles), t. 8, no. 93/94, sept./oct. 1932, p. 1810.

JEAN, MARCEL, 15 mars, 7 juin, 14 juill. 1952; 7 avril 1953, undated [1953]; 20 juin, 4 août 1955; 31 déc. 1956; 3 janv., 18 fév., 14 oct., 25 oct., 22 nov., 2 ou 3 déc. 1958; 24 nov., 30 déc. 1959; 15 juin 1967; 15 janv. 1968; 22 fév. (1968) in Lettres à Marcel Jean de Marcel Duchamp, München, Verlag Silke Schreiber, 1987, 104 p., Trilingual edition: German pp. 7-36 French pp. 39-66 English pp. 69-96; 31 déc. 1956 (extract): 8 janv. 1958; 12 mars 1958. Undated; ed. Jean-Pierre de Monza, Coll. "Art Vif", 1991, 230 p., pp. 185, 188, 189, 197.

LE BOT, MARC, 11 fév. 1962 (extract) in MARC LE BOT, Francis Picabia et la crise des valeurs figuratives, Paris, éd. Klincksieck, Coll. "Le signe de l'art", 1968, 208 p., p. 51.

LOY, MINA, New York, 2 mars 1946 in Arthur Cravan, Œuvres. Poèmes, articles, lettres, Paris, éd. Gérard Lebovici, 1987, 288 p., p. 232.

MASSOT, PIERRE DE, juin 1922 in Catalogue de la librairie Nicaise S.A., Paris "Poésie - Prose - Editions rares", no. 11, 1964, p. 100 (cat. no. 265).

MAYOUX, JEAN, 8 March 1956 (extract) in BONK, p. 252.

OPPENHEIM, MERET, Postcard, undated in BICE CURIGER, Meret Oppenheim. Defiance in the Face of Freedom, Zürich, Frankfurt, New York, Parkett Publ. and the Mit Press (Cambridge, Massachusetts), 1989, 276 p., p. 43.

PICABIA, FRANCIS, New York, 8 sept. 1932. Letter signed by M.D. New York 8 déc. 1922; 20 janv. [1923] in MICHEL SANOUILLET, Dada à Paris, Jean-Jacques Pauvert éditeur, 1965, 648 p., pp. 552-3.

ROCHÉ, HENRI PIERRE, West Redding, 12 July 1934 (extract) New York, 9 May 1949 in BONK, pp. 198-9, 170. New York, 9 May 1949, p. 74, no. 129 [New York], 15 May 1953; p. 172, no. 307 [New York, 1 Aug. 1953; p. 212, no. 372, 5 June 1956, p. 199, no. 354. Also "Rotorelief Dépenses du 1er mars au 20 juillet 1935", p. 73, no. 125, in CARLTON LAKE and LINDA ASHTON, Henri Pierre Roché: An Introduction, Harry Ransom Research Center, the University of Texas at Austin, 1991, 238 p.

STAUFFER, SERGE, New York, 18 août 1957 (Also see extract in BONK, p. 179); New York, 17 avril 1958; Cadaqués, 11 mai 1959; Paris, 16 sept. 1961; New York, 12 nov. 1961; Cadaqués, 18 août 1960; Paris, 30 sept. 1960; New York, 3 déc. 1960; New York, 28 mai 1961; Cadaqués, 25 juin 1961; Paris, 9 sept. 1961; Paris, 16 sept. 1961; New York, 2 janv. 1962 (Also see extract in BONK, p. 208); New York, 2 mars 1962; New York, 28 mars 1965 (Also see extract in BONK, p. 208); Neuilly s/ Seine, 25 mai 1967 in SERGE STAUFFER, Schrift, ten, Zürich, Regenbogen Verlag, 1981, pp. 252-78. See M.D.'s replies to Stauffer's "Cent Questions": pp. 279-96.

STETTHEIMER, ETTIE, Paris, 27 March 1925 (Extract) in BONK, pp. 244-5.

STIEGLITZ, ALFRED, New York, 22 May 1922 in Manuscripts (N.Y.),

"Cops pullulate, Copley copula-tes", invitation card, exhibition Bill Copley, N.Y., Alexander Iolas Gallery, 9-28 Jan. 1960.

"Si la scie ...", announcement card for Jean Tinguely's "Homage to New York", N.Y., M.O.M.A., 17 March 1960.

Texts translated by SERGE STAUFFER in Dokumentation über Marcel Duchamp, Zürich, Kunstgewerbemuseum, 30 Juni bis 28 August 1960. Texts by HANS FISCHLI, MAX BILL, SERGE STAUFFER.

"... Fusils et fusées d'un refusé...", exhibition catalogue Kurt Seligmann, New York, d'Arcy Galleries, 1960.

"Par conséquent Takis ...", exhibition catalogue Takis, Milano, Galleria Schwarz, 14 April-4 May 1962. Reproduced in Takis, Dix ans de sculpture 1954-1964, Paris, Galerie Alexandre Iolas, 8 Oct.-7 Nov. 1964.

"Mi Sol Fa Do Ré", on slip of paper glued to cover, exhibition catalogue MICHEL CADORET - EDGAR VARÈSE La Passoire à connerie, N.Y. Galerie Norval 14 Nov.-15 Dec. 1960. Also in exhibition catalogue Michel Cadoret, Paris, Galerie de Lille, 11 May 1977.

Cover "For Arp, art is Arp", for exhibition catalogue Surrealist Intrusion in the Enchanters' domain, N.Y., D'Arcy Galleries, 124 p.; 28 Nov. 1960-14 Jan. 1961, p.39. Reprinted Expo Arp, Milano, Galleria Schwarz, 8 Maggio-4 Giugno 1965.

"Se volete una regola di grammatica ...; "Le nègre aigrit ...; "Mâcheur Fran(fort sau(cisse...", exhibition catalogue Alfred Jarry; Librairie Française, Milano, 30 Nov.-18 Dic. 1960, p. 42.

"Une NNNNNNNNNNN de récifs ...", exhibition catalogue Enrico Donati, Palais des Beaux-Arts de Bruxelles, 21 Oct.-5 Nov. 1961. Also in exhibition catalogue Donati, München, Neue Galerie im Künstlerhaus, 27 Februar-28 März 1962 and Enrico Donati. Recent printings, N.Y., Berry Hill Galleries, 1991.

"Il arrange or, jus n'y est", exhibition catalogue Georges Hugnet, Paris, Galerie Marignan, 20 Mars-10 April 1962.

"Bravo! for your 60 Ism-packed years", Art News, Vol. 61, no. 8, Dec. 1962, p. 26. (In "Editorial: Dix", Paris, pp. 26-7).

"Morton Livingston Schamberg", in BEN WOLF, Morton Livingston Schamberg: A Monograph, (Phil). University of Pennsylvania Press, 1963, p. 15.

"Having heard so much ..." in exhibition catalogue Armory Show: 50th Anniversary Exhibition 1913-1963, p. 93. Utica, Munson, Williams Proctor Institute, 17 Feb.-31 March 1963, 212 p. and New York, Armory of the Sixty-Ninth Regiment, 6-28 April 1963.

"Route Jura-Paris", Catalogue no. 7, Galerie Büren, Stockholm, April-May 1963, p. 17.

"La vie en ose", Announcement of the exhibition Man Ray, N.Y., Cordier and Ekstrom Gallery, 30 April-18 May 1963. Reprinting p. 33, exhibition catalogue Man Ray, Los Angeles County Museum of Art, Lytton Gallery, 1966, 148 p.

"There was a painter named Copley ..."; column "Nos lecteurs nous écrivent", in Iris-Time (Paris), no. 6, 13 Mai 1963, [p. 2]. Also in Iris CLERT, Iris-Time (l'artventure), Paris, Denoël, 1978, p. 277.

"Francis Picabia", in exhibition catalogue Picabia. 40 dessins 1903-1953, Milano, Galleria Schwarz, 25 Maggio-14 Giugno 1963. (Critical note of the Société Anonyme 1950). Reproduced in exhibition catalogue Picabia Mécanique, Milano, Galleria Schwarz, 5 Maggio-1 Giugno 1964; and in Katalog, Städtisches Museum Schloss Morsbroich, Leverkusen, 7 Februar-2 April 1967; also in WILLIAM CAMFIELD, Francis Picabia, Paris, Galerie Louis Carré, 1972, 80 p., pp. 5-7.

"Salissez ...", exhibition catalogue E.L.T. Mesens 125 collages et objets, XVIe festival belge d'été, Knokke-le-Zoute, Albert Plage, 6 Juill-30 Août. 1963, on cover 4.

"G Séié é la Suil Réza", in "Speech by Modern Artists", directed by YOSHIAKI TONO, Tokyo, Mizué, June 1963.

"Uniformes et livrées ... Baj 1963", half-title for Enrico Baj, Dames et Généraux, introductory tes by ANDRÉ BRETON and 10 plates by Baj that illustrate 10 poems by BENJAMIN PÉRET; Paris, Berggruen and Milano, Schwarz, 1964. Half-title reproduced in I Libri di Baj, Milano, Electa, 1990, p. 94.

"Certificat inaliénable ..." for Il Reale Assoluto, collection of poems by ARTURO SCHWARZ, Milano, Galleria Schwarz, 1964. Edition: 100 numbered copies. Reproduced in catalogue no. 52, December 1964 "1954-1964. Ten years of numbered editions...", p. 15.

Cover for Hopps WALTER, LINDE ULF and SCHWARZ ARTURO, Marcel Duchamp - Ready-mades, etc (1913-1964), Paris, Le Terrain Vague, 1964 and Milano, Galleria VII, no. 60, 1966.

"Je dois malheureusement partir vite ..." in LOUIS GOLDAINE and PIERRE ASTIER, Ces peintres vous parlent, Paris, édit. du Temps, Coll. "L'Œil du Temps", 1964, 200 p., M.D. p. 48.

"Fr'en 6 π qui habillarrose Sélavy", insert in exhibition catalogue Francis Picabia, Chapeau de paille? 1921, Paris, Galerie Louis Carré, 4 Nov.-4 Déc. 1964.

Cover exhibition catalogue Pasadena Art Museum 8 Oct.-3 Nov. 1963 (By or of Marcel Duchamp or Rrose Sélavy).

"La vache à lait ..." exhibition catalogue Arman, N.Y., Sidney Janis Gallery, 29 Dec. 1964-27 Jan. 1965.

Cover for Not Seen and/or Less Seen of/by Marcel Duchamp/Rrose Sélavy, 1904-1964, New York, Cordier and Ekstrom Gallery, 14 Jan.-13 Feb. 1965.

"Aimer tes héros", cover for Metro, Milano. 9 April 1965.

"Dieu Bourdelle Dieu", cable 18 June 1923 in Francis Picabia et papa, édited by BENJAMIN CARN-nec, Paris, édit. Erik Losfeld, 1966, p. 150.

"With Segal it's not ...", exhibition catalogue New Sculpture by George Segal, N.Y., Sidney Janis Gallery, 4-30 Oct. 1965.

"Speculations", Art in America, Vol. 54, no. 2, March-April 1966, pp. 73-5.

"Apropos of 'Readymades'", Art and Artists, N.Y., Vol. 1, no. 4, July 1966, p. 47.

"A propos des Ready made", Subsidia Pataphysicarum, no. 2, 29 tatane 93EP (11 Aug. 1966), pp. 87-8.

"Isabelle sculpte, ausculte ...", invitation card for the exhibition Isabelle Waldberg, Paris, Galerie G. Bongers, 29 Avril-14 Mai 1969.

[A la manière de Delvaux] cover 1969.

A l'Infinitif (The White Box), N.Y., Cordier and Ekstrom, 1967, 79 notes in a Plexiglas box designed by M.D. 150 signed copies.

"Ici a vécu... Paris-Normandie (Rouen), 29-30 April 1967. Plaque set into the wall of the house at 71 rue Jeanne d'Arc in Rouen, 28 Juin 1967, p. 17.

"Suzanne Duchamp" by KATHERINE S. DREIER; text for the catalogue of the Société Anonyme, translation by Marcel Duchamp (1967) in Catalogue Salon d'Automne, Paris, Grand Palais, 1-28 Juin 1967.

"Musique d'Ameublement ...", exhibition catalogue Yo Sermayer, N.Y., Bodley Gallery, 14-25 Nov. 1967. Also in Rrosopopées, no. 10, special exhibition Yo Sermayer, Kunsthalle Bern, 22 January-27 February 1983, January 1983, p. 16.

"Le Grand ennemi de l'art ..." p. 13 and "Faut-il réagir contre la paresse ...", p. 87, in La chtienlit de papa, édited by FRANÇOIS CARADEC, Paris, éd. Albin Michel, 1968 (juin), 126 p.

"Cher John attention ..." dédication on p. 129 by JOHN CAGE, Journal, translated by MONIQUE FONG, Paris, éd. Maurice Nadeau/Papyrus, 1983, 160 p.

"Pour Emilio Puignau ..." dedication on the drawing The Mayor of Cadaqués, 1968, Art in America, Vol. 57, no. 4, July-Aug. 1969, p. 39.

"A propos of myself", in Marcel Duchamp, edited by KYNASTON McSHINE and ANNE d'HARNONCOURT, N.Y., M.O.M.A. and Chicago Art Institute, 1973, 348 p. London, Thames and Hudson, 1974.

Duchamp du signe, edited by MICHEL SANOUILLET. Revised and enlarged edition with the assistance of ELMER PETERSON, Paris, Flammarion, 1975, 318 p. (Contains: "L'artiste doit-il aller à l'université?", pp. 236-9). New edition, 1991.

"Where do we go from here?", Studio International, Vol. 189, no. 973, Jan.-Feb. 1975, p. 28. Facsimile of a typed and corrected original in French, dated Phi 1946-Symposium at Philadelphia Museum College of Art, March 1961. Translated by HELEN MEAKINS.

Notes, Preface by PONTUS HULTEN, foreword and translation PAUL MATISSE, Paris, C.N.A.C. Georges Pompidou, 1980; 289 notes by M.D. (contains items from the Green Box).

"On Three Main Aspects of Chess" - Allocution at the Banquet of New York State Chess Association, 30 Aug, 1952, in ECKEBONK, The Portable Museum. The Making of the Boîte-en-Valise de/ par Marcel Duchamp ou Rrose Sélavy, Inventory of an Edition, London, Thames and Hudson, 1986, 324 p., pp. 172-3.

Étant donné: 1° La chute d'eau... 2° Le gaz d'éclairage, Phila-

BIBLIOGRAPHY

Jean Metzinger 1943 p. 100; Joan Miró 1946 p. 108; Georges Braque 1943 p. 110; Max Ernst 1945 p. 114; Jacques Lipschitz 1945 p. 132; André Derain 1949 p. 135; Jacques Villon 1949 p. 138; Paul Klee 1949 p. 141; Albert Gleizes 1943 pp. 145-6; Joseph-Alexandre Czaky 1943 p. 147; Antoine Pevsner 1949 p. 150; Fernand Leger 1943 pp. 152-3; Louis Eilshemius 1943 p. 154; Gino Severini 1949 p. 164; Man Ray 1949 p. 174; Umberto Boccioni 1943 p. 180; Georges Ribemont-Dessaignes 1949, p. 187; John Covert 1945 p. 192; Émile Nicolle 1949 p. 201.

All notes are published in *The Société Anonyme and the Dreier Bequest at Yale University. A Catalogue Raisonné*, by ROBERT L. HERBERT, ELEANOR S. APTER, ELISE K. KENNEY; published for the Yale University Art Gallery by Yale University Press, New Haven and London, 1984, 791 p.

"Terminologistes amateurs...," exhibition catalogue Hans Richter, Paris, Galerie des Deux Iles, 10-28 Fév. 1950 lp. 4].

"A Tribute to the Artist", in *Charles Demuth* by ANDREW CARNDUFF-RITCHIE, N.Y., MOMA, 1950, 96 p. See p. 17.

"La gaia pittura...", invitation card, exhibition Enrico Donati, N.Y., Alexander Iolas Gallery, April-4 May 1952.

"Almost fifty years ..." (M.D., N.Y., 1951) in exhibition catalogue Kupka, N.Y., Louis Carré Gallery, May-June 1951.

"Landscaped Tables ..." by JEAN DUBUFFET, foreword to exhibition catalogue, Galerie Pierre Matisse, N.Y., 12 Feb. 1 March 1952. Text translated by Marcel Duchamp.

"In speaking of Schwitters ...," by TRISTAN TZARA; translated into English by Marcel Duchamp in exhibition catalogue, Kurt Schwitters, N.Y., Sidney Janis Gallery, 13 Oct.-8 Nov. 1952.

Dada 1916-1923, Sidney Janis Gallery, N.Y., 15 April-9 May 1953. Poster, catalogue, invitation, layout by M.D., T. Tzara, M.D. H. Arp, "I comply with your desire ...", translated by M.D.

Cover (Montgolfière), exhibition catalogue Duchamp-Picabia, N.Y., Rose Fried Gallery, 7 Dec. 1953.

"A Guest ...", on sweets packing paper, exhibition catalogue Bill Copley, Paris, Galerie Nina Dausset, Déc. 1953.

"Non, car ...", *Combat-Art*, Paris, no. 12, 6 Déc. 1954, p. 1.

"The Creative Act. Between intention and expression is the art coefficient", *Art News*, Vol. 57, no. 4, Summer 1957, pp. 28-9. Reprinted in LEBEL: French text by M.D. Also in *Le jardin des Arts*, no. 69, 1960. "Le processus créatif" pp. 39 and 42. Reproduced as a booklet, Caen, l'Echoppe, 1987; French and English text.

"En 6 qu'habilla ...", reproduction of *L'Œil Cacodylate* and scroll reproducing Duchamp's inscription enlarged. In *Francis Picabia 1879-1954*, folder not for sale published under the *Orbes* label, printing finished on 20 April 1955. Edition numbered copies.

"For over 35 years ..." in catalogue *The 1913 Armory Show in Retrospect*, Amherst College (Mass.) 17 Feb.-17 March 1958, 36 p. Text reproduced in an article by WAYNE C. SMITH, "Armory Show and en couleurs". Published in D.D.S. p. 243: "Des Magritte, *en hausse, en cher*, en noir et en couleur".

"Des Magritte en cher, en hausse, en noir et en c uleurs", invitation card for exhibition René Magritte, N.Y., Alexander Iolas Gallery, 2-28 March 1959. Also in PATRICK WALDBERG, Bruxelles, éd. de Rache, 1965. Entry no. 654 of Blavier's bibliography: "Des magritte en cher, en hausse, en noir et en couleurs". Published in D.D.S. p. 243: "Des Magritte, *en hausse*, en cher, en noir et en couleur".

Front unique, Milano, no. 1, primavera/estate 1959. Ripr. p. 42: *La foglia di vigna femmina*, 1950.

"Francis Picabia (1949)" in *Fixe* (de la revue *Dau al set*), Barcelone, issue dedicated to Picabia. 30th anniversary of the exhibition held at the Galerie Dalmau (1922-1952). Galerie Dau al set, Agost-Setembre de 1952. Critical note of the Société Anonyme translated by Angèle Levesque.

"C'est fini la peinture ..." in exhibition catalogue *Fernand Léger*, Musée des Arts Décoratifs, Paris, juin-Oct. 1956, p. 30. Also in exhibition catalogue *50 ans d'art moderne*, Palais International des Beaux-Arts de Bruxelles, 17 Avril-21 Juill. 1958, attributed to: Marcel Duchamp.

Cover for *Le surréalisme, même*, no. 1, Oct 1956.

Layout for exhibition catalogue Jacques Villon, Raymond Duchamp-Villon, M.D., Solomon Guggenheim Museum, N.Y., 1957.

Cover for GEORGES HUGNET, *L'Aventure Dada 1916-1922*, Paris, Galerie de l'Institut, 16/6/1957. Introduction by T. Tzara. On the occasion of the exhibition *Dada 1916-1922*, 15 March-12 April 1957. "Oculisme de précision, Rrose Sélavy" pp. 158-62 du mé-ume ouvrage. New enlarged edition, Paris, Seghers, 1971, 240 p.

"...mages", cover of exhibition catalogue "*Le dessin dans l'art magique*", Paris, Galerie Rive Droite, 21 Oct.-20 Nov. 1958.

Lettre de Marcel Duchamp à Tristan Tzara, s.l. [Ales], P.A.B., s.d. [déc. 1958]. Edition: 25 copies on Auvergne certified by the publisher and signed by M.D., original etching on celluloid signed by Tristan Tzara is included.

Reynolds Collection. A bibliography compiled by HUGH EDWARDS, The Art Institute of Chicago, Arts, 6 April-11 May 1958.

"Possible", unpublished working note for the *Large Glass* (1913). S.l. [Ales], P.A.B., s.d. [juin 1958]. Edition: 30 copies on Rives, signed by the author and the publisher.

Etching signed in FRANCIS PICABIA, *L'Equilibre*, Ales, P.A.B. [août 1958]. Edition: 44 copies on Auvergne, signed by the author and the publisher.

"Il y a 70 ans, jeune Gargantua..." (30 März 1958) in Katalog Akademie der Künste, Hans Richter. *Ein Leben für Bild und Film*, Berlin 17 Okt.-16 Nov. 1958, n.p. + Photos from the film 8 x 8. Reprinted in exhibition catalogue Galerie Denise René 4-31 March 1960.

Etching in PIERRE DE MASSOT, *Tiré à Quatre épingles*, s.l. [Ales], P.A.B., s.d. [été 1959]. Edition: 36 copies on Auvergne, of which 6 have two states of the etching signed.

"Possible" in 691, Picabia, Ales, P.A.B., été, 1959, with Arp, PANSAERS, PICABIA, TZARA. Edition: 100 copies on Rives, of which 10 include the following documents: Un papier déchiré de M.D. Un papier découpé de ARP; Un poème calligramme de Tzara.

Etching in P.A. BENOIT, *Première lumière*, Ales, [P.A.B.], Aug. 1959. Edition: 5 copies on Rives. All numbered and signed by Marcel Duchamp.

Marcel Duchamp de ROBERT LEBEL, London, Trianon Press, 1959, 194 p. *Sur Marcel Duchamp* by ROBERT LEBEL, Paris, Trianon Press, 1959, 194 p. Design and layout by MARCEL DUCHAMP and ARNOLD FAWCUS. Colour and monochrome plates printed under

Duchamp's supervision. Duchamp, "The Creative Act", pp. 77-8 (translation by Duchamp of his own texts for the French edition) and "Style télégraphique". The original French edition contains 137 items signed Duchamp and Lebel, including: 10 copies with "autoportrait" signed: Marcel De-chiravit, a proof of the *Grand Verre* hand-coloured by Duchamp and signed Marcel Coloravit, plus an original stencil used for the frontispiece; the cover has a readymade *Eau et gaz à tous les étages* signed by Duchamp.

"Man Ray, n.m. synom de king note for the Large Joie..." exhibition catalogue Man Ray, London, Inst. of Contemporary Arts, 31 March-25 April 1959; Exhibition catalogue Man Ray, Paris, Galerie Rive Droite, Oct. 1959; Man Ray, *Autoportrait*, Paris, éd. Robert Laffont, 1964, 360 p., p. 9; Italian translation. Invitation card for *Man Ray e la moglie Juliet*, 19 Aprile 1969, Centro Duchamp di Bologna.

"Bien pataphysic ...", *Dossier du Collège de Pataphysique*, no. 7, 11 Gidouille 86EP (25 June 1959), p. 77. Also in *Subsidia Pataphysicien*, no. 6, 10 Sable 96EP (10 Dec. 1968), p. 31.

"Granell en son..." exhibition catalogue E. Granell, N.Y., Bodley Gallery, 23 March-4 April 1959.

"Mina's Poems ...". Invitation card Mina Loy exhibition, N.Y., Bodley Gallery 14-25 April 1959.

Marchand du Sel, (MdS) Writings by Duchamp edited and presented by MICHEL SANOUILLET. Bibliography by POUPARD-LIEUSSOU, Paris, Le Terrain Vague, Coll. "391", 1959, 232 p. 40 copies on Auvergne, numbered and signed by Duchamp and Sanouillet. *Salt Seller, the writings of Marcel Duchamp*, N.Y., Oxford University Press, 1973. Ed. M. Sanouillet and Elmer Peterson. *The essential writings of Marcel Duchamp. Salt Seller*, London, Thames and Hudson, 1975, 196 p. Edited by MICHEL SANOUILLET and ELMER PETERSON. *Marchand de sel*, translation and introduction by ALBERTO BOATTO, Salerno, Rumma editore, 1969.

Exposition InteRnatiOnale du Surréalisme, Paris, Galerie Daniel Cordier, 15 Déc. 1959-Jan. 1960. Régie de l'exposition ANDRÉ BRETON et MARCEL DUCHAMP. De luxe edition: *Boîte Alerte, Missives lascives* includes 200 copies numbered from 1 to 200 sous Boîte-Alerte containing neuf "missives lascives" ..., a cable by M.D.: "Je purule, tu purules, la chaise purule ...", le catalogue, disques souples, lithographies originales, cartes postales ...; 20 copies "de grand luxe" (1 to XX) contain a *Couple de tabliers* signed with white ink by M.D.

Quatre inédits de M.D., Ales, P.A.B. édit., 1960, n.p., tirage 24 ex.

"The Mary Reynolds Collection", foreword (pp. 5-6) to *Surrealism and its Affinities*, the Mary Reynolds Collection. A bibliography compiled by HUGH EDWARDS, The Art Institute of Contemporary Arts, 6 April-11 May 1958.

"Seventy years...," exhibition catalogue Hans Richter, Washing-ton, Institute of Contemporary Arts, 6 April-11 May 1958.

BIBLIOGRAPHY

Percy Lund, Humphries & Co. Ltd and N.Y., George Wittenborn Inc., 1960. Supervised and approved by M.D. Reprinted 1963 and 1976. *The Large Glass and Related Works*, 2 Vol. Galleria Schwarz, Milano 1967-8. With Nine Original Etchings by Marcel Duchamp, and 144 facsimile reproductions of his notes and preliminary studies for the Large Glass. *Die Schriften*, Kommentar und Notiz von SERGE STAUFFER, Regenbogen Verlag, 1981, 320 p.

Cover for *Minotaure*, no. 6, Winter 1934/1935.

Cover (*Témoins oculistes*) for *Orbes*, 2nd series, no. 4, Winter 1935-1936.

"The Bride", in JULIEN LEVY, *Surrealism*, N.Y., Black Sun Press, 1936, pp. 126-8. (Translation by J. LEVY).

"Teinturerie Rrose Sélavy ..." 4-page brochure, Galerie Quatre Chemins (Paris), Surréalists drawings, 13-31 Déc. 1935 [p. 3].

"Moustiques domestiques ...," "Obligations roulette ...," *Konkrétion*, no. 5/6, special number "Surrealismen i Paris", København-Oslo-Stockholm, mars 1936, p. 155.

Cover (couverture-cigarette) for *La septième face du dé*, poèmes dé-

coupages de GEORGES HUGNET, Paris, Jeanne Bucher, 80 p., 1936.

Cover (cœurs volants) for *Cahiers d'Art*, 11e année, no. 1/2, "Spontanéité", p. 26. Reproduced in ANDRÉ BRETON, *Œuvres complètes*, T. II, Paris, Gallimard, Coll. Pléiade, 1992.; See M.D. pp. 793, 814, 837, 838, 840.

La Bagarre d'Austerlitz, "fenêtre de M.D." in ANDRÉ BRETON, *Au lavoir noir*, Paris, GLM éd, [janv.] 1936. Edition: 70 copies.

"Echecs", chess column for *Ce Soir*, Paris, Dir. ARAGON. 5 Mars 1937, no. 1, p. 8; 13 Mars 1937, no. 2, p. 5; 21 Mars 1937, no. 3, p. 9; 26 Mars 1937, no. 4, p. 9; 3 Avril 1937, no. 5, p. 9; 10 Avril 1937, no. 6, p. 9; 17 Avril 1937, no. 7, p. 9; 24 Avril 1937, no. 8, p. 9; 1er Mai 1937, no. 9, p. 8; 8 Mai 1937, no. 10, p. 9; 15 Mai 1937, no. 11, p. 9; 22 Mai 1937, no. 12, p. 9; 29 Mai 1937, no. 13, p. 7; 5 Juin 1937, no. 14, p. 7; 12 Juin 1937, no. 15, p. 7; 19 Juin 1937, no. 16, p. 7 20 Oct. 1937, no. 17, p. 4.

[30 texts] in ANDRÉ BRETON, *Anthologie de l'humour noir*, Paris, Sagittaire, 1940, 264 pp. 222-5.

"En 1916 Francis Picabia évolue encore ..." in exhibition catalogue *Francis Picabia Peintures Dada. Paysages récents*, Paris, Galerie de Beaune, 19 Nov.-2 Déc. 1937 (Extract from "80 Picabias").

"Rendez-vous du 6 février 1936" [sic], *Minotaure*, no. 10, hiver 1937, n.p.

ris, éd. José Corti, 1969, 78 p.; "Bas.", p. 4; "Hasard", p. 13; "Poussière", p. 22; "Ready Made", p. 23; "Retard", p. 23; "Spontanéité", p. 26. Reproduced in ANDRÉ BRETON, *Œuvres complètes*, T. II, Paris, Gallimard, Coll. Pléiade, 1992.; See M.D. pp. 793, 814, 837, 838, 840.

"The Bride ...", extracts in *London Gallery Bulletin*, no. 3, June 1938, pp. 27-8, and no. 4-5, July 1938, pp. 17-9.

Mariée (1912), reproduction in *London Gallery Bulletin*, no. 12, 15 March 1939, p. 15.

"Oseur d'Influence", *London Gallery Bulletin*, (London), no. 13, 15 April 1939, p. 12.

"SURcenSURE", *L'Usage de la Parole*, (Paris), 1er année, no. 1, Déc. 1939, p. 16.

Rrose Sélavy, Paris, éd. GLM, coll. "Biens nouveaux", no. 4, 19 Avril 1939, non paginé. Edition: total of 15 copies on vieux Japon and 500 copies on vélin blanc.

Boîte-en-Valise, de ou par Marcel Duchamp ou Rrose Sélavy, Paris-New York, 1941-1942. Edition of XX de luxe boxes each contained in a leather valise with an original; regular edition of 300 boxes assembled in series between 1942-1968 with modifications made to the outer container, structure and number of contents.

Writings by M.D. contained in the *Boîte-en-Valise*: "3 ou 4 gouttes de hauteur"; "Combat de boxe"; "IR..CAR E LONG SEA [A bruit secret]" 1916; "Any act red ... [Apolinère Enameled]" 1916-17; "LHOOQ, 1919"; "Tzanck"; "Wanted", 1923"; "Chèque Tzanck"; "Wanted", 1923"; "Obligations de Monte-Carlo", 1924; "Rrose Sélavy et moi esquivons..."; "Morceaux choisis (Written Rotten)..."; "Recette", 1918; "Rendez-vous du 6 février", 1916. Reproduction in: *The Portable Museum. The Making of the Boîte-en-Valise, de et par Marcel Duchamp ou Rrose Sélavy.* Inventory of an Edition by ECKE BONK, London, Thames and Hudson, 1986, 324 p. See Duchamp's Texts pp.: 36, 83, 91, 95, 97, 98, 99, 101, 115, 119-22, 123, 124-5.

Cover of *First Papers of Surrealism*, exhibition catalogue coordinating Council of French Relief Societies Inc., N.Y., 14 Oct.-7 Nov. 1942. Foreword by SIDNEY JANIS. Portrait of M.D.

"Dessin successif"(with: Ernst, Breton, Seligman, Matta, Sekula), *VVV* (New York), editor D. HARE; ed. advisers: BRETON, DUCHAMP, ERNST, no. 2/3, March 1943, p. 68. "Rébus", p. 116 (Nounou cage aux lions) (replica). Cover, pp. I and IV, by M.D.

Le surréalisme en 1947. Exposition Internationale du surréalisme présentée par André Breton et Marcel Duchamp, Paris, Galerie Maeght. Editions Pierre à feu, Juine 1947, 142 p. Edition: total of 999 copies on vélin supérieur; of which 49 copies signed by Breton and Duchamp; these are included in a pink mat-board container the cover of which is an object by Duchamp and ENRICO DONATI; "Prière de toucher". The cover of

"L'enfant qui tête ...", IIIe Convoi, Paris, no. 3, Nov. 1946; [p. 24-25].

"Jurors are always...", exhibition catalogue *The Temptation of St Anthony*, Washington, American Federation of Arts, 1946, p. 3.

ANDRÉ BRETON, *Yves Tanguy*, N.Y., Pierre Matisse Editions, 1946, 98 p., bilingual. English translation by BRAVIG IMBS. This book has been designed by Marcel Duchamp. Edition: 50 copies on Picabia paper with an original etching by Tanguy, 1150 copies on ordinary paper.

the ordinary edition has a photograph by RÉMY DUVAL of this object.

"Je soussigné déclare ...," exhibition catalogue *Antoine Pevsner*, Paris, Galerie René Drouin, Juin 1947 (facsimile of a telegram).

Cover exhibition catalogue *Man Ray (Objects of my Affection)*, N.Y., Julien Lévy Gallery, 10-30 April 1945.

Cover and dust jacket for ANDRÉ BRETON, *Young Cherry Trees secured Against Hares. Jeunes cerisiers garantis contre les lièvres*, translated by EDOUARD RODITI, Dragon View Editions, N.Y., 1946. 25 copies on vélin Hollande; 200 copies on vélin Hollande, all of them numbered.

"Ombres portées ...", *Instead*, N.Y., no. 1, [Febr.] 1948. Facsimile reprod. and extract translated in English.

"... toir"; *Memento Universel Da Costa*, Paris, éd. J. Aubier, fascicule II [1949], p. 16 (extract from "Rendez-vous du dimanche 6 février 1916").

"Francis Picabia est une vis ..." in *491* edited by la Galerie Drouin, Paris, to coincide with a Picabia retrospective, 4 March 1949.

"Any act red ..." ("Apolinère Enameled), "Air de Paris", p. 36; "Si vous voulez une règle de grammaire...", cover by M.D.; "Quand la fumée de tabac ...", cover by M.D., Série V, no. 1 "Marcel Duchamp Number", March 1945.

"Quand la fumée de tabac ...," *Les Quatre vents*, (Paris), no. 8 "Langage surréaliste", 1947, p. 7.

"Teinturerie Rrose Sélavy ..." in MAURICE NADEAU, *Documents surréalistes*, éd. du Seuil, 1948, 400 p.; p. 316.

"Sens", *Memento Universel Da Costa*, Paris, éd. J. Aubier, fascicule I, [1948], p. 15.

Collection of the Société Anonyme, New Haven, Yale University Art Gallery, 1950, XXIV + 224 p. Catalogue compiled and planned by K.S.D. and M.D., edited by GEORGE HEARD HAMILTON. Critical notes signed M.D.: W. KANDINSKY 1943 p. 2, Raymond Duchamp-Villon 1943 p. 3, Picabia 1949 p. 4-5; Henri Matisse 1943 p. 14; Louis Marcoussis 1949 p. 21-2; Alexander Archipenko 1943 p. 23; Pablo Picasso 1943 p. 33-4; Alexander Calder 1949 p. 52; Juan Gris 1943 p. 60; Sophie Tauber-Arp 1949 pp. 68-9; Jean Arp 1949 p. 69; G. de Chirico 1943 p. 76; Katherine S. Dreier 1946 p. 91;

BIBLIOGRAPHY

Writings by Marcel Duchamp and/or Rrose Sélavy (including covers, layouts, and selected reproductions of works)

"Féminisme. La femme Curé", Le Courrier Français, no.47, 19 Nov. 1908.

"Si j'avais su ... [Le Lapin]", Le Courrier Français, no. 3, 14 Jan. 1909.

"La mère", Le Courrier Français, no. 4, 21 Jan. 1909.

"L'accident", Le Courrier Français, no. 7, 11 Fév. 1909.

"Nuit blanche", Le Courrier Français, no. 44, 6 Nov. 1909, p. 10.

"Au palais", Le Courrier Français, no. 45, 13 Nov. 1909, p. 9.

"Vice sans fin", Le Courrier Français, no. 47, 27 Nov. 1909, p. 11.

"La morue ...", Le Rire, no. 356, 27 Nov. 1909.

"La purée", Le Courrier Français, no. 48, 4 Déc. 1909, p. 11.

"Expérience" Le Courrier français, no. 50, 18 Déc. 1909, p. 9.

"Bébé marcheur", Le Courrier Français, no. 1, 1er Jan. 1910, p. 5.

"Objets et Mont-de-Piété", Le Courrier Français, no. 5, 29 Jan. 1910, p. 9.

"Musique de Chambre", Le Courrier Français, no. 6, 5 Fév. 1910, p. 11.

"Le maestro dans ses oeuvres", Le Courrier Français, no. 11, 12 Mars 1910, p. 9.

"Triplepatte", Le Courrier Français, no. 15, 9 Avril 1910, p. 5.

"Vous êtes juif ...", Le Témoin, no. 14, 9 Avril 1910.

"La critique est aisée ...", Le Rire, no. 392, 6 Août. 1910, [p. 6].

"La mode ample", Le Rire, no. 404, 29 Octobre 1910, [p. 5].

"The", Rogue (N.Y.), Vol. II, no. 1, Oct. 1916, p. 2.

Boîte de 1914, Paris, 16 handwritten notes and a drawing (L'apprenti) mounted on marboards contained in a box of photographic plates (Kodak or Jougla) 25 × 19 cm approx. Edition: three photographic copies. Reprinted in MdS and DDS.

The Blind Man, N.Y., no. 2, May 1917, edited by Henri Pierre Roché, Beatrice Wood and M.D. P.[ierre] B.[eatrice] T.[otor]. Cover: reproduction of Broyeuse de Chocolat, No. 2, photograph by Alfred Stieglitz of Fountain [p. 4].

Rongwrong, (N.Y.), no. 1, August 1917. Edited by M.D.

Combat de boxe, Redrawn by Man Ray T.N.T., (N.Y.), [no. 1], March 1919, p. 3.

"Walter C. Arensberg n'a pas encore ...", Bulletin Dada, (Paris), no. 6, 5 Fév. 1920 [p. 3].

Dessin Dada: Chèque Tzanck, Cannibale, no. 1, 25 Avril 1920, p. 1.

"Il faut dire ...", and "Conseil d'hygiène intime ...", Le Cœur à Barbe, journal transparent (Paris), [no. 1], Avril 1922 [p. 5].

Some French Moderns Says McBride, ed. Sté Anonyme Inc. Texts reprinted with permission from the series of articles in the New York Sun and the New York Herald, 1915-1922, by Henry McBride. Format copyrighted, 1922, by Rrose Sélavy (n.p.).

Elise K. Kenney, The Société Anonyme and the Dreier Bequest at Yale University. A Catalogue Raisonné, Published for the Yale University Art Gallery, by Yale University Press, New Haven and London, 1984, 791 p., p. 43.

Reproduction de La Mariée, 1914, in Catalogue Salon Dada, Galerie Montaigne, 6-30 Juin 1921, [p. 7].

"Si vous voulez une règle de grammaire ...", Le Pilhaou-Thibaou (illustrated supplement to 391), 10 Juill. 1921, p. 6.

"En 6 qu'habilla ..." sur L'Œil cacodylate de Picabia (reproduction), Comœdia (Paris), 23 Nov. 1921, p. 2.

"En 6 qu'habilla ...", Little Review, Vol. VIII, no. 2, Spring 1922 [pp. 40-1].

New-York Dada (N.Y.) [no. 1], April 1921, edited by M.D. and Man Ray. Cover by M.D. Eau de Voilette.

"Oh! do shit again! ...", "Du dos de la cuillère ...", p. 1; "Rrose Sélavy et moi", insert, 391, no. 18, Juill. 1924.

"Oh! do shit ...", "Du dos de la cuillère ...", in Curnonsky and J. W. Bienstock, Le Musée des erreurs, ou le français tel qu'on l'écrit, Paris, éd. Albin Michel, 1925, 320 p., p. 314.

9 Discs for Anémic Cinéma, 1925: "Bains de gros thé ...", "Si je te donne ...", "On demande ...", "Inceste ou passion ...", "Esquivons ...", "Avez-vous déjà mis...", "Parmi nos articles ...", "L'aspirant habite Javel ...", "L'Enfant qui tête ...".

"Rrose Sélavy et moi ...", cover of The Little Review, (N.Y.), Vol. XI, no. 1, Spring 1925.

"80 Picabias", signed "Rrose Sélavy" Insert in the auction catalogue, Tableaux, Aquarelles, Dessins par Francis Picabia; vente à l'Hôtel Drouot, salle no.10, le lundi 8 mars 1926. An extract, signed Duchamp in catalogue Francis Picabia in catalogue Peintures Dada, passages récents, Paris, Galerie de Beaune 19 Nov.-2 Déc. 1937. Reprinted unabridged in Francis Picabia, notes by Olga Mohler, Francis Picabia, notes by Maurizio Fagiolo, Torino, Edizioni Notizie, 1975, 180 p., p. 38.

16; "Paraître", p. 24, Littérature, nouvelle série, no. 5, 1er Oct. 1922.

"Leçons du soir et du matin" and "Teinturerie Rrose Sélavy", Littérature, nouvelle série, no. 10, 1er Mai 1923, p. 10.

"Moustiquesdomestiquesdemistock" on recto, statues on verso, Roulette de Monte Carlo (issue of 30 bonds), Paris, 1er novembre 1924.

17 Puns on the back cover of, The Wonderful Book. Reflections on Rrose Sélavy, de Pierre de Massot (Paris - Imprimerie Ravilly), s.d. [1924], limited edition.

"Preface" to Exposition de dessins par Francis Picabia, Galerie Léonce Rosenberg, Paris, 1-24 Déc. 1932. English preface by Gertrude Stein [pp. 1-2]. Preface translated into French by Marcel Duchamp [pp. 3-4]. Reprinted in Orbes, no. 4, Winter 1932-1933: G. Stein, "Stanza 69 from the Stanzas of Meditation", pp. 64-5. G. Stein, "Stance 69 des stances de méditation", pp. 65-7. Translation by Marcel Duchamp. English text and translation by M.D. reprinted in Olga Mohler, Francis Picabia, Torino, Ed. Notizie, 1975, 180 p., p. 43.

Eugène Znosko-Borovsky, Comment il faut commencer une partie d'échecs, Méthode simple et logique pour comprendre les débuts ... French version by M.D., Paris, Les Cahiers de l'Echiquier français, les "Comment" de l'Echiquier, no. 2, 1933, 168 p.

Reflections on the Art of Katherine S. Dreier, New York, Academy of Allied Arts, 1933, 24 p. Contains: Antoine Pevsner, "To Kath. S. Dreier", p. 10. Jacques Villon, "For many years ...", p. 11. English translation by M.D. [unpublished letter to K. S. Dreier]. (Cover p. III, Portrait of M.D. by ...

"Formule de l'opposition hétérodoxe dans les domaines principaux", Le Surréalisme au service de la révolution (Paris), no. 2, Oct. 1930, pp. 18-9.

L'Opposition et les cases conjuguées sont réconciliées, par Duchamp et Halberstadt, Bruxelles, L'Echiquier, 1932, L'Echiquier, Paris, 2 × 113 p. Layout and cover by Marcel Duchamp. Trilingual edition: French, German, English.

"The Bride ...", This Quarter, Vol. V, no. 1, "Surrealist number" Sept. 1932, pp. 189-92. Rendered into English by J. Bronowski.

"Mann vor Dem Spiegel" puis "Men before the Mirror", Photographs by Man Ray 1920 Paris 1934, James Thrall Soby, Hartford, Cahiers d'Art, Paris, 1934, unpaginated; two texts signed Rrose Sélavy between photos no. 66 and 67.

"La Mariée mise à nu par ses célibataires mêmes" [sic], Le Surréalisme au Service de la Révolution, Paris, no. 5, 15 Mai 1933, pp. 1-2. H.t. [p. 53], M.D.: La Mariée ... (1915-1918).

"Moustiques domestiques ...", reprod. Obligations de Monte Carlo, no. "Intervention surréaliste", 1934, p. 32. Republished in L'Arc, 1969 and L'Arc (éd. Duponchelle) 1990. Also inset in XXe Siècle, no.4, Noël 1938 (recto, verso).

La Mariée mise à nu par ses célibataires, même [The Green Box] Paris, éditions Rrose Sélavy, 18 rue de la Paix, 1934. In a cardboard box 33 × 28 cm, covered in green suédine. Edition: 300 copies + 20 copies of which 10 signed and numbered on de luxe paper; each box contains, in addition to the colour reproduction, original photographs and a manuscript page; it includes a page example of the ordinary copy. Paris, 1934. And advertisement in Minotaure, no. 5, 1934, reproducing the publication of 110 different documents. Reprinted in MdS, pp. 34-95, DdS, pp. 39-102. Extracts in Notes (1980). "Cette boîte doit contenir 93 documents (photos, dessins et notes manuscrites des années 1911-15, ainsi qu'une planche en couleurs), Marcel Duchamp, Paris, 1934". Edition: 300 copies.

The Bride Stripped Bare by her Bachelors, even, typographic version by Richard Hamilton of Marcel Duchamp's Green Box, translated by George Heard Hamilton, London and Bradford ...

	FRANCE	USA	OTHER COUNTRIES		FRANCE	USA	OTHER COUNTRIES
1966 **1967**			28.12 - 12.2 - **Germany** Staatliche Kunsthalle, Baden-Baden (Labyrinthe) **Australia** City Art Gallery Auckland (Not seen and/or Less seen) National Art Gallery, Wellington (Not seen and/or Less seen) Robert McDougall Art Gallery, Christchurch (Not seen and/or Less seen) Tasmanian Museum & Art Gallery, Hobart (Not seen and/or Less seen) Art Gallery of New South Wales, Sydney (Not seen and/or Less seen) National Gallery of Victoria, Melbourne (Not seen and/or Less seen) Queensland Art Gallery, Brisbane (Not seen and/or Less seen) The Art Gallery of South Australia, Adelaide (Not seen and/or Less seen) The Western Australian Art Gallery, Perth (Not seen and/or Less seen)	**1967** **1968**		19.3 Doors, Cordier & Ekstrom Inc., New York City - Entrance Door for Gradiva (replica) 27.3 - 9.6 Dada, Surrealism and their heritage, The Museum of Modern Art, New York City n. 76, The Bride n. 77, The Passage from Virgin to Bride n. 78, Bicycle Wheel n. 79, Chocolate Grinder n. 1 n. 80, Bottlerack n. 81, Nine Malic Molds n. 82, The Bride Stripped Bare by her Bachelors, even n. 83, Traveler's Folding Item n. 84, Tu m' n. 85, Fresh Widow n. 86, Rotary Glass Plates n. 87, Why not sneeze? n. 88, Rotoreliefs (travels to Los Angeles) 3.4 Parke Bernet Galleries, New York City - Paysage aux arbres 16.7 - 8.9 County Museum of Art, Los Angeles (Dada, Surrealism and their heritage)	26.11 - 5.1 - **Italy** Dal Dada al Surrealismo, Galleria Narciso, Turin n. 22, Apollinère n. 23, Chèque Tzank n. 24, LHOOQ n. 25, Obbligation pour la Roulette de Monte-Carlo n. 26, Gilet pour Benjamin Peret n. 27, Les Joueurs d'échecs (engraving nn. VII/XXV) n. 86, Allevamento di polvere (photo Man Ray) December - **Italy** I maestri del Surrealismo, Museo d'Arte Moderna, Turin 28.12 - 15.3 - **Switzerland** Le Surréalism est-il un art érotique? Galerie Saqqarah, Gstaad - Coin de chasteté - Objet dard - Feuille de vigne femelle - Mona Lisa - Boîte-en-valise 13.1 - 15.4 - **Germany** Ars Multiplicata, Vervielfältigte Kunstzeit, 1945, Wallraf-Richartz Museum in der Kunsthalle, Köln n. 120, Rotorelief n. 121, I Buch über die Ready-Mades n. 122, Il reale assoluto n. 123, 13 Ready-Mades n. 124, The Large Glass and related works n. 125, 9 Radierungen 6.6 - **Great Britain** Presentation at Editions Alecto, London Morceaux choisis
1967	15.4 - 1.6 Les Duchamps: Jacques Villon, Raymond Duchamp-Villon, Marcel Duchamp, Suzanne Duchamp, Musée des Beaux Arts, Rouen (82 œuvres) 7.6 - 2.7 Raymond Duchamp-Villon, Marcel Duchamp, Musée national d'art moderne, Paris (Rouen's exhibition without J. Villon and Suzanne Duchamp)	14.2 - 4.3 Marcel Duchamp between 1912 & 1928 "A l'infinitif", Cordier & Ekstrom Inc., New York City 27.9 - 22.10 Painters of the Section d'Or, The alternative to Cubism, Art Gallery, Albright Knox n. 1, The King and the Queen	March - **Germany** Kunsthalle, Norimberga (Labyrinthe) June - July - **Italy** Marcel Duchamp, Galleria d'Arte La Bertesca, Genoa 7.11 - 10.12 - **Italy** Marcel Duchamp disegni dal 1902 al 1910, Galleria Solaria, Milan 7.11 - 5.12 - **Italy** The Large Glass and related works, Biblioteca Comunale, Milan (cfr. volume completo, incisioni I e II stato)	**1968**			
1967 **1968**	22.11 - mid January Table d'Orientation pour une sculpture d'aujord'hui, Galerie Creuzevault, Paris - A Bruit Secret 7.6 Ready-Mades et Editions de et sur Marcel Duchamp, Claude Givaudan, Paris	5.12 - 6.1 Polly imagists, Cordier & Ekstrom Inc., New York City - Pollyperruque	4.11 - 7.1 - **Switzerland** Sammlung Marguerite Arp-Hagenbach, Kunstmuseum Basel n. 145, Boîte-en-valise XIX/XX				The titles of works cited in the Chronological table of exhibitions are taken from the original sources.

Year	FRANCE	USA	OTHER COUNTRIES
1964	Francis Picabia), Galerie Louis Carré, Paris - L'œil cacodylate (M.D. signataire)		
1964 1965			23.10 - 29.11 - **Switzerland** Marcel Duchamp, Wassily Kandinsky, Casimir Malevitsch, Joseph Albers, Tom Doyle, Kunsthalle Bern (Omaggio a M.D.)
			15.12 - 16.1 - **Great Britain** Marcel Duchamp, Gimpel Fils, London (Omaggio a M.D.)
			31.12 - 7.3 - **Great Britain** The Peggy Guggenheim Collection, Arts Council at the Tate Gallery, London n. 9, Sad Young Man in a Train (travelling exhibition)
1965	November Réhabilitation de l'objet, Galerie Breteau, Paris - Porte bouteille	14.1 - 13.2 Not seen and/or less seen of/by Marcel Duchamp/Rrose Sélavy 1904-64 (Mary Sisler Collection), Cordier & Ekstrom, Inc. New York City (90 works exhibited +35 miscellanea) (travelling exhibition)	3.2 - 15.3 - **Netherlands** Marcel Duchamp, Schilderigen Tekeningen Gemeentemuseum, The Hague (Omaggio a M.D.)
	29.6 - 14.8 Pop Por, Pop Corn, Corny, Galerie Jean Larcade, Paris - Boîte-en-valise	23.2 - 28.3 The Museum of Fine Arts, Houston (Not seen and/or less seen)	3.2 - 14.3 - **Netherlands** Kinetische Kunst uit Krefeld, Gemeentemuseum, The Hague n. 2, 12 Rotoreliefs (travels to Eindhoven)
		11.5 - 20.6 Museum of Art, Baltimore (Not seen and/or less seen)	20.3 - 2.5 - **Netherlands** Stedelijk von Abbemuseum, Eindhoven (Kinetische Kunst)
		5.8 - 29.8 The Rose Art Museum, Brandeis University, Waltham (Not seen and/or less seen)	20.3 - 3.5 - **Netherlands** Marcel Duchamp, Schilderigen Tekeningen, Stedelijk von Abbemuseum, Eindhoven (Omaggio a M.D.)
		9.9 - 3.10 Art Center, Milwaukee (Not seen and/or less seen)	June - **Italy** Marcel Duchamp, Readymades, Galleria Gavina, Rome
		14.10 Parke Bernet Galleries, New York City (Nu sur nu)	19.6 - 1.8 - **Germany** Marcel Duchamp, Museum Hans Lange, Krefeld (Omaggio a M.D.)
		18.10 - 21.11 Walkers Art Center, Minneapolis (Not seen and/or less seen)	7.9 - 28.9 - **Germany** Marcel Duchamp, même, Kestner-Gesellschaft, Hannover (Omaggio a M.D.)

Year	FRANCE	USA	OTHER COUNTRIES
1965 1966	7.12 XIe exposition internationale du Surréalisme, L'Œil, Galerie d'Art, Paris n. 28, Why not Sneeze n. 29, Fresh widow n. 30, Torture morte		3.12 - 9.1 - **Germany** Licht und Bewegung, Staatliche Kunsthalle, Baden-Baden n. 50, Rotative Plaques Verre n. 51, 10 Rotoreliefs
			4.12 - 3.2 - **Italy** Marcel Duchamp, Early Drawings, Late Graphics, Rare Editions, Galleria Schwarz, Milan (61 N°s)
1966	12.2 - 26.2 USA, Nouvelle Peinture, Musée des Beaux-Arts, Lyon	8.2 - 26.2 Hommage à Caïssa, Cordier & Ekstrom, New York City	15.2 - March - **Switzerland** Marcel Duchamp, Cinquantenaire de Dada, Galerie Krugier et Cie, Geneva n. 7 a 26
	15.6 - 10.7 Première Biennale de Peinture, Hôtel de Ville, Puteaux n. 7, Les joueurs d'échecs		18.6 - 31.7 - **Great Britain** The Almost Complete Works of Marcel Duchamp, Tate Gallery, London (244 N°s)
			24.6 - 30.9 - **Italy** Cinquant'anni Dada, Dada in Italia, 1916-1966, Civico Padiglione d'arte contemporanea, Milan (19 N°s)
			23.6 - **Great Britain** Sotheby and Co., London - Objet Dard
1966 1967			8.9 - 17.11 - **Switzerland** Dada, 1916-1966, Kunsthaus Zurich - Nu descendant un escalier - Tu m' - Boîte-en-valise - LHOOQ - Maquette de Fountain - Liste de contrepèteries - Boîte verte (exemplaire de Brancusi) (travels to Paris)
			October-November - **Germany** Labyrinthe, phantastische Kunst vom 16. Jahrhundert bis zur Gegenwart Kunstverein, Berlin n. 337, Boîte-en-valise (travelling exhibition)
			26.11 - 8.1 - **Sweden** Peggy Guggenheim, Moderna Museet, Stockholm (travelling exhibition)
			30.11 - 30.1 Dada 1916-1966, Musée national d'art moderne, Paris (travels from Zurich)

	FRANCE	USA	OTHER COUNTRIES
1961	Surréalisme et Précurseurs, Palais Granvelle, Besançon n. 71, Pharmacie n. 72, Rotorelief n. 73, Boîte-en-valise n. 74, La Mariée (gravée par J. Villon) n. 75, Moulin à café (gravé par J. Villon)	18.1 - 19.2 The World of Dada, Museum of Modern Art, School of Design, Rhode Island n. 1, Bicycle Wheel n. 2, Bottlerack n. 6, Rotoreliefs n. 15, In Advance of the Broken Arm n. 22, Boîte en valise n. 30, Roulette de Monte-Carlo n. 31, Rotoreliefs n. 58, The Green Box 6.2 Paintings from the Arensberg and Gallatin Collections of the Philadelphia Museum of Art, The Solomon R. Guggenheim Museum, New York City 2.10 - 12.11 The Art of Assemblage, The Museum of Modern Art, New York City (travels to Dallas and San Francisco) n. 74, Bicycle Wheel n. 75, Bottle Dreyer n. 76, Comb n. 77, With Hidden Noise n. 78, Apolinère Enameled n. 79, Fountain n. 80, Tu m' n. 81, LHOOQ n. 82, Paris Air n. 83, Fresh Widow n. 84, Why not sneeze? n. 85, The green box n. 86, Boîte-en-valise	1.3 - 15.3 - **Italy** L'oggetto nella pittura, Galleria d'arte Schwarz, Milan - Tabliers de blanchisseuse - Rotorelief 10.3 - 17.4 - **Netherlands** Bewogen Beweging, Stedelijk Museum, Amsterdam n. 71, Reconstructie van het Fietswiel n. 72, Duplicaat van de Rotary glass - plaques n. 73, Schijven met woordspelingen n. 74, Reconstruktie de decor van het atelier, 11 rue Larrey, Paris n. 75, Draaiende halve bol n. 76, 12 rotoreliefs n. 77, 2 valises (travels to Stockholm) 16.5 - 10.9 - **Sweden** Rörelse I Konsten, Moderna Museet, Stockholm Including the first replica of the Large Glass (travels from Amsterdam)
1962	23.5 - 30.6 L'œil, Galerie d'Art, Paris n. 18, A propos de jeune sœur n. 19, Deux nus, un fort et un vite n. 20, Boîte verte n. 21, Machine optique n. 22, Rotoreliefs	9.1 - 11.2 Museum for Contemporary Art, Dallas (The Art of Assemblage) 5.3 - 15.4 The Museum of Art, San Francisco (The Art of Assemblage)	21.9 - 4.11 - **Austria** Kunst von 1900 bis heute, Museum des 20. Jahrhunderts, Vienna n. 65, Studie zum König und Königin von schnellen Akten n. 109, La Mariée mise à nu par ses célibataires, même (copie de Ulf Linde) n. 110, Feuille de vigne femelle n. 111, Boîte verte n. 112, Boîte-en-valise n. 113, Coin de chasteté
1962 **1963**	24.10 - 17.11 Collages et objets, Galerie du Cercle, Paris n. 15, Obligation pour la roulette de Monte-Carlo 2.12 - 12.1 Collages Surréalistes, Galerie Le Point Cardinal, Paris n. 15 bis, Porte-bouteilles - Pharmacie - Anémic Cinéma (8 disques) - Autoportrait		

	FRANCE	USA	OTHER COUNTRIES
1963	8.6 - 15.9 La Grande Aventure de l'art du XXe siècle, Chateau de Rohan, Strasbourg n. 31, A propos de jeune sœur	7.1 - 2.2 Duchamp, Picabia, Schwitters, The Alan Gallery, New York City n. 1, Bottle Dryer n. 2, Feuille de vigne femelle n. 3, Rotorelief n. 4, Objet Dard n. 5, Boîte-en-valise n. 6, Tablier de blanchisseuse 17.2 - 31.3 1913 Armory Show, 50th Anniversary Exhibition, Munson-Williams-Proctor Institute, Utica n. 239, The King and Queen surrounded by Swift Nudes n. 240, Portrait of Chess Players n. 241, Nude descending a staircase n.2 n. 242, Nude (watercolour) (travels to New York City) 6.4 - 28.4 Armory of the Sixty-ninth Regiment, New York City (50th Anniversary) 8.10 - 3.11 By or of Marcel Duchamp or Rrose Sélavy, a retrospective exhibition, Art Museum, Pasadena	7.4 - May - **Sweden** Marcel Duchamp, Galerie Burren, Stockholm n. 1, Cœurs volants n. 2, Rotorelief n. 3, Young Cherry trees Secured against Hares n. 4-5, Feuille de vigne femelle n. 6, Eau & Gaz n. 7, Cykelhjulet n. 8, Fresh widow n. 9, Trois stoppages etalon n. 10, Flasktorkaren n. 11, A Bruit Secret n. 12, Peigne n. 13, Fontaine n. 14, In Advance of the Broken Arm n. 15, Pliant de voyage n. 16, Air de Paris n. 17, Why not sneeze? n. 19-22, Ur Grona Asken n. 23-31, Ur Boîte-en-valise
1964	24.4 Le Surréalisme: Sources-Histoire-Affinités, Galerie Charpentier, Paris n. 109, La Mariée mise à nu par ses célibataires, même (copie de Ulf Linde) 10.6 Exposition "8 ans d' agitation", Galerie Daniel Cordier, Paris n. 19, Couple de tabliers 4.11 - 41.2 Chef d'œuvre du mois: Chapeau de paille? 1921 (Hommage à		3.3 - 13.3 - **Italy** Patamostra, Galleria Schwarz, Milan 5.6 - 30.9 - **Italy** Omaggio a Marcel Duchamp, Galleria Schwarz, Milan (108 works) (travelling exhibition) 24.6 - 30.8 - **Netherlands** Nieuwe Realisten, Gemeentemuseum, Den Haag n. 41, Roue de bicyclette n. 42, Porte-bouteilles 17.10 - **Italy** 1908-1928, Galleria Schwarz, Milan - Roue de bicyclette - Fountain

	FRANCE	USA	OTHER COUNTRIES
1958	21.10 - 20.11 Le Dessin dans l'Art Magique, Galerie Rive Droite, Paris - Boîte-en-valise	9.1 - 16.2 The disquieting Muse: Surrealism, Contemporary Arts Museum, Houston - The Bachelors	17.4 - 21.7 - **Belgium** 50 ans d'Art Moderne, Palais International des Beaux-Arts, Bruxelles n. 80, Le Passage de la Vierge à la Mariée n. 81, Broyeuse de chocolat n. 2 n. 82, Réseaux des Stoppages étalon
		16.2 - 17.3 The 1913 Armory Show in retrospect, Amherst College, Amherst n. 12, Nude Descending a Staircase	5.9 - 19.10 - **Germany** Dada: Dokumente einer Bewegung, Kunstverein für die Rheinlande im Westfalen, Düsseldorf n. 138, Roue de bicyclette n. 139, In Advance of the Broken Arm n. 140, Fontaine n. 141, Boîte-en-valise n. 142, Manuscrit La Mariée (gravée par J. Villon) (travels to Frankfurt am Main and Amsterdam)
		October - November Old Masters of Modern Art, Hackley Gallery, Muskegon - The Bachelors	23.12 - 2.2 - **Netherlands** Stedelijk Museum, Amsterdam (Dada: Dokumente einer Bewegung)
1959		12.1 - 6.2 Art and the found object (American Federation of Arts), Time-Life Building, New York City (travelling exhibition) - Roue de bicyclette - Bottle Dryer - In Advance of the Broken Arm	
1958 1959		22.2 - 15.3 Williams College, Williamstown (Art and the found object)	
1958 1959		6.4 - 2.5 (On the occasion of the publication of Lebel's book) Sidney Janis Gallery, New York City - Nu n. 3	

	FRANCE	USA	OTHER COUNTRIES
1959	5.5 - 30.5 Sur Marcel Duchamp (Publication of Lebel's book), La Hune, Paris	- The Bride - First Study for Cemetery	27.4 - 16.5 - **Italy** Mostra Surrealista Internazionale, Libreria Schwarz, Milan - Feuille de vigne femelle - Boîte-en-valise
	5.6 - 11.7 Dessins surréalistes, Galerie le Bateau Lavoir, Paris - Nous nous cajolions	8.4 - 28.4 Cranbrook Academy of Art Galleries, Bromfield Hills (Art and the found object)	September - **Great Britain** On the occasion of the publication of Lebel's book, I.C.A., London
	24.6 Vente de solidarité au profit de Benjamin Peret, Hôtel Drouot, Paris n. 135, Gilet pour Benjamin Peret	20.5 - 10.6 The Arts Club, Chicago (Art and the found object)	27.9 - 18.10 - **Canada** Musée des Beaux-Arts, Montréal (Art and the found object)
1959 1960	27.11 - 19.12 Multiplication d'objets, Société d'Art Saint-Germain-des-Prés (Edouard Loeb), Paris - Rotoreliefs	1.7 - 21.7 University of Notre Dame, O'Shaughnessy Hall Gallery, South Bend (Art and the found object)	
1960	15.12 - 29.2 Exposition Internationale du Surréalisme, Galerie Daniel Cordier, Paris - Autoportrait (With my Tongue in my Cheek)	4.11 - 24.11 Vassar College, Poughkeepsie (Art and the found object)	
		1.2 - 15.2 Bamberger's Store (Window), Newark - Nude Descending a Stair n.3 (charcoal) - Study for the Virgin (watercolor)	7.5 - **Sweden** Marcel Duchamp, Bokkunsum Stockholm
1960 1961	4.11 - 23.1 Les Sources du XXe siècle, Musée national d'art moderne, Paris n. 135, Sonate n. 136, Les Joueurs d'échecs n. 137, Nu descendant un escalier n. 2	25.5 National Institute of Arts and Letters, New York City - Artist's father - Chocolate Grinder n. 2 - Passage de la Vierge à la Mariée	May - June - **Switzerland** Kinetische Kunst, Kunstgewerbemuseum Zurich - Rotoreliefs (ed. MAT)
		28.11 - 14.1 Surrealist Intrusion in the Enchanters' Domain, D'Arcy Galleries, New York City n. 208, Pharmacy n. 338, Wedge of chastity	30.6 - 28.8 - **Switzerland** Dokumentation über Marcel Duchamp, Kunstgewerbemuseum, Zurich

	FRANCE	USA	OTHER COUNTRIES
1953	n. 39, Dr. Tzanck n. 40, Fountain (replica) n. 41, La Bagarre d'Austerlitz * n. 42, Fresh widow n. 43, Apolinère enameled * n. 44, À Bruit secret * n. 46, L.H.O.O.Q. * n. 47, 50 cc air de Paris * n. 48, Pliant de voyage * * from the boîte-en-valise	24.4 – 28.6 The classic tradition in Contemporary Art, Walker Art Center, Minneapolis n. 34, The Bachelors October Inaugural exhibition, Art Center, Fort Worth n. 27, Tu m'	
1953 1954		7.12 – 8.1 Marcel Duchamp – Francis Picabia, Rose Fried Gallery, New York City n. 1, Objet-dard n. 2, Feuille de vigne femelle n. 3, Boîte-en-valise n. 4, Rotoreliefs n. 5, Green Box	February – March – **Sweden** Objekt eller Artefakter verklig helten for verklig AD, Galerie Samlaren, Stockholm
1955	21.1 Regards sur la peinture contemporaine, Musée Galliera, Paris n. 33, Le Printemps n. 34, Pour une partie d'échecs 18.2 – March Pérennité de l'Art Gaulois, Musée Pédagogique, Paris n. 464, À propos de jeune sœur n. 465, Deux nus: un fort, un vite h.c.: – Machine optique – Cimetière des uniformes et livrées 6.4 – 30.4 Le Mouvement, Galerie Denise		

	FRANCE	USA	OTHER COUNTRIES
1955	René, Paris – Rotative Demi-Sphère	19.10 – 4.12 Twentieth Century Painting from Three Cities: New York, New Haven, Hartford. Wadsworth Atheneum, Hartford – The Bachelors	24.6 – 26.9 **Switzerland** Le Mouvement dans l'Art contemporain, Musée Cantonal des Beaux-Arts, Lausanne – Machine optique – Rotoreliefs – 2 Nus, un fort, un vite
1956		3.1 – 4.2 Cubism 1910-1912, Sidney Janis Gallery, New York City n. 8, Nu Descendant un escalier, n.1 n. 9, Nu Descendant un escalier, n.2 January Dada…, Yale University Art Gallery, New Haven – Les Célibataires – In Advance of the Broken Arm – Boîte-en-valise	
1957	13.3 – 12.5 Retrospective Dada, Galerie de l'Institut, Paris – Rotative demi-sphère – Projet pour Rotative demi-sphère – L.H.O.O.Q. – Porte-Bouteilles 20.5 – 31.7 Bosch, Goya et le Fantastique, Bordeaux n. 243, Obligation pour la roulette de Monte-Carlo 4.6 – 4.7 Dessins Cubistes, Galerie Le Bateau Lavoir, Paris – Deux Nus, un fort, un vite	8.1 – 17.2 Jacques Villon, Raymond Duchamp-Villon, Marcel Duchamp, The Solomon R. Guggenheim Museum, New York City (travels to Huston) – The Artist's Father – The Chess Players – Nude Descending a Staircase n. 1 – Portrait of Chess Players – The Sonata – Yvonne and Magdeleine Torn in Tatters – The Bride – The King and Queen surrounded by Swift Nudes – Nude Descending a Staircase n. 2 – Le Passage de la Vierge à la Mariée – Chocolate Grinder II – Why not sneeze Rose Sélavy? 22.3 – April Jacques Villon, Raymond Duchamp-Villon, Marcel Duchamp-Villon, The Museum of Fine Arts, Houston	

	FRANCE	USA	OTHER COUNTRIES
1949	27.5 – 30.6 L'Art Abstrait. Les Préliminaires, Galerie Maeght, Paris n. 15, Pour une partie d'échecs n. 16, La Mariée (gravée par J. Villon)	- In Advance of the Broken Arm 4.6 – 1.7 and 6.9 – 2.10 The Société Anonyme Collection of the 20th Century Painting, Institute of Contemporary Art, Boston (travelling exhibition) - The Bachelors 10.10 – 6.11 Mount Holyoke College, South Hadley (The S.A. Collection) 8.4 – 10.4 Western Round Table on Modern Art, Museum of Art, San Francisco - Nude descending the Staircase	
1950		19.10 – 18.12 Twentieth Century Art from the Louise and Walter Arensberg Collection, The Art Institute, Chicago n. 52 to 81 included 27.2 – 25.3 20th Century Old Masters, Sidney Janis Gallery, New York City - Chess Players 30.4 An exhibition commemorating the 30th Anniversary of the Société Anonyme, Museum of Art 1920, Yale University Art Gallery, New Haven - The Bachelors 25.9 – 21.10 Challenge & Defy, Extreme examples by XX century artists, French & American, Sidney Janis Gallery, New York City n. 10, Fountain (first replica) 3.11 – 11.2 Masterpieces in America, Museum of Art, Philadelphia - Nude descending a Staircase 5.10 – 23.3 Art Museum, Saginaw - The Bachelors	Spring – **Italy** The Peggy Guggenheim Collection, Associazione Artisti d'Italia, Palazzo Reale, Milan (travelling exhibition)
1950 1951			

	FRANCE	USA	OTHER COUNTRIES
1950 1951		- Rotoreliefs - In Advance of the Broken Arm (The S.A. Collection)	
1951		2.1 – 3.2 Climax in 20th Century Art 1913, Sidney Janis Gallery, New York City n. 7, Wheel [first replica] n. 8, 3 Stoppages Etalon 17.9 – 27.10 Brancusi to Duchamp, Sidney Janis Gallery, New York City n. 1, Chess Players, drawing n. 2, Drawing for Jules Laforgue's "La Siesta" n. 3, Drawing for the Large Glass n. 4, Reseaux de Stoppages-Etalon n. 5, The Bachelors, watercolor n. 6, Boîte-en-valise n. 7, Knight, drawing 25.2 – 3 Duchamp, Frères & Sœur, œuvres d'art, Rose Fried Gallery, New York City 24.11 – 31.12 Corcoran Gallery, Washington - The Bachelors (The S.A. Collection)	? – **Switzerland** The Peggy Guggenheim Collection, Kunsthaus Zurich (travelling exhibition) 15.7 – 9.9 – **Belgium** 75 œuvres du demi-siècle, Knocke-le-Zoute, Albert Plage n. 51, A regarder d'un œil (photo) n. 52, Eau de Voilette (photo) ? – **Belgium** The Peggy Guggenheim Collection, Palais des Beaux-Arts, Bruxelles (travelling exhibition) ? – **Netherlands** The Peggy Guggenheim Collection, Stedelijk Museum, Amsterdam (travelling exhibition)
1952	May-June L'œuvre du XXe siècle, Musée national d'art moderne, Paris n. 25, La Mariée n. 26, Nu descendant un escalier (then to London)		23.1 – 5.2 – **Italy** Marcel Duchamp, Amici della Francia, C. Vittorio Emanuele, 31, Milan - La Mariée mise à nu par ses Célibataires, même (Green Box) 15.7 – 17.8 – **Great Britain** Twentieth Century Masterpiece, Tate Gallery, London n. 20, The Bride n. 21, Nude descending a Stair (L'œuvre du XXe siècle)
1952 1953		15.12 – 1.2 In memory of Katherine S. Dreier (Her own collection of Modern Art), Yale University Art Gallery, New Haven n. 25, Tu m'	
1953	30.1 – 9.4 Le Cubisme (1907-1914), Musée national d'art moderne, Paris n. 60, Les Joueurs d'échecs n. 61, A propos de petite sœur n. 163, Formes maliques	15.4 – 9.5 Dada, Sidney Janis Gallery, New York City n. 36, Tu m' n. 37, A regarder d'un œil, de près... n. 38, La Joconde	

YEAR	FRANCE	USA	OTHER COUNTRIES
1945	1945	n. 29, Three Stoppages Etalon n. 30, The Bachelors n. 31, Disturbed Balance n. 32, Revolving Glass Machine n. 33, Fresh Widow n. 34, Soins dentaires du Dr. Tzanck n. 35, Six Roto-reliefs n. 36, La Mariée mise à nu par ses célibataires, même (green-box) n. 37, Valise n. 38, In advance of the Broken Arm h. c., Pocket Chess Set 13.3 – 11.4 European Artists in America, Whitney Museum of American Art, New York City n. 26, Boîte-en-valise n. 27, Allégorie de genre October – November Duchamp and Villon, College of William and Mary, Williamsburg (travelling exhibition) - The Bachelors - Six Roto-reliefs - In Advance of the Broken Arm	
1945 1946		December – 20.1 California School of Fine Arts, San Francisco (Duchamp and Villon) 1.5 – 15.5 Allegheny College, Meadville (Duchamp and Villon)	
1946	4.6 – 13.6 Hommage à Antonin Artaud Galerie Pierre, Paris - poisson japonais July Window of the bookshop La Hune, Paris - Boîte-en-valise - Porte-Bouteilles - Rotoreliefs - documents and photos	4.4 – 6.5 Plastic Experience in the 20th Century Contemporary Sculptures, Yale University Art Gallery, New Haven 8.9 – 22.9 St. Paul Gallery and School of Art, Maryland (Duchamp and Villon) 30.9 – 25.10 Carleton College, Northfield (Duchamp and Villon) 16.10 – 6.11 "1910-12", The Climatic Years of Cubism, Jacques Seligmann & Co., Inc., New York City	

YEAR	FRANCE	USA	OTHER COUNTRIES
1946		n. 7, Nu descendant un escalier (for Carrie Stettheimer's doll's house) Eleven Europeans in America, The Museum of Modern Art, New York City	
1946 1947		10.11 – 30.11 Duke University, Durham (Duchamp and Villon)	18.3 – 3.5 – **Great Britain** The Cubist Spirit in its time, The London Gallery, London n. 15, Excerpts from the Duchamp valise n. 16, Excerpts from the Duchamp valise n. 33, Jeune Homme Triste dans un Train - Boîte-en-valise n. 37, Photograph of a glass
1947		4.1 – 18.1 University of Maine, Orono (Duchamp and Villon) 18.11 – 17.12 American Print-Making 1913-1947, Brooklyn Museum, Brooklyn - Six Roto-reliefs	? – **Italy** The Peggy Guggenheim Collection, Twenty-fourth Biennale, Venice
1948		5.3 Painting and Sculpture by the Directors of the Society Anonyme since its foundation 1920-me, Yale University Art Gallery, New Haven n. 26, The Chess Players n. 27, Sieste éternelle n. 28, Le Passage de la Vierge à la Mariée n. 29, Study for La Mariée n. 30, The Bachelors n. 31, Trois Stoppages Etalon n. 32, In Advance of the Broken Arm n. 33, Disturbed Balance n. 34, Revolving Glass Machine n. 35, Valise	
1948 1949		2.10 – 21.11 Mobiles and Articulated Sculpture, California Palace of the Legion of Honor, San Francisco - 6 Roto-Reliefs	? – **Italy** The Peggy Guggenheim Collection, Strozzini Gallery, Strozzi Palace, Florence (travelling exhibition)
1949		3.2 – 9.3 Isms in Art since 1800, Rhode Island School of Design, Providence - Three Stoppages Etalon - The valise	

	FRANCE	USA	OTHER COUNTRIES		FRANCE	USA	OTHER COUNTRIES
1940		2.4 - 30.4 Origins of Modern Art, The Arts Club, Chicago n. 50, Young Man in a Train		1943 1944	22.12 - 31.1 Le Temps d'Apollinaire, Galerie Breteau, Paris n. 10, La Partie d'Echecs		
1942		14.1 - 22.2 Yale University Art Gallery, New Haven (Inaugural) Modern Art from the Collection of the Société Anonyme: Museum of Modern Art 1920. n. 56, Revolving Glass structure		1944		8.2 - 12.3 Abstract and Surrealist Art in the United States, Art Museum, Cincinnati (travelling exhibition) n. 73, Selection from "Boîte-en-valise"	
		20.5 United Nation Festival, Museum of Art, Santa Barbara - Nude descending a Stair n. 2				19.2 - 18.3 Color and Space in Modern Art since 1900, Mortimer Brandt Gallery, New York City n. 25, Les Joueurs d'échecs n. 26, Le Passage de la Vierge à la Mariée n. 27, Boîte-en-valise	
		14.10 - 7.11 First Papers of Surrealism, 451, Madison Av., New York City - A la manière de Delvaux - Cimetière des Uniformes et Livrées				26.3 - 23.4 Art Museum, Denver (Abstract and Surrealist Art in the USA)	
		20.10 Opening for the Benefit of the American Red Cross, Art of this Century, New York City - Sad young Man in a Train - Valise containing miniature reproductions of the complete works of Marcel Duchamp				7.5 - 10.6 Art Museum, Seattle (Abstract and Surrealist Art in the USA)	
		30.11 - December Joseph Cornell, Marcel Duchamp, Laurence Vail, Art of this Century, New York City - Box - Valise				May-June Museum of Art, Santa Barbara (Abstract and Surrealist Art in the USA)	
1943		13.3 - 10.4 Paintings, 15 Early, 15 Late, Art of this Century, New York City n. 209, Sad young Man in a Train				24.5 - 15.10 Art in Progress, a survey prepared for the Fifteenth Anniversary, The Museum of Modern Art, New York City [The Large Glass]	
		16.4 - 15.5 Exhibition of Collage, Art of this Century, New York City				July Museum of Art, San Francisco (Abstract and Surrealist Art in the USA)	
		7.12 "Through the Big End of the Opera Glass"; Marcel Duchamp, Yves Tanguy, Joseph Cornell, Julien Levy Gallery, New York City - Box - Valise (n. X/XX)				12.12 The Imagery of Chess, Julien Levy Gallery, New York City - Miniature Chess Board with rubber glove	
				1945		1.3 - 1.4 Duchamp, Duchamp-Villon, Villon, Yale University Art Gallery, New Haven	

	FRANCE	USA	OTHER COUNTRIES
1935		Vassar College, New York (8 Modes)	
1936	22.5 - 31.5 Exposition Surréaliste d'objets, Charles Ratton, Paris - Porte Bouteilles [first replica] - Why not sneeze, Rrose Sélavy? - La Bagarre d'Austerlitz	2.3 - 19.4 Cubism and Abstract Art, The Exhibition, New York Museum of Modern Art, New York City (travels to San Francisco) n. 57, Nude descending a Staircase n. 58, The Bride n. 59, The Bachelors n. 60, Disturbed Balance n. 61, Six roto-reliefs 26.6 - 12.10 The Twentieth Anniversary Exhibition, Museum of Art, Cleveland n. 316 Nude descending a Staircase 5.8 Cubism and Abstract Art...., San Francisco **1936 1937** 9.12 - 17.1 Fantastic Art Dada Surrealism, The Museum of Modern Art, New York City n. 216, Coffee mill n. 217, The Bride n. 218, The King and Queen traversed by Swift nudes n. 219, Pharmacy n. 220, The Bachelors n. 221, Ready-made (photo) n. 222, Rotating apparatus n. 223, 3 Stoppages-étalon n. 224, Why not sneeze? n. 225, Monte Carlo share n. 225 a-e, Roto-Reliefs	11.6 - 4.7 - **Great Britain** The International Surrealist Exhibition, New Burlington Galleries, London n. 78, The King and Queen crossed rapidly by Nudes n. 79, Chemist's Shop n. 80, About a Young Sister n. 81, Roto Relief
1937		5.2 - 27.2 Exhibition of Paintings by Marcel Duchamp, The Arts Club, Chicago n. 1, Nude descending the Stairs n. 1 n. 2, Nude descending the Stairs n. 2 n. 3, The King and Queen traversed by Swift Nudes n. 4, Sonata n. 5, The Chocolate Grinder n. 6, The Bachelors n. 7, Water color study for "The King and Queen traversed by Swift Nudes"	

	FRANCE	USA	OTHER COUNTRIES
1937	12.3 - 31.3 Exposition organisée par *Orbes*, au bar "La cachette", Paris - La Mariée mise à nu par ses célibataires, même (boîte verte) May Gradiva, Paris (exposition inaugurale)	n. 8, Jeune Homme triste dans un train n. 9, Le Passage de la Vierge à la Mariée 15.10 - 15.12 Los Angeles n. 148, Nude descending a staircase n.2	Spring - **Netherlands** Exposition Internationale du Surréalisme, Galerie Robert, Amsterdam n. 37, La Mariée mise à nu par ses célibataires, même (livre-boîte) n. 38, Couverture cigarettes (1936) photographie en couleurs du "dé" de Georges Hugnet 3.11 - 26.11 - **Great Britain** Exhibition of Collages, papiers collés and photomontages, Guggenheim Jeune, London n. 28, Obligation
1938	17.1 - February Exposition Internationale du Surréalisme, Galerie Beaux-Arts, Paris n. 62, Pharmacie n. 63, Neuf moules mâlic n. 64, La Bagarre d'Austerlitz n. 65, Rrose Sélavy et moi... (Rotary) n. 66, Ready made, 1914	6.11 - 11.12 Contemporary Movements in European Painting, Museum of Art, Toledo n. 30, Nude descending a staircase 18.2 - 2.12 Golden Gate, San Francisco - Nude descending a staircase n. 2 10.5 - 30.9 Art in our time, The Museum of Modern Art, New York City n. 176, Young Man in a Train	
1939	10.5 - 3.6 Témoignage, Galerie Matières, Paris - disques optiques 17.6 Guillaume Apollinaire et ses peintres, Galerie de Beaune, Paris	9.11 - 17.12 Some New Forms of Beauty 1909-1936, a selection of the Collection of the Société Anonyme - Museum of Modern Art, 1920. The George Walter Vincent Smith Gallery, Springfield (travelling exhibition) n. 15, Revolving Glass	
1940		4.1 - 4.2 Wadsworth Atheneum, Hartford (Some New Forms of Beauty)	

	FRANCE	USA	OTHER COUNTRIES
1927		25.1 - 5.2 International Exhibition of Modern Art assembled by Société Anonyme, The Anderson Galleries, New York City n. 51, Peau Brune	
1928		5-8.2 The John Quinn Collection, American Art Galleries, New York City	
1930	March Exposition de Collages, Galerie Goemans, Paris n. 6, L.H.O.O.Q. (1919) n. 7, L.H.O.O.Q. (1930) n. 8, Pharmacie n. 9, Eau de voilette n. 10, Roulette de Monte-Carlo	17.4 (Examples of Cubist painting with Modern Sculpture shown to illustrate Pr. Joseph Pijoan's lecture), Rembrandt Hall, Pomona College, Pomona - Nude descending the Staircase 7.4 - 30.4 Cubism 1910-13, De Hauke Galleries, New York City n. 28, Nude descending a Staircase	
1931			25.4 - 24.5 - **Belgium** L'art vivant en Europe, Palais des Beaux-Arts, Bruxelles n. 292, Une glissière contenant un moulin à eau
1932	23.4 - 14.5 L'époque héroïque du Cubisme (1910-1914), Galerie Jacques Bonjean, Paris - Mariée - Passage de la Vierge à la Mariée - Joueurs d'échecs	29.1 Surrealism Paintings, Drawings & Photographs, Julien Levy Gallery, New York City	
1933	7.6 - 18.6 Exposition Surréaliste. Sculptures-Objets-Peintures-Dessins, Pierre Colle, Paris n. 13, Pharmacie	1.6 - 1.11 A Century of Progress Exhibition of Painting and Sculpture, The Art Institute, Chicago n. 773, Nude descending the Stairs	12.5 - 3.6 - **Belgium** Exposition Minotaure, Palais dss Beaux-Arts, Bruxelles n. 44, Le Roi et la Reine traversés par des nus en vitesse
1934		3-26.4 Modern Paintings from the Collection of Mr. Earl Horter of Philadelphia, The Arts Club, Chicago n. 23, Nude descending the Staircase	

	FRANCE	USA	OTHER COUNTRIES
1934 1935		?, 8.6 - 8.7 French Painting from the Fifteenth Century to the Present Day, California Palace of the Legion of Honor, San Francisco n. 184, Nude descending the Stairs n. 185, The Sonata 8 Modes of Painting, Société Anonyme Inc. cooperating with the College Art Association (travelling exhibition) - Drawing for Big Glass 20.11 - 20.1 Modern Works of Art, Fifth Anniversary Exhibition, The Museum of Modern Art, New York City n. 164, Disturbed Balance 7.1 - 19.1 Dartmouth College, Hanover NH (8 Modes)	22.10 - 3.11 Julien Levy Gallery, New York City (8 Modes) 12.11 - 24.11 Lawrence Hall Museum, Williams College, Williamstown (8 Modes) 3.12 - 22.12 Taylor Hall Museum (8 Modes) 28.1 - 9.2 Sweet Briar College, Virginia (8 Modes) 19.2 - 24.3 Museum of Art, Cleveland (8 Modes) 7.4 - 28.5 Institute of Art, Detroit (8 Modes) 8.4 - 20.4 Florida State College (8 Modes)
1935	30.8 - 7.10 33e Concours Lépine, Parc des expositions, Porte de Versailles, Allée F (Stand 147), Paris - Rotorelief		10.5 - 24.5 - **Spain** Exposition internationale du Surréalisme, Ateneo, Santa Cruz n. 33, Farmacia n. 64, Espiral n. 65, Porqué no estornuda?

YEAR	FRANCE	USA	OTHER COUNTRIES
1916		4.4 – 22.4 Exhibition of Pictures by Jean Crotti, Marcel Duchamp, Albert Gleizes, Jean Metzinger, Montross Galleries, New York City n. 7, Chocolate grinder n. 8, Chocolate grinder n. 50, 2 Ready Mades n. 52a, Boxing match n. 23, Landscape n. 24, Yvonne et Magdeleine déchiquetées n. 25, Virgin n. 26, Portrait n. 27, Pharmacie	
1917		9.4 – 6.5 The Society of Independent Artists, 20 West 31st Street, New York City - Fountain (rejected) 17.5 – 15.6 Advanced Modern Art, McClees Galleries, Philadelphia - The King and the Queen surrounded by Swift Nudes	
1919		29.4 – 24.5 The Evolution of French Art, Arden Gallery, New York City n. 226, Nude Descending a Staircase n. 227, Combat de boxe n. 228, The King and the Queen	
1920		30.4 – 15.6 International Exhibition of Modern Art (inaugural), Société Anonyme, Inc. Gallery, New York City - Disturbed balance	
1921	6.6 – 30.6 Salon Dada. Exposition Internationale, Galerie Montaigne (Théâtre des Champs Elysées), Paris n. 28, n. 29, n. 30, n. 31	2.8 – 11.9 Third Exhibition, Société Anonyme, Inc. Gallery, New York City - With hidden Noise	
1921	1.11 – 20.11 Salon d'Automne, Grand Palais, Paris n. 1876, L'œil cacodylate by F. Picabia [inscribed by MD: en 6 qu'habilla Rrose Sélavy]		
1922		19.9 – 22.10 Exhibition of Paintings from the collection of the late Arthur Jerome Eddy, The Art Institute, Chicago n. 20, Chess players American Show, Belmaison, New York City	
1923		10.3 – 31.3 Exhibition (selected by Sheeler) works by Duchamp, Picasso, Braque, de Zayas, African Sculptures and next door photos by Sheeler, Whitney Studio Club Exhibition, New York City - Nude Descending a Staircase - The King and Queen surrounded by Swift Nudes - A propos of little Sister - Chocolate grinder n. 2 - The King and Queen traversed by Swift Nudes	
1924		9.1 – 1.2 An Exhibition of Modern French Art, Museum of Art, Baltimore n. 33, Le Passage	
1925		7 – 30.1 The John Quinn Collection of Paintings, Watercolors, Drawings & Sculpture, Art Center, New York City - Study of a Girl - Study for Nude Descending the Stairs - The Chess Players - Le Peau Brune	
1926 / 1927		19.11 – 1.1 International Exhibition of Modern Art assembled by Société Anonyme, Brooklyn Museum, Brooklyn (travels to New York City) n. 34, Disturbed Balance n. 35, Glass	

	FRANCE	USA	OTHER COUNTRIES
1911	n. 401, Jeune homme et jeune fille dans le printemps n. 402, Portrait 20.11 - 16.12 Exposition d'Art contemporain (Société Normande de Peinture Moderne), Galerie d'Art ancien & d'Art contemporain, Paris n. 9, Sonate		
1912	20.3 - 16.5 Société des Artistes indépendants, 28e exposition, Quai d'Orsay, Paris n. 1001, Nu descendant l'escalier n. 1002, Dessin 15.6 - 15.7 Société Normande de Peinture Moderne, 3e exposition, Grand skating, Rouen n. 113, Portraits n. 114, Portraits de joueurs d'échecs 1.10 - 8.11 10e Salon d'Automne, Grand Palais, Paris n. 506, Vierge 10.10 - 30.10 La Section d'Or, 64, rue La Boétie, Paris n. 17, Portrait de joueurs d'échecs n. 18, Le roi et la reine entourés de nus vites n. 19, Nu descendant un escalier		20.4 - 10.5 - **Spain** Exposició de Arte cubista, Galeries J. Dalmau, Barcelona n. 13, Sonata n. 14, Desnú baixant una escala
1913	n. 20, Peinture n. 21, Aquarelle n. 22, Le Roi et la Reine traversés par des nus vites	15.2 - 15.3 International Exhibition of Modern Art (Association of American Painters and Sculptors), 69th Regiment Armory, New York City (travels to Chicago and Boston) n. 239, King and Queen surrounded by nudes n. 240, Chess players n. 241, Nude figure descending a staircase n. 242 Sketch of a nude	

	FRANCE	USA	OTHER COUNTRIES
1913		24.3 - 16.4 International Exhibition of Modern Art, The Art Institute, Chicago n. 105, King and Queen surrounded by nudes n. 106, Chess players n. 107, Nude figure descending a staircase n. 108, Sketch of a nude 28.4 - 19.5 International Exhibition of Modern Art, Copley Hall, Boston n. 39, Nude figure descending a staircase n. 40, Sketch of a nude October-November Post-Impressionist Exhibition, Art Museum, Portland - Nude descending a staircase Vickery Atkins & Torrey, San Francisco - Nude descending a staircase	
1914 **1915**		December - 2.1 First Exhibition of Works by Contemporary French Artists, Carroll Galleries, New York City n. 44, Virgin	
1914		1.1 - 3.2 Second Exhibition: "French Modernists and Odilon Redon", Carroll Galleries, New York City Nu descendant un escalier, n. 1	
1915		8.3 - 3.4 Third Exhibition of Contemporary French Art, Carroll Galleries, New York City n. 15, Portrait n. 16, Chocolate grinder I n. 17, Chocolate grinder II n. 18, Chess players n. 19, Study of a girl	
1916		3.4 - 29.4 Modern Art after Cezanne, Bourgeois Gallery, New York City n. 5, The King and Queen surrounded by swift nudes n. 6, Celibated utensil	

	FRANCE	USA	OTHER COUNTRIES
1907	25.5 – 30.6 Salon des artistes humoristes, Palais de Glace, Paris - Inquiétude de cocu - Le lapin - Femme cocher - Flirt - Les toiles de Jouy 7.3 – 5.4 Société des Artistes Rouennais, 2e exposition, Musée de Peinture, Rouen n. 83, Etude d'enfant n. 84, Sur le balcon n. 85, Paysage d'automne n. 429, Scène de ménage n. 430, Femme cocher, tarif horo-kilométrique		
1908	10.5 – 30.6 2e Salon des humoristes, Palais de Glace, Paris n. 6, Digestion n. 7, American Bar n. 8, Gigolo de luxe n. 9, Croquis 1.10 – 8.11 6e Salon d'Automne, Grand Palais, Paris n. 599, Portrait n. 600, Cerisier en fleurs n. 601, Vieux cimetière		
1909	27.2 – 30.3 Société des Artistes Rouennais, 3e exposition, Musée de Peinture, Rouen n. 102, Vieux cimetière 25.3 – 2.5 Société des Artistes indépendants, 25e exposition, Jardin des Tuileries, Paris n. 525, Saint-Cloud n. 526, Paysage 1.10 – 8.11 7e Salon d'Automne, Grand Palais, Paris n. 458, Etude de nu n. 459, Veules (Eglise) n. 460, Sur la falaise		

	FRANCE	USA	OTHER COUNTRIES
1909 1910	20.12 – 20.1 Société de Peinture moderne, 1e exposition, 65 rue Ganterie, Rouen n. 19, Eglise de Veules n. 20, Falaises n. 21, Bords de Seine n. 22, Saint-Sébastien n. 23, Nuit blanche n. 24, Digestion n. 25, Belle-mère		
1910	18.3 – 1.5 Société des Artistes indépendants, 26e exposition, Cours la Reine, Paris n. 1581, Etude de nu n. 1582, Etude de nu n. 1583, Nature morte n. 1584, Masque 9.4 – 9.5 Société des Artistes Rouennais, 4e exposition, Musée de Peinture, Rouen n. 204, Etude de nu 1.10 – 8.11 8e Salon d'Automne, Grand Palais, Paris n. 346, Partie d'échecs n. 347, L'armoire à glace n. 348, Paysage n. 349, Nu couché n. 350, Toile de Jouy		
1911	21.4 – 13.6 Société des Artistes indépendants, 27e exposition, Quai d'Orsay, Paris n. 1958, Le buisson n. 1959, Falaise n. 1960, Paysage 6.5 Société Normande de Peinture Moderne, 2e exposition, 41, rue du Gros Horloge, Rouen n. 13, Partie d'échecs n. 14, Portrait n. 15, Figure 1.10 – 8.11 9e Salon d'Automne, Grand Palais, Paris		

INDEX OF WORKS

Index to the Catalogue and to the Ephemerides of the works by Marcel Duchamp and Rrose Sélavy

The title of the work is followed by the year in which the work was made (and the translation of the title when appropriate); the date in square brackets on the right refers to the principal entry for the work in the Ephemerides; when the work is illustrated in the Catalogue, the page number is given for reference. The works exhibited in the exhibition are printed in bold and those which have been lost, or remain unidentified, are marked #.

Index of Works